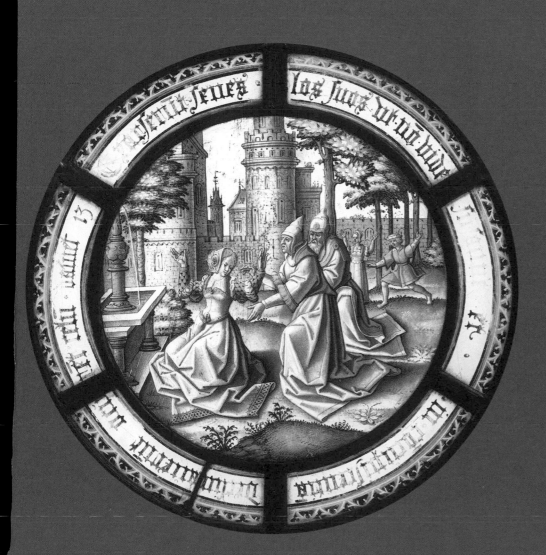

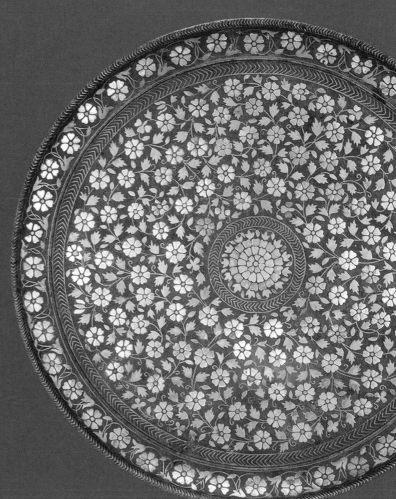

History of Design

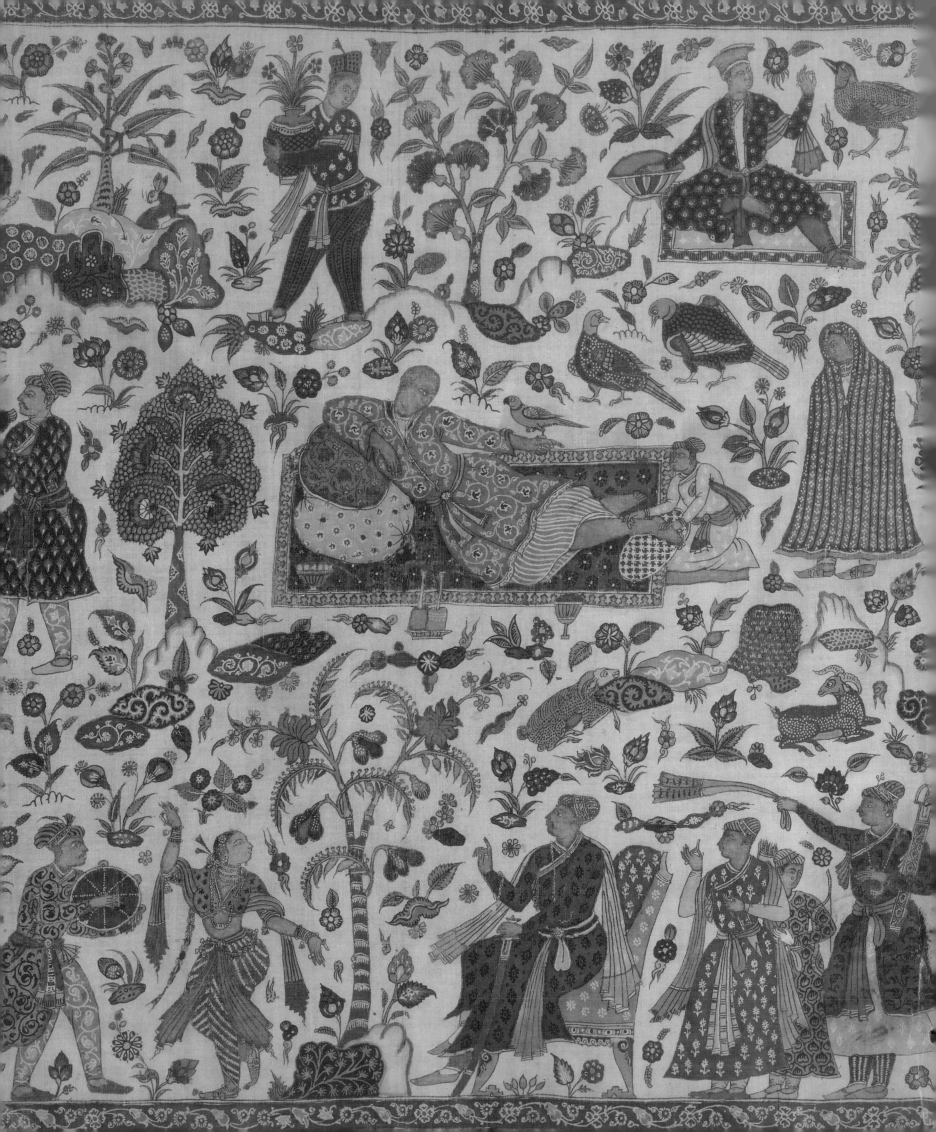

Pat Kirkham
Susan Weber

EDITORS

THE BARD GRADUATE CENTER

History of Design

DECORATIVE ARTS AND MATERIAL CULTURE, 1400–2000

PROJECT EDITOR
Heather Jane McCormick

WITH CONTRIBUTIONS BY

John Robert Alderman

Marcus B. Burke

Silke Bettermann

Jeffrey Collins

Aimée E. Froom

Annette Hagedorn

David Jaffee

Rose Kerr

Pat Kirkham

Patricia Lara-Betancourt

Christian A. Larsen

Dana Leibsohn

Sarah A. Lichtman

Andrew Morrall

George Michell

Barbara E. Mundy

Amy F. Ogata

Jorge F. Rivas Pérez

Maria Ruvoldt

Tomoko Sakomura

Enid Schildkrout

Lee Talbot

Sarah Teasley

Carol Thompson

Tom Tredway

Norman Vorano

Catherine L. Whalen

PUBLISHED BY

Bard Graduate Center: Decorative Arts,
Design History, Material Culture
NEW YORK

Yale University Press
NEW HAVEN AND LONDON

Project Director: Pat Kirkham
Project Editor: Heather Jane McCormick
Senior Manuscript Editor: Martina D'Alton
Managing Editor (2009–11): Sarah B. Sherrill
Design: Rita Jules, Miko McGinty Inc.
Typesetting: Tina Henderson

Printed in China

LIBRARY OF CONGRESS CATALOGING-IN-PUBLICATION DATA
History of design : decorative arts and material culture, 1400–2000 /
[edited by] Pat Kirkham and Susan Weber.
 pages cm
Includes bibliographical references and index.
ISBN 978-0-300-19614-6 (hardback)
1. Decorative arts—History. I. Kirkham, Pat, editor of compilation.
II. Weber, Susan, 1954– editor of compilation.
NK600.H57 2013
745—dc23
 2013019464

Cover illustrations
 Front: fig. 19.20. Kimono, Japan, 1900–50. Museum of Fine
 Arts, Boston.
 Back (from top left to bottom right): figs. 18.4; 8.30; 23.77; 7.30;
 23.80; 6.15; 23.48; 16.8; 10.12; 22.8; 11.37; 19.25; 3.28; 9.14; 12.34
Endpapers (left to right)
 Front: figs. 23.10; 3.6; 5.18; 8.30
 Back: figs. 8.34; 1.7; 5.1; 11.25
Frontispiece: fig. 8.22. Cover, Deccan, 1640–50. The Metropolitan
 Museum of Art.
pp. vi–vii: fig. 17.14. Giovanni Battista Piranesi, Egyptian-style
 chimneypiece, 1769.

This book has been typeset in Mercury and Ideal Sans designed
by Jonathan Hoefler and Tobias Frere-Jones, winners of the 2013
American Institute of Graphics Arts Medal. Mercury, released
in 1996, is a contemporary font family inspired by the spirited
forms of Dutch Baroque typefaces, including the punches cut by
Johann Michael Fleischman (1701–1768). Ideal Sans, released
in 2011, engagingly incorporates the clarity of sans serif letterforms
with humanist proportions and modulated strokes suggesting
hand craftsmanship.

The Bard Graduate Center gratefully acknowledges
The Tiffany & Co. Foundation for its leadership support
of this publication.

THE TIFFANY & CO. FOUNDATION

Additional funds were generously given by The Sherrill Foundation
and Fundación Cisneros/Colección Patricia Phelps de Cisneros.

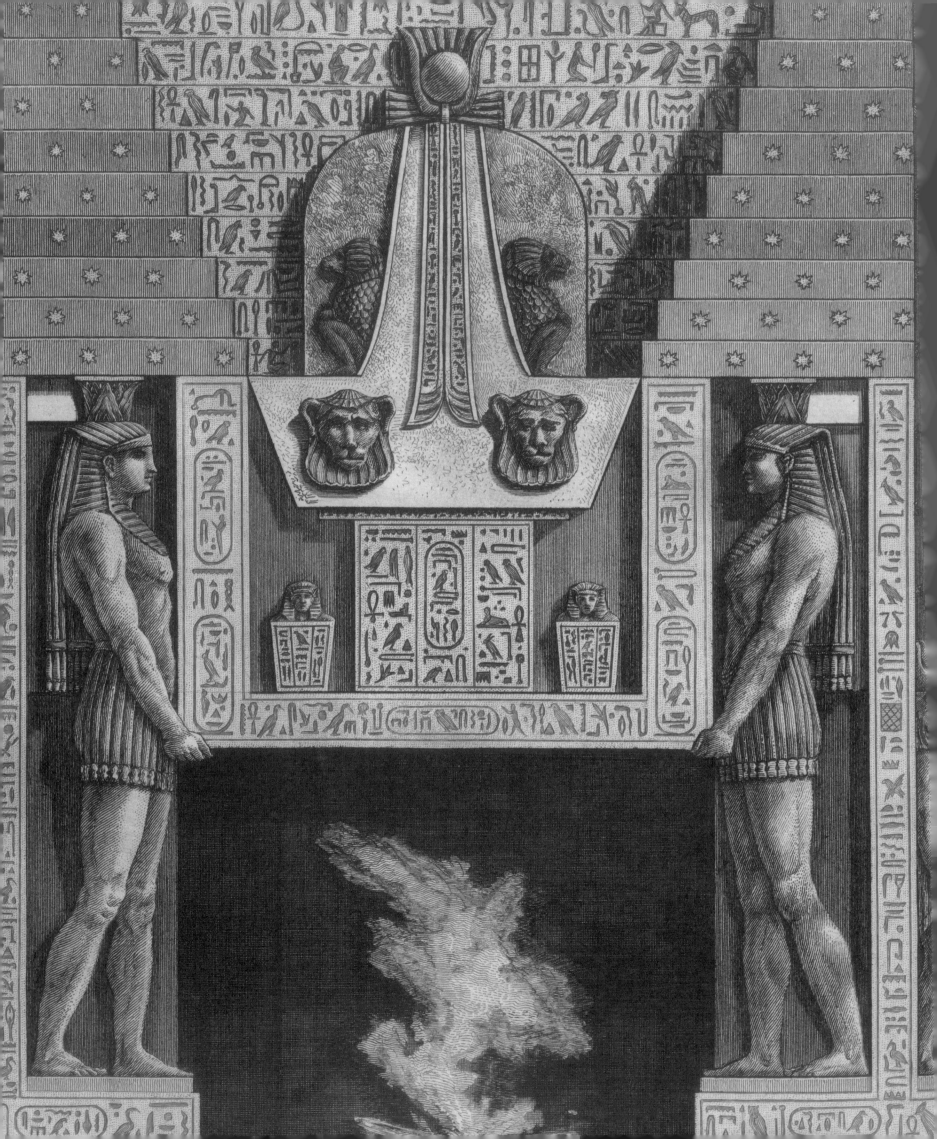

CONTENTS

1400–1600

1600–1750

1750–1900

1900–2000

RESOURCES

CONTRIBUTORS

JOHN ROBERT ALDERMAN—Independent art historian and writer on India, contributor to *African Elites in India* (2006), and author of numerous book reviews about India.

MARCUS B. BURKE—Senior Curator, The Hispanic Society of America, New York, has written extensively on Spanish and Latin American art and culture. Publications range from *Spain and New Spain* (1979) to *El Alma de España / The Soul of Spain* (2005) and "The Madrazo-Fortuny Family" in *Fortuny y Madrazo: An Artistic Legacy* (2012).

SILKE BETTERMANN—Librarian and scholar at the Beethoven-Haus, Bonn, specializing in correlations between fine arts and music. Publications include *Naoum Aronson und Ludwig Van Beethoven* (2002), "Oriental Themes in the Work of Moritz Von Schwind," in *Facts and Artefacts: Art in the Islamic World* (2007), and *Beethoven im Bild* (2012).

JEFFREY COLLINS—Professor and Chair of Academic Programs, Bard Graduate Center. Publications include *Papacy and Politics in Eighteenth-Century Rome: Pius VI and the Arts* (2004), *Pedro Friedeberg* (contributing author, 2009), and studies of painting, prints, sculpture, architecture, urbanism, museology, furniture, and film.

AIMÉE E. FROOM—Independent scholar, formerly Hagop Kevorkian Associate Curator of Islamic Art, Brooklyn Museum, New York, and former visiting professor at Brown University and the Bard Graduate Center. Publications include *Spirit and Life: Masterpieces of Islamic Art from the Aga Khan Museum Collection* (2007) and *Persian Ceramics from Collections of the Asian Art Museum* (2008).

ANNETTE HAGEDORN—Independent scholar specializing in Islamic applied arts and European Orientalism in the decorative arts. Publications include *Auf der Suche nach dem neuen Stil: Die Einflüsse der osmanischen Kunst auf die europäische Keramik im 19. Jahrhundert* (1998), *The Phenomenon of "Foreign" in Oriental Art* (editor, 2006), and *Islamic Art* (2009).

DAVID JAFFEE—Professor and Head of New Media Research, Bard Graduate Center, specializes in North American material culture. Publications include *The New Nation of Goods: Material Culture in Early America* (2010) and numerous essays on early American artisans and the visual and material culture of nineteenth-century New York.

ROSE KERR—Honorary Associate of the Needham Research Institute, Cambridge, has written widely on Asian art and design. Publications include *Ceramic Technology: Science and Civilisation in China* (2004), *Song China Through 21st Century Eyes* (2009), and *Chinese Export Ceramics* (2011).

PAT KIRKHAM—Professor, Bard Graduate Center; Editorial Board: *Journal of Design History* (1988–1999). She has written widely on design, gender, film, and material culture. Publications range from *The London Furniture Trade* (1988) to *The Gendered Object* (editor and contributing author, 1996), *Women Designers in the USA, 1900–2000* (editor and contributing author, 2000), and *Saul Bass: A Life in Design and Film* (2011).

PATRICIA LARA-BETANCOURT—Research Fellow, the Modern Interiors Research Centre, Kingston University, London. Publications include *Performance, Fashion and the Modern Interior* (co-editor, 2011) and articles on the history of the nineteenth-century drawing room in Colombia.

CHRISTIAN A. LARSEN—Doctoral candidate and Curatorial Fellow, Bard Graduate Center; former Assistant Curator, Department of Architecture & Design, Museum of Modern Art, New York. Publications include *Digitally Mastered* (2006–7), *50 Years of Helvetica* (2007–8), and *Ateliers Jean Prouvé* (2008–9).

DANA LEIBSOHN—Professor, Art Department, Smith College, specializes in indigenous visual culture in Spanish America and trans-Pacific trade in the early modern period. Publications include *Script and Glyph* (2009) and *Vistas: Visual Culture in Spanish America, 1520–1820* (with Barbara E. Mundy, 2010).

SARAH A. LICHTMAN—Assistant Professor of Design History, Parsons, The New School for Design, New York. Publications include articles and reviews in *The Journal of Design History, Studies in the Decorative Arts, Design and Culture,* and *West 86th.*

ANDREW MORRALL—Professor, Bard Graduate Center; has written widely on the arts and culture of early modern northern Europe. Publications include *Jörg Breu the Elder: Art, Culture and Belief in Reformation Augsburg* (2002) and *English Embroidery from The Metropolitan Museum of Art, 1580–1700: 'Twixt Art and Nature* (co-editor and contributing author, 2008).

GEORGE MICHELL—Independent scholar, trained as an architect and studied Indian art and archaeology at the School of Oriental and African Studies, London. His publications range from two volumes of *The New Cambridge History of India* (1993, 1995) to *Hindu Art and Architecture* (2000) and *The Majesty of Mughal Decoration* (2007).

BARBARA E. MUNDY—Associate Professor, Art History, Fordham University, New York. Publications include *The Mapping of New Spain* (1996), *Vistas: Visual Culture in Spanish America, 1520–1820* (with Dana Leibsohn, 2010), *Remembering Tenochtitlan: The Transformation of Mexico City* (forthcoming).

AMY F. OGATA—Professor, Bard Graduate Center, has written widely on European and American modern architecture and design. Publications include *Art Nouveau and the Social Vision of Modern Living: Belgian Artists in a European Context* (2001) and *Designing the Creative Child: Playthings and Places in Midcentury America* (2013).

JORGE F. RIVAS PÉREZ—Curator, Colección Patricia Phelps de Cisneros. Publications include *Arte del Período Hispánico Venezolano* (2000), *Devoción Privada* (2004), *El Repertorio Clásico en el Mobiliario Venezolano* (2007), *De Oficio Pintor* (2007), and *Cornelis Zitman* (2011).

MARIA RUVOLDT—Assistant Professor, Fordham University, New York. Publications include *The Italian Renaissance Imagery of Inspiration: Metaphors of Sex, Sleep, and Dreams* (2004), *Approaching the Italian Renaissance Interior* (contributing author, 2007), and "Michelangelo's Slaves and the Gift of Liberty" (*Renaissance Quarterly*, 2012).

TOMOKO SAKOMURA—Associate Professor of Art History, Swarthmore College, specializes in the visual culture of late medieval Japan and the relationships between text and image in Japanese art and design. Contributing author to *Kazari: Decoration and Display in Japan, 15th–19th Centuries* (2002), *Asian Games: The Art of Contest* (2004), and *The Golden Journey: Japanese Art from Australian Collections* (2009).

ENID SCHILDKROUT—Curator Emerita, American Museum of Natural History, New York, and former Director of Exhibitions and Publications, Museum for African Art, New York. Publications include *African Reflections: Art from Northeastern Zaire* (1990), *Grass Roots: African Origins of American Art* (2008), and *Dynasty and Divinity: Ife Art in Ancient Nigeria* (2009).

LEE TALBOT—Curator, Eastern Hemisphere Collections, The Textile Museum, Washington, DC, and doctoral candidate, Bard Graduate Center. Publications include *Threads of Heaven: Textiles in East Asian Rituals and Ceremony* (2006) and *Woven Treasures of Japan's Tawaraya Workshop* (2012).

SARAH TEASLEY—Reader in Design History and Theory, Royal College of Art, London. She has written widely on design and architecture in modern and contemporary Japan. Publications include *Global Design History* (co-editor, 2011) and *Designing Modern Japan* (2013).

CAROL THOMPSON—The Fred and Rita Richman Curator of African Art, High Museum, Atlanta. Exhibitions and publications include: *African Art Portfolio, An Illustrated Introduction* (1993), *For This World and Beyond* (2002), and *Radcliffe Bailey: Memory as Medicine* (2011).

TOM TREDWAY—Doctoral candidate, Bard Graduate Center. Author of several book chapters and articles on twentieth-century designers and architects, including Eva Zeisel, Elsa Schiaparelli, and Paul Rudolph.

NORMAN VORANO—Curator of Contemporary Inuit Art, Canadian Museum of Civilization; has lectured, taught, and published widely on Indigenous North American arts, museum studies, and modernism. Publications include *Inuit Prints, Japanese Inspiration: Early Printmaking in the Canadian Arctic* (2011) and *Creation and Transformation: Defining Moments in Inuit Art* (contributing author, 2013).

SUSAN WEBER—Director, Founder, and Iris Horowitz Professor, Bard Graduate Center. She has served as editor or co-editor and contributing author to a range of publications, including *E.W. Godwin: Aesthetic Movement Architect and Designer* (1999), *James "Athenian" Stuart, 1713–1788: The Rediscovery of Antiquity* (2006), *The American Circus* (2012), and *William Kent: Designing Georgian Britain* (2013).

CATHERINE L. WHALEN—Assistant Professor, Bard Graduate Center; has written and lectured widely on North American decorative arts, craft, and design; history and theory of collecting; gender and material culture; and vernacular photography.

DIRECTOR'S FOREWORD

Creating some form of textbook of decorative arts has been in the back of my mind since I founded the Bard Graduate Center for Studies in the Decorative Arts (BGC) in 1993. I realized that to expand the range of graduate and undergraduate courses addressing the decorative arts, we needed more pedagogical tools, and better ones. I remembered how central *Janson's History of Art* was to the survey courses I had taken while studying at Barnard College, and how, together, the book and the courses had provided me with a framework for further research. I envisaged a similar type of resource for our degree candidates at the BGC, and for students, teachers, and others outside the Center. There was simply nothing comparable at the time. This was largely because the examination of such things was seen as secondary to the exploration of the "fine arts" of painting, sculpture, and architecture. Indeed, to overturn this relegation of the decorative arts to a place of lesser importance was why I founded the BGC in the first place.

Publications have always been central to activities at the BGC (now the Bard Graduate Center: Decorative Arts, Design History, Material Culture). Over the past two decades, the Center has created pioneering exhibition catalogues; supported books by outside scholars; published the scholarly journal *Studies in Decorative Arts* (expanded in 2011 and relaunched as *West 86th*); and, most recently, inaugurated a monograph series entitled *Cultural Histories of the Material World*. The volume before you, which covers a period of six hundred years and was almost ten years in the making, is part of the BGC's continuing commitment to encouraging and facilitating studies of the decorative arts, design, and material culture.

In 2013, the BGC celebrates its twentieth anniversary as a Center for graduate studies, exhibitions, and publications. Looking back, I realize that our achievements have far outreached even my most ambitious aims. Without the vision and leadership of Leon Botstein, President of Bard College, the BGC would never have taken shape. He was a constant advisor even when the Center was little more than an abstract idea, and I want to thank him for all his help and guidance over the last two decades. Dean Peter Miller, under whom the Center has grown to its recent status as a research institute with a broad disciplinary, methodological, and geo-cultural scope, also deserves my thanks, as does Nina Strizler-Levine, Gallery Director, who for almost twenty years has guided our ground-breaking exhibitions programs. I also owe tremendous thanks to my fellow editor and the director of this particular project, Professor Pat Kirkham, who took on an enormous project with energy and enthusiasm. Her broad knowledge and insights helped to shape and refine this book at every stage, from the commissioning of the chapters to their final iteration.

As Director of the BGC, I gratefully acknowledge The Tiffany & Co. Foundation for its leadership role in supporting this publication and The Sherrill Foundation and Fundación Cisneros/Colección Patricia Phelps de Cisneros which generously provided additional funds. Finally, as the BGC celebrates its twentieth anniversary, an occasion this publication helps to mark, I want to thank everyone who believed in the Center's mission, and supported its development, as well as all those who are are contributing to its future growth.

Susan Weber
Iris Horowitz Professor, and
Founder and Director of the Bard Graduate Center

EDITORS' ACKNOWLEDGMENTS

For a project that has been in the making for nearly a decade we have many people to thank. The title of Project Editor does not begin to cover the extraordinary contribution of Heather Jane McCormick (who holds an MA and an MPhil from the BGC and is also a doctoral candidate here). She assisted us in many and varied ways, and her subject knowledge, love of the chase, wonderful people skills, and unfailing attention to detail have been central to the quality of this publication. We thank her from the bottom of our hearts, as we do Martina D'Alton, Senior Manuscript Editor, whose consummate skills and tenacity have done so much to shepherd yet another major BGC publication (our largest ever) to completion. Sally Salvesen, the BGC's longtime editor at Yale University Press in London, once again provided wisdom and guidance in the many decisions, small and large, faced by our team at every stage of publication. These three women are the very best and most professional and congenial of colleagues.

We were also blessed with designers who understood our many ambitions for this project: Rita Jules, who brought to the project much that she learned while gaining an MA at the BGC, and Miko McGinty, whose previous commissions have included editions of *Janson's History of Art*. Their design skills and aesthetic sensibilities shine through the beautiful book they have produced.

We count ourselves fortunate in that specialists from many countries and areas of interest graciously agreed to write for this project, and we extend our deepest appreciation to them: John Robert Alderman, Silke Bettermann, Marcus B. Burke, Jeffrey Collins, Aimée E. Froom, Annette Hagedorn, David Jaffee, Rose Kerr, Patricia Lara-Betancourt, Christian A. Larsen, Dana Leibsohn, Sarah A. Lichtman, Andrew Morrall, George Michell, Barbara E. Mundy, Amy F. Ogata, Jorge F. Rivas Pérez, Maria Ruvoldt, Tomoko Sakomura, Enid Schildkrout, Lee Talbot, Sarah Teasley, Carol Thompson, Tom Tredway, Norman Vorano, and Catherine L. Whalen.

Our thanks also to the consultants who took time out of busy schedules to advise us. They are: Kenneth L. Ames, Hazel Clark, Gustavo Curiel, Erin Eisenbarth, Aaron Glass, Stephan Heidemann, Amin Jaffer, Helena Kåberg, François Louis, Michele Majer, Sarah B. Sherrill, Caron Smith, and Paul Stirton. By the nature of their task, our peer reviewers and external readers must remain anonymous, but we thank you nonetheless for your suggestions and expertise.

We extend our appreciation to our copy editors, Margaret A. Hogan, Heidi Downey, Karyn Hinkle, and Jason Best, who did a wonderful job, as did our Photographic Rights Assistant, Emily Orr, proofreaders Caroline Hannah and Roberta Fineman, and typesetter Tina Henderson. Thanks also to those BGC faculty and guests who have contributed to our ever-evolving survey course, and whose knowledge and ideas helped shape this book. This project could not have been completed without the help of many other colleagues and collaborators at the BGC, including the Librarians and staff in Visual Media Resources, Dean Elena Pinto Simon, Izabella Elwart, Daniel Lee, Alexis Mucha, Earl Martin, Ivan Gaskell, Allison Ong, Deborah Tint, and Lynn Thommen, as well as BGC students Luke Baker, Tenann Bell, Yenna Chan, Martina D'Amato, William DeGregorio, Shoshana Greenwald, Craig Lee, and Sequoia Miller. Special thanks also to Fernanda Kellogg and Ann Pyne for their support throughout this project.

Last but not least, we thank all the private individuals as well as the many museums, libraries, picture agencies, and other institutions that have permitted us to publish images of items in their care. We are especially grateful to The Metropolitan Museum of Art and Brooklyn Museum in New York, and the British Museum and Victoria and Albert Museum in London.

EDITORS' INTRODUCTION

This book began with the idea of producing a series of introductory texts for students entering the Bard Graduate Center. We were expanding and reshaping our year-long "Survey of the Decorative Arts, Design and Material Culture: The Ancient World to the Present" (required of all entering MA students) in order to reflect the greater plurality of approaches that inform the BGC's work and reinforce its ambition to be the leading study center for the cultural history of the material world.

This project represents both a new direction for the BGC and a reaffirmation of the ideals that brought the institution into being. It was founded to address a gap in university curriculums in the United States which placed the decorative arts (sometimes referred to as the applied arts), if they considered them at all, within the contexts of art history and architectural history, while seeing them as secondary to the fine arts. The many rich and compelling histories offered by studies in decorative arts, design, and material culture stand at the heart of the BGC curriculum, and we hope that this publication will play its part in raising the profile of such studies.

The lack of a broadly based "textbook" or "survey book" on the model of those in other educational fields has often been commented upon, especially by students. Our intention is for this book to provide a platform on which to construct broad geo-cultural introductions to the study of decorative arts, design, and material culture at graduate and undergraduate levels, and to help familiarize students with a wide range of objects, contexts, materials, and techniques, as well as approaches and issues. We are not seeking to establish canons, but rather to give frameworks, encourage discussion, and point to fertile areas for further study and research. The book's title invokes "History," but there are many histories, and we envision the ones told herein taking their place alongside existing and future ones.

The diverse voices that shine through the chapters that follow indicate something of the variety of approaches between and within particular academic disciplines. Various approaches to the study of objects are evident. Some, for example, are associated with the academic disciplines of Art History and Architectural History, others with Anthropology, but all are informed by the various shifts within the discipline of History to include wider ranges of people, events, movements, and ideas than had previously been considered worthy of serious examination. Sometimes referred to as "history from below," this perspective challenged traditional hierarchies. In some circles, even the term "decorative arts" came under attack, in part because some curators and scholars focused so greatly upon elite objects that everything else seemed marginalized. As they emerged in the 1970s, two new disciplines—Design History and Material Culture Studies—both of which addressed the intersections between objects and culture and embraced sociological, ethnographic, and anthropological approaches to objects, neatly sidestepped accusations of elitism and marginalization while broadening the questions asked of objects, their appearance, production, and consumption. They also accommodated a wider range of objects—such as clothing, graphics, interiors, gardens, and theater and film design—not traditionally considered within the purview of the decorative arts. In the years since we began the project, the fields of study have further expanded, with a renewed interest in inter- and cross-disciplinarity. Post-disciplinary approaches to scholarship have also grown significantly. Art History and Architectural History have become more welcoming of Design History, Material Culture Studies, and "object studies" approaches. Many historians, philosophers, sociologists, literary scholars, and others now take greater notice of materiality, and this book, by its scope at least, contributes to current concerns for international, transnational, and global histories.

One of our challenges was to identify expert and adventurous scholars willing to write across broad swathes of time and place, including some relatively new areas of study. In some of the latter, such as the Americas, we felt that the material was best served by scholars working in teams. From the outset, we encouraged authors to address continuities as well as changes, in part to transcend Modernist narratives of innovation but also to stress the deep immersion of objects and ideas in broader cultural, ideological, socio-economic, and political contexts. Our contributors have been attentive to the ways design and the decorative arts enriched daily life, as well as to special ceremonies and rituals. Readers are encouraged to think about how prevailing ideas, tastes, technologies, materials, and traditions shaped the ways things looked and how they were fabricated, thought about, and used. The chapters that follow raise questions about hierarchies of value, relationships between "high" and "low" culture, the intersection of objects with notions of race, class,

status, and gender, as well as personal, regional, and national identities. When read together, the chapters presented here encourage attention to wide-ranging issues of manufacture, patronage, consumption, reception, cross-cultural appropriation, and cross fertilization.

Collaboration has been central to this project; indeed, all scholarship, especially surveys, builds upon what has gone before. We and all of our contributors remain deeply grateful to the teachers, peers, and students, both past and present, on whose research and ideas we have drawn and to whom we owe so much. We thank all the generations of scholars whose pioneering efforts in little-trodden, nontraditional, and sometimes unorthodox fields have made a project such as this not just thinkable but doable. It is only because of those who came before that we can offer this contribution to a burgeoning field of historical inquiry. If this project has taught us one thing, it is that we are all students with a great deal more to learn. We hope this book takes you, and us, some distance toward where we want to go.

Pat Kirkham, BGC Professor, Project Director, and Editor
Susan Weber, BGC Founder and Director, Professor,
 and Editor

EDITORS' NOTE TO THE READER

As the project took shape, it became clear that it would be beyond the scope of a single volume to explore every period, from antiquity to the present, while still preserving the desired level of detail and interpretive complexity. We therefore decided to begin our coverage in 1400. The six centuries this book addresses are divided into four chronological sections—1400–1600, 1600–1750, 1750–1900, and 1900–2000—and six geo-cultural areas, namely East Asia, India, the Islamic World (including North Africa), Africa (primarily sub-Saharan Africa), Europe, and the Americas. In future editions, we plan to include Australia/Oceania.

To help orient readers and guide those who wish to read continuously through chapters related to a particular area, pages are color-coded with a tab in the margin: East Asia, for example, is always ORANGE, Africa always TURQUOISE BLUE. This aids navigation within and across the four sections, as does the repetition of chapter number, title, and date at the foot of each page. The area chapters build on each other from section to section, with numerous cross-currents within and across the sections. Rather than burden the printed text with a plethora of cross-references, the index serves as a means of identifying thematic and historical connections. Wherever possible, we have included references to images in other chapters which help to reinforce these cross-cultural connections. The figure numbers begin with the chapter number; "fig. 20.3," for example, is the third illustration in chapter 20 (India 1900–2000).

Primarily for reasons of accessibility and ease of reading, we also decided not to encumber the texts with extensive notes or citations of the specific sources used in researching the texts. Only sources for direct quotations are given in endnotes, which start on page 660. Instead, further reading lists are provided for those seeking more information; many of these entries were consulted by the authors. Decorative arts terms and techniques are often explained in a general way when they are first mentioned, but readers in search of more detailed information will discover excellent resources online, such as the databases on the Getty Research Institute website, and again, our index will serve as a guide.

In the captions, the reader will find enough information to enhance their understanding of the object, particularly within the framework of this book. In general, we identify the designer(s) or maker(s) responsible for originating the object, give the title or a description of the piece illustrated, and state where and when it was made. We are sometimes able to identify others who contributed to the piece, such as craftspeople or manufacturers, and in a few places we have included inscriptions or other relevant information. Dimensions are arranged with height preceding width preceding depth. Occasionally a single dimension is used, with an abbreviation: L. (length), Diam. (diameter), and H. (height). The repository that owns an object is identified in the caption, but all photographic credits are listed separately at the end of the book.

Maps for each geographical area, starting on page 656, are intended to complement the text rather than provide the level of information available in a comprehensive historical atlas.

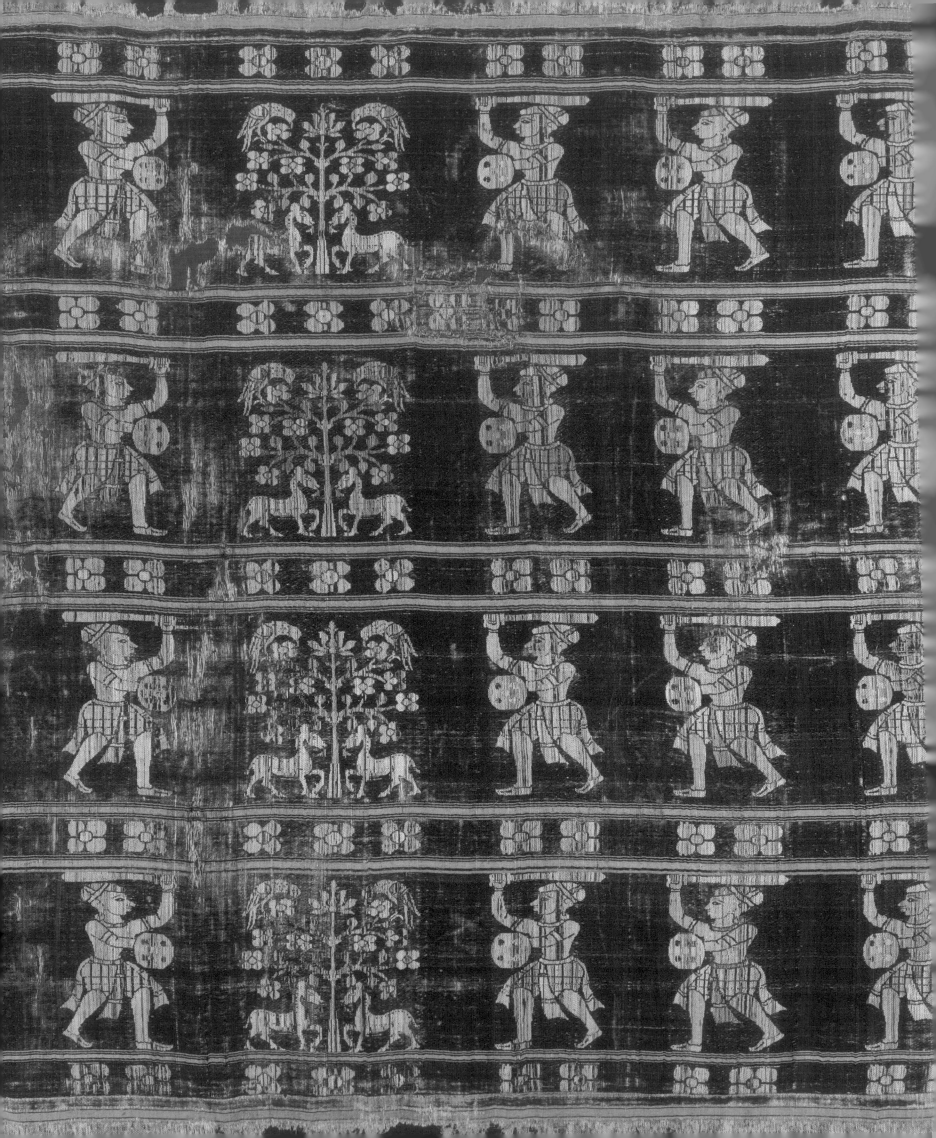

1400–1600

Fig. 2.13 detail

EAST ASIA

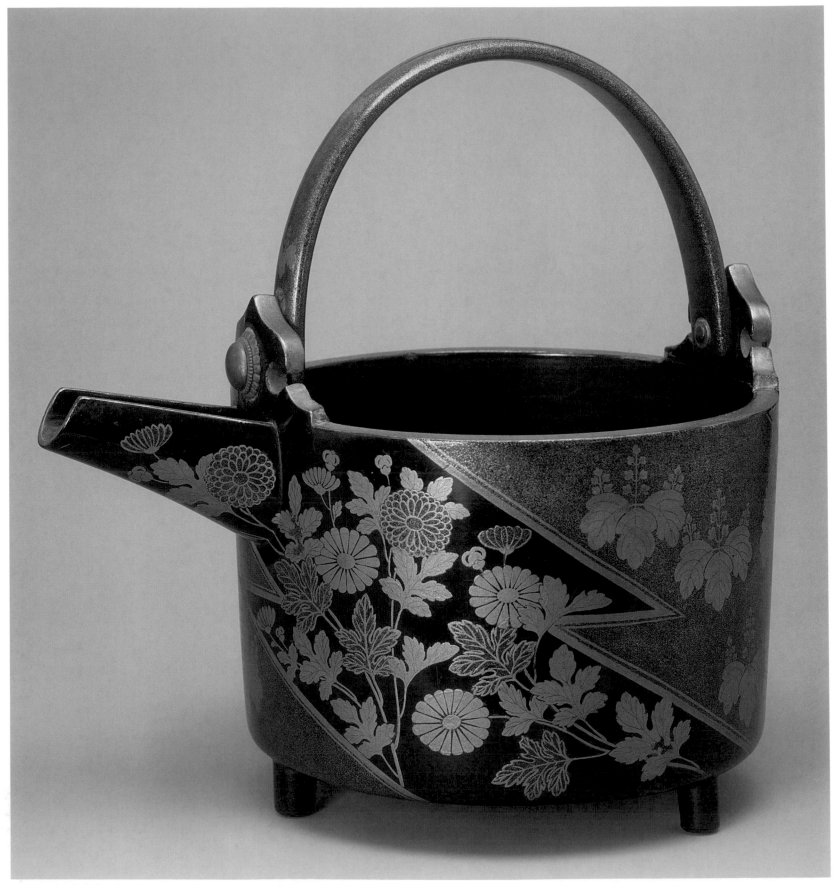

Fig. 1.28

CHINA

As early as the Late Neolithic period, ancestors of the Chinese people displayed an aptitude for transforming raw materials into objects of beauty and cultural significance. These Neolithic people made several remarkable discoveries: that the cocoons of the *Bombyx mori* moth could be unraveled and woven into silk; that the *Toxicodendron vernicifluum* tree could be tapped to obtain lacquer; that jadestones could be polished and shaped by grinding; and that clay could be fired to make pottery. These materials and processes remain important in Chinese decorative arts to the present day. Across the millennia, textiles, lacquerware, and ceramics not only served the daily needs of the Chinese people but also played important roles in the formation of personal identities and the forging of social and political relationships.

Finely made objects proclaimed their owners' temporal power and sacral efficacy. From the earliest historical record in the Shang dynasty (c. 1500–1046 BC) through the late nineteenth century, rulers and the states they controlled exerted control over the manufacture and distribution of luxury goods. By the time of the Han dynasty (206 BC–220 AD), large workshops mass-produced textiles, lacquers, ceramics, and bronzes in enormous quantity, and Chinese silks became fashionable with consumers as far away as the Roman Empire. For the next two thousand years, China remained one of the world's most prolific producers and exporters of high-quality manufactured goods, and craft production was a driving force in the Chinese economy. Dynastic China's accomplishments in artistic manufacture, technical innovation, and the quality of visual and material life were the achievements of a cohesive, highly ordered society held together by a common written language and an effective political organization. The Chinese script, in use since the Shang dynasty, transmitted knowledge and united people across place, dialect, and time, while the governmental system that developed over the centuries, in which the emperor presided over a complex pyramidical bureaucracy, administered the empire while harnessing its considerable human and material resources.

Between 1400 and 1600, emperors of the Ming dynasty (1368–1644) presided over the world's largest unified territory, population, and economy. Across the heterogeneous empire, homes and furnishings reflected their owners' wealth, social status, and taste as well as the local culture and climate; even "average" Ming citizens enjoyed a diverse material culture and a high standard of living compared with their counterparts elsewhere.

China's commercial expansion and cultural ebullience during this period owed much to the ambitions and energies of Zhu Yuanzhang (r. 1368–98), a former peasant and rebel leader who seized the imperial throne from the Mongol overlords in 1368 and declared himself the Hongwu (vast military) emperor of a new dynasty—the Ming (brilliant). The Hongwu emperor set about consolidating political and military power while rebuilding China's agricultural base and infrastructure, which lay decimated after decades of civil war. During his thirty-year reign, he set in motion economic and social transformations that affected the Chinese material world: the area of land under cultivation more than tripled; thousands of dikes, reservoirs, and canals were built and refurbished; faster-growing, higher-yielding strains of rice introduced; and over a billion trees planted to provide wood, fruit, and mulberry leaves (for silkworms).

All this stimulated commodity production. Merchants drew producers and consumers into sophisticated regional, national, and global commercial networks, and the new wealth created through these transactions further stimulated demand. As China's population almost tripled between 1400 and 1600, from approximately 65 million to nearly 200 million, so too the quantity and diversity of goods multiplied in response to the demands of the ever more numerous, increasingly urbanized and affluent populace.

Imperial patronage, particularly massive palace-building projects and the reestablishment of crafts workshops, propelled innovation in Chinese decorative arts and design during the early Ming period. The Hongwu emperor constructed and furnished an immense palace in his capital city of Nanjing, and when his son, the Yongle emperor (r. 1402–24), decided to transfer the capital to Beijing, the Ming state mobilized hundreds of thousands of laborers between 1406 and 1420 to build the enormous palace complex known today as the Forbidden City.

To create the vast quantities of objects required for the court's everyday, ritual, and diplomatic use, the Yongle emperor's imperial workshops overseen by the *Neiwufu* (Imperial Household Department) retained approximately 27,000 master craftsmen, many of whom had numerous assistants. Those who made designs for textiles, lacquers, porcelains, and other objects inherited the rich art and design traditions of the Mongol Yuan dynasty (1271–1368), when the synthesis of regional Chinese traditions and foreign influences from Central Asia, the Islamic world, the Himalayas, and other areas had introduced new forms, techniques, and motifs. Although the Hongwu and Yongle emperors professed the desire to eradicate lingering Mongol influence and return to "Chinese" traditions in social and material life, as will be seen below, the objects designed and made for them continued to reflect Yuan heritage as well as the empire's ongoing diplomatic, economic, and religious ties with other cultures.

The Ming imperial family and court acquired objects from workshops established within the palace; from state manufactories located across the empire; and from private workshops in areas with well-developed artisanal specialties. Many of the finest silks, for example, came from both state-owned and state-patronized manufactories in the southeastern cities of Suzhou, Hangzhou, and Nanjing, while porcelains came from imperial and private kilns in the Jingdezhen area of Jiangxi province. By commissioning objects from these geographically disparate workshops for delivery to the palace in Beijing, the court stimulated production, invigorated local and regional economies, and helped develop routes of transportation and communication. Furthermore, patterns created by court designers were disseminated to workshops throughout the empire and imitated by manufactories eager to meet the burgeoning demand of the status-conscious gentry and merchants.

During the early Ming period a corvée, or forced labor system, required the most highly skilled artisans to devote a fixed amount of time to the production of luxury goods for the imperial family and court. Until the middle of the sixteenth century, such craftsmen living in the capital had to work ten days per month in the imperial workshops. Those residing elsewhere were required to serve three months every three to four years. Since the same craftsmen and workshops often made objects for both the court and the wealthy, the sumptuous material culture enjoyed by these elite patrons became closely related. The objects and environments designed for the Ming imperial family and aristocracy—the former expanding from around sixty members at the beginning of the dynasty to as many as 100,000 by the end—thus established patterns of taste, consumption, and living emulated across the social spectrum.

Between 1400 and 1600, social boundaries in China became increasingly blurred in the wake of economic development, population growth, and the emergence of an urban bourgeoisie that began to displace the imperial family and aristocracy as the chief patrons of the decorative arts during the sixteenth century. Nonetheless, the vocabulary of forms, techniques, and designs that coalesced at the early Ming court remained current throughout the dynasty.

OBJECTS AS INDICATORS OF RANK AND SOCIAL STATUS

In certain objects, the forms, materials, and iconography visibly communicated the high social status and wealth of the owners (figs. 1.1–1.3). A strong correlation between the social and material worlds was a fundamental goal of the Hongwu emperor, who ordered his ministers to draft a wide-ranging program of laws and regulations aimed at defining the social hierarchy and the types of possessions allowed each social rank. Influential in early Ming thought, Neo-Confucian teachings maintained that the roots (*ben*) of the state lay in farming and textile production, and that the manufacture and trade of products other than necessities were relatively superfluous branches (*mo*). The ideal Neo-Confucian social

structure thus comprised four hierarchical ranks: two "roots" (the ruling class and farmers) and two lesser "branches" (the artisans and merchants). In the Neo-Confucian worldview, if each person knew his or her proper place in society, and acted appropriately within their roles, then order, peace, prosperity, and even cosmic harmony would prevail for all. Although the Mongols had discarded this hierarchy and introduced dozens of new social categories during the Yuan dynasty, the Hongwu emperor and his advisors reinstated the Confucian social template. Sumptuary laws articulated the specific forms, materials, colors, and ornament that were prescribed for the various social ranks for their homes and furnishings. Ming rulers hoped that by observing rules and demarcations related to dress, belongings, and dwellings, citizens would be able to distinguish one another's position in society immediately and to determine the appropriate manner in which individuals should be addressed and treated, thus ensuring politically, socially, and cosmologically advantageous interaction. As economic expansion gained momentum in the fifteenth and sixteenth centuries, however, the allure of certain types of goods proved stronger than the fear of state penalties, and, in the end, Ming rulers failed to fully enforce sumptuary laws, as did their counterparts issuing such legislation in contemporaneous Europe. Nonetheless, throughout the Ming period, finely crafted objects made of precious materials, often ornamented in patterns associated with court rank, remained potent expressions of their owners' affluence as well as of the power and privilege accompanying great wealth.

TEXTILES AND CLOTHING

Clothing was an immediate visual indication of an individual's social status. It was the subject of frequent comment and, of all the objects of material culture, was extensively discussed in sumptuary legislation. The fifteenth-century robe seen in figure 1.1 is a rare survival of early Ming production in fine silk, then the most costly and prestigious of fabrics. Hand-embroidered with over a million stitches, this garment was extremely valuable at the time, signaling the wearer's wealth.

Silk weaving and dyeing workshops were among the first state-owned manufactories to be reestablished by the Hongwu emperor. Silk not only clothed the upper classes and furnished their dwellings in suitable splendor but also served as a form of currency, a medium of tax payment, and a primary commodity in trade and diplomatic exchanges. Although a single silk garment such as that in figure 1.1 required three or more years of skilled labor to complete, state workshops manufactured 5,000 fine robes and 643,150 bolts of silk during the 18-year reign of the Hongzhi emperor (r. 1487–1505) alone. Even then, they could produce only about half of the luxury silks required by the court; private silk manufactories supplied the remainder.

Innovations such as improved looms and more productive varieties of mulberry trees further encouraged the development of China's silk industry, which became the largest and most technically advanced in the world. Silk remained China's primary export throughout the Ming period, and for-

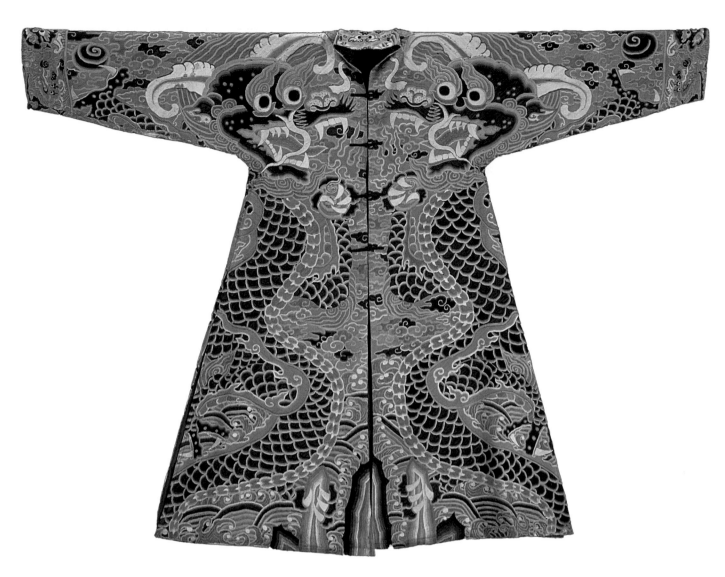

Fig. 1.1. Robe, China, c. 1450. Embroidered silk; 48 x 66⅛ in. (122 x 168 cm). Chris Hall Collection, Asian Civilisations Museum, Singapore (CH 110).

eign currency, especially the Japanese and Spanish-American silver that flowed into the Chinese market through trade, helped fuel the economic expansion and accumulation of wealth that further transformed Ming society in the sixteenth and seventeenth centuries.

To eliminate residual Mongol influence in sartorial styles and to strengthen visual matters of social distinction, the Hongwu emperor ordered the circulation of patterns for particular garments and hats deemed acceptable for the upper class, while court artists designed a range of motifs intended to signify various ranks in the social hierarchy. For example, *long* (five-clawed dragons) denoted the emperor and his immediate family, while the dramatically posed *dou niu* (literally "dipper ox") seen on this robe identified the wearer as a high-ranking courtier or an imperially favored subject. In 1447 the Zhengtong emperor (r. 1435–49) ordered the death penalty for those unlawfully manufacturing silk robes with restricted patterns, but colorful silk garments were extremely desirable luxury goods among the urban wealthy, and literary sources reveal that such garments remained readily available for purchase by those who could afford them. Ming writers mention that some weaving workshops creatively circumvented sumptuary laws by manipulating designs to resemble forbidden patterns without actually replicating them.

Fine silks represented a significant store of wealth, and as such played important social roles in the creation and extension of *guanxi* (connections), the web of mutually beneficial interpersonal relationships maintained by gifts and favors. The Ming Chinese expressed all human relationships in terms of hierarchical reciprocity, and thus the presentation of gifts was a significant factor in the distribution of luxury goods. Ming novels such as the late fifteenth-century *Jin Ping Mei* (The Plum in the Golden Vase) chronicle the utility of silk bolts and garments as "bribes" for securing favors, a phenomenon underscored by the inventory of the disgraced Grand Secretary Yan Song (1480–1567), who accumulated 14,331 textile bolts and 1,304 silk robes during his tenure in the sixteenth century. The emperor bestowed fine silks on loyal subjects and respected clergy as tokens of imperial favor. Gifts of luxury objects such as silk and lacquerware played a crucial role in Ming China's diplomatic relations with neighboring countries; indeed, gifts of silk had served to appease China's more belligerent neighbors since at least the Han dynasty. In Ming China, textile production played as crucial a role as weapons technology in maintaining the empire's political and military might, and the state's enormous financial outlay on the manufacture and acquisition of silk—as much as 10 percent of total state revenue—represented an essential expenditure on legitimacy, loyalty, and power.

JADE

Ming-dynasty Chinese valued jade over gold or precious stones for personal jewelry, and they prized finely worked jades not only for the aesthetic appeal and rarity of the material but also for the prodigious amount of time and effort required to shape this extremely hard stone. Imbued with great cultural significance over the millennia, it was variously attributed the power to ward off evil, prolong life, and bestow virtue on its users. The sixteen jade plaques shown in figure 1.2, shaped in openwork designs of dragons among flowers, originally would have been attached to a textile or leather belt. The Chinese first began to decorate belts with carved jade stones during the third to fourth century, and by the Tang dynasty (618–906) sumptuary laws restricted the use of jade-ornamented belts to the highest ranks of society.

Belts with multiple jade plaques largely fell out of fashion during the Yuan dynasty, but they regained popularity during the early Ming when the Hongwu emperor revived native Chinese styles. Although legislation entitled only the emperor, princes, and first-rank officials to wear jade-ornamented belts, the emperor could bestow this privilege on anyone he chose, and among upper-class men of the Ming period, elaborately decorated belts became the predominant form of personal ornament. Sumptuary laws dictated the material and iconography allowed each particular rank.

Ming imperial studios produced many thousands of sets of jade belt plaques for personal use by the imperial family and court as well as for presentation to meritorious subjects. Some Ming writers disparaged what they saw as the emperor's contribution to the blurring of social distinctions by so copiously presenting silk robes and jade belts to those of lowly rank. By the end of the sixteenth century, some of the private jade studios burgeoning in southeastern China were creating

fashionable but ostensibly forbidden jade adornments for wealthy, nonaristocratic clients. Jade belt plaques excavated from Ming tombs of known personages suggest a marked divergence between government strictures and actuality because a large number were buried with owners of insufficiently high rank to be entitled to them lawfully.

LACQUERWARE

Ming sumptuary laws reserved the particular combination of material (red lacquer) and ornament (five-clawed dragons and phoenixes) seen on the table in figure 1.3 exclusively for use by the immediate imperial family. Carved in lacquer tinted red with cinnabar (a form of mercuric sulfide), the tabletop depicts a vigorously posed imperial dragon and phoenix within an ogival frame, with phoenixes soaring among flowers of the four seasons in each of the corners. Red, the color most commonly used for lacquer objects made for the court, held strong symbolic associations for Ming rulers. *Hong*, the Chinese word for "red," is a homonym for the first character of the Hongwu emperor's reign name, and the imperial family's surname Zhu, literally means "vermillion." The joined depiction of dragon and phoenix symbolized the union of the emperor and empress and, by extension, the cosmic balance of the *yin* and *yang*. Like the ornament seen on so many objects created for court consumption, this decorative scheme presented a graphic representation of imperial rule within a perfectly ordered cosmos.

Although the many dragons on this table were originally carved with five claws on each foot to denote imperial status, at some point one claw on each foot was carefully chiseled away to render them *mang*, the four-clawed dragons allowed princes, dukes, and certain high-ranking officials. Subsequent to that, several of the removed claws were restored. A number of extant lacquered objects and textiles of the Ming period feature dragons that have had their fifth claws removed, suggesting a fairly common practice. The emperor may have given such items as gifts or they may have been taken without permission; late Ming sources record the regular sale of stolen imperial lacquered objects at Beijing's City Temple market. Whatever the circumstances of the removal of claws from the dragons, it underscores the perceived significance of design in the articulation of social messages during the early Ming period. Certain symbolic imagery was so important that it required physical alteration to ameliorate anxieties arising as objects changed hands among owners of different social rank.

The lacquered objects used at the Ming court came from various workshops located in southeastern China and within the palace in Beijing, and the table seen here (fig. 1.3) sheds light on the subdivision of tasks among specialist workers in these manufactories. After a carpenter constructed the unadorned wooden base, a craftsman known as a primer applied the first coat of lacquer. Liquid lacquer requires high humidity, warmth, and contact with oxygen in order to harden properly; as oxygen cannot penetrate very deeply into the lacquer, the viscous lacquer must be applied in very thin coats. A second lacquerer applied dozens of additional layers, each requiring several days to paint on and approximately

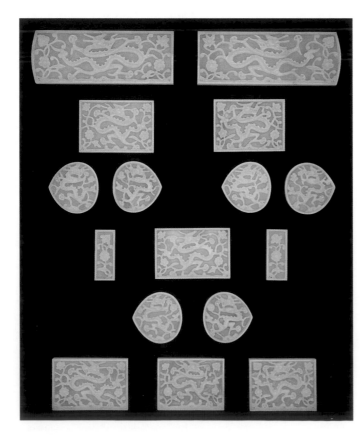

Fig. 1.2. Set of belt plaques, China, 16th–17th century. Jade; max. L. 6 in. (15.4 cm). Trustees of the British Museum (1989,0613.1.1-16).

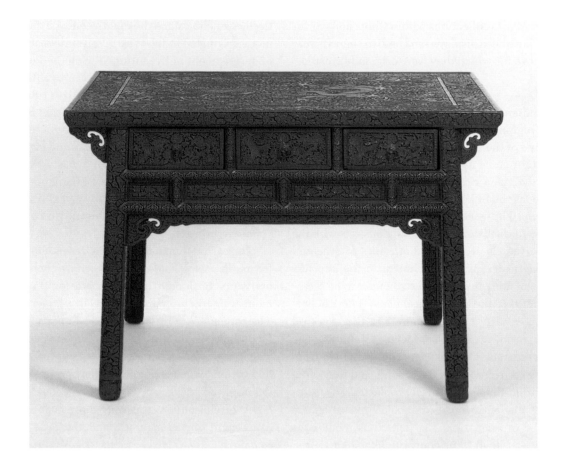

two days to harden before being polished. Building up a lacquer coating thick enough for the deep carving seen on this table could have required as long as two years. A finisher applied the final coat of lacquer, and then an ornamental design provided by a court artist was transferred onto the surface and chiseled in relief by a master carver, who varied the depth of his incisions to produce highly detailed, almost sculptural patterns. After the carving was completed, the table was passed on to a polisher, and finally to the "responsible person" (supervisor) for final inspection. Early Ming statutes legally bound craftsmen to their jobs in order to curb social mobility and ensure the transmission of high-level artisanal skills from one generation to the next.

Such a meticulously planned division of labor enabled Chinese manufacturers in all media to produce a variety of goods in large quantities; goods also came in varying qualities, particularly in the heightened commercial atmosphere of the middle to late Ming periods. As the tight social hierarchy disintegrated in the wake of rising prosperity and commercial expansion, the newly wealthy appropriated forms and designs originally created to express the rank and power of the ruling class, while the less well-to-do settled for versions made with inferior materials and craftsmanship. Although mid- to late Ming writers bemoaned rampant profligacy and the material transgression of social boundaries, the government all but ceased updating and enforcing sumptuary laws during the last century of Ming rule, presumably resigned to its inability to control spiraling consumption.

RITUALS AND SEASONAL CELEBRATIONS

In the Neo-Confucian worldview, the emperor's primary responsibility was to uphold the social and cosmic orders by living virtuously and offering sacrifices at appropriate times and places to the divine forces thought to control the universe. Confucian philosophy postulated that if the ruler properly carried out state rituals and required social obligations—including attentiveness to ministers and paternalistic concern for his subjects—then the people would emulate his virtuousness, the cosmos respond beneficently, and the empire flourish.

The emperor, or an officiant acting in his place, conducted over ninety official sacrifices per year, many of which involved a large number and variety of objects, including garments, musical instruments, vessels, and other ritual paraphernalia. Official state sacrifices included ancestral veneration rituals, which honored the spirits of deceased monarchs, as well as sacrifices to natural forces such as the sun, moon, earth, and heavens. The Ming court also held various Buddhist and Daoist ceremonies, the type, frequency, and lavishness of which depended on the personal convictions of the individual emperors, as well as an annual round of festivities associated with seasonal progression.

Among the most finely made of all Ming decorative arts, the objects created for court rituals and festivals reveal the aesthetic accomplishment and technical advances realized in crafts production at the time while shedding light on the empire's multifaceted relations with other cultures and the belief systems that informed Chinese material life. Over time, many of the items designed and made for Ming court ceremo-

Fig. 1.3. Table, Beijing, 1425–35. Carved lacquer on wood; H. 31⅛ in. (79.2 cm). Victoria and Albert Museum, London (FE.6:1 to 4-1973).

nies were disbursed into collections within China and worldwide, where they have been displayed and used in contexts very different from those for which they were originally created.

METALWORK

Most imperial audiences and rituals at the Ming court took place amid the fragrant haze of incense burned in beautiful censers. The shape of the incense burner shown in figure 1.4, probably created for court use in the early fifteenth century, resembles that of a *gui*, a ritual food vessel made of bronze and used as early as the Shang dynasty. During the first two millennia BC, China witnessed one of the world's great Bronze Ages, when rulers marked political and religious acts with the casting of bronze vessels used to hold offerings to deceased ancestors, believed to require nourishment in the afterlife. Regular offerings of food and wine were thought to be reciprocated with benefits to the living descendants. These beliefs lived on in Ming-dynasty China, manifest in the ancestral veneration rites formalized in Confucian teachings. The Ming elite collected ancient sacrificial bronzes, which from time to time were recovered from the ground, and they often assigned these antiquities near-magical properties. The forms and ornament of ancient bronzes, tangible links to an era viewed as worthy of emulation, also served as models for many of the objects used in Ming court rituals.

This incense burner features polychrome ornament created with cloisonné enameling, which involved a craftsman bending or hammering copper or bronze wires into the desired patterns and then pasting or soldering them onto the metal body of an object to form small *cloisons* (meaning "partitions" in French). Using a brush, the craftsman filled the *cloisons* with glass paste pigmented with a metallic oxide, and then fired the vessel at a low temperature (700–800° C). As enamels often shrink with firing, he repeated the process until the *cloisons* were fully filled with the various colors. Finally, the craftsman burnished the vessel until the edges of the *cloisons* became visible and then gilded the exposed borders.

Although Chinese artisans had created various forms of colorful inlay since at least the Shang dynasty and had prac-

ticed enameling since the eighth century, the cloisonné technique originated in the West. Cloisonné reached a high point of development in Byzantium during the tenth and eleventh centuries, and in the first half of the twelfth century, rulers of the Great Seljuq Empire (1037–1194), in what is today the Middle East and Central Asia, enjoyed fine, locally made cloisonné wares. Although its precise route of transmission to China remains obscure, the cloisonné technique probably was introduced during the Yuan dynasty via the province of Yunnan, which included a large Islamic population at that time. While Byzantine craftsmen typically applied cloisonné ornament to vessels made of gold, the Chinese preferred cast copper or bronze.

The early Ming elite typically reserved cloisonné objects for use in palaces and temples because their flamboyant colors were considered inappropriate for the homes of commoners or traditionalist Confucian scholars and collectors. The connoisseur Cao Zhao's *Gegu Yaolun* (Essential Criteria for Judging Antiquities, 1388) referred to cloisonné objects as *guiguo yao* (ware from the devil's country), dismissing such decoration by gendering it as appropriate only for women's quarters. By the reign of the Xuande emperor (1425–35), however, cloisonné wares were quite fashionable among the Ming court and aristocracy, and the taste for bright color remained a definitive characteristic of Ming decorative arts. For the ornament of this censer, the craftsman chose a design of scrolling lotus flowers, the spiky rendering of their blossoms typical of the early fifteenth-century style. By the sixteenth century, collectors already prized such fine early Ming cloisonné wares as valuable antiques.

CERAMICS

Many Ming emperors followed the Buddhist faith and commissioned large numbers of splendidly crafted implements to be used in worship at court or given as gifts to clergy and dignitaries. Tibetan Buddhism received generous sponsorship from the Ming state during the reign of the Yongle emperor, who maintained close and frequent contact with religious and secular leaders from Tibet, a politically independent and strategically important kingdom at the time. During the Yongle reign, craftsmen working for the imperial court created large numbers of objects with Sino-Tibetan imagery for presentation to prominent Tibetans as well as for use in court Buddhist rituals.

The ewer shown in figure 1.5, probably used for the ritual pouring of ablutions in a Buddhist ceremony, is known as a "monk's cap" ewer. While its shape resembles that of hats worn by certain Tibetan monks, it probably derives more directly from Tibetan metalwork. The top part of this ewer features an incised design of scrolling lotuses, while the body displays an invocation to the protective deity Mahashri.

China first produced true porcelain—a white-bodied, vitrified, resonant ceramic fired at a high temperature—during the Tang dynasty, and fine white porcelains seem to have been the preferred medium for both daily and ceremonial ware at the Ming court during the Yongle and early Xuande reigns. Over 90 percent of the ceramics recovered in the Yongle strata at Jingdezhen (the site of the imperial kilns)

Fig. 1.4. Incense burner, China, 1400–30. Cloisonné enamel on bronze; H. 9⁷⁄₁₆ in. (24 cm). Victoria and Albert Museum, London (507-1875).

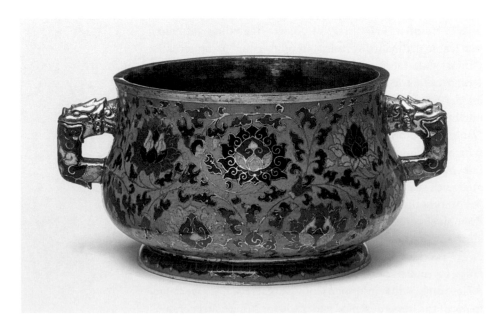

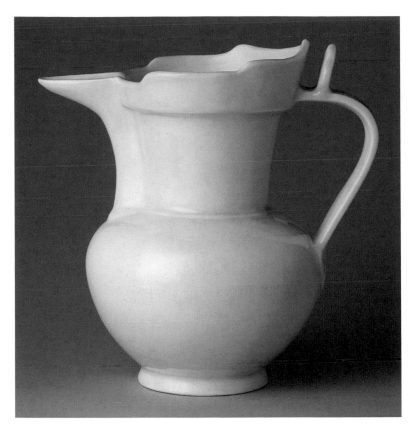

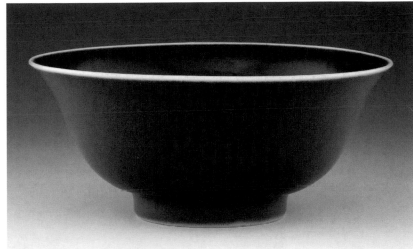

were pure white. Although the Yuan court had used white wares extensively, the Chinese associated white with mourning and filial piety. The Yongle emperor conducted lavish ceremonies of mourning for his parents and constructed an enormous temple faced with white porcelain bricks in their honor, actions some historians suggest were intended to mitigate public disapproval arising from his bloody usurpation of the throne from his nephew, the Jianwen emperor (r. 1398–1402). In the Buddhist faith, white also was a symbol of purity associated with the Buddhas Vairocana and Akshobhya, so the predominance of white porcelains may also represent another manifestation of Buddhist influence in the court art of the Yongle period.

By the early Ming period the manufacture of fine porcelains centered around the Jingdezhen area in Jiangxi province. Renowned for its porcelains since the Song dynasty, Jingdezhen received government sponsorship during the Yuan period, when it developed into a major manufacturing center. Around a dozen kilns at Jingdezhen were placed under court supervision in the early Ming dynasty, but by the mid-fifteenth century that number had increased to over fifty. From the early fifteenth though early twentieth century, Jingdezhen continued to produce, with only minor interruptions, the tens of thousands of ceramics required annually for the court's ritual and daily use. In 1433 alone, for instance, the Xuande emperor ordered 443,500 pieces, and, since only perfect examples were acceptable and the rest were deliberately broken, the total amount made would have been even more staggering in number.

Court patronage resulted in higher quality as well as quantity. In order to create lustrous white porcelains like the ewer in figure 1.5, known from the sixteenth century as "sweet white" (*tianbai*) ware, craftsmen had to learn how to filter all contaminants from the white clay and produce a clear glaze that eliminated any traces of blue or gray. They also discovered that by including a higher kaolin content in the clay, and firing at a higher temperature, they could create vessels with walls so thin and translucent as to be referred to by Chinese connoisseurs as *tuotai*, or "bodiless." As seen on this ewer, potters often incised sweet-white porcelains before glazing to create ornamental patterns visible only on close inspection and known therefore as *anhua*, or "hidden decoration." Until the Chenghua reign (1464–87), imperfect products of the imperial kilns usually were smashed, but in the increasingly commercial atmosphere of the sixteenth century, pieces deemed to be of insufficiently high quality for court use began to be sold on the open market.

Although emperors of previous dynasties preferred vessels made of bronze for court ritual use, from the reign of the Hongwu emperor until the end of the dynasty, Ming rulers overwhelmingly favored fine porcelain. While perfecting the production of fine white wares, potters at Jingdezhen also developed a number of color glazes that were used to create a range of more vibrantly hued vessels for imperial altars. The bowl in figure 1.6, which was probably made for ritual use at the court of the Xuande emperor, is decorated with a type of copper-red glaze known as *xianhong* (fresh red) or *jihong* (sacrificial red). In addition to its homophonic connection with the imperial family, the color red held potent cosmological associations in Ming China. In Chinese cosmology, all natural phenomena were explained by the *wuxing* (literally "the five phases"), an interrelationship among the five elements of metal, wood, water, fire, and earth. *Wuxing* analogies correlated the five elements with other groupings, including the primary colors, the cardinal directions, the seasons, and human emotions. The *wuxing* concept was fundamental to

Fig. 1.5. Ewer in the shape of a monk's hat, Jingdezhen, probably 1402–24. Porcelain; H. 7¾ in. (19.7 cm). The Metropolitan Museum of Art (1991.253.36).

Fig. 1.6. Bowl, China, 1425–35. Porcelain; 3⅜ x 7⁵⁄₁₆ x 7⁵⁄₁₆ in. (8.5 x 18.5 x 18.5 cm). Trustees of the British Museum (1947,0712.321).

Fig. 1.7a–b. Basin, China, 1402–24. Porcelain; 5½ x 12¼ x 12¼ in. (14 x 31.1 x 31.1 cm). Asian Art Museum, San Francisco (B60P33+).

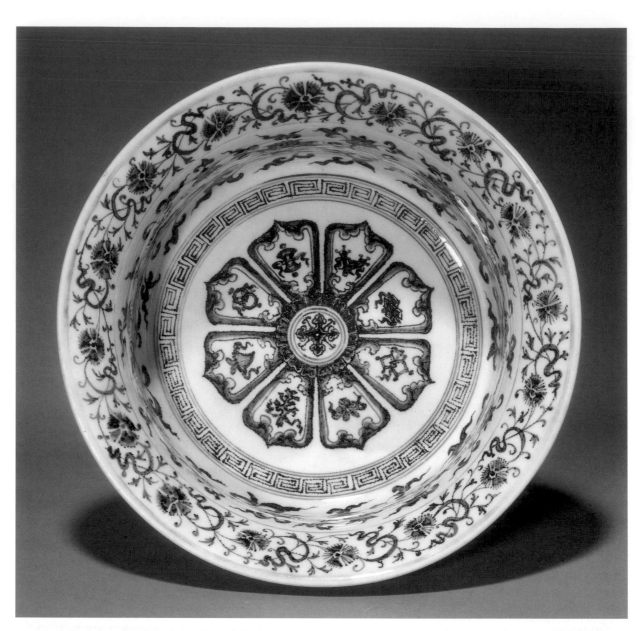

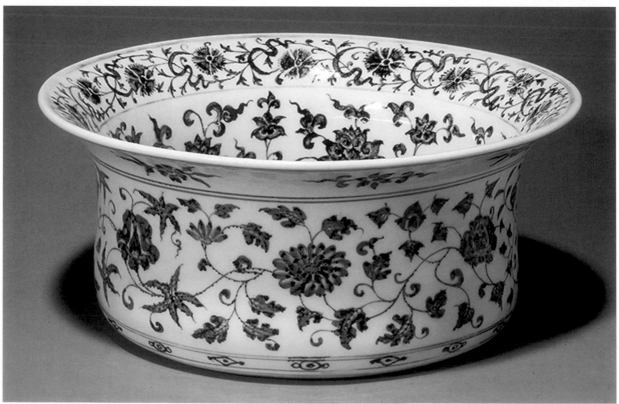

Chinese science, philosophy, medicine, and astrology during this period, and the use of color remained greatly influenced by it. The Chinese character "Ming" is written with the ideograph "sun," a symbol associated with the fire element in the *wuxing*, and therefore the color that correlated with fire—red—became further emblematic of Ming rule. *Wuxing* analogies also associated the color red with the human emotion of joy, the summer season, and the cardinal direction south.

By the early sixteenth century, many state rituals followed a system of color coding, according to which ceramics were decorated in colors corresponding to the directional position of the altars at which they were held. While such ceremonial requirements probably encouraged the development of certain glazes in cosmologically and directionally significant colors such as red, yellow, and blue, vessels in these colors also seem to have served secular purposes for dining and decoration at court. To create the deep red seen on this bowl, the most elusive hue in the glaze spectrum, the potter added a small amount of copper oxide to the clear glaze. The addition of too much copper would have resulted in a brownish color, too little in a dull gray or no color at all. Firing required extremely high temperatures (more than 1500° C) and a carefully controlled reducing atmosphere in the kiln (whereby air is blocked from the firing chamber to below the level needed for combustion).

Excavations at the kiln site indicate an approximately 80 percent rate of failure, and not surprisingly, by the sixteenth century, Jingdezhen potters had abandoned this type of red glaze in favor of more easily controlled overglaze red enamels. As an indication of the esteem in which the Ming court held such fine ceramics, the bowl shown in figure 1.6 features a reign mark, a practice that began in the late fourteenth century and became more common in the early fifteenth.

While monochrome wares remained popular for ritual use at the Ming court, some ceremonies included porcelains finely painted with decorative patterning, such as the Buddhist ablution bowl shown in figure 1.7a–b. As demonstrated by this vessel, court artists creating patterns for porcelains drew inspiration from an eclectic range of design sources, from Chinese traditions stretching back millennia to foreign luxury goods currently making their way to the Ming capital. The non-Chinese form of the basin indicates early Ming ties with the Mamluks (1260–1517) based in Egypt and Syria, where similarly shaped examples were produced in metal and glass. Painted in underglaze cobalt blue with an artist's brush, the ornament on the interior bottom of this bowl depicts a band of *leiwen*, the "thunderline" meander pattern used by Chinese artists since the Shang, encircling an eight-petaled lotus flower. Each petal of the lotus contains one of the *bajixiang* (Eight Auspicious Emblems), a set of motifs introduced to China through Tibetan Buddhism during the Yuan dynasty.

Although Chinese potters had used cobalt in and under glazes since the Tang dynasty, by the middle of the fourteenth century they had perfected the technique of painting unfired wares with cobalt blue ornament and covering them in a transparent glaze before a single firing. This type of ceramic may have developed in response to the demand of foreign markets,

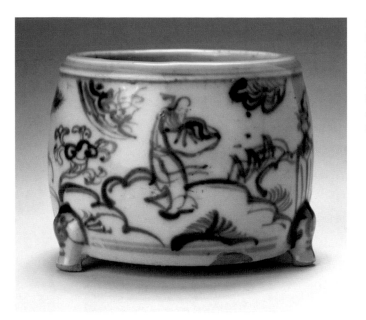

Fig. 1.8. Tripod incense burner, Jiangxi province, mid-15th century. Porcelain; 6¾ x 7¾ x 7¾ in. (7.3 x 9.6 x 9.6 cm). Asian Art Museum, San Francisco (B60P1763).

particularly the Middle East, where Persian potters had painted ceramics with underglaze cobalt for at least two centuries.

During the early Ming period, the horror vaccui that characterized Yuan-dynasty blue-and-white design gave way to more coherent decorative schemes; images from woodblock prints, textiles, and Sino-Tibetan art were absorbed into the decorative vocabulary, while ceramic forms, like this example, often drew inspiration from vessels in other media. Although early Ming writers such as Cao Zhao, author of the above-mentioned *Gegu Yaolun,* disparaged blue-and-white porcelain wares as vulgar, they slowly began to gain acceptance among the upper class, probably because of increased familiarity and the development of ornamental schemes more suited to Chinese tastes.

This basin demonstrates the clarity of brushwork and richness of color that characterize early Ming blue-and-white wares. The china painter used a large brush heavily laden with pigment to create a scheme of Buddhist symbols, lotus scrolls, and flowers of the four seasons. Characteristic of early fifteenth-century blue-and-white wares, the cobalt pigment varies in shade from blue to blue-black and is applied heavily in certain areas in an effect called "heaped and piled" (*duihedui*). By the end of the Yongle reign, Chinese blue-and-white wares displayed a repertory of forms and decorative patterns that has remained current to the present day with only minor additions and variations.

Jingdezhen kilns manufactured blue-and-white pieces in a wide range of qualities to satisfy consumers at various income levels. The small tripod incense burner in figure 1.8 probably was used in a domestic ritual during the mid-fifteenth century. Ritual was extremely important in China, permeating many levels of social interaction and encompassing everything from ancestral veneration rites, funerals, and weddings to proper ways of greeting guests and eating. Sumptuary laws dating back to the Hongwu reign dictated the types of rituals allowed families of various social ranks as well as the elaborateness with which they could be performed. During the fifteenth and sixteenth centuries, however, the formal observation of ancestral veneration rites gradually spread to prosperous

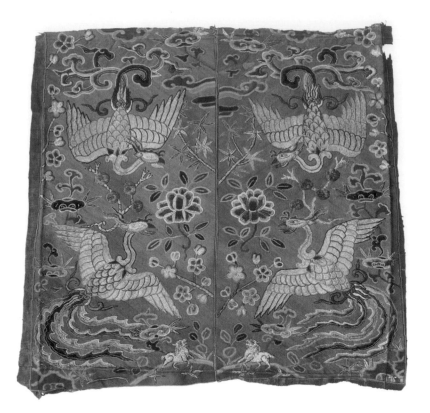
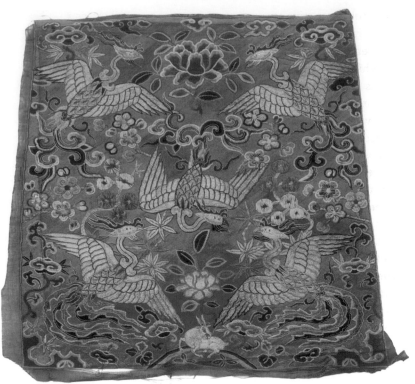

commoners from aristocratic and high-ranking families, for whom they ostensibly were reserved. Domestic rituals often mirrored court customs, with the patriarch and matriarch presiding over the rites like the emperor and empress, and the other family members positioned hierarchically according to age and generation. The decoration on this incense burner, painted in sweeping freehand, depicts human figures and pavilions in a cloudy landscape, imagery commonly found on mid-fifteenth-century blue-and-white vessels made for the popular market.

RANK BADGES

Of vital importance to all social classes in the overwhelmingly agricultural Ming empire were the rituals and festivities attached to the progression of the seasons. Celebrated by commoners and the imperial court alike, the annual cycle of festivals that centered around solstices, equinoxes, and the changing seasons was viewed as a defining feature of Chinese cultural identity during the Ming, a key distinction between the Chinese and their "barbarian" neighbors. During these celebrations, people reunited with their family and friends, ate special foods, and displayed seasonally appropriate motifs, which cosmological beliefs assigned the power to promote seasonal change.

The pair of badges shown in figure 1.9a–b would have been attached to the front and back of a high-ranking woman's robe during winter solstice celebrations at the Ming court. Ming sumptuary laws reserved the phoenix motif for princesses, the emperor's secondary wives, and wives of princes, while the other motifs on these examples as well as the green color of the ground fabric were associated with the winter solstice.

At that time of year, it was believed that the cosmic *yang* principle began to gain ascendancy over the *yin*, a change encouraged at court by wearing what period sources call

"*yang*-producing badges." In the Chinese language, *yang* is also the word for sheep or goat, so depictions of these animals often were used to evoke the cosmological *yang*. On these badges, the three sheep sitting on red sun disks create the visual rebus *san yang kai tai*, which refers to a seasonally relevant hexagram from the classic text, the *Yi Jing* (The Book of Changes) and translates as "three *yang* open up the *tai* [hexagram]," meaning that spring has arrived—an extremely auspicious occurrence. (Although the hexagram itself is not shown, it is expressed graphically through the three sheep, a homonym for *san yang*, and the sun disks, homophonous for *tai*.) The *Yi Jing* hexagram associated with the previous month is *kun*, which comprises only broken, or *yin*, lines, so the *yang* was at its nadir; in the month of the winter solstice, the first solid *yang* line appears in the *fu* hexagram; in the next month, two *yang* rise from the bottom in the *lin* hexagram; then in the following month, three *yang* lines form the *tai*, or peace hexagram, spring arrives, and the new year begins.

The depiction of nine phoenixes was also significant; nine was considered to be the perfect *yang* numeral, and in the Chinese calendar there were nine nine-day periods between the winter solstice and the onset of warm spring weather. The custom of "counting the nines"—physically marking time by tracing the eighty-one days from the winter solstice to the advent of spring—on decorative wall charts or graphs—seems to have originated in farmer's calendars and rural traditions, but was practiced by the court and commoners alike.

The visual record of Ming seasonal celebrations reveals a strong interplay between popular traditions and imperial practice, with many of the seasonal motifs embroidered in costly silk threads on court textiles, painted on fine porcelains, and featured as cursorily rendered images on objects widely used by the greater populace. These motifs underscore the perceived power of symbolic iconography and colors to

render objects active agents capable of positively influencing the universal order and creating a beneficial congruence between the earthly and cosmological settings.

While emperors continued to take part in seasonal festivities as well as various Buddhist and Daoist ceremonies at court through the mid- and late Ming periods, their strict observation of formal state sacrifices declined markedly. Indeed, by 1540 emperors usually delegated the performance of most state rituals, even exalted sacrifices at the Altar of Heaven, to proxies. Numerous Ming writers noted with disdain the emperors' lack of interest in ritual obligations and lamented that many state sacrifices no longer were conducted in accordance with Confucian protocol. When observing a ritual venerating the Hongwu emperor, held at the emperor's tomb near Nanjing two years before the fall of the Ming, the scholar Zhang Dai (c. 1597–1680) was shocked at the cursory performance of the ceremony and the poor quality of the ritual implements used, indiscretions viewed as ominous for the future of the weakening dynasty.

OBJECTS IN MOTION: THE MERCANTILE SIXTEENTH CENTURY

The Ming empire underwent profound social and economic transformations during the sixteenth century as a result of population growth, greater commercial activity, and the steady inflow of foreign silver. The traditional agrarian order, typified by large manorial estates and serflike tenancies, steadily declined as capital moved away from land and agriculture toward commercial and manufacturing enterprises. The Ming government gradually relaxed its direct participation in, and control over, the economy: taxes were paid in silver instead of labor, grains, and textiles; objects for court use that were obtained through tribute and corvée labor began to be acquired from manufactories that paid wages to employees and bought raw materials on an open market. After the lifting of a long-standing ban on maritime trade in 1567, unprecedented amounts of foreign silver streamed into China as payment for textiles, ceramics, tea, and other exports, a phenomenon that further stimulated economic expansion and the development of a money economy. Manufacturing growth promoted domestic interregional trade; the improvement of waterways, roads, and other transportation routes helped villages to develop into thriving towns; and the interdependence of communities facilitated the flow of goods and ideas between city and country. The wealthy migrated toward culturally vibrant urban centers, where traditional social divisions became increasingly fluid and Confucian conservatism, frugality, and prudence gave way to greater ideological freedom and new, more consumer-focused lifestyles. Particularly in the prosperous coastal provinces, life in the late Ming was characterized by heightened commercial activity and social mobility.

LATE-MING LACQUERWARE

Freed from corvée duties, artisans were able to engage more fully in commercial production. The manufacture of lacquerware gained momentum, particularly in towns and cities along the lower reaches of the Yangtze River, near to the main sources of raw lacquer and the nexus of the booming mercantile economy. Workshops making fine lacquers varied the forms, styles, and ornament of their products to satisfy the differing tastes and preferences of customers, who included the urban wealthy, the court (which purchased goods through special agents), and foreign markets, the most significant of which was Japan.

Popular decorative techniques in sixteenth-century manufactories included *qiangjin*, whereby designs incised into lacquer surfaces were filled with gold, as well as mother-of-pearl inlay like that seen on the box in figure 1.10. Boxes of this shape and size commonly were used for the presentation of gifts, the frequent exchange of which helped forge and maintain social networks among the Ming elite. The contents of these lacquer boxes—fruit, sweetmeats, or even precious commodities such as silver ingots—constituted the actual gift: recipients often returned the boxes to the giver (along with an appropriate token of appreciation) after consuming or removing the contents.

Depicting two elegantly dressed men and a servant embarking on a journey under the full moon, the imagery on this box would have rendered it appropriate for presentation to a departing friend. During the Ming period, educated men often commemorated their friends' departures by composing poems of farewell and sometimes presenting the traveler with paintings or other objects bearing images of journeys or of leave-takings. Ming government officials were obliged to serve wherever they were needed in the empire, and therefore the moving of people and households, often across great distances, was commonplace among Ming bureaucrats. Fur-

Fig. 1.10. Box, China, late 16th–early 17th century. Lacquer, mother-of-pearl inlay; 3¾ x 9⅛ x 9⅛ in. (9.5 x 23.2 x 23.2 cm). The Metropolitan Museum of Art (L. 1996.47.42).

Fig. 1.11. Folding armchair, China, late 16th–early 17th century. *Huanghuali* hardwood, iron; 41³⁄₁₆ x 30⅛ x 30 in. (104.6 x 76.5 x 76.2 cm). Minneapolis Institute of Art (98.80.3).

thermore, many leisured members of the Ming elite undertook extended journeys for pleasure, as travel was considered to be a significant component of a gentleman's education and a critical means of expanding his social and educational horizons. Although early Ming statutes mandated severe flogging for any commoner traveling more than thirty-six miles away from his home without special dispensation, this stricture was routinely ignored during the late Ming, particularly for business and commercial reasons.

LATE-MING FURNISHINGS

For the wealthy, the material culture of travel included sedan chairs, fine luggage, and mobile furnishings, while the social rituals that accompanied separation and reunion, an ongoing cycle of shared repasts and reciprocal obligation, could be given material expression in objects such as this box. Lacquerware inlaid with mother-of-pearl also was a popular export item, particularly in the interregional trade linking East and Southeast Asia. Studies of the mother-of-pearl-

inlaid lacquers produced in China, Japan, Korea, and the kingdom of Ryūkyū (known today as Okinawa) have revealed the mutually enriching exchange of techniques and motifs that resulted from political and economic links between these countries.

Greater overseas trade in the second half of the sixteenth century allowed Chinese craftsman access to a variety of new raw materials. For example, the folding round-back armchair shown in figure 1.11 was made from *huanghuali* (*Dalbergia odorifera*), a beautifully grained, fragrant tropical hardwood from Southeast Asia that became available at that time. The design, construction, and overall quality of Chinese furniture reached its apex in the late Ming dynasty, when craftsmen achieved a harmonious integration of structure and form that set standards to which later craftsmen often aspired. The use of newly accessible hardwoods such as *huanghuali* enabled craftsmen to create furniture with elegant, slimmer proportions without sacrificing structural integrity, and to embellish it with crisp, sharp carving.

Folding round-back armchairs originated in the Song dynasty (960–1279), when chairs replaced woven mats and raised wooden platforms as the preferred form of seating in the Chinese domestic environment. The Ming Chinese reserved chairs for those holding authority or high social status, and folding round-back armchairs were considered the most prestigious of the various seating forms available at the time. These large chairs physically elevated the sitter, and in Ming visual culture (as in many others) the status of a person or building often was expressed by raising them above others in height. Ming paintings and wood-block prints show folding round-back armchairs used in front of standing screens during formal receptions, serving as thrones for dignitaries and emperors, and as the preferred seating in ancestral portraits. Lightweight and easy to store and transport, such chairs were used indoors and out, for both formal and everyday occasions, but because of their relative fragility only a few examples have survived from this period.

While the decorative metal fittings on folding round-back armchairs were more typically of brass, on this chair they are made of iron finely inlaid in silver with scrolling lotus motifs, suggesting production for an extremely wealthy patron. The wooden footrest is covered with an iron plate depicting a coin flanked by pairs of crossed rhinoceros horn cups, a rebus offering the sitter protection from poisoning. This type of ornamentation, which graphically expressed protective or auspicious wishes through written characters, rebuses, or symbolic motifs, proliferated in Chinese design from the Ming through the Qing (1644–1912) dynasties.

With the reinstatement of maritime trade during the late Ming, China was increasingly drawn into the greater global economy. The Portuguese, active in East Asia from the beginning of the sixteenth century, established a permanent settlement in Macau in 1557, and the first Spanish galleons arrived in Manila from Acapulco in 1573 to trade New World silver for Chinese luxury goods. The porcelain ewer in figure 1.12, bearing a reign mark of the Jiajing emperor (r. 1521–67) and a European coat-of-arms, was probably created for an early Portuguese visitor. By the fourteenth century Chinese porcelains had made their way to Europe, where they were prized as luxury objects of great rarity. Many of the early Chinese porcelains arriving in Europe, like this example, were fitted with silver mounts after they left China, which served to emphasize their preciousness in countries where the secret of porcelain production was yet to be discovered.

LATE-MING CERAMICS AND METALWARE

With the establishment of regular overseas trade, Chinese potters in Jingdezhen proved to be extraordinarily adept at producing ceramics in forms and designs tailored to foreign tastes. By the end of the sixteenth century, Chinese porcelains, chief among them the blue-and-white wares that so appealed to European consumers, were arriving in Western ports in some quantity. Between 1550 and 1800, an estimated 30 to 40 percent of all the silver mined in the Americas went to China as payment for luxuries such as raw silk, woven textiles, tea, spices, medicines, and ceramics. This influx of capital provided a tremendous, if at times inflationary, stimu-

lus to the Chinese economy, and resulted in the accumulation of great fortunes among enterprising Chinese merchants.

Reign marks such as that seen on the ewer in figure 1.12 offered consumers an assurance of high quality, and during the late Ming, some artisans began signing their own names on their work, "branding" their products and capitalizing on the market value of name recognition in the competitive commercial atmosphere. The hand warmer in figure 1.13 bears the seal of Zhang Mingqi (act. 1580–1630), a native of Jiaxing, Zhejiang province, whose family was famed for the highly skilled crafting of small metal objects such as incense burners and hand warmers. Although artisans ranked low in the Confucian social hierarchy, Zhang Dai commented in the mid-seventeenth century that members of the metalworking Zhang clan and other leading craftsmen brought renown and elevation to their families and sat as equals and exchanged greetings with members of the gentry. Indeed, a number of late Ming writers noted the signing of crafts products by well-known artisans, as well as the social interaction between

Fig. 1.12. Ewer with European arms, Jingdezhen, 1521–67. Porcelain, Turkish silver mounts; H.13³⁄₁₆ in. (33.5 cm). Victoria and Albert Museum, London (C.222-1931).

craftsmen and the elite, as novelties of their time and therefore worthy of comment.

Although for centuries the Chinese had used portable metal or ceramic vessels filled with burning wood or charcoal to warm their hands, feet, and beds, during the late Ming period, hand warmers became fashionable accessories. In metalworking, as in many areas of manufacture, market growth stimulated technical innovation. The development of high-quality copper alloys provided strong, lightweight materials with excellent conductive qualities, while the craftsmanship of hand warmers reached new levels of refinement. This octagonal example features gently curving vertical walls and a domed lid created in an openwork floral design. While hand warmers remained closely associated with the literati, who sometimes praised them as their steady companions as they studied through long cold nights, women also carried them in their voluminous sleeves during cold weather.

BOOK ARTS

The late Ming elite were keenly aware that all possessions expressed social messages about their owner's wealth, taste, and erudition, and for some people, therefore, the selection of even the smallest of personal accessories was carefully deliberated. A potential customer might be influenced by recognizable names, but she or he might also be swayed by one of the burgeoning number of publications in which eminent

writers offered practical advice regarding the purchase, care, and display of objects.

One of the most popular was *Zun sheng ba jian* (Eight Discourses on the Nurturing of Life, 1591), written by the wealthy playwright and art collector Gao Lian (act. c. 1573–81). Much plagiarized by later authors, it instructed the reader on how to live healthfully and elegantly, covering topics from medicines and yoga-like exercises to interior decoration and the connoisseurship of artworks. While Gao offered practical guidance regarding the purchase and display of various objects, he situated this discussion of material life within a greater cosmic dimension. Through the eight discourses in *Zun sheng ba jian,* he emphasized that by taking proper care of our bodies, living in pleasant environments that harmonized with nature, and surrounding ourselves with artful furnishings, we can achieve both physical health and advantageous alignment with the universal life force.

The book was illustrated with wood-block prints including the one in figure 1.14, which accompanied a section discussing the ink stones that were common desk accessories and collectors' items at the time. Although wood-block printing was developed before Ming times, in the late Ming period increased literacy led to a dramatic upsurge in the quantity and variety of publications. Entrepreneurial publishers found ways to reduce costs, by adopting bronze movable type, and the proliferation of regional markets and trade routes enabled the swift circula-

Fig. 1.13. Zhang Mingqi. Hand warmer, China, 1580–1630. Copper alloy; 4 x 4¾ x 4¼ in. (10.1 x 12 x 10.8 cm). Asian Art Museum, San Francisco (R2002.49.42.a–.b).

Fig. 1.14. Illustration showing an ink stone, from Gao Lian, *Zun sheng ba jian* (Eight Discourses on the Nurturing of Life), China, 1591. Wood-block print. Harvard-Yenching Library, Harvard University (T 7912 0233).

tion of relatively inexpensive printed materials. Popular texts included novels, plays, encyclopedias, and primers as well as how-to guides for travel, business contracts, proper conduct in brothels, and a range of other topics that evoke the social complexity and material diversity of life in the late Ming.

The nouveaux riches, wishing to convert newfound affluence into cultural capital, could turn to books such as Gao's to help negotiate the marketplace for luxury goods, where forgeries were rife and fine distinctions between "elegant" and "vulgar" difficult to fathom for the uninitiated. Knowledge of this sort, previously disseminated by word of mouth or by example among a small group of privileged families, became itself a type of commodity when published in book form in the late Ming.

Illustrated books provided sources for decorative arts designs. The maker of the archaic-looking jade cup shown in figure 1.15 probably drew inspiration from a wood-block print found in books on antiquities and collectibles. Although jade carving remained closely associated with the court during the early Ming period, the imperial workshops scaled back production in the sixteenth century. The wealthy urban class in coastal southeast China became the primary consumer of fine jades, and the art of jade carving flowered in the second half of the sixteenth century as a result of this new patronage and the increased availability of jadestones.

LATE MING JADE

Native sources of jade had been exhausted for centuries, but political changes in Central Asia made jades from Khotan, the ancient trading center, celebrated for its jade, in what is now western China, more readily accessible after about 1550. Many of the finest Chinese jade objects were created in private studios in Suzhou, near Lake Tai, the area where the Neolithic Liangzhu culture had produced large quantities of jade objects. Using tools and techniques that would have been familiar to their Neolithic predecessors—quartz or ground garnet as an abrasive, water, and various kinds of drills and wheels—Ming jade craftsmen created all manner of objects, ranging from small utensils and statuettes to hairpins, necklaces, pendants, and rings.

As the hollowing out of jade stone to create cups and bowls required a prodigious amount of time and wasted a large amount of precious material, vessels such as these were enormously expensive. Although a decree issued in 1521 declared that not even first- and second-rank officials had the right to use jade vessels, jade cups nonetheless became desirable status symbols among the elite. Jade was closely associated with the Daoist quest for immortality. Discussion of ingesting elixirs made of powdered jade in the effort to achieve long life dates back to the Han period at least (206 BC–220 AD), and many of the Ming elite thought that imbibing from jade cups conveyed some of the stone's precious, immortal essence to the drinker. Writers also praised jade's smoothness to the touch and the pleasant tinkling sounds created when jade objects struck one another when used. Like the sheen and rustle of silk, these sensory qualities were an important part of the ways in which jade objects were experienced by their owners, and further contributed to their popularity and appeal.

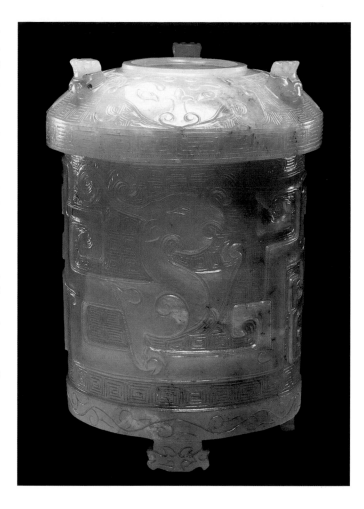

Fig. 1.15. Lidded cup, China, 16th–17th century. Nephrite jade; H. 4¼ in. (10.8 cm). Victoria and Albert Museum, London (FE.47&A-1980).

In creating jade cups and bowls, late Ming craftsmen frequently amalgamated forms, styles, and ornament from different eras of China's venerated ancient past. The cylindrical form of the cup shown here derives from bronzes and lacquers made during the Han dynasty, while the interlaced birdlike creatures depicted in low relief on the sides recall the ornament of bronze vessels produced in the earlier Eastern Zhou dynasty (770–256 BC).

From jade and lacquer to metalwork and silk, the hand-crafted products of the Ming dynasty remain greatly admired today. While the imperial state was responsible for the stability and order that underpinned the economic upsurge of the late Ming period, by 1600 the dynasty's political power and cultural influence had been rendered moribund by a variety of factors including struggles among the bureaucracy, costly military campaigns, and the increasing detachment of emperors from state affairs. Nonetheless, the newly emergent urban elite enjoyed unprecedented levels of prosperity, a rich and complex material life, and a vibrant cultural milieu in which novelists, playwrights, poets, philosophers, painters, and craftsmen created a profusion of works now considered to be "classics" of Chinese civilization. While traditionalist Confucian writers looked back with nostalgia on a reimagined agrarian order of the early Ming, when the population was less mobile socially and geographically, that way of life was never to return as China embraced an economic trajectory and an engagement with the material world that today is recognized as "modern."

LEE TALBOT

KOREA

Fig. 1.16. Lady Ning performing a memorial rite, from *Oryun haengsil do* (Illustrated Guide to the Five Obligations), Korea, 16th or 17th century. Wood-block print. The British Library, London (15113.c.5, sect. 3, folio 59).

The location of the Korean peninsula in northeast Asia—bordering China and Russia in the north and facing Japan to the east and south—has profoundly influenced the history and culture of its inhabitants. The Korean people descend largely from tribes who migrated from Manchuria and Siberia to the Korean peninsula around five or six thousand years ago. Rugged mountains cover approximately 70 percent of the Korean landmass, contributing to the development of distinct regional cultures, still perceptible today, especially in the north, southeast, and southwest.

During the first centuries AD, the various fiefdoms and tribal confederacies in these regions coalesced into three rival kingdoms—Goguryeo, Baekje, and Silla—which united in 668 as a single state. Over the centuries, Koreans developed a strong sense of national solidarity, and came to view the peninsula as a discrete geographical unit occupied by an ethnically homogeneous population sharing a common cultural identity. This tenacious nationalism helped preserve a cultural independence in the face of frequent, often devastating, invasions and occupations by foreign powers.

Korea served as a land bridge between the Asian mainland and the Japanese archipelago, absorbing cultural influences from the Asian continent to the northwest and passing them on to Japan and the kingdom of Ryūkyū (present-day Okinawa). While the Koreans assimilated certain Chinese cultural concepts and practices—including the Chinese writing system, Confucianism, Buddhism, and various artistic forms, techniques, and designs—invariably they transformed them to accommodate and reflect native needs and preferences. Korea maintained a rich and sophisticated creative and cultural heritage quite distinct from those of its neighbors, yet of all the East Asian artistic, design, and craft traditions, those of Korea have received the least attention in the West until very recently.

In the late fourteenth century, Korea's Goryeo dynasty (918–1392) began to collapse after years of warfare and more than a century of de facto occupation by the Mongols. In 1392 a powerful general, Yi Seong-gye, deposed the Goryeo king and proclaimed himself ruler. The new dynasty, the Joseon (1392–1910), ruled Korea for more than five hundred years. Yi, known posthumously as King Taejo (r. 1392–98), and his ministers embraced Neo-Confucianism as the guiding philosophy and instigated dramatic reforms that transformed state and society. The early Joseon court annihilated the authority and privilege of the aristocracy and Buddhist clergy, who had held the reins of power during the Goryeo period. The Joseon created a new legal code; redesigned the educational system, governmental institutions, and civil service; and in many other ways implemented Neo-Confucian ideals as state policy. King Taejo inaugurated tributary relations with China's newly established Ming dynasty, thus ensuring his nation's independence and protection. The diplomatic missions sent regularly from Korea's new capital city of Hanyang (modern Seoul) to the Ming court served as important conduits of Chinese culture. Envoys brought back and disseminated texts, objects, and ideas that enriched Korean culture throughout the Joseon period.

Some Neo-Confucian social tenets—such as preferred marriage and funerary practices—ran counter to Korean customs, and therefore the early Joseon government devoted substantial resources to the publication and dissemination of instructional books that encouraged the popular acculturation of Neo-Confucianism. Texts such as the *Oryun haengsil do* (Illustrated Guide to the Five Obligations), a page of which is shown in figure 1.16, explained Confucian ideals and offered

practical advice regarding their implementation in daily life. While the government typically printed books with carved wood blocks during the early years of the dynasty, King Taejong (r. 1400–18) established the *Jujaso* (Government Typecasting Office) to create bronze types. In 1403 the *Jujaso* completed the dynasty's first metal type, comprising between 200,000 and 300,000 characters, and over the decades it refined techniques for casting and setting bronze type and printing texts on paper.

Under the leadership of King Sejong (r. 1418–50), court scholars developed one of the dynasty's crowning achievements—a phonetic script for the Korean language. Up to this time, Korea had used Chinese ideographs, devised for a language totally different from Korean and taking many years of study to master. Only upper-class males received formal education during the Goryeo and Joseon dynasties, and, although some elite women learned to read and write Chinese from family members, the majority of the population was illiterate up to the early Joseon period. In 1446 King Sejong formally introduced the new script to the public, calling it *Hunmin-jeongeum* (The Correct Sounds for the Instruction of the People). Official government documents and much literature continued to be written in classical Chinese, but the phonetic script became widespread among commoners, women, and children, and proved to be an expedient means for disseminating information to groups other than the adult male elite. Through vigorous efforts in publication, education, and legislation over the first two hundred years of Joseon rule, the government succeeded in establishing Neo-Confucian ideals as the foundation of the Korean social order.

As illustrated by the scene in figure 1.16, in which a table has been set with candlesticks and vessels for a domestic memorial observance, the correct performance of Confucian ritual required appropriate objects. Early Joseon rulers revitalized the production of ceramics, which were ubiquitous in Korean ceremonial and daily life. The two principal products were white porcelains and *buncheong* (powder green) stoneware like that used to produce the wine bottle in figure 1.17. Joseon potters inherited the rich ceramic tradition of their Goryeo predecessors, famed throughout East Asia for the production of elegant and technically refined celadons, but they reinterpreted the Goryeo vocabulary of forms and repertory of techniques in response to early Joseon exigencies. The sophisticated, often precious taste that prevailed in ceramics patronage during the aristocratic Goryeo gave way to a more robust aesthetic in keeping with Neo-Confucian notions of modesty and unpretentiousness. With its heavy potting and bold, uncontrived ornament, this *buncheong* wine bottle characterizes the strength and vitality of the early Joseon ceramic style. Although manufactured in great quantity during the first two hundred years of Joseon rule, stoneware made with coarse gray bodies, white slip (liquid clay) decoration, and greenish glaze, like the example shown here, lacked a designated name at the time they were produced. In the twentieth century, the Korean art and decorative arts historian Go Yu-seop (1905–1944) coined the term *bunjang huicheong sagi* (powder-dressed, gray-green ceramics), shortened to *buncheong*, to describe this type of early Joseon stoneware.

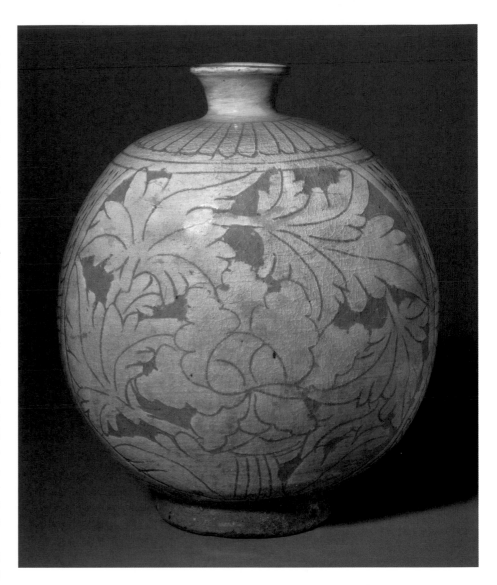

Fig. 1.17. Bottle, Korea, mid- to late 15th century. Stoneware; 8¾ x 7 x 7 in. (22.2 x 17.8 x 17.8 cm). Brooklyn Museum (75.61).

Produced in dozens of kilns throughout central and southern Korea, *buncheong* wares were acquired by all social classes, from the peasantry to the royal court. Some pieces stamped with names of the government bureaus for which they were made—including the palace offices in charge of food service and entertainment—are only slightly less coarse than those made for everyday use by commoners. Early Joseon potters excelled in the technique of carving through slip to reveal a contrasting clay underneath (called sgraffito in the West), and in this manner created a variety of seemingly spontaneous, abstract patterns. The wine bottle in figure 1.17 was formed on a wheel using dark gray clay. The exterior was painted with white slip, into which a design was carved—peony blossoms on the body and chrysanthemum petals on the neck. The surface was then glazed with iron oxide before firing. When fired with the proper degree of reduction, *buncheong* wares could achieve the blue-green color characteristic of Goryeo celadons, but early Joseon kilns rarely exerted such exacting control, resulting in more muted shades of gray-green.

Propelled by ceramics and technologies imported from China, Korean kilns also began to produce high-quality white porcelains, called *baekja* (white ware). Like their Ming counterparts, the early Joseon court began to favor white porcelains for daily and ceremonial use at the palace, and around 1460 the king established a group of kilns (known as the

Fig. 1.18. Bottle
(Treasure No. 1054),
Korea, 15th century.
Porcelain; H. 14¼ in.
(36.2 cm). National
Museum of Korea,
Seoul (11448).

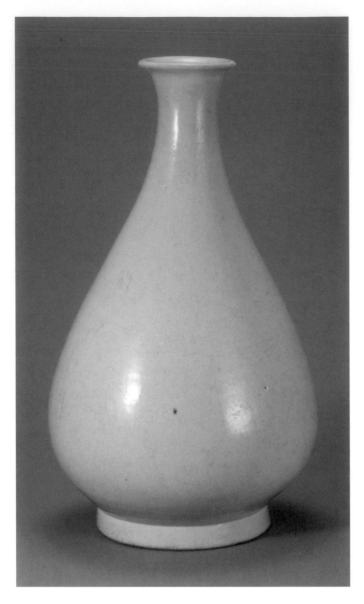

wares by selecting simple ceramics originally made for Korean or Japanese peasants, wares he saw as reflecting Zen Buddhist ideals of frugality, humility, and unpretentiousness. Rough, utilitarian *buncheong* ceramics thus became vessels of choice for sixteenth- and seventeenth-century Japanese tea masters. As such, during the devastating invasions of Korea led by Japanese warlord Hideyoshi Toyotomi in the late sixteenth century, Japanese troops relocated entire pottery-making villages from Korea to Japan. This influx of Korean potters permanently altered the nature of Japanese ceramics production, but in Korea itself the *buncheong* tradition soon disappeared, not to be revived until the twentieth century (see figs. 19.13, 19.14).

To administer and govern their kingdom, Joseon rulers relied on a class of men known collectively as *yangban* (two ranks)—the civil and military officials of the state bureaucracy. This highly educated elite was expected to pursue governmental office, follow Neo-Confucian teachings through study and self-cultivation, and serve as moral exemplars for the rest of society. Together with the royal court, the *yangban* were the primary patrons of fine decorative arts production during the early Joseon period. Like Chinese "scholar-officials," *yangban* devoted themselves to scholarship, which they pursued in studios equipped with furniture and desk accessories chosen to express their taste and erudition. Desk accessories could be made from a variety of materials, such as ceramic, wood, and bamboo, but among the most costly were those made of lacquer inlaid with mother-of-pearl, a technique that gained Korean craftsmen renown throughout East Asia.

The box in figure 1.19, probably used to store paper and writing supplies, illustrates the preference of early Joseon *yangban* for bold designs and richly textured surfaces. Stylistic developments in the ornament of inlaid lacquers from the Goryeo through the early Joseon periods parallel those in ceramics, with the Goryeo emphasis on fine detail and pictorial patterning giving way to a bolder aesthetic during the Joseon. Scrolling vines bearing luxuriant leaves and three different kinds of flowers cover the surface of this box, while small circles scattered throughout the interstices de-emphasize the pictorial effect of the pattern. The maker formed the vines with thinly cut mother-of-pearl strips and created the flowers and leaves using irregularly incised mother-of-pearl fragments. Scholarship has revealed little about the development of this distinctively Korean technique, in which mother-of-pearl was carved with crackled patterns before being set in lacquer, but it may have been inspired by the crazing on ceramics, a visual characteristic much admired by the Koreans and Chinese at the time. This finely made box exemplifies the technical virtuosity of early Joseon lacquer workshops, as well as the restrained, elegant aesthetic of their *yangban* patrons.

Throughout the Joseon period, folding screens were ubiquitous in upper-class Korean homes. The Korean name *pyongpung* (wind block) implies the basic function of these portable partitions, but they played a variety of practical and symbolic roles in interiors and outdoor spaces. Screens not only enhanced the living environment aesthetically but also provided an indispensable backdrop for the ceremonies that marked life's passages—birthdays, weddings, and funerals—as

Bunwon) near the capital to manufacture *baekja* for the court. Undecorated white wares like the bottle in figure 1.18, made with highly refined clay and glazed with feldspar, characterized the early phase of porcelain manufacture at the *Bunwon* kilns. Reflecting the austerity and restraint espoused by Neo-Confucian ideology, plain white porcelains were considered particularly suitable for use in rituals, such as memorial services performed at ancestral altars. The *Bunwon* kilns produced several grades of white ware, not only for the court but also for various governmental bureaus and wealthy patrons. By the sixteenth century, white wares were no longer associated exclusively with the elite, and regional kilns throughout Korea began to produce such wares, often of lesser quality than the *Bunwon*, to satisfy burgeoning demand.

The sustained popularity of white ware contributed to the demise of *buncheong* production. Another factor was the high regard of *buncheong* in Japan, where connoisseurs had begun to recognize the artistic and technical merits of these ceramics as early as the sixteenth century. Before this time, Japanese connoisseurs had mainly favored Chinese luxury wares, such as Song-dynasty celadons and Ming carved lacquers, for use during the tea ceremony. The tea master Takeno Jō-ō (1502–1555), however, overturned this taste for Chinese

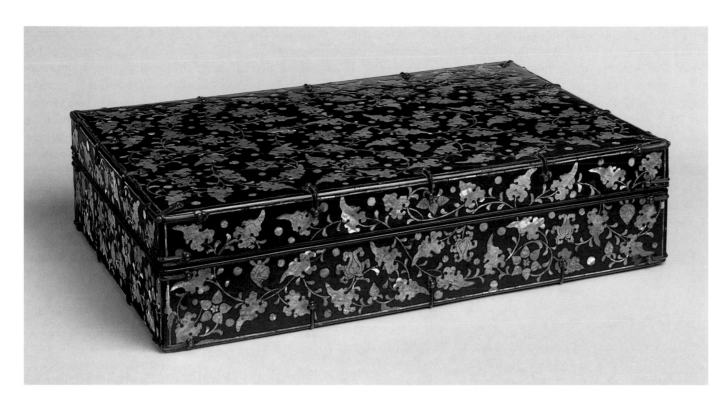

Fig. 1.19. Stationery box, Korea, 15th century. Lacquer, mother-of-pearl inlay; 3⅝ x 14⅜ x 9½ in. (9.2 x 36.5 x 24.1 cm). The Metropolitan Museum of Art (L.1992.62.3a,b).

well as Confucian rituals of ancestor veneration. Screens served honorific functions; sitting in front of a screen, for example, during a social gathering signified a person's importance and high status. Some Korean screens featured colorful patterns on one side for use during happy occasions such as weddings and birthdays, and more somber designs on the other side for display during funerals and ancestral memorial rites.

The decorated panels on folding screens could be created from a variety of materials, including paper and lacquered wood, but among the most valuable were those made of embroidered silk. While professional studios produced embroidered screens for sale, women in *yangban* families embroidered panels for screens used in their own households. Embroidery was a cornerstone of upper-class girls'

education, and even *yangban* women were expected to make or embellish at least some of their family's clothing and textile furnishings by hand. Few embroidered screens have survived from the early Joseon period, however, and fewer still can be linked to a known maker. The screen shown in detail in figure 1.20 may be a rare exception. Its four central decorative panels are attributed to Shin Saimdang (1504–1551), a celebrated poet, painter, calligrapher, and embroiderer, and the mother of talented children (including the seminal Confucian philosopher Yi Yul-gok, 1536–1584). The panels by Lady Shin depict some of her favorite subjects—delicate flowers and colorfully stylized rocks—rendered in embroidered silk and surrounded by butterflies and bees, which she hand-painted using a brush.

Fig. 1.20. Attributed to Shin Saimdang. Folding screen (detail), Korea, 16th century. Embroidered silk, paper, wood; each panel, 21¾ x 11¾ in. (54 x 30 cm). Sookmyung Women's University Museum, Seoul.

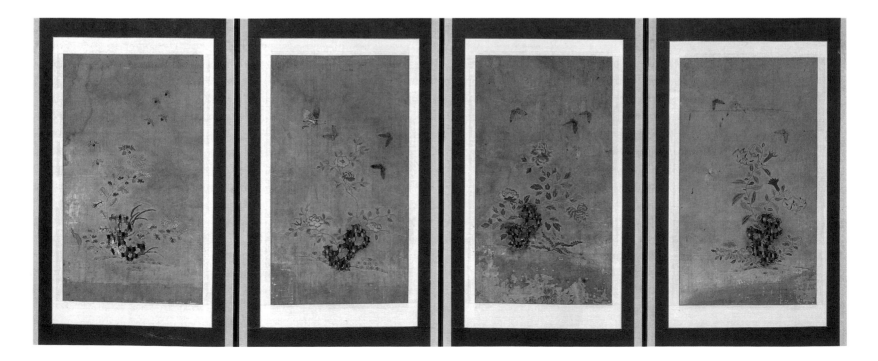

To the present day, many Korean women esteem Lady Shin for so capably fulfilling her duties as a wife and mother while also achieving success as an artist. Like many upper-class women during the Goryeo and early Joseon periods, Lady Shin enjoyed greater social and economic freedom than her later Joseon counterparts. In line with prevailing customs, she continued to live in her parent's house for several years after marriage. She seems to have traveled freely and bequeathed her property equally among sons and daughters. Over the next generations, however, these practices would be overturned and women's freedoms curtailed as Korea adopted a more strictly Confucian, patrilinear social structure.

During the first two hundred years of Joseon rule, Korea experienced relative peace and political stability and signifi-cant cultural achievement. While Ming China remained a wellspring of new artistic and intellectual currents, the early Joseon period also witnessed the development of important local innovations in thought and material culture. The adoption of Neo-Confucianism as state policy transformed the system of government, the composition and interests of the elite, and, more gradually, the daily lives of the Korean people, from marriage and funerary customs to the roles of women in society and the design and production of decorative arts. In forging this new path for their country, early Joseon rulers established the political, societal, and cultural norms that underpinned Korean social and material life through to the twentieth century.

LEE TALBOT

JAPAN

The fifteenth and sixteenth centuries make up the second half of what scholars now refer to as the medieval period in Japan. It began with the eclipse of rule by the emperor and imperial court aristocracy in the western city of Kyoto and the rise of a new form of military government known as the *bakufu*, or shogunate, in the eastern city of Kamakura. The original shogunate gave way to the new line of Ashikaga shoguns, who returned the seat of shogunal governance to Kyoto and whose reign would be known as the Muromachi period (1336–1573) after the area from which they ruled.

The years 1400 to 1600 were marked by a steady devolution of power away from the emperor and shogun in Kyoto and toward the emerging domains of provincial warlords (daimyo). This process was accelerated by the Ōnin War (1467–77), which devastated the capital city of Kyoto and challenged the authority of the Ashikaga rule. Later historians designated the succeeding century of strife as Sengoku, the era of "warring states."

Despite the instability and conflict, the Sengoku era was one of accelerating economic growth and an expansion of cultivated land. Improved transportation enabled commerce among different parts of Japan, and demands by its new daimyo class stimulated the growth of artisanal skills in many centers of production throughout the country. Kyoto culture spread as court aristocrats and priests, fleeing the battle-torn capital, took refuge with provincial warlords. Kyoto itself was rebuilt under the leadership of a newly energized merchant urban class. The expansion of commerce also had an increasingly international dimension, with overseas trade between Ming China, Joseon Korea, the Ryūkyū Kingdom (Okinawa), the Philippines, Vietnam, Indonesia, and Siam (present-day Thailand) leading to the import into Japan of a rich diversity of luxury goods and other products, providing further stimulus to domestic productivity.

Trade was further energized by the arrival of Western missionaries and traders. Shipwrecked Portuguese traders reached Tanegashima (off the coast of Kagoshima prefecture in southern Japan) in 1543, and the Roman Catholic Jesuit missionary Francis Xavier (1506–1552) arrived in Japan six years later. The port city of Sakai, near Osaka, was a major import center, and some of its successful merchants participated in the arts, particularly the practice of tea, or the tea ceremony as it is popularly known.

The increasing daimyo power in the provinces led to a new phase of military reconsolidation and political unification under three dynamic leaders. First, Oda Nobunaga (r. 1573–82) unseated the fifteenth and last Ashikaga shogun in 1573. The extraordinary rise to power of Nobunaga's successor, Toyotomi Hideyoshi (r. 1590–98), from peasant birth illustrates the "lower overcoming the higher" (*gekokujō*) of late medieval Japan. Nobunaga and Hideyoshi ushered in the great era of building castles and "castle towns" (*jōkamachi*), complete with new shrines, temples, and commoner quarters. This sustained period of urban development created demand for interior decoration in a wide variety of forms and media. The Momoyama period (1573–1615) was a time of remarkable achievements in decoraties arts, design, and material culture. Tokugawa Ieyasu (r. 1603–5), who helped to unify Japan, established a shogunate in Edo (present-day Tokyo) that would govern for more than two and a half centuries.

Until the mid-nineteenth century, there were few distinctions between decorative and fine arts in Japan. Objects were considered components of cultural practices such as *kazari* (adornment), involving the production and orchestration of artifacts as ensembles tailored for specific occasions. Room partitions such as sliding door panels (*fusuma*) and folding screens (*byōbu*) provided opportunities for pictorial display, and renowned artists accepted commissions for them as well as for decorations for items such as folding fans (*ōgi*), writing desks, and saddles for the elite.

The objects themselves were made from multiple materials: the sheets of silk or paper of the hanging scroll (*kakemono*) and handscroll (*makimono*)—prominent formats for pictorial and calligraphic expression in both secular and religious realms—were affixed to textile mounts, fitted with rollers of wood and precious materials, and stored in custom-made

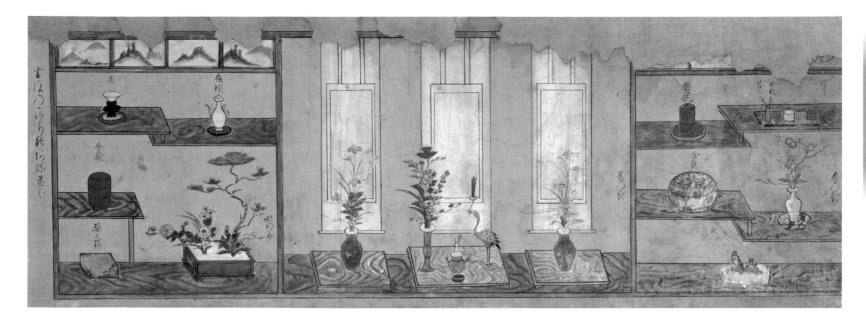

boxes. Producing such objects required the coordinated efforts of papermakers, textile makers, woodworkers, and mounters. Between 1400 and 1600, the intermingling of various media figures prominently in the design, manufacture, collecting, and display of objects and clothing. The extant objects, primary records, and scholarly research chiefly reflect elite material culture, but ordinary objects and the formal language of the everyday also can be seen, particularly in the context of tea culture, which brings together architecture, calligraphy, painting, ceramics, textiles, lacquerware, metalwork, and woodwork.

COLLECTING AND DISPLAY IN ELITE INTERIORS

Official and private trade among Japan and its neighbors China and Korea fostered a native–foreign or local–imported dialectic that shaped much of the material and visual culture in Japan, thus increasing the number of outside influences that informed local production for centuries. Beginning in the thirteenth century, the Zen temples in Kamakura and Kyoto attracted monks from China, and with them ideas and artifacts from the Song (960–1279) and Yuan (1279–1368) dynasties. With Ashikaga shogunal support, the Zen monasteries flourished as cultural centers. Artifacts came from a variety of places and times, but imported objects were prized and generally recognized under the broad designation *karamono* (literally "Chinese things").

Fifteenth-century records indicate that *karamono* featured prominently in elite social events. For the annual votive flower display for the Star Festival (*tanabata*) in 1432 (held on the seventh day of the seventh month), flowers arranged in fifty Chinese bronze vases were delivered to the residence of the imperial prince Fushiminomiya Sadafusa. Two rooms—the residential quarters (*tsune gosho*) and guest hall (*kyakuden*)—were combined temporarily to form a reception room (*kaisho*) by opening or removing the sliding doors

between them. Against a backdrop of two pairs of folding screens, an impressive display of Chinese objects—seven hanging scroll paintings and tables arrayed with vases—transformed the room into a ceremonial space. This was the setting for the events of the day, which included a Buddhist ritual, a banquet, poetry composition and recitation, the judging of floral arrangements, and music. The open-plan *shinden*-style interiors had a central "sleeping hall" (*shinden*) that could be used as a ceremonial or living space depending on the decoration and placement of movable furnishings. Flexible interior decoration (*shitsurai*, or "furnishing"), such as movable shelves for storage and display, had been incorporated into *shinden*-style residences of the court aristocracy since Heian times (794–1185).

Standardization of the display of *karamono* developed in tandem with a type of residential architecture known as *shoin* that emerged from the *shinden* style, but with permanent fixtures. Central to this systemization of display were three generations of cultural advisers: Nōami (1397–1471), Geiami (1431–1485), and Sōami (d. 1525). They served the Ashikaga shoguns Yoshinori (r. 1429–41) and his son Yoshimasa (r. 1449–73) and oversaw the connoisseurship, appraisal, mounting, conservation, and storage of *karamono* in the shogunal collection, begun in the mid-fourteenth century. They were also charged with deploying that collection in displays of shogunal authority. Their knowledge was passed down through the *Kundaikan sōchōki* (Manual of the Attendant of the Shogunal Collection), written in the fifteenth century. For each fixture of the *shoin*-style structure—such as the fitted desk (*tsukeshoin*), staggered or uneven shelving (*chigaidana*), low shelves or boards for display of objects (*oshiita*), and display alcove (*tokonoma*)—the manual gives methods of arrangement, complete with annotated diagrams and evaluative descriptions of the objects to be used.

Chinese objects placed in context with identifying descriptions appear in another manual, *Mon'ami kadensho* (Mon'ami's Secret Flower Arrangement Teachings, fig. 1.21), thought to have been written by the flower arrangement

Fig. 1.21. Handscroll: *Mon'ami's Secret Flower Arrangement Teachings*, Japan, 1522 (1559 copy). Ink and color on paper; 1 x 19 ft. (.3 x 5.8 m). Kyushu National Museum, Japan (P2).

specialist Mon'ami (d. 1517). The image shown here illustrates the display alcove flanked by staggered shelves. Three blank scrolls serve as placeholders in the alcove, representing the display of a triptych. In front of the middle scroll are the "three implements" (*mitsugusoku*)—candlestick, incense burner, and flower vase—that denote the Buddhist origins of ritual flower offering and display. The implements are flanked by two vases with irises accompanied with the annotation "summer flowers." There are two other groups of flowers with annotations: to the far right, an arrangement of plums in a white vase was captioned "spring flowers," while the arrangement with chrysanthemums to the far left was "autumn flowers." This manual was part of a larger effort to systematize the arts, including tea practice, in the mid-sixteenth century.

If *karamono* bespoke imported cultural authority, lacquer objects adorned with the *maki-e* (literally "sprinkled picture") technique bespoke traditional refinement and wealth. The technique had been in use since at least the ninth century for the ornamentation of the Buddhist implements and furnishings of the imperial court aristocracy. It was an expensive and labor intensive process whereby thin layers of lacquer were gradually built up and decorated with sprinklings of metallic powder, or flecks of metal leaf, usually gold or silver. This meant that only wealthy patrons could afford *maki-e* objects, thus furthering its association with the elite upper classes. One example of sixteenth-century lacquerware, a writing box (*suzuribako*), is typical of the fusion of function and technique with subject matter, in this case the landscape of a noted poetic site (fig. 1.22). Its decoration combines densely speckled gold (*nashiji*, or pear skin) and a picture created with sprinkled relief (*takamaki-e*), a process in which lacquer mixed with charcoal powder is built up in relief and then dusted with gold or silver powder, used here to accentuate the forms of trees, rocks, shrine structures, shells, and waves.

Painterly gradations of density are achieved through manipulation of the particle size of the metal, the type of metal used, the choice of lacquer (translucent or tinted), and the surface texture. Through these means, in the writing box shown, the mountains recede into the distance, the waves undulate, pine needles are of a requisite sharpness, and the tree trunks are appropriately textured. Writing boxes, which held brushes, ink stick, water dropper, and inkstone, played a prominent role in poetry gatherings. Accordingly, they were often ornamented with literary themes evoking knowledge dating back to the perceived golden age of courtly culture in the Heian period. These themes range from *waka* poetry (Japanese courtly verse in thirty-one syllables) to such narrative texts as *Genji monogatari* (The Tale of Genji) and *Ise monogatari* (The Tales of Ise)—literary essentials of an elite education. Near the tree trunks on the box shown here, seven letters offer clues to a poem from the eighth imperial poetry anthology *Kin'yōshū* (1127), revealing that the scene on this writing box is Futamigaura Bay in present-day Mie prefecture.

The making of such lacquerware was a family trade, and in the fifteenth and sixteenth centuries, the Kōami and Igarashi families, who produced lacquered objects for the shogunal family, were especially prominent. Along with other artistic families, such as the Gotō metalworkers and the Kanō painters, they prospered into the seventeenth century.

Other lacquerware, made without *maki-e* decoration, includes *negoro* ware. Negoroji, a temple in Kii province (present-day Wakayama prefecture), was once the foremost producer of this monochromatic lacquer. They specialized in forms for monastic and ceremonial use, such as this sake vessel, which was employed on altars at Shinto shrines (fig. 1.23), but *negoro* lacquerware was also made for everyday domestic use. Layers of black and red lacquer were built up on a wooden base, and the resulting vessels are now prized for the subtle tonal effects created through extended use and handling.

TEA CULTURE AND THE PRODUCTION OF TASTE

Introduced from Song China through Zen temples in the late twelfth century, the preparation and consumption of powdered green tea (*matcha*) evolved into a highly formalized practice in sixteenth-century Japan. Previously, tea would have been made in a separate room and brought to guests in the reception room. By the sixteenth century, as residences came to include dedicated spaces for tea and as stand-alone tea houses were built, "tea" became an event performed in front of guests by their host. The practice became known as *chanoyu* (literally "hot water for tea"; in English it is often referred to as the tea ceremony). It reflected personal taste in the selection of utensils and the adornment of spaces for presenting tea to guests.

Because the practice required a number of vessels and utensils, it created a demand for a range of suitable objects. In place of the "sets" of *karamono* displayed in the fifteenth century, mixing of imported and locally made utensils as well as combinations of materials were preferred for *chanoyu*, including ceramics (tea bowls, tea caddies, fresh- and used-water containers), metal (kettles, vases, and lid rests), lacquer (tea and incense containers), and bamboo (baskets), tea whisks, tea scoops, and ladles. The choice of utensils for *chanoyu* was made by the host according to the season, time, place, guests, and occasion of the gathering. Over time, choreographed movements were established for the preparation of tea, and the kettle became the centerpiece for the arrangement of charcoal, ashes, and incense in the hearth, all of which were critical for the optimal boiling of water. Cast-iron kettles from Ashiya, a region in southern Japan (present-day Fukuoka prefecture) that had long produced metalwork for temples and shrines, became especially coveted by *chanoyu* enthusiasts (fig. 1.24). The design of pine trees at a shore on this kettle finds its counterpart in paintings of the period and also alludes to the sound of water boiling in the kettle, which is likened in *chanoyu* to wind blowing through pines.

In the sixteenth century, *chanoyu* flourished among the urban merchant elite in Kyoto and Sakai. Murata Jukō (1423–1502), Takeno Jōō (1502–1555), and Sen no Rikyū (1522–1591) are celebrated practitioners and teachers associated with a philosophical approach that championed austerity, later known as *wabicha* (*wabi* tea) or tea of the *sōan* (thatched hut). The proponents of *wabi* tea embraced and promoted certain qualities, such as simplicity of form, wear associated with age, and "non-matching" implements. In doing so they moved away from the ideals of balance and perfection embodied by *karamono*. *Wabi* tea thus explored new aesthetic territory and encouraged the redefinition of conventional objects and the production of new ones. Tea records, kept by merchants, offer insights into the type and ownership of objects used in tea gatherings, often with commentary on a notable utensil, usually a tea jar, tea caddy, painting, or calligraphy.

Such records also provide a window onto the interactions and transactions among merchants, warriors, monks, and courtiers in the context of tea practice, demonstrating the significance of *chanoyu* for networking and the influence of

tea culture and tea practitioners in elite social life. The unprecedented mingling of social groups facilitated by *chanoyu* also contributed to what may be called the "art of value making" among late sixteenth-century tea practitioners, who excelled at appropriating objects not previously used in *chanoyu*. Humble "found objects" were elevated to the status of revered implements, demonstrating the transformative power of the connoisseurial selection by the tea masters. Rikyū famously adopted a well bucket as a vessel for fresh water, and some objects crafted or approved by Rikyū himself, such as bamboo baskets for flower arrangement (*tatehana*, *rikka*, *ikebana*) and bamboo tea scoops, were subsequently marked with his lacquered signature (*kaō*), imparting new value to the object. *Wabi* tea also promoted locally produced objects, such as utilitarian vessels made at the ceramic centers of Bizen, Shigaraki, Tanba, and Iga. A storage jar from Bizen features a dramatic flow of natural ash "glaze" that ran down its side during firing, an unplanned effect that almost overpowers the roughly combed geometric hatching around the shoulder of the vessel (fig. 1.25). Such seemingly spontaneous effects came to be appreciated aesthetically as "views" (*keshiki*), like a landscape, and were coveted by emergent tea aficionados.

Tea records from the 1580s mention both Japanese- and Korean-made tea bowls, marking a shift away from the earlier practice under the Ashikaga shoguns, which had been dominated by Chinese objects. A celebrated type of tea bowl specifically made for *chanoyu* from around the end of the sixteenth century is known as Raku, after the family of potters who made these wares and trace their lineage to the time of Rikyū. Raku bowls were and are individually constructed and fired in small updraft kilns (where the heat source comes from the bottom of the kiln). Though of a slightly later period, the bowl illustrated here, attributed to Sōnyū (1664–1716), of the fifth generation of the Raku family, captures the ideals

Fig. 1.24. *Shinnnari*-type tea kettle, Ashiya region, 15th century. Cast iron; H. 6¾ in. (17 cm). Tokyo National Museum, Important Cultural Property (E19998).

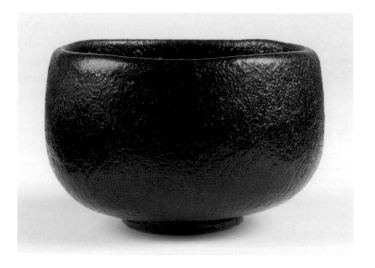

seventh century that adopted glazed stoneware technology from Seto in the early fifteenth century. Indeed, it appears that Mino products were marketed in Kyoto as "Seto" in the shadow of that better-known site.

One distinctive type of stoneware produced in the Mino region was Yellow Seto (Kiseto), a yellow-glazed ware. The thin-walled pieces were incised with plant designs colored copper green and iron brown and modeled after metalware and Chinese ceramic vessel types. Shino ware, the first underglaze-decorated ceramic produced in Japan, featured a characteristic thick, semiopaque white feldspathic glaze tinged with red, layered over brush-painted designs of brown iron oxide. Development of these glazed stonewares in Mino depended on the advanced technology of the partly buried, single-chamber "great kiln" (ōgama), introduced in the early sixteenth century. Imported wares had substantial impact on ceramic development in Japan and on Kyoto's *karamonoya* (merchants of imported goods), who connected the ceramic centers in the provinces to the markets in the capital.

CROSSCURRENTS IN DESIGN

The late sixteenth century was an extremely creative period in the decorative arts in Japan, a time when innovative styles and designs emerged in textiles, lacquer, and ceramics. One exuberant design, known as *katami-gawari* (alternating sides), lent itself to various media. Its mix-and-match designs, materials, colors, and patterns created a dynamic and distinctive composite imagery.

An example of a *kosode* robe demonstrates the *katami-gawari* dynamic, with different ground colors and designs alternating left and right (fig. 1.27). A precursor of the modern *kimono*, the *kosode* (small sleeves) was named for the small wrist openings of the garment. Here, the panels with the light ground combine embroidered designs of seashells and paper strips for poetry (*tanzaku*) hanging from the branches of a weeping cherry. The section with red ground consists of two panels, wandering stripes (*tatewaku*) overlaid with bridge and iris (upper panel) and snow-laden willow branches accented with paulownia and arrowheads (lower panel). This robe was made with the *nuihaku* technique, characterized by a three-

Fig. 1.25. Bizen ware storage jar, Imbe, 15th century. Stoneware; 20¹⁄₁₆ x 14¹³⁄₁₆ x 14¹³⁄₁₆ in. (51 x 37.7 x 37.7 cm). Freer Gallery of Art, Smithsonian Institution, Washington, DC (F1998.25).

Fig. 1.26. Attributed to Raku Sōnyū. Tea bowl, Kyoto, 1691–1716. Earthenware; 3 x 4½ x 4½ in. (7.6 x 11.4 x 11.4 cm). Victoria and Albert Museum, London (240-1877).

of the *wabi* aesthetic in its restrained and earthy hand-built form (fig. 1.26). The Raku lineage has continued for fifteen generations since and exemplifies the families of makers in Kyoto and beyond who have sustained the art of *chanoyu* over the centuries.

Recent archaeological discoveries along Kyoto's Sanjō Avenue document the great variety of local ceramics that were available in the capital by the end of the sixteenth century. The clustering of ceramics dealers was likely a result of Toyotomi Hideyoshi's redevelopment of the area in the 1590s, and documents from the 1620s identify it as the "precinct of pottery shops" (*Setomonoya-chō*). This name derives from the long-standing ceramics center of Seto (Owari province, now Aichi prefecture), which lent its name to the term *setomono* ("Seto things") as a common way to refer to ceramics. Excavated shards offer evidence of the quantity and variety of ceramic objects associated with tea culture that were sold along Sanjō Avenue, with each shop functioning as a key distributor for goods from particular locales, such as Seto and Karatsu (Hizen province, now Saga prefecture). A site in Nakanomachi yielded nearly 1,500 restorable tea utensils, the majority of which were new products of kilns in Mino province (now part of Gifu prefecture), a ceramics center since the

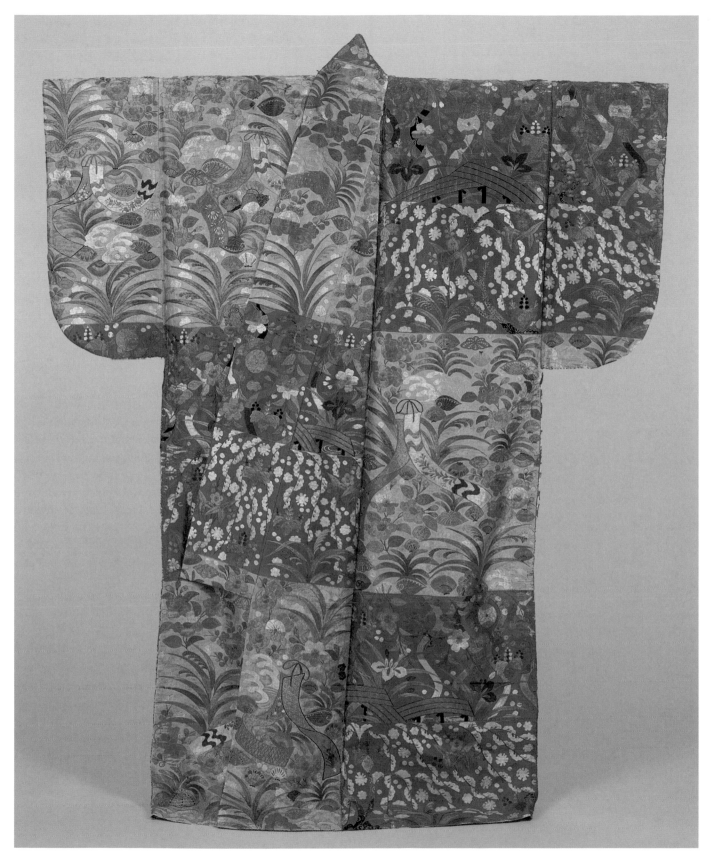

Fig. 1.27. Robe (*kosode*), Japan, 16th century. Embroidered silk, gold and silver foil; 54⅛ x 23¼ in. (137.6 x 59 cm). Tokyo National Museum, Important Cultural Property (I2904).

dimensional effect of densely embroidered glossy silk stitches (*nui*) set against the unembroidered areas adorned with imprinted gold or silver foil (*haku*).

Novel methods of embroidery and dyeing flourished on *kosode*, as seen in this example, which was passed down in the collection of the Mōri family of warriors of Suō province (now Yamaguchi prefecture), as a costume for Noh (masked, musical drama). The stylized blossoms of the paulownia (a tree native to Asia), embroidered on the red panels, may connect this *kosodo* to Toyotomi Hideyoshi, who was granted the use of this imperial crest by Emperor Goyōzei (r. 1586–1611) in 1586. Hideyoshi was an ardent patron and practitioner of Noh, even commissioning plays that celebrated his achievements.

Originally an undergarment worn by women at the court in Heian times, by the late sixteenth century, the *kosodo* had evolved into outerwear for people at all levels of society and

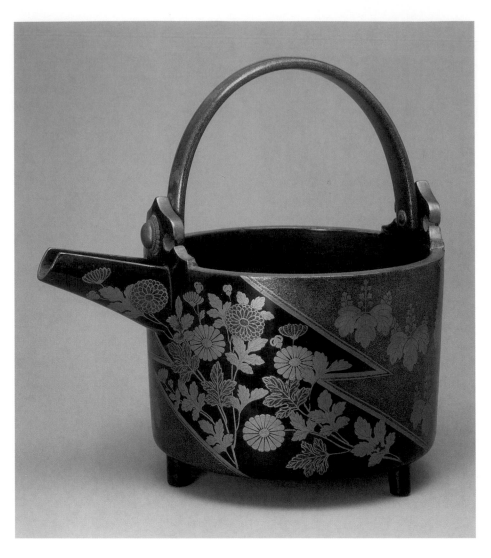

Fig. 1.28. Wine ewer, Japan, c. 1596. Lacquer on wood, gold; 10 x 10⅛ x 7 in. (25.4 x 25.7 x 17.8 cm). The Metropolitan Museum of Art (1980.6).

period, *karaori* had been reserved for a select circle of officials around the shogun. In the fifteenth century, the Nishijin weaving district in Kyoto was the largest in Japan, but the devastation and disruption of the Ōnin War led to a shortage of new, quality clothing and courtiers purportedly shared garments in order to conduct court ceremonies. Many Kyoto weavers and dyers moved to Sakai, where they found patronage from regional warlords and moneyed merchants. They adopted new styles of weaving and embroidery, many derived from techniques imported from Ming China.

In lacquerware, the *katami-gawari* design strategy manifested itself in a new style of *maki-e* lacquer that emerged in the late sixteenth century and is known now as Kōdaiji *maki-e*. The name comes from the Zen temple Kōdaiji, built by Hideyoshi's wife, Nene (1548–1624). The ewer illustrated here displays three distinct traits of Kōdaiji *maki-e*, namely, the motifs of autumn flowers and grasses, bold application of family crests, and the use of *katami-gawari* (fig. 1.28). Here a dramatic zigzag border creates a contrast in color and design between chrysanthemum sprays on black lacquer and paulownia, the Toyotomi family crest, on the red- and gold-flecked *nashiji*.

In contrast to the sculptural relief of the writing box shown earlier (see fig. 1.22), the two-dimensional pictoriality of the Kōdaiji style is fresh and bold. The difference in effect largely comes from the "flat" sprinkled picture (*hiramaki-e*) technique, which dispensed with the drying time between layered relief applications. Chrysanthemum flowers and leaves are outlined with gold raised lines (*tsukegaki*, created by fine painted lines sprinkled with gold) and filled in with gold-flecked red *nashiji*. Needle drawing (*harigaki*)—finely engraved lines made with a pointed tool—delineates the veins of chrysanthemum leaves rendered in flat gold *maki-e*, as well as the paulownia leaves on the red-gold ground. Largely forgoing the use of preparatory designs on paper, these designs and patterns were drawn freehand or stenciled onto the lacquer surface. Hideyoshi is known to have included the emblematic chrysanthemum and paulownia crests on a range of objects and structures, rendering them in luxurious *maki-e* even on everyday dining wares and bath pails.

Flat *maki-e* technique was also used for export lacquer produced during this period, but with a radically different aesthetic sensibility. In lacquer goods for export, mother-of-pearl inlay and gold flat *maki-e* typically covered the entire surface of a black ground, as in the example of a missal stand with the Jesuit Christogram "IHS" that is now in the Peabody Essex Museum in Salem, Massachusetts. Roman Catholicism was introduced to Japan by the Jesuits in the mid-sixteenth century and propagated there until its official ban in 1614, after which it went underground. In the intervening years, *maki-e* artisans in Kyoto were commissioned to make a variety of objects for export, such as the portable cabinet (*barqueño*) of the late sixteenth or early seventeenth century illustrated here (fig. 1.29).

This type of export lacquer made to Western specifications is called *namban* (or *nanban*; literally "southern barbarian"), a term used to denote foreigners other than Chinese and Koreans and, by extension, items made for export. At first,

was particularly favored by warriors and commoners. It was worn layered or as a part of an ensemble as dictated by class and occasion. In late sixteenth-century cityscapes of Kyoto, a genre known as *Rakuchū-rakugai zu* (scenes in and around the capital), for example, commoners wear *kosode* alone or with a layer of undergarment, loosely fastened at the waist with a thin sash. In a formal portrait, the thirteenth Ashikaga shogun Yoshiteru (r. 1546–65), dated 1577, wears a long-sleeved jacket and trouser set called *hitatare*, under which is a *kosode* of alternating designs in white and crimson. *Kosode* were also worn beneath *kataginu,* a sleeveless jacket that gained favor as warrior formalwear during the mid-sixteenth century. Yet despite the long history of the *kosode*, most surviving examples date from the end of the sixteenth century or later. Many of these are women's *kosode*, some of which were offered to temples after the owner's death where they might be reconfigured into altar cloths (*uchishiki*).

In the late sixteenth century, dyed and embroidered designs such as those on the *kosode* illustrated in figure 1.27 replaced woven patterns in the decoration of clothing created for the elite. Embroidery and dyeing not only allowed for more flexibility in the design of a pattern than weaving would allow, but also marked a significant departure from the attitude that woven designs were superior to dyed ornament. Some woven garments such as *karaori* ("Chinese weave") continued to enjoy a privileged status. In the Muromachi

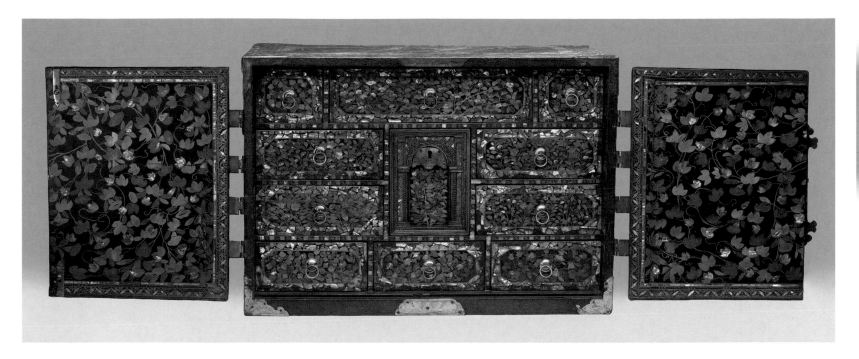

these were mostly religious furnishings commissioned by Jesuit missionaries for the Portuguese, although the items also were purchased by the Spanish, Dutch, and English. Such lacquer objects were likely produced from the 1580s until 1639, when trade with Portugal was suspended. Thereafter, trade was conducted with Dutch, English, and Chinese merchants through the port of Nagasaki. Along with domed coffers, this type of portable chest was popular with a stand often being custom-made at its destination. This example opens to reveal multiple drawers, each decorated with staple motifs in Japanese lacquer design, such as Chinese bellflowers (*kikyō*) and *tachibana* citrus, while the interior of the door panels are adorned with bottle gourd flowers (*yūgao*). Applying these motifs to distinctly Western forms results in hybrid objects illustrative of global trade of the time.

A ceramic incarnation of *katami-gawari* appears in a style of Mino ceramics known as Oribe ware (produced around 1600–30), illustrated here by a set of dishes that juxtapose areas of glossy green glaze and geometric and plant motifs drawn with iron against a white ground (fig. 1.30). Oribe ware is renowned for innovative shapes, such as these molded in the shape of fletchings (the feathers attached to arrows), and for dynamic designs often contrasting a distinct copper-green glaze with loose freehand underglaze iron painting. This juxtaposition was enabled by the high temperatures achieved with the multichambered climbing kilns introduced in the Mino region during the Keichō era (1596–1615). The new kiln technology, brought from Korea to the Karatsu region in southern Japan, produced temperatures high enough to transform milky-white glazes to glossy, transparent coatings, thus allow-

Fig. 1.29. Portable cabinet (*barqueño*) made for the Portuguese export market, Japan, late 16th–early 17th century. Lacquer on wood, gold, mother-of-pearl inlay, metal fittings; 17¼ x 24½ x 13⅜ in. (43.8 x 62.2 x 34 cm). Brooklyn Museum (84.69.1).

Fig. 1.30. Mino ware Oribe-style dishes, Mino region, 1600–30. Stoneware; each, 2¼ x 5¾ x 4½ in. (5.8 x 14.5 x 11.5 cm). Victoria and Albert Museum, London (FE.73-1982 and FE.73A-1982).

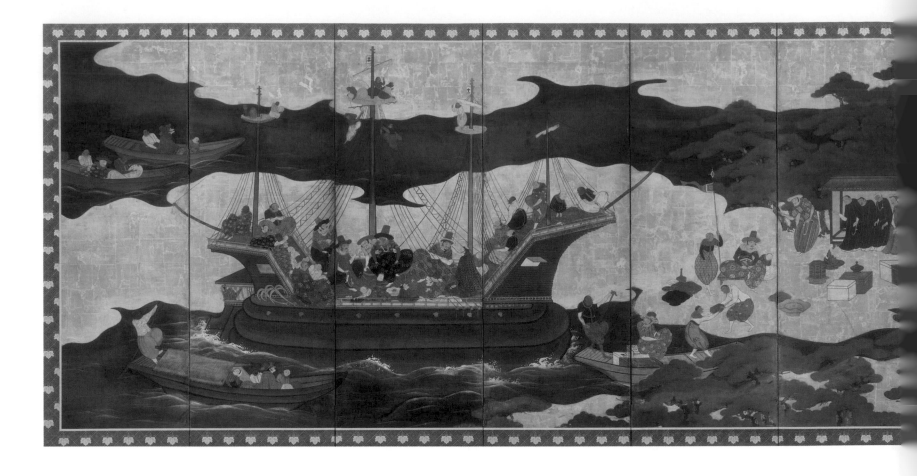

ing potters to use the colors of the clay and of decoration painted under the glaze.

Also prized is the improvisational quality of the painted decoration on Oribe ceramics. Sets of small dishes and other Oribe tableware survive in significant numbers, indicating their extensive use in elite dining, including the meals served during *chanoyu* gatherings. Icons of Oribe ware include dynamically distorted "clog-shaped" tea bowls that were favored by the tea master Furuta Oribe (1544–1615), whose name is intimately linked to this ware but whose involvement in its development is not altogether certain. Oribe was Rikyū's disciple in *chanoyu*, but unlike his mentor, who preferred balanced shapes and the restrained aesthetic of *wabi*, Oribe cultivated and promoted distortion. Oribe ware was also in tune with fashions in the capital, appropriating motifs from

Kōdaiji *maki-e* and designs from the *tsujigahana* textiles (a form of resist-dyed textiles) that were being made there.

Oribe potters also supplied the market for whimsical and exotic pieces, including a candleholder in the shape of a man in European dress, resembling the pantaloons (*karusan*, from the Portuguese *calcao*) worn by merchants in screen paintings depicting *namban* (fig. 1.31). Figures on the left screen banquet aboard a *namban* carrack while others unload goods—lacquerware, textiles, ceramics, and exotic rocks, many of Chinese origin—as Jesuit and Franciscan monks look on. On the right screen, the carrack's captain, shielded by a red umbrella, and his crew parade through town as locals catch a glimpse from their storefronts, through windows and curtains bearing their trademarks. These screens capture the Japanese fascination with *namban*, from their Christian faith to the practice of leashing dogs. *Namban* figures and motifs, such as the Cross, came to be featured in other forms of fine craft, including lacquer writing boxes and ceramics.

Imported wool felt (*rasha*, derived from the Portuguese *raxa*), presented by Portuguese merchants, became a status symbol among daimyo who sought to display their wealth and power. A campaign jacket (*jinbaori*; fig. 1.32)—a tunic worn over armor during battle—dynamically arranges two crossed sickles appliquéd over a bright vermilion *rasha*. Daimyo likely favored *rasha* for campaign jackets owing to its water-resistance and warmth. The curving hem shows European influence; garments like *kosode* had straight hems. The lining of white damask is embroidered with the Chinese character for "eternity," perhaps reflecting the wishes of Hideyoshi's nephew Kobayakawa Hideaki (1577–1602), the purported owner of this jacket. Such ostentatious jackets

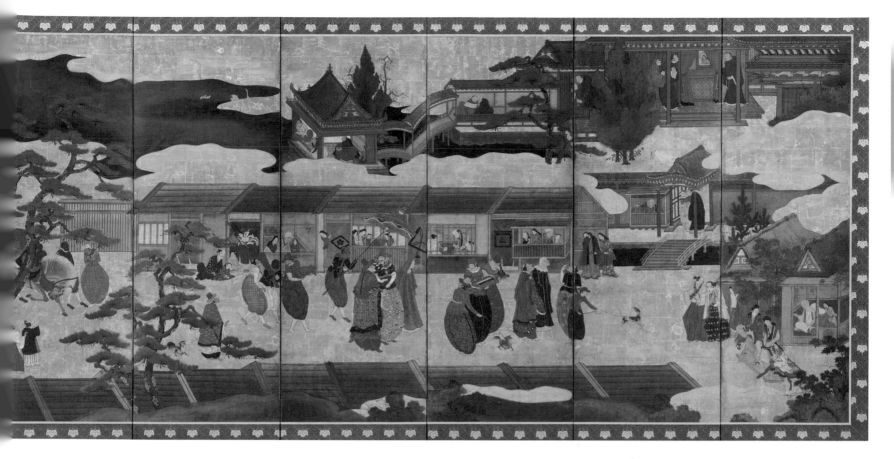

would stand out on a battlefield and no doubt create a wondrous visual statement when paired with sculptural "spectacular helmets" (*kawari kabuto*) and lavishly decorated swords and saddles. The commander's need to be visible was prompted by new types of battles after the introduction of firearms from Europe in the late sixteenth century. The shift from close combat with swords and staff weapons to the use of matchlock firearms also led to a transformation in the style of armor, from the conventional *yoroi* (consisting of laced small plates of iron or leather) to sheet iron known as *tōsei gusoku* (literally "modern armor").

The Ōnin War introduced an age of sparring between regional daimyo lords, and the years 1400 to 1600 were shaped by strife in Japan. Although unrest may have been the norm, alliances forged by courtiers fleeing the war, itinerant poets, and provincial lords fostered cultural networking. Just as residents worked together to rebuild the city of Kyoto, castle towns around the country contributed to regional decorative arts and design. The decorative arts tied to the highly social arts of poetry, tea, incense, and Noh flourished as a result of their widening circles of appreciation. Cultural production was fueled by native court culture and imported Zen culture, as well as an awareness of the world beyond Asia. With coexisting methods and ideals for the display of cultural prowess and the enrichment of daily life, decorative art and design of the fifteenth and sixteenth centuries saw a rich cross-fertilization of subjects and motifs from the courtly, warrior, and Zen milieus, between the capital in Kyoto and the provinces. Different occasions called for specific objects and effects, from the principled austerity of the *wabi* aesthetic to the ostentatious display of battle garments, yet a sense of integration and dynamism characterizes much of the decorative art and design of the era.

TOMOKO SAKOMURA

INDIA

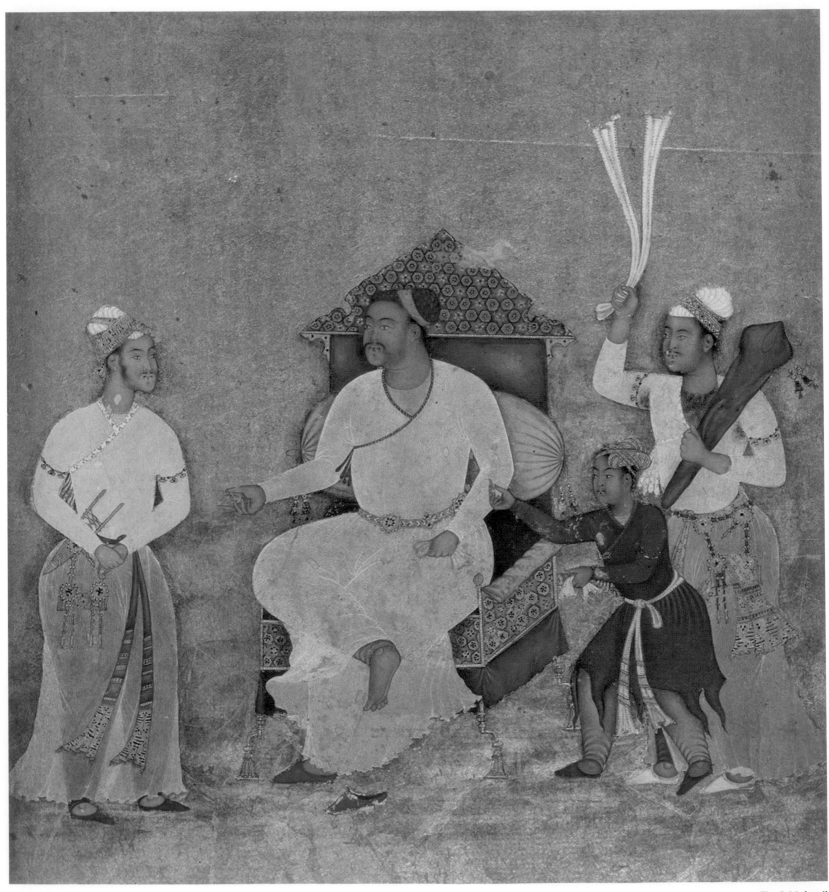

Fig. 2.16 detail

From the fifteenth through the seventeenth century, the Indian subcontinent (comprising present-day India, Pakistan, Bangladesh, and Sri Lanka) was a land consisting of dozens of states of various sizes. Many of these were gradually incorporated into more extensive and powerful kingdoms and empires, until by the end of the sixteenth century, the largest, the Mughal Empire (1526–1858), comprised all of northern India. By the end of the seventeenth century, it encompassed all of the rest of India as well, except a very small area at the southern tip of the peninsula and Ceylon (after 1972, Sri Lanka). The second most important power was the Vijayanagara Empire (1336–1646), which, until the encroachments of the Mughal Empire, included much of the southern part of the subcontinent. The predominant religions of this period were Hinduism, Islam, Jainism, and Sikhism. The Muslims in India included Sunnis and Shiites—the two main sects of Islam. Among the decorative arts in India, textiles have been admired since ancient times (in the fifth century BC, the Greek historian Herodotus referred to Indian cotton clothing), but other media also have long traditions there, including metalwork, ceramics, woodwork, ivory, jewelry, and architectural decoration. During the period 1400–1600, the forms and motifs of decorative arts and architecture reflected the influence of the rich visual cultures of both Persia and India.

India's monsoonal climate guaranteed the deterioration of organic materials, whether of plaster, wood, cloth, or paper, and few examples of these decorative arts from the period survive. Moreover, there was no well-developed tradition of storing and safeguarding precious items, such as silks or jewelry, as there was, for instance, in Southeast Asia or China. There is, however, no shortage of surviving buildings—temples, palaces, mosques, and tombs—that were decorated with a wide range of materials in a variety of styles and motifs. Architectural decoration, together with the rare surviving objects and miniature paintings, attest to the breadth and quality of Indian design and the decorative arts at the time. The paintings frequently depict courtly interiors replete with sumptuous carpets, jeweled thrones, and silver basins and ewers, as well as sultans, princes, and nobles dressed in richly patterned clothing, bearing finely crafted weapons (fig. 2.1). Such interiors, costumes, and objects complement the plentiful references in the accounts of European traders and travelers who journeyed to India at this time.

THE HINDU AND SULTANATE COURTS

Many of the designs, forms, and motifs in use between 1400 and 1600 had origins in earlier styles and techniques. The

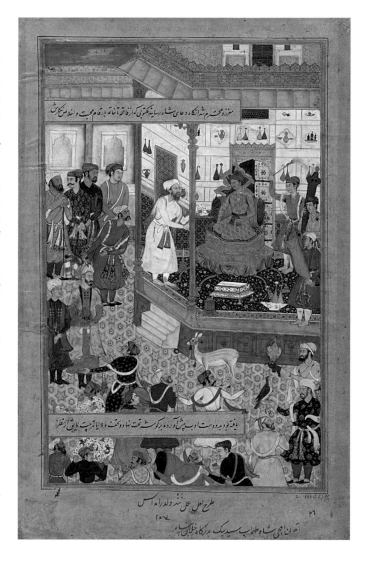

Fig. 2.1. La'l (composition) and Nand (painting). Akbar receiving the Iranian ambassador Sayyid Beg in 1562, Mughal court, 1590–95. Watercolor, gold; 12⅛ x 7½ in. (30.8 x 19.1 cm). Victoria and Albert Museum, London (IS.2:27-1896).

fifteenth- and sixteenth-century rulers of central and western India (Rajasthan and Gujarat) built profusely carved structures for Hindu and Jain cult worship that were closely related to previous temple forms and sculpture. Illustrated manuscripts were commissioned by wealthy Jain merchants in Rajasthan and Gujarat.

During this period, southern India was dominated by the kings of a Hindu state founded in 1336 that became the large and powerful Vijayanagara Empire, reaching its peak in the early sixteenth century. It was named for its capital, Vijayanagara (City of Victory; in present-day Karnataka), one of the largest and wealthiest cities in Asia at the time. Vijayanagara rulers and their representatives were noted for their patronage of Hindu monuments, painting, and decorative arts objects. The capital was sacked in 1565 and subsequently abandoned, and apart from a few isolated weapons, no courtly objects have survived. Later rulers in southern India continued to

commission architecture and decorative arts objects, not least because the embellishment of Hindu temples was considered an essential part of governance. Granite sanctuaries, adorned with sculptures and murals dating from the fifteenth and sixteenth centuries, are found throughout the Vijayanagara territories. Details from temple murals in which costumes and cotton hangings are depicted testify to a vital textile tradition. Metal workshops also thrived there, judging from the superbly crafted weapons manufactured for royal armories that have been preserved.

Much of the rest of India was divided into small Muslim kingdoms, generally referred to as sultanates, such as Delhi in the north, Gujarat in the west, Bengal in the east, and Malwa in central India. To these must be added the Muslim Bahmani dominion of the Deccan plateau (the peninsula of India south of the Narmada River), which was succeeded at the beginning of the sixteenth century by the breakaway kingdoms of the Nizam Shahis in Ahmadnagar (Maharashtra), Baridis in Bidar (Karnataka), Adil Shahis in Bijapur (Karnataka), and Qutb Shahis in Golconda (Andhra Pradesh). Rulers of each of these dynasties commissioned mosques, tombs, and sumptuously appointed palaces. Delhi was noted for its plasterwork, Gaur (western Bengal) for terracotta panels, and Bidar for colored tile mosaic, a virtuoso technique requiring great craftsmanship. The shapes of each motif in blue, turquoise, yellow, or white are skillfully cut out of glazed tiles of the appropriate color and fitted together to form various geometric and calligraphic patterns. This labor-intensive and commensurately expensive technique was used only for special monuments. In the more usual tilework, motifs were painted on square tiles laid next to each other, an easier and less-expensive practice.

The rich diversity of techniques, forms, and motifs is partly explained by the various indigenous responses to Central Asian and Persian building and design traditions, from the first wave of Muslim conquerors from Central Asia in northern India at the very end of the twelfth century to the Mughal conquest in 1526 by the first Mughal ruler of India, Babur, a descendant of Timur and Genghis Khan. Central Asian and Persian visual culture—especially calligraphic, geometric, and arabesque designs—intermingled with well-established Indian motifs, most notably the lotus flower in all of its variant forms, the *kalasha* (water pot), and the fantastic leonine beast known as the *vyala* or *yali*.

Surviving examples of sultanate arts include: miniature paintings associated with the courts of Mandu (Malwa), Gaur, and the Deccan; textiles produced in Gujarat (annexed by the Mughals in 1573), including cottons and silks exported to the Ottoman world and Southeast Asia; and spectacular mother-of-pearl-encrusted boxes, manufactured in Gujarat. The latter made their way west to the Ottoman Empire and Europe via Arabian Sea merchants, until in the sixteenth century, when Portuguese traders who reached India in 1498 (the first Europeans to do so) established a base in 1510 at Goa, on the peninsular west coast of India.

EARLY MUGHAL PERIOD

The Mughal emperor Akbar, who ruled from 1556 to 1605, took an intense personal interest in both the decorative arts and architecture, and buildings and objects made during his reign display considerable energy and inventiveness. A skilled warrior and politician, Akbar commissioned the repair of the fortresses at Agra (Uttar Pradesh) and Lahore (now in Pakistan) and the construction of a new palace city of Fatehpur Sikri (near Agra), built chiefly of local red sandstone, between 1571 and 1585. After the annexation of Gujarat in 1572–73, there was an influx of Gujarati masons to the new city, bringing with them arabesque and geometric designs that soon appeared in carved relief ornament, polychrome stonework, and *jalis* (perforated stone screens).

Akbar established *kar-khanehs* (imperial workshops) at his various capitals, meeting regularly with specialists, some of whom were Persian emigrés, recruited to train local craftsmen in particular ways of making miniature paintings, textiles, carpets, metalwork, furniture, and other luxury items, many of which survive. Similar designs appeared in various media: sandstone and marble panels, carpets and cotton textiles, and metal and glass objects, while characteristic patterns employed floral motifs, either stylized blossoms linked by scrolling vine stems or as rows of repeated naturalistic flowers. Such ornament reappeared in the decoration of court buildings and carpets (discussed below), suggesting a widespread fascination with the natural world, including depictions of animals and birds. Together with human figures, such flora and fauna enriched the visual environment of the early Mughal period.

Floral, animal, and figural themes also featured in the textiles, furniture, and other objects commissioned by the Portuguese from their trading headquarters in Goa and their various "factories" at Kochi (Cochin) in Kerala (1502), Cambay in Gujarat (1535), Satgaon in Bengal (1535), and Galle in Ceylon (1585). These were strategically located ports, where foreign merchants could commission Indian goods, which were made to order for the following season's ships bound for Europe and Southeast Asia. From these bases the Portuguese came to dominate the Arabian Sea shipping routes from India to the Ottoman lands and Europe. Textiles were a major component of this commerce, especially embroidered silk quilts from Bengal, stitched with depictions of Portuguese people and, on occasion, the emblems of aristocratic Portuguese families. Carved ivory boxes produced in Ceylon were similarly embellished with Portuguese figures and coats of arms, as were those made as gifts to accompany a diplomatic envoy to Portugal in 1542 (see fig. 2.19).

STONEWORK

Highly developed in India, stone carving was the main means of decorating religious and secular buildings, inside and out. The tradition extends back more than two thousand years in the religious architecture and sculpture of Buddhism, Hinduism, and Jainism. Although temples had suffered earlier from the destructive actions of Muslim invaders, sufficient craft

skills survived in southern and western India to ensure that the highest-quality workmanship persisted, as can be seen in the granite carvings that enliven temple interiors in Karnataka and Tamil Nadu. In the *mandapa* (great hall) that leads to the Vitthala temple at Vijayanagara, commissioned in 1554 by a prominent military commander of the Vijayanagara emperor Sadashiva, the ceiling is supported by piers with columns of slender, clustered "stems" and curving lotus brackets, and there are three-dimensional carvings of deities, musicians, dancers, and the magically protective *yalis*. An outstanding example of similar animal decoration is found in the mid-sixteenth-century *kalyana mandapa* (marriage hall) of the Jalakanteshvara temple at Vellore (Tamil Nadu), the external columns of which are ornamented with *yalis* and horses, both ridden by armed warriors. Lifelike in scale and cut out of granite in a strikingly naturalistic manner, these animal and human figures contributed a distinctly martial spirit to the interior. In contrast, the central ceiling panel featured rings of petals, parrots, and dancing maidens, all executed in high relief surrounding an elaborate lotus medallion.

Ornate stone interiors were also created elsewhere in southern India, as for example at the late sixteenth-century Virabhadra temple at Keladi (Karnataka). The *mandapa* ceilings here were carved in shallow relief with geometric, looped, and knotted patterns derived from contemporary textiles, as well as a *gandabherunda* (double-headed eagle) clutching two small elephants set among deeply incised foliate and floral ornament (fig. 2.2). Probably introduced into southern India by the Portuguese, this bird motif was adopted as a royal emblem by the local Nayaka kings of Keladi.

Fig. 2.2. Ceiling panel, Virabhadra temple, Keladi, Karnataka, late 16th century. Granite.

Religious buildings in western India also had richly carved stone interiors. The Adinatha temple at Ranakpur (Rajasthan), for example, begun in 1439, was built of the purest white marble, inside and out, with the *mandapa* columns embellished by looped garlands and hanging bells, stylized lotus motifs, and ferocious *kirtimukhas* (monster masks), in addition to a full array of Jain saviors. Slender columns superimposed in two or three tiers carried domed ceilings fashioned from concentric masonry rings supported on corbels—a traditional Indian structural device—and decorated with friezes of lotus petals and figural brackets radiating outward from intricately carved, central pendant lotuses (fig. 2.3). As daylight entered the temple, it accentuated the sharply incised details of the sculpted decoration, the visual density adding greatly to the beauty of the interior.

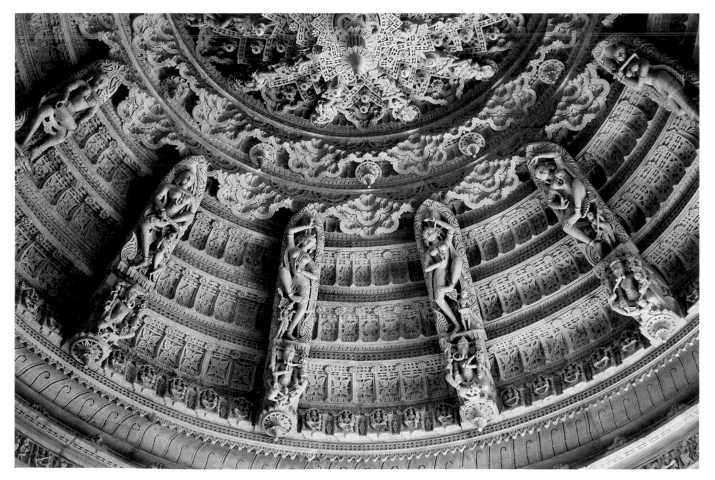

Fig. 2.3. Dome with tiers of lotus and figural brackets, Adinatha temple, Ranakpur, Rajasthan, 1439. Limestone.

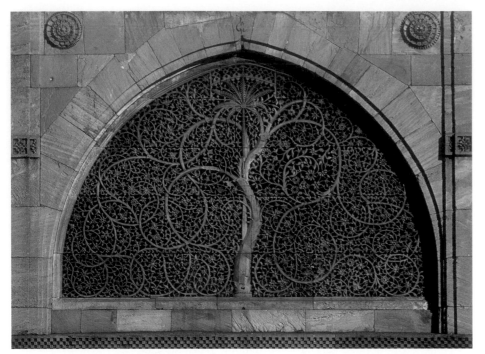

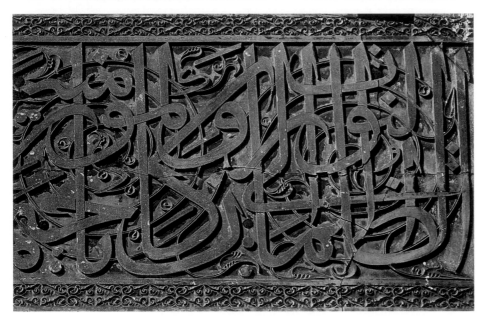

Fig. 2.4. Carved screen (*jali*), Sidi Sayyid mosque, Ahmadabad, Gujarat, 1572. Sandstone.

Fig. 2.5. Doorway lintel with a Koranic inscription, Chaukhandi tomb of Shaykh Khalilullah, Bidar, Karnataka, 1450. Basalt.

Mahmud Begra, built in Ahmadabad in 1514. The finest surviving screens in Ahmadabad, in Sidi Sayyid's mosque of 1572, feature palms and fantasy trees with swirling trunks surrounded by stylized stems and leaves (fig. 2.4).

Another region where the tradition of stone carving was well developed was the Deccan, the seat of the Bahmani rulers in the fifteenth century. Outstanding Deccan sculpted decoration includes the black basalt inscriptions in Arabic over the doorways of the 1450 Chaukhandi (tomb of Shaykh Khalilullah, the religious teacher of the Bahmani sultan Ahmad Shah II, r. 1436–58), outside Bidar. Here Koranic passages in majestic *thuluth* script (one of the cursive Arabic scripts) are set on a background of sharply incised volutes of foliated scrollwork (fig. 2.5). The work of a calligrapher from Shiraz in Iran, these compositions are among the most refined examples of Indian Islamic calligraphy of the period. Other examples of well-executed stone carving on this monument are the basalt stringcourses, with deeply modeled palmette motifs and interlocking spiral patterns, that frame the arched panels of the tomb's facade.

Polychrome stonework was employed by the sultans of Delhi in the fifteenth century and first half of the sixteenth century. White marble was contrasted with yellow and red sandstone on the monuments associated with Sher Shah Suri (r. 1540–45), the Afghan military commander who compelled the Mughal emperor Humayun to flee India in 1540. The facade of the mosque in the Purana Qila citadel in Delhi, for example, erected in 1541 after Sher Shah assumed control of northern India, features bold, multicolored geometric designs, contained in panels framed by arches with cut-out fringes of lotus buds—a design with a long tradition in Delhi. The combination of bold polychrome and richly textured stonework was continued by Akbar after the reestablishment of Mughal rule in 1555. Indeed, the Delhi tomb that Akbar raised for his father Humayun in 1562–71 is a veritable lexicon of stonework designs. The facades of the mausoleum, and the gateways that give access to the great *chahar-bagh* in which it stands, are enlivened by inlaid polychrome geometric designs, including six-pointed stars, a pattern popular during Akbar's reign.

As on Sher Shah's mosque, the inlays on Humayun's tomb are composed of different colored stones set into a red sandstone background. The *chahar-bagh* (Persian, "four gardens") follows the traditional Persian garden layout with intersecting water channels dividing it into regular square plots. The channels are often associated with the four rivers of Paradise described in the Koran, which flow to the four quarters of Heaven. For Muslims, heaven is a garden; the word "paradise" is of Iranian origin, meaning a walled garden. On Earth, such gardens were extremely expensive undertakings, partly because of the cost of establishing and maintaining the extensive systems of aqueducts and underground channels (*qanats*) that brought water from distant sources. Affordable only to the very wealthy, normally such gardens were restricted to palace complexes and royal tombs. Palace gardens were filled with lush beds of flowers and flowering trees, which attracted birds of many species, while fish and ducks swam in the pools and water channels. These gardens often featured a central pavilion in which the fortunate owner, his consorts, and

Many of the decorative themes and construction techniques of Jain temple architecture and design in western India are also found in the contemporary Muslim buildings there, suggesting that the same masons and craftsmen were employed. Temple-like columns and corbeled dome-shape ceilings fashioned out of golden yellow sandstone were common in the mosques and tombs erected by the sultans of Gujarat in and around Ahmadabad, their capital. Additionally, motifs in sharply cut relief derived from local temple architecture included lamps hanging from chains, and scrolling arabesque stems and petals, both surrounded by stylized foliage. Such motifs in sharply carved relief adorned the minarets that flank the arched entrances of mosques, such as that of Qutb al-Din Ahmad Shah, built in Ahmadabad in 1449.

Also characteristic of Muslim design in Gujarat was the use of *jalis* with geometric and vegetal patterns. Such carved stone screens admitted light to the corridors that surrounded important tombs, like those of Shah 'Alam, a saintly figure who died in 1475, and of Rani Sipri, a queen of the sultan

guests could relax in cool, shaded surroundings, catered to by attendants bearing refreshments, by musicians, or by poets reciting their verses. Such scenes are depicted in both Indian and Persian paintings.

The high level of design skills and handcraftsmanship during Akbar's rule can be seen in *jalis* with repeated hexagonal and octagonal perforations. The earliest-known examples are in Humayun's tomb, but even finer workmanship are the white marble screens with various geometric patterns that encase the corridor surrounding the tomb of the saint Shaykh Salim Chishti, erected in 1581 in the courtyard of the Jami Masjid (Friday Mosque) in the royal city of Fatehpur Sikri. The resemblance of these designs to *jalis* in Ahmadabad, some 450 miles to the southeast, is a reminder that Akbar imported craftsmen from Gujarat to northern India after annexation. By contrast, carved sandstone decoration in the residential apartments in Fatehpur Sikri incorporates a profusion of motifs drawn from nature, akin to that in temple art, suggesting that the craftsmen were deeply steeped in local design traditions.

The use of indigenous motifs is particularly well illustrated in a pavilion that overlooked Anup Talao, an ornamental pool in the private quarters of Fatehpur Sikri's palace. Its stone wall panels depict lifelike pomegranates, grapes, and other fruits on curving stems, as well as imaginary landscapes of palms and flowering bushes, all crisply carved in relief. Other panels have sharply incised friezes of garlands or chevron patterns imitating thatch construction.

More closely related to the Persian-influenced traditions of Central Asia and Iran were calligraphic and geometric relief stonework designs at Fatehpu Sikri. The Jami Masjid, completed in 1571, for instance, is entered through a lofty monumental portal (*iwan*) surrounded with a band of calligraphy quoting passages from the Koran. The flowing Arabic *thuluth* script was cut in shallow relief into yellow sandstone and framed by bands of red sandstone so that the eye is drawn to the inscription. A similarly colorful calligraphic composition surmounts the *mihrab* (prayer niche) of the prayer hall inside the mosque. This is surrounded with bands of geometric patterns in white marble with tiny insets of bright blue glazed earthenware. Such carved motifs already had a long history in the decoration of pre-Mughal palace design in northern India. The tradition is evident in the apartments of the Man Mandir palace in Gwalior (Madhya Pradesh), built at the beginning of the sixteenth century by Raja Man Singh Tomar, with their lotus buds, fantastic beasts, *jalis*, and wall panels with imposing semicircular motifs.

MURALS AND TILES

Although stone carving was the principal means of decorating religious and secular Indian buildings and interiors in the fifteenth and sixteenth centuries, other materials and techniques were also used, including tilework, plasterwork, painting, and terracotta ornament, but, unfortunately, they survive only in fragments. The remaining evidence for mural decoration is meager, but enough survives to suggest that murals were an important component of interior decoration. The paintings consisted of vivid pigments applied to a dry and polished plaster base in a manner similar to the Italian technique called *secco*.

There is a remarkably complete set of ceiling paintings in the Hindu Virabhadra temple at Lepakshi (Andhra Pradesh) in southern India. Commissioned by governors serving the Vijayanagara emperors in the 1540s, they portray Hindu mythological episodes and scenes of courtly reception. The latter show male and female figures clothed in boldly patterned dress, wearing elaborate jewelry, headgear, and hairstyles, providing evidence for clothing and other adornments of the period that are now almost entirely lost.

That Muslim monuments in the pre-Mughal period were also embellished with murals is demonstrated by the tomb of Ahmad Shah Bahmani I in Bidar (1436), the interior walls of which were entirely covered with painted designs (fig. 2.6). The range of patterns and quality of execution testify to the sophisticated nature of the Deccan workshop sponsored by the Bahmani rulers in the first half of the fifteenth century. Significantly, these Indian designs are earlier than their counterparts elsewhere in the Islamic world. The murals in this tomb include star-shaped motifs based on hexagons and octagons, alternating with lobed cartouches containing stylized arabesques. Mirror-image calligraphy in oval frames fills nichelike corner squinches supporting the base of the dome, while rings of calligraphy in lobed cartouches surrounded by fanciful foliation fill the dome itself. Executed in a dazzling palette of reds, dark blues, and brilliant white, the tomb's

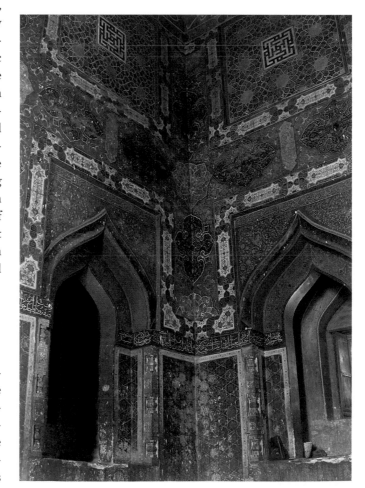

Fig. 2.6. Painted mural with arabesque designs in lobed cartouches, tomb of Ahmad Shah Bahmani I, Bidar, Karnataka, 1436.

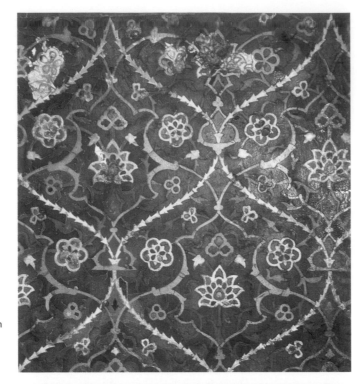

Fig. 2.8. Tile-covered sandstone facade of Man Mandir palace, Gwalior, Madhya Pradesh, early 16th century.

polychrome ceramic techniques perfected in Iran and Central Asia in the fourteenth and fifteenth centuries. The vivid blue, turquoise, and white mosaic tile band of Arabic script spells out Koranic passages across the upper part of the facade, while polychrome mosaic tile chevrons clothe the single surviving minaret at one end. Mosaic tiles also decorate the entrance to the tomb of Shah Abul Faid (Mahmud Gawan's son-in-law) in Bidar (1474). There, bold arabesque motifs with split-leaf palmettes, leaves, and stems are depicted in mostly blue and white but also in typically Indian tones of rich mustard yellow and grass green.

That this luxurious ceramic mosaic technique survived even later at Bidar is illustrated in the residential apartments of the Rangin Mahal palace, remodeled in the middle of the sixteenth century under the later rulers of the Barid Shahi dynasty (c. 1619), who took over the central domains of the much-reduced Bahmani kingdom. Walls were paneled with mosaic tile work in complex, richly colored arabesque patterns, (fig. 2.7). Similarly striking are the mosaic tile compositions in the spandrels of the arched portals at the entrance to the ceremonial hall of the palace, featuring leaping tigers on sunburst emblems—a royal motif derived from depictions of the lion and sun used symbolically in pre-Islamic and Islamic Central Asia and Persia. Another decorative technique characteristic of sixteenth-century Bidar was the setting of minute pieces of mother-of-pearl into polished black basalt; delicately worked gleaming calligraphic and arabesque designs of this type adorn one of the innermost apartments within the palace.

Architectural tilework during this period was by no means confined to the Deccan, but it rarely attained the same level of sophistication elsewhere. The ceramic decoration on the Man Mandir palace in Gwalior, for example, is comparatively crude in its workmanship, though assured in its design. The facades of the building feature varied patterns of intricately cut, bright yellow and blue mosaic tilework: friezes of diamonds, chevrons, and merlons, and imagery of palms and banana trees, tigers with savage claws, elephants, and geese (fig. 2.8). These tiled designs contribute to the overall effect of visual richness and splendor. Although spectacular examples of murals and ceramics remain in the Deccan and central India, Akbar's Jami Masjid and the residential and ceremonial apartments in Fatehpur Sikri preserve only the barest traces of their original painted and ceramic decoration.

CARVED WOOD, PLASTERWORK, AND TERRACOTTA

Wood was widely used in India from earliest times, but little survives from this period. A significant exception is the mid-sixteenth-century residential apartments of the Rangin Mahal palace, Bidar, which retains its original wooden columns, capitals, and beams, richly carved with lotus petals, pendant buds, and lotus stems in shallow relief. The slender angled brackets set into the end walls to support a cornice across the front of the hall were imitated in stone in Mughal palaces, including Akbar's residential apartments in Agra and Fatehpur Sikri.

designs anticipated later sixteenth-century carpets and textiles from Iran and the Ottoman Empire.

Polychrome decoration in other media was also used in Deccan buildings in the fifteenth century. The *madrasa* (school of higher learning) built in Bidar in 1472 by Mahmud Gawan, prime minister under several of the later Bahmani sultans, shows the influence of Central Asian traditions, in terms of both layout and mosaic tile decoration similar to

Plasterwork, another technique with a long tradition, suffers greatly from the ravages of time and humidity, and relatively little survives from the period 1400–1600. In southern Indian Hindu temples, brightly painted forms of divine, human, and demonic figures made from plaster applied to brick substructures appeared on *mandapa* parapets, sanctuary towers, and entrance *gopuras* (towered gateways). Their fragility meant that this type of temple decoration was regularly replaced, but some original plasterwork is preserved in the sixteenth-century *gopuras* at Kumbakonam and Kanchipuram (Tamil Nadu).

Muslim religious buildings were also adorned with plasterwork, although the design repertory was mostly restricted to geometric and abstract floral forms. The Deccan region furnishes some of the best examples from the period. Monuments at Gulbarga (Karnataka), including the 1422 tomb of Firuz Shah Bahmani, for instance, were ornamented with bands and roundels of sharply incised plasterwork. The interior of Firuz's tomb was especially exuberant, with stylized lotuses, rows of petals, diamonds with serrated edges, and interlaced strapwork. Once painted in bright colors, this high-relief decoration now appears faded and somewhat dour. Equally extravagant were the plaster roundels and friezes on the facade of the Takht-i Kirmani, a ceremonial gateway in Bidar dating from about 1430. Also in Bidar, inside a small mosque associated with the 1577 tomb of 'Ali Barid Shah I (r. 1542–80), densely packed arabesque motifs in sharply cut plasterwork fill both the lobed panels above the arched wall niches and the faceted pendentives.

In northern India, mosques and tombs also preserve traces of highly refined plaster decoration, including the Jamali-Kamali funerary complex in Delhi, completed in 1529, built in a style that recalled the Delhi sultanate period (1206–1527). The interior plaster decoration is of the highest quality: sharply incised, stylized lotus motifs fill arched bands and roundels in the mosque, while an arabesque pattern, expanding outward from the center, spreads across the dome in the adjacent tomb (fig. 2.9). Sparingly highlighted with turquoise tile insets, these motifs are set against a brightly painted ground of red and dark blue.

In Bengal—where the land of the Ganges River delta offered little stone—terracotta panels and friezes, so sharply modeled that they created highlights and shadows within the design, were used on brick mosques and tombs erected by local sultans. Facades were decorated with terracotta friezes of floral and geometric motifs, while wall niches incorporated pot-on-chain compositions surrounded by bands of flowers and intertwined stems. All of these motifs were used on mosques and tombs in Gaur in West Bengal, including the shrine known as the Qadam Rasul, built in 1530. Particularly elaborate was the treatment of the spandrels over the arches of the nearby Tantipara mosque (c. 1580), which were filled with curving leafy stems that encircle roundels occupied by full lotus flowers (fig. 2.10).

TEXTILES

Cotton cloth is the historic basis of India's textile industry. The indigenous plant grows well in many places, including in the west in Gujarat and Maharashtra, in the east in Bengal, and farther south in the area near Madras. Thread was spun on spinning wheels and woven on small handlooms to standard widths in the home or in small workshops. While little cotton from this period survived in India, cotton fragments unearthed in Egypt, at Fustat on the outskirts of Cairo, testify to the trade in cloth exported from western India—Gujarat in particular—to Red Sea ports at least as early as Roman times. Woven cottons and silks were important to this overseas commerce, but dyed plain-weave cottons constituted the bulk of the Fustat finds. Striking in the variety of their designs, these textiles were mainly hand painted, block printed, or a combination of both. All colors, including the most popular red, blue, and black, were achieved using mordants (natural agents such as alum and iron) to fix the colors, or resist techniques such as tie-dyeing or wax resist.

Fig. 2.9. Ceiling (detail), tomb of the Jamali-Kamali funerary complex, Delhi, 1529. Painted plaster relief.

Fig. 2.10. Spandrels, Tantipara mosque, Gaur, West Bengal, c. 1480. Terracotta plaques set into brickwork.

Other fragments from the fifteenth and sixteenth centuries reveal a great variety of geometric and abstract designs, including mosaic patterns of interlocking circles, scrolling vines with floral clusters, leaves, stepped squares and crosses, and floral rosettes. Some patterns were inspired by Arabic script, others by architecture, especially arch-shaped merlons or *mihrab*-like niches filled with floral motifs. Similar designs were found on contemporaneous stone relief decoration on mosques and tombs like those in Ahmadabad (described above).

Until the advent of synthetic dyes in the second half of the nineteenth century, colors were obtained from natural sources. The indigo plant provided a deep, rich blue; the roots of certain plants, such as madder, yielded alizarin for reds, and the turmeric plant produced yellow. Although indigo was a fast dye, other natural dyestuffs required mordants to fix the colors. In the case of hand-painted cloths, mordants and resists were applied with a brush before they were dyed. Block printing was the more common means of transferring a pattern onto cloth. A small block of hardwood was carved on one side with a particular motif and the printer would apply mordant to the block before repeatedly stamping the motif on the cloth. When the cloth was dipped into the dye bath, the chemical reaction between the mordant and the color ensured the fastness of the color.

Complicated designs were achieved by using multiple blocks and colors. On a village level, rough cloth decorated with bold designs (usually stylized floral or animal motifs or geometric decoration) was produced in many places in India, but most notably in western Rajasthan and Gujarat.

Block-printed and resist-dyed Indian textiles, in blues, reds, and orange, were also found on the Indonesian island of Sulawesi. The patterns include rows of stylized flowering

Fig. 2.11. Textile made for the Indonesian market, Gujarat, c. 1450. Block-printed, mordant-dyed cotton; 99⅝ x 41¾ in. (253 x 106 cm). Tapi Collection, Surat, India (01.27).

Fig. 2.12. Coverlet with a Portuguese coat of arms, Bengal, 1600–25. Quilted cotton, silk embroidery; 10½ x 8¼ ft. (3.2 x 2.5 m). Victoria and Albert Museum, London (T.438-1882).

trees and bushes, rosettes, lobed medallions filled with foliation, and quatrefoils surrounded by ornate leaves. More unusual patterns feature rows of seated sages and mounted warriors, as well as processions of elephants, horses, peacocks, or geese (fig. 2.11). Two of the largest of the Indian painted-and-dyed cotton cloths found on Sulawesi (now in the Tapi Collection, Surat, India) measure more than 16 feet 6 inches (5 m) in length and depict human figures on a bright red ground. One shows a richly dressed couple flanked by male and female dancers and musicians; the other a row of twelve female figures dancing, playing musical instruments, and holding flowers and parrots, imagery that suggests they may represent courtesans. The facial profiles—with protruding eyes, elaborate jewelry, including large circular earrings and boldly patterned costumes—also reflect the conventions of fifteenth- and early sixteenth-century Jain manuscript painting in Gujarat, which is when and where these textiles were probably made.

Bengal was celebrated for the fine near-transparent *malmal* cottons known in Europe as muslin, and the Portuguese established trading posts there, at Satgaon and Chittagong (Bangladesh), from the 1530s onward. Surviving examples of Indian cotton products from the period include large rectangular quilted bedcovers, often measuring in excess of 9 feet (3 m) long, made for the European market. Woven in white cotton, they were embroidered with yellow or blue raw *tasar* silk (known as tussah in the West), in designs that largely reflected European preferences.

A quilt cover with a central panel shield depicting the Judgment of Solomon surrounded by smaller reserves with Old Testament scenes (now in the Victoria and Albert Museum, London), for example, features Portuguese sailors and hunters in the framing bands, as well as motifs from Hindu mythology and imagery, such as *kirtimukhas* and *kinnaras* (celestial musicians with part-animal bodies). Another quilt in the same collection is decorated with heraldic eagles, sailing ships, and the coat of arms of the aristocratic Portuguese family for which it was made (fig. 2.12). Other examples of quilted Bengali bedcovers dating from this period depict Portuguese galleons as well as images of Europeans drinking and hunting. In most examples, the scenes are arranged in concentric bands around a central rectangular or circular panel.

Other textiles manufactured in India in the second half of the sixteenth century included brocaded silks, or a combination of silk and cotton, woven in the imperial *kar-khanehs* established by Akbar. Despite documentary references to such textiles, not one example from this era is known to have survived. The same is true for *kalamkaris* (see fig. 8.23), brilliantly colored cottons produced by a series of dyeing and painting processes in workshops on the Coromandel coast of southeast India (Andhra Pradesh), which were exported to Europe and Southeast Asia in the sixteenth century, probably on Portuguese ships.

Some examples of *lampas*, an intricately woven, figured cloth with silk warps and wefts, datable to the sixteenth century, feature a variety of ornamental themes drawn from Hindu art as well as from the Persian-influenced traditions of the early Mughal period. Both influences can be seen in a pair

Fig. 2.13. Hanging or curtain fragment, probably Ahmadabad, Gujarat, c. 1600. Silk; 67¹¹⁄₁₆ x 43¹¹⁄₁₆ in. (172 x 111 cm). The Metropolitan Museum of Art (1991.347.1).

of matching hangings, now dispersed between The Metropolitan Museum of Art, New York, and The Cleveland Museum of Art. Probably woven in Ahmadabad at the end of the sixteenth century, the cloths are divided into panels occupied by rows of warriors mounted on horses, as well as foot-soldiers bearing swords and shields, all proceeding toward trees depicted at the center (fig. 2.13). The figures are Indian but the stylized floral border motifs reflect Persian influence.

Indian clothing was closely related to caste and religion, and therefore a person's social status could be readily decoded by their manner of dress. Some of the same garment types that were worn in the period 1400–1600 are still in use today. At their simplest, they consisted of unstitched lengths of cloth wrapped around the body in a mode originating thousands of years earlier. The *sari* for women, normally about 6 yards (5.5 m) long, was (and still is) draped in such a way as to cover almost the entire body; it was often worn over a petticoat. For men, a simple length of cloth was tied around the waist and worn like a skirt to cover the lower half of the body. In south India, this is called a *lunghi* and was also worn by women and draped in many different ways according to caste and region. In northern India, the Hindi word *dhoti* refers to a similar garment worn exclusively by men, in which the end of the cloth is pulled up between the legs and wrapped in a knot at the waist. The *dupatta* and *odhani* for women and the shawl for both sexes were long pieces of cloth used to cover the head or shoulders.

Fig. 2.14. Carpet fragment, India, 1580–85. Wool, cotton; 70.5 x 76 in. (179.1 x 193 cm). Detroit Institute of Arts (31.64).

Fig. 2.15. Carpet, Lahore, c. 1590–1600. Wool, cotton; 36¼ x 24 in. (92 x 61 cm). MAK–Austrian Museum of Applied Arts/ Contemporary Art, Vienna (OR 292).

Other traditional attire was more tailored. Trousers called *paijama* or *shalwar,* with a wide waist drawn in with a cord and usually wide in the leg but sometimes tailored tightly around the calves, were worn by both men and women. Over this, women wore a loose, hip-length tunic, the *kameez,* and

men a slightly longer tunic or *kurta.* From these basic types came myriad local styles and variations: peasant women in Rajasthan wore full, gathered skirts, for example, and at both Hindu and Muslim courts, clothing followed Mughal traditions and thus included elegant coats and long dresses worn over the trousers (see fig. 2.1).

CARPETS

Carpet production in India in the fifteenth and sixteenth centuries is also attributed to the *kar-khanehs* established by Akbar at his various capitals, where Persian masters usually supervised local weavers. The material evidence of carpet design comes from a limited number of surviving examples, all of good, occasionally exceptional, hand-workmanship in wool pile on cotton warps and wefts, and from carpets represented in contemporary miniature paintings.

The most common type of sixteenth-century Mughal carpet design featured symmetrically disposed (horizontally and/or vertically) vine scrolls and lobed cartouches containing stylized arabesque patterns with red grounds and dark blue borders. So similar were these designs to certain Safavid carpets from Herat that sometimes there is confusion about the place of manufacture of certain examples, and this type has been known generally by Western scholars as "Indo-Persian." Fighting animals regularly featured in the designs, and a combination of scrolling vines and animals was typical of a number of Persian-influenced carpets believed to have been woven in Lahore.

More Indian in character are the so-called "grotesque"— animal, knotted wool-pile carpets with cotton warps and wefts of Akbar's era. Surviving fragments feature fantastic composite creatures, with the heads, bodies, tails, and feet of real and imaginary animals and birds, arranged in complex grids (fig. 2.14). The animal motifs in this example are disposed in mirror and rotational symmetries. Such creatures have been likened to animal imagery in Hindu art, such as *kirtimukhas* and *makaras* (aquatic creatures with crocodile-like bodies), and here they are imbued with the energy and inventiveness characteristic of the decorative arts under Akbar. Unsurpassed in Indian design at that time for the fantastic nature of their compositions, these "grotesque"-animal carpets are believed to have been woven in Fatehpur Sikri before Akbar moved his court and workshops to Lahore in 1585.

The animal theme took on even greater prominence in the celebrated pictorial carpets produced in Lahore until Akbar's death in 1605. Surviving knotted wool-pile carpets on cotton warps and wefts of this type are recognizable by their deep red central panels, which contain imagery of animals, birds, human figures, and buildings. In one example, the life-like imagery consists of cranes, peacocks, and peahens, with smaller birds of other species, populating a landscape filled with flowering trees (fig. 2.15). The naturalism of the landscape contrasts with, and is enhanced and framed by, the stylized borders of deep red and blue palmettes linked by scrolling leafy stems.

FURNITURE

Carpets, textile hangings, and covers were common in Indian palace interiors during this period, but wooden furniture was a comparative rarity. Wooden thrones and chairs were fashioned for rulers and other dignitaries to sit on during formal occasions, and chests and caskets for precious items, large and small, graced palaces and the homes of the wealthy. No thrones survive from the fifteenth and sixteenth centuries, but a portrait of Murtaza Nizam Shah, ruler of Ahmadnagar (c. 1575), shows the sultan seated in a chair with arm rests and a high back with a pyramidal crest rail (fig. 2.16). Significantly, the painting is devoid of superfluous detail, as if to emphasize Murtaza himself and his chairlike throne, the sides and back of which appear to be inlaid with geometric marquetry.

The thrones depicted in miniatures produced for Akbar also seem to be of wood inlaid with precious materials, as were the low octagonal seats surrounded by balustrades, sometimes with ornate backs in the shape of a pointed leaf. The inlay was often of geometric or arabesque pattern. In a painting depicting a court assembly (from a manuscript of the *Anwar-i Suhaili*, 1598, in the Bharat Kala Bhavan, Varanasi), the throne is shown with multicolored patterns on its sides, and on its back a lobed cartouche with arabesque designs surrounded by golden ornament. It is not known what materials were used, but some surviving items of furniture made in India in the late sixteenth century for the European market preserve ivory inserts. European-style chairs and chests feature Mughal floral decoration in delicate ivory inlay: stylized flowers linked by swirling leafy stems create curving symmetrical patterns that recall those in contemporary carpets.

Mother-of-pearl was also used, as on the near-iridescent, wooden canopies erected over the graves of saintly figures that survive in Fatehpur Sikri, Ahmadabad, and Delhi. Created a few years after the death of Shaykh Salim Chishti in 1571, the canopy sheltering his tomb at Fatehpur Sikri has octagonal columns, lotus capitals, and a curved vault covered in tiny pieces of mother-of-pearl embedded in black mastic that form a shimmering swirling design of vinelike scrolls with leafy tendrils set against a dense background of stems and leaves (fig. 2.17). Similar patterns are found on smaller items of furniture, notably cabinets, writing chests, and wooden caskets with mother-of-pearl decoration that were made in Gujarat.

During the sixteenth century, a number of such objects were shipped by the Portuguese to Europe, where they entered various royal treasuries, including those in Lisbon, Paris, Munich, and Dresden. The vegetal patterns varied from stylized arabesques with prominent flowers and curling tendrils to more naturalistic compositions with trees. The most spectacular examples, such as a desk with a folding top (now in the Victoria and Albert Museum, London), incorporate leaping animals, birds, and courtly figures. A box in the same collection has a lid embellished with a lobed cartouche filled with a fluid arabesque design of the utmost elegance.

More common, perhaps, were caskets clad in a mosaic of fish-scale-shaped pieces of mother-of-pearl. An example belonging to the French monarch, François I, was set into

Fig. 2.16. Sultan Murtaza Nizam Shah seated on a throne, Ahmadnagar, Karnataka, c. 1575. Watercolor; 9 x 8 in. (22.9 x 20.3 cm). Bibliothèque nationale de France (Département des manuscrits, Supplément Persan 1572, fol. 26).

Fig. 2.17. Canopy inside the tomb of Salim Chishti, Fatehpur Sikri, late 16th century. Wood, mother-of-pearl inlay.

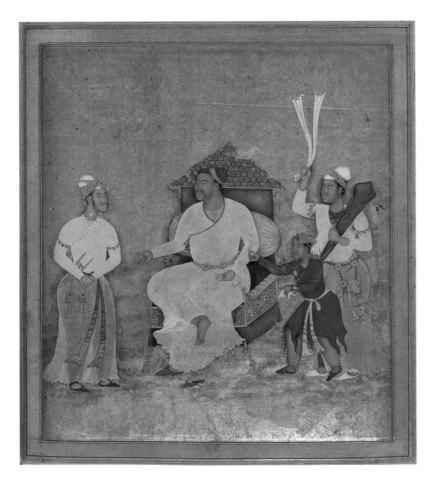

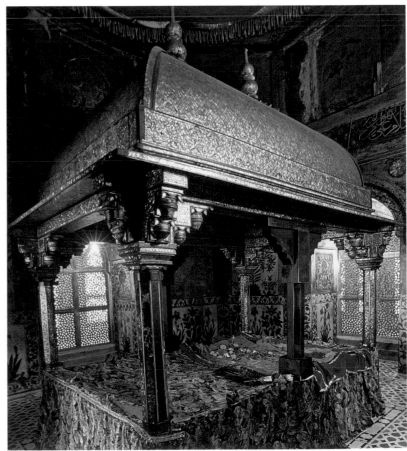

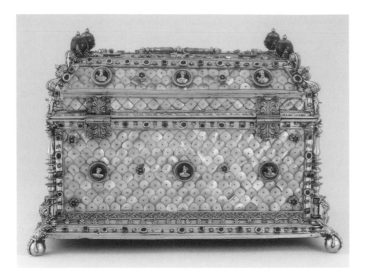

Fig. 2.18. Casket, Gujarat, early 16th century. Mounts by Pierre Mangot, France, 1532–33. Teak, mother-of-pearl inlay, silver gilt, precious stones, enamel; 11⁷⁄₁₆ x 15¾ x 10¼ in. (29 x 40 x 26 cm). Musée du Louvre, Paris (OA 11936).

of the craftsman and the date of manufacture (1587). Mother-of-pearl inlay was also used for other types of objects intended for Turkish clients, including ceremonial shields.

In addition, several small caskets fashioned out of tortoiseshell—a material shipped to Goa from the Maldive Islands in the Indian Ocean—have survived. Dating mainly from the late sixteenth century, such caskets were rectangular, usually with beveled lids, and undecorated, except for silver framing, hinges, and locks. These fittings, of Indian workmanship, were often engraved and chased with bands of foliate scrollwork, and sometimes tiny animals and birds.

IVORIES

Of the surviving carved ivories, some from Orissa in eastern India may once have served as legs of ceremonial seats used by local rulers; others formed pedestals for displaying votive images within temple sanctuaries. Carved in the round, they take the form of rearing animals with leonine bodies and heads, or sometimes elephant heads and trunks. The belligerent character of these imaginary beasts, akin to the *yalis* in southern Indian art, is emphasized by protruding eyes, savage fangs, and exaggerated claws.

More Ceylonese ivory carvings from this period have survived than those from mainland India. The earliest-known examples to reach Europe date from the sixteenth century. A casket commissioned in 1542 by Bhuvaneka Bahu, a local Singhalese ruler, was one of a pair given as a diplomatic gift to Dom João III to help secure the Portuguese king's support for the succession of Bhuvaneka's grandson and heir, Dharmapala (fig. 2.19). Solid ivory panels carved in relief feature

silver-gilt mounts by French royal jeweler Pierre Mangot in 1533, indicating that such items were exported from Gujarat well before the mid-sixteenth century (fig. 2.18). Indeed, Vasco da Gama, on his second voyage to India in 1502, was presented with "a bedstead of Cambay wrought with gold and mother-of-pearl" by the sultan of Melinde (today Malindi) on the east African coast.[1]

The wooden furniture and other objects with mother-of-pearl made for the Ottoman market during this period consisted mainly of writing cabinets and pen boxes adorned with Arabic letters ingeniously composed of tiny interlocking pieces of shell set into a black lacquered composite. A pen box now in the Los Angeles County Museum is inscribed with Persian verses, as is a teak writing chest in the Benaki Museum, Athens, with inscriptions that also include the name

Fig. 2.19. Casket, Ceylon, c. 1542. Ivory, gold, rubies, emeralds, semiprecious stones, diamonds, pearls. Residenz, Schatzkammer, Munich (1242).

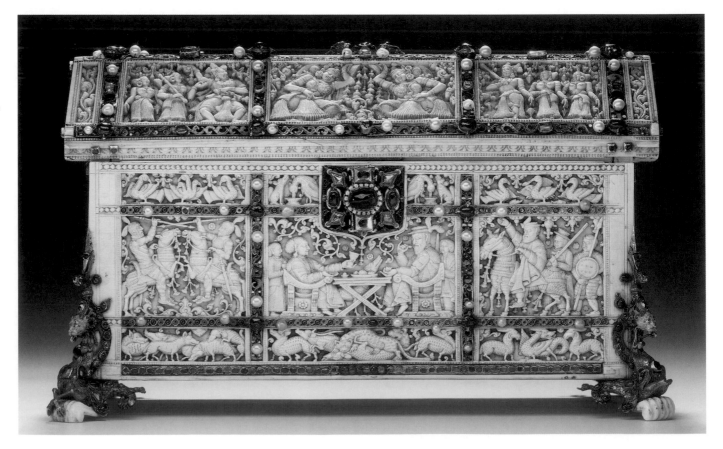

courtly scenes, one of which represents the imagined crowning of Dharmapala by Dom João. Other panels show attendants, dancers, and hunters from the Ceylonese court, Portuguese soldiers mounted on horses clad in European trappings, and the Portuguese coats of arms. In 1558 Dharmapala converted to Christianity, probably in an attempt to secure the alliance with Portugal. This conversion explains the presence of Christian scenes—the Betrothal of the Virgin, for example, and the Nativity—that embellish another ivory casket that he sent to Portugal (now in the Victoria and Albert Museum). Most likely based on contemporary European woodcut illustrations that are known to have reached the Ceylonese court, these scenes are complemented by indigenous Ceylonese motifs such as scrolling vines encircling tiny birds and animals.

The Ceylonese ivory workshops also produced objects for local consumption during the sixteenth century, such as the fan shown here (fig. 2.20). The lower section of the handle is sculpted in high relief as an undulating floral stem with leafy tufts supported on a diminutive *yali,* the upper part in shallow relief with a *hamsa* (goose representing sacred water). The junction between the top and the bottom sections of the handle is marked by a miniature seated figure of Lakshmi, the Hindu goddess of prosperity, wealth, and wisdom. She is the household goddess of most Hindu families, and a favorite of women. Such a mingling of propitious animal, bird, and vegetal themes with a popular divinity suggests that the fan may have been commissioned by a royal figure for ceremonial use.

METALWORK

The large number of bronze icons of deities produced for Hindu and Jain temples in the fifteenth and sixteenth centuries testifies to the thriving metalworking industry in western and southern India during this period. In addition to items intended for worship, the secular metal vessels manufactured in workshops in northern India and the Deccan under the patronage of sultans reveal the dominant influence of Persian metalwork forms and motifs. A copper wine bowl (now in the Chhatrapati Shivaji Maharaj Vastu Sangrahalaya, Mumbai), for example, with a date equivalent to 1582, has a poetic inscription in Persian on its rim. It also depicts a scene with figures mounted on horses and elephants pursuing deer through a landscape closely related to the Persian-inspired hunting scenes that appear in contemporary Mughal miniature paintings.

Equally Persian in spirit is a sixteenth-century copper salver chased and engraved with a landscape filled with animals and birds of all types. Although much of the fauna, both real and imaginary, falls within Indian design traditions—notably the tigers, deer, elephants, peacocks, geese, and *yalis*—the presence of *simurghs* (fantastic birds with dragon-like beaks and long swirling tails) signals a Persian artistic element, since these birds (of ultimate Chinese origin) reached India via Persia. A link with Persian design traditions is also evident in the typically Indian form of a vase, possibly produced in Lahore toward the end of the sixteenth century, engraved and inlaid

with lobed cartouches enclosing arabesque ornament and Persian inscriptions of verses that proclaim a Shia affiliation, all on a hatched ground filled with black lac (fig. 2.21).

Zoomorphic vessels were popular during this period, with ewers, incense burners, oil lamps, and other vessels fashioned as diverse animals and birds, the *hamsa* and peacock being particularly prevalent, to judge from surviving examples. One of the finest and largest is a ewer in the shape of a *hamsa* (fig. 2.22). A leafy serpentine spout, curving up from the goose's breast to meet tendrils that spew from its bill, is balanced by a handle in the form of a leafy tail. While the place of manufacture of these bird-shaped vessels is not known, zoomorphic bronze incense burners in the form of miniature *yalis* were produced in workshops in the Deccan.

Other vessel types alluded in less overt ways to animal and bird forms. Surviving examples include bronze ewers with swelling bodies, articulated by swirling flutes, and spouts

Fig. 2.20 Fan, Ceylon, c. 1550. Ivory, horn; 16⅞ x 13 in. (43 x 33 cm). Kunstkammer, Kunsthistorisches Museum, Vienna (KK 4751).

Fig. 2.21. Vessel, probably Lahore, Pakistan, c. 1580–1600. Engraved brass, black composition inlay; 4⅞ x 6 x 6 in. (12.3 x 15.4 x 15.4 cm). Victoria and Albert Museum, London (IS.21-1889).

Fig. 2.22. Ewer, Deccan or Northern India, c. 16th century. Bronze, brass repairs; H. 15 in. (38.1 cm). Museum of Fine Arts, Boston (37.470).

with animal-like open-mouthed ends (fig. 2.23). Such ewers were Persian in form and decoration, but indigenous types of brass ewers developed in India during the sixteenth century, featuring either pointed tops or bodies of squat proportions, somewhat resembling the Indian *lota* (water vessel). Metal workshops also produced bronze and brass oil lamps for temples, mosques, and shrines. A surviving example is the bronze oil lamp that stands near the entrance to the tomb of Shaykh Mu'in al-Dīn Chishti at Ajmer (Rajasthan). Presented to the shrine in 1576 by Akbar, it consists of a circular shaft nearly 5 feet (150 cm) high, rising from a circular base divided into three tiers by round trays. More decorative forms of lighting devices were produced in the sixteenth century, as, for example, a brass pillar candlestick the base of which is embellished with lobed cartouches filled with arabesque ornament, cast in Lahore in 1539 (according to an inscription on the candlestick itself), and given to the Imam Riza Shrine in Mashhad, Iran.

ARMS AND ARMOR

Of the swords and daggers associated with the Hindu and Muslim courts of India during the fifteenth and sixteenth centuries, most extant examples are linked with the Vijayanagara kingdom. They feature curving steel blades and finely chiseled hilts cast in bronze and inlaid with gold and silver, fashioned as compositions of entwined lions, elephants, peacocks, and cobras. In one example, the sinuous bodies of the animals are cut out with considerable dexterity to create complex, three-dimensional compositions (fig. 2.24). Even more intricate were the cut-out handles of daggers probably originating in the Vijayanagara-period armory of Tanjavur (Tanjore, Tamil Nadu).

A superbly crafted elegant bronze standard, cast in a Kerala workshop in the second half of the sixteenth century, was originally mounted on a wooden pole and carried in temple processions. It presents a treelike composition with cut-out decoration of symmetrically disposed leafy tendrils terminating in tiny lotus buds and geese, with pairs of cows and monkeys, as well as a coiled cobra, embracing the central trunk (fig. 2.25). This standard, along with the other examples in this chapter, indicates that although relatively few objects survived from the period 1400–1600, design and skilled craftsmanship flourished in India at this time, reinforcing the continuing vibrancy of local traditions.

GEORGE MICHELL

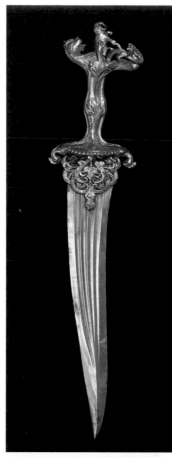

Fig. 2.23. Ewer with dragon heads, Deccan Plateau or Lahore, 1500–50. Brass, traces of gilding; 20 x 7⅞ x 6⅓ in. (51 x 20 x 16 cm). Ashmolean Museum, University of Oxford (EA 1976.43).

Fig. 2.24. Dagger, Vijayanagara or Deccan Plateau, mid-16th century. Steel, gilt bronze, rubies; L. 16⁹⁄₁₆ in. (42 cm). The David Collection, Copenhagen (36/1997).

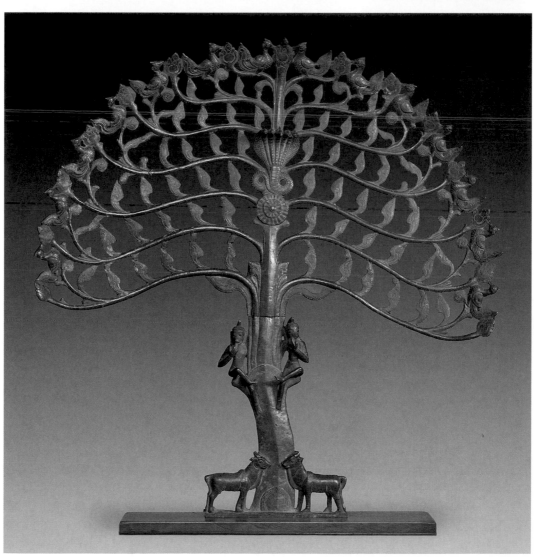

Fig. 2.25. Processional standard, Tamil Nadu, late 16th–early 17th century. Bronze; 24 x 23 in. (61 x 58.4 cm). The Nelson-Atkins Museum of Art, Kansas City (41-35 A,B).

THE ISLAMIC WORLD

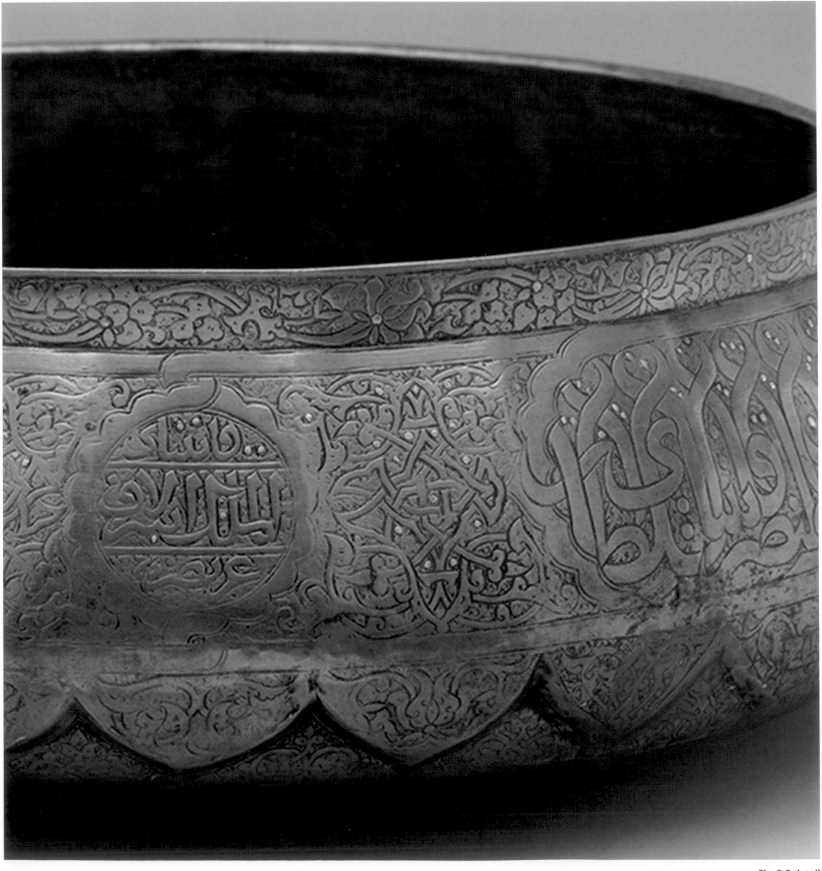

Fig. 3.2 detail

Prior to 1400 several major design traditions flourished and disappeared from the Islamic world. The fifteenth century saw the "golden twilight" of Islamic Spain before the Christian Reconquest of 1492. In other parts of the Islamic world, a decorative style based on floral vine scrolls, arabesques, and Chinese-inspired motifs spread far and wide from Iran and Central Asia and influenced production in Iran, the Ottoman Empire, and India in the fifteenth and sixteenth centuries. A high degree of technical finish and a bold use of color were evident in gold and polychrome silk textiles, the bright tomato red of Iznik ceramics, and the prismatic palette of Mamluk carpets, not to mention exquisitely illustrated manuscripts and magnificent mosques covered with tile mosaics. In Islamic decorative arts the accomplished use of color went hand-in-hand with great attention to detail and highly skilled craftsmanship.

The early sixteenth century was a period of empire building, including the three great early modern Islamic empires: the Safavids in Iran, the Ottomans in the eastern Mediterranean, northern Africa, and southeastern Europe, and the Mughals in India. It was a time of expansion, with new trade routes to accommodate the robust maritime and overland trade among Islamic lands and their neighbors, and increased contact with Europe and China. This rich cross-cultural exposure influenced design and the decorative arts. Indeed, many rulers, such as the Ottomans, were eager to construct powerful images of their empires through a unified decorative vocabulary, from the architectural tile revetments (facings on the underlying wall surface) that covered mosques to the luxurious silk clothing used in elaborate court ceremonies, and the gold and silver vessels that filled Islamic treasuries or were prized possessions in European ones.

Islamic art, architecture, and design can be secular or religious and reflect a broad geographical landscape, stretching from the shores of the Atlantic to the Indian Ocean and from the Central Asian steppe to the African desert, all Islamic lands at various times. This chapter focuses on Egypt, Islamic Spain, Iran, and the Ottoman Empire, which were dynamic cultural centers during the 1400–1600 period.

Understanding the basic tenets of Islam provides background to much of Islamic art and design. Islam means "submission" to God (*Allah* in Arabic). The Koran, the Muslim holy book, was revealed to the Prophet Muhammad (c. 570–632) in the early seventh century, and over time the new faith spread across the Arabian Peninsula under Muhammad and his successors, although the conversion of the majority of the followers of Islam (Muslims) in that area stretched over several centuries. There are Five Pillars of Islam, or rules, for Muslims: the profession of faith ("There is no god but God

and Muhammad is the messenger of God"); prayer five times a day; fasting during the month of Ramadan; giving alms to the poor; and pilgrimage to Mecca (*hajj*) at least once in a lifetime. Muslims worship God directly, so prayer can be accomplished anywhere, even in the desert: one simply performs a ritual washing using sand, if water is not available, and faces the direction of Mecca.

There was no unified Islamic culture transcending boundaries of ethnicity, geography, and time, but there were many commonalities in visual and material culture—a love of ornament, or decoration, being one of the most characteristic features. Ornament covered the objects of daily life—from humble pottery bowls and coarse wool carpets to the finest counterparts in palaces and elite residences. Decorative arts—ceramics, metalwork, textiles, carpets, and glass, for example—were the major arts of Islam; large-scale painting and sculpture were nearly absent until the twentieth century. Textiles, in particular, were a vital component of many Islamic economies. In addition to carpets and fabrics, special textiles were used for particular functions, as, for example, to drape the Kaaba at Mecca (the place, considered a sacred site, where Muslims believe Abraham erected a house for God). They were given as robes of honor and used for clothing to wear at court ceremonies.

There were four main types of decoration: calligraphic, geometric, figural, and vegetal. Calligraphy takes pride of place, and a variety of scripts are seen, including the angular script known as Kufic and the cursive known as *thuluth* (see fig. 2.5). Because Islam is revealed in the Koran, the arts of the book are highly esteemed, with calligraphy appearing in designs in almost every medium. The development of epigraphic, geometric, and vegetal decoration in religious Islamic art and design was not based on a Koranic prohibition of figural imagery, as is often claimed. Instead it derived from the idea of the Word of God. Since God is represented by his word, there could be no place for figural imagery in religious Islamic art and design. Avoiding figural imagery in religious settings also prevented any kind of idolatry in places of worship and in the veneration of God. Secular art and design in the Islamic world, however, embrace a rich tradition of figural imagery, as seen in illustrated manuscripts and in the decorative arts. A variety of styles, techniques, and modes of decoration were developed to embellish the surfaces of objects. Factors such as local and historical traditions, the availability of materials, and widespread trade also influenced the appearance and development of decorative arts objects.

THE MAMLUKS IN EGYPT AND SYRIA

The central and western Islamic lands enjoyed an artistic and cultural flowering in the fifteenth century before the axis of power shifted definitively north and east. The Mamluk dynasty ruled Syria and Egypt from 1260 until the Ottoman conquest of Cairo in 1517. Cairo had been founded in 969 under the Fatimids (909–1171) and had grown into a large, bustling cosmopolitan city. Under the Mamluks, it became the main stage for politics, patronage, and ceremony. The period 1400 to 1600 was particularly strong in metalwork, ceramics, woodwork, and textiles, including carpets, as well as architecture and interiors, but by 1400 enameled glassware, such as mosque lamps, beakers, and goblets, had all but disappeared.

The Mamluk sultans relied on an unusual, and ultimately unstable, system of rule. The name "Mamluk" derives from the Arabic word for "slave," and indeed the sultans and ruling elite were originally imported slaves, mostly Turkic ones from the southern Russian steppes. They converted to Islam, learned the arts of war, and were assigned to various official posts as they climbed the Mamluk political ladder. The Mamluk system was meant to ensure total loyalty among the milittary.

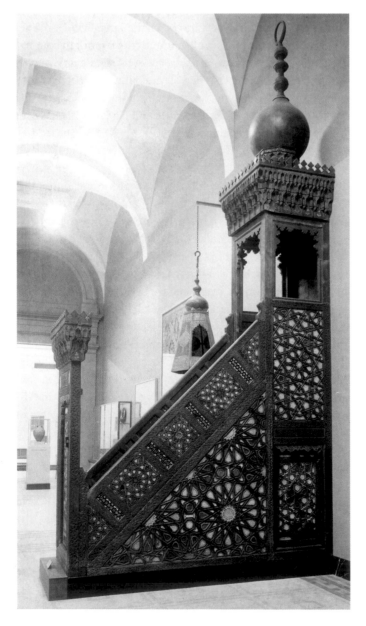

Fig. 3.1. *Minbar*, probably Cairo, c. 1470. Carved wood, ivory inlay; H. 23¼ ft. (7.1 m). Victoria and Albert Museum, London (1050:1 to 2-1869).

The political, legal, and economic system directly influenced the types of buildings, interiors, and furnishings produced. Architecture, interiors, and furnishings took precedence over other Mamluk design traditions, largely because of inheritance regulations. Other than the sultans, the ruling elite could not bequeath their status, money, or property to their wives, children, and descendants. According to Islamic law, however, they were permitted to establish religious endowments (*waqf*s) that were exempt from taxation and confiscation, thus providing income to support their offspring. Often centered on the tomb of the founder, these complexes incorporated mosques, schools of higher learning (*madrasa*s), hostels, public water fountains, and hospitals. Many were created from the late thirteenth century onward in Mamluk cities, including Cairo, Aleppo, and Damascus, which also served as hubs for maritime and overland trade between the East and the Mediterranean, and beyond.

A great deal of Mamluk creative endeavor went into the decoration of the endowed buildings. Koran manuscripts, Koran holders, metalwork candlesticks, basins, ewers, and a range of wooden furnishings, all were produced on a large scale. Elaborate calligraphic inscriptions spelling out the name and titles of the donor often served as ornamentation, not only commemorating the bounty of the donor but also showcasing the craftsman's technical skills. Objects were commissioned by patrons, as well as by those wishing to honor the patron. Aspiring court officials, for example, would try to enhance their career prospects by having beautiful objects inscribed with dedications to the ruler.

An outstanding example of religious furniture produced under the Mamluks is the wooden *minbar* of Sultan Qa'itbay (r. 1468–96), whose name appears on the front and back of the entry doors (fig. 3.1). A *minbar* is a pulpit in a mosque from which the Friday midday prayer sermon is delivered. This *minbar* is impressive in terms of size and for its exquisite woodwork inlaid with ivory. The complex geometric patterns of inlaid woodwork were not new, having been a hallmark of Islamic design since the twelfth century. The *minbar*'s triangular sides demonstrate the integration of form and decoration. The main pattern is based on a series of large sixteen-point stars visible from afar; up close the individually cut, precisely placed minute pieces of wood inlay become apparent, as do the small plaques of ivory with decoration matching that of the woodwork. In this later Mamluk period, costly ivory was often replaced by less-expensive bone.

Qa'itbay, the most important ruler and patron of architecture and design of the late Mamluk period, reigned for almost thirty years, fostering economic stability, promoting trade, and instituting legal and military reforms, while also fighting costly and continuous wars with the Ottomans and the Aqqoyunlu Turkmen in eastern Asia Minor. The *minbar* in figure 3.1 was probably made for one of the many mosques Qa'itbay ordered to be restored in Cairo. He also contributed to the restoration of religious buildings in Mecca and Medina, especially after a fire in 1481 at the Mosque of the Prophet in Medina, and created numerous *waqf*s.

Much of the metalwork produced for the *waqf*s and for court use looked back to the glory days of the fourteenth cen-

Fig. 3.2. Basin, Egypt
or Syria, c. 1468-96.
Brass, silver inlay; 5 x
14½ x 14½ in. (12.7 x
36.8 x 36.8 cm). The
Metropolitan Museum
of Art (91.1.565).

Fig. 3.3. The
"Simonetti" carpet,
probably Cairo, c. 1500.
Wool; 29½ x 7¾ ft.
(8.9 x 2.4 m). The
Metropolitan Museum
of Art (1970.105).

tury, when finely formed brass objects were decorated with gold and silver inlay. By the fifteenth century, engraving had largely replaced inlay. A luxurious effect was achieved by the addition of a black bituminous material that contrasted with the polished brass, making it gleam like gold. Traditional object shapes and decorative styles continued to be used, as, for example, the group of five extant candlesticks made for Muhammad's tomb in the Mosque of the Prophet in Medina, with horizontal bands of decoration featuring inscriptions in a thick Mamluk-style *thuluth* script, against a background of arabesque vine scrolls. In metalwork produced at this time, the letters often crossed each other at the top to form a pincer-like shape, as in a basin with lobed petal-like forms made in repoussé characteristic of late-Mamluk-period metalwork (fig. 3.2).

MAMLUK CARPETS AND TEXTILES

Knotted-pile carpets were among the most impressive examples of Mamluk material culture, judging by the several dozen or so surviving carpets and fragments mainly from the later fifteenth century. The distinctive designs featured large octagonal motifs and a supporting cast of smaller geometric motifs, umbrella- or papyrus-like leaves, and cypress trees that filled the main field, which was surrounded by a wide border of alternating roundels and cartouches. The glowing palette of red and green, with touches of blue and sometimes yellow and ivory, contributed to the prismatic effect of the design. The surviving examples were made from wool (warp, weft, and pile knots), with one exception made in luxurious silk (now in the Museum für angewandte Kunst, Museum of Applied Arts/Contemporary Art, Vienna). Smaller carpets usually featured a central octagon bordered above and below by rectangular strips filled with roundels or cypress trees; some larger carpets were unusually long, with three octagons over a surface of approximately 36 by 13 feet (11 by 4 m). The Simonetti carpet, named after a former owner, is the only extant Mamluk carpet with five octagons (fig. 3.3). Mamluk carpets were probably made in Cairo. They are mentioned in mid-fourteenth-century sources as being made at the royal manufactories in Cairo, and in 1474 Giuseppe Barbaro, a Venetian merchant, praised the superior quality of Cairene carpets over those made in Tabriz, in northwestern Iran. Cairene carpet production continued under the Ottoman successors, with splendid Ottoman-court carpets being exported back to Istanbul or sold to Europeans.

Fig. 3.4. Mantle for a statue of the Virgin Mary, Egypt, possibly c. 1422–38. Silk lampas, gold thread; 27¾ x 43¾ in. (70.5 x 111.2 cm). The Cleveland Museum of Art (1939.40).

In Mamluk Egypt, other textiles, including clothing, continued to hold an important place. Clothing was an immediate visual symbol of wealth, rank, and power—or the lack of it—and, with their slave origins, the Mamluks understood the importance of textiles. Dress announced one's position at court and one's military rank. Appropriate cut, color, and type of fabric were keenly observed and noted. Elaborate court ceremonies demanded grand clothing, and rulers distributed robes of honor featuring bands inscribed with the ruler's name and titles to court officials and foreign diplomats. In addition to clothing, Mamluk status symbols included the personal blazons (heraldic emblems) that were added to decorative arts objects such as ceramics, glass, and metalwork.

The textile industry suffered many setbacks, from workers lost to the plague to increased competition in the form of cheaper European silks and woolen fabrics. By the fifteenth century, however, control of the silk trade from eastern lands to the West was an important source of income for the Mamluks, as well as for the Timurids and Ottomans (discussed below). Surviving Mamluk silk textiles indicate high quality production. Such textiles were greatly appreciated by Europeans, who used them in various ways, from religious vestments to furnishings.

The adaptive reuse of Islamic textiles in European contexts helped to preserve certain Mamluk and other Islamic textiles, notably from Spain, Iran, and the Ottoman Empire. In one example, an ornate Mamluk silk textile of about 1430 was reworked in Spain at an unknown date into a mantle for a statue of the Virgin (fig. 3.4). The pattern is composed of floriated ogival vine-scrolls punctuated by large peony blossoms and small octagonal inscribed medallions. Superimposed on that ground pattern, large, stylized lotus blossoms contain mirror-image (identical but reversed) Arabic inscriptions conveying benevolent wishes. The elegance of the pattern is matched by the high quality of the weaving and the material

used—satin ground with precious-metal highlights. The gold color was achieved by wrapping a silver-gilt membrane around a silk core thread. The white details and blue background set off the gold, adding to the richness of this silk. This mantle resembles a patterned textile (now in the Victoria & Albert Museum, London) thought to be from the reign of al-Ashraf Barsbay (r. 1422–38) because it has medallions inscribed with the title *al-ashraf*. A similar pattern can also be seen in an Italian painting of about 1430, *Enthroned Madonna with Saints* by the Master of the Bambino Vispo (now in the Martin von Wagner Museum, Würzburg, Germany).

Ogival-patterned silks featuring lotus blossoms and peonies were fashionable under the Mamluks, the blossoms echoing the more naturalistic ones seen on imported Yuan dynasty Chinese silks. Chinese products, especially fine silks and ceramics, were highly regarded by the Mamluks, some of whom collected them. It is still not clear whether or not the Chinese works were made specifically for the Islamic market, but Chinese motifs such as lotus blossoms, peonies, cloud motifs, doubled fruits, and chrysanthemums were incorporated into Mamluk decorative traditions, especially in textiles, metalwork, woodwork, glass, and ceramics. The Mamluks also produced striped silks, which were exported and copied in Spain by the Nasrids (1232–1492).

MAMLUK CERAMICS

Mamluk ceramics from the late thirteenth and fourteenth centuries closely resembled two groups of Chinese ceramics: Yuan celadons and blue-and-white wares. Uniquely Mamluk, however, were the tall cylindrical jars with cross-cultural decorative compositions of Chinese lotus blossoms, Arabic inscriptions in *thuluth* script, and European coats of arms. Made in luster or the less-expensive underglaze slip-painted technique, the jars were used to transport drugs, oils, and spices to Europe, where they appeared in apothecaries' inventories.

Islam arrived on the Iberian Peninsula in the eighth century (711) with an invasion led by North African Berbers and Arabs. The Arab amir ʿAbd al-Rahman I (r. 756–88) established the Umayyad dynasty (756–976) in Spain, and it became a major axis of power in the Islamic world, along with the Abbasids (749–1258) in Mesopotamia and the Fatimids (909–1171) in North Africa and Egypt. The Umayyads conquered nearly the entire peninsula and maintained diplomatic ties with Christian kingdoms as well as their Muslim counterparts. From the decline of the Umayyads to the Christian Reconquest in 1492, a number of dynasties ruled in Spain and North Africa. The Umayyad cities of Cordova, Madinat al-Zahra, and later Seville and Granada, served as elegant backdrops for refined court life and ceremonies. Throughout Spain, decorative pottery, textiles, metalwork, carved woodwork, and architectural features influenced by Islamic culture became part of the daily lives of Muslim and Christian inhabitants.

NASRID CARPETS AND TEXTILES

In Granada, the Nasrids reigned over the last flowering of Islam in Spain from the Alhambra, their palace city. Known across Europe for its architecture, interior decoration, and furnishings, the Alhambra, which was completed in the mid-fourteenth century, is the best-preserved Islamic palace of its time. The arts and accoutrements of daily court life were coveted by Christians in courts across Spain and Europe. Some splendid Nasrid textiles are preserved today in European church treasuries, and it was from Spain that the Islamic ceramic technique of lusterware was introduced to the rest of Europe.

Three surviving Nasrid silk curtains inscribed with the dynasty's motto, "There is no victor but God," give an idea of the sumptuous lifestyle of the Nasrid ruling elite. The largest, best-preserved curtain was formed from two large side panels (fig. 3.5) and a narrow central panel. The decoration of arabesques, interlacing, geometric motifs, cursive *thuluth* inscriptions, and inscriptions in angular, Kufic script, is typically Nasrid and also found on tile and stucco decoration in the Alhambra.

In the fifteenth century, carpets were woven in several towns in southern Spain, primarily Alcaraz, Murcia, Cuenca, Letur, and Liétor. The designs included adaptations of certain fifteenth-century Ottoman provincial carpet patterns, as well as armorial bearings of Spanish royal patrons, on fields with small polygons and borders with large-scale Kufic-style script.

NASRID CERAMICS

The luster technique for ceramics probably reached Spain sometime after 1171, when craftsmen fled Egypt after the fall of the Fatimids. A magnificent tin-glazed earthenware bowl decorated with luster, made in Malaga, Spain, in the second quarter of the fifteenth century (Malaga was under Muslim rule until 1487), attests to the florescence of the luster tradition in Spain. Lusterwares were first painted with slip (a mixture of fine clay and water used on vessels of coarser clay to render them less porous), glazed, and fired once; then designs

were painted over the glaze with metallic compounds; and in the second firing the oxygen was removed and the metallic compounds fused to the glaze leaving a small amount of copper or silver that reflected light once polished. The copper turned a ruby red, the silver salts a pale brassy yellow. The large ship with sgraffito (see fig. 1.17) details in the well of this lusterware bowl resembles a type of Mediterranean trading ship known as a *coca* or *nao*, an adaptation of ships used in northern Europe (fig. 3.6). Its sail displays arms similar to those of Portugal, indicating that the bowl may have been produced at the request of a Portuguese merchant. The ship theme, large size, and shape of this footed bowl are characteristic of fifteenth-century Nasrid lusterwares, and those from Spain were exported widely.

Fig. 3.5. Curtain (one of a pair) Granada, 15th century. Silk lampas; 14½ x 9 ft. (4.4 x 2.7 m). The Cleveland Museum of Art (1982.16a-b).

THE ISLAMIC WORLD

Fig. 3.6. Bowl, Málaga, 1425–50. Tin-glazed earthenware, luster; 7⁹⁄₁₀ x 20⅛ x 20⅛ in. (20.1 x 51.2 x 51.2 cm). Victoria and Albert Museum, London (486-1864).

IRAN

In the eastern Islamic lands, the Timurid dynasty ruled Central Asia and Iran from 1370 to 1506, and their patronage had a significant impact on the architecture and decorative arts of Iran, India, and the Ottoman Empire. The dynasty's founder, Timur (r. 1370–1405), a nomadic chieftain descended from Turkicized Mongols, with aspirations to be the universal ruler, did everything on a grand scale, from military campaigns to buildings and objects. He subdued Iran, Anatolia, and Mesopotamia and brought back booty along with the most talented craftsmen. Adept in the most refined techniques and using the finest, costliest materials, from jade and agate to silk, sandalwood, and silver-and-gold-inlaid metalwork, these craftsmen produced objects for an elite patron base: members of the royal family (including women), as well as court, military, and religious figures. The Timurid capital cities of Shahr-i Sabz, Samarqand, Bukhara, and Herat demonstrated the wide range of architectural patronage in the form of splendid buildings in brick with colorful tile revetments.

TIMURID BOOK ARTS

The arts of the book and architecture were the paramount expressions of Timurid visual culture. Illuminated manuscripts made at this time influenced the future development of this genre, notably in Iran, the Ottoman Empire, and India. Significantly for the decorative arts, the elite Timurid workshops that produced manuscripts (Persian, *kitab-khaneh*, literally, "book workshop") also created designs and patterns to be used in establishments specializing in other media, thus promoting a unified decorative style, based on elegant vine scrolls, arabesques, and Chinese-inspired motifs (peonies, lotus blossoms, clouds, dragons, and fantastic creatures). From architecture to metal bowls, the Timurid style found wide appeal across Islamic lands and beyond.

A high point in the production of illustrated manuscripts occurred under the patronage of Timur's great-great-grandson Sultan Husayn Bayqara (r. 1470–1506). The elegant and functional objects, finely robed figures, and architectural backdrops of tiled and painted interiors in miniature paintings on

Fig. 3.7. Jug, Herat, Samarqand, 1420–50. Nephrite; H. 5¾ in. (14.5 cm). Calouste Gulbenkian Foundation, Lisbon (328).

the manuscripts allude to the luxuries and refinements of Timurid courtly life. One of these, a copy of the celebrated collection of stories, the *Bustan of Sa'di* (1488), includes a frontispiece depicting the sultan's court and featuring carpets, textiles, and luxury objects such as metalwork jugs and trays and imported Chinese blue-and-white ceramics.

TIMURID STONE- AND METALWORK

Agate, white nephrite (a kind of jade), green jade, and other hard stones were highly valued by the Timurids and later rulers, some of whom added their own names to Timurid pieces. A celebrated example is a white nephrite jug inscribed in relief around the neck with the name and titles of Ulugh Beg (r. 1447–49), grandson of Timur (fig. 3.7). In the seventeenth century, the Mughal emperor Jahangir (r. 1605–27) took possession of the jug and had his name and titles carved around the rim. His son, Shah Jahan (r. 1627–58), then added his own name and titles below the handle.

The jug's pot-bellied shape was a popular form for Timurid metal jugs (*mashrabe*), seen as early as the late twelfth to early thirteenth century and imitated and adapted later by Safavid metalworkers in Iran and by the Ottomans. The sinuous dragon-headed handle may have been inspired by Chinese export blue-and-white porcelains. The jugs usually were made of cast brass with the body and neck joined by a molded collar echoed by a molded rim. The splayed foot, dragon-headed handle, and lid (often missing today) were cast separately. Decoration was abundant: horizontal bands of arabesque scrollwork and inscriptions were achieved in inlaid silver and gold, and set against a background of crosshatched areas filled with a black composition.

The epigraphy often reveals a function of the jug: the earliest dated example, probably intended for a prince or court official (now in the Victoria and Albert Museum, London), contains inscriptions of two well-known mystical odes from Hafiz of Shiraz, the great Persian lyric poet of the fourteenth century, that praise the pleasure of drinking wine. A similar jug in the British Museum, signed by Muhammad ibn Shams al-Dīn al-Ghuri and dated the equivalent of April 7/8, 1498, is inscribed with the same verses and the name of Timur's great-great-grandson Sultan Husayn Bayqara. The appearance of Persian poetry on at least these two vessels suggests that courtly society, especially the courtly circle of Herat in the late fifteenth century, understood and appreciated such poetry as well as the usual Arabic inscriptions of felicity.

TIMURID CERAMICS

Fine blue-and-white porcelain objects were imported from China, and surviving examples of local versions suggest that they were mostly characterized by coarse potting and thick glazes, although some finer blue-and-white and turquoise-and-black wares were also made locally. A few Timurid ceramics contain dates, including a dish with an inscription in Persian (fig. 3.8). The chrysanthemum motifs in the center well and the rocks and waves decorating the rim suggest Chinese inspiration. In general, however, Timurid ceramics pale in comparison to the glories of Timurid architectural tile work and other media, including metalwork and manuscript painting.

Fig. 3.8. Dish, Mashhad, 1473/74. Fritware; Diam. 13¾ in. (35 cm). The State Hermitage Museum, St. Petersburg (VG-2650).

SAFAVID IRAN

The design traditions of fifteenth-century Iran and Central Asia, in particular vine scrolls, arabesques, and Chinese-inspired motifs, were passed on to the three great early modern Islamic empires: the Safavids of Iran, the Ottomans, and the Mughals of India. The Safavids ruled Iran from 1501 to 1732. They were Shiites (Shias), a branch of Islam that traced its lineage from 'Ali ibn Abu Talib, the successor and son-in-law of the Prophet Muhammad. The name "Safavid" derives from Shaykh Safi al-Din (d. 1334), the revered founder of a Sufi order at Ardabil in northwest Iran. Sufism is an Islamic tradition espoused by ascetic, mystical orders. The founder of the Safavid dynasty, Shah Isma'il I (r. 1501–24), unified Iran politically, geographically, and religiously as a Shiite state. He and his son and successor, Shah Tahmasp I (r. 1524–76), encouraged design and the decorative arts, with calligraphy and illumination reaching an unparalleled apogee in the first half of the sixteenth century. Drawings prepared in the manuscript workshops were often also used as motifs for carpets, textiles, metalwork, ceramics, and architectural decoration, resulting in a unified style for a range of products.

SAFAVID CARPETS AND TEXTILES

Some carpets and textiles attained the same high quality as the arts of the book at this time. The more than fifteen hundred surviving Safavid carpets of wool and silk, including five that are dated, indicate a flourishing industry from rural weavings to court carpets and carpets made for gift giving and export to Europe, India, and the Ottoman Empire. Royal manufactories (*kar-khaneh*) for carpets existed at Tabriz,

Kashan, Isfahan, and Kirman. The earliest surviving Safavid examples are from the sixteenth century, but depictions of carpets in Persian manuscript paintings indicate a major design shift from geometric and animal designs to medallion and arabesque-style patterns by the late fifteenth century. Scholars have suggested that this dramatic change resulted from shifts in weaving practices and materials, such as the use of silk for warp, weft, and pile, and a more extensive use of cartoons (full-size preparatory drawings).

Two matching silk and wool carpets from the early sixteenth century are among the finest carpets of the Safavid period (fig. 3.9; the other is in the Los Angeles County Museum of Art). The pattern is organized around a central sunburst medallion with sixteen radiating pendants, vertically anchored by a mosque lamp at either end of the field. The main field is filled with arabesques, and the four corners contain quarter medallions and pendants that echo the central medallion. The motifs resemble illuminations in a manu-

script made for Shah Tahmasp of the *Shahnameh* (Book of the Kings) by the Persian poet Ferdowsi (c. 935–1023).

Contained in a cartouche at the top of each carpet is a couplet from an ode of Hafiz: "Except for thy threshold, there is no refuge for me in all the world. Except for this door, there is no resting-place for my head." Following the couplet is a signature, "The work of the slave of the court, Maqsud Kashani," suggesting that Maqsud may have been the designer, perhaps of the cartoon, if not the actual weaver. In this context "Kashani" possibly refers to Maqsud's birthplace or residence rather than identifying the celebrated weaving center of Kashan as the place of manufacture.

Although the pair of carpets reportedly came from the Ardabil shrine of Shaykh Safi al-Din, and they are sometimes known as the "Ardabil" carpets, this connection is not certain. Evidence for their having been made as a royal commission is suggested by the fact that Shah Tahmasp and his father paid, maintained, and extended the Shaykh Safi al-Din shrine

Fig. 3.9. "Ardabil" carpet (one of a pair), Tabriz, c. 1539-40. Wool, silk; 34¼ x 17½ ft. (10.4 x 5.4 m). Victoria and Albert Museum, London (272-1893).

Fig. 3.10. Attributed to Aqa Mirak and Sultan Muhammad. Hunt carpet (detail), Kashan, c. 1530. Silk, metal-wrapped patterning wefts; 15¾ x 8¼ ft. (4.8 x 2.5 m). Museum of Fine Arts, Boston (66.293).

complex. The presence of mosque lamps and the absence of figures on the carpets reinforce a reading of the carpets as intended for a sacred location.

Some of the most luxurious Safavid carpets were similarly made of silk. A spectacular example, woven in Kashan, depicts hunting scenes—a popular theme for Safavid carpets and textiles (fig. 3.10). The shimmering silk pile and the highlights of silver- and silver-gilt-wrapped threads in the central medallion depicting phoenixes and dragons create a rich effect. The tightness of the weave and the similarity of the decoration to that in illuminated manuscripts suggest that this was a royal commission. Its designer may have been one of the elite court artists, such as Sultan Muhammad or Aqa Mirak.

Three large sixteenth-century silk carpets with hunting scenes (including fig. 3.10) and sixteen related small carpets (with seven different patterns among them) survive and are referred to by scholars as the "large silk Kashan carpets" and the "small silk Kashan carpets," so-named after the Kashan textile production center. The small examples feature floral

decoration with scrolling clouds and, sometimes, animals in combat (fig. 3.11). Many have central lobed medallions and quarter medallions in the corners. The shared decorative vocabulary is drawn from a variety of sources, including Chinese-inspired floral motifs and fantastic creatures derived from earlier Timurid designs and appearing on a variety of decorative arts objects. The book arts of the early sixteenth century, particularly some Safavid decorated bindings of manuscripts, also provided rich design sources.

Silk textiles were made in the royal and commercial manufactories, and the robust Iranian silk industry and textile trade played an important role in the Safavid economy and trade. The sixteenth and seventeenth centuries mark the apogee of Safavid silk production. Raw and woven silks were exported via the Ottoman Empire, to the West, mainly to Italy. A sixteenth-century Safavid coat, designed to be worn by a man, woven in silk with highlights of silver- and silver-gilt-wrapped thread, illustrates the high levels of skill attained by Iranian weavers (fig. 3.12). Observed by a fierce-looking

Fig. 3.11. Animal carpet, probably Kashan, 16th century. Silk; 94⅞ x 70 1⁄16 in. (241 x 178 cm). The Metropolitan Museum of Art (14.40.721).

Fig. 3.12. Coat, Iran, 16th century. Silk lampas, silver- and silver-gilt-wrapped threads; L. 39 in. (99.1 cm). State Historical and Cultural Museum–Preserve, "The Moscow Kremlin" (25668 oxr/TK-2845).

phoenix in a tree, a man throws a rock at a fire-breathing dragon—a popular theme in Safavid illuminated manuscripts and decorative arts. Light reflected by the silk, gold, and silver in the weave adds to the shimmering effect.

A group of textiles depicting Persians and their prisoners fits stylistically within the mid-sixteenth-century aesthetic, but, contrary to usual practices, these figures were not the kind of stock images used in miniature paintings (fig. 3.13). The prisoners may represent captives taken during Shah Tahmasp's military campaigns in Georgia between 1540 and 1553, in which case the textiles would have had a more obviously propagandistic purpose, and probably would have been used publicly, and/or made into robes of honor.

By contrast, the design on a silk velvet tent roundel paralleled developments in contemporary book arts (fig. 3.14). The leafy landscape of flowers and trees is a swirl of activity. The clarity of design comes from the narrow black outlines around figures, flora, and fauna. Even the strands of a horse's mane and the folds of a hunter's garment are visible. How did the weavers achieve such precise detail? The secret lies in the way designs were transmitted from paper to loom. Instead of simply using a drawing or cartoon as in carpet making, weavers created an exact scale thread-model of the repeat unit. Once attached to the loom, the model could be referred to by weavers and assistants, allowing for greater precision.

The roundel would have been placed high around a pole on the inside of a tent, with additional pieces of velvet cut into lobed medallion shapes radiating from it. The design compensated for an insufficient loom width by varying the repeat through alternating the direction of the rows of figures and changing colors, thus joining the pieces discretely. The roundel demonstrates how the Safavids were able to recreate the luxury of court life in portable tent encampments, from carpets and furniture to objects in gold, silver, silk, and porcelain. Based on a nomadic tradition steeped in history, such lavish temporary settings under Iranian rulers like the Safavids (and before them the Timurids) were a way of demonstrating the power of the ruler.

SAFAVID METALWORK

A glimpse into court culture transferred to temporary quarters comes from the Portuguese ambassador who visited Shah Isma'il's encampment east of Tabriz in 1515 and noted bottles of silver and gold decorated with turquoise and rubies. Among such finery one can imagine a silver bowl, such as that illustrated in figure 3.15, with its bands of delicate gold filigree plaques filled with paired angels, animals, or courtly figures drinking or eating. The interior decoration, of gold filigree appliqués (inlaid with turquoise, emeralds, and rubies), however, is of inferior quality and is probably a later, Ottoman, addition—a fairly common practice. Much of the Safavid metalwork that survives was enhanced with Ottoman-style gold openwork plaques studded with turquoise and rubies.

Early Safavid objects in gold, silver, zinc, copper, and steel, worked in a variety of techniques, were taken to the Topkapı Sarayı palace in Constantinople (Istanbul) as part of the war

Fig. 3.13. Textile panel, probably Iran, mid-16th century. Silk lampas, metal-wrapped threads; 47½ x 26½ in. (120.7 x 67.3 cm). The Metropolitan Museum of Art (52.20.12).

Fig. 3.14. Tent roundel, Persian, 1525-50. Cut and voided silk velvet, brocade, metal-wrapped threads; 39⅛ x 38½ in. (99.4 x 97.8 cm). Museum of Fine Arts, Boston (28.13).

booty after the Battle of Chaldiran in 1514 and the occupation of Tabriz. The victorious Sultan Selim I (r. 1512–20) also relocated the most artistic and skilled metalworkers to Istanbul. The Safavid steel-working trade at Tabriz never recovered, but Safavid craftsmen greatly influenced Ottoman design traditions, often rising to head the particular craft organizations to which they belonged, as documented by the Topkapı Sarayı payroll registers.

The Ottomans captured Safavid steel standards (Persian, 'alam), which were used as military emblems from the fourteenth century onward and symbolized royal power or religious beliefs. These were often embellished with menacing dragons or religious inscriptions that varied from repetition of a single word, such as the name of Allah, to verses from the Koran pertaining to victory, or Shiite poems. Some of the more aesthetically refined standards featured mirror-image inscriptions and floral vine scrolls (fig. 3.16). The large mirror-image inscriptions had the advantage of being legible on both sides of the standard, and close observation sometimes reveals a face with eyes, nose, and cheeks created by the lettering—a visual device with a long history in Islamic calligraphy.

SAFAVID CERAMICS

Early Safavid ceramics were less spectacular in terms of quality or quantity than contemporary decorative arts in other media. There were no major developments to compare with the technical and stylistic advances of the previous centuries in Iran and Central Asia, but there was an ongoing demand for blue-and-white ware. Chinese porcelain (see figs. 1.7, 1.8), available in parts of the Islamic world since the eighth or ninth century, became more widely available after the Mongol conquest of large parts of Eurasia in the fourteenth century. Both Chinese blue-and-white porcelain and the local wares it inspired continued to be fashionable throughout the region, from Iran to Syria, Egypt, and Istanbul. Shah 'Abbas I, for example, donated more than one thousand pieces of Chinese porcelain to the shrine of Shaykh Safi al-Din at Ardabil (see above). In addition to its pleasing patterns, Chinese porcelain was superior technically. Being harder and denser than local pottery, it was watertight and more resistant to extreme temperatures. Persian fritware (a composite body made primarily of ground quartz powder, white clay, and glass frit, also known as stonepaste and quartzpaste ware) was developed in imitation of Chinese porcelain in the twelfth century and achieved something akin to the fine white body of Chinese porcelain without the requisite kaolin—a material difficult to find in Persia. Chinese-inspired motifs like peonies, pomegranates, lotuses, lotus ponds, and ducks figured prominently in early Safavid ceramics, but generally these Persian versions were less naturalistic (fig. 3.17).

By the mid-sixteenth century, major political, military, and social changes affected the visual and material culture of Iran. In 1555, the capital was moved from Tabriz on the exposed northwestern edge of Iran to Qazvin, a safer, more central location. As Shah Tahmasp lost interest in the arts and increasingly became involved with religious matters, the patronage of painting, design, and architecture broadened to include his brothers, extended family, and officials. Crafts

Fig. 3.15. Bowl, Iran, early 16th century. Silver, zinc, gold, turquoise, emeralds, rubies; 1¾ x 5¹¹⁄₁₆ x 5¹¹⁄₁₆ in. (4.4 x 14.5 x 14.5 cm). Topkapı Sarayı Müzesi, Istanbul (2/2869).

Fig. 3.16. Top of processional standard (*alam*), Iran or India, 16th century. Pierced steel, molded iron; 32¼ x 12¹³⁄₁₆ in (82 x 32.5 cm). Aga Khan Museum, Toronto (AKM679).

production took on a more commercial focus in terms of both domestic and foreign trade. Qazvin, a trading post for centuries, was favorably located on the east–west route from India to Anatolia, and some Safavid artists and craftsmen left Iran for the Ottoman Empire and India, where they influenced local styles and, in turn, were influenced by them. Shah 'Abbas I moved the capital again in 1598, from Qazvin south to Isfahan, where he gathered artists and craftsmen and created a new period of splendor, especially silk production.

OTTOMAN EMPIRE

The Ottomans were the Safavids' western neighbors and rivals, and ruled the largest of the three great early modern Islamic empires from 1281 to 1924. At their height, the empires had far-sighted rulers, plentiful economic resources, and efficient bureaucracies. The imperial styles of art and design—usually combining local influences with ones from outside—reflected the power and identity of each dynasty. Beginning in Central Asia, the Ottoman Empire eventually expanded to include areas as different as Anatolia, the Balkans, the Crimea, present-day Iraq and Syria, the Arabian Peninsula, Egypt, and North Africa. It was characterized by a rich mixture of peoples with diverse roots and cultures. The high point of Ottoman imperial style came in the sixteenth century under Sultan Süleiman I (r. 1520–66), also known as Süleiman "the Magnificent."

The earliest Ottoman carpets depicted stylized animals in large octagons framed in square panels. Based on their appearance in fourteenth-century Persian illustrated manuscripts and fourteenth- and fifteenth-century Italian paintings, these carpets have been dated to that period. One of the best-known examples, from about 1400, is known in the West as the "Marby" carpet, having been "found" in a church in Marby, Sweden, in 1925 (fig. 3.18). By at least the end of the fourteenth century, animals (including birds) were replaced by geometric motifs drawn from the Ottomans' Central Asian Turkic heritage in carpets. Because such Ottoman carpets appear in certain fifteenth- and sixteenth-century European paintings, their production has been attributed to those centuries. For the same reason, Western scholars have categorized these carpets according to the artists who portrayed them, such as Holbein, Lotto, Memling, Crivelli, Bellini, and Ghirlandaio.

Two types of "Holbein" carpet, further categorized as "large-pattern" and "small-pattern" Holbeins, were made from the fifteenth through the seventeenth century. The former have a format similar to the early Ottoman animal carpets, but with geometric ornament replacing animals and birds in the large octagon framed in a square panel. The small-pattern Holbeins feature small octagons edged with a looped ornament derived from the Chinese "endless knot" motif, alternating in offset rows with a cross shape formed of angular arabesques. Both types of Holbein carpet often had alternative Kufic-like calligraphy in the borders.

A more unified style developed in the last quarter of the fifteenth century. Mehmed II Fatih (r. 1444–81, with brief interruption), also known as Mehmed the Conqueror, captured the Byzantine capital, Constantinople, in 1453, and soon established workshops to supply illuminated books and other objects to the court. The quality of book illumination and calligraphy improved greatly thereafter, and about seventy-five illuminated manuscripts are known to have been produced during his reign. His Fatih Complex (including a mosque, religious school, hospital, Turkish bath, bazaar, library, and tombs) and the new imperial palace, the Topkapı Sarayı (1463–71), which also served as the administrative and educational center of the state, marked the beginning of a major program of building and furnishing. Tiles, carpets, textiles, and ceramic and metal objects were created in a highly sophisticated style inspired partly by the foreign artists, designers, and craftsmen whom Mehmed welcomed to the capital. These included European painters such as Gentile Bellini and bronze workers such as Costanzo da Ferrara, who created portrait medallions of the ruler. More Italians arrived after the treaty with Venice in 1479, which officially ended a

books, suggesting that the designs were possibly created at the Ottoman court workshop under the master painter Baba Nakkaş and dispersed for production in other media, including the raised decoration of floral vine scrolls and leaves on the silver-gilt jug shown here (fig. 3.20). The jug's shape is the familiar Timurid pot-bellied drinking vessel (see fig. 3.7).

Among the carpet designs associated with the provincial town of Ushak in western Anatolia was one known today as the "Medallion Ushak"—a design made from the late fifteenth through nineteenth century, and related to the book arts of the fifteenth century (fig. 3.21). It featured large oval medallions alternating with sixteen-lobed medallions on a field covered with small leaves and blossoms, usually yellow on a blue ground—recalling the gold on lapis color schemes found

Fig. 3.19. Bowl, probably Iznik, c. 1480. Fritware; 6¹¹⁄₁₆ x 14³⁄₁₆ x 14³⁄₁₆ in. (17 x 36 x 36 cm). Musée du Louvre, Paris (AD5150).

Fig. 3.20. Jug, probably Istanbul, c. 1500. Silver gilt; H. 6⁵⁄₁₆ in. (16 cm). Victoria and Albert Museum, London (158-1894).

fifteen-year war between the Republic of Venice and the Ottoman Empire. Other foreign artists and craftsmen were also brought as booty; Persian book artists, taken from Tabriz after the victory against the Turkmen in 1474, for example, filled the Ottoman book workshops and influenced a wide range of designs in a variety of media.

The appearance of ceramics and carpets changed dramatically. In the late fifteenth century, Byzantine coarse and heavy red-bodied earthenware was supplanted by a hard fritware covered with a bright white slip and painted in colors under a transparent glaze. At the end of the century, the Chinese influence on blue-and-white fritware was evident, as in a bowl with peony scrolls (fig. 3.19). The shapes of ceramic objects reflected those of Ottoman precious metalwork, and the decoration consisted of Timurid traditions interpreted by the Ottomans as compact but lively compositions of arabesques and Chinese-inspired motifs. There are clear parallels between such designs and those found in illuminated

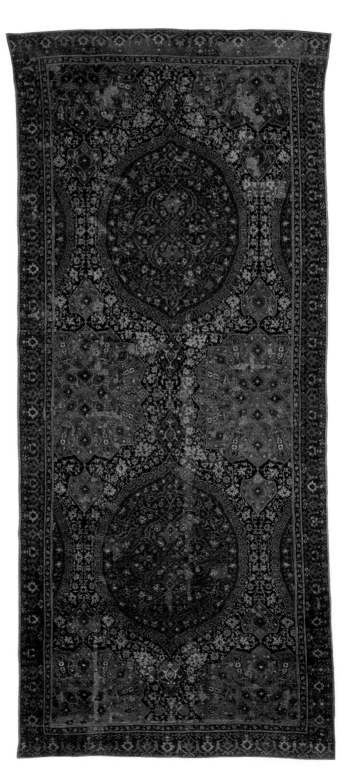

Fig. 3.21. Medallion carpet, Ushak, western Anatolia, 1475–1500. Wool; 23½ x 10½ ft. (7.2 x 3.3 m). The al-Sabah Collection, Dar al-Athar al-Islamiyyah, Kuwait (LNS 26 R).

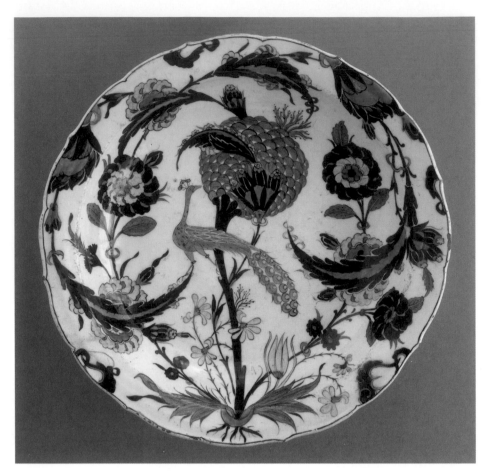

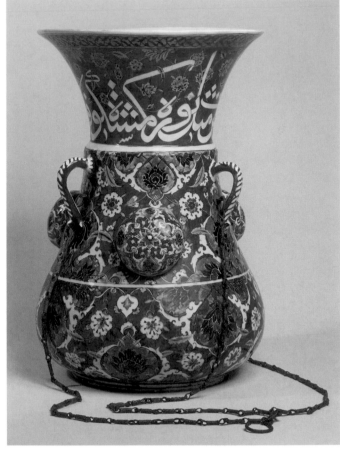

Fig. 3.22. Dish, probably Iznik, mid-16th century. Fritware; Diam. 14¾ in. (37.5 cm). Musée du Louvre, Paris (K3449).

Fig. 3.23. Mosque lamp, probably Iznik, c. 1557. Fritware; 18⅞ x 12¼ x 12¼ in. (48 x 31 x 31 cm). Victoria and Albert Museum, London (131-1885).

in book illumination. Furthermore, both medallion shapes and pendants were similar to those on Ottoman bookbindings, although in later carpet examples, the motifs were more angular. Another outstanding design associated with Ushak from the late fifteenth through the nineteenth century, was the "Star Ushak," with large dark blue, eight-lobed stars alternating with small diamond shapes on a red ground; it, too, related to contemporary book arts.

The Ottoman victory at the Battle of Chaldiran and the capture of the Safavid capital of Tabriz, also in 1514, were pivotal events for Ottoman art and design. The output of the royal workshops (*nakkaş-khaneh*) was greatly influenced by the influx of the highly skilled Persian artists and craftsmen who arrived as part of the impressive booty from Selim I's victory, along with gold, silver, and other precious objects: deluxe manuscripts and albums, furs and silk garments, porcelains, and carpets. The Persian master painter Shah Kulu (d. 1556) became chief designer of the book arts workshop and creator of what scholars today call the *saz* style, after the Persian, *saz qalami* (reed pen). Distinctive characteristics of the style include curving serrated leaves and composite flowers (known as *hatayi* blossoms, the Turkish word derived from "Cathay," a Western term for Central Asia and China). Under Sultan Süleiman I—whose forty-six year reign was the the longest in the Ottoman dynasty—the empire more than doubled, stretching to three continents. During this time the *saz* style became the dominant Ottoman decorative style and was soon translated from ink drawings on paper to a wide range of media: ceramics, textiles, woodwork, metalwork, and the tile revetments on the mosques found in the far-flung reaches of the empire.

OTTOMAN CERAMICS

The tiles on the façade of the Circumcision Room in the Topkapı Sarayı are an excellent example of the *saz* style. Most ceramics destined to decorate Ottoman buildings were made in Iznik, in western Anatolia, but these tiles were probably produced in an Istanbul workshop around 1527–28. Still in place, they depict swirling forests of elaborate composite flowers and serrated leaves, painted in blue and turquoise under the glaze, and inhabited by birds with long tail feathers and Chinese deerlike animals.

Iznik potters gradually added more colors, including green and manganese purple, and the designs became larger and more dynamic. The decoration of one dish (fig. 3.22), depicting a small blue peacock amid gigantic *saz* leaves and floral vine scrolls, is so exuberant that blossoms are cut off at the dish's edges, as though the creator forgot the limits of the dish form. A new red pigment made of an Armenian bole clay gave a bright tomato-red relief against the ceramic support. A lamp made about 1557 for the Süleimaniye Mosque in Istanbul is the earliest datable piece featuring the pigment, albeit in an experimental form (fig. 3.23). The technical refinement of the new red pigment in the second half of the sixteenth century marked a high point in Ottoman ceramics production, and red became the signature color for the tulips, carnations, hyacinths, and composite flowers that adorn so much of the pottery of the period. The combination of blue, turquoise, and emerald green serrated *saz* leaves and floral motifs with the red flowers proved a winning one that graced architectural tile revetments and a wide variety of ceramic vessels throughout the Ottoman Empire and beyond. Iznik ceramics

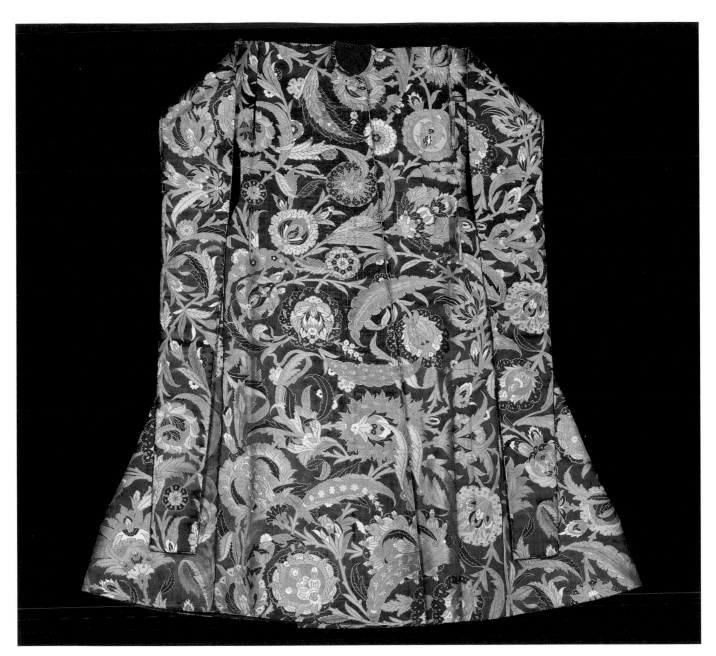

Fig. 3.24. Caftan, probably Istanbul, c. 1550. Embroidered silk brocade, silver-gilt thread; L. 57⅞ in. (147 cm). Topkapı Sarayı Müzesi, Istanbul (13/37).

were so successful commercially—both at home and abroad— that in 1585 a royal decree ordered Iznik potters to finish royal commissions (which were paid at relatively low rates) before making pieces for the more lucrative open market.

OTTOMAN TEXTILES AND THE SAZ STYLE

Luxurious Ottoman textiles advertised the *saz* style through complex weaves of colored silks enhanced with silver-gilt-wrapped thread. Ottoman court life and its ceremonies required a vast wardrobe of clothing and accessories, and various textiles, including banners, curtains, and ground coverings proclaimed the pomp and splendor of Ottoman rule. Specific cloths and costumes were required for each type of ceremony, from royal accession celebrations to funerals, from parades and ceremonies of war and diplomacy to the weekly procession to the mosque each Friday, the day of communal prayer. More than one thousand caftans for adults and children survive in the Topkapı Sarayı, attesting to the elegance and visual splendor of court dress. Ottoman textiles also made their way into European collections as diplomatic gifts or booty.

The center of the Ottoman silk industry, from cocoon to woven textile, was located at Bursa, on the east–west silk route. When silk merchants arrived from Iran, the Ottomans controlled their trade with European buyers (mainly Italians) by collecting customs duty, taxes, and brokerage fees. There was a blending of courtly and noncourtly tastes, mainly because, besides the royal manufactories in Istanbul, commercial centers of production in the provinces, including Bursa, Ushak, and Iznik, produced objects for both the court and the wider domestic and foreign markets.

Two silk caftans with *saz*-style patterns are unusual as they have the greatest number of colors and largest, most complex patterns known in surviving Ottoman silks. The first, a ceremonial caftan, was made from a piece of magnificent silk cloth covered with a dense swirl of *saz* leaves and floral motifs (fig. 3.24). The textile departs from the norm by having a pattern that does not repeat, exhibiting the skills of both the designer and the weavers. The silver-gilt threads and the range of colors, set against the dark purple ground, produce what must have been a brilliant effect when worn in Ottoman cere-

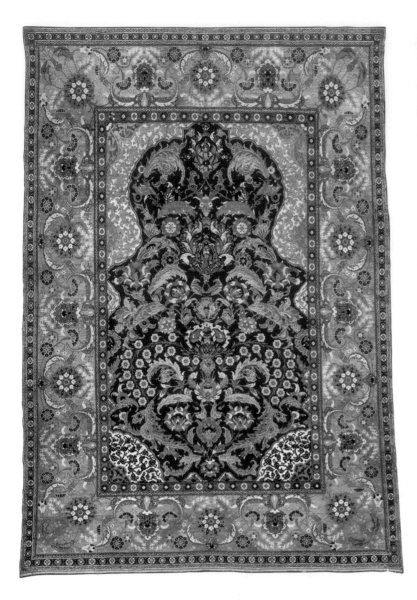

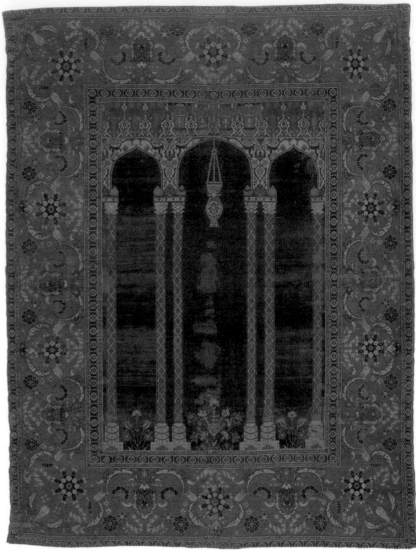

Fig. 3.25. *Saz*-style carpet, Istanbul or Bursa, late 16th century. Silk, wool, and cotton; 72 x 50 in. (183 x 127 cm). MAK–Austrian Museum of Applied Arts / Contemporary Art, Vienna (T 8327).

Fig. 3.26. Prayer rug, probably Istanbul or Bursa, c. 1575–90. Silk, wool, and cotton; 68 x 50 in. (172.7 x 127 cm). The Metropolitan Museum of Art (22.100.51).

monials. The caftan may have been made in the mid-sixteenth century for Sultan Süleiman's son Bayezid (d. 1562). The second caftan, also in the Topkapı Sarayı, has the same pattern as this one but is short-sleeved and uses a different colorway.

The *saz*-leaf and floral compositions seen in Ottoman textiles, ceramics, and architectural tile revetments also featured in so-called Ottoman-court carpets produced in Bursa, Istanbul, and Cairo, a visually homogeneous group. Ottoman-court carpets were valued and acquired in large numbers by Europeans, including the prayer rug shown here (fig. 3.25). The design's framework of an arched niche with corner medallions recalls the blue-and-white tile panels still on the façade of the Circumcision Room of the Topkapı Sarayı palace.

The same *saz*-style floral borders, arched forms, and technical aspects of wool and cotton pile on a silk foundation appear in a related group of carpets. The main field design features columns and hanging mosque lamps, and the carpets are sometimes referred to as coupled-column, triple-arch prayer rugs (fig. 3.26). The design appears to have been popular because it was copied for weavings made in provincial

urban manufactories, village rugs, and even carpets with Hebrew inscriptions that were used in synagogues as curtains for the niche in which the Torah was kept. (For a later example of this design, see fig. 9.21.)

OTTOMAN METALWORK

The sixteenth century was a particularly rich period for Ottoman work in precious metals, some of which was embellished with gemstones. The Ottoman treasury (*hazine*) was founded by Mehmed II in the Topkapı Sarayı palace in the mid-fifteenth century. Over the centuries it was filled with ceremonial and personal items, as well as booty, mostly from the Safavids and Mamluks, and exotic curiosities worthy of any European or Asian *Kunstkammer*. Decorated objects of gold, zinc, rock crystal, jade, jasper, black stone, and Chinese porcelain were studded with gemstones in gold mounts resembling flowers. These gemstone "flowers" were connected by gold-wire vine scrolls, thus creating a secondary layer of pattern above the surface pattern of the objects. A Chinese porcelain pen box with Ottoman embellishments,

now in the Topkapı Sarayı, is a harmonious example of the use of mixed-media and multidimensional layers of decoration: Ottoman rubies in gold floral mounts placed in the center of the Chinese blue lotus blossoms create an aesthetically pleasing ensemble. In the case of the pen box, the precious gemstone embellishments are subsidiary to the decorative scheme derived from Chinese porcelain, whereas on objects of Ottoman origin, the embellishments took pride of place, seeming to dissolve the object beneath, as in a hammered gold canteen encrusted with jade plaques, large rubies, and emeralds (fig. 3.27).

The water canteen, a well-known Ottoman object type, can be seen in sixteenth-century miniature paintings in which the master of the wardrobe carries the sultan's drinking water in a bejeweled gold *matara* (canteen). Its shape derived from centuries-earlier examples from Central Asia executed in leather, as were less opulent versions at the Ottoman court. Indeed, Sultan Murad III (r. 1574–95) presented an appliquéd leather *matara* to Habsburg Emperor Rudolf II (r. 1576–1612), perhaps for his *Kunstkammer*.

The Ottomans, like the Safavids and Mughals, had ornate swords and daggers that visually and symbolically announced their power and wealth. These were often one-of-a-kind pieces made by the most highly skilled metalworkers using expensive materials and complex techniques, such as damascening whereby wavy patterns were etched or inlayed into the steel. Most examples were ceremonial, such as the sword (*yatağan*) made for Sultan Süleiman in 1526/27 by Ahmed Tekelü (fig. 3.28). The damascened steel blade features elaborate decoration on both sides, with a scaly, fire-breathing dragon confronting a *simurgh*, or phoenix, their ruby-inlaid eyes fixed on one another, and detailed *saz* scrolls winding sinuously around the dragon's body. The creatures were cast separately and attached to the blade. The *saz*-style decoration continues in the middle section of the blade with composite blossoms and animal heads. The third section features Süleiman's names, titles, and a date; the spine of the blade carries Persian verses and the name of the maker, who may have been a Turkmen brought back from Tabriz by Selim I. Considered a "masterpiece," like other top-quality objects

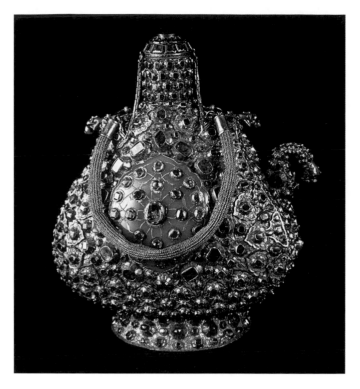

Fig. 3.27. Canteen, Istanbul, mid-16th century. Gold, jade, jewels; H. 10⅝ in. (27 cm). Topkapı Sarayı Müzesi, Istanbul (2/3825).

produced under Sultan Süleiman, it has decoration that combines elements of the Timurid and *saz* styles to make a uniquely Ottoman statement.

By the end of the sixteenth century, power in the Islamic world was firmly in the hands of the three early modern empires: the Safavids of Iran, Ottomans, and Mughals of India. Persian was the shared court language, and all three dynasties looked to the Persianate cultural and artistic heritage of the Timurids. By 1600, however, power in the Islamic world had shifted, and although there was a drop in the rate of production and quality of many decorative arts objects in the Safavid and Ottoman empires, there was a great resurgence of interest in the decorative arts in Iran under Shah 'Abbas I (r. 1588–1629) and a second golden age of Ottoman art, architecture, and design would come under Sultan Ahmed III (r. 1703–30).

AIMÉE E. FROOM

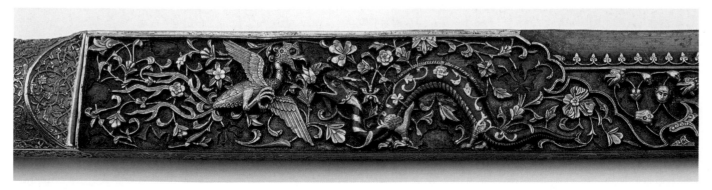

Fig. 3.28. Ahmed Tekelü. Sword (*yatağan*), Istanbul, 1526–27. Steel, gold inlay, gems; L. 26 in. (66 cm). Topkapı Sarayı Müzesi, Istanbul (2/3776).

AFRICA

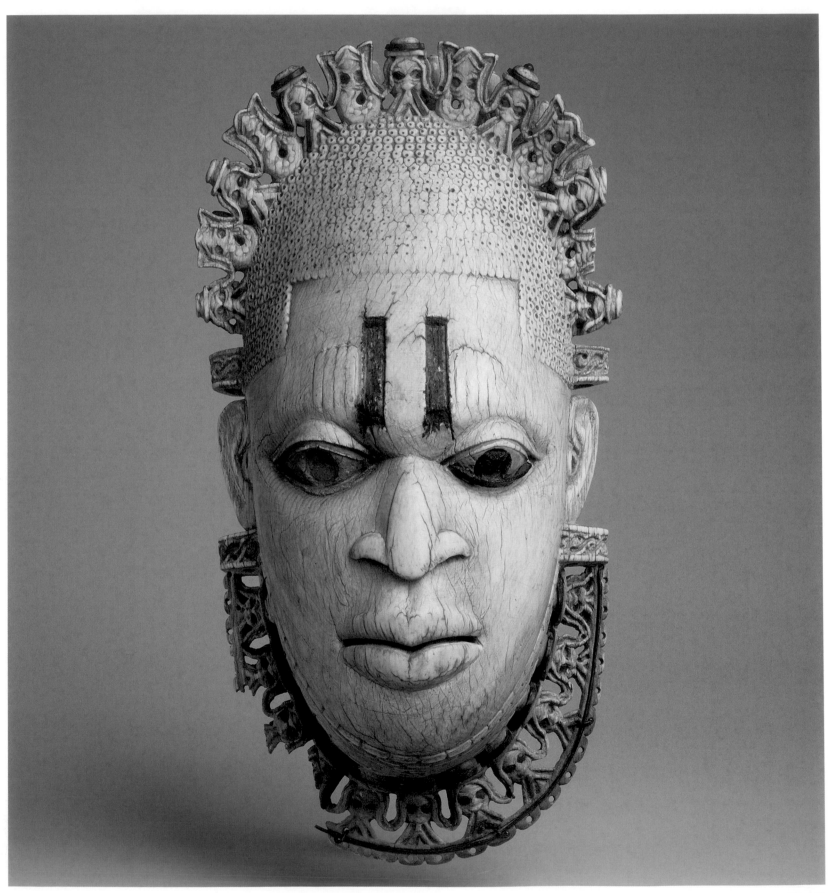

Fig. 4.13

In the period 1400 to 1600, Africa comprised a multitude of cultures and linguistic groups with widely varied traditions and practices relating to the decorative arts. The continent was crisscrossed by ancient trade routes across the Sahara desert and through the equatorial regions of Central Africa. The Nile valley connected East Africa to Egypt and to the Middle East, and links across the Indian Ocean had put African people in contact with Asia. There were migrations, and as people moved, they took with them the knowledge necessary to continue or re-create the cultural worlds they had left behind.

A geo-cultural map of Africa in this period would show great diversity of both natural environments and cultures: pastoralists and grain farmers in Africa's vast grasslands, hunter-gatherers and root crop farmers in the tropical forests and forest edges, and fishing communities along the coasts and great inland rivers. In all of these environments, people used what was around them to create the objects and adornments of daily life. They made low-fire ceramics; built houses from local materials; made fish traps, containers, shields, and hats from a variety of reeds and grasses. Locally grown cotton, wild silk, bark, and leaves were used for clothing. They tanned and dyed animal hides to make shields, bags, and clothing. Feathers, shells, stones, animal horns and teeth (including ivory), and gemstones were used to make ornaments; wood, ivory, and metals were used for sculpture, musical instruments, and furniture. Iron smelting, and copper and bronze forging technologies, as well as gold mining and gold working, were well established in many regions.

A number of independent kingdoms (sometimes referred to as empires) flourished, each keen to monopolize trade in gold, salt (mined in the Sahara), ivory, copal, ebony, ostrich eggs, feathers, and slaves. Around the great Niger River in West Africa, these states flourished and declined. They included Ghana (c. 750–1078, in what is now Senegal and Mauritania), to the Mali Empire (c. 1230–c. 1600, in what is now Mali, Burkina Faso, Niger, and beyond), to the Songhai Empire (c. 1400–c. 1700). Together with Kanem-Bornu (in what is now northern Nigeria and Chad), Igbo-Ukwu, and Oyo (in what is now western and northern Nigeria), they controlled the local and long distance trade routes across the Sahara and into the forest.

In East Africa, wealth was generated by trade in ivory and gold as well as slaves, and this led to the growth of cities with distinctive decorative arts practices, including buildings made of crushed coral, and household furnishings that reflected Asian connections made through trade with the East. In southern Africa, the monumental complex of Great Zimbabwe included a large walled capital that indicated its political and economic dominance in that region.

This was also the period during which the Europeans "discovered" the western coast of Africa. Once the Portuguese sailed along the Atlantic coast in the late 1400s, there was constant contact between Europe and Africa, and increasing trade in African commodities. By about 1500, for example, more than 1,000 pounds of gold were exported each year through trading forts in the area of the Gold Coast (later the modern nation of Ghana) alone. Indeed, much of the ivory, gold, and indigo used in Ottoman and European decorative arts between 1400 and 1600 came from Africa. By the end of this period, states such as Asante and Benin grew to control Africa's Atlantic trade (increasingly focused on the traffic in human beings), and eventually supplanted those earlier kingdoms whose trading activities had been oriented toward North Africa.

Evidence relating to the decorative arts and material culture in the 1400–1600 period is disparate and fragmentary, but sculpture and the architectural remains of once-thriving towns and cities tell us something about how people lived, dressed, demarcated status, worshiped, and governed. Accounts by Arab chroniclers who followed trans-Saharan and Indian Ocean trade routes, oral histories, and items collected by European traders and explorers also offer tantalizing hints of the material richness of this period—of what Africa was like before Europeans first sailed along the coasts of sub-Saharan Africa, and how Africans responded to these new contacts in the late fifteenth century.

WEST AFRICA: MATERIAL CULTURE OF IFE

Located not far from the Niger River, the city of Ife is the ancient spiritual capital of the modern-day Yoruba people, and the present Ooni, or king, of the Yoruba, traces his ancestry to legendary rulers from centuries ago. Ife has a long history of superb metalwork, using lost-wax casting to make exquisitely refined, naturalistic sculptures representing their divine rulers. As with the metal sculptures from Benin (discussed below), most were made of brass, an alloy of copper and zinc, with traces of other metals, including gold, although they are often described as bronze, which is an alloy of copper and tin.

In lost-wax casting the metalworking begins with an actual object or clay model, which will be replicated in metal as the casting proceeds. This model is coated with beeswax or latex made from a cactus plant, into which delicate details are drawn or applied. The wax-covered core is then encased in clay and hollow iron rods are inserted through the clay and

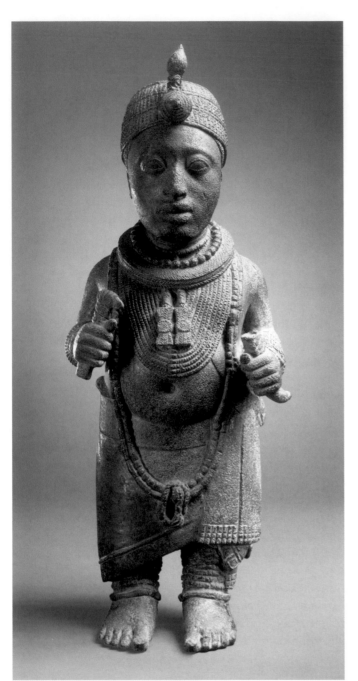

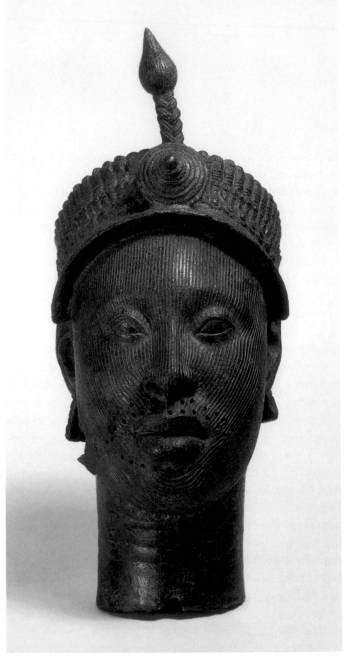

wax to allow air to escape during the heating process. The jets formed by these rods are attached to a funnel through which the molten metal will later be poured into the mold. After several layers of fine clay, and then layers of coarser clay, are applied to the wax surface, the mold is baked and the wax melts leaving only the clay shell. The molten metal is then poured into the cavity left by the melted wax. After it has cooled the clay is removed, the iron rods are cut off with a chisel, and the piece is further finished by polishing.

For centuries the palace of the Ooni housed a number of important metal and terracotta sculptures (transferred to the Nigerian Department of Antiquities in the 1950s) and other pieces survived elsewhere. Yet the extraordinary metalwork of Ife was not well known to the rest of the world until the twentieth century. When an Ife brass head was found in a shrine in 1910, it was assumed to be Greek and to have come from the lost city of Atlantis. By 1938, when a trove of life-size naturalistic brass heads was discovered by chance at a build-

ing site, it became evident that there had been a major civilization in Ife for at least eight hundred years. Along with the cache of brass heads, there were two smaller crowned heads, a life-size copper mask, a full figure, and a torso of a king, all dating from the late thirteenth to the sixteenth centuries.

A magnificent brass sculpture of a king (fig. 4.1) displays multiple examples of royal adornment that were in use during this period and continue to the present day. The figure wears royal insignia in the form of pendants and a crown, and holds a buffalo horn which was probably a medicine container. His wrapper, which has a woven or embroidered edge and is held in place by a knotted sash tied over the left hip, attests to the importance of textiles at this time. Most striking are the multiple strands of beads cast in metal around his ankles, wrists, and neck. Once painted red and black, they represent the thriving glass bead industry that flourished in Ife in this period. Certain colors were associated with specific deities—white for Obatala, the supreme deity and once a

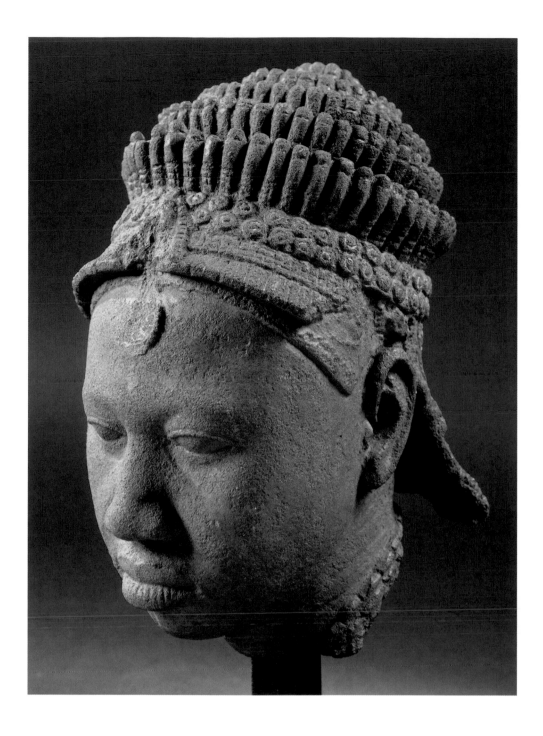

living king in Yoruba belief; red for Shango, the god of thunder; and blue for Olukun, the deity of the sea—and are still meaningful among Yoruba people today.

While the face of this figure is smooth, in about half of the other copper alloy castings from the same time period, the faces bear delicate striations that represented either beaded royal veils or body scarification (fig. 4.2). Such scarification continued in this region well into the twentieth century, as in many parts of Africa, sometimes to represent ethnicity or to signify status. Terracotta was another material used to make figures, and many terracotta heads from Ife also bear scarification marks.

The terracotta sculptures from the twelfth to the sixteenth centuries found at Ife demonstrate the range of this cosmopolitan society: some show royal individuals wearing copious beads and fine cloths, while others depict people with physical afflictions. Sculpted in relief on a number of pottery jars dating from the twelfth to the fifteenth centuries

are images of altars on which are placed animals, human heads, knives, and other implements suggesting that terracotta figures were associated with offerings to the deities.

The Ife head of a queen (fig. 4.3), a fragment of a larger figure, illustrates the importance of beadwork and feathers as symbols of personal status. This head, which dates to sometime between the twelfth and fifteenth centuries, was uncovered in a shrine context with fragments from at least seven full figures, two thirds of them life-size. The head bears traces of red and white paint. Its intricate crown consists of five rows of beads arranged in concentric circles radiating upward like a flower, encircled below by two rows of double beads. On the edge of the crown, there is a row of red tail feathers of the African gray parrot, neatly trimmed to a straight line. Headdresses with red parrot feathers have a wide distribution across the continent. Consistently associated with high social, religious, and/or political status, they remain important in Yoruba religious rituals to this day.

Fig. 4.3. Head of a queen, Ita Yemoo, Ife, 12th–15th century. Terracotta; H. 9 in. (23 cm). National Commission for Museums and Monuments, Nigeria (79. R. 7).

Little is known of the wooden objects with which the people of Ife lived—whether sculpture, furniture, or other household objects—but we do know that several stool forms were important as seats and symbols of authority. A granite stool is in the collection of the Nigerian National Commission of Museums and Monuments, while a large quartz stool (fig. 4.4) from a shrine that dates to between the twelfth and fifteenth centuries has a looped handle that likely represents the trunk of an elephant. A similar stool is depicted in a unique tiny brass sculpture of a queen and another is known from a fragment of an almost life-size terracotta statue that shows a seated king or queen whose legs are astride the looped handle. The figure's bare feet rest on another rectangular stool that probably was made of wood and decorated with brass bands and glass bosses. In the twenty-first century, stools, often carved from wood but sometimes sheathed in metal or carved of stone (as in one case of a stool from ancient Ife), still stand as a symbol of royalty.

Although the present-day city of Ife contains few buildings dating to its peak period (from about 1000 to the late 1400s), remnants of stone walls, foundations, and pavements made of small stones and potsherds have survived. Often arranged in herringbone patterns, these pavements defined ritual spaces such as those in enclosed courtyards. For reasons that are not entirely clear, the work ceased: those who made these pavements as well as the extraordinary Ife sculptures may have been killed in a dynastic struggle or may have moved to the southeast, to the Kingdom of Benin. During this period, trade shifted toward the Atlantic coast as Venetian glass beads, guns, and other items of European manufacture began to enter the African economy in exchange for Africa's many resources, the most important to outsiders being gold and enslaved Africans.

WEST AFRICA: KINGDOM OF MALI

The earliest European map of Africa, in the *Catalan Atlas* of 1375, made by Abraham Cresques of Majorca, Spain, for King Charles V of France, places an African king, wearing a gold crown and holding a large gold orb, at the center of West Africa (fig. 4.5). This image was inspired by the *hajj* (pilgrimage) of the king of Mali, Mansa Musa, to Mecca in 1324. Merchants in Venice and other European cities became aware of this African king's great wealth via stories of his travels, of his luxuriously outfitted caravan flooding the cities they visited with great quantities of gold, dramatically devaluing currencies and upsetting local economies. Mansa Musa made Islam the official state religion of the Kingdom of Mali, though it was a very accommodating form of Islam, allowing great latitude to indigenous, ancestral religious beliefs.

During the 1400–1600 period, cities in the Mali and Songhai empires (in present-day Niger, Bukina Faso, Senegal, and Mali) were built around market centers. Arab visitors wrote of the large royal earthen buildings, great mosques (some of which still stand today), and the colorful silk clothing and furnishings of the rulers. Ibn Khaldun, a Tunisian scholar, for example, described how Mansa Musa commissioned the Andalusian architect Abu Ishaq al-Saheli to build a recep-

Fig. 4.4. Stool from the shrine of Olurogbo, Ife, 12th–15th century. Quartz; 21½ x 16⅛ x 27⅛ in. (54.5 x 41 x 69 cm). Trustees of the British Museum (Af1896,1122.1).

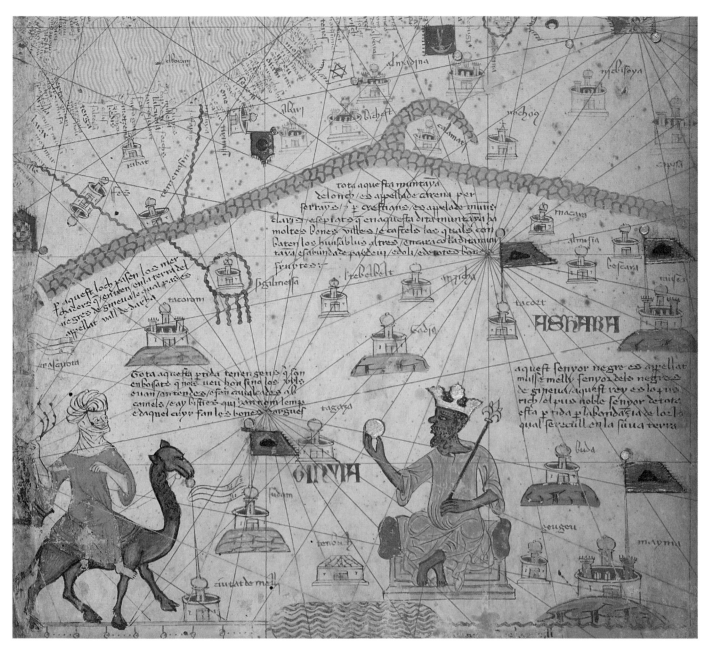

Fig. 4.5. Abraham Cresques. Detail of the *Catalan Atlas* showing northern Africa; Majorca, Spain, 1375. Vellum; folio, 25⁹⁄₁₆ x 19¹¹⁄₁₆ in. (65 × 50 cm). Bibliothèque nationale de France (Département des manuscrits, Espagnol 30).

tion room on his return from the *hajj*. "He decided that it would be solidly built and faced with plaster; because such buildings were unknown in his country, Abou-Ishaq-et-Toueidjen . . . built a square room, surrounded by a cupola. . . Having rendered with plaster and ornamented it with arabesques in glowing colors, he made there an admirable monument."[1] Morrocan explorer Ibn Batutta described how the sultan, wearing a red tunic of European fabric and a gold skull cap attached with a gold band, held audiences in that very building. He sat on a dais, covered with silk, adorned with pillows, and "above it rises a parasol which resembles a silk dome, and on the summit of it one sees a golden bird, large as a hawk."[2]

The vertical towers and pillars on many important buildings in the West African savannah are thought to be based on the tall cylindrical ancestor shrines that were found in many homes and that were associated with the religious practices of non-Islamic communities. The outer walls of many imposing earthen buildings, on the other hand, are decorated with geometric motifs based on Arabic calligraphy. The script became less legible and more abstract over time, having been made by masons who were not necessarily literate scholars. Nevertheless, the decorative ideas, and their association with Islam, have persisted for over five hundred years. This synthesis is typical of the way that Islamic and non-Islamic practices have merged throughout the region.

In northern Nigeria, painted designs or embossed plasterwork on buildings continue to evoke the work of Abu Ishaq al-Sahali. Similar designs are, and presumably formerly were, applied to carved calabashes and wooden boxes, leatherwork, and embroidery. A chest, made in Morocco sometime in the fourteenth–sixteenth century, is an example of a similar synthesis of styles. It was covered with Kufic script, a form of early Arabic with predominant geometric characters (fig. 4.6). In both North and West Africa this script was incorporated into tiling, plasterwork, woodwork, pottery, silver jewelry, leatherwork, and embroidery.

Through trade in portable objects and the travels and exchanges of scholars, architects, masons, and merchants, decorative arts practices circulated over vast areas with neither

Fig. 4.6. Chest,
probably Fez, 14th–
16th century. Wood,
iron, traces of paint;
23¼ x 34⅝ x 19⁵⁄₁₆ in.
(59 x 88 x 49 cm).
Musée du quai Branly,
Paris (74.1987.8.1).

oceans nor deserts forming significant barriers. The Kingdom of Mali was a flourishing center of trade and Islamic scholarship. The cultural interconnection of North Africa, sub-Saharan Africa, and southern Europe is reflected in the biographies of Leo Africanus (1485–1554) and Ahmed Baba (1556–1627). Born in Granada, Spain, Africanus grew up in Fez in Morocco, and traveled widely throughout the Islamic world and beyond— including to Timbuktu, Constantinople, Cairo, Tunis, Bologna, and Rome. The author of a description of Africa published in Venice in 1550, he noted that manuscripts were sold along the trans-Saharan trade routes between Morocco and kingdoms of the Western Sudan. While this trade included fabrics, sugar, salt, spices, horses, and enslaved Africans, he recorded that manuscripts attracted the highest prices.

The life of Ahmed Baba, Timbuktu's most eminent scholar and author of more than forty books, also suggests the value placed on manuscripts and scholarship during this period. Three years after Morocco invaded Timbuktu in 1591, Baba was taken hostage, accused of sedition, and deported to Marrakesh. Highly regarded by scholars and students, even while in captivity, he had access there to the royal libraries of the Sultan al-Mansur and his son Zaydan. After the death of Al-Mansur, in 1603, Baba returned home to Timbuktu and

en route he borrowed an important manuscript from another scholar. He kept it for fifteen years, making a copy before returning it. His passion for books and his obsession with collecting them is remembered in Timbuktu, where the library named for him houses a large collection of historical Arabic and African manuscripts.

Embroidery, another important industry in Timbuktu during this period, was closely allied with scholarship and healing. Embroiderers often used the same designs, based on Arabic script, which were written on paper and enclosed in leather amulets or written in ink on Qu'ranic boards. (The ink could be washed off and the inky water was swallowed as a medicine.) Almost all of the embroidery motifs found on even the oldest garments are patterns directly transferred from the geometric designs found in the scholarly books that, among other things, give advice on healing.

Djenne (in present-day Mali), the oldest known city in sub-Saharan Africa, was inhabited by 250 BC. Its Great Mosque, today a UNESCO World Heritage site, was originally built in the thirteenth century (rebuilt in 1907). The historical importance of Djenne as a mercantile center predates the building of the Great Mosque and even the introduction of Islam in West Africa, which started as a gradual process

linked to trans-Saharan trade, as early as the eighth century. During the eleventh and twelfth centuries, textiles made in this region were used as currency throughout West Africa and traded to southern Europe. And, as Mansa Musa's pilgrimage made clear, supplies of gold eventually found their way into the decorative arts of Europe, as jewelry and other valuable commodities as well as through gilded lettering on illuminated manuscripts.

Throughout the Sahel region south of the Sahara, the iron-rich red earth of the dry Sahelian region was used to create buildings, magnificent figurative sculptures, and ceramic vessels. As in Ife, Djenne terracotta sculptures show the elaborate adornment of the period and depict people of different classes. Some portray high-status individuals wearing beads and textiles, carrying weapons, or mounted on horses while others, most likely placed on shrines, depict people with diseases and deformities.

Origin myths, still current in the twenty-first century, describe the founders of the great west African kingdoms as powerful warriors, often on horseback. Scholars agree that the rise of these states was related to the knowledge of blacksmithing and the adoption of cavalry in the thirteenth century, when new breeds of horses and combat techniques spread from Islamic North Africa. The rulers of these kingdoms encouraged Muslim scholars and merchants who assisted with trade and brought new forms of mystical protection. The elaborately adorned terracotta equestrian figure (fig. 4.7), made sometime between the twelfth and sixteenth centuries, represents a warrior of high status, with a hat strapped to his chin and bracelets around his wrists and arms. The horse's trappings include a string of neck bells. From behind its ears, a band of cowrie shells attests to the wealth of the wearer, as cowries, imported from the Indian Ocean, were used as currency throughout West Africa. An iron horse-bit, uncovered at an archaeological site in Koumbi Saleh, Mauritania, dating to sometime between the eleventh and the fifteenth century is further evidence of the importance of blacksmithing in West African history.

The Bandiagara Escarpment, located in present-day Mali, is formed by a row of steep cliffs—more than 125 miles long, some nearly 2,000 feet high. The cliffs run parallel to the Niger River at the southern edge of the Sahara Desert. Excavations in the dry cliff-side caves of the escarpment have revealed some of the material culture of the people, known as Tellem, predecessors of the present-day Dogon people. The Tellem settled on the escarpment during the fifteenth and sixteenth centuries to escape slave-raiding cavalry who threatened them in more open country.

The escarpment has been the site of important twentieth-century discoveries of cloth dating to this period. Textiles are notoriously fragile, but in these cliffs, used for burials by both Tellem and Dogon, some fragments survived for centuries. The cloth trade was one of the means by which the Kingdom of Mali, like the earlier Kingdom of Ghana, established itself and expanded its influence. Narrow-band, strip-woven cloths made of locally grown, hand-spun cotton, dyed with indigo, were found with fragmentary remains of red wool in the weft fibers. The cloth so closely resembles textiles that are still

made today that we can surmise that the techniques used to make it were probably the same: women make yarn from locally grown cotton. Men then weave the cotton into long strips using their highly portable narrow-band looms. The long narrow bands are rolled into large portable spirals which can then be sold and the strips stitched together to make blankets and garments.

Another fragile object type made in Mali for more than six hundred years is the coiled basket, used in this region most importantly for winnowing grain, particularly rice. African farmers developed a unique form of rice cultivation, including technologies for moving fresh water on and off the rice fields. They took this process to the coastal areas of the southern United States, where enslaved Africans continued to make coiled baskets. Some of the elaborate baskets made in South Carolina and Georgia in the twentieth century developed from these winnowing baskets.

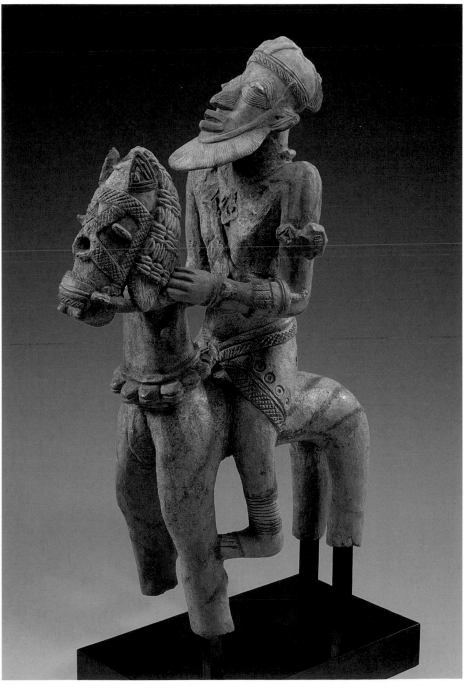

Fig. 4.7. Equestrian figure, Djenne, 12th–16th century. Terracotta, pigment; 21 x 11 x 6 in. (53.3 x 27.9 x 15.2 cm). The Nelson-Atkins Museum, Kansas City (2000.31).

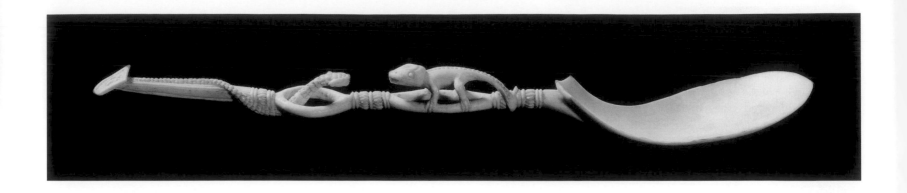

IVORY OBJECTS IN WEST AFRICA

Beginning in this period, African ivory became an important material for high-status objects. Based on the archaeological record, elephant ivory does not seem to have been widely used for decorative objects before the late fifteenth century, although we can conjecture that tusks were made into ornaments, hammers for pounding bark into cloth, and trumpets. Ivory was traded across the Sahara along with salt, gold, cloth, and slaves. Once the Portuguese sailed along the west African coast, however, in addition to procuring ivory in its raw form, they also engaged Africans to make objects for a European clientele. Workshops of skilled ivory carvers developed in the region of present-day Sierra Leone and in the kingdoms of Owo and Benin (in what is modern Nigeria). These carvers made objects based on European models but with African details, creating an extraordinary corpus of hybrid works. As the trade in slaves supplanted more benign forms of commerce, ivory carvers ceased working for Europeans directly and instead made pieces for African merchants and chiefs who controlled the coastal commerce from the African side.

The "Afro-Portuguese ivories," as these works are often now called, were collected in a period when Europeans had only limited contact along the coast of Africa. Because Africa has few easily navigable ports that provide natural access to the interior, it took another three centuries for Europeans to venture there. Meanwhile, however, trade along the coasts intensified steadily. Over two hundred of these ivories are known to have made their way into some of the wealthiest homes and palaces of Europe in the fifteenth and sixteenth centuries. Covered cups (saltcellars and pyxes), spoons, forks, knife handles, and oliphants (horns or trumpets) were commissioned in what is now Sierra Leone, and in the region of the Kingdom of Benin, now Nigeria, as well as in the region of the former Kingdom of the Kongo, now the Democratic Republic of the Congo, Republic of Congo, and Angola.

An exquisitely detailed spoon, with a snake confronting a chameleon carved on the stem, was commissioned shortly after the Portuguese arrival on African shores in 1460 (fig. 4.8). We do not know who made the carving, but in an account of 1506–10, Valentim Fernandes portrayed the people of the region (referring to them as Sapi) as very skilled in manual arts: "the men of the country [Sierra Leone] are black and very talented in making things, that is ivory salts and spoons; whatever sort of object is drawn for them, they can carve in ivory."[3]

A sixteenth-century Portuguese oil painting, *The Death of the Virgin* (c. 1520–30, Museu Nacional de Arte Antiga, Lisbon) by Maestre do Paraiso, shows an ivory spoon like those known to have originated in the same area, inserted into a dish of cherries. Similar spoons now in European collections all have shallow, fig-shaped bowls and what appear to be heraldic devices ornamenting the tips of the handles. In some cases, such spoons were misidentified in Europe as East Indian, along with many other fifteenth- and sixteenth-century ivories from West Africa. The German artist Albrecht Dürer (1471–1528), for example, who owned two ivory saltcellars from West Africa probably acquired during a trip to the Netherlands in 1520 to 1521, misidentified them as "from Calicut."[4]

A fascinating combination of African and European imagery is carved in relief on a magnificent ivory oliphant (fig. 4.9). This horn may have arrived in Italy when Beatrice of Aviz, daughter of King Manuel I of Portugal, married Charles III, Duke of Savoy, in 1521. Carved in high relief are: an African crocodile; a wyvern, a large, winged monster with two paws that frequently appears in European medieval sculpture; and a snake. Similarly, the scenes of a stag hunt, carved in low

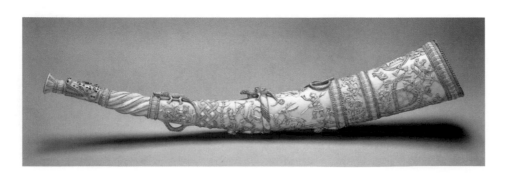

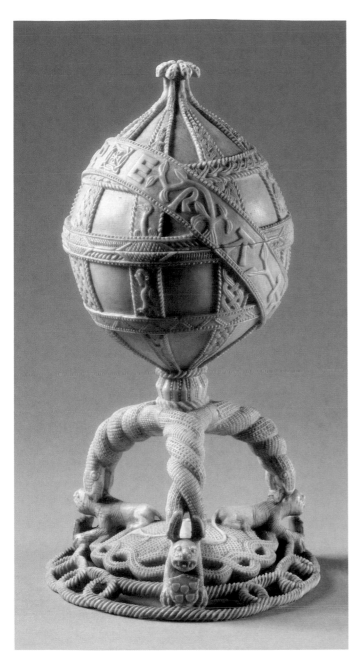

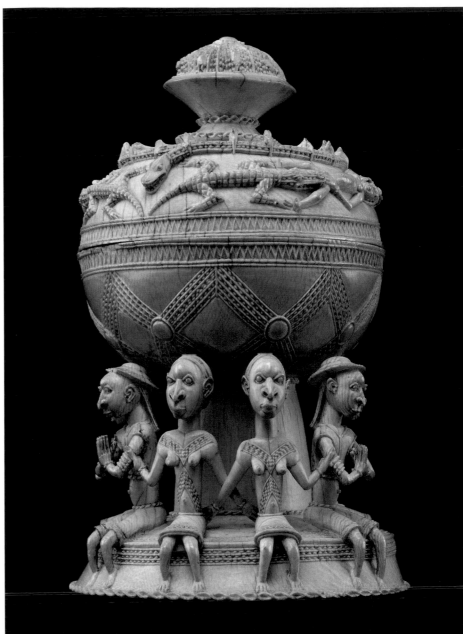

relief, paralleled those codified in European iconography over the course of several centuries, especially as seen in late Gothic miniatures and tapestries of the Franco-Flemish school of the late fifteenth and early sixteenth centuries. The coat of arms of the king of Portugal is also carved in low relief, suspended from a leafy tree, flanked by unicorns standing on their hind legs.

The Aviz arms also appear on an ivory saltcellar (fig. 4.10) that was inspired, in part, by the classicized "Renaissance" architecture of Manueline Portugal. The bowl is supported by lions surmounted by intertwined snakes, a feature seen on stone buildings in Portuguese cities of the period. The largest known saltcellar from Sierra Leone, encircled by a ring of interlocking figures, male and female, dates to about 1490–1530 (fig. 4.11). With nearly identical faces, the female figures represent African women, wearing skirts or cloth wrappers and displaying elaborate chest scarification. The male figures represent straight-haired Portuguese men wearing short pants, short-sleeved shirts, and brimmed hats. On the lid, two crocodiles attack a reclining figure.

While European iconography appears on virtually all of these objects, there are clear similarities with African decorative techniques and aesthetic vocabulary. Soapstone carvings, known as *nomoli*, from the same area and time period as the Sierra Leone ivories, often show people with similar facial features interacting with wild and dangerous animals such as crocodiles or lions. In contrast, the triumphal hunting scenes found on many of the ivories were probably copied from European publications or objects. Humans and animals interacting in scenes of daily life were, and still are, common themes in African representation, whereas the likely European models for these works more often had nonfigurative designs, such as plants, or Biblical or hunting scenes. In the nonfigurative sections of the ivory carvings, the alternation of smooth surfaces and intricately carved geometric patterning is reminiscent of widespread treatments on African pottery, textiles, and woodcarving. Furthermore, the fact that a single piece of ivory is used for each bowl or lid, no matter how intricate and open the design, conforms to the way African woodcarvers worked from single blocks of wood.

Fig. 4.10. Saltcellar, Sapi, 1490–1530. Ivory; H. 8¼ in. (21 cm). Ethnologisches Museum, Staatliche Museen, Berlin (III C 17036a,b).

Fig. 4.11. Saltcellar, Sapi, c. 1490–1530. Ivory; 9 1/16 x 5½ x 5⅞ in. (23 x 14 x 15 cm). Trustees of the British Museum (Af1867,0325.1.a,b).

The exact date of the founding of the Kingdom of Benin, in present-day Nigeria, is not known, but it almost certainly predates the first recorded contact with Portuguese explorers in the late fifteenth century. A number of ivory carving workshops made objects that depicted the material culture of the Europeans, as for example in a saltcellar attributed to "The Master of the Heraldic Ship" (fig. 4.12). This carver portrayed a Portuguese ship complete with anchors dangling at both sides and Portuguese men, from a sailor peeking out from the crow's nest, to men with long beards wearing European dress, including jerkins, trousers, capes, stockings, and shoes, cross pendant necklaces, and tall feathered hats. There are seventeen similar saltcellars from Benin, and it has been suggested that they were carved in a single workshop, using specific imagery provided by the Portuguese who commissioned them. Other ivory pieces offer evidence of the way of

life of the people of Benin, from how they dressed to their ideas about hierarchy and privilege.

When the Portuguese first made contact with the Kingdom of Benin, the reigning king, or Oba, Ewuare (r. c. 1440–73), is said to have introduced the wearing of coral beaded regalia, along with scarlet cloth (*ododo*). Both have remained important elements of royal regalia; in the early twenty-first century only the king of Benin has the prerogative to wear a complete costume, including a crown and gown, made of coral beads. Individuals, including women, in lesser offices of the royal court wear coral hair ornaments, necklaces, bracelets, and anklets. It is not known to what extent the royal dress of Benin's rulers was influenced by the dress of the European visitors, but gifts and exchanges of luxury goods were part of these early contacts. The first European to record his visit to Benin, João Afonso d'Aveiro, entered Benin City in around 1486 during the reign of Oba Ozolua (r. c. 1481–1504). Subsequently, emissaries from Benin traveled to Portugal and brought back gifts from the Portuguese king. In

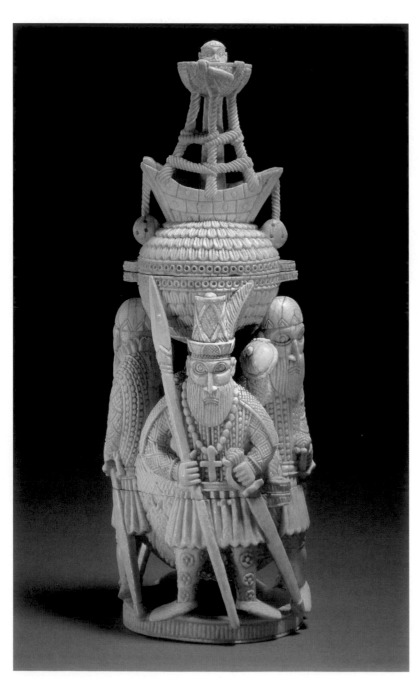

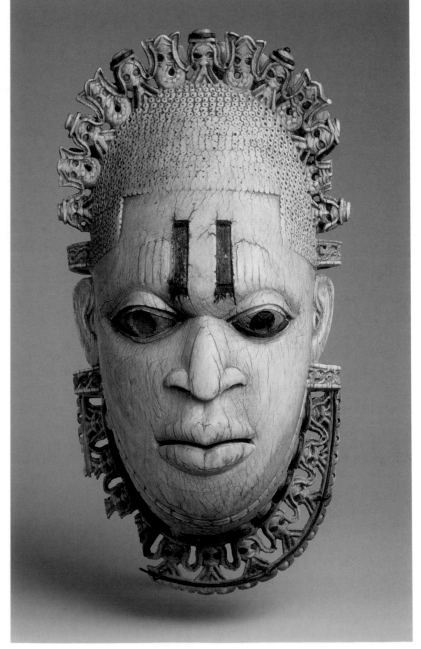

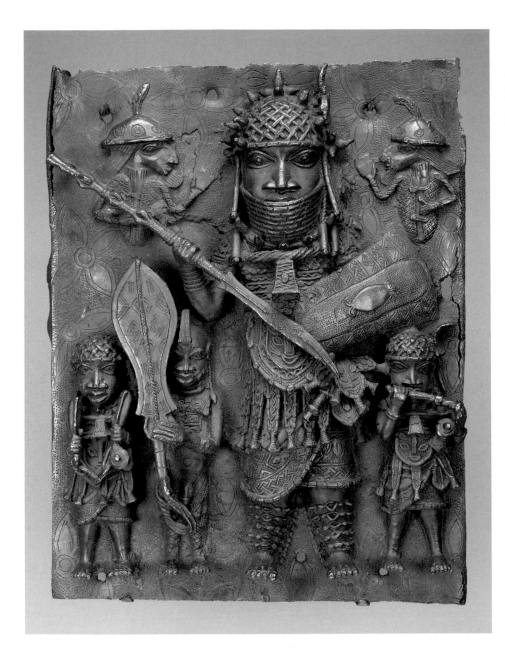

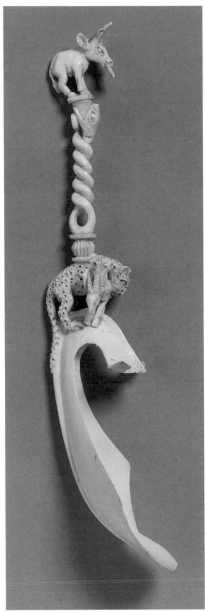

Fig. 4.14. Plaque, Edo, Benin Kingdom, mid-16th–17th century. Bronze; 17¹⁵⁄₁₆ x 13¾ x 3½ in. (45.6 x 35 x 8.9 cm). National Museum of African Art, Smithsonian Institution, Washington, DC (82-5-3).

Fig. 4.15. Spoon, Edo or Owo, 16th century. Ivory; L. 10 in. (25.5 cm). Palazzo Madama, Turin (PM Top 423).

1505 the Oba of Benin received a gift from King Manuel I consisting of a decorated horse, an Indian necklace, Indian cloth, and a variety of silk and linen clothing.

In Benin's royal art, social hierarchies are reflected through hieratic proportions, explicitly depicted. Politically powerful individuals are the largest, and in the cast bronze plaques that were hung on palace walls, most were fully three-dimensional. Less powerful people appear flat and diminutive. From the fifteenth century onward, there were interesting contrasts in scale in portrayals of Africans and Portuguese depending upon who commissioned the work. When the Portuguese commissioned works, such as the salt-cellars, they were depicted as larger than Africans, whereas when Africans commissioned ivory carvings and bronze castings, Portuguese faces appeared as small decorative ornaments. In the tiara-like coiffure and openwork collar of an ivory pendant mask portraying Queen Mother Idia, the small faces of Portuguese men alternate with mudfish. Her son, Oba Esigie (r. 1504–50), commissioned this mask (fig. 4.13) to commemorate the new title "Iyoba," or queen mother, he established in her honor. A tenacious warrior in her own right, Idia is said to have given invaluable counsel, support, and protection to her son.

Oba Esigie is remembered as the first king to commission metal plaques to decorate the palace walls, later produced by the hundreds. The imagery of the plaques documents royal history, pageantry, and social hierarchy. A central figure of the king of Benin (or an important warrior), wearing a coral cap and collar, dominates the sixteenth- or seventeenth-century bronze plaque illustrated here (fig. 4.14). The Oba dictated the terms of trade relations with Europeans, and during Oba Esigie's rule, Portuguese mercenaries accompanied him on raids and in battles with people to the north of the kingdom. On the plaque, two Portuguese figures hover in the background; cast in low relief, they are minor characters, small in proportion to the central figure.

Animal imagery is important in the ivory and metal art of Benin. In one ivory spoon carved in the sixteenth century in Benin Kingdom the imagery includes a leopard attacking an antelope with a tightly coiled snake surmounted by another antelope (fig. 4.15). Like the oliphant and perhaps the saltcellar previously discussed (see figs. 4.9 and 4.10), this spoon

Fig. 4.16. Oliphant, Kongo, 16th century. Ivory; L. 32⅝ in. (83 cm). Museo degli Argenti, Florence (Bg. 1879. n. 2).

Fig. 4.17. Crucifix, Kongo, 16th–19th century. Brass, wood; 18 x 8½ in. (45.7 x 21.6 cm). The Metropolitan Museum of Art (1999.295.8).

may have been part of the dowry of Princess Beatrice of Aviz. Other spoons include images of small duiker antelopes chewing medicinal *akoko* leaves, a motif commonly found in the visual and material culture of Ife and Owo.

Domestic animals were sacrificed in shrines, but wild animals were used as metaphors in visual culture, including performance. They stood for various human qualities and for relationships between the more and less powerful. Small duiker antelopes are associated in Yoruba thought with cleverness and exceptional intelligence while the leopard in Benin and elsewhere in Africa is an important royal symbol. As king of the forest, the leopard is the alter ego to the Benin king. A pair of leopards in brass or ivory was usually placed beside him when he sat in state, and the seventeenth-century Dutch writer Olfert Dapper described captive leopards in the Benin King's entourage. Brass lost-wax castings of leopards were made in Benin from the sixteenth century onwards (see fig. 10.18).

KONGO TEXTILES AND IVORY CARVING

The Kongo Kingdom, with the hilltop city of Mbanza Kongo as its capital and home of its king, located in what is now Angola, flourished for several centuries before the Portuguese explorer Diogo Cão reached it in 1482. Between about 1300 and 1400, through conquest and political alliances, a number of groups in the region united to form a centrally organized kingdom, divided into provinces ruled by governors under the king's leadership.

When the Portuguese arrived on the coast, Kongo men and women were already making sumptuous raffia textiles, intricate baskets, and decorated ivory trumpets, which played an important part in court ceremonies. The raffia textiles, made with a cut-pile technique, and therefore often described as "velvets," were used as currency throughout the kingdom. While accounts from the period indicate that Portuguese royalty received many of these cloths between 1451 and 1500, the only surviving examples date to the seventeenth century or later (see figs. 10.20, 10.21).

Because ivory is more durable, more of it has survived, including seven examples of ivory trumpets from the sixteenth century, three of which entered the collection founded by Cosimo I de'Medici (1519–1574), Grand Duke of Tuscany, by 1553. The addition of rings for attaching a cord

suggests that these were commissioned for Europeans or made in imitation of European horns; African trumpets, or oliphants, typically do not have such rings. The fine geometric designs carved on the trumpet in figure 4.16 echo the designs woven into cut-pile raffia cloth, carved into wooden objects, and incorporated into beadwork. The alternations of plain and decorated spaces, and the repetition and variation of geometric motifs, are also familiar elements in the decorative arts from this region.

In the late fifteenth century, Mvemba a Nzinga ruled the Kongo as King Afonso I (r. 1506–42), with the support of the Portuguese. He had converted to Christianity and wrote and spoke Portuguese. Pope Leo X made his son, Henrique, a

bishop. For the next two hundred years, Christianity was an important part of royal Kongo culture and state religion. While there was significant fusion between traditional Kongo belief and Christianity, a number of surviving objects from this period, such as the brass crucifix (fig. 4.17), are clearly based on European prototypes.

Faced with the deleterious impact of the slave trade, in 1526, King Afonso I sent letters to Lisbon saying his kingdom was being devastated. By the late seventeenth century, it had broken into fragments and many of its citizens had been shipped to the Americas. The motif on the cross, from the sixteenth century, however, has continued to appear in many examples of Kongo material culture and religious practice, both in Africa and the Americas. It symbolizes not just the Crucifixion of Christ, but also the crossroads, or boundary, between the living and the dead, earth and sky, God and man.

GREAT ZIMBABWE AND THE SWAHILI COAST

The palace complex known as Great Zimbabwe (inhabited from around 1100 to 1550) is a large complex of ancient stone structures, its walls and buildings undulating across almost 1,800 acres. Great Zimbabwe was the center of government of a large state that reached its peak during the late fourteenth and fifteenth centuries. The curved stone walls are made of granite blocks hewn from the nearby hills and fitted together without mortar (fig. 4.18). They were carefully stacked into round structures and solid round towers reaching as high as 36 feet (11 m), and in some places nearly 300 feet (91 m) in diameter. Narrow walkways, terraces, and stone staircases followed the terrain. Combined with timbers and thatch, the walls formed elegant housing for a ruling class of perhaps two to three hundred people. Secondary mud and thatch dwellings, linked to the stone structures through a series of adjoining courtyards, housed perhaps an additional ten thousand people in the outlying part of the complex. Remains of residential and ceremonial buildings show that clay, or Daga (mud and thatch), sometimes beautifully painted with geometric patterns, was used to create not only the outer walls but also sleeping platforms, earthen seats, and raised shelves with indentations for ceramic pots of water or beer. In some enclosures, there were secluded royal chambers, throne platforms, and wooden posts covered with gold.

While little remains of sculpture from Great Zimbabwe, eight surviving soapstone bird carvings, each about 16 inches (41 cm) in height (fig. 4.19), suggest that figurative sculptures

Fig. 4.18. Stone walls, palace complex of Great Zimbabwe, Kingdom of Zimbabwe, 11th–14th century.

Fig. 4.19. Figure of a bird from the palace complex of Great Zimbabwe, Kingdom of Zimbabwe, 11th–14th century. Soapstone. H. approx. 16 in. (41 cm).

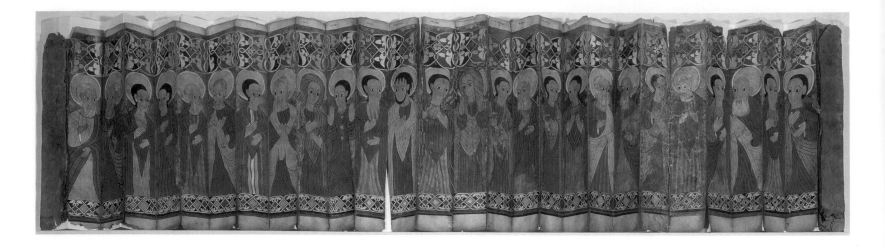

were likely made to honor royal ancestors. The bird carvings have human features and once stood on columns more than 3 feet (1 m) high. Unlike these birds, which have no parallels with art forms from outside the region, some of the surviving pottery from Great Zimbabwe, with interlace and cable patterns, shows evidence of extensive trade with Muslim artisans from the East African coast (some of whom may even have worked in Great Zimbabwe). Trade networks were extensive, with the most important part of the trade economy being ivory and gold.

As many as 7,000 ancient mining sites have been found between the Zambezi and Limpopo rivers, nearly all of them dating to before 1500, and gold production continued into the sixteenth century, through the height of Great Zimbabwe's power. The miners and gold workers were skilled in the techniques of finding gold-bearing rock, crushing the ore by hand, smelting it, and producing ingots, ornaments, and jewelry. A chance discovery in 1902 revealed gold sheets and beads as well as coiled wire made of gold, copper, iron, and bronze.

Of the gold exported from Great Zimbabwe between 1000 and 1500, most of it was sold to merchants living along the coast of East Africa, who in turn exported it through the Red Sea or across the Indian Ocean. These contacts explain why, among the locally mined gold and ceramic wares found in Great Zimbabwe, there were many imported items including stoneware vessels, enameled Syrian glass, a Persian faience bowl bearing an Arabic inscription, and tens of thousands of glass beads. In the fifteenth century, if not before, China had direct contacts with the merchants of East Africa who in turn traded with Great Zimbabwe. Chinese coins have been found along the coast of East Africa from Mogadishu (in present-day Somalia) to Kilwa (in present-day Tanzania). Zheng He, a Chinese explorer and fleet admiral, commanded seven expeditions to the east coast of Africa, and in 1416, envoys from Mogadishu arrived at the Chinese court. In exchange for their gold, the Africans received Indian cottons, brassware, Chinese silks, and vast quantities of porcelain, celadon, and blue-and-white ware.

The coastal cities of East Africa grew in importance during the twelfth and thirteenth centuries. Kilwa, one of the most prosperous, was described by Ibn Battuta, an Arab traveler who visited there in 1331, as one of the most beautiful towns in the world. The people of these cities were, and still

are, known as Swahilis. They developed a distinctive form of domestic architecture quite different from the curvilinear meandering walls characteristic of Great Zimbabwe. Swahili architecture and design was strongly influenced by Islamic traditions, and in many of the coastal cities, great mosques, built with crushed coral, or coral slag, had arches, domes, and tall pillars supporting the roofs. Wealthy merchants constructed stone houses with multiple rectilinear courtyards, interior wells, large carved wooden doors, and many interior niches (see fig. 10.24). Some scholars have noted Muslim Indian influence in some of this architecture, while others find similarities with ancient Rome, Arabia, and the Persian Gulf. As in Great Zimbabwe, there is also evidence of trade with China. Blue-and-white wares were used as inlaid decoration in the exterior and interior walls of some houses and mosques and also were embedded in the crushed-coral walls of Swahili burial tombs.

By 1503–5, the Portuguese had largely usurped the Indian Ocean trade. With a sense of mission inspired by their commitment to Christianity and their antagonism toward Islam, not to mention their sophisticated vessels and weapons of war, they sacked Kilwa and other towns, building forts along the coast and taking control of the sea traffic. Despite this, the influence of Islamic cultures on the architecture, dress, language, and decorative arts of coastal East Africa proved to be more profound and long-lasting.

DEVOTIONAL CHRISTIAN IMAGERY IN ETHIOPIA

Christianity in Ethiopia dates to a much earlier period, to the conversion of Ezana, King of Aksum, in around 324 AD. The fortunes of Aksum faded, and in the twelfth century, during the Zagwe dynasty (c. 900–1270), the center of administration moved to Roha (present-day Lalibela). The defeat of the Zagwe dynasty ushered in the Early Solomonic period, whose rulers claimed to descend from King Solomon and the Queen of Sheba. (The dynasty ended with Emperor Haile Salassi, who was overthrown in 1974.) It was during the Early Solomonic period that the interiors of churches were decorated with lavish wall paintings, gold, and fine fabrics.

Lalibela, in the highlands of northern Ethiopia, is the site of thirteen remarkable Christian churches carved into the solid rock of the surrounding hills. These stone churches provide a dramatic backdrop for ceremonies that honor the

saints, with pilgrims winding their way down steep staircases to reach the below-ground entrances of the churches. They chant prayers and carry elaborately decorated bronze, silver, and wooden crosses as they pass through narrow tunnels and pathways that surround each church.

Remarkably, a late fifteenth-century folding processional icon in the shape of a fan has survived, one of only three known examples (fig. 4.20). Painted on five sheets of parchment, stitched together and folded, it was likely used in pilgrimage processions or displayed during church services, where it would have been unfolded to create a giant wheel, roughly 4 feet (122 cm) in diameter. The saints, portrayed to either side of the Virgin Mary, wear a variety of clothing associated with this period—long, crimson, blue, and gold draped garments, lavishly embroidered with gold thread.

The Virgin Mary was especially revered, and Monastic scholars created finely illustrated books that celebrated her life and miracles. Among the few books to survive from the period under discussion is the first translation of the *Miracles of Mary* from Arabic to Ge'ez (a Semitic language no longer spoken). Commissioned by Emperor Dawit (r. 1382–1413), it contains images of Mary, with her name written in gold leaf. At around this time, a Florentine painter then working in Venice is thought to have arrived in Ethiopia, and this book may have been illustrated by him. Other artists followed, sent by Alfonso V of Aragon, at the request of Dawit's son, Yeshaq (r. 1414–28). In the 1440s, Emperor Zara Ya'qob (r. 1434–68) made the veneration of Mary mandatory and encouraged the processional use of icons and the display of panel paintings. The tradition of icon painting in church interiors, books, and on painted scrolls used in healing rituals has lasted to the twenty-first century.

The Virgin and Child are the central focus of a late fifteenth century Ethiopian panel painting attributed to a follower of Fre Seyon, the first Ethiopian artist to become known for his painting style, combining Italian and Ethiopian imagery (fig. 4.21). In this work, Mary's face is in three-quarter view, as in Italian paintings. As the objects discussed here suggest, Ethiopian artists and craftspeople were in close touch with artistic developments that derived from Byzantium to Renaissance Italy.

NORTH AFRICA

In the period 1400–1600 the decorative arts of North Africa were part of the complex of Islamic arts crossing geographic boundaries, from Spain south into North and West Africa and eastward to the edges of the Indian Ocean. Throughout the Islamic world, we see the importance of calligraphy as both a decorative and religious motif, the building of imposing mosques with exquisite tilework, the use of vibrant color and

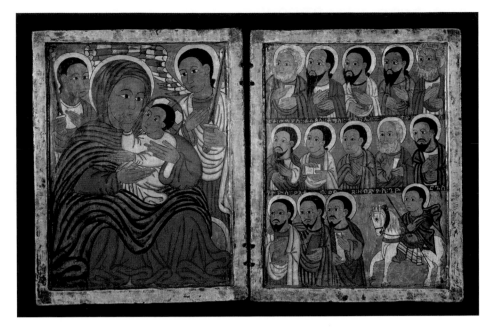

gold leaf in illuminated manuscripts, fine weaving in silk and wool, and the crafting of silver and gold jewelry with precious and semiprecious stones. These craft and artistic practices took different forms in different places in Africa and elsewhere depending on local power structures and the cultures of the pre-Islamic populations.

Events of the 1400–1600 period had a profound impact in Africa. The vast, diverse continent had many different histories surrounding material culture, varying from place to place, but even in the far interior, from Asante to Great Zimbabwe, international trade was a major catalyst of change. Long before Europeans sailed along the West Coast of the continent, trading caravans across the Sahara, and ships sailing up the Nile or across the Red Sea and Indian Ocean, connected Africa to Europe, the Middle East, and Asia. Spices, ivory, gold, and enslaved Africans were among the many exports from Africa in this era. After the arrival of European traders along the coasts in the late 1400s, trading patterns shifted and the range of exports and imports radically changed. Ivory, for example, found new uses in forms tailored to the tastes of the European elites; at the same time, European materials, such as metal bars, glass beads, and textiles were imported and refashioned to comply with African tastes. Most important, in this period, the Atlantic slave trade intensified and caused major shifts in population and power structures. Despite these profound changes, African cultures with their many vital decorative arts practices, survived, adapted, and innovated, as they have continued to do to this day, both on the continent and in the Diaspora.

ENID SCHILDKROUT AND CAROL THOMPSON

Fig. 4.21. Follower of Fre Seyon. Virgin and Child (left panel), Apostles and Saints (right panel), Ethiopia, late 15th century. Tempera on wood; left, 8⅞ x 7¹³⁄₁₆ in. (22.5 x 19.8 cm), right, 10¹⁄₁₆ x 7¾ in. (25.6 x 19.7 cm). The Walters Art Museum, Baltimore (36.12).

EUROPE

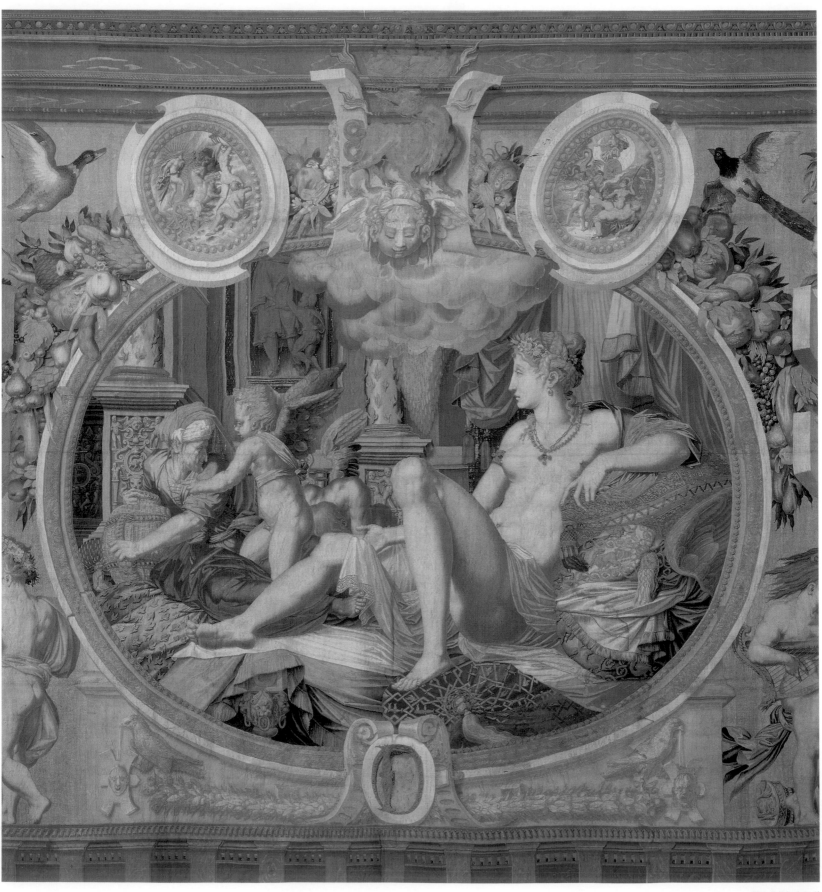

Fig. 5.22 detail

In 1400, and for most of the fifteenth century, Europe remained medieval in outlook. Underlying every aspect of life were the teachings of the Christian Church, which had determined the European worldview for almost a millennium. In a world bound by biblical authority, history, and the limitations of experience, even the concept of Europe as a geographical, political, and cultural entity had yet to emerge. For most of the population, Christendom was a more meaningful concept, defined by communality of religion and, increasingly, by the pressure of Ottoman expansion from the east. Traditional authority taught, for instance, that there were no lands beyond the sea, and that Jerusalem, the Holy City, stood at the center of the earth. Felix Faber, a Dominican friar of Ulm in Swabia, could travel twice to the Holy Land and still insist in his 1476 account of his voyages that the "infallible truth of Holy Scripture" proved "that Jerusalem is in the middle of the world."[1] This belief was shared by most contemporaries, even after decades of Portuguese exploration and colonization of the west coast of Africa; by 1500, their ships were also rounding the horn of Africa to India. Despite three voyages of exploration to the west, Christopher Columbus still failed to recognize the new continent for what it was (it took the Italian Amerigo Vespucci to do so in 1499–1502).

As horizons expanded, however, a new concept of "Europe" slowly developed, requiring its own series of reorientations—geographical, intellectual, and cultural. Exploration, burgeoning overseas trade, economic prosperity, and new knowledge, spread by the revolutionary invention of printing with movable type, were among the engines that prompted a sea change in European consciousness, and gave impetus to a new, secular outlook. The other crucial factor in breaking down the medieval, theologically bound worldview was the spread of a cultural movement, inspired by the revival and emulation of the arts and ideas of antiquity. Beginning in Italy in the fourteenth century with the rediscovery and translation of classical literary and philosophical texts, the movement spread to almost every aspect of social and cultural life across the continent over the two succeeding centuries.

Dubbed humanism by contemporaries, after the *studia humanitatis*, the program of classical study promoted by its adherents, organized around ethics, poetry, history, rhetoric, and grammar, its effect over time was to produce a set of cultural attitudes based on the emulation of classical examples. These colored every aspect of life, from an understanding of statecraft as an art, to the adoption of a classical vocabulary of style and to a new, distinctive sense of the individual in relation to the world. What had begun as a specifically Italian movement of conscious innovation, of *rinascimento* ("rebirth" or "renaissance"), became part of everyday practice for diverse

Europeans as it spread across countries and social groups. In northern Europe, the Protestant Reformation was equally instrumental in transforming the cultural landscape. It developed from fifteenth-century calls for institutional and doctrinal reform of the Catholic Church and gathered unstoppable momentum after Martin Luther published his ninety-five theses in Wittenberg in 1517. These factors, accompanied by an overall increase in the disposable income of the mercantile and landed classes, were central in fostering new attitudes to the work of artists and craftsmen. Concepts governing lifestyle were defined by the acquisition of aesthetically desirable household goods and collectible objects. The decorative arts of fifteenth- and sixteenth-century Europe are best understood within this larger framework of profound cultural, political, economic, and religious transformation. Indeed, by 1600, Europe had witnessed the most concentrated wave of intellectual and creative energy that had yet passed over the continent and with it emerged a new and pervasive attitude as to what constituted the most valued aspects of civilized life.

Change and the spread of new ideas, however, came slowly. At the beginning of the fifteenth century, many parts of Europe were still recovering economically and demographically from the ravages of a century of the Black Death, the bubonic plague that first appeared in Europe in 1347 and left large areas blighted by depopulation. The kingdoms of the Iberian Peninsula remained underpopulated and economically undeveloped for much of the period, as did large tracts of agricultural land in areas of central Europe. Long periods of warfare and unstable rulership in many regions also played a role. In Bohemia, the Hussite Wars (1419–36) disrupted the economy, diminished the cultural standing of Prague, and reduced the population. The Hundred Years War (1336–1453) between England and France left much of the French countryside in ruins. In England, in the fifteenth century alone, aristocratic coalitions deposed no less than eight monarchs in the near-continuous civil conflagration known as the Wars of the Roses (1455–85).

The artifacts and monuments that survive from the period mostly bear witness to prosperity rather than to the adversities of the time. The parts of Europe that were the most productive economically and artistically were the most populated and urbanized. In Italy, these were city-states and principalities such as Florence, Milan, and Venice; north of the Alps, they were the trading and manufacturing cities of southern Germany and the southern Netherlands, like Bruges and Ghent, cities of considerable size, probably around thirty thousand inhabitants, that owed their prosperity to textiles. In such cities, progressive economic recovery and population growth to preplague levels over the course of the fifteenth century were accompanied by artistic and cultural renewal.

ITALY

The city-states and courts of northern Italy, above all, first fostered an intellectual and artistic climate of classical renewal. A portrait medal commissioned for the marriage of Leonello d'Este, marquis of Ferrara (fig. 5.1a–b), which was designed and made by the artist-metalworker Pisanello (c. 1395–1455), introduces some of the themes that shaped the history of decorative arts in Italy in this period. Leonello appears in profile, in the manner of a Roman emperor, reflecting the imagery on ancient coins that inspired such medals. His titles are rendered not in the vernacular Italian, but in Latin—the language of humanism—in classicizing letters and abbreviations that imitate the form of antique inscriptions. On the reverse, in a witty allegory of the taming power of love, the ancient god Cupid teaches a lion (Leo/Leonello) to sing. This visual evocation and self-conscious imitation of the classical past were part of the larger project of revival and recovery that gives the name "Renaissance" to the fifteenth and sixteenth centuries in Italy.

Although medieval artists and scholars had woven references to antiquity into their work, adopting Latin-style scripts and illustrating subjects from classical mythology and history, the new style was characterized by the reintegration of classical subject matter with classical form. It replaced, for example, the chivalric tradition of depicting the ancient gods and goddesses as courtly ladies and gentlemen with a revival of classical canons of proportion and beauty and classical styles of dress. This new fascination with the ancient past, however, was grafted onto a deeply held Christian faith, reconciling ancient conceptions of the dignity of man with a faith predicated on the idea of God taking on human form, while creating a new emphasis on the human body and a new perception of individualism.

The revival of classical antiquity began in earnest in the fourteenth century in literary culture with the rediscovery and translation of ancient texts, but its influence was soon felt in the wider visual culture. Wealthy patrons, such as Leonello d'Este, sought to emulate the magnificence of their ancient predecessors as described by Pliny, commissioning works to embellish their cities, homes, and reputations. Architects turned to Vitruvius's treatise on architecture (*De Architectura,* c. 25 BC) to learn the proper proportions and characteristics of the classical orders, which they applied to modern buildings and designs. The visible material remains of the ancient past, from buildings to sarcophagi, statues, and coins, inspired new creations and provided an ornamental vocabulary that included egg-and-dart patterns, acanthus leaves, festoons, classicizing vases and trophies, columns and capitals. All were adopted and adapted in architecture, furniture, textiles, and ceramics as well as painting and sculpture.

The rediscovery of Nero's palace, the Domus Aurea, in Rome in the late fifteenth century provided many with their first glimpse of ancient painting and interior design. The motifs discovered there—scrolling foliage interspersed with masks and fantastic hybrid creatures—gave birth to a new style, the "grotesque," whose name derived from the underground "grottoes" where they were found. The new printing press brought these ancient wonders and the modern works they inspired to others unable to see them firsthand. Ornament prints such as the one illustrated here enabled the broad dissemination of designs and their translation into a variety of media including paint, stucco, metalwork, wood, and textiles (fig. 5.2). Featuring a vertically oriented grotesque pattern that is denser than the relatively spare decorations of the Domus Aurea, the print incorporates frolicking putti, masks, a monumental urn, female figures in classical garb, and a female nude whose lower body metamorphoses into scrolling leaves. The text beneath the image likens the inventive powers of artists to those of poets, a common trope borrowed from Horace, and implicitly encourages the creative license associated with the grotesque, revealing a tension between archaeological precision and freedom of invention that characterized Renaissance art and design.

Fig. 5.1a–b. Pisanello. Medal: Leonello d'Este, Marquess of Ferrara (obverse) and Cupid with lion (reverse), Italy, 1444. Bronze; Diam. 3¹⁵⁄₁₆ in. (10.1 cm). National Gallery of Art, Washington, DC (1957.14.602.a,b).

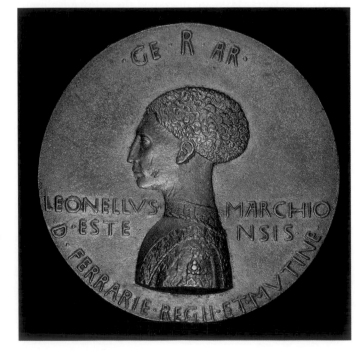

Even as it participated in the revival of classical antiquity, Pisanello's medal revealed modern concerns. A prominent inscription on the reverse proclaims that it is "the work of Pisanello the painter," an assertion of authorship that points both to an attention to authorship and to the role fifteenth-century painters and sculptors played as designers, be it the design of small objects in precious metals or buildings. Although its form reflects classical precedents, its scale is considerably larger than that of the ancient coins on which it was modeled, the larger format announcing the medal's novelty. So, too, does Leonello's fashionable contemporary attire; Pisanello took great care to indicate the patterns of the elaborate textiles that adorn his body.

In its simultaneous revival of, and rivalry with, the classical past, the medal captures the paradoxical nature of a cosmopolitan Renaissance culture wherein many were preoccupied with the ancient past yet determined to outdo its achievements. Renaissance scholars recovered, translated, and analyzed ancient texts, promoting knowledge of the classical past as an essential part of a well-rounded education and imitation of ancient virtues as the measure of a true gentleman. At the same time, this was a moment of technological innovation and exploration, including the invention of the printing press by Johannes Gutenberg (c. 1397–1468) in about 1450, the discovery of the so-called New World, the development of new types of scientific inquiry, and the expansion of cross-cultural exchange. Beginning in the fifteenth century, increased distribution of wealth, greater political stability, and a growing emphasis on private life created what has been termed a "culture of consumption" that fueled the demand for luxurious goods produced for domestic use, ranging from paintings and sculptures to metalwork, ceramics, and glass. In the fifteenth century, Italian artists, designers, and architects broke with inherited Gothic traditions by gleaning ideas not only from the remains of classical antiquity available to them but also from the Moresque and arabesque designs on ceramics, textiles, and metalwork imported from the Islamic world. Venice provided an important point of contact with the East; through its ports passed Oriental carpets, damascened blades, leather-bound books whose covers were decorated with intricate interlace and knot-work patterns, and other "bizarre but ingenious things from the Levant," to borrow the words of Sabba da Castiglioni, a sixteenth-century collector.[2]

The transition from the fifteenth to the sixteenth century was marked by a shift in style as the idealized naturalism, emphasis on classical proportions, and revival of antique forms in what is often referred to as High Renaissance style (c. 1480–1520) gave way to the greater visible artifice, attenuated proportions, and intricate compositions of Mannerism, a movement whose name derives from the Italian *maniera* ("manner" or "style"). Created almost a century after Pisanello's medal (see fig. 5.1), the saltcellar (fig. 5.3) by Benvenuto Cellini (1500–1571) demonstrates the continuities and changes that accompanied this shift. Designed as a functional object—a container for salt and pepper—and executed in gold and enamel, it is monumental in conception if not in scale. The ancient gods of Sea (Neptune) and Earth (Ceres) recline on an oval base, their languid bodies improbably balanced as

Fig. 5.2. Perino del Vaga. Grotesque ornament, Rome, 1532–33. Engraved by Master of the Die. 8⅞ x 5⅞ in. (22.5 x 15 cm). Victoria and Albert Museum, London (E.1384–1897).

their legs entwine to represent their interdependence. Rising from an enameled sea, Neptune holds his trident over the golden ship that contains the salt, as fish and sea monsters swarm beneath it. Animals and plants surround Ceres as she scoops up the bounty of the earth in her hand. A miniature triumphal arch at her right side opens to reveal the pepper within. Figures representing the Times of Day and the Four Winds, some inspired by large-scale sculptures by Michelangelo (1475–1564), encircle the supporting base. Destined for the table of King Francis I of France (r. 1515–47), the saltcellar testifies to the refinement and elaborate rituals of dining and display that were the hallmarks of European courts in the late fifteenth and early sixteenth centuries.

Complex in its iconography and extravagant in its materials, Cellini's saltcellar is a tour de force of both design and goldsmithing. Yet Cellini was equally famous for his works of monumental sculpture, an indication of the limitations of making rigid distinctions between the "fine" arts and designing decorative arts objects in this period. Artists such as Michelangelo and Raphael (1483–1520) designed saltcellars, candlesticks, and daggers for the same patrons who sought out their work in painting, sculpture, and architecture. At the same time, craft specializations continued with master craftsmen trained in particular crafts and familiar with particular types of design and objects. Beds and imported carpets were the most expensive items in a household, along with engraved gems, fine ceramics, and other luxury goods. The set of ten

Fig. 5.3. Benvenuto Cellini. Saltcellar (*saliera*), Paris, 1540–43. Gold, enamel, ebony, ivory; 11¼ x 8½ x 10⅜ in. (28.5 x 21.5 x 26.3 cm). Kunstkammer, Kunsthistorisches Museum, Vienna (KK 881).

tapestries that Pope Leo X commissioned for the Sistine Chapel, for example, designed by Raphael in 1515–16 and executed in the Brussels workshop of Pieter van Aelst between 1516 and 1519, cost more than five times the amount paid to Michelangelo for the decoration of the chapel's ceiling. Although the categories applied today to differentiate "decorative" and "fine" arts might not be recognizable to those fifteenth-century artists who worked across multiple media, artistic practice was becoming specialized by the sixteenth century. The advent of artistic academies in the later part of the sixteenth century contributed to the development of a hierarchy of the arts that privileged painting, sculpture, and architecture above other forms of visual expression and began to distinguish the category of "decorative arts."

THE URBAN PALAZZO

The homes of the Italian urban elite reflected both a fascination with classical antiquity and an appreciation for modern innovation. Principles of classical architecture informed the design of the modern *palazzo*, a grand urban dwelling suited for public reception and private retreat, and inhabited by the growing class of wealthy merchant families whose disposable income made up for their lack of noble titles. The façades of buildings such as the Palazzo Strozzi in Florence, designed by Benedetto da Maiano (1442–1497) in 1489, featured a logical progression from street level, decorated with rusticated stone, to the lighter, more finished masonry of the *piano nobile* (the story above the ground floor), which housed the more private living spaces. This organization of space continued inside the building, with rooms laid out in clear, linear progression from public to increasingly private spaces. Featuring rounded arches, classical columns, cornices, and other elements of antique ornament, such buildings were influenced by Vitruvius's treatise on architecture and a series of texts

inspired by it. Publications by contemporary architects such as Leon Battista Alberti (1401–1472), Filarete (Pier Antonio Averlino, c. 1400–c. 1469), Sebastiano Serlio (1474–c. 1554), and Andrea Palladio (1508–1580), testify to the intellectualization of space designed according to principles of classical architecture, but adapted to meet the modern needs of wealthy Renaissance families.

Regional differences account for variations in the arrangement of rooms in private *palazzi*, but the principal rooms were the *sala* (a large reception room for public gatherings, dining, and dancing) and the *camera* (a smaller, more private, space that functioned as both bedchamber and intimate reception space). In the fifteenth century, rooms in private dwellings were largely multipurpose, used by multiple members of a household. By the late sixteenth century, however, interior spaces were frequently divided into suites of rooms, or apartments, for a single user, increasing in privacy as they decreased in size. The *anticamera*, a smaller room opening into the *camera*, for example, provided a transitional space for the reception of guests before proceeding into the space where bed and lavatory were located. Walls featured decoration in paint, carved or inlaid wood, or coverings of silk and leather.

The *studiolo* or *scritorio* (study or office) emerged as a private space for contemplation that also served as a public display of its owner's inner character. Designed for the exclusive use of one person, to house private papers and precious collectibles, it could be a modest space, tucked beneath a stairway, or a much grander specially designed room, decorated from floor to ceiling. An exceptional *studiolo* was made for Federigo da Montefeltro, duke of Urbino (r. 1444–82) (fig. 5.4), and originally installed in his ducal palace in Gubbio. Its elaborate illusionistic intarsia (wood inlay) depicts an ideal space outfitted with cabinets, the open doors of which reveal a virtual catalogue of the appropriate ornaments for a princely study, including musical instruments, scholarly tomes, astrolabes, armor, and chivalric decorations, all manifestations of the duke's interests and achievements.

The illusionistic wall decoration of the Gubbio *studiolo* creates a fictive and fixed space that contrasts with the changing decoration of most rooms in a Renaissance home. The multifunctional nature of the *sala* and the *camera* called for multipurpose furnishings, from compact adjustable tables and wooden folding chairs to small, high-backed and readily portable *sgabelli* (stools) that could quickly transform a space. In contrast, large tables with heavy bases and intricately worked surfaces and other imposing pieces such as *credenzas* (large display cabinets) were also used in the *sala,* and *lettucio*s (daybeds) in the *camera,* to anchor a sparsely furnished space. Made from walnut, pine, cypress, and elm, such furniture was variously decorated with paint, carving, and inlay of multicolored woods, bone, and ivory.

The design of furniture also responded to the increasing specialization of domestic space. Fifteenth-century beds were characterized by planar woodwork and designed for sleeping, storage, and seating as shown in a fresco by Domenico Ghirlandaio (fig. 5.5). Decorated with painted or inlaid woodwork, the bed was set against the wall, which might be deco-

EC·VLLVM·POENITET·ALTRICI·SVCCVBVISSE·SVE

Fig. 5.4. Francesco di Giorgio Martini, workshop of Giuliano da Maiano. Study (*studiolo*; detail) from the ducal palace in Gubbio, Italy, 1479–82. Walnut, beech, rosewood, oak, fruitwoods. The Metropolitan Museum of Art (39.153).

rated in similar fashion. By the sixteenth century, storage and seating pieces became detached from the bed frame, carving replaced painted and inlay decoration, and the bed itself was hung with canopies and curtains.

A characteristic piece of domestic furniture was the *cassone*, or storage chest. Usually commissioned in pairs on the occasion of marriage, *cassoni* were large, rectangular boxes decorated with narrative paintings or heraldic devices and carvings. The rituals of betrothal and marriage required that certain objects be commissioned, purchased, assembled, and exchanged. Used to store the bride's trousseau, *cassoni* played a critical role in the visible transfer of wealth between the families of the bride and groom, and to emphasize this role, they were paraded through the streets as part of the public procession of the bride from her father's house to that of her husband.

Made for the wedding of Lorenzo Morelli and Donna Vaggia Nerli in 1472, the *cassone* illustrated here is one of a pair that has survived intact (fig. 5.6). Inspired by ancient sarcophagi, it is decorated with scalloped carving on the lid, the egg-and-dart pattern and vegetal ornament borrowed from classical precedents. The painted decoration illustrates exemplary scenes from Roman history; *cassoni* featured narrative paintings that were meant to instruct and to compare their owners with the ancients. Battle scenes and subjects such as the Rape of the Sabine Women demonstrated the important role of private marital alliances in the larger fabric of public life, underscoring the interrelationship of civic virtue and married life.

Although the *cassone* was a necessary piece of furnishing throughout the period, its form—like that of the bed—changed from the fifteenth to the sixteenth century, as painted decoration fell out of favor and was replaced with intricate carving and inlay. The painted panels were often detached when chests were disassembled, and they migrated to the walls of the home, surviving as independent objects.

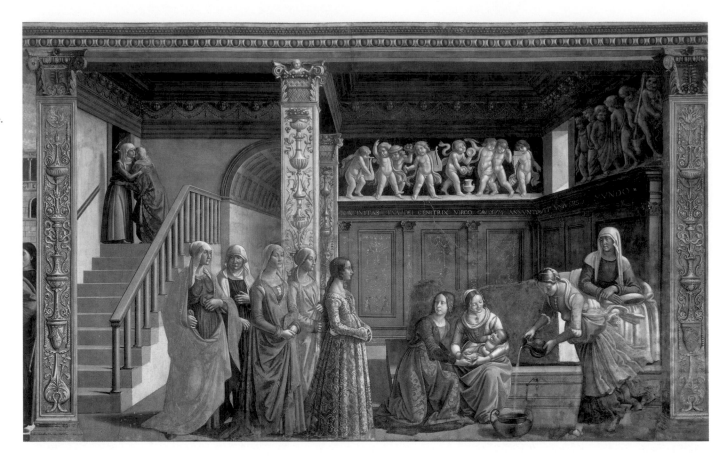

Fig. 5.5. Domenico Ghirlandaio. *The Birth of the Virgin*, 1486–90. Fresco; W. 14¾ ft. (4.5 m). Cappella Tornabuoni, Santa Maria Novella, Florence.

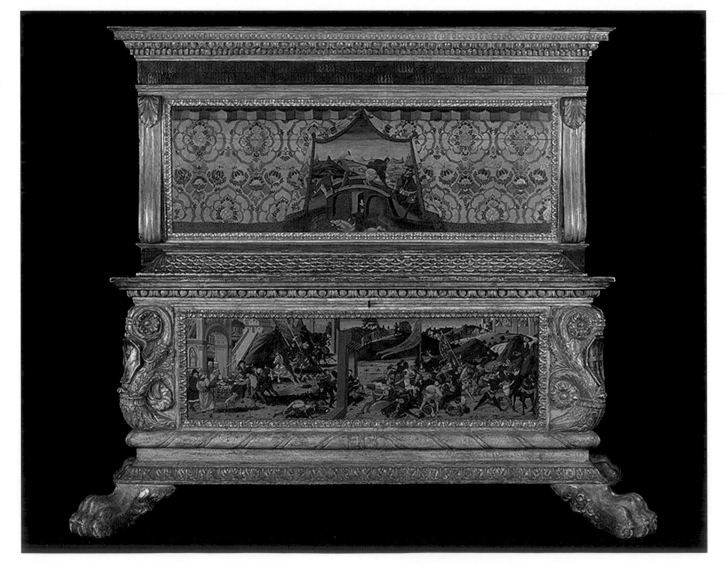

Fig. 5.6. Biagio d'Antonio, Jacopo del Sellaio, and Zanobi di Domenico. Chest (*cassone*) and backboard (*spalliera*), Florence, 1472. Wood, tempera, gesso, gilding; 83½ x 76 x 29⅞ in. (212 x 193 x 76 cm). The Courtauld Gallery, London (F.1947.LF.4).

MAIOLICA

Tin-glazed earthenware, known as maiolica, was developed in Italy during the course of the fifteenth and sixteenth centuries as a more affordable alternative to expensive wares imported from Islamic Spain. Its rapid expansion in multiple locations occurred in response to the growing demand for objects for domestic use. Over time, it eliminated the import market in such goods and became sought-after abroad in its own right.

The term "maiolica" reflects the origins of these wares, referring either to the Spanish island of Majorca, where ships carrying lusterware from Valencia stopped on their way to Italy, or to *obra de malagua* (Málaga ware), the Spanish term for these ceramics, imported into Italy since the twelfth century. Italian centers of maiolica production were concentrated near rivers, where deposits of clay were available. Workshops in Florence and its environs were early leaders in the maiolica trade; by the sixteenth century, Deruta, Faenza, Pesaro, and Urbino were all producing maiolica.

Early Italian maiolica was restricted in palette and shape. The opaque white surface created by the tin-oxide glaze was decorated in a palette of cobalt blue, manganese brown, greens, and yellows, in simple, repeating designs of floral and vegetal inspiration that emulated Spanish wares. Basic shapes, including the tall, cylindrical *albarello* (a kind of storage jar), long-necked bottles, and spouted jars imitating Islamic and Asian forms were used in large sets in apothecaries and hospitals, often decorated with the insignia of the relevant institution and with inscriptions identifying their contents. When arranged on shelves in the shop in a colorful yet uniform decorative scheme, theses utilitarian wares also served an aesthetic purpose.

By 1460, maiolica workshops had adopted a wider palette, and polychromed wares became the norm. Between then and about 1530, both the decorative vocabulary and the shapes of maiolica wares expanded. Large-scale plates and jars featured profile portraits of idealized beauties, smaller sculpted plaques carried devotional subjects, such as the Madonna and Child, and tiles were used to embellish domestic interiors.

By 1520, *istoriato* wares featuring narrative scenes, often drawn from classical mythology and history and designed to attract erudite consumers, became fashionable. Maiolica painters often adapted such images from prints and signed their work, making it possible to trace the emergence of talented practitioners such as Nicola da Urbino (c. 1480–1537), Francesco Durantino (act. 1543–54), and Francesco Xanto Avelli (c. 1487–1582). Xanto Avelli's elaborate composition, *The Triumph of Neptune* (fig. 5.7), epitomizes the inventive and painterly nature of this type of imagery. His central figure, a Venus-type if not the goddess herself, was derived from a print by Marcantonio Raimondi (c. 1470/82–1527/34), which in turn was based on a design attributed to Raphael, while at least ten different prints provided sources for other figures. More than a copyist, Xanto Avelli transformed the different elements into a cohesive composition, signing and dating the plate on the reverse, and offering a brief description of its subject. The combined coats of arms of two prominent Vene-

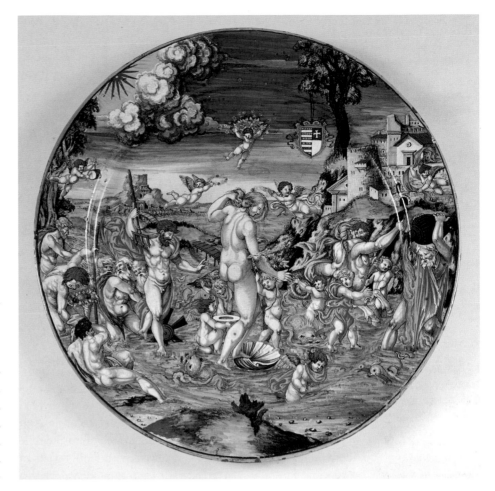

tian families, the Michiel and the Gritti, indicate that the plate was part of a dining service made for Giacomo Michiel and his wife, Laura Gritti. The density of the decoration covering the surface of the plate in a swirling mass of bodies and landscape is typical of sixteenth-century *istoriato* wares. Elaborate designs such as this, featuring brilliant colors locked into the glaze during the firing process, dominated the market until about 1560, when they were ousted from favor by designs imitating ancient grotesques that left large areas of the white ground untouched. By 1600, however, the age of maiolica was over, eclipsed by the production of imitation porcelain and other wares.

Maiolica played a significant role in the customs surrounding childbirth in Renaissance Italy. Bedchambers were frequently decorated in anticipation of a birth, designed for the comfort of the expectant mother during her confinement and for the reception of guests celebrating the arrival of the infant. Patrons commissioned wooden birth salvers, featuring talismanic figures and game boards, and maiolica childbirth sets that were used to serve the ritual foods required after childbirth. The latter were stacking wares, in sets of five or nine pieces, including a low bowl for broth, a shallow dish that served as its lid, and a salt with a cover. When assembled, they formed a vaselike structure, decorated on the exterior with a variety of ornament, and on the interior with scenes of childbirth or idealized infants. The style for birth wares followed trends in maiolica decoration, from richly ornamented pieces produced in the 1520s and 1530s, to simplified designs on white ground in the later part of the century.

Fig. 5.7. Francesco Xanto Avelli. *The Triumph of Neptune,* Urbino, 1533. Maiolica; Diam. 18⅞ in. (48 cm). The Wallace Collection, London (C89).

EUROPE

Fig. 5.8. Footed bowl (*coppa*), Venice, c. 1500. Free-blown chalcedony (*calcedonio*) glass; 4⅞ x 7¾ x 7¾ in. (12.4 x 19.7 x 19.7 cm). The J. Paul Getty Museum, Los Angeles (84.DK.660).

Until the mid-fifteenth century, Italian domestic tableware, much like domestic furniture, was sparse and multifunctional. Initially, maiolica basins, dishes, and ewers provided a cheaper substitute for silver and other metal tableware. But increasingly elaborate rituals of dining among elite clientele demanded far more extensive services, with family coats of arms and carefully selected narrative subjects, such as that on Xanto Avelli's plate. From the late fifteenth to the early sixteenth centuries, dining services grew in size and complexity, from sets with fifty pieces to sets with more than three hundred. The forms included plates, bowls, and dishes of various shapes and sizes, cruets for oil and vinegar, large serving pieces, and coolers for bottles of wine. Displayed on *credenzas*, such wares contributed both a sense of luxury and an affiliation with the classical past, through the narrative subjects on display.

GLASS

Unlike maiolica, which was inspired by imported goods and produced in many centers on the Italian peninsula, glass was a signature Italian product whose manufacture was concentrated in Venice. Venetians had been making glass for centuries; the first written rules for glassmakers were codified in 1271. Soon afterward, fearful of fires from glass furnaces, the Venetian authorities transferred the glassmaking industry to the island of Murano. Craft secrets were protected and sales of this lucrative and prestigious product were limited to only seven months of the year in order to artificially increase demand. Venetian glassmakers were forbidden to work elsewhere, while the importation of foreign glass was prohibited, as was the participation of "foreigners," a term that encompassed anyone not trained in Venetian workshops.

Fifteenth-century glass, characterized by simple forms in brilliantly colored glass of blue, red, and green, was enhanced with decorative techniques such as gilding and enameling. Glass painters used the circular forms of goblets and cups to depict triumphs and processions that seemed to unfold as the glass was turned in the hand. As with maiolica, painted coats of arms and profile portraits were popular motifs.

The ability of Venetian glassmakers to imitate gemstones and other precious materials allowed glass to function as an inexpensive substitute. The bowl illustrated here (fig. 5.8) is an example of "chalcedony glass," an opaque, richly colored glass that resembles the natural chalcedony stone. The basic form of the bowl, typical of fifteenth-century production, recalls the simple vessels carved from hard stones, which were and are difficult to work. The production of a milky-white glass called *lattimo* provided an alternative to Chinese porcelain, complete with painted designs, while *millefiori* glass was made by slicing multicolored rods of glass, known as canes, into sections to create a flowery pattern. The techniques for chalcedony, *lattimo*, and *millefiori* glass, known to Roman glassmakers in antiquity, were further developed in the fifteenth century in self-conscious imitation of the ancients.

Around 1450, the glassmaker Angelo Barovier (d. 1460) invented a technique for producing a transparent glass, free of impurities, that mimicked the appearance of rock crystal. This new *cristallo* glass brought about a major shift in glass production, as glassmakers eschewed painted decoration in order to emphasize the clarity of the glass. They also began experimenting with elaborate shapes and designs. The ductility of molten glass allowed for freedom of invention, including fantastical shapes that appealed to sensibilities attuned to the Mannerist style. During the sixteenth century, complex glass vessels competed with the most elaborate metalwork, while intricate patterns were created by embedding canes of colored glass within the transparent *cristallo*.

These technical refinements and formal inventions reflect the innovation so valued by Italian Renaissance culture in general. Indeed, the elite style that characterized the decorative arts in urban and court centers, including Rome, Florence, and Venice, migrated beyond the Italian peninsula. By the sixteenth century, Italians dominated fields of production that had been centered elsewhere. Ceramics, originally an imported luxury from Spain, had become a major industry. The preeminent tapestry workshops were still located in northern Europe, but tapestry designs by artists such as Raphael and Rosso Fiorentino penetrated and changed the markets there. The Medici grand-ducal court in Florence became a hive of state-sponsored artistic production, as well as a center for the manufacture of luxury goods, in particular the art of *pietra dura*, a decorative inlay of hard stone and marble. By the end of the sixteenth century, Italian style was an international phenomenon, defining the visual culture of many European courts.

NORTHERN EUROPE

In Italy cultural change was hastened by identification with the arts, letters, and the physical remains of its own classical past, together with the adoption of the notion of "the arts" as a defining aspect of society and an index of its civilization. In northern Europe, this collective idea of "the arts" as possessing a defining cultural role was slower to emerge and was not, at first, associated with the revival of classical forms. In the sphere of letters, too, northern European humanism defined

itself more as a means of revitalizing Christian faith than as a revival of classical language and literature as in Italy. The efforts of humanist philology in the north were focused on biblical translation rather than the reclamation of pagan philosophy or poetry. These differing attitudes depended in part on two distinct attitudes to the past. Whereas Italian humanists developed a view of the past in terms of discontinuity from a lost golden age of classical art and learning, which they sought to revive, northern Europeans continued to regard history in terms of unbroken heritage and connection. This was best grasped in political terms, in the line of German Holy Roman Emperors, for instance, that could be traced back to those of the Roman Empire. For northern Europeans, there was thus no "Middle Ages," and the centuries, roughly from the fifth to the fifteenth, denigrated as "barbaric" by Italian humanists, were celebrated for their achievements in political organization, technology, engineering, and architecture.

Given this more fluid and continuous relationship with the past, northern European artists and designers of the fifteenth and early sixteenth centuries placed greater emphasis on the continuity and elaboration of medieval traditions. Interest in the arts of Greek and Roman antiquity came more slowly and at second hand, largely through contemporary Italian art and design, and chiefly via prints. Classicism was, therefore, but one of several stylistic choices available in societies that were increasingly pluralistic and subject to manifold and powerful artistic influences from within and across cultures: Netherlandish realism, Rhenish and Parisian metalworking and sculpture, a flamboyant Gothic style as developed in Flanders and Spain, as well as Byzantine, Iznik, and Islamic design. Nevertheless, by 1600, Italian culture had proven to be the strongest unifying element in terms of European culture. For the decorative arts, the reception and assimilation of Renaissance Italianate aesthetics and design—and by implication, ideas about art and lifestyle—across the wide geographical expanse of northern Europe was one of the chief currents of the period.

FRANCE, BURGUNDY, AND ENGLAND

In 1400, and for most of the fifteenth century, the prevailing style in architecture and design was Gothic and the dominant cultural ethos came from the conventions of medieval chivalry. A decisive moment of patronage for the arts came in 1420 when Philip the Good, duke of Burgundy, moved his court to the Low Countries. In tying the luster of a great princely court to the commercial prosperity of the Netherlandish cities, he was to make the Duchy of Burgundy, whose territories stretched from Mâcon to Amsterdam, the greatest cultural center in fifteenth-century northern Europe. In doing so, he ensured that the Netherlands enjoyed a period of artistic preeminence in which innovation was conditioned by the continuity of medieval, chivalric traditions of the Burgundian court.

The culture that emerged was above all one of material splendor. Most of its trappings have been lost or dispersed, and knowledge of their nature and appointments is derived largely from illuminated manuscripts, inventories, and chronicle descriptions. The manuscript illuminations of the

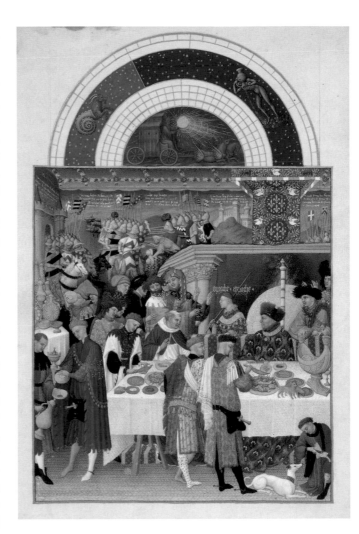

Fig. 5.9. The Limbourg Brothers. "January," from the *Très Riches Heures* of Jean, duc de Berry, 1412–16. Colors on vellum; 11⅜ x 8¼ in. (29 x 21 cm). Musée Condé, Chantilly (Ms 65/1284 f.1v).

so-called *Très Riches Heures* of Jean, duc de Berry, who ruled over the western French territories of Berry, Poitou, and the Auvergne, are a case in point. Made between 1411 and 1416 by the Limbourg brothers (act. 1400–1416), Pol, Herman, and Jan, this Book of Hours (personal prayer book) includes a calendar section, which illustrated the months and the occupations appropriate to them, showing both the leisurely activities of the court and the toiling peasantry. The calendar begins with the month of January (fig. 5.9) and depicts the duke presiding over a New Year's Day banquet in one of his palaces. Though idealized, the scene conveys a vivid picture of the luxurious paraphernalia of court life and of the hierarchy of materials and media. The duke sits at table with a clerical guest. Behind him is a grand fireplace supported by columns with foliate capitals, and an immense basket-weave fire screen. In France and England, such carved fireplaces and overmantels constituted major pieces of fixed interior architecture, and typically for the period, the main possessions were portable. For most of the fifteenth century, rulers tended to be peripatetic, traveling at different points of the year with their court entourages and their trappings among residences within their dominions, thereby helping to maintain order in the localities and ensuring that the economic and agricultural resources of any one place were not exhausted. The duc de Berry, an avid builder in his own right, owned at least seventeen châteaux and grand private houses. Courtly display was thus expressed through easily transportable goods, particularly clothing, textiles, and metalwork.

In a culture whose wealth depended on the textile trade, the minute attention to detail of texture and decoration evident in the miniature in the Book of Hours bespeaks a broad visual literacy in the nature and varieties of worked cloths. The attention given to types of cloth, even to specific stitches, in inventories of the day is the corollary of the Limbourg brothers' careful detailing of expensive white damasks draped over the buffet (left center) that supports a display of gold or silver-gilt plate and covering the trestle dining table (whose plain wooden supports are just visible). Equal attention was given the embroidered draperies that cover the raised settle on which the duke and his guest are seated. A suspended cloth of honor above the fireplace marks the duke's position at table, embroidered with his personal emblems of swan and bear, and the fleur-de-lys, proclaiming his familial ties to the French royal house. An elaborate tapestry, illustrating an episode from the Trojan War, covers the side and back walls, below an ornamented wooden vaulted ceiling. Such epic themes were popular in an age when the ruling dynasties of both Burgundy and France sought to legitimize their rule by claiming descent from the noble house of Troy, whose heroes, such as Hector and Aeneas, acted as exemplars of rulership. These textile furnishings vie with the brilliant hues and elaborately embroidered costumes of the duke, his guests, and entourage.

Behind the opulent display of luxury goods and works of art at banquets of this type lay a theory of "magnificence," drawn from Aristotle, by which the ruler expressed his authority and grandeur through expenditure on the luxury arts. The public display of costly tablewares on the buffet in this miniature was a conventional means of expressing power through material wealth. On the dining table, at the far right, a gold *nef*, a container in the shape of a ship, holds dishes; its finials form the duke's personal insignia. Such centerpieces might also hold the host's knife, fork, and napkin, as well as salt and spices. In this scene, an additional covered salt stands beside it. A servant pours wine into a gold or gilded cup. Few of these possessions, meticulously listed in an inventory of the duke's possession in 1414–16, have survived. In an age before international banking and established systems of credit, such precious metal vessels were part of the duke's realizable assets. In 1412, for example, immediately before this scene was painted, the duke had been forced to melt down reliquaries and other precious metal objects that he had donated to his palace chapel in order to pay his troops.

The Limbourg brothers' elegant stylizations of figures and gestures reflect a carefully choreographed artifice of display, dress, and noble behavior, which articulated and maintained a strict social hierarchy. Court festivities employed the language and rituals of a chivalric knightly ideal. John Paston the Younger (1444–1504), writing home to England from Bruges in 1468, likened them to the mythical King Arthur's court. One of the most famous festivities was the Feast of the Pheasant, held at Lille in 1454 by Duke Philip the Good as a means to rally aristocratic support for a crusade to retake Constantinople, which had fallen to the Turks the previous year. It involved a series of theatrical installations and performances, so-called *entremets*—acrobatic stunts, dances, musical performances (including live musicians bursting through a monumental piece of pastry), tableaux vivants, and mechanized stage props situated in front of, or hovering over, the tables.

Tellingly, the term *entremet* (literally, "between dishes") referred not only to such performances but also to the objects placed on the table, often mechanical works of virtuoso artifice, designed to arouse wonderment and delight. A fourteenth-century table fountain is a rare survivor of such an *entremet* (fig. 5.10). Made of gilded silver with translucent enamel, the fountain was designed so that water was pumped up a central pipe to cascade through thirty-two outlets—lions, winged dragons, and fantastical animal heads—down the stepped terraces, turning wheels that rang small bells, all intended to entertain. The elaborate and imaginative composition of the fountain—comprised of slender columns, pointed arches, turrets, crenellated terraces, and gargoyles—make it an impressive piece of High Gothic architecture in miniature. Accounts of Philip the Good's pleasure gardens at his castle at Hesdin in Artois, refurbished in 1432, record pavilions decorated with analogous fountains on a larger scale in the form of a tree with water-spouting birds, as well as statues—a hermit, fools, and a devil—and mechanical figures that could drench with water and even hit unsuspecting visitors. Such artifice highlights the importance of aristocratic play in the culture of the court. Olivier de la Marche, the official chronicler of the festive ceremonies of the Burgundian court, used the term *l'espace de l'artifice* ("the arena of artifice") in his description of the theatrical aspects of these festivities. Such semimechanical artifacts as the table fountain (see fig. 5.10) had their

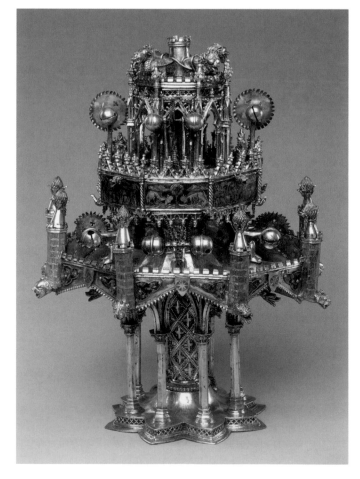

Fig. 5.10. Table fountain, possibly Paris, 1320–40. Silver gilt, translucent enamels; 13¼ x 10 x 10¼ in. (33.8 x 25.4 x 26 cm). The Cleveland Museum of Art (1924.859).

antecedents in medieval Baghdad and Byzantium as well as in a literary tradition of fabulous travel and romance, contained in such works as the *Travels of Sir John Mandeville* (first circulated between 1357 and 1371).

The Limbourg brothers' suggestive blurring of the woven scene in the "January" tapestry with the space as lived in by the duke gives some idea of the powerful visual impact such large-scale tapestries could make. Tapestry was undoubtedly the most important elite visual medium of fifteenth-century Europe. The principal centers of manufacture were located at Paris, Tournai, Arras, and, from the later fifteenth century onward, Brussels. Monumental in scale, the most splendid examples were fashioned in silk and silver- and silver-gilt-wrapped threads; indeed, their representational value lay as much in their material opulence as in their imagery. Public in character, tapestry was used as a backdrop to most occasions of court. Contemporary accounts record that the entrance routes through cities were regularly lined by tapestries hung from the façades of urban homes to greet arriving monarchs and nobles as they passed. Such accounts also describe the grand spectacles of state being staged before the most lavish tapestries.

Material opulence was accompanied by historical or mythological themes, chosen to embody the values and character of the owner or to match the occasion. During the Feast of the Pheasant, the guests were surrounded by a tapestry series displaying the Twelve Labors of Hercules, a pointed backdrop to the central event of the gathering: the swearing of an oath on a live pheasant that committed each noble to participation in the crusade, and the promise of individual deeds of valor. Similarly, a set of tapestries depicting the Old Testament story of Esther and Ahasuerus was used during the wedding festivities in Bruges of Charles the Bold, duke of Burgundy (r. 1467–77), and Margaret of York in 1468. These biblical figures—Queen Esther, a royal consort who combined wifely submissiveness with regal strength of character when intervening to safeguard her people, and Ahasuerus, a powerful and magnanimous potentate—offered appropriate role models for the royal couple while endowing their union with ancient biblical authority. A late fifteenth-century tapestry fragment of a larger series, showing Esther kneeling in submission before Ahasuerus and receiving him at a banquet she has prepared, reflects these twin symbolic roles (fig. 5.11).

Flemish tapestries were exported to all parts of Europe. Though few survive today, period sources show that they existed in abundant numbers in fifteenth- and sixteenth-century England. Records of gifts by foreign dignitaries to English kings go back at least to the reign of Richard II (1367–1400), when the duke of Burgundy presented that monarch with a series depicting the Seven Virtues, with a virtuous king at the feet of each personification, and the Seven Deadly Sins, with vicious kings similarly placed. Flemish tapestries owned by Henry VIII (r. 1509–47) numbered in the thousands and followed the full gamut of late medieval courtly taste. These included several sets of Petrarchan Triumphs, the Deadly Sins, a set of the Cardinal Virtues, and the Prodigal Son. Although some were described in inventories as "counterfeit," probably alluding to painted cloths, most were

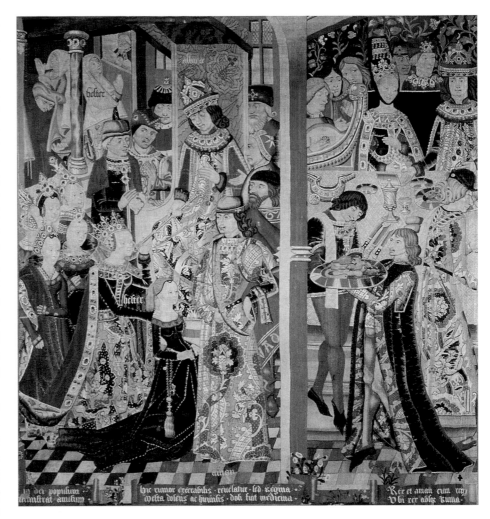

woven, and the king kept a staff of "arras-makers" to keep them in good repair. When, in 1522, Cardinal Wolsey, the king's minister, procured sets of Netherlandish tapestries for his palace at Hampton Court, they included the Seven Deadly Sins in nine pieces and in the following year, the Petrarchan Triumphs in eight pieces, four of which are still in situ.

A milestone in the history of tapestry weaving in England was the establishment of looms at Barcheston Manor in Warwickshire by William Sheldon (c. 1500–1570), who had been engaged in weaving since about 1550 and had sent an assistant to the Low Countries to study the craft. The history of the Sheldon looms is obscure, yet for more than half a century from the later sixteenth century, they produced the best tapestries in England and the business seems to have carried on until the outbreak of the Civil War in 1642.

Nonetheless, the dependence on French or Flemish products is indicative of England's marginality in European artistic and cultural affairs. Throughout the fifteenth century, in both manufacture and trade, England remained underdeveloped. Not even London, its largest city, could compete with sophisticated urban centers such as Antwerp or Venice. England's chief export was rough, semifinished woolen cloth. Local craft expertise generally lacked the technological and aesthetic sophistication of continental Europe, and wealthy patrons relied heavily on products and craftsmen from abroad, especially the Low Countries and Italy. England's cultural isolation can be measured by the fact that even the Perpendicular style of architecture, perhaps its greatest artistic

Fig. 5.11. Tapestry fragment: Esther and Ahasuerus, Tournai, Flanders, 1460–85. Wool, silk; 11¼ x 10¾ ft. (3.4 x 3.3 m). Minneapolis Institute of Art (16.721).

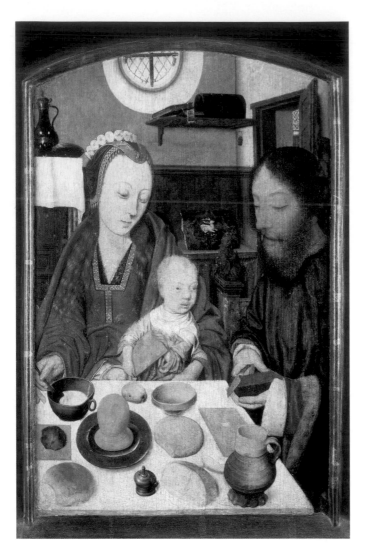

Fig. 5.12. Jan Mostaert. *The Holy Family at Table*, Haarlem, 1495–1500. Oil on oak panel; 14¹¹⁄₁₆ x 9⅜ in. (37.3 x 23.8 cm). Wallraf-Richartz-Museum and Fondation Corboud, Cologne (WRM 0471).

DEVOTION, DECORATION, AND URBAN VALUES

The illustrative quality of the Limbourg brothers' January page (see fig. 5.9) makes it easy to forget that the illuminated image was part of a prayer book that conformed to a fashion among the literate classes for personal prayer and reflection. Prayer books of this kind represented a form of piety that was separate from the institution of the Church, whose dogmas and liturgy—largely exclusionary of lay participation and conducted in Latin—were increasingly remote from the average churchgoer. Such personal forms of devotion became an important aspect of the spiritual culture of the period, particularly in the Low Countries and in Germany. These were influenced by the so-called *Devotio Moderna*, a lay movement based on the teachings of Thomas à Kempis, an Augustinian monk and mystic in Zwolle in the Netherlands. His book *The Imitation of Christ* (c. 1418–27) offered a model of personal everyday devotion that required intense meditation and identification with the life and passion of Christ.

The modest domestic piety that this movement promoted, and which Erasmus of Rotterdam, the greatest biblical humanist of the sixteenth century, was later to espouse, conditioned the character and tone of urban domestic decoration. It became common for the literate wealthier classes to own personal prayer books, elaborately carved rosary beads, and, within the home, small-scale devotional sculptures and religious paintings on panel or glass. A panel painting by Jan Mostaert of the Holy Family (fig. 5.12) exemplifies this type of object and provides an (idealized) glimpse into the household of a well-to-do, late fifteenth-century Flemish burgher. The scene is one of simple familial intimacy, an appropriate model for the urban family in whose guise the biblical figures are dressed. The table accoutrements are modest—a pewter porringer and dish, simple glazed earthenware drinking vessels, and wooden trenchers. The wooden wainscoting and fitted seating are discreetly expensive. Touches of richness and comfort are found in the clear glass windows (an expensive commodity), carved dragon finial, heraldic shield and gilding, embroidered cushion, and linen cloth and jug. The parents are dressed in expensive, fashionable fur-lined clothes. The carved detailing of the bench supports is in the form of decorated Gothic arches, a style transmitted from medieval ecclesiastical architecture into the secular sphere.

The late fifteenth-century buffet illustrated here (fig. 5.13) is an elite example of this type of secular furniture and of Parisian furniture making. The buffet—the grandest examples were called *buffets de parade*—was a kind of sideboard, which developed from an altar furnishing and was adapted to both serve and display the family's precious metal tablewares. The central panel bears the royal arms of France, elaborately carved in walnut, a fine-grained wood that offered far crisper carved detail than oak, the other staple wood for northern European elite furniture and paneling in this period.

EASTERN EUROPE

These essentially Gothic forms of domestic decoration prevailed in the rest of northern Europe, with local variations, in the later fifteenth century. An important exception was Hungary, on the frontier lands of Europe, where Italian style

achievement during the fifteenth century, had little appreciable influence abroad. The turmoil of the Wars of the Roses (1455–85) was not conducive to a stable court culture or a nobility able to exert strong cultural leadership. Only with the accession in 1485 of the first Tudor monarch, Henry VII, who established the foundations of a stable, unified state, did a more coherent program of royal artistic patronage emerge. For the building and decoration of Richmond Palace (1499–1501), he brought artists and craftsmen from the Netherlands and Italy. One of these, Florentine sculptor Pietro Torrigiano (1472–1528) created the great bronze and marble tomb (completed about 1518) of Henry VII and his queen, Elizabeth of York, set below the fan-vaulted roof of the Chapel of Henry VII in Westminster Abbey (completed 1519), one of the most elaborate examples of English Perpendicular Gothic. Despite introducing putti and other Italianate decorative features, as well as a Florentine realism of physiognomy, Torrigiano modified his Renaissance style to conform to an established Gothic funerary type, with reclining figures and a Gothic bronze screen. The chapel's stained glass, by contrast, was the work of Flemish craftsmen, as were the many carved figures of saints. This pluralism of styles, this mixing of the new elements with the traditional, of English with Italian and Flemish, was typical of the development of design and the decorative arts in England over the next hundred years.

and culture made significant inroads in the fifteenth century. This was largely due to Matthias Corvinus, king of Hungary (1458–90), who, building on his predecessors' strong ties with Italy, became an important patron of humanist learning, amassing an impressive library and attracting Italian humanists to his court. His second wife, Beatrice of Aragon, whom he married in 1476, was the daughter of the king of Naples and brought Italian fashions in the form of clothing, jewels, sets of maiolica, paintings, and music to the Hungarian court. After his marriage, Matthias, who had secured the services of architect and engineer Aristotele Fioravanti (c. 1415/20–1485) of Bologna in 1465, employed an increasing number of Italians, especially Florentines, or ordered works from them. The sculptor and engineer Giovanni Dalmata (c. 1440–1509), built parts of the palace at Buda, as well as suburban villas at Nyék and Visegrád, based on classical descriptions. The prominent Florentine artist Antonio Pollaiuolo designed drapery for the king's throne, and Benedetto da Maiano, another Florentine, carried out designs for intarsia, while the goldsmith Caradossa (Cristoforo Foppa, 1452–1527) produced metalwork for the court. The result was an adoption of relatively undiluted Florentine forms, rather than their assimilation into an existing local stylistic tradition as was the case elsewhere. A pair of portrait reliefs of the king and queen, attributed to the Lombard Gian Cristoforo Romano (1465–1512), shows Corvinus in the costume of a Roman emperor. Such classical trappings, also expressed in coins and architecture, constituted a self-conscious identification with the grandeur of ancient Rome by a ruler who was both a usurper of the throne and an assertive military leader. Corvinus succeeded in consolidating and extending his lands (present-day Hungary, Croatia, Slavonia, Transylvania, Slovakia, and Austrian Burgenland), by pushing back the Turks south to the Balkans and gaining control over Moravia (today in the Czech Republic), Silesia (now in southwestern Poland), and Lusatia (now in eastern Germany). These turned out to be short-term gains, however, and the subsequent reoccupation by the Turks left little evidence of the character of secular urban culture under Corvinus.

Even the state of Muscovy, at the easternmost periphery of Europe, was influenced by western European Renaissance ideals. Ivan III, grand prince of Muscovy (r. 1462–1505), for instance, took the new title "czar" (derived from "Caesar"), because it implied a direct link with imperial Rome. His wife, the niece of the last emperor of Byzantium, Zoe (Sofia) Palaeologa, had lived in Rome as a ward of the Pope and, like Beatrice of Aragon, brought Italian tastes with her. Yet despite the importation of Italian architects and engineers, including Aristotile Fioravanti, who built the Cathedral of the Assumption in Moscow, Italian styles and values gained little purchase. This was because, unlike Hungary, Muscovy was oriented toward Constantinople rather than Rome—particularly in its Orthodox religion (based on the Eastern Byzantine Church) and Cyrillic alphabet. It is testament to the cultural remoteness from western Europe that Ivan insisted that Fioravanti model his designs for the cathedral not on a Western archetype but on the twelfth-century Eastern Christian Orthodox Cathedral of the Assumption in the city of Vladimir, to the east of Moscow.

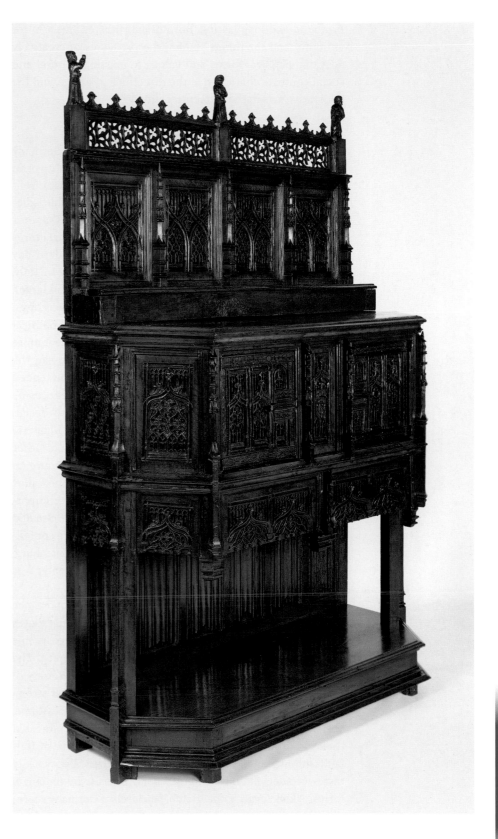

By 1500 and well into the sixteenth century, with the exception of Hungary and the eastern frontier lands, Gothic style and decoration still prevailed in both the secular and ecclesiastical spheres of northern Europe. It developed into a complex, "flamboyant style" in the Netherlands and Spain. Yet from the early years of the sixteenth century, Italianate elements were intermingled with and eventually absorbed the Gothic. Their introduction was sporadic and local and their application ungrounded in theory. Nonetheless, the accumulated, long-term effects went beyond surface appearances, signaling changes in cultural attitudes that were to be

Fig. 5.13. Buffet, France, c. 1500; with 19th-century restorations. Walnut, oak; 93¾ x 61⁷⁄₁₆ x 22 in. (238.1 x 156 x 55.8 cm). The Wallace Collection, London (F13).

profound and long lasting. Born of an initial enthusiasm for antiquity and for things Italian, the processes of creatively adapting classical forms and values to existing cultural and social contexts characterize the directions of design and the decorative arts in the sixteenth century.

THE GERMAN LANDS

In the sixteenth century, the area known today as Germany was geographically and politically fragmented, made up of an eclectic mixture of principalities, duchies, bishoprics, religious estates, imperial free cities, and other forms of jurisdiction. All owed political allegiance to the Holy Roman Emperor and were nominally subject to the administrative structures that governed the territories of the empire: modern-day Austria, Hungary, Germany, Switzerland, and parts of Italy, France, and the Netherlands. Such a loyalty, and the larger, historical sense of political belonging it provided, was often precariously balanced against local allegiances and political interests. In the early century, the territories of the empire lacked a single political and cultural center (unlike, say, the court in France). As a consequence, craft production tended to be local in character. As elsewhere in Europe, cities became the dominant centers of innovation and craft and design excellence. Of these, Augsburg and Nuremberg best illustrate the changing nature of craft production in the period. Other cities, notably Frankfurt am Main to the west, Strasbourg on the French border, and Cologne in the upper Rhine valley close to the Netherlands, were of only slightly lesser importance. In the north, on rivers flowing into the North Sea and Baltic, lay the port towns of the Hanseatic League (a confederation of free towns), notably the cities of Bremen, Hamburg, and Lübeck, while to the east, the most important center was Dresden, seat of the dukes of Saxony.

Augsburg and Nuremberg owed their cultural importance to economic ties with Italy. Both lay on the main trade routes northward from the Italian peninsula; both enjoyed economic and commercial privileges as free cities of the empire. The great merchant families, like the Fuggers and the Welsers of Augsburg or the Tuchers of Nuremberg, maintained strong commercial links with Italy, keeping offices in Venice, Rome, and Genoa. They adopted Italian business methods, educated their children at Italian universities, and took notice of Italian fashions, commodities, architecture, and art. The worldly tastes of such families stimulated an interest in Italianate forms. Jakob Fugger ("the Rich"), patriarch of Germany's foremost international banking and trading empire, exemplifies this process of acculturation. Having spent several formative years in Venice, he based his Augsburg residence and a monumental funerary chapel in the local church of St. Anna on Venetian prototypes. At its inception, therefore, the Italianate style in the German-speaking lands was associated with the new urban elite of wealthy banking families. Ulrich von Hutten, contemporary scion of the feudal nobility, saw in this Italian influence the vulgar trappings of new money, of "ennobled shop keepers" (*nobiles mercatores*), and complained that it was "unnatural to bring into Germany" things that did not originate there. The Italianate was thus on some level understood in social terms, its reception colored by political

and ideological factors and associated with high finance, power, and international prestige.

Patronage of things Italian stimulated a growing humanist culture, characterized by the ideals and activities of educated patricians such as Conrad Peutinger, the secretary to the Augsburg City Council, who from 1499 built up a collection of antique marbles and Italian weapons, prints, medallions, plaques, books, and manuscripts. He maintained a wide correspondence with humanists in Italy and elsewhere in Europe and was a patron of humanist literary enterprises. His role as advisor to the literary and artistic projects of the Holy Roman Emperor Maximilian I (r. 1493–1519) gave him a position of influence. Indeed, the emperor's attachment to the city of Augsburg, his frequent and prolonged visits there, and his employment of local artists and craftsmen gave impetus to the revival of interest in the city's imperial Roman past (retained in its Latin name, "Augusta") and to the formation of a classicizing imperial style, appropriate to the emperor's propagandist ambitions. These contexts for the Latinate style—mercantile wealth, learning, and political power—encouraged a process of stylistic infiltration that was already underway and would transform the visual and material culture of northern Europe.

These developments coincided with an explosion of imported Italian ornament prints and their emulation by northern printmakers. The printing revolution and easy access to new design ideas lie at the heart of the "Northern Renaissance," as artists and craftsmen adopted and developed the new style. This process can be followed in a printed instructional handbook on art (*Kunstbüchlein*) by Heinrich Vogtherr the Elder (1490–1566), first published in Strasbourg in 1538, which was a conscious exercise in the new Italianate manner (fig. 5.14). Addressed to "all painters, sculptors, goldsmiths, stonemasons, and arms and sword makers," it offered a series of Italianate designs of headdresses, armor, weapons, escutcheons, capitals, and pilasters—"the like of which has not been seen or rendered in print before."[3] These were less direct design quotations than imaginative elaborations on Italian architectural and ornamental types: the capital, the pilaster, the Roman cuirass, and so on. Vogtherr hoped that others would adapt them in inventions of their own.

The Nuremberg artist-designer Peter Flötner (c. 1485–1546) was an influential pioneer of this new idiom. His design for a pokal, or ceremonial drinking cup, one of the most traditional and prestigious object types in the German lands, shows him developing the kinds of motifs found in Vogtherr's manual into a coherent, unified style (fig. 5.15). (Compare for instance the use of the leaf face at the center of the stem with that in Vogtherr's capital.) The main feature was an overall covering of the form with surface decoration, the characteristic organization of which depended on the aggregative and proportionate assemblage of discrete forms. In this example, Italianate elements include garland-supporting putti and pairs of satyrs on the base, a pair of sphinxes, a knop containing a frieze of processing *amorini*, ornamental leaf- and grotesque work, a running arcade containing representations of famous women, including Cleopatra, Dido, Lucretia, and a Caritas figure, and a frieze of alternating shells and mermaids on the

cover. On the finial, amid this classical ornament, is a hunting scene, set within a miniature craggy landscape. Executed in a naturalistic, "Germanic" style, it coexists with the Italianate without apparent anachronism.

Vogtherr's book and Flötner's works indicate something of the means and ease by which this modern style became tied to one of the central aesthetic principles of the age, namely, ornamentation—a principle that ran through many art forms, including music and literature. Indeed, it was through ornamentation that the classical vocabulary entered into the aesthetic mainstream of northern Europe. Essentially untheoretical, yet rich in semantic and associative meanings, it was applied to surfaces of all kinds.

The pokal's importance also derived from the fact that it constituted the apprentice goldsmith's "masterpiece," acceptance of which gained him (no girls were apprenticed) entry into the guild. It was, therefore, an opportunity for expressing technical skill and ornamental inventiveness. Within a

culture where the communal or shared drink was part of nearly every public and private ceremony, commercial bargain, or craft ritual, the pokal played an important symbolic role. It was frequently used as a diplomatic gift. When welcoming a distinguished guest to the city, for instance, an elaborate pokal might be presented, filled with gold coins rather than drink. Indeed, such vessels owed their high survival rate to the fact that they were displayed as much as used, carefully looked after, and passed down through generations. Other kinds of metalwork, such as eating implements, lighting devices, candelabra, salts, plates, and spoons, by contrast, more often fell victim to subsequent melting down for reasons of financial need or fashion.

The highpoint of this kind of production, and one of the greatest surviving pieces of Northern Renaissance metalwork, is the so-called Merckel Table Piece by the leading Nuremberg goldsmith Wenzel Jamnitzer (c. 1507–1585) (fig. 5.16). Equally famous for his studies in perspective and

Fig. 5.14. Heinrich Vogtherr the Elder. Plates from *Ein Frembdes und Wunderbares Kunstbüchlein,* Strasbourg, 1538. Woodcut; each, 7⅜ x 5¹¹⁄₁₆ in. (18.8 x 14.5 cm). The Metropolitan Museum of Art (19.62.2).

Fig. 5.15. Peter Flötner. Design for a drinking cup, Nuremberg, 1520–30. Ink, yellow wash; 29½ x 10⅞ in. (75 x 27.5 cm). Bibliothèque nationale de France (Rés. B 7 boîte format 5).

Fig. 5.16. Wenzel
Jamnitzer. The Merckel
Table Piece, Nuremberg,
1549. Silver gilt, enamel;
H. 39¼ in. (99.8 cm).
Rijksmuseum,
Amsterdam
(BK-17040-A).

so heavy a burden of pendulous fruits? The goddess replies: "Sum terra, mater omnium" ("I am earth, mother of all things"). Jamnitzer's mother earth is a late manifestation of a neo-Platonic tradition, that, beginning in the humanist movement of the twelfth century, explained Nature as a universal force and personified her as the goddess *Natura*, who stood midway in a hierarchy that included God, matter, and the generative impulse. Drawing on a poetic tradition going back to the early Roman poets Boethius and Lucretius, *Natura* came to embody all the vitality, mutability, and generative power of the created universe. Nowhere in Renaissance visual and material culture is the persistence of this vision better personified than in Jamnitzer's creation. *Natura*'s generative principle is evoked not only in the expressive fecundity of the figure's form but also in the implied transformation of the natural from a primal, untamed state at her feet to the ripe pendant fruits held in the basin. The imagery relates directly to the poem, which characterizes the goddess as a beneficent power that tames untrammeled fertility in agriculture and stands as the great provider for humankind. Beyond this, in the technical metamorphosis by which Jamnitzer cast living plants and creatures and transmuted them into creations of silver, another transformation is at play, namely, the metamorphosis of the transient beauty of natural life into the permanent beauty of art.

THE ARTS OF THE KUNSTKAMMER

A number of Jamnitzer's greatest works were made for Holy Roman Emperor Maximilian II (r. 1564–76) and his successor, Rudolf II (r. 1576–1612), whose courts, in Vienna and Prague, together with those of other central European rulers, such as Elector August of Saxony, Archduke Ferdinand of Tyrol, and Duke Albrecht V of Bavaria, emerged as centers of artistic patronage in the second half of the sixteenth century. From the 1560s onward, habits of courtly collecting, already well established in the fifteenth century, coalesced around the concept of the *Kunst- und Wunderkammer*, the cabinet of curiosities. Collections were organized around an encyclopedic principle that saw in the multitude of objects a microcosm of the larger world, allowing the collector to contemplate the universal in material form. Samuel Quiccheberg, Flemish advisor to Duke Albrecht of Bavaria and author of a treatise on the *Kunstkammer*, called the Bavarian collection a "theatrum sapientiae" (theater of wisdom), by which he meant a system for organizing knowledge about the universe.[4] The objects within these collections conformed to two broad categories: natural objects (*naturalia*) and man-made objects (*artificialia*). Natural objects, drawn in large part from the explorations of new worlds, were chosen for their rarity, exotic provenance, or aberration from nature's norms. Man-made objects were collected for their ingenuity, intricate skill, and the beauty or value of their raw materials.

The effect of these new categories of collecting was to bring the inventions of craftsmen into registration not only with the highest expectations of luxury, inventiveness, and technical expertise but also with the sometimes arcane world of natural philosophy and contemporary science that the *Kunst- und Wunderkammer* fostered. Collectors sought out

geometry, he served an array of noble patrons and was court goldsmith to four successive Holy Roman Emperors. The Merckel Table Piece, conceived as a centerpiece and receptacle for fruit, was created in 1549, probably intended as a diplomatic gift from the Nuremberg Council to Emperor Charles V. Its stem consists of a Venus-like figure, standing on a mound of natural grasses and flowers, all cast meticulously from life, a technique that Jamnitzer pioneered and for which he was famous in his own day. The Venus figure supports a basket-like basin, surmounted by an elaborately enameled vase containing a bouquet of naturalistic, cast flowers. A Latin poem running from the base to the rim of the basin in a series of engraved tablets asks rhetorically: who is she that carries

instruments (*scientifica*) that could chart the natural world—terrestrial and astronomical globes, astrolabes, odometers, sundials, and compasses that could tell the hours of the day and night, or cosmic clocks on which the movements of the planets moved in synchronic order. The dual categories of art and nature also encouraged an implicit rivalry between the powers of nature and of human ingenuity. Philosophers and craftsmen alike came to believe that by "improving" on nature's raw material they could learn something of nature's laws. Craftsmen manipulated exotic natural materials such as shells, coral, and hard stones, creating fantastically wrought mounts of their own that often blurred the distinction between the natural and the man-made; or they might work to bring out the material's intrinsic qualities. In Archduke Ferdinand's collection in Schloss Ambras, a piece of unworked agate might be juxtaposed with an agate dish, carved and polished to bring out dazzling bands of polychrome, the better to reveal its "true," ideal, nature, which was obscured in its dull natural state.

Such lessons in the transformative hand of craft were also applied to exotic natural materials thought to hold special powers or ward off evil. A covered cup fashioned from rhinoceros horn, for instance, made in 1611 for Emperor Rudolf II, was carved and mounted so as to enhance the material's intrinsic power to neutralize poisons (fig. 5.17). The horn's surface is carved to suggest coral, another potent apotropaic material. Enmeshed within the coral branches, as if symbolizing malignant forces caught in its neutralizing strands, are snarling dogs heads, snakes, lizards, and beetles, while more beneficent human faces emerge spirit-like from within the horn's matter. This apparent reification of the horn's occult forces is reinforced by a cover in the form of a demonic dragon's face, flanked by horns of an African warthog, while a serpent's tongue (in reality, a fossilized shark's tooth), set between the open jaws, provided a further protection against poison.

These amalgams of the natural and man-made together with the ingenious automatons and clockworks of the instrument makers reflect the aspirations of talented craftsmen, who were keen to raise themselves socially and professionally by associating themselves and their inventions with the tastes and interests of the courts. An important consequence of these intellectual and practical interests was a reevaluation of the status of craft from an index of luxury or status to one of knowledge and learning. Above all was the sense, implicit in these works, that human ingenuity could challenge the existing order of nature. The rivalries between human and natural energies that were explored in the workshops and collections of the later sixteenth century were to give rise to the experimental culture of the "Scientific Revolution" of the following century.

MATERIAL CULTURE AND THE REFORMATION

While creations for the *Kunstkammer* represent elite taste at its most sophisticated, other factors affected the broader development of the decorative arts and decoration further down the social scale. The two most important were the Protestant Reformation and, coincident with it but more general in its impact, the influence of humanist, ethical values.

Fig. 5.17. Attributed to Nikolaus Pfaff. Cup and cover, Prague, 1611. Rhinoceros horn, African warthog tusks, silver gilt, paint; 19⅝ x 10⅞ x 7 in. (49.7 x 27.5 x 17.7 cm). Kunstkammer, Kunsthistorisches Museum, Vienna (KK 3709).

From 1517, when Martin Luther (1483–1546), Augustinian priest and professor of theology, published his ninety-five theses in Wittenberg, Saxony—challenging the doctrines and fiscal policies of the Roman Catholic Church—individuals, towns, and principalities all over northern Europe converted to Protestantism. Throughout the 1520s and 1530s, different kinds of reformed religion took root in the cities and towns of the Holy Roman Empire and among the Swiss cantons of Geneva and Zurich. In England, King Henry VIII broke with the Pope in 1533 (largely over his desire to divorce his queen, Catherine of Aragon) and proclaimed himself "supreme governor" of the English Church. In Bohemia the turn to Protestantism among the nobility was facilitated by almost a century of earlier radical religious dissent, and large parts of Scandinavia also succumbed to reformed thinking. In the provinces of the northern Netherlands, Protestants combined with a nobility disenchanted with Spanish rule and broke away from the Southern States ruled by Habsburg Spain, a process formalized by the Union of Utrecht of 1579.

A massive wave of iconoclasm had already swept over the Netherlands in 1566 in an uprising against the religious and political oppression of Spanish Habsburg rule. This was devastating in its effects on the artistic heritage of the Middle Ages. As in other newly Protestant regions, church furnishings such as altarpieces, statues, stained glass, liturgical plate, and vestments—the brilliant visual culture of the medieval church—were removed either by iconoclastic riot or by

Fig. 5.18. Pseudo-Ortkens group. Roundel: Susanna and the Elders, Antwerp or Brussels, c. 1520. Glass, vitreous paint, silver stain; Diam. 13 in. (33 cm). The Metropolitan Museum of Art (1990.119.1).

Fig. 5.19. F. Trac. Jug (*Kanne*), Siegburg, 1570–72. Salt-glazed stoneware; H. 14³⁄₁₆ (36 cm). Museum für Angewandte Kunst Köln (E4243).

related preparatory drawings) attributed to the circle of Aert van Ort (fl. 1490–1536), offered an exemplar of chastity and marital fidelity, suitable for the edification and education of women. A Latin inscription, drawn from the biblical text, gives it the character of a visual sermon. The roundel is an example of so-called silver- or yellow-stain glass, a popular form of household decoration often created, as here, in narrative series, that emerged in the later fifteenth century in urban centers such as Augsburg, Nuremberg, Antwerp, and Zurich, and flourished in the first half of the sixteenth century. The yellow stain, which formed the basic ground color, was composed chiefly of a compound of silver and antimony sulphide. The survival of large numbers of roundels, and even larger numbers of preparatory designs for them, indicates that they were probably relatively affordable. The imagery ranged from biblical subjects, as in this one, to scenes of Roman history, classical myths, allegories, and contemporary moral tales; painted heraldic designs, known as *Wappenglas*, usually representing a marriage alliance between two families, were popular in Switzerland.

Similar values were expressed in ceramics. Whereas in Italy tin-glazed earthenware—maiolica—became the dominant type of ceramic, in the North the production of salt-glazed stoneware vessels expanded on a similar scale. Stoneware is a hard, nonporous pottery made from clay and fusible minerals, fired at high temperatures. Since the Middle Ages, the center of production had been the Rhineland. From the early sixteenth century onward, manufactories in Cologne, and later in Frechen, Raeren, and Siegburg, near Aachen, achieved a measure of artistic distinction, producing jugs and drinking vessels decorated with molded reliefs of increasing variety and sophistication. Renaissance designs, mediated through prints, transformed the nature and appeal of these

orderly means. With them went the main source of patronage of many artists and craftsmen, who were forced to work in other media, create new object types, and develop new subject matter. The consequence was a broad transfer of creative energies from the religious to the secular sphere and, in general, a decline in monumental forms and a concentration on the smaller-scale and the domestic.

This is to be seen in the spread of exemplary religious subject matter as a form of household decoration. Although most reformers banned images in churches in attempts to eradicate the superstitious and cultic practice of the veneration of saints, for the most part they encouraged biblical imagery in the home. As long as it was understood in its "historical sense," it could be of use in teaching and admonition, as the reformer John Calvin put it. Such views were in keeping with a broader humanist ethos espoused by moderate Catholic reformers, preeminently Erasmus of Rotterdam and Juan Luis Vives, who regarded the stories of the Bible as both historical truth and as a fixed code of laws from which people could learn how to conduct their lives. Thus, across the social and confessional divides, on painted glass, woodwork, textiles, plasterwork, and ceramics, exemplary stories from the Bible, drawn mostly from the Old Testament, became a normative part of the aesthetic experience of northern Europe.

One example is a small painted-glass roundel that illustrates the biblical story of Susanna and the Elders. It is the tale of the beautiful and chaste wife of a Babylonian official who withstood seduction and blackmail by two Elders, seen here accosting her as she bathes in her private garden (fig. 5.18). Her ordeal and vindication by Daniel, told across a series of four roundels (the remaining three are known from

wares and created new markets among the higher social classes, unaccustomed to drinking from ceramic vessels. A *Kanne*, or jug, signed by F. Trac and made in 1570–72 in Siegburg, a center famous for its ceramics with near-white fine-grained body, shows delicately molded decoration with biblical scenes of Abraham sacrificing Isaac and of Lot and his daughters, set in fields of Italianate leafwork and grotesque ornament (fig. 5.19).

A similar reformist ethos also informed the decoration of another form of ceramics, the *Kachelofen,* or tiled stove. Since the thirteenth century, such monumental stoves had provided efficient heating in the homes of wealthy citizens and of civic buildings in southern Germany and the Alpine regions. By the mid-sixteenth century, they had developed into a prominent, sometimes theatrical, feature of interior decoration. The ornamentation of the more elaborate stoves was influenced by printed picture Bibles and emblem books, with themes ranging from local history to Bible stories and moral allegories that were both didactic and representative of familial values. Attributed to the Nuremberg potter Thomas Ströbel, one example from a Salzburg residence contains biblical narratives with explanatory inscriptions: Jeremiah lamenting the destruction of Jerusalem, Susanna and the

Elders, and Daniel in the Lion's Den (fig. 5.20). Representations of the Virtues stand in niches on the sides. The main scene on the stove front is the Allegory of Law and Grace, derived from Lucas Cranach the Elder's famous image of around 1530 that illustrated the central tenet of the Lutheran faith, namely, justification (or salvation) by faith alone. "Everyman" stands at the center, flanked by Moses with the Tablets of Law and Christ, pointing to his own crucifixion. A tree, dead on Moses's side, in living bloom on Christ's, symbolizes the right and wrong paths to salvation and the central Lutheran belief that, because man's nature is ineluctably evil by virtue of Adam's Original Sin (seen in the left background), it is not sufficient merely to follow the Laws of Moses; salvation can be achieved only by "faith alone" that is, faith in a gift of grace freely bestowed by God. The stove, as the chief source of heat around which the family would gather, thus acted as a locus of homiletic instruction and proclaimed the family's confessional allegiance. Such stoves embodied the values of the sixteenth-century Protestant burgher household: wealth and sophistication of taste, tempered by the dues of piety and by an understanding of the home as a site for the inculcation of morality, even of a means of grace.

Fig. 5.20. Attributed to Thomas Ströbel. Tiled stove, Nuremburg, 1550–1600. Tin-glazed earthenware. MAK–Austrian Museum of Applied Arts / Contemporary Art, Vienna.

FRANCE

France discovered Italian Renaissance design directly from Italian artists and designers who came to work at the French court of Francis I. Ambitious to consolidate the powers of the French monarchy by centralizing authority at home and pursuing military exploits abroad, Francis also recognized the value of cultural prestige and lavish artistic patronage to the aura of monarchy. His early military successes in Italy had confirmed his importance in international politics and exposed him to Italian art and culture. On his return he recruited Italian artists, architects, and craftsmen to his court, of whom the most famous were Leonardo da Vinci (1452–1519), Andrea del Sarto (1486–1530), and Cellini. But it was those Italian craftsmen and artists engaged in the building and decorating of Francis's palace at Fontainebleau between 1528 and 1540 who most influenced the direction of French art, architecture, and design. The defining monument of what has become known as French Mannerism is the so-called Gallery of Francis I, decorated between 1534 and 1539, a long ceremonial hall that served as a private reception space for the king (fig. 5.21).

Its sumptuous and original decoration was designed and painted by Florentine artist Rosso Fiorentino (active in France, 1494–1540), while Francesco Primaticcio (1504–1570) was responsible for the stucco, and Francesco Sibeco da Carpi, the intricate inlaid, wooden wainscoting. The iconographic scheme celebrates Francis's life and reign in obscure and esoteric imagery. One of a set of tapestries woven at Fontainebleau in the 1540s that faithfully reproduced the central section of the mural decoration, with only slight changes to the central fresco (fig. 5.22), contains all the motifs characteristic of the so-called School of Fontainebleau, which influenced the decorative language not only of France but of northern Europe in general. Its self-conscious, often tortuous elegance and mannered sense of style prompted its designation as Mannerist.

Most notable were the bold stucco decorations, consisting of figures with elongated proportions, that were set amid aggressively scrolled strapwork, a form of decorative banding evocative of square-sectioned cut leather. Influenced by Michelangelo's Sistine Chapel ceiling, which was made up of compartmented scenes, framed by huge, illusionistically painted, nude male figures, Rosso and Primaticcio played with the conventional relationship between the central pictorial field and the surrounding frame by giving equal, sometimes greater, formal and iconographical weight to the latter. The use of the frame to comment on the subject matter of the

Fig. 5.21. Rosso Fiorentino. Gallery of Francis I at the palace of Fontainebleau, France, decorated 1534–39. Stucco by Francesco Primaticcio; wainscoting by Francesco Sibeco da Carpi.

Fig. 5.22. Claude Badouin, after Rosso Fiorentino and Francesco Primaticcio. Tapestry: Danaë, Fontainebleau, probably 1540–50. Woven by Jean and Pierre Le Bries. Wool, silk, gold- and silver-wrapped thread; 10¾ x 20½ ft. (3.3 x 6.2 m). Kunstkammer, Kunsthistorisches Museum, Vienna (KK T CV 1).

central field was to become a key characteristic of Mannerist design; such framing lent itself to a variety of forms, from the title pages of books to the lintels of doorways.

The style was disseminated through series of prints made by Rosso's and Primaticcio's assistants and followers, among them Antonio Fantuzzi (act. 1537–50), Léon Davent (act. 1540–56), and Jean Mignon (act. 1535–55), who copied or elaborated on the designs. These were taken up and extended by Flemish engravers such as Cornelis Bos, Cornelis Floris, and Hans Vredeman de Vries in Antwerp (see below), or the Orléans-based Jacques Androuet Du Cerceau (c. 1515–after 1584). In the mid- to later sixteenth century, Mannerist print designs were appropriated and adapted by craftsmen in all media. A densely ornate example can be seen in a table base, illustrated here (fig. 5.23) which is in the style of the Dijon ornamentalist, furniture maker, and city architect Hugues Sambin (c. 1520–1601), who came to prominence as the designer of the ephemeral decorations of the entry of Charles IX into Dijon in 1564. Sambin's ideas became known via a number of theoretical works and prints including a set of thirty-six images published in 1572 as *L'Oeuvre de la diversité des termes* (The Book of the Diversity of Terms).

The additive and eclectic qualities of French design, and the emphasis on the decorative over the structural, were also present in the fragile ceramic productions of "Saint-Porchaire" pottery, one of the most original and complex productions of the Northern Renaissance (fig. 5.24). Little is known of this manufactory, which was active before 1542, not even its precise location. The nature of the white clay body, inventory and other textual references, and identifiable patrons link this class of ceramics to the Poitou area, though recent archaeological evidence suggests that it was also produced in Paris. Several pieces contain the initials "H" inter-

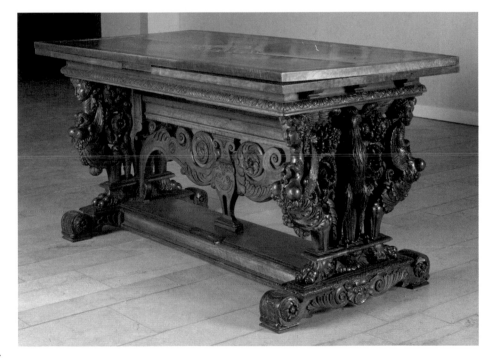

twined with "C," which have been taken to indicate those of King Henry II (r. 1547–59) and his queen, Catherine de' Medici, or of his mistress Diane de Poitiers, who appropriated the crescent moon of the goddess Diana as her personal symbol. Other pieces contain the arms and initials of Anne de Montmorency, Constable of France. Categorized as "Saint-Porchaire," these were invariably small-scale, fragile showpieces, of unrivaled complexity of surface decoration and of little utility. The candlestick illustrated here suggests a variety of influences: the masks on the base and the broken contour of form were probably inspired by Venetian and Paduan metalwork designs by such artists as Andrea Briosco (known

Fig. 5.23. Table in the style of Hugues Sambin, Burgundy, 1580–1600. Walnut, bone inlay, gilding; 35⅜ x 66⅞ x 34⅝ in. (90 x 170 x 88 cm). Musée des beaux-arts de Dijon (CA 1545).

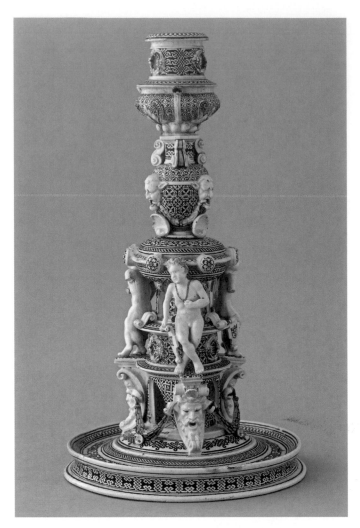

Fig. 5.24. "Saint-Porchaire" candlestick, France, before 1551. Kaolinic clay; H. 12⅜ in. (31.3 cm). Petit Palais, Musée des Beaux-Arts de la Ville de Paris (ODUT01126).

as il Riccio, 1470–1532) and Giulio Romano (1499–1546), as well as by Jacques Androuet Du Cerceau. By contrast, the foliated arabesques and knot-work patterns that form the surface decoration derive from Hispano-Islamic metalwork originating in Spain, probably transmitted via engraved pattern books, bookbindings, and textiles. The technical ingenuity of these pieces is revealed in the knot work, which was achieved by stamping the pattern onto thin, still-damp strips of white clay using an embossing iron—akin to a tool used in leather bookbindings—and filling the cavities thus created with a brown or reddish clay slip or paste. The completed strips were then applied to the body of the vessel and glazed with a clear lead glaze.

The equally innovative work of Bernard Palissy (1510–1589), the most famous French potter of the period, had little in common with the polite conventions of the Fontainebleau style. A lifelong autodidact and experimentalist, with a profound interest in natural philosophy, Palissy invented what he called *rustiques figulines*, lead-glazed, earthenware dishes and platters that re-created pond environments, using casts from actual animals and plants (fig. 5.25). In this typical example, aquatic and amphibian creatures, such as frogs, lizards, and snakes, are placed in a pool among rocks and plant fronds. Cast meticulously from life, the decoration laid claim to a kind of scientific verisimilitude that related to his own close study of nature and his idiosyncratic theories about the generation of matter and the cycle of life, which he expounded in public lectures and two published treatises. In the light of such writings, it is possible to regard his clay creations as

Fig. 5.25. School of Bernard Palissy. Platter, probably Paris, 1575–1600. Earthenware; 2¹³⁄₁₆ x 20½ x 15⅝ in. (7.1 x 52.1 x 39.7 cm). The Metropolitan Museum of Art (53.225.52).

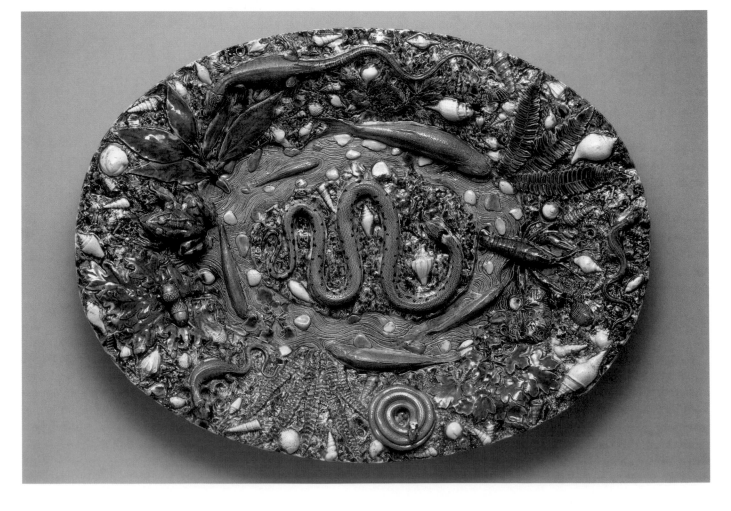

scientific demonstrations of natural processes, suited to the collecting interests of the elite classes (see above). Palissy's use of muddy colors floated in a clear lead glaze on earthenware spawned many imitators. This class of French ceramics became known generally as *faience* after Faenza, the Italian center of maiolica production. Both the Constable de Montmorency (1555) and Catherine de' Medici (1566) commissioned ceramic grottoes from him, the latter at the Palace of the Tuileries in Paris (neither survives). A vocal Protestant, Palissy was arrested in 1586 for heresy and spent the last three years of his life in the prison of the Bastille.

THE NETHERLANDS

Though Bruges remained an important international trading center, by the beginning of the sixteenth century the hub of the economy in the Netherlands was shifting to Antwerp, which could more easily accommodate the larger ocean-going vessels of the Atlantic trade. Over the next century, Antwerp became the largest international port in the north, a thriving nucleus of craft production, including tapestry weaving, metalworking, and jewelry; a major marketplace for paintings; and a center of book publishing. From this nexus of craftsmen and printers emerged a school of ornamental designers, which, like the School of Fontainebleau, produced a distinctive ornamental vocabulary that was influential across northern and eastern Europe. Among these designers, for example, Cornelis Bos, Cornelis Matsys, and Hans Collaert developed inventive and fantastical variations of the grotesque style, while Hans Vredeman de Vries (1527–1604) published twenty-seven volumes of designs between 1557 and 1587, covering objects ranging from architecture to furniture, silverware, and perspective designs for wood inlay.

Vredeman's originality lay in combining a personal form of ornament with the architectural precepts of the first-century BC Roman architect Vitruvius, whose *De Architectura* was translated into several northern vernacular languages during the 1540s, including English as *Ten Books of Architecture*. Vitruvian ideas were further laid out in easily digestible form by the Italian architect Serlio, who worked in Paris in the late 1530s for Francis I. Vredeman drew from the Vitruvian notion that classical columns and their capitals were based on human proportions and character: the Corinthian order on the proportions of a young girl, the Doric, those of a male athlete, the Ionic, a mature matron, and so on. Furthermore, the orders were not applied arbitrarily but belonged *a priori* to particular building types or decorative schemes. According to Vitruvius, temples to strong "virile" gods, such as Mars or Hercules, should be built in the Doric mode; temples to "softer" gods, such as Venus, Proserpine, or Flora, in the gentler, more ornamented Corinthian mode; and those to Juno, Diana, Bacchus—who mingled strong with gentle characteristics—in the Ionic. Serlio's *Regole generali di architettura sopra le cinque maniere de gli edifici* (General Rules of Architecture on the Five Styles of Buildings, 1537), available in the north in various translated editions from 1542 onward, made the Vitruvian system of proportions further accessible to builders and craftsmen and adapted the principle of decorum to contemporary building types. After Serlio, it was no

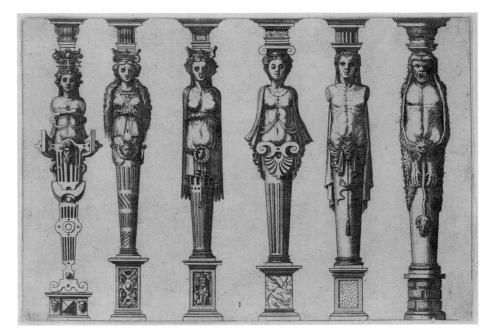

Fig. 5.26. Hans Vredeman de Vries. Plate from the *Caryatidum*, Antwerp, c. 1565. Etching; 6⁵⁄₁₆ x 9³⁄₁₆ in. (16 x 23.4 cm). The Metropolitan Museum of Art (66.545.4 [2]).

longer possible to use Corinthian capitals indiscriminately as Albrecht Dürer (1471–1528) and his contemporaries had done. Columns now had a doubly human aspect: in their proportions and their associative meanings.

Vredeman applied this anthropomorphic principle to ornament, as can be seen in his *Caryatidum* of 1565, a series of sixteen engravings of playful variations on the Vitruvian orders (fig. 5.26). The figurative nature of the terms and caryatids allowed the expressive human element implicit in the orders to be realized. Reading from right to left, the terms follow the genders of the orders: the "rustic" Tuscan, Doric as male athlete, the Ionic and Corinthian females, and finally free variations. Such figures were adopted throughout Europe as ornamental bordering in architectural and other contexts, such as the Swiss tiled stove (see fig. 5.20).

A buffet (fig. 5.27), probably made in Zeeland or Antwerp around 1600, illustrates this influence. Its overall form resembles examples in Vredeman's series of furniture designs, *Différents pourtraicts de menuiserie* (1565), while its doors are decorated with intarsia perspective views of ancient street scenes and ruins inspired by Vredeman's oval perspective designs of around 1562. The cornice is supported by two half-figure Ionic caryatids, which, together with the lion heads and strapwork decoration of the volutes, were also taken from Vredeman's ornamental vocabulary. The swelling and tapering of the architectural elements of the volutes and cornices can be understood as Ionic in character, expressive of a kind of largesse appropriate to the buffet's function. The buffet is an example of grand showpiece furniture that developed in the sixteenth century out of the context of courtly feasts, where, as discussed, it was usual to display the host's costly precious metal tablewares.

Such Flemish ornamental designs were transmitted to culturally more remote parts of northern Europe, notably Scandinavia and England. Term figures from another plate of the *Caryatidium*, for example, provided the basis for the lower section of a late sixteenth-century fireplace overmantel in the Great Chamber of South Wraxall Manor in Wiltshire,

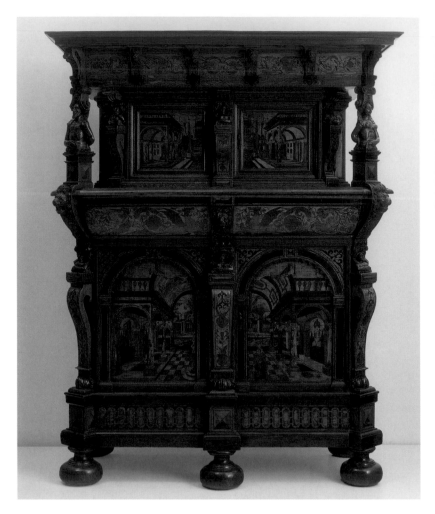

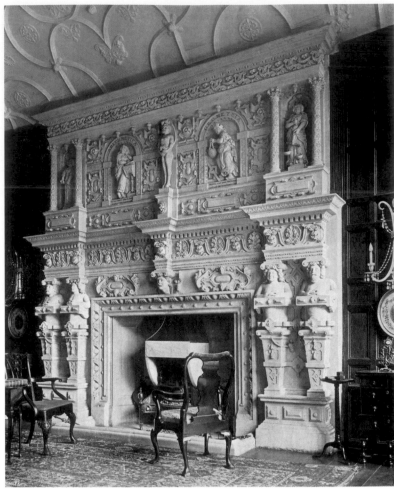

Fig. 5.27. Buffet, possibly Zeeland or Antwerp, c. 1600. Inlaid oak, various woods; 76⅜ x 59⅞ x 27½ in. (194 x 152 x 70 cm). Museum Boijmans Van Beuningen, Rotterdam (Div. M 16 [KN&V]).

Fig. 5.28. Drawing room chimneypiece, South Wraxall Manor, Wiltshire, built c. 1600 (photographed c. 1904).

England (fig. 5.28), while the allegorical figures on the overmantel all derived from prints published in Antwerp after Maarten de Vos: Justice and Prudence between the paired columns and Arithmetic and Geometry in the main panels, the latter based on prints by Crispijn de Passe. In later sixteenth-century England, ornament was characterized less by Vitruvian decorum than a sense of exuberant excess, a riotous vernacular interpretation of the classical, mediated via Flemish variants, that delighted in this new vocabulary but remained largely oblivious to its grammar and syntax.

This rich visual culture was founded on unprecedented prosperity. It was underpinned by decades of domestic peace and by the immense transfer of property from the Church to the laity after the dissolution of the monasteries by Henry VIII, and the creation of a new, upwardly mobile, politically ambitious, landowning class of moderate wealth that far exceeded the nobility in number. In his *Description of England* (1577), the clergyman William Harrison commented on the general rise of living standards of this expanding middle stratum, observing that barons, the lowest rank of nobility, now built new houses on a scale formerly reserved for great princes, while further down the social scale, knights, gentlemen, merchants, wealthy farmers, and others had the wherewithal to acquire precious metal tablewares, carpets, hangings, and fine linens for their homes.

Henry's break with Rome and Catholic Europe isolated England from the currents of the Italian Renaissance and produced a period of relative but nonetheless cultural seclu-sion. Henry's reign had begun with enthusiastic appropriations of Italian Renaissance culture and the hiring of Italian artists and decorators to work on his considerable building projects, but the break with Rome led to an exploration of older, medieval forms that were English in origin. This tendency is exemplified in the creation of a style of palace and large domestic architecture unlike anything elsewhere in Europe. Known as "prodigy houses" for their ornate splendor, the large country houses, built in the later sixteenth century by the courtiers of Henry's daughter Elizabeth I (1558–1603), incorporated Italianate and Flemish forms and motifs, but applied them in a local manner. While the plan of a house like Hardwick Hall (fig. 5.29) was based on classical symmetry, its elevation was a mixture of English medieval, Flemish, and deliberately archaic elements, expressive of a form of neochivalric romanticism. Its towers recalled the castellations of medieval castles, but its large glazed windows and lacelike stone fringing incorporating the owner's initials on the roofline, conveyed a delicacy of effort that was wholly modern. Profuse surface decoration characterized the interior. Its carved woodwork and paneling, tapestries, and stucco ceilings together created a dazzling concatenation of colors, shapes, textures, and imagery, both emblematic and allegorical—a dense space, quite different from the neoclassical sense of proportionate volumes. To a greater extent than elsewhere in Europe, the function of such display was ideological: in a Protestant culture, where the pictorial was regarded with suspicion, ornament became an important signifier of social

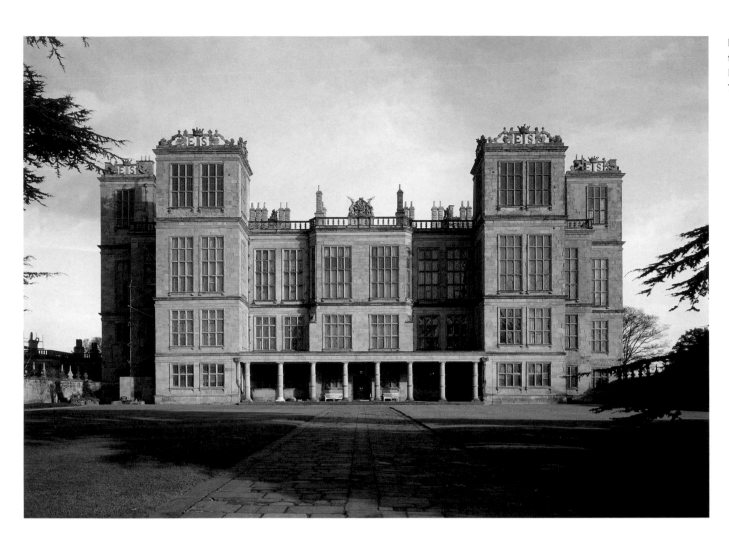

Fig. 5.29. Entrance front of Hardwick Hall, Derbyshire, built 1591–97.

status. Broadly speaking, in architecture, interior decoration, and in dress, the more elaborate the degree of ornamentation, the greater the authority. The extravagant state costumes worn by Elizabeth I, known from surviving portraits and royal inventories, with their layers of sumptuous materials, jewels, and emblematic imagery, stood at the pinnacle of this system of signification (fig. 5.30).

THE IBERIAN PENINSULA

Under Elizabeth I, England became the foremost Protestant nation in Europe. It developed as a maritime power in competition with Catholic Spain, which emerged as the richest and most powerful country of sixteenth-century Europe. In 1400, however, Iberia was a remote peninsula, separated from mainland Europe by the Pyrenees. It was divided within by a series of competing states with different languages and customs. Over the previous five centuries since the disintegration of the Muslim Umayyad dynasty, the peninsula had fragmented into Christian and Muslim principalities, each jostling for power. Yet, within the space of two generations spanning the cusp of the fifteenth and sixteenth centuries, a unified Spain emerged as a world power, fueled by a sense of historical destiny and ideological purpose. It became the hub of an empire that encompassed much of northern, central, and southwestern Europe, parts of Italy, and vast territories in the New World and Asia.

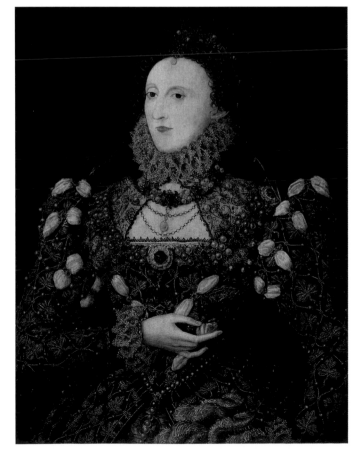

Fig. 5.30. Attributed to Nicholas Hilliard. Portrait of Queen Elizabeth I, England, c. 1575. Oil on panel; 31 x 24 in. (78.7 x 61 cm). National Portrait Gallery, London (NPG 190).

EUROPE

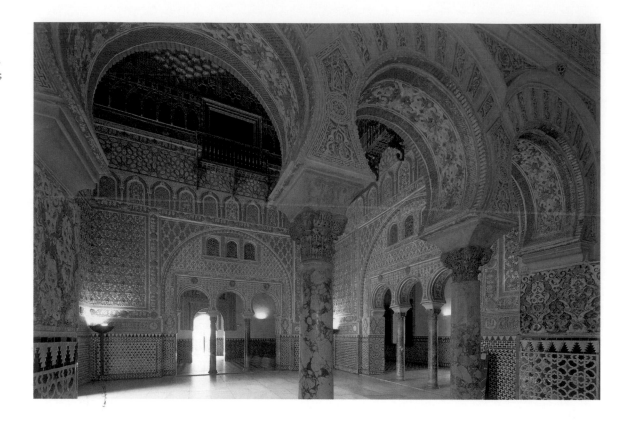

The unification of Spain began in 1469 with the linking of the two principal kingdoms through the marriage of Ferdinand II of Aragon (r. 1479–1516) and Isabella of Castile (r. 1474–1504), the so-called Catholic Kings, and culminated in the year 1492 with the final victory over Muslim Granada and the "discovery" of America. The latter became an immense source of wealth after Cortés conquered Mexico (1519–22) and Pizarro took possession of Peru (1531–34). The marriage in 1496 of Juana of Castile, daughter of Ferdinand and Isabella, to Philip the Fair, son of Emperor Maximilian I, paved the way for the Spanish crown to become an imperial power. When Philip died in 1506, his son, crowned Charles I of Spain (r. 1516–56), found himself heir to three of Europe's leading dynasties—the houses of Habsburg, Valois-Burgundy (that brought with it the Burgundian Netherlands), and Trastámara (with which came the crown of Castile-León and Aragon). In 1519 he became Holy Roman Emperor Charles V. Spain's presence in the Netherlands and Italy and its adopted role as defender of Catholicism in its northern European territories ensured a new close cultural involvement with western Europe.

Yet in the fifteenth century, the Iberian Peninsula was distinguished by its comparative isolation and a legacy of internal political struggle for territorial dominance between the Islamic dynasties in the south and the Christian kingdoms in the north. By the end of the thirteenth century, with the exception of Granada in the south, all of Spain was in Christian hands, although in cultural terms, enduring interrelationships between the Muslim, Christian, and Jewish communities remained. In the realm of decorative art and architecture, this gave rise to forms and a style often referred to as "Mudéjar." The term, from the Arabic *Mudajjan*, applies both to Muslims literally "left behind" after the Christian conquests of Islamic territories and to a style that integrated the forms and decorative traditions of Muslims, Christians, and Jews. The most influential of such forms were adapted from those of the Islamic Almohad (1130–1269, 1147–1214 in Iberia) and Nasrid (1232–1492) dynasties, in particular the use of glazed ceramic tiles, stucco, wood latticework (*artesonado*), and highly structured decorative patterns dominated by foliate and geometric designs. In the course of the fourteenth and fifteenth centuries, and well into the sixteenth century, the rulers of Christianized Castile-León adopted the Mudéjar style as a marker of courtly taste. They appropriated for their own use the Islamic monuments in the territories they conquered and used the same decorative forms in their own building projects. King Peter I of Castile-León (r. 1350–69), for example, took inspiration from the palace of the Alhambra, in then-Muslim Granada, as well as prior Muslim architecture in other areas, for his chief residence the Alcázar in Seville (commissioned in 1364).

The Salón de Embadajores (Ambassador's Hall), which was used for official receptions and affairs of state, epitomizes this Christian appropriation of Islamic elements (fig. 5.31). The room follows the architectural scheme of a *qubba* (Islamic mausoleum). The tile mosaics on the dado derive from the Nasrid ornamental repertoire, tracing star-shaped and geometrical interlacing and undulating patterns in an array of contrasting colors. Rich stucco panels above contain Arabic inscriptions that proclaim the glory of Allah and his protégé King Peter I. The upper frieze consists of an interlocking pattern with truncated eight-pointed stars, enclosing *ataurique* (stylized plant motifs), studded with escutcheons bearing the emblems of the house of Castile—the lion, the castle, and the *Orden de la Banda* (Order of the Sash). A new wooden dome, centered by a twelve-pointed star, designed by Diego Ruiz in 1427, epitomizes the Christian appropriation of Islamic elements in the fifteenth century.

Onto the basic Islamic form of the star, a series of portraits of the Castilian monarchs, set within running Gothic arches, and a further thirty-two female portraits, were added in the late sixteenth century.

When Ferdinand and Isabella conquered Granada in 1492, they assumed ownership of the Nasrid Alhambra palace with little sense of anachronism. Indeed, their royal patronage and that of most of the succeeding Christian monarchs kept the lavish palaces of the Nasrids well protected, such that they survive as the best preserved examples of Islamic palaces of the fourteenth and fifteenth centuries from anywhere in the Islamic world.

The blending of Moresque, Islamic, Christian, and Gothic forms and decoration characterized Iberian media well into the sixteenth century. This was particularly so in the case of ceramics. Tin-glazed earthenware, the favored medium for vessels and architectural tilework in the Islamic Middle East from the ninth century onward, continued to flourish in Iberia in the succeeding centuries, especially in Málaga, Paterna, and, from the fifteenth century, Valencia. Throughout the fifteenth and sixteenth centuries, potters continued the traditional Moresque techniques of cutting, molding, and stamping designs onto their work. The two most characteristic techniques were *arista* (stamped, also called *cuenca*, meaning a bowl or depression), and *cuerda seca* (dry cord). In the latter, areas of different colored glazes are separated by greasy lines of manganese pigment that burn off during the glaze firing, leaving a light brown unglazed line separating each color. (An analogy may be made to cloisonné enamel; see fig. 1.4) *Cuerda seca* tiles made possible large-scale wall treatments, replacing the earlier, more labor-intensive *alicatado* process (literally "cut work"), whereby pieces of colored tile were sawed into regular shapes and arranged in geometrical patterns. In the *arista* process, used increasingly by the 1400s for tilework in Castile, Andalucía, and Moorish Granada, the raw clay of each tile was stamped with a pattern of raised lines and depressions before the firing; different colored glazes were applied in each depressed area, and the raised lines kept the colors from mixing. (The analogy here is with champlevé enamel, that is, carving into a surface and filling the incisions with enamel to create a flush finish). This process also made more efficient the large-scale production of high-quality tiles and ensured the ubiquitous use of tilework in Hispanic interiors.

The most important type of Iberian ceramics in the period 1400 to 1600 was tin-glazed lusterware (see fig. 3.6), a technique which had been imported from the Middle East into North Africa and Spain. Produced at Málaga under the Islamic Nasrid dynasty of Granada (1232–1492), lusterware was also typical of ceramics fired in Christian Catalonia and particularly at Manises, near Valencia (fig. 5.32). Islamic potters—Moriscos, as Spanish Muslims, especially those who had converted to Christianity, were known—had been attracted there by noble patrons in the early 1300s. The spectacular winged amphorae (later called "Alhambra vases") are the most famous examples of this kind of Iberian lusterware.

They developed a superb repertoire of Mudéjar amalgamations of Islamic and Gothic form and motifs: in many examples, the heraldic devices of the commissioning family, or other, often Christian, motifs were incorporated into overall Islamic patterns of stylized Kufic script. A lusterware piece might have Gothic motifs, such as an ivy or vine-leaf pattern, but arrayed in a distinctly Moresque form of patterning. This was the case with a large two-handled lustered vase, made in Valencia for the Medici family in Florence, whose heraldic balls, or *palle,* are painted on one of its sides (fig. 5.33). This form, with long neck, globular body, and large wing handles, was typical of earlier Nasrid amphorae.

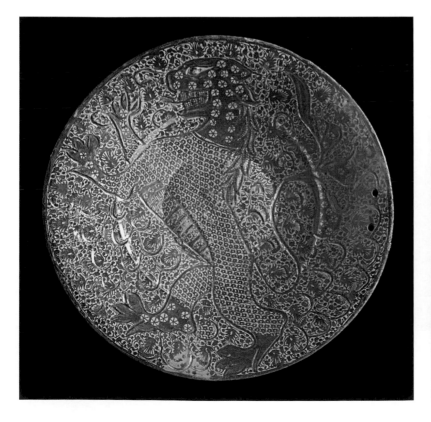

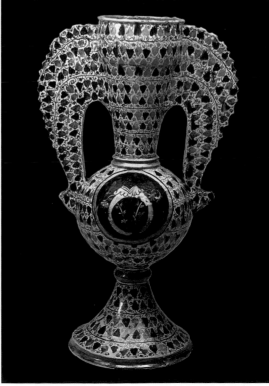

Fig. 5.32. Dish depicting a lion, probably Manises, Valencia, early 16th century. Tin-glazed earthenware, luster; Diam. 16¹³⁄₁₆ in. (42.7 cm). Victoria and Albert Museum, London (C.2050-1910).

Fig. 5.33. Vase with the arms of Piero or Lorenzo de' Medici, possibly Manises, Valencia, 1465–80. Tin-glazed earthenware, luster; H. 22½ in. (57 cm). Trustees of the British Museum (G.619).

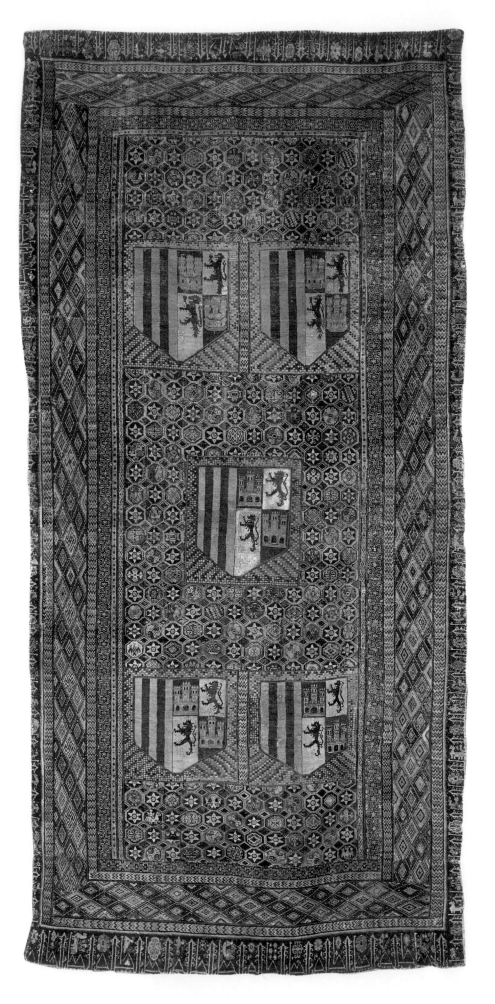

Valencian lusterware was sought after by the merchant and noble classes of other parts of Europe, notably Tuscany and the Netherlands. The decoration typically included bands of leaf patterns alternating in cobalt blue and golden luster pigment. Often referred to in western Europe as Hispano-Moresque pottery, it frequently appeared in fifteenth-century Netherlandish and Italian paintings. Even in ceramics showing the increasing influence of Renaissance forms, stylistic hybridization is evident. After 1609, when the Moriscos were expelled from Spain in what today would be called a wave of "ethnic cleansing," Levantine lusterware continued to be made but its quality declined, surviving as a form of popular ceramics in both Valencia and Catalonia.

What relatively scant information survives about late medieval and early Renaissance Iberian interiors suggests that they varied widely according to local traditions. As in France, the Netherlands, and England, late Gothic designs prevailed. The interior design of southern Castilian royal and noble residences in the 1400s, however, continued the taste for Mudéjar designs established by the fourteenth-century rulers. Strong Islamic references remained in ceramic wall decorations, the use of cushions and rugs for seating, and stucco decorations. By contrast, in areas of northern Castile and Catalonia, where European Christian culture had dominated for centuries, biblical imagery and historical subjects were common features of surface decoration on chests, beds, chairs, and hangings, though, even in these northern regions, Islamic-style knotted carpets (including those of Iberian manufacture) were common. The Islamic custom of using cushions on the floor instead of chairs was maintained among women well into the seventeenth century. Indeed, from the Renaissance period into the subsequent Spanish golden age (roughly from the late sixteenth to the late seventeenth century), larger homes had suites of sitting rooms (*estrados*) designated as women's areas, decorated with cushions, rugs, and hangings.

Islamic Spain produced a remarkable variety of textiles, including carpets and elaborate woven silk textiles used as covers and wall hangings. Woven rugs in wool and silk were produced in the southeastern provinces from the twelfth century onward, typically using a single-warp knot (often identified as the "Spanish knot"). Trade and diplomatic gifts ensured that Muslim and Christian areas shared a common textile heritage, which by the late 1300s and 1400s had become part of the Mudéjar tradition in the non-Muslim areas. Among the most arresting forms were "Admiral" carpets (so-named because some of them had the coat of arms of a family that bore the inherited title of Admiral of Castile)

Fig. 5.34. "Admiral" carpet with the arms of María de Castilla, Queen of Aragón, Letur, 1416–58. Goat hair; 16½ x 7¾ ft. (5 x 2.9 m). The Hispanic Society of America, New York (H328).

with small-scale geometric field patterns reminiscent of pavement tile designs and with borders featuring interlaced and figural bands (fig. 5.34). During the Renaissance period, centers of carpet manufacture in Aragon, Valencia, and New Castile, particularly at Cuenca, began to eclipse the Hispano-Islamic production, except at Alcaraz, where workshops survived the fall of Granada in 1492.

Woven silk textiles had been produced in Islamic Spain from the late eighth century, and by the fourteenth century the silk weavers of Nasrid Granada were famous internationally. Earlier medieval designs, often showing Egyptian influences such as paired-animal motifs as well as geometric designs of the Almohad period (1130–1269), continued to be elaborated in Nasrid Granada and in Sevillian workshops. Technical levels were extremely high: silver-gilt-wrapped silk threads combined with colored silks of great stability in elaborate combinations of geometric or figurative patterns, which often included the Arabic inscriptions associated with Islamic manuscripts. The intricacy of weave and design was frequently matched by largeness of scale. Silk weaving was also common in the Christian areas of Spain, especially in Valencia and Toledo, where velvets, brocades, and damasks of great complexity (some with four heights of pile) were produced in pomegranate, pineapple, palmette, floral, and interlaced patterns.

The embroidery of textiles was also an important Iberian craft. In the late "Middle Ages," elaborate embroidered or embroidered appliqué panels adorned both secular and religious textiles, from wall hangings to devotional and processional banners, copes, dalmatics, and altar frontals. The imagery included coats of arms, biblical scenes, saints, allegories, and, after about 1430, Italian Renaissance motifs such as classical grotesques and Della Robbia–inspired festoons and wreaths. Textile manufacture varied from city to city according to local regulations, whether dominated by guilds, as in Valencia and Aragon, or by convents and other groups. The survival of imported panels, including Flemish work, suggests that there may have been an international exchange of these luxury goods within the Spanish dominions. Flemish influence was especially evident; indeed, the Flemish technique of using colored threads to shadow silver or silver-gilt embroidery was ubiquitous in figurative panels made in the period. From the early 1500s, south Asian and East Asian textiles imported from Portuguese India and the Spanish Philippines (see fig. 2.11) began to influence both woven and embroidered examples. Tapestries were imported from the Low Countries, especially after 1519 when Charles I of Spain became Holy Roman Emperor Charles V.

Like textiles, leather was used to cover walls. It could be stamped, gilded or silvered, lacquered, dyed, or painted. Decorative leather hangings in the rooms and halls of palaces and large houses must have been spectacular, though little from the fifteenth and sixteenth centuries remains. Sometimes leather hangings were used above a dado of Moresque tiles, as in the Alhambra (1238–1358). A panel of stamped and gilded leather, patterned to imitate Valencian Renaissance silk brocades, can be seen in the background of a portrait of a cardinal (fig. 5.35), painted about 1600 by El Greco (Doménikos

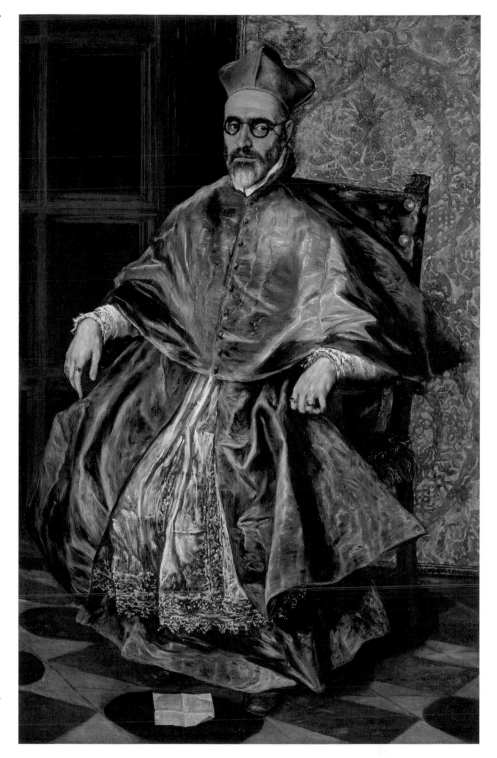

Theotokópoulos, 1541–1614). The back of the chair is also made of leather. The city of Cordova was famous for a type of soft but highly resilient leather called *guadameci*, which could be gilded, punched, or embossed, and this was used to cover seats and cushions, and as bookbindings and polychrome wall coverings. Surviving contracts of the *guadamecileros* in Cordova give some idea of the magnitude of the trade. In 1604, for instance, a group of nineteen master leatherworkers (nearly all the workers in Cordova at that time) secured a contract for over ten thousand panels for the palace of Philip II in Valladolid. As Spain's empire expanded into the Americas, the leather products of Spain's sheep- and cattle-herding culture became models for colonial objects as well as inspiration for new forms that would be developed in the viceroyalties. In

Fig. 5.35. El Greco (Doménikos Theotokópoulos). Portrait of a cardinal, probably Cardinal Don Fernando Niño de Guevara, Toledo, 1600–1604. Oil on canvas; 67¼ x 42½ in. (170.8 x 108 cm). The Metropolitan Museum of Art (29.100.5).

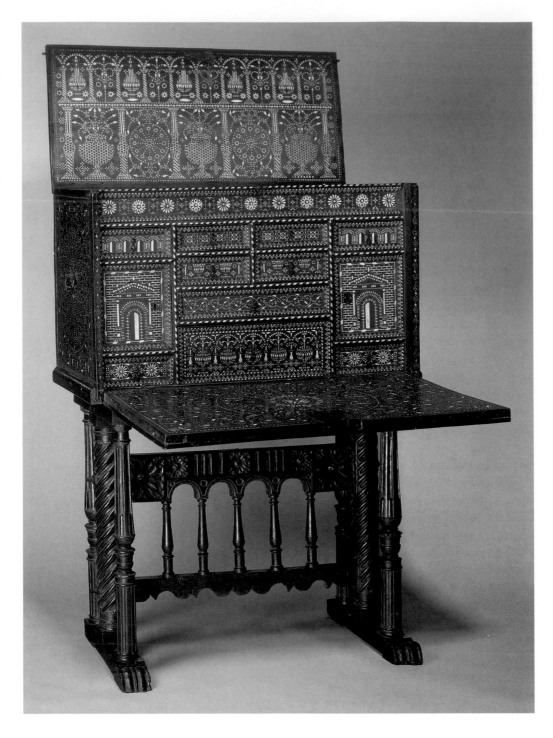

Spain, however, the trade seems to have gone into a steep decline after the expulsion of the Moriscos in 1609, passing to the Netherlands, especially Antwerp, which became the principal producer of gilt hangings in Europe.

During the fifteenth and early sixteenth centuries, furniture included Gothic forms of French inspiration in the north of Spain; forms such as the Catalan *arcones de novia* (wedding chests), which were somewhat similar to Italian *cassone*; and inlaid chests in the Islamic tradition in areas of the east and south. A single piece of furniture from this period, however, has come to typify Spanish design, namely the *escritorio*, a form of writing cabinet, containing multiple drawers, in which a large hinged panel, usually of walnut, dropped down to become a writing surface (fig. 5.36). The use of such portable desks may have been dictated by the peripatetic nature of the Spanish court before Philip II established Madrid as

the capital in 1561. Even toward the end of the seventeenth century, however, a degree of mobility was maintained as the royal family passed from its principal residence, the Alcázar of Madrid, to the palace of El Escorial, and to summer palaces at Aranjuez and La Granja, and palaces on the outskirts of Madrid. By then, *escritorios* were so popular that they were imitated internationally. A smaller, tabletop version, with multiple decorated drawers but without the drop front, was known as a *papelera* (paper holder).

The Mudéjar style continued to influence the surface design of these objects. Early sixteenth-century drop-leaf *escritorios* might incorporate classical motifs engraved in bone or ivory into an Islamic design made up of inlaid fruitwoods. In a spectacular type of mid-sixteenth-century breakfront cabinet-secretary, probably originating in Barcelona, doors of geometric Islamic inspiration open to reveal a min-

iature Italianate courtyard around which the compartments of the interior are organized. Even when, in the sixteenth century, many of the details of Iberian furniture decoration were almost entirely European in derivation and imitated classical or Mannerist architectural motifs, the over-all effect often remained "Mudéjar."

Seat furniture included carved high-backed wooden chairs found throughout Europe, the "Dantesca" type with crossed supports (Spanish, *silla de caderas*, or "hip chair"), a "friar's chair" armchair (*sillón de frailero*) generally with a leather back and slung leather seat above a decorative stretcher bar (see fig. 5.35), and "sling stools" (often with crossed supports). "Refectory" and trestle-style tables were common, the latter with detachable leg units, reinforced by wrought-iron, crossed curvilinear braces, and supporting an immense plank of walnut. Again, the reference to a once peripatetic upper class is obvious in the portable nature of the pieces.

Furniture in sixteenth-century Portugal showed the influence of Flanders and France, along with affinities to Spain, especially after the crowns of Castile and Portugal were united under Philip II in 1581. Elaborately cut profiles and pierced work on leg stretchers or the facing panels of sideboards were characteristic features. Elite beds typically featured turned corner posts to support canopies and elaborate headboards, some with two tiers of arches on turned pillars. The use of mahogany and other exotic hardwoods from Brazil, India, and Southeast Asia also distinguished Portuguese furniture from objects of Spanish manufacture which were typically made out of walnut. By the end of the sixteenth century, furniture from the Portuguese colonies in India, along with luxury objects from Japan, including *namban* lacquer pieces (see fig. 1.29), had begun to influence domestic furniture production.

Medieval Iberia was an important center of technical innovation in iron and steel production, benefiting from the exchange of European and Middle Eastern technologies, and steel continued to be used for swords and armor well after the introduction of gunpowder changed the nature of European warfare in the 1400s. Throughout the 1400–1600 period, Castile (especially Toledo) was celebrated for the quality of its flexible steel swords—famously damascened in gold and black by Toledo metalsmiths. Equally characteristic of this period are *rejas* (elaborate wrought-iron screens), made to enclose chapels and cover window openings, which often included classical ornament, gilding, enamel polychromy, and bands of repoussé relief or pierced work. By the late sixteenth century, *rejas* had increased in size and could span even the largest arches in late Gothic and Renaissance churches.

Iberian jewelry showed strong Islamic influence. A typical form of necklace used cylindrical filigree units enameled in the manner of cloisonné work and strung together on a chord with a pendant rosette. Delicate goldwork with champlevé, transparent, and cloisonné enamel took floral and cruciform shapes and featured both secular and devotional imagery. As the sixteenth century progressed, figural pendants featured classical motifs, such as centaurs and mermaids, or avian shapes of eagles and swans. Precious metals and elaborate enameling were often used with large emeralds and baroque pearls from Colombia and other colonies, or diamonds. Among the most famous jewels of the Renaissance period was the necklace created for Mary Tudor of England as a gift from her husband Philip II of Spain, and subsequently worn by queens Isabel and Margarita of Spain. It showcased the *peregrina* ("pilgrim") pearl, the largest known in Europe, said to have been discovered by slaves in the New World.

From the late fifteenth century onward, the main orientation of Iberian art and design was toward Western Europe, and Mudéjar forms began to decline, though they survived in certain localized crafts until the late seventeenth century in Spain and even longer in Central and South America. They were replaced by two main stylistic developments: the first was a modern form of Gothic, a reinterpretation of great refinement and complexity, best exemplified in the architecture of the Monastery of San Juan de los Reyes in Toledo (1477–1504), designed by Juan Guas (c. 1430–1496) as a mausoleum for the Catholic kings. This style, which shared many affinities with contemporary developments in the Netherlands, drew from the delicate filigree forms of fifteenth century liturgical silverwork. The second development was the adoption of Italianate forms and motifs that mingled with, and edged out, the Mudéjar influences. Terms such as Hispano-Flemish or plateresque (from the Spanish *plata*, "silver," a term especially applied to architecture, denoting a connection between the two media), have been used to identify the Iberian variants of Italianate classicism.

In Seville, for example, polychrome, flat-ground maiolica tiles with Italianate grotesque decoration were introduced by the Italian Francesco Niculoso Pisano (d. 1529), who settled there in about 1498, and these tiles were used concurrently with the local *arista* tiles in a tradition that continued well into the nineteenth century. Pisano also combined the *arista* technique with luster when making large-scale ceramic altar ensembles. Given Seville's role as the gateway to the "New World" and one of Spain's foremost trading ports, Pisano-style tiles were soon also dispersed to Mexico and other Spanish viceroyalties.

The Italian style became established in the second half of the century, when a new center for ceramic production developed at Talavera de la Reina near Toledo. Encouraged by Philip II's construction of the palace-monastery-mausoleum complex of El Escorial north of Madrid in the years after 1560, the new manufactory's painted figural and *istoriato* vases and plates became a new standard for Spanish production. The name "Talavera" came to be synonymous with "earthenware" throughout the Hispanic world, so much so that the tin-glazed ceramics produced at the city of Puebla in Mexico are still popularly called Talavera Poblana. Usually large in scale and decorated in yellow, green, and manganese on a cream ground, Talavera wares displayed classical subjects, such as Roman heads in profile.

The reorientation of Iberian design toward pan-European trends is best charted in the domain of silverwork, which, of all the crafts, became the most prestigious. The enormous influx of bullion from the New World, especially after the silver mines at Potosí in Bolivia and Guanajuato in Mexico began to be exploited in the 1540s, gave great stimulus to the production of both secular and ecclesiastical precious metal objects.

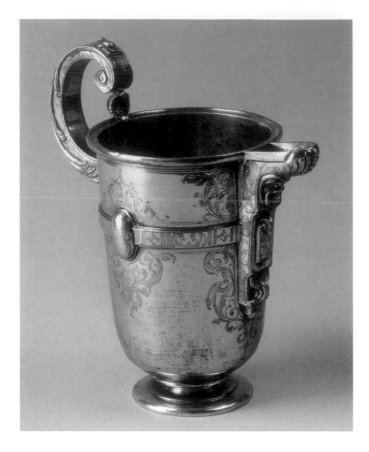

In the early sixteenth century, secular tablewares in precious metal were frequently characterized by a type of dense surface ornamentation of classical Italianate motifs that paralleled the plateresque in architecture. Gradually the Gothic and Mudéjar elements disappeared. One typically Hispanic form is the *jarro de pico* (spouted jug, fig. 5.37), a type that remained popular for three centuries. This example is decorated with parcel-gilding and elaborately tooled arabesque scrolling on the side bands and spout.

The large number and high quality of surviving sixteenth-century silver objects created for religious use—chalices, patens, crucifixes, tabernacles, monstrances, and lecterns—are testament to the fervent Catholicism of the Hispanic countries. The most spectacular and characteristically Iberian religious object was the large-scale silver processional *custodia* or *ostensorio* which contained a monstrance in which the Eucharistic Host was exposed for veneration. Many processional *custodias* were theatrically conceived as miniature architectural ensembles, rising in some cases to about 10 feet (3 m). Intended to be paraded through the streets during the festival of Corpus Christi, *custodias* became objects of collective religious and social prestige for cathedrals and other large religious houses.

Two *custodias*, created by two equally skilled members of the famous de Arfe family of silversmiths, at either end of the sixteenth century, demonstrate the development of this form in Spain and of styles in silver in general. The first, a monumental filigree Gothic structure (fig. 5.38a–b), was made for the Toledo Cathedral by Enrique de Arfe (c. 1475–1545), a German who settled in Spain. Commissioned between 1517 and 1524 (but not gilded until 1595), this *custodia* houses a small late fifteenth-century silver and gold monstrance,

which had belonged to Queen Isabella. It exemplifies in its monumental, filigree splendor the high point of sixteenth-century Gothic. Some sixty years later, in 1587, Enrique's grandson, Juan de Arfe y Villafañe (1535–1603), regarded as the greatest of the *custodia* makers, completed an even larger example for Seville cathedral (fig. 5.39). Consisting of four ascending tiers, each supporting the next by means of proportionate, classical columns, it includes thirty-six typologically linked narrative scenes from the Bible, an array of saints representing the church militant, and sheaves of wheat and clusters of grapes, symbolizing both the Eucharist and the fertility of Seville. The figure of Faith, which originally stood in the center triumphing over the dragon of heresy, was replaced in 1668 by a statue of the Virgin of the Immaculate Conception, a doctrine that had been given papal approval six years earlier. The correct adherence to Vitruvian architectural precepts displayed here is paralleled by the historical self-consciousness de Arfe exhibited in his theoretical writings.

The accession in 1556 of Philip II of Spain marked a shift away from the ornamented plateresque decoration to a more severe, *desornamentado* ("unadorned") form of classicism, exemplified by the palace-monastery-mausoleum complex of El Escorial, built for the king by Juan Bautista de Toledo (d. 1567) and Juan de Herrera (1530–1597) between 1563 and 1584. Even so, within this so-called "unadorned" aesthetic, the apartments and many of the principal public rooms contained polychromed ceramic tile walls, elaborate marquetry doorways, and furniture that evoked the intricacy and splendor of Mudéjar design traditions, each object serving as

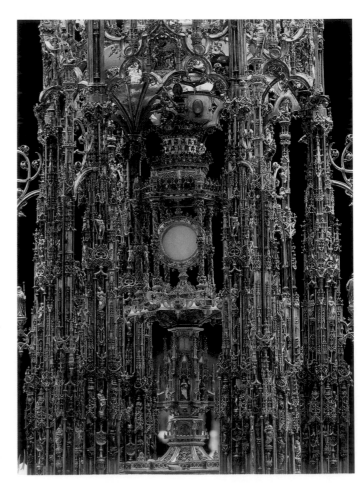

a decorative focal point in its own right. At El Escorial, stamped leather hangings, tapestries, and paintings from Philip's collection were used as the primary decorative elements. The "court style," as it has also been called, set the standard for architecture and interior design well into the following century.

By the second half of the sixteenth century, therefore, across Europe the decorative vocabulary of the Renaissance, in its many local variants, had come to express a broad homogeneity of cultural reference and response throughout the upper echelons of society. Decoration acted as a unifying factor, crossing geographical and political boundaries and establishing through the movement of designers and craftsmen and the easy transportability of printed designs and patterns, a common set of aesthetic and associative criteria. When a design by the Augsburg craftsman Peter Flötner (see fig. 5.15) was used as a source for a bronze relief model by a north German silversmith, which in turn inspired a small silver plaque by a Netherlandish goldsmith to decorate a drinking cup that was subsequently sold in England, the motif and its stylistic characteristics had lost most of the connotations of either original authorship or "national" origin. The consequence was a broadly classicizing style, which earlier in the century had signified to northern Europeans a generally unfamiliar "foreign" culture, but which, as the century progressed, came to proclaim greater adherence to a universally understood, pan-European set of humanist values.

MARCUS B. BURKE, ANDREW MORRALL,
AND MARIA RUVOLDT

Fig. 5.38a–b. Enrique de Arfe. Processional monstrance (*custodia*), Spain, 1515–24. Detail (opposite): interior monstrance by Jaume Almrich. Silver, gold, precious stones; overall, H. 98⅜ in. (249.9 cm). Catedral Primada Santa María de Toledo, Spain.

Fig. 5.39. Juan de Arfe. Processional monstrance (*custodia*), Spain, 1580–87. Silver gilt; H. 10¾ ft. (3.2 m). Catedral de Sevilla, Spain.

THE AMERICAS

Fig. 6.11a

INDIGENOUS AMERICA: NORTH

Imagine a snapshot of North America around the year 1400. Millions of people live on the continent—individuals, families, clans, communities, and nations—linked by overlapping trade networks, alliances, and contact spheres. Political boundaries circumscribing hunting, travel, and agricultural privileges striate the forests, deserts, hills, and rivers. Rivers are super-highways connecting the oceans with almost every corner of the interior: marine shell from the Gulf of Mexico is en route to what is now Boston Harbor; native copper from Lake Superior is traded, first by bark canoes, down to the chiefdoms along the southern Mississippi River; hides, maize, and ceramics are crisscrossing the plains and prairies from east to west. It was a world in motion.

Material objects did not travel alone. They moved with people, who also brought ideas across geographic and cultural boundaries. The shifting and borrowing of designs between and among Native groups was dependent upon particular contexts of exchange. The Potlatch, a ceremonial festival practiced by the Indigenous people of the Northwest Coast, for example, brought guests together in displays of wealth and prestige in which the presentation of elaborately carved and painted crests played an important role. Communal trade fairs, common throughout North America, drew people together, oftentimes women, who traveled many miles to trade objects and admire designs and patterns from different cultures. Warfare or raiding parties provided circumstances in which men sometimes encountered novel objects and designs.

The archaeological record suggests that large political, demographic, and cultural shifts occurred across many parts of North America between the years 1300 to 1400. In the high Canadian arctic, the Dorset people were quietly being displaced by relatively recent arrivals from the western Arctic, the kayak-paddling Thule (ancestors of contemporary Inuit). Along the St. Lawrence River, the Iroquoian people were forming complex political alliances during a period of warfare and upheaval. The Indigenous city of Cahokia, near present-day St. Louis, Missouri, rapidly diminished in size after 1350, and the Navajo may have arrived around this time, or shortly thereafter, to the Four Corners area of the Southwest (Arizona, New Mexico, Utah, and Colorado) after their long migration from the western Canadian subarctic. This was a dynamic world, with goods, people, and ideas in constant circulation and transformation.

In this world in motion, design and decoration played a vital role in the lives of Indigenous peoples. Most all manner of items—from woven baskets to painted pots, from quilled (and later beaded) clothing to tattoos and body adornment, from tools to ceremonial accoutrements—were valued not

Fig. 6.1. Pipe in the form of a mountain lion, Late Mississippian, 1300–1500. Limestone; 1⅝ x 3¾ x 1³⁄₁₆ in. (4 x 9.5 x 3 cm). National Museum of the American Indian, Smithsonian Institution (17/893).

only for their utility and visual pleasure but also because they were embedded with rich and complex meanings. Designs expressed communal and familial affiliations, power, social standing, and identity, and were embedded with beliefs about the natural and supernatural worlds. As familial symbols, crests or spiritual beings, feline creatures, for example, thought to possess supernatural powers, were part of the ceremonial beliefs and world views of many Indigenous peoples, from the American Southeast north through the Great Lakes region, and were reproduced on clothing and other ceremonial objects (fig. 6.1).

Many of the techniques, patterns, and symbols seen in Indigenous American objects today long predate the "New World" arrival of Europeans, who began to have sustained contact with Indigenous peoples during the mid-sixteenth century. Some designs and object types, however, were the result of the often forced encounters between settlers and Indigenous peoples. Before and after contact with Europeans, Indigenous groups traded decorative traditions with each other, giving rise to many shared symbols and practices across the continent. Europeans brought an influx of foreign materials, such as steel and metal alloys, glass beads, and various types of cloths, which were selectively appropriated by Native people because of their appearance, availability or ease of use, and, perhaps most importantly, compatibility with existing traditions. Such processes of incorporating the "new" were not confined to material objects.

Religious, spiritual, and even political ideas were sometimes assimilated, often in a process anthropologists call syncretism (when "outside" concepts are grafted upon or

combined with long-established traditions, preserving dimensions of both). Thus, new materials did not always create a *rupture* with the past. On the contrary, although new materials were borrowed wholesale at times, they were also creatively absorbed in imaginative and hybrid ways that were compatible with existing traditions. In some cases, new materials—such as glass beads—served to expand those traditions of design and textile decoration.

COLONIALISM AND ITS LEGACY: ON NAMES AND NAMING

Colonialism in North America began in the mid-sixteenth century with the establishment of English, Dutch, and French settlements along the eastern coasts in the north and Spanish settlements in the southwest and southeast. The long-term viability of colonial ventures depended upon complex alliances and counter-alliances between settlers and Indigenous peoples, and a recurring feature of these encounters was the back-and-forth trade of goods as well as the reciprocal borrowing of designs. Trade goods served mutually beneficial economic, utilitarian, aesthetic, and spiritual purposes but settlers also introduced new diseases, alcohol, and patterns of conflict, and set in motion the great upheavals, internal displacements, and widespread death that had devastating effects on Indigenous ways of life. Indigenous spiritual practices were denigrated by the earliest Christian missionaries, and conversions accelerated as life grew increasingly dire for Indigenous peoples. In later centuries, as colonial governments continued to appropriate lands away from Indigenous communities, they declared illegal certain ceremonies and gatherings, and restricted the use of native languages, even as late as the twentieth century. The undoing of this colonial legacy and the reclamation of Indigenous histories is now a central task for many Native Americans.

While later chapters will discuss in further detail the affects of colonialism by era, a word about colonialism and naming is warranted at the outset. Many stereotypical and racist depictions of Indigenous peoples, including the view that Native American life either was archaic and unchanging, grew directly out of the European colonial encounter. Likewise, most names that gained currency during the colonial period were exonyms, that is created by "outsiders" rather than self-designated. A political act, naming was embedded in the dynamics of colonial power.

Indian, Native American, or Amerindian? Eskimo or Inuit? First Nations or First Peoples? Indigenous or Native? These and other names are widely used today, sometimes interchangeably, but they must be used with care and according to context. In broad strokes, most Indigenous people in Canada today do not use the word "Indian" (or use it ironically), preferring the self-designated term "First Nations" to distinguish themselves as non-Métis ("Métis" meaning people of mixed European and Indigenous ancestry) and non-Inuit First Peoples of North America. Since the 1970s, the word "Eskimo" has no longer been used in Canada, replaced by the word "Inuit" (meaning "the people"). Although still used in

Alaska, "Eskimo" is currently being overtaken there by the more specific names Yup'ik, Aleut, and Iñupiat. The word "Indian" continues to be frequently used by Indigenous people in the United States, reflected in the naming of the National Museum of the American Indian, a branch of the Smithsonian Institution in Washington, DC, which was developed and named through consultation with many Indigenous curators and historians. There is little consensus to be found in the alternative designations. "Indigenous," "Native," "Native American," or "Amerindian" are all problematic, though for different reasons. Over the past century, the trend has been toward a public recognition of local names, or endonyms. Native communities increasingly use their tribal names, for themselves and also for their land. Throughout this book, both popular exonyms and preferred endonyms are used, as appropriate, for the purpose of clarity for the reader.

PLACE, MATERIALS, DESIGN, AND COSMOLOGIES

Baskets, pots, clothing, and many other objects made by Indigenous peoples are best understood within their larger original contexts, along with earthworks, building types, body decorations, and other expressive forms such as song, dance, language, storytelling, and dramatic performances. Seen this holistic way, it is easier to think of Native designs, motifs, and imagery as belonging to larger systems of representation that constituted elaborate ways of spiritually and intellectually understanding the universe (what anthropologists call cosmologies) and systems of knowledge (epistemologies).

For most Native Americans, Creation stories passed down orally over many generations attest to an ongoing sense of place, belonging, and kinship that is deeply rooted in the land, its local geographic features, and its flora and fauna. Native designs and symbols associated with such stories often illuminate complex relationships among people, animals, plants, and a sacred geography. For instance, the strawberry, one of the first fruits to appear each year in the eastern Great Lakes region, is a symbol of thanksgiving and renewal for the Haudenosaunee (Iroquoian people). In some versions of the Haudenosaunee Creation story, Sky Woman falls from an opening in the sky into the endless oceans below, landing on the back of a great turtle. Pulling up mud from the bottom of the oceans, she creates a large island—the world—and plants tobacco and strawberries, traditional medicinal plants for the Iroquois. Motifs based upon these plants symbolized the ongoing renewal of life and continue to do so.

Materials also had metaphorical or symbolic values. The reflective properties of substances such as quartz, copper, and polished shell were greatly admired by many peoples of the Northeast. Pieces were sometimes sewn onto garments or used in ceremonies and were, for many Native people of the Great Lakes regions, associated with metaphors of light, knowledge, or the ability to "see." For ancient arctic Thule Inuit, materials reinforced gender divisions as well as the conceptual division of the world into the winter and summer seasons. The border design on this pair of snow goggles

(fig. 6.2), which protected the eyes from the harm of reflected solar rays, is similar to the types of banding found in Inuit garments, suggesting a visual continuity between sculptural objects and sewn garments. Ivory from the walrus and other marine mammals, associated mainly with winter hunting on the ice, was used to make the spears and other implements required for seal and walrus hunting, while in the summer, implements made of caribou antler and bone were used on the land to hunt birds, caribou, and other animals. Thus materials took on metaphorical meanings in addition to their functional or aesthetic roles.

Common among many Indigenous groups was a world view that living and nonliving entities are endowed with animate forces or spirits that link human beings, animals, the land, and climate in dynamic relationships. Certain individuals, called "shamans" or "medicine men" by missionaries, possessed a unique ability to see, communicate with, and sometimes influence these forces. Through inheritance or a dream sequence, shamans could acquire a personal guardian spirit, often in the form of an animal, a clan symbol, or a totem (derived from the Ojibwa word *dodem*) that helped identify the hereditary, social, or cosmological position of an individual or family. Shamans and hunters used ceremonial objects embellished with these and other special designs to gain access to the forces that linked the visible and invisible worlds. Such forces could be personified in mythological beings, expressed metaphorically in special goods, or symbolized in highly abstracted images with meanings accessible only to the maker or user.

Design elements found across North America include circles, quadrilaterals, bilateral symmetry, and double-curve patterns, suggesting a widely shared formal lexicon of design. Integrated into many decorative patterns on garments, tools, and earthworks, circles have been linked with the power of the sun, the giver of life. The use of the circle as a design element is plentiful among surviving artifacts, as for example, an ornament at the neck of a figure carved on a Caddoan Mississippian whelk, or conch shell (fig. 6.3).

Ancient ceremonial "sun-circle" plazas, created with markers of wood embedded into the ground in the American Southeast, or the giant circles of rocks that dot the Southern Plains, suggest the veneration of the sun and its life-giving force. Anthropological analogy illuminates potential meanings of the quadrilateral pattern, another recurrent motif, which may reflect the four cardinal directions and therefore function as a cosmogram for the structure of the universe. Likewise, double curves have been interpreted by some as abstracted visions or dreams, or as symbols of the social division of the community into opposing moieties and clans (see figs. 12.2 and 18.5). Used in tandem with appropriate songs, recitations, and dances, objects bearing these designs helped endow individuals with strength and assisted them in their hunting or in communicating with ancestors. Thus design encompassed not only aesthetic but also moral, ethical, and spiritual dimensions, some of which were essential for physical survival.

While a number of basic patterns feature in many Indigenous cosmologies, Native North America was, and remains,

a kaleidoscope of cultural traditions and spiritual beliefs differentiated through language, geography, and tribal histories. Ecologies and geography influenced regional designs, as the people who made objects drew inspiration from the world around them, as they do today. The extraordinarily diverse ecological zones within North America—polar and tundra, boreal and coniferous woodlands, subtropical zones, deserts, dry steppes and grassy prairies, maritime and coastal—often functioned as the mise-en-scène of shared or unshared Creation stories. The Creation story of the Haida, who iden-

Fig. 6.2. Snow goggles, Thule Inuit, 1300–1600. Ivory; L. 4¹⁵⁄₁₆ in. (12.5 cm). Canadian Museum of Civilization (IX-C:4775).

Fig. 6.3. Shell cup with Falcon-Man, Caddoan Mississippian, found at Craig Mound, Le Flore County, Oklahoma, 1200–1400. Whelk shell; 13⅜ x 7⅛ x 5⅛ in. (34 x 18 x 13 cm). National Museum of the American Indian, Smithsonian Institution (18/9121).

tify their ancestral homeland as Haida Gwaii (Queen Charlotte Islands) along the Northwest Coast of British Columbia, for example, involves a curious raven that opened a clamshell after a giant flood, out of which emerged the first human beings. By contrast, in the arid Southwest, in the Navajo Creation story the first man and first woman emerge from a sacred reed within a symbolic hogan, a traditional log and earth home, situated between the four sacred mountains of *Sisnaajiní* (Mount Blanca), *Tsoodzil* (Mount Taylor), *Doko'oosłííd* (the San Francisco Peaks), and *Dibéntsaa* (Mount Hesperus). These peaks make their appearance in ephemeral dry paintings (sandpainting), created during medicine ceremonies.

"MISSISSIPPIAN" DESIGNS

Cahokia was the largest city north of Mexico from about 1050 to 1350. Around 1250, its population of an estimated 40,000 people was comparable in size to London, England. Perhaps 100,000 more people lived in the outlying agricultural areas. No other North American city matched it until the industrial development of the eastern United States in the early 1800s. Temples of wood and thatched grass formed the physical and ceremonial heart of this bustling metropolis. Built upon enormous earthen mounds almost 100 feet above the alluvial flood plains of the Mississippi River, they were created one basketful of soil at a time.

Taken together, the people living in the American Southeast, called "Mississippians" by archaeologists, comprised several distinct language groups but were linked by shared ideas, trade, and common ceremonies. While Cahokia was the largest city, there were many others along the Mississippi River and its tributaries, and there were trade networks ranging from east Texas and Florida in the south, to Wisconsin, Illinois, and possibly even Manitoba in the north. These elite ruling chiefdoms supported a considerable degree of specialized labor related to agriculture, pottery, religion, and carving. Foodstuffs and "prestige" items such as engraved shell and copper objects moved through extensive trade networks.

Fig. 6.4. Feline vessel, Caddoan Mississippian, found at Ouachita Parish, Louisiana, 1300–1600. Ceramic; H. 3 in. (7.6 cm). National Museum of the American Indian, Smithsonian Institution (17/3247).

Archaeologists continue to speculate on what caused the fortunes of Cahokia and other such cities to take a sharp downturn around 1350—resource depletion, broken alliances, climate change, or a combination thereof have all been proposed as possible reasons for this decline. The Mississippian peoples, however, carried on, making a transition to ways of life that were more egalitarian than those that had gone before.

The so-called Mississippian period was over by the start of the 1500s, but the Mississippian peoples left behind a variety of richly decorated objects: utilitarian, ceremonial, and symbolic of political power. Surviving examples show a high degree of attention to form, decoration, and symbolism as well as technical excellence (see fig. 6.1). Mississippian graphic expression involved representations of mythological or costumed beings (usually associated with chiefs and other elite personages) shown with their bodies flattened and heads in side profile. This imagery appears on painted pottery, rendered in repoussé on copper adornments, or engraved on whelk, or conch shells.

The "Spiro birdman," so-named because it was unearthed in a mound near Spiro, Oklahoma—part of Cahokia's vast trade network—is an engraved conch gorget that depicts a masked man with a raptorial beak wearing a heart-shaped loincloth and costumed wings (see fig. 6.3). Zigzagging power-lines emanate from his arms. Most likely, the gorget depicts a "falcon-impersonator" which, according to Mississippian cosmology, is associated with the celestial forces of the life-giving "upperworld." These forces were in a perpetual struggle against those of the watery lowerworld. The birdman and its related set of beliefs, archaeologists speculate, represented the political interests of an elite class, possibly serving as a symbol of Mississippian power against other political classes in society.

Alongside these figural designs, the Mississippian people also used abstract modes of representation, verging on the nonrepresentational. While the engraved ceramic jar in figure 6.4 is feline-formed, it also displays the integration of different modes of decoration creating a dynamic interplay between the regulated, parallel hachure strokes and the sinewy form—a coiled, feathered serpent winding around the vessel. In contrast to the birdman, the imagery suggests an association with the mythological beings of the underworld: horned snakes, panthers, or a creature that combines features of both. Feared by some, the horned serpent was possibly adopted as a symbol of earthly fertility, something of great importance in a culture heavily dependent upon the seasonal cycles of agriculture.

SOUTHWEST PUEBLO INDIAN POTTERY

In the arid American Southwest, between the Rio Grande, the Little Colorado River, and the San Juan River, pottery has played a functional, aesthetic, and religious role for Indigenous peoples for at least 1,500 years. The peoples of this region are now collectively known as Pueblo Indians, a term that relates to the former Spanish presence there (from 1540):

"pueblo," a Castilian word for "village," was used because the Indigenous people lived in permanent apartment-like complexes. The Pueblo Indians trace their origins to the Anasazi (a corruption of a Navajo word meaning "enemies of our ancestors," although they are now referred to simply as Ancestral Puebloans), along with their neighbors, the Mogollon and the Hohokan people. In late prehistoric times, these three groups were joined by the Navajo and other Apachean peoples who migrated into this region from the western Canadian subarctic. Until a major population shift around 1300—possibly caused by climate change—the Anasazi lived in massive, terraced apartment-like complexes nestled into cliff recesses. Shortly thereafter, many Pueblo Indians moved into villages with central plazas (some of which were continuously occupied thereafter). Throughout these periods of change, the Pueblo peoples' complex ceramic traditions were also transformed but continued to play important functional and spiritual roles in their lives.

Painted pottery from the period 1400 to 1600 reveals a common repertory of figural motifs, including birds, masked humans, and other mythological creatures, as well as frogs and tadpoles, dragonflies, ground animals, and plants. Beautifully conceptualized two-dimensional designs decorated the continuous and complexly formed three-dimensional surfaces. The upper half of a Sikyátki polychrome jar (the name "Sikyátki" derives from a protohistoric Hopi archaeological site) is painted with stylized dragonflies, squash blossoms, and corn, arranged in a lyrically repeating pattern around the shoulder (fig. 6.5). The more regular interlocking pattern of geometric shapes and symbols along the jar's belly, which contrasts positive and negative form, introduces a strong visual counterpoint to the overall design. The horizontal line circumnavigating the lower belly includes a ceremonial break, or gap, common in Pueblo vessel design. This feature is known variously as a "spirit path" or "roadline," the latter a translation of the Zuni word *onane* (road). This incomplete line is considered by many Puebloans as a metaphor for life itself, suggesting that earthly life is in a perpetual state of incompleteness.

bic mud shell. The site has yielded thousands of objects for interpretation by archaeologists, historians, and contemporary Makah and Nuu-chah-nulth elders who are descendants of the Ozette people.

A carved cedar box from the site (fig. 6.6), dated around the sixteenth century, features the face of a Thunderbird on the front panel. Executed in red cedar inlaid with sea-otter and fish teeth (valued for their luster and as symbols of wealth and power), it includes characteristics of the shared design traditions of numerous Northwest Coast peoples. Among these are elongated triangle and ovoid forms that define the feathers, eyes, and other facial features of the bird. The various elements are aesthetically arranged in accordance with the compositional rules of the tradition, which include an even distribution of repeating formal elements and an emphasis upon bilateral symmetry. The mythological Thunderbird depicted on the panel is shown in a state of perpetual transformation that evokes the mutability of animal and human spirits, a concept that was shared among many Northwest Coast peoples, who traded goods and ideas extensively prior to European contact.

Fig. 6.5. Seed jar, Protohistoric Hopi Sikyátki, 1400–1625. Ceramic; 8⅝ x 14⅛ x 14⅛ in. (22 x 36 x 36 cm). University of Pennsylvania Museum of Archaeology and Anthropology (29-77-703).

NORTHWEST COAST OBJECTS

The peoples living along the Northwest Coast, from Washington State and British Columbia up through lower Alaska, shared a distinctive style of carving and painting called "formline," which made heavy use of interlocking ovoid, U-form, and trigon shapes to depict zoomorphic and anthropomorphic beings. Formline motifs were painted or carved in low-relief on wooden house poles, ceremonial boxes, masks, and rattles, or woven into baskets and blankets. Few wood or woven objects survive from before the early encounters with English, Russian, and Spanish traders in the late eighteenth century, but many examples from that period were found at a single archaeological site. Excavated in the 1970s, the "Ozette Site" consisted of a prehistorical village on Washington's Olympic Peninsula which had been buried in a mudslide around 1750, allowing artifacts to be preserved in an anaero-

Fig. 6.6. Harold Ides, a Makah elder, with a 16th-century carved red cedar box front found at Ozette Site, Olympic Peninsula, Washington, photographed 1970s. Photo and box front, Makah Cultural and Research Center, Neah Bay, Washington (box front, 27/IV/6).

The kayak (fig. 6.7), perhaps the most recognizable of all Inuit inventions today, is over a thousand years old and traces its origins to the first Thule migrations. Developed for hunting water mammals, fowl, and river-crossing caribou, this low, swift, extremely maneuverable and quiet watercraft was adapted to suit every region of the arctic, according to water conditions and intended use. Most kayaks were light enough to be carried and propelled in the water by one person, typically using one double-bladed paddle. Piloting a kayak required great skill, especially in rough water or when confronting a thrashing walrus or narwhal.

Inuit men carefully shaped the U-form ribs of the kayak's long, narrow hull out of driftwood or bone, and lashed the parts together using sinew (fig. 6.8a–b). Skilled Inuit women braided sinew into strong stringlike threads with which they stitched together seal or caribou hides using bone needles and making overlapping joints, twice-sewn to ensure watertight seams. The women stretched this large skin over the entire kayak armature, pulling it drum-tight to make the vessel seaworthy. In the nineteenth and twentieth centuries, as Inuit traded more frequently with *qallunaat* (non-Native people from the south), they introduced metal components such as nails, wire, and screws into their kayak frames for facility and added durability.

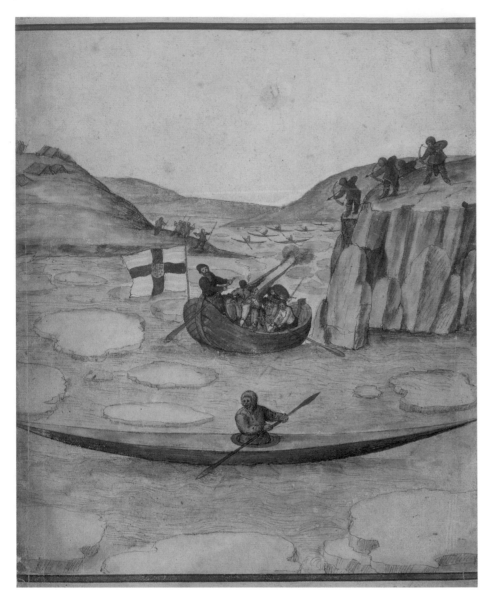

Above: Fig. 6.7. After John White. A skirmish at Bloody Point, Frobisher Bay, in 1577 between Inuit and English, 1585–93. Ink, watercolor; 15³⁄₁₆ x 10⅜ in. (38.6 x 26.4 cm). Trustees of the British Museum (SL,5270.12).

Far right and below: Fig. 6.8a–b. Kayak, overview and detail of interior ribs, Inuinnait, western Arctic, Canada, c. 1913–16. Sealskin, wood, sinew; L. 24½ ft. (7.5 m). Canadian Museum of Civilization (IV-D-1057).

INUIT—A DESIGN FOR LIFE

Around the thirteenth century, groups of Eskimoan-speaking people—ancestors of contemporary Inuit—followed the Arctic Ocean coastlines in an eastward migration from Alaska, eventually spreading over the entire upper rim of North America from Canada to Greenland. Much of this arctic region was already inhabited by at least one other Native group—the Dorset, or *Tunit*, as they were known to the Inuit—that had disappeared from the archaeological record by the fifteenth century in most of the central arctic. The livelihood and success of the Inuit can be attributed in part to ingenious technologies as well as to the deeply entrenched values that helped them adapt to and thrive in a harsh northern climate which, fortunately, was rich in marine life.

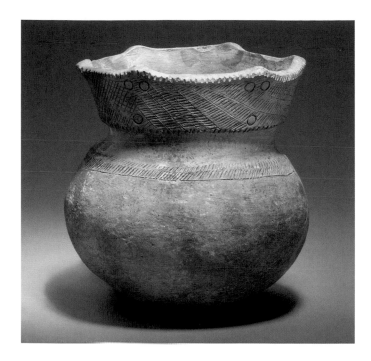

ALGONQUIAN PEOPLES OF THE EASTERN COAST—POWHATAN'S MANTLE

"Powhatan's Mantle," an ornamented deerskin that has been in England since the first half of the seventeenth century (fig. 6.10), was allegedly acquired from the Algonquian Chief Powhatan, near the English settlement of Jamestown, Virginia, before 1609, although it was likely made earlier. Taken to England sometime later, it was in the collection of John Tradescant the Elder, an English botanist and collector, at the time of his death in 1638, making it one of the earliest Native North American objects to have entered a European collection. Consisting of four deer hides stitched together with sinew and embroidered with animal, human, and circular forms in marine shells, it was originally thought by Europeans to have been a sleeveless cloak (hence its traditional moniker) but is now considered to be a hanging that was used for ceremonial or status purposes at the residence of a high-ranking person.

Far left: Fig. 6.9. Pot, St. Lawrence Iroquoian, 1400–1500. Ceramic; 7½ x 7¼ x 7¼ in. (19 x 18.5 x 18.5 cm). Canadian Museum of Civilization (VIII-E:14).

Below: Fig. 6.10. Ceremonial hanging known as "Powhatan's Mantle," probably Algonquian, before 1656. Embroidered deer skin, marginella shells; 92 ½ x 63 in. (235 x 160 cm). Ashmolean Museum, University of Oxford (AN1685.B.205).

IROQUOIAN CERAMIC TRADITIONS

The ancestral land of the Iroquois, or Haudenosaunee ("People of the Longhouse"), is along the St. Lawrence River and eastern Great Lakes in present-day upstate New York and southern Ontario and Quebec. In the fifteenth and sixteenth centuries, families lived in shared longhouses (bark-covered structures with numerous hearths) in communities numbering several hundred people. These communities were the building blocks of the Iroquoian nations, five of which—the Seneca, Cayuga, Onondaga, Oneida, and Mohawk—formed a confederacy in the fifteenth century after the arrival of the Great Peacemaker, a prophet known as Dekanawida. In 1722 the Tuscarora joined the confederacy, thus constituting the Six Nations, a political entity that continues today. The longhouse remains the symbol of this political union, in which six different national "families" live symbolically together as one united confederacy.

Iroquoian men hunted and fished while women undertook domestic duties and tended the "three sisters": corn, squash, and beans. It was most likely the women, not the men, who fabricated and decorated the clay pottery vessels used for foodstuffs (fig. 6.9). Generally rounded in form and portable in size, these pots were fired at relatively low temperatures and were unglazed on the exterior. The upper rims of many of them were incised with decorative patterns of fine, overlapping hachure strokes, circles, and elegant facelike forms. Some jars featured a castellated upper lip, or other embellishments along the contour, which served to heighten the rhythmic incisions along the upper outer edge. Archaeological evidence shows that pottery was widespread among the Iroquoian peoples, traded between communities, and, very likely, of great value.

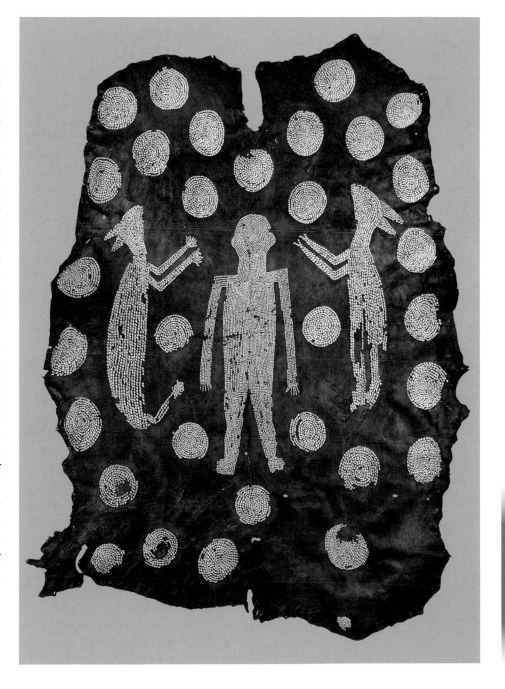

As one of the earliest surviving decorated hide objects from North America, this object offers important clues about the visual traditions and widespread beliefs of the Algonquian-speaking peoples along the eastern coast of America. Archaeological evidence as well as recorded accounts from the sixteenth century provide evidence that marine shell was traded extensively around the Northeast for centuries, long before the Europeans arrived, and was used for jewelry and garment decorating. For the many different Algonquian-speaking peoples in this and the Great Lakes region, shells were valued for their luster and luminosity and likely served as a metaphor for light, knowledge, and the ability to physically and spiritually "see."

The imagery on Powhatan's Mantle, created out of shell stitched into hide, is enigmatic though possibly equally supernatural: a silhouette of a central figure flanked by animals on both sides. Based on the stitching holes, it is evident that the animals had long tails, making them quite unlike local animals such as bears, deer, or dogs. One interpretation is that the two animals represent the "underwater panther," a mythical being that, according to traditional Algonquian beliefs, could be a guardian spirit or alternatively bring misfortune or death. The powerful underwater panther, sometimes depicted as snakelike, or with horns and even wings, is a design motif that can be found on later baskets and beaded clothing from the Great Lakes region. Aspects of this imagery on Mississippian objects far to the south suggest a cultural practice and set of related symbolism that was extraordinarily widespread in eastern North America.

Powhatan's Mantle and its imagery, together with the other objects from the 1400–1600 period, suggest the existence of long-established craft and design traditions in northern America. They help to provide a broad panorama of the rich and complex visual and material cultures in a period for which little physical evidence remains. Surviving objects from later periods (discussed in later chapters) help us to understand this early period better and to recognize how Indigenous design and craft traditions continued while being transformed and hybridized through the seemingly relentless waves of settlers over the next four centuries.

NORMAN VORANO

INDIGENOUS AMERICA: SOUTH

The period from 1400 to 1600, linked elsewhere to what has come to be known as Early Modern Europe and to Ottoman power, was marked by the rise of indigenous empires in South and Central America, and the effects of European conquest. While the rupture of conquest has often been considered the, or at least a, defining moment for native peoples of the Americas, and "loss" has been the leitmotif of much scholarship, there was a considerable degree of continuity of indigenous visual and material culture before and after the arrival of the Spanish beginning in 1492. Nevertheless, ideas, materials, and motifs introduced would thereafter become integral to local practices. After first contact and conquest of the native peoples, multiple interrelationships, tensions, complementarities, and contrasts between existing traditions and new ones took form, many of which are highlighted below.

The focus here is on the works created in two great empires that rose independently of each other, the Aztec and Inka (Inca). In North-Central America, a geographical region now known as Mesoamerica, the Aztec Empire's territory covered much of today's central Mexico. In South America, in a 2,600-mile (4,200-km) band that ran along the Andean mountains, Inka lands included today's Ecuador, Peru, and Bolivia. Both the Aztec and Inka capital cities—Tenochtitlan (now Mexico City) and Cuzco—were founded in the mid-fourteenth century and, as a result of aggressive military expansion, the Inka and Aztecs had established large empires by the mid-fifteenth century, with perhaps 25 million people living in central Mexico, many under Aztec rule, while perhaps 10 million lived in the Inka Empire. Even after the toppling of these empires by Spanish conquistadors between 1521 and 1573, however, objects reflecting earlier indigenous traditions continued to be made under the patronage of the elite indigenous nobles (who were key intermediaries in the colonial states) and of the Roman Catholic Church.

THE AZTECS

Within Mesoamerica, major cities of Nahuatl speakers—Tetzcoco, Azcapotzalco, Cempoala, and Cholula—lay within the tributary zone of the Aztecs (Mexicas). To the south were the less urbanized community-kingdoms of Mixtec speakers. All boasted centers for the production of textiles, ceramics, and metalwork. Within Tenochtitlan, a network of tributaries, who were required to deliver specified goods three times a year to the city, supplied a vast range of raw materials. No form of art or design was more highly prized in pre-Hispanic central Mexico than feather mosaics, which were made from feathers originating in the tropical forests to the south and east. The shield illustrated here (ca. 1500) was probably intended for display as part of a larger ensemble of military regalia, perhaps during a muster of warriors (fig. 6.11a–b).

The center of the shield features a brilliant blue rampant coyote, his body covered with feather symbols, each outlined in thin gold wire, set on an orange-red background. Out of his mouth comes a symbol that twists together two bands: One stands for water (*atl* in Nahuatl, the lingua franca of the Aztec empire) and the other for "burnt thing" (*tlachinolli*). The craftsmanship is extraordinary; the process labor-intensive. The shield was made out of tens of thousands of bird feathers, each carefully pasted onto a background of paper made from the bark of a fig tree and then affixed to a woven reed support.

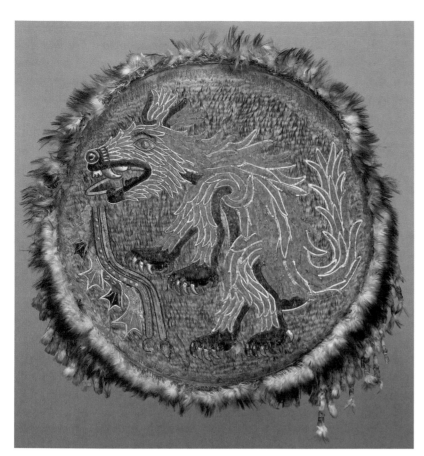 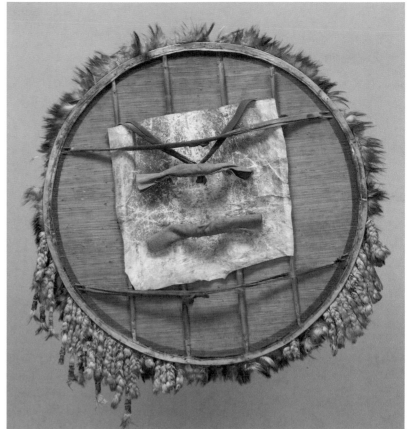

In other feather mosaics, less valuable feathers were dyed to serve as a chromatic background, and rarer feathers, usually iridescent ones, were laid on top to create reflective surfaces. The *amanteca* (feather workers) were specially trained to undertake such work.

The *teocuitlahuaque* (gold workers), who beat out the thin wires of gold that lined the different color fields, enjoyed a similar level of prestige to the feather workers, and like other artisans, had their own tutelary deity, Xipe Totec. Further down on the craft hierarchy were reed workers, who wove together the background support, and leather workers, who supplied the edging and handles (fig. 6.11b). Reed specialists also made much of the furniture used in Aztec palaces and houses of nobles, including chests and seating. Commoners usually only had mats, and tables do not seem to have been used. The demands of elite patrons for a variety of goods involving more than one craft led to groups of specialists living and working near to each other in tightly packed urban neighborhoods of Tenochtitlan (a city of perhaps 150,000 people in 1500), much as they did in contemporary Europe.

While there are elements of naturalism in the visual vocabulary of the shield, it is decidedly tilted toward the iconic. In many of the surviving Aztec objects, there is a close relationship between images and pictographic symbols used as words. In this case, the words *atl* and *tlachinolli* are literally spelled out in the streams of glyphs emanating from the coyote's mouth; together they read *atl tlachinolli*, a metaphor for war. The animal is shown in profile, its limbs arrayed for maximum visual clarity. The brilliant red background, perhaps feathers from macaws, sets off the turquoise of the body, likely feathers from a bird of the blue cotinga family, the

flatness of which is mitigated by the gold dividing wires and the iridescent and changeable surfaces of the feathers. Because the particular materials used to create colors, be they feathers or pigments, carried specific meanings, colors were rarely intermixed. The solar orb, generator of the life-giving heat of the sun, for example, was understood to be brilliant turquoise. The chromatic purity and density visible in this feathered surface is also found in other works from across Mesoamerica. The self-reflexivity—a feathered coyote is literally made of feathers—is also characteristic.

The image of the rampant coyote spewing a cry for war underscores the importance of militarism to the Aztec Empire. The Aztecs gained their first foothold in the Valley of Mexico through mercenary service, and subsequently built a vast tributary empire through military prowess. The army was a crucial factor in the production of many types of decorative arts. The strict sumptuary requirements, whereby successful warriors wore feather suits on the battlefield and luxurious embroidered textile cloaks off of it, kept many craftspeople at work in the capital city. So too did the great amounts of raw materials that poured in as tribute in the wake of military conquests, including feathers and cotton from the tropical lowlands, and jade and gold from points south.

The brilliant, pure colors, rarity of materials, and additive technique used in mosaics were highly valued elements of the indigenous aesthetic system in Mesoamerica. Often made for ritual use, nonfeather mosaic pieces incorporating turquoise, obsidian, and coral were prized. The skull mask shown here likely represents Tezcatlipoca, an Aztec deity, and was probably worn as part of a priest's attire (fig. 6.12). Leather straps were used to tie it to the waist. It is exceptional among

Fig. 6.11a–b. Shield with coyote (obverse and reverse), probably Tenochtitlan (Mexico City), c. 1525. Feathers, gold, agave bark, rattan, wood, hide; Diam. 27 9/16 in. (70 cm). Museum für Völkerkunde, Vienna (MVK 43380).

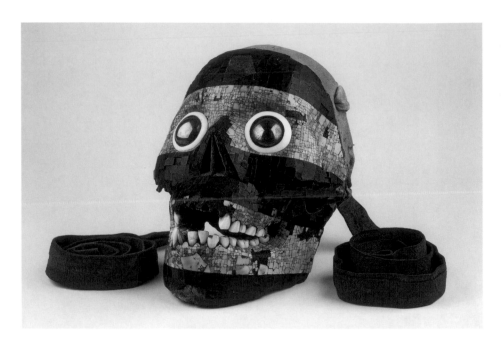

surviving objects for the quality of its workmanship and the variety of materials, all used to create pure chromatic areas. The bright blue band was made from tiny pieces of turquoise, each a different dimension. Many measured no more than two millimeters in diameter and some were cut like cabochons (polished, convex gemstones). Like feathers, turquoise was acquired through long-distance traders, with the nearest source of quality turquoise thousands of miles from central Tenochtitlan. The ones used in this mask, for example, came from mines located in what is now the southwestern United States. The shiny black areas are of lignite while the eyes are made of iron pyrite. These earthy materials were paired with aquatic ones: the rings around the eyes are made from *Strombus* shell (white conch) and the nose from *Spondylus* shell (thorny oyster), a material prized throughout the New World for its red color. Such materials carried metaphoric associations: turquoise, as noted, was allied to the sun and its life-giving warmth; *Spondylus* with blood and regeneration; and conch with the watery, primeval world of the ocean.

For both technical and aesthetic inspiration, Tenochtitlan's craftspeople often looked to objects from the empire's southern districts, including the Mixtec regions. Turquoise mosaics probably began there. Inlaid skulls like the one illustrated were found in elite Mixtec tombs dating to 1000 AD, well before the Aztecs came to power, and this Tezcatlipoca skull mask may have been made by Mixtec craftspeople living in Tenochtitlan. Dominated by community kingdoms, each ruled by a hereditary elite closely knit to other kingdoms through marriage alliances, the Mixtec political, artistic, and manufacturing landscape was different from that of their Aztec neighbors. One career path open to second-rank sons who stood outside the inheritance structure (and there were many in a polygamous society) was to become makers of sumptuary goods that would be given to other elites to cement alliances, particularly as part of dowries.

Mixtec gold objects were also prized. The small corpus that survives (many were melted down by the Spanish for bullion)—mostly jewelry or costume ornaments made using a lost-wax technique—attests to the intricacy and sophistication of both design and execution. Gold jewelry was also depicted in codices made in the Mixtec regions in what is now known as the postclassic period (1000–1520). These books, best known from postconquest examples, were painted on gessoed deerhide and conveyed information via icons and pictographic script. Their subject matter ranged from divination procedures to genealogical records, including dowries and gifts for royal brides. The codex illustrated here shows gold work laid out among the gifts enjoyed by a nuptial couple (top left, fig. 6.13).

While many towns produced ceramics for local use, trading networks of top-quality ceramics had a millennia-long history in Mesoamerica. Within the constellation of cities in the Aztec Empire, the most esteemed ceramics came from Cholula, a region east of Tenochtitlan, the abundant clays of which sustained it as a ceramic center. New World ceramics were low fired and usually burnished or slip-glazed; the chromatic range achieved is visible in the polychrome vessel illustrated in figure 6.14. In the background of this vessel, the ceramist created different color zones using a reddish slip, the burnished orange-red clay, and flat symbol-images colored with a very dark brown slip incised to reveal the ground. Just as with the shield, the floating images are icons: crossed bones connoting sacrificial rituals or the world of the dead; a decorative feather ornament tied with a knot, a hank of plumes protruding from its top. The ornament resembles ones worn by priests impersonating deities and thus suggests the vessel was intended for ritual use. More visually dramatic were the large, sometimes life-sized, ceramic sculptures created as censers or to represent deities. Recent finds in Mexico City show the technical sophistication achieved by ceramists working at low temperatures (fig. 6.15).

Because of the wet climate in Mesoamerica, few textiles from the period 1400 to 1600 survive. In the Aztec Empire, however, tribute was often paid with cloth, and a page from the *Codex Mendoza*, a postconquest book produced by indigenous scribes and painters for a Spanish patron, illustrates the decorated cloaks and feathered costumes to be worn by elites and warriors as demanded by Aztec rulers. Other postconquest books illustrate the elaborate designs embroidered or painted on the cotton mantles used for cloaks. Aztec sumptuary laws dictated both the material and design of one's garments, and throughout the region, both men and women wore garments made from uncut cloth draped, folded, and tied around the body. The complexity of the surfaces more than compensated for these simple forms. *Codex Ixtlilxochitl* shows the ruler of the city of Tetzcoco, Nezahualpilli (r. 1472–1515) wearing a particular kind of tilma, or cloak (fig. 6.16). Made of woven cotton, it was tie-dyed with indigo (an indigenous plant known as *xiuhquilhuitl* in Nahuatl) in a diamond-and-dot pattern. The bright red of the embroidery of the lower border was produced by cochineal dye (one of the largest Spanish-American exports by the end of the sixteenth century). Such clothing was reserved for the highest elite, and sumptuary distinctions were enforced by law: clothing for commoners was to be made of rougher fiber from the maguey plant, a kind of agave that thrives in dry environments.

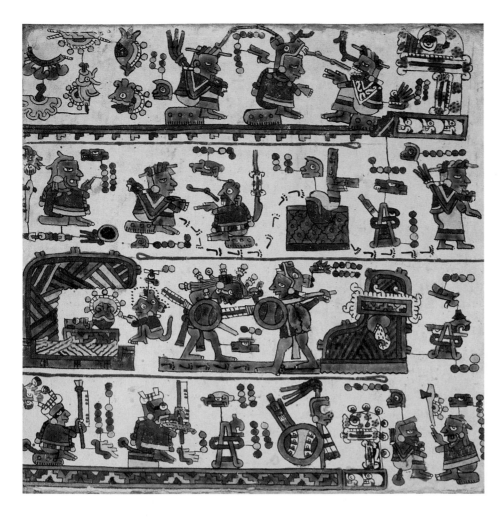

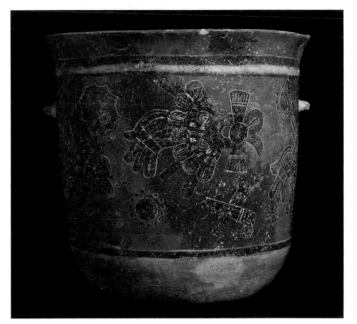

Left: Fig. 6.13. Page from the *Codex Selden*, Mixtec, Oaxaca, c. 1540. Painted deerskin; 10¹³⁄₁₆ x 10¹³⁄₁₆ in. (27.5 x 27.5 cm). The Bodleian Libraries, University of Oxford (MS. Arch. Selden. A. 2, sheet 6).

Below: Fig. 6.14. Vessel, Cholula, Mexico, 1300–1521. Terracotta, pigment; H. 13⁷⁄₁₆ in. (34.2 cm). Yale University Art Gallery (1973.88.43).

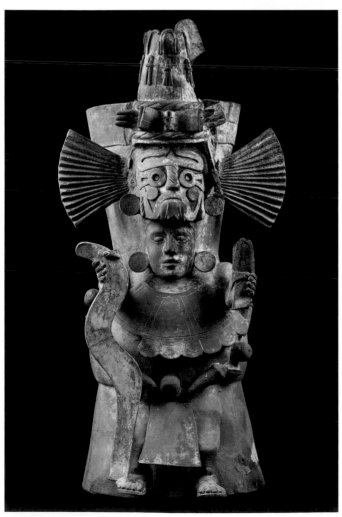

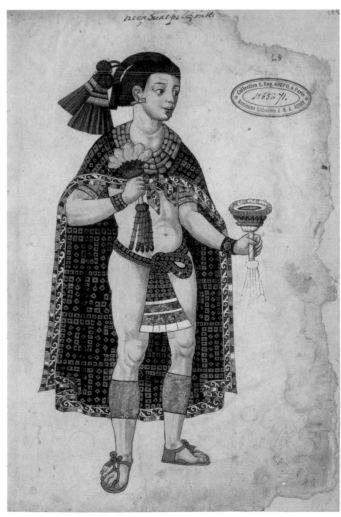

Far left: Fig. 6.15. Urn in the form of the deity Tlaloc, probably Tenochtitlan (Mexico City), c. 1500. Ceramic, pigment. Museo del Templo Mayor, Mexico City.

Left: Fig. 6.16. Portrait of Nezahualpilli in the *Codex Ixtlilxochitl*, probably Tetzcoco, Mexico, early 17th century. Ink and color on paper; 12³⁄₁₆ x 8¼ in. (21 x 31 cm). Bibliothèque nationale de France (Département des Manuscrits, Mexicain 65-71).

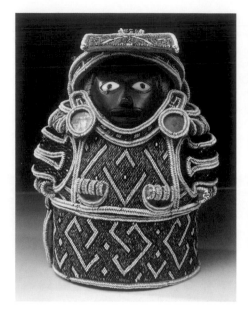 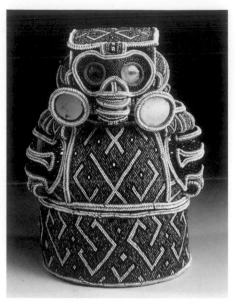

Fig. 6.17a–b. *Zemi* (front and back), Taíno, Caribbean, 1510–15. Beaded cotton, mirror, shell, glass beads; H. 12⅝ in. (32 cm). Museo Nazionale Preistorico Etnografico "Luigi Pigorini," Rome (MPE 4190).

TEXTILES

Even more so than in Mesoamerica, in the highly regimented Inka state people literally wore identity. For high-status men, daily clothing consisted of an *unqo*, a tunic made of a folded cloth stitched at the selvage edges; a headdress; and a cloak worn over the shoulders. The illustration of elite female dress featured here (fig. 6.18) was included in the unpublished manuscript *Historia general del Piru* (1616) by Martín de Murúa, a Spanish Mercedarian friar, one of the two illustrated histories of the Inka to exist from the era. In it a native noblewoman wears a length of uncut woven cloth (an *acsu*); the checkerboard pattern seen at the hem, whose small squares were called *t'oqapu*, was worn only by the highest elite. A *lliclla*, another length of fabric, is draped over her shoulders and fastened with a *tupu* (pin) with a crescent-shaped head. The tripartite design—two wide, yellow decorative borders framing a blue center field—was common.

In the pre-Hispanic period, Andean weavers often used a combination of cotton and camelid fibers, such as those from llama and vicuña; stronger and more tensile cotton fibers served as the hidden warp, with the dye-saturated camelid fibers on the weft. *Qompi*, the highest status cloth, featured elaborate patterns created using a difficult, tapestry-like technique involving discontinuous warps and wefts. After the conquest, Andean weavers absorbed design motifs from the luxurious fabrics imported by the Spanish, including Persian textiles and European lace, and they used iridescent Chinese silk thread in ways accordant with their own techniques and garment types.

Across Central America and the Caribbean, elites used dress and personal adornment to display wealth and rank. The *zemi*, a hollow figure often used as a reliquary for sacred bones, shown in figure 6.17a–b, was created by the Taíno people, inhabitants of the Caribbean who were decimated, if not extinguished, by slavery and epidemic diseases introduced by Europeans. Made shortly after contact with Spaniards, it features green Venetian glass beads around the eyes of the zoomorphic faces and European mirrors for the eyes, although the thinly hammered sheets of gold behind one of the mirror-eyes were made locally. In addition to being a reliquary, the detachable bottom piece of beadwork was likely originally worn as a chieftain's belt. Its pattern can be traced back to Saladoid motifs, produced in Venezuela and the Caribbean some 1,500 years earlier. Because so many works of adornment by the Taíno and other indigenous groups have not survived, this object offers a fleeting glimpse of the magnificent textile traditions in the eastern edge of what would become Spanish America.

THE INKA

The corpus of surviving Andean textiles is one of the richest from the New World. The value of textiles to Andean peoples cannot be overstated. They were a means of remaking political landscapes: the gifting of such luxury goods by a seated ruler created bonds of reciprocity between the Inka state and its tributary populace. Upon learning of encroaching Spanish armies, the soldiers under the command of the reigning Inka emperor Atawalpa (r. 1527–33) chose to burn the massive textile warehouses rather than have them fall into enemy hands. The brutal Spanish conquistadors who led the Andean campaign, however, had little interest in clothing; they wanted gold. They captured Atawalpa and held him for ransom. But although the gold treasure paid them has been estimated to be worth some 50 million dollars at today's rates, they nonetheless garroted Atawalpa on the main square of Cajamarka in 1533.

Fig. 6.18. Rahua Ocllo, wife of the Inka king Huayna Capac, illustrated in Martín de Murúa, *Historia general del Piru*, La Plata, Bolivia, completed in 1616. Ink and color on paper; 11⅜ x 7⅞ in. (28.9 x 20 cm). The J. Paul Getty Museum, Los Angeles (83.MP.159.79).

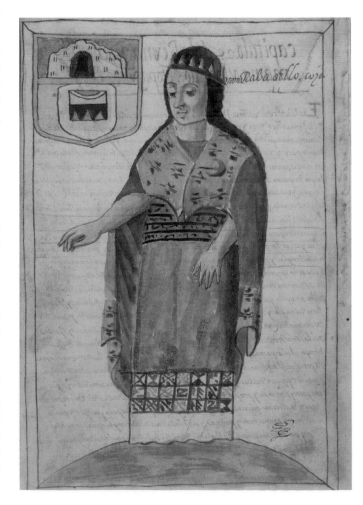

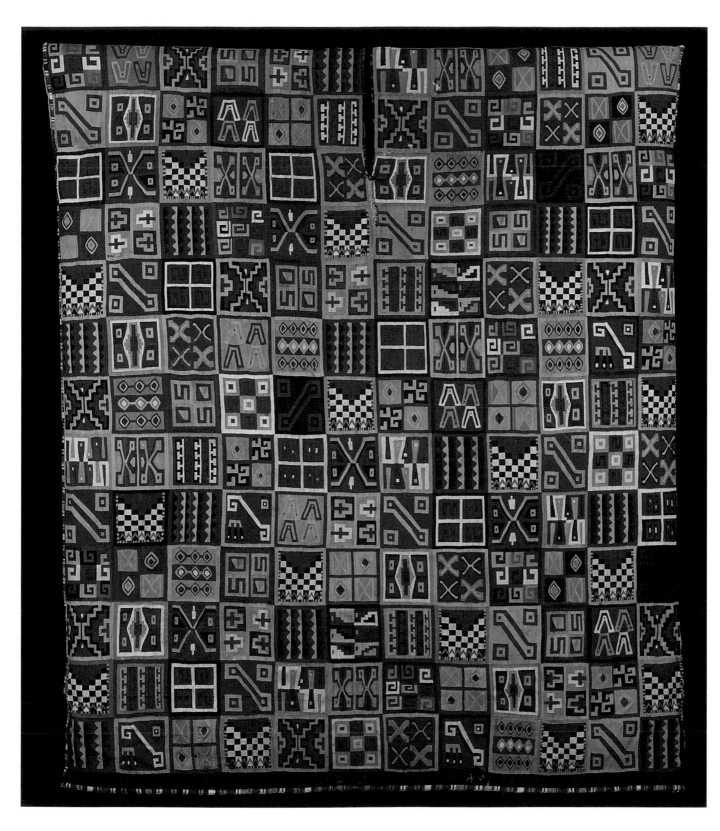

Fig. 6.19. *T'oqapu* tunic, Inka, Late Horizon, Andes, 1450–1540. Wool, cotton; 35½ x 30⅜ in. (90.2 x 77.15 cm). Dumbarton Oaks, Washington, DC (PC.B.518).

The process of weaving, where design units are laid out on a grid, made it easy to play with scale, and such scale-play— a central feature of the aesthetic system—was often used for symbolic purposes. For example, the royal tunic illustrated here is made entirely of *t'oqapu*, some of which are scaled-down designs of other tunics, including ones worn by Inka soldiers and state administrators (fig. 6.19). When worn by a member of the Inka elite, possibly the Inka ruler himself, the tunic allowed him to "wear" the empire, his garment symbolically peopled by the tiny tunics. Scale-play is also apparent at the imperial summer retreat of Machu Picchu, where live rock was carved into sculptures (some

10–13 feet [3–4 m] high) that copied the forms of distant mountain peaks, thus connecting manmade architecture to the natural landscape.

To knit together the vast and disparate regions of their huge empire, Inka rulers bound local elites into a system of reciprocal obligations, often initiating the relationship with gifts so lavish that they could never be repaid in kind, and sponsoring elaborate feasts during which such goods were given. Textiles were the mainstay of this symbolic economy, but also important were paired drinking cups known as *keros* (also *q'eros*; see fig. 12.14), which were given out as tokens of the bonds forged during these feasts.

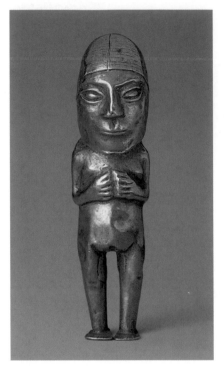

Fig. 6.20. Female figure, Inka, Peru, 15th–early 16th century. Gold; 2⅜ x ⅝ x ⅞ in. (6 x 1.6 x 2.2 cm). The Metropolitan Museum of Art (1979.206.1058).

Fig. 6.21. *Urpu* vessel, Inka, Peru, 15th–early 16th century. Ceramic; 8⅝ x 7⅜ x 5¾ in. (21.9 x 18.8 x 14.6 cm). The Metropolitan Museum of Art (1978.412.68).

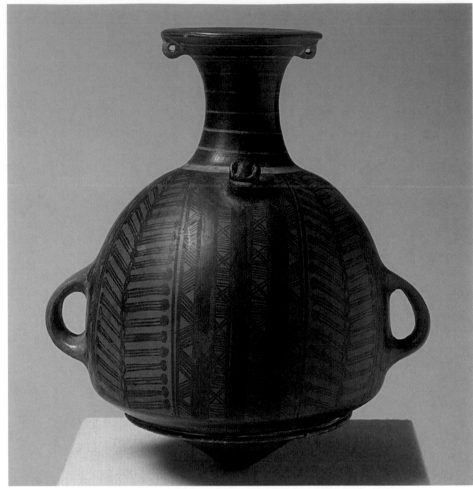

METALWORK

Metallurgy was highly developed in South America in 1400 and metalsmiths drew on designs and technical knowledge developed over millennia. Techniques at their command ranged from simple hammering and repoussé, to lost-wax casting (used mostly in Colombia) and electrochemical replacement plating, which coated objects made of gold-copper alloys with a surface of pure gold by removal of the surface copper. Spanish conquistadors reported seeing an entire garden of gold maize "growing" in the Korikancha, the temple dedicated to the sun deity in Cuzco. Other accounts told of "idols" and images of llamas made from precious metals. A great deal of this Inka gold was melted down into Spanish bullion, and objects that survive are small, hollow figures representing men, women, or llamas (fig. 6.20). Given as offerings at high-altitude mountaintop shrines, they were wrapped in small pieces of woven cloth that may have been more precious than the figures themselves.

Keros were also often made of hammered gold or silver, as well as ceramic and wood. After the conquest, however, less expensive woods predominated, and some were painted with narrative scenes, a practice unknown in the pre-Hispanic period.

CERAMICS

High-quality ceramics were also created as part of the feasting culture. The vessel (the Inka likely called it an *urpu*) seen in figure 6.21 shows patterning typical of that which emerged with the Inka state around 1400. Surface designs, created from slipped (liquid) clay, are repetitive and geometric, and the overall scheme is relatively plain. The quality of manufacture was high. This, and similar ones, were fired in pits or trenches, yet surviving objects show few signs of firing irregularities. Vessels of such size were used to transport and store large quantities of *chicha*, a fermented maize drink used in feasting. The knob and handles allowed a tumpline to pass through the vessel for transport on the head, and the rounded bottom was designed to be set on a sandy floor, so that its contents could be easily poured into waiting *keros*.

Such vessels, with their repetitive and easily copied designs, were probably produced in large numbers under the watchful eyes of master craftsmen in centers staffed by tributary labor. Huánaco Pampa, in highland Peru, was one such center. Built about 1475, following the Inkan conquest of a region some 400 miles (600 km) to the north of the capital, its four thousand structures included large feasting halls. Some fifty establishments—staffed by a rotation of men and women from the larger region who paid tribute with their labor—were devoted to manufacturing high-quality textiles and brewing *chicha*. Upon the execution of Atawalpa, these temporary workers left the center of Huánaco Pampa and decamped to their permanent homes.

THE EARLY COLONIAL PERIOD

The Spanish conquest took much of the sixteenth century, from the first landing in the Caribbean in 1492 to the execution of the last claimant to the Inka throne in 1572. But because Spanish colonists and priests depended on native elites to maintain order and deliver tribute, the indigenous patronage networks were never entirely dismantled and were sometimes even buttressed by the demands of a new set of ecclesiastical patrons. Crucial to the survival and development of indigenous high-status objects was the maintenance of the supply networks for raw materials.

Although turquoise mosaics from after conquest are virtually unknown (perhaps because of the collapse of the trade networks linking Central Mexico to the American Southwest), feather mosaics flourished, finding favor with both members of the church and wealthy conquistadors alike. The skull mask described above (see fig. 6.12) came from a European collection assembled quite soon after the conquest. Indeed, many of the most splendid objects surviving from Mesoamerica—including featherwork and codices—were sent to Europe between 1521 and the 1570s as diplomatic and ecclesiastical gifts. The great encyclopedia of Aztec life written by native elites under the patronage of the sixteenth-century Franciscan friar Bernardino de Sahagún recorded that, around 1570, anyone interested in learning about featherworking "will be able to see them with their own eyes" in Mexico City.[1]

An image of the mass of Saint Gregory, created entirely out of feathers pasted on a backing, illustrates how aspects of preconquest material culture continued and were transformed (fig. 6.22). The central image of a miraculous vision of Christ was likely based on a northern European fifteenth-century print that had probably made its way to Seville through Netherlandish trade networks centered on Antwerp, and from there to New Spain, along with hundreds of other books and paintings.

The text that frames the feather image allows us to reconstruct how it was made. Arriving in Mexico-Tenochtitlan, as the early colonial city was rechristened, the print would have come into the hands of one of the city's most powerful Franciscans, Peter of Ghent (Pedro de Gante), a confidant of Spain's King Charles V (r. 1516–56). He joined with the indigenous governor of the city, Don Diego de Huanitzin—nephew and son-in-law of Motecuzoma II (r. 1502–20), the last independent Aztec emperor—to sponsor the feather image as a gift to Pope Paul III, whose name is inscribed along with those of the others. It may have been made in San José de los Naturales, one of the two Franciscan schools established in Mexico City where "mechanical" arts were taught to young native men. Feather mosaics continued to be made in the New World, but the images grew simpler over time, drawn from devotional prints featuring a single saint or the Virgin and child, and by the eighteenth century were made for largely local markets.

While this feather mosaic adhered to traditional methods of manufacture, the quick absorption of European imagery by indigenous craftsmen paralleled an embrace of imported technologies. In ceramics, glazes were adopted, as were closed kilns. Perhaps most importantly for the development of textiles in the Andes, a wider loom powered by foot treadles was introduced, thereby enabling the faster production of wider textiles and reducing the cost of fabric. Often, the high level of craftsmanship that the indigenous elite demanded of their textiles, feather mosaics, and metalwork was undercut; new Spanish-born patrons or their American-born offspring shared few of the same cultural or aesthetic expectations for such objects. Postconquest, artisanal labor was funneled increasingly into new types of work, particularly the large gilded retablos and painted wooden sculptures used to decorate churches. Although indigenous Andean elites still demanded, and wore, textiles of a traditional style through the seventeenth century, other Andeans used simpler homespun cloth and, later, textiles made in large workshops on treadle looms.

By 1600, the indigenous population was severely weakened and reduced as a result of epidemic diseases, and the Spanish and Creole elite had a firm hand on the political reins of much of the so-called New World. But native artisans and artisanry were not extinguished. As the indigenous population rebounded over the course of the seventeenth century, native peoples took up afresh the challenge offered them by the new materials and techniques that they saw in imported goods, while developing entirely new classes of objects for wealthy patrons.

DANA LEIBSOHN AND BARBARA E. MUNDY

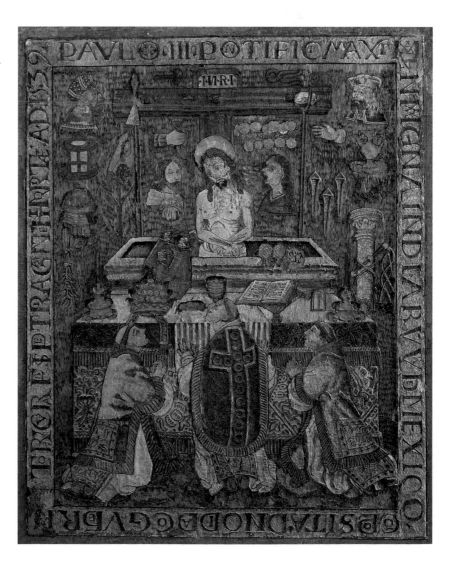

Fig. 6.22. School of San José de los Naturales. *Mass of Saint Gregory*, Mexico, 1539. Feathers, wood; 26 ¾ x 22⅛ in. (68 x 56 cm). Musée des Jacobins, Auch (986.1.1).

In October 1492, just months after Spain's Catholic Monarchs Ferdinand of Aragon (r. 1475–1504) and Isabella of Castile (r. 1474–1504) conquered Iberia's last sovereign Muslims and expelled its long-settled Jews, their Genoese seafarer Christopher Columbus, seeking a new trade route to Asia, landed on a Caribbean island he believed to be the Indies and claimed it for the Spanish crown. As the reality sank in that this was, for Europeans, an entirely new world, Columbus's "discovery" initiated the most lethal but perhaps ultimately fruitful encounter of peoples and civilizations in human history. Indigenous Americans and arriving Europeans met, in part, through their respective material cultures. In 1519, the Spanish explorer Hernán Cortés, on his way to conquer Mexico, received fine featherwork and cotton cloaks from Moteuczoma II's (r. 1502–20) ambassadors—likely similar to those illustrated in figures 6.11a and 6.16. He reciprocated by sending the Aztec emperor a crimson velvet cap and a carved and painted *silla de caderas* (X-framed chair) of a type descended from the Roman curule throne. Spanish clothing and furniture thus entered Tenochtitlan even before Spanish conquerors, heralding a vast exchange of goods—from food, drink, and household implements to precious metals and luxury objects—that paralleled the movement of peoples.

If this encounter often resulted in blending and hybridization, it also reinforced political and cultural division. As late as 1615, the native Andean chronicler Felipe Guaman Poma de Ayala (1534–1615) distinguished Peru's royal treasurer from an Indian *cacique* (leader) or official (fig. 6.23), not just through posture and attire but by detailing the spindles and tenons of the official's *sillón frailero* (friar's armchair; see fig. 5.35). Like the hierarchies they embodied, these visibly Spanish forms exemplified what the seventeenth-century Spanish Jesuit Baltasar Gracián termed "portable Europe"—a complex not just of new tools and technologies but new habits and ideas that transformed life in the Americas.[1]

As rivals for overseas dominion, Spain and Portugal took alternate approaches to empire building. A series of papal pronouncements and treaties between 1481 and 1529 effectively divided the globe into Spanish and Portuguese sectors, with the former granted rights to the Americas and the latter to Africa and much of Asia. Yet whereas Spain moved to consolidate territory, Portugal crafted a largely maritime and mercantile empire via networks of coastal forts. In 1500, the European discovery of Brazil, which was first thought to be an island, east of the treaty meridian, by a navigator bound for India gave the Portuguese a beachhead in South America. There, they traded for *pau-brasil* (ember-wood) from the rain forest—the source of a valuable red textile dye that soon gave the fledgling colony its name. Working from fortified outposts, fifteen privately chartered commercial captaincies (hereditary fiefs) established in the 1530s introduced sugar cultivation using first native, then African slaves. Only after most captaincies failed was a royal capital established at Salvador de Bahia in 1549 (transferred to Rio de Janeiro in

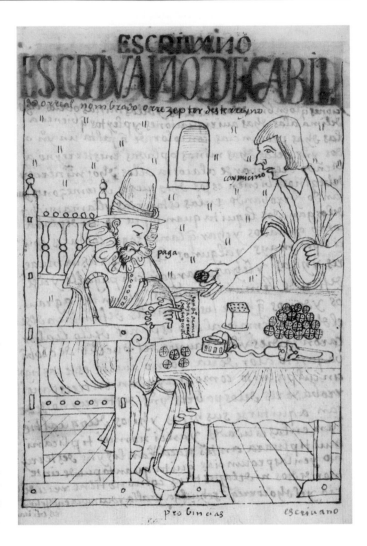

1763), although a single viceroy was not appointed until 1775. Portuguese Brazil thus remained decentralized, sparsely populated, and focused on the coast until the gold rush of the 1690s pulled settlement southward into Minas Gerais. Surviving visual and material culture is likewise scanty until city foundation began in earnest in the seventeenth and eighteenth centuries.

Permanent settlement started much sooner in the larger, western portion of the hemisphere under Spanish control. Santo Domingo was established on the island of Hispaniola (1496) by Columbus's brother Bartholomew, and Havana on neighboring Cuba (1514), where the superb harbor made it a natural entrepôt. On the mainland, the conquest of Tenochtitlan in 1521 inaugurated the transformation of the Aztec (Mexica) capital into a European-style metropolis. New Spanish cities were founded at Antequera (Oaxaca), laid out in 1529 and declared a city in 1532; Puebla de los Angeles (1531); Guadalajara and Mérida (both 1542); and Santiago de Guatemala (reestablished in 1543), many employing the expandable urban grid codified in Philip II's (r. 1556–98) "Ordinances of Discovery, New Settlement, and Pacification of the Indies" (1573). The subjugation of South America was sealed when Francisco Pizarro and Diego de Almagro

defeated the last Inka ruler, Atawalpa, in 1532 and captured Cuzco the following year, though continuing resistance delayed the consolidation of Spanish rule until the 1570s. While Cuzco, too, was gradually rebuilt on European models, Pizarro's new capital rose near the coast at Lima (founded in 1535 as La Ciudad de los Reyes, the City of Kings), soon joined by Quito (1534), Asunción (1537), Bogotá and Sucre (1538), Arequipa (1540), and the Andean mining town of Potosí (1545), a major source of "New World" silver.

Following a system tested in southern Italy, the Spanish crown governed its vast holdings through two royal deputies or viceroys, assisted by regional *audiencias* (appellate courts). The Viceroyalty of New Spain, established in 1535 and governed from Mexico City, encompassed a large part of North America, including not just present-day Mexico and Central America but much of what would become the southern and western United States as well as the Caribbean islands of Cuba, Hispaniola, Puerto Rico, Jamaica, and Trinidad. The addition of the Spanish East Indies in 1565, headquartered in Manila (established 1571) and including the Philippines, the Mariana and Caroline Islands, Taiwan, and part of the Moluccas, made New Spain a global entity with a globalized material culture. In South America, the sprawling Viceroyalty of Peru (founded in 1542 as the Viceroyalty of New Castile and later subdivided to include the viceroyalties of New Granada and the Río de la Plata) stretched from Panama to the Tierra del Fuego, encompassing all but Portuguese Brazil. Throughout this broad and culturally diverse zone, the decorative arts—indeed, the arts in general—proved central to the project of transplanting Iberian culture to America and linking the new possessions to expanding worldwide empires.

DESIGN AND AUTHORITY: METROPOLITAN CHURCHES

The arrival of Europeans disrupted native religious systems as Christian invaders destroyed indigenous temples, "idols," and manuscripts in a campaign that many participants saw as a sequel to the Catholic reconquest of Spain: the Hieronymite monks sent to evangelize the Antilles referred to their inhabitants as "Moors," while Cortés termed Tenochtitlan's temples "mosques." From the beginning, royal authorities pursued the twin goals of converting the natives to Christianity and establishing metropolitan churches for the colonists, both often on or near precontact religious sites. Whereas rural complexes often fostered cultural exchange, their urban counterparts—European in form and audience and tightly supervised by the crown—embodied royal authority while reflecting Iberia's own stylistic diversity.

The western hemisphere's first cathedral, whose present building was begun in Santo Domingo in 1521 by an Italian humanist bishop, was constructed and decorated by Spanish-trained craftsmen following plans sent from Seville, the administrative center and main point of embarkation for the "Indies." The design relied heavily on late medieval modes; its square bays, ribbed vaulting, ogee arches, Gothic canopies, and cusped pinnacles conforming to the Isabelline style (then termed "modern") were still current in Iberia. Given the settlers' confusion over native religions, not to mention repeated,

if ineffective, restrictions on emigration to "Old Christians" (thereby excluding converts from Judaism or Islam, and their descendants), it might seem odd to encounter ornaments with Moorish pedigrees, including abstracted pearl moldings recalling bronze or iron nailheads. Yet these so-called Mudéjar features were part of a widespread Spanish taste for Islamic-inspired design that ranged from ornamental tiles and bricks to the fine structural woodwork known as *carpintería de lo blanco* (see figs. 5.31, 12.25). The latter was widely used in Ibero-American churches, most notably the intricate, coved wooden ceilings known as *artesonados* from their resemblance to *artesones* (kneading troughs), typically formed from grids of intersecting beams termed *alfarjes* (from the Arabic *al-farsh* [carpet] or *al farkh* [space between]) and adorned with starlike lattices called *lacerías*. Although most early examples are lost, the late sixteenth- or early seventeenth-century trapezoidal *artesonado* crowning the choir of the convent church of San Francisco in Quito, with its complex interlacing and pendant bosses, exemplifies the technical demands of assembling thousands of pieces of wood without the use of nails (fig. 6.24). Whether or not such Mudéjar echoes explicitly invoked a New World *Reconquista* for the craftsmen and their patrons, as some scholars have suggested, they were unequalled testaments to American artistry.

At the cathedral at Santo Domingo, medieval and Mudéjar features coexisted with ornaments in the Renaissance or "Roman" style, including elements today termed plateresque for their resemblance to the products of contemporary silversmiths (*plateros*). On the main portal, for instance, statuesque saints standing in shell-headed niches are flanked by pilasters with floriated candelabra, masks, sphinxes, and weapons; above, perspectively foreshortened entrance arches support a frieze of putti and acanthus-dragons also inspired by classicizing Italian models. Similar plateresque motifs dominated the lavish mahogany choir stalls and episcopal throne (inscribed 1540, now partly demolished), which featured low-relief figures of St. Peter and *Ecclesia* (an allegory of the Christian Church), cherubs, wreathed busts, and fish-tailed tritons derived from ancient grotesques—"excellent Roman-style carvings" that the island's resident chronicler Gonzalo Fernández de Oviedo judged equal to examples in Toledo and Seville. Oviedo was just as enthusiastic about the stalls' construction from two shades of native mahogany ranging from silvery brown to a deep reddish-purple, which he termed, respectively, "oak" (*roble*) and *caoban* (after an indigenous term) and praised as ideal for making "very handsome" tables and chests (*caxas*) as well as doors, planks, and ornamental beams.[2] With its strength, large available dimensions, rich figuring, and suitability to detailed carving, mahogany quickly became one of the Spanish West Indies' most valuable exports and a preferred wood for furniture throughout Europe and its American colonies.

A Spanish-born craftsman was also responsible for fabricating the silver Eucharistic coffer presented to the cathedral in 1579 by Doña Juana de Mesa, identified in a prominent inscription as the wife of the island's constable and accountant (fig. 6.25). Tomb-shaped, like a medieval chasse (reli-

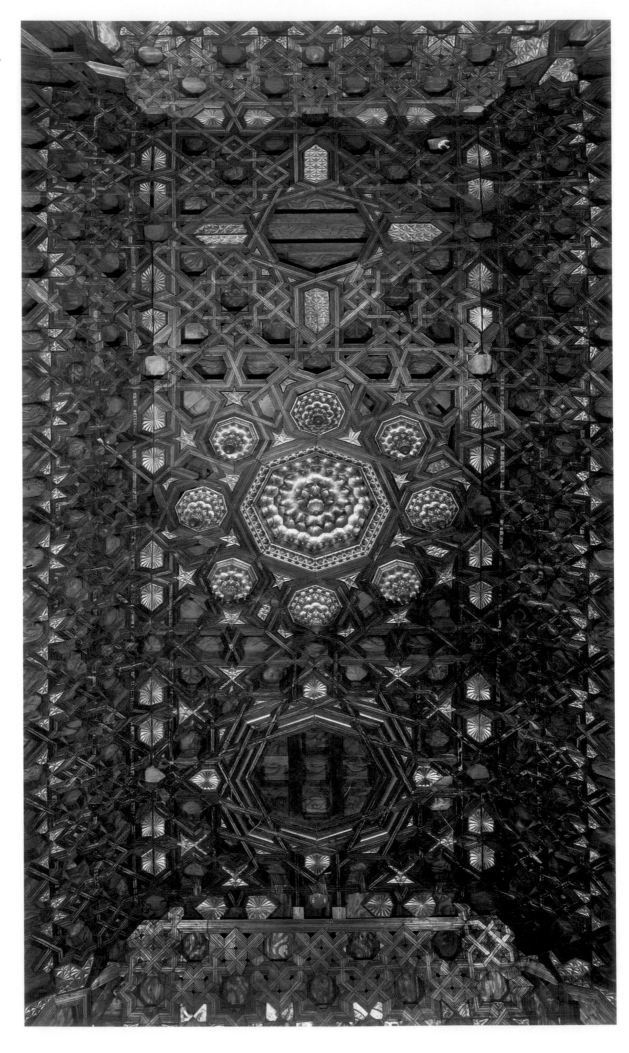

Fig. **6.24.** Mudéjar-style ceiling (*artesonado*), church of San Francisco, Quito, late 16th or early 17th century. Carved, painted, and gilded wood.

quary casket) and bearing an image of the Crucifixion, the coffer was designed to house the consecrated host—believed to be one with the body of Christ—in an elaborate shrine erected annually on Holy Thursday. Reflecting Post-Tridentine practices, the contents could be displayed for adoration by lowering the hinged front panel, as in a contemporary *escritorio* (desk; see fig. 5.36). The engraved decoration, however, echoed the cathedral's classicizing ornament: on the body of the coffer, twelve statuesque apostles appear under shell-headed niches as on the facade and choir stalls, while on the lid, winged angels bearing the instruments of the Passion are separated by spiral columns matching those in the apse itself. A rare survivor of the city's sack during the Anglo-Spanish War (1585–1604), the coffer suggests the settlers' commitment to importing both familiar devotions and the latest architectural and design styles.

Similar imperatives guided the growth of Mexico City, which by 1550 supplanted Santo Domingo as New Spain's administrative capital. Cortés had founded the city's cathedral in 1524 as a modest, flat-roofed basilica, setting octagonal wood columns (another Muslim legacy) atop blocks removed from the Aztec pyramids as if to literalize Christian triumph over idolatry. Rebuilt in stone on a sober but imposing Renaissance plan from 1573, the Catedral Metropolitana became the largest and perhaps grandest building in colonial America. Its furnishings were equally impressive, beginning with an elaborate velvet gremial (a lap cloth used at high mass) embroidered around 1539 for Mexico's first bishop, Fray Juan de Zumárraga, by the bishop's nephew and an unidentified but expert indigenous assistant (fig. 6.26). Like the featherwork *Mass of St. Gregory* (see fig. 6.22), the gremial featured the *Arma Christi* (arms of Christ) expressive of his Passion, including the cross, crown of thorns, lance, sponge, nails, silver coins, and tomb. Further shields in each corner bear Christ's five wounds, while jewel-like wreaths and the knotted ropes of the Franciscan habit (themselves symbolic of the friars' vows) fill the blue velvet field. Used in the cathedral before an exclusively Spanish audience, the gremial's sacred heraldry echoed European tradition. Yet in the context of Spanish America, the design's investment of everyday objects with intense symbolic meaning heralded a search for effective ways to communicate with a vast, nonliterate population.

The growth of Mexico's cathedral treasury tracked the viceroyalty's exploding fortunes. By 1541, it owned five silver chalices (one in the Gothic style with bells and paten), a silver censer, incense vessel, crucifix, verges (staffs of office), cruets, candelabra, and a gilded pyx (small box to hold the consecrated host) with enameled coats of arms and griffin-shaped handle. By 1588, the treasury boasted two multistory processional *custodias* (monstrances enclosing the sacred host) fabricated of silver (see figs. 5.37a–b and 5.38): one "old," perhaps brought from Spain, and one "rich and new," commissioned by Mexico's archbishop, weighing over 300 troy pounds (110 kg) and adorned with figures of the prophets, evangelists, Church Doctors, and St. Michael defeating the devil. By 1600, the cathedral had also acquired twenty-two imported tapestries narrating the stories of King Saul, Judith and Holofernes, and the acts of Solomon, together with one

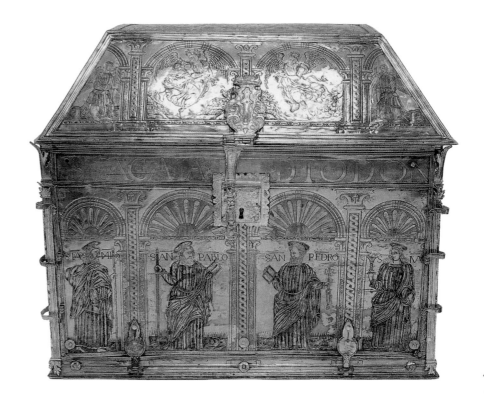

particularly precious panel depicting the Incarnation. Both silver and silk were central to the lavish public festivals, most notably for the Feast of Corpus Christi, that echoed precontact ceremonies and helped forge colonial society. Paraded past sacred tapestries over grounds once used for indigenous rites, the cathedral's costly *custodias* reinforced Christian and royal hegemony while fostering participation across the social spectrum.

Fig. 6.25. Eucharistic coffer, probably Santo Domingo, Hispaniola, 1579. Silver; 18⅜ x 20½ x 13¼ in. (46.5 x 52 x 33.5 cm). Cathedral of Santa María la Menor, Santo Domingo, Dominican Republic.

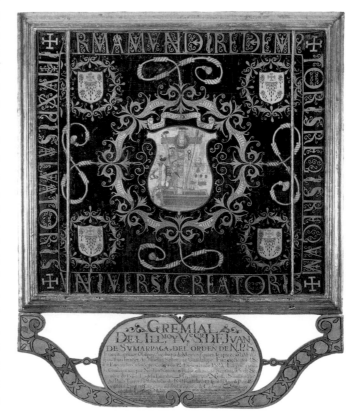

Fig. 6.26. Attributed to Sancho García de Larraval. Framed and mounted gremial of Archbishop Juan de Zumárraga, Mexico City, c. 1539. Velvet, silk appliqué, gold, silver, and silk threads; 44½ x 39¾ in. (113 x 101 cm). Museo Nacional del Virreinato, Tepotzotlán (10-12571).

Fig. 6.27. Chalice, Mexico City, 1575–78. Silver gilt, rock crystal, boxwood, hummingbird feathers; H. 13 in. (33 cm). Los Angeles County Museum of Art (48.24.20).

CRUCIBLES OF ACCULTURATION: MENDICANT SCHOOLS AND MISSIONS

While European immigrants strove to replicate familiar patterns of life, many native communities were decimated by foreign diseases or brutally enslaved by new overlords. The impact varied widely: on Hispaniola, the precipitous collapse of indigenous Taino and Arawak populations—in 1516, the island's new governors described the island as fruitful but nearly empty—meant that Iberian-trained craftsmen followed almost exclusively European models. On the mainlands of North and South America, by contrast, and particularly in highland Mexico and Peru, far denser indigenous populations with highly developed craft and design traditions fostered enduring cultural and aesthetic negotiations between native and European artisans. The key steps toward integration were taken not by the cathedral clergy but by the mendicant or begging orders (so named for their members' commitment to poverty), which assumed the task of converting native inhabitants to Christianity and protecting them from rapacious settlers. In New Spain, the first group to arrive were the Friars Minor or Franciscans, whose first twelve missionaries—evoking the twelve apostles—landed in 1524, followed by the Dominicans (1526) and Augustinians (1533). In Peru, the Dominicans (1532) arrived first, then the Franciscans (1535), Mercedarians (1533), and Augustinians (1551). Despite differences in taste and temperament, all these orders fostered artistic activities and projects that helped bridge ethnic and cultural divides.

One of the mendicants' key contributions was to provide religious, liberal, and artisanal education to indigenous students, beginning with the school of arts and crafts established in 1529 at the chapel of San José de Belén de los Naturales within the Franciscan complex in Mexico City. Founded on the site of the Aztec *totocalli* (aviary) by the Flemish lay friar Peeter van der Moere of Ghent (1490–1572, known as Pedro de Gante), a relative of Charles V of Spain (r. 1519–56), the school at San José employed European, native, and mestizo (mixed race, European-indigenous) instructors to teach artistic, craft, and performance skills useful to evangelization, including European-style painting, carving, writing, bookbinding, bell-smelting, and religious singing, as well as trades such as carpentry, cabinetmaking, metalsmithing, embroidery, and jewelry making. The initiative was echoed in an Augustinian trade school for the Purépecha in Tiripetío, Michoacán, and Dominican craft schools for the Mixtecs and Zapotecs in Yanhuitlán, Oaxaca, all established in the 1540s. Additional Franciscan schools were opened at Maní and Mérida in the Yucatán, and in Quito, where the Flemish polymath Fray Jodoco Ricke (1498–1575) established the Colegio de San Andrés (1549) to teach Quechua and Aymara Indians, mestizos, and poor Spaniards painting, sculpture, wood- and metalworking, watchmaking, weaving, and the fabrication of shoes, hats, and clothing. The new ideas, idioms, materials, and forms introduced at such schools reverberated throughout Spanish America: *Mulattos of Esmeraldas*, for instance (see fig. 12.7), was painted by an Andean artist trained at the Colegio de San Andrés.

Besides introducing European tools and techniques, mendicant schools redirected indigenous arts and crafts for Christian use across ethnic lines. While Nahua "picture writers" (*tlacuiloque*) at the prestigious Royal College at Tlatelolco drafted illustrated chronicles documenting native civilization and the Spanish Conquest, feather mosaicists (*amantecas*) at San José crafted devotional pictures portraying Jesus, Mary, and the saints, as well as liturgical objects including episcopal miters and stoles (many depicting the Tree of Jesse, or Passion and Resurrection scenes derived from European prints), ornamental covers for precious reliquaries and chalices, and paxes or osculatories (small images to be kissed by the congregants before Communion). Many were destined for European patrons: the *Mass of St. Gregory* (see fig. 6.22), for instance, was produced under Pedro de Gante as a gift for Pope Paul III, who had proclaimed in 1537 that Indians were rational beings with souls and thus had the right to receive the sacrament. Like other objects from convent schools, feather objects spoke bilingually. Whereas European viewers were awed by these objects' unaccustomed materials and display of artistic skill—Fray Toribio de Benavente averred in 1540 that such "rich and very brilliant works" would be admired in Italy and Spain "with open mouths," just as they were by "those who are newly arrived"—Nahua viewers who read iridescence as a sign of the sacred may have associated featherwork images of Christ and martyred saints with the ritual pluming of preconquest sacrificial victims.[3]

The schools' fusion of native and imported traditions helps explain ambitious and distinctive liturgical objects, such as a

chalice made and marked in Mexico City around 1575 (fig. 6.27), presumably in a Spanish-run shop. Following Gothic and Renaissance models, the gilt silver cup and foot are cast, chased, and engraved with Passion scenes, while the image of a helmeted conquistador, perhaps a portrait of the patron, is concealed within the stem. This imported framework is embellished with indigenous materials, including columns and knobs of rock crystal like those used in Aztec jewelry, as well as minute boxwood carvings depicting further episodes from the Passion (on the foot) and the apostles (on the stem) set against mosaics of hummingbird feathers under glass domes, as in contemporary devotional pendants and portable triptychs. While the carvings—comparable in scale and complexity to European prayer nuts—might have been made by Spanish specialists, the presence of feathers suggests that they were produced by indigenous craftsmen who had learned the craft from Flemish monks and were now selling to, or working for, European masters.

A similar melding characterized Spanish-style altar crosses on rock crystal skulls or silver bases teeming with native plants and animals that imply indigenous work. Others defy clear categorization: according to a 1549 inventory, Cortés's private chapel in Cuernavaca featured "a gilded cross with its figure and base of silver, all gilded, which they say was made by Indians"—a reminder that authorship was not always clear even to contemporaries.[4]

No less important than the mendicants' craft schools were the hundreds of provincial convents and missions (*doctrinas* or *congregaciones*) they constructed throughout the Americas as anchors of a utopian Indian republic, or "Jerusalem," parallel, at least conceptually, to the republic of the Spaniards. These, too, became sources of artisanal production and sites for cross-cultural exchange. Begun as simple adobe sheds, these complexes were rebuilt from the mid-sixteenth century as massive, fortress-like structures of rammed earth, a project fueled by the friars' millennial conviction that converting the Americas would usher in Christ's Second Coming and the establishment of God's kingdom on earth. Their ground plans bespoke outreach and conversion, featuring a broad patio or *corral* (now generally termed an atrium) designed to shelter native catechumens under orderly shade trees, with corner chapels used during processions, monumental crosses, and open-air pulpits. Laid out in ways that echoed both preconquest temple precincts and Iberian mosque courtyards, these sites of invitation and instruction were decorated with didactic frescoes and carvings based on imported templates but fabricated by indigenous craftsmen under a system of tribute labor. As Fray Gerónimo de Mendieta emphasized in 1596, "Who built New Spain's many churches and monasteries if not the Indians with their own hands and sweat. . . . And who provided the churches with their vestments and altar textiles, silver vessels, and all their other adornment and decorations, if not these same Indians?"[5]

The friars' redirection of indigenous skills is evident in the carved ornaments applied to otherwise utilitarian structures. The Augustinians, the mendicant order least constrained by vows of poverty, may have involved European craftsmen in the sophisticated portals at Actopan, Acolman,

and Ixmiquilpan, inspired by Renaissance treatises including Sebastiano Serlio's *Regole generali di architettura* (General Rules of Architecture, published from 1537). With its sculptured baluster columns, figural frieze, and decorative niches filled with saints, angels, and an arrow-pierced heart (an Augustinian motif), the facade of Acolman in particular (c. 1560) exemplified the plateresque vocabulary (see fig. 6.31). By contrast, the great Franciscan missions ringing Mexico City and Puebla, including Tecamachalco, Huaquechula, and Huejotzingo, favored inventive, Isabelline Gothic doorways incorporating knotted cords of the Franciscan habit, chains of the Order of the Golden Fleece (a Burgundian, and later Habsburg, order of chivalry here used to indicate royal patronage), and medallions imitating wax seals or stamped eucharistic wafers, sometimes with narrative or figural reliefs adapted from European woodcuts in a distinctly flattened style.

Spanish patrons chose a third, Moorish-inspired ornamental language for the facade of the remote Franciscan mission at Angahuan in Michoacán (c. 1580), which was executed by indigenous carvers (fig. 6.28). Following Andalusian mod-

Fig. 6.28. Portal of the Franciscan mission church of Santiago, Angahuan, Michoacán, c. 1580. Carved stone.

Fig. 6.29. Atrial cross from the hermitage at Tepeyac, c. 1550. Carved stone; H. 11½ ft. (3.5 m). Museo de la Basílica de Guadalupe, Mexico City.

frequent leaf-shaped terminations) were themselves central to Nahua cosmology, anchoring the four quadrants of the universe and linking celestial and subterranean realms.

Inside the churches, where access was reserved for the baptized, the concern for iconographic orthodoxy often fostered the employment of European-trained artists even in indigenous communities. At Huejotzingo, for instance, the Flemish-born Simón Pereyns (c. 1530–1600)—a fashionable painter at the Spanish court who had arrived with the new viceroy in 1566—planned, supervised, and signed the great painted, sculptured, and gilded Roman-style *retablo* (altarpiece) dated 1586 that fills the main apse (fig. 6.30; see fig. 11.24). As in Castilian Renaissance examples, Huejotzingo's four-story structure recounts Christ's childhood and Passion through narrative canvases and freestanding wooden figures, watched over by God the Father, martyrs, Church Doctors, and monastic saints.

The surviving contracts reveal that Pereyns took an old tabernacle worth 1,000 pesos as partial payment, and that for an additional 5,000 gold pesos, he and his associate Andrés de la Concha (act. 1575–1612) agreed to do all the painting and *encarnación* (sculptural coloring) themselves, while subcontracting the figural reliefs and fifteen freestanding saints to the Andalusian-born sculptor Pedro de Requena. Nonetheless, the same contract informs us, the town's Nahuatl-speaking caciques ("indios principales y naturales," typically electors of the native town council) were among the retablo's patrons and that it was they, advised by their *padre guardián* Fray Gerónimo de Mendieta, who chose the holy figures to be represented.[6] Furthermore, Pereyns was to be granted indigenous assistants for the duration of the project: three painters to grind gesso and perform other tasks, three experienced carver-carpenters (who presumably realized the elaborate baluster columns, putti, and friezes laden with seraphim, drapery, shields, and fruit), two cooks to make tortillas, and four workmen. Pereyns, again communicating through an interpreter, also subcontracted the vitally important gilding to an Indian specialist named Marcos de San Pedro from Mexico City. Huejotzingo's new *retablo* thus conjoined Spanish and indigenous contributions, a sign of the respect accorded native masters who acquired imported skills, and of the fundamental but often overlooked native patronage of objects that appear European in form and style.

els, the door and window arches were enclosed within stacked, rectangular *alfices* (frames, from the Arabic word for container) filled with dots, a bricklike diaper pattern, and repetitive *atauriques* (stylized floral patterns and tendrils, from the Arabic *al-tawriq*, "foliated ornament") as in Islamic plasterwork. An ambitious *artesonado* featuring rope moldings, crowns of thorns, and flat-carved interlace patterns caps the sanctuary. The use of Islamic decorative motifs on the Purépecha frontier highlights the question of intent. Were the Franciscans, like Cortés, recalling the Christian reconquest of Iberia, or merely evoking Islamic-inspired textiles? By the same token, did native artisans working in imported modes understand their products as hybrid—a term that reinforces potentially misleading notions of purity—or did they navigate a complex, changing culture without a sense of division or discontinuity?

Similar questions are posed by the lightweight processional statues of Christ molded by native image-makers out of a paste made from corn pith, maguey fiber, and other organic materials, applied to an armature of corn-stalks and/or reused manuscripts, and by the monumental stone crosses carved by indigenous sculptors on orders from the friars for mission atria or patios (fig. 6.29). Perhaps to minimize confusion with Aztec sacrifice, most examples depicted only Christ's face or the crown of thorns between the arms, surrounded by Passion symbols like those in the gremial and *Mass of St. Gregory*. Others substituted the polished obsidian disk of Tezcatlipoca ("Lord of the Mirror"), an Aztec deity associated with night and divination. Crosslike world trees (a link suggested by the

EUROPE IN TRANSLATION: SECULAR DECORATIVE ARTS

Less evidence remains of secular design and decoration in the first generations after the conquest, since flooding, earthquakes, fires, and civil disturbance destroyed most sixteenth- or seventeenth-century civil or domestic structures in the viceregal capitals. Their contents have largely succumbed to hard use and changing styles. Even fewer survivals document the material lives of the poor or the enslaved, including the tens of thousands of Africans imported by force to work the sugar plantations of Pernambuco and Bahia in coastal Brazil.

Nonetheless, the *alcázar* (palace) of Diego Columbus in Santo Domingo (begun about 1510 after his marriage to the grandniece of the Spanish king) and the palace of Cortés in

Cuernavaca (begun 1520s) show that the conquerors conceived their houses as both fortress and villa, combining the massive crenellated walls of military architecture with classicizing arcaded loggias in the latest "Roman" style. In Brazil, too, Garcia d'Ávila, heir to an entailed estate that eventually reached half a million square miles, erected the castle-like House of the Tower (begun c. 1550) in the late Gothic-Renaissance mode now known as the Portuguese "Manueline" style. The desire of *encomenderos* (feudal overlords) to broadcast their authority is made explicit in the elaborate portal of the Casa de Montejo, built in Mérida in 1549 for the son of a conquistador. The masterful Renaissance decoration, perhaps executed by immigrant carvers, features grotesque beasts, defeated warriors, and other signs of domination. On the upper story, armored Spanish soldiers, flanking the Montejo coat of arms, crush their enemies' severed heads; beside and below them stand hairy, club-wielding wild men, symbols of paganism and disorder that here suggest the local Maya.

Inside their homes, the immigrant elite strove to reproduce European signs of status. Probate inventories suggest that, as in Iberia, sixteenth-century Spanish-American furniture was largely limited to chests of wood or leather, decorated with ornamental nails (or, in New Spain, embroidery in maguey fiber, plants of the agave family). Brightly lacquered boxes, desks, and beds provided notes of color. Tables were simple and rectilinear, while armchairs, whether folding or straight-backed (see fig. 6.23), remained symbols of rank and authority. Although associated with the Spanish, such chairs were also embraced—along with European-style clothes, armor, and household goods—by native leaders. Guaman Poma (1535–1615), for instance, shows Don Andrés Hurtado de Mendoza, Peru's third viceroy, seated during negotiations with Sayri Túpac (r. 1544–60), its indigenous king or Inka, in an identical pair of *sillones fraileros*. Even in Spanish homes, seating was more typically provided on platforms and benches softened, in an echo of Muslim practices, by cushions and textiles. The 1549 inventory of Cortés's palace in Cuernavaca included fourteen rugs, enough to carpet all the rooms, and eight door curtains to aid against drafts. Cortés also possessed numerous imported tapestries, one depicting a king and Cupid, and fifteen large *guadameciles* (tanned, gilded, and painted leather wall-hangings from Córdoba) worked in gold and silver with medallions, perhaps hot-weather substitutes for the tapestries.

Wall paintings offered an even more economical substitute for precious textiles in both religious and domestic settings. At the Augustinian convent at Malinalco, the former site of an Aztec garrison and medical garden, at least five Nahua painters (perhaps *tlacuiloque* brought from the Imperial College at Tlatelolco) painted frescoes in the semipublic lower cloister in the 1570s, creating an elaborate illusionistic garden combining native and imported elements into an American garden of Eden. The largely monochrome composition was purely European, based on heraldic medallion and *mille-fleurs* tapestries with grotesque and floral borders inspired by imported woodcuts.

The house of the cathedral dean in Puebla (decorated around 1590) likewise preserves a rare secular painted cycle

Fig. 6.30. Simón Pereyns and others. Principal *retablo* in the chancel of the Franciscan convent church of San Miguel, Huejotzingo, Puebla, 1584–88.

that blends a show of imported learning with native animals and speech scrolls suggesting that the painters were indigenous. One room features Petrarchan triumphs copied from 1565 engravings by Maarten van Heemskerck (1498–1574), with chariots representing Time, Death, Love, Chastity, Fame, and Faith (now lost); an adjoining room depicts a parade of sibyls, harbingers of Christ's birth, derived from the moralized versions of Ovid popular among European humanists. Another European compendium—the illustrated *Emblemas morales* of Sebastián de Covarrubias (Madrid, 1610)—may have been the source for the slightly later painted ceilings at the sixteenth-century Casa del Fundador of Capitán Gonzalo Suárez Rendón in Tunja, Colombia. Above Mudéjar-style latticework *tirantes* (tie beams), the vaults feature a parade of symbolic animals—elephants, horses, a rhinoceros, boar, stag, and ox—separated by apple, palm, laurel, and pomegranate trees, each evoking particular qualities, virtues, and maxims promoted by European humanists.

Fig. 6.31. Perfume burner, Mexico City, c. 1550. Silver gilt. 6⁵⁄₁₆ x 5¼ x 5¼ in. (17.6 x 13.3 x 13.3 cm). Victoria and Albert Museum, London (M.62-198).

control standards, provide charity, confer social status, and protect members from competition, especially from skilled native artisans who nonetheless (again, often in spite of legal restrictions) joined workshops run by European masters.

Just as important as the guilds was the introduction of new tools, materials, and technologies that transformed the production of household goods. Whereas preconquest ceramics had been produced by molding, coil-building, and burnishing, by 1540 European masters active in Mexico City had introduced the potter's wheel as well as vitreous lead and tin glazes and high-temperature kilns. Although most early wares were plain or simply decorated, they established Mexican dominance of an industry that reached its height in seventeenth- and eighteenth-century Puebla (see fig. 12.20).

Textile production was similarly reoriented. Before the Spaniards' arrival, indigenous home weavers had used mobile backstrap looms to make thin strips from cotton, maguey, or camelid fibers. The introduction of fixed, horizontal treadle looms in both small-scale workshops known as *obradores* or *trapiches* and larger ones termed *obrajes* allowed for much wider widths of fabric, while the introduction of merino sheep throughout New Spain and Peru by the end of the sixteenth century provided a ready source for woolen cloth that increasingly rivaled Iberian imports in quality. Similarly, the explosion of cattle on *encomenderos'* ranches led to the widespread working of hides—a Spanish specialty perfected by Mudéjar craftsmen—into saddles and other equestrian trappings, bookbindings, and ornamental covers for seating furniture (see fig. 11.26) as well as chests, trunks, and other storage containers. Ibero-American silk production was shorter lived. Although silk farming (sericulture) was introduced on Hispaniola at the beginning of the sixteenth century, and domestic production initiated in the 1530s, the industry could not compete with the Chinese silks that began arriving from Manila in 1573, much less Spain's recurrent desire to limit colonial production in order to protect its own exports.

The special status of silver working in Ibero-America reflected both high local demand and the prodigious output of mines so bountiful that in 1554 and 1555, domestic silver cost less than imported iron. Equally important was the discovery in 1563 of mercury (an essential ingredient for the efficient refining of silver) in the Andean city of Huancavelica, a resource which, linked to the Cerro Rico (rich mountain) at Potosí, formed what one viceroy described in 1573 as "the most important marriage in the world."[7] By the end of the century, important centers of production included Mexico City, Guatemala, Lima, and Cuzco, as well as Potosí. Inventories testify that elite viceregal households were furnished with many silver objects, from saltcellars and lighting devices to furniture and horse tack, although their bullion value ensured that few have survived changing fashions and fortunes.

One rare exception, long presumed to be of Spanish manufacture, is a perfume or incense burner made in Mexico City around 1550 in an elegant Renaissance style (fig. 6.31). Such devices were prized at a time when disease was thought to be spread by foul odors and miasmas. Portable versions included both small-scale spice containers worn on the body and censers employed in liturgical settings. This secular, tabletop

The importation of European objects and models was paralleled by the introduction of new institutional structures for producing consumer goods. From the beginning, immigrant Spanish and Portuguese artisans established confraternities, guilds (*gremios*), and trade associations on Old World models. Despite official restrictions (eventually repealed), European gold- and silversmiths were active in New Spain by the 1530s, and already in 1539 Guatemala's annual Corpus Christi procession included, in this order, armorers and gunsmiths, silversmiths, merchants, barbers, tailors, woodworkers, blacksmiths, and cordwainers, all professions essential for transplanting a new European society. In Mexico City, ordinances regulating craft practices and prices spawned guilds for silk weavers (1542); embroiderers (1546); painters and gilders (1557); carpenters, woodcutters, joiners, sculptors, and violin makers (1568); blacksmiths and locksmiths (1568); goldbeaters (1598); architects and masons (1599); and potters (1677), to name just a few. As in Europe, Ibero-American guilds aimed to regularize training and apprenticeship,

example features a ring-shaped base with Roman-style profile portraits, supported by eagles sporting military helmets and topped by a domed, openwork lid whose plateresque motifs, including putti, festoons, and floriated candelabra, suggest wafting tendrils of scented smoke. That such an elegant implement was made and used in New Spain indicates the close adherence by the social elite to Iberian practices.

Further knowledge of domestic silver comes from shipwrecks, such as that of the *Nuestra Señora de Atocha*, lost off the Florida Keys while bound from Cartagena to Seville in 1622. Alongside stores of bullion were passengers' personal effects including emeralds, gold and silver jewelry, candlesticks, tableware, and spoons. Perhaps most revealing of the cultural exchanges occurring even at elite levels were the surviving drinking vessels representing both worlds: Spanish-style *bernegales* (two-handled footed cups) with Renaissance ornament, alongside pairs of Inka-style *aquillas* (tall gold or silver beakers) bearing indigenous and European motifs.

Those strains converged in an impressive silver basin whose form and fortunes encapsulate Ibero-American aesthetic and material exchanges (fig. 6.32). Made in Potosí before 1576, presumably with a matching ewer, the lobed basin is Spanish in form, with a rim decorated with flowering vases and portrait medallions depicting a knight, hunter, and two elegant ladies. These motifs are separated by scenes of a hilly Andean landscape set with houses, a church, and animals ranging from the fantastic (harpies, dragons, winged serpents,

and a half-human archer) and mundane (horses, dogs, lions, and roosters) to indigenous creatures (viscachas, tarucas, chinchillas, and guemals). In one sensitively observed detail, two traditionally dressed native figures encourage a laden llama to its feet. While the indigenous costumes, poses, and fauna—recalling both painted wooden *keros* like that in figure 12.4 and silver wares from the Atocha—suggest a native craftsman, the use of overlapping and perspective denotes European training. Perhaps multiple artisans collaborated.

Just as intriguing is the basin's subsequent history. After descending from the Andes to the Atlantic Coast, perhaps via a clandestine trading route, the basin was acquired by or on behalf of Dom Garcia II Afonso, Christian king of the Congo (r. 1641–61), who presented it along with two hundred African slaves to Prince Johann Maurits, governor of the short-lived Dutch Brazil colony (1637–44), in gratitude for military assistance against the Portuguese in Angola. Some scholars have proposed that the basin itself traveled to Africa and back. Maurits is known to have brought it to Europe from Brazil and donated it in 1658 to the reformed church at Siegen, in Westphalia, where it was gilded, inscribed, and mounted as a baptismal font. Whether the Bolivian basin made three Atlantic crossings or just one, it encapsulates the material legacy of a colonizing process that yoked movements of goods to movements of people while forever altering both.

JEFFREY COLLINS

Fig. 6.32. Basin (with later arms of Johann Maurits, Prince of Nassau), Potosí, c. 1586. Silver, later gilding; 4½ x 21¼ x 21¼ in. (11.5 x 54 x 54 cm). Evangelische Kirchengemeinde Nikolai, Siegen.

1600–1750

Fig. 10.8

EAST ASIA

Fig. 7.6a

CHINA

In April 1644, after a century of dynastic decline characterized by inattentive emperors, power-hungry eunuchs, and a belligerently dissatisfied populace, the last emperor of the Ming dynasty (1368–1644) committed suicide as Chinese rebel forces streamed largely unopposed through the city gates of Beijing. Over the next few months, the Manchu, a formidable non-Chinese power centered north of the Great Wall, succeeded in ousting the rebels and conquering northern China. In October 1644, the Manchu enthroned their boy monarch as the first emperor of a new dynasty—the Qing (pure)—which was to rule China until 1912.

Despite the political and civil unrest that accompanied the demise of the Ming and ascendance of the Qing dynasty, seventeenth-century China witnessed tremendous commercial expansion and remarkable artistic and intellectual achievements. While the individualistic and experimental tone of the late Ming artistic, intellectual, and political world gave way to a controlled orthodoxy that came to characterize Qing culture, overarching socioeconomic trends nascent in the sixteenth century—including urbanization, population growth, rising prosperity, and increased literacy—continued unabated through the seventeenth and eighteenth centuries. Between 1600 and 1750, some of those trends helped to blur traditional social distinctions and erode barriers to class entry. An increasingly interrelated upper class, comprising gentry, scholar-officials, and wealthy merchants, partook equally in cultural activities formerly limited to the ruling elite, including the building and furnishing of grand homes and gardens, and the acquisition of fine objects, ranging from those considered works of art to items of everyday use.

Increased wealth, literacy, and artistic patronage stimulated the development of regional cultural centers across southern China, and free competition among numerous independent producers facilitated an increase in the quantity and quality of luxury goods available for purchase. While the production of fine furniture, metalwork, carved hard stones, and other luxury goods developed into significant regional enterprises, silk and porcelain manufacture remained on a large scale and of national and international importance. The empire's most prosperous, populous region was Jiangnan (meaning "south of the river"), which in the Ming and Qing periods referred to the Yangtze River's delta region in southeastern China. Throughout most of the seventeenth century, China's finest decorative arts were created not in imperial workshops for the court but rather in Jiangnan-based studios and manufactories for wealthy local consumers. With the consolidation of Qing dynastic rule during the reign of the Kangxi emperor (r. 1662–1722), the imperial court in Beijing reemerged as a major center of decorative arts production

and patronage, but the taste of the Jiangnan elite remained an influence on courtly material culture.

The primary arbiters of taste in seventeenth- and eighteenth-century Jiangnan were members of the scholar-official class, the educated elite who typically staffed the governmental bureaucracy. While in theory scholar-officials achieved their posts through success in a series of rigorous examinations, many secured their official rank through family connections or purchase. Attaining a position in the imperial bureaucracy became a primary goal for many educated men, as governmental rank ensured financial security and social prestige for an entire family. Civil service examinations technically were open to all classes, but in reality only the wealthy could afford the many years of formal education they required. Only a small percentage of those who sat for the tests ever passed and received imperial appointments, but a standard curriculum and written language provided cultural cohesion for the Chinese upper class across a diverse, multilingual empire. Those who failed could find employment as teachers, artists, government clerks, or administrators of public works projects, all acceptable occupations in the Confucian worldview, which frowned on trade. At the same time, however, mercantile opportunities abounded in economically dynamic Jiangnan, and the divide between scholar-officials and merchant families increasingly became less pronounced. As court patronage waned in the seventeenth century, prosperous urbanites became China's principal consumers of decorative arts objects, and the homes, furnishings, and customs of the Jiangnan literati established patterns of living that the wealthy and upwardly mobile widely emulated.

DOMESTIC ENVIRONMENTS

A portrait of the scholar Wang Shi-min (1592–1680) and his family provides an image of an upper-class domestic environment in early Qing-dynasty Jiangnan (fig. 7.1). The grandson of a senior grand secretary to the Wanli emperor (r. 1572–1620), Wang rose to high rank in the Ming bureaucracy without ever having passed the civil service examinations. After the Manchu conquest he retired to his family estate in Jiangnan and achieved fame as an artist, while his son Wang Shan (1645–1728) went on to serve the new dynasty as grand secretary to the Kangxi emperor. Although paintings cannot always be relied on as accurate representations of lived reality, this scene depicts physical features common in upper-class homes in seventeenth- and eighteenth-century Jiangnan. The most typical form of residential architecture was a sprawling, walled enclosure in which low buildings formed

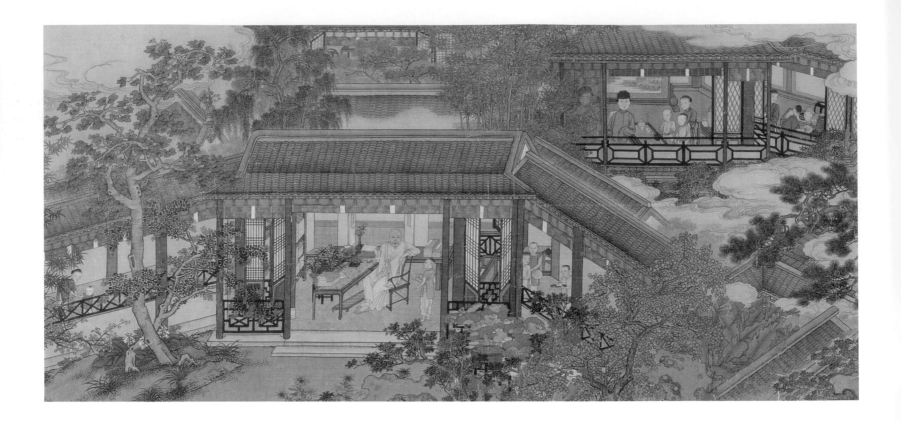

Fig. 7.1. Gu Jianlong. Portrait of Wang Shi-min and his family (detail), China, late 17th century. Ink and colors on silk; overall, 13⅞ x 47⅛ in. (35.2 x 119.7 cm). Minneapolis Institute of Arts (96.68.2).

a series of courtyards. The structure of residential buildings in southern China, with latticed windows, verandas, and removable doors, blurred the barrier between indoors and outdoors, enabling living areas to be comfortably extended into courtyards during pleasant weather. The arrangement of domestic space embodied the hierarchies of rank, generation, and gender that defined the Chinese social order, with specific areas coded as public and private, male and female.

The main subject of this painting, the Wang family patriarch, is shown with attendants and adolescent sons in his studio, the area that served as the center of daily activity for upper-class males and the primary locus for their artistic, intellectual, and business pursuits. The women and young children are shown in the women's quarters in the rear courtyard, a private area where no males other than immediate family members were allowed. Typically, homes were arranged on a north-south axis facing southward, so the women's quarters were placed to the north, the direction associated with the *yin*, or female cosmic principle. All members of the Wang household are surrounded by the accoutrements of upperclass daily life for which the Jiangnan region was renowned, including fine furniture, ceramics, textiles, books, and tea.

These objects, like many that survive from seventeenth- and early eighteenth-century China, originally served practical functions in wealthy households and palaces. Examined within the context of these domestic environments, late Ming and early Qing decorative arts shed light on the lifestyles enjoyed by the elite as well as the historical circumstances and belief systems that informed Chinese material culture. Homes and furnishings shaped everyday life experience in Ming and Qing China, and through their design the Chinese sought to correlate the material world they inhabited with the social and cosmic order they saw as desirable.

THE MAIN HALL

The main hall functioned as the nucleus of an upper-class home in seventeenth- and eighteenth-century China, providing a physical space where family members could commune with each other, society at large, and the numinous world of gods and ancestors. In the main hall the family conducted rituals of ancestor veneration, supplicated the gods, entertained friends and relatives, and celebrated life's transitions and the passage of time. Whereas in the contemporaneous West, rituals surrounding birth, maturation, marriage, and death often took place outside the home in churches, in Ming and Qing China these rites almost invariably were held in the main halls of family dwellings. The size, embellishment, and furnishing of the main hall visually proclaimed the family's social status, wealth, and taste. Ming and Qing sumptuary laws dictated the size and decoration of the main halls allowed to various social ranks, with the number of bays (*jian*, the space defined by four columnar roof supports arranged in a square) indicating the position of the heads of household in the hierarchy. The emperor was permitted halls of nine or more bays in length; dukes, five to seven; first or second rank officials, five with entrance halls of three bays; and so on down the social ladder to commoners, whose main halls could be no larger than three bays. Laws also regulated roof form and decoration—no nonimperial residential building could have double eaves, stepped brackets, painted ceilings, or polychrome roof tiles.

Among the most prevalent forms of furnishings in the main halls of upper-class Chinese homes were long side tables such as in figure 7.2. Centered on the room's back wall, such a table provided a focal point, and its large size (this example is over 9 feet long) underscored its great symbolic importance. During rituals and ceremonies these tables held incense, food offerings, candles, and ancestral memorial tablets, while for

everyday use they could display seasonal flowers, antiques, or other artworks. Made of richly grained *huanghuali* (a precious hardwood), this table features openwork side panels carved in an unusual composition of paired male and female dragons encircling small baby dragons. Crisply detailed dragons and angular scrolls decorate the front spandrels, while the back spandrels are carved less ornately since the table was designed to be placed against a wall. The archaistic, abstracted style of the carved ornament was popular in seventeenth- and early eighteenth-century Jiangnan and was paralleled in contemporaneous textile design.

While long, rectangular side tables were used throughout upper-class residences in Ming and Qing China, those with everted flanges usually were reserved for formal use in the main hall. The use of tables with flared tops in ceremonial contexts extends far back into Chinese history; pictorial ornamentation on an Eastern Zhou (770–221 BC) bronze vessel, for example, shows ritual wine jars placed on long tables with everted flanges, and an intact example made of lacquered wood, strikingly similar in form to Ming and Qing examples, was excavated from a Spring and Autumn Period (770–475 BC) tomb at Zhaoxiang, Dangyang, Hubei province.

Side tables, which featured so prominently in a family's most public space, were the subject of frequent comment. Texts such as *Zun sheng ba jian* (Eight Discourses on the Nurturing of Life, 1591; see fig. 1.14), published by the wealthy merchant Gao Lian (act. 1573–81), *Zhangwu zhi* (Treatise on Superfluous Things, 1621–27) by the scholar Wen Zhenheng (1585–1645), and *Xianqing ouji* (Occasional Records of Leisurely Sentiment, 1671) by the artist and playwright Li Yu (1610–1680) offered a wealth of information about the design and furnishing of homes as well as the types of objects available for consumption at the time. These writers reveal some of the criteria with which the elite evaluated their surroundings, including perceptions of elegance (*ya*), antiquity (*gu*),

and refinement (*jing*), yet opinions regarding how these ideas should be manifested in the physical environment varied from author to author. Wen Zhenheng disparaged side tables like the example in figure 7.2 as tasteless and overly ornate. Decrying what he saw as a decline in aesthetic standards, Wen exhorted readers to avoid long, narrow tables with sharply pointed flanges and elaborate carvings in "vulgar" patterns such as dragons and phoenixes. His opinions notwithstanding, a number of these intricately carved tables have survived, indicating their likely popularity as well as the high quality of their construction. Li Yu, on the other hand, was concerned less with the form of the table than with the objects placed on it. Li opined that it was vulgar to cover side tables with ostentatious objects such as coral branches, peacock feathers, and gold or silver vessels, and suggested displaying only a single object, such as an interestingly shaped stone, an ancient bronze, or a flower in a vase. According to him, the most important item in furnishing the main hall was the *tanghua*, the scroll painting that hung above the side table, and he recommended that an object carefully chosen to create harmony with the spirit of the *tanghua* be placed on the table in front of it.

A folding screen was another essential hall furnishing (fig. 7.3). From ancient times through to the twenty-first century, screens demarcated and divided physical space in Chinese homes; provided protection from drafts; created privacy for sleeping, dressing, and living areas; and enhanced the living environment with the beauty of their materials and workmanship. Ming and Qing literature and representational arts indicate that high-ranking family members and honored guests typically sat in chairs backed by tall screens during social gatherings in the main hall, and that large screens served as backdrops for ancestral veneration rites as well as family ceremonies and celebrations. Although the historical record testifies to the widespread use of screens in upper-

Fig. 7.2. Side table, China, 17th century. *Huanghuali* hardwood; 39 x 112½ x 20¾ in. (99.1 x 285.8 x 52.7 cm). The Metropolitan Museum of Art (1996.339).

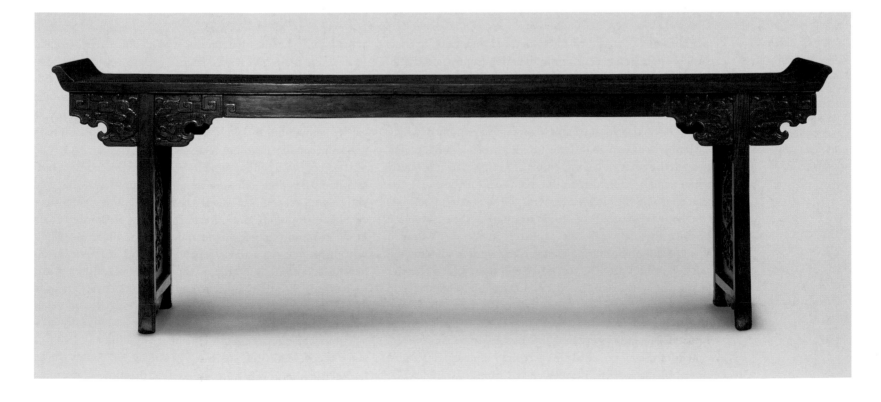

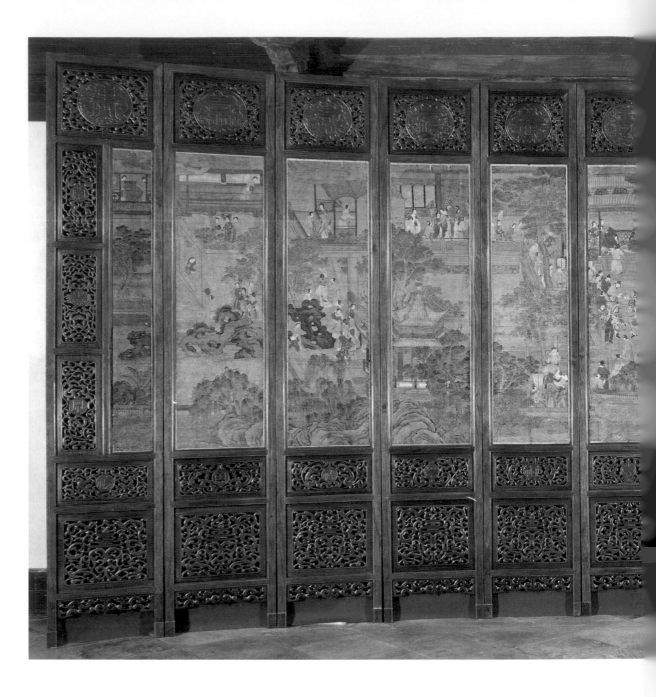

Fig. 7.3. Folding screen, China, late 17th century. *Huanghuali* hardwood, ink and colors on silk; each panel, 128¼ x 22¾ x 1⅜ in. (325.8 x 57.8 x 3.5 cm). Minneapolis Institute of Arts (96.124.1a–l).

class households, very few have survived intact due to their relatively light construction: thin wooden frames and fragile panels covered with silk or paper.

The paintings framed in the twelve-panel screen illustrated here depict a coming-of-age celebration in an upper-class household, a young man's "capping" ceremony in which long hair was drawn up into the topknot worn by adult males. Through the courtyard compounds of a large mansion, family members make their way to the main hall for the event, the women leaving the "inner quarters" to the north (upper left) and the men departing the studio complex to the east (on the right). In the main hall, the patriarch sits on a silk-draped chair in front of a multipaneled screen, while a silk-covered chair awaits his wife. The wooden panels that directly border the paintings are carved with *shou* (long life) characters in roundels, each glyph rendered in slightly different script, while the lower register features dramatically stylized *shou* characters set among writhing dragons. Like so many objects created for use by the elite, this screen graphically illustrates cultural ideals to which upper-class Chinese aspired while

articulating specific auspicious wishes for their families. Indeed, the main hall where such a screen would have been displayed often featured an entry flanked by paired calligraphic couplets exhorting Confucian values such as filial piety, harmony, and diligence, along with architectural details carved or painted in symbolic motifs intended to summon good and repel malevolent fortunes.

Despite the frequent appearance of written moral exhortations in the domestic environment, many late Ming and early Qing authors lamented that their countrymen were steadily abandoning the puritanical tenets of Confucianism in favor of more materialistic and sybaritic lifestyles. Their writings relate that lavish banquets and dinner parties became increasingly common among all classes during the seventeenth century, and the utensils and decorations used and entertainments presented at such events became ever more extravagant. Among the most costly and visually conspicuous objects were silk furnishings like the silk hanging and seat cover illustrated here (fig. 7.4 and fig. 7.5). Finely woven fabrics such as these were created in the time-consuming

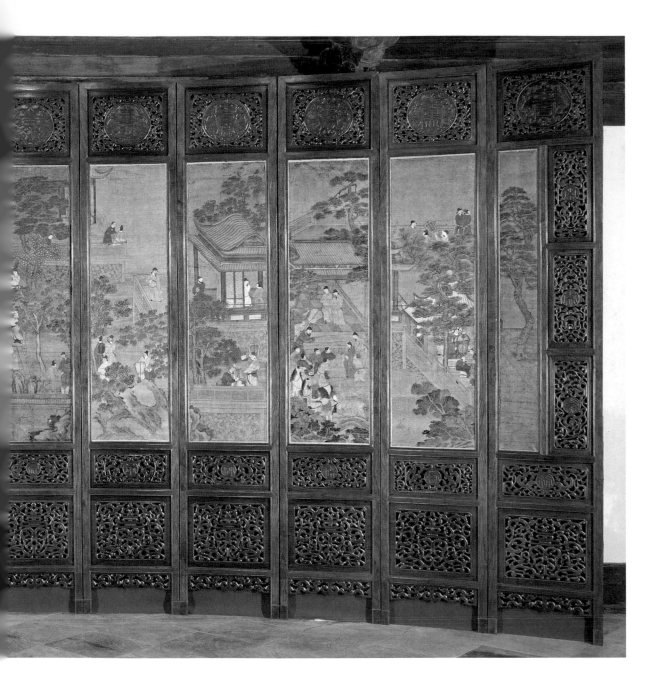

kesi (slit-tapestry) technique, whereby wefts of the individual colors interlace with the warp only where required for the pattern and are not carried from selvage to selvage. Such fabrics with polychrome and gold-wrapped silk yarns represented a significant store of household wealth. Textiles also provided a chief source of color and meaningful pattern in domestic interiors. When all but imperial homes were constructed with wooden beams and columns darkly stained or painted in subdued monochromes, gray floors and roof tiles, and plain whitewashed plaster walls, colorful and richly ornamented silk furnishings stood out prominently against the neutral-toned settings.

Like screens, silk hangings could be placed directly behind the seat of honor to emphasize the high status of the sitter. Chinese cosmological beliefs correlated red with happiness, and throughout the Ming and Qing periods red textiles were worn and displayed during joyful occasions such as weddings and birthday celebrations. The motifs depicted against the bright red background of the hanging illustrated in figure 7.4 are replete with meanings that would have been readily understood by contemporaneous viewers. Phoenixes often were associated with the *yin*, paired birds were common symbols of fidelity and conjugal happiness, and butterflies represented joy and the summer season. The roundels in the top register contain peaches (signifying longevity) and persimmons (connoting joy) as well as a type of scepter known as a *ruyi* (meaning "as you wish"). *Ruyi* were common birthday gifts symbolizing a wish for long life and the fulfillment of desires. In Ming and Qing China, bird, flower, and butterfly motifs remained closely associated with women, and a magnificent hanging such as this would have been particularly appropriate for display during birthday celebrations for the matriarch of a wealthy Chinese family. Although women participated actively in family-only events and ceremonies held in the main hall, when male guests from outside the family were present, upper-class women typically remained out of direct view and discreetly observed the proceedings from behind gauze or bamboo partitions.

As illustrated in the scene depicted on the folding screen in figure 7.3, during formal and festive occasions in the main

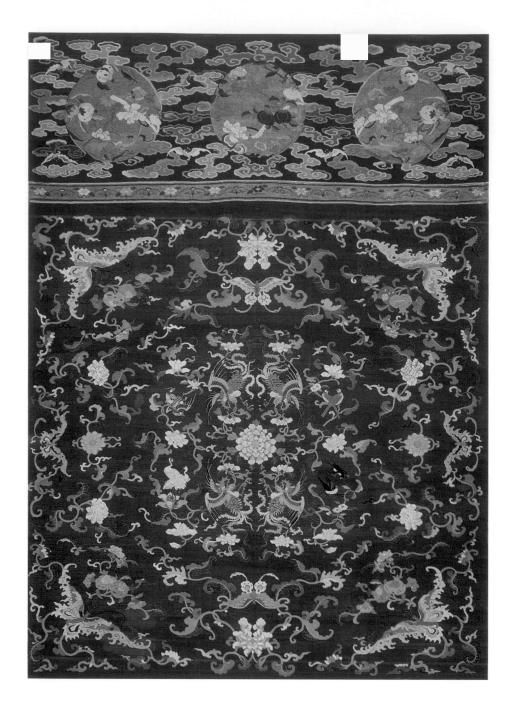

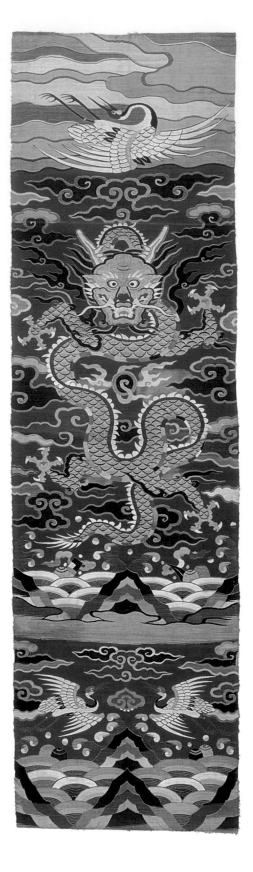

Fig. 7.4. Hanging, China, 1600–50. Silk; gilded, lacquered, and paper-wrapped threads, paint; 93⅛ x 67½ in. (236.5 x 171.3 cm). Art Institute of Chicago (1943.17).

Fig. 7.5. Chair cover, China, early 17th century. Silk, gold thread; 70⅛ x 19¾ in. (178 x 50 cm). Chris Hall Collection, Asian Civilisations Museum, Singapore (CH21).

hall distinguished attendees sat on chairs draped with colorful silk covers. In Ming and Qing China, chairs were reserved for family members and guests of high rank; those of insufficient status either stood or sat on stools during social events. The Chinese did not use fixed upholstery, with textiles and padding tacked directly onto the wood, but rather used removable cushions and covers like that shown in figure 7.5. Such items could be easily changed to render furniture appropriate for a specific user, season, or occasion. Although too thin to contribute significantly to the sitter's physical comfort, silk covers heightened the formality of chairs and elevated the contexts in which they were used.

This type of rectangular chair cover would have covered a yoke-back chair such as that used by Wang Shi-min (see fig. 7.1). With its bold decorative patterning, created by juxtaposing two-dimensional fields of contrasting colors, this chair cover typifies seventeenth-century-style luxury textile design. The dragon motif symbolized imperial rule, with *long* (five-clawed dragons) appearing on objects made for the

emperor himself and *mang* (four-clawed dragons) on those used by courtiers and high-ranking officials. The central pattern on this chair cover shows a golden *mang* set within a politically and cosmologically significant landscape of mountains and waves. The designs of the top and bottom registers depict cranes, common symbols of longevity chosen by both the Ming and Qing governments to represent first-rank officials in the civil bureaucracy. While this chair cover's ornamental patterning expressed notions of a harmoniously integrated political and cosmological order, these shimmer-

ing motifs rendered in precious silk and gold contributed to the grandeur of the occasion in which it was used while conspicuously expressing the owner's material prosperity.

THE STUDIO

In contrast to the color and pageantry often associated with the main hall, the studio (*shufang*, literally "library") ideally provided a quiet, more soberly decorated retreat where the men of the family could pursue intellectual and artistic endeavors. As the center of male socialization and learning in upper-class households, the studio expressed the refinement and education of the scholar-official class in three-dimensional terms, and its design and furnishing provided a primary vehicle for the articulation of individual taste and erudition. Finely equipped studios became essential trappings for men who aspired to elite status in late Ming and early Qing China, and the newly wealthy often turned to distinguished writers for advice regarding their construction and furnishing. Commentators such as Gao Lian, Wen Zhenheng, and Li Yu agreed that scholars should eschew strong colors and ornate patterning when decorating their studios, and suggested that the ideal aesthetic for these spaces should reflect the austerity of Confucianism and the eremitism of Daoism, like the minimally yet elegantly appointed studio of Wang Shi-min (see fig. 7.1). Literature and visual arts reinforced the ideal that in studios such as this, amid the emblematic accoutrements of a scholar's life—from desk accessories and books to art objects—educated men should study the art and literature of revered masters and develop their own skills in the "three perfections": poetry, painting, and calligraphy.

The degree of conformity to this ideal varied from individual to individual, and at least some of the newly wealthy who built studios in the late Ming and early Qing period seem to have harbored little interest in the traditional cultural pursuits of the literati or the restrained taste they typically espoused. The semiliterate, nouveau riche antihero of the late Ming novel *Jin Ping Mei* (The Plum in the Golden Vase), for instance, maintains a lavishly furnished studio where he carouses with his cronies, while Li Yu and a number of other writers disparaged the ostentatious displays they observed during visits to homes of the emerging merchant class. Nonetheless, men of diverse socioeconomic backgrounds seem to have paid great attention to matters of interior decoration during the late Ming and early Qing, and most of these men probably balanced different styles, ranging from the unadorned to the elaborate, according to their personal taste. Surviving texts and objects testify to the widespread demand for artful studio furnishings as well as the technical and aesthetic virtuosity of Jiangnan artists in satisfying desires as varied as their patrons.

Hair-tipped brushes used for writing, painting, and calligraphy, and brush holders like the carved bamboo example shown in figure 7.6a–b were among the most common desk accessories in scholars' studios during the Ming and Qing dynasties. While brush pots could be made from a variety of materials, including wood, porcelain, and even jade, the form may have originated in bamboo, and brush holders made of other materials often imitated its appearance. The bamboo plant held particular symbolic resonance in Chinese culture; its hollow stalk represented humility and an unprejudiced

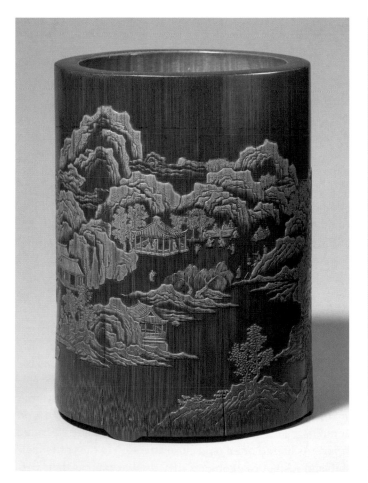
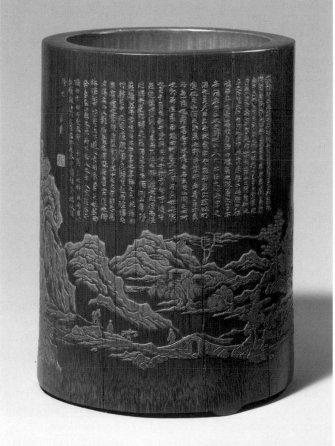

Fig. 7.6a–b. Zhang Xihuang. Brush holder, Jiangnan, early 17th century. Bamboo; H. 5¼ in. (13.4 cm). The Metropolitan Museum of Art (1994.208).

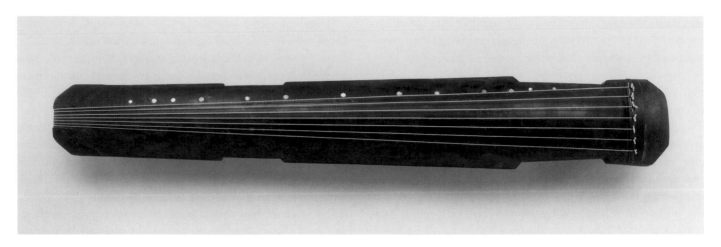

Fig. 7.7. Zither (*qin*), Hangzhou, 1634. Wood, lacquer, jade, silk strings; 4¼ x 46⅝ x 10½ in. (10.8 x 118.4 x 26.7 cm). The Metropolitan Museum of Art (1999.93).

mind, while its resilience in strong winds and inclement weather rendered it a metaphor for scholar-officials who steadfastly maintained their integrity in the face of adversity. Bamboo became one of the most widely evoked forms and materials in Chinese visual and material culture, particularly in the design of objects used on scholars' desks. Although Wen Zhenheng opined that any object carved of wood or bamboo could not be considered *ya* (elegant), many Ming and Qing literati seem to have enjoyed carving bamboo in their leisure time.

A high point of bamboo carving occurred in seventeenth-century Jiangnan, where several professional carvers achieved particular renown. The brush holder in figure 7.6a–b was signed by Zhang Xihuang (active in the early seventeenth century), who was known for his achievement in the technique of *liuqing* (reserve green), a form of shallow relief carving in which a design cut from the greenish bamboo skin stands in relief against a background of the darker, inner layer of the stalk. While many bamboo carvers based their designs on contemporaneous wood-block print illustrations, the composition on this brush holder recalls the ink-wash landscape paintings so esteemed by the literati at the time. The scene depicts a famous gathering of scholars that took place in 1045 and was recorded in the poem *Zuiweng Tingji* (Ode to the Pavilion of the Inebriated Old Man) by Ouyang Xiu (1007–1072), a scholar and statesman who in later generations was regarded as a paragon of Confucian ideals. Gatherings such as this, where gentlemen could practice the "three perfections" while enjoying the company of friends, sipping tea or wine, and listening to music, had remained an important means of socializing among the scholar-official class for centuries, and depictions of these events became a recurring theme in paintings, lacquer, and patterned silks as well as carved wood and bamboo.

In the scene shown here, the human figures, banqueting in the pavilion and amusing themselves with games, are dwarfed by the panoramic mountain landscape. The lower portion of the reverse side shows more figures in a mountainous landscape, with the text of Ouyang's poem finely carved in running script at the top. On this brush holder, Zhang's skillful carving transforms a humble material into a beautiful and functional object that conveys the scholar-official's reverence for calligraphy, landscape imagery, and past exemplars as well as the burgeoning market for attractively wrought desk accessories that conferred monetary value and cultural capital with the signatures of the recognized artists who created them.

Music offered the literati an important means of socializing, recreation, and self-expression during the Ming and Qing dynasties, and scholar-officials considered the playing and appreciation of music to be among the most proper and edifying of pastimes. In *Lunyu* (The Analects), Confucius is recorded as saying, "Let a man be stimulated by poetry, established by the rules of propriety, and perfected by music," and Confucius himself is thought to have enjoyed playing the *qin*, a type of zither (fig. 7.7). While legend attributes the invention of the *qin* to the mythical sages Fuxi or Shennong in the third millennium BC, ideographs depicting *qin* appear on oracle bones from the Shang dynasty (c. 1500–1046 BC); *qin* dating to the Eastern Zhou period have been excavated archeologically, and Han-dynasty (206 BC–220 AD) treatises discuss the principles of *qin* playing and list the names and narrative intent of many *qin* compositions.

Although the construction of *qin*, and thus probably the music played on them, changed over the millennia, they remained the most highly regarded musical instruments in late dynastic China, and the playing of *qin* ranked first among the *siyi*, "the four arts of the scholar" (the others being the board game *weiqi*, calligraphy, and painting). *Qin* playing remained closely aligned with poetry and painting—each was thought to require the same strict discipline of body and mind—and Chinese scholars believed that the playing of *qin* could express, as well as control, human emotion. Both the music and the physical form of *qin* were imbued with strong cosmological associations. *Qin* music, for example, was thought to connect intimately with the harmony of the universe, while the instrument's upper and lower boards symbolized, respectively, heaven and earth.

Avidly collected as well as played, *qin* over a century old were considered the most desirable among late Ming and early Qing literati, who attempted to determine the age of an instrument by examining the patterns of cracks in its lacquer coatings. Passed down from generation to generation, treasured *qin* often were given evocative names, including "one day in autumn," "jade frosting the heavens," and "night-wearying crane." As literati often paid close attention to the craftsmanship and aesthetics of objects they used to express their per-

sonalities, many made their own *qin* or commissioned them to be made according to their specifications. The example shown in figure 7.7 was made in 1634 for a member of the Ming imperial household, a descendant of the first prince of Lu (1568–1614), brother of the Wanli emperor. A twenty-two-character poem inscribed on the back of the instrument reads,

The moonlight is being reflected by the river Yangzi,
A light breeze is blowing over clear dewdrops,
Only in a tranquil place
Can one comprehend the feeling of eternity.
[signed] Jingyi Zhuren

When not in use, *qin* hung prominently on the walls of scholar's studios, appreciated for the beauty of their form as well as the cultural associations and latent aural pleasure they embodied. Despite their importance in late Ming and early Qing culture, *qin* have attracted little attention among Western collectors and academics, and, like so many non-Western musical instruments, remain little researched in English-language scholarship.

Although the traditional Confucian worldview regarded the studio as well as the artistic and intellectual activities pursued there as male preserves, Chinese women nonetheless succeeded in forging avenues for participation in literati culture. During the late Ming period, women entertainers (*ji*), known for their beauty as well as their accomplishment in arts and letters, frequented the studios of the Jiangnan elite to attend "elegant gatherings" often recorded in poetry written by participants. At the same time, the wives and daughters of gentry families found increased opportunities for education as economic growth propelled literacy and

book publication during the seventeenth and eighteenth centuries. Unprecedented numbers of women began to write and publish books, and many seventeenth-century novels and literary works, by men and women, featured heroines with physical charms rivaled only by their literary abilities.

In some rare instances, women attained success as professional artisans, like Gu Erniang (c. 1662–1724), who achieved fame in the early eighteenth century as a maker of ink stones (fig. 7.8a–b). Gu married into a family of professional ink-stone makers living in Suzhou's Zhuanzhu Alley, the primary jade-working center during the early Qing period. In imperial China, artisan skills typically were passed down from one generation of males to the next, and Gu's husband learned the art of ink-stone carving from his father, who had learned from his own father. Following the deaths of both her father-in-law and husband, Gu took control of the family enterprise, developing a distinctive style that garnered commercial success before ultimately passing the business along to her nephew.

The literati lavished great attention on the selection of their "four treasures of the scholar's studio" (*wenfang sibao*)—ink stone, brush, ink, and paper. The most visibly conspicuous of these items on the scholar's desk, the ink stone was a prominent symbol of individual taste. Although ink stones could be created in a variety of shapes and sizes, their function required two features: a flat area for grinding an ink stick and mixing it with water and a well for holding the liquid ink. On this irregularly shaped ink stone (see fig. 7.8a–b), Gu carved a phoenix in low relief, its wings and tail spread luxuriantly across both sides of the stone. In its mouth the phoenix holds a branch of *lingzhi*, the fungus of immortality, while the inkwell forms a swirling cloud, another symbol of

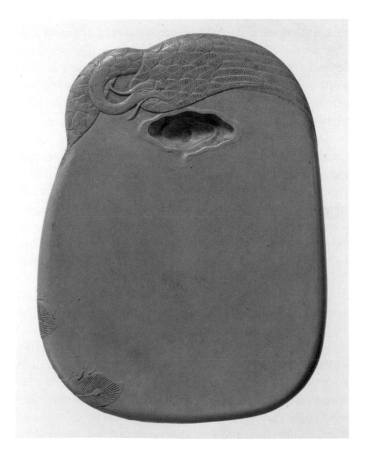
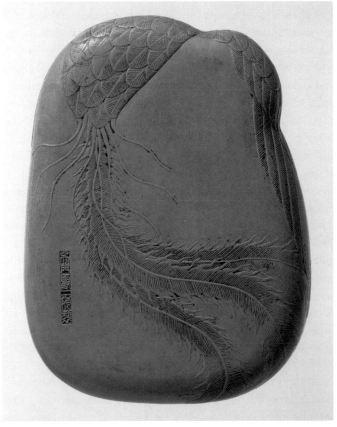

Fig. 7.8a–b. Gu Erniang. Ink stone, Wumen (now Suzhou), early 18th century. Limestone; 5¹⁄₁₆ x 3¾ in. (12.9 x 9.5 cm). The Metropolitan Museum of Art (1989.99.1a, b).

long life. Gu's reliance on linearity and detailed surface patterning rather than a sculptural, three-dimensional articulation of the design may reflect the influence of wood-block carving techniques. The famed wood-block carver Zhu Gui (c. 1644–1717) was Gu's neighbor on Zhuanzhu Alley, suggesting the possibility of artistic exchange.

Gu's ink stones remained popular desk accessories among Jiangnan literati and merchants throughout the Qing period. Although Gu gained acceptance as an accomplished practitioner within the male domain of stone carving during her lifetime, patrons and collectors seem to have associated Gu's work closely with her gender, and her persona became eroticized in many of the stories and legends that developed around her. For example, some Qing writers describe Gu's style as ornate, rounded, and voluptuous—qualities associated with the feminine—while one popular legend relates that she could determine the quality of a stone by touching it with the tips of her dainty shoes, a highly charged symbol of female sexuality at that time. Nonetheless, Gu's success as an artisan and businesswoman challenges the later categorization of Ming and Qing women as oppressed, silenced, and lacking personal agency. Indeed, recent scholarship has begun to explore the ways in which women in seventeenth-century Jiangnan forged a vibrant literary and visual culture that paralleled, and at times overlapped with, the creative pursuits of the scholars in their studios.

THE WOMEN'S QUARTERS

Formative in Chinese thought and culture during the Ming and Qing, Neo-Confucian philosophy taught that maintaining a desirable social and cosmic order required a strict separation of the male and female spheres. Neo-Confucian doctrine assigned women the *nei* (inside) and men the *wai* (outside), designations that referred not only to the physical spaces men and women inhabited but also the activities and responsibilities deemed appropriate for each gender. In the "inner quarters," unseen by any men outside the family, women were to oversee the management of the household and engage in tasks judged "women's work"—cooking, cleaning, caring for children and the elderly, and producing textiles. Although a married man might spend the night in the inner quarters, in the bedroom of his wife or concubine, in the morning he was promptly to depart for work in his fields, office, shop, or studio and not return until evening. Although the degree of conformity to these ideals doubtless differed among families and individuals, the gendered division of living space and daily activities was the norm throughout Chinese society. Neo-Confucian philosophies viewed male and female domains and duties as complementary—earthly embodiments of the cosmological *yin* and *yang*, each necessary for sustaining the other. Throughout the Ming and Qing periods, girls and boys alike were instilled with the belief that in properly fulfilling their gender roles and creating family units ordered along Confucian principles, they actively promoted social, political, and cosmological harmony.

Within the inner quarters, upper-class women inhabited living spaces allocated according to rank and generation. The senior couple and their oldest son and daughter-in-law occu-

pied rooms with the most cosmologically auspicious location, centrally situated and facing south, while younger married sons and their families typically lived in south-facing rooms placed less centrally or in different courtyards. Concubines, lower in status than legal wives, often occupied the least auspiciously placed quarters, facing east or west. Seventeenth- and eighteenth-century visual and literary sources reveal that the bedrooms of upper-class wives and high-ranking concubines were richly appointed with furniture, textiles, utensils, toiletry items, and storage boxes filled with garments and jewelry, many of which may have been part of bridal dowries. While men tended to avoid bright colors and ornate patterns in furnishing their living spaces, women were allowed more sumptuous displays.

Elaborate canopy beds, hung with colorful textile draperies, were the most visually prominent feature of women's bedrooms. Beds held tremendous symbolic importance as the place where children were conceived, particularly sons who would stay with the family and maintain the ancestral altar. Probably for this reason, beds are the only item of furniture in the *Lu Ban Jing* (Manuscript of Lu Ban)—a fifteenth-century carpentry manual popular throughout the Ming and early Qing periods—for which ritualistic and magical considerations are taken into account for their construction, decoration, and placement. Made of *huanghuali*, this six-post canopy bed (fig. 7.9) features a lower railing elaborately carved in an openwork swastika pattern (a symbol known as *wan* in Chinese, meaning "ten thousand"), a motif Wen Zhenheng derided as neither "antique" nor "elegant" but suitable for use in the women's quarters. On this bed the *wan* pattern is interspersed with heads of *ruyi* scepters. Together these motifs articulate hopes for the unlimited granting of desires.

Although a canopy bed functioned chiefly as a sleeping platform, during the day curtain hooks held the draperies back so that the bed could be used as a sofa or seat where women worked and entertained friends. Small tables could be placed on or in front of it for eating, writing, doing needlework, and playing games. Ming and Qing sources indicate that beds were the site of much socializing for Chinese women, particularly older women and their daughters and granddaughters. Sitting together on such beds, they would embroider the quilts, shoes, and other trousseau items that young women took with them when they left their natal families at marriage. With the beds' elaborate construction and many yards of expensive textile hangings, they also represented a significant store and display of wealth, often forming the cornerstone of a woman's dowry and remaining her property if the marriage dissolved. Dowries provided upper-class women with at least a modicum of financial agency and security; for example, period sources tell of women who successfully invested their dowry wealth in businesses and land or lent money to cash-strapped husbands.

Upper-class Chinese women lived their lives surrounded with decorative patterns that visually reminded them of their primary social role as the bearers of male offspring to continue their husbands' family lines. Widely held cosmological beliefs bolstered the perception that the display of symbolic motifs could contribute to the realization of the desires

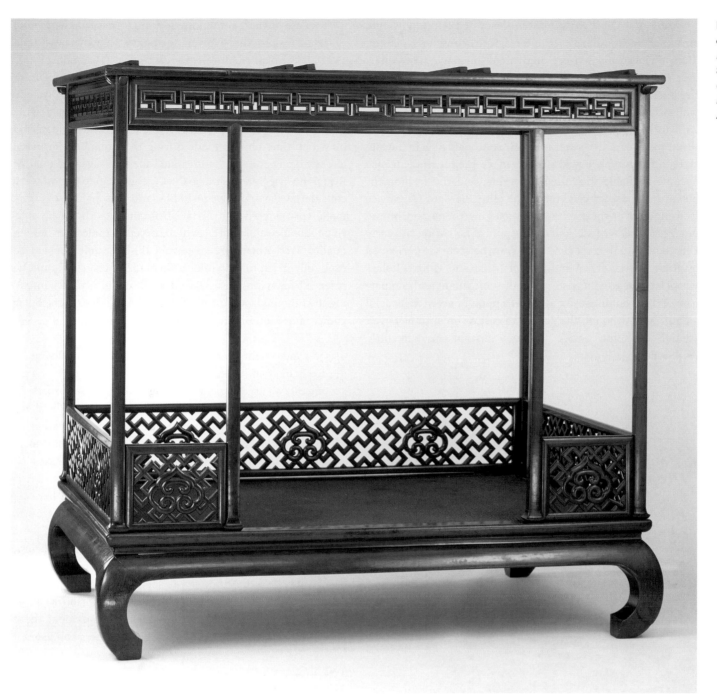

Fig. 7.9. Bed, China, early 17th century. *Huanghuali* hardwood; 89¾ x 91¾ x 67 in. (228 x 233 x 170.2 cm). Minneapolis Institute of Arts (96.11.1a-ee).

depicted, and therefore bed curtains and other furnishings in the women's quarters commonly featured ornaments associated with marital bliss and childbirth. Paired mandarin ducks, phoenixes, and other birds, for example, were visual metaphors for conjugal happiness, while pomegranate and lotus patterns, because of their many seeds, represented wishes for numerous children. The desire for sons was expressed quite literally in the popular "one hundred boys" (*baizi*) pattern, illustrated on the lidded jar in figure 7.10. Skillfully painted with underglaze blue and polychrome enamels, the jar was created in Jingdezhen in southern China, which remained the empire's greatest center of ceramics manufacture through the Ming-to-Qing transition, producing for both export and the home market. This storage jar depicts a large group of healthy, happy boys playing in a garden. One of the boys rides a *qilin*, a mythical animal associated with the delivery of children, much like the stork in the West.

Families hoped not only for the birth of sons to carry on the family name but also that those sons would become distinguished scholars or government officials, thus bringing honor to the family. The boys shown on this jar are under the supervision of three men, presumably their teachers, amid tables laden with the accoutrements of Confucian scholars: books, a *qin*, and the board game *weiqi*. One boy holds up a blossoming sprig of the osmanthus tree, which symbolized passing the highest civil service examination, the *jinshi* (presented scholar). At the beginning of the Qing dynasty, when this jar was made, attaining a governmental position was a particularly elusive wish for the elite in Jiangnan, a region where many cities had fiercely resisted the Manchu conquest. Although the Qing reinstituted the imperial examinations in 1646, the majority of official positions in the early Qing went to men from the north who had aided the formation of the new dynasty.

Ming and Qing writers often described sumptuous silk curtains, colorful hangings, and fragrant scents to evoke the luxuriousness and sensory enjoyment of the women's quarters. The burning of incense was a fashionable pastime among the late Ming and early Qing elite, and beautiful censers, as well as fine boxes for storing incense, seem to have been standard furnishings in upper-class interiors (fig. 7.11). With the resumption of active sea trade with Southeast Asia in the late sixteenth century, a wide range of aromatics and incense became available in Chinese markets, and the fashion for burning incense spread among the elite. Pleasant fragrances from flowers or incense were a recurring theme in Chinese poetry as well as prose, and the authors of late Ming and early Qing fiction took great care to convey the scents experienced by their characters. A number of Ming and Qing scholars wrote treatises on incense, while the enjoyment and comparison of different incense types was a popular activity at social gatherings. Although the Japanese cult of incense has been studied in some detail, Chinese customs remain little explored in the West.

Fig. 7.10. Jar with *baizi* (one-hundred boys) motif, Jingdezhen, 1650–60. Porcelain; 16½ x 10⅜ x 10⅜ in. (42 x 26.5 x 26.5 cm). Victoria and Albert Museum, London (78&A-1883).

Incense burners often imitated the form of ancient ritual vessels, a fashion that evolved during the Song dynasty (960–1279). The form of the censer in figure 7.11, made of cast bronze inlaid with gold and silver, is based on that of a *gui*, an ancient food vessel. Although this censer bears a Xuande (r. 1425–35) reign mark and the signature of the early Ming artist Shi Shou, it was probably made in the late Ming period by which time objects made during the Xuande reign were already being collected and valued for their age and quality. Ritual incense burners made during the Xuande period were considered particularly desirable, and the majority of fine metalwork censers that survive from the late Ming bear spurious Xuande reign marks, which served as indicators of high quality. Wen Zhenheng suggested that ceramic censers be used only in summer, while those made of bronze should be reserved for winter usage. In describing an idyllic winter's night in the bedroom of his favorite concubine, the scholar and painter Mao Bijiang (1611–1693) recalled,

> On winter nights in a tiny chamber with curtains falling down on four sides, carpets spreading one over the other . . . we used to gather together a few incense burners of the Hsuan Te [Xuande] period, large and small, with ashes glowing like melted gold or brown jade . . . sending forth a hot pleasing odour somewhat like the flavour of half open plum-blossoms or of goose-pears. . . . We kept quiet, inhaling the fragrant air to our heart's content. . . . Alas! both the fragrant smell and my concubine have disappeared in the clouds.[1]

Today we can appreciate the beauty and technical accomplishment of the censers that survive from the late Ming and early Qing periods. Although the scents and warm glow they produced have "disappeared in the clouds," period writings help us to envisage the layers of sensory enjoyment these objects must have afforded their original owners and users.

THE PALACE

For reasons both symbolic and pragmatic, the Manchu conquerors retained the Forbidden City—the Ming imperial palace in Beijing—as the primary residence of their emperors and the nexus of the Qing government. While they changed the names and uses of certain buildings, early Qing rulers repaired and reconstructed the immense, war-damaged palace complex according to the Ming ground plan. Although far larger and more splendid than the upper-class Chinese homes described above, the imperial palace shared the same general layout with one-story buildings arranged in a series of courtyards, as well as their designation of certain areas as male and female, public and private. The objects shown in figures 7.12–7.14, created in early Qing imperial workshops for use within the palace or for gifts, shed light on the sumptuous lifestyles enjoyed by the emperor and his family, the technical and aesthetic accomplishments of the artists who worked in their service, and the ways that the Manchu navigated as a conquest dynasty through courtly material culture.

Although the imperial workshops had collapsed in the late Ming, in 1661 the Qing reestablished workshops for the

production of objects deemed necessary for court use and gift exchange. The number and scope of imperial manufactories increased through the late seventeenth and early eighteenth centuries as Qing rulers achieved greater political stability and wealth. By the end of the seventeenth century, the Manchu had consolidated political control over their vast empire, and under the enlightened rule of three emperors—Kangxi, Yongzheng (r. 1722–35), and Qianlong (r. 1735–96)—China witnessed tremendous agricultural and commercial expansion, rapid population growth, and a steady increase in prosperity and consumption. In 1693, the Kangxi emperor was able to expand the imperial workshops to fourteen units producing textiles, metalwork, glass, leather goods, enamels, books, paintings, and religious paraphernalia. Throughout the remainder of his reign, he periodically enlarged the imperial workshops to accommodate greater production and new crafts, and during the rule of his grandson, the Qianlong emperor, the number of palace workshops peaked at thirty-eight. The refined personal tastes and diverse collecting interests of these three emperors sustained a long period of innovation in decorative arts production for the court, and under their patronage the imperial workshops attained a level of technical virtuosity unsurpassed in Chinese history.

Among the first workshops reestablished were the state silk manufactories in Jiangnan. Clothing was a necessity for the imperial household and a primary means through which the Qing could express both their political power and Manchu identity. Although sovereigns of China, the Qing emperors were ethnically and culturally distinct from the Chinese people whom they ruled, and while the Manchu enthusiastically adopted many aspects of Chinese culture, they rejected others. The Manchu castigated Ming court robes—with their wide sleeves and voluminous cut requiring nearly 40 feet (12 m) of expensive silk—as effete and impractical, and decreed that the Qing imperial court and those in its service would wear garments like that in figure 7.12, patterned after clothing worn by the horse-riding, previously seminomadic Manchu. This robe's tapered cut, curved neck opening fastened with spherical buttons pushed through silk loops, vents in the center front and back, and narrow sleeves ending in flaring, protective cuffs called *matixiu* (horsehoof cuffs), all were viewed as Manchu characteristics. Chinese men in the Qing civil and military service were required to wear Manchu-style garments, a condition some found repugnant at the beginning of the dynasty. Over time, however, even everyday Chinese dress began to incorporate certain Manchu features, such as front openings fastened with loops and toggles.

While Qing rulers rejected many Ming clothing forms, they accommodated certain aspects of Ming Court culture without any diminution of their assertion of power. Cannily, they retained the colorful symbols of power that ornamented Ming court costume, such as the dragon, cloud, mountain, and wave patterns embroidered on the robe (fig. 7.12). Court artists working under the supervision of the Imperial Household Department (*Neiwufu*) supplied the workshops with painted designs to be replicated in silk by China's most skilled dyers, weavers, and embroiderers. Finely made in polychrome silk and precious gold, such robes required between one and three

years to manufacture and were enormously costly. Garments were among the most visually prominent indicators of social status in imperial China, and Qing court painters and administrators developed a design vocabulary that clearly communicated the wearer's proximity to the center of political power. Thus the role of what we call the court artist included design. The design of the garment in figure 7.12 indicates that it was worn by a male member of the imperial family for semiformal occasions. Five-clawed dragons designated the highest status, and yellow garments, in accordance with cosmological beliefs that equated the color yellow with the earth and the center of the world, were reserved for imperial clansmen. Garments made in this cut and design were appropriate for nonceremonial occasions at court and, in colors such as blue, were integral to the uniforms worn by governmental officials throughout the empire. Known as *mangpao* (dragon robes) or *jifu* (festive dress), these intrinsically valuable and visually powerful representations of imperial rule became coveted status symbols during the Qing dynasty.

In addition to fine clothing, the emperor and his court required enormous quantities of ceramics for utilitarian, ceremonial, and diplomatic purposes. As evidenced by extant documents exchanged between the court and the imperial manufactories at Jingdezhen, the Kangxi, Yongzheng, and Qianlong emperors were keenly interested in ceramics production, spending significant sums to rebuild and expand the imperial kilns, remaining involved in their management, and expressing great enthusiasm for certain colors, forms, and decorative styles. Following instructions from the emperor and the Imperial Household Department, court artists drew designs on paper to indicate desired shapes, colors, and ornament. Those drawings were then sent to Jingdezhen, over a thousand miles to the south, for manufacture. When the emperor wanted the kilns to reproduce prized pieces in his

Fig. 7.11. Censer, China, probably 17th century. Bronze, gold and silver inlay; Diam. 5¼ in. (13.3 cm). Phoenix Art Museum (1994.388).

Fig. 7.12. Manchu-style court robe, China, 1725–50. Embroidered silk satin, silver gilt-wrapped threads; L. 54¾ in. (139 cm). Musée des Arts asiatiques, Nice (98.5).

collection, from ancient bronzes to Song- and Ming-dynasty ceramics, court artists took on the task of creating wooden models of the original to send to the imperial kiln, although in some cases the original itself was carefully transported to Jingdezhen. Under the patronage of the Kangxi, Yongzheng, and Qianlong emperors, the output of the imperial kilns far exceeded that of earlier periods, reaching an apex of technical refinement. In ceramics production, as in military might and territorial expansion, the Manchu emperors sought to justify and glorify their rule over China by surpassing the achievements of previous dynasties.

Imperial porcelains made in the early Kangxi period resembled popular wares of the time and were often painted in underglaze blue with landscape, floral, and figural patterns. By the end of the Kangxi reign, however, the imperial kilns had expanded their repertoire by reviving monochrome glazes and developing a new type of enamelware painted in a pastel palette. Among the rarest and most technically sophisticated of the monochrome porcelains were those made using the copper-red glaze seen here on a circular box (fig. 7.13). Such glazes presented ceramists with a particularly daunting

challenge, as the fugitive pigment could easily turn black, brown, or gray when fired. The Ming imperial kilns used copper-red glazes for only a brief period in the early fifteenth century (see fig. 1.6), but during the Kangxi reign the practice was revived with great success. Under the capable leadership of Lang Tingji (1663–1715), the kilns produced deep, even red glazes known in the West as *sang-de-boeuf* (ox blood) as well as the delicately mottled red glaze seen on the box in figure 7.13, called "peach bloom" in the West and *jiangdou hong* (cowpea red) in China. The cover is glazed a richly dappled dark red, while the glaze on the lower section is paler, turning to light green at the bottom. Although *sang-de-boeuf* glazes sought to suppress natural variations in copper-red pigment, the peach-bloom glaze exploited them for decorative effect, creating subtly variegated reds, pinks, grays, and light greens that Chinese connoisseurs have differentiated with evocatively descriptive appellations such as "skin of newborn mouse" (*ru shu pi*) and "apple green" (*pingguo qing*).

Peach-bloom glazes decorated a limited range of forms: small vases and writing utensils used on a scholar's desk. This box was designed to hold vermilion paste for the seals used in

lieu of signatures on documents, paintings, and other items needing personal acknowledgment or verification of authorship. Each day the Qing emperors received copious paperwork requiring their scrutiny and commentary, and when equipping their writing desks they appropriated the material culture of the Chinese scholars' studios. In order to govern effectively, the Manchu espoused Chinese ideals of government, adopting Confucianism as the foundation of the state and reinstating civil service examinations based on the study of Confucian classics as the primary method of recruitment for the bureaucracy. The Kangxi, Yongzheng, and Qianlong emperors spoke Chinese fluently and from early childhood until late in life received instruction from leading scholars in Confucian literature and philosophy.

To write memorials and respond to state documents, the emperor needed a broad knowledge of philosophy and historical precedents to understand the subject at hand, a strong command of Chinese literature for phrasing, and familiarity with ancient manuscripts and the work of famous exemplars for calligraphy, which the Chinese considered the most direct, visible expression of an individual's erudition and personality. By demonstrating their acceptance and mastery of Chinese cultural traditions, Manchu rulers aimed to validate their dynasty's legitimacy and win the support and respect of their Chinese subjects. To further communicate their command of the Chinese literati tradition, early Qing emperors commissioned portraits of themselves posed in elegant studios, brush or book in hand, surrounded by the fine desk accessories favored by Confucian scholars.

Although the seal-paste box in fig. 7.13 may have been created for everyday use on the Kangxi emperor's desk, during the reign of his son, the Yongzheng emperor, peach-bloom-glazed seal boxes were prized collectibles. A handscroll in the collection of the Victoria and Albert Museum entitled *Guwan tu* (Picture of Ancient Playthings), painted in 1729 as a pictorial inventory of the Yongzheng emperor's decorative arts collection, depicts a peach-bloom-glazed seal-paste box among the antiquities and other rare curios. In its role as a precious collectible, the box continued to proclaim the emperor as an upholder of Chinese civilization, for in the collection and delectation of art objects Qing rulers also followed a venerable imperial tradition that cast them as ideal Confucian monarchs.

The Kangxi, Yongzheng, and Qianlong emperors avidly collected European luxury goods, and their courts in Beijing included European painters, sculptors, architects, astronomers, mathematicians, fountain designers, and other specialists, many of whom were Jesuit missionaries. Talented and educated foreigners from Europe, Central Asia, and other regions provided early Qing emperors with access to knowledge and desirable luxuries, and their presence at court reinforced imperial claims of universality. The vase in figure 7.14, painted in enamel on copper, illustrates a technique introduced to Qing palace workshops through objects and artisans from Europe. Since late Ming times, Jesuit missionaries visiting China customarily brought gifts that the Chinese viewed as "exotic," such as velvets, clocks, scientific and musical instruments, and painted enamelwares.

In 1687, Father Jean de Fontenoy, leader of a Jesuit delegation sent by Louis XIV of France to the Qing court, wrote to colleagues in France that the European painted enamels presented to the Kangxi emperor had been well received. At the Kangxi emperor's request, the Jesuits dispatched to Beijing an expert enameler on metal, Jean-Baptiste Gravereau, who during the second decade of the eighteenth century taught European techniques to Chinese craftsmen in the palace workshop. Many of the Chinese enamelers came to the capital from Guangzhou, where missionaries had introduced European techniques as early as the 1680s. By the late Kangxi period, the imperial enamel workshop was producing not only fine cloisonné, a technique with a long history in China (see fig. 1.4), but also champlevé and painted enamel on metal, glass, and porcelain. The Yongzheng emperor maintained his father's interest in painted enamels, asking the Jesuits to send additional enamelers from Europe in 1726, and, in a memorial dated 1724, expressing his wish that artisans in imperial studios surpass the achievements of their Ming predecessors in overglaze enameling on ceramics.

The tiny vase in figure 7.14 illustrates a new merging of Chinese and European techniques and aesthetic sensibilities in Qing courtly art and design. The flowers painted on the body of the vase draw inspiration from the naturalistic style of Yun Shou-ping (1633–1690), an artist admired among the Jiangnan literati, but the flowers' delicate shadings reflect the nascent influence of European light-and-shade modeling. While enamels made during the Qianlong reign began to feature Western figures and exotically Occidental ornament, those produced in the earlier Kangxi and Yongzheng periods typically adhered to Chinese decorative themes. The pattern on this vase includes tree peonies, white magnolia, and crab apple blossoms, a combination of motifs forming the rebus "wealth and rank in the Jade Hall" (*yutangfugui*), referring to the highest honor in the civil service: acceptance into the Hanlin Academy.

To create this design, an enameler first coated the surface of the copper vase with white enamel pigment, then fired it at a low temperature in order to secure the enamel to the metal body. Next a painter used a brush and colored enamels to apply the flower and leaf patterns. The vase was fired again, and, finally, a gilder covered the exposed copper areas on the mouth and foot with gold leaf. Although the palace workshop had to import enamel pigments from Europe during the first

Fig. 7.13. Seal-paste box with Kangxi mark, Jingdezhen, 1662–1722. Porcelain; 1⅜ x 2¹³⁄₁₆ x 2¹³⁄₁₆ in. (3.5 x 7.2 x 7.2 cm). National Gallery of Art, Washington, DC (1942.9.506).

Fig. 7.14. Vase with Kangxi mark, China, 1662–1722. Enamels over gilded copper; H. 5⅜ in. (13.5 cm). National Palace Museum, Taipei.

years of production, by 1728 it was using enamels made domestically in the imperial glass workshop. Key pigments included opaque white derived from lead arsenate, which could be used on its own or mixed with other colors to create the pastels and subtle shading effects favored at the time: rose-pink made of colloidal gold and opaque yellow based on lead stannate. During the Yongzheng reign, delicately variegated pastels referred to as *yangcai* (foreign colors) became the dominant palette for overglaze decoration on imperial porcelains, and ceramics painted in this style, called *famille rose* in the West, were popular exports to Europe.

By the 1750s, the Qing dynasty was at its zenith. Having appeased their Chinese subjects, pacified non-Chinese peoples along the empire's borders, and centralized imperial control, early Qing emperors brought peace and political stability that engendered unprecedented expansion in agriculture, manufacturing, and commerce, and offered to many citizens a rich and diverse material life, an ebullient artistic and literary environment, and a high standard of living by global comparisons. In the building and furnishing of fine homes, the Jiangnan literati remained significant as arbiters of taste, and while this elite continued to influence courtly material culture throughout the Qing dynasty, by the early eighteenth century, the court in Beijing had emerged as a trend-setting patron of the decorative arts. Early Qing emperors ushered in one of China's most accomplished periods in artistic production, including design and the decorative arts, and, in forging their multiethnic empire, created the cultural, economic, and geopolitical foundation for modern China.

LEE TALBOT

KOREA

In the late sixteenth and early seventeenth centuries, a series of devastating invasions by foreign armies shattered the peace and stability Korea had enjoyed during the first two centuries of Joseon-dynasty (1392–1897) rule. Successive waves of Japanese troops attempted to conquer the Korean peninsula between 1592 and 1598. Before the country could fully recover from this six-year cataclysm, Korea was invaded in 1627 and again in 1636 by Northeast Asia's newly emergent power, the Manchu. Despite these decades of destruction and upheaval, the Joseon government retained political control over the kingdom, established a long-lasting peace with its belligerent neighbors, and oversaw the slow but successful rebuilding of Korea's economy. Having preserved national independence in the face of formidable odds, the Korean people gained a buoyant self-confidence that fostered unprecedented creativity in philosophy, academic inquiry, and the visual arts during the late seventeenth and eighteenth centuries. Whereas artists, writers, and intellectuals previously adhered closely to Chinese models, those in the seventeenth and eighteenth centuries looked with newfound interest at things Korean, celebrating the landscape, language, and customs of their native land.

During the able reigns of three intelligent and conscientious rulers—Sukjong (r. 1674–1720), Yeongjo (r. 1724–76), and Jeongjo (r. 1776–1801)—Korea witnessed economic and societal transformations that profoundly affected social and material life. The widespread dissemination of agricultural technologies boosted the quantity and variety of crops grown, while the trade of agricultural surplus stimulated commercial activity and the production of marketable goods. Tax reforms in the late seventeenth century, particularly the Uniform Tax Law (*Daedongbeop*), which allowed taxes to be paid in rice, cloth, or cash instead of various tribute products, further accelerated commerce and enabled the rise of an affluent farmer and merchant class. The capital city of Hanyang (Seoul) developed thriving commercial districts, while towns and villages throughout the country began to host periodic markets, typically held every five to ten days and selling local products as well as goods brought by itinerant merchants. As Korea's population multiplied—from under 2.5 million in the mid-seventeenth century to more than 8 million at the beginning of the nineteenth century—the quantity and diversity of commodities expanded to meet the demands of the increas-

Fig. 7.15. Jar, Korea, 1700–50. Porcelain; H. 23⅜ in. (59.4 cm). National Museum of Korea, Seoul (Dongwon 460).

Fig. 7.16. Bottle, Korea, early 18th century. Porcelain; H. 10⅞ in. (27.5 cm). National Museum of Korea, Seoul (Sujeong 137).

ingly numerous, prosperous, and educated populace. By 1750, Korean society and material culture were more diverse and sophisticated than ever before.

The manufacture of luxury goods faltered during the Japanese and Manchu invasions, but by the middle of the seventeenth century, the production of high-quality clothing and furnishings had begun to revive. The royal court reemerged as a significant consumer of fine decorative arts, employing hundreds of skilled craftsmen in workshops producing textiles, furniture, metalwork, and other objects. The foreign invasions decimated the palace supply of porcelains and severely damaged their production facilities. Since the court required vast numbers of ceramics for its daily and ceremonial needs—as many as 14,000 pieces annually—the royal kilns were among the first manufactories to be revived. A court document dated to 1618 mentions that no blue-and-white wares had survived the Japanese attacks on the capital and laments that the local production of replacements for an upcoming state event would be impossible. Although the royal kilns were active again by the 1620s, the financially strapped court could not afford the expensive, imported cobalt pigment necessary for production of these items. As a result, white porcelains painted with underglaze iron-brown pigment, a material readily available in the Korean countryside, became the most common type of decorated ceramic used at the seventeenth-century Joseon court.

The jar illustrated here, painted in underglaze iron brown with a sinuous dragon design, illustrates the technical and aesthetic achievement of the Bunwon (branch office), the state kiln complex (fig. 7.15). Overseen by the Saong-won, the government bureau in charge of court dining, the Bunwon

moved from site to site around Gwangju in Gyeonggi province during the seventeenth and early eighteenth centuries to be near forests needed for firing ceramics. The kilns generally relocated every decade, but deforested areas were replanted, and the Bunwon returned to certain sites periodically. In 1752, however, the Bunwon moved to a new location on the Han River (present-day Bunwon-ri), allowing the convenient delivery of firewood from multiple sources, and it remained there until 1883.

Employing between three and four hundred potters, the Bunwon specialized in the production of white porcelain, the shade varying according to the quality of the clay, the transparency of the glaze, and the amount of iron in the glaze. During the turbulent first half of the seventeenth century, Bunwon porcelains had a grayish white tone, but the late seventeenth century saw the return of a pure white hue highly esteemed by Korean connoisseurs at the time. Court artists sometimes traveled to the kilns to decorate the most prized wares, and the fluid brushwork seen on this jar suggests the hand of a highly skilled painter. Emblematic of the king and his rule, dragons appeared throughout the visual landscape at court, from architecture and sedan chairs to clothing, furnishings, and ceramics. Monumental jars of this type were used primarily to hold wine during royal ceremonies and ancestral veneration rites.

The production of porcelains painted with underglaze iron-brown pigment began to wane at the end of the seventeenth century, when economic recovery and the resumption of regular trade with China allowed for the steady importation of cobalt. The bottle in figure 7.16, painted in underglaze cobalt blue with floral and bamboo patterns, illustrates the

possessions, symbolized her authority. On this embroidered *yeolsui-bae,* cosmologically significant colors and symbolic imagery—including birds, flowers, chili peppers, eggplants, and lotus seeds—invoke protection, conjugal joy, and abundant offspring for the family.

Yangban women worked, ate, slept, socialized, gave birth, and died in the *anbang,* the main room in the women's quarters (*anchae*). Dynastic law forbade *yangban* women from leaving the *anchae* except under rare circumstances, and the *anbang* was off limits to all males except a woman's husband and sons. Furnishings used in the *anbang* often were vividly colored with bright lacquer, mother-of-pearl inlay, painted oxhorn, and polychrome embroidery in auspicious motifs summoning wealth, longevity, happiness, and fertility. Grandmothers, mothers, and sisters worked together to create richly and meaningfully patterned textiles such as *yeolsui-bae,* pillow ends, and other *anbang* furnishings, many intended for young women to take to their new homes upon marriage.

Confucian writings sanctioned a gendered division of labor. Texts that were widespread in seventeenth- and eighteenth-century Korea named tasks associated with textiles as foremost among proper women's work, which typically included spinning and weaving, sewing and tailoring, cleaning and care-giving, food preparation, and educating children. Confined to the *anchae,* barred from attaining a formal education, and encouraged to produce textiles by widely disseminated philosophical and instructional writings, *yangban* women invested large amounts of time in raising silkworms, spinning, dyeing, weaving, and embroidering. Although textile production was a prescribed activity, it gave women financial agency. Fabrics functioned like money in Joseon-dynasty Korea, and their production was the only socially acceptable means through which *yangban* women could generate income for themselves and their families. The senior female oversaw the production as well as the storage and distribution of textiles within the household, and the family's best clothing and furnishing fabrics, some of the clan's most valuable assets, were chief among the possessions that she kept under lock and key in the *anchae.*

In late seventeenth- and eighteenth-century Korea, a burgeoning population with expanding financial resources fueled an outpouring of cultural activity. Destructive foreign invasions and the Manchu conquest of Joseon Korea's staunchest ally, Ming-dynasty China, engendered a deeper appreciation within Korea of its customs and the emergence of distinctively native expressions in decorative arts and design. Begetting new forms in literature and innovative themes in art, design, architecture, and scholarship, this period can be regarded as the last great flowering of traditional Korean culture before the intrusions of the modern world in the nineteenth century.

LEE TALBOT

Fig. 7.19. Key holder (*yeolsui-bae*), Korea. Embroidered silk; L. 23⁹⁄₁₆ in. (59.9 cm). Sookmyung Women's University Museum, Seoul.

JAPAN

In 1603 the eastern city of Edo (present-day Tokyo) became the seat of the new shogunal government and a century later was the world's largest city, with a population of more than a million, and a dynamic economic and cultural center. Edo's development was helped along by the 1635 system of alternate attendance, which required feudal lords (daimyo) of some 260 domains to alternate residency between their city mansions and provincial domains, while the main wife and heir were kept in Edo. In addition to establishing a degree of political unity, this practice spurred improvements along the five overland routes connecting Edo and daimyo castle towns throughout the country, encouraging urbanization and the movement of people, goods, and information by land and sea. Production of goods in regional provinces and domains supported the larger urban centers, with skilled artisans and workshops producing objects for social and political exchange, such as presentation pieces for the shogunate. While many earlier modes of production and consumption were still practiced, the new era boasted technological innovations and new ventures, often promoted by provincial daimyo, such as the production of porcelain in southern Japan. The movement of goods across Japan was complemented by the country's trade relationships with Asia and Europe, vigilantly regulated by the shogunate and mainly conducted through the international port of Nagasaki in southern Japan.

While the relocation of the shogunate prompted an eastward shift in the country's cultural and economic center of gravity, for most of the seventeenth-century developments in the east were informed by trends in the historical centers of the west. Merchants in the commercial cities of Kyoto and Osaka (and nearby regions of Omi and Ise), who operated under shogunate control, accommodated the expanding needs of Edo. Some eventually opened establishments there, such as the textile merchandiser Echigoya (forerunner of the Mitsukoshi department store) in 1673, whose success rode on a new business model: no surcharge for cash payment.

Merchants and artisans, as members of the thriving urban cultural class of townspeople (chōnin), became major players in the world of art and design. Beginning at the turn of the seventeenth century, new technology allowed the commercial publishing industry to disseminate knowledge previously available only through laboriously hand-copied manuscripts. Greater circulation of information transmitted literary and historical knowledge to a wider audience, leading to exchanges in design initiatives among different media. For example, an illustrated private publication of Ise monogatari (The Tales of Ise) in 1608 initiated popular enthusiasm for this tenth-century courtly classic; the story was presented in a variety of media and in turn inspired many forms of performance art. Publishing also propagated the visual vocabulary and motifs of Kyoto court culture that informed the material culture of the period from 1600 to 1750, alongside imported visual and material culture from China, Korea, and Europe.

OBJECT AND STATUS: THE BRIDAL TROUSSEAU

The year 1620 marked the historical union of two powers—the imperial household in Kyoto and the newly established Tokugawa military shogunate in Edo—through the marriage of Emperor Go-Mizunoo (r. 1611–29) to Masako (Empress Tōfukumon'in, 1607–1678), the daughter of the second shogun Hidetada (r. 1605–23). The wealth of the Tokugawa was on full display when Masako's bridal procession, which included hundreds of attendants, traveled from the Nijō Castle to the Imperial Palace. Her trousseau comprised 260 chests packed with all manner of objects and 30 sets of folding-screen paintings (as depicted in the painting Wedding Procession of Tōfukumon'in, now in the Mitsui Bunko Art Museum, Tokyo).

The few objects that survive from Tōfukumon'in's trousseau represent the earliest examples of such objects since the custom was started among the daimyo in the sixteenth century. Another early trousseau has fared better, with some seventy-five pieces now designated as national treasures, centering on lacquerware. Known as the Hatsune Trousseau, its name taken from the Hatsune chapter (First Song of the Bush Warbler) of Genji monogatari (The Tale of Genji, an eleventh-century courtly romance), it was commissioned in 1637 for Chiyohime, the newborn daughter of the third Tokugawa shogun. The lacquer objects were produced by the workshop of Kōami Nagashige (1599–1651), the tenth head of the Kōami family of lacquerers (fig. 7.20), in just two and a half years. They were completed in time for Chiyohime's politically motivated wedding to a lord of a Tokugawa branch family in 1639. Given the scale of the trousseau and the time-consuming process of maki-e ("sprinkled picture") lacquer (see fig. 1.22), this was an extraordinary feat of craftsmanship.

As was the custom, Chiyohime later presented objects from her trousseau to her son and to her granddaughter upon their own marriages, and her other possessions were distributed posthumously among family members. The surviving examples give an idea of the practical and symbolic objects that were part of the trousseau of an elite warrior bride in the early 1600s. Every object is emblazoned with the Tokugawa triple-aoi (asarum) crest and motifs that refer to The Tale of Genji. The two octagonal lacquer vessels containing clamshells used in a matching game were the first items of the trousseau presented to the new household. The shell perfectly symbolizes fidelity, with each half shell matching only with its mate. Other extant objects (displayed here in a museum installation; fig. 7.20) include a basin and stand for blackening teeth (blackened teeth were a marker of marriage for a woman), mirror stand, writing case atop a writing table, and an elbow rest upholstered in velvet.

In front of the pair of folding screens are the trousseau's three centerpiece shelves: zushidana (cabinet shelf, right),

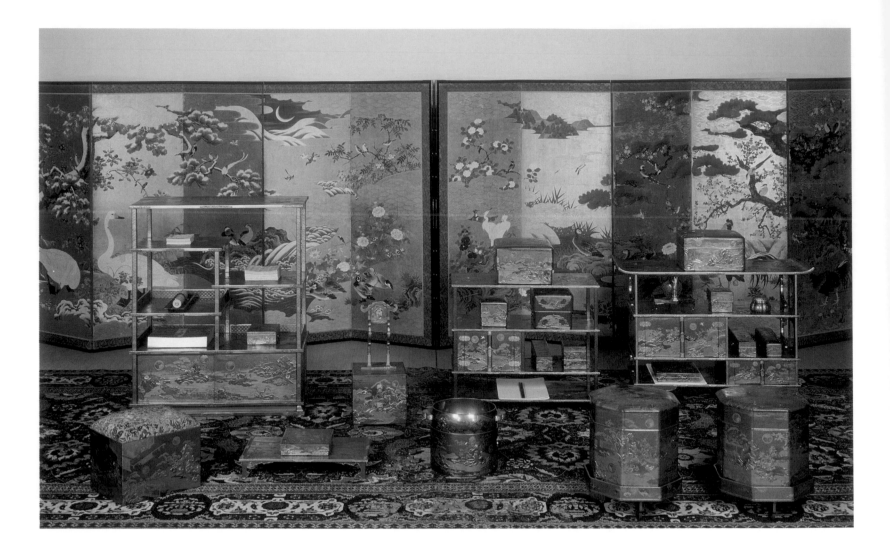

Fig. 7.20. Kōami Nagashige (Chōjū). Furnishings from the *Hatsune* Trousseau, Edo, 1637–39. Lacquered wood, coral, gold, silver, and other materials. The Tokugawa Art Museum, Nagoya, National Treasure.

kurodana (black shelf, center), and *shodana* (writings shelf, left). The *zushidana* holds an accessory box at the top containing twelve smaller boxes of personal items, such as mirrors, combs, hair oil, face powder, brushes, and tweezers, and rows of incense utensils and boxes for poetry slips, letters, and writing utensils placed next to double-door cabinets. The *kurodana* displays more boxes of personal items, and the *shodana* holds literary objects—classic courtly romances, poetry anthologies, illustrated scrolls, and specially prepared calligraphy models. Garment racks, board games, pillows, and swords also formed part of the trousseau.

The Tokugawa shogunate enacted regulations governing marriage and ownership of sumptuary goods. The scale, quality, and design of objects were determined according to rank and family status. The symphony of textures in the *Hatsune* Trousseau lacquerware underscores the status of its owner. The various sprinkled-picture techniques—polished, raised, and flat *maki-e*—are further elaborated with coral inlays and particles of gold, silver, and *aokin* (alloy of gold and silver with a bluish tint). The importance of display is also reflected in the *Hatsune* Trousseau. In addition to high-status objects, Chiyohime had a set of alternate, everyday furnishings consisting of simpler designs of gold *maki-e* on a black lacquer ground.

The tradition of the daimyo bridal trousseau was later adopted by wealthy townspeople. A set purportedly made for Riyo, the daughter of the head of a currency-exchange house active during the Genroku era (1688–1704), indicates the great wealth of the exchange houses, forerunners of department stores such as Mitsukoshi. Although the trousseau tradition ceased, many objects remain familiar today, with miniature trousseaus known as *hinadōgu* displayed in homes on the third day of the third month *hinamatsuri* (Doll Festival), also known as *momo no sekku* (Peach Festival).

KYOTO CULTURAL NETWORKS AND TASTEMAKERS

Kyoto, hailed as the *miyako* (capital) since the late eighth century, represented the symbolic center of Japan and long served as a cultural ideal. Although Edo witnessed remarkable development in the seventeenth century, culture and manufacturing in Kyoto shaped many aspects of visual and material production in the early Edo period. At the most elite level, the cultural salon of Emperor Go-Mizunoo (r. 1611–29) and Empress Tōfukumon'in extended beyond the imperial family to include notable figures from various groups, such as government official and tea master Kobori Enshū (1579–1647), and Zen abbot Hōrin Jōshō (1593–1668), who documented in his diary meetings with more than a thousand individuals across the social strata, thus providing a snapshot of cultural activities at the time.

The courtly aesthetic manifested itself not only in the selection of design motifs or subject matter but also in architecture,

ceramics, metalwork, and textiles. Often cited in connection to this circle is the Katsura Imperial Villa, the earliest extant example of *sukiya*, an informal take on the *shoin* style. A hallmark style of Edo-period architecture, *sukiya* was characterized by austerity and restraint, virtually lacking ornament other than such features as columns formed of tree trunks and walls of earth. Every aspect of the Katsura complex, down to the smallest details such as the metal door pulls and nail covers (*kugikakushi*), evinced an understated and delicate design sensibility, also influenced by tea culture.

NINSEI AND THE TEA CIRCLES

The potter Nonomura Seiemon (act. 1646–94), better known as Ninsei, is noted for his polychrome designs rooted in courtly visual culture. His kiln likely served as the official kiln of the imperial Ninnaji temple, near which it was located, in the Omuro district of Kyoto. An incense burner created by his workshop showcases Ninsei's technical prowess and his use of carefully formed stoneware vessels as canvases for polychrome overglaze enamel (green, purple, red, gold, and silver) achieved through several firings (fig. 7.21). The square-shaped vessel features flowers of the four seasons (plum, cherry, chrysanthemum, and bamboo), framed by scalloped clouds evocative of illustrated courtly narratives. On the top, a geometric checkerboard design alternates swirls and *hanabishi* (diamond-shaped flowers).

These patterns connoted conventions in textiles and furnishings used at the imperial court, thus suggesting Ninsei understood the taste for things courtly. Linked to Kyoto court culture, such objects held great appeal to those outside Kyoto, including the daimyo, who often maintained agents in Kyoto to procure for them a range of goods, including textiles, paper, gold foil, and lacquerware.

The tea master Kanamori Sōwa (1584–1656) helped shape the production of high-end teaware made by Ninsei, one of the first potters to sign his vessels. Sōwa used and promoted Ninsei's work and facilitated the reception of the Ninsei brand among various elites, including the Emperor Go-Mizunoo and Empress Tōfukumon'in, as well as the powerful Maeda warrior clan in the northern domain of Kaga. Ninsei's multicolored designs, applied over his distinctive white glaze, offer a striking take on conventions of Chinese-style tea-leaf jars, which are known for their earth tones and iron glazes. Ninsei also produced a series of sumptuously decorated jars—commissioned by a provincial domain lord—featuring the ingenious application of two-dimensional pictorial design that invites viewing in the round.

Sōwa's contemporary Kobori Enshū was a student of the tea master Furuta Oribe (1543/44–1615), who continued the connoisseurial practice of transforming objects into tea utensils by the acts of selection, naming, and inscription. During the early seventeenth century, when *chanoyu* (the art of tea) became a preferred practice among daimyo lords as a way of establishing social connections, the demand for heirloom teaware increased. Enshū responded to the rise in demand by elevating new or locally made utensils as "important" objects,

carefully coordinating objects and materials to create an ensemble worthy of a daimyo lord.

To establish a worthy "pedigree" for an object, Enshū engaged in the practice of "naming" objects and associating them with an array of other objects. A tea caddy, given the name "Ōsaka," now in the Nezu Museum in Tokyo, is an example of artistic direction by Enshū, in this case for his own collection. Locally made, the tea caddy was elevated to the status of treasured object by Enshū's skillful orchestration of markers of pedigree, including its name, a reference to a courtly poem that endowed the object with the aura of a millennium of literary tradition. "Ōsaka" was produced in the Seto kilns during the fifteenth century, and its subdued aesthetic of earthy colors emulated those of imports from China that were treasured as *meibutsu* (famous objects) in tea circles. Accoutrements were prepared for "Ōsaka": a red lacquered tray for displaying it at gatherings; four silk bags of *donsu* (damask) and *kinran* (gold brocade); six ivory lids; a *hikiya* (protective container) made of black persimmon wood for its storage; and a scroll that recounts the story of the Ōsaka name. All of these were kept in a special storage case, wrapped with *sarasa*, a textile imported from India. Through *hakogaki* (inscriptions), an object's provenance was often recorded on the lid of the case, and Enshū's inscriptions came to be appreciated among connoisseurs of tea. Enshū is also known to have commissioned tea bowls to his taste, patronizing kilns such as the Takatori kiln (in Fukuoka prefecture).

Fig. 7.21. Workshop of Nonomura Seiemon (Ninsei). Incense burner, Kyoto, mid-17th century. Stoneware; 6¾ x 7¼ x 7¼ in. (17.1 x 18.4 x 18.4 cm). The Metropolitan Museum of Art (29.100.668).

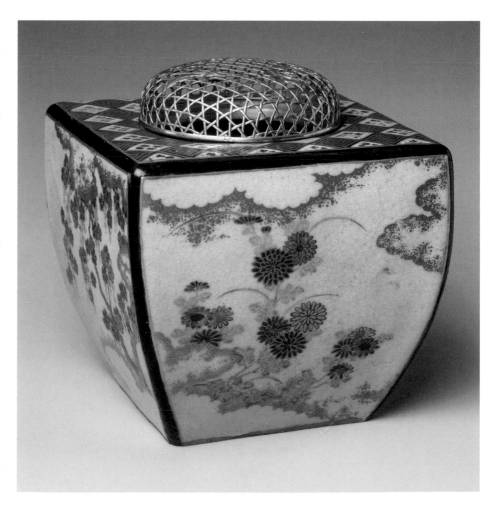

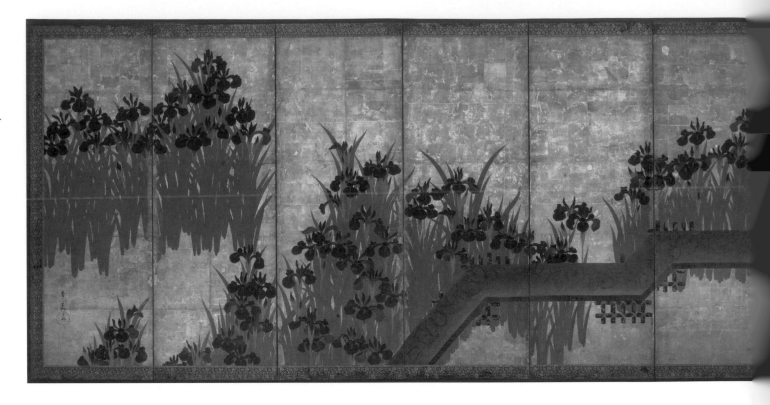

CELEBRATED PRACTITIONERS: KŌETSU, KŌRIN, AND KENZAN

A percolating down of courtly knowledge—hitherto a privilege of those who had access to manuscripts—marks one facet of cultural production during the early seventeenth century. In 1608, an iconic deluxe edition of *The Tales of Ise* was published as part of a collaboration known as *Saga-bon* (Saga Editions), funded by the merchant Suminokura Soan (1571–1632), who built his fortune by trading with Vietnam. *Tales of Ise* featured work by Soan's calligraphy teacher, Hon'ami Kōetsu (1558–1637), as well as wood-block illustrations.

Kōetsu was celebrated in tea circles and today is known for his multifaceted artistic collaborations, including calligraphy scrolls of courtly poetry that accompanied the bold designs prepared by the town painter Tawaraya Sōtatsu (d. c. 1643). Kōetsu also made tea bowls glazed and fired at the Raku kiln and designed lacquer writing boxes that were produced by specialist craftsmen. He spent his final decades at what is believed to have been an artistic and religious community of followers of the Hokke (Lotus) sect of Buddhism at Takagamine, at the northern edge of Kyoto. Among the members were families of artisans, including papermakers, brushmakers, and lacquer artists who moved with Kōetsu from the capital.

Descendants of one of these families, the Ogata family, included Ogata Kōrin (1658–1716) and his brother Kenzan (1663–1743), a potter, who are considered iconic artist-designers from the Genroku era, which is often identified as a time of cultural flourishing among wealthy residents of Kyoto and Edo. The Ogata family owned the Kyoto textile shop Kariganeya, which catered to warrior and aristocratic elites. Empress Tōfukumon'in was perhaps its best-known client. Despite their specialties, Kenzan and Kōrin worked in a variety of media, including lacquerware and metalwork, thus facilitating cross-media applications of designs and subject matter. Their source materials—courtly texts, Chinese folklore and visual culture, and performing arts such as Noh drama—reflect their cultivated upbringing and wide knowledge of historical artifacts.

Kōrin's best-known works include the folding screen *Irises at Yatsuhashi (Eight Bridges)* (fig. 7.22), based on a popular episode from *The Tales of Ise*. In the bold rendering of bridge segments and irises, the viewer becomes the exiled traveler from the story, standing on the famed bridges of Mikawa province where he composes a poem of reminiscence about his home in Kyoto, using the word *kakitsubata* (iris) as inspiration.

Kōrin took up this theme again in his design of a lacquer writing box (fig. 7.23), employing lead slabs for the bridge, mother-of-pearl inlay for the iris blooms, and gold low-relief *maki-e* for the leaves, and placing the viewer at the top of the

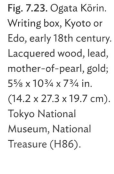

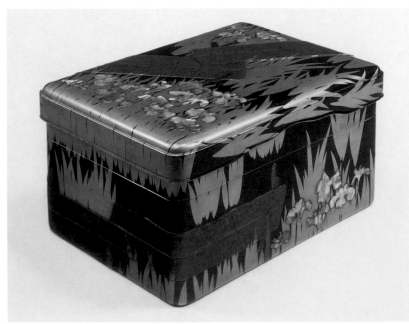

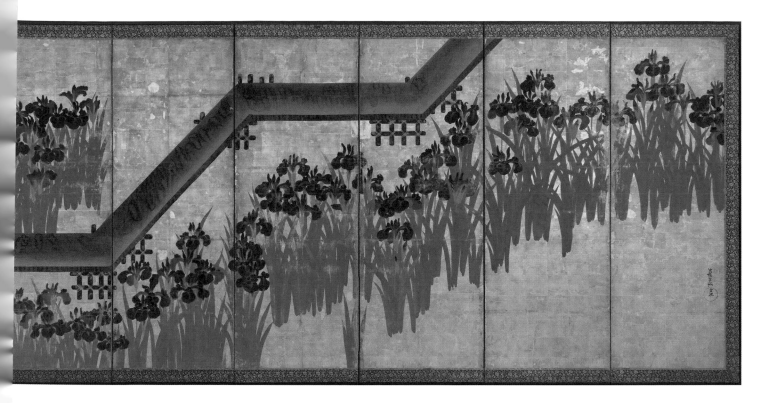

bridge. Removing the lid and insert (which holds the inkstone and brushes) reveals an interior of waves. Unusual in its two-level construction, magnified motifs, and the combination of materials, this object demonstrates a successful collaboration between a designer, in this case Kōrin, and the specialized craftsmen who realized his visions. Kōrin worked in a variety of object types and media: fans, incense wrappers, playing cards, ceramics, lacquerware, and the silk of *kosode* robes. In a testament to the strength of Kōrin's influence, long after his death, his designs for robes continued to be found in pattern books published in the Kyoto region (see fig. 7.27).

Kōrin's brother Kenzan opened his first kiln in 1699 in Narutaki and wrote the manual *Tōkō hitsuyō* (Potter's Essentials) which was published in 1737. His legacy spans many styles and a multitude of subjects, from courtly motifs typically realized in polychrome overglaze enamel in the manner of his teacher Ninsei, to Chinese literati-inspired monochrome brushwork. As a student of the new Ōbaku sect of Zen introduced to Japan in the mid-seventeenth century, Kenzan belonged to a thriving network linking China and Japan through the sect's temple headquarters in Kyoto and Nagasaki. Objects from his kiln suggest that Kenzan had firsthand experience with work from the Jingdezhen kilns in China, with Delftware, and with Vietnamese pottery. His more personal works, decorated in a monochrome underglaze—iron pigment under transparent lead glaze—showcased the "three jewels" of Chinese literati expression—painting, calligraphy, and poetry. Kenzan used ceramics as a vehicle for expressing the cultural range of a well-educated member of the Kyoto merchant elite, and in this way he made a distinct contribution to the material culture of his time.

Kenzan's workshop specialized in high-end banquet ware and teaware. Sets of bowls and plates were typical products of the Kenzan kiln, such as the five dishes illustrated here (fig. 7.24). This set features pampas grass, an autumnal motif

in Japanese culture, painted with a combination of underglaze cobalt blue, iron brown, and white slip. Typically, each plate features a different design. It has been suggested that the motif was taken from the cover design of a *Saga-bon* Noh libretto, thus representing another example of media crossover. Kenzan ware was frequently made in molds which may seem to emphasize decoration over form, but the kiln was also known for its innovative forms, such as openwork rims. Like Ninsei, Kenzan boldly inscribed his name on his works and in some cases noted "Nihon" (Japan) beside his name, perhaps as a way to compete with the imported ceramics that flooded the market during his time. Kenzan and Kōrin were also known for their collaborations, including square dishes with Kōrin's painting and Kenzan's calligraphy. Contemporary imitations suggest the immediate popularity of their work.

Fig. 7.24. Ogata Kenzan. Set of dishes, Kyoto, early 18th century. Stoneware; each approx. 1⅝ x 5½ x 5½ in. (4.1 x 14 x 14 cm). Philadelphia Museum of Art (2002-75-1–5).

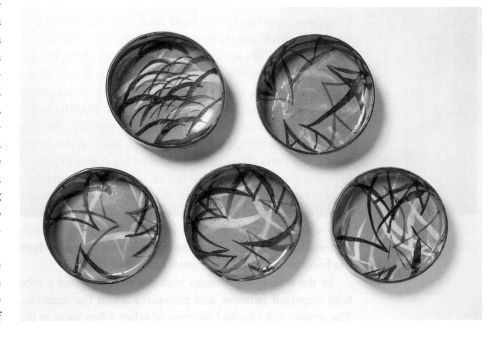

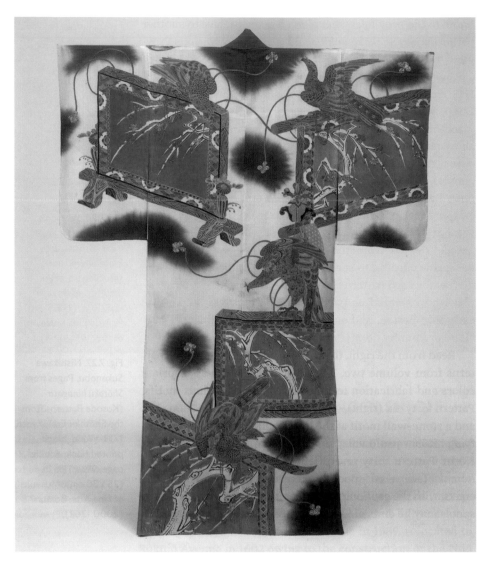

were combined to produce purple, green, and orange and were complemented with black and gray from ink and pine soot. The imagery depicts hawks perched on standing screens, on which snow-covered plum branches are painted. These and other fine details, such as individually colored hawk feathers and the articulation of the wood grains and textile textures of the standing screen, showcase the range of the Yūzen technique.

THE GLOBAL AND THE LOCAL: DESIGN AND THE MOVEMENT OF GOODS

Between 1600 and the 1750s, ceramic production included objects made for banquets as well as everyday use. By the turn of the eighteenth century, large-scale ceramic workshops made porcelain tableware available for daily use among townspeople and farmers, who until that time had often used unglazed *kawarake* (earthenware) or wooden vessels. Heirloom ware, including both Chinese and Korean imports and products of the Seto kilns, consisted largely of tea utensils, demonstrating the continued impact and spread of *chanoyu* as an elegant pursuit in Japanese life and the importance of the tearoom as a venue for displaying wealth.

A confluence of events at the beginning of the seventeenth century led to the start of porcelain production in the Arita region of Hizen province in southern Japan (present-day Saga and Nagasaki prefectures). Transplanted Korean potters—some at the request of domain lords, others abducted during invasions of Korea by the warlord Toyotomi Hideyoshi in the 1590s—played a critical role in early porcelain production in Japan. Marrying Korean porcelain technology with Chinese forms and designs, early Japanese porcelain wares were decorated with underglaze cobalt blue (*sometsuke*, literally "dyed ware"). Although collectively known in the West as "Imari ware" from the name of the shipping port, several distinct styles of porcelain catering to local and export markets coexisted in the Arita region.

The introduction of the overglaze enameling technique in the 1640s by a Chinese merchant in Nagasaki led to a variety of local polychrome porcelain styles. The "Kutani" ware made in Arita, for example, was a limited-production item during the mid-1600s. Created for the domestic market, Kutani ware was characterized by dynamic geometric motifs referencing paintings and textile designs and by distinctive greens, yellows, and purples applied on banquet plates nearly 12 inches (about 30 cm) in diameter. The made-for-export Kakiemon ware, also from Arita, featured bird-and-flower and landscape designs in the Chinese mode and was rendered in polychrome overglaze enamels on a milky-white body (fig. 7.29). Its name derives from the potter who originated the style, Sakaida Kakiemon (1596–1666).

Production expanded after the fall of the Ming dynasty in China in 1644 and a trade ban instituted by the succeeding Qing dynasty in 1656 that prevented the export of porcelain from China to Europe until 1684. The jar in figure 7.29 evokes Chinese taste through its shape, mode of brushwork, landscape motifs, decorative pattern circling the neck of the jar,

Fig. 7.28. Yūzen-technique robe (*kosode*), Japan, 18th century. Dyed and painted silk crepe; L. 63⅜ in. (161 cm). Tokyo National Museum (I-3869).

In this context, Yūzen likely referred to both the design style and the dyeing technique. Often enhanced by or combined with such techniques as embroidery, bound-resist dye, and tie-dye, the Yūzen technique is characterized by the use of paste-resist (mainly outlining designs with threadlike applications of paste to prevent the bleeding of colors) and brushwork (the application of dye with a brush on stretched cloth). This enabled a quicker application of complex designs. Yūzen was embraced by townspeople, whose robes were largely dyed as opposed to embroidered. The sumptuary law of 1683 banned the use of *kinshi* (gold thread), embroidery, and *sōkanoko* ("allover fawn spots") as too lavish. *Hinagata* books published in Edo and Kyoto thereafter were quick to claim *sōkanoko* out of fashion, suggesting that the law also played a role in the shift toward dye-oriented garments. Some scholars, however, argue that the law had little effect and that sumptuous *kosode* with extensive embroidery and fawn spots remained in vogue during the Genroku era.

A *kosode* decorated with the Yūzen technique demonstrates the stunning pictorial effects of this double method, with its multicolored palette, fine lines, and delicate shading (fig. 7.28). The motifs were outlined by funnel-applied rice paste, colored with brush-applied dyes, then protected with paste before the background was dyed. Color was fixed by steaming the cloth. Three base colors of blue, red, and yellow

and the Chinese lion atop the lid, but the distinctive colors firmly place production in Japan. In turn, the Kakiemon-style porcelain spurred imitations, beginning at Meissen, Germany, under the order of Augustus I (whose vast collection of porcelain is known to have included more than 250 Kakiemon-style pieces), and subsequently in France and England during the eighteenth century.

In Japan, Chinese porcelain had been among the annual tributes presented to the Tokugawa shogunate. The Nabeshima domain of Hizen province, in seeking an alternative to the increasingly scarce Chinese porcelain it had given the shogunate, began producing porcelain at home in the 1640s, establishing an official kiln and quality control office that supervised hundreds of craftsmen. Nabeshima ware was made strictly as presentation pieces for the shogunate and other military and court families, and not for general sale. Manufacturing processes were kept secret from rival manufactories. As high-end banquet ware, plates, serving dishes, and cups were made in sets of standardized sizes, the remarkable consistency in measurement, shape, and design application in any given set is a hallmark of Nabeshima ware (fig. 7.30).

Porcelain wares were fired twice: first to harden the body and fire the underglaze and clear overglaze at a very high temperature (2,400° F [1,300° Celsius]); second, a lower-temperature firing, to fuse the colors used in the enamel decoration that was applied over the glaze. New designs were mined from printed *hinagata* textile books, such as the scene from a cherry blossom viewing illustrated in figure 7.30. The standardized plate (the largest of three sizes of individual serving dishes) and tightly demarcated and precise application of three bands of underglaze—blue, celadon, and iron—are typical of Nabeshima ware. The decoration represents the curtains that marked the banquet area for outdoor events.

Decorative arts and design during the early Edo period centered around Kyoto. Production, consumption, and patronage of objects of material culture expanded to a wider base during the years 1600 to 1750, supported by print culture. Not only did publications disseminate knowledge, but pattern books and other works in print also documented how various designs proliferated and migrated across and between media, class, and location. And while trade was highly regulated, extant objects offer an understanding of the ways in which Japan was connected to the outside world and its products. After 1750, while Kyoto continued to be a production center, innovation and trendsetting in design and crafts shifted to Edo.

TOMOKO SAKOMURA

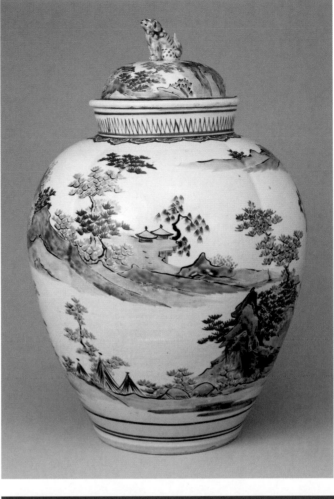

Fig. 7.29. Kakiemon-ware jar, Arita, 1660–80. Porcelain; H. 17½ in. (44.5 cm). Victoria and Albert Museum, London (FE.24&A-1985).

Fig. 7.30. Nabeshima-type dish, Hizen province, late 17th century. Porcelain; Diam. 7¾ in. (19.7 cm). The Metropolitan Museum of Art (1975.268.555).

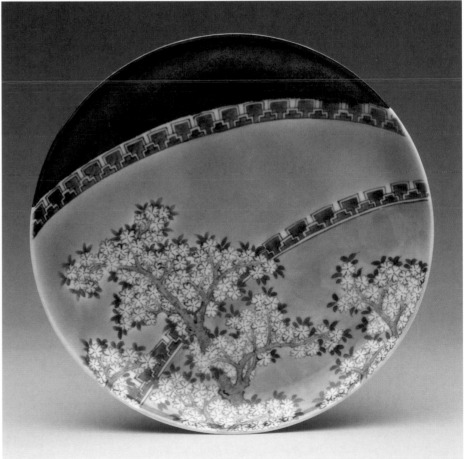

INDIA

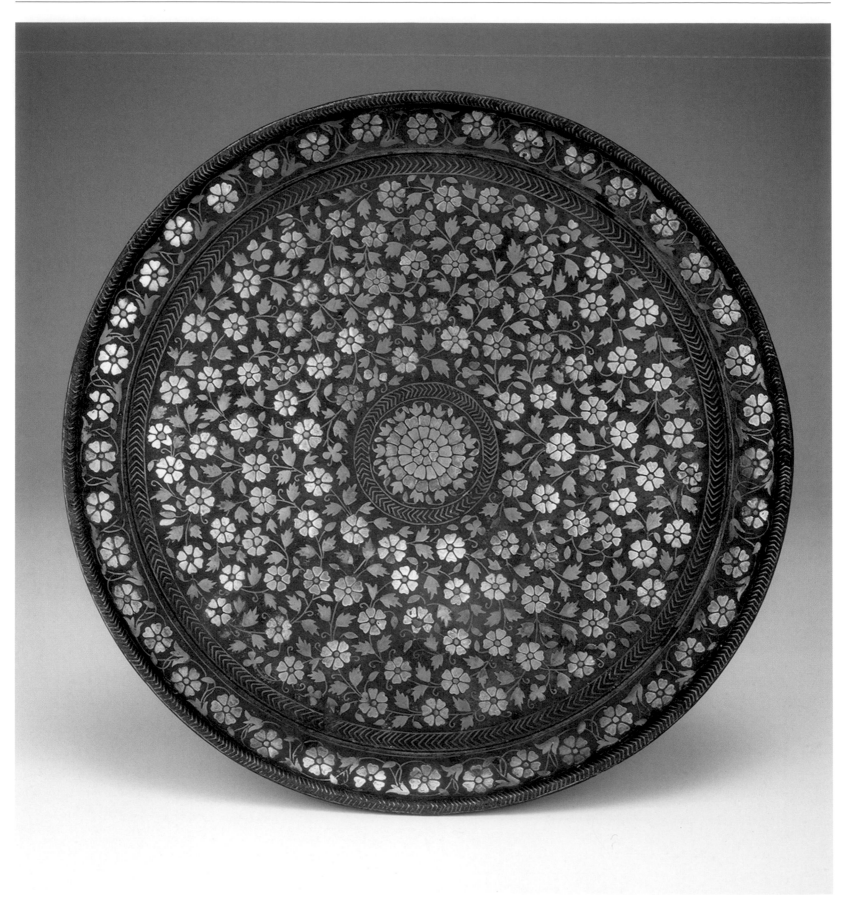

Fig. 8.30

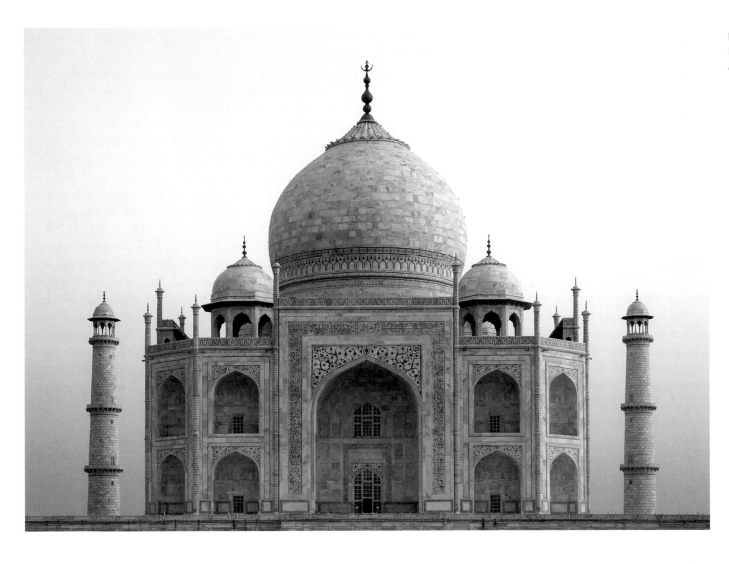

Fig. 8.1. Ustad Ahmad Lahauri and others. Taj Mahal, Agra, 1632–48.

India from 1600 to 1750 was marked by courtly patronage of art, architecture, and design. The magnificent surviving civic and religious buildings and objects indicate the richness and variety of form and decoration within Indian material culture at this time. The Mughal emperors dominated the subcontinent, and their power, wealth, and sponsorship of architecture and the decorative arts rivaled those of contemporaries elsewhere in Asia, notably the Ottomans, Safavids of Persia, and Ming emperors of China. During the seventeenth century, centralized Mughal control was near hegemonic, but it began to disintegrate in the first half of the eighteenth century. And even under Mughal domination, native-born rulers in Rajasthan (in northwestern India), the Deccan, and southern India continued to commission buildings and decorative arts objects. European traders struggled to monopolize the lucrative export market in luxury goods, and their investment in local commerce contributed to the prosperity of the country.

THE IMPERIAL MUGHAL COURTS

Spanning the seventeenth century, the reigns of Jahangir (r. 1605–27), Shah Jahan (r. 1628–58), and Aurangzib (r. 1658–1707) marked the highpoint of the fortunes of the Mughals in India. Following the precedent set by Akbar (r. 1556–1605), who established *kar-khanehs* (workshops) at his various capitals in Agra, Fatehpur Sikri, and Lahore, the Mughal emperors took a particular interest in architecture and the decorative arts, both of which flourished under their guidance and sponsorship. Jahangir and Nur Jahan, his favored wife, were sophisticated connoisseurs, arranging for the building of monuments with exquisite ornamentation. The silk textiles, miniature paintings, and coins influenced by European naturalism from Jahangir's reign are of the finest materials and craftsmanship. Shah Jahan boosted his imperial image by commissioning portraits of himself as the governor of a great empire, and ambitious architectural projects,

including the Taj Mahal in Agra (1632–48; fig. 8.1) and Shah-jahanabad (1639–1739), a walled city complete with a fortified palace beside the Yamuna River in Delhi. Although his successor, Aurangzib, reportedly took less interest in the arts, there is no shortage of objects of high quality in both design and execution surviving from his long reign.

Imperial Mughal design in India expressed a delight in the natural world. It owed much to Central Asian and Persian influences, introduced to India by the Mughals themselves and sustained by artists and craftsmen, including painters, weavers, and metalworkers, who emigrated to the Mughal court. Links with the wider Islamic world can be seen in the Persian style of calligraphic, arabesque, and foliate decoration on architectural panels and portals, and, on a smaller scale, carpets, illuminated manuscripts, inlaid mother-of-pearl boxes, and sculpted jades.

Not surprisingly, these imported forms, techniques, and tastes were profoundly affected by local traditions in terms of design, craft, and materials, since most of the artists and craftsmen employed in the Mughal *kar-khanehs* were Indian. Also, the immigrants themselves absorbed the visual and material culture that surrounded them. Indigenous elements included the use of local materials, polychromy, sculpted detail, geometric *jalis* (perforated screens), and floral motifs—either as complete plants or as isolated blossoms linked by trailing vines—in the borders of miniature paintings, carpets, and enameled inlays on gold dishes. This blend of foreign and indigenous design traditions is sometimes described as "Indo-Persian." At the same time, however, Mughal decorative arts were also influenced by European practices, as, for example, in the shading and perspective of miniature paintings and the Italian inlay technique of *pietra dura* (see "Stonework" opposite).

THE OTHER COURTS OF INDIA, NEPAL, AND CEYLON

During the seventeenth century, the Mughal style spread across much of India then beyond the imperial frontiers into neighboring territories. This occurred first in Rajasthan following alliances between the Mughals and Rajputs, who came to serve in the imperial service. The building of Mughal-style audience halls and pavilions in various Rajput capitals then followed and Mughal-influenced miniature portraits, hunting scenes, clothing, and arms were introduced. This tendency lessened after 1727, when Jai Singh II of Amber (r. 1699–1743) laid out his new capital of Jaipur in Rajasthan, an act that reflected the declining power of the Mughals in northern India in the early eighteenth century.

Mughal influence in the Deccan dates from the 1680s, by which time Aurangzib had conquered this region. Prior to that time, however, the different sultanate kingdoms of the area had enjoyed more than a century of independent artistic patronage and craft development. This process resulted in a series of splendidly decorated monuments—especially those of Ibrahim 'Adil Shah II (r. 1580–1627) of Bijapur (Karnataka) and his near contemporary Muhammad Qutb Shah (r. 1611–

26) of Golconda-Hyderabad (Andhra Pradesh)—as well as miniature paintings, metalware, and textiles. Metal vessels were inlaid with brass and silver in a technique known as *bidri* (see "Metalwork" below). Cotton textiles were dyed and painted with brilliant colors in workshops on the Bay of Bengal shore of the Qutb Shahi kingdom, known to Europeans as the Coromandel Coast.

During this period, the Nayaka rulers of Gingee (Senji), Tanjavur (Tanjore), and Madurai in Tamil Nadu in Southern India continued to sponsor the long-standing Hindu practice of renovating and enlarging older temples in their territories. The same is true for the outlying zones of Kerala in the extreme southwestern corner of India, and of Nepal in the Himalayan foothills far to the north, both of which also came under the control of local Hindu rulers. A related but distinctive aesthetic tradition flourished on the island of Ceylon (after 1972, Sri Lanka) under the patronage of Buddhist kings.

The severe rains experienced in Kerala, Nepal, and Ceylon explain the localized steep-roofed wooden architecture. During the seventeenth and early eighteenth centuries, palaces and temples there employed a time-honored tradition of richly embellished timber carving. By contrast, granite was the medium of monumental architecture in Tamil Nadu, with its attendant sculptural tradition. Hindu themes predominated in the architecture and in the murals that adorned temple ceilings and palace walls. Tamil Nadu and, to a lesser extent, Kerala were also known for their metal workshops, which produced images of Hindu divinities as well as elaborately worked ceremonial weapons, standards, and lamps. Ivories from Tamil Nadu and Ceylon were another aspect of the material culture of these zones, best seen in objects intended for palaces and temples.

FOREIGN MARKETS

The workshops of the Mughals in northern India, the Sultans in the Deccan, and the Hindu rulers in southern India not only fulfilled orders for local clients but also produced furniture and textiles for Asian and European markets. Portuguese merchants first dominated the profitable export trade, but during the seventeenth century, the Dutch and English seized much of it. Thousands of bales of cloth were regularly loaded onto ships at various Indian ports.

It is a testament to the technical skills of Indian craftsmen that they so expertly imitated and adapted the foreign patterns they acquired, realizing them in inlaid wood, carved ivory, printed cotton, and embroidered silk. Furniture made for export in Gujarat and Sindh (in present-day Pakistan), as well as the Portuguese trading headquarters at Goa, included European-style cabinets in Indian woods, often decorated with floral designs and figures, while ivory boxes from Ceylon sometimes featured biblical subjects. Textiles from Gujarat and the Coromandel Coast with motifs derived from Southeast Asian arts found ready markets abroad, judging from the many extant examples in Thailand and the Indonesian islands. Workshops in the same area produced quasi-Italianate floral designs for furnishing fabrics in response to English and Dutch tastes.

A distinctive feature of Indian design in this context is the portrayal of Portuguese and Dutch figures on items of furniture and cloth hangings: entertaining Indian companions, sitting in chairs, smoking pipes, and even riding in palanquins, in addition to the occasional depictions of European ships, flags, and coats of arms. Realized in ivory inlay set into teak chests, or dyed and painted in bright colors onto cotton hangings, designs with such subjects were commissioned by foreign traders as personal souvenirs and gifts, or for sale in Europe.

STONEWORK

Stonework decoration by masons and sculptors employed at both Muslim and Hindu courts continued to dominate monumental architecture in all parts of India between 1600 and 1750. Mughal-style polychrome geometric patterning in red sandstone, white marble, and other colored stones remained a major feature, but certain refinements were introduced under Jahangir. The tomb that he completed in 1613 for his father, Akbar, at Sikandra near Agra stands in the middle of a gigantic *chahar-bagh* (grid-layout garden). The imposing arched portal is adorned with geometric patterns in boldly contrasting colored stones, including stylized white marble blossoms set into the red sandstone background that cloaks the side walls, rather in the manner of a draped textile. Finely crafted marble *jalis* with interlocking geometric designs define the terrace at the summit of the tomb itself.

Similar features occur in an even more exquisite mausoleum, erected between 1626 and 1628 by Nur Jahan for her father, I'timad al-Daula, in a *chahar-bagh* overlooking the Yamuna (Jumna) River outside Agra (fig. 8.2). The tomb is entirely faced with white marble; the interior and exterior walls, pavements, floors, and circular shafts of the four corner minarets are enlivened by patterns of inlaid stones, including rare fossilized specimens. The patterns include geometric designs with alternating stars and two- or three-pronged motifs, stylized arabesques in lobed cartouches, and images of cypress trees and wine vessels in arched frames. The floor of the upper chamber presents a dazzling display of polychrome stonework covered with an ever-expanding arabesque design of curling stems and stylized flowers in yellow and black marbles. The *jalis* encasing the upper chamber feature an array of perforated geometries based on stars with six, eight, ten, and even twelve points.

Polychrome, perforated, and relief stonework enhanced the equally splendid building projects of Shah Jahan, whose reign saw the beginning of the widespread use in India of *pietra dura*. This laborious technique of inlaying minute various colored, semiprecious stones, such as agate, jasper, carnelian, and lapis lazuli, into a marble base was introduced by Italian craftsmen employed at the Mughal court. *Pietra dura* technique is to be distinguished from the stone inlays of earlier periods, which employed larger pieces of valuable and rare specimens. Examples of Italian workmanship were certainly familiar to Indian craftsmen: imported *pietra dura* panels with bird motifs, and even one panel portraying Orpheus strumming his lyre, were set into the walls of Shah Jahan's

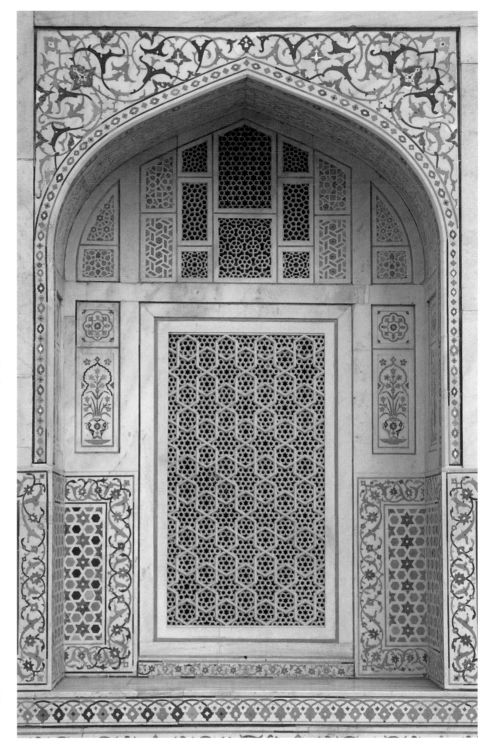

throne in the audience hall of his palace at Shahjahanabad, the new capital city north of Delhi begun in 1639 and completed in 1648.

In the hands of Shah Jahan's craftsmen, *pietra dura* was used on a large scale without losing its intricate, lyrical quality, as in the mausoleums for his father, Jahangir, at Shahdara outside Lahore (1627–28), and for his beloved wife, Mumtaz Mahal, at Agra (1632–43). Known worldwide as the Taj Mahal, the latter tomb is elevated on a terrace between an extensive *chahar-bagh* and the Yamuna River (fig. 8.1). Marble tombstones within both monuments are embellished with *pietra dura* arabesques and flowers (fig. 8.3). No less skillful are the *pietra dura* arabesques with Italianate, lyre-

Fig. 8.2. Inlaid stone and *jalis*, tomb of I'timad al-Daula, Agra, 1626–28. White marble, semiprecious-stone inlay.

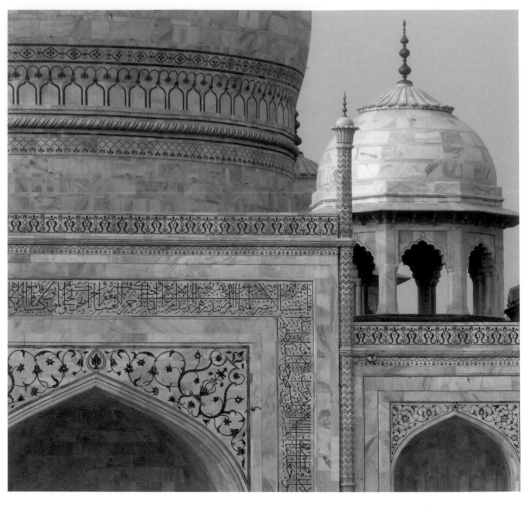

Fig. 8.3. Floral inlay, cenotaph of Shah Jahan and Mumtaz Mahal, Taj Mahal, Agra, 1632–48. White marble, semiprecious-stone inlay.

Fig. 8.4. Arabesque and calligraphic inlay, Taj Mahal, Agra, 1632–48. White marble, semiprecious-stone inlay.

Fig. 8.5. Wall panel, Taj Mahal, Agra, 1632–48. Carved white marble, semiprecious-stone inlay.

shaped motifs that fill the spandrels over the arches of the exterior portals and the majestic Koranic inscriptions inlaid in black marble into white that frame the arches (fig. 8.4) with curving Arabic letters flawlessly realized in stone. Relief carving is also employed to great effect; groups of seminaturalistic flowers carved in white marble around the inner walls of the tomb (fig. 8.5) are echoed in red sandstone in the adjacent mosque. Depicted as if growing from earthy tufts, or bunched together in vases, these floral compositions bridge the gap between nature and imagination by employing lifelike blossoms in artificial, symmetrical compositions.

Floral themes, in *pietra dura* or stone relief, featured elsewhere in Mughal buildings, interiors, and objects, but there was a noticeable decline in quality of workmanship and a gradual shift to plaster and painted imitations as the seventeenth century progressed. Nonetheless, excellent carved and inlaid stonework can be found in the palaces of several Hindu Rajput rulers, such as that in the private apartments of Jai Singh I (r. 1621–67), built in the 1660s in his fortified headquarters in Amber (Rajasthan).

Stonework in the Deccan had a different aesthetic, best seen in the sultanate monuments of Bijapur, many of which

were vehicles for elaborate relief decorations on walls, arches, parapets, and finials. The Ibrahim Rauza (1626), comprising the tomb and a mosque of Ibrahim ʿAdil Shah II, is a showcase of this ornate style (fig. 8.6). The calligraphy on the basalt wall panels of the tomb is carved with particular virtuosity. Other examples in Bijapur include the seventeenth-century gateway known as the Mihtar-i Mahal—with its balconies carried on angled struts fashioned to appear like woodwork with cutout lions, geese, and foliation—and the basalt *mihrab* (prayer niche) added in 1636 to the interior of the late sixteenth-century Jami Mosque. The magnificent composition of the latter contains a central polygonal arched recess filled with calligraphic medallions surrounded by foliation in fantastical forms, all in relief stonework dressed with stucco and gloriously picked out in gold and blue paint. Relief stone decoration in the Deccan was not confined to the Bijapur kingdom, however, as is evident from the sixteenth- and seventeenth-century basalt tombstones of the Qutb Shahi sultans in the cemetery in Golconda, near to Hyderabad, many of which are adorned with Koranic passages in different calligraphic scripts, incised in sharp relief.

PLASTERWORK, MIRRORWORK, MURALS, AND TILES

Mughal monuments were also showcases for decorative techniques in other materials. Plaster was used in place of marble in domes and vaults with Persian-style *muqarnas* (honeycomb, stalactite-like geometric facets), especially when more colorful effects were required. The vestibule leading to the central chamber in Akbar's tomb in Sikandra, for example, has domes filled with arabesque ornament in precisely modeled, gilded plaster relief on dark or pale blue backgrounds (fig. 8.7). Panels below accommodate ornate foliate ornament and flowering trees, also in plaster relief. Even more spectacular is the ceiling of the lower chamber of I'timad al-Daula's tomb outside Agra, which was conceived as a star-shaped medallion surrounded by *muqarnas*-like facets in different planes, all packed with polychrome arabesque and stylized flowers. In later Mughal architecture, such as the vaults of the Badshahi mosque in Lahore (1674), plaster was often used for molded geometric compartments containing floral motifs of a type similarly found in carpets of the period (see "Carpets" below).

Magnificent *shish mahals* (mirror halls) in Mughal palaces were decorated with mosaics of tiny pieces of mirrored glass. Such interiors were widely imitated by the Rajputs, as in the palace of Jai Singh I at Amber, where the *shish mahal* exceeded in splendor any produced for a Mughal patron (fig. 8.8). The vaulted ceiling is entirely covered with plaster medallions, while faceted *muqarnas* motifs cover the half-domes at either end. Each element is enhanced by mirrored glass, guaranteeing a gleaming, scintillating interior.

Mughal monuments were also embellished with vivid mural decorations. The interior walls of Akbar's tomb at Sikandra, for example, were painted with pale blue blossoms and trailing vines on a gold background, similar to those

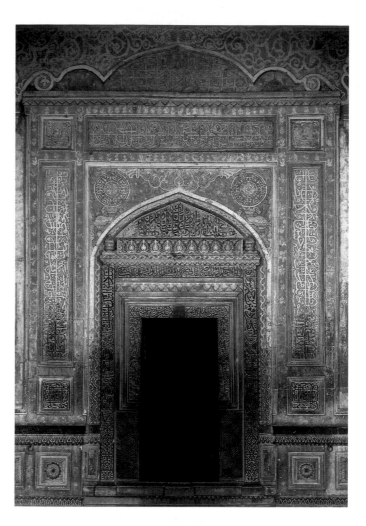

Fig. 8.6. Doorway, tomb of Ibrahim ʿAdil Shah II, Ibrahim Rauza, Bijapur, Karnataka, 1626. Carved and painted basalt.

depicted on carpets of the period. The upper walls of I'timad al-Daula's tomb featured arched niches decorated with brightly painted flowers in vases of diverse, fanciful designs. Geometric rigor is evident in the painted interiors of Mughal mosques. The dome above the central chamber in the prayer hall of the mosque associated with the Taj Mahal, for instance, is covered with a spiral design of intersecting and outwardly expanding strands.

Mughal tilework was largely restricted to Sindh and Punjab (Pakistan), where ceramic decoration had been used in religious monuments since the fourteenth century. The labo-

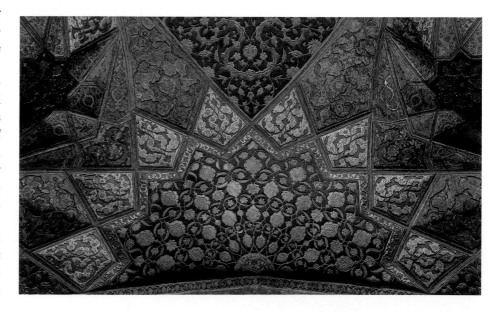

Fig. 8.7. Vaults in the tomb of Akbar, Sikandra, completed 1613. Painted and gilded plaster.

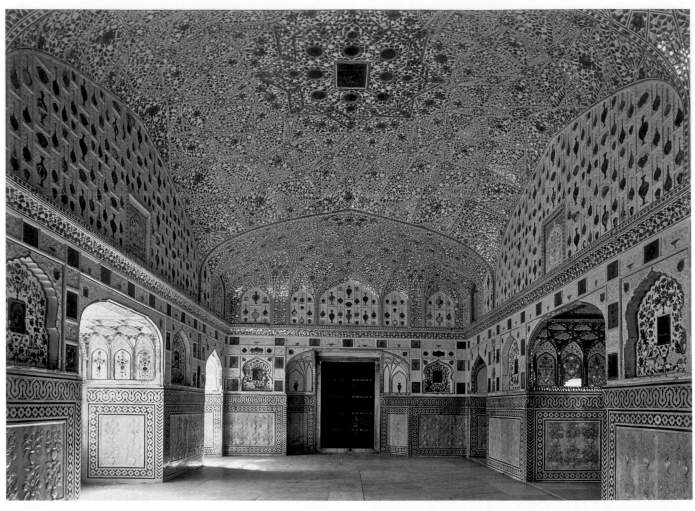

Fig. 8.8. Mirror hall (*shish mahal*), Jai Mahal, Amber, mid-17th century. Molded plaster with inset mirrors.

Fig. 8.9. Mosaic tilework, mosque of Wazir Khan, Lahore, 1634.

Fig. 8.10. Mosaic tilework wall (detail), Badshahi 'Ashurkhana, Hyderabad, 1611.

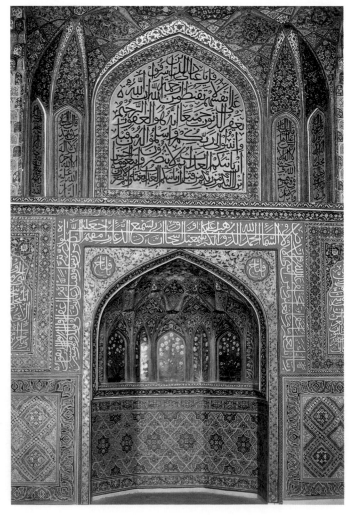

rious mosaic technique (see fig. 2.7) produced the most brilliant effects, and panels on the outer ramparts of Jahangir's extensions to Lahore Fort feature intricate geometric designs and animal and figural compositions. Better preserved are the tile mosaics on the walls and minarets of Wazir Khan's mosque (1634), also in Lahore (fig. 8.9). In addition to Arabic letters painstakingly cut out of tiles, panels with flowers, vines, and trees decorated mosques and shrines in Punjab and Kashmir in the seventeenth century. Many of these compositions were executed in vivid purple, turquoise, green, and blue tiles on contrasting yellow and white tiled backgrounds, generally with yellow and green tones predominating.

Throughout this period, plasterwork, murals, and tiles continued to adorn buildings in the Deccan. Qutb Shahi monuments in Golconda-Hyderabad display crisply worked plaster foliation and geometric interlace motifs in roundels and friezes, as in the ornate Toli mosque built in 1672. Surviving Hyderabad tilework is best appreciated in the wall panels added in 1611 to the Badshahi 'Ashurkhana (1594), used for annual Shiite Muslim rituals. Compositions of interwoven feathery leaves and blossoms, and hexagons filled with diamonds and stars, are all realized in a mosaic of blue-, turquoise-, and yellow-glazed ceramic shards. Illustrated here, one panel represents a giant *'alam* (see fig. 3.36), a religious metal standard carried in Shia processions, in the form of a leaf filled with calligraphy (fig. 8.10).

The full extent of mural painting in the Deccan is not known, but paintings in the upper chamber of the Asar Mahal in Bijapur (built as a palace in the early seventeenth century and later converted to a reliquary for hairs from the Prophet Muhammad's beard) show traces of courtly figures and even Christian imagery. This suggests that they were executed by artists employed at the 'Adil Shahi court who were familiar with European paintings or engravings. Other murals featured flowering creepers and vases decorated with fanciful arabesques, all in shimmering gold and blue.

FURNITURE

Virtually no furniture survives from the Mughal or Deccan courts because little was produced. On formal occasions, only the ruler was seated; nobles, commanders, and envoys stood in rows according to rank. At other times, emperors, sultans, or maharajas, as well as courtiers, sat on carpets or cloths according to the season, comfortably leaning on bolsters and cushions. The most celebrated piece of Mughal furniture was the Peacock Throne, first used by Shah Jahan in 1635 and then by successive Mughal emperors until 1739, when it was carried off by the Persian ruler Nadir Shah (r. 1736–47) to Persia and subsequently dismantled (fig. 8.11). According to descriptions by foreign visitors and depictions in miniature paintings, the throne consisted of a low, square seat surrounded by a balustrade and sheltered by a vaulted canopy topped by a pair of peacocks. This symbol of Mughal magnificence was entirely covered with pearls, diamonds, emeralds, and rubies set into solid gold.

Jeweled thrones such as this and another that ultimately found its way to the Topkapı Sarayı Palace, Istanbul, were probably designed and assembled at the royal workshops in Agra, Lahore, and Delhi, but furniture was also manufactured at other centers. Wooden floor cabinets and boxes decorated with inlaid ivory and various woods were made in Gujarat and Sindh. Some examples with European-style fall-front lids and decoration featuring European figures may have been made for export. One such example, a rosewood-veneered teak cabinet now in the Victoria and Albert Museum is embellished inside and out with Indian and Portuguese courtiers and hunters, on foot or mounted on horses and elephants, as well as ducks and other animals, and flowering

trees, all realized in intricately cut pieces of ivory and tropical woods. A similar cabinet in the same collection has painted and varnished panels on the top and sides with Portuguese hunters in an imaginary landscape and an Annunciation-like scene of a woman conversing with an angel, suggesting that it was designed for a Christian patron.

At the turn of the eighteenth century, pictorial cabinets with drawers and pairs of doors from Gujarat and Sindh replaced those with fall-front lids. An example now in the Museu Nacional de Arte Antiga, Lisbon, has exterior surfaces veneered with ebony and inlaid with ivory compositions of figures in Mughal-style clothing, animals, and birds in leafy landscapes. A cabinet with a pyramidal top mounted on a low

Fig. 8.11. `Abid. The Emperor Shah Jahan on the "Peacock Throne," Mughal court, 1640. Watercolor and gold on paper; 14⁷⁄₁₆ x 9¹³⁄₁₆ in. (36.7 x 25 cm). The San Diego Museum of Art (1990.352).

Fig. 8.12. Cabinet, Northern India, early 18th century. Teak, ivory inlay; 9½ x 13⅜ x 9⅞ in. (24 x 34 x 25 cm). The David Collection, Copenhagen (24/1981).

Fig. 8.13. Cabinet, Goa, 17th century (with restorations). Rosewood, teak, other woods, ivory, paint, brass; 55⅞ x 55⅞ x 27½ in. (142 x 142 x 70 cm). Museu Nacional de Arte Antiga, Lisbon (1312 Mov).

Fig. 8.14. Chair (one of a pair) for the European market, South India or Ceylon, 1660–80. Ebony, cane; 38⅝ x 21⅝ x 19¼ in. (98.1 x 54.9 x 48.9 cm). Peabody Essex Museum, Salem, MA (pair, AE85711.1-2).

Fig. 8.15. Casket with *yalis*, Ceylon, 17th century. Ivory, teak, silver; 6⅞ x 9⅝ x 6¼ in. (17.5 x 24.5 x 16 cm). Musée national des arts asiatiques Guimet, Paris (MA5262).

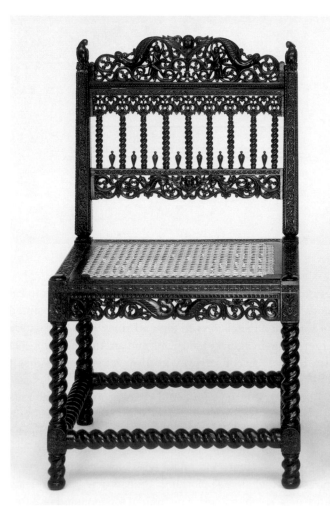

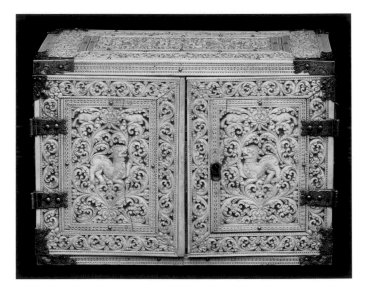

table in the Victoria and Albert Museum repeats this iconography, but the inside faces of the doors, as well as the drawers within, are adorned with eight-pointed stars. Another group of cabinets produced at about the same time in workshops in northern India features repeated flowers arranged in grids on the tops, sides, and drawer fronts, as in the fall-front example illustrated here (fig. 8.12). Almost certainly intended for European use, such cabinets were mostly made in provincial workshops in the Mughal domains.

The furniture made toward the end of the seventeenth century in Goa, both for Portuguese clients residing there and

for export, was quite distinctive. Large cabinets on stands with multiple drawers (fig. 8.13), fashioned out of rosewood or teak, were embellished with bold but intricate floral patterns in ivory or black teak inlays, as well as pierced brass mounts with abstract geometric designs. Supporting legs were carved in the semblance of human figures or stylized beasts and birds, such as pelicans. Goan workshops produced traveling chests with drawer fronts decorated in the same manner and similar furniture for local Portuguese clients. A suite consisting of chest of drawers and cabinets, embellished with ornate brass mounts bearing Latin inscriptions surrounded by arabesque ornament, in the Sacristy of the Basilica of Bom Jesus in Old Goa, dates from the second half of the seventeenth century.

Further examples of seventeenth-century furniture include ornately carved ebony chairs produced in workshops on the Coromandel Coast, probably intended for English and Dutch markets (fig. 8.14). Although the chairs were modeled on European forms, their twisted columns and pierced-work panels with flowing scrollwork reflect Indian tastes. Furniture of the period also includes ivory-veneered cabinets made in Ceylon and Tamil Nadu, which were probably intended for both domestic and foreign clients. Old Testament and Christian themes predominate in a Ceylonese cabinet now in the Victoria and Albert Museum, the doors of which are decorated with relief panels of Adam and Eve encountering the serpent. Other ivory-veneered cabinets had panels adorned with floral and vegetal ornament, varying from the prevalent blossoms-in-a-central-vase motif to leafy scrollwork that took on a more exuberant character when combined with *yalis*, fantastic leonine beasts (fig. 8.15). Similar carving can be found on an ivory writing box now in the Museu Nacional de Arte Antiga, Lisbon, decorated with *yalis* and Portuguese figures, one seated in a chair, others mounted on horses and elephants.

CARPETS

Among the most splendid items made in the Mughal imperial workshops in the seventeenth century were carpets produced for Jahangir and Shah Jahan and members of their nobility. Influenced by Persian techniques and taste, these exhibited indigenous color schemes and animal and foliate designs. Pictorial carpets with central panels crowded with animals on bright red backgrounds continued to be produced under Jahangir as they had been earlier under Akbar. By the time Shah Jahan ascended to the Mughal throne, however, pictorial carpets were being replaced by ones with overall floral patterns, often abstracted and fanciful blossoms in pale colors linked by trailing leafy stems in dark colors on bright red backgrounds. A huge carpet of this type, woven with wool pile on a cotton foundation, has stylized cream and white blossoms surrounded by feathery gray-blue leaves (fig. 8.16). In other examples, the pattern is interrupted by one or more lobed medallions filled with floral motifs. Borders have smaller flowers set in cartouches filled with arabesque designs.

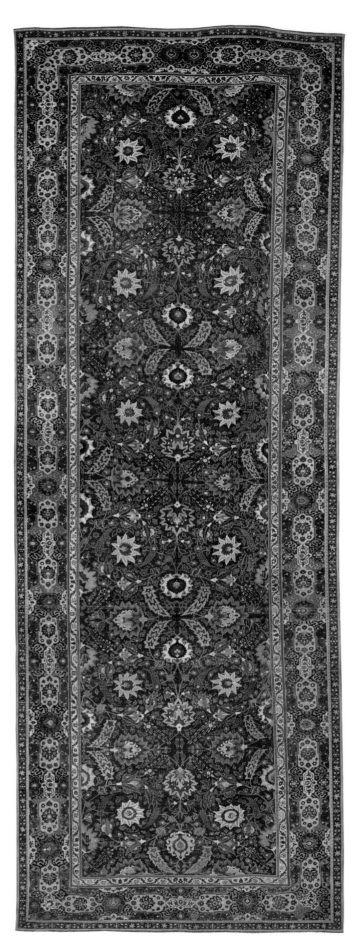

Fig. 8.16. Carpet, Lahore, mid-17th century. Wool, cotton; approx. 30¼ x 11 ft. (9.2 x 3.4 m). The Metropolitan Museum of Art (17.190.857).

Fig. 8.17. Carpet (detail), Kashmir, 1700–50. Pashmina wool, silk; overall, 74 x 57 in. (188 x 144.8 cm). Museum für Kunst und Gewerbe Hamburg (1961.27).

Fig. 8.18. Wall hanging, India, c. 1650–1700. Embroidered cotton, silk; 46 x 32 in. (117 x 81.3 cm). Victoria and Albert Museum, London (IS.168-1950).

Fig. 8.19. Mughal royal tent, mid-17th century. Embroidered silk velvet, metal-wrapped yarns, cotton; 13 x 24¾ x 24½ ft. (3.9 x 7.5 x 7.5 m). Collection of Maharaja Sri Gaj Singhji II, Mehrangarh Museum Trust, Jodhpur (L21/1981).

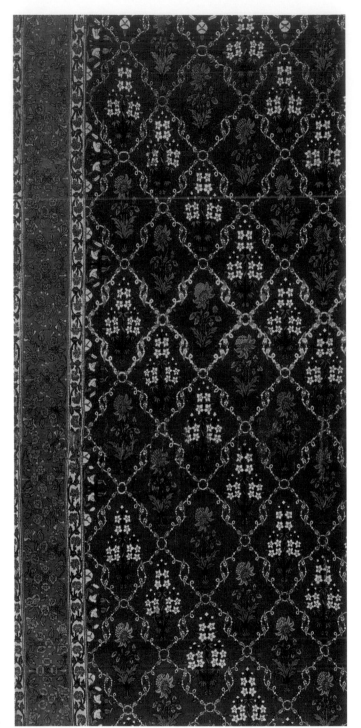

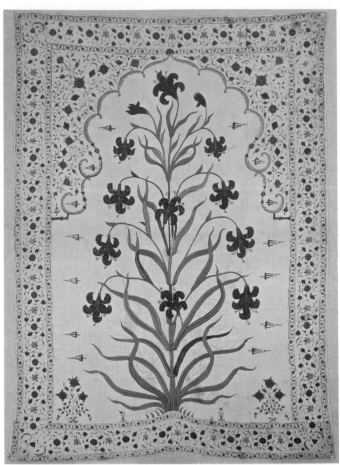

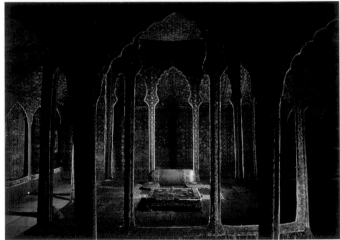

Toward the middle of the seventeenth century, another development occurred in Mughal carpet design: central panels were filled with rows of flowers, sometimes recognizable as roses, tulips, irises, or poppies. Later in the century, carpet makers reduced the size and increased the number of flowers, producing a *mille fleurs* effect, especially on carpets woven with pashmina (goat's wool) pile on silk foundations. In some cases, the flowers were represented with convincing realism, showing delicately shaded leafy stems and blossoms in the central field and surrounding borders. A variant of these floral carpets featured a leafy lattice creating a diagonal geometric grid with compartments occupied by single blossoms of alternating species and colors (fig. 8.17). The carpet illustrated here demonstrates that lattice designs with diverse flowers continued into the first half of the eighteenth century.

These carpets were likely manufactured in Lahore and Kashmir along with a number of smaller examples featuring a single large flower in an arched niche (echoing the *mihrab* niche in a mosque), generally on a red background. Rather than serving as prayer carpets, they may have been intended as hangings, as in the embroidered cotton panel illustrated (fig. 8.18). In most of them, plants with five or more full blossoms are arranged symmetrically around a central leafy stem. Here, a symmetrical array of blossoms emerges from a clump of leaves, with smaller flowering plants at either side.

Northern India was not the only region associated with carpet manufacture. Carpets of different shapes and sizes were produced in the Deccan, many with Mughal-influenced patterns, including some with multiple rows of arched niches. Unlike their Mughal counterparts, however, these carpets

were mostly woven for mosques and used for prayer. Since the knotting of the pile was often less dense than that in Mughal carpets, the patterns in Deccan examples tend to be more crudely rendered, but are by no means lacking in boldness of design or color.

TENTS, CLOTHING, AND OTHER TEXTILES

Plentiful evidence survives of a rich and varied textile tradition in this period, including pieces produced for the Mughal court, lesser rulers at other centers, personal apparel, and adornments for palaces, mansions, mosques, and temples. By far the largest textiles were those intended for the halls and tents in which the Mughals and other rulers held *darbar* (formal audience). These pieces included cotton, silk, and velvet hangings, either embroidered with silver- or silver-gilt-wrapped threads, or stenciled and painted in bright colors. Known as *qanats*, such textiles came from the Mughal workshops as well as from the warehouses of Rajasthan, and most were produced in the late seventeenth and early eighteenth centuries. Designs typically consisted of nichelike panels with lobed arches containing flowering plants with symmetrical blossoms and, like contemporary carpets, were often produced in pale colors on brilliant red backgrounds.

The largest and most complete surviving *qanat* textile is the tent illustrated here (fig. 8.19), made in a Mughal *kar-khaneh*

in the mid-seventeenth century, when Maharaja Jaswant Singh of Jodhpur (Rajasthan, r. 1638–78) was serving under Shah Jahan. Floral niche designs adorn its cloth walls, column covers, and sloping roof panels. This tent was made from embroidered silk velvet, but most were decorated with painted or dyed flowers on central stems emerging from miniature vases. Similar *qanat* textiles manufactured at workshops in Rajasthan and the northern Deccan (especially Burhanpur, Madhya Pradesh) are now known only in fragments. Other types of textiles, decorated in the same manner and produced for the Mughal and Rajput courts, include cotton floor coverings used as alternatives to wool-pile carpets during the hot season, as well as silken velvet floor and cushion coverings.

Clothing had a significant place in Indian textile design during this period. Contemporary miniature paintings show rulers and nobles at the Mughal, Rajput, and Deccan courts wearing near-transparent cotton or embroidered silk *jamas* (coats) with long sleeves, secured by hanging *patkas* (waist sashes) with fringed ends, but little actual clothing has survived. Exceptions include a man's richly embroidered riding coat dating from Jahangir's reign (fig. 8.20a). Sumptuously embroidered with colored silks, this knee-length, flared coat is covered with a landscape of flowering bushes inhabited by animals and birds in pale pink, green, and blue silk chain stitching (fig. 8.20b). If the workmanship of this *jama* is Gujarati, as has been suggested, then the style of the ornamentation is definitely Persian, conforming to Mughal courtly taste of the time.

Fig. 8.20a–b. Hunting coat, possibly Gujarat, 1620–30. Embroidered silk satin; 39.5 x 36 in. (97 x 91.4 cm). Victoria and Albert Museum, London (IS.18-1947).

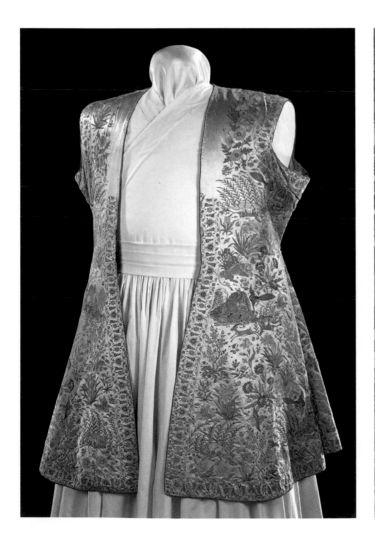

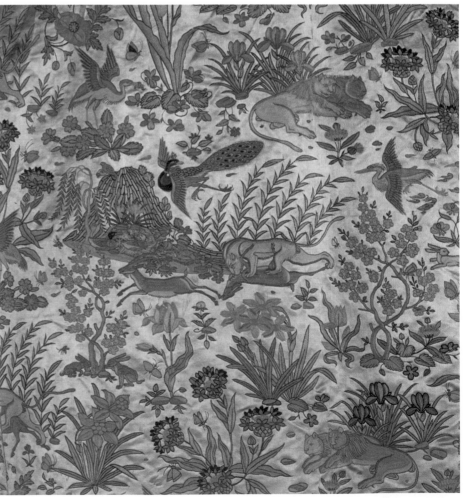

Fig. 8.21. Textile (detail), India, mid-17th century. Silk velvet, metal-wrapped thread; joined fragments, 36 x 29 in. (91.4 x 73.7 cm). The Metropolitan Museum of Art (30.18 and 1991.347.2).

Fig. 8.22. Cover (*rumal*), Golconda, Deccan, 1640-50. Painted and dyed cotton; 25¼ x 36 in. (64.1 x 91.4 cm). The Metropolitan Museum of Art (28.159.2).

Opposite: Fig. 8.23. Pen work (*kalamkari*) hanging (one of seven panels), Madras-Pulicat, c. 1610–20. Painted, dyed cotton; 109¼ x 38¼ in. (277.5 x 97.2 cm). Brooklyn Museum (14.719.7).

Other rare surviving pieces include brocaded fabrics and *patkas* (waist sashes) dating from the late seventeenth and early eighteenth centuries. The waist sashes, woven in vivid colors with silver- or silver-gilt-wrapped threads, feature end borders decorated with rows of repeated flowers (fig. 8.21). The naturalistically rendered floral elements contrast with the more stylized flowers linked by curving stems on the side borders, creating an eye-catching design. Distinctive combinations of floral and geometric elements and colors indicate specific centers of production, from those at the Mughal capitals to provincial cities such as Ahmadabad and Surat in Gujarat and Varanasi and Chanderi in Uttar Pradesh. The same motifs are present in surviving cotton *patkas* decorated with stenciled, painted, and dyed floral motifs.

Also attributed to the mid-seventeenth century is a group of cotton textiles made in workshops on or near the Coromandel Coast for the sultanate court of Golconda-Hyderabad. Produced by the laborious *kalamkari* (literally, "pen work," from Persian *kalam* for "pen" and *kar* for "work") process that involved stenciling, painting, or dyeing, as well as mordants and resists, these cloths were, and remain, celebrated for their brilliant and durable designs on bright red, blue, or cream backgrounds. Floor cloths made according to this method generally had floral patterns, whereas the smaller *rumals* (cotton covers sometimes embroidered with silk thread for ceremonial gifts) from the same area depict courtiers, musicians, dancers, hunters, and, occasionally, Indian rulers or Portuguese people seated in chairs (fig. 8.22). Wearing Indian, Persian, or European dress, these diverse figures occupy scenes crowded with birds, animals, flowering plants, and exotic trees. In some *rumals*, imaginary landscapes become the major subject, with the figures displaced to the edges of central panels bordered with stylized floral motifs.

Painted and dyed cotton hangings of the same brilliance were also produced on the Coromandel Coast for formal display in audience halls, but whether for the palaces in Golconda-Hyderabad or in the Hindu courts of Tamil Nadu is not known. The largest known such hanging, prized for its depiction of different *darbar* scenes, was at some stage cut up into seven panels, now all in the Brooklyn Museum (fig. 8.23). In each panel, figures arranged in four or more tiers have clearly differentiated features and dress typical of Mughal Delhi, sultanate Deccan, Hindu southern India, Buddhist Siam, and Christian Portugal.

TEXTILES FOR EXPORT

Throughout this period, Indian textiles constituted a significant component of the lucrative overseas trade conducted by Dutch, Danish, French, and English merchants to Europe, Southeast Asia, and the Far East. As in earlier centuries, workshops in Gujarat and on the Coromandel Coast produced most of this cloth. High-quality textiles from this period, recently "discovered" in near perfect condition in Thailand, the Indonesian islands, and Japan, suggest that they were highly valued abroad, where they were used as personal adornments and ceremonial hangings.

Gujarat was the center of production for block-printed and mordant-dyed cottons intended for the Asian market. Many of these had bold patterns of white strapwork in geometric formation or interlocking floral or bird motifs in cream and blue, generally on bright red backgrounds. Others had figures of hunters or processions of male and female entertainers, dancers, and musicians. Another specialty of Gujarati workshops was the double-*ikat* silk cloths known as *patola* (see fig. 20.8), which were made for export, particularly to Southeast Asia. (In double *ikat*, both warp and weft threads are tie-dyed in the pattern colors before weaving begins, a process even more demanding than normal *ikat*, in which only the warps are tie-dyed.) Featuring repeated animal motifs and sometimes figures of warriors, *patola* designs generally consisted of geometric patterns in white, yellow, and dark brown on deep red backgrounds.

From the Coromandel Coast came vibrantly colored *kalamkari* cottons. Among the finest examples shipped to Indonesia were *palampores* (bed covers), each decorated with a single fantastical flowering tree on a rocky mountain base, a composition which is strongly Indian in inspiration. Decorative motifs related to the countries to which such textiles were exported include celestial worshippers in flame-like settings and diagonal squares or diamond-shaped patterns filled with stylized foliation—motifs associated with the design traditions of Thailand and Indonesia.

Fine printed and painted cloths from the Coromandel Coast also reached Europe, where they were known as chintz (Hindustani for "spotted," from the Sanskrit *chitra* for "many-colored" or "bright"). Bold floral patterns were particularly popular among the significant and growing merchant classes in the Netherlands and Britain, which considered them suitable for wall hangings, bed coverings, and items of dress. Chintz designs exported in the greatest quantities featured brilliantly colored, fantastical flowering trees with continuous interwoven branches, leaves, and flowers on white backgrounds (fig. 8.24). Such designs were also produced in embroidery in Gujarat for bed coverings and wall hangings for the Dutch and English markets.

More unusual is a group of pictorial cloths produced on the Coromandel Coast, probably commissioned by Dutch and Portuguese merchants. Similar in technique and composition to the pictorial cloths made for the Deccan and southern Indian courts, just described, they may have been made in the same workshops. Two such cottons, probably from the mid-seventeenth century and now in the Victoria and Albert Museum and The Metropolitan Museum of Art, feature Indian and Portuguese figures framed by small arched niches (fig. 8.25). A similarly large figural cloth of about the same date, now in the Musée de la Mode et du Textile, Paris, features a flower-strewn landscape with three pavilions, one of which is occupied by Dutchmen sitting in high chairs. The imaginary composition also includes Dutch ships with full sails, a flagstaff with Dutch flags, the insignia of the Dutch East India Company, a scene of foreigners being entertained by local female dancers, and a procession of Indian dignitaries carried in palanquins.

IVORY, JADE, AND ROCK CRYSTAL

Among the most prized objects produced in the Mughal workshops during the seventeenth and early eighteenth centuries were those made of ivory, jade, and rock crystal. Except for ivory, these precious materials were imported at considerable expense from outside India. Ivories made for the Mughal court were usually decorated with animals, birds, or related themes, and typical forms included gunpowder horns used for hunting, which were carved with ingeniously combined representations of prey: birds and animals, especially deer, antelope, and tigers (fig. 8.26).

Adopted in the early seventeenth century, jade carving in India was derived from earlier Central Asian and Chinese traditions. The Mughals collected fifteenth-century Timurid jades (see fig. 3.7), which possibly served as prototypes for jade vessels made for Jahangir between 1608 and 1613. Surviving examples include an inkpot with floral designs in lobed cartouches, an opium cup carved with a frieze of lotus petals, and a wine cup incised with calligraphy. Fashioned out of dark green nephrite and inlaid with delicate gold traceries, these small but luxurious objects testify to the skill of Indian jade carvers. Drinking vessels associated with Shah Jahan were often sculpted as open flowers with fully modeled petals. In the example illustrated here, the delicate floral form transforms into a ram's head at the tip (fig. 8.27). Life-

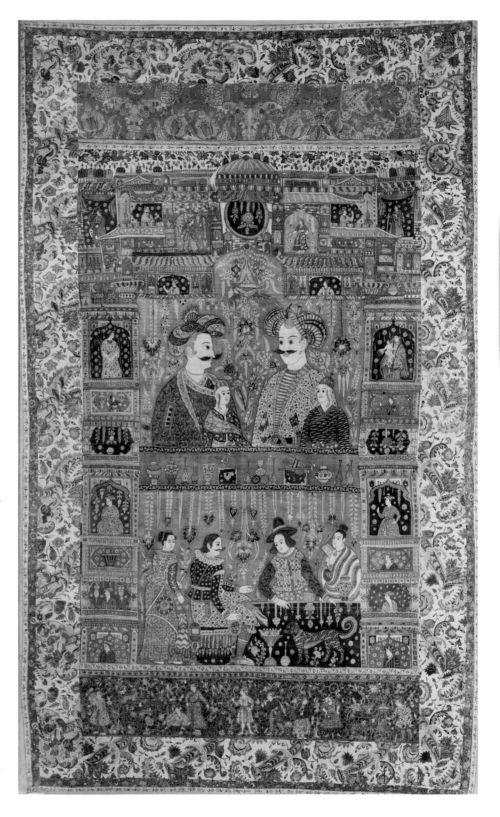

like animal "portraits" were a favorite subject for jade carvers, borne out by the numerous dagger hilts fashioned as the heads of horses, deer, rams, and even the occasional camel, often with the eyes and trappings picked out in gold, rubies, and diamonds (fig. 8.28). Such miniature, three-dimensional animals testify to the convincing naturalism that jade carvers could attain.

Surviving jade vessels of the Mughal period include a set of white *huqqas* (water pipes, hookahs) with swelling spherical bodies enhanced by diagonal grids of petals inlaid in dark green jade and framing six-lobed blossoms in lapis lazuli, encased in minute strips of gold in the *kundan* jewelry tech-

Fig. 8.25. Wall hanging, Coromandel Coast, c. 1640–50. Painted, dyed cotton; 102 x 59⅞ in. (259 x 152 cm). Victoria and Albert Museum, London (687-1898).

Fig. 8.26. Gunpowder horn, Northern India, 1600–50. Ivory, brass, gold, amber; L. 10.7 in. (27.2 cm). Rüstkammer, Staatliche Kunstsammlungen Dresden (Y 381).

Fig. 8.27. Wine cup of Shah Jahan, Northern India, 1657. Nephrite jade; 7⅜ x 5½ in. (18.7 x 14 cm). Victoria and Albert Museum, London (IS.12-1962).

Fig. 8.28. Dagger in the form of a bull, India, c. 1640. Nephrite jade, watered steel; L. 15 in. (38.1 cm). The Metropolitan Museum of Art (1985.58a, b).

nique discussed below. The preference for floral decoration is also seen in seventeenth-century dagger hilts, whether carved in jade or rock crystal, inlaid with precious stones encased in gold strips, or modeled in delicate relief. Small objects made from jade and rock crystal included miniature boxes embellished with gold and precious stones in abstract floral patterns, and tiny cups and bowls carved in delicate relief. Flower imagery also enhances a number of surviving jade mirrors with backs laid out in diagonal grids of gold strips framing blossoms of multicolored jades.

METALWORK

Metalware was made throughout India in this period. One of the most elaborate types was as bidriware, after the *bidri* technique that took its name from Bidar (Karnataka), capital of the lesser Baridi rulers in the Deccan, where it is supposed to have been invented. But bidriware workshops also flourished in other centers of the Deccan, both before and after the Mughal conquest of the region. In this laborious process, silver, brass, and gold are inlaid into a dark alloy of zinc and other metals to produce objects with gleaming floral and geometric patterns. Bidriwares ranged from furnishing accessories such as *mir-i farsh* (literally, "slave of the carpet"; that is, corner weights for floor coverings) to ewers, basins, spittoons, trays, dishes, and *huqqas*. Bidriware carpet weights and stoppers inlaid with silver sometimes took the form of three-dimensional lotus flowers with spreading petals, or domical forms covered with petals or leafy grids, while elegant arabesque designs followed the swelling bodies of vessels such as ewers (fig. 8.29). Many ewers had matching basins inlaid with grids of petals or blossoms linked by trailing stems that expanded evenly across the circular bodies and rims.

Spittoons with flaring rims were similarly covered with such patterns, mostly with repeated flowers, but circular trays and dishes were decorated with flowers of the same or alternating specimens, continuous sprays of blossoms linked by curling stems (fig. 8.30), or rings of chevrons that radiated outward to create visually dizzying patterns. In all these compositions, the contrasts between silver and gold or brass and the black zinc background led to glittering effects. Bidriware featuring other designs included hemispherical *huqqa* bases decorated with imaginary gardens, flowering bushes, or lotus ponds, and sometimes birds and animals. A small number of *huqqas* were created out of solid gold sheet, hammered, in relief, and chased and punched with floral designs.

Another extravagant metalwork technique perfected in India at this time was enameling on gold (*minakari*). Judging from surviving examples, this method seems to have been confined to Mughal workshops. Several enameled gold items dating from the seventeenth century, now in the Hermitage in St. Petersburg, are thought to have come from the imperial Mughal collection. They include circular solid-gold dishes with dazzling green, red, and white enameled designs of radiating petals, spreading blossoms, and repeated flowers. Octagonal *pandans* (boxes for storing *pan*, betel leaf) and

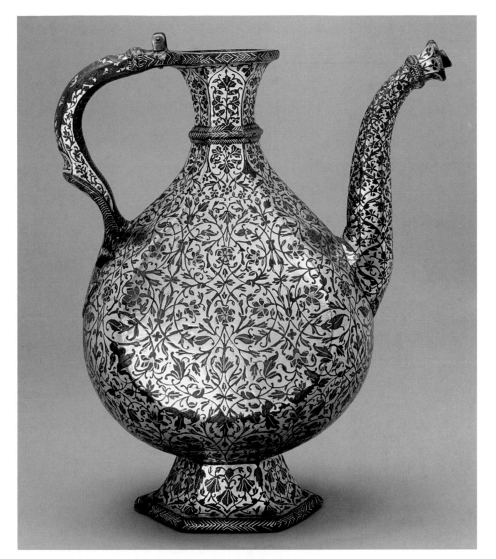

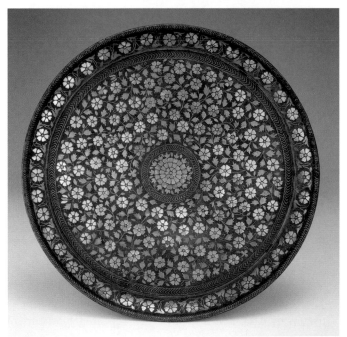

Fig. 8.29. Bidriware ewer, probably Deccan, mid-17th century. Zinc alloy, brass and silver inlay; H. 11¼ in. (28.5 cm). Victoria and Albert Museum, London (1479-1904).

Fig. 8.30. Tray, probably Bidar, 17th century. Zinc alloy, brass and silver inlay; Diam. 13¼ in. (33.7 cm). Virginia Museum of Fine Arts, Richmond (86.196).

matching trays covered with blossoms and leaves observed the same color scheme: red (blossoms), green (leaves), and white (background). Enamels were also employed on gold vessels of other shapes, including a small jar with a diagonal lattice of white enamels containing similarly colored flowers on a luminous green background (now in the Cleveland

Fig. 8.31. Water pipe (*huqqa*) base and chillum support, Udaipur, Mewar, early 18th century. Enameled gold on lac; base Diam. 8¼ in. (21 cm). The Nasser D. Khalili Collection of Islamic Art (JLY 1974).

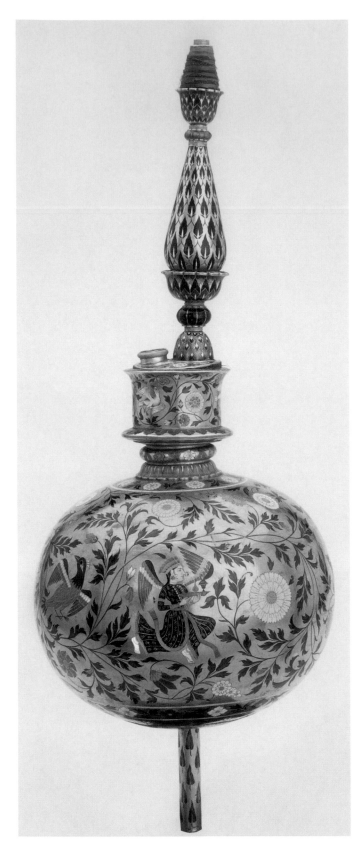

A number of jewel-encrusted gold objects now in the Hermitage may have been part of the Mughal imperial collection. These tall-necked flasks and spoons with long handles are entirely covered with rubies, emeralds, diamonds, and pearls in dense floral patterns similar to those of Mughal jeweled turban ornaments and necklaces (see "Jewelry and Coins" below and fig. 8.33). As in Mughal jewelry, the precious stones were secured using the *kundan* technique, in which each individual stone was surrounded by a thick gold strip. The result is a richly textured surface adorned with sprays of leaves, petals, and blossoms. Similar gem-encrusted goldwork was employed for dagger hilts and *chauris* (fly whisks) that were displayed on ceremonial occasions at court, as seen in contemporary miniature paintings.

Among the other metalwares produced during the seventeenth and early eighteenth centuries were bronze and brass ewers and vases with elegant bulbous sides and curving spouts or engraved floral patterns and straight spouts. Engraved decoration featuring animals and birds or human figures also enhanced brass *pandans* from Gujarat and Rajasthan. In some, the design was picked out in inlaid colored lac (resin). Hemispherical bronze *lotas* (water carriers) are a characteristic Indian vessel form, either with fluted sides from northern India, engraved floral patterns from the Deccan, or engraved designs of stylized animals, dancing figures, and Hindu divinities, mostly from Tanjavur (Tanjore, Tamil Nadu) in southern India. Most surviving *lotas* with figural decoration were made no earlier than the first half of the eighteenth century.

Foreign in inspiration are the late-sixteenth-century metal "pilgrim flasks" with swelling sides and curving twin handles. These bottles date to ancient Roman times in the West and to seventh-century China in the East. The pear-shaped form, either fully rounded or flattened on one side, derived from pilgrims' water containers made from leather or dried gourds, and the object type and form were adapted in the sixteenth century for highly decorative wine decanters, made in precious metals, colored glass, stoneware, or earthenware, probably of Chinese inspiration. Some were produced in fourteenth-century Syria and Persia, where the form was used by at least the early thirteenth century, and later in India. Based on Persian prototypes, tinned brass or copper vessels, especially cups with fluted stems and boat-shaped "begging bowls" (*kashkul*, from the Persian word *kashti* for "boat") with tapering ends, were also made in India, mostly at the beginning of the seventeenth century (fig. 8.32).

The begging-bowl form derived from vessels used by itinerant ascetic mystics in Persia. Surviving examples are completely covered, sometimes both outside and inside, with engraved Arabic script ranging from Koranic excerpts to the Shia profession of faith, the letters crisply worked in shallow relief to facilitate legibility. These vessels were intended for religious purposes, possibly for particular shrines in northern India and the Deccan. Other religious objects include *'alams*, standards used in Shia processions (see fig. 3.36). Fashioned out of brass to form calligraphic roundels, leaf-shaped medallions, or open hands, often with cut out spaces between the letters, such objects were placed in *'ashur-khanehs* (Shia shrines) like that in Hyderabad (see fig. 8.10).

Museum of Art), and a *huqqa* with repeated blossoms of white and yellow encrusted enamels, also on a green background (now in the Musée national des arts asiatiques Guimet, Paris). Enameling techniques were likewise expertly practiced at Rajput courts, as demonstrated by a gold *huqqa* made in Udaipur (Rajasthan) depicting birds and winged angels, both composed of blue, turquoise, and green enamels, flying through a floral design of white blossoms linked by blue leafy stems on a bright gold background (fig. 8.31).

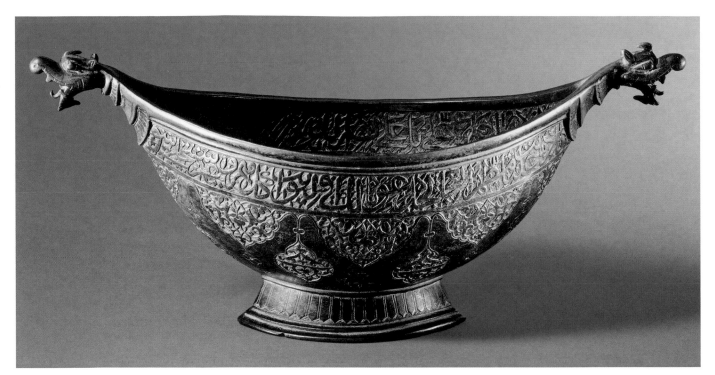

Fig. 8.32. Begging bowl (*kashkul*), Deccan, c. 1600. Tinned bronze; 6⅝ x 15⅛ x 6¼ in. (16.7 x 38.5 x 16 cm). The David Collection, Copenhagen (61/1998).

JEWELRY AND COINS

Contemporary portraits and history paintings show Mughal emperors and Deccan sultans bedecked in extravagant long strings of pearls hung with emeralds and rubies. They also wore earrings with huge pendant pearls as well as turban ornaments with jeweled, leaflike sprays (fig. 8.33). Yet so complete was the devastation of the imperial treasury by the invading Persian ruler Nadir Shah in 1739 that scarcely any such jewels survive from the Mughal court. An exception is a small number of emeralds from Colombia that reached India in the early seventeenth century through Portuguese traders. Intended as pendants and centerpieces of turban ornaments, these emeralds were engraved in shallow relief with floral designs and occasionally Persian inscriptions. A few diamonds from the celebrated Golconda mines, intended for necklaces and turban jewelry for the Mughal court, have also survived. These gems were cut into bold facets to achieve maximum refraction. Equally impressive are unshaped spinel rubies from Afghanistan, engraved with the signatures of Jahangir, Shah Jahan, and Aurangzib, intended to be strung together to create great necklaces.

In spite of the scarcity of surviving Mughal jewelry, some idea of its forms may be gained from Mughal-style necklace pendants, armlets, bracelets, rings, and turban ornaments created mostly in Rajasthan and the Deccan in the late seventeenth and eighteenth centuries. Pendants were often shaped like flowers, with diamond, ruby, and emerald petals, each gem encased in thick gold strips in the *kundan* technique. The gems were set either unbacked, to admit light from behind, or on gold backs with floral designs, in delicate relief or in bright red, green, and white enamels. Other pendants were leaf shaped and filled with minute eagles or parrots made of rubies set into jade or solid gold, with enameled birds among flowers on the backs. Armlets and bracelets

Fig. 8.33. Turban ornament, Delhi or Lahore, 1700–50. Nephrite jade, gold, rubies, emeralds, probably topaz, rock crystal, pearl; 7¾ x 1¾ in. (19.7 x 4.6 cm). Victoria and Albert Museum, London (02569[IS]).

Mughal *mohurs*) minted in Agra for Jahangir in 1613 (fig. 8.34). Some of Jahangir's coins are of interest for their zodiac signs, complete sets of which were issued in the 1620s. Others depict a bust of the imperial figure, generally holding a wine cup.

ARMS AND ARMOR

During this period, weapons were among the major products of royal workshops. In addition to bows, arrows, and shields, steel-bladed swords and daggers, often with imported European blades, were favored. Intended for ceremonial rather than martial use, weapons for the Mughal emperor, princes, and courtiers were of the highest design and craftsmanship, as is apparent from a sword now in the Victoria and Albert Museum originally owned by Dara Shukhoh, Aurangzib's brother, who lost his life in the struggle for the throne. Dated to 1641, the sword has a curving, *jawahar* ("damascened") steel blade with stamped and inlaid gold inscriptions. The hilt is overlaid with gold in a sumptuous design of expanding blossoms and leaves, and the wooden scabbard is clad in green velvet and red brocade with enameled gold mounts.

Among other inscribed weapons associated with Mughal royalty is a curved, double-edged dagger (now in the National Museum, New Delhi) with inlaid gold letters on both sides giving the names of Aurangzib. Many other highly decorated daggers and swords survive, with sumptuous floral designs in gold inlaid on steel or in enamels with gems inlaid in the *kundan* technique, and invariably curving blades of *jawahar* steel. Mughal *katars* (daggers) included those with double handles brightly enameled or overlaid in gold with floral patterns, and examples with single handles of jade and ivory, inlaid with gems or carved as animals. Weapons were also embellished with delicate gold filigree work, among them a shield with inscriptions on foliate panels and a dagger with an ivory hilt covered with arabesque patterns, both now in the Salar Jung Museum, Hyderabad. Other weapons such as spearheads and maces were vehicles for elegant inlaid gold ornament, while saddle axes had curving blades inlaid with gold.

Mughal weapons were widely imitated in the workshops of Rajasthan, but the decoration betrays a Hindu rather than Muslim affiliation, as in blades chased with relief designs of warriors on elephants and horses. Matchlocks were used in Rajasthan by the end of the seventeenth century, having been introduced into northern India by European mercenaries. Conceived as aesthetically pleasing objects, these guns had barrels of *jawahar* steel gilded or carved in relief, while the wooden stocks were often covered with black lac and inlaid with ivory floral motifs. Rajasthani leather shields used in warfare were often painted with hunting scenes, as in an example made for Sangram Singh II of Udaipur (r. 1710–34), now in the National Museum, New Delhi.

The sultans of the Deccan had Mughal-style weapons, with an emphasis on scrollwork patterns and lobed medallions, as can be seen on seventeenth-century perforated steel armguards overlaid with gold. Calligraphic excerpts from the

Fig. 8.34. Thousand-*mohur* presentation coin, Agra, 1613. Gold; Diam. 7 in. (17.8 cm). The al-Sabah Collection, Dar al-Athar al-Islamiyyah, Kuwait (LNS 12377 N V2).

worn close to the skin were usually enameled, again with flowers and leafy stems. In some examples, the ends were modeled as the heads of tigers or *makaras* (aquatic monsters), with diamond or ruby eyes. Rings, both in gold and jade, were also set with precious stones. They included archery rings worn on the thumb, some of which were of gold with enameled designs and even inscriptions, including two with the name of Shah Jahan and dates in the 1630s.

The only surviving examples of turban ornaments in the *kundan* technique appear to have been commissioned for provincial governors of the Mughal Empire and Rajput princes in the first half of the eighteenth century. These ornaments were formed as floral sprays with symmetrical arrays of petals and leaves set with various gems, sometimes with feather-like curving tips and pendant jewels in a formation known as *sarpati*. Some scholars suggest that such ornaments became fashionable as a result of European influence. Prior to Shah Jahan's reign, turbans were adorned with plumes in Persian fashion, whereas jeweled aigrettes (sprays of feathers) were known in India through European portraits.

Coins of the period, especially those of the Mughal emperors, were often splendid. Gold *mohurs* or rupees bearing the names and titles of successive emperors and dates of regnal years were issued by the royal mints at Agra, Lahore, and Delhi. The inscriptions, generally in flowing *thuluth* script, were often set against backgrounds of delicately worked floral motifs, as in an unusually large, one-thousand-*mohur* presentation coin in solid gold (one of two surviving giant

Koran sometimes appeared in the decoration of such armguards, as in an example from Golconda now in the Jagdish and Kamla Mittal Museum of Indian Art, Hyderabad. Other Deccan arms featured southern Indian elements, making it difficult to distinguish swords and daggers made for the armories of Bijapur (Karnataka) and Golconda-Hyderabad from those commissioned by the maharajas of Mysore (Karnataka) and Tanjavur. Both Deccan and southern Indian arms were adorned with animals and birds that were considered magically protective. Cast and chased, or even molded and perforated, in both brass and steel, the hilts were conceived as fantastic *yalis* with feathered bodies, curving heads, and savage fangs. The armguard of a seventeenth-century *pata* (long-bladed gauntlet sword) now in The Metropolitan Museum of Art, for instance, was made in the form of a magnificent pierced and embossed *yali* swallowing an elephant, while the pierced and chiseled steel grip of a three-bladed dagger in the same collection features a central floral medallion flanked by birds and *yali* busts. This dagger may have been produced for Raghunatha (r. 1600–45), the greatest ruler of the Tanjavur Nayak dynasty, known for his patronage of the arts.

The perforated handles of some double daggers, probably from the same region, featured animal, bird, and even fish shapes, and were expanded into fluted, shell-like handguards topped by a peacock form or crescent moon (associated with the Hindu deity Shiva, who wears it atop his matted hair). Other southern Indian daggers with fluid, elegantly curved steel blades had handles of carved ivory or gold-inlaid steel with double-curved prongs. In addition, there were ceremonial axes and maces, with molded or perforated animal designs, as well as armguards modeled as the heads of tigers or *yalis* with fierce expressions, and with fluted chevron or scale patterns or bands of lotus buds in raised metalwork.

By far the most elaborate of all animal-shaped weapons from southern India during this period were the *ankushas* (elephant goads) chiseled with extraordinary precision from the finest steel in the early seventeenth century, for use at the courts of the Wodeyar rulers in Mysore and their contemporaries in Tamil Nadu. The handles, points, and curving blades of these weapons were vehicles for densely composed animal and vegetal ornament. One example presents an array of crouching *yalis*, open-mouthed *makaras*, and composites of these and other beasts, linked by bands of lotus ornaments and interwoven leafy stems (fig. 8.35). These fantastic elements in chiseled metal achieve an unparalleled visual density.

All the objects from Mughal and princely Indian courts discussed here were consistently high in quality, not surprisingly given the wealth of those for whom they were produced. That same quality also suggests many years of training to master the skills required. Many of the same techniques, materials, forms, and motifs continued into the period 1750–1900, but some disappeared with major political, economic, and social changes related in large measure to encroaching European presence.

GEORGE MICHELL

Fig. 8.35. Elephant goad (*ankusha*), southern India, probably early 17th century. Steel; L. 27⅝ in. (70.1 cm). Museum of Fine Arts, Boston (1995.114).

THE ISLAMIC WORLD

Fig. 9.4 detail

The three major early modern empires—Safavid, Ottoman, and Mughal—continued to provide the main patronage of design and decorative arts in the Islamic world during the period 1600 to 1750. The quality of both the design and the manufacture of ceramics, metalwork, textiles, carpets, lacquerwork, and other objects fluctuated considerably, largely but not exclusively paralleling shifts and changes in political and economic power. The period began with a resurgence of the arts in Iran under Safavid Shah 'Abbas I, "the Great" (r. 1588–1629), an important patron of art, architecture, and design. His initiatives included a major building program, and he fostered foreign trade and diplomatic ties, especially with Europe and India, which, in turn, provided new sources of design inspiration. The end of the period saw a second "golden age of Ottoman art" under Sultan Ahmed III (r. 1703–30), who sought to emulate his ancestor, the great patron and ruler Sultan Süleiman I (r. 1520–66). The expanded geopolitical and economic role played by European powers, as well as the increasing economic power of trading partners China and India, affected the design and manufacture of decorative arts in the Islamic world during this period and would do so even more profoundly in the nineteenth century.

SAFAVID TEXTILES

The building campaign initiated by Shah 'Abbas I in his new capital, Isfahan, made it the symbolic center of the Safavid empire with new palaces and mosques. 'Abbas I also promoted state-sponsored patronage of the arts in many other media. Revenue from control of the Persian Gulf and strong maritime and foreign trade bolstered the economy, as did newly developed commercial infrastructures across the empire, such as bridges and caravansaries (large buildings where caravans stopped at night). This state patronage came to an end under 'Abbas I's successors, who proved far less able than he. A combination of ineffective rulers, Turkmen tribal revolts, border skirmishes, and Afghan invasions in the early eighteenth century led to the collapse of the dynasty in 1736.

Standards of design and technical excellence in Safavid silk textiles and carpets were at a high point in the late sixteenth century and remained so under 'Abbas I, who made the silk trade a state monopoly. His state workshops (*kar-khaneh*) augmented general commercial production. Some Iranian and Western sources suggest that Yazd and Kashan were celebrated for their silk textile production, but it is not certain where the main centers of production were. The robust silk and silk textile trade, at home and abroad, controlled by Armenians, who were ordered by 'Abbas in

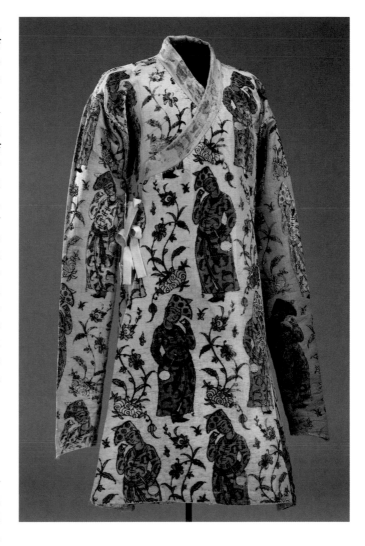

Fig. 9.1. Coat, Isfahan, early 17th century. Silk velvet; L. 48⅜ in. (123 cm). Livrustkammaren, Stockholm (6195 [3414]).

1604/5 to resettle in the Isfahan suburbs of "New Julfa" from their community in Julfa, Azerbaijan, was an important source of state revenue. Raw and woven silks were exported to the West via the Ottoman Empire, with raw silk used in the Ottoman workshops at Bursa. Safavid silks also took a more northerly route to Europe via Russia, probably to circumvent Ottoman customs duties, and some Safavid silks remain in collections in Russia and Scandinavia, including a group of fine silk velvets now preserved at Rosenberg Castle, Denmark. These were probably given to Frederick III (1597–1659), Duke of Holstein, by the Persian ambassador of Shah Safi (r. 1629–42) in 1639.

A silk velvet coat, rare because it is complete, features a pattern of male figures, elegantly attired in long leaf-patterned coats, holding long-necked ewers and small cups between floral compositions (fig. 9.1). The young men resemble the style of the languid youths, lovers, and courtly figures seen in contemporary albums or manuscript paintings by the

Fig. 9.2. Wall hanging, Iran, 17th century. Silk, metal thread; 72⁷⁄₁₆ x 46 in. (184 x 117 cm). Victoria and Albert Museum, London (T.9-1915).

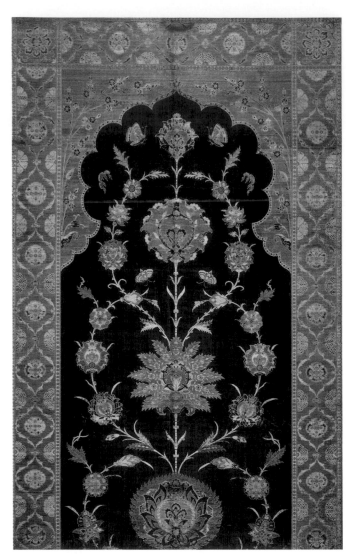

sixteenth-century more naturalistic floral style of the Ottomans. The decorative motifs in the panel's borders, on the other hand, recall some of the finest contemporary Mughal and Deccani silk-velvet textiles and pashmina wool carpets that depict similar rounded floral motifs set in a lobed latticework of delicate serrated leaves. The European, Ottoman, and Indian design influences demonstrate eclecticism in these late seventeenth-century textiles.

Safavid textiles were made for the home market, to be traded abroad, or given as diplomatic gifts. Among those created for domestic consumption were woven silk covers intended to be donated to Shiite shrines to cover sarcophagi. The religious context meant that these textiles required a different, nonfigural design, as opposed to textiles for secular use. Tomb-cover designs generally favored verses from the Koran and invocations of the Shiite imams, since the Safavids were followers of Shiite Islam. A strikingly beautiful example, a reflection of the sophistication of the Safavid textile industry, is a compound silk tomb cover (fig. 9.3). The decoration includes inscriptions from the Koran discussing God's help and victory as well as a Shiite prayer requesting the aid of 'Ali—in bold *thuluth* script—and the signature of the calligrapher, one Muhammad Mu'min. More unusual inscriptions reveal that the textile was endowed by a woman pilgrim named Hajjiyya Khwandzade who had made the *hajj* (pilgrimage to Mecca; thus her title *hajjiyya*) and who was the daughter of a *khwand* (mulla, or religious figure). There is a date (most likely the equivalent of 1740/41 AD) and the name of the textile's maker, Muhammad Husayn ibn Hajji Muhammad al-Kashani. The textile was probably woven in Kashan.

court artist Riza 'Abbasi (c. 1565–1635), suggesting that his work was copied in other media, including textiles. The designer of the pattern made masterful use of the Riza-style S-curve of the young men's bodies. It is echoed in the sinuous curves of the flanking flowers, adding to the "movement" of the pattern, which follows the Safavid convention of alternating directions for each row of repeat thus reducing the visual impact of the underlying grid that held the pattern together. The impression of luxury and softness imparted by the coat's gently swaying pattern of figures and flowers is further heightened by the use of silk velvet, the finest fabric produced during the time of Shah 'Abbas I. That the coat was highly valued by Europeans is suggested by the fact that it was either given or traded to the Russian czar, who, in turn, presented it as a gift to Queen Christina of Sweden in 1644.

A woven silk wall hanging from the late seventeenth century shows an unusual and eclectic interpretation of European, Ottoman, and Indian influences (fig. 9.2). Stylized butterflies or moths appear at the top of the multilobed arched niche. The composite palmettes that punctuate the vertical and curving vine scrolls of the central dark blue panel especially recall Ottoman *saz*-style ink drawings, textiles, ceramics, and architectural tiles (see fig. 2.7), although the serrated edges of the leaves are simpler and more stylized. The flowers in the spandrels seem to follow the later

Fig. 9.3. Muhammad Husayn ibn Hajji Muhammad al-Kashani (weaver) and Muhammad Mu'min (calligrapher). Tomb cover, Kashan, 1740–41. Silk; 46½ x 35⅞ in. (118 x 91 cm). The David Collection, Copenhagen (30/1971).

SAFAVID CARPETS

The carpet industry was greatly expanded under Shah 'Abbas I. The Safavid court remained the primary consumer, but carpet making for sale at home and abroad increased. The most spectacular carpets from this time were dubbed "carpets of silk and gold" by European travelers to Iran because they included silver- and silver-gilt–wrapped threads among the silk pile. Highly prized by Safavids and Europeans alike, some found their way to Europe, having been given as presents or commissioned, and sometimes were woven with the client's coats of arms. Somewhat confusingly, these carpets later became known as "Polonaise" carpets in the West after examples with embroidered coats of arms added by the Polish Czartoryski family were seen at the Paris International Exhibition of 1878 and erroneously thought to have been woven in Poland. More than three hundred "Polonaise" carpets, often woven in pairs, survive today.

Precious and fragile, surviving carpets of this type have suffered from exposure to light and use: unstable dyes fade, silver tarnishes, and the silk pile gets crushed and worn down. Most of the carpets originally had a muted pastel palette of salmon, green, yellow, and light blue, although some had brighter colors. A rare example that has retained much of the bright glory of its original colors is now in the Tehran Carpet Museum, one of a pair once owned by the Italian Doria family. All the carpets featured substantial borders—usually floral vine scrolls—and nonfigural main-field patterns with a wide range of floral-based motifs. The main-field patterns ranged from tightly organized designs in the earlier carpets, such as a carpet with overlapping cartouches (fig. 9.4), to more free-flowing, baroque compositions filled with large lotus blossoms in the later carpets.

The combination of silk pile and metallic-wrapped-thread brocading is seen in a cope (a Christian ecclesiastical cloak-like vestment). The dense silk pile makes the textile seem like velvet, but it is knotted like a carpet (fig. 9.5). Long thought to have been produced for one of the Armenian churches in Isfahan (where the shah ordered Armenian communities to resettle in 1604/5), it may have been given to a Catholic church established in Isfahan by Portuguese priests of the Augustinian order in celebration of their completed building (the decoration of which was paid for by Shah 'Abbas) on Christmas Day, 1608, or to commemorate the installation of Persia's first Catholic bishop in 1612. Looking for clues in the cope reveals Catholic, Armenian, and Persian elements. The Crucifixion image on the cope is Western, with "INRI," abbreviation for the Latin phrase that translates "Jesus of Nazareth, King of the Jews," at the top of the cross. The two depictions of the Annunciation are located at the cope's opening as in Armenian designs; models for the Virgin Mary and the angel Gabriel are seen in contemporary Persian paintings of the late sixteenth and early seventeenth century.

Several types of wool carpet were produced during the reign of Shah 'Abbas and later in the seventeenth century. Wool is sturdier and more economical than silk, but extremely detailed patterns can be achieved if the wool is finely woven. Some, but not all, of a group of seventeenth-century carpets

Fig. 9.4. "Polonaise" carpet (one of a pair), probably Isfahan or Kashan, early 17th century. Cotton, silk, metal-wrapped thread; 164 x 70¼ in. (416.6 x 178.4 cm). The Metropolitan Museum of Art (50.190.2).

are known in the West today as "vase" or "vase-technique" carpets (fig. 9.6). The pattern illustrated here, one of the seven design types within this group, depicts a flower vase containing multicolored, composite flowers and leafy stems that make up the main field. Peonies, lotus blossoms, lilies, rosettes, and pomegranates are frequently seen. The colors—which can number twelve or more—are bright and stand out against the dark red or blue ground of the main field. Although the design is clearly organized into a subtle directional lattice based on three superimposed planes of spiraling vine scrolls, the effect can be kaleidoscopic. As a group, these "vase" carpets shared a technical structure and have been ascribed to Kirman, in central Iran, where carpets were made with a similar technique in the nineteenth and twentieth centuries.

Fig. 9.5. Cope, probably Isfahan, early 17th century. Silk pile; 66⅞ x 102⅜ in. (170 x 260 cm). Victoria and Albert Museum, London (477-1894, T.30-1926, T.211-1930).

Other designs woven in the same technique featured gardens, arabesques, and landscapes. Some of these are generally known as "garden" carpets depicting the formal Persian gardens constructed in Isfahan and elsewhere by Shah 'Abbas (fig. 9.7). The formal Persian garden (*chahar-bagh*) originated well before Shah 'Abbas: there are literary references and depictions in miniature paintings from the fifteenth century onward. "Garden" carpets were also appreciated abroad such as a large and magnificent example that was inventoried in India in 1632, at the Amber palace outside Jaipur, according to the carpet's label. Such carpets were produced until the nineteenth century, although the later designs were more stylized.

Fig. 9.6. "Vase" carpet (fragment), Kirman, mid-17th century. Wool, cotton, silk; 19½ x 13 ft. (6 x 4 m). Musées des Tissus de Lyon (MT 25385).

Fig. 9.7. "Wagner Garden" carpet, Kirman, early 17th century. Wool, cotton, silk; 17½ x 14 ft. (5.3 x 4.3 m). The Burrell Collection, Glasgow (9.2).

Metalwork flourished across Iran in the late sixteenth century and into the seventeenth, with objects made in a wide range of forms—serving dishes, platters, carafes, wine basins, wine cups, and so on—for specific functions such as royal banquets. Bathing also demanded a variety of forms, from bath pails to ewers, and jugs. New trends in metalwork shapes and decoration included sleek, tapered forms decorated with vegetal, abstract, and figural motifs. New, too, was the organization of motifs into cartouches and quatrefoils separated by spaces of undecorated metal, instead of all-over scrolling decoration. The resultant clarity of design is apparent, and also a sense of monumentality, even on smaller objects. Decoration was achieved by engraving, with hatched backgrounds; the precious inlaid metalwork of the earlier period was almost abandoned.

Popular from the mid-sixteenth century, pillar-shaped lamp stands epitomized the new tapered forms. Such stands, also called torch stands, consisted of a tall cylindrical, flared base and a chamfered or faceted midsection. The engraved decoration followed the contours of the cylindrical shape and usually consisted of all-over vegetal scrollwork based on the arts of the book and organized in bands (fig. 9.8). Chevrons appeared in the latter part of the sixteenth century, sometimes in relief. Some stands featured inscriptions in *nasta'liq* script, a cursive script that was the chief form of Persian calligraphy in the fifteenth and sixteenth centuries. They often made reference to light and flames—a common convention for metal objects. When taken from mystical poetry, the inscriptions sometimes likened mystical love to a burning and consuming fire, and may refer to both the desire to reach unity with God and the Sufi idea of the union with the divine and annihilation of the individual. (Sufism is a tradition espoused by ascetic, mystical orders within Islam.) Some stands contain dedications to well-known Shiite shrines; some survive with owners' names inscribed on them, and, judging by the names, some of the patrons were Armenians. A few stands have empty cartouches, suggesting that they were speculatively produced and awaiting a purchaser who might then add a name, much the way some textiles could have personalized panels attached (see fig. 9.3).

There was a close relationship between bulbous metal ewers (*aftabe*) with a high flared base and ogival silhouette made in Iran and India. The earliest dated Iranian example is from the equivalent of 1602/3 (fig. 9.9). Liquid was poured into the hinged top above the handle, circulated via the hollow arch-shaped handle to the bulbous middle, and poured out through the sinuous, curving neck spout. The date and an owner's name, Qasim (possibly Qasim Beg Abdarbashi, who served drinks at royal receptions), are inscribed on either side of the rectangular opening of the handle. Some ewers contain *nasta'liq* inscriptions referring to their function.

Its main decoration is set within a series of quatrefoils and cartouches filled with spiraling floral vine scrolls. The animals in the quatrefoils reflect a return to figural imagery, something not seen in Iranian metalwork since the fourteenth century. The style of decoration was also new. Instead

Fig. 9.8. Lamp stand, possibly Isfahan, 1550-1600. Brass, black compound inlay; H. 13⅝ in. (34.6 cm). The Metropolitan Museum of Art (91.1.579).

Fig. 9.9. Ewer, probably Isfahan, 1602. Brass, black compound inlay; H. 12⅝ in. (32 cm). Victoria and Albert Museum, London (458-1876).

Fig. 9.14. Dish, probably Tabriz, c. 1600. Fritware; 2½ x 13⅛ x 13⅛ in. (6.2 x 33.5 x 33.5 cm). The al-Sabah Collection, Dar al-Athar al-Islamiyyah, Kuwait (LNS 320 C).

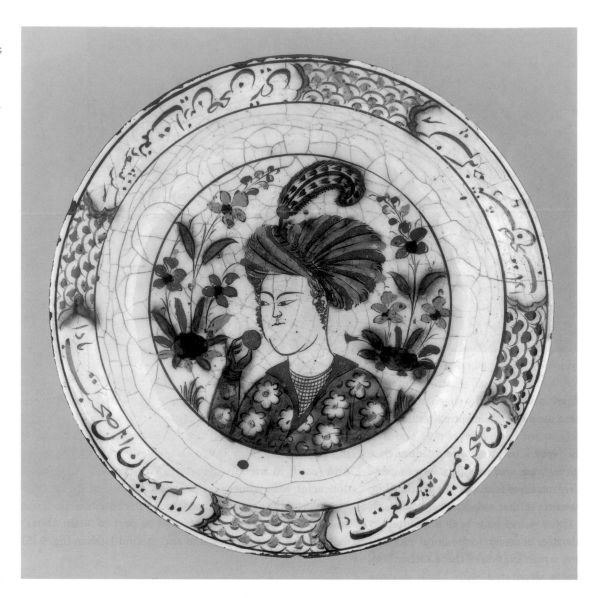

Fig. 9.15. Tile panel, probably Isfahan, 1600–25. Fritware; 41 x 74 in. (104.1 x 188 cm). The Metropolitan Museum of Art (03.9c).

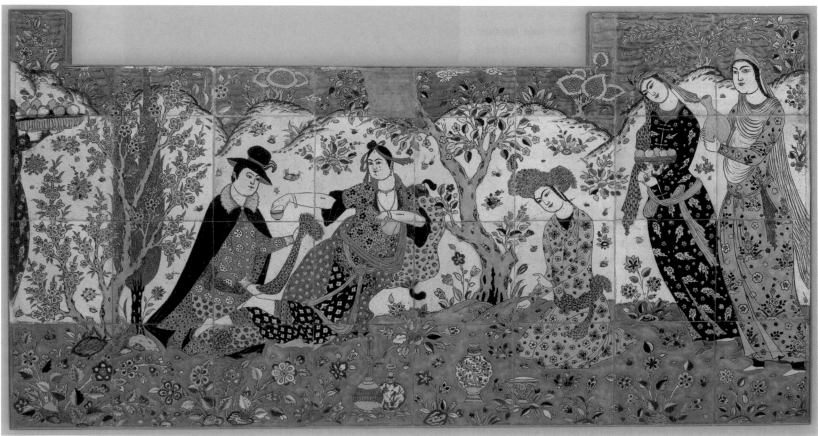

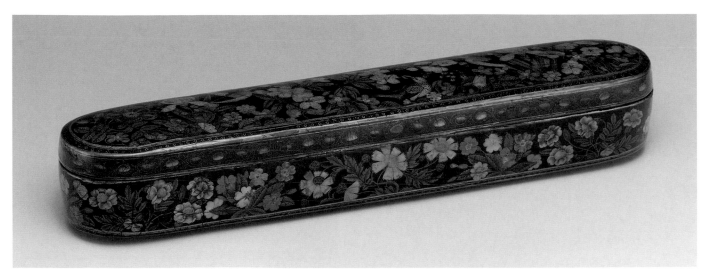

Fig. 9.16. Hajji Muhammad. Pen box, Iran, late 17th-early 18th century. Papier-mâché, paint, lacquer; L. 11 in. (27.9 cm). The Metropolitan Museum of Art (2000.491a, b).

Filled with scenes of courtly outdoor banquets in lush garden settings, these lavish tile panels reflect the prosperity enjoyed by the elite during the Safavid empire. They continued to be made through the mid-seventeenth century. The latest known tile revetments in this style used in royal garden pavilions seem to be those in Shah Suleiman II's Hasht Bihisht palace in Isfahan, 1666–69. Unlike the costly and labor-intensive tile mosaics seen on Safavid mosques, they were composed of square tiles individually painted in a distinct palette of yellow, blue, turquoise, green, and white, with the colors separated by black outlines. The subjects include courtly figures and their attendants, lovers, and languid youths, all familiar from contemporary Safavid painting, while the blue-and-white serving vessels depicted could be of either Chinese or Safavid production.

SAFAVID LACQUERWARE

Lacquer was popular during the 1600–1750 period, although the high-water mark of Persian lacquerware came in the nineteenth century. Technically different from Chinese lacquer (made with sap from the "lacquer tree," or *Toxicodendron vernicifluum*, formerly *Rhus verniciflua*, see figs. 1.3, 1.10), the Islamic version consisted of a protective resin varnish applied over a painted surface. Persian literary sources from the sixteenth to nineteenth century onward referred to the varnish as *rawghan-i kaman*, or bow gloss. In the seventeenth century, leading Safavid artists such as Riza Abbasi (see above) and his student Mu'in created varnished bookbindings with figural scenes familiar from manuscript illustration. By mid-century, the repertory of lacquered objects had expanded to include writing accessories, such as pen cases and boxes, mirrors, and other small objects of papier-mâché. They were decorated with a broad range of subjects including figures, flora, fauna, landscapes, and fashionable European-style scenes like those painted by the celebrated artist Muhammad Zaman. Many of the objects are dated and signed, including a pen box with Europeanized decoration signed by artist Hajji Muhammad, brother of Muhammad Zaman (fig. 9.16). Mirror cases with closing shutters, popular from the mid-seventeenth cen-

tury onward when mirror glass was introduced from Europe, were often decorated with familiar Persian themes like the poetic "rose and nightingale," as well as Europeanized ones (see fig. 15.11a).

THE OTTOMANS

Under the patronage of Sultan Süleiman I (r. 1520–66), the Ottoman Empire experienced a golden age of art, architecture, and design that continued for the next two generations, especially during the reign of Süleiman's grandson Murad III (r. 1574–95). By the end of the sixteenth century, however, the empire's economic power had diminished, largely because of the influx of New World silver currency, resulting in soaring prices and shortages of goods, and the lack of new dominions or military booty to restock the treasury. Inflation was rampant, yet the court's pricing system remained fixed at low rates, with direct ramifications for production, particularly ceramics and carpets. As craftsmen sought a wider domestic patronage base as well as more lucrative foreign markets in which to sell their work, royal commissions were left unfinished, despite government edicts. The royal scriptorium shrank in size, and quality suffered, except in calligraphy—the traditional art of beautiful writing, which relates the word of God in the Koran. In the decorative arts, traditional Ottoman design motifs of naturalistic flowers, stylized composite flowers, and *saz* leaves continued to be employed, but the designs became more formulaic.

The Ottoman defeat at the siege of Vienna in 1683 was a huge blow to the empire. By 1718, however, and the Treaty of Passarowitz with the Austrians and Venetians, the Ottomans were more receptive to European diplomacy and ideas, and actively sent diplomatic envoys to Europe. This peace brought a second golden age during the reign of Sultan Ahmed III (r. 1703–30). It is known retrospectively as the Tulip Period (in Turkish, Lâle Devri; 1718–30), because it drew upon the traditional decorative forms of the Sultan Süleiman I period for inspiration, especially imagery related to tulips (introduced to Europe by the Ottomans in the mid-sixteenth century), and also European Baroque influences.

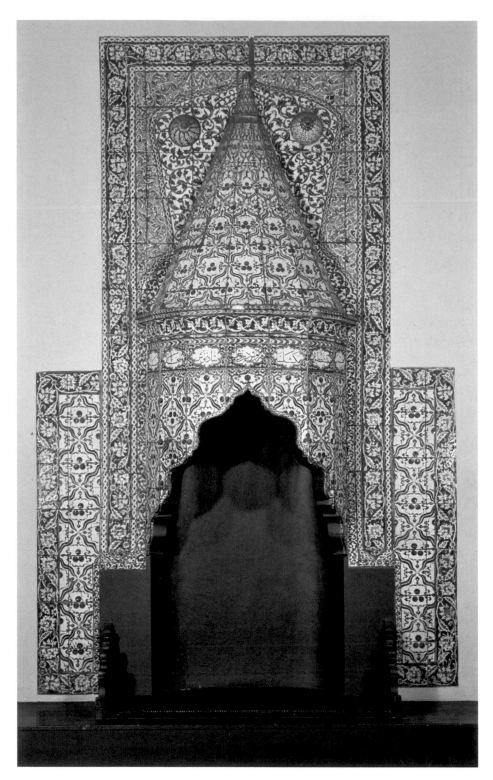

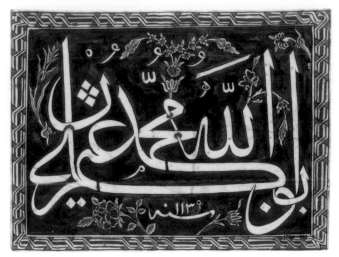

Fig. 9.17. Fireplace, probably Istanbul, 1731. Fritware, marble; 12 × 8¼ × 2½ ft. (3.7 × 2.4 × 0.9 m). Victoria and Albert Museum, London (703-1891).

Fig. 9.18. Tile, probably Istanbul, 1727. Fritware; 11 × 14⅝ in. (28 × 37 cm). Victoria and Albert Museum, London (1756-1892).

Tulips, which came originally from eastern Anatolia and Iran, were omnipresent in gardens and as decorative motifs in a wide range of media in the 1720s, including architectural tiles, woodwork, ceramics, textiles, glass, and metalwork.

OTTOMAN CERAMICS

Iznik ceramics, including tiles, continued to be made during this period, although in reduced quantities and quality compared to the high-water mark in the second half of the sixteenth century; craftsmen, crippled financially by royal commissions paid at artificially low prices, had to scrimp on quality of mate-

rials and craftsmanship. New decorative themes, such as ships, churches, and animals, as well as Greek inscriptions, were introduced, almost certainly in an effort to appeal to a wider range of clients. Royal patronage remained important, however, and when the Ottoman court built a new (but relatively short-lived) royal workshop in 1719 at Tekfur Saray near the Istanbul city walls, ceramics production at Iznik effectively ended.

An elaborate tilework fireplace made for an Ottoman official in 1731 was probably created at Tekfur Saray (fig. 9.17). The calligraphy panels name the "seven sleepers," young Christian men who, according to Muslim and Christian legend, were persecuted for their religion and walled up in a cave by the Romans only to awake years later to a period of tolerance. Their names are thought to ward off evil. The rich and diverse mosaic pattern evokes the glory days of sixteenth-century Ottoman design but with a twist. Here there are vine scrolls of *saz* leaves, composite flowers, and split leaves, and stylized combinations of triple-ball motifs (*çinte-mani*) accompanied by doubled wavy lines, while generations of color harmonies mixed together in an original way: blue and white; turquoise and white; and the multicolor blue, red, and green on white.

An Ottoman tile dated the equivalent of 1726/27 demonstrates the use in the eighteenth century of design elements taken from sixteenth-century designs featuring tulips, rosettes, and prunus blossoms and of adaptations of the cobalt blue, red, and green color palette popular in the sixteenth century (fig. 9.18). The calligraphic ligature composition includes the names of God, the Prophet Muhammad, and the first four caliphs Abu Bakr, Umar, Uthman, and ʿAli, all of whom were recognized by Sunni Muslims, including the Ottomans.

Tiles continued to be produced in Ottoman-ruled Damascus. Of lesser quality yet attractive nonetheless, they were mass-produced by hand and can be recognized easily by the green, turquoise, blue, and aubergine palette under a thick, crackled glaze. Characteristic of Damascus production were small nine-tile panels depicting the Gateway to Paradise that were probably created for tombs, mosques, and private households. One example now in the Museum of Fine Arts, Boston, features a triple-arched gateway similar to a pattern seen in certain Ottoman carpets (see fig. 9.21). The tile version evokes the shape of the former gateway of

the Kaaba in Mecca, with hanging lamps, cypress trees, date palms, and carnations that symbolized paradise as a heavenly garden. The proclamation "Glory to God" in the central panels, together with names of Allah, Muhammad, and the first four caliphs, indicates that the panels were made for Sunni Muslims.

Kütahya, located southeast of Istanbul, was another ceramics center, the best-known products being tiles produced for the Armenian Cathedral of St. James in Jerusalem in 1718–19. Among the small ceramic vessels also made there, such as bowls, plates, jugs, and censers, were the ceramic "eggs" that hung on the suspension chains of oil lamps. Decorative motifs ranged from Christian subjects familiar to the Armenian population of Kütahya, including saints, angels, and the Virgin and Child to more traditional floral motifs, often sketchily painted in a lively palette of yellow, apple green, brown, blue, and turquoise.

OTTOMAN TEXTILES

Fabrics, garments, and carpets, produced across a range of quality levels largely in a design vocabulary shared with other media such as ceramics and architectural tiles, were also an important aspect of Ottoman material culture. The most sumptuous cloths of gold and silk, velvets, and brocaded silks were made from the second half of the sixteenth century through the seventeenth century (see figs. 3.24–3.26). Bursa continued to control the robust Ottoman silk trade, bringing in important revenue, and, together with Istanbul, was a main center of silk textile production. Given the lack of woven signatures or dates, it is difficult to determine the provenance or date of most textiles; scholars recently have focused on technical and structural analysis and continue to rely on design similarities and documented examples, such as the Ottoman textiles that made their way to churches and imperial treasuries in Europe.

Textile fashions were generated by the court, which required a wide variety of clothing in specific weaves and designs for particular ceremonies. The importance placed on design layout distinguished Ottoman silks from other traditions, and most surviving silks display motifs in one of two vertically oriented compositions: undulating vines or staggered rows. The most powerful patterns, however, featured single, large motifs on a plain ground, such as a ceremonial caftan associated with Sultan Ibrahim (r. 1640–48; fig. 9.19). Huge çintemani motifs (see above), a traditional symbol of power, were applied in red satin to an ivory silk ground stamped with carnation motifs. The dramatic motifs, which fit evenly together when the caftan is fastened in the front, added a sense of theater to the power embodied in the function of the garment. Ottoman sultans eschewed figural motifs almost entirely on their clothing, preferring garments with fewer colors than Safavid clothing and the floral decorative vocabulary familiar from other media such as ceramics, carpets, and architectural tile revetments. Super-sized and set against a contrasting ground color, these decorative motifs constituted a bold visual statement of Ottoman power.

Silk velvets were used for horse trappings, caftans, and a range of furnishings such as cushion covers, floor coverings, and wall hangings, as well as book covers because of their strength and resilience. Often made in pairs, sofa cushion covers (yastık yüzü) of red and ivory silk velvet with silver-and/or silver-gilt-wrapped threads were very popular (fig 9.20). Easily identified by the standard row of six lappets at either end, the cushion covers' main field designs varied from conventional staggered rows of carnations to new configurations featuring large wavy tulips. The large floral motifs usually contained smaller floral motifs, such as the tulips, carnations, and hyacinths that fill the petals of the large stylized carnations in the cushion cover in figure 9.20.

Velvet cushion covers continued to be made into the eighteenth century. They, too, are difficult to date, but a pair given by Kurd 'Abdi, Dey of Algiers (r. 1724–31), to King Frederick I of Sweden in 1731 survives in the Royal Armory, Stockholm. Cushion covers infused new life into Anatolian carpet weaving: the small rectangular format of the covers—measuring about 3 feet long (1 m)—and the large, graphic floral motifs found favor with village weavers, thus spawning generations of small yastık-style wool carpets across Anatolia.

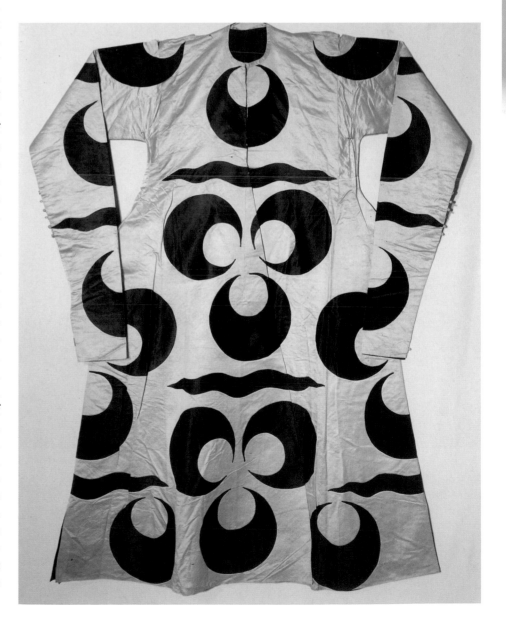

Fig. 9.19. Caftan, Turkey, 17th century. Silk; L. 65 ⅜ in. (166 cm). Topkapı Sarayı Müzesi, Istanbul (13/486).

OTTOMAN CARPETS

The main carpet types of the previous period continued to be produced but the heyday of Ottoman carpet design and production during the sixteenth century was over. Carpet designs originating after that time (especially those from provincial urban workshops) were distinguished by the angularity of their designs—even the florals and arabesques. Lower-density knotting was used for most commercial production aimed at the European market because when woven that way the carpets were less labor-intensive and thus cheaper to produce. Although court demands decreased, carpet production within the Ottoman Empire increased and some of the designs were copied in England and elsewhere in Europe, including Spain and France.

Sixteenth-century Ottoman court carpet designs found new life as inspiration for both commercial and village weavings. The Anatolian village woolen prayer rug shown here,

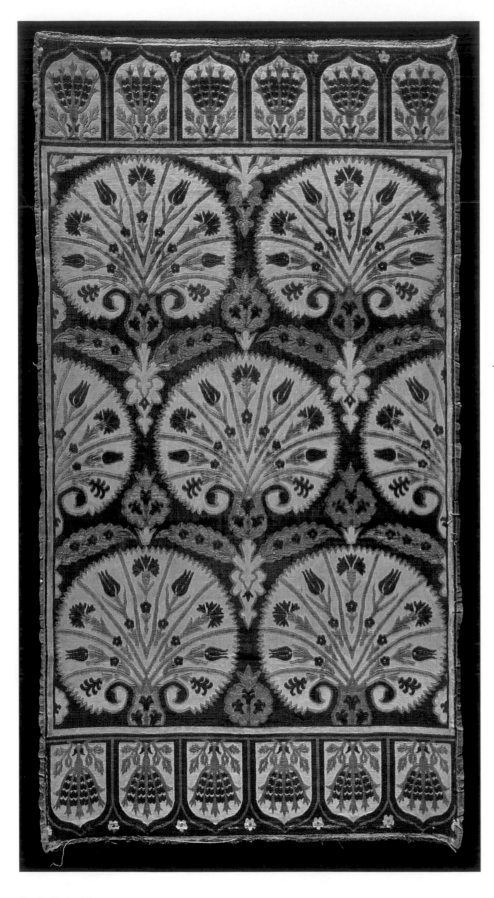

Fig. 9.20. Cushion cover (*yastık yüzü*), Bursa, Turkey, c. 1600. Silk velvet, cotton, metal threads; 47¼ x 25 in. (120 x 63.5 cm). Los Angeles County Museum of Art (M.73.5.688).

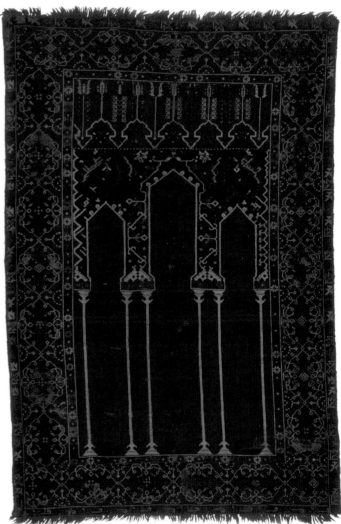

Fig. 9.21. Prayer rug, Turkey, 17th or early 18th century. Wool; 66⅛ x 44 in. (168 x 112 cm). The Textile Museum, Washington, DC (R34.22.1).

for example, with its coupled-column and triple arch, recalls an earlier Ottoman court manufactory example in overall design format, if not color or style of motifs (fig. 9.21; see also fig. 3.26). This village rug, however, has a brighter red and blue palette and the designs are much bolder and more angular, as was fashionable at the time: large, jagged *saz*-style leaves fill the spandrels of the arches, which are balanced on impossibly narrow columns. Some of the decorative motifs seen here, such as stylized tulips and the crenellations in the horizontal panel above the arches as well as the floral, leaf, and geometric motifs in the main and guard borders—the inner and outer borders flanking the main border—were found in both village and urban workshop weaving traditions derived from Ottoman-court carpet design. That some Anatolian village carpets found their way to Europe is suggested by a similar carpet depicted in a Netherlandish painting, *Still Life*, 1664, by Nicolaes van Gelder (Rijksmuseum, Amsterdam).

OTTOMAN METALWORK

Even after the highpoint of the *saz* style in the sixteenth century, Ottoman metal wares continued to be decorated in that manner, the most sumptuous objects still fashioned from gold and silver (and zinc) and decorated with chasing, repoussé, inlay (in niello, a black enamel-like alloy, usually of sulfur with silver, copper, and lead), and filigree-work, and encrusted with gems. The goldsmith known as Mehmed the Bosnian, a master of the *saz* style, was mentioned in palace documents from 1596 until 1605 and can be associated with three signed and dated objects as well as a crown presented to the Transylvanian ruler Stephen Bocskay by Sultan Ahmed I in 1605.

Many everyday objects in copper and copper alloys—brass and bronze—were also decorated in the *saz* style, the copper pieces often tinned or gilded to enhance their appearance, but a large number of copper, silver, and brass wares were either simply decorated or left plain. From basins, bowls, and ewers to candlesticks, the visual priority was an elegant shape and decoration that enhanced but did not obscure the form. A pair of extremely large silver candlesticks illustrated here, nearly 30 inches (76 cm) in diameter and 46 inches (117 cm) tall, are ornamented on the base with widely spaced medallions reminiscent of Ottoman bookbinding and on the top with a delicate latticework of vine scrolls (fig. 9.22). Inscriptions on the candlesticks suggest that they were made for the mausoleum of Sultan Ahmed I (r. 1603–17) and Sultan Murad IV (r. 1623–40) next to the Blue Mosque in Istanbul. One reads, "fire of Sultan Ahmed [I] Khan"; another, "fire of Sultan Murad [IV] Khan conqueror of Baghdad."

Although fewer pieces survive from this period than from the mid-sixteenth century, among those that do are some of the finest items in the Ottoman treasury. Ottoman craftsmen added gold, rubies, emeralds, and pearls to sculpted jade and rock crystal imported from China and India, and a miniature Chinese Ming dynasty porcelain garden seat was transformed into an incense burner by adding a gilded metal base and canopy (fig. 9.23). An inscribed cartouche indicates that the

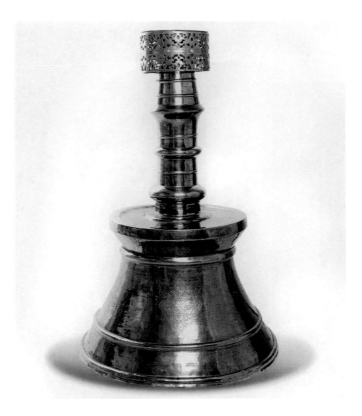

Fig. 9.22. Candlestick, Istanbul, 1640. Silver; 46¼ x 29¾ x 29¾ in. (117.5 x 75.5 x 75.5 cm). Türk ve İslâm Eserleri Müzesi, Istanbul (93 A-B).

object was given as *waqf* (endowment) to the mausoleum of Ahmed I by the chief eunuch of the imperial harem Hajjı Mustafa in the equivalent of 1616/17.

Among the most luxurious objects in the treasury were a dagger and its jewel-studded sheath that were to have been given by Sultan Mahmud I (r. 1730–54) to the shah of Persia in 1747, but the latter was assassinated before the gift was transferred (fig. 9.24). In addition to the impressive jewels—three large emeralds on the gold hilt as well as a generous amount of rose-cut and table-cut diamonds on the sheath—in the pommel there was a small English watch covered by an emerald. The latter reflects the vogue for enameled watches, clocks, and jewelry in the second half of the seventeenth century, while the colorful fruit and flower basket on the sheath demonstrates the continued interest in the floral style of Ahmed I.

Exquisite silver-gilt metalwork adorns one of the earliest known Ottoman clocks, which resembles an astrolabe and has both Arabic numerals and pierced floral scrollwork made according to designs and techniques that are more European than traditionally Ottoman (fig. 9.25). The treasury also holds more than three hundred European clocks (English, Russian, French, Swiss, German, Austrian) collected from the sixteenth to twentieth century as diplomatic gifts or purchases. Clocks were valued in mosques (as well as palaces) to indicate the times for prayer.

NORTH AFRICAN DECORATIVE ARTS

By 1600 the Ottoman Empire was well established in North Africa, beginning with the defeat of the Mamluk sultanate in Cairo in 1517. With the local Mamluk elite still in charge in Cairo, the Ottomans ruled by provincial governates and

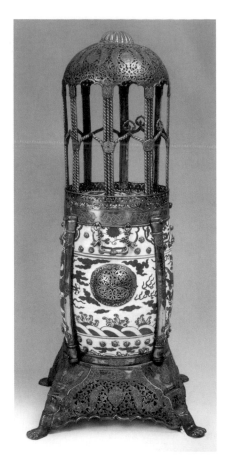

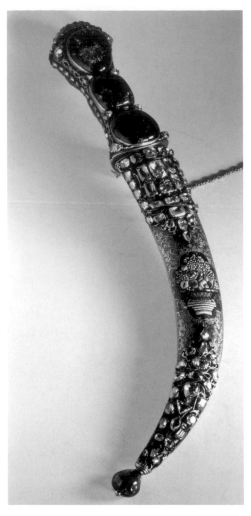

Fig. 9.23. Incense burner, Turkey, 1616–17. Gilded metal, Chinese porcelain; H. 3¾ in. (9.5 cm). Türk ve İslâm Eserleri Müzesi Istanbul (29).

Fig. 9.24. Dagger, Turkey, 1746–47. Gold, diamonds, emeralds, enamel; L. 13¾ in. (35 cm). Topkapı Sarayı Müzesi, Istanbul (2/160).

Fig. 9.25. Bulugat. Clock, Turkey, mid-17th century. Silver-gilt filigree; Diam. 7 ⅛ in. (18 cm). Topkapı Sarayı Müzesi, Istanbul (53/86).

corsairs in city-states along the North African coast, including Algiers (1529), Tripoli (1550s), and Tunis (1574), but, by the late seventeenth century, Ottoman authority was dramatically reduced. The decorative arts in the provinces west of Egypt continued Spanish/North African traditions and merged them with the imported Ottoman style, except in Morocco, which was ruled by the Sa'adis (1510–1659) and 'Alawis (1631–the present day)—two dynastic lines descended from the Prophet Muhammad—and resisted Ottoman attempts at expansion.

Craft and design practices and decorative motifs generally were based on distinctive local Spanish/North African traditions, sometimes with Ottoman influences, right up to the twentieth century, when new European influences became more prominent, especially French and Spanish. Fez, an important Moroccan crossroads of trade and manufacture, produced distinctive everyday ceramics, including food storage jars, bowls, plates, pitchers, and oil flasks, decorated in cobalt blue on white slip. Fez was home to about 180 ceramics workshops by 1600, but the earliest blue-and-white lead-glazed earthenwares, which frequently imitated finer Ottoman Iznik ceramics, date from the seventeenth century. Polychrome ceramics appear to have been made in the same workshops, as some wares mixed blue-and-white decoration with multicolored combinations of blue, green, and yellow-orange with brown outlines. Other cities had their own ceramic traditions, including monochrome green-glazed wares at Meknès and salt-glazed earthenwares at Safi. In Tunisia, the pottery and tilework industries benefited from the expertise of emigrant craftsmen from the Andalusian area of Spain in the fifteenth century, especially so after the Moors' expulsion from Spain by Philip III in 1610. Qallalin (Tunis) workshop tiles and earthenware objects were distinguished by their polychrome palettes in yellow, manganese brown, and emerald green under a transparent glaze.

The silk-weaving tradition inherited from Nasrid Spain (see fig. 3.5) persisted in many North African textiles, including a silk and metallic thread banner meant to be taken on the pilgrimage to Mecca (fig. 9.26). The banner was made for a North African Sufi order, the Qadiriyya, according to the textile's Maghribi script inscription dated the equivalent of 1682/83. The format of the banner, however, is Ottoman, including its shape and the anthropomorphic depiction of 'Ali's double-edged sword. Ottoman textiles were highly revered in North Africa, where they were collected and the designs copied locally.

Ottoman embroideries also influenced regional styles, as seen in Algerian embroideries from this period. Two panels (one shown) from a curtain depict Ottoman-style composite palmette or artichoke/pomegranate-style motifs and carnations in a predominantly red and blue palette (fig. 9.27). Differentiated from other Mediterranean embroidery traditions in terms of design, technique, and color, this typical Algerian example shows vertically oriented motifs embroidered in red, two blues, gold, yellow, white, brown, and purple on an undyed linen ground. Panels such as these, numbering up to six, were joined together by silk ribbons and hung vertically as curtains; those of highest quality would have decorated

bridal chamber beds. Embroidered headdresses, headbands, and kerchiefs were also created.

The period 1600–1750 was a time of ebb and flow for decorative arts and design in the Islamic world, with the quality of design and production fluctuating greatly. The rulers of the three major early modern Islamic empires—Safavid, Ottoman, and Mughal—had more or less solidified the borders of their empires, refined their imperial styles, and domestic and foreign trade had developed considerably. Europe played an expanded geopolitical and economic role in the Islamic world. The promise of more lucrative European markets drove production away from court commissions, while imports from Europe, as well as the influx of New World silver, affected local production and damaged local economies. In the period 1750 to 1900, Europe was to play an even more expanded and complex role.

AIMÉE E. FROOM

Fig. 9.26. Pilgrim's banner, North Africa, 1683. Silk brocade, metallic thread; 12 x 7 ft. (3.7 x 2.1 cm). Harvard Art Museums/Arthur M. Sackler Museum, Harvard University (1958.20).

Fig. 9.27. Curtain panel, Algeria, 17th century. Linen, silk embroidery; 96⅞ x 14⅛ in. (246 x 36 cm). The Nasser D. Khalili Collection of Islamic Art (TXT 117).

AFRICA

Fig. 10.6 detail

The period from 1600 to 1750 was marked by significant changes in trading relations along the Atlantic coast, with profound consequences for Africans living there and inland. Gold had been the primary export, but by the beginning of the seventeenth century, the value of slaves exceeded that of gold. The demand for labor in the New World ushered in radical shifts to African political systems. African power brokers along the coast took advantage of their new wealth and of the weapons that they obtained from their European trading partners, while vulnerable populations farther inland were destined to supply forced manpower for the plantations of Brazil, the Caribbean, and North America.

From the late fifteenth to the beginning of the seventeenth century, the Portuguese dominated the trade along the West African coast. Two of their forts—one at Elmina on the coast of what is now Ghana, originally built in 1482, the other in Luanda built in 1618 in what is now Angola—ensured the smooth running of trading operations. As the plantation economies in the Americas expanded, however, Dutch, and then British traders began to challenge the hegemony of the Portuguese-Spanish crown.

Much of what we know of decorative arts in this period comes from European trading records, as well as writings, illustrations, and material collections assembled by wealthy European merchants or rulers. King Frederick III of Denmark for example, created a *Kunstkammer* (room of art) in Copenhagen in 1650, filled with "exotic" objects from Africa and other faraway places. A careful examination of these sources provides some clues, not only to the luxury goods sought by the elite, but also to the everyday decorative arts used by the populace.

A 1788 painting of a slave ship, now in the Danish Maritime Museum, Helsingor, Denmark, shows an African woman on deck pounding grain, probably African rice, with a wooden pestle and mortar. Such mortars and pestles were used during "the middle passage" for preparing food, and for centuries they were the main way that Africans processed grain on both sides of the Atlantic. Enslaved Africans may have made drums out of the mortars, since musical instruments were forbidden on some plantations and slaves were not allowed to bring musical instruments with them from Africa.

During the eighteenth century, an Akan-style drum was collected in the American colony of Virginia for Sir Hans Sloane (1660–1753), the British physician whose natural history and curiosity collection became part of the founding bequest that led to the opening of the British Museum in 1759 (fig. 10.1). Pegs fasten the hide membrane of the drum to a hollowed log that is incised with delicate lines on its surface. Made between 1700 and 1735, the wood (*Baphia nitida*) of the

drum and deer or antelope skin are native to Africa, suggesting that it crossed the Atlantic on a slave ship, probably carried by a member of the crew or a slave trader, and was used aboard the ship in the compulsory exercise known as "dancing the slaves"—that is, forced jumping up and down. In its African context, it would have been played in court ensembles along with other drums and ivory horns.

Mid-seventeenth century documents indicate that brass bracelets, cowry shells, beads, textiles, copper rods, and iron bars were among the goods exchanged for African slaves. There was considerable regional specialization in terms of what was traded, but as the Atlantic slave trade spread along the coast, guns, gunpowder, tobacco, and alcohol gained in importance. Many objects traded into Africa in this period, including weapons and textiles (among them Chinese silks), were used as raw materials and reworked into objects that stylistically and functionally had local meaning. Metal tacks and studs were used to decorate knives and shields, chairs and stools; glass beads from Venice and Central Europe and pearl buttons from Britain were added to baskets, leatherwork, woodcarvings, and textiles. European woolen blankets and Chinese silks were disassembled and rewoven and Chinese porcelain plates were inset into walls as decoration.

WEST AFRICA: THE AKAN AND OTHER GROUPS

Two paintings made in about 1641 by the Dutch artist Albert Eckhout (c. 1610–1665) depict a number of objects that were part of West African material culture at the time. The paintings are part of a group of twenty-six given in 1654 to King Frederik II of Denmark by his cousin Johan Maurits van Nassau-Siegen, a German count who was noted for directing the Dutch takeover of Elmina in 1637 and was Governor of Dutch Brazil from that date until 1644. Although probably painted by Eckhout in Brazil or the Netherlands, rather than Africa, these larger-than-life images include African items of dress and material culture. The man seen in figure 10.2 is a Guinean trader, while the woman in figure 10.3 may be a slave or African noble. The fishing nets, lookout ladder, and ships suggest a coastal spot in Africa or Brazil. The bare-breasted woman wears a short blue-and-white-checked cloth wrapper, likely of handspun, strip-woven, indigo-dyed cotton made in West

Africa. Tucked into her red sash is a simple white clay pipe of a type popular in seventeenth-century Holland. The peacock feathers encircling her broad-brimmed woven fiber hat were an African adornment. Portuguese accounts tell of how, in the 1590s, the king of the Kongo raised peacocks and used their feathers as trade items. Her metal bracelet and red bead necklace made of coral or stone belonged to West African ornamental traditions, while the pearl necklace and droplet earrings show Dutch influence.

The man wears the same type of cloth as the woman and carries an elaborate, sheathed sword, which may have been a gift to Maurits van Nassau-Siegen when he was in Elmina. Ceremonial swords such as this continue to be used by the Akan people in Ghana and Côte d'Ivoire. (Akan refers to a number of culturally related ethnic groups in south-central Ghana and Côte d'Ivoire including the Asante, the Baule, and the Fante.) It is similar to one that entered the Danish royal collection in the 1600s (fig. 10.4) and another in the Ulmer Museum, Germany. All three have long, curved iron blades

Fig. 10.4. Sword and sheath, Akan, before 1641. Wood, iron, ray skin, gold, horsehair, seashells; L. 31½ in. (80 cm). Etnografisk Samling, Nationalmuseet, Copenhagen (Cb8).

Fig. 10.5. Tunic, collected in the Kingdom of Allada before 1659. Indigo-dyed cotton; 55⅛ x 63⅜ in. (140 x 161 cm). Weickmann Collection, Ulmer Museum, Ulm (13c).

with wooden handles covered with ray skin, hammered gold, and remnants of black horsehair. Bright red seashells are also used as decoration. In 1673 Wilhelm Johann Müller, a German clergyman who had lived near Elmina in the 1660s, described how people from Accarâ (Accra) decorated swords with blood-red seashells. These shells were widely believed in West Africa to have protective properties and were so highly valued among the Akan that they could be exchanged for gold dust. They were also traded by the Portuguese. In Eckhout's painting, a massive ivory tusk that would have been used as a side-blown trumpet in Africa, and seashells, including cowries, which were used as currency, are strewn at his feet.

Clergyman Müller further commented on the splendid clothing he saw, citing a fine man's undergarment of precious linen or silk, tied or wrapped around the body, as well as a full-length over-garment draped below the right arm and held firm with the left, a custom that continues to the present day. He reported that distinguished men paid up to three ounces of gold for clothes from the East Indies or Europe, adorned themselves with precious ornaments, and had their wives plait their hair and beards, threading into it gold beads and precious stones.

Most of the clothing worn by Africans, however, including high status garments, was made locally. Two seventeenth-century garments illustrate the most widespread techniques of textile production in West Africa at the time—indigo resist dying, narrow strip weaving, and embroidery. The first is one of the oldest examples from sub-Saharan Africa—a man's tunic that was described by Christoph Weickmann, a German merchant and collector, in the 1659 catalogue of his collection as a royal gown with very large, wide sleeves, from the kingdom of Allada, in what is now the Republic of Benin (fig. 10.5). It was made of ten narrow bands of finely woven hand-spun cotton and resist dyed with indigo to reveal two parallel lines of small, white dots criss-crossing the chest and a larger white circle below the neckline.

The patterning of the second tunic closely resembles the blue-and-white strip woven clothes still being made in many

areas of West Africa (fig. 10.6). While the first garment was decorated through resist- or tie-dying, the second incorporated a woven horizontal design made on a double heddle narrow strip loom. Small weft-based horizontal blue and white stripes, sometimes filled in with triangular supplementary weft designs, created a counterpoint of horizontality and verticality. Small bits of red embroidery appear around the neck, with the thread possibly coming from an imported European cloth. Whether this tunic was made locally or imported from farther north in West Africa is not known.

The great demand for gold, and then slaves, had a profound effect on internal political and social relations in West and Central Africa. Major kingdoms whose rulers dealt with African traders along the coast thrived during this period,

Fig. 10.6. Man's tunic, collected in the Kingdom of Allada before 1659. Indigo-dyed cotton, silk; 50⅜ x 75¼ in. (128 x 191 cm). Weickmann Collection, Ulmer Museum, Ulm (13d).

notably Asante, Dahomey, Benin, and Kongo. As in earlier times, the decorative arts helped to define status. Textiles, copper rods, and beads imported from Europe were incorporated with local gold, textiles, cast metal, and wooden and ceramic objects. This fusion of materials is evident in the many kinds of metal containers that were crafted and used in West Africa in this period. Europeans exchanged an array of vessels made of various alloys of brass, tin, copper, and iron for African gold and human cargo. The Dutch trader Pieter de Marees wrote in 1602 of the many types of European-made metal basins that were put to African use as containers, served as water vessels for grooming, or were placed on graves.

African metalsmiths melted down and reworked many of these objects. Two types of vessels, often made of reworked metal, were in common use among the Akan. One, a *furowa*, made of sheet copper or brass, was usually a round, compartmented container, decorated with repoussé, stamping, and incised designs. These were used to hold gold dust, valuables, or skin ointments. The other type, known as a *kuduo*, was a heavier cast-metal container used for holding valuables, offerings for the dead, and for objects placed on shrines. Many *kuduo*, such as one dated c. 1730–49, had cast-brass figures of animals or people on the lid (fig. 10.7).

Located at the periphery of the medieval empire of Mali, Akan city-states had risen to power by the beginning of the fifteenth century. Most accounts attribute their rise to the incursions of northerners, who often arrived on horseback and gained hegemony over the resident agrarian population. As gold trade routes shifted from the Sahara to the coast,

Fig. 10.7. Vessel for valuables (*kuduo*), Asante, 1730–49. Cast brass; 5½ x 4⅛ x 4⅛ in. (14 x 10.5 x 10.5 cm). National Museums Liverpool (16.2.06.36).

Akan royal courts in the forested region of what is now Ghana, about 150 miles from the Atlantic coast, became the most sumptuous in Africa. The Asante confederacy was formed around 1700, and according to legend, Osei Tutu I (born c. 1660) consolidated the various Akan states into a confederacy when his chief priest, Okomfuo Anokye, summoned a golden stool from the sky. The stool, which was thought to contain the *sunsum* (soul), of the newly consolidated nation, landed on Osei Tutu's knees and identified him as the first Asantehene, as the king of the Asante was known.

After this, the Golden Stool became a sacred symbol of the unity of the Asante nation. One is still kept in the palace in Kumase (the royal capitol but also a large regional capitol) and displayed on important ceremonial occasions. Among the Akan, this seating form—generally made of a single piece of wood and sometimes embossed with metal—is considered a seat of power. If properly prepared through libations and offerings, it can also represent the soul of an important individual. On the death of a prominent person, his or her stool is blackened with soot and blood and may become part of an ancestral shrine, which is periodically honored with offerings and prayers.

Gold dust was the Asante currency, and the Asantehene controlled its use, sale, and taxation. His courts as well as those of lesser regional and village chiefs were resplendent with gold ornaments. Crowns, scepters, swords, staffs, pectorals, rings, bracelets, and beads were made of locally mined gold in a variety of techniques, including lost-wax casting, hammering, repoussé, and filigree with gold wire and granules. Many objects, such as sword handles, staffs, and finials, were carved in wood and then covered with thin layers of gold leaf.

The large, gold ornament representing King Ntim Gyakari (r. 1694–1701; fig. 10.8) of Denkyira in what is now western Ghana was cast using the lost-wax technique and made to be attached to a royal sword or stool as a commemorative war trophy. Gyakari had been beheaded by Osei Tutu in 1701 during the struggles to consolidate the Asante confederacy. Oral histories describe how Ntim Gyakari, who had controlled trade with Europeans, contributed to his fate by sending armed officials to threaten the ruler in Kumase and demand gold, wives, and items of gold regalia. After Osei Tutu's victory over Gyakari, swords called *afena* were adopted as state insignia. This impressive gold head, with the jaw held shut by prongs that jut from the upper lip, became a war trophy in 1874 when the British seized it from the treasury of Asantehene Kofi Karikari (r. 1867–74).

Similar in scale to the gold trophy head, an Akan terracotta head from southern Ghana commemorated a deceased family member or important leader (fig. 10.9), its date of creation (mid-1700s) determined by thermoluminescence. On both heads, the broad smooth foreheads conform to Akan ideals of beauty; a newborn's head was repeatedly rubbed to make it flat and wide. The spirals that decorate the terracotta head depict either locks of hair or gold ornaments. Painted clay figures were mentioned in 1602 by Pieter de Marees, in his description of elaborate burials found near Elmina among the Fante people. Such terracotta sculptures were also said to

be portraits of deceased leaders and members of his, or possibly her, entourage. Patterns of scarification, hairstyles, dress, jewelry, and other ornaments were rendered with such precision that individuals could be easily recognized. Adorned with fine cloth and seated in state surrounded by both terracotta and living human attendants, the figures were paraded through the streets to the royal graveyard and displayed during annual commemoration rites, and then stored in what was known as the "place of pots" adjacent to the actual graveyard.

Two finely detailed ivory staff finials from the Lagoons region of what is now the Ivory Coast (fig. 10.10) portray in exquisite detail the European-style clothing and possessions of African notables. Imported items of dress and adornment served as symbols of wealth in the seventeenth and eighteenth centuries. The two figures are seated on throne-like chairs. The man clasps a staff of office modeled on a European cane; he wears a European-style, broad-brimmed hat. Strings of beads adorn the bare-breasted woman who holds an umbrella overhead, the umbrella itself having become a status symbol by this time.

Fig. 10.8. Effigy of King Ntim Gyakari of Denkyira, Asante, probably 18th century. Gold; H. 7⅞ in. (18 cm). The Wallace Collection, London (OA1683).

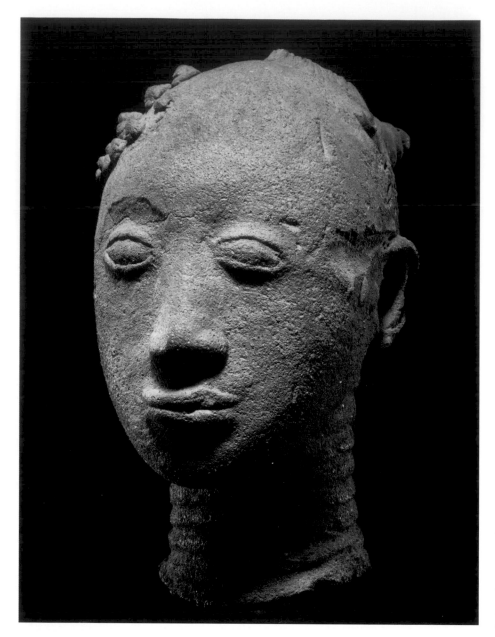

described seeing more than eighty canoes filled with fighting men going on a coastal military expedition in 1706 with flags and banners flying.

Ifa divination has long been a practice associated with Yoruba-speaking people of western Nigeria, as it is known today, but also found in what is the present-day Republic of Benin (formerly Dahomey). A priest throws cowrie shells or palm kernel nuts on a board or tray, such as the carved wooden tray in figure 10.11, and interprets their meaning based on a body of knowledge known as Ifa. This example was collected in the Kingdom of Allada (Dahomey) before 1659, and, according to Weickmann's collection notes, it had been used by the King of Allada. This and the Akan-style drum (see fig. 10.1) are among the earliest known pieces of African woodcarving.

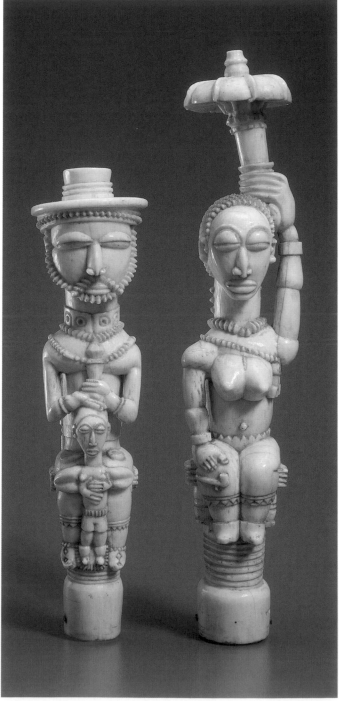

Fig. 10.9. Portrait head, Akan, mid-18th century. Terracotta; H. 8 in. (20.3 cm). Private collection, New York.

Fig. 10.10. Staff finials, Attie group, Lagoons peoples, 17th–18th century. Ivory; H. 5⅞ (15 cm), 7¹⁄₁₆ in. (18 cm). Collection of Laura and James J. Ross.

As the seventeenth century progressed, the Portuguese lost their trading monopoly along the west coast of Africa. The leaders of Fante states invited other European powers to build forts, and eventually the Dutch, Spanish, French, Prussians, and British all had a presence there. This diplomatic maneuvering was expressed in several new hybrid objects, such as appliquéd flags and linguist staffs. Modeled after European flags and banners, cotton flags were appliquéd and embroidered with colorful imagery that describes power relations and local events. Similar flags continue to represent civic associations called *asafo* (war, *sa*, people, *fo*), in processions in southern Ghana. Although no seventeenth-century examples of Fante *asafo* flags are known, images of the Portuguese fort at Elmina adorn a flag from about 1900 (see fig. 16.10). Earlier flags have been noted in contemporary accounts. In 1693, for example, an English trader described how the Danish fort, Christiansborg Castle, was flying an African flag—white with a painted central image of a black man brandishing a sword. The fort had been captured by an African general from Akwamu, in the southern Akan region. In another account, the Dutch Director-General of Elmina

Ifa divination was not officially recognized within the Kingdom of Allada, until the reign of King Agaja (1708–40), but this board provides evidence that Ifa was widely practiced if not sanctioned there during the seventeenth century. The tray's carving, in continuous bands of low relief, includes diverse imagery: male and female figures, birds, animals, tusks (or divination tappers), a sword (upper left corner), and other objects. One of the male figures smokes a pipe, another holds a weapon, and one of the female figures carries a large load on her head. As is true of all Ifa divination boards, the face of Eshu, or Elegba, the Yoruba trickster deity who presides over divination sessions, mediating opposites to bring together different worlds, is at the center of the top rim. Here, Eshu's face is crowned with three calabash gourds that would have held medicines. Sixteen cowries, similar to those that were cast by the diviner, are carved in low relief in four vertical rows at the lower edge of the board's center circle.

Another seventeenth-century African divination object, from a different collection, dates to before 1700 when it was already in the home office of the Dutch West India Company. Made of shiny white ivory, a kneeling female supports a cup above her head (fig. 10.12). It is made in the so-called Owo style, after the Yoruba center famed for ivory carving and terracotta sculpture. The woman's neck, chest, and arms are decorated with pearls; flame-shaped scarification marks typical of Owo ivories adorn her torso. Three views of this figure appear in the *Selecta Sacra* by Johannes Braun (1628–1708), a professor of theology and Hebrew at Groningen University in the Netherlands. Like the Ifa board, this object functioned within the context of divination ceremonies. The cup, known as an *agere-Ifa*, held the sixteen cowrie shells or palm nuts, which the diviner cast and then correlated with the 256 known Ife verses to invoke the advice of deities.

In areas at the southern edge of the Sahara Desert, many more wood objects have survived than in central and coastal West Africa. During recent decades, objects carved in wood attributed to the Dogon and Bamana people of Mali have been reexamined to determine when they were made. Radiocarbon testing and dendrochronology (tree-ring analysis) have proven that items once dated to the late-nineteenth or early-twentieth centuries, were in fact made much earlier, between the eleventh and seventeenth centuries. One of these, a Dogon figure from Mali, was carved between 1667 and 1725 (fig. 10.13). This seated musician has both breasts and a beard, as do many mythical Dogon ancestors, and is playing a harp or lute which, in some Dogon myths, is linked to fertility. Beneath the iron necklace and bells is another necklace carved in relief that bears tiny amulets.

WEST AFRICA: BENIN

The Kingdom of Benin, located in present-day Nigeria, whose people are known as Edo, rose to prominence in the sixteenth century and, according to some accounts, was a successor to the Kingdom of Ife. In both Benin and Ife, the legendary Yoruba hero Oranyiman is acknowledged as a founding ruler. Some oral histories suggest that when Ife's metal casters left

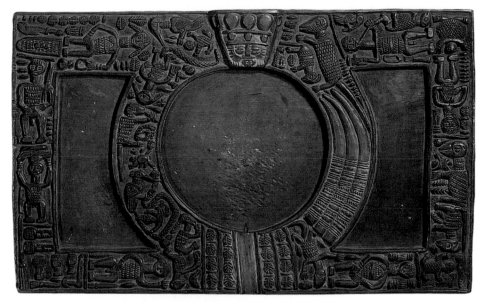

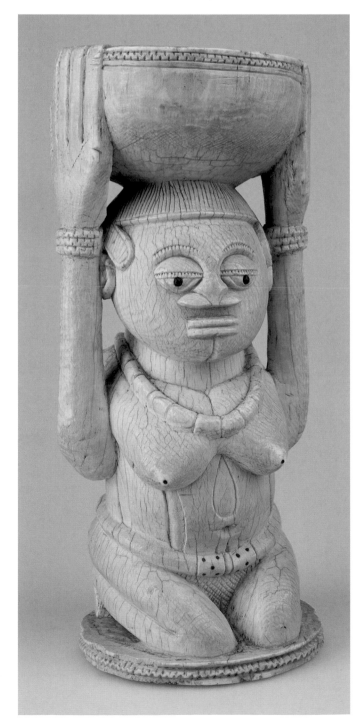

Fig. 10.11. Ifa divination board, Kingdom of Allada, early 17th century. Wood; 13½ x 21⅞ in. (34.4 x 55.7 cm). Ulmer Museum, Ulm (A.V. 1786).

Fig. 10.12. Divination figure with cup (*agere-Ifa*), possibly Owo, before 1700. Ivory; 10¼ x 4⁷⁄₁₆ x 4⅛ in. (26 x 11.3 x 10.4 cm). Rijksmuseum Volkenkunde, Leiden (1415-1).

Fig. 10.13. Seated
musician, Dogon,
Bandiagara escarpment,
1667–1725. Wood, iron;
22 x 7 x 4¼ in. (55.8 x
17.7 x 10.8 cm). Brooklyn
Museum (61.2).

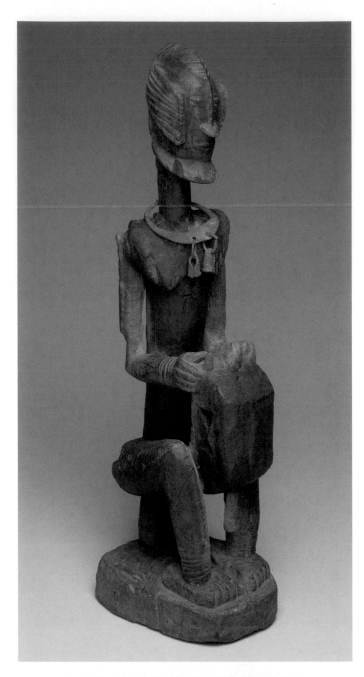

Ife (perhaps because of warfare or disease), they may have moved to Benin. As in the Kingdom of Asante in Ghana, Benin's power and wealth grew after the trans-Atlantic trade with Europeans, starting with the Portuguese, increased.

In 1702, when David van Nyendal, a Dutch official, visited Benin City, the capital of the Kingdom of Benin, he described how the outer gate to the king's palace and the entrance to his living quarters were protected by towers adorned with gigantic snakes. In Benin, pythons were and are considered one of the alter egos of kings. A massive seventeenth-century brass sculpture of a python head that once hung on a palace turret (fig. 10.14) and was attached to a long curving body is one of at least fifteen surviving python heads from Benin. It is unique, however, in being animated by a brass tongue that moved with the wind.

An image of the palace at Benin City, with three turrets surmounted by large birds, appeared in a panoramic view of the city published in 1668, by Olfert Dapper, a Dutch compiler of travel lore. Although Dapper never visited Africa, he based his texts and images on reports from travelers of the early seventeenth century who claimed that the palace complex in Benin City was as large as the Dutch city of Haarlem with beautiful, large square galleries resting on copper-covered wooden pillars engraved with images of war battles. Two cast brass objects provide further clues about the design of the palace—a plaque showing the interior of a palace courtyard (fig. 10.15), and a hinged box in the shape of the building (fig. 10.16)—both of which show the turrets adorned with snake sculptures.

Hundreds of plaques had adorned the palace's interiors since the reign of the powerful king, Oba Esigie (r. 1504–50). Most illustrated some feature of court life. The plaque shown here depicts the exterior of the king's conference chamber, even illustrating how nails secured the shingles of its wooden roof. Because of damage to the upper edge of the plaque, only the tips of the talons of a large bird on the turret are visible, but birds are fully depicted on the roof-shaped lid of the box where Portuguese figures aim guns at them (one is missing). On the plaque, four wooden pillars that support the roof are decorated with rows of faces of Portuguese men, identifiable by their tall hats, wide moustaches, and long beards, stacked one on top of the other, to emphasize the close alliance between the Kingdom of Benin and the Portuguese. Men wearing cloth wrappers, coral neckbands, anklets, and agate hair decorations stand guard, holding shields and maces. Smaller figures wear similar beaded necklaces, metal armlets, and hair ornaments. Their circular fans made of leopard skin identify them as royal attendants.

By about 1700, power in Benin had shifted from the royal family to the mercantile aristocracy, and the plaques were removed from the palace walls for safekeeping. According to oral tradition, early in Oba Ewuakpe's reign (c. 1700–12), a rebellion, caused by the killing of his subjects after his mother's death, forced him out of the palace and stripped him of his right to wear a beaded coral crown. An eighteenth-century altar sculpture that was likely made after his death shows him wearing a European helmet and flanked by foreigners, possibly slaves, identifiable by their heavy facial scar-

Fig. 10.14. Python head,
Benin Kingdom, 17th
century. Brass; 8¼ x
20⅞ x 15 in. (21 x 53 x
38 cm). Museum für
Völkerkunde, Vienna
(MVK VO 64739).

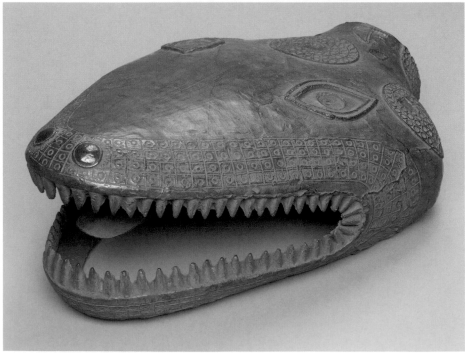

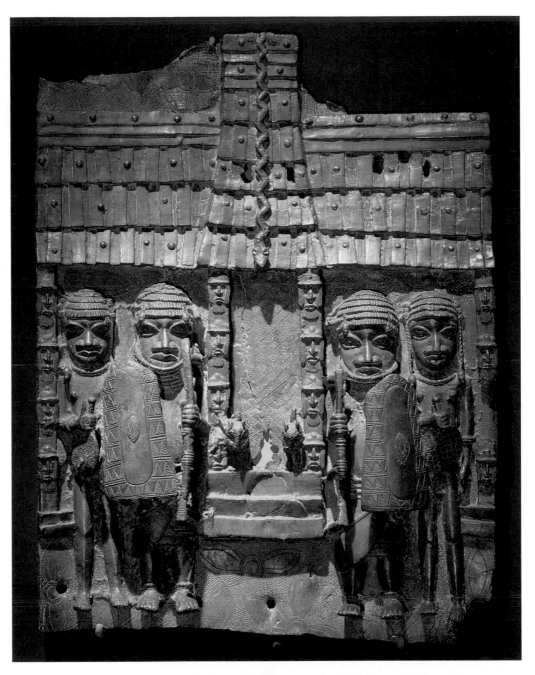

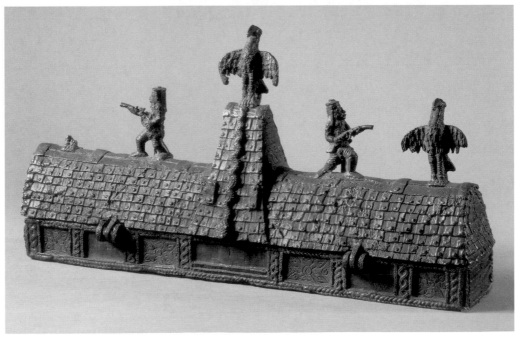

Fig. 10.16. Palace shaped container, Benin Kingdom, 17th–18th century. Brass; 12¼ x 23⅝ x 5⅞ in. (31.1 x 59.9 x 14.8 cm). Ethnologisches Museum, Staatliche Museen zu Berlin (III C 8488).

AFRICA

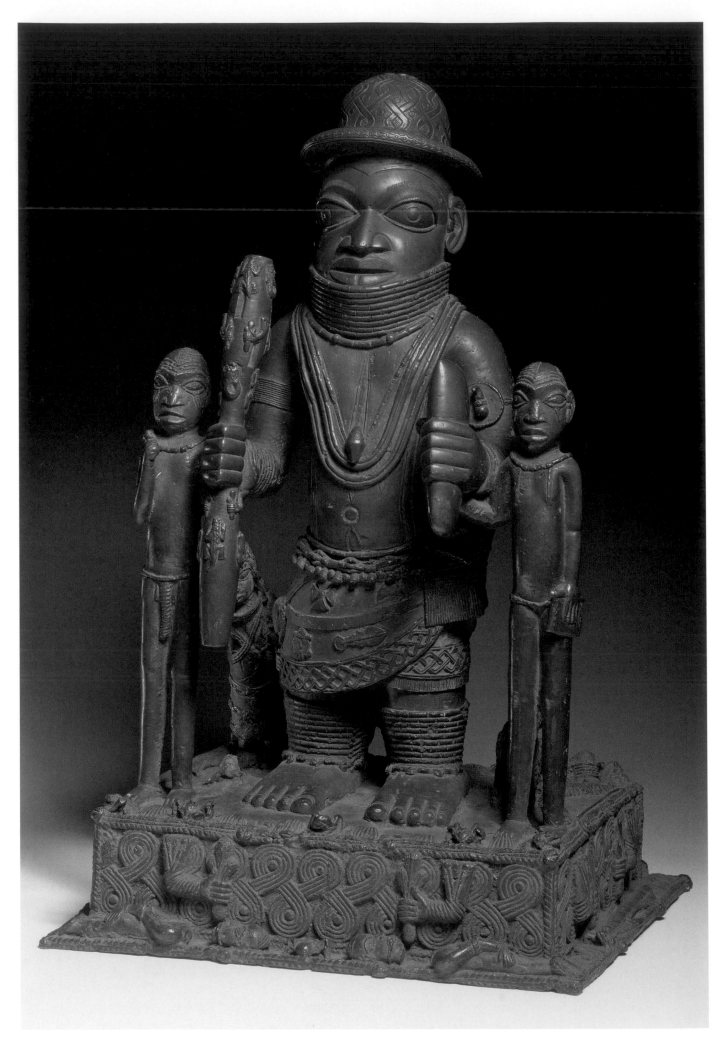

Fig. 10.17. Altar group (*aseberia*) with Oba Ewuakpe, Benin Kingdom, 1700–50. Brass; H. 22⅞ in. (58 cm). Ethnologisches Museum, Staatliche Museen, Berlin (III C 8165).

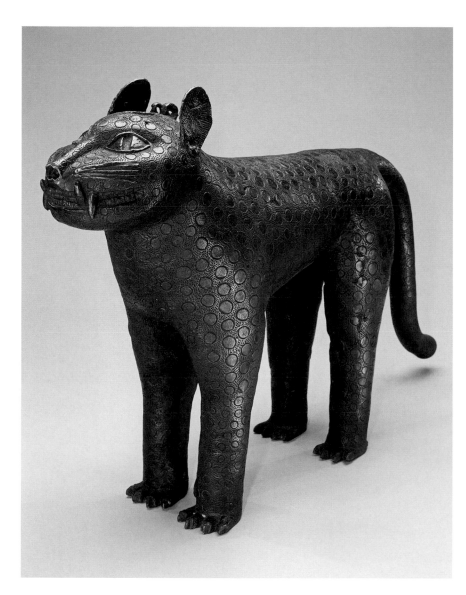

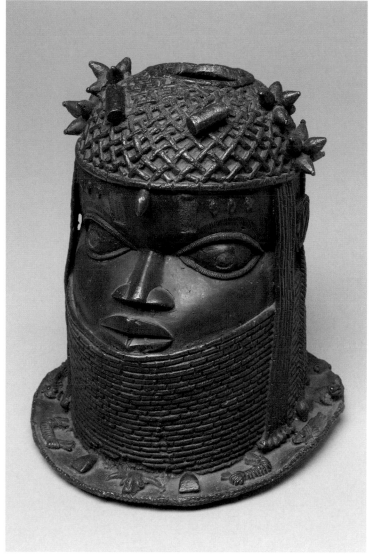

ification (fig. 10.17). In addition to the helmet, the king wears a beaded collar and a wrapper embroidered with designs of a cross, a moon, a ceremonial sword (*eben*), and the head of a Portuguese, all emblems referring to the legitimacy of the monarchy, which the Oba regained only after making concessions to those who had forced him out of office. At the base of the altarpiece, two decapitated figures represent the human sacrifices Oba Ewuakpe made in the early part of his reign, exercising his prerogative as a divine monarch.

Benin kings were associated with powerful animals, such as leopards, another of their alter egos. Special guilds presided over the capture, taming, and sacrifice of leopards. In an engraving published by Dapper in 1668, pairs of leopards on leashes precede the king, who wears a leopard skin garment and is on horseback, during a pageant. Leopard-shaped aquamaniles, introduced during the fifteenth century by Oba Ewuare the Great (r. 1440–73), continue to be used today in royal hand-washing ceremonies (fig. 10.18). A hinged lid on the head allowed the vessel to be filled with liquid.

Elephants were also associated with royalty, and whenever an elephant was killed, one tusk was automatically the property of the Oba who also had first bid on the second tusk. Van Nyendal commented on the ivory he saw on display in royal shrines, describing one altar furnished with seven elephant tusks, and another with eleven, all mounted on cast metal pedestals in the form of crowned heads. This practice started in the fifteenth century when portrait heads made of cast brass were placed on altars to honor royal ancestors and legitimize the living ruler. Tusks, carved with low relief imagery, projected from the circular hole at the top, as in the seventeenth or eighteenth century commemorative head shown here (fig. 10.19).

The Oba's cap is depicted as made of coral netting with coral bundles attached on the top, and strands of beads dangling to the side and back. As in Renaissance Europe, where coral was thought to avert the evil eye, in Benin, it was believed to have powerful medicinal and magical properties. Coral regalia, including necklaces, bracelets and anklets, collars, mesh tunics, and whisk- and knife-handle covers, were the exclusive prerogative of kings and high-ranking dignitaries (see fig. 16.18). While red agate and jasper beads were in use before the Portuguese introduced Mediterranean coral in the late fifteenth century, the influx of coral beads thereafter enabled each Oba to create new and more elaborate regalia that enhanced his status. Loss of power meant losing the right to wear such regalia, as in the case of Oba Ewuakpe.

Fig. 10.18. Aquamanile, Benin Kingdom, 18th century. Bronze; 17 x 26 in. (43.2 x 66 cm). Minneapolis Institute of Art (58.9).

Fig. 10.19. Commemorative head of an Oba, Benin Kingdom, 17th–18th century. Brass; 9⅞ x 8¼ x 9½ in. (25 x 21 x 24 cm). Museum für Völkerkunde, Vienna (MVK VO 98160).

Fig. 10.20. Cloth,
Kongo, 17th century.
Raffia pile; 18⅞ x
22⁷⁄₁₆ in. (48 x 57 cm).
Etnografisk Samling,
Nationalmuseet,
Copenhagen (Dc108).

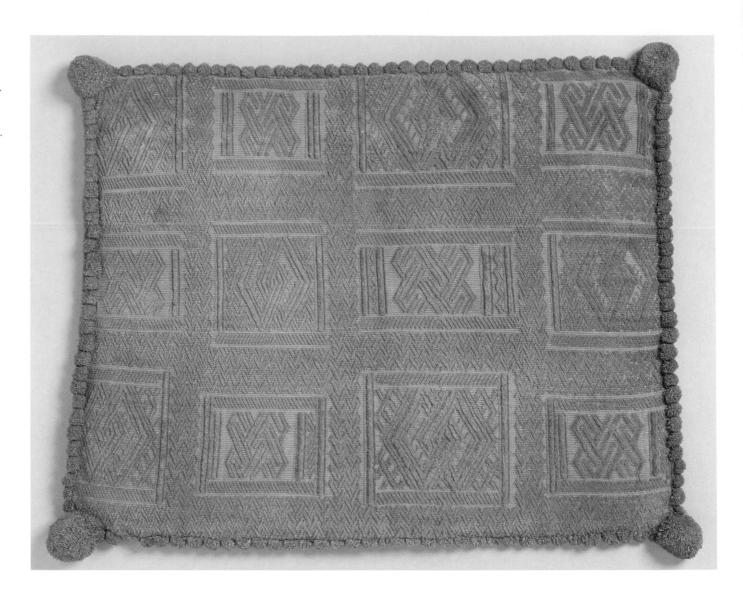

CENTRAL AFRICA

During the seventeenth century, plush velvet-like cloth made from raffia palm fiber was the most important currency in much of Central Africa (fig. 10.20). The most basic cloths were made from *Raffia vinifera*, or *ntombe*. Finer cloth was made from the leaf fibers of the fan palm, *Hyphaene guineensis,* or *nteva*. Men and boys tended the trees, cut the leaves, extracted and prepared the fibers, and wove the cloth on upright looms. Used as currency, a square approximately 14 inches (about 36 cm) of plain weave raffia cloth was called *mbongo* or *libongo*. While several such squares could be woven in a day, more than two weeks were required to complete the finest royal cloths dyed with *takula* (redwood), charcoal, and chalk. Portuguese soldiers stationed inland were paid in *mbongo*, which they exchanged for food and supplies.

Statistics for early seventeenth-century Luanda (now the capital of Angola), where many of the eastern Kongo textiles were traded, suggest that hundreds of thousands of meters of cloth were sold annually, placing Kongo among the major textile-producing and trading centers of the world. According to trade accounts from 1611, two or three ships were sent annually from Luanda to Loango, which was Dutch-controlled, in the Kongo to obtain raffia palm cloth. Visitors to Loango described in 1612 how palm trees grew wild but were also cultivated. They were planted around the royal court of the Loango king, where the houses were filled with ivory, copper, and raffia cloth, and where royal weavers produced special cloth that could be worn only with permission from the ruler.

In 1624, the Portuguese governor in Luanda tried unsuccessfully to persuade the king of Loango to stop trading with the Dutch. In 1641, the Dutch West India Company extended its control along the coast, expanding its slave trade, by conquering the fort that the Portuguese had built at Luanda. When the Dutch assumed control of Luanda, they recognized the complexities of the existing trade network. Raffia palm cloth and cowry shells, both in widespread use as currency, were essential to the slave trade into the interior. By 1648, the Portuguese had retaken Luanda, and by 1665 they controlled the Kongo Kingdom, and the Dutch turned their attention to ports on the Indian Ocean.

While in Loango, the Dutch gradually replaced raffia cloth with cotton cloth from Europe and India. By the mid-seventeenth century, while the king of Loango and his administrators continued to wear leopard fur, copper jewelry, woven hats, and other locally produced emblems of power,

they also used fine imported trade cloth wrapped around the waist, rather than traditional raffia cloth. The more voluminous the cloth's folds, the greater the wearer's wealth.

As in Benin where coral-beaded caps were worn exclusively by the king, headwear conveyed political status on the Loango coast, in the Kingdom of the Kongo and region of the Congo River estuary. A royal hat called *mpu*, made from raffia fiber and decorated with leopard claws, was given to the Society of Antiquaries of Scotland in 1796 (fig. 10.21). It is finely crafted with complex geometric patterning, suggesting that there were specialists in the making of elite headwear.

The caps were generally constructed from a single strand of raffia, starting with a small central ring as a foundation. The cap was created by passing the end of the strand over a portion of the preceding row. The stitchery varied from cap to cap, and often in the same cap, including overhand knots and complex knotless loops. The mazes of interlocking geometric patterns constitute a form of royal insignia, and recall the patterns on woodcarvings and used in scarification. Such caps continued to be worn by the political elite of various Kongo peoples, including the Yombe, Vili, Sundi, Solongo, Nzadi, and Mboma, into the early twentieth century.

The geometric patterns of Kongo royal hats echoed the alternating light and dark geometric patterns seen in surviving baskets from this region, such as a lidded oval basket with a mazelike pattern on its lid (fig. 10.22). Baskets were used as containers and as units of measure, but even at this early date Africans and European collectors valued them for their unique and complex designs. A historical relationship between the coastal Kongo Kingdom and the Kuba city-states further inland is suggested by the interlocking geometric patterns that dominate both Kongo and Kuba decorative arts production and that is clearly visible in this Kongo basket.

Kuba oral histories of the founding of the kingdom between 1568 and 1630 cite a strong political structure that allowed the Kuba elite to become the patrons of metalsmiths, weavers, embroiderers, and woodcarvers. A wood sculpture of the Kuba King Mishe miShyaang maMbul (r. c. 1760–80) includes on the base patterning similar to that in the cap (fig. 10.23), as does much Kuba woodcarving from that time forward. At the time this figure was collected, King Kot áPe (r. 1902–16) told the ethnographer Emil Torday, who collected other such figures for the British Museum, that these sculptures, known as *ndop*, were made to ensure the remembrance of kings. They were placed in the women's quarters so that during childbirth the figure could look over the proceedings to assure a safe delivery.

As in West Africa, kingship in Central Africa was closely linked to iron working. The smith status, like that of king, was hereditary. Smiths and hunters feature prominently in many accounts of the origin of African states, and in some Central Africa oral histories the first kings are identified as blacksmiths. Among the Kuba, miniature anvils were sewn into chiefs' caps, a reminder of the importance of iron in the founding of the kingdom. Farther northeast, among the Mangbetu, a new double iron bell continues to be made for each leader, to be used in installation ceremonies. Throughout Central Africa, iron was used for tools, marriage payments, and currency. It was an important insignia of royalty, crucial in investiture ceremonies for rulers.

Just as Islam had a profound impact on the decorative arts of parts of East and West Africa, in Central Africa, particularly among the Kongo, Christianity was influential in this period. Many aspects of Kongo religious belief fused with Christianity, and many people followed both practices simultaneously. The Christian cross, for example, an emblem of power and spiritual authority, was integrated into Kongo ancestral cults and burial rituals, and believed to contain magical protective properties. Like much other Congolese sculpture, if properly honored, it could offer protection and guidance in human affairs. Similarly, among the southern Yoruba and Fon in West Africa, where Christian influence

Fig. 10.21. Royal hat (*mpu*), Kongo, arrived in Europe before 1751–1800. Raffia, leopard claws; H. 10¹⁄₁₆ in. (25.5 cm). National Museum of Scotland, Edinburgh (A. 1956.1153).

Fig. 10.22. Basket, Kongo, arrived in Europe 1651–1700. Fiber; L. 11³⁄₈ in. (29 cm). Linden-Museum Stuttgart (19.446).

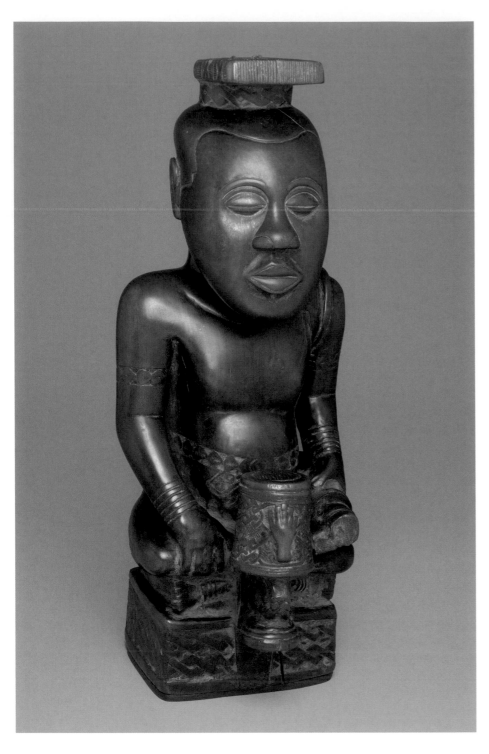

Fig. 10.23. Memorial portrait (*ndop*) of King Mishe miShyaang maMbul, Kuba-Bushoong, 1760–80. Wood, camwood powder; 19½ x 7⅝ x 8⅝ in. (49.5 x 19.4 x 22 cm). Brooklyn Museum (61.33).

certain East African coastal cities repeatedly changed hands as the Portuguese fought for control with the Dutch, with powerful Arabs from Oman, and with local Swahili merchants.

The surviving buildings found in the many urban settlements along the Swahili coast of East Africa, particularly on Lamu Island (now designated as a UNESCO World Heritage Site), bear fixed holes attesting to wall hangings that once adorned interior walls, while carved coral discs with intricate interlaced patterns were inset into mosque walls. Descriptions from the period mention sultans' thrones made of ebony and inlaid with silver, similar to Swahili chairs of the present day.

A former trading hub for gold, spice, ivory, and slaves, the city of Lamu was a thriving port. Its population, predominantly Muslim since the thirteenth century, consisted of a mercantile aristocracy known as *waungwana* and a much larger once-enslaved majority known as *watumwa*. This composite population and culture has become known as Swahili, literally "people of the coast," a mixture of African, Arab, Persian, and even Indian cultural influences.

While few objects survive from the seventeenth century, Lamu's elite arts included poetry, architecture, architectural decoration, furniture, woodcarving, and metalwork. Its popular arts included dancing, music, and song, unglazed pottery, mat weaving, and boat making. Since the fourteenth century, the patrician elders of Lamu and other Swahili cities have lived in stately houses called *jumba*, built of stone, skillfully ornamented with lime plaster and coral decoration.

The construction of a Swahili *jumba* was the result of the combined efforts of many generations. Their ornamentation was an indicator of the living generation's physical and social well-being as well as a sign of the family's prosperity, noble past, and religious purity. While Swahili mosques were a male domain, the *jumba* was within a woman's purview. Within Lamu's patrician families, a father began to accumulate building materials when a daughter was born, because when a woman first married, her father would provide her with a stone house. This house was constructed either as an addition to her family's house or as a separate dwelling. Elevated bridges connected nearby relatives' homes to create a strong, vibrant community, based on a continuity of lineages.

Ceilings constructed with poles made of mangrove wood supported flat, cement-covered roofs. A porch entrance, called *daka*, faced the street. Inside the porch, to the side, the plan allowed for a majestic double wooden door with an elaborately carved frame, a signature element of Swahili architecture. The wide door opened to a courtyard flanked by staircases. Parallel rows of long, narrow, rectangular rooms, *msana*, oriented east/west, perpendicular to the exterior walls, filled the building's interior, with the front and lower rooms being more public. Doorways faced north toward Mecca. Moving from the courtyard to the interior, each *msana* rose one step higher than the preceding one. Women and their children lived on the airy upper levels. A sacred space, deep within, was the highest, coolest, and most private room. It was where women gave birth, tended the dead, and mourned. It contained family tombs. Domestic furnishings, often painted black and vermillion, included beds with hanging curtains, rugs, matching pairs of chairs, carved chests, and stools.

also was significant, parallels were drawn between African deities and Christian saints. In this period, at the height of the slave trade, Africans from both West and Central Africa carried these fused belief systems with them to the Americas.

EASTERN AND SOUTHERN AFRICA

Seventeenth-century East Africa also was characterized by a rapid succession of radical shifts in political alliances. A long-standing Indian Ocean trade linked East African coastal cities to ports across the Red Sea, the Mediterranean, and the Indian Ocean. Trade was stimulated and stabilized by the common religion and culture of Islam. The Portuguese challenged this at the end of the fifteenth century, and thereafter

226 CHAPTER 10 AFRICA

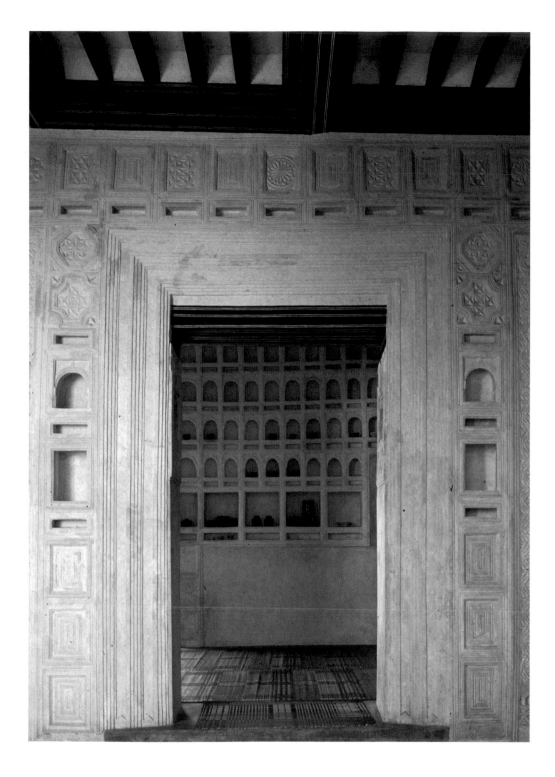

House walls were made of rough pieces of fossilized coral, limestone, and seashells cemented together with crushed limestone and coated with white plaster. The technique of chip-carved plasterwork was used throughout the Indian Ocean region. The plaster consists of lime slaked from beach coral mixed with grass and a retarding agent; over this base coat, a glossy cream-colored skim coat forms the final layer which is carved and chipped into decorative patterns. These include floral motifs resembling the decorative borders of Korans, geometric patterns, and stylized leaves, as well as chain, zigzag, and fluted forms. Patterns are organized within a modular grid. Subtle variations in repeat motifs show that the work was hand-carved in situ, without using a mold. Swahili ornamental plasterwork achieved the height of its artistic expression during the mid-eighteenth century.

The plasterwork became progressively more densely and elaborately decorated the farther into the house one moved. The porch's veranda was framed by plasterwork on the frieze at the top and along the side pilasters. Carved storage niches, *zidaka*, with "chip-carved" decorative patterns were set within interior walls and doorway frames (fig. 10.24). Further into the house, niches increased in frequency. The last wall in the inner gallery was almost entirely covered with elaborately carved niches, with arched and rectangular openings of varied proportions. Imported porcelain bowls and glazed ceramic plates and vases were displayed in the niches.

Stone houses have survived into the twenty-first century on the islands of Lamu and Pate off the coast of Kenya, and Swahili-style doors and furnishings continue to be made, but the only surviving objects from the 1600–1750 period are some

Fig. 10.24. Swahili house interior with storage niches (*zidaka*), Lamu Island, 18th century. Coral masonry, plaster.

carved coral disks with intricate patterns and a counterweight that was part of a *siwa* (a long, tusk-shaped, side-blown trumpet; fig. 10.25). The counterweight was a heavy, ornate finial that would have been hinged to the cylinder of a *siwa* to balance it when the horn was slung over the shoulder of the trumpeter. Its carved, perforated decoration hints at the luxurious detailing of Swahili plasterwork interiors. The inclusion of Islamic motifs in the intricate geometric design suggests the mixing of Arab and African design and craft traditions in this period.

Like African side-blown trumpets from the interior, *siwa* served as symbols of leadership and were brought out for weddings, enthronements, and other special occasions. Two celebrated examples from this period indicate a variety of techniques and materials used in their manufacture in East Africa (which sets them apart from similar horns made elsewhere). One, from Lamu Island (now in the Lamu Museum) is made of brass, cast using the lost-wax method. Measuring about 42 inches (108 m) long, it consists of a long perforated cylinder decorated with a corrupted rendering of Mamluk script, and dates from about 1720, a period when Lamu was an Omani protectorate. The 1696 *siwa* of Pate Island is even longer than the Lamu example and is made of several hinged ivory tusks, decorated with intricate carvings that resemble the decoration on stone buildings along the East African coast. (It is now in the Nairobi Museum.) East African *siwa* were also made of wood.

ETHIOPIA

Between the fourteenth and sixteenth centuries, the Muslim Adal dynasty in what is today northern Ethiopia and Somalia entered into many battles with the Christian Solomonic dynasty. The Adal were allied with the Ottomans, whereas the Ethiopians, also known as Abyssinians, claimed the Portu-

guese as allies. In these battles, which were followed by even more destructive invasions by the Oromo people from the south, Christian paintings, manuscripts, and other treasures were destroyed, although monks were able to save some by hiding them in the inaccessible churches and monastaries.

In the seventeenth century, Gondar became the capital of the Solomonic rulers, many of whom, especially Emperor Fasiladas (r. 1632–67) along with a growing class of aristocrats, were patrons of the arts. They supported architects who built them large palaces and monks who created wall paintings, icons, manuscripts, amulets, and magic and divinatory scrolls for both public and private use. The painted prayerbook *Arganona Weddase* (The Harp of Praise) by a scribe named Baselyos focuses on the Virgin Mary and its 148 pages are arranged according to the days of the week (fig. 10.26). The colors, geometric borders, and images of the Virgin and saints are typical of this period in Ethiopian art and design.

SOUTHERN AFRICA

There are few securely dated examples of decorative arts objects from Southern Africa in this period. Europeans had settled there from the late 1600s—first the Dutch, then Germans, French Huguenots, and eventually British, but most of them were farmers and not interested in collecting luxury items or preserving items of local material culture. A variety of African cultures and peoples coexisted in Southern Africa, including the hunting and gathering Khoisan peoples, and groups of Bantu-speakers who had arrived from farther north in successive waves (known as the Bantu migration) a millennium earlier. By around 1550 Great Zimbabwe (see figs. 4.18, 4.19) had declined, either because its population had grown too large and dispersed, or because of changes in trading patterns. A series of successive states emerged, and archaeologi-

cal excavations have uncovered trade goods from China, and remains of red and black burnished (unglazed) pottery of a type that continued to be made from the sixteenth century to the present.

Many of the surviving African objects from the seventeenth and first half of the eighteenth century once graced the palaces and homes of European princes and aristocrats. Most of these came from areas along the West and Central African coasts where contact with European traders was most frequent. It is these objects that have given us a rich, yet very fragmentary picture of the decorative arts in this period. At the same time, contact between North Africa, especially the area west of Egypt known as the Maghreb, and Sub-Saharan Africa was also frequent, and in terms of decorative arts, these North African cultures, especially the Islamic world, offer many insights into understanding the objects found in other parts of the continent. (For a discussion of North Africa during this period, see chap. 9.) Islamic teachings, objects, and craft practices recognized no geographic boundaries. In all of these vastly diverse regions, objects of the decorative arts, combined with oral traditions, archaeological discoveries, and evidence of cultural continuity in some places, provide a suggestive glimpse of the variety and splendor of African decorative arts between 1600 and 1750.

ENID SCHILDKROUT AND CAROL THOMPSON

Fig. 10.26. Baselyos. Prayer book: *Arganona Weddase* (The Harp of Praise), Lasta region, Ethiopia, late 17th century. Hide, pigment, wood, fiber; 6½ x 6⅛ in. (16.5 x 15.5 cm). The Metropolitan Museum of Art (2006.99).

EUROPE

Fig. 11.38

In many areas of Europe, the period from 1600 to 1750 was an age of grandeur, marked by expansive claims to status and authority expressed through equally exuberant languages of ornament and decoration. Sacred spaces, like St. Peter's Basilica in Rome, offered a symphony for the senses in which colorful hardstone-encrusted walls, gilded altar furnishings, and glittering mosaics vied with marble statues and painted altarpieces to inspire worshipers and reaffirm their Catholic faith. Protestant churches employed their own visual rhetoric in furnishings like the monumental wooden pulpit in Amsterdam's Nieuwe Kerk, carved with stagelike biblical scenes that illustrated and intensified the preacher's call to Christian virtues. Royal palaces were no less grandiose: at Versailles, outside Paris, Louis XIV used solid silver furnishings and elaborate formal gardens to announce his glory as the Sun King, while in Russia, Emperor Peter the Great adopted contemporary Western European modes of dress and decoration as signs of modernization. Across the continent, aristocratic dwellings proclaimed their occupants' status through displays of tapestries and precious metals, while homes of members of emergent commercial classes were increasingly well furnished with objects embodying bourgeois values of privacy, domesticity, and comfort. What linked these disparate phenomena was a heightened impulse to deploy all the arts, in Cicero's formulation, "to teach, to delight, and to move"—in short, to persuade.

What shapes did persuasion take in seventeenth- and early eighteenth-century Europe, and how did these affect design? Among the first to confront these questions was the Swiss scholar Heinrich Wölfflin (1864–1945), whose influential *Principles of Art History* (1915) systematically distinguished the stable, linear, and "classic" forms of the Renaissance from the newly dynamic, painterly, and "baroque" style that emerged around 1600. Rehabilitating the pejorative term "baroque," originally derived from irregular pearls or convoluted syllogisms, Wölfflin presented the Baroque not as a decline from earlier standards but as a coherent form of modernity with its own rules and logic—an insight since extended to "Baroque" literature, music, philosophy, and science.

Wölfflin's insistence that style encompassed the entirety of a period's aesthetic vision and imagination also underscored the links between the "fine" arts and a wide range of objects such as furniture, metalwork, ceramics, and textiles, themselves often designed by prominent architects, sculptors, and painters. It was in fact a conscious search for integrated, harmonious, and persuasive ensembles—what the

seventeenth-century art critic Filippo Baldinucci termed the *bel composto* (beautiful assemblage)—that helped blur the boundaries between Baroque art, design, and craft and among discrete craft specialties.

But whereas Wölfflin saw the Baroque as extending until the rise of Neoclassicism, today most scholars detect a break after 1700, as courtly formality and complex metaphysics gave way to more relaxed, "natural" modes in both art and life. Generally designated "Rococo"—a term derived from pebble work, which also began as a slur—this new aesthetic spawned a distinctive ornamental vocabulary of shells, "raffle" (serrated) leaves, and sinuous C- and S-scrolls. The Rococo spread outward from France and survived in Europe, alongside modes derived from Chinese, ancient Roman, Greek, Etruscan, "Turkish," and other sources, into the 1780s.

Europe's changing aesthetics were matched by profound economic and geopolitical shifts. As statesmen in Spain, France, and England centralized government bureaucracies, merchants and speculators in the Dutch Republic developed modern financial institutions, including a stock exchange. Europe's overseas traders and colonial agents laid the foundations for global empires, while its scientists and philosophers established the principles of rational inquiry and empirical observation that characterized the Enlightenment. These developments directly affected the design, production, and consumption of material goods. Whereas in 1600 most ambitious commissions were contracted within established frameworks of elite patronage and social hierarchies, by 1750 the rapid increase in small-batch, serial, and large-scale production, both by hand and by machine, generated a wide range of goods for an expanding middle class without inherited wealth or position.

The period also saw increasing movement of craftsmen, entrepreneurs, artists, and architects, as well as the rise of professional designers separate from craftworkers. An explosion in printed designs and pattern books accelerated fashion cycles, while a flood of imports from outside Europe—as well as local imitations—responded to consumer desire for the exotic. Throughout it all, material objects remained embedded in social rituals, sometimes reinforcing ideas expressed in other media, and sometimes offering messages of their own. A broad history of Baroque and Rococo design not only reveals neglected sides of well-known artists but also illuminates the legion of innovative but often anonymous craftspeople who reshaped Europe's visual and material culture to meet changing social, aesthetic, and economic needs.

ITALY

Despite a growing sense of Italian identity, seventeenth- and eighteenth-century Italy remained a mosaic of independent republics (Genoa, Lucca, Venice, among others), duchies (including Savoy, Milan, Mantua, Modena, Parma, and Tuscany), kingdoms (Naples, Sicily, and Sardinia), and the sprawling Papal States, a diverse and unwieldy entity governed by the pontifical court in Rome. Although Rome's population was modest—about 100,000 in 1600, just a third that of Naples—the popes' resurgent and increasingly cosmopolitan capital boasted an outsized artistic influence and supported a flourishing luxury trade. The elective papal system ensured regular infusions of new patrons and ideas, as each cultured and increasingly princely pontiff arrived in Rome with relatives, scholars, architects, artists, and designers in tow.

Fig. 11.1. Design attributed to Gian Lorenzo Bernini. Chasuble with the arms of Urban VIII, Rome, 1625–27. Silk damask, gold thread. Museo Storico, Basilica Papale di Santa Maria Maggiore, Rome.

Among the most ambitious papal families was the Tuscan clan of Barberini, who swarmed Rome like their heraldic horseflies—soon upgraded to bees—after the election of Cardinal Maffeo Barberini (1568–1644) as Pope Urban VIII in 1623. Urban's expansive vision of papal magnificence accorded with the conclusions of the Council of Trent (1545–63), an ecumenical conference that, rejecting Protestant challenges, upheld traditional Catholic teachings about saints, the celibate priesthood, pontifical primacy, and the utility of sacred splendor. The ecclesiastical hierarchy responded by reinvesting in church furnishings—from gilt-metal gates and marble wall revetments (ornamental cladding, often in elaborate patterns) to altar equipment consisting of candelabra, crucifixes, monstrances, reliquaries, mass cards, chalices, patens, censers, situlae (holy-water pails), and aspergilla (sprinklers)—to help focus public attention on the Church's sacred rites and communicate its religious doctrines.

One of the finest survivals of seventeenth-century Roman liturgical design is a set of vestments (including a chasuble, or sleeveless cloak, dalmatic, tunicle, stole, maniple, and altar frontal), likely designed by Gian Lorenzo Bernini (1598–1680), employing a custom-woven damask of red silk and gold thread overlaid with multicolored embroidery. Bearing Pope Urban VIII's coat of arms, these vestments were likely commissioned for his use in the small church of the Early Christian martyr Saint Bibiana after the saint's relics, miraculously emitting "a great fragrance and very strong scent," were rediscovered within the ancient high altar in 1624.[1] An accomplished poet, Urban composed a hymn for Bibiana's feast day and charged Bernini (whom he dubbed his "Michelangelo") to rebuild and refurnish the church for the Jubilee, or Holy Year, of 1625.

The chasuble displayed the Barberini arms in embroidery, along with the papal tiara or triple crown (denoting imperial, regal, and priestly authorities), and crossed keys signaling the papal power to open or shut the gates of heaven (fig. 11.1). Woven in the damask itself—crimson to mark the liturgical season and symbolize Bibiana's blood—three bees alternate with leaves of a laurel tree. This motif derives from a Barberini *impresa* (emblem) with the motto "hic domus" (here a home), commemorating the family's move to Rome and Urban's attraction, as a poet, to Apollo's sacred tree. Although heraldry had long featured in courtly commissions, apian references permeated Bernini's design: the cloth's geometric golden weave evoked a honeycomb shimmering under beeswax tapers, while the orphrey (the central panel) was embroidered with dozens of bees climbing toward the pontiff's beehive-shaped tiara. Just as bees are lured to the hive by the scent of nectar and honey, the Barberini were supposedly drawn to Rome by the example of a saintly virgin who died "in the odor of sanctity" twelve centuries before.[2]

Urban's symbol-laden vestments illustrate how Baroque patrons and designers embraced expressive metaphors or *concetti* (conceits) to convey deeper meanings. At the church of S. Maria del Popolo, for instance, Bernini situated the pipes of an organ renovated during the papacy of Alexander VII (r. 1655–67) beneath the branches of an oak tree miraculously

growing through the transept wall so that they appeared to form the trunks of a grove of trees. Here the design not only wittily played on form but evoked another legendary tree once on the site of the high altar. The tree, a walnut thought to be haunted in antiquity by the ghost of Nero, persecutor of Christians, had been cut down by S. Maria del Popolo's founder Pope Paschal II (r. 1099–1118) but now miraculously regrew as a life- (and music-) giving oak inspired by Alexander's coat of arms.

One of Bernini's cleverest *concetti* honored Queen Christina of Sweden, who abdicated her throne and came to Rome in 1655 after converting to Catholicism. Rethinking a familiar *memento mori* (literally, "reminder of death"), Bernini designed a colossal mirror in which Father Time pulls back a cloth to reveal eternal Truth, personified by the reflected image of the queen (fig. 11.2). In typical fashion, Bernini first laid out the concept in bold strokes, later adding additional ribbons and tassels to conjoin the separate panes. The final design was then modeled by assistants in clay or plaster as a guide for a team of specialist carpenters, carvers, gilders, and glaziers.

An extraordinary bed created for Princess Maria Mancini Colonna (1639–1715) on the birth of her firstborn son and heir in 1663 suggests how sophisticated visual metaphor supported social performance (fig. 11.3). Like many noble families, the Colonna maintained its wealth and influence through strategic marriages. The princess was the niece of Cardinal Jules Mazarin, as well as the former mistress of Louis XIV of France. She married Lorenzo-Onofrio Colonna, Grand Constable of Naples, great-great-grandnephew of Pope Martin V and later viceroy of Aragon. The bride's familiarity with French royal traditions may have inspired the construction of this elabo-

rate *zampanaro* (state bed) of carved, gilded, and painted wood for use during congratulatory visits from the College of Cardinals and fellow aristocrats. Its form, however, was novel. In a mythological conceit, the princess would be presented emerging from her confinement like Venus rising on a half-open oyster shell pulled over the waves by hippocampi (legendary half-horses of the sea), guided by sirens, dolphins, a lizard, and sea turtle. Her child, evidently, is the pearl.

The *concetto* came from the court designer Johann Paul Schor (1615–1674), who hailed from the Tyrol and designed coaches, chairs, and silverware as well as coordinating operas in the palace theater. Recalling her moment of glory, Maria noted that the bed's "novelty and magnificence filled everyone with admiration . . . the whole thing was admirably sculptured and the brilliance of the gold had so perfectly disguised the material underneath that it seemed to be made of that precious metal."[3] Reinforcing the importance of the majestic purple canopy, certainly the *composto's* costliest element, she added that "ten or twelve small cupids served as hooks for

Fig. 11.2. Gian Lorenzo Bernini. Design for a looking glass for Christina, Queen of Sweden, c. 1656. Pen and brown wash over chalk; 9 x 7⅜ in. (23 x 18.8 cm). Royal Collection, London (905586).

Fig. 11.3. Pietro Santi Bartoli after Johann Paul Schor. State bed for Maria Mancini Colonna, 1663. Etching; 29¼ x 20¹¹⁄₁₆ in. (74.3 x 52.6 cm). Gabinetto Nazionale dei disegni e delle stampe, Istituto Nazionale per la Grafica, Rome (F.C. 52512).

est in aesthetic currents from Northern Europe. Both trends are visible in the work of Turin's Pietro Piffetti (1700–c. 1777) who, as cabinetmaker to the kings of Sardinia from 1731, supplied a wide range of items including case furniture, secretaries, tables, altar frontals (*paliotti*, also called antependia), walking sticks, spinning wheels, and even spittoons. Piffetti owed his promotion to Filippo Juvarra (1678–1736), the Sicilian architect with whom he created lavish interiors for the House of Savoy; in 1738 the visiting English poet Thomas Gray described the palace of Sardinian King Vittorio Amedeo II as "the very quintessence of gilding and looking-glass; inlaid floors, carved pannels, and painting, wherever they could stick a brush."[5]

Piffetti's designs, materials, and techniques suggest familiarity with French developments, perhaps encountered through the Paris-trained *ébéniste* (cabinetmaker) Pierre Daneau (settled in Italy c. 1725) during a stay in Rome. Besides the use of sculptured metal mounts, these include a preference for bombé shapes, legs with sinuous curves, and fine veneers of imported rosewood, kingwood, purplewood, and palisander inlaid with ebony, tortoiseshell, ivory, or shell (sometimes tinted) engraved with mythological or floral motifs, or in grander, elaborate historical and mythological scenes. Piffetti's whimsical vision is exemplified in a rich casket-on-stand (fig. 11.7), whose dripping contours and opalescent surface, reminiscent of fish scales, epitomize the virtuoso artistry and technical skills with which Italian craftsmen inspired much of Europe.

THE NETHERLANDS

Whereas papal and princely courts led Italy's cultural and artistic developments throughout the seventeenth and eighteenth centuries, in the Netherlands, or "Low Countries," united under the Duchy of Burgundy and claimed in the early sixteenth century by the Spanish Habsburgs, production and patronage were dominated by an expanding commercial market. This was particularly true in the rebellious northern provinces that threw off Spanish rule in 1568, declaring themselves the independent Republic of the Seven United Netherlands and embarking on a radical experiment in nationhood. Although peace was not concluded for another eighty years, migration based on political allegiance, class, and creed soon distinguished the largely Protestant Dutch Republic in the north (present-day Holland) from the ten Flemish and Catholic provinces (roughly today's Belgium and Luxembourg) in the south.

It was in these southern, "Spanish" Netherlands, where princely and ecclesiastical patronage remained important, that the Baroque first took hold. Peter Paul Rubens (1577–1640), who made his career as a painter and designer by blending Flemish realism with Italian grandeur, exemplifies the trend. After converting to Catholicism, Rubens left Antwerp in 1600 for extended study in Mantua, Rome, Genoa, and Spain; after returning in 1608, he put his artistic training into practice at the city's new Jesuit church (begun in 1615), conceiving figural reliefs for its facade, designing the elabo-

Fig. 11.7. Pietro Piffetti. Casket-on-stand, Turin, c. 1745. Mounts by François Ladatte and Giovanni Paolo Venasca. Mother-of-pearl, gilt bronze and copper, king- and spindle wood, poplar, ivory, paint; 56 x 27 x 22½ in. (142.3 x 68.5 x 57 cm). Victoria and Albert Museum, London (W.34-1946).

chained African slaves or "Moors," traditional adversaries of the maritime Republic of Venice, which also featured in Baldassare Longhena's colossal state tomb of Doge Giovanni Pesaro of the 1660s. The vase stand is emblematic of Venetian valor: Hercules subdues Cerberus and the Hydra while supporting the tabletop with his club; river gods reclining on Chinese porcelain urns at the edges of the tabletop stress Venice's international trade, while three Nubians lift a colorful Chinese jar. The rare materials lend a dramatic naturalism—skin carved of ebony, mother-of-pearl eyes, and soil or rocks rendered in striped boxwood—while the prominent inscription, "Pietro Venier ordered it, Andrea Brustolon made it," located on the base, showcases the productive partnership of patron and sculptor in wood.

Sculptural paradigms dominated elite Italian design well into the eighteenth century, tempered by an increasing inter-

rate high altar tabernacle, and supplying thirty-nine illusionistic, Venetian-inspired ceiling canvases. But Rubens's triumph as a designer in a Counter-Reformation mode came in 1635, with festival decorations for the ceremonial entry into Antwerp of Cardinal-Infante Ferdinand of Spain, Catholic victor over the Protestant armies of Sweden and Germany. To mark the Infante's processional route, Rubens conceived an array of arches, statues, stages, backdrops, and platforms combining architecture, sculpture, and painting, wherein every figure and motif personified a kingly virtue or the benefits of peace. Later lavishly engraved and published, Rubens's exuberant but classicizing designs set new standards for diplomatic pageantry throughout Europe.

Rubens was equally influential as a designer of tapestries, still regarded as the most sumptuous and prestigious element of interior decoration. As the grandson of a tapestry merchant, Rubens understood that Flemish workshops, mostly run as independent or family ventures, could only compete with Europe's proliferating and heavily subsidized state and royal manufactories by providing innovative products of the highest quality. His solution was both to push the boundaries of tapestry design and to find new ways to facilitate its translation into wool and silk.

After developing his initial ideas in preliminary drawings, Rubens typically roughed out his composition in oils on small wooden panels (often termed sketches), which he or studio assistants would work up and refine into larger, more detailed models. Once corrected and approved, these master models would be translated by specialized assistants—supervised by Rubens himself—into full-sized templates or "cartoons" (from Italian *cartone*, thick paper), typically drawn in black chalk with gouache or body color and cut into thin strips for use at the loom. Because the weavers worked from the back of the tapestry, the cartoons and most of the preliminary stages were inverted images of the final product. For special commissions like the Triumph of the Eucharist series discussed below (fig. 11.8), Rubens took the unusual step of producing his cartoons in oil on canvas, the better to communicate his subtle painterly and coloristic effects to the weavers.

By mid-century an expanding group of Rubens's pupils, including Jan van den Hoecke (1611–1651), had so enlarged the repertory of available subjects that clients could select and customize suites of the four seasons, the four elements, the twelve months, the times of day, biblical proverbs, famous women, antique heroes, or scenes of country life. Rubens himself concentrated on ambitious historical and narrative cycles that showcased his erudition and appealed to princely patrons. His first such project, commissioned by Genoese merchants in 1616, illustrated the life of the self-sacrificing Roman consul Decius Mus in seven panels. His second cycle, a heroic, twelve-part life of Constantine, Rome's first Christian emperor, was begun in partnership with French weavers in the early 1620s. The subject may have been planned to appeal to the young King Louis XIII, then locked in a power struggle with his mother, Marie de' Medici, for whom Rubens was simultaneously creating a cycle of grandiloquent biographical canvases. In the end, Louis presented the half-completed series to Pope Urban VIII, who had it finished in Rome

at the newly founded Barberini tapestry works directed by Tuscan painter and architect Pietro da Cortona.

Although the majority of tapestries were created for secular settings, Rubens's most magnificent cycle was commissioned in 1625 by Archduchess Isabella Clara Eugenia of Spain, daughter of Philip II and regent of the Spanish Netherlands, for the convent of Royal Discalced (Barefoot) Franciscan nuns, or Poor Clares, in Madrid (fig. 11.8). The tapestries themselves were anything but poor, however, and even without the use of gold or silver thread (an absence likely due to political and economic instability), the cost of weaving their approximately 9,500 square yards (8,000 sq. m) reportedly rose to 100,000 florins, with another 30,000 paid to Rubens for the designs. Meant to celebrate a Dutch surrender at Breda, the twenty large panels represented Spanish victory with a procession of triumphal chariots converging on the convent chapel's high altar.

Rubens's conception of the suite was groundbreaking. Whereas previous tapestry cycles, including Raphael's Acts of the Apostles for the Sistine Chapel (woven in Brussels, 1516–21), had consisted of discrete scenes set off by ornamental borders, Rubens designed a trompe l'oeil double colonnade (with the Doric order below, and spiral or "Solomonic" columns above) onto which "tapestries" appeared to be "draped" by flying putti. When hung as intended, the eleven principal scenes enveloped worshipers in an illusionistic space that made reference to the eleven curtains surrounding the Holy of Holies in Solomon's lost temple at Jerusalem. These could be given a typological interpretation in which figures and episodes from the Old Testament were understood as models thought to prefigure the Eucharist, such as the Israelites' gathering of manna in the desert and Melchizedek's presentation of bread and wine to Abraham. In a similar way, complex allegorical scenes left no doubt about Catholicism's victory over her enemies. In one lower panel, Faith (borne on a chariot and surrounded by the implements of Christ's Passion) leads her "captives" (including personifications of Science, Philosophy, Nature, Poetry, and Heathenism) toward a Christian altar. In a related upper panel, captioned "Hoc est corpus meum" (this is my body, a key text from the Catholic Mass), a sickle-wielding Father Time reveals a voluptuous, eternal Truth while trampling defeated heretics, including Martin Luther and John Calvin. As in Roman liturgical arts, theological principles were reinforced through novelty and wonder. Here, the arresting visual conceit of tapestry-within-tapestry directs viewers' attention to the symbolically charged vignette of a lion (Faith) struggling with a fox (Heresy) beneath the "fabric's" heavy folds.

Rubens's Italo-Flemish style proved equally adapted to the domestic realm. Rubens transformed his own Antwerp home into a classicizing showpiece by adding a studio and garden portico suffused with ornamental motifs inspired by Italian Mannerism, a late Renaissance style characterized by an exploration of architectural fantasy and an elongation of form. The exterior bristled with rusticated quoins, scrolling brackets, and split pediments, with sculptured herms (male and female figures similar to caryatids or telamons, with lower bodies formed as shafts or pedestals) taking the

Fig. 11.8. Peter Paul Rubens. *Modello* for a tapestry: "Victory of Catholic Truth" from the series *Triumph of the Eucharist,* Antwerp, 1625–26. Oil on panel; 33⅞ x 36¼ in. (86 x 92 cm). Museo Nacional del Prado, Madrid (P01697).

place of columns or pilasters. Inside Rubens's studio, coffered ceilings capped rooms furnished with sculptural cabinets and buffets set against stamped and gilded leather hangings or filled, like the domed and top-lit "Pantheon," with ancient sculptures bought from the British collector Sir Dudley Carleton.

Those who could not afford their own domestic museum could acquire a miniature version in the form of elaborate Antwerp cabinets or chests on stands, inspired by Augsburg models, that combined precious materials to brilliant effect (fig. 11.9). Lustrous ebony, acquired through trade from tropical Mauritius and the East Indies, was used for delicate turnings, veneers, and ripple moldings. The scales of Pacific sea turtles were pressed, polished, and backed with red or gold foil. Luminous alabaster was sometimes used for drawer fronts. Mirrors enlivened both exterior and interior compartments, and elaborate bronze or silver caryatids depicted the

elements or the seasons. The grandest examples, like the one illustrated, featured drawer fronts painted with classical myths, Italianate landscapes, or biblical scenes, often copying famous paintings by Flemish masters. Most of these chests were probably not commissioned individually from a master craftsmen, as they might have been in Italy, but produced serially for an international market, using elements supplied by subcontractors. Behind the rich veneers, construction was usually crude and the alloys often substandard. Nonetheless, Antwerp's alluring cabinets offered upwardly mobile clients an instant art collection, with all its cultural cachet.

Antwerp's rising cultural sophistication was nontheless at odds with its political and economic decline in the wake of the Reformation. The city's favorable position near the mouth of the Scheldt River had made it Northwestern Europe's premier port in the early sixteenth century, handling up to 40 percent of world trade (especially East Indian pepper, Ameri-

can silver, and European textiles). Antwerp's banking sector collapsed in 1572 after the outbreak of the Eighty Years' War, while the Dutch blockade of the Scheldt from 1585 (not fully lifted until the early nineteenth century) cut off Antwerp's access to the sea. Yet as the Dutch usurped Antwerp's bulk trade in raw materials, the still cosmopolitan city redoubled its production of smaller, more portable luxury items, including gems, book bindings, harpsichords, and furnishings.

One of Antwerp's distinctive exports was lace, a craft it shared with other Flemish centers including Brussels, Mechlin, and Valenciennes. European lacemaking had arisen in fifteenth-century Italy from cutwork (a technique in which threads were removed from a woven textile, and the remaining ones wrapped or embroidered in buttonhole stitch), although the earliest surviving examples date from a century later. Whereas lace was created using only a needle to loop fine linen thread (sometimes wrapped in gold or silver), bobbin lace employed turned spindles of wood or bone to braid or twist the threads together following a pattern drawn on parchment and pinned to a pillow.

Among the most popular needle laces was the highly textured *point de Venise* (developed in seventeenth-century Venice), featuring scrolling floral patterns with raised elements. Flemish bobbin laces had a smoother surface texture, including the *pottenkant* ("pot" lace) produced in Antwerp and exported throughout Europe and Spanish America. Featuring flower pots outlined in flat thread (the *cordonnet*) on a ground of six-pointed stars, *pottenkant* proved perfectly suited to decorating the long scallops of the falling bands popular in the 1630s. Elite consumers favored lace for ornamental cuffs and collars, as well as cravats (for men) and caps and lappets (for women). Lace was equally prized for liturgical vestments and altar textiles. Everywhere, lace was a sign of wealth and sophistication, requiring intensive laundering and starching to keep clean and shapely. As an industry, lace's combination of high value and portability made it particularly attractive to now-landlocked Antwerp, where it has been estimated that 50 percent of the population was involved in lace making in the seventeenth century.

Seventeenth-century Antwerp was equally famous for jewelry. Bolstered by Jewish refugees from Iberia, the city boasted over one hundred gem-cutting workshops organized into two separate guilds. Cameo engraving also remained an Antwerp specialty, as did elaborate work in precious metals. To satisfy elite diners, Flemish goldsmiths created lavish silver-gilt dishes, ewers, and basins chased with mythological or Old Testament stories, as well as immense banquet platters in such impractically high relief that they were evidently intended for displaying on the sideboard. New or reconceived forms answered the flood of global foodstuffs to Western tables and reflected the tastes of patrons invested in global trading endeavors. Towering saltcellars jostled with containers for exotic spices. Nautilus shells from the South Seas were mounted into drinking vessels. Covered wine jugs might sport mermaid handles, and ceremonial standing cups could take the form of local windmills.

Individual cutlery and flatware, still a relative rarity, were typically supplied by each guest in a carrying case. Among the novelties were traveling sets with folding or removable handles, some doing double duty thanks to a removable spoon bowl that could be fixed with special loops to the tines of the fork (fig. 11.10a–b). The courtly figures carved or cast onto the engraved and/or gilded handles evoked their status-conscious owners: cultured, worldly, and determined to make the right impression.

As the fortunes of the Catholic south declined, the rise of the northern, largely Protestant United Provinces altered the Netherlands' military, commercial, and financial balance. The redirection of Antwerp's maritime trade helped trans-

Fig. 11.9. Cabinet with scenes from the Old Testament, Antwerp, 1680–90. Walnut, ebony, rose- and olive wood veneers, pine, oak, ivory, tortoiseshell, painted marble and gilded copper plaques; 104⅜ x 59¼ x 21⅞ in. (265 x 150.5 x 55.5 cm). Rijksmuseum, Amsterdam (BK-16434).

Vianen, like Rubens, strove to convey an integrated and inseparable whole (what Wölfflin termed Baroque "unity"). His memorial ewer thus transposed his brother's *snakeryen* from decorative edges and borders into a central, controlling metaphor for silver's malleability. Although close inspection reveals a few identifiable details, such as a bear or monkey crouching above the foot and a naked woman whose long hair forms the handle, the vessel itself dissolves into ambiguous liquid eddies evoking shells, waves, and seaweed.

Van Vianen's peers embraced this virtuoso mode. Rembrandt, who owned a plaster copy of the ewer, included an auricular-style dish in his portrait of Johannes Lutma, a German-born goldsmith who published a book of auricular cartouches and designed a monumental brass choir screen with auricular elements for Amsterdam's Nieuwe Kerk. Once unleashed, the fashion spread to bookplates, furniture, picture frames, and architecture, where its organic contortions enlivened the gables of stylish Dutch houses into the 1680s.

While the auricular offered flamboyance and fantasy, most seventeenth-century Dutch objects expressed middle-class Protestant values of solidity, functionality, and self-control. These are the virtues captured in domestic idylls such as Pieter de Hooch's *Linen Cupboard* of 1663, set in an idealized

Fig. 11.10a–b. Master of the Crowned Hammer. Fork and spoon set, Antwerp, 1616–17. Silver; assembled, L. 5½ in (14 cm). Royal Museums of Art and History, Brussels (6296).

form Amsterdam, hitherto a modest North Sea port, into an increasingly important and prosperous entrepôt. The founding of the United East Indian Company (*Vereenigde Oost-Indische Compagnie,* or VOC) by Dutch merchants in 1602 inaugurated a flood of Asian porcelain, tea, and spices into Amsterdam, and by the century's end successful Dutch burghers had achieved a higher standard of living than most merchant classes elsewhere.

A virtuoso silver ewer crafted in 1614 by the Utrecht goldsmith Adam van Vianen (1569–1627, fig. 11.11) attests to the tandem rise of wealth and aesthetic ambition. Echoing the form of a ceremonial pokal, or standing cup (see fig. 5.15), the ewer was commissioned as a showpiece by the Amsterdam silversmiths' guild in memory of Adam's brother Paulus, a goldsmith who had died the previous year at the court of the Holy Roman Emperor Rudolf II in Prague. There, alongside other Dutch and German artists, Paulus had pioneered an ornamental vocabulary now called "auricular" for its earlike forms but known in the seventeenth century and earlier as grotesques (see fig. 5.2) or *snakeryen* (drolleries). Intentionally ambiguous, these visual puzzles challenged viewers to a game of imagination. Adam's son Christiaen emphasized just this point by publishing a selection of his father's designs in 1650 as *Modelli artificiosi . . . et altre Opere capriciozi* (Models of artifice . . . and other works of caprice).

As a conscious show of ingenuity, the auricular followed Mannerist models by Italian artists such as Giulio Romano and Enea Vico and the Flemish architect, sculptor, and printmaker Cornelis Floris III. But whereas sixteenth-century designers generally sought harmony by balancing distinct and recognizable components (a preference Wölfflin identified with the Renaissance taste for "multiplicity"), van

Fig. 11.11. Adam van Vianen. Covered ewer for the Amsterdam silversmiths' guild, Amsterdam, 1614. Silver, later gilded; 9⅞ x 14 x 3½ in. (25 x 14 x 9 cm). Rijksmuseum, Amsterdam (BK-1976-75).

Fig. 11.12. Pieter de Hooch. *The Linen Cupboard*, 1663. Oil on canvas; 27½ x 29¾ in. (70 x 75.5 cm). Rijksmuseum, Amsterdam (SK-C-1191).

interior in which a mistress and her maid store freshly laundered linens in a monumental cupboard, known as a *kast*, with the solemnity of a sacred ritual (fig. 11.12). Realistic as they seem, such views cannot be taken as strictly documentary. Comparison with surviving inventories shows that de Hooch, like other painters, overrepresented picturesque luxuries like marble pavements and mantelpieces, large windows, and brass chandeliers, even while including well-documented interior features such as wood-beamed ceilings, double doors, tightly winding stairs, floors with painted oil-cloths, base moldings of Delft tiles, rush-bottomed chairs with separate pillows, and framed mirrors and paintings, here with an auricular twist. Like the *voorhuis* (front hall) depicted by de Hooch, Dutch rooms often served multiple functions, frequently maximizing square footage with curtained "box beds" set into the paneling, or space-saving draw-leaf tables. Yet aspirational interiors like de Hooch's do capture both the new cultural interest in domesticity and the cleanliness and material abundance of Dutch middle-class

homes. British traveler Peter Mundy noted in 1640 that even "indifferent" Dutch houses contained "costly and curious" paintings, cupboards, cabinets, porcelain, and bird cages, as if the whole nation were united in its striving for "pleasure and home contentment."[6]

Some of these furnishings contained explicit or implied moral messages. Popular early in the century, lavish "sculpture-cupboards" bore carved personifications of the theological virtues of Faith, Hope, and Charity, as well as edifying biblical scenes, similar to those depicted on pulpits. Others, like the cupboard painted in de Hooch's scene, were conceived as buildings or temples complete with pilasters, arches, friezes, and cornices. These architectural elements reflect longstanding craft links between furniture construction and house carpentry. But over the course of the seventeenth century, the traditional practice of joinery, in which solid oak stiles, rails, and fielded panels were attached with mortises and tenons, gave way to the lighter, more elegant technique of cabinetmaking, whereby a hidden carcass con-

structed of finely dovetailed boards was concealed with veneers cut from more costly woods.

Cabinetmaker Herman Doomer (c. 1595–1650), a German émigré from Anrath in the Rhineland, arrived in Amsterdam just as a new community of ebony workers sought to distinguish themselves from traditional *kistenmakers* (makers of cupboards and chests). Doomer's masterpiece, a luxuriously veneered *troonkast,* or "throne cupboard," crafted around 1640, derives its two-story form from earlier German and Flemish buffets, but the projecting, twisted corner columns create a novel sense of expansion echoed in rippling wave moldings on the doors (fig. 11.13). The use of gleaming tropical ebony offset with opalescent inlays suggests the same sort of sumptuous sobriety seen in the contemporary bourgeois taste for black-and-white clothing that was nonetheless of the finest materials and tailoring.

Restraint vanished in the cupboard's lavish interior, where colorful, exotic kingwood, rosewood, pseudo-acacia, ivory, and mirror glass dazzled the eye, and mother-of-pearl insects inlaid over colored foils seemed to flicker to life. These flourishes may have been provided by the inlay specialist Dirck van Rijswijck (1596–after 1679), creator of a celebrated tabletop—lauded by the poet Joost van den Vondel as "the feast-table of the gods"—that became a contemporary tourist attraction in Amsterdam.[7] Rijswijck's fame reflects the prestige Dutch society accorded to fine furnishings; both

Doomer and his wife were painted by Rembrandt, and when their estate was inventoried in 1678, the ebony cabinet (valued at 945 florins) was the most expensive item, worth far more than paintings by such celebrated artists as Pieter Claes, Ferdinand Bol, and Judith Leyster, each assessed at between two and twelve florins.

Questions of value are also implicit in the cabinet's mother-of-pearl tulips. Introduced to the United Provinces from Turkey in the late sixteenth century, tulips became hugely popular and greatly valued, and by 1637, when the tulip market crashed, rare bulbs could command ten times a workman's annual salary. Were the perennial blooms ornamenting Doomer's cabinet intended to celebrate Dutch commerce or to remind users of fleeting fortune? Or were they a paean, like van den Vondel's verses, to the craftsman's talent? Whatever their symbolic intent, tulips embodied Dutch domestication of the exotic, appearing widely in seventeenth-century furniture, metalwork, textiles, and ceramics.

Porcelain, another Eastern import, first arrived in the northern provinces with the capture of a Portuguese cargo ship in 1602 and quickly became a lucrative but economically volatile commodity in the Dutch East India trade. With its beauty and durability, Asian porcelain—especially the underglaze blue-and-white type favored in Western markets (see figs. 1.7a–b, 1.8), including the export wares known as *kraak* from their prevalence in Iberian carracks or merchant vessels—rapidly outshone the utilitarian domestic earthenware or German stoneware hitherto typical of Dutch homes. Importers soon learned to send wooden models, diagrams, and design specifications to Chinese manufacturers to ensure that products better answered domestic tastes. Besides patterns for family heraldry, Dutch vendors even sent their own chinoiserie designs, as Asia itself became an increasingly appealing cultural and aesthetic model in Western eyes.

When political instability in China disrupted supply at mid-century, demand remained such that the East India Company looked to substitute sources in Japan, where kilns in Arita developed bolder "Imari" patterns with underglaze iron-red and gilding, and "Kakiemon" styles using overglaze enamels in a wider range of hues (see fig. 7.29). Both of these modes were added to the Chinese repertory once production resumed at Jingdezhen around 1690.

Not even the millions of imported porcelains could answer domestic demand, however, and Dutch entrepreneurs soon imitated and supplemented them with local products that were also cheaper. Since the secrets of porcelain production were not to be known in the West until 1709 (discussed below), Dutch potters adopted an expedient pioneered in the Middle East and in Spain and perfected in Renaissance Italy. They disguised low-fired earthenware by adding tin oxide to clear lead-based glazes in order to provide an opaque white ground for decoration. Europe's "porcelain craze" led to further refinements in technique, including the blending of clays and the addition of a clear overglaze for added depth and luster.

Versions of European tin-glazed earthenware (called maiolica in Italy and faience in France) were being made in Antwerp by 1512 and Amsterdam by the 1580s. By 1640 the

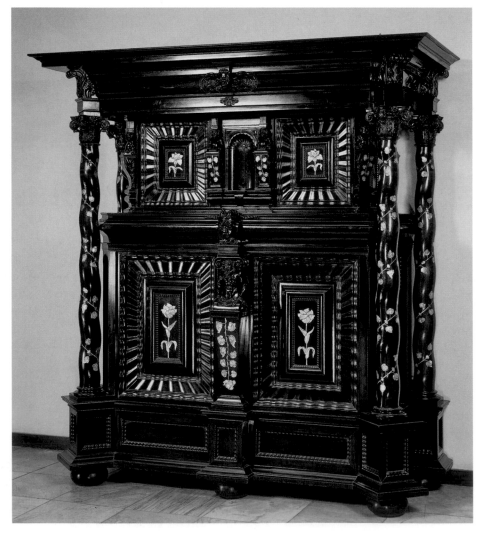

Fig. 11.13. Herman Doomer. *Troonkast,* Amsterdam, c. 1635–45. Oak, ebony veneer, king- and rosewood, pseudo-acacia, mother-of-pearl, ivory; 86¾ x 81⅛ x 32⅞ in. (220.5 x 206 x 83.5 cm). Rijksmuseum, Amsterdam (BK-1975-81).

town of Delft, near Rotterdam, dominated the domestic manufacture of finer blue-and-white ware, with dozens of manufactories producing functional domestic goods ranging from chamber pots to plates and tiles, millions of which are thought to have been made in the seventeenth and eighteenth centuries. Other products were primarily decorative, such as matching *kaststel* sets, ornamental garnitures adapted from Chinese altar vases (see fig. 13.1). Arrayed atop a cabinet (see fig. 11.12), they approximated the look, if not the fineness or durability, of porcelain. Whereas products from the 1620s closely imitated Asian models, later wares included Christian subjects, such as Jesus's Entry into Jerusalem, within "oriental" decorative schemes.

Delftware flower and bulb pots were particularly popular forms evocative of the East. Smaller fan-shaped forms followed Persian examples, while the most sumptuous creations of the "Greek A" manufactory in Delft—tall pyramids of stacking sections intended for cut blooms (fig. 11.14)—may have been inspired by pagodas illustrated in travelogues such as Johan Nieuhof's frequently reprinted *Embassy from the East India Company of the United Provinces, to the Grand Tartar Cham, Emperor of China* (Amsterdam, 1665). Closely associated with the English court of the Dutch stadholder William III and his wife Mary Stuart (r. in England 1689–94) and perhaps conceived by the French-trained designer Daniel Marot (1661–1752), these vases were royal pieces featuring the same iconography of dynasty and abundance—crowns, ciphers, bust portraits, and gamboling putti—as the elaborate Delft-made revetments lining the summer pavilions and orangeries William and Mary added to their new palace at Hampton Court. Made of humble materials yet monumental in impact, these triumphs of Dutch pottery encapsulate the nation's technical and aesthetic achievements as well as its global reach.

FRANCE

If Italy remained Europe's trendsetter throughout the fifteenth and sixteenth centuries, that balance began to shift as France gained influence, confidence, and power during the seventeenth. Two Italian-born queens—the Florentines Catherine de' Medici (1519–89), wife of Henry II, and Maria de' Medici (1575–1642), wife of Henry IV—did much to introduce France to Italian courtly developments and to bring expert foreign craftsmen to France. By 1600 an increasingly cosmopolitan Paris was awash with luxury goods. The most fashionable shops were located at the Palais de Justice on the Île de la Cité, where the young Louis XIII (r. 1610–43) went to buy a toy coach, and in 1640 the printmaker Abraham Bosse (1602–1676) satirized the elegant shoppers searching there for books, gloves, fans, lace trimmings, and "everything human ingenuity has ever invented to seduce the senses through gallantry," as his caption explained.[8] The 1630s and 1640s also saw significant developments in interior design, as the rooms of Parisian aristocratic houses (*hôtels particuliers*) were marked by increasing symmetry, comfort, and color coordination. The so-called *précieuses* (literally, "precious,"

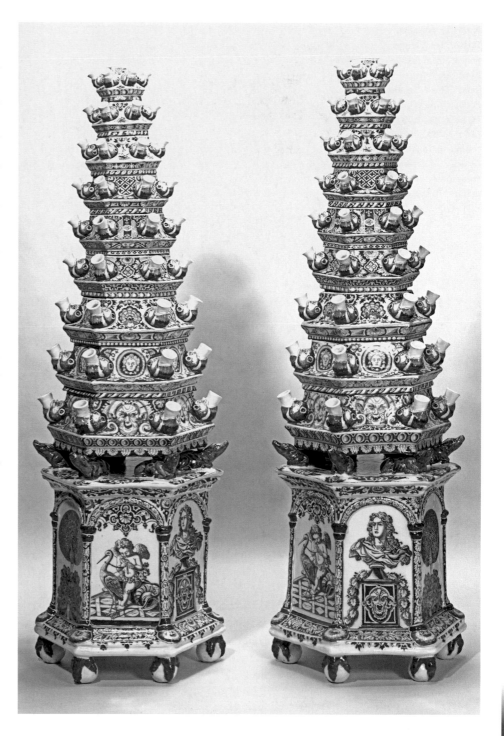

meaning "affected ones") led these trends, including the marquise de Rambouillet, who hosted literary gatherings in her famed *chambre bleue*, attended by guests in matching blue stockings. Bosse commented on such excesses in his parable of the *Wise and Foolish Virgins* (c. 1635, fig. 11.15), in which the latter, in modern dress, waste time playing cards, coordinating the fringes on matching backstools, selecting hair ribbons, and checking their reflections in fashionable, ebony-framed mirrors.

Fig. 11.14. "Greek A" factory of Adriaen Kocks. Tulip vases for Mary II of England, Delft, c. 1694. Tin-glazed earthenware; each, H. 58 in. (147.2 cm). Royal Collection, London (1085.1-.2)

THE COURT OF LOUIS XIV

It was under the absolute monarchy of Louis XIV (r. 1643–1715), the self-styled Sun King who believed he was divinely appointed and inspired, that royal architects, artists, designers, and craftsmen consolidated France's preeminence in the art of elegant living. An aristocratic revolt known as the

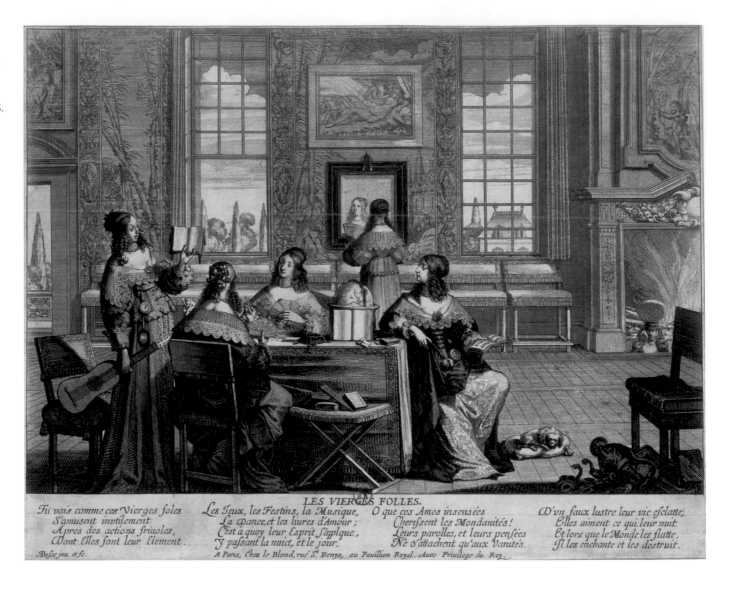

Fig. 11.15. Abraham Bosse. "Les Vierges Folles," from *Les Vierges sages et les Vierges folles* (The Wise and Foolish Virgins), c. 1635. Etching; 10¼ x 13 in. (26 x 33 cm). Bibliothèque nationale de France (Département Estampes et photographie, Reserve FOL-QB-201 [29]).

LES VIERGES FOLLES.

Tu vois comme ces Vierges foles / S'amusent inutilement / Apres des actions friuoles, / Dont Elles font leur Element.

Les Jeux, les Festins, la Musique, / La Dance, et les liures d'Amour; / C'est à quoy leur Esprit s'aplique, / J'pasant la nuict, et le jour.

O que ces Ames insensées / Cherissent les Mondanités! / Leurs parolles, et leurs pensées / Ne s'attachent qu'aux Vanités.

D'vn faux lustre leur vie esclatte; / Elles aiment ce qui leur nuit / Et lors que le Monde les flatte, / Il les enchante et les destruit.

Bosse jnu. et fe. A Paris, Chez le Blond, ruë S.t Denys, au Pauillion Royal. Auec Priuilege du Roy.

Fronde (1647–53) increased Louis's determination to govern without a chief minister and to assert and secure his absolutist authority through a dazzling display of magnificence. His finance minister Jean-Baptiste Colbert, who also served, in concert with the king's "first painter" and artistic advisor Charles Le Brun (1619–1690), as superintendent of royal buildings, arts, tapestries, and manufactures, was in charge of revitalizing crown-sponsored manufactories to provide the court with luxury goods, many conceived in distinctive, classicizing versions of Italian Baroque designs.

One such workshop, established at the Gobelins dyeworks in Paris, produced a series of tapestries chronicling the history of the king by juxtaposing Louis's patronage of luxury arts with his military and diplomatic victories. In one panel designed by Le Brun (fig. 11.16), Louis XIV (in a red-plumed hat) and his ministers inspect the Gobelins workshops, as royal artisans heap products at his feet: massive candlestands, ewers, dishes and braziers in solid silver; figural carpets and history paintings ready for translation into tapestry; table tops in inlaid *pietre dure*; and a gilt-mounted table veneered with tortoiseshell by the cabinetmaker Pierre Gole (discussed below), who stands immediately behind it. To Gole's right, Domenico Cucci (c. 1635–1704/5), a furniture maker from Florence, points to a sumptuous cabinet with lapis lazuli columns in the now-familiar spiral-

ing form (see figs. 11.8 and 11.13). Attracting foreign craftsmen, from Flemish weavers to Venetian glassmakers, and improving the quality of domestic production were central to Colbert's mercantilist theory that prosperity came from conserving capital, restricting imports, and establishing a favorable balance of trade. But there was propaganda value too in French products and designs outdoing those from elsewhere, especially Italy.

By the time the tapestry was completed in 1680, Louis XIV had worked for two decades to transform his father's hunting lodge at Versailles into Europe's most sumptuous palace. In 1682, when Versailles officially became the seat of government, the king unveiled a new suite of state apartments whose grandeur took the art of visual persuasion to new heights. Drawing in part on Italian church decoration, Le Brun and the royal architect Louis Le Vau (1612–1670) wrapped the walls with rich marble and gilt-bronze revetments and designed the ceilings with boldly sculptured compartments painted with histories and mythologies alluding to the king. The top-lit Ambassadors' Staircase led to an enfilade of "planetary" rooms dedicated to Olympian gods and goddesses, including Diana, Mars, Mercury, and Apollo. Inspired by Medici prototypes at the Palazzo Pitti, the suite hosted both state functions and weekly evening entertainments featuring dancing, board games, billiards, and buffet suppers.

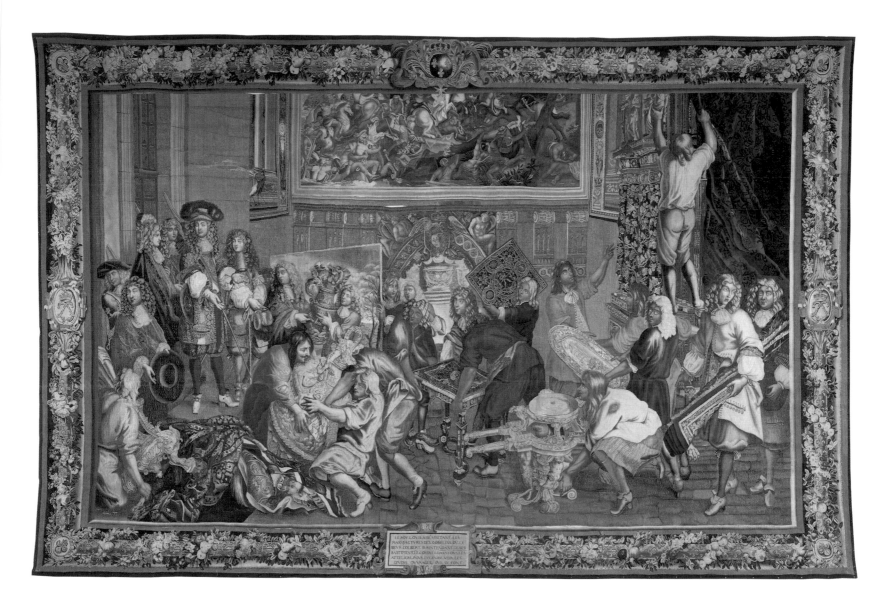

Fig. 11.16. After Charles Le Brun. Tapestry: "Visite de Louis XIV à la Manufacture des Gobelins, le 15 octobre 1667," from the series *L'Histoire du Roi* (1665–79); this example, 1729–34. Woven in the Gobelins workshop of Etienne Le Blond. Wool, silk, gold thread; 12¼ x 19 ft. (3.75 x 5.8 m). Château de Versailles (Vmb14197; GMTT9810; V38412).

The final room in the sequence, the Salon of War (fig. 11.17), served as a literal and symbolic fulcrum. After admiring an immense plaster relief by Antoine Coysevox in which the king tramples his enemies while being crowned by Fame, guests would turn to enter the dazzling Hall of Mirrors. Here, a new Gallic architectural order, incorporating national emblems such as the cock and the fleur-de-lis, stretched for 240 feet (73.2 m) toward the Salon of Peace in the Apartment of the Queen. The gallery's sheer magnificence could not fail to impress visiting dignitaries who, having metaphorically traversed the solar system, found themselves suspended between war and peace, with ample opportunity to reflect upon their choice.

The visual impact of the state rooms was enhanced by an extensive suite of solid silver furniture that embodied the radiance of a solar monarch. In the Salon of War, for example, the walls were ringed with eight solid silver candlestands (torchères), flanked by tall vases, with four additional silver vases on gold and blue stands in the corners. At the room's center, a massive, eight-branched silver chandelier hung over a silver brazier adorned with lion heads (compare similar examples depicted in fig. 11.16). These ponderous furnishings embodied Colbert's belief that the might and greatness of a state were measured by the quantity of silver it possessed, all the more so if it could be prominently displayed. Yet at the same time, Colbert's mercantilist theory discouraged forms of investment that kept specie out of circulation, and by 1689, when an acute shortage of cash sparked by a severe recession and the outbreak of war prompted sumptuary laws forbidding silver or gold chandeliers, tables, and large vases, Louis chose to melt his furniture for bullion, rather than offer it for sale at a potentially higher price. In a court culture where the king's possessions (and even his food) required ritual obeisance, it proved more politic for Louis XIV to liquidate his assets than to allow private purchasers to acquire them.

From the state rooms, visitors could look onto gardens stretching almost to the horizon, a vast and highly artificial landscape upon which the king lavished huge amounts of money and for which he wrote a guidebook. Some scholars link the centralized order of the French formal garden to the analytic rationalism of French philosopher René Descartes, or relate the technology involved in such a massive operation (including extensive earth moving, terracing, and the channeling of water) to warfare, seeing Versailles's carefully bounded terrain as a microcosm of the French "territorial state." Others connect the illusion of endless expanse with evolving mathematical conceptions of the infinite. All concur that French garden designers expanded Italian princely prototypes to a scale befitting absolute monarchy, thereby transforming the Renaissance knot garden, with its framed

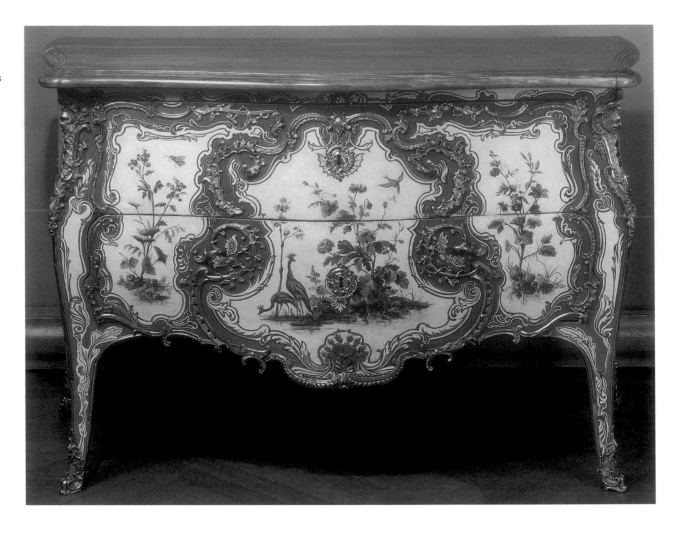

Fig. 11.21. Matthieu Criaerd. *Commode*, Paris, 1742. Oak and fruitwood veneer, *vernis Martin* lacquer, silvered bronze, *bleu turquin* marble; 33½ x 52 x 25 in. (85 x 132 x 63.5 cm). Musée du Louvre, Paris (OA 11292).

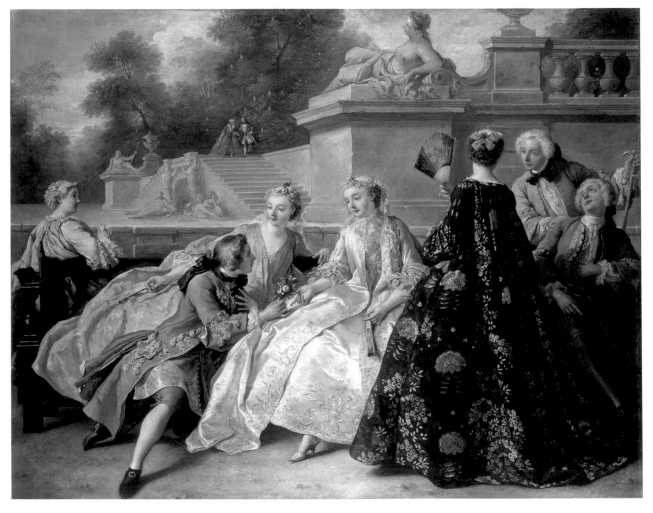

Fig. 11.22. Jean François de Troy. *La Déclaration d'Amour* (The Declaration of Love), 1731. Oil on canvas; 28 x 35⅞ in. (71 x 91 cm). Preußische Schlösser und Gärten Berlin-Brandenburg (GK I 5634).

Grand Tour, advised young English travelers to learn to speak, walk, dance, fence, salute, and enter a room in the French manner, but not to succumb to "all their Phantastical and fanfaron clothings."[9] Six years later, Sir George Etherege made just such a fashion victim, lately returned from Paris, the butt of his popular satirical play *The Man of Mode: or, Sir Fopling Flutter.*

Fashion was a particularly serious topic at court, where Louis XIV enforced strict sartorial codes, restricting red heels and soles of shoes to members of the royal family and high aristocrats, while personally issuing a limited number of scarlet-lined blue warrant coats (*justaucorps à brevet*) that conferred special privileges. Female courtiers were required to wear the confining, shoulder-baring *grand habit*, with tightly boned, short-sleeved bodices and elaborate trains. By the 1660s, the three-piece suit for men had been established, consisting of coat, waistcoat, and breeches cut from the same cloth, including fine Italian velvets adorned with braid or embroidered trim. Over the next century and a half, the proportions would slim considerably, revealing more of the figure. Men's wigs, too, changed from the high-piled and full-bottomed models popular under Louis XIV to the lighter bag wig tied with a black ribbon (*en solitaire*), which became almost universal by the middle of the eighteenth century (fig. 11.22).

Women's dress changed more dramatically over the period, first with the adoption in the late seventeenth century of the unstructured *manteau,* or mantua, a gown open at the front, with wide, elbow-length sleeves and a trained, looped-up skirt, worn belted at the waist with a stomacher, a triangular fabric that was pinned to the boned corset. The still freer "sack" dress or *robe à la française*, introduced in the 1720s and immortalized by painters Jean-Antoine Watteau and Jean François de Troy, proved even more influential. Originating as an informal *négligé*, and also known as a *volante* or "flying" robe, the sack dress was loose, unwaisted, and often open in front, with pleated back panels hanging freely from the shoulders (see fig. 11.22). It was worn over a hooped petticoat that enhanced the floating effect. Depending on the wearer's taste, the bodice could be closely fitted with stays, or the skirt partially pulled up into the side pockets. The dress was often customized with ribbons and trimmings supplied by a *marchand* (or *marchande*) *de modes*, milliners who kept their clients abreast of rapidly shifting fashions.

Fabrics changed too, with royal support of Lyon's silk mills ensuring their continued dominance. While brocaded silks and embroideries survived for formal occasions, women increasingly preferred lighter satins, taffetas, or painted Asian (or domestic) silks and cottons. At the beginning of the eighteenth century, especially bold or "bizarre" silks were popular both for women's dresses and for men's waistcoats and dressing gowns. These gave way to softer floral patterns—both stylized and naturalistic—and, by the 1780s, to plain colors or stripes. Few people could afford such luxurious textiles, and in France, as elsewhere, less wealthy consumers followed prevailing trends with simpler fabrics and cuts. A thriving second-hand clothing trade also ensured that garments were recycled at all economic levels.

SPAIN AND PORTUGAL

Despite mounting inflation and a series of bankruptcies, upon the death of Philip II in 1598, Spain was still a world power sustained and financed by its global empire. The next century, however, saw economic crisis at home and declining influence abroad, as Philip IV (r. 1621–65) acknowledged the independence of the Northern Netherlands, suffered military defeats in the Franco-Spanish War (1635–59), and lost the control over Portugal established in 1580. Internally, Spain remained decentralized and torn by popular unrest, while a crumbling economy, declining birthrate, plagues, and colonial emigration sapped the nation's strength. The population, which peaked around 1590 at about 9 million, declined by some 25 percent over the seventeenth century and by 1700 was barely more than a quarter that of France. As the Dutch, French, and English wrested control of its overseas trade, many Spaniards lamented that their empire had failed to bridge the gap between its haves (crown, nobility, and clergy, all tax-exempt) and have-nots. Paradoxically, as Iberia's fortunes declined, the arts flourished, leading some historians to interpret the Spanish and Portuguese Baroque as a response to political and social crisis. What is clear is that the peninsula's creative class, including writers Miguel de Cervantes, Luis de Góngora, and Francisco de Quevedo, painters Francisco de Zurbarán, Diego Velázquez, and Bartolomé Esteban Murillo, and a legion of skilled but lesser-known architects, designers, and craftsmen, responded brilliantly and distinctively to international currents.

Befitting its geographical position, Iberia's visual and material culture continued to be shaped by both its Islamic heritage and its links to Asia and America. As the seventeenth century dawned, Spain's Atlantic ports of Cadiz and Seville were flooded with silver and gold bullion from Peruvian and Mexican mines, one fifth of which was reserved for the crown; cochineal, a red dye derived from cactus parasites used to produce crimson textiles, including liturgical vestments (see fig. 11.1); and chocolate, an Aztec delicacy adopted and adapted by Iberian consumers. Although the colonial system discouraged imports of American manufactures, exceptions included indigenous curiosities such as *búcaros*, burnished ceramic vessels made near Oaxaca that sweetened the taste of water and were sometimes ground and eaten as a tonic (see fig. 12.9); lacquered gourds from Michoacán; and pictorial feather mosaics (see fig. 6.11a).

Even more important than goods from the Americas were the Asian imports carried as part of the Manila Galleon Trade, established in 1565, a yearly convoy of ships laden in the Philippines with goods including luxury silks, porcelains, ivories, spices, and exotic hardwoods. Having crossed the Pacific to the western coast of New Spain, the goods were unloaded at Acapulco and carried overland to Veracruz in the Gulf of Mexico for onward shipment to Seville. Although many of these goods remained in Mexico and Peru, others found a prominent place in Spanish churches, houses, and palaces. Conversely, Spain's American possessions offered a lucrative export market, turning Seville into a bustling entrepôt for

European paintings, ceramics, brocaded silks, lace, silver- and ironwork, furniture, and other finished goods destined for the western hemisphere.

As in Italy, the Church remained a leading patron of the arts, as Iberia's vigorous support of Counter-Reformation Catholicism fueled the continuing production of liturgical decoration and furnishings. Italian and Flemish Baroque modes only gradually displaced the severe "official" or court style epitomized by Philip II's great monastery-palace of the Escorial (1563–84). In silverwork this late-Renaissance *estilo disornamentado* (unadorned or plain style), marked by simple geometric forms, plain surfaces, and inset gems or enamel cabochons (see fig. 5.36), remained popular well into the seventeenth century.

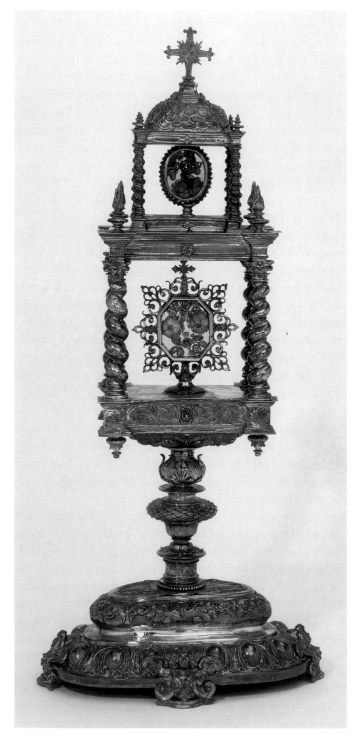

Fig. 11.23. Reliquary, Zaragoza, c. 1665. Silver, glass; H. 24⅞ in. (63.2 cm). Victoria and Albert Museum, London (M.341-1956).

A sign of change may be observed in a small silver pedestal reliquary made in Zaragoza around 1665 (fig. 11.23). Its two-story, architectural form reflects Spain's tradition of processional monstrances (see figs. 5.37a–b and 5.38). A newly sculptural and painterly conception, however, is seen in the bulbous base with bold floral chasing set atop winged cherubs, the tightly spiraling salomónicas (helical Solomonic columns) with flamelike finials, and the filagree scrolls radiating like a sunburst from the lower of the two relic holders.

Despite the difference in scale, these features draw attention to the reliquary's precious contents—the holy remains—in much the same way that Bernini's bronze baldachino in St. Peter's in Rome (1624–33, itself a scaled-up, Solomonic canopy) frames his soaring Cathedra Petri (Chair of St. Peter) for visitors entering the basilica. Similar ambitions guided Iberia's distinctive gilded *retablos* (altarpieces). These elaborate fusions of architecture, sculpture, painting, and metalwork were set like walls or screens behind important altars. In theory these were merely supports for polychrome devotional sculpture, a Spanish specialty wherein carvers, painters, and gilders created lifelike effects through techniques of *estofado* (imitation of luxury fabrics with gesso, paint, and scratched-off gilding), *encarnación* (naturalistic evocation of flesh), and sometimes the application of resin tears or real human hair. Yet in the seventeenth and eighteenth centuries, these ornamental supports, together with related liturgical furniture like wrought-iron *rejas,* or grills screening off the choir, chancel, and lateral chapels, became tours-de-force in their own right, offering visions of paradise on earth.

A sense of the otherworldly permeates the *retablo* at the convent church of San Esteban in Salamanca (fig. 11.24), designed and constructed by Bernardo Simón de Pineda (1638–ca. 1702) and José Benito de Churriguera (1665–1725), son of a Catalan cabinetmaker, gilder, and altarpiece-joiner. This exemplar of the "Churrigueresque" style epitomizes Baroque Iberia's embrace of sacred drama. Whereas Renaissance *retablos* were typically flattened, gridlike arrays of niches enclosing individual figures or reliefs (compare fig. 6.30), here the vine-covered salomónicas are staggered within the concave apse, suggesting a heavenly temple interspersed with garlands, niches, crowns, "cloth" canopies, and tabernacles, and populated by polychrome statuary including Dominican saints, frolicking putti and angels, and (at top) painter Claudio Coello's luminous canvas depicting the saint's martyrdom. Sophisticated, multihued gilding dematerializes the massive structure, while alternating matte and burnished surfaces suggest woven fabric. During the eighteenth century, the Churrigueresque ornamental language embraced the yet-more complex *estípite*, a tapering spindle or candelabra-pillar that combined inverted cones or obelisks, floral capitals, shells, lambrequins, and fragmentary cornices into a decorative motif particularly popular in Spanish America.

Furniture forms remained traditional in most seventeenth- and early eighteenth-century Spanish homes. The drop-front *escritorio* (writing desk, also known by the nineteenth-century term *bargueño*; see fig. 5.36), formerly an elite luxury object, became available to wider segments of Iberian society and gradually replaced older types of storage such as trunks

and chests. Although theoretically portable, *escritorios* (like the Flemish cabinets discussed above) became increasingly grand, often set atop a high, matching *puente* (trestle base) and presenting a bank of doors and drawer fronts embellished with painted or engraved ivory, tortoiseshell, bone, papier mâché, or geometric wood inlay indebted to Mudéjar ornament. Smaller *papeleras*, which lacked folding writing surfaces, could be ordered in pairs or stacked into graduated sets that offered visible evidence of literacy alongside the suites of formal furniture—mirrors, console tables, cabinets, and sideboards—set against walls densely hung with tapestries or paintings.

Chairs, still rare in 1600, also became more common. The traditional *sillón frailero,* or friar's armchair (also termed *silla de brazos* or *de cardenal* in early documents; compare fig. 5.35), was supplemented with simpler turned stools (*taburetes*) and backstools (also called back chairs, the English period term for fully upholstered chairs without arms) that were enlivened with spiral stiles and stretchers. Iberian lathe-workers embraced the Baroque taste for an illusion of movement by turning legs for cabinet stands and table bases with elaborate bobbin or "barley-sugar" forms, as they were known in the English-speaking world, a twisting design akin to salomónicas. Bedsteads increasingly relied on visible turned or carved wooden corner posts and canopies. In Portugal, these included elaborate headboards with architectural arcades mounted with brass or topped with religious figures, and bed frames constructed from tiers of virtuosic turnings in exotic woods. Yet the continuing appeal of the *estilo disornamentado* ensured the popularity even in grand houses of simple plank benches, joined walnut tables and chairs, and plain, sometimes dismountable trestle tables (*bufetes*) braced with sinuous wrought-iron stretchers.

Construction of the Escorial had occasioned massive orders for architectural tiles from the Castilian maiolica (in Spanish, *mayólica*) workshops at Toledo, Talavera de la Reina, and Puente del Arzobispo, which soon branched out to produce ceramic vessels for the kitchen and table. Although lusterware was still made in Spain's eastern regions of Valencia and Catalonia, quality declined after the ill-conceived expulsion in 1609 of the Moriscos (Muslims permitted to remain after 1492). The Italianate tin-glaze tradition introduced by the Pisan Niculoso Francisco now dominated, with Castilian workshops producing polychrome wares in the style of Deruta and Faenza by 1580 (see fig. 5.7). Native tastes in maiolica had emerged by 1600, including a pure white type promoted as a substitute for silver, a family of stippled wares, and three-color wares bearing human or animal figures painted in blue, orange, and manganese. Cobalt blue decoration became popular with the arrival of Chinese porcelain and the circulation of European earthenware imitations (see above), including Portuguese *mayólica*. Blue-and-white wares exported from Talavera, some with Ming-inspired fern-leaf borders, proved especially popular in New Spain, where they inspired similar elite pottery (*loza fina*) produced in Puebla de los Angeles and later christened *talavera poblana* in honor of Castilian prototypes.

By the late seventeenth century, new styles took root, including one inspired by the patterns of bobbin lace (a vogue

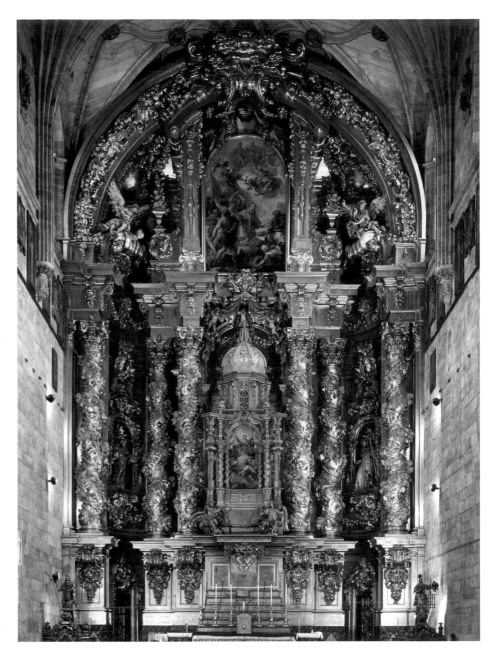

echoed in Puebla), and a new polychrome type featuring atmospheric outdoor scenes painted in copper-green, yellow, orange, blue, and manganese purple, inspired by Mannerist prints. These visually sophisticated products revived the prestige of Talavera among Spain's nobility and court elite, who commissioned elaborate pictorial wall panels. Tablewares became similarly ambitious. One virtuoso platter presents a mounted hunter plunging through the forest in pursuit of game (fig. 11.25). The painter has overlapped and blurred the colors to suggest speed, a Baroque dynamic echoed by the hares and hounds leaping in eternal chase around the rim.

In Portugal, the seventeenth century was a productive and creative period, during which it achieved independence from Spain in 1640 under the Braganza dynasty and recaptured Brazil from the Dutch in 1654. During the ensuing period of relative stability, Portugal reaped riches from sugar and tobacco produced through slave labor in the New World and, from the 1690s, profited from America's first gold rush, which brought a flood of bullion (and later diamonds) rarely equaled in European history.

Fig. 11.24. Bernardo Simón de Pineda and José Benito de Churriguera. High altar and *retablo*, convent church of San Esteban, Salamanca, 1693–96. Painting by Claudio Coello.

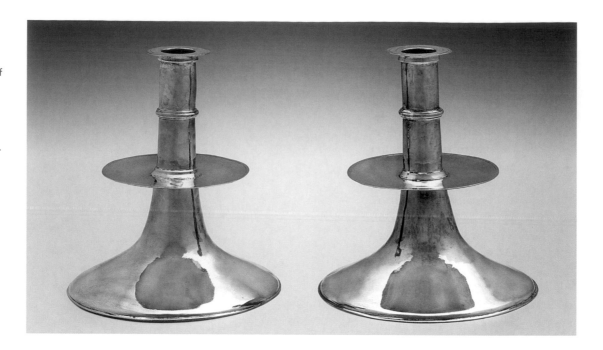

BRITAIN

The long, stable reign of Elizabeth I of England (r. 1558–1603), capped by the defeat of the Spanish Armada in 1588, encouraged a florescence in design and the decorative arts. The accession of James Stuart in 1603 united England and Scotland, while the cosmopolitan court of his son Charles I (r. 1625–49) had close dynastic and artistic connections to the continent. The royal architect Inigo Jones (1573–1652), an admirer of sixteenth-century Italian architect Andrea Palladio (1508–1580), significantly changed British taste by introducing new forms of Italian classicism at the Queen's House in Greenwich (begun 1616) and the more elaborate Banqueting House at Whitehall Palace (1619–22), the latter crowned with an illusionistic ceiling by Rubens celebrating James's reign. Besides inventing sets and costumes for court masques, Jones also designed London's first public square at Covent Garden, a classical, Italian-style piazza with three terraces of houses set above arcaded loggias and facing a church with a classical portico in the severe Tuscan order (1631–33). Royal support for the Mortlake tapestry works, founded in 1619, and Charles's patronage of the Dutch goldsmith Christiaen van Vianen (1600–1667), confirmed the Stuart court's intent to compete with continental rivals in terms of material splendor.

Court dress was a visible index of the increasing concern with luxury. Sixteenth-century fashions had featured stiff doublets (tight-fitting, long-sleeved jackets) with billowing hose for men and tight bodices with voluminous skirts for women, all heavily embroidered or cut from densely textured brocaded silks. Such clothing inhibited bodily movement in a way that emphasized rank, formality, and social distance. By contrast, Charles I and his French Queen Henrietta Maria promoted a more relaxed yet luxurious style, embodied for men by flowing satin suits with longer, less structured doublets and narrower breeches and accessorized with broadbrimmed hats, turned-down boots, floppy lace collars, and purposely asymmetrical hairstyles in line with the *sprezza-*

tura (nonchalance) championed in Baldassare Castiglione's *Book of the Courtier* (Venice, 1528), which was translated into English in 1561.

Elite women wore simple bodice-and-skirt combinations or all-in-one dresses of relatively simple form in monochrome satins that highlighted elegant bodily motions. The visual effect of "liquefaction," as poet Robert Herrick termed it in 1648, was enhanced by the "sweet disorder" of a strategically "erring lace" or "a cuffe neglectful."[10] Stuart women also appropriated and reconfigured aspects of male attire, including hats, collars, and jackets, feminizing them with diaphanous scarves and bows. In a similar way, domestic interiors, which had achieved magnificence in the Tudor and early Stuart periods by grafting Renaissance details onto late Gothic forms, now strove—as at the Double Cube Room at Wilton House, designed by Jones's pupil John Webb (1611–1672) in 1649—for a noble harmony of classical proportions and restrained floral ornament.

In ecclesiastical contexts, decoration was a matter of faith and in some cases proved a fuse for long-simmering conflicts. As leader of the High Anglican faction within the established (state) church, Archbishop William Laud (appointed by Charles I) took that branch of English Protestantism closer to Roman Catholicism, reviving elaborate and costly church furnishings largely banished under the Tudors. Stained glass, stone altars, altar crosses, chalices, and railings separating the congregation and clergy now adorned many Anglican churches, often produced in a self-conscious Gothic style that referred back to the pre-Reformation church. Such objects offended both those within the established church who favored simpler rituals and surroundings, and the various Puritan groups who regarded them as the trappings of popery.

The outbreak of the Civil War (1642–51), fought over political and economic as well as religious issues and culminating in King Charles's beheading in 1649 and the institution of the Commonwealth (1649–60) under Oliver Cromwell, brought a sharp rupture in the patronage and production of

design and architecture. A new emphasis on plainness pervaded church furnishings as well as dress and domestic furnishing, where simplicity and sobriety stood as markers of religious preference. The prevailing repudiation of ornament is captured in an arresting pair of silver candlesticks made by Arthur Manwaring about 1653 (fig. 11.28). In contrast to the elaborate silver of previous periods, their wide drip trays and flaring bases, perhaps inspired by contemporary brassware, imply not just a change in taste but also a reluctance to spend money on decoration in a climate in which precious objects might have to be (re)converted quickly into specie.

Silver, however plain, remained out of reach for most British households, which favored less costly wooden vessels known as treen, or earthenware for the table, living areas, and chambers. One popular and widely circulated type of earthenware was produced by the mid-seventeenth century in Staffordshire, a region in central England with ample deposits of clay, coal, and the necessary metals. The red- or buff-bodied earthenware was decorated with contrasting white, red, or brown slips (liquid clay, sometimes with color added) trailed over the surface and sealed with a clear lead glaze. Decorations included simple geometric patterns (often straight or wavy lines), combed or marbled designs (in which slips of various colors were applied and feathered with a wire brush), and pictorial or figural designs, including biblical or tavern scenes. Several dozen large, shallow dishes bear the names of the Toft family of potters—Thomas (act. 1663–89), his brother Ralph, son James—amid distinctive cross-hatched borders. Other Toft family wares featured eye-catching, often patriotic designs including royal portraits, crowned lions, unicorns, and other heraldic insignia. These were probably to advertise the clan's humbler wares, which presumably included plates, cups, and posset pots (used to serve a beverage of milk curdled with wine or ale) sold at fairs or by traveling vendors. One charger (fig. 11.29) features a voluptuous mermaid holding a mirror and comb and surrounded by heartlike motifs that appear in several dishes bearing Thomas Toft's signature.

Pewter, an alloy of tin with variable amounts of copper, lead, antimony, and bismuth, was another popular substitute for silver and followed its forms. Objects produced in pewter included wares for serving and eating food (plates, dishes, chargers, porringers, salts, and spoons), containers for liquids (mugs, beakers, cups, tankards, beer jugs, and flagons), and objects for use throughout the home (such as candlesticks, shaving bowls, inkstands, and snuff or tobacco boxes). Because of the alloy's low melting point and relative rigidity, most pewter items were cast in bronze or iron molds, sometimes in sections that were then soldered together, hammered for hardness if needed, then turned and burnished on a lathe. Decoration was either cast or engraved, often using a zigzag or wrigglework technique.

Pewterers' considerable investment in their molds (generally a workshop's most valuable items) discouraged stylistic innovation, keeping certain designs and object types in production far longer than their silver counterparts. A large caster (fig. 11.30) exemplifies the restrained geometry that appealed to pewterers and their patrons: a skirted foot

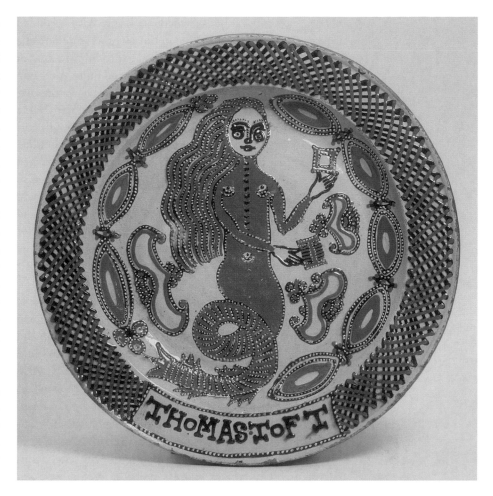

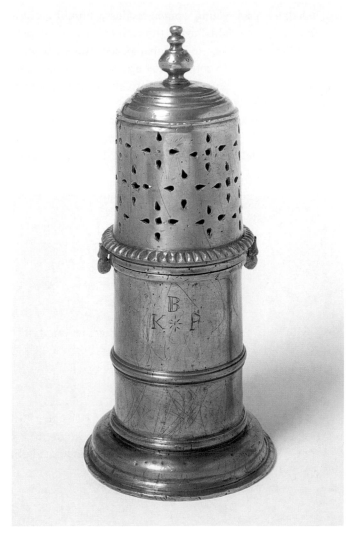

Fig. 11.29. Thomas Toft. Charger, Staffordshire, 1670–89. Earthenware; 2¾ x 17⅜ x 17⅜ in. (7 x 44 x 44 cm). Victoria and Albert Museum, London (299-1869).

Fig. 11.30. Sugar caster, England, c. 1700. Pewter; H. 8 in. (20.3 cm). Victoria and Albert Museum, London (M.985:1,2-1926).

anchors a cylindrical body ornamented only with a molded girdle and the owners' engraved initials, while the detachable lid, pierced and ringed with simplified gadrooning (a kind of decorative fluting), carries a baluster-shaped finial. Although lighthouse-shaped casters of this type were also popular in silver, their production in pewter signals the expanding desire and ability of less affluent English consumers to participate in the genteel table practices of the elite—including the sprinkling or "casting" of imported spices and crushed loaf sugar, an expensive New World import. Pewter was also extensively produced (with distinctive regional variations) in Germany, France, the Netherlands, northern Italy, and central Europe, where the high reputation of British pewter induced many continental manufacturers to incorporate devices like the Tudor rose, or the word "English," in their punchmarks.

British virtue and British ornament were entwined in embroideries created in the home by women of the landed and merchant classes. Often given as tokens of affection and preserved as family heirlooms, such "amateur" textiles lent an air of softness and gentility to domestic interiors when made into window valances, covers for cupboards and tables, or cushions for stools and chairs. Others were used to decorate clothing, gloves, mirrors, bibles, or jewel boxes. Mythological or pastoral subjects reflected the maker's cultural horizons, while royal portraits, sometimes with coded slogans or emblems, might express political sympathies. But above all, as conventional female accomplishments, embroideries helped teach young women modesty, humility, chastity, and obedience. John Taylor, the author of a 1631 manual, saw needlework as key to national peace, urging women "from the court to the cottage" to "use their tongues lesse, and their Needles more."[11] Over fifty years later, Hannah Woolley's *Guide to Ladies, Gentlewomen & Maids* (1688) described needlework as "both needfull and pleasant," and "commendable in any woman, for it is time well spent for both profit and delight." The linkage of needlework to female virtue helps explain the preponderance in amateur embroideries both of biblical heroines such as Sarah, Esther, and Judith (in scenes often adapted from continental prints or illustrated handbooks) and cautionary examples of unbridled femininity such as Susanna or Bathsheba.

It was in this moralizing spirit that young Miss Bluitt, a student at the Ladies University of the Female Arts at Hackney, then outside London (a school that educated over 800 girls during the Civil War and Commonwealth periods) created technically accomplished embroideries depicting the story of Abraham, Sarah, and Hagar, mounted as a casket, sometime before the Great Plague of 1665 (fig. 11.31). The rear and side panels display simple tent-stitch embroidery with seed pearls, while the front and top exhibit the three-dimensional, Baroque-inspired stumpwork (a padded and raised embroidery technique) characteristic of Stuart design. The left-hand door employs silk- and hair-wrapped wires to form Abraham and Hagar's hands and coiffures, while the satin-worked cover boasts peacock feathers and padded figures enriched with added draperies, collars, and cuffs. While some women embroiderers may have created their own designs, many followed outlines created by specialist pattern-drawers. A professional "upholder" (later known as "upholsterer") may well have finished Miss Bluitt's casket, reminding us that even domestic embroidery by women, with all its opportunities for self-expression or even resistance, took place within wider craft and commercial networks that remained largely male.

The restoration of the monarchy in 1660 brought a new wave of continental influences as Charles II and his courtiers returned from exile in France and the Netherlands and inaugurated a full-blown English Baroque. Court dress reverted to elaborate displays of lace, velvets, and metallic embroidery inspired by developments in Paris and cut for maximum decorative effect. Interior decoration also achieved new levels of grandeur through plasterwork featuring scrolls, shells, and festoons, and exuberantly carved woodwork—most notably by the Dutch-born Grinling Gibbons (1648–1721)—that graced mantels, mirror frames, and wall panels with illusionistic vegetal and animal motifs. As diarist John Evelyn noted, the "politer way of living" after the Restoration proved costly to householders, while the wholesale rebuilding of London after the Great Fire (1666) provided unparalleled employment for both native and foreign craftsmen.[12]

New and specialized furniture forms proliferated, including cabinets on turned stands, gateleg tables, tea tables, toilet tables with their associated silver dressing services, caned and crested chairs or "backstools" (compare fig. 11.26 and fig. 12.40), and adjustable winged and sleeping chairs, a sign of the rising demand for comfortable upholstery. Luminous, highly figured walnut replaced oak as the preferred furniture wood, while the fashion for pictorial marquetry was stoked by the productions of the cabinetmaker Gerrit Jensen (act. ca. 1680–d. 1715), a Netherlandish disciple of Pierre Gole (discussed above) who settled in London by 1680 and crafted furniture mounted with silver, "Boulle" work, and *verre églomisé* (reverse-painted glass). Increasing demand for imported luxuries spurred expanded production of domestic substi-

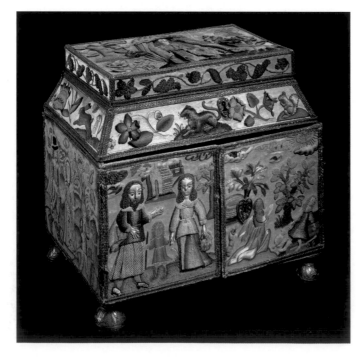

Fig. 11.31. Miss Bluitt (later Mrs. Payne). Casket with scenes from the life of Abraham; probably Hackney, before 1665. Silk embroidery on silk satin, velvet, linen lace, silk-wrapped wire, peacock feathers, pearls, silver attachments; 11¾ x 10⅜ x 7¼ in. (29.7 x 26.5 x 18.5 cm). Ashmolean Museum, University of Oxford (WA1947.191.315).

tutes, like "Turkey work" (knotted wool and pile on a hemp ground, so named for its similarity to imports from the Middle East), Mortlake tapestries, and furniture with ebonizing (black-staining to imitate ebony) or "japanning," a form of imitation lacquerwork for which instruction manuals were published beginning in the 1680s.

Britain's embrace of the Baroque was facilitated by Louis XIV's revocation of the Edict of Nantes in 1685 and the resulting departure of French Protestants or Huguenots, an act of religious extremism that deprived France of hundreds of trained goldsmiths, ironsmiths, clock makers, gunsmiths, gardeners, and silk weavers. Continental influence intensified after the "Glorious Revolution" of 1688, which expelled the Catholic James II (r. 1685–88) in favor of the Protestant William of Orange (r. as William III 1689–1702) and his English wife Mary II (r. 1689–94), ushering in an "Anglo-Dutch" court style that drew heavily on the talents of Huguenot craftsmen.

Among the émigrés was Daniel Marot, the elder (1661–1752), the son of a French royal architect and engraver. He trained at Versailles and became court designer to William of Orange at Het Loo and other Dutch palaces. After working in England for a mere five years or so (1694–98), he returned to his elite Dutch clients and also published designs for furniture, interiors, stage sets, triumphal arches, garden ornaments, vases, and funerary monuments that circulated across national boundaries and helped transform European taste.

Marot's legacy in Britain is visible in objects like the richly draped bed ordered by the first Earl of Melville (secretary of state for Scotland) for the royal apartment in his palatial seat in Fife, which was begun in 1697 (fig. 11.32). Even though it was never used by King William, at nearly 16½ feet (5 m) high, it proclaimed Melville's loyalty to crown and state by suggesting a curtained baldacchin or stage, not unlike Schor's theatrical *zampanaro* for Princess Colonna (see fig. 11.3). Reflecting the new importance of the upholsterer, the oak frame was completely covered with about 200 yards (183 m) of fine fabric: crimson Genoa velvet trimmed with matching braid and fringe for the exterior, and ivory-colored Chinese silk in the interior. The headboard incorporated an elaborate cipher for Melville and his wife, crowned with an earl's coronet, while the richly sculptured cornice and "flying" corner tassels can be traced to beds designed for Louis XIV's Porcelain Trianon in the 1670s. During previous reigns, such objects would have been ordered from Paris, but now they could be made in London, the frame by joiners and the rich hangings by émigré upholsterers such as Francis Lapiere.

The Duke of Marlborough's victories over Louis XIV in the War of the Spanish Succession heralded a new international role for the United Kingdom of Great Britain, formed in 1707 by the union of England, Scotland, and Wales, and enlarged with Ireland in 1801. Britain's expanding trade, commercial and political influence, and economic prosperity established it as an important trendsetter, not least in the custom of tea drinking. By the 1670s, Chinese tea had joined Arabian coffee and American chocolate as a fashionable beverage among the elite, and by 1727, when painter Richard Collins portrayed a provincial family sitting down to tea, the ritual

had become widespread and the paraphernalia largely standardized in terms of object types (fig. 11.33). In the painting, a polished table holds an array of specialized silver objects. A pear-shaped kettle, its shape adapted from Chinese ceramic wine pots, sits on a four-legged stand above a burner; tea leaves, stored in an airtight canister (left), are brewed in an octagonal serving pot with a wooden handle that protected the pourer's hand from the heat. Sugar from the West Indies—a reminder that much European "refinement" rested on slave labor—is offered in a bowl, its cover leaning against it, to be dispensed with miniature tongs and stirred with small spoons proffered on a fluted tray. Collins was at pains to demonstrate the proper ways in which to hold the small, handleless porcelain cups with matching saucers, whose contents could be emptied when cold into an elegant slop bowl. The family engages in a polite show of manners, with even the pet joining in.

Although utensils for the service of hot beverages would continue to change and multiply, by 1750 they were an estab-

Fig. 11.32. Possibly Daniel Marot (frame). Bedstead, probably London, c. 1700. Upholstery attributed to Francis Lapiere. Oak and pine frame, velvet, silk, linen, iron; 15½ x 8½ x 8¾ ft. (4.7 x 2.6 x 2.7 m). Victoria and Albert Museum, London (W.35.1 to 61-1949).

lished part of the expanding inventory of objects related to the table, from toast racks and egg stands to cruet sets and sauceboats, punch bowls, monteiths (footed bowls with scalloped rims to suspend wine glasses in cool water), epergnes (centerpieces), cake baskets, and flatware increasingly supplied in matched services for the tables of the elite and merchant class. Many objects were engraved with the owner's coat of arms or at least a monogram, which advertised possession and helped guard against theft. The value of domestic plate still lay overwhelmingly in the metal, often provided by the client, with a variable surcharge to the goldsmith for fabrication. Huguenot dynasties of metal-workers, led by Paul de Lamerie (1688–1751), Anthony Nelme, Simon Pantin, or Augustine Courtauld, supplied goods in French Régence and Rococo styles adapted for British taste. Among British craftsmen, Rococo design would not come into its own until mid-century. Most typical of the eighteenth century's second quarter were simpler wares produced by native craftsmen, some almost as austere and unembellished as Manwaring's candlesticks (see fig. 11.28).

Influential between 1720 and 1750 (and longer in Britain's North American colonies) was the refined neo-Palladian style associated with Richard Boyle, third Earl of Burlington (1694–1753), an ambitious Whig politician who sought to reform British taste according to Palladio's interpretation of ancient Roman models. Scottish architect Colen Campbell's *Vitruvius Brittanicus* (1715)—an homage to Inigo Jones (discussed above)—had led the way by demonstrating how to adapt Palladian ideas to town houses and country seats. Campbell's symmetrical and well-ordered designs seemed to accord with Whig notions of limited, constitutional monarchy as enshrined in the Hanoverian succession of 1714 that placed George I (Elector of Hanover from 1698, r. as king of Great Britain and Ireland 1714–27) on the British throne.

On his second trip to Italy in 1719, Burlington befriended the painter William Kent (1685–1748), a keen promoter of Italian classicism who adapted Palladianism to interior decoration and was among the first British designers to fashion unified interiors—creating everything from furniture to chimneypieces, door cases, looking glasses, console tables, picture frames, and silverwares. Beginning with Burlington's villa at Chiswick (1725–29), Kent's grand interiors featured simple but varied geometric volumes enriched with coffered ceilings, apses, niches, herms, brackets, and split pediments picked out with judicious gilding. His furniture was equally imposing, featuring luxurious damasks and velvets with heavy frames of gilt wood or, increasingly, mahogany imported from the West Indies. The boldly sculptural forms of the settee (fig. 11.34) and matching chairs designed for Lady Leicester's dressing room at Holkham Hall recalled Roman Baroque palace prototypes. The scrolling arm supports, for instance, include snarling lion heads and paw feet, while the twinned cornucopias forming the top rail, and the garlands and shells below the seat, quoted architectural ornaments from Jones's Banqueting House at Whitehall (discussed above).

British gardens had followed the formality of French patterns since the Restoration, but Burlington and Kent revived the spirit of ancient Roman gardens described by Pliny and Horace, working with, rather than against, nature—consulting "the genius of the place," as Alexander Pope put it in a poem praising Burlington—and introducing a greater degree of informality.[13] Drawing upon his painterly skills and sense of theater, Kent enlivened landscapes with features such as serpentine rivulets and meandering paths that created variety and surprise and may have been inspired by the concept of *sharawadgi*, a Japanese term for irregularity and asymmetry, introduced to the west by seventeenth-century Dutch traders and Jesuit missionaries. Kent's accomplishment was to fuse these ancient Roman ideas and Asian aesthetics in gardening and landscape practices that were later codified by Lancelot "Capability" Brown (1716–1783) and others working in the 1750s. Looking back in 1780, Horace Walpole observed that it was Kent who first "leaped the fence, and saw that all nature was a garden."[14] At some sites, Kent embraced inventions like the ha-ha, a concealed ditch that kept livestock away from land immediately around the house while maintaining an unbroken vista. In others, he operated more like a stage designer, creating shifting tableaux that evoked a variety of emotions and associations as visitors progressed from scene to scene.

At Stowe, the Buckinghamshire estate of Richard Temple, first Viscount Cobham, Kent softened a formal park laid out in the late 1710s and 1720s by Sir John Vanbrugh (1664–1726) and Charles Bridgeman (d. 1738), adding a Temple of Venus in 1731 and thereafter creating the "Elysian Fields" in a gentle valley, complete with irregular screens of trees, a rustic grotto shell bridge, and classicizing structures arranged along a grassy stream renamed the river Styx. The exedra-shaped Temple of British Worthies presented busts of sixteen Whig heroes representing the active life (including King Alfred, Elizabeth I, Sir Francis Drake, and William III) and the contemplative (William Shakespeare, John Milton, John Locke, and Inigo

Jones; fig. 11.35). Across the river, the circular Temple of Ancient Virtue enclosed statues of Lycurgus, Epaminondas, Homer, and Socrates, in deliberate contrast to the Temple of Modern Virtue, which was constructed as a ruin and contained a headless statue of Cobham's political enemy, Prime Minister Robert Walpole. The link between style and civic virtue was reinforced by James Gibbs's Gothic Temple of Liberty, added in 1741 to celebrate the Cobham family's defense of political rights believed to descend from ancient Saxons. Even if its moralizing overtones were not always followed, the new "informal" English garden exemplified at Stowe became a model for so-called picturesque landscapes—where nature somehow seemed both natural and reminiscent of old masters—elsewhere in Europe, especially in Germany, Italy, and France.

CENTRAL EUROPE

Unlike the more homogeneous and centralized states to the west and south, the areas now known as Germany and Central Europe constituted a linguistic, ethnic, and political mosaic difficult to characterize in terms of shared styles, patronage, or technologies. This zone, roughly bounded by the Alps, the Baltic Sea, and the Rhine and Bug rivers, comprised much of the Holy Roman Empire, kingdom of Hungary, and the Polish-Lithuanian Commonwealth. The empire was less a unitary realm than a supranational patchwork of territories, each with shifting religious, dynastic, and cultural alliances. While Catholic Austria and Bavaria looked primarily to Italy for design ideas, the autonomous and largely Protestant cities to the north reflected strong Netherlandish and British influences. Augsburg and Nuremberg exploited their privileges as "Free Imperial Cities" (subject only to the emperor) to promote goldsmithing, clock making, cabinetmaking, glass engraving, and the manufacture of parade armor and musical instruments, while other previously powerful towns and cities ceded influence to the aristocracy and their courts. French influence increased after Strasbourg, an important center for faience, fell to Louis XIV in 1681, and as Francophilic sovereigns took the throne in Munich and Berlin. Although there were commonalities of styles, materials, and object types within this diverse region, particularly in the aftermath of the Thirty Years' War (1618–48) and the Peace of Westphalia, each Central European duke, margrave, prince-bishop, or elector strove to outdo his neighbor by importing foreign talent and promoting local craft skills and materials.

Fig. 11.34. William Kent. Settee, England, c. 1735. Gilded wood, damask; 43 x 60 x 32¼ in. (109.2 x 152.4 x 81.9 cm). Viscount Coke and the Trustees of the Holkham Estate, Norfolk.

Fig. 11.35. William Kent. Landscape with the Temple of British Worthies, Elysian Fields, Stowe, Buckinghamshire, c. 1734–35.

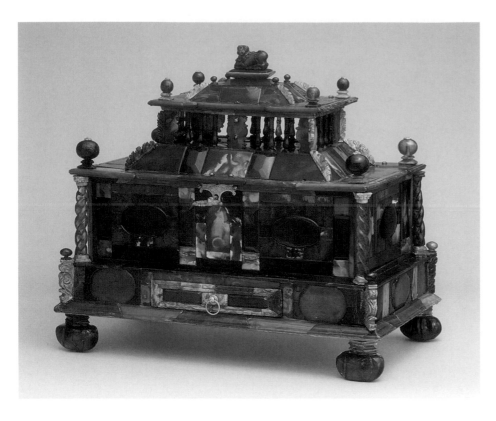

Fig. 11.36. Attributed to Michael Redlin. Casket, Danzig, c. 1680. Amber, gold foil, gilt brass, wood, silk satin, paper; 11¹³⁄₁₆ x 13 x 8¼ in. (30 x 33 x 21 cm). The Metropolitan Museum of Art (2006.452a–c).

One such material was amber, a semiprecious fossilized tree resin found almost exclusively in the Duchy of Prussia, then part of the Polish-Lithuanian Commonwealth and now in Russia. Long thought to have magical and medicinal properties, this "gold of the north" was controlled for centuries by the Teutonic Knights, who used it to bolster their political and religious prestige. By the sixteenth century, secular applications predominated. Amber wares were sought out by princely collectors as ornaments of the cabinets of curiosities known as *Wunderkammern* (rooms of natural wonders) and *Kunstkammern* (rooms of art), where, like objects made of ivory and coral, they demonstrated the craftsman's ability to compete with and transform nature. The gifts that the Polish-Lithuanian Prince Krzysztof Zbaraski's embassy took to Constantinople in 1622–24, for instance, included a casket, large mirror frame, and chess set to amuse the women of the seraglio.

In 1688, the newly crowned Elector of Brandenburg, Friedrich III, commissioned Danzig amber worker Michael Redlin to create three gifts for the Russian czar: an amber chessboard, two-tiered architectural cabinet, and twelve-branch chandelier with "portraits of German emperors and heroes painted on gold foil and covered with transparent amber."[15] These objects have vanished, but surviving table caskets document Redlin's style and techniques. In one example (fig. 11.36), the base is built around a wooden core and stands on carved amber knob feet; above, alternating panels of translucent, opaque, and "milky" amber form a roofed box adorned with cabochons (engraved with landscapes in intaglio), golden Solomonic corner columns, ball-shaped finials, and a turned openwork attic surmounted by a lion. All these Baroque features, together with Redlin's skillful modulation of hue and shading, endow the casket with a monumental character belying its modest dimensions.

The carving of ivory was another specialty of German craftsmen, who excelled in working tusks imported from Africa and Asia. The softer ivory (mainly from East Africa) preferred in the West also made it suitable to turning on a lathe, a challenging pastime favored by princes. For the most part, ivory vessels followed the shapes of contemporary goldsmithing, as seen in a tall standing cup carved in Salzburg about 1680 by Balthasar Griessmann (1620–1706) from Wasserburg am Inn, near Munich (fig. 11.37). Like equally elaborate silver cups from Augsburg or Nuremberg, this vessel which probably functioned as an ornamental centerpiece was perhaps a wedding gift. The decoration offers a paean to the virtues and perils of wine. A tipsy putto balancing atop the finial examines his reflection in a brimming cup, recalling the ancient notion that wine is the mirror of man, while two rings of putti illustrate the stages of inebriation, from frenzied dancing (around the lid) to stuporous slumber (around the foot). Around the walls of the vessel, above a stem carved with grapevines, Griessmann adapted the Flemish painter Otto van Veen's *Allegory of the Temptations of Youth* (c. 1595), in which Venus and Bacchus ply their sleeping victim with breast milk and wine while Time and Minerva seek to rouse him to the pursuit of virtue and honor. Griessmann's tour-de-force indicates the ways in which objects could be charged with intellectual, didactic, and moral meanings, and, in this instance, allusions to pleasure.

To the north, in the Duchy of Saxony, wealth from mineral deposits and semiprecious stones supported the court of Augustus II ("the Strong") at Dresden, which was nicknamed "Florence on the Elbe." An ambitious elector who acquired the kingdom of Poland in 1697 and sought further territory from Sweden, Augustus had traveled in Italy and France in the 1680s and understood the role of splendor in European power politics. Dresden attracted creative talents including Matthäus Daniel Pöppelmann (1662–1736), architect of the Zwinger festival ground, sculptor Balthasar Permoser (1651–1732), who worked in stone, wood, and ivory, and goldsmith Johann Melchior Dinglinger (1664–1731), appointed court jeweler in 1698 to provide chivalric and military orders and decorations featuring local stones. Determined to emulate the Medici, Augustus established a court workshop to supply the royal treasury. One of Dinglinger's most impressive creations was a large diorama titled *The Court of Delhi on the Birthday of the Great Mogul Aurangzeb*. The fruit of an eight-year collaboration with his brother Georg Friedrich (1666–1720), an enameler, it featured 132 figures bearing gifts ranging from elephants and camels to jeweled ewers and lacquered furniture, with Aurangzeb constituting an exotic proxy for Augustus himself.

The elector's collecting impulses extended to porcelain, including tall Chinese vases he exchanged in 1717 with Friedrich Wilhelm of Prussia for 600 dragoon guards. *Kameralwissenshaft*, a German form of mercantilist theory, spurred the king to develop porcelain locally. European potters had long searched for the secret recipe or arcanum of true or "hard-paste" porcelain, at best devising "soft paste" imitations by blending ground glass, soapstone, or other additives with the clay. Augustus employed the mathematician and sci-

entist Ehrenfried Walter von Tschirnhaus (1651–1708), who, assisted by the alchemist Johann Friedrich Böttger (1682–1719), produced Europe's first white porcelain in the Chinese manner using Saxon kaolin clays. The breakthrough was announced in four languages in 1710, and hard-paste porcelain produced in the Albrechtsburg castle at Meissen, northwest of Dresden, soon appeared at trade fairs in Leipzig and Naumberg, and was distributed farther through traveling salesmen and foreign agents.

Under Böttger, Meissen wares were often left white, and the manufactory relied on outside *Hausmalern* (painters), many of them women, to decorate the wares with elaborate gilded or polychrome designs (fig. 11.38). This practice declined with the arrival in 1720 of porcelain painter Johann Gregorius Höroldt (1696–1775), who introduced the colored decoration for which Saxon porcelain became famous, including chinoiserie or harbor scenes painted in overglaze enamels within lacy gold cartouches. Höroldt also promoted an underglaze company "signature" of crossed swords derived from the electoral arms—one of Europe's first commercial trademarks—to deter competition from rival factories. The emphasis on maritime trade and exoticism (even if the Chinese scenes were frequently derived from Dutch prints) suited a medium still closely connected in the European imagination to the riches of Asia, all the more when used, as in the teapot shown, to serve imported Chinese tea. By 1730 an influential new mode of decoration had been introduced, featuring plain, colored grounds of lemon yellow, pea green, cobalt blue, and even black, with simple lobed reserves containing Chinese figures, birds, or landscapes. Other successful lines featured free adaptations of Japanese Imari and Kakiemon styles (discussed above, and see fig. 7.29) and a popular pattern known as *Indianische Blumen* (eastern flowers).

Porcelain production at Meissen reached its zenith after the arrival in the later 1730s of sculptor Johann Joachim Kändler (1706–1775), who modeled allegorical vases in high relief for Louis XV of France and enlarged the menagerie of life-size porcelain animals at the elector's "Japanese Palace" in Dresden. Kändler's small figures, created to decorate the dessert table and including many drawn from the commedia dell'arte (a form of theater based upon masked "types" that began in Italy in the sixteenth century) and contemporary life, established a taste that spread throughout Europe. By mid-century, the wares from this ambitious manufactory also included garnitures of vases, sculptural centerpieces, altar implements, portrait busts, and Europe's first complete dinner, dessert, and beverage services in porcelain. Meissen's products were a vital ingredient in Dresden's efforts at diplomacy, whereby exchanges of gifts helped cement its prestige throughout Europe.

In Potsdam, Frederick the Great of Prussia (r. 1740–86) sketched ideas for an intimate, villa-like palace, which came to be known as Sanssouci (literally, "carefree"; 1745–47). Frederick designed it with his architect Georg Wenceslaus von Knobelsdorff, whom he had sent to train in Rome, Venice, Florence, and Paris. Realized with the assistance of decorators from the Hoppenhaupt and Spindler families, who

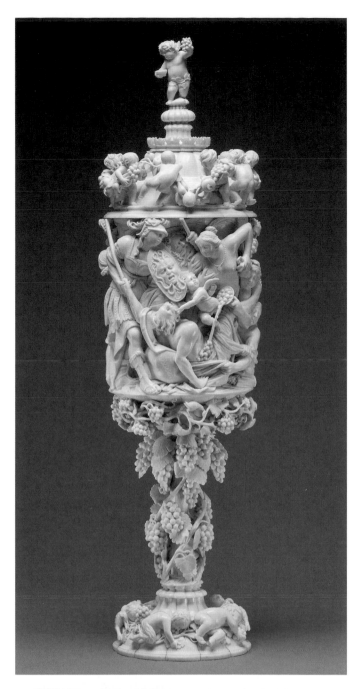

Fig. 11.37. Balthasar Griessmann. Goblet, Salzburg, c. 1680. Ivory; H. 20⅝ in. (52.4 cm). The J. Paul Getty Museum, Los Angeles (2006.26).

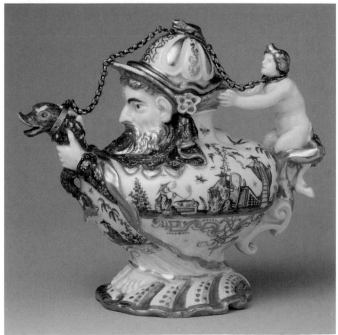

Fig. 11.38. Meissen Manufactory. Teapot, Meissen and Augsburg, 1719–30. Painted decoration by Sabina Aufenwerth. Porcelain; 6¹⁄₁₆ x 6⅞ x 3⅞ in. (15.4 x 17.5 x 9.8 cm). The Metropolitan Museum of Art (1970.277.5a, b).

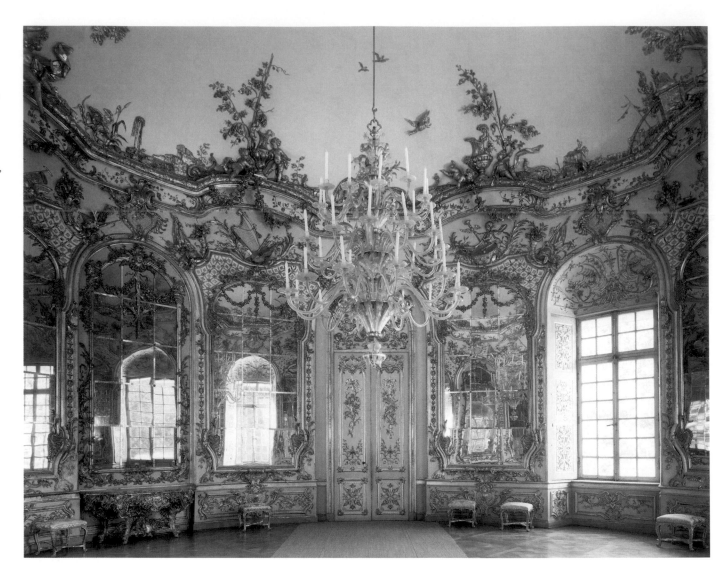

drew on models from France and the Netherlands, Sanssouci embodied the vivid Prussian style sometimes referred to as Frederician Rococo. The Rococo's fullest realization in German lands, and perhaps all of Europe, however, was the pheasant-hunting lodge of Amalienburg (1734–39) designed by François de Cuvilliés (1695–1768) for Prince-Elector Karl Albrecht of Bavaria on the grounds of the Nymphenburg summer palace outside Munich (fig. 11.39). Cuvilliés, a Walloon born near Brussels, studied architecture in Paris alongside Germain Boffrand in the early 1720s, and his work complements trends observed at the Hôtel de Soubise (discussed above). His designs for the pavilion's small pink and yellow bedrooms reflected the French preference for the intimate niche bed, while the central Spiegelsaal (mirrored salon) illustrated here took its pastel blue and silver color scheme from the arms of the Wittelsbach, the ruling Bavarian dynasty. The room's matching stools and pier tables, also designed by Cuvilliés, harmonized with the paneling. Like Boffrand, Cuvilliés minimized the architectural elements, giving prominence to scenes of fountains, putti, nymphs, nets, animals, and soaring birds by stuccoist Johann Baptist Zimmermann (d. 1758). The giddying effect was akin to stepping into a Rococo ornament print, brought to life through the use of mirrors, crystal, glass, and silver foil.

SCANDINAVIA AND RUSSIA

During the seventeenth and early eighteenth centuries, Scandinavia, which also saw the growth of absolutist courts, became increasingly open to ideas from Germany, France, and the Netherlands. Much of the nobility in the kingdom of Denmark, which controlled Norway until 1814, was of German descent, and most Danish guilds sent journeymen south to Augsburg and Nuremberg. Amsterdam's assumption of the lucrative Baltic trade in grain and timber after 1600 extended Dutch commercial, political, and artistic influence, while British demand for Danish timber and iron after the Great Fire of London (1666) greatly increased trade between the countries. These commercial ties fostered the spread of Anglo-Dutch furniture forms, including fall-front writing desks, chests of drawers topped by tall cabinets and bookcases, and carved and caned high-backed chairs whose popularity makes it difficult to distinguish imported British examples from the products of Baltic and Scandinavian makers (see fig. 12.40). Indeed, so-called "English" chairs were so widespread in Stockholm that an early Georgian-style example was depicted on the new trade card of the city's chairmakers' guild in 1765, long after such chairs had gone out of fashion in London.

Lutheran Sweden emerged as an independent nation under Gustav Vasa in the 1520s and became a European power after his grandson Gustavus Adolphus (r. 1611–32) established a Baltic empire embracing Finland, Estonia, Livonia, and Pomerania. Gustavus Adolphus's defense of the Protestant cause in the Thirty Years' War quickened the flow of ideas and objects. In gratitude for his support, the city of Nuremberg sent Gustavus two covered goblets in silver by Christoph Jamnitzer (1563–1618) in the form of Atlas and Hercules supporting the celestial and terrestrial globes. In Augsburg, the Protestant city councillors marked the (formerly Catholic) town's capitulation to Gustavus by presenting him in 1632 with an elaborate ebony *Schreibtisch* (writing desk) supplied by the patrician dealer-diplomat Philip Hainhofer. Like other showpieces of its type, this desk was less a working piece of furniture than a *Kunstschrank,* a tabletop version of the *Wunderkammer,* its contents ranging from ancient coins and cameos to modern ivories and intarsias (wood inlay), from mineral specimens, corals, rare shells, to a self-playing virginal, trick eyeglasses and gloves, and a variety of distorting mirrors. Topped with a detachable wine ewer fabricated from a Seychelles nut, or coco-de-mer, the cabinet displayed a range of *naturalia* and *artificialia* that made it a metamorphic microcosm of the universe.

Perhaps inspired by such treasures, Gustavus's daughter Christina (r. 1644–54; see fig. 11.2) became an avid collector and scholar who immersed herself in the study of languages, art, music, and philosophy and elevated Stockholm to an important cultural and artistic center. As queen, Christina recruited foreign artists and craftsmen to her court, including the French miniature painter Paul Signac (1623–1684),

who established a school of enameling. While still in Paris, Signac made a watchcase for the queen in 1646 (fig. 11.40). Originally encrusted with 575 diamonds, the watch's enameled gold cover celebrated Christina through scenes and emblems drawn from court ballets. In an echo of Rubens's Triumph of the Eucharist tapestries, the exterior shows the queen's chariot vanquishing her enemies, surrounded by Strength, Justice, and Prudence; on the reverse Christina triumphs by sea, alluding to Sweden's defeat of the Danish navy at the Battle of Fermen in 1644. Inside the lid, the queen appears as Diana and her opponents as captured predators, while on the watch face, invoking old notions of monarchs as timekeepers, a motto exhorts her to "make the laws and follow them yourself."

Christina's penchant for political symbolism was manifested in court pageantry and ceremonial. For her coronation in 1650, strategically delayed until the conclusion of the Thirty Years' War, a Roman-style triumphal arch announced her imperial ambitions, while her throne, in silver (crafted by Abraham Drentwett in Augsburg), featured large figures of Justice and Prudence. Just four years later, however, Christina converted to Catholicism and renounced her title in a formal reverse-investiture. Within hours, her cousin Charles X (r. 1654–60), who had worn black at the abdication, was crowned in a golden costume with embroidery acquired in Paris. Despite spending much of the next thirty-four years in voluntary exile in Rome, Christina continued to influence Swedish taste by introducing visiting students from Sweden, such as the architect Nicodemus Tessin the younger (1654–1728), to Italian luminaries including Bernini, a personal friend, and Carlo Fontana, an architect from Ticino. As Swe-

<div style="writing-mode: vertical-rl">EUROPE</div>

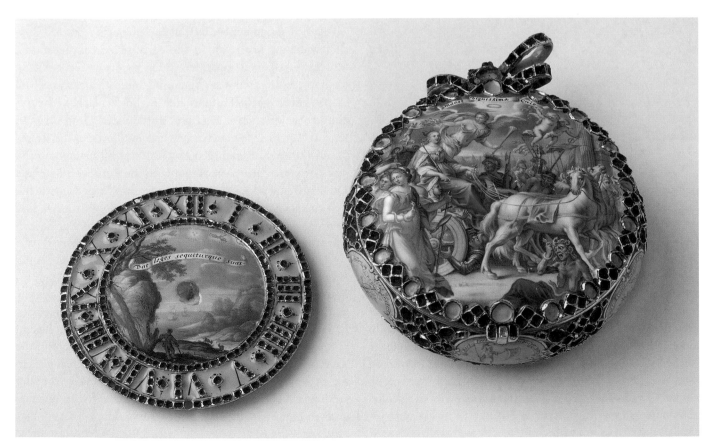

Fig. 11.40. Attributed to Pierre Signac. Watchcase, Paris, 1646. Gold, enamel, originally set with diamonds; Diam. 3¼ in. (8.4 cm). Kungliga Hovstaterna/ The Royal Court, Sweden (SS 244).

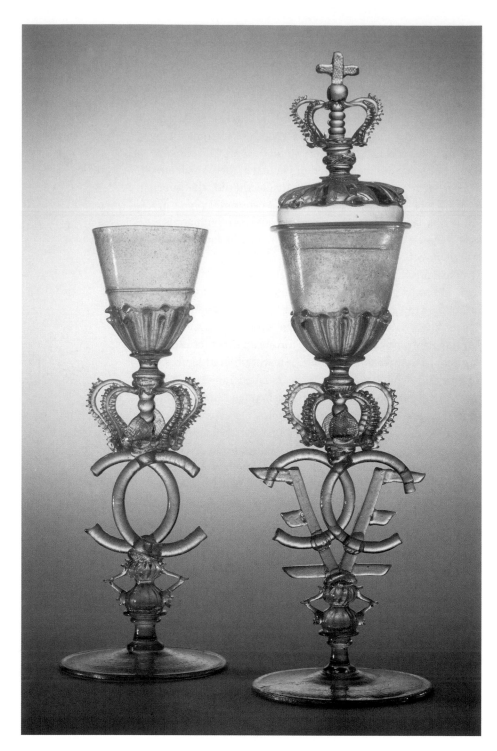

as drinking glasses of Venetian-style *cristallo*. Transferred under local management to Kungsholm in 1686, the glassworks survived until 1815. Like other Venetian-inspired enterprises, Kungsholm specialized in twisting and tooling tall stemware into serpents, dragons, and three-dimensional flowers. Its famous "monogram pokals," likely produced for the royal wedding of King Charles XI of Sweden and his Danish queen Ulrika Eleonora in 1680, featured large crowns and royal ciphers—intertwined Cs and CUE—in their stems. These matrimonial goblets were as fragile as Baltic politics. Contracted in 1675, the marriage was delayed when Denmark declared war on Sweden and was concluded only after Charles triumphed on the battlefield.

Russia, by contrast, remained largely outside the orbit of the rest of Europe for much of the seventeenth century. After a protracted "Time of Troubles," the election of Mikhail Federovich in 1613 as the first Romanov czar brought a period of peace that fostered renewed investment in commerce and manufactures, including decorative arts. Production of glass, polychrome ceramics, enamels, and printed textiles expanded, while the traditional prestige sectors of embroidery and goldsmithing were revitalized by the recruitment of master craftsmen from the Ukraine and Belorussia, then part of the Polish-Lithuanian Commonwealth. The Romanovs resurrected the royal workshops at the Moscow Kremlin in order to produce jeweled objects for secular and ecclesiastical use. Indeed, those two realms remained tightly linked. As the Orthodox church's foremost protectors after the fall of Byzantium in 1453, the czars—a title adopted in 1547 by Ivan the Terrible to evoke both Roman Caesars and Old Testament kings—were crowned by the Patriarch of Moscow and saw it as their duty to present church treasuries with precious icons, coverings for books, altars and reliquaries, vestments, and jewel-studded crosses.

The changing appearance of such objects reflected Russia's widening horizons. In the early seventeenth century, Moscow craftsmen extended their repertory by reviving medieval motifs from Kiev, including fantastic beasts, as well as pre-Christian techniques like niello, a blackened compound of copper, silver, lead, and sulphur inlaid into silver. In later decades, the Western specialists employed at the Kremlin encouraged an embrace of greater polychromy and the more dynamic forms associated with the European Baroque. Russian metalworkers blended these new trends with the traditional technique of encrustation, wherein pearls and colored gemstones were applied to gold or silver surfaces in ways that evoked embroidery and luxurious textiles.

The monumental chalice illustrated here was made at the Kremlin workshops in 1695 for the Cathedral of the Assumption in Rostov (fig. 11.42). Although Russian silver was rarely marked at that time and never identified the maker, an elaborate inscription names the patron as the Metropolitan Bishop of Rostov and Yaroslavl, formerly reponsible, as abbot of the Kremlin's Chudov monastery, for arranging liturgical gifts to the provinces. Reflecting its Eucharistic function, the cup section is inlaid with scrolling vines, overlaid with jeweled ovals in high relief depicting the Crucifixion, Christ in majesty, the Virgin Mary, and John the Baptist, the last three

Fig. 11.41. Kungsholm Glass Works, possibly by Jean Guillaume Reinier. Monogram pokals, Stockholm, c. 1680. Glass; left, H. 12¼ in. (31.2 cm), right, H. 17¼ in. (43.7 cm). Nationalmuseum, Stockholm (NMK CXV 1701 and NMK CXV 183).

den's court architect, Tessin played a crucial role in spreading Franco-Italian design to Scandinavia.

Sweden's embrace of the Baroque is manifest in a group of ambitious glass goblets, or pokals, produced in Stockholm around 1680 (fig. 11.41). Like other courts, Sweden sought to reduce its dependence on luxury imports, and despite the Venetian Republic's strict attempts to monopolize the glass industry, by the seventeenth century former Murano craftsmen had spread the secrets of Venetian glass production to Spain, France, England, Germany, Austria, Bohemia, and the Netherlands. Swedish glass greatly improved after 1676 when the "Marquis Giacomo Guagnini" (in reality a wayward monk named Giacomo Bernardini Scapitta) arrived with two skilled glassblowers from Amsterdam and secured a royal patent for a small furnace to produce window and mirror glass as well

forming the traditional Deësis inherited from Byzantine art. The foot boasts niello roundels depicting eight Orthodox Christian feasts, while winged seraphs and cherubs, also in niello, decorate the central knop. The vessel thus exemplified Russia's position between East and West, balancing Byzantine motifs including *vyaz,* a form of Cyrillic calligraphy, as well as floral arabesques derived from Eastern silks, with a classical solidity and sculptural realism indebted to the Italian Renaissance. The richness reflects Russia's long tradition of liturgical splendor.

By the late seventeenth century, Czar Peter I "the Great" (r. 1682–1725) recognized that Russia was lagging behind much of Western Europe and launched a comprehensive modernization of government, church, and society. Ostensibly seeking allies against the Turks, in 1697–98 Peter broke six centuries of isolation by visiting Prussia, England, Austria, and the Netherlands, where he spent four months honing his naval skills in the Dutch East India Company's shipyards. Peter's "Westernizing" policies included the forced adoption of Western European-style dress and the abolition of beards among boyars (aristocrats) and government officials, subject to an annual fine. He also ended Russia's system of arranged marriages and eased social restrictions on women. Most importantly for the arts, in 1703 he founded the city of St. Petersburg on land recently won from Sweden, designating it his capital in 1712 and inviting Jean-Baptiste Alexandre Le Blond (1679–1719), a disciple of the French gardener Le Nôtre, to Russia to submit an ideal master plan (1716, unexecuted).

After the acquisition of Ingria, Livonia, Estonia, and Karelia, Peter proclaimed himself Emperor of All Russia in 1721, the same year he unveiled his sprawling palace complex at Peterhof (Dutch, "Peter's court") near St. Petersburg. This "Russian Versailles," complete with a garden cascade featuring gilded statues celebrating Russia's victory over Sweden, and French-style Rococo interiors by the Parisian carver and designer Nicolas Pineau (1684–1754) stood as an expression of Peter's modernizing ideals. For his personal use, he preferred the smaller, Dutch-inspired retreat of Monplaisir (French, "my delight") in the gardens below, an unpretentious red-brick summerhouse overlooking the Gulf of Finland. In this consciously modest setting, the czarina supervised the Delft-tiled kitchen while the czar worked in a Chinese-style study embellished with ninety-four panels of red, gold, and black lacquer. Long assumed to be Asian originals (a logical supposition given Russia's proximity to China), they have recently been recognized as Russian imitations made by painters from the Admiralty Department, perhaps inspired by similar efforts in France, Germany, and England. Russian Chinoiserie seems less a reflection of the nation's far eastern border than of its leader's determination to import Western modes.

In Peter's day, the impact of his reforms was largely limited to those in the military establishment, imperial court, and state administration. Popular material culture shifted at a much slower pace, reinforced by the entrenched serfdom that would not disappear until the mid-nineteenth century. The same was true of much of Europe. While the ecclesiastical, political, and commercial elites fostered the experiments and innovations charted in this chapter, most people continued to live much as they had for centuries. In spaces inherited from their ancestors, self-assembled, rented from the rich, or exchanged for labor, they lived surrounded by goods fashioned from humble materials according to well-established patterns. For every elite table set with Rococo silver, there were thousands of laboring and artisan families who ate off plain trenchers of wood or pewter while seated on sturdy communal benches crafted by village joiners. Yet the continent's material futures were beginning to expand, and even if most Europeans made do with far less luxurious, old-fashioned, or secondhand goods, scholars have shown that the "consumer revolution," long identified with the rise of steam power, had its roots generations and even centuries before. Strong as courtly models of design, production, and distribution remained in 1650, and even in 1750, it was increasingly the urban workshop, open market, and ever more informed and demanding consumers that brought echoes of royal and aristocratic forms and styles to steadily expanding sectors of the population.

JEFFREY COLLINS

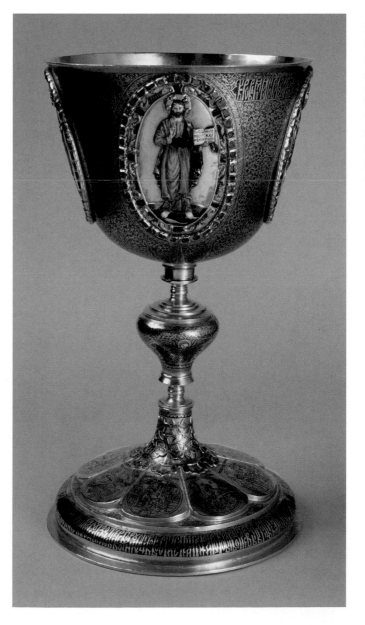

Fig. 11.42. Chalice, Kremlin workshops, Moscow, 1695. Gold, gemstones, niello, enamel; 12¾ x 7⅜ x 7⅜ in. (32.5 x 18.7 x 18.7 cm). State Historical and Cultural Museum-Preserve "The Moscow Kremlin" (19818 oxr/ MR-1855).

THE AMERICAS

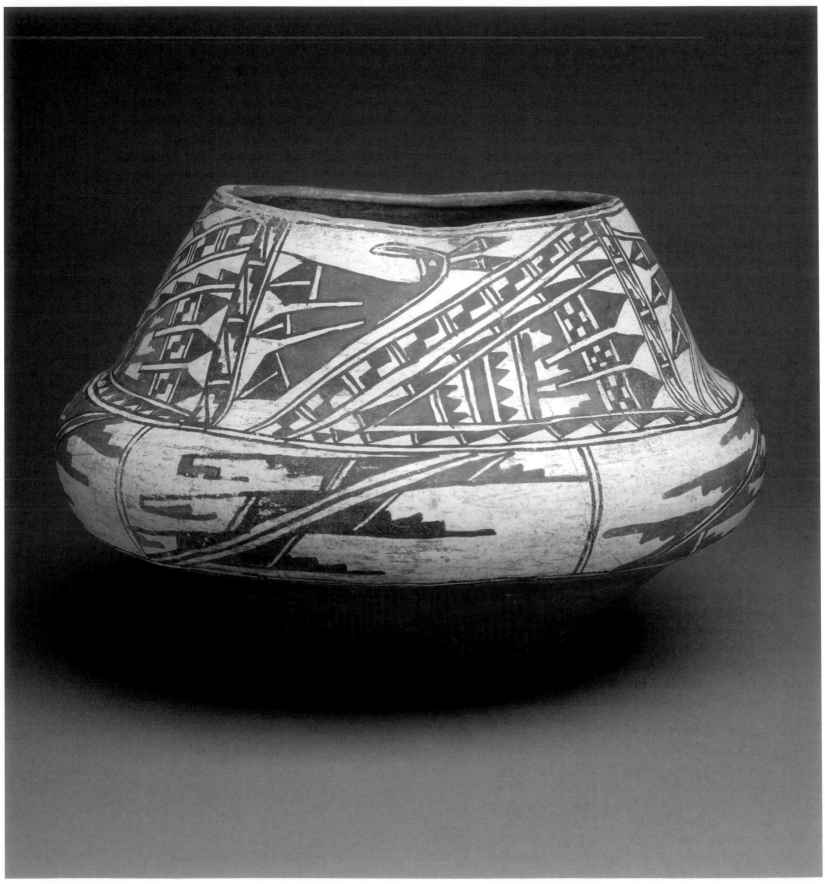

Fig. 12.13

INDIGENOUS AMERICA: NORTH

In the seventeenth century, new and highly prized European trade goods began to enter North America through the growing colonial settlements along the East Coast and in the Southwest. The establishment of fisheries and a fur trade precipitated alliances (and counter-alliances) between Aboriginal groups and English, French, Dutch, and Spanish settlers. Unfamiliar commodities brought by these Europeans entered into and transformed existing networks of trade and travel. This back-and-forth consumption of goods was in many ways a creative process that involved the imaginative and adventurous appropriation of new objects and ideas, but it was in other ways destructive. Europeans, for instance, carried infectious diseases that ravaged Native populations and caused massive cultural dislocations; the introduction of alcohol and gunpowder exacerbated the situation.

Against the backdrop of colonial wars, encroaching farmsteads, and the influence of missionaries, trade brought both new pressures and opportunities for Native artisans. Novel European fashions began to influence Native American styles of coats, boots, and headwear in many corners of the continent. European trade silver replaced shell neck collars, or gorgets, as status-conferring ornaments worn by high-ranking chiefs in the East and Midwest. The crucifix and other Christian symbols began to be embroidered, beaded, or quilled on garments and other goods, sometimes used along with symbols of traditional Native spiritual practices. And yet, across the continent during the early decades of colonization, Aboriginal artisans also continued their traditions of design and craft making unabated, still untouched by the shock of arriving settlers.

SYMBOLS OF POWER IN NORTHEAST QUILLWORK

A British royal charter in 1670 granted the Hudson's Bay Company a monopoly on trade that covered the entire Hudson Bay drainage region, an area of 1.5 million square miles. The fur trade became a lucrative enterprise for the company and brought many an adventurer to North America to work alongside Native trappers, traders, middlemen, and explorers in the fledgling industry. The northern Cree, an Algonquian-speaking people of the eastern and western James Bay region (at the southern end of Hudson Bay), traded with both the British and French, who competed for the Cree's wares.

The neck ornaments and belt illustrated here were made by a Cree woman—among many Native groups, quillwork was usually women's work—on the James Bay coast in the late seventeenth century (fig. 12.1). Early British traders acquired these pieces in the same period, and the survival of some of these objects makes them among the earliest known examples of porcupine quillwork in existence. These startlingly colorful accessories, beautifully decorated and meticulously crafted, would have been worn on the body during a dance, festival, or other community gathering. The dangling tassels, made of hide backings covered with tightly wrapped, colorfully dyed porcupine quills, would swing and sway as the body moved to the beat of a drum. Public celebrations to mark events such as the shifting seasons, a successful hunt, or the joining together of families were occasions for elaborate costuming among many North American Native peoples. Elaborate quillwork decorations almost certainly conveyed

Fig. 12.1. Neck and arm ornaments and belt, Cree, James Bay coast, 1662–76. Birch bark, porcupine quills, vegetable fiber thread, hide, red ocher, metal cones, animal hair; necklace, L. 34⅝ in. (88 cm). Canterbury Cathedral Archives, England (B58i-iii).

tions. Plains robes were made from the single large hide of a buffalo, elk, deer, or sometimes a horse, and were traditionally worn over the shoulders by men with the opening in the front and the painted images facing outward. Preparing the hide was a time-consuming task that required stretching, careful scraping, and water-soaking to remove the flesh. The final tanning process used a solution made from the animal's own brain matter, which contained enzymes that softened the rough hide, making a pliable surface suitable to wear against the body, particularly on chilly winter evenings.

Early recorded history in the eighteenth century indicates that three basic types of painted robes were created and used on the Plains. Winter counts were pictorial records of events that occurred in a given year (marked from one winter to the next), arranged in a calendar-like fashion to show extended tribal history. Other robes, now known as pictographic exploit robes, by contrast, recounted the personal histories of individuals, such as the great battles of a warrior. Both of these robe types were painted by men. A third category, geometric robes, were painted by women. These designs included abstracted animal forms or centrally placed sunburst patterns and other geometric motifs similar to those they beaded on garments, bags, and other objects.

Painted on a buffalo hide with the hair removed, the robe illustrated here follows, in storyboard-fashion, the exploits of a warrior (fig. 12.4a–b). Such a robe would have functioned as a mnemonic device to assist the owner in tracing his personal narrative of battles, great hunts, coups (feats of bravery), negotiations, and important meetings. The narrative is rendered in discrete scenes linked by visual clues such as human or animal footprints. A striking aspect of pictographic hide painting in this period is the apparent lack of facial features on the people depicted—a device that would normally help distinguish different historical actors from one another. The bodies and faces are curiously bereft of physiognomic detail: torsos are reduced to simple trapezoids with sticklike appendages as arms and legs, while heads are depicted as circles. Such attributes are also typical of the historic, and even prehistoric, rock painting of the Plains, suggesting that this tradition of representation stretches far back in time.

Despite their lack of specificity, the figures depicted on the robes were neither anonymous nor fictitious. Robes recounted stories of actual people and events and included depictions of accessories, such as shields, headdresses, horses, or haircuts (which had a special significance to men on the Plains). These conveyed identity. The painter of this robe devoted great attention to capturing the intricacies of a warrior's shield, which is drawn as a circular object connected to an arm (fig. 12.4b). This robe has ten separate shields, each featuring a different configuration of color, feather placement, or unique symbol such as a centrally placed bear. On some robes, shields were repeated, indicating the reappearance of a person in the narrative. In contrast to the empty faces, the shields were rich in detail—sumptuous visual feasts.

Thus, in early pictographic robe painting, we find a system of representation that relied mainly on the use of symbolic attributes, including depictions of a person's most meaningful possessions such as a sacred shield or pipe, to reveal identity. The use of a man's shield or pipe to symbolize his identity on robes can best be understood in terms of a cosmology that was shared among the people on the Plains. A shield and its design were the sacred property of a person, a source of great power to the shield's owner, and became, in effect, a man's "medicine," used to gain access to the world of spirits and spiritual forces. Shield designs were created after a personal vision quest or fasting, or during a religious ceremony at which time a person might also assume a new name. The act of painting a shield was linked to the acquisition of a person's actual identity and denoted his changing social status within the community. For the robe painter, depictions of a person's shield, rather than realistic portrayals of his body and face, were the most effective way to convey a person's true status.

HAIDA IMAGERY AND IDENTITY

The pictographic robe suggests one way of representing individual identities through design in Native North America. Related to the concept of identity is the question of *personhood*, that is, how different cultures create categories of "being-ness," distinguishing between persons and nonpersons. Cultural anthropologists investigate how different cultures shape their own categories of personhood, and how these categories are both supported through cosmologies and reflected in everyday cultural practices, like design or decoration. Although ethnohistorical research shows that Native people of North America held divergent views about personhood, a common view was the capacity for animals or other entities to be person-*like*, possessing an inner consciousness or will, and to be deserving of moral concern. For example, at the close of the nineteenth century, historians recorded the stories of Ojibwa hunters along the Great Lakes who viewed some thunderstorms, lightning, or pieces of lustrous quartz as "living" entities endowed with their own spirit, sharing many attributes of humans. Similarly, in the Canadian arctic, Inuit poured fresh water into the mouth of a seal after it was caught, in the belief that seals, like normal humans, enjoyed the taste of water; once satiated, the seal's spirit will remember the hunter's kindness and return again in the future to provide meat. Imagining personhood not as an innate property belonging to humans but as a moving category that can be extended to flora, fauna, and other materials affords us a wider context for appreciating the meanings and uses of ritual objects, designs, and motifs in Native life.

For the Haida, the Indigenous peoples of Haida Gwaii (the Queen Charlotte Islands), along British Columbia's coast, individuals became socially recognized persons in the context of their clan lineage. Social life was hierarchical and structured, with the community divided into two moieties, Raven and Eagle, and subdivided into clans or lineages—each with its own set of rights and entitlements to both real and intangible property, such as access to a repository of names, or the privilege to sing songs, tell stories, and perform certain dances. Mirroring the human world, the animal world was

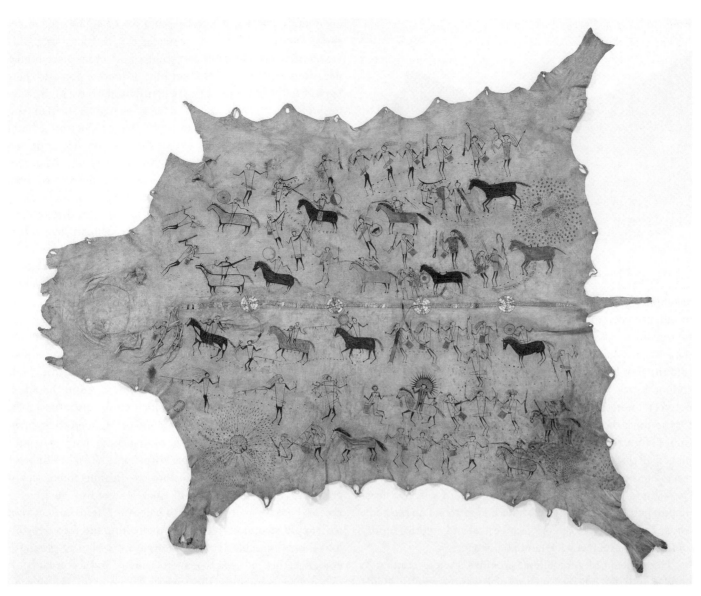

Fig. 12.4a–b.
Pictographic exploit
robe and detail, Mandan
Sioux, early 19th
century. Buffalo hide,
porcupine quills,
pigments; 97¼ x
43¾ in. (247 x 111 cm).
Musée du quai Branly,
Paris (71.1886.17.1).

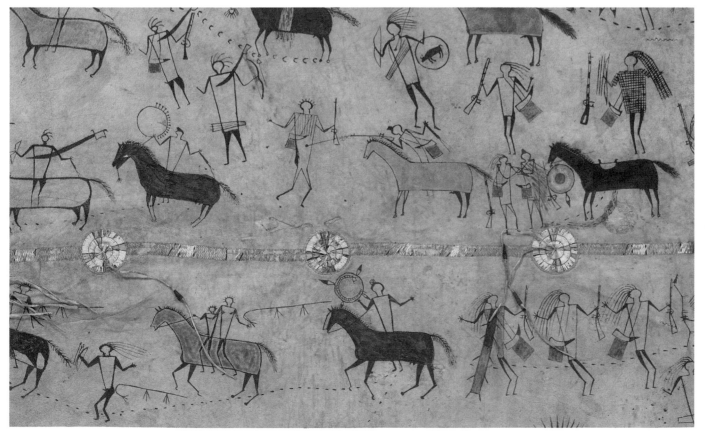

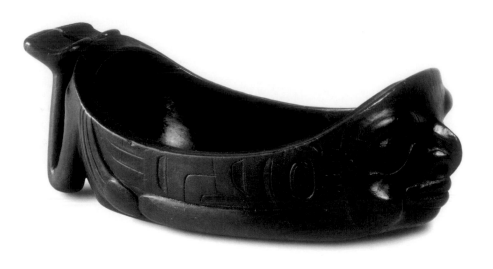

eighteenth century, it is representative of a late precontact carving style found in the region. Serving as a feast dish, this vessel was used during Potlatches and other ceremonial occasions at which large quantities of food and goods (perhaps even the bowl itself) were distributed from a high-ranking chief to invited guests. The presence of British and American traders influenced both the production of and demand for objects made by Indigenous peoples along the Northwest Coast by the late eighteenth century. The new wealth generated from the trade in sea otter pelts spawned a flourishing of carving, as chiefs sought increasingly elaborate ways to signify their growing status and wealth through art. For carvers, the abundance of iron tools brought by traders facilitated the production of their work. They also "miniaturized" their carvings on argillite, a black rock found on Haida Gwaii, and created pipes, bowls, and figures as souvenirs for the traders.

The Haida's sophisticated graphic style is based on a systematic arrangement of a limited repertoire of shapes joined together by flowing lines to create human–animal forms. The distinctive style, aspects of which were shared throughout much of the Northwest Coast, likely developed in the north among the Haida, Tlingit, Tsimshian, and northern Haisla, centuries before first European contact. Dubbed the "formline system," it was a painted graphic scheme that began with the application of evenly spaced primary (black) shapes—ovoid, triangular, and U-shaped forms—forming likenesses of creatures recognizable by distinctive features such as a raven's beak, beaver tooth, or whale fin. The painter would then apply secondary (red) lines in the interstitial spaces, followed by a possible tertiary color, usually blue or green, to embellish the spaces between the primary and secondary colors and to help unify the various elements of the design. Painters often included clever visual puns, with faces emerging from within the eyes or mouth of other creatures, or through intentionally ambiguous blendings of human and animal beings. This system could also be rendered through bas-relief carving. A combination of both flat and rounded formline is evident in this unpainted feast dish, in which the formlines wrap tightly around the side of the bowl and are rendered in deeper relief on the figure's face. The carvers and painters along the Northwest Coast refined an elegant, visual language that combined an aesthetic sense of purpose and artistry with social and mythic meaning.

also highly hierarchical, with some animals, such as the raven or killer whale, considered the most powerful with the ability to transform at will into human-like beings. Clans traced their origins back to supernatural animals who transformed into the first humans and migrated onto the land. Thus, personhood was a dynamic process involving transformation between animal and human bodies, which acted like vessels for the spirit. Because each clan had its own heraldic "crests" (most often represented by animals), design and craft have played an important (and ongoing) role in Haida life to communicate social identity to others. Mythic clan animals were carved and painted on house poles, boxes, tools, and feast dishes; painted on woven bark hats; and tattooed on the body. These crests bespoke a person's ancestral and mythic identity and situated him in a wide familial lineage.

The concept of personhood provides a wider context to understand the imagery on the eighteenth-century Haida bowl illustrated here, which depicts a being in transformation between human and bird (fig. 12.5). Haida visual culture frequently evokes the supernatural animals that bestowed social identity and reminds others of the rights and entitlements inherited through clan identity. The image, carved in low relief on the bowl, depicts a human-like figure resting on its stomach, with upward-facing arms along its sides. The carver implied feathers by cutting out bowlike negative shapes along the bulging sides of the bowl. Taken together with the beaklike nose of the figure's face, the carver has suggested a transformation between a human and a bird, or alternatively, a human-like bird. Such imagery evokes the dynamic quality of personhood in the Haida world and reminds his audience of the mythic ancestors of the dish's owner, the beings through whom his personhood was established.

This bowl was obtained from the Haida at Haida Gwaii in 1787 by Captain George Dixon, who served under Captain James Cook during Cook's voyage up the northwest Pacific Coast of America. Estimated to have been created early in the

The vignettes presented in this chapter exemplify a few of the different cultural expressions in various regions of North America and provide evidence of the long history of craft and design predating European settlers. These visual languages and craft and design traditions continued into later periods, while some of the examples given in this chapter foreshadow the creative integration of ouside materials and designs that came with the arrival of more settlers in the later periods.

NORMAN VORANO

INDIGENOUS AMERICA: SOUTH

In the seventeenth and early eighteenth centuries, silver—extracted from rich mines in Potosí, Bolivia, and northern Mexico, in cities like Zacatecas and Tasco—nourished the visual and material culture of Spanish America. From the 1570s onward, a fleet of galleons loaded with silver ingots and coins made annual transits across the Pacific Ocean to the city of Manila in the Philippines which was under Spanish rule and an entrepôt for Asian goods. The returning galleons carried porcelain, silk, inlaid furniture, and spices, as well as slaves. As Spanish America became deeply involved in global trade networks, its urban centers became settings of extraordinary spectacle and dramatic displays of the empire's wealth, and increasing numbers of luxury commodities were consumed.

A painting created in the 1690s by one of the most famous painters of Mexico City, Cristóbal de Villalpando (c. 1649–1714), highlights the central plaza of this urban capital—one of the largest and most ethnically diverse cities in the contemporary world, and the seat of the viceroyalty of New Spain (fig. 12.6). The Parián—a large, open-air, rectangular structure depicted at the center of the scene—was a main marketplace for Asian and other luxury imports. The image shows indigenous people plying their wares, confirming the consumer desire and mercantile verve of Mexico City, and the presence of thriving indigenous craft production and consumption.

Until the mid-1980s, some scholars portrayed the seventeenth and early eighteenth centuries as a period of decline in indigenous visual material culture, but scholars since then have demonstrated that this was far from the case. Pre-Hispanic customs, beliefs, and material traditions did not persist unchanged; even before colonization, indigenous culture was not static. Among the dominant changes in the colonial period was an increase in what today is referred to as hybridity: a mixing and juxtaposition of objects, styles, and techniques of diverse sources, some indigenous, some European, others African or Asian. How often and in what ways native people of the period noted this range of resources is unknown. More often than not, visual and material culture seems to have warranted little explicit commentary. Yet for viewers today, the mix of visual genealogies experienced, if not also embraced, by indigenous people of the period is striking.

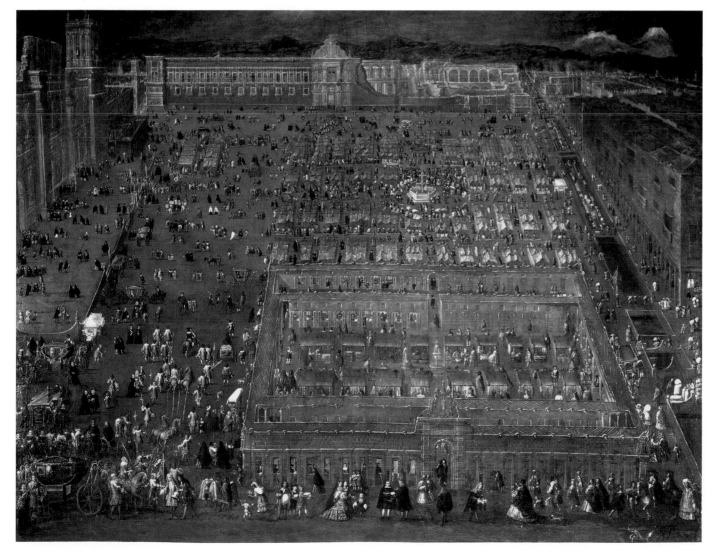

Fig. 12.6. Cristóbal de Villalpando. View of Plaza Mayor, Mexico City, c. 1695. Oil on canvas; 70⅞ x 78¾ in. (180 x 200 cm). Corsham Court, Wiltshire.

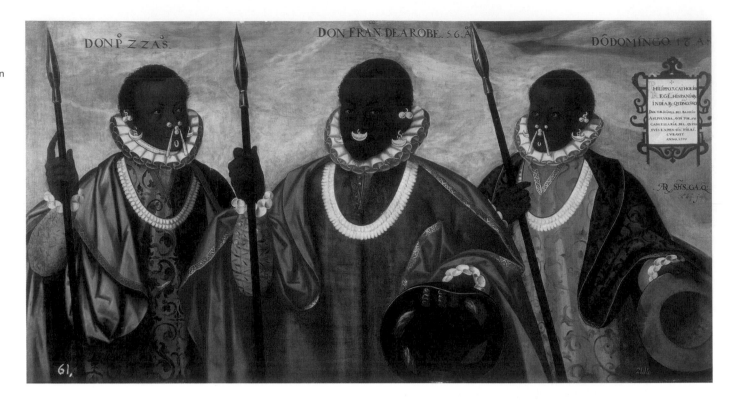

Fig. 12.7. Andrés Sánchez Gallque. *The Mulatto Gentlemen of Esmeraldas*, 1599. Oil on canvas; 36¼ x 68⅞ in. (92 x 175 cm). Museo de América, Madrid (00069).

Fig. 12.8. Tray (*batea*), Peribán, Michoacán, 17th century. Lacquered wood, inlaid pigments; 3⅛ x 22¼ x 22¼ in. (8 x 56.5 x 56.5 cm). The Hispanic Society of America, New York (LS1808).

We sense something of this mix from a painting of Don Francisco de Arobe, Don Pedro, and Don Domingo (likely a father, at center, and his sons), dressed in their sartorial best (fig. 12.7). Created in 1599 by Andrés Sánchez Gallque (act. c. 1585–1615), an indigenous painter trained by Dominican friars in Quito, the painting commemorates a truce forged among leaders from the region known today as Esmeraldas in Ecuador and representatives of the Spanish Crown. The documentary intention of the painting is underscored by the fact that it was commissioned by a colonial official, Juan del Barrio de Sepulveda, and sent to Spain to King Philip III (r. 1598–1621)—a pictorial confirmation of the bond between this South American community of people of African and indigenous descent and the foreign power that ruled over them.

The first known signed portrait to survive from Spanish America, this painting boldly juxtaposes native gold and spears with imported silk and lace. The spears suggest the military roles of these leaders, while their formal clothing, most likely assembled in Quito, perhaps for the portrait itself, reveals a mix of European and indigenous influences. The men sport ruffled collars and cuffs, a style introduced to the Andes from Europe, but they also wear Andean-style tunics (*unqo*) and capes, whose foliate patterning and sheen suggest they are made of imported cloth. The gold jewelry hanging from their ears, lips, and noses has antecedents in pre-Hispanic goldwork for native elites, as do their shell necklaces. On the cusp of the seventeenth century, such jewelry functioned as a sign of "indigenous otherness" for Europeans. It, along with the abundance of luxury fabrics, also signaled the persistence of indigenous wealth.

It is difficult to know who would have made these collars and tunics, but indigenous hands most likely crafted the gold and shell ornaments. Almost every object made in the New World involved indigenous makers at some moment of its creation—be they woodworkers roughing out figures in a

workshop, or master painters like Diego Quispe Tito (1611–1681) painting a canvas—even though many items cleaved to European models. In the early seventeenth century, in his *Memoriales* (1609–24), Bishop Alonso de la Mota y Escobar (1546–1625) praised the work of Totonac carpenters in Hueytlalpan, Puebla, who made beds, chairs, writing desks, and footstools out of walnut and other local wood. This furniture, like other household furnishings made by indigenous craftsmen, was probably very similar to if not indistinguishable from that made by the Europeans who emigrated to the New World and their Creole (people of European descent born in the New World) brethren. Europeans living in the Americas and the native elite might have bought furniture made by native carpenters, as would Creoles.

In Mexico City soon after the conquest, Spanish immigrant craftsmen formed their own guilds along European models, a system that was well-developed by the seventeenth century. Guild members were forbidden from buying the work of native carpenters and carvers for resale, and the regulation suggests that some could (and did) pass off indigenous work as their own. All too often, indigenous craft traditions and aesthetics of the seventeenth and early eighteenth centuries have been "invisible" in histories of the period. While the hand of indigenous creators is often not immediately evident in particular objects, other historical sources tell of the participation of native craftspeople in the creation of a range of goods, frequently ones that circulated well beyond the Americas.

In northern Mexico, Antonio Vásquez de Espinosa, a traveling Carmelite (act. 1612–30), noted in his *Compendio y descripción de las India Occidentales* that among the Purépecha people, there were ingenious carpenters who made *escritorios y escribanias*—portable writing desks derived from Spanish models that were a prized and necessary household item among Creole elites. The Purépecha were famed throughout New Spain and Spain for their use of a lacquer inlay technique—one that probably drew upon both pre-Hispanic and Asian sources (fig. 12.8). In pre-Hispanic times, artisans used *aje* (a fatty substance secreted by insects) with *chia* oil and mineral compounds to create a paste that could be layered. After building up multiple layers of this lacquer, carvers engraved designs into the surfaces of the gourds, bowls, and furniture; inlays of powdered pigments made possible objects of many colors. Tightly packed figures and dense design work, as seen here, were common in the seventeenth century; at this time, designs often had European sources although in the eighteenth century, decorative elements of Asian inspiration became more prevalent.

Also in the north of Mexico, indigenous potters in the town of Tonalá, near Guadalajara, created red ceramic drinking vessels called *búcaros*, made of fragrant clay and based on Portuguese *búcaros* popular in the Iberian peninsula. By the seventeenth century, the production center in Tonalá competed with others in Nata (near Panama) and Chile, all supplying American versions of the prized red-slipped earthenware—called *búcaros de Indios*—to the export market (fig. 12.9).

In Peru, textiles for upscale homes in Lima and other urban centers were fashioned in a variety of fibers. The large bed or table cover in figure 12.10, for example, was woven of cotton, linen, silk, and wool. The various materials—especially the silk and linen—indicate that textiles were expensive, while the combination of threads of different densities, textures, and elasticity speaks to the extremely high skills of the weavers, some of them almost certainly native Andeans. The patterns reveal the influence of trade networks that bound Peru to Europe and Asia. The repeating peony flowers and mythical beasts of the design were inspired, at least in part, by Chinese textiles imported in the seventeenth century (see fig. 7.4), while the cover features both crowned lions derived from European imagery and frolicking llamas, which were unique to the Andes. Textiles like this were probably

Fig. 12.9. *Búcaros de indios*, Tonalá, Guadalajara, 17th century. Earthenware. Museo de América, Madrid.

Fig. 12.10. Bed or table cover, Peru, late 17th–early 18th century. Wool, silk, cotton, linen; 93¹³⁄₁₆ x 81⅝ in. (238.3 x 207.3 cm). Museum of Fine Arts, Boston (11.1264).

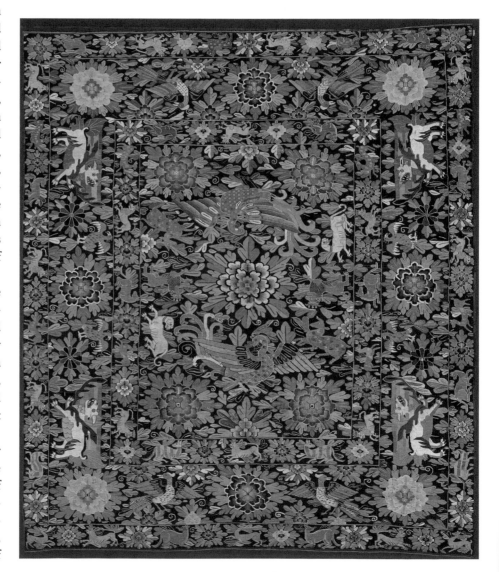

woven in a workshop under a master weaver, whose social standing was far beneath the urban patron for whom he worked. The "trace" of indigenous handwork in such objects is not always easily seen. This was less true for objects made for and used in indigenous communities, such as the Andean textiles discussed below.

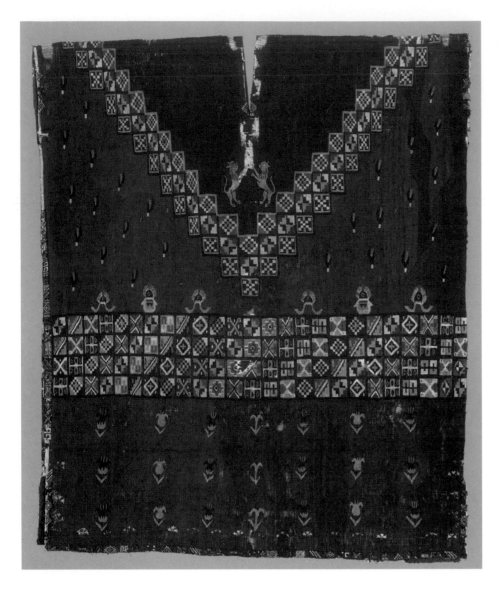

Fig. 12.11a–b. Man's tunic (*unqo*) front and back (detail), southern Andes, probably 17th century. Llama wool, cotton; 35 x 29¾ in. (88.9 x 75.6 cm). Private collection.

WEAVING

In both New Spain and the Andes, textiles were a focus of indigenous labor and aesthetic creativity in the period 1600 to 1750. Andean examples have survived in greater numbers, and men's tunics stand out for the quality of their design and use of materials. Typically woven from local cotton and llama wool and shaped along lines reminiscent of pre-Hispanic clothing, they exhibit signs of cross-cultural exchange. The *unqo* in figure 12.11a–b, for instance, probably dates from the seventeenth century, made for an elite indigenous man. Its shape emulates tunics of the Inka (Inca) Empire, with the v-slit at the neck and a decorated yoke and band across the waist. The geometric patterns—zigzag at the yoke and stacked in rows to form a thick horizontal band at the waist—are known as *t'oqapu* and are direct references to Inka tunic designs (see fig. 6.19). Yet at the neck, two rampant lions appear, and on the reverse, in the same position, the weaver has added a bicephalic eagle (fig. 12.11b), the emblem of the European Habsburg Empire, whose domain included Spain and Spanish America until the ascent of the Bourbons to the Spanish throne in 1700. Beyond iconographic references to colonial motifs on such *unqos*, the mottled purple background may be an Andean interpretation of European *torna-sol* textiles, which employ contrasting blue and red warp and weft fibers in order to catch the light and shimmer. If this is correct, it suggests that the visual effects of such Andean tunics called attention not only to ancient models of elite dress that remained known in the region at this time but also to high-status European imports.

In shape and materials, a seventeenth-century tunic in the collection of the Museo Inka, Universidad San Antonio Abad del Cusco, resembles those woven in the sixteenth century. Its small size suggests it was worn by a child or a *santo de vestir*, a religious statue designed to wear clothes. While the embroidered *t'oqapu* have indigenous, Andean origins, the Habsburg heraldic lions and Christian orb with cross are postconquest motifs. At the bottom of the tunic, alphabetic lettering spells out (in reverse) the name "Diego Dias," which may refer to the tunic's patron. If so, it directly connects the textile to a person, a rare case in Spanish America. The lettering also reveals something of the weaver's working method. The garment fabric was double-faced: meticulously woven so that both sides were finished, yet its maker chose (coincidentally or otherwise) the side that faced away from the weaver during the process of weaving as the outside of the garment. An effect of this decision is reversed lettering. The name "Diego Dias" reveals a familiarity with, and commitment to, alphabetic expression. If this tunic was, indeed, donned by a saint's figure, then it also evokes a culture at once strongly indigenous, colonial, and Christian—a combination born of political and military force but cultivated in unique ways by the indigenous residents of Spanish America.

Woven shoulder bags from the Andes, often created to carry coca leaves, have also survived from this period. Stimulants—yerba mate (a species of holly), chocolate, and tobacco—were part and parcel of everyday life in Spanish America, with coca the most widely used among native Andeans of all classes. Thus, it seems likely that the small bag in figure 12.12 was produced and used in an Andean community, probably one in Bolivia. Using an elaborate weave of camelid fibers, its maker possessed a keen aesthetic sense. The division into three vertical panels and the juxtaposition of geometric and plantlike forms create a balanced yet vibrant design, suggesting that color, pattern, and form were integral to textile aesthetics in the colonial Andes.

THE MEANING OF MATERIALS

Indigenous ceramics also responded to European influence, including the introduction of certain technologies in the seventeenth century, but responses varied in different areas. In northern New Spain, in what is now the southwestern United States, for instance, Zuni potters created vessels such as the boldly patterned object in figure 12.13. While their names are rarely known today, Pueblo women bore primary responsibility for making ceramic jars during the colonial period, with men often painting the vessels. As with most Pueblo ceramics, this jar was hand-built from coils of local clay (not thrown on a potter's wheel) and painted with locally made earth and mineral slips.

Other vessels of the sixteenth and seventeenth centuries employed glazes made of powdered glass that melted in firing. Although not introduced by the Spanish, they appeared frequently on ceramics created for Spanish missions and their trade networks. While revealing much about seventeenth-century ceramic-making in Pueblo communities, the particular choices on the part of this vessel's makers also suggest how indigenous resistance to colonial rule could be embedded in material form and visual expression. The iconography—a design of abstract feathers and birds—had a long history in Zuni Pueblo. Matte-slip decoration, seen here, existed before the Pueblo Revolt of 1680–92, when Pueblo peoples rose up against the Spanish in the region, expelling priests and destroying missions. Its use on this vessel shows a return to using matte slips after a period of heavy use of glazes. Recently, scholars have suggested that the return to matte slips in the wake of the revolt may represent an intentional break from vitreous glazes, which were more strongly associated with mission culture. From this example we sense how indigenous visual culture and its technologies could both respond to overt political acts such as a revolt, and express desires for autonomy.

Indigenous *keros*, drinking cups made in the Andes in pairs and used in rituals of reciprocity and political allegiance, also show evidence of material and visual changes. Typically used to drink maize beer, *keros* did not feature mimetic imagery prior to the arrival of Europeans. By the seventeenth century, however, *keros* such as the one in figure 12.14 were decorated with pictorial scenes. Prominent themes in surviving examples include kings and queens standing below rainbows, pumas, enemies in defeat, agricultural scenes, dances, and battles. This example refers to pre-Hispanic history both in form and iconography. In the upper register, the Inka engage in battle with indigenous rivals; an agricultural scene appears in the lower portion. The battle scene includes rituals that took place during harvest season and involved

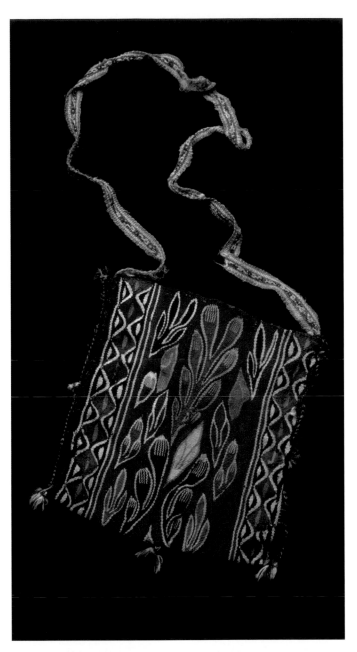

Fig. 12.12. Coca-leaf bag (*chuspa*), Andes (probably Bolivia), 17th century. Camelid fibers; without strap, 7½ x 6½ in. (19 x 16.5 cm). San Antonio Museum of Art (86.43).

Fig. 12.13. Storage jar, Zuni Pueblo, northern New Spain, 1680–1700. Clay with earth and mineral slips. School for Advanced Research, Santa Fe (IAF.1).

Fig. 12.14. Drinking cup (*kero*), Peru, late 17th–18th century. Wood, *mopa-mopa* inlay; 7⅞ x 6⅛ in. (20 x 15.6 cm). Brooklyn Museum (42.149).

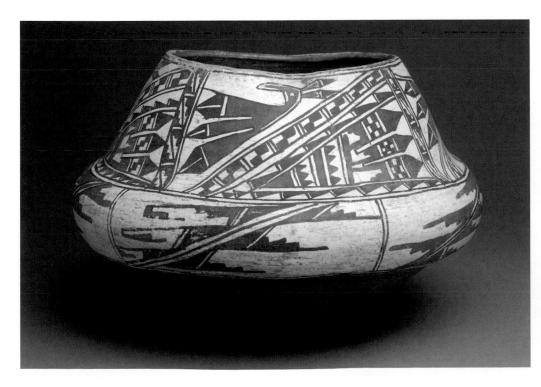

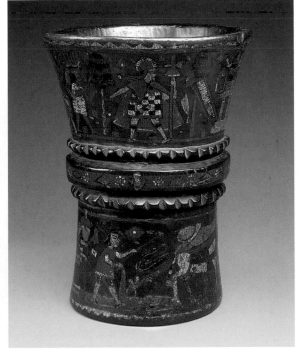

ritual drinking, thus linking the imagery with the function of the cup.

The materials used to make *keros* offer clues to complex systems of exchange. Tropical hardwoods, often used for the bodies of such cups, were imported into the Andes from Amazonian regions. The colorful designs inlaid into their outer surfaces were made of *mopa-mopa*, a gumlike substance that also originated in jungles to the east of the Andean communities where *keros* were used. (When applied in elaborate, lacquer-like inlays to decorate Spanish-style furniture, such as writing desks, *mopa-mopa* decoration is called *barniz de Pasto* after one of the colonial centers of production, which is today in southern Colombia.) Other examples of indigenous drinking vessels were made of silver. Silver *keros* were made before the arrival of Europeans, and seventeenth-century examples—like those of wood and *mopa-mopa*—testify to continuities in material use, even as designs and native political rituals shifted to take into account colonial realities. Interestingly, some of the best-known examples of silver *keros* are those recovered from the 1622 shipwreck of the *Nuestra Señora de Atocha*, found off the Florida Keys, revealing that some native pieces were dispatched to Europe.

CROSSING CULTURAL BOUNDARIES

If indigenous objects from this period evoked pre-Hispanic histories, and at times may have rejected European influences (as the Zuni example above suggests), indigenous people also embraced ideas and styles from outside their communities. The taste for elaborate Baroque objects, which infused Creole visual and material culture of the period, however, was not foreign to indigenous elites from urban centers in both New Spain and Peru. Portraits show that such people were concerned with luxury products and social standing (see, for example, figs. 12.7, 18.7). No less important were objects that appear in settings indicative of the cultural

appropriation and reuse of indigenous-made objects and traditions. For instance, in the mid- to late eighteenth century in New Mexico, Apache parfleches—painted hide envelopes made to carry a variety of indigenous objects—were sometimes recut and fashioned to create covers for record books of baptisms and marriages either by indigenous people or perhaps by friars serving in indigenous communities.

The *biombo*, or folding screen, in figure 12.15 illustrates the permeation of indigenous visual culture in Creole and Spanish urban centers. Such screens took their cues from Asian imports and were luxury items in well-to-do homes. This one, from the late seventeenth century, was likely made in Mexico City. The festival scenes unfold against the backdrop of a Mexican village, spreading across ten panels. At the center is a popular *volador*—or flying—performance. A tall pole has been erected and indigenous men, dressed in the outfits of conquistadors, fly around the pole, attached by ropes. Elsewhere indigenous men dressed in consciously "antique" Aztec garb—including feathered headdresses and loin cloths—dance, while in the foreground indigenous women serve *pulque*, a fermented brew made from the maguey plant. Elite Spaniards and Creoles witness the festivities.

From this object, we see the continued presence of indigenous performance culture in colonial New Spain, both as painted image and living spectacle. It suggests the importance of indigenous practices linked to ritual and spectacular display, both within native communities and in imprinting Spanish-American traditions more broadly. The hybrid origins of the *biombo* (as an Asian object type made in New Spain) and its iconography (with "Aztec" dancers commingling with Creole elites) portray something of cosmopolitan indigenous visual culture in the late seventeenth century. This would change in the late eighteenth and across the nineteenth century, as outsiders' ideas of indigeneity focused increasingly on pre-Hispanic models—especially those of the Aztec, Inka, and Maya.

DANA LEIBSOHN AND BARBARA E. MUNDY

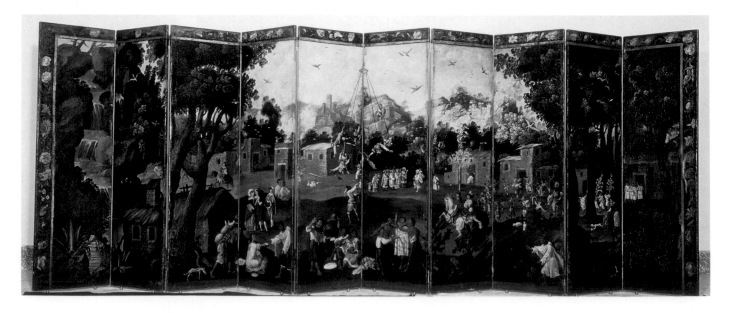

Fig. 12.15. Folding screen (*biombo*), probably Mexico City, c. 1690. Oil on canvas; 5¾ x 16½ ft. (1.8 x 5.1 m). Museo de América, Madrid (06538).

SPANISH AND PORTUGUESE AMERICA

By the dawn of the seventeenth century, Spain and Portugal's policies of conquest and religious conversion, and their rapacious pursuit of wealth, had consolidated political and economic structures into a system that funneled the fruits of indigenous and imported African labor to a prosperous colonial elite in the Americas. In settled areas, most native inhabitants had accepted Christianity, although missionary efforts continued on the northern frontier of the Viceroyalty of New Spain (present-day Texas and the southwestern United States) and in inland South America. From 1609, priests from the Society of Jesus established semiautonomous *reducciones* or *reduções* (forced gatherings) of Guaraní and Chiquitano peoples in the jungles and lowlands of Paraguay, Brazil, Argentina, and Bolivia. As Counter-Reformation "soldiers of the pope," the Jesuits supplemented or supplanted the mendicant friars, who were increasingly subordinated to a parish-based clerical hierarchy more closely linked to Rome, the local diocese, and the crown. A parallel push to streamline civil administration prompted fiscal and bureaucratic reforms, including the creation in 1717 of the Viceroyalty of New Granada out of Peruvian territory as a bulwark against British incursions in the Caribbean. Refounded and expanded in 1739, New Granada encompassed today's Panama, Colombia, Ecuador, Venezuela, Guyana, and parts of Brazil, Peru, Costa Rica, and Nicaragua.

The decades after 1600 also witnessed crucial demographic shifts. Although an estimated 250,000 Iberian conquistadors, missionaries, priests, and *encomenderos* (lay settlers) had arrived in the 1500s, they still comprised a mere sliver of the population. Even in Mexico City, the 5,000 or so Spaniards inhabiting the central *traza* (gridded quarter) by 1600 were outnumbered by tens of thousands of native people in surrounding swampy *barrios*. Yet these numbers mask the devastating increase in the rate of indigenous mortality caused by forced labor and imported diseases, which reduced the Americas' native populations by as much as 90 percent. The death toll and trajectory varied by region: whereas Caribbean Indians were largely extinct by 1600, and indigenous groups in Venezuela, Chile, Argentina, Paraguay, and parts of Brazil declined throughout the colonial period, those in central and southern Mexico, highland Central America, and the Andes gradually recovered from their low points. In some rural areas, life largely continued on traditional lines despite the change of religion and overlord.

By contrast, cities and towns—the focus of this chapter—were dominated by residents of European descent, including both foreign-born, usually transient *peninsulares* (Iberian peninsulars) sent on government service, and native-born, often extremely wealthy *criollos* (Creoles). Derived from the word *criar* (to raise or rear), the latter term designated the ethnic Spaniards born in the Americas, who were proud of their Iberian ancestry but politically subordinated to, and culturally distinct from, new arrivals.

The *criollos'* position between two different cultures informs a portrait by Miguel Cabrera (1695–1768) of Don

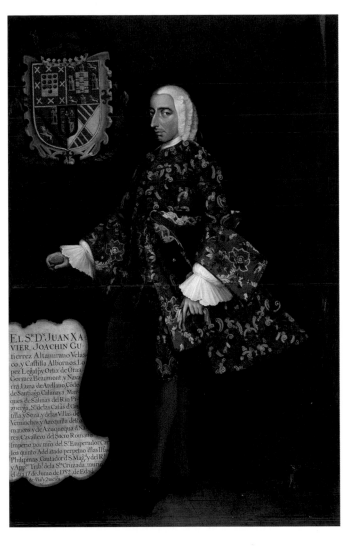

Fig. 12.16. Miguel Cabrera. Portrait of the seventh Count of Santiago de Calimaya, Mexico, c. 1752. Oil on canvas; 81⁵⁄₁₆ x 53½ in. (206.5 x 135.9 cm). Brooklyn Museum (52.166.1).

Juan Xavier Joaquín Gutiérrez Altamirano Velasco, y Castilla Albornos, López Legaspi Ortiz de Õraa Gorraez Beaumont, y Navarra (1711–1752), seventh Count of Santiago de Calimaya (near Toluca) and seventh Marquis of Salinas del Río Pisuerga in Castile and León (fig. 12.16). Reflecting Renaissance and Baroque models, this American descendant of two viceroys stands at a richly carved table with a cloth enumerating his titles beneath an enormous quartered coat of arms. While such bombast was outmoded in Spain itself, the count's up-to-date French-style costume conforms to Bourbon modes introduced by Philip V of Spain (r. 1700–24), including a powdered wig and tricorn hat, patterned coat with red lining, contrasting *chupa* (waistcoat) and turned-up sleeves, knee breeches, and long-tongued, silver-buckled shoes. By contrast, the exuberant, Asian-style floral and feathered brocades—whether imported from Manila or imitated in Mexico—exceeded contemporary Iberian norms and seem designed to underscore the count's honorary title as life governor of the Philippines, a title inherited from his ancestor who had annexed them for Spain in the 1560s. With its mix of stiffness and flamboyance, the portrait evokes the blend of conservatism and extravagance (not to mention East and West) associated with *criollo* taste.

Although Don Juan Xavier would have understood the term *criollo* as a mark of racial purity, today the words "creole" or "creolized" are more typically applied to hybrid languages or peoples produced through cultural and ethnic fusion. This early semantic shift paralleled demographic realities, as Ibero-America's indigenous and European communities were joined by growing numbers of free and enslaved Africans, as shown in images like the 1599 *Gentlemen of Esmeraldas* (see fig. 12.7) and Albert Eckhout's 1641 portraits of Africans in coastal Brazil (see figs. 10.2 and 10.3). These transplants were supplemented by occasional immigrants from Asia and above all by an expanding population of *mestizos* (of Iberian and Indian descent), *mulatos* (of European and African ancestry, especially in Brazil and the Caribbean), and other mixed-race *castas* (castes; see fig. 18.17). The resulting social, cultural, and aesthetic creolization—Cabrera himself was a *mestizo*, while the Rococo table he depicted may have been made by a native joiner (fig. 12.16)—complicates easy ethnic or aesthetic distinctions.

It can be just as awkward, if not outright misleading, to apply Old World labels to New World products. Just as "the Baroque" followed different forms and timelines in Madrid, Puebla, and Quito, Ibero-American objects and spaces drew on multiple craft and aesthetic traditions to answer local needs. Rather than prioritize style, medium, or perceived ethnicity, this chapter therefore focuses on three interwoven themes—modes of production and consumption that harnessed indigenous talent for European markets, inspiration from Asia, and the endurance of religion—that shaped products made in or for viceregal America's expanding urban centers.

MAKING AND CONSUMING

The early establishment of guilds reflected anxieties over indigenous competition and a concern for social status. Admission was usually limited to master craftspeople of European blood, sometimes with further restrictions against converted Jews or Muslims. The potters' guild, founded by three emigrant Spaniards in Puebla in 1653, is a case in point. Besides establishing levels of quality—utilitarian (*loza amarilla*), "everyday" (*loza común*), and fine (*loza fina*), soon followed by an even more "refined" (*refina*) type—guild ordinances stipulated that master potters must sign their wares, undergo yearly examinations, and be of pure Spanish descent. Yet in Puebla, as elsewhere, indigenous talent proved an irresistible resource, both because there were not enough European-descended craftsmen to supply the burgeoning colonial markets and because Indians were willing to work—and to sell their wares—more cheaply. Indeed, throughout Ibero-America, legal prohibitions on native craft labor were routinely evaded. European shops simply hired *mestizo* and mulatto artisans outright (as in Puebla) or subcontracted work out to them (as at Huejotzingo; see fig. 6.24), and indigenous artisans established alternative illegal guilds of their own (as with the prolific associations of Afro-Brazilian silversmiths).

Another example of the channeling of indigenous ideas, materials, and labor toward European markets comes from the unglazed ceramics produced with local aromatic clays and colored slips (*engobes*) by native potters at Tonalá near Guadalajara (west of Mexico City, in the present state of Jalisco), much of which was for export to Europe. Termed *búcaros de Indios* after Italian and Spanish prototypes, these vessels were lionized by elite collectors for the sweet taste they imparted to water and by women who believed—to the detriment of their health—that eating the cups themselves improved their complexions. While smaller *búcaros* retained indigenous forms (see fig. 12.9), larger water jugs or vases (termed *tibores* or *archibúcaros*) echoed the European amphorae (round-based containers developed in the ancient Mediterranean) that carried wine, oil, and foodstuffs to the New World (fig. 12.17).

The inventive potters of Tonalá embellished that utilitarian form with rampant lions, bicephalic eagles, and lambs from the Spanish Habsburg arms. Some examples added

Fig. 12.17. Water jar or vase (*tibor* or *archibúcaro*), Tonalá, late 17th–early 18th century. Earthenware; 32⅞ x 23 x 23 in. (83.5 x 58.5 x 58.5 cm). Museo de América, Madrid (04898).

relief-molded heads, sheep, or pomegranates, while all featured sculptural lids and carved or gilded stands that gave the jars an architectural grandeur. By the late seventeenth century, such *archibúcaros* adorned palaces in Rome, Florence, and Turin, quenching aristocratic thirsts for water perfumed by American clay.

A second New World specialty drew on indigenous traditions of decorating organic surfaces with colored, water-resistant gums and oils, termed *pinturas* (paintings) or *barnices* (varnishes) in early sources but now generally called lacquerware or "japanning." Instead of using the sap of the Chinese lacquer tree (*Toxicodendron verniciffuum*, not present in the New World), artisans used various other recipes, according to region. In the towns of Peribán and later Pátzcuaro in the Mexican province of Michoacán, for example, Purépecha craftsmen mixed fats derived from female scale insects (*Coccus axin* or *aje*) with oil from the seeds of *chia* (*Salvia hispanica* or *chián*) or poppy (*chicalote*) plants to make a paint used to decorate desks, boxes, chests, trays (*bateas*; see fig. 12.8), gourd bowls (*tecomates*), cups (*jícaras*), and other domestic implements and furnishings with vivid colors on a dark ground (often black or red). Although produced in the rural west, all were popular in Mexico City and widely documented in colonial inventories beginning in the sixteenth century.

By the mid-eighteenth century, Michoacán lacquer workers were producing wares that melded Asian and European prototypes, with *bombé* profiles and cabriole legs terminating in bold ball-and-claw feet. Some of the finest were produced and signed by the workshop of the native nobleman José Manuel de la Cerda of Pátzcuaro. These included trays, wardrobes, desks, and cabinets featuring scenes of the *criollo* elite courting or conversing among weeping willows, butterflies, and pagodas inspired by European *chinoiserie*—a reminder that for all its direct contacts with Asia, Ibero-America interpreted the East partly through fantasies and paradigms imported from the West. A related lacquer industry in Olinalá (in the present Mexican state of Guerrero) used only *chia* oil and perfected a *rayado* (scored) technique by which differently colored strata would be layered then cut away to produce contrasting, often boldly stylized figural and vegetal decoration in low relief.

In South America, a separate lacquer tradition known as *barniz de Pasto* (varnish from the city of Pasto) was followed by native or *mestizo* craftsmen in the Andean regions of Colombia, Ecuador, highland Peru, and Bolivia. The practice was based on a resin obtained by boiling the leaf buds of the *mopa-mopa* tree (*Elaeagia pastoensis*). After an initial purification, the sticky resin was kneaded or chewed to incorporate organic and mineral colorants (including annato for red, indigo for blue and black, and indigo mixed with a powdered yellow root for green) and stretched into paper-thin sheets from which designs were cut, sometimes backed with reflective foils, and heat-fused to the wooden surface. First used to decorate indigenous beakers or *keros*, *mopa-mopa* work was soon applied (perhaps at the initiative of a local *encomendera*) to a wide range of European-style secular and religious objects, such as drop-front desks, chests, coffers, bookstands, picture frames, and table implements.

Fig. 12.18. Portable writing desk (*escritorio*), Pasto, c. 1680. Wood, *barniz de Pasto*, silver fittings; 7⅞ x 14¼ x 12¼ in. (20 x 36 x 31 cm). The Hispanic Society of America, New York (LS2000).

Among the finest surviving examples of *mopa-mopa* work is a portable *escritorio* (writing desk) made in Pasto around 1680 for Don Cristóbal Bernardo de Quíros, twelfth bishop of Popoyán (Colombia), as a gift for his brother, secretary to King Charles II of Spain (r. 1665–1700; fig. 12.18). While the form is Spanish, its interpretation was inflected by sixteenth-century *namban* lacquer cabinets imported to the Spanish Americas from Japan (see fig. 1.29), named after non-Asian "southern barbarians"—initially Portuguese traders and missionaries in Japan, but later Spanish and Dutch—who eagerly purchased them. On the *escritorio*, the inside of the lid features the Quíros coat of arms, flanked, as in the Tonalá *tibores*, by lions and heraldic-looking parrots, and surrounded by a riot of foliage incorporating European grapes, Asian peonies, Turkish-style carnations, and a Chinese or Japanese squirrel-and-grapevine motif (known from lacquers imported from Okinawa), here reinterpreted with South American monkeys. Although the exterior has darkened, the vibrant colors on the inner lid, drawer fronts, and writing surface convey how effectively *barniz de Pasto* evoked both Asian lacquers and polychrome porcelains.

Central Europe also provided models, as seen in the prolific, if unexpected, production of marquetry-inlaid furniture in the town of Villa Alta de San Ildefonso, a remote customs outpost in the province of Oaxaca, some 200 miles southeast

of Mexico City on the route between the Pacific and the Gulf port of Veracruz. Local Dominicans seem to have given indigenous woodworkers from the barrio of Analco access both to German boxes and desks imported from Augsburg and Nuremberg (well-documented in sixteenth- and seventeenth-century Mexican inventories and themselves inspired by Spanish models) and to a rich variety of European ornamental and figurative prints. Using these prototypes, the craftsmen of Villa Alta became famous for employing local materials to produce ornamental trunks, chests, coffers, *papeleras* (writing cabinets with drawers and compartments), *bufetillos* (small cabinets), and other portable boxes. One seventeenth-century chronicler reported that the town's furniture was renowned even in distant Spain and Italy for its exquisite craftsmanship and use of aromatic native woods, including cedar, mahogany, ebony, *granadillo* (also known as maca-wood, kira, or trebol), and aloe- or eaglewood.

The sophisticated objects produced at Villa Alta belie the town's provincial location. They featured ambitious depictions of Christian subjects (Adam and Eve in Paradise, the Pietà, and the Stigmatization of St. Francis), mythological or allegorical motifs (Orpheus, the Sibyls, the bodily humors), and secular vignettes (promenading couples or, in one case, six gentlemen playing billiards), all surrounded by Renaissance and Mannerist strapwork, cartouches, masks, and grotesques. One impressive *escritorio* (fig. 12.19) was likely commissioned around 1671 by Villa Alta's chief magistrate, Fernando Luis Altamirano de Velasco Legazpi y Albornoz, third Count of Santiago de Calimaya and an ancestor of the nobleman pictured in figure 12.16. While the exterior of the fall front offers a panoramic view of Villa Alta itself, with

the barrio of Analco pictured on the side, the interior writing surface and drawers depict the Four Elements, the Four Seasons, and the recently canonized St. Ferdinand III of Castile (r. 1217–52), who was the patron's namesake.

This coded iconography suggests the woodworkers' reliance on European woodcuts and engravings, an impression reinforced by the use of strong shading lines and volumetric hatching. Yet in Villa Alta, these lines were not burned into the wood with a hot tool, as in Europe, but rather incised with pointed chisels (as in the woodcuts or engravings that inspired them) and filled with *zulaque*, a tarlike paste of goat hair, burnt lime, linseed oil, and charcoal or colored vegetable dyes. Nor were the hundreds of individual components merely glued as in German workshops, but instead were pinned to the pine or red cedar core with contrasting wooden plugs, creating a distinctive, speckled appearance. If Villa Alta's labor-intensive methods bespeak local particularity, its products' international clientele suggests the cosmopolitan networks that brought distant design ideas and aesthetics to rural Mexico, to be reconfigured and exported in new forms throughout the Atlantic world.

ASIA IN AMERICA

Although Europe remained Ibero-America's primary source of imports in terms of volume, value, and often prestige throughout the period from 1600 to 1750, the Count of Santiago de Calimaya's silks and the popularity of domestic "lacquer" suggest Asia's growing importance as an alternative source of design ideas and object types. If the Americas were

not in fact the Indies, they offered a way station for Europe's commerce with the East. As early as 1604, the Spanish-born poet Bernardo de Balbuena (1568–1627) praised Mexico City as the place where "Spain and China meet, / Italy is linked with Japan, and ultimately / an entire world converges in commerce and customs."[1]

New Spain's intercontinental role was made official in 1565 with the establishment of the annual Manila Galleon (*Nao de la China* or *de Acapulco*), sturdy teak ships that left Acapulco each spring for the three-month trip to the Philippines (largely governed from Mexico City), where Mexican and Peruvian silver and cochineal (a red dye made from insects) were exchanged for luxury goods from all over Asia. After six- to nine-month return voyages, the galleons would unload at Acapulco, site of a booming trade fair, from which goods were shipped south to Panama City (and thence inland to Bogotá, Popoyán, and Quito) and Lima (whence to highland Arequipa and Potosí), or packed by mule train to northern locales as well as eastward to Puebla and then on to Veracruz on the Gulf Coast. Once laden, vessels from Veracruz (the *flota*) would proceed to Havana, joining *galeones* arriving from Cartagena (Colombia) and Portobelo (Panama), key transit points for ore and goods from South America, before the combined treasure fleet set out with an armed convoy for Cádiz and Seville in early summer, hoping to avoid hurricanes. The Portuguese colony of Brazil had even more frequent and direct contact with Asia. The Indian armadas (*Carreira da India*, literally "India run"), a Portuguese equivalent to Spain's Manila Galleon, stopped regularly at Salvador and Rio de Janeiro on voyages from Lisbon around the Cape of Good Hope to Portugal's lucrative trading colonies at Goa (India), Malacca (Malay Peninsula), and Macao (China).

Both the *Carreira da India*, which survived in diminished form until the opening of the Suez Canal in 1869, and the Manila Galleon, which functioned until 1815, were primarily designed to funnel Asian goods to Iberia. Yet at times, so many of these cargoes found intermediate buyers that Ibero-America occasionally led Europe in adopting Asian styles, ideas, and products. Mexico City—by 1600 the largest single market in the northern hemisphere—became the principal destination in Spanish America for imports from Manila, boasting, according to one Spanish visitor in 1574, "rich goods better than any to be found in Spain and more finished than anything of its kind in the rest of the world, such as satins, damasks, taffetas, brocades, gold- and silver-cloth, woolen shawls of a thousand kinds," as well as "chinaware finer than that of India, quite transparent and gilded in a thousand ways so that even the most experienced persons here cannot make out how it is made."[2]

Diffusion was not limited to the cities. Travelers' accounts, probate and estate inventories, and archaeological finds testify that Chinese porcelain was distributed as far north as today's Florida, Alabama, Arizona, and California. By one estimate, ten million pieces reached colonial Brazil, becoming so common and affordable that they could be acquired by slaves, used as chamber pots, or set by the thousands into church steeples. Asians traders, merchants, servants, slaves, and perhaps also artisans were present in both New Spain

and Peru, although their adoption of Christian names impedes identification in the archives. But mostly it was Asian goods that flooded American markets. Mexico City's Parián (see fig. 12.6), for example, set up in the Plaza Mayor by the Philippine traders' guild, echoed the Chinese neighborhood and market in Manila and gave a distinctly Eastern cast to material life in viceregal America.

One area of manufacturing that responded directly to Asian imports was wheel-thrown, tin-glazed earthenware, or *loza blanca*, known today as *mayólica*, first produced in Mexico City by the mid-sixteenth century. Although the goal, as in Europe, was to replicate the look of porcelain with opaque white glazes, Mexican ceramists soon developed their own aesthetic. By the seventeenth century, the city of Puebla de los Angeles had taken the lead, profiting from abundant local clays, talented indigenous potters from Cholula, and a strategic location on the Acapulco–Veracruz trade route. Puebla's finer wares—*loza fina* and *refina*, today often but erroneously called *talavera poblana* in honor of the Castilian ceramic center of Talavera—quickly became the most widely distributed forms of pottery in Spanish America.

Distinctive types included *lebrillos*, steep-sided, flat-bottomed basins introduced to Spain by Moorish potters in the ninth century and used for washing or as baptismal fonts; *albarelos*, tall pharmacy jars; plates, platters, and bowls for serving food; and large jars and vases (*jarrones* and *tibores*), some fitted with lockable iron lids (*chocolateros*) for storing precious cacao beans, vanilla, or sugar. Early wares looked to Talavera prototypes, employing strapwork or bobbin-lace patterns painted in purplish-black manganese, as well as Moorish designs from Valencian lusterware.

More typical of late seventeenth-century production were bold, freehand designs in imported cobalt oxide (used as a blue pigment) that riffed on the late Ming- and Qing-period blue-and-white wares passing in quantity through the town. Some featured landscapes with Chinese-style figures, while others, like a group of wares signed "he" and often attributed to the Spanish-born guild founder Damián Hernández (1607–1653; fig. 12.20), paired Asian motifs with European-style figures riding processional chariots derived from Italian mythological prints. Other typical motifs included meandering cloud forms, soaring parrots, long-tailed Guatemalan quetzals (inspired by Asian phoenixes), and leaping hares or deer.

By the early eighteenth century, Puebla design hewed more closely to Chinese models, sometimes adding Islamic motifs or characteristically Mexican repetitive patterns. Some Puebla vessels inspired by models originating in China's Wanli period (1572–1620) even substituted the traditional crane-on-bush image with a stork or eagle perched on a *nopal* cactus with a snake below, an explicit homage to the Aztec symbol of Tenochtitlan incorporated into the arms of Mexico City.

Besides being heavier than their Asian prototypes, what most distinguished the Puebla wares was the lavish use of cobalt pigment, often laid on in thick dots or blobs (a technique referred to in 1682 regulations as *aborronado* or

"blurred") to create a raised or dimpled surface. Such liberal use was itself a display of wealth, showcasing a costly commodity, cobalt, which, being unavailable locally, had to be imported from the Middle East or northern Africa via Spain, or from China.

Similar parading of foreign imports marked certain aspects of colonial architecture and clothing. Lima's Franciscans embraced splendor after the earthquake of 1655, using polychrome tiles imported from Seville when reconstructing their monastery's vestibule and main cloister, for example. Even the modest parish church of San Francisco Acatepec near Cholula (c. 1730) boasted a dazzling facade with columns, moldings, walls, and towers sheathed in custom blue, yellow, green, and red tiles. Secular buildings were also wrapped in permanent polychromy, as in Mexico City's famous Casa de los Azulejos, an older residence redecorated from 1737 for Doña Graciana Suárez de Peredo, the fifth Countess del Valle de Orizaba, who had previously resided in Puebla.

An interest in glittering surfaces fueled the taste for mother-of-pearl inlay, a technique introduced into Spain by Moorish craftsmen but popularized in New Spain and Peru by Asian furniture and decorations imported through Manila. Especially influential were the late sixteenth- and seventeenth-century Japanese *namban* crafts, including screens, boxes, and *maki-e* lacquerware with nacreous inlays (see fig. 1.29). Around 1660, *namban* wares inspired the

Fig. 12.20. Attributed to Damián Hernández. Jar with serpentine handles (*jarrón con asas*), Puebla de los Angeles, c. 1660. Tin-glazed earthenware; H. 18½ in. (47 cm). The Hispanic Society of America, New York (E991).

Fig. 12.21. Nicolás Correa. *The Wedding at Cana*, Mexico, 1693. Oil and mother-of-pearl on canvas; 22⅞ x 29¾ in. (58 x 75.5 cm). The Hispanic Society of America, New York (LA2158).

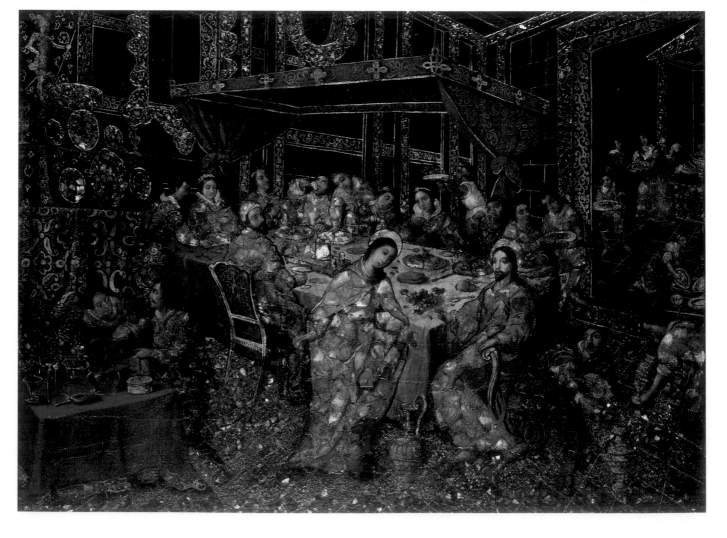

González family of lacquer workers and painters active in Mexico to create the first *tableros de concha y pintura* (pictures made of shell and painting) or *láminas de concha* (shell plates or sheets), but now usually called *enconchados*. This novel object type remained popular until about 1725. After attaching thin slices of shell to a wooden or canvas-lined support, and filling in the spaces with plaster and animal glue, the opalescent surface was overpainted in translucent tempera and oils. Powdered gold would sometimes be added (as in Asian *maki-e*), and the whole was sealed with a lacquer-like resin or varnish.

The resulting iridescence and shimmer—reminiscent of feather mosaics (see fig. 6.22)—was widely used for images of holy figures including the Virgin of Guadalupe, a famous apparition promoted by *criollo* patrons. Other popular subjects included the conquest of Tenochtitlan and the life of Christ; the frames (often featuring chrysanthemums, birds, and other Asian motifs) could be as elaborate as their contents. Sets of six, twelve, or even twenty-four shell pictures animated viceregal interiors or were mounted on folding screens, or *biombos* (from the Japanese *byōbu*, "wind wall").

One of the finest surviving examples, now without its frame, was crafted by Nicolás Correa (b. c. 1670/75), nephew of the successful mulatto painter Juan Correa (c. 1646–1716). It depicts the Wedding at Cana, the occasion of Jesus's first public miracle, set within a contemporary interior complete with a formal, canopied table (fig. 12.21). Pearly slabs beneath the figures' clothing evoke satins and velvets, while sparkling chips enliven the paved floor, framed mirrors, tapestry or leather hangings, and banquet silver arrayed on the credenza. This scene, created with an inspired fusion of Asian and Western techniques, epitomized the sumptuous interiors and luxurious displays valued by Creole elites.

A different form of encrustation marks an elaborate *contador* (bureau) on a matching *bufete* (table with drawers, fig. 12.22). Made in mid-eighteenth-century Lima, the *contador* was crafted in a technique typically reserved for small-scale boxes and trunks. The tiered composition follows German and Flemish precedents and evokes the ornamental stacking of *escritorios* in Iberian and Ibero-American salons. The architectural conception recalls European Baroque models, with twisted, Solomonic columns supporting an arcade and two undulating balustrades with vaselike finials (see, for example, figs. 11.13, 11.24). The surface is veneered in deep red and brown tortoiseshell, perhaps imported from the Caribbean, into which abstracted lozenges, floral garlands, garden parterres (complete with tulips), and Mudéjar star patterns are inlaid in mother-of-pearl.

Scholars have found formal precedents in seventeenth-century Korean Joseon ornament and in sixteenth- and seventeenth-century teak and mother-of-pearl caskets from Portuguese Gujarat in western India (see fig. 2.18), but inspiration may also have come from Asian textiles, such as the dark-ground brocades or embroideries worn by the Count of Santiago de Calimaya (see fig. 12.16). Unique to the New World were the painted panels depicting Christian saints, the Virgin Mary, and John the Baptist, inserted beneath flamelike patterns recalling the halos of Buddhist icons—a

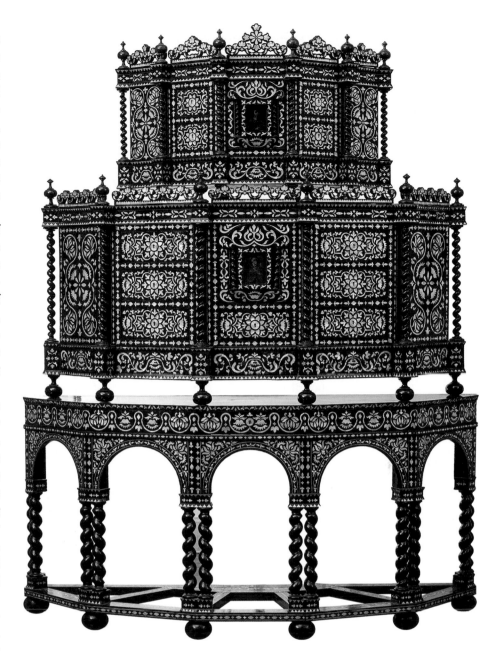

synthesis of form and motif that evokes Lima's position on the edge of the Pacific.

Whereas both Puebla's *loza fina* and *enconchado* inlays invoked the East primarily through surface decoration, the vogue in New Spain for folding screens marked the embrace of a specifically Asian form. Although the first such *biombos* were documented in Acapulco by 1598, the form's popularity took off after the 1614 embassy of Shogun Tokugawa Ieyasu was sent to King Philip III (r. 1598–1621) of Spain, during which 184 envoys bearing 5 crates of screens and other diplomatic gifts traversed Mexico on their way from Tokyo to Madrid and Rome. Rather than duplicate the delicate paper-and-bamboo construction of these imported screens (most of which were painted in ink or gouache), craftsmen in New Spain produced sturdier versions using oil paint on canvas or wood, sometimes with added gilding or inlaid mother-of-pearl.

Although some early *biombos* were clearly conceived in a Japanese style—including gold clouds floating in front of New World scenes—most ranged from simple flower-painted canvas or decorated leather to fanciful depictions of the vic-

Fig. 12.22. *Contador* on a *bufete*, Lima, mid-18th century. Wood, tortoiseshell, mother-of-pearl, silver, glass, oil paint; 94½ x 72¹⁄₁₆ x 24 in. (240 x 183 x 61 cm). Museo Pedro de Osma, Lima (0000010686-82.0.4103).

tory of Hernán Cortés over Moteuczoma II (r. 1502–20). Some two-sided *biombos* paired urban panoramas of Aztec Tenochtitlan under siege with its orderly Spanish successor, a clear paean to the virtues of royal rule. While functional, such screens were considered and inventoried as paintings, and later examples, signed by or attributed to important painters such as Juan Correa and Miguel Cabrera, introduced humanist themes including the Four Elements, the Four Continents, the Liberal Arts, or the Muses on Parnassus. By the mid-eighteenth century, perhaps inspired by Japanese models, popular subjects included leisure activities—gaming, dining, courting, music-making—to be enjoyed in Mexico City's *alameda* (a poplar grove on the site of an Aztec market) or the suburban estates and *haciendas* in nearby Tlalpan, a popular aristocratic retreat.

The prominence of these distinctly Mexican subjects, including views of indigenous performances like the *voladores* (see fig. 12.15), suggests the appeal of these screens to both patriotic Creoles and transient peninsulars, thus accounting for their presence in old Spanish collections. Like equally propagandistic *enconchados*, historical *biombos* bolstered America's ancient pedigree while visualizing the Conquest as the Habsburgs' valid defeat of a worthy imperial adversary. In New Spain itself, *biombos* were used in both churches and homes as shields against drafts and unwanted gazes, a key concern within Spanish etiquette. Screens of lower height (called *rodastrados*) gave privacy on the raised daises or *estrados* where elite women reclined on rugs and cushions, while taller versions (*biombos de cama*) cordoned off beds and other personal zones. With up to thirty or even forty leaves, the largest screens created flexible and welcome micro-environments within grandiose colonial interiors.

Asia was also the source of goods for the religious sphere. The largest of these was the majestic bronze choir screen in Mexico City's cathedral, ordered by the city government in 1728. Fabricated in Portuguese Macao by Chinese metalsmiths to designs prepared by the Mexican painter Nicolás

Rodríguez Juárez (1667–1734), it was shipped to Acapulco in 125 boxes and unveiled to great acclaim in 1730. Far more common were ivory carvings imported from Manila, ranging from realistic, large-scale crucifixes to saints' heads, hands, and feet created *en masse* for attaching to wooden or papier-mâché bodies.

The high cost of even small Asian ivories, however, led Ibero-American artisans to develop local substitutes. A miniature carving produced in Quito presents a manger scene with the Holy Family and angels, the Holy Spirit in the form of a dove, and God the Father above (fig. 12.23). All New World products, the colors used—deep red (from cochineal), dark blue (from indigo), bright green (from copper silicate), and bright gold—typified the often restricted palette. In this case, even the "ivory" may have been local, produced from the so-called *tagua* nut (the egg-sized seed of a palm tree from the lowland rain forests), which hardens when carved and soon becomes virtually indistinguishable from African or Asian ivory. Although easily overlooked amid the flood of foreign imports, this prized keepsake suggests the lure of "vegetable ivory" for Ecuador's colonial consumers.

OBJECTS OF DEVOTION

Although pre-Hispanic religions were not entirely eradicated—as late as 1621, Jesuit missionary Pablo José de Arriaga boasted of burning six hundred finely clothed and ornamented idols (*huacas*) in highland Peru—most of viceregal America embraced Post-Tridentine Catholicism (marked by adherence to decrees adopted after the Council of Trent) and its new Baroque visual language. Indeed, the "Baroque" in its myriad variations is often taken as synonymous with colonial Latin America, reflecting not just the term's widespread (if inaccurate) use for anything extremely ornate or highly gilded, but also the style's enduring popularity among designers and craftsmen who transplanted and transformed European ideas.

A Baroque language was particularly appealing to designers of retable facades, giant ornamental screens that turned churches of all sizes into stages for sacred dramas. Early examples include the portals of the Jesuit Church (Compañía) in Cusco, rebuilt after the earthquake of 1650 to designs by the Flemish Jesuit Jean-Baptiste Gilles or the retablo maker Martinez de Oviedo, and the related facade of San Francisco in Lima (1657–74; fig. 12.24). In both facades, the familiar European classical orders are further embellished with scrolled and broken pediments, ornately molded aedicules, and "grotesque" masks and angel heads. Later facades, especially in New Spain, were even more sculptural, many featuring virtuosic variations on the *estípite* ("candelabra" column) pioneered in Spanish retablos by the Churriguerras and adopted in the Americas (see fig. 11.24). Examples include the church of Santa Prisca, built by a wealthy silver magnate in the mining town of Taxco between 1751 and 1758, where slender *estípites* cap bell towers as light and airy as spun sugar. In Mexico City, dense forests of *estípites* mark the twin portals of the Sagrario Metropolitano, the parish church

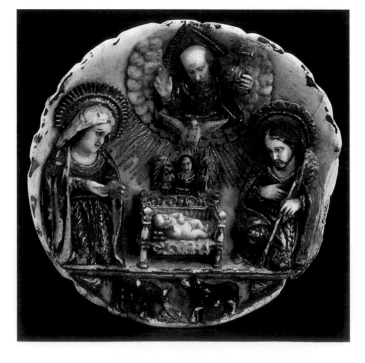

Fig. 12.23. Pendant: Holy Family with God the Father and the Holy Spirit, Quito, 18th century. *Tagua* nut, pigments, gilding. Museo Nacional de Arte Colonial, Casa de la Cultura Ecuatoriana, Quito (0221).

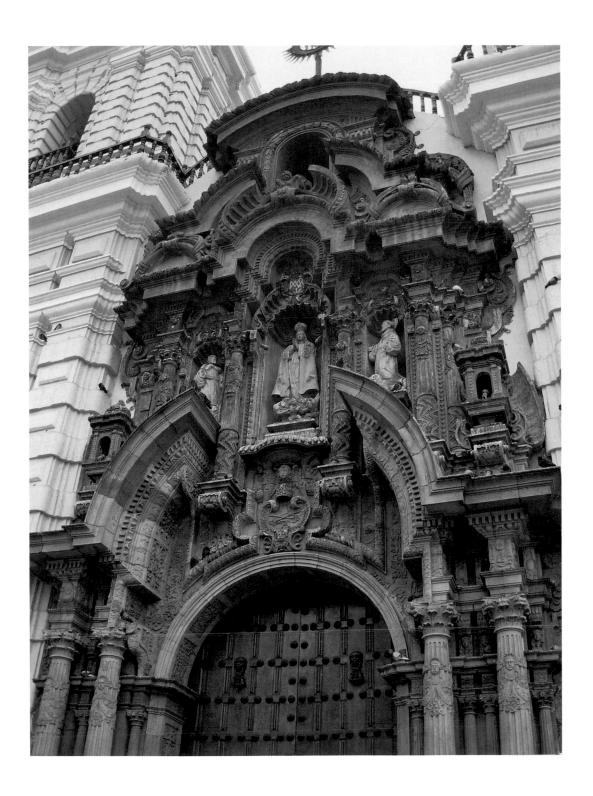

adjoining the cathedral. Begun in 1749 to designs by the Andalusian-born Lorenzo Rodríguez (c. 1704–1774), its facade appears like filigree portcullises between crimson curtains of *tezontle*, a local volcanic rock.

In Brazil, by contrast, exterior ornamentation was comparatively restrained, relying—as at the gridlike facade of São Francisco in Salvador, Bahia (1686–1737)—on a few bold motifs like paneled pilasters, swan's-neck pediments, and vinelike gable scrolls. The interior of this church, however, offers one of the most complete and dazzling fusions of interior architecture and ornament in the Americas (fig. 12.25). The vestiges of classical architectural forms melt under layers of decorative cladding. The walls, designed by the secular Franciscan sculptor Luiz de Jesus ("o Torneiro," the turner), are encrusted from floor to ceiling with white and gold stucco leafwork. Glittering webs of scrolling foliage are punctuated by putti, parrots pecking at grapes, and candleholders shaped as human arms, all in full color. In the choir, broad panels of *azulejos* (blue-and-white tiles; see fig. 11.27) imported from Lisbon illustrate biblical scenes. This concerted striving for a *Gesamtkunstwerk* (total work of art) envelops or even overwhelms the visitor, as was characteristic of Baroque design throughout Ibero-America.

Other examples of Baroque interiors include the vaulted Chapel of the Rosary in the Dominican church at Puebla (completed in 1690), with its looping skeins of gilded strapwork inhabited by holy figures, and the more economical painted sacristy (now called Capilla de San Ignacio or Capilla Policromada) at the Jesuit church in Arequipa, Peru (begun 1740), which resembles a jungle thicket rife with exotic birds.

Fig. 12.24. Constantino de Vasconcelos and Manuel de Escobar. Portal of the church of San Francisco, Lima, facade constructed 1669–74.

Fig. 12.25. Luiz de Jesus (wall design). Interior of the church of São Francisco de Assis, Salvador, Bahia, 1686–1737.

Fig. 12.26. Cuzco School. Holy Family with angels, 18th century. Oil with gold on canvas, gilded wood frame with mirror inlay; 55⅛ x 39⅜ x 7⅞ in. (140 x 100 x 20 cm). Museo de América, Madrid (1982/07/01).

Although some scholars have tended to associate a *horror vacui* and love of pattern with indigenous taste, it should be emphasized that both Puebla and Arequipa were strongly European cities in which the arts were dominated by *criollo* patrons and craftspeople.

If Baroque visual culture reached its heights in the public sphere, a pair of anonymous devotional pictures, probably painted in Cuzco and enclosed in carved and gilded frames, suggests the style's adaptability to smaller, even intimately scaled objects. The depictions of the Christ Child watched over by his parents and two angels (fig. 12.26) and the Infant Jesus carrying his cross were likely inspired by *The Mystical City of God* (published 1670) by Sister Maria de Jesús de Ágreda (1602–1665), a supposedly miraculous dictation denounced as heretical by the Lima Inquisition in 1699. Their rendition, as shown in the example illustrated here, typifies the preference among Andean artists for bold colors, somewhat flattened perspective, lush background landscapes, and gold highlights that seem to float on the surface of the canvas. In this case, the exuberantly sculptured frame is as eye-catching as its contents, incorporating inlaid mirror glass—their play of light recalling the *enconchados* of New Spain (see fig. 12.21)—in a technique frequently employed in Peruvian retablos. Here the reflective chips, which some scholars have linked to pre-Hispanic notions of divine illumination,

further dematerialize a porous and hypnotic web of C-scrolls, vines, angel heads, and pomegranates, fruits symbolic of the Church, sacrifice, healing, and eternal life.

As in the sixteenth century, civic communities and religious orders competed in creating the finest altar furnishings and utensils for the Mass. One of the most lavish and best documented is a monstrance, a standing holder designed to display the consecrated Host on the altar or in ceremonial processions. It was made for the Jesuit church of San Ignacio in Bogotá in 1707 by the Colombian goldsmith José de Galaz (act. 1700–1707; fig. 12.27). Nicknamed "La Lechuga" (The Lettuce), it was fabricated from pure gold and contains, according to the contract, 1,485 emeralds, 168 amethysts, 62 baroque pearls, 28 diamonds, 13 rubies, a sapphire, and a topaz—a dazzling testimony to the ability of the Jesuits, and their patrons, to command the first fruits of Colombian mines.

Befitting the sacramental theme, grape clusters and vine leaves (symbolic of Communion wine) are embossed on the base of the monstrance and applied in a naturalistic ring around the central reserve, which is topped by a cross. The unusual support for the sunburst is an angel, here with a blue robe and wings enameled in colors of the gemstones within the starburst. Similar stems on Jesuit commissions for monstrances throughout Peru and New Spain express the order's Counter-Reformation exaltation of the Eucharist (compare fig. 11.8). The angel's presence also recalls the sets of "military" archangels painted in highland Bolivia and Peru in the early eighteenth century, inspired by imported prints. Dressed in elaborate European fashions and wielding harquebuses (matchlock guns), these celestial defenders against idolatry may have been associated in indigenous communities with stars or thunder, a preconquest sign of the divine whose sound was echoed by the Spaniards' own guns.

Animals were readily mobilized as Christian symbols, nowhere more dramatically than in pelican-shaped silver urns from coastal Peru and the Altiplano, designed to hold the Communion wafers on Holy Thursday (fig. 12.28). Whereas both the San Ignacio monstrance and the sixteenth-century casket from Santo Domingo (see fig. 6.25) were intended to display the Eucharist to the faithful, these urns dramatized its distribution. Pelicans offered apt metaphors for Christ's redemption of humankind, since the birds were believed to nourish their young with their own blood. The example shown here, with outstretched wings, glass eyes, a movable tongue, and a gem-studded headdress known as an aigrette, picks at its chest to feed its chick. A heart-shaped aperture gives access to the Hosts stored in the central chamber. Like other Andean liturgical wares, including missal stands, tabernacles, altar frontals, and ornamental plaques, the urn was constructed from beaten sheet silver, vigorously and naturalistically chased. The design, however, looks less to native Peruvian pelicans than to prototypes known from European prints. Made for the monastery of Nuestra Señora del Prado in Lima soon after the earthquake and tsunami of 1746 that leveled the city and its port, causing six thousand deaths, this life-giving pelican, designed to be seen from below, must have offered spiritual sustenance to the surviving congregation.

Fig. 12.27. José de Galaz. Monstrance for the Jesuit church of San Ignacio, Bogotá, 1707. Gold, enamel, emeralds, amethysts, pearls, diamonds, rubies, sapphire, topaz; H. 31½ in. (80 cm). Collection of the Banco de la República, Bogotá.

Liturgical objects were a mainstay of Brazilian silversmiths, who flourished despite a series of repeated attempts by the crown to limit, tax, or prohibit the working of precious metals in the colony. The first practitioners arrived from Portugal in the 1560s, some of them recently converted Jews hoping to escape persecution in Iberia. By the seventeenth and eighteenth centuries, however, African slaves and their free descendants dominated the profession in many areas, despite a Portuguese royal ordinance of 1621 specifically barring them from this trade. This was a testament both to the high standards of gold and silver working in Africa (compare fig. TK Africa) and to the resilience of Afro-Brazilian craftsmen, despite the horrors of slavery.

Attributing and dating Brazilian silver is difficult, as early works were rarely marked, notwithstanding official regulations to do so. The metal was imported from Peru in an active

Fig. 12.28. Eucharistic urn, probably Lima, 1750–60. Silver, gold, precious stones, glass; H. 32⅝ in. (83 cm). Monasterio Nuestra Señora del Prado, Lima.

Fig. 12.29. Incense boat (*naveta*), possibly Bahia, 18th century. Silver; 6¼ x 8¼ x 3⅛ in. (16 x 21 x 8 cm). Museu de Arte Sacra de Universidade Federal da Bahia.

and often contraband trade along the Río de la Plata (River of Silver, named by explorer Sebastian Cabot after silver objects acquired from Guaraní Indians). This silver was then shipped from Buenos Aires to São Paulo, Rio de Janeiro, Recife, and Olinda in exchange for African slaves. Brazilian smiths worked the bullion into a wide range of sacred implements including bust-, arm-, or leg-shaped reliquaries; flasks for holy oils; elaborately chased crowns for statues of the Virgin; shell-shaped baptismal fonts; processional crosses and lanterns; and sets of lacy foliate or floral plaques with which to adorn the altar.

One popular form in Brazil was the ship-shaped *naveta*, or incense boat, with a hatched "hold" to contain the fragrant resins (fig. 12.29). Some *navetas* were realistic depictions of ocean-going vessels, with detailed rudders, keels, figureheads, planking, gunwales, and chain plates. Others were more schematic, with scrolled prows and poop decks and hulls with abstracted foliate or wave patterns. Besides recalling the early Christian metaphor of the church as St. Peter's bark, or the ship-shaped nefs (ornamental containers) holding imported spices and salt on European royal tables, such *navetas* may well have evoked the trade that brought both silver and incense to South America. They probably had special resonance in coastal Brazil, where everyone from European priests and plantation owners to Afro-Brazilian slaves and silversmiths was directly or indirectly linked to the sea. If the *navetas* were made by black craftsmen, did they suggest the ships that

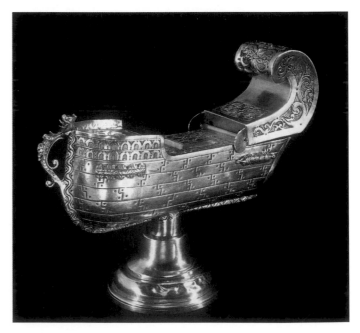

brought them or their ancestors in chains? Whatever stories they contain, *navetas* and other Ibero-American colonial objects—from the Río de la Plata to the Río Grande—were the fruits of an increasingly complex cultural synthesis both more dynamic and more freighted than the sum of its parts.

JEFFREY COLLINS

BRITISH, FRENCH, AND DUTCH NORTH AMERICA

European colonizing enterprises competed for control of the North American continent in the early modern era, vying with each other and with the resident Native American peoples. Colonists attempted to transplant European traditions of settlements, buildings, decorative arts, and design across the Atlantic. But encounters among the various European, African, and Native American peoples also resulted in some striking changes and adaptations due to the dynamic nature of their interactions and the realities of life in a "New World." Although many of the material objects created by colonial craftspeople during the early periods of settlement focused on goods and tools that were needed for survival, North American producers and consumers were full participants in a transatlantic world of stylistic and material exchange.

By the 1600s, the Spanish, French, and English had established significant permanent centers in Santa Fe, Quebec, and Jamestown, respectively. Spain's colonial power stretched from the southern tip of South America to as far north as modern-day St. Louis, and from California across to Florida and the Caribbean. New France, which eventually ranged from present-day Quebec to Newfoundland and from the Hudson Bay south to Louisiana, was established by explorer Samuel de Champlain in 1608. Intended as a money-making venture for the French state, the colony focused on the lucrative fur and fishing trades and on exchanging French manufactured goods with the native peoples. Its population grew slowly, due in part to Catholic France's refusal to allow French Protestants (Huguenots) to emigrate to the colony. Rather than renounce their faith, many French Huguenots chose instead to move to English colonies. The Catholic Church sponsored a number of settlements in the region, most importantly Ville-Marie (which would become Montreal) in 1642, but settlers faced constant conflict with the local Iroquois.

In 1650, New France became an official royal province, and the crown attempted to redress the colony's gender imbalance (there were nearly twice as many men as women) by sponsoring the immigration of women. Although church and government officials brought some furniture, metalwork, and other goods with them to the colony, most early settlers lived in modest homes furnished with homemade goods. There were not many craftspeople in the colony in its early years, and it was not until the Catholic Church began actively recruiting artisans to build and furnish churches in the last quarter of the seventeenth century that they were present in large numbers.

Many of New France's settlers were from northwestern France, particularly Brittany and Normandy, and surviving furniture reflects these provincial origins. Necessity as well as freedom from the rigid craft hierarchies of France led colonial woodworkers to produce both architectural elements and furniture according to French stylistic precedents. They used native woods, however, as well as mortise-and-tenon construction (a technique suited to both furniture and large-scale building), and carved and plane-cut molded decoration, rather than the more elaborate modes favored by skilled ébénistes (cabinetmakers) in France. The moldings on the birch and pine buffet illustrated here (fig. 12.30) are reminiscent of French styles popular in the first half of the sixteenth century, while the paneled construction has precedents in Renaissance chest forms. The iron drawer pulls may have been imported from France.

Because English colonies dominated the Eastern seaboard, French explorers and settlers focused their efforts on establishing forts and outposts along the Ohio and Mississippi River valleys and the Gulf of Mexico. Attempts were made to create settlements in the area, but most were unsuccessful due to disease, conflicts with indigenous peoples, and lack of supplies and support. Explorers founded what would become Detroit in 1701; Mobile, in what became Alabama, in 1702; Natchitoches, the first permanent settlement in Louisiana, in 1714; and New Orleans in 1718. In 1763, as part of the resolution ending the Seven Years' War, French holdings west of the Mississippi River were ceded to Spain while New France and French holdings east of the Mississippi were ceded to the British, and a new wave of British immigrants and administrators became a powerful political and stylistic force in Quebec.

Like early Spanish colonists, those settlers heading to the first English settlement at Jamestown, Virginia (founded

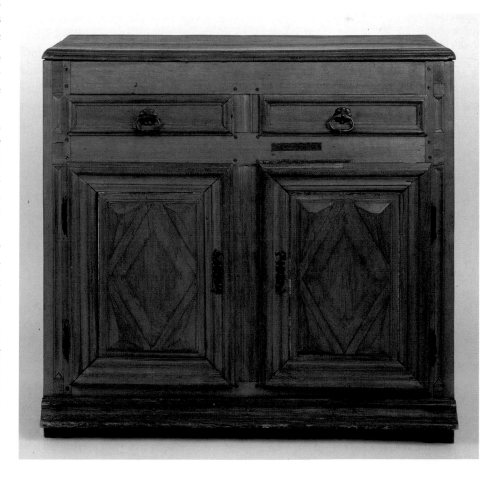

Fig. 12.30. Buffet, New France (Quebec), 1680–1720. Birch, pine, iron; 40¼ x 42 x 19¼ in. (102.2 x 106.7 x 48.8 cm). Royal Ontario Museum (948.25).

1607–13) in the Chesapeake Bay dreamed of abundant gold and easy wealth. The Virginia Company, a joint stock company of London merchants and craftsmen, operated the colony, supplying household goods and tools to the colonists. Archaeological discoveries have revealed a cosmopolitan mix of Chinese porcelain, Portuguese tin-glazed wares, and northern Italian ceramics, among other items, all of which arrived in the Chesapeake via London. The early years were difficult, from conflicts arising with Native Americans to problems of steady sustenance and stable government. In 1624, James I (r. 1603–25) revoked the company's charter and declared the area a royal colony.

Successful experiments with tobacco, which proved an exportable commodity, brought prosperity and created a landowning gentry that controlled land and labor. A slipware dish from 1631, fashioned of local clay, marks the earliest dated piece of pottery made in the British American colonies. The work is now attributed to Thomas Ward (act. 1621–35), an accomplished potter who arrived in America in 1621. Subsequent archeological research locating wasters (discarded ceramics damaged during the manufacturing process) and roofing tiles suggests the presence of a domestic ceramics trade at the Carter's Grove settlement, sponsored by the Martin's Hundred Society—a colony within a colony located ten miles from Jamestown. The lead-glazed earthenware found in this area includes cooking pots, pans, dishes, storage jars, chamber pots, and a piece of distillation equipment called an alembic.

Across the Chesapeake Bay, Cecilius Calvert, Lord Baltimore, established the colony of Maryland in 1634. Here, half the settlers arrived as indentured servants, laborers working on four- to seven-year contracts to pay for their Atlantic passage. Once they fulfilled the terms of their contracts (if they survived the high levels of mortality), they received small tracts of land, unlike African slaves who had no opportunity for emancipation. Both Virginia and Maryland developed agrarian societies centered around extensive farmlands and tobacco cultivation where planters built large houses and adopted increasingly aristocratic ways of life based on abundant unpaid labor.

North along the Atlantic Coast, religious dissenters from the Protestant Church of England founded New England, arriving in family groups rather than the mostly single male colonists of New Spain and New France. First, a group of Separatists (Protestants who did not conform to the Church of England), calling themselves Pilgrims, left England for the Netherlands then crossed the Atlantic Ocean on the *Mayflower*, landing in 1620 in what became Plymouth, Massachusetts. The Puritans, a more prosperous and worldly group led by John Winthrop, arrived in Boston in 1630 and formed the Massachusetts Bay colony. The settlers who came as families tried to re-create English ways in their new home. The "Great Migration" (1630–40) from England to Massachusetts comprised about thirteen thousand people—along with a significant number of English objects such as chests and ceramics—who brought with them plans for towns and artisanry based on those they had left behind. Alongside continuities came changes, arising from, among other things, a wider temperature range, ample woodlands, and a labor shortage.

When the first New Englanders dispersed from their original sites in Plymouth and Boston, they began a process of serial settlement, spreading their ideal plans of 6-square-mile (about 15-square-km) towns with tightly clustered houses and outlying fields across New England. Some movement came as a result of religious difference. The Massachusetts Bay colony required religious orthodoxy, and Roger Williams's call for the separation of church and state led to his banishment. After purchasing land from the Narragansett in 1636, he established Providence, forming the colony of Rhode Island. Other colonists shifted inland to the rich agricultural lands of the Connecticut River Valley. William Pynchon, for example, led a group to what became Springfield, Massachusetts, which also proved a good site for trade in beaver pelts with the Native Americans. Towns were self-governing, each with its own local institutions including a Congregational church and school. Originally, land was relatively equitably allocated, either granted or purchased but owned outright, enough for what was called a "sufficiency." But over time, social and economic distinctions—derived from size of family, changing social status, and economic activity—evolved.

NEW ENGLAND WOODWORKING

Material culture in New England represented a middling society due to the moderate origins of the emigrants and their social values. New England's original generations lived long, healthy, and reasonably comfortable lives in homes each consisting of one large, central room with a fireplace and chimney at the end; deep, massive timber framing; unplastered walls; and a loft for children's sleeping quarters. Expansion was provided by a lean-to at the house's rear. The few larger homes, which stood in contrast, included those built by the community for the minister or a leading citizen. The Parson Capen House (1683) in Topsfield, Massachusetts, was such a

Fig. 12.31. Chest, probably Windsor, Conn., 1640–80. Oak, eastern white pine, yellow poplar; 27 x 47¾ x 19⅝ in. (68.6 x 121.3 x 49.8 cm). Photographed c. 1891. Yale University Art Gallery (1930.2262).

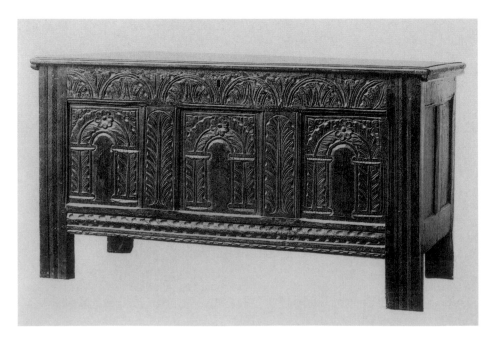

"second generation" house with two stories around a central chimney and two rooms to each floor. English settlers brought furniture and textiles with them, along with the artisans and patterns to re-create such objects.

Some furniture arrived with the early settlers, but transatlantic freight charges were high and furniture makers enjoyed a steady trade in the colonies from early on. Chests used for storage of textiles, clothing, and various small objects have become "foundational" objects for the scholarship of New England furniture. One such chest, based on English West Country prototypes and probably made in Windsor, Connecticut, was "discovered" by Irving Lyon about 1880 and published in his *Colonial Furniture of New England* (1891; fig. 12.31). Like a similar one made in New Haven, it is constructed of red and white oak, held together with mortise-and-tenon joints, strengthened with wooden pins, and is enriched with vivid carved decorations. The vertical stiles and horizontal rails form frames with grooves into which the panels sit, leaving room for expansion or contraction in the New England weather.

Immigrant joiners, versatile artisans who built houses with post-and-beam construction along with cupboards, tables, chairs, and other items in the seventeenth century, probably crafted these two chests. Large rectilinear boxes with lids, chests stood low to the ground. Some were made using the frame-and-panel method, with the frame constructed of thick stock shaped by saw or axe. Chests constructed of boards simply nailed together were the most common and affordable form, usually made of pine. They are, however, less frequently represented in surviving examples and museum collections. Probate inventories indicate that some families owned both types.

In New England, commercial entrepreneurs challenged the authority of the ministers, part of a larger set of conflicts over how, or whether, to maintain the founding generation's religious zeal and check a growing materialism and increased demand for goods, artisans' services, and grander houses. A rising tide of imports of textiles, silverware, and other products reached across the Atlantic even as provincial production of crafts flourished. A distinctive group of joined chests made in the upper Connecticut River Valley in the late seventeenth and early eighteenth centuries demonstrates the growth of an increasingly stable and sophisticated society, with an emerging merchant class in the North providing markets for these wares.

The similarities found in this group of about 250 chests, cupboards, and related forms demonstrate the growth of a multigenerational community of artisans connected by family, marriage, and training, along with patterns of patronage in the emerging colonial elite. Two types of chests from the late seventeenth and early eighteenth centuries have become known as Hadley and Wethersfield chests, the first named after a town in Massachusetts, the second after one in Connecticut. Hadley chests and related forms such as drawers, boxes, and tables constitute the largest body of early joined furniture made in an area of the Connecticut River Valley stretching from Enfield and Suffield, to Deerfield and Northfield, Massachusetts.

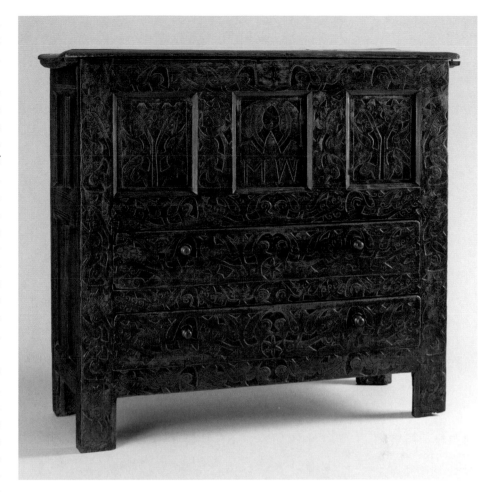

Fig. 12.32. Chest, Massachusetts, 1690–1710. Oak, yellow pine; 42 x 45 x 18½ in. (106.7 x 114.3 x 47 cm). The Metropolitan Museum of Art (48.158.9).

The chest illustrated here (fig. 12.32), with two drawers, bearing the initials "MW" on the central panel, is typical of Hadley forms. The Hadley chests continued seventeenth-century joinery techniques into the next century, but featured distinctive tulip flowers and leaves carved in shallow relief (and probably originally painted in contrasting colors) that were created with a template rather than a rule and compass.

Wethersfield chests, also known by early twentieth-century collectors as sunflower chests because of their embellishment with carved, multipetal flowers, usually sported two outer front panels with large tulips and a center panel with three circular flowers with rows of petals. Peter Blin (c. 1640–1725) of Wethersfield, a French-speaking Huguenot joiner, may have produced the applied-ornamental work of these chests.

Carved initials on chests and other storage pieces usually represent the name of a young woman who was the original owner of the piece. For example, when John Marsh and Hannah Barnard married in 1715, Hannah brought to the household a cupboard with her name boldly displayed and elaborately decorated in a newer, Baroque-inspired aesthetic with heavy moldings and exuberant paint on a white background (fig. 12.33). Chests like Hannah's remained a woman's property after her marriage and often descended in the female line, with the use of a woman's maiden name or initials marking a piece as her own rather than her husband's.

Joiners also made chairs, such as those known as great chairs, grand oak armchairs attributed at different times to

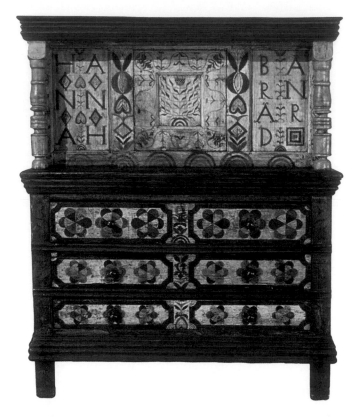

Fig. 12.33. Cupboard, Hadley, Mass., c. 1715. Oak, pine, paint; 61 x 50 x 22 in. (155 x 127 x 55.9 cm). The Henry Ford, Dearborn, Mich. (36.178.1).

William Searle (1634–1667) and Thomas Dennis (1638–1706), both of whom were born and trained in woodworking in Devonshire, England, and later worked in Ipswich, Massachusetts. Searle may have produced the great chair illustrated here for his own household (fig. 12.34), though it has also been attributed to Dennis, who married Searle's widow and took over his workshop after Searle's death. Thronelike in their massive and assertive presences, these armchairs used the same system of joinery as the framed and paneled chests discussed above.

Wood turners, who shaped pieces with chisels and gouges while turning them on a lathe, also made chairs. This resulted in a cheaper (and faster) construction using simpler, round mortise-and-tenon joints that were easier to produce and assemble than rectangular sawn and chiseled joints. Roughly contemporary with the Searle/Dennis joined armchairs are a number of elaborate chairs from late seventeenth-century New England featuring delicately turned spindles arranged in runs of four or six to create an intricate, boxlike frame for the sitter (fig. 12.35). Most of these pieces were made of ash, a

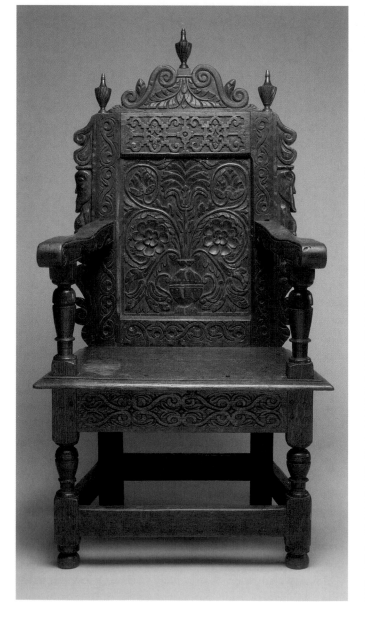

Fig. 12.34. William Searle or Thomas Dennis. Great chair, Ipswich, Mass., 1663–67. Oak; 48½ x 25½ x 17⅞ in. (123.2 x 64.8 x 45.4 cm). Bowdoin College Museum of Art, Brunswick, Me. (1872.1).

Fig. 12.35. Armchair, Charlestown, Mass., 1640–80. Ash; 44¾ x 23½ x 15¾ in. (113.7 x 59.7 x 40 cm). The Metropolitan Museum of Art (51.12.2).

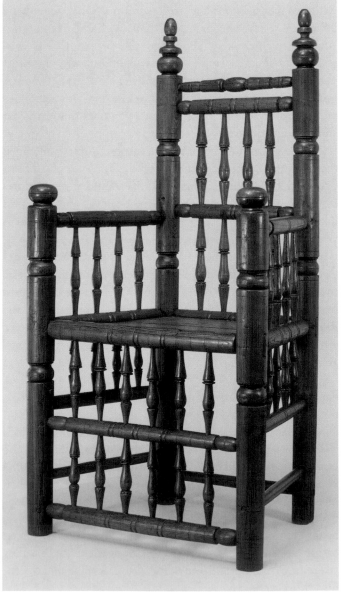

strong indigenous wood that accepts precise turning. Throughout the eighteenth and nineteenth centuries, the low capital investment required to set up a wood-turning shop guaranteed continued production of turned chairs, some plain, some fancy.

DUTCH INFLUENCES

In 1609, the Dutch East India Company sent Henry Hudson to explore the area around present day New York City and the river heading north that was eventually named for him. Hudson's claims led to the establishment of the New Netherlands colony. Its capital, New Amsterdam, resembled a Dutch town with winding streets, canals, brick houses, and gabled roofs. Dutch energies focused on the fur trade, exchanging European metal utensils with the local Iroquois who controlled access to the beaver pelts, fashioned into popular felt hats in Europe. The prosperous Dutch, however, had difficulty finding potential colonists, and therefore everyone who transported fifty people across the Atlantic received large estates along what became the Hudson River. These settlers were known as patroons (from the Dutch patroon, the head of a company). The colony's organizers were receptive to immigrants of many religions and ethnicities, and a cosmopolitan community evolved. William Kieft, the director general of the colony, told one visitor that the inhabitants of New Amsterdam spoke eighteen different languages. Under him, the patroons ruled like feudal lords and secured wealth from the labor of their tenant farmers.

Continued imperial rivalries led to British occupation of the colony in 1664, and the New Netherlands colony became the colony of New York. Dutch settlers retained their religious rights and properties, and maintained their traditions of decorative arts and design well into the eighteenth century. Such continuity can be seen in the painted kast from around 1700 (storage cupboard, plural kasten) illustrated here (fig. 12.36), which is but one distinctive example from the Middle Colonies—the region including New York, Pennsylvania, New Jersey, and Delaware—drawn from about two hundred surviving pieces by different makers working over four or five generations. Functioning as free-standing closets, kasten were important material possessions and often mentioned in wills that listed furniture. French, Dutch, and German colonists favored closets or armoires, while chests of drawers were the preferred English furniture form.

Although the illusionistic painted surface suggests otherwise, the piece was constructed from flat boards joined with rose-head nails. The painting on kasten, which were made throughout Europe in the seventeenth, eighteenth, and nineteenth centuries, more than compensated for any lack of sophistication in terms of construction. The exterior is painted in grisaille, a trompe l'oeil effect in gray paint that imitates carved stone sculpture. Each of the illusionistic niches on the doors is overfilled with lush swags of ripe fruit, overt symbols of fertility and abundance, suggesting that these kasten, like Hadley and other chests, may have been dowry or premarriage pieces for young women. Because

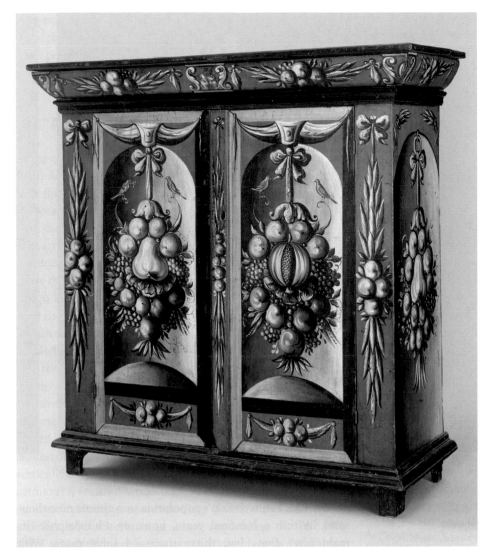

Fig. 12.36. Storage cupboard (kast), New York City, c. 1700. Painted yellow poplar, red oak, white pine; 61½ x 60¼ x 23 in. (156.2 x 153 x 58.4 cm). The Metropolitan Museum of Art (09.175).

painted surfaces do not hold up well over time, painted furniture was more common in the North American colonies than surviving examples suggest.

MID-ATLANTIC SILVERSMITHS

Proprietary colonies such as Pennsylvania and the Carolinas were founded as part of a second wave of colonization during the Restoration era (1660–88) by supporters of Charles II, king of England, Scotland, and Ireland (r. 1660–85) and his brother James II (r. 1685–88). William Penn, a wealthy Quaker and friend of Charles II, received a large tract of land west of the Delaware River in 1681 and encouraged other European religious dissenters to emigrate by promising them religious freedom. Thus, Quakers, Amish, Baptists, and Mennonites settled along the Delaware River. These Middle Colonies remained more tolerant of nonconformity than New England and the South, and Pennsylvania grew rapidly. German farmers, mostly Pietists from the Rhine region, settled in the countryside, establishing prosperous farms and weaving, shoemaking, and cabinetmaking workshops. In the early eighteenth century, large numbers of Presbyterian Scots-Irish also settled in the rural areas of Pennsylvania, supporting themselves by hunting and farming.

Boston side chair shown here, likely made between 1689 and 1705, subtly curved legs and backs shaped by sawing and carving replaced the straight legs and back posts of earlier chairs (fig. 12.40). Aimed at the upper middle-class market rather than the elite, such English-style high-back cane chairs were both produced in the colonies and exported by the thousands from England to the Americas in the late 1600s. Materials for the woven cane backs and seats came from Asia, but the caning was done in the Americas.

The increasing prevalence of sets of chairs gave more people the opportunity to sit individually, compared to the earlier use of stools and benches, thus furthering particular types of sociability. At the beginning of the eighteenth century, the easy chair provided a new kind of individual comfort with its high padded back, wings, double scroll arms, and feather-filled seat cushion. Chests of drawers—high and low—replaced joined chests as the principal storage containers and offered greater differentiation of stored items in their several drawers, so that owners no longer had to bend to reach individual items. Such expensive furniture demonstrated the owner's economic success and cultural prestige.

TEA DRINKING AND THE DECORATIVE ARTS

By the 1720s, the material world was changing visually even more quickly as refined domestic interiors featured increasingly Baroque forms in wood and silver, smooth surfaces on tables and other objects, and new types of furniture such as dressing tables. Tea, an exotic commodity initially esteemed for its medicinal purposes, came to be associated with gentility, luxury, and performance, as its use spread through all ranks of society including the ministry. New to the West, this Asian beverage carried considerable cachet. Its preparation, service, and consumption required an entirely new panoply of goods: teapot, sugar bowl, imported cups and saucers, and even a new furniture type, the tea table. These goods for preparing and serving tea were appearing in southern estate inventories (records of individuals' belongings at the time of their death) by the 1710s.

The first North American tea tables had square or rectangular shapes inspired by Asian traditions but with European ornamentation. An eastern Virginia example from the 1720s features applied molding around the top, an attractive feature that also prevented the expensive wares from being pushed off the tables (fig. 12.41). A somewhat later Williamsburg example used the same basic shape and size but with a top

Fig. 12.40. Side chair, Boston, 1689-1705. American beech, cane; 51⅞ x 18¼ x 16¼ in. (131.8 x 46.4 x 41.3 cm). Winterthur Museum, Wilmington, Del. (1973.0382).

Fig. 12.41. Tea table, eastern Virginia, 1720-30. Black walnut; 27½ x 26⅜ x 21½ in. (69.9 x 67 x 54.6 cm). The Colonial Williamsburg Foundation, Va. (1976-429).

Fig. 12.42. Jacob Hurd. Teapot, Boston, 1745. Silver, wood; H. 5¼ in. (13.3 cm). Hood Museum of Art, Dartmouth College, Hanover, N.H. (M.967.42).

projecting over the skirt of the table—probably following Asian prototypes—similar to the thousands of tea tables exported from London in the late seventeenth century. This one also featured pad feet, a convex applied skirt, and lathe-turned columnar legs—a design element with English antecedents that was popular in the Chesapeake region.

Tea drinking required mastery of a special kind of etiquette dictating how to hold a teacup and how to prepare and pour tea. The performance of this ritual eased one's inclusion into the ranks of the refined, and excluded those unwilling or unable to participate. The new beverage signaled the growing commodity culture of the British Atlantic world. Connecticut minister Ebenezer Devotion, for example, owned in 1771 a tea table, along with three sets of china teacups and saucers, as well as several silver teapots, tea tongs, and spoons. Silver teapots became fashionable in Britain shortly after 1700 and the same was true for the North American British colonies.

Colonial Boston's leading silversmith, Jacob Hurd (1702–1758), made much of the surviving silver of his generation and trained two of his fourteen children to follow him in the silversmithing trade. This teapot (fig. 12.42) is one of more than twenty-five of Hurd's manufactures known today. Hundreds of other objects from his shop have also survived, including beakers, bowls, casters, coffee pots, cream pots, ladles, pepper boxes, porringers, salvers, sauceboats, silver bowls, sugar tongs, and spoons of various sorts. This example, globular in form and diminutive in size, represents the scarcity and cost of tea itself, which was generally brewed in small quantities. It was commissioned in 1745 as a wedding gift to Farr Tollman and Hannah Fayerweather by Edward Tyng, a noted naval officer, and features an elaborate, asymmetrical engraving of the Fayerweather coat of arms that hints at the coming Rococo style that would dominate the third quarter of the eighteenth century.

THE CONSUMER REVOLUTION AND SOCIAL RANK

Poorer families entered into the world of goods mainly through the acquisition of inexpensive clothing and decoration. Shortly before Christmas in 1721, William Moore, "a Pedler or Petty Chapman," journeyed to the remote frontier town of Berwick, Maine, with a pack of manufactured goods from Boston. While there, he sold Daniel Goodwin "a yard and halfe of Stuff for handcarchiefs" and Goodwin's daughter Sarah "three quarters of a yeard of muslin," fine thread, and black silk, along with enough "Lase for a Cap." To protect the interests of local merchants, Berwick's local authorities confiscated Moore's "bagg or pack of goods" according to provincial legislation, which cited the "great hurt to and decay of trade" occasioned by "hawkers and pedlars passing through the country." Moore's wares were left in a neighbor's charge after his arrest, and upon his release, he found that most of those eagerly sought-after goods were missing.[1]

The revolution in consumption was also reflected in less portable goods. By mid-century, mansions were reorienting space and status in urban centers as many middle-class gentry rebuilt or built anew stately homes with symmetrical Georgian facades and fashionable central halls and staircases. West of the town of Dover, Delaware, Nicholas Ridgely in 1749 incorporated an adjoining older structure to his home, and the new space provided the desirable center passage and staircase. At his death only a few years later, his belongings were typical of his middle-class status. The house's interior was sparsely furnished with no curtains or carpet, according to the assessors, but the best room—the parlor—contained a tea table, two other tables, and eight chairs, the necessary equipment for genteel entertaining.

The growing stratification of society, as manifested through the increasing numbers and forms of domestic furnishings

owned by some families, was not limited to northern society, and was advanced in the South by the strategic arrangement of marriages and inherited forms of office-holding. In the Chesapeake, Virginia moved its capital away from coastal Jamestown to Williamsburg, the site of the College of William and Mary (est. 1691) and the colony's permanent capital from 1699. Williamsburg's earliest documented cabinetmaker was Peter Scott (1694–1775), who operated a workshop from 1722 until his death. With enough demand from wealthy clients to support full-time cabinetmaking shops, Williamsburg served as the colony's leading site for furniture production.

Significant buildings in Williamsburg included the Governor's Palace, completed in 1722 with its five-bay, Georgian-style facade and grand entrance hall. It became a model for domestic buildings of the colony's grandees. Likewise, William Byrd, an English-educated member of the Royal Society of London for Improving Natural Knowledge, sought to emulate English models in Westover, his house along the James River. As part of a process now known as the Anglicization of the British colonies in the eighteenth century, Byrd tore down his father's wooden mansion and replaced it with a new red brick one in the style of London architect Christopher Wren (1632–1723), featuring a classical front, symmetrical array of sash windows, and elaborate entrance in Portland stone imported from England. Byrd probably brought over London craftsmen to fashion the stately door with its fluted Corinthian pilasters and broken pediment. John Drayton's Drayton Hall in South Carolina is another example of the new, more elegant homes built as theaters for display and sociability, with their grand entrance halls, broad staircases, lavish parlors, dining rooms, and other spaces for public entertaining (fig. 12.43).

The language of goods became the lingua franca across the colonial cultural landscape. Alexander Hamilton, a Scottish physician traveling through the colonies in 1744, met three strangers at an inn outside Philadelphia. One of them, named Morison, was, according to Hamilton, "very rough spun" but "desirous to pass for a gentleman." He grew upset when he was mistaken by the landlady for "some ploughman or carman" because of his dirty cap, greasy clothes, and clownish air. To rectify the mistaken social identification, Morison replaced his worsted night cap with a linen one from his pocket, informing the company that, although he might appear a plain fellow, "he was able to afford better than many that went finer: he had good linen in his bags, a pair of silver buckles, silver clasps, and gold sleeve buttons, two Holland shirts, and some neat nightcaps; and that his little woman att home drank tea twice a day."[2] The traveler was sure that the landlady and others would recognize his true social status after his reference to the commonly understood language of goods, with his ownership of buckles and consumption of tea clinching his claims to gentility.

TEXTILES

Period probate inventories reveal the existence of significant numbers of textiles in homes and often note their economic value. In many instances, these documents record both the raw materials and the spinning wheels and other machinery needed for the household production of wool and linen thread. Significant household textile production continued into the nineteenth century until made obsolete with the advent of factory-made goods.

Domestic textile production was largely women's work. Utilitarian textiles meant for everyday use were worn out long ago and are rare today. On the other hand, "fancy goods" can still be found. For instance, needlework samplers in which girls demonstrated their skill at working letters, numbers, and decorative designs; various needlework pictures; and small articles for personal use, produced by affluent young women at leisure, survive in relatively large quantities compared to more utilitarian wares such as sheets or napkins. New England's colonists replicated both English educational institutions and the textiles that were an important component of women's education, such as Anne Gower's (c. 1607–1629) white-work linen sampler with its intricate needle lace now in the Peabody Essex Museum. Similar motifs can be found on clothing and fine household linens from England, demonstrating how colonists transmitted craft practices and cultural patterns. These items were most likely packed along with the family's other precious possessions when they sailed on the *Abigail* in 1628 during the Great Migration.

Fig. 12.43. Stair hall, Drayton Hall, Charleston, S.C., 1738-42. Mahogany with traces of vermilion stain, plaster.

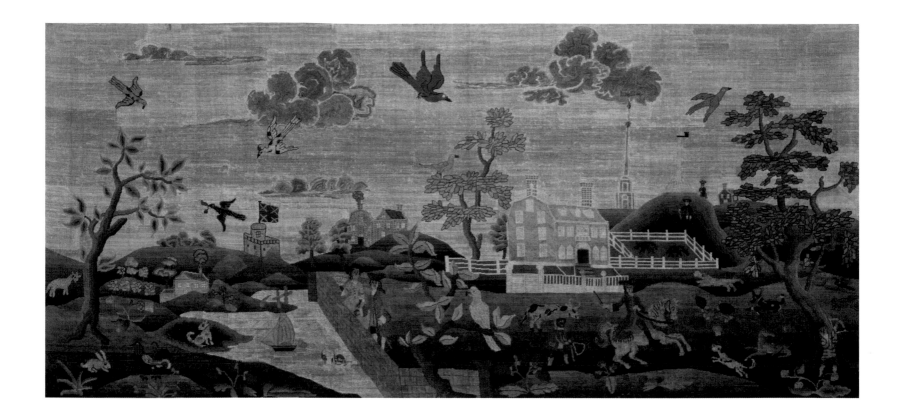

Other typical samplers included band samplers with floral and geometric patterns organized in horizontal patterns, usually derived from English pattern books, emblem books, herbals, and prints. Needlework pictures frequently depicted bucolic landscapes populated with human figures, various benign beasts, colorful birds, and flowers; such pastoral subjects recurred in many genres, including paintings, wallpaper, prints, textiles, ceramics, and other objects. Samplers served to demonstrate one of the accomplishments taught to girls in eighteenth-century schools. Only after a student had completed a sampler at home or in a local "dame school" (named for the women who ran them) would she move on to more complex embroidered pictures. A completed work often found a prominent place in the parlor, demonstrating the daughter's patience and skill along with the family's belief in the culture of refinement and their pride in their ability to send their daughter to school.

A cluster of Adam-and-Eve–themed embroideries began with English models, but girls and their instructors soon adopted new designs. The best-known group are referred to as "fishing lady pictures," because they feature female anglers, appearing on sconces, screens, chimney pieces for mantels, chair seats, tops for card tables, and samplers.

Among the most famous of the Boston embroideries is a chimney piece from about 1750, signed "a boarding school lesson of Hannah Otis" (fig. 12.44). Otis rendered both familiar birds and berries, as well as a realistic local view of Beacon Hill including Thomas Hancock's Georgian-style house overlooking the Boston Common—a three-story granite mansion standing amidst gardens, orchards, and pastures. The couple by the wall (center left foreground) may be Hancock and his wife, Lydia Henchman; the horseman may be their nephew John Hancock, the future governor, attended by a black groom (possibly one of the enslaved people who lived on the

Hancock estate). A British flag flies above the fortress-like building (left), with West Church on the right. Other embroidered items produced by women included pockets (small purses), book covers, and chair seat covers. Most of the latter were so-called slip seats, which could be easily removed for cleaning or replacement.

SOCIAL REFINEMENT IN THE HOME

Immigrant clock makers first set up shop in the early eighteenth century in Boston and Philadelphia, the leading port cities, bringing the latest style of tall case clocks with them. The first clocks made in North America were built in Philadelphia by Samuel Bispham (act. c. 1696) and Abel Cottey (1655–1711), both of whom had arrived from England by 1700. Cottey had trained in England and worked in Devon before emigrating with his family to Philadelphia, and a 1709 tall clock is his earliest known American product. His only known apprentice, Benjamin Chandlee (1685–1745), came from Kildare, Ireland, and joined Cottey's shop soon after his 1702 arrival in Philadelphia, marrying Cottey's daughter a few years later. Apprenticeship was the most reliable pathway to a craft. In time, as daughters married their father's apprentices or other youths in the same trade, or sons were apprenticed to male relatives, interlocking clans of artisans arose. Such alliances insured that a shop would endure and its craft processes would pass to a subsequent generation. In the close confines of a shop, through observation, careful training, and the casual interactions among apprentices, journeymen, master, and others, the apprentice learned handicraft and design skills.

Upon Cottey's death in 1711, Chandlee inherited the Philadelphia shop and the Cottey home in Chester County. They followed a pattern, common in the regions around Philadel-

Fig. 12.44. Hannah Otis. View of Boston Common, Boston, c. 1750. Wool, silk, linen, metallic threads, beads, gilded pine frame with glass; 24¼ x 52¾ in. (61.6 x 134 cm). Museum of Fine Arts, Boston (1996.26).

phia and into Delaware and New Jersey, of marking success by buying a farm outside the city. Chandlee trained his four sons in the clock-making trade, and, in turn, his eldest son, Benjamin Jr. (1723–1791), continued the trade and trained his own four sons while extending the business to include making scientific instruments, telescopes, and other metalwork. Philadelphia clock makers were mobile in the eighteenth century, many moving to other port cities such as New York.

Boston was another center of English-style brass clock making. In 1707, James Batterson (act. 1705–27), who advertised that he had recently arrived from London, stayed in Boston only a short while before moving to New York and then Charleston. Benjamin Bagnall (1689–1773) carried on his business in Boston from 1713 to 1771 in the English style. Clock makers also moved inland. Seth Youngs (1711–1761), who settled in Windsor, Connecticut, in 1742, was one of a new generation of specialist clock makers in the eighteenth-century Connecticut River Valley, although clocks were not normally found in typical valley households. Mechanical timepieces were rare; the most common device for telling time was a sandglass. For the wealthy, however, Youngs produced

eight-day brass clock movements; he also offered a cheaper thirty-hour timepiece with fewer gears that indicated time by only an hour hand—a mode of time-keeping suggestive of country living. Cost drove innovation in the clock trade. The brass tall clocks made by Gawen Brown and other Boston clock makers required large amounts of imported metals fashioned into delicate gears and works, making them both expensive to manufacture and sell and difficult to transport safely.

Benjamin Franklin (1706–1790)—printer, inventor, and politician—played an important role in reorganizing domestic space and improving household comfort with the invention of his Franklin stove, a cast-iron furnace that spread heat in all directions from its position in the middle of the room. This system offered a dramatic improvement over the traditional fire in a hearth set in a wall. Franklin set about solving the problem of domestic heating with his neighbor Robert Grace. Their 1744 pamphlet, *An Account of the New Invented Pennsylvania Fire-Places*, spread knowledge of this innovative design. Grace produced the stoves, such as the example illustrated here (fig. 12.45), at his Warwick Furnace in Chester County, Pennsylvania, one of the many iron foundries that

Fig. 12.45. Attributed to Warwick or Mount Pleasant Furnace. "Franklin" or open stove, Chester or Berks County, Pennsylvania, 1742–48. Cast iron; 30¾ x 27½ x 35 in. (78.1 x 69.9 x 88.9 cm). Collection of the Mercer Museum, Doylestown, Penn. (04519).

sprang up in the colonies. One of the earliest known examples, this stove was made in the 1740s with a wide hood that prevented smoke from spreading through the room, a sun-face decoration surrounded by foliage, and the motto *Alter Idem* (Another Like Me), connecting the heat put out by the stove to the warmth of the sun.

Iron ore was plentiful in North America, and by the later eighteenth century, the British North American colonies supplied one-seventh of the world's production of pig, wrought, and cast iron. Other metals such as sheet copper and brass, however, were mostly imported in the colonial period. Attempts were made to produce glass as early as 1608 in Jamestown, Virginia, and subsequently in Salem, Philadelphia, and New York, but commercial success was not achieved until the eighteenth century. Few domestic production ventures became profitable because they all faced British mercantilist regulations that attempted to restrict the development of industries in the colonies in order to encourage continued imports from the mother country.

In the eighteenth century, several immigrants from the German Palatinate established successful glassworks. For example, Caspar Wistar (1696–1752) in 1717 joined the many people leaving their homeland for "the best poor man's land," as Pennsylvania had come to be known.[3] Wistar's success in the brass-button–making trade facilitated his entry into the colony's merchant elite, along with his conversion to the Quaker faith. In 1738, he established a glassworks in a wooded site (a source of needed timber to heat the furnace) in Salem County, New Jersey. The town became known as Wistarburgh, and a group of newly arrived German glassblowers provided his labor force. More than 15,000 bottles of all shapes and sizes were produced each year. These included this light green glass bottle with the seal of Richard Wistar, Caspar's eldest son (fig. 12.46). The works also produced window glass, glass tubes for scientific experiments, and table glass. The glass attributed to the Wistar glassworks, such as waffle designs on the finials of sugar bowls, shows the Continental training of its blowers. Franklin noted in a letter that Wistarburgh glass had a "greenish cast," but that its clear and hard glass was better for electrical experiments than the white glass of London.

By the mid-eighteenth century, colonial British North America had become more integrated into British material culture as part of what is now referred to as the Atlantic consumer revolution. Benjamin Franklin described how his domestic scene had changed in the 1740s:

> My breakfast was a long time bread and milk (no tea), and I ate it out of a two-penny earthen porringer, with a pewter spoon. But mark how luxury will enter families, and make a progress, in spite of principle: being called one morning to breakfast, I found it in a china bowl, with a spoon of silver! They had been bought for me without my

Fig. 12.46. Wistarburgh Glassworks. Bottle, Alloway, New Jersey, c. 1745–55. Glass; 9¼ x 4⅜ x 4⅜ in. (23.5 x 11.2 x 11.2 cm). The Corning Museum of Glass, Corning, N.Y. (86.4.196).

> knowledge by my wife, and had cost her the enormous sum of three-and twenty shillings, for which she had no other excuse or apology to make but that she thought *her* husband deserved a silver spoon and china bowl as well as any of his neighbors. This was the first appearance of plate and china in our house, which afterward, in a course of years, as our wealth increases, augmented gradually to several hundred pounds in value.[4]

His original spoon was pewter, a common material for utensils, plates, and other tableware; his earthenware bowl was made by a local potter. Both were traded for items requiring greater artisanal skill and labor, including a Chinese porcelain bowl made halfway around the world. He had added to his social status and become a gentleman: the runaway printer's apprentice had joined the consumer revolution.

DAVID JAFFEE

1750–1900

Fig. 17.34

EAST ASIA

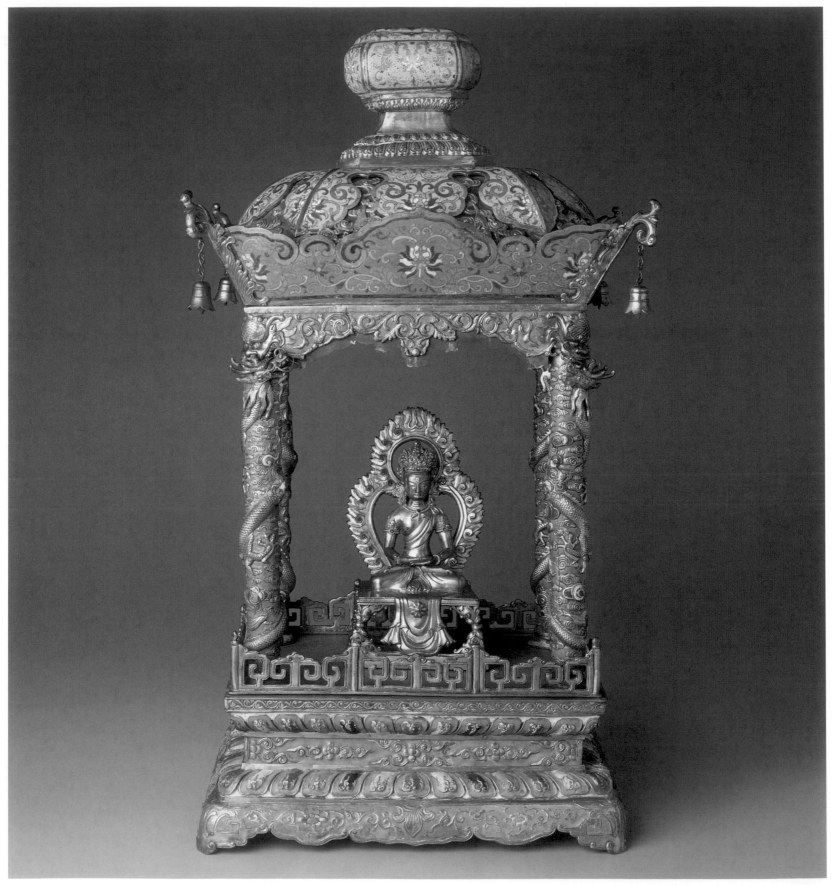

Fig. 13.2

CHINA

In 1750, China was at the height of its power and the most populous country in the world, strengthened by a century of decisive Manchu rule under the Qing dynasty (1644–1911). The economy was strong, agriculture efficient and productive, and, with the reign of the Qianlong emperor (r. 1736–95), military campaigns further enlarged the vast Chinese territories. General prosperity, combined with a long history of technological innovation and development, encouraged a flourishing of the decorative arts under Qianlong, who was a significant and enthusiastic patron of the arts.

By the end of the eighteenth century, however, China's global ascendancy had begun to falter, partly through a failure to modernize the economy, political systems, and manufacturing. European nations, particularly Great Britain, sought to profit from trading with China, but tensions arose because China saw European embassies as "tributary"— subservient sources of tribute—rather than equal trading partners. China's attempts to restrict Britain's opium trade led to the Opium, or Anglo-Chinese, Wars (1839–42, 1856–60) and China's reluctant signing of the Treaties of Nanjing and Tianjin. Known in China as the Unequal Treaties, they opened new ports to unrestricted foreign trade. The humiliation of these defeats, together with weak rule by a corrupt bureaucracy, led to internal strife and uprisings such as the Taiping and Boxer rebellions (1850–64, 1899–1901). During this period, the main areas of decorative arts production were the traditional ones: metalwork, ceramics, jade, furniture, lacquer, carvings, textiles, and dress.

Even as political and social tensions arose, reverence for antiquity remained a characteristic feature of eighteenth- and nineteenth-century Chinese thought and culture, expressed both through collecting and documenting antiquities. During the eighteenth century, early illustrated catalogues (twelfth-century Song and later) of ancient bronze and metalwork collections were reprinted, and new catalogues appeared, including a series that illustrated and described the bronzes in the imperial collection (*Xiqing gujian* [Western Clarity Hall's Mirror of Antiquities] 1749). Qianlong, the greatest collector of antiques in the history of China, decreed that ritual objects for temple altars and formal spaces within palaces were to be made in the shapes and forms of ancient bronzes. For the emperor and his contemporaries, objects conceived in these earlier styles evoked a past deemed superior to the present. Indeed, they considered archaism synonymous with the cultivation of refinement in craftsmanship and with an elevated style believed to be missing in contemporary times.

The production of Chinese goods took place at a variety of levels, from the homes and shops of individual village crafts-men to the imperial workshops overseen by the *Neiwufu* (Imperial Household Department). Established in the capital, Beijing, as well as in provincial cities with venerable traditions in the production of particular crafts, the imperial workshops kept up a steady manufacture of luxury items in a variety of media for palaces and temples. Such items were used by emperors and members of the court when presiding over religious and state rites, as well as at Buddhist, Daoist, and Confucian temples and at state temples. Court officials also had under their jurisdiction numerous palaces in the capital, summer palaces to the north, and many other notable buildings throughout the empire, for which they ordered objects.

METALWORK

Metalwork from the imperial workshops included vessels and other objects in gold, silver, gilt bronze, and cloisonné enamel. Ritual objects for temples and palaces included altar vessels as well as bowls, dishes, statues, bells, and shrines (figs. 13.1 and 13.2). Individual altar vessels were kept in stock in palace storerooms and assembled into sets when needed. Old and tarnished objects could be melted down and recast into new pieces, and well-worn items were regilded.

Bronze was first cast in China around 2000 BC, when it became a material of the highest status for the powerful and wealthy, partly because the raw materials used in its manufacture (chiefly copper and tin) needed to be mined and often transported long distances. In ancient times, bronze objects had been used for feasting—at banquets for both the living and the dead—and those associations were still recognized in the eighteenth and nineteenth centuries. In this period, some bronze items were made for domestic use, such as incense burners, which produced a fragrant, aromatic smoke that kept insects away. Many other objects were made for religious use. Characteristic ritual bronzes included the sets of five altar vessels known as *wu gong* ("five-offering vessels"), which consisted of an incense burner with flanking candlesticks and vases (fig. 13.1). Such sets were used on temple altars, in palace halls and household shrines, and at funerals.

The most luxurious bronze vessels were cast for imperial use, either at state-controlled temples or at the state sacrificial ceremonies that had been performed since the Bronze Age. The Qianlong emperor decreed in 1748 that new temple vessels were to be made in archaic forms to allow for this. Bronze was also used to cast statues, chiefly religious, for display in household shrines and temples. The largest were pairs of Buddhist lions created to stand before temple and palace gateways.

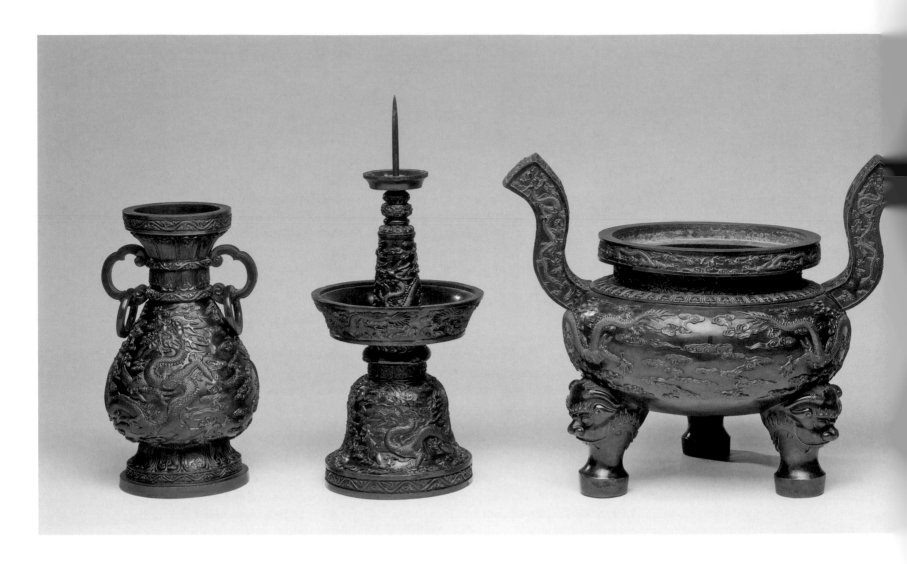

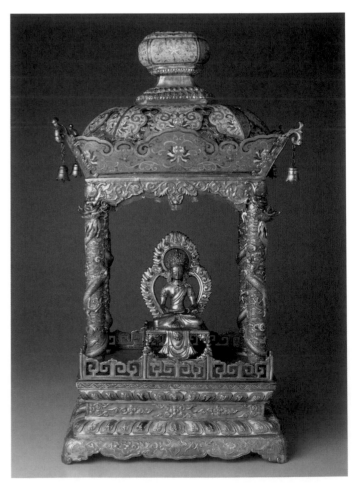

Fig. 13.1. Imperial altar set (*wu gong*), China, mid-18th century. Bronze. Phoenix Art Museum (1994.396.1-5).

Fig. 13.2. Shrine with a bodhisattva, China, 1736–95. Cloisonné enamel and gold wire on gilt copper alloy, gilt bronze Tibetan figure, semiprecious stones; 25¼ x 14⅜ x 10⅝ in. (64.1 x 36.5 x 27 cm). Brooklyn Museum (09.520a–b).

Known in China since the Yuan dynasty (1279–1368), cloisonné was an expensive and time-consuming technique used for decorating metal objects with colorful, mosaic-like vitreous enamels. In eighteenth-century Chinese cloisonné decoration (called *jingtailan* in Mandarin), as in earlier times, the wire lines and other exposed metal were often gilded, making it appear as if the objects were made of solid gold beneath the enamel (see fig. 13.2).

By 1750, cloisonné vessels and statues of considerable size were being made in the imperial workshops for palaces, temples, and other formal settings. In 1764, Qianlong and his mother, the dowager empress, presented lavish gifts of cloisonné to the Tanzhe Monastery outside Beijing. The costliness of cloisonné ensured that it was owned mainly by a small social elite and used largely in circumstances demanding sumptuous decorative effects such as palace halls and imperial temples. Elaborate, high-quality cloisonné was made until about 1850. Thereafter, as cloisonné became more widely affordable, problems of quality developed. As styles became simpler, colors became muddier, enamels were often pitted with holes where bubbles had burst in substandard firing, and cheaper material and less time-consuming techniques were used.

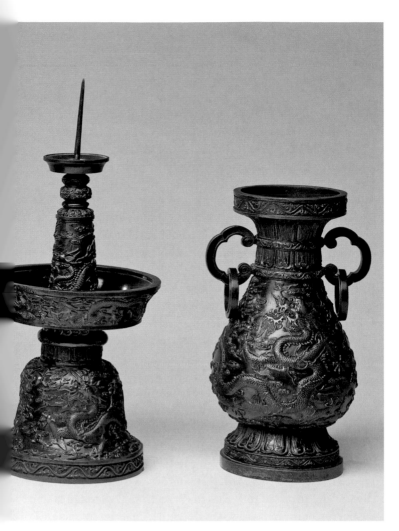

[1,250° and 1,400° C]). This single-firing process was less costly than enamel decoration, in which fired porcelain was painted with vitreous pigments in various colors and then fired again at a lower temperature to fuse the enamels to the surface. The gilding used on certain pieces was also fired at low temperatures in a supplemental firing.

Overglaze enameled and gilded porcelain was more expensive than underglaze painted wares, and was usually seen as more desirable. In this period, the use of pink enamels predominated, a palette that Western collectors call *famille rose*. Later eighteenth- and early nineteenth-century enamel decoration could be extremely fine, detailed, and delicate. Vessels made for the court were often highly complex, featuring, for example, perforated outer walls that rotated to reveal glimpses of painted scenes on the solid inner walls (fig. 13.3). Intricately decorated in overglaze enamels and gilding, the beauty and sophistication of such double-walled vases were intended to appeal to the taste of the imperial court, which valued technical virtuosity.

In addition to goods for the court, the kilns at Jingdezhen produced ceramics for all levels of society as well as for export. Some export porcelain was extremely fine in quality, and wealthy individuls in Europe and the Americas paid high prices for special orders. Blue-and-white wares dominated production, and hundreds of thousands of such pieces were made (fig. 13.4). In the mid-eighteenth century, these pieces were bought in large numbers by European East India Companies, but after about 1780 export orders began to decline because of the increasing success of European imitations of

CERAMICS

In the eighteenth and nineteenth centuries, Jingdezhen, in Jiangxi province, remained the most important center for porcelain making in China. An industrial center with many private and publicly owned factories, the city was situated near abundant deposits of kaolin and petuntse, the essential raw materials of hard-paste porcelain. Good networks of waterways not only conveyed finished goods to markets around the country; they also supplied transportation for the vast amounts of wood, brush, and charcoal needed to fuel hundreds of kilns. At the center of the city, the largest government-managed kilns were those of the imperial porcelain manufactory, *Yuyaochang*, which made goods for the court and sent them up the Grand Canal (Da Yunhe), the longest artificial river in the world, to the capital. Outside the walls of the imperial factory, large and small private kilns lined the city streets, in operation day and night.

In 1750, porcelain quality was extremely high, both technically and artistically. Wares of all shapes and sizes were possible, ranging from huge vessels made for temples to more delicate items for scholars' desks. Decoration included plain glazes as well as underglaze and overglaze painting. Underglaze pigments—cobalt (for blue), copper (for red), and iron (for green)—were applied directly to the unglazed porcelain body, then covered with a layer of transparent glaze and fired at extremely high temperatures (between 2,300° and 2,500° F

Fig. 13.3. Double-walled vase with revolving scenes of the seasons, Jingdezhen, after 1743. Porcelain; H. 15⅞ in. (40.2 cm). The Palace Museum, Beijing.

blue-and-white ware for the home markets. Following the American War for Independence (1775–83), ports in the United States began trading with China (which lasted until the mid-nineteenth century).

The city of Jingdezhen sustained considerable damage during the Taiping Rebellion in 1854–55, and the imperial manufactory was destroyed. Even greater devastation befell the city in 1861 as imperial soldiers battled Taiping troops, who were not driven out until 1864. In 1866, the imperial factory was partially rebuilt but production never regained the levels of quality and volume attained before mid-century. Manufacture for domestic demand continued, but key markets for high-quality goods in Japan, Europe, and North America were lost, and exports mainly consisted of lower-quality goods destined for Southeast Asia, the Middle East, and Africa.

In addition to Jingdezhen, two other Chinese centers made ceramics especially for Asian markets and the Chinese diaspora: Shiwan, near present-day Guangzhou in Guangdong province, and Dehua to the north in Fujian province. Shiwan kilns produced tough stonewares with lively, splashed glazes and specialized in artistic vessels and figurines. Dehua emphasized the manufacture of pure white glazed porcelain figurines (known in the West as *blanc de Chine*). Frequently depicting Buddhist and Daoist deities and religious figures such as Bodhisattva Guanyin (fig. 13.5), they were made for the increasingly prosperous communities of Chinese living in Hong Kong, Taiwan, and Southeast Asia, with some examples finding their way to Europe and the United States. Dehua potters often signed pieces with their names, which was unusual within the context of Chinese ceramics and other trades.

Jade has been revered in China for thousands of years, and in 1750 the lapidary industry was thriving. A Western term, "jade" refers to two minerals, nephrite and jadeite, although the Chinese term *yu* refers to both of these, together with a variety of other stones. The northwestern region of Xinjiang was at the time the primary source for nephrite, which ranged in color from green and yellow to white, gray, brown, and black. This territory, along the Silk Route and far from the center of Chinese power, was often contested by northern nomadic peoples, thereby interrupting jade supplies. Between 1755 and 1759, Qianlong waged a series of battles to pacify Xinjiang and thus assure the supply of large quantities of top-quality nephrite. Late in Qianlong's reign, jadeite began to be imported from Burma, and by the nineteenth century, jade carvers in Guangzhou were working almost entirely in either "spinach green" nephrite from Xinjiang or brilliant green Burmese jadeite. In contrast, carvers in Beijing, Suzhou, and Shanghai confined themselves chiefly to white Xinjiang jade, the color traditionally most admired in China.

Once imbued with powerful ritual significance, jade was used mainly for ornamental objects in the eighteenth and nineteenth centuries, including models depicting mountainous scenes. The largest carved jade mountain, housed in the Forbidden City in Beijing, employed the biggest piece of nephrite rock ever found (fig. 13.6). It stands over 6.5 feet (200 cm) in height and required ten years to carve, from 1778 to 1788.

Connoisseurs appreciated the tactile qualities of jade, favoring small objects that could be easily handled, and artisans predominantly crafted pieces into human figures, ani-

Fig. 13.4. Platter, probably Jingdezhen, 1790–1800. Porcelain; W. 22 in. (56 cm). Peabody Essex Museum, Salem, Mass. (E49440).

Fig. 13.5. Figure of Bodhisattva Guanyin, Dehua, 1870–1910. Porcelain; H. 9½ in. (24 cm). Asian Civilisations Museum, Singapore (2000.3434).

mals, fruit, and other forms from nature. Carved by abrasion, jades were subjected to a long sequence of increasingly fine polishing which made them very smooth; oils from the human hand were believed to add to their patina. Tiny pieces of jade were made into buttons or jewelry, often in combination with other stones or kingfisher-feather inlay, a technique whereby the iridescent feathers of that bird were glued to the surface as shimmering decoration.

Jade was also used to serve food and wine in wealthy households and for scholars' desk accessories. Before the early twentieth century, the highest mark of achievement in Chinese society was to pass the imperial examinations and become a scholar. In keeping with their status, these educated men chose beautiful and skillfully made brushes and other tools, which served for both writing and painting. The range of objects one might find on a scholar's desk was fairly extensive, including ink boxes and stones, water droppers, brush pots and washers, and other items. In Chinese calligraphy and painting, ink is freshly prepared for each use. Water is dribbled from a dropper onto an ink stone, and then solid ink is ground into it to make a liquid pigment, which is applied with a soft-haired brush. During and after use, the brush is moistened with water and cleaned in a brush washer, and then stored with its tip up in a brush pot.

To catch good light, the scholar's desk was positioned in front of a window, and table screens, with attractive and edifying imagery and inscriptions to uplift or pleasantly divert, could provide shade. As the scholar moved his brush across the paper from right to left, his sleeve would be protected from the spreading ink by an arm or wrist rest, which also made the brush more comfortable in the hand. When he finished his composition, the scholar's seal—stamped on the work in vermilion paste—would record his name, the name of his studio or workplace, or simply a good-luck wish or poetic saying. Seals in particular, but also brush handles, water droppers, and the various vessels associated with painting and writing, were all made in jade in the eighteenth and nineteenth centuries, although many were produced in other materials too such as carved bamboo or lacquer.

Jade, like bronze, was associated with antiquity, and during the Qing dynasty, Chinese and Western collectors eagerly sought ancient pieces, thus creating a market for forgeries. Illustrated catalogues of jade objects, printed in some quantity since the Ming dynasty (1368–1644), provided shapes and patterns for forgers as well as legitimate craftsmen, and many fake "antique" jades found their way into prominent museum collections. In the late nineteenth and early twentieth centuries, jade forgery was particularly active in Suzhou, where items carved in imitation of older pieces were given the spurious appearance of age by staining, burying in the earth, or superficial roughening and pitting.

Fig. 13.6a–b. Carved mountain (and detail): *Da Yu zhishui yushan* (Sage King Yu Controlling the Flood), China, 1778–88. Jade, copper stand, gold inlay; with stand, H. 9¼ ft. (2.8 m). The Palace Museum, Beijing.

FURNITURE

Furniture made during the Qing dynasty was of two main types: contemporary pieces which privileged novelty and traditional-style objects based on furniture from the Ming dynasty, made in unadorned hardwoods including *huanghuali* ("yellow flowering pear wood," a type of rosewood), *zitan* (purple rosewood), *hongmu* (rosewood), *nanmu* (cedar), *wumu* (ebony), and *jichimu* ("chicken-wing wood," a species of *Ormosia*).

Thousands of pieces of very lavish furniture were executed for the Qianlong emperor, all made to the highest technical standards and almost always embellished with inlay in various combinations of materials, including gold, silver, coral, jade, ivory, gem- and hardstones, and enamels. The large, barrel-shaped stool in figure 13.7, for example, has painted copper inlay. Ornate furniture of this kind was placed in sumptuously decorated rooms with other finely made objects, contributing to an overall effect of opulence.

During Qianlong's reign, new types and fresh designs for furniture appeared, such as writing tables with drawers or cleverly designed cabinetry with hundreds of compartments meticulously arranged to display individual objects to the best advantage. Small versions of these cabinets were also made, including *duobaoge* ("treasure boxes") with hidden compartments (fig. 13.8). Other novel designs included multifunctional objects such as tables with space to heat food, barrel-shaped stools that housed chamber pots, and a kind of wooden couch with multiple attachments such as a hat stand, clothes rack, bottle holder, hanging shelf, or adjustable spittoon.

At the end of the eighteenth century, the Jiaqing emperor (r. 1796–1820), who advocated living in simpler ways, cur-

tailed many projects at the imperial workshops. As a result, less new furniture was available and many pieces were made from reused timber. Subsequent nineteenth-century emperors were not the great patrons of the imperial workshops that Qianlong had been. Warfare occupied more of their time, as did politics, in particular the rise of European power in Asia.

The flamboyance of the Qianlong era gave way to more austere designs for palace furniture that emphasized the traditions of a past perceived as glorious. Furniture made for the domestic market fell into three main groups: *Guangzuo* and *Suzuo*, named for the cities in which they were made, and *Jingzuo*, which was furniture made in Beijing. European and Asian influences are evident in many Guangzhou pieces, while furniture making in Suzhou, the source of elegant and restrained Ming furniture in the sixteenth and seventeenth centuries, became more formulaic after about 1820 as craftsmen increasingly reproduced past styles as faithfully as possible, as opposed to drawing on them in creative ways. Much Beijing furniture retained the high quality for which it was known, but even there the weakening economy, and social corruption that saw the downfall of old families and the rise of new wealth with new priorities, led to a drop in demand for traditional, fine-quality furniture.

Throughout the period, imperial furniture had an influence beyond the courts. Members of the aristocracy were often rewarded with gifts of furniture from the emperor, and therefore styles, techniques, and frequently materials used in the imperial workshops were imitated by craftsmen in different localities. In their turn, regional workshops sent tributes to court, and thus furniture from various regions of China influenced imperial furniture design and production.

Fig. 13.7. Stool, China, 18th century. *Zitan* hardwood (red sandalwood), enamel on copper; H. 20½ in. (52 cm). The Palace Museum, Beijing.

Softwood furniture was available for those who could not afford the expensive hardwoods prized by the wealthy. Indeed, in the south, ubiquitous bamboo was employed for all sorts of domestic items, including furniture, buckets, drain pipes, and scaffolding. Chinese bamboo furniture, real and imitation, was most popular in Europe in the early nineteenth century, especially in England when the Prince Regent was furnishing the Royal Pavilion at Brighton (see fig. 17.2).

LACQUER

The painstaking craft of lacquering had become extremely sophisticated by the eighteenth century. A readily available plant-based resin, lacquer was used—in layer upon thin layer—to coat the surfaces of vessels and other household objects to make them both decorative and durable. Except for the simplest objects, costly lacquerware was reserved for the upper classes and the court. Workshops in the Forbidden City in Beijing created for throne rooms, temples, and domestic quarters in the various imperial palaces objects of exceptional design and workmanship, such as the exquisitely carved and painted lacquer cabinet illustrated here (fig. 13.8). Such cabinets were used to display treasured objects, including bronzes, jades, and porcelain, both antique and contemporary. This cabinet is believed to have been made in the workshops of the Imperial Household Department because the imagery on the door panels matches that on a handful of objects that remain in imperial palace collections in China. Its interior surfaces imitate Japanese lacquer techniques, and Christian

Fig. 13.8. Cabinet, probably Beijing, 1720–80. Lacquered wood; 45⅝ x 33⅛ x 11¼ in. (116 x 84 x 28.5 cm). Victoria and Albert Museum, London (FE.56 to B-1983).

missionary records of the period, including letters, diaries, and reports, reveal the extent to which Chinese lacquer workers in the imperial workshops were able to imitate fashionable imported Japanese *maki-e* ("sprinkled picture") lacquers (see fig. 1.28).

The outer surfaces of this cabinet are densely carved with long-life symbols and flowers with auspicious meanings. The deep carving, cut down through dozens of gradually applied layers of red lacquer to a yellow ground, shows that this piece would have taken many months of preparation alone, before the carving and painting began.

Outside the capital, particularly in the south of China, many private lacquer workshops plied their craft, some attaining quite high standards. Although lacquer was never cheap, costs were reduced in some instances by leaving the lacquer plain and relying on its color and surface sheen for effect. A lower-cost method for producing decorated lacquer involved painting into a layer of wet lacquer with colored pigments and then sealing the surface with a clear layer. What Europeans called "Coromandel" lacquer—carved wood covered with thin layers of colored lacquer and gilding—proved more cost effective than carving lacquer, and was used for screens and many other items of furniture exported to the West.

Lacquer products were an Asian monopoly because the lacquer tree does not grow in cooler climates. The substantial number of surviving examples in Europe attests to the large quantities of Coromandel and other lacquer objects that were shipped out of Chinese centers, such as Guangzhou, as well as Japan. Greatly valued by European customers, high-quality lacquer, often tailored to Western tastes and requirements, had been exported by the Japanese since the sixteenth century. By the eighteenth century, however, Chinese export lacquerwares were cheaper than Japanese and generally lower in quality. They were more frequently made in greater quantities, with fewer layers of lacquer and containing less detail in the decoration. Like Japanese lacquer, Chinese export lacquer was usually black (colored by the addition of carbon or soot), but its surface was often embellished with decorative gilding and mother-of-pearl inlay. After black, red (produced by the use of cinnabar) was the most prevalent color for lacquer, whether for China itself or the export market.

CARVING

Intricate carving in animal and vegetable substances, such as wood, bamboo, coconut shell, gourd, horn, and ivory, was widely practiced throughout China in the eighteenth and nineteenth centuries, with some of the best workshops found south of the Yangtze River in cities such as Suzhou and Guangzhou. Many carvers applied their skills to a variety of materials. In addition to small family workshops in regional centers, larger workshops existed in cities such as Canton. The best-known carvers might be summoned to court.

Bamboo and other woods were used to make pieces that were both useful and ornamental, such as brush pots for scholars' desks, boxes, cups, incense burners, perfume holders, and religious figurines. These natural materials had been in use for millennia, and carved antique examples were highly esteemed by the literati, some of whom took up the craft of bamboo carving. Professional bamboo carvers were among the most skilled craftsmen in China and among the rare few who sometimes signed their work.

In the tropical deep south of China, coconut shells were also carved, and with gold or silver liners, they became vessels. The dried skins of gourds were used as containers, as they had been in China from the very earliest times. By the eighteenth century, a specialized craft had developed that involved growing gourds inside elaborately carved wooden molds so that the gourd took on the shape of the mold. Objects of everyday life were made in this way, from utilitarian bowls and flasks to ornamental cages for crickets kept for fighting—cricket fighting was a long-established, popular pastime.

Rhinoceros horn, prized in China for its purported medicinal powers, was imported from India, Nepal, Malaysia, Thailand, Vietnam, and Indonesia, and in the nineteenth century by steamship from Africa. Its scarcity meant that it was more costly than gold, but despite the rarity and expense, Chinese carvers continued to make horn drinking vessels of a type that had been used since the Bronze Age. Some of these imitated archaic bronzes, while others were carved with landscapes or in the form of plants. A few were largely unworked, save for details such as handles in the forms of Buddhist or Daoist deities.

Ivory carving also continued during this period, and the best examples were extremely intricate and highly polished. Elephant ivory was shipped from India, and by the end of the nineteenth century, huge amounts of ivory were reaching the ports of south China from Africa. There was a large domestic market for ivory objects including chopsticks, writing implements, fans, hairpins, screens, boxes, cups, dishes, and religious articles. Small numbers of items such as fans, sewing boxes, and chess sets were also exported from China to Europe, where by the eighteenth century they were extremely popular.

TEXTILES AND DRESS

China's long-established, thriving silk industry continued to flourish in the later Qing dynasty. Woven silk was used for many things, from furnishing fabrics and bedding to celebratory hangings and items of dress. Silk thread was spun for use in embroidery, and China exported bolts of silk cloth around the world, bringing much-needed revenue to the state. Cotton, hemp, and ramie (a fine fiber spun from the nettle shrub *Boehmeria nivea*) grew in China and were widely used for garments and domestic textiles.

Cushions for seating furniture, curtains for beds, and frontals for tables were all common household textiles. Layers of textiles often hid most or even all of the form of the furniture. Hangings were popular for special occasions. For example, a large embroidered panel made in 1863 during the reign of the Tongzhi emperor (r. 1861–75) celebrated the ninetieth birthday of a certain Mr. Huang (fig. 13.9). Embroidered on a crimson satin ground (red being the most auspicious color for Chinese celebrations), the panel bore a long inscrip-

tion praising Huang's merits and listing the names of donors in gold leaf. Stylistically, the embroidery resembles examples from the Chaozhou region of Guangdong, which according to the inscription, was the recipient's home province.

During the Qing dynasty, two main ethnic groups comprised the Chinese population: the majority Han Chinese and the ruling-class Manchus, originally invaders from the steppes northeast of China. Although Manchus retained some distinctive customs (Manchu women did not bind their feet, for instance), by the second half of the eighteenth cen-

tury, dress styles in both groups were broadly similar. The most elaborate clothing was used at court. Both men and women wore robes of simple construction. Men wore lavishly patterned *ji fu* ("festive dress," known in the West as "dragon robes"; fig. 13.10) with imagery of dragons in various poses and numbers that denoted rank according to law. Their wives also dressed in robes that might incorporate family insignia or imagery signifying nobility and rank, including water, mountains, clouds, and dragons. The cut of these garments revealed Manchu influence in the long horseshoe-

Fig. 13.9. Hanging, possibly Chaozhou, 1863. Embroidered silk, silver threads, gold leaf; 14¼ x 8¼ ft. (4.4 x 2.5 m). Victoria and Albert Museum, London (T.159-1964).

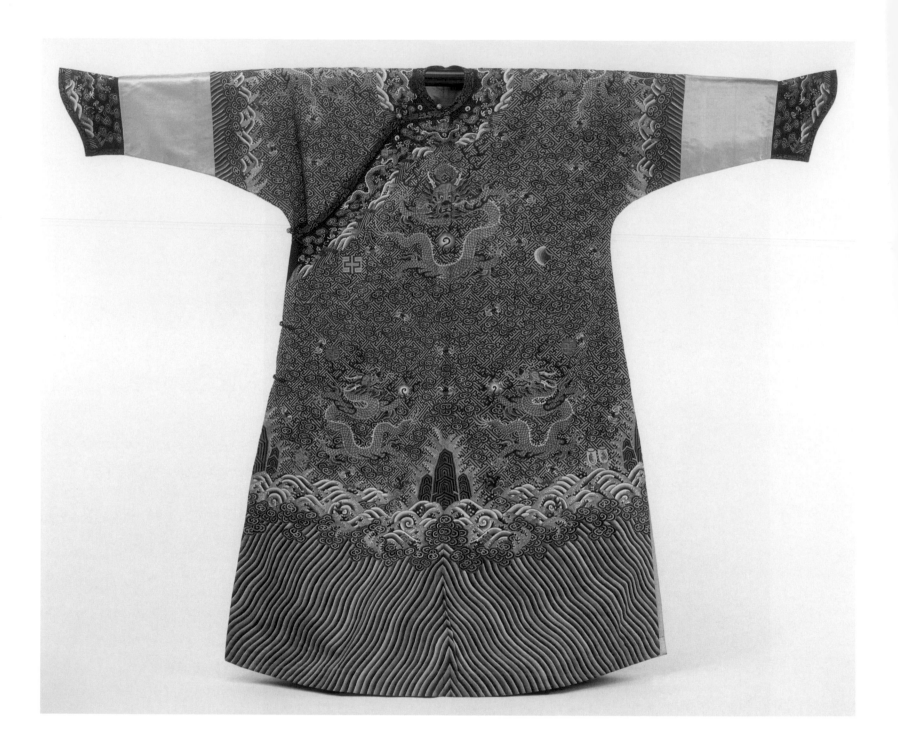

Fig. 13.10. Robe (*ji fu*), China, 1780–1850. Tapestry-woven silk (*kesi*); 60⅝ x 76⅜ in. (154 x 194 cm). Victoria and Albert Museum, London (T.199-1948).

shaped cuffs that fell over the backs of the hands. The robes worn by civil and military officials bore square embroidered badges on the chests and backs indicating rank (see fig. 7.18).

Outside of the court, men wore gowns that signified by length the social status of the wearer: the longer the robes, the higher the status. Manual workers wore relatively short garments with trousers underneath. Manchu women had full-length gowns, while Han Chinese women used skirts beneath shorter robes with wider sleeves. Men and women both often wore short jackets and sleeveless waistcoats over their long garments.

Satins, brocades, velvets, and other fabrics for luxury clothing were sometimes patterned with imagery and motifs woven into the fabric. Elaborately patterned silks could be woven as brocades (in which supplementary weft yarns, often in gold or silver, achieved an effect like embroidery) or

as velvets, with supplementary warps forming a deep pile. Fabrics could be further embellished with embroidery in a wide range of complicated stitches such as "Peking knot" and "Peking stitch," names used in the West to describe tiny, three-dimensional embroidery stitches of great intricacy.

As with court garb, colors and motifs frequently conformed to conventions. Older women, for example, wore dark blue, lilac, and mauve, while patterns of flowers and butterflies were considered appropriate for adolescent and young women. Other kinds of textiles were considered appropriate to specific circumstances, such as red robes for weddings, while white clothing signified mourning. Special embroidered slippers were made for Han women with bound feet when they reached adulthood. For Manchu women, high platform-soled slipper shoes with embroidered uppers became fashionable in the 1880s.

ROSE KERR

KOREA

In the mid-eighteenth century, Korea under the Joseon dynasty (1392–1910) was a highly centralized monarchy. Its bureaucracy, state rituals, philosophy, and cultural values were strongly influenced by Chinese Confucianism. As in China, special examinations were required to enter the high-status state bureaucracy, but unlike China, only upper class men, literati (*yangban*), were eligible. Society as a whole was rigidly stratified according to status, occupation, and gender. By the end of the eighteenth century, corruption and internal strife threatened political and social stability, and beginning in the mid-nineteenth century there was considerable pressure within Korea for exchange with European countries and the United States, which sought trade and diplomatic concessions. Meanwhile, Sino-Japanese rivalry over control of Korea continued. In 1876, Korea signed a trade treaty with a rapidly modernizing Japan, which went on to defeat China in the First Sino-Japanese War (1894–95), a conflict played out partly on the Korean peninsula. Heated debates between pro-Japanese factions and those who supported the old order continued after "Joseon" was renamed the Korean Empire in 1897. By 1905, Korea was a Japanese protectorate, and in 1910, it was annexed by Japan, which ruled Korea through a governor-general until the end of World War II (1945).

HOMES AND FURNISHINGS

Despite political and social upheaval, during the years between 1750 and 1900 many design and craft traditions persisted and flourished in Korea, in part because of the state's long-standing isolationism. In the traditional Korean home, rooms were heated by an under-floor system (*ondol*) that conducted warm air from a stove in or adjacent to the kitchen through channels in a masonry floor. Floors were made of stone, covered with clay, and faced with oiled paper. They were kept scrupulously clean since everyone sat on the floor and used portable tables and cushions. Furnishings were sparse, and larger pieces of furniture were placed against the walls. Upper-class households had segregated women's and men's areas. Women's furniture was colorful and often adorned with lacquer, inlay, and painting, while men's furniture was relatively sober and fashioned from plain wood.

The calm, peaceful interior of the *sarangbang*, a room used both for reading and reception by educated men, was the setting for furniture of high quality. Much of the beauty of this comparatively plain furniture came from the grain of the woods and the craftsmanship of the *somokjang* (master carpenters), who created pieces with complicated joints and wooden pegs from local pine, zelkova, and imported amboyna wood, all of which feature very pronounced grain. Bare wood surfaces were polished with camellia or walnut oil to highlight grain patterns. The *changsok*—metal fittings, locks, and hinges—were often remarkable examples of design and craftsmanship in their own right, supplied by a separate trade of metalworkers.

Objects designed and produced for women were often decorated with horn or mother-of-pearl inlay. Lacquer objects inlaid with mother-of-pearl, like the piece illustrated here (fig. 13.11), were called *najeon chilgi*. Using metal wires to attach small pieces and strips of mother-of-pearl to a prepared surface, craftsmen applied layers of lacquer until the mother-of-pearl was completely covered—a process similar to cloisonné but, unlike cloisonné, not fired. The surface was polished to achieve a glossy finish and reveal the inlay.

Fig. 13.11. Two-tiered chest with stand, Korea, 1800–50. Lacquered wood, mother-of-pearl inlay; 54⅛ x 29⅟₁₆ x 14½ in. (137.5 x 73.8 x 36.8 cm). Asian Art Museum, San Francisco (1992.30.1-.3).

Although ox horn was employed elsewhere in Asia, its use in Korea is particularly notable, not least because Koreans greatly respected the ox as a symbol of faithfulness, sincerity, and integrity. An ox was one of the most valuable assets a farmer possessed; even with its death it provided food, bone, skin, and horn. Unique to Korea, *hwagak* ("brilliant horn") was a centuries-old technique of applying paper-thin pieces of brightly painted ox horn to the surfaces of furniture and other household objects to create vivid and intricate designs. Laborious and time-consuming, it required the horn to be soaked in warm water or steamed, cut open and flattened, and then separated into layers. Cut into regular-sized squares or rectangles, the thin horn sheets were painted on the back and then glued to a wooden frame or surface with the painted side down so the imagery showed through the translucent horn. The outer surface was polished to a brilliant finish in order to protect the painted decoration. Sadly, this decoration is highly susceptible to changes in temperature and humidity, which cause the horn panels to split, crack, or peel away from the wooden substrate, making the survival of these objects relatively rare.

Unlike many other types of Korean craftwork, *hwagak* objects were brightly colored and decorated with a wide range of auspicious imagery and motifs from nature, including symbols representing longevity and happiness on the hinged box illustrated here: deer, tigers, peonies, rocks, and various types of birds (fig. 13.12). By the eighteenth and nineteenth centuries, *hwagak* was used for many kinds of case furniture, as well as small boxes and personal objects. Above all, it was employed for women's personal belongings, including jewelry and cosmetic boxes, sewing boxes, spools, and combs. This box reinforces its link to a female owner with a brass lock shaped like a butterfly at its top and a five-petaled flower below.

METALWORK

During the Joseon period, state-run metal workshops in both the capital, Seoul, and the provinces controlled the distribution of the bronze, brass, and copper items used daily in kitchens throughout the country. Records attest that as many as 30 percent of the government-supported artisans in the capital were metalworkers.

The highest quality kitchen utensils, those used in royal and aristocratic households, were made using a technique called *bangjja yugi* ("forged brassware"). Heated, copper-rich metal was hammered into shape in a laborious process that required thousands of blows to transform the material into fine vessels that were thought to indicate the presence of poisons and keep food fresh. Although nineteenth-century brass and inlaid metalware can be difficult to date with precision, European travelers to Korea in the 1890s remarked on the high quality of the brass vessels in private homes, and noted that silver-inlaid ironware was for sale in shops.

Koreans greatly appreciated inlaid metal. Thin silver and gold wire was hammered into finely chiseled grooves to form

Top: Fig. 13.12. Box, Korea, 1880–1910. Wood, ox horn, brass; 11 x 20 x 9⅝ in. (27.9 x 50.8 x 24.5 cm). Victoria and Albert Museum, London (W.38:1 to 3-1920).

Bottom: Fig. 13.13. Brush pots, Korea, 1850–1900. Iron, silver and gold (left) inlay; left, 7¾ x 3 x 3 in. (19.6 x 7.6 x 7.6 cm). Victoria and Albert Museum, London (M.302-1912 and M.401-1912).

patterns on the surface of bronze and iron objects. Birds, butterflies, and flowers were prevalent motifs; so too were messages of good luck. The scholar's iron brush pots illustrated here are inlaid with silver-wire imagery symbolic of long life—pine trees, bamboo, a waterfall, deer, cranes, and a tortoise—and the flaming pearl of knowledge pursued by a dragon (fig. 13.13).

CERAMICS

Korea began producing high-fired, vitreous porcelain in the ninth and tenth centuries, the second country in the world after China to do so. From 1750 to 1900, white porcelain continued to be the mainstay of Korean ceramic production. In the first half of the eighteenth century, royal ceramic production had been moved to a site at Kwangju, just south of Seoul, in an area with ample high-grade porcelain stone, porcelain clay deposits, and firewood, where it continued until 1883.

Plain white porcelain exemplified the Korean taste for simple, unadorned forms as well as the influence of Confucianism, a philosophy that emphasized purity and a lack of pretension. Although blue-and-white Chinese porcelain from Jingdezhen had been introduced into Korea in the first half of the fifteenth century, Korean potters found it difficult to reproduce because the cobalt necessary for its decoration had to be imported from China. By the second half of the eighteenth century, however, cobalt had been discovered locally and a wide range of forms were in production, including tall footed ritual vessels, bottles, and large jars. Copper-red underglaze decoration was also used in this period, alone or in combination with underglaze blue. First developed in a Korean context in the twelfth century, underglaze red was not used on white porcelains until around the eighteenth century; by the nineteenth, it was in use on a wide range of wares.

Angular shapes were typical of this late Joseon period, as were vessels with beveled and faceted sides. In the case of large pieces, firing difficulties sometimes led to imperfections such as warping and slumping, requiring the forcible removal of wares from kilns when the glaze fused the vessel to its support. Such kiln effects are highly valued by collectors today, who believe that they add to the appealing spontaneity of Korean porcelains.

In the first half of the nineteenth century, the range of decorative ceramic techniques expanded to embrace lively painting, carving, incising, and piercing. Previous prohibitions against the use of porcelain by people outside the royal family eased, and objects, including brush pots and water droppers, were made for the scholar's desk. Wine jars and bottles were produced in large numbers, as were pipe rests, made to cater to the newly popular pastime of tobacco smoking. Round cloth pillows were commonly made with decorative ends of wood, lacquer, or, as shown here, porcelain (fig. 13.14). This example, which features two blue-and-white cranes in opposition, has a circle of holes that were used to sew the end to the pillow.

PAPER AND SCREENS

The Korean aphorism that "paper lives a thousand years but silk for only five hundred" may explain the many uses for paper in Korean culture, from floor and window coverings to bags, boxes, and umbrellas. Korean paper making has a long and prodigious history and was admired by the Ming Chinese, who were not inclined to prize foreign goods. In the eighteenth and nineteenth centuries, paper products were ubiquitous in Korean life. Strong and durable, paper was used for brightly colored storage containers of various kinds in the women's quarters of Korean homes. Needlework boxes might be decorated with butterflies, bats, and other lucky symbols, often used in combination to form rebuses against misfortune and ensure happiness.

Paper was also used for screens, an essential element of Korean room design. Those for women's rooms were often painted with peonies (symbols of fertility and prosperity), while men's screens were decorated with *chaekkori* (books and other scholarly equipment; fig. 13.15). *Chaekkori* screens were ideally displayed behind the desk in a scholar's study, where they conveyed dignity, luxury, and a reverence for scholarship through imagery which included books, writing brushes, ink stones, and Chinese porcelain and bronzes. Strictly Confucian, the Joseon state accorded scholars superior social status and high government rank. The scholarly accoutrements portrayed on screens were evidence of the aspiration to rise to the highest levels of society.

Fig. 13.14. Pillow end, Korea, 1800–70. Porcelain; Diam. 3¾ in. (9.5 cm). Victoria and Albert Museum, London (C.444-1920).

TEXTILES AND DRESS

Koreans produced a variety of fabrics to suit different seasons and meet varied needs. For clothing, silk, cotton, hemp, and ramie were the most common fibers, and padded fabrics helped the wearer withstand the winter cold. Spinning, weaving, sewing, and fabric care typically were done at home by women. Many Korean garments were extremely time-consuming to launder. Ramie, for example, had to be pounded with heavy sticks while wet in order to release its natural starch, which gave a crisp, glossy texture to the fabric when it dried.

Clothing fabrics were chiefly plain or woven with self-colored patterns, but clothes were augmented by colorfully embroidered accessories. For example, embroidered panels denoting rank were elements of official or wedding garments.

Women used embroidered purses attached by long cords to their belts but the pouches men carried were usually not embroidered. Embroidered textile screens and scrolls often embellished the otherwise austere interiors of Korean homes.

In the Joseon dynasty, both men and women wore a style of clothing called *hanbok* (literally, "Korean clothing"), characterized by simple lines and a lack of pockets. Women's *hanbok* consisted of a *jeogori* (bloused shirt or jacket) and *chima* (wrap-around skirt). The *chima* skirt was full, especially around the hips, and many undergarments were worn to achieve the desired silhouette. Men wore *jeogori* and *baji* (baggy pants). Over time the style of these garments changed. For example, women's *jeogori*, which had been baggy and fell below the waist in the sixteenth century, gradually became shorter and more closely fitted. By the nineteenth century, the shirts were so short that they did not cover the breasts and a

Fig. 13.16. Sin Yun-bok (Hyewon). Spring scene from an album of paintings, Korea, late 18th–early 19th century. Ink and colors on paper; 11 x 13¾ in. (28 x 35 cm). Gansong Art Museum, Seoul (National Treasure 135).

Fig. 13.17. Wrapping cloth (*pojagi*), Korea, c. 1900. Embroidered cotton; 16 x 16 in. (40.6 x 40.6 cm). Asian Art Museum, San Francisco (1995.78).

supplementary white cloth (*heoritti*) was required as a cover-up; it also functioned as a kind of corset. At the end of the nineteenth century, a new Manchu-style jacket was introduced for men and women that is still often worn with *hanbok* today. Called *magoja*, these long-sleeved jackets fasten with buttons instead of the ties typically used in Korean dress.

Korean clothing incorporated many markers of an individual's class and age. Commoners wore plain colors. They were restricted by law to white clothes for everyday wear, but for special occasions they could wear dull shades of pale pink, light green, gray, and charcoal. The upper classes wore a greater variety of colors, although bright colors were generally worn by children and young girls, and subdued colors were worn by older men and women (fig. 13.16). Unmarried women dressed in red and yellow skirts, whereas married women wore blue. According to the regulations, when Korean men went outdoors they were required to wear overcoats known as *durumagi* that reached the knees, but only upper-class men wore the tall, hard, brimmed black hats made of horsehair called *gat*.

Court dress worn by nobility and royalty was vibrantly colored and luxuriously decorated. One kind of textile used by all levels of society was *pojagi*, the decorative wrapping cloths used daily to, among other things, wrap gifts, protect garments in storage, and cover items such as bedding or food (fig. 13.17). Made in different sizes, *pojagi* could be lined or unlined; painted, printed, or plain; and made of silk, ramie, or cotton.

The development of the decorative arts and design between 1750 and 1900 followed different paths in China and Korea. In China, design and the decorative arts experienced a period of innovation and flourished in the eighteenth century, whereas in the nineteenth century they tended to be more conventional. Korean crafts took a steadier path. As in past centuries, close political and economic ties with China introduced Korea to new techniques, materials, and forms, but the Koreans inevitably transformed these to suit local lifestyles and aesthetic preferences. In both China and Korea, production and consumption were affected by changing political and economic circumstances, the nascent impact of European and United States trade, and the political presence of Europe and the United States in Asia, as well as burgeoning Japanese colonialism, all developments that would have even greater significance in the twentieth century.

ROSE KERR

JAPAN

After two and a half centuries of stable political rule, Japan gained a new government in 1868 and subsequently underwent major political, economic, and social reorganization. As a result, the period 1750–1900 is usually considered in three parts: an early modern period that ends in the 1850s, a transitional moment in the 1850s and 1860s, and a modern period beginning in 1868. This chapter flags continuities between the pre- and post-1868 situations and shows how the production and consumption of design and decorative arts changed over the entire period, not just after 1868.

From 1615 to 1868, Japan was ruled by the Tokugawa family. The Tokugawa or Edo period as it is known was a time of remarkable political and social stability. Communication with the outside world continued to be limited and controlled primarily through interaction with Chinese and Dutch trad-

ers in Nagasaki, the one foreign foothold allowed in Japan by the Tokugawa. Japan's population remained largely stable at around 30 million from the seventeenth century to the 1860s, as did the population of the major cities and the urban-rural distribution (90 percent of Japan's population lived in villages; 10 percent in towns). The political system of regional lords (daimyō) responding directly to the Tokugawa shogunate in the capital, Edo (present-day Tokyo), did not change until the 1860s, nor did the tax structure, which saw payments levied in rice from villages to daimyō, and from daimyō to the Tokugawa. Daimyō traded rice for credit on the commodity market in Osaka and used the credit received to fund their trips to Edo and their long-term households located there.

The hierarchical social structure, which divided all Japanese into either warriors (samurai), peasants, artisans, merchants, or "unclassifiable others" (in descending order of status), remained in place, as did most of the materials and technologies of everyday life. In terms of the decorative arts, the main object types, patronage, methods of manufacture, and ways of using things—from kosode fashion and pattern books to lacquerware—continued across the 1868 divide.

That the Edo period did eventually end, however, indicates that there is more to the story. The latter half of the period was marked by considerable and fairly consistent transformation as rural areas industrialized, creating friction among changing economic realities and economic, political, and social structures that seemed increasingly calcified. By the late eighteenth century, boundaries between certain occupations had begun to blur, as farming households began moving into and profiting from "cottage industry" production. Urban merchants prospered, creating a rich culture of material goods and entertainment in Osaka and Edo. The expansion and refinement of markets for luxury goods, as well as investment in technology and the dissemination of specialized knowledge to new production centers, shaped urban consumer culture. All of this led to new developments in manufacturing, including decorative arts industries such as textiles and printing.

At the same time, peasant uprisings punctuated the period, often in response to famines or drastic austerity measures implemented by the government. Likewise, daimyō in outlying domains became increasingly wealthy, powerful, and independent of the Tokugawa. Samurai, integral in pre-Edo conflicts between warlords seeking to rule a unified Japan but employed thereafter as functionaries by the Tokugawa and the daimyō, found themselves with declining incomes and the need to adopt trades formally associated with townspeople to survive. Compounding domestic tensions, the Tokugawa policy of isolation was at odds with geopolitical shifts of power in East Asia. Western nations such as the United States, France, Britain, and Russia expanded their geographic reach in the 1820s and 1830s and sought trading and other connections there. Although many elements of the material culture remained more or less as they had been, a number of produc-

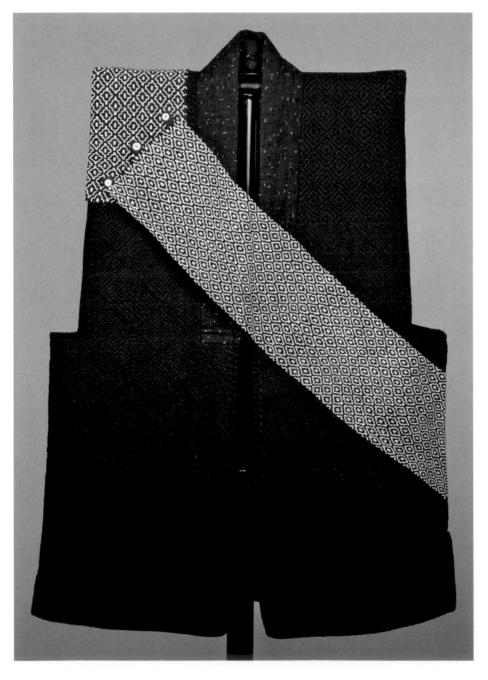

Fig. 13.18. Vest, Shōnai, late 19th century. Indigo-dyed, quilted cotton; L. 32⅝ in. (83 cm). Victoria and Albert Museum, London (FE.108-1982).

tion and consumption practices changed, both marking and contributing to the structural shifts that eventually led to the end of the Edo period in 1868.

VILLAGE MATERIAL CULTURE, C. 1750–1868

Until the late nineteenth century, nearly 90 percent of Japan's population was based in small villages in multigenerational households, often in extended family groups. The object types used in village homes, however, were more or less the same as those found in everyday urban life. Such items included storage chests of various sizes, tray tables, writing boxes, mirror stands, baskets, wooden bowls, trays and utensils, metal pots, bathtubs, buckets, kimonos, mattresses, cushions, candlestands, paper lanterns, and paper and inkstones for letter-writing. Peasant items used outside the home included agricultural implements in wood and/or metal such as rakes and plows, fishing nets, and ceramic trap and storage jars. Clothing was made most commonly of woven cotton dyed with indigo or other natural dyes. In the north, a type of quilting known as *sashiko* made farmers' garments warmer and more durable, and allowed for decoration and visual variety (fig. 13.18). The vest shown here, intended to be worn when hauling a sledge, features three different *sashiko* designs—a zigzag pattern around the hem, a large diamond pattern in the midriff, and concentric diamonds at the top. The diagonal sash has been quilted in white thread for further decoration and serves a functional purpose, to protect the textile from the heavy rope that looped around the wearer's torso as he hauled the sledge.

Wood, bamboo, and straw were the most common materials used for everyday household objects. Straw-woven hats, snow boots, and sledges were important in snowy mountain areas. Most wooden objects were left unpainted, but some villagers in Tohoku, in northern Japan, applied matte coatings of red and black lacquer to wooden serving vessels, particularly pitchers for *sake*. The region's rich iron deposits meant that iron teapots, candlestands, and other objects were available to those nearby, while villagers living in ceramics-producing regions, like Seto and Mino, had similarly greater access to ceramic tableware. In most village households, however, metalware and ceramics were reserved for work implements and storage jars that were crucial to the family's livelihood. Decorated ceramics, whether stoneware or porcelain, were valuable rarities, owned by the village headman and other prosperous members of the community. Despite the lack of surface decoration and relative simplicity of form, these objects still brought aesthetic pleasure and conveyed a range of cultural, even religious, references.

The wooden pot hanger illustrated here, used in a village dwelling in the Kaga domain (now Ishikawa Prefecture), dates from the nineteenth century (fig. 13.19). It was used with a chain from which an iron cooking pot could be hung and would have been located over a central open hearth in the main living room (*ima*)—a space used for eating and sleeping as well as for ceremonial occasions such as wed-

Fig. 13.19. Pot hanger, Kaga domain, 19th century. Wood; H. 17⅜ in. (44 cm). The Japan Folk Crafts Museum, Tokyo.

dings and funerals. The hook is well-finished, with beveled edges and a well-balanced, near-circular curve. Its size points to its strength and durability, and suggests the wealth of the household to which it belonged. The hook carried particular religious associations legible to the household and visitors; the shape of its rooflike upper part refers to the floppy hat worn by Daikoku, the Shinto god responsible for wealth and a popular household deity.

Households acquired furnishings over time, purchasing some things, either from the village carpenter or forge or from traveling peddlers, and making simpler objects themselves. Most villages had at least one carpenter who specialized in house construction, joinery, and cabinetry; a blacksmith who made agricultural implements and knives; and a cooper for buckets and barrels. The village carpenter would have made the fireplace hook using a small saw, a knife, a hammer that served as a plane and measure, a length of chalked line to serve as a plumb line and level, and wooden pegs. Small handsaws took time but produced cuts that did not need sanding. Planing was done with hatchets like adzes, used in small, short strokes. The high level of carpentry skills can be seen in the dovetailing and intricate interlocking wooden parts used to join together different pieces of wood, as opposed to using metal nails or screws.

Agriculture and fishing were the main peasant occupations, but many households also engaged in cottage industry production. Once the household was supplied, any surplus sandals, raincoats, hats, and similar items woven from sedge (a type of grass) were redistributed within the village. Other modes of craft production, including silk weaving and dyeing, fan making, embroidery, and carving, were organized by agents who supplied (and charged for) tools and materials and returned to purchase fully finished products for distribution elsewhere. In umbrella making, for example, peasants supplied the wooden spine and ribs, and dealers the necessary paper, lacquer, oil, glue, and paint.

Many households used the money made from such work to support the household economy and help pay heavy taxes. Such taxes were levied on the projected amount of rice produced, but that amount often fell short, particularly during periods when natural disasters hurt agricultural production. The more fortunate households used their earnings to purchase goods from traveling peddlers who distributed silks, cottons, metal products, tools, and other items on regular trade routes.

As the period progressed, the economic basis of many village households shifted from agriculture to the manufacture of goods for townspeople and wealthy rural households (*gōnō*). The 1780s saw networks of increasingly wealthy village households, urban merchants, and distribution guilds (*kabu nakama*) challenging the economic model set by the Tokugawa system of taxation paid in rice up through the classes, a challenge that some historians argue hastened the end of the Tokugawa regime. In the short term, however, it provoked the shogunate to implement a set of control measures known as the Kansei Reforms (1787–92), which banned distribution guilds, attempted to cajole peasants into restricting their activities to farming, and canceled rising samurai debt. These ineffectual and short-lived reforms reflected the tension between urban merchants and regional producers, and the gap between a centralized economic policy centered on agriculture and the economic realities of village manufacturing and entrepreneurship.

URBAN MANUFACTURING, C. 1750–1868

Daimyō were required to live part-time in Edo but retained administrative seats in their respective domains or "castle towns" (*jōkamachi*—former military strongholds transformed into market towns and centers for regional government). Like Edo, these towns were roughly divided into two neighborhoods: one for samurai retainers, characterized by high earthen walls surrounding residential compounds, and one consisting of two-story wooden or wood-and-mortar row houses for tradesmen, who provided the daimyō and samurai with everyday and luxury goods. Households specialized in particular crafts, with ownership and skills passed down through the generations, often to the eldest daughter's husband in families with no sons.

Construction was well-represented among the trades found in towns and cities, with carpenters, smiths, plasterers, roof tilers, and decorative roof-tile carvers demonstrating the importance of building in towns made of wooden houses and thus prone to fires. Standing screen (*byōbu*) painters and makers, paper window (*shōji*) makers, reed window screen (*sudare*) makers, and *tatami* makers all speak to the constant refurnishing of the home. For consumption within the home, embroiderers, lacquerers, fan makers, mirror polishers, mother-of-pearl craftsmen, and inkstone makers targeted the samurai and wealthy chonin markets with luxury objects for personal adornment.

Fig. 13.20. Tachibana Minkō. Playing-card makers, from *Saiga Shokunin burui* (Various Classes of Artisans in Colored Pictures), Edo, 1770. Stencil-printed book; each page, 11¼ x 7½ in. (28.5 x 19 cm). Trustees of the British Museum (1979,0305,0.118).

As with rural cottage industries, some products involved the labor of the entire family, including wives and daughters, whereas trades such as carpentry were male domains. Senior tradesmen took in apprentices, who joined the household and learned the trade skills through observation and practice. The prints, in an illustrated dictionary of common trades published in Edo in 1770 by Sawa Isake and Nemura Tosaburō, depict, among other artisans, a master maker of playing cards (karuta—the name derived from European cards imported by the Portuguese; fig. 13.20). He is painting polychrome floral patterns on a large sheet of stiff paper, divided into the individual cards but not yet cut, while an apprentice flattens the cards individually in a wooden press. Seated on the ground, the master uses a low wooden desk as his workspace; the apprentice perches on a stool to turn the hand press. The image illustrates the division of labor as well as the different tools used, including brushes, ceramic vessels for water and ink, and baskets for catching the cards. The combination of handwork and hand-powered machinery employed in Japan in this period was similar to that in France, Britain, and elsewhere, where a kind of mechanized handwork combined with steam technology within heavy industry and textiles.

Karuta were used widely amongst urban men and women, both samurai and townspeople. The makers of musical instruments, chess (shōgi) sets, and gambling dice supplied other goods for urban amusements that crossed class lines. While some trades catered to wide markets, however, others had more narrow appeal or even legal restrictions to their customer base. Sword making, for example, was limited to samurai clientele, as only they were entitled to carry weapons. In fact, male samurai were expected to carry both long and short swords. Even after samurai military duties had ceased, makers of armor, bows, stirrups, and saddles all continued to provide equipment—embellished with decoration, for display and ritual use only in horseback riding and archery, among other activities. Decorative sword fittings made of elaborately carved, inlaid, or hammered metals (tsuba) were particularly prized as they were interchangeable, so they could be collected and traded.

Other specialists with assured markets included metal casters who made the candlesticks, flower vases, and incense burner sets that decorate a Buddhist altar (sanbusoku). Some artisan households, often located near temples, carved and gilded religious sculptures and other objects specific to Buddhist temples and Shinto shrines. Rosary makers and sutra makers, by contrast, specialized in small objects for household religious worship, readily available for purchase at shops near temples and shrines. Kyoto was home to the most famous artisans, but makers could be found in cities around Japan.

Some small urban workshops sold goods directly to the public from their premises, which were clustered in trade-specific neighborhoods where, for example, wooden sandals or bolts of cloth for kimonos were made. Others, particularly the elite Kyoto manufacturers, sent their goods to shops in Edo. A print depicting a procession of men in ceremonial clothing passing by a silk textiles shop in the Odenma-cho neighborhood of Edo shows the decorative elements with

Fig. 13.21. Utagawa Hiroshige. "A Textiles Shop in Odemma-cho," from *Meisho Edo Hyakkei* (One Hundred Famous Views of Edo), Edo, 1858. Wood-block print; 14⅛ x 9⅝ in. (36 x 24.4 cm). Trustees of the British Museum (1906,1220,0.669).

which shopkeepers marked their premises (fig. 13.21). Emblazoned with the shop's trademark and serving as both advertising and signage, indigo-dyed half-curtains (noren) hung across the open fronts, protecting shops from rain and wind. Noren makers used a paste-resist process, in which paste was applied to the cotton, ramie, or linen curtain in the appropriate pattern or text before dyeing. Leaving a trace of the brush at the end of the brushstroke was a stylistic flourish, visible in the large characters in the print illustrated. Once dyed, the curtains took on a deep indigo hue but the characters remained white. While indigo was most common, other dyes such as the deep red seen here were used to indicate a shop's status or help it to stand out along a row of shop fronts.

Trademarks were often created by enclosing one character from the shop's name within a geometric form, such as a circle or trapezoid, sometimes forming visual-aural puns.

CHANGING GEOGRAPHIES OF LUXURY GOODS PRODUCTION

Luxury silk production was located primarily in Kyoto in 1750, but by the end of the eighteenth century, increased demand for novelty and luxury in other urban areas drove the development and expansion of regional manufacturing centers. Silk-weaving allowed farmers and tradesmen to supplement their income, particularly in areas with poor agricultural land, while increasing local coffers through additional taxes. There were two main kinds of silk cloth production: simple, rougher cloth woven on a one-treadle loom (*izaribata*) in villages and areas with sericulture, used in garments like the vest in figure 13.18, and the complicated textiles made in dedicated workshops in the Nishijin district of Kyoto, used in kimonos like that shown below in figure 13.25. Patterned textiles required a foot-operated loom (*takabata*) imported from China in the sixteenth century, or a two-person variant in which one operator perched high above the weave, the *sorabikibata*. Both the *takabata* and *sorabikibata* kept the weavers' hands free to produce patterns, and their construction and techniques were fiercely guarded to prevent competition.

As urban demand for decorated textiles rose, Nishijin's techniques and technology were disseminated by weavers from other places who infiltrated the Nishijin workshops. Also, technicians and artisans traveled to other areas, invited by daimyō eager to develop new industry using the most advanced technologies. Most significantly in terms of future production, the Kiryū region, two days' travel from Edo, was known for broadcloth production but acquired the *takabata* technology in 1738, which allowed it to make patterned cloth as well as plain, selling it to Edo shops such as Echigoya, a textile merchandiser. By 1837, Kiryū had nearly six hundred weaving workshops. In Kaga in western Japan, the daimyō invited Nishijin weavers to Kanazawa in the 1830s and created a weaving factory for high-end silk woven products there. By the 1850s, production was diffused throughout Japan, although Nishijin retained both the bulk of products requiring complex skills and methods of manufacture and one-third of the total value of silk goods production, well above that of any other region.

PATRONAGE AND LUXURY GOODS: CASTLE TOWNS

The domains that maintained high revenues into the nineteenth century, such as Kaga, a fertile rice-growing area situated in the west of Japan between high mountains and the Japan Sea, were able to develop and sustain local communities of luxury goods makers who sold their products to local consumers, rather than shipping nationwide. From the seventeenth to the nineteenth century, local products included polychrome Kutani ceramics, lacquerware, wood inlay, gold leaf, decorative screen painting, and *yūzen* (paste-resist) silk textiles. There was considerable continuity of production methods and materials, and the patronage of its rulers, the Maeda family, remained relatively constant due to stable rev-

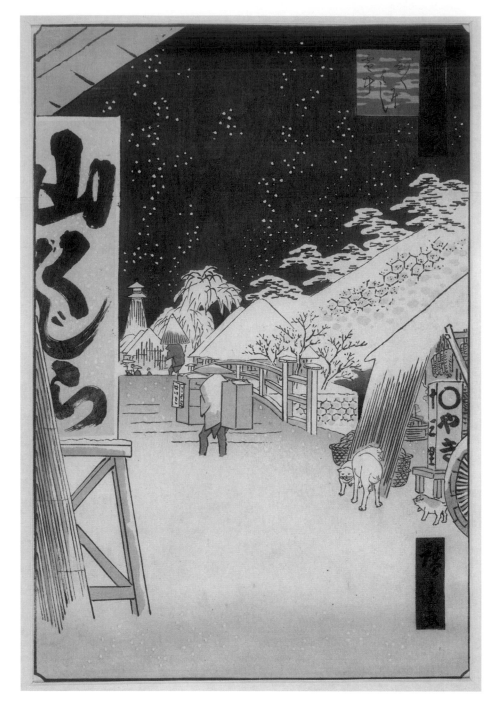

Fig. 13.22. Utagawa Hiroshige. "Bikuni Bridge in the Snow," from *Meisho Edo Hyakkei* (One Hundred Famous Views of Edo), Edo, 1858. Wood-block print; 14⅛ x 9⅝ in. (36 x 24.5 cm). Trustees of the British Museum (1948,0410,0.86).

Here, a circle (*maru*) encloses the character "dai" (large), directly alluding to the name of the shop, "Daimaru-ya" ("ya" means shop). Smaller characters on either side of the symbol spell out the name in full and give its location.

Wooden signboards, painted or carved with the shop's name, were also designed to catch the eyes of passers-by and indicate the type of goods sold. The signs were made by town carpenters (*machi daiku*), but specialist calligraphers executed the lettering. Similar but simpler signs for humbler shops were made of paper and sometimes functioned as lanterns, as in this depiction of the Bikuni bridge outside Edo castle in wintertime (fig. 13.22). Another type of lettered sign can be seen on the portable box of goods strapped to the back of the lone peddler; it too bears the shop name and advertises the goods he has for sale.

Fig. 13.23. Hosokawa Hanzō Yorinao. Illustration of a tea-carrying automaton, from *Karakuri zui* (Illustrated Compendium of Automata), Japan, 1796. Wood-block printed book; 8⅞ x 6¼ in. (22.5 x 15.9 cm). Trustees of the British Museum (1998,0218,0.55.1-3).

enue. Patrons' concerns and interests, however, changed over time to incorporate new knowledge and in reaction to internal (social and economic) and external structural changes.

In Kaga and other wealthy domains, like Saga and Satsuma in southern Japan, the desire of daimyō patrons for novelty in the luxury goods market supported research into European technologies and their incorporation into Japanese decorative objects and items for entertainment and play. A doll commissioned by Kaga daimyō Maeda Nariyasu (1811–1884) illustrates this trend well. One of a small number of similar dolls created in the early to mid-nineteenth century, the "tea-carrying doll" (*cha-hakobi ningyō*) is dressed as a servant, complete with silk robes and lacquer tray (depicted in fig. 13.23). When activated through a pulley in its back, the doll rolls forward to deliver a cup of tea to a guest, entertaining beholders with its human-like form and movement.

Wind-up animals and humans who executed tricks and tasks such as shooting arrows or playing music first appeared in Japan in the Muromachi period, after Portuguese missionaries introduced European clocks and firearms. Metal precision machinery with intricate, small moving parts were known generally as *karakuri*; the word later became applied to automata specifically. By the mid-eighteenth century, daimyō, high-ranking officials, and wealthy merchants commissioned automata to provide novelty and amusement. The display of such rare possessions also impressed one's peers. Townspeople could catch a glimpse of them on festival days at markets and open gathering spaces (*sakariba*) like Edo's Ryōgoku, where street performers would entertain passersby with the toys.

Early knowledge of *karakuri* spread by word of mouth, but the publication in 1796 of *The Illustrated Compendium of Automata* (*Kirakuri zui*), a three-volume collection of technical specifications, descriptions, and diagrams for Japanese-style clocks and *karakuri* dolls, increased the flow of information. Ōno Benkichi (1801–1870), maker of the Maeda doll, based his

upon one in this book (fig. 13.23). Ōno's career helps illustrate how technological knowledge was transmitted, and how it was often used for entertainment and conspicuous consumption. Born in Kyoto into a crafts household, he traveled to Nagasaki at the age of twenty to study European books on natural history, botany, mechanics, astronomy, and medicine brought by Dutch and Chinese traders. Known collectively as *rangaku* (literally, "Dutch knowledge"), European science and medicine was taught first to sons of high-ranking domainal officials and others in Nagasaki, but by the eighteenth century was spreading across Japan, competing with nativist scholars and those of Chinese learning in domainal schools and study circles. In 1831, Ōno moved to Kanazawa and, under Maeda patronage, established a workshop in which he experimented with steam, electricity, and photography as well as automata and other mechanical devices.

The tea-carrying doll demonstrates how curiosity about the natural world and an interest in display and luxury resulted in applied mechanics as a decorative art. The doll is also an example of import substitution: the adaptation of local knowledge, technology, and materials to replace foreign equivalents that could not be replicated. This and other automata were powered by clockwork mechanisms with as many as thirty moving parts. The European exemplars were made of metal, but Japanese craftsmen were unable to replicate the crucial mainspring, wound to store tension and thus propel the doll, and so they made it and other moving parts out of wood and whale bristles.

FASHIONABILITY AND THE WEALTH OF GOODS: EDO

In the eighteenth century, Edo was the largest city in the world with over one million inhabitants, thanks to the alternate attendance system that required daimyō and their staff to spend a set portion of each year in Edo, and their families to live there permanently. The system fostered service industries catering to daimyō daily household needs, which constituted the largest luxury market in Japan. In effect, Edo was two cities—one of daimyō estates, the other of row houses, shops, and warehouses of merchants and artisans. Osaka was another important luxury market, with its increasingly wealthy merchants controlling the banking industry and distribution networks throughout Japan.

Many luxury goods companies had shops in Edo or Osaka but kept their headquarters in Kyoto, a city of about half a million people (much the same number as Osaka, Paris, and London) known for its decorative arts industries. This allowed these businesses access both to the latest trends and most esteemed producers, and to their key markets. The Mitsui Echigoya store, forerunner to today's Mitsukoshi department store, began as a sake shop in western Japan but reorganized its business in 1673 to concentrate on exporting Kyoto silks to Edo, moving its headquarters to Kyoto and main store to Edo.

Like the Kaga daimyō, Edoites aimed to distinguish themselves through the possession of unusual, stylish, or artisti-

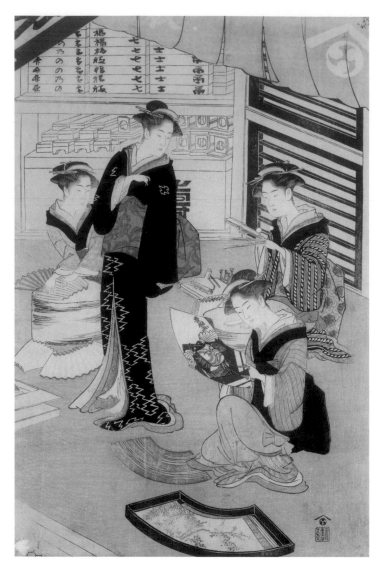

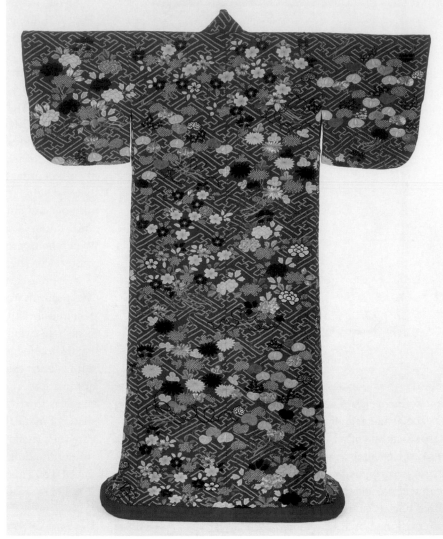

cally significant accessories. Rather than commission bespoke objects, however, most went shopping. The print shown here illustrates four women in a paper fan shop: a customer, identifiable as samurai by her black over-kimono, and three clerks distinguishable as employees by the woven stripe patterns of their own robes (fig. 13.24). The clerks sit on *tatami* matting, raised above the earth-floor entrance and bordered by a thin wooden platform; the customer has joined them to peruse the shop's wares. In a shop such as this, the painted or wood-blocked printed fan papers were stored flat in wooden boxes and shelves to be withdrawn to show customers on request. Once selected, fan papers could be purchased for display in folios as artworks in their own right, or pasted onto articulated frames with tools such as those visible here.

The illustration also shows the rich variety of items for women's personal adornment, including wood and tortoise-shell haircombs, metal hairpins, intricately woven sashes (*obi*), and kimono fabric, which was sold in bolts and sewn at home into garments. Women followed the latest fashions through *hinagata* wood-block–printed pattern books (see fig. 7.27); prints such as the one in fig. 13.24 also functioned as fashion plates.

Stylish clothing differed according to status categories. Both samurai and town women retained the *kosode* kimono, layering several robes underneath one decorative outer robe.

But the eighteenth century saw samurai women replacing the narrower, thinner outer layer with a more substantial robe, the *uchikake*, which was worn open on formal occasions. The garment's padded hem allowed it to retain its expansive shape. The early nineteenth-century *uchikake* illustrated here is made of silk crepe (*chirimen*) embroidered with silk and metal thread, and dyed with paste-resist (*yūzen*) and tie-dye (*shibori*) techniques (fig. 13.25). The expensive, labor-intensive *shibori* traces a geometrical key-fret pattern over which hollyhocks, peonies, and chrysanthemums—all auspicious flowers with seasonal and poetic allusions—have been embroidered. Samurai women favored such floral or geometrical motifs and enjoyed extravagance of materials and technique, while wealthy town women favored more pictorial decoration, such as landscapes, for formal occasions.

Urban men were also concerned with fashion. The textiles for men's kimonos also varied in pattern, weave, and material, and men accessorized with small, intricately carved objects. The *netsuke* shown here is a toggle used to suspend small pouches and containers (*inrō*) from the sash of the kimono by a silk cord (fig. 13.26). *Netsuke* became popular in the early Edo period, and by the late eighteenth century were used to display the wearer's knowledge, taste, and wealth. This one illustrates something of the ingeniousness, novelty, carving skills, playful representation, and unusual subject

matter characteristic of desirable *netsuke*. Demand for novelty pushed *netsuke* carvers to constantly create new forms, and toward exotic materials and motifs. *Katabori* ("shape-carving") *netsuke* in the form of animals, vegetables, or characters from famous legends (Japanese and Chinese) were popular, in part, because such pieces alluded to the wearer's wit, connoisseurship, and access to rare, sometimes foreign, knowledge. (Chinese illustrated books of legends and natural history had been popular with Japanese connoisseurs since the seventeenth century.)

Interior decorations and other objects decorated with animals from the Chinese zodiac, which assigns a different animal to each year in a twelve-year cosmological cycle, were displayed prominently during the new year's festivities and featured throughout the rest of the year. Since ivory was not native to Japan but rather imported from India through Nagasaki by Dutch and Chinese traders, the material of this horse *netsuke* is another allusion to China—and therefore to the exotic.

Interest in displaying connoisseurship through decoration also applied to the domestic interior. *Zashiki kazari* (room decoration), the practice of decorating a room to receive a guest, was imported to Japan from China in the fourteenth century, another period when an interest in China was considered novel and exotic. At first, elite men practiced *zashiki kazari*, which referred to the careful placement of objects: a hanging scroll, a flower arrangement in a vase, a metal incense burner or other decorative object, and painted folding screens (*byōbu*). By the late eighteenth century, however, wealthy urban merchants sought more elaborate and costly objects and arrangements, commissioning painters and sculptors to decorate walls and screens within which to display their favorite items. Porcelains and textiles were applied to walls and ceilings, and objects such as unusual stones, coral, fossils, lacquerware, metalwork, and handscroll paintings were placed in elaborate combinations, with Chinese porcelain and Indian calicos among the most valued objects. These interiors were luxury objects in their own right.

THE MATERIAL CULTURE OF URBAN ENTERTAINMENT: EDO

By the 1770s, Edo was home to myriad amusements, including Kabuki theater, a highly stylized dramatic form illustrating incidents from the past in elaborate costumes, makeup, and wigs. Okazaki-ya Kanroku (known as Kantei, 1746–1805), a calligraphy teacher, devised a showy style for the signboards of the Kabuki Nakamura Theatre. Known as the Kantei style, it was characterized by convolutions and overly thick, black brushstrokes. Handbills and posters for Sumo and *yose* vaudeville performances each developed a singular style distinctive from not only other forms of entertainment but also from the shop sign lettering discussed above.

In the Yoshiwara licensed brothel district, well-known artists and sculptors created screen paintings and wood carvings to decorate the interiors of teahouses, restaurants, and the private chambers of high-ranking courtesans. Many interiors were painted deep colors, finished with lacquered woodwork and hammered metal nail covers, and the luxurious finishes extended to the objects therein. The wood-block print shown here depicts the courtesan Takao celebrating the acquisition of new bedding with two male guests, both well-known actors, and a bevy of attendants (fig. 13.27). The room is filled with expensive things, from the maple leaf–patterned bedding (in the background) and lacquered tables and food boxes (foreground), to the large bonsai tree, the lacquered wood-and-hide drums played by the attendants, and the occupants' robes and hair ornaments.

Urban amusements such as fireworks, theater, and licensed quarters were known as the "floating world" (*ukiyo*), a wry reuse of the Buddhist concept that the pleasures of today are transient. The illustrated wood-block prints known as "floating world pictures" (*ukiyo-e*) were both a product and a document of that world. Very few Japanese would have visited the Yoshiwara, but its most famous occupants were style icons for much wider audiences, thanks to wood-block printed images such as figure 13.27, which served as publicity not only for the artist and publisher but also for the brothel, the courtesan, and the particular types of textiles featured. The image of Kabuki actor Iwai Kumesaburō II (1799–1836) impersonating a famous courtesan includes exaggerated hairpins, elaborate sash, high clogs, and layers of highly patterned robes (fig. 13.28). The textile patterns, shown in detail, reveal the latest fashions in weaves and prints: here, oversized peonies and phoenixes rendered in silk and metallic thread embroidery, *shibori* tie-dyed spots, and a paste-resist pattern on the green underrobe.

Popular festivals offered an opportunity for fashionable Edoites to show off, as can be seen in a print depicting a fireworks display (fig. 13.29). They also provided opportunities for crafts production, such as the paper lanterns shown here, which cheekily give the maker's family name, Utagawa, as a kind of intertextual advertisement. More often, such lanterns depicted famous sites, scenes from Kabuki plays, Kabuki actors, curiosities, classical motifs, and parodies of classical literature. Other decorative crafts made for festivals included the wooden *mikoshi* palanquins shouldered by local men at

Fig. 13.26. Ohara Mitsuhiro and Kaigyokusai Masatsugu. *Netsuke*: octopus in a trap, Osaka, c. 1825–75. Carved and stained ivory; H. 1⅛ in. (2.9 cm). Victoria and Albert Museum, London (A.55-1919).

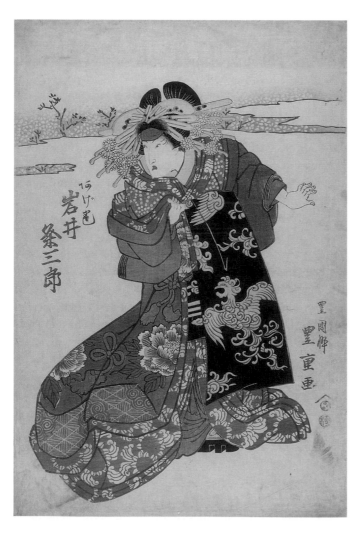

Fig. 13.27. Kitagawa Tsukimarō. *The Courtesan Takao Displaying New Bedclothes*, Edo, 1804. Wood-block print; 15 x 30⅛ in. (38 x 76.5 cm). Victoria and Albert Museum, London (E.2124-1899).

Fig. 13.28. Utagawa Toyokuni II (Toyoshige). *The Actor Iwai Kumesaburō II in the Role of Celebrated Courtesan Agemaki*, Edo, 1824–25. Wood-block print; 15⅛ x 10¼ in. (38.4 x 25.9 cm). Victoria and Albert Museum, London (E.12645-1886).

temple and shrine festivals, decorated poles (see fig. 13.21), the fireworks themselves, and seasonal toys like the shuttle-cock and battledore, played at the new year.

Wood-block prints were extremely popular. In 1800, there were 917 publishers in Edo, 504 in Osaka, and 494 in Kyoto. Prints today are known by the name of the particular artist, but they were a collaborative process among the publisher, artist, wood-block carver, and printer. Indeed, both the publisher and artist included their seals on the print and often the carver as well. Print runs averaged between two hundred and four thousand copies, indicating the popularity of the medium, and ranged from expensive, limited edition folios to cheap, one-page images. Printed images were also published as books or folios, usually as sets, and sold in book-shops in urban centers. Many publishers printed catalogues, which circulated to bookshops elsewhere for ordering.

Some technological changes affected the look of prints. Monochrome black *sumizuri-e* prints, developed in the late seventeenth century, gave way to duo-tone prints decorated first with orange-red metallic pigment (*tan-e*), then with ver-milion safflower (*beni*-e) ink in the mid-eighteenth century. Polychrome prints, such as those illustrated in this chapter, used multiple plate printing (*nishiki-e*), one for each color, and replaced the earlier techniques after the 1760s, as they enabled the cheaper mass production of more complex images with a complete background.

Berlin (Prussian) blue, a coal tar–based dye first produced in Prussia, was brought to Dejima (the artificial island in Nagasaki harbor that served as the sole base in Japan for foreigners) by the Dutch as a replacement for indigo in the late eighteenth century and was used in wood blocks from the 1820s. This pigment had a great impact on wood-block printing, not least because of its greater staying power. Indigo

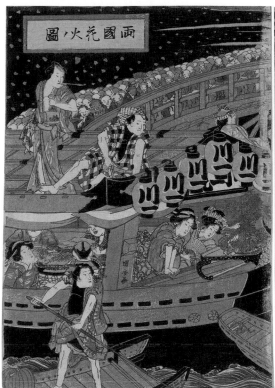

fades to a light grayish orange with repeated exposure to light (as in figs. 13.24 and 13.27) whereas images printed with Berlin blue retain their vibrant hue. The types of prints changed too; the famous *Views of Edo* series by Hiroshige (1797–1858), for example (see figs. 13.21 and 13.22), used the new pigment generously.

IMPORTED VISUAL AND MATERIAL CULTURE AT THE END OF THE EDO PERIOD

By the early nineteenth century, increasingly common sightings of foreign trading, whaling, and military ships off the Japanese coast indicated that the world was changing, as European and American powers extended their empires into East and Southeast Asia. In the 1850s, bowing to foreign pressure, the Tokugawa shogunate signed diplomatic and trade treaties with foreign powers including Great Britain, the United States, and Russia. These treaties required Japan to allow foreigners to live and trade in designated ports, of which Yokohama was the largest and best known.

The renewed presence of foreigners—European, American, and Asian—marked the 1850s and had an impact on material and visual culture. European and American traders often moved from existing hubs like Shanghai, Hong Kong, and Singapore, and brought with them Chinese-made wooden furniture as well as domestic furnishings from their home countries. Yokohama was also known for its small population of Chinese carpenters who could produce furniture to suit Westerners' tastes. In Kobe and Yokohama, enterprising wooden shipbuilders translated their woodworking skills to make Western-style furniture and homes for the new arrivals. Japanese silk textiles

from Kyoto and Kiryū were an important export commodity for foreign traders, and competed with French and Italian silks in European and American markets (fig. 13.30). Foreign demand for Japanese silk helped prices triple by the early 1860s, pleasing producers but angering many Japanese.

For wood-block print publishers and artists, foreigners were a new subject whose exotic appearance sold well in the national market. A new category of prints known as *Yokohama-e* and depicting foreigners' demeanor, clothing, and environment appeared. As seen in fig. 13.30, these prints used existing wood-block technology, genres, and the aesthetic of juxtaposing multiple patterns and forms to create a decorative surface. Also present is the fascination with the exotic, here in the attention given to the English merchant's face, clothing, and chair and to the hairstyle, face, and textiles of the English woman. (Inset portraits in genre pictures or landscapes were a common compositional tool in earlier wood-block prints.)

Photography arrived in Japan with the first foreigners' settlements; early photographers such as the Italian-British Felix Beato (1832–1909), active in Yokohama, produced reportage images for the European and American press. Japanese photographers like Ueno Hikoma (1838–1904), who opened his studio in Nagasaki in 1862, soon followed. Ueno was well-situated: his father had imported the first daguerreotype to Japan and, like Ōno Benkichi, the inventor of the tea-carrying doll, Ueno had studied "Dutch learning" in Nagasaki, specializing in chemistry. Unlike foreign photographers, who produced landscapes and genre scenes that were hand-tinted and bound into albums for sale to Western tourists, most early Japanese photographers made their living through commissioned portraits of samurai and foreigners. Thanks to the vast popularity of wood-block prints and limited supplies

Fig. 13.29. Utagawa Kuniyasu. *Fireworks at Ryōgoku Bridge*, Japan, early 19th century. Wood-block print; 14⅝ x 30½ in. (37 x 77.5 cm). Museum of Fine Arts, Boston (11.16109-11).

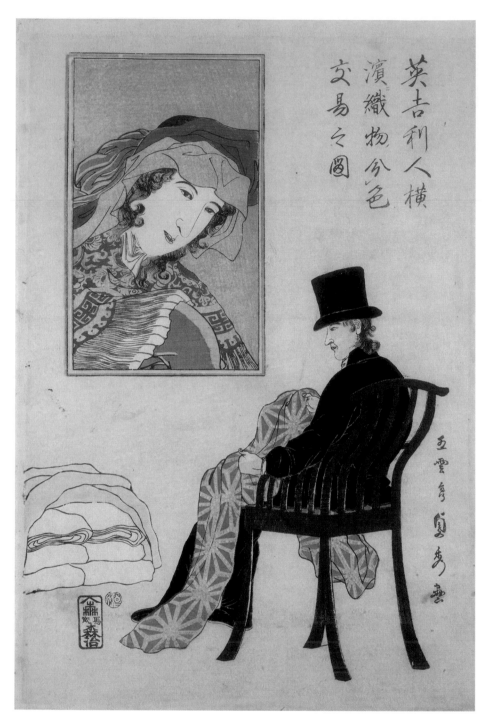

英吉利人横浜織物分色交易之圖

of photographic materials and knowledge, photographs did not replace prints as the standard visual medium until the end of the century; notably, war photographers used photographs as well as prints in the Russo-Japanese (1904–5) war.

Japan made its first appearance at international expositions in this period. In 1862, Sir Rutherford Alcock, Britain's diplomatic envoy to Japan, organized a display of Japanese products including lacquerwork, basketry, and wood-block prints for the International Exhibition in London. The relatively small display and subsequent Japanese-organized displays at the Universal Exposition in Paris in 1867 piqued British and French interest in the materials and aesthetic of Japanese decorative arts, leading to the popularity of Japanese products known as "Japonisme."

EXPORT CRAFTS AND THE MEIJI RESTORATION OF 1868

By the 1850s, the Tokugawa government faced internal as well as external pressures. The domains in southern Japan were increasingly powerful and conducting their own foreign relations (some even contributed displays to the 1862 International Exhibition in London), and the maturation of the urban market and development of village industry meant that the Tokugawa distinctions among classes and social strata began to blur. Cheap imports of foreign cotton hurt domestic producers, and foreign purchases of Japanese commodities created steep inflation, leading to violent protests and strong antiforeigner sentiment in the early 1860s. The shogunate attempted to respond with reforms, but these were too few and too late. After two years of civil war led by the southern domains, the Tokugawa shogunate was abolished in 1868, and a new system of government established.

The Meiji Restoration, as this event was known, launched sweeping political, economic, social, and infrastructural changes. The emperor was restored to a central role, and the daimyō system was abolished, to be replaced by centrally appointed governors and a bureaucratic system of centralized ministries. In 1885, the government was remodeled along the lines of a European cabinet with a prime minister. Japan became a constitutional monarchy with a public assembly, the Diet, in 1889. The status system was officially disassembled: restrictions to occupation and dress based on social status were removed in the 1870s, and stipends to samurai were first reduced, then abolished entirely. Samurai were also prohibited from wearing swords.

The new government's policies did not directly impact the manufacture of everyday goods in villages or urban workshops; indeed, most villagers and townspeople lived as they had before. Changes such as the abolition of the daimyō system and samurai stipends, however, had a large and direct impact on luxury crafts producers. Without their guaranteed income, daimyō could no longer afford the elaborate lacquer dowry sets previously so important for marriage preparations (see fig. 7.20). Luxury lacquerware makers thus lost an important income stream, as did the armor makers and metalworkers whose workshops had been supported by samurai customers.

The collapse of the domestic market for samurai metalwork in the 1870s coincided with the new government's engagement with international expositions. The first official display was in Vienna in 1873, followed by expositions in Philadelphia (1876), Paris (1878 and 1889), Chicago (1893), and Paris (1900). The goal was a kind of cultural diplomacy and assertion of national sovereignty through decorative arts. Recognizing that highly skilled decorative arts might convey an image of advanced technical skill and artistic heritage to an international audience, the Japanese government selected a sample of crafts from the Edo period for display, and commissioned new work in forms that could be used or shown in European and later American museums and homes.

The lacquer glove box shown here demonstrates this application of local skill, techniques, materials, and aesthetic to a product for a Western lifestyle (fig. 13.31). The box's rectangular form and use of layered, carved gold leaf on black lacquer to depict a scene from classical poetry are common to writing boxes and boxes for cosmetics; the hinged construction was used in caskets for tea utensils. The box's shape is low, long, and thin, however, to conform to that of European glove boxes. A number of these boxes were shown in Vienna in 1873, then purchased by the new Museum of Applied Arts in Vienna (present-day MAK—Austrian Museum of Applied Arts/Contemporary Art, Vienna) as a reference for artists, designers, manufacturers, and the public. The South Kensington Museum in London (present-day Victoria and Albert Museum) also purchased many Japanese items from expositions for its public teaching collections.

Not all fine craftsmen selected to produce work for the expositions had suffered the loss of domestic clients. Suzuki Chōkichi (1848–1919), trained in metal casting, transferred his skills to making elaborate pieces for exhibition, such as an antique-style bronze incense burner, which he cast for display at the 1878 Paris Universal Exhibition (fig. 13.32). The object, purchased first by the Paris dealer Siegfried Bing then sold to the South Kensington Museum, balanced on a tree stump around which stand a peacock and peahen. It was cast in several pieces then assembled. The burner, stump, and birds are naturalistic and carved in minute detail, with particular attention to the birds' feathers and the gnarled texture of the stump. The object is a highly realistic imitation of nature; its combined motif of birds and plants may also be a translation of the "bird-and-flower" motif used in paintings and woodblock prints to the three-dimensional medium of bronze.

In its time-consuming craftsmanship, its reference to Chinese and Japanese classical motifs, use of lifelike animal and plant figures, and combination of massive scale and intricate detail, Suzuki's work demonstrates the preferred char-

Fig. 13.31. Glove box: *The Six Tama Rivers*, c. 1873. Lacquer, gold; L. 10⅞ in. (27.7 cm). MAK–Austrian Museum of Applied Arts/ Contemporary Art, Vienna (OR 2523).

Fig. 13.32. Suzuki Chōkichi (Kako). Incense burner (*koro*), Japan, c. 1877–78. Bronze; H. 7½ ft. (2.3 m). Victoria and Albert Museum, London (188:1 to 9-1883).

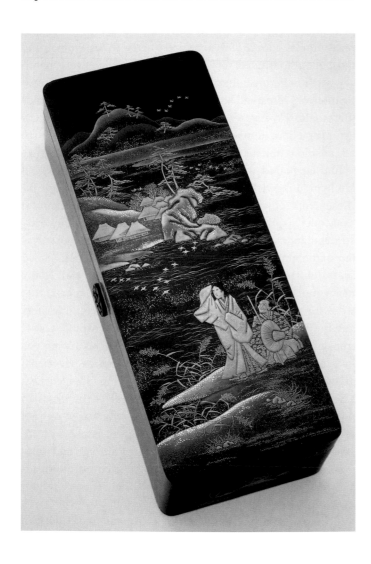

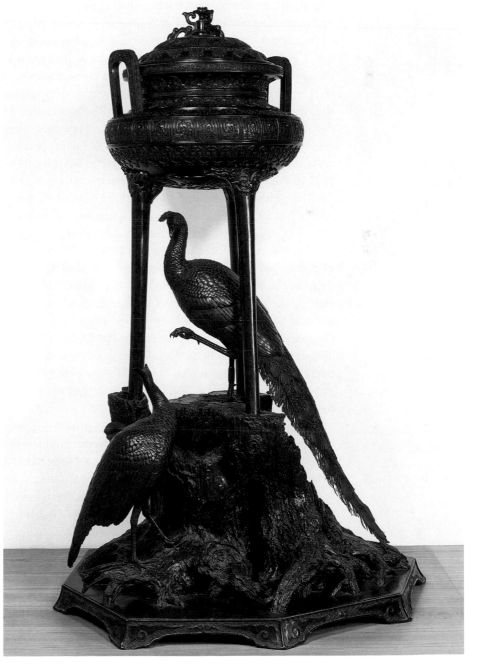

acteristics for decorative arts commissioned for international display. Objects conveyed a political message: Japan was an independent nation with a long cultural and intellectual heritage, advanced technical skills, and a civilized aesthetic sensibility. During a period when decorative arts displays in international expositions formed an important part of economic and political rivalry, the Japanese government sought to situate Japan within the league of "civilized" nations by borrowing display tactics used by the West, especially Britain and France.

Participation in international expositions also had an economic goal. The new government needed foreign capital to purchase machinery and materials for its policy of "increasing production and promoting industry" (*shokusan kōgyō*): steam engines for steel processing and new silk and cotton mills that used power looms. While seemingly small, sales of display objects to museums, dealers, and private collectors helped to fund these purchases. In 1873, the government set up a company, the Kiriu Kōshō Gaisha, to manage sales of objects shown in Vienna. This organization later expanded operations to design and commission objects for display under the direction of master craftsmen such as Suzuki Chōkichi, and ran until 1891. Other private companies specializing in ceramics and cloisonné sprung up as well to provide the government with display products and manage sales.

The Kiriu Kōshō Gaisha was only one of the mechanisms the new government created to support the production of decorative arts objects suitable for export. A few men were responsible for much of this work. In 1873, the young bureaucrats Hirayama Eizō (1855–1914) and Nōtomi Kaijirō (1844–1918) traveled to Vienna for the international exposition. After the close of the fair, Notomi briefly studied ceramics production in Europe, and Hirayama spent four years at the School of Applied Arts in Vienna. Upon returning to Japan, Hirayama was appointed to the Product Design Department of the Board of Commerce. Between 1876 and 1885, the department compiled and circulated the *Onchi Zuroku*, an eighty-four-volume catalogue of artistic crafts designs distributed to workshops involved in producing work for the Centennial International Exhibition in Philadelphia in 1876. The department also helped to organize a domestic industrial exhibition system, which displayed artistic crafts as well as agricultural, industrial, and other products in five exhibitions in Tokyo, Kyoto, and Osaka between 1877 and 1903.

For his part, Nōtomi advised on ceramics production, created designs for the *Onchi Zuroku*, and selected products for the 1876 Philadelphia exhibition. In 1887, he founded the first of a number of prefectural and municipal schools for teaching crafts techniques in Kanazawa, known for its luxury crafts. While officially unrelated, the elite Tokyo School of Art was established in 1886. The school's founders appointed master craftsmen in metal carving, casting, ceramics, cloisonné, and other crafts as professors of their respective techniques and materials, alongside professors of Western-style oil painting and Japanese-style painting. In the 1890s, many of these men were also designated as Imperial Court Artists, a new system established in 1890 that ensured continued patronage for acknowledged masters of traditional artistic crafts. The 1890s saw the creation of a national, standardized curriculum for technical education—including woodworking, metalworking, and pattern design—and requirements for each prefecture to establish a technical school.

THE MODERNIZATION OF CRAFTS INDUSTRIES IN THE LATE NINETEENTH CENTURY

For most Japanese, the material culture of daily life changed little after the Meiji Restoration. While the nobility and Japanese military adopted Western dress in the 1870s, women and most men continued to wear kimonos, which were hand-sewn at home from bolts of cloth as in the Edo period. Domestic interiors remained largely the same; wealthier households might add a Western clock or other imported object to the arrangement of items displayed, but households continued to use cushions and mattresses on *tatami* mats, to eat from individual lacquered wooden trays, and to cook in unchanged kitchens. Likewise, the production methods and shops for these items remained substantially unchanged.

Modernization along European lines of economically strategic industries that could be developed for exports was one of the state's greatest priorities, however, and this included craft industries such as ceramics and textiles as well as the heavy industries (primarily iron, steel, pulp, and paper) that were the main government concern. To this end, ministers and bureaucrats gathered foreign knowledge through travel, translations of European and American texts, and invited visits by foreign technical experts. They then created new social and physical infrastructure based on what they had learned. The army was reconstituted along the lines of the Prussian Army, for example, and a new legal code was based on that of France. Compulsory childhood education began in 1872, grounded largely in American models. Railroad and telegraph networks were installed, and banks, corporate headquarters, and government offices in major cities were rebuilt in Western-style brick and mortar.

The government began inviting European and American technical specialists to Japan, where they advised bureaucrats on establishing new industries and modernizing older

ones, and taught in the government's new higher education institutions: the Imperial College of Engineering (1871) and the liberal arts and sciences–focused Tokyo Imperial University (1877). Early efforts were directed toward mechanizing, expanding, and updating extant industries, particularly silk and ceramics. After French traders complained about the declining quality of Japanese silk, the government hired an expert from Lyons to advise on the construction and operation of a mechanized silk-reeling factory at Tomioka. This model factory, built in brick and mortar to the advisor's specifications and furnished with steam boilers, engines, and reeling machinery imported from France, was controversial: critics pointed out that Japan could not build the machines, and that other silk-reeling factories would not have the capital to import them. Nonetheless, the factory's brick building and "modern" technology made it a showcase, even as rival factories still using wooden machinery powered without iron boilers (Japan was not yet producing iron for industrial use) adopted new technologies that could be sourced in Japan—much like the *karakuri* earlier in the century.

The ceramics industry was also important for domestic consumption as well as exports. In 1868, the German researcher Gottfried Wagener (1831–1892) arrived in Japan. He first served as advisor to the Arita potteries, which had become Japan's largest and most technologically advanced ceramics region during the Edo period under the patronage of a powerful southwestern domain. Wagener then taught natural sciences at the Imperial University, organized the Japanese displays for the Vienna (1873) and Philadelphia (1876) expositions, and conducted and publicized research into glazes and firing techniques for ceramics and cloisonné. Unlike the elite artistic crafts workshops, whose goal was to produce impressively complex handcrafted objects with extant materials and techniques, Wagener's work was to introduce new materials and processes that could create innovative products or improve the production process.

The Arita potteries demonstrate how commercial workshops and individuals responded to new markets and sought knowledge from abroad, supported by local governments eager to maintain their region's or city's economic base. Members of the Japanese nobility and industrialists added Western-style homes for entertaining guests, and the emperor began appearing in public in Western dress. Following this trend, some Nishijin weavers developed a sideline in large-scale luxury textiles for use as wall-hangings in Western-style rooms. Companies like Chisō and Kawashima commissioned Kyoto painters to design the images for these tapestries, which unlike the Tomioka factory's insistence on new technology were woven on the *sorabiki* looms for which Nishijin was famous.

These commissions may have been just a small part of Nishijin's income but they served as advertisements and maintained the region's prestige as the spread of weaving that had begun in the Edo period accelerated. In 1873, the Nishijin weavers sent three young technicians—one each from weaving, dyeing, and loom construction—to study in Lyons, the center of the French textile industry. The technicians brought metal Jacquard looms back to Japan. These were put to use in a new model weaving factory in Kyoto and served as the model for a wooden Jacquard loom, which, after development by a Nishijin technician, spread to other textiles regions.

The period 1750–1900 saw continuity in the habits of everyday life and in material culture as well as massive change in Japan's political, social, and economic systems. An expanded geography of luxury production typified by the rise of Kiryū as a center for decorative textiles, the local development of imported technologies and materials, the increased demand for luxury objects from both samurai and townspeople, and the booming production of wood-block prints documenting urban pleasure culture, all testify to deeper changes.

After the Tokugawa regime ended and the new government restructured the nation, ministers identified export crafts as a vehicle to gain capital and increase Japan's image as a civilized nation in Western terms. They viewed this perception as imperative to ensuring favorable treatment for Japan in trade and diplomatic negotiations. Luxury crafts producers' loss of the daimyō market, which had largely supported some industries, was mitigated partly by the new export market and the wealth of merchants, particularly the new industrialists who invested in banking, mining, and infrastructure.

Some traditional industries, such as the making of lacquerware, had to develop new product types. The adoption of new technologies, including the power loom and photography, significantly changed other crafts industries, allowing for the expansion of some (in this case, weaving), and the contraction of others (printmaking). In 1900, the daily lives, spaces, and objects of many Japanese, particularly in rural areas, remained the same, but government attitudes toward crafts manufactures had altered fundamentally in volume and direction. As elsewhere, good design and the continued improvement of specialized crafts and mechanized manufacturing was a matter of national importance.

SARAH TEASLEY

INDIA

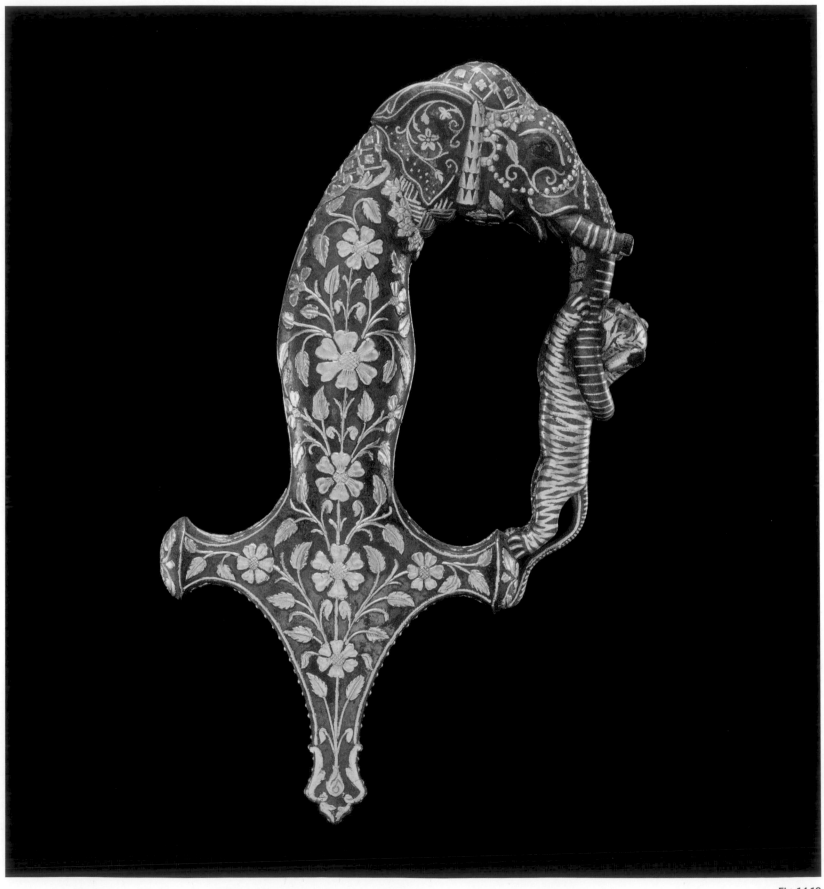

Fig. 14.18

In 1750, at the start of this period, the political map of the Indian subcontinent was a patchwork of warring regional power centers. By 1900, India had become a more unified nation subjugated first to British colonial administration and then, after 1857, to direct rule. In the early eighteenth century, Mughal power in Delhi declined rapidly after the death of the emperor Aurangzib (r. 1658–1707). In fact it had never fully recovered from a 1739 invasion led by the Persian ruler Nadir Shah (r. 1736–47), when much of the vast Indian Mughal treasure of gold and jewels, including the jewel-studded Peacock Throne and the famous Koh-i-noor ("mountain of light") diamond, was taken to Persia. By the late eighteenth century, the British East India Company was a dominant power on the subcontinent, with bases at Calcutta in Bengal and Madras far to the south on the Coromandel Coast. And by 1876, the country had become the "Jewel in the Crown" of Britain's Queen Victoria (r. 1837–1901), who in that year assumed the title "Empress of India." During the nineteenth century, India experienced a new type of globalization, based on colonial systems of trade, commerce, and communications in which European nations used their superior power to stake claims to empire.

Even before the 1739 Persian invasion, the Deccan in south-central India had slipped from Mughal control, and in 1724, Asaf Jah (r. 1720–48), a local governor formerly representing the Mughal emperor, led a revolt and established himself as the nizam of the Hyderabad state, founding a dynasty that lasted until 1948. Other Mughal governors seized power and created semi-independent kingdoms. Elsewhere, in the Punjab, Rajasthan and the Kathiawar area of Gujarat, the Maratha Empire in the southwest, and the kingdom of Mysore in the south, independence from central Mughal authority increased after 1707.

In 1799, the British East India Company consolidated its control by defeating the chief ally of France, Tipu Sultan of Mysore (r. 1782–99). Nominally reinstating a previous Hindu dynasty to the throne, the company in effect annexed much of the Mysore territory, a pattern followed by the British elsewhere. By 1854, the kingdoms of the Punjab and Oudh had been swept away and their territories placed under company rule, while in Delhi the weak Mughal dynasty lived out its last years of titular power. A massive uprising in 1857 sought to expel the British from India, but they managed to retain control. Thereafter, British territories in India were ruled directly by the British government in the name of the Crown, and, although local rulers such as the Muslim nawabs, the nizams of Hyderabad, and the Hindu rajas retained some authority, they were closely controlled by their British agents.

Beyond the political changes wrought by the "mutiny" (as it was known in Britain), the British administration used its new authority as an opportunity to reorganize the Indian economy, ensure greater control, and secure power through alliances with local princes and elite business castes who were given exclusive rights to exploit profitable concessions in exchange for political loyalty. Commercial life centered on the rising new industrial and financial capital, Bombay, where the business community included Europeans, Zoroastrian Parsis, Jain and Muslim traders from Gujarat, Sindhis from the coast of present-day Pakistan, and Jews from Baghdad. Many of the wealthy merchants who emerged from this cosmopolitan mix became important patrons of the arts, including the decorative arts, architecture, and design.

Examination of Indian decorative arts and design, however, must not focus solely on the taste of the higher castes and ruling elites, either in cities or princely courts. Indian design traditions, particularly those related to houses, objects of everyday use, both secular and religious, and to the adornment of the body, remained strong among the settled agricultural castes in villages and the nomadic tribes of the hills and forest areas. While the development of decorative arts objects for elite society is fairly easy to trace and was often similar throughout India, village and tribal traditions varied greatly. The decoration of a mountain village house in the Himalayas, for example, bore little resemblance to that of a traditional home in Kerala, and the clothing of the nomadic Banjaras of western India and the Deccan was unlike that of Nagaland in the east. To do more than suggest the variety is impossible in a short survey, but to ignore it would not present a true picture.

During this period, people in areas distant from the seats of power had limited interaction with colonial rulers, and their design traditions remained little changed by European influence. Developing a precise time frame for the changes that did occur is difficult, partly because until recently some were nearly imperceptible, and partly because so few items produced in far-flung rural areas survive from this period. Unlike an emperor's precious cup, villagers' belongings wore out or were recast or discarded when the owner died. Although they might be nearly identical to goods produced centuries earlier, most surviving objects of village culture date to the late nineteenth and twentieth centuries. Indeed, systematic studies of folk and village decorative arts only commenced in the second half of the nineteenth century, and, not surprisingly, the earliest-known surviving objects belong to collections made at that time.

On the subcontinent and in the West, many aspects of architecture, design, and the decorative arts were strongly affected by the absorption of India into a global imperial trad-

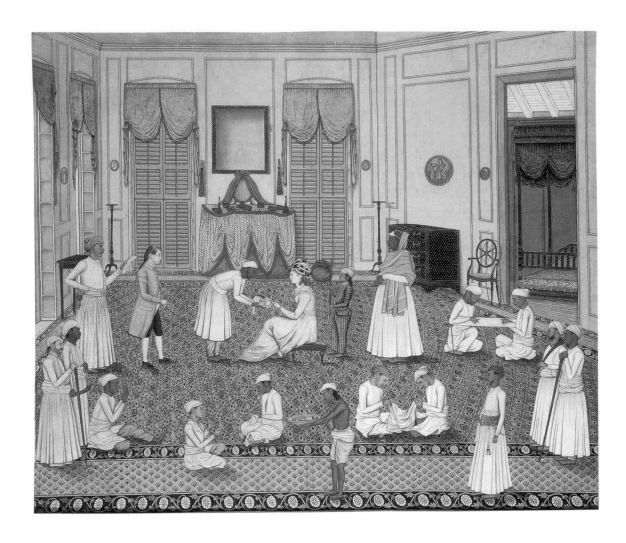

Fig. 14.1. Attributed to
Shaikh Zain al-Din of
Patna. *Lady Impey
supervising her
household, Calcutta,*
c. 1780. Watercolor;
17⅞ x 21 in. (45.5 x
53.3 cm). Private
collection.

ing system controlled from London. The British architect and designer John Nash (1752–1835), enthralled with drawings he had seen of Mughal and other Indian architecture, created an "Oriental" fantasy worthy of Asaf al-Daula's capital city of Lucknow on the east front of the Prince Regent's Brighton Pavilion (begun in 1815; see fig. 17.12). Meanwhile, early nineteenth-century Neoclassical British buildings, such as Nash's terraces of Regent's Park in London, were widely copied in Calcutta and Madras. Indian craftsmen delighted in absorbing foreign fashions and motifs, but they did so on their own terms, and the resultant hybrid pieces were as much the products of Indian culture as any others. High standards of craftsmanship continued, largely because of the hereditary caste system through which craftspeople passed on skills to new generations. That system of production was later challenged by greater division of labor and other means of producing work more cheaply, the demands of the export market, and both hand- and steam-powered mass production.

STYLISTIC VARIETY AND ECLECTICISM

Stylistic developments during this period can only be understood in the context of broader shifts in power. In 1750, the Mughal style was still popular with both Hindu and Muslim elites, but by 1775, Mughal design was freely interpreted in a fantastical, Baroque- and Rococo-like manner when the philanthropic ruler of Oudh in northern India, Asaf al-Daula

(r. 1775–97), commissioned major buildings for Lucknow, the new capital. Asaf al-Daula involved himself in the designs of the new buildings, and, largely because he was advised by the French mercenary general Claude Martin, the resultant aesthetic showed a strong French influence. Scale and form were stretched and exaggerated, and the surfaces ornamented with inventive decorative motifs, many from European sources. The most skilled craftsmen of Delhi, from architectural carvers to silversmiths, flocked to Lucknow and other rich Muslim provincial courts such as Murshidabad in Bengal.

The building of Lucknow coincided with British modernizations of the cities of Calcutta (capital of British India, 1773–1912) and Madras, designed in the late eighteenth century in the Neoclassical style then popular in Europe. The necessity of furnishing houses for Europeans led to the manufacture of new types of products such as silver tableware, tables, chairs, chests and coffers for storage, and toiletry sets—types little known in India outside of Portuguese Goa. Many of these items, all produced in India, can be identified with near certainty in a watercolor of the British aristocrat Mary, Lady Impey supervising her household in Calcutta in about 1780 (fig. 14.1): chintz cloth (from the Coromandel Coast), black lacquer furniture (from Bihar), and white muslin clothing (from Bengal), as well as an elaborate silver toiletry set and a magnificent *dhurrie* (tapestry-woven cotton carpet). Demand from local elites as well as exports to Europe and the United States expanded the markets for such objects. But not all British residents favored European-style prod-

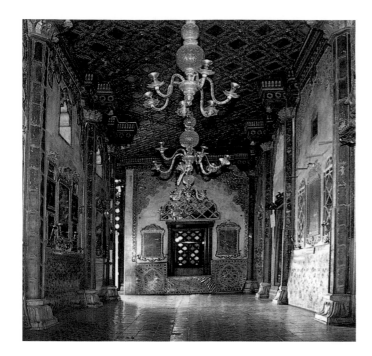

ucts. Many early foreign residents adopted a "native" way of life, took local wives, and immersed themselves in Indian art, music, and philosophy.

European training and influence is evident in the Hall of Mirrors in the Aina Mahal palace (fig. 14.2), which was created in the 1750s at Kutch for the ruler of Gujarat, Maharaja Lakho (1697–1761; known locally as Lakhpatji, r. 1741–61). Lakho's chief architect, Ram Singh Malam, had spent eighteen years in Europe learning tile- and enamel work, clock making, architecture, iron founding, and glassmaking. He then trained local craftsmen in European styles and techniques, and while some of the objects in the corridor leading to the maharaja's bedchamber had been purchased in Europe, the floor tiles, silk-embroidered panels used as a dado, and gilded gesso frames and coffered ceiling were made locally. Cooled by an ingenious arrangement of pool and fountains, Lakho's chamber was a princely *Wunderkammer* filled with European objects where he wrote poetry and entertained.

With its interplay of European and Indian taste, the Hall of Mirrors established a precedent that became typical during the next two hundred years for royal interiors in India. For much of the nineteenth century, Neoclassicism coexisted in India alongside Indo-Islamic design traditions. The third quarter of the century witnessed an eclectic new style, often misleadingly known as Indo-Saracenic, developed primarily by Charles Mant (1839–1881) and Robert Fellowes Chisholm (1840–1915), two British military architects. They believed that only by making their designs look "Indian" could they be relevant to the local population, and they left the surface decoration to local Indian draftsmen. The style combined modern European building plans with details and ornamentation from Hindu, Islamic, and Venetian Gothic sources and was used in many buildings and interiors in Bombay.

This mix of European features with design traditions familiar to Indians led many maharajas to adopt the style. One of the grandest and largest palaces, Lakshmi Vilas (1878–90), was begun by Mant for Sayaji Rao III (r. 1875–1939), the

ruler of Baroda and a Westernized social reformer. It was completed by Chisholm after Mant's death. The entrance hall to the private apartments shows both the infectious exuberance and stylistic eclecticism associated with the style (fig. 14.3). The florid stone carving in the cusped arches and cornices is loosely based on Indo-Islamic motifs, in contrast to the Italianate marble floor and statuary, while neo-Byzantine mosaic work by a team of Venetian artisans and stained glass ordered from Heidelberg depict the Hindu pantheon and mythology. Bas-relief Neoclassical figures and crystal chandeliers added to the eclectic mix.

In Kapurthala, the maharaja, an avid Francophile, drew inspiration from the palace of Versailles, whereas the rajas of Mysore used the Gothic Revival of Windsor Castle as a model for the royal palace in Bangalore (1887). At Gwalior and Hyderabad, the Indian rulers preferred a grandiose classicism, while British civic buildings and interiors were often rendered in a more sober, Greco-Roman version—one meant to convey the legitimacy of their rule by association with the powerful Greek and Roman empires.

Behind the impressive reception areas in the new palaces were less-Westernized spaces, particularly those for women. In both Hindu and Muslim traditions, women lived in seclusion in the *zenana*, or women's quarters; the only men they saw were close male relatives. Decorated in about 1880, the reception room at Jasdan Palace in Kathiawar, Gujarat, was designed for the maharani (the wife of a maharaja) to receive female visitors (fig. 14.4). These spaces were private in the sense of being separate from men, but collective in that all the women of the household lived there. Many of the contents came as part of women's dowries. The maharani would sit on a bolster or solid silver swing like the one shown here, a standard accoutrement in Gujarati houses. This reception room also contains wooden and brass chests used to store *saris* and other clothing, and cushions and bolsters that are ready to be placed on the floor, while armchairs in the European Regency style await European or elderly guests. Upturned against the

Fig. 14.2. Ram Singh Malam. Hall of Mirrors, Aina Mahal palace, Bhuj, Gujarat, 1750–60. Photographed before 2001 earthquake.

INDIA

Fig. 14.3. Charles Mant and Robert Fellowes Chisholm. Entrance to the private apartments, Lakshmi Vilas palace, Baroda, Gujarat, 1880s.

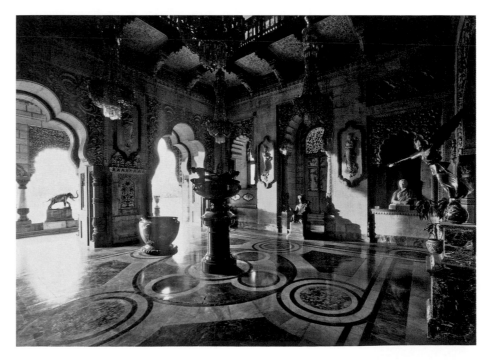

wall at the left, next to the low table, is a *charpoy* (a traditional Indian bed whose frame is strung with tape or rope), while on the left wall are panels of local beadwork embroidery, a popular craft in Gujarat that used European glass beads. Framed oleograph prints of Hindu gods hang on the right wall. Around the door is a beadwork *sakh-toran* (door hanging). The glass lanterns and Bohemian glass chandelier would have created a glittering light, reflected in the mirrors at floor level, which would also have reflected the seated guests.

naturalistic or stylized, such as the *boteh* (or *buta*), the "paisley" motif, were also common, as were designs organized around a central medallion and corner quarter medallions within a rectangular field, ogival and trellis patterns, birds and animals inhabiting a foliate design, multiple borders with geometric motifs, and objects inspired by the shapes of fruits or that imitate architectural forms. The Hindu pantheon and religious symbols were the source of much figural decoration, while Islam brought a wealth of geometric designs and new types and forms of objects.

DESIGNS AND MOTIFS

The various media that comprise Indian decorative arts—textiles, metalware, jewelry, stone, ivory and woodcarving, furniture, lacquerware, among others—continued to share many designs, and to do so across both diverse geocultural groupings and urban, village, and tribal production. In previous centuries, Indian visual and material culture had absorbed Greco-Roman, Chinese, and Central Asian ornament, and during the Mughal period, Buddhist and Hindu design traditions fused with those of Islam to form powerful new amalgams. From 1750 to 1900, Indian craftsmen similarly took in European designs, expanding the already rich vocabulary of Indian design. Devices prevalent in India in the period 1750–1900 included the scrolling vine or arabesque, which was often used as a border surrounding a rectangle and appears frequently on textiles, woodwork, carved hard stones, ivory, and metal decoration. Repeated floral patterns,

TEXTILES

Few surviving Indian textiles can be dated before the mid-eighteenth century, but their techniques and designs can often be traced back millennia. The late eighteenth and nineteenth centuries saw many changes in the fortunes of India's famed textile industry. The colonial powers controlled markets to their advantage, and from the early nineteenth century, Indian goods exported to Britain faced prohibitive duties, whereas British cloth arriving in India was barely taxed. During the nineteenth century, local artisanal production increasingly gave way to modern industrial mills. (The first Indian cotton mill using steam power was established in Bombay in 1854 by Cowasji Davar.) As their rule solidified, the British suppressed some local textiles, particularly those made with cotton, in favor of exporting raw cotton to British mills. British cloth was then exported to India.

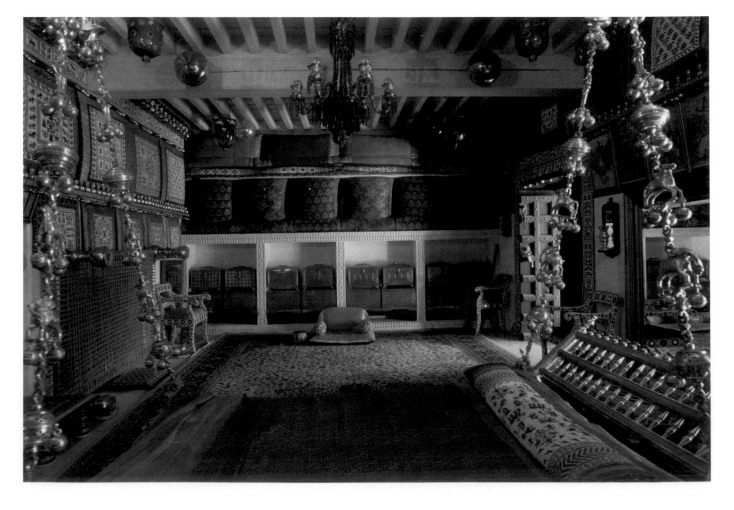

Fig. 14.4. Maharani's reception room in the women's quarters (*zenana*) of Jasdan Palace, Kathiawar, Gujarat, decorated c. 1880.

In spite of British interference through tariffs and taxation, textiles and other decorative arts continued to be a vital part of Indian culture, selling in both domestic and foreign markets. Indian displays at the great international exhibitions in Europe in the second half of the nineteenth century not only fueled a fashion for Indian goods but also greatly influenced Europe in taste and beyond. In 1883–84, the first international exhibition to be held in India took place in Calcutta, with many of the displays later shown in London at the Colonial and Indian Exhibition (1886), causing a stir among British designers.

In many parts of the world, particularly Europe, East Asia, and the Islamic world, Indian cloth was a luxury item, created for the taste and requirements of the particular importing country. But the primary consumer of Indian cloth remained the local population. Fine textiles were presented at Indian courts as gifts and awards, and brides' dowries required innumerable *saris* and other garments to proclaim the wealth of her family. In the nineteenth century, some clothing made according to Indian design and craft traditions began to incorporate Western features such as buttons and fasteners, while sewing machines changed the ways in which garments were made. Western fashions also affected Indian customs, and by the late nineteenth century, men who worked in urban areas for British employers often wore Western attire during the day and Indian dress in the privacy of the home, although most women continued to wear traditional clothing.

In India, cloth was mainly cotton, silk, or wool, and was dyed, woven, and decorated according to regional styles and techniques. Production ranged from simple village homespun cloth to highly sophisticated and technically accomplished textiles. Cotton cloth was usually decorated by printing and dyeing; printed cotton designs were sometimes further embellished with hand-painting. Complex designs were also hand-embroidered on silk and wool, but more frequently a loom-weaving process was used. One popular, traditional cotton was plain white muslin, the finest coming from the area around Dhaka in Bengal, now Bangladesh. Loosely woven, soft, and sometimes almost transparent, Bengali muslin was a fashion sensation in late eighteenth-century and early nineteenth-century Europe, where it was used for dresses based on those of ancient Greece and Rome, and often worn with softly draped shawls from Kashmir.

Centers for sophisticated printed fabrics included Sanganer, near Jaipur, which provided cloth for export and for Rajasthan court dress from the eighteenth century until the political demise of the princely states after 1947. It continues to supply cloth for garments and household furnishings. *Jamas* were coats worn by men at court and block-printed with finely carved floral stamps in an overall repeat pattern on a plain-colored ground. They were typical of Sanganer production, as were tunic dresses, gathered skirts, and head coverings for women. Elaborately carved blocks created borders with plants and animals, sometimes printed with gum and overlaid with gold or silver leaf or powder (for a later example, see fig. 20.18).

Resist dyeing is a complicated process in which design areas are shielded with paste or wax so they will not absorb

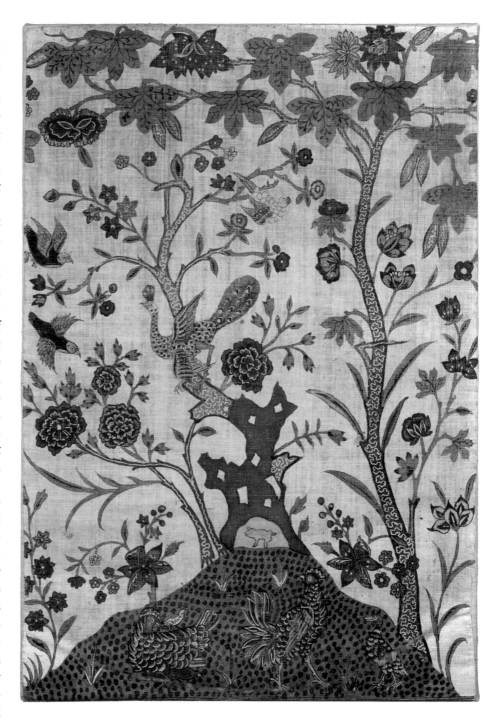

Fig. 14.5. *Palampore* panel, Coromandel Coast, c. 1770. Mordant-painted, resist-dyed cotton; 18⅛ x 12 in. (46 x 30.5 cm). Courtesy of Simon Ray, London.

unwanted colors. The designs themselves are often created by a combination of block printing and painting, both done by hand. The south Indian center of Masulipatam and other towns along the Coromandel Coast that had provided chintz (glazed cotton) to Europe and Persia from the seventeenth century continued to do so throughout the nineteenth century. The area was famous for its *palampores* (literally, "bedcovers," but also used as wall hangings), which were in considerable demand in Europe as well as East Asia (fig. 14.5; see also fig. 8.24).

South Indian *kalamkari* also combined resist printing and dyeing techniques with hand painting (see fig. 8.23). By the nineteenth century, the most striking *kalamkari* were produced at several centers in Tamil Nadu and used for temple rituals and ornamentation. Hindu religious epics such as the Ramayana, the legendary tale of Prince Rama, were told pictorially in horizontal registers divided by borders of geomet-

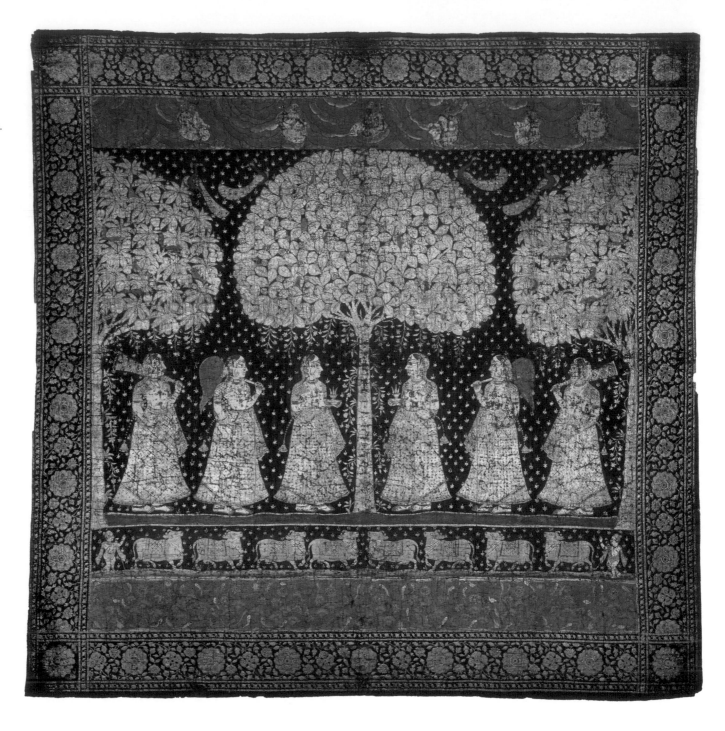

Fig. 14.6. Temple hanging (*picchavai*), Rajasthan or Deccan, late 18th century. Cotton, watercolor, gold, silver; 96¹⁄₁₆ x 100 in. (244 x 259 cm). Museum of Fine Arts, Boston (67.837).

ric or floral design, or sometimes filled with script describing the scenes. Large rectangles in the middle of the compositions show the gods and main characters in the stories.

Tie-dye techniques, long associated with Indian textile production, continued to be extremely popular in the nineteenth century. In the *ikat* method, warp threads (plus the weft threads in double *ikat*) are bundled and tied in patterns so that the tied portions remain unexposed to the dye. The resulting partially dyed threads are then assembled on the loom, where they produce patterns when woven. Used for both cotton and silk weaving, the *ikat* technique has produced some of India's most distinctive textiles. Made in many centers, usually those with a large Muslim population, *mashru'* is a particularly striking form of *ikat*, often with zigzag designs, produced in satin weave with silk warps and cotton wefts, so that the fabric has two faces, one shiny silk, the other cotton. The technique has a long history: simi-

lar fabric was produced in Central Asia, Iran, and the Ottoman Empire. It was widely used in India from the nineteenth century until recently for trousers for men and women, blouses, wall hangings, and linings of ceremonial trappings for horses and elephants. Since only the cotton side touches the skin, *mashru'* (Arabic, "legal") is more absorbent and thus cooler than pure silk, and it also allows Muslims to wear silk garments, something otherwise forbidden, hence the name *mashru'*. They are also called *misru*, a Sanskrit word meaning "mixed." Although the design range is limited, *mashru'* weavers achieved a broad range of subtle variations and effects.

In addition to *kalamkari*, hand-executed pigment paintings on cotton cloth were widely produced in the nineteenth century for devotional purposes. Large-scale paintings called *picchavai* (literally, "something at the back") were associated with a sect that worships Krishna Govardhana incarnated as

a divine child-king, Shrinathji. At Nathadwara, the group's center in Rajasthan, colorful *picchavai* provided backdrops in temples. A number of standard iconographic schemes determined the imagery and changed according to the seasons or festivities being celebrated. A common composition featured a central figure of Shrinathji surrounded by milkmaids (*gopis*) against a background of vegetation such as banana and mango trees, with small square images depicting his iconography bordering the central field. Local painters who produced large temple hangings also provided smaller versions for the domestic shrines of pilgrims.

In the Deccan, a group of prosperous followers of the sect commissioned *picchavai* characterized by dark brown, black, or red cotton grounds with painted and printed decoration. Gold and silver leaf, adhered to the surface with gum, was used extensively. Rows of cows and milkmaids or cow-herders (male) are depicted bringing their offerings to Krishna, who is sometimes symbolized by a *kadamba* tree in the center of the composition. In the example shown here (fig. 14.6), six maidens, against a brilliant red ground, face the tree and are further sheltered by two mango trees filled with parrots and peacocks. Below, a row of cows survey the scene, a river brimming with fish and lotus blossoms at their feet. Freely painted by highly skilled artists, Deccani *picchavai* developed out of regional traditions of miniature and manuscript painting in the seventeenth and eighteenth centuries.

Although the Indian silk industry had been well established since the early Mughal period, the cultivated moth that was used to make silk in China, Europe, and elsewhere did not thrive in India, except in Kashmir. Skeins of raw silk were therefore imported for weaving, while the rough silk cloth derived from local wild silk moths was widely used for simple clothing. Because silk fabric is fragile, most of the earliest existing pieces date from the nineteenth century, when it was woven in Bengal, Gujarat, Madras, and Bombay. Although plain fabrics in stripes and checks were popular with both locals and Europeans, the brocade-woven silks of Benares (Varanasi) were most highly prized, particularly for wedding *saris*. Woven on a silk warp with a gold or silver weft pattern made from fine, metal-wrapped thread, the designs featured continuously repeating floral motifs or trellis patterns, and elaborate borders of meanders or scrolls and figural patterns. As the nineteenth century progressed, European Jacquard looms, a French invention of 1801 that used arrangements of perforated cards to produce particular designs, increasingly replaced Indian handlooms, speeding up production and allowing for more complex designs. Exotic patterns derived from European wallpapers or velvets became popular, and, as in Europe, in the second half of the century, bolder, more strident tones and new colors of synthetic dyes replaced the palette of natural pigment.

Embroidery on cotton, silk, wool, and velvet was important throughout the period. At court, finely embroidered cotton "summer carpets" replaced wool ones in hot weather and were often used by Europeans in India and Europe as bed covers. The cream-colored cotton grounds were lightly quilted and stitched with polychrome silk and silver- and silver-gilt-wrapped threads. Some examples had small repeating floral designs, but the more dominant design motif was a central rectangle with a large medallion in the center and four quarter corner medallions surrounded by multiple borders. Tents used by Mughal and other rulers were decorated with similar embroidery; such stitching was used as a decorative dado in the Aina Mahal Palace (see fig. 14.2).

Wall hangings and horse and elephant trappings were made of velvet with heavy embroidery of silk threads wrapped with silver-gilt strips to achieve a relief effect. A superb example of this *zari,* or *zardozi* work (from the Persian words *zar* for "gold" and *dozi* for "embroidery"), is a red velvet saddlecloth taken by the British after the sack of Tipu Sultan's palace at Seringapatan in 1799 (fig. 14.7). With its dense floral designs and elaborate fringe in silver-gilt-wrapped thread, wire, and spangles, the piece is similar to trappings made in the same tradition until the early twentieth century. Such items were highly praised at the major international exhibitions and provided much of the splendor at the *durbars* (coronation ceremonies) of 1903 and 1911 in which the British monarchs Edward VII (r. 1901–10) and George V (r. 1910–36), respectively, were proclaimed emperors of India.

The Pahari Hills region in the north of India was famous for *rumals* (cotton head covers embroidered with silk thread) for ceremonial gifts, depicting scenes from epics related to the legends of the deity Lord Krishna (fig. 14.8). So fine is the drawing that the outlines of the composition may have been done by painters at the court of Chamba (in Himachal Pradesh), which were then stitched by the women of the court. In the example illustrated here, a royal Hindu bride-

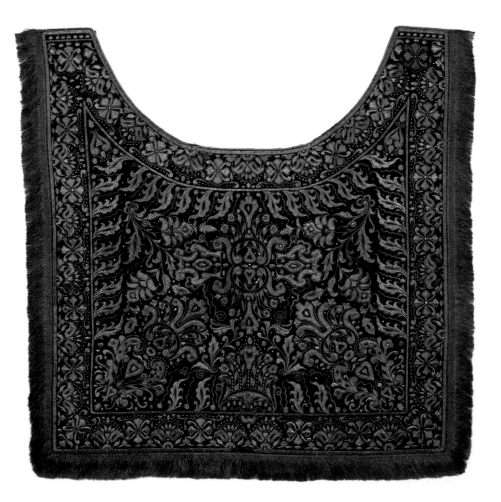

Fig. 14.7. Saddlecloth owned by Tipu Sultan of Mysore, Deccan, late 18th century. Embroidered velvet, silver-gilt–wrapped threads, wire, sequins; 56½ x 56 in. (143.5 x 142.2 cm). Victoria and Albert Museum, London (784-1864).

groom rides in procession on his elephant and, as the scene continues, pays homage to the elephant god Ganesh.

Closer to traditional Islamic designs were the *chikan* or *chikankari* embroideries of Lucknow and the shawls and *saris* from Bengal. *Chikan* refers to fine white cotton fabric embroidered with white cotton thread. The stitching and pattern could cover the entire garment or only the hems and necklines of otherwise plain cotton shirts, which were embroidered with delicate floral arabesque borders. As a further refinement, the flowers or vine leaves might be *jali*, or openwork (a word also used for carved openwork screens; see fig. 8.2). In *jali* embroidery, the threads of the ground fabric are kept very taut and pulled into lacelike patterns. The Bengali garments had patterns similar to Kashmir shawls (see below) but were rendered in near-monochromatic tones—white cotton, embroidered with threads of white cotton or wild silk.

The richest traditions of popular embroidery were in the Kutch region of western Gujarat and the Sindh region of present-day Pakistan. Among the few embroideries known to be from the early nineteenth century are temple hangings made by devotees of the Krishna cult. They are similar in iconography and style to the Nathadwara *picchavai* and embroidered covers for Jain religious books. The latter were decorated with illustrations from the text or, more often, graceful floral and geometric designs derived from Mughal embroidery. Although embroidery was practiced throughout this period, most of the extant datable Gujarat and Kutch embroidered clothing, coverlets, and hangings were made in the late nineteenth or the early twentieth centuries.

Fig. 14.8 Ceremonial cloth (*rumal*), Chamba, Himachal Pradesh, late 18th–early 19th century. Embroidered cotton, silk threads, silver metal foil, ink; 31¼ x 31½ in. (79.4 x 80 cm). Virginia Museum of Fine Arts, Richmond (95.16).

CARPETS

One of the great glories of earlier Indian craft production, the knotted-pile wool carpet, declined with the collapse of Mughal wealth and patronage during the second half of the eighteenth century. Although some high-quality carpets continued to be produced in Kashmir and the Deccan, the era of India's most artistic and expertly made carpets came to an end. A remarkable late flowering of Indian carpet design and manufacture, however, is represented here by a late eighteenth-century pashmina niche-and-*millefleur* carpet, probably from Kashmir (fig. 14.9). Densely decorated, the rigid and schematic design is notable for the unusual form of the central niche—resembling an animal skin lying on top of the rectangular yellow field, while also evoking the *mihrab* niche in mosques toward which Muslims face for prayer. Highly stylized red cypress trees appear to flank the lower part of the niche. The Deccan was also known for multiple-niche *saf* carpets, which were designed so that individual worshipers had a clearly defined space to say prayers in the mosque. A number of late eighteenth-century Deccan carpets, adapted from other Persian or Turkish designs, were sent as trade items to Japan, where many have been preserved.

For much of the nineteenth century, the Indian carpet industry was moribund, but it was revived on a large-scale commercial basis late in the century, producing rugs and carpets mainly based on Persian designs. Such production continues today in north India and Pakistan. The main centers included the Punjab (Amritsar and Lahore), Kashmir, the United Provinces (Agra, Mirzapur, Allahabad, and Jabalpur), and Hyderabad (Deccan). The decline in the quality of the carpets was sometimes blamed on European traders who demanded cheapness and failed to appreciate the high level of skill and quality of materials involved in making the best examples. Competition from workshops established in jails to exploit prison labor further challenged the livelihoods of carpet weavers. These so-called jail carpets were made of poor-quality "dead wool," a dry and brittle material that had been removed with harsh chemicals from sheep skins obtained from butchers, as opposed to good-quality wool shorn from live sheep. Carpets made from dead wool had no sheen and a short life span. The tapestry-woven cotton carpets called *dhurries* (see fig. 20.10) were also associated with the prison ateliers, but *dhurries* mainly continued to be a traditional village craft throughout India.

KASHMIR SHAWLS

Few textiles exported from India to Europe were more highly prized or of greater economic importance than the Kashmir pashmina shawl (fig. 14.10). The shawls were traditionally made of high-quality wool (from the undercoat of a particular species of mountain goat) imported into Kashmir from Tibet and Central Asia. Passing through the hands of numerous workers, each performing specialized tasks, the wool was graded, spun into yarn, and then dyed. Eighteenth-century shawls often had a plain field woven by hand on a simple

Fig. 14.9. Carpet, probably Kashmir, 1750–1800. Cotton, pashmina wool; 74³⁄₁₆ x 47¹¹⁄₁₆ in. (188.5 x 121.2 cm). The Metropolitan Museum of Art (1970.302.7).

shuttle loom. The edges and borders were covered in floral or arabesque patterns created in a twill-tapestry technique in which the weft threads were woven around the warp threads wherever a particular color was needed. In later shawls, the different elements were then stitched together with such finesse that the joins are often invisible to the naked eye. The whole process was extremely labor intensive, taking months, sometimes years, to produce a single shawl.

A characteristic design element of the Kashmir shawl is the repeated *boteh,* a motif that evolved from delicate naturalistic floral forms common to much Mughal design. This motif was abstracted until, by the early nineteenth century, it had acquired its familiar "comma" shape, now often called "paisley," after the Scottish town that mass-produced shawls

inspired by Indian examples. Another Kashmir design much admired in the early nineteenth century was the square "Moon" shawl, which had a central and quarter corner medallions and a geometric pattern for the ground of the inner square decorated with finely woven floral motifs. As the century progressed, however, Indian designs changed according to the dictates of European agents and the growing demand for Kashmir shawls abroad. By the last quarter of the nineteenth century, the *boteh* was increasingly stretched, elastic, and abstract, interlacing with itself and consequently becoming an overall repeat pattern. Later shawls were usually rectangular and very densely decorated.

Fashionable European women in the late eighteenth and nineteenth centuries turned the Kashmir shawl into an inter-

Fig. 14.10. Shawl (detail), Kashmir, c. 1820–30. Pashmina wool; overall, 4½ x 11 ft. (1.4 x 3.3 m). Courtesy of Simon Ray, London.

ans living in India, or to satisfy the changing tastes of the local elites, however, were less tied to such traditions.

The use of metal objects in the home was common in India, not least because in Hindu culture, ceramic objects are considered unclean and polluted once used. Consequently, for many Indians, vessels and other objects connected with hygiene, cooking, and eating were made of metal. India, unlike neighboring China and Iran, did not develop sophisticated domestic ceramics, except for tiles used for architectural and wall decoration—an area in which India traditionally excelled. Crockery and porcelain only became common in India with the widespread impact of European culture. Muslims, on the other hand, had no cultural prohibitions regarding ceramics and, as can be seen in the details of miniature paintings (see fig. 2.1), their courts were avid consumers of Chinese, Persian, and, later, European ceramics. Nonetheless, they tended to use metal utensils at table. As a general rule, Hindu vessels were brass and Muslim ones copper, except for drinking vessels, which were usually silver. For the wealthy, silver was also used to make *thali*, large round trays with a raised edge used for eating. Numerous small bowls (*katori*) for food were placed on the tray, along with rice and flatbreads. Spoons were the only utensils; otherwise food was eaten by hand.

Although some domestic metalware forms changed radically under European influence in the second half of the nineteenth century, objects used in aristocratic or prosperous households adhered to conventional forms, many of which derived from the shapes of fruits such as melons, mangoes, gourds, and pears. Other metal objects adapted architectural forms, such as the dome and its drum. The most frequently used items of traditional metalware in this period included *pandans*—round, rectangular, or polysided domed containers for preparing and storing the ingredients for *pan* (stuffed betel leaves chewed as a digestive)—bell-shaped water pipes (*huqqas*) used for smoking tobacco; and tall, pear-shaped ewers (*aftabas*) with long spouts and curved handles for serving liquids or pouring water over the hands at table before a meal, a practice that necessitated a wide-rimmed basin with a squat bulbous base to receive the water. A small version of the basin shape was used as a spittoon.

Other everyday items included long-necked flasks with pear-shaped bellies, round trays and serving dishes, and pierced incense burners. The most common object was the *lota*, or water vase, used for a variety of purposes including personal hygiene, with a broad mouth, out-turning rim, and globular melon-shaped body flattened on the top. The Hindu *lota* had no spout, while Muslim *lotas* were spouted to comply with the Koranic edict that ablutions should be performed in running water. The basic forms and decorative repertory associated with these objects allowed for a great variety of subtly different shapes and surface decoration.

The elegant design of a cast-bronze, iris-shaped *pandan* shows what effects could be achieved by using unadorned base metals (fig. 14.11). Made in Rajasthan in the late eighteenth century, the interior is divided into a large central mango-shaped compartment with surrounding compartments in the shape of the petals. The various spaces would have held all the ingredients necessary for preparing *pan*, the

national luxury item, usually plain-field shawls with floral borders, and French and British manufacturers began producing copies of Kashmir shawls using modern tools and production methods, such as the Jacquard loom, thus undercutting Kashmiri weavers. In response, the latter tried cost-cutting changes of their own. Rather than having one weaver make an entire shawl on a single loom, the weavers produced the component parts separately and stitched them together, reducing production time. It also proved cheaper to hand embroider over roughly woven designs than to weave a whole shawl, and in the 1860s and 1870s, "paisley" patterns on some Indian shawls were entirely embroidered.

The Kashmir shawl industry collapsed in the early 1870s. By then, a British-made Jacquard-woven shawl was no longer considered a luxury item and could be purchased for as little as one pound sterling. Changes in fashion and economic upheaval during and after the Franco-Prussian War (1870) and the Paris Commune (1871) brought a sudden end to the French market for Kashmir shawls. Indian shawl workers and their families faced impoverishment, sometimes starvation, and the industry never revived.

METALWARE AND JEWELRY

Between 1750 and 1900, Indian artisans continued to produce an array of finely crafted objects in bronze, steel, and brass. As in other media, the shapes, designs, and patterns often repeated long-established traditions, particularly for objects used in villages, in Hindu rituals, or by very conservative castes. Items produced for export markets and Europe-

consumption of which was considered a mark of leisured refinement conducive to conversation and social conviviality. Kerala in south India also excelled in producing undecorated, superbly cast, plain bronze vases, bowls, and *lotas*. Like the local architecture, Keralan vessels show the influence of trade contacts with China, Indonesia, and Southeast Asia.

Bidri, a kind of inlaid metalwork named after the Deccan town of Bidar where the finest objects of the kind were produced, involved casting forms in a dark alloy of zinc and copper, which was then engraved and inlaid with fine decoration in silver or sometimes brass and silver. The black background, achieved by applying a mud paste containing sal ammoniac, creates a brilliant contrast with the shiny metal inlay. The most visually arresting design and decoration predate 1800, as, for example, a bold, bell-shaped *huqqa* from the third quarter of the eighteenth century decorated with large roses (fig. 14.12). The production and popularity of *bidri* increased throughout the nineteenth century. *Huqqas* followed a stylistic trajectory from delicate bell-shaped late eighteenth-century examples to ever-larger bell-shaped models heavily inlaid with overall floral or geometric designs. The earlier versions were decorated with large flowers and bands of foliate arabesque or Neoclassical-style motifs reminiscent of British designers such as Robert Adam (see fig. 17.8). By the mid-nineteenth century, *bidri* craftsmen had learned to produce much stronger zinc alloys, which allowed for the production of larger items such as tables, chairs, and bed legs. Throughout the century, northern Indian craftsmen in Bengal, Lucknow, and Purnea made metalwares similar to *bidri*.

Another technique that is still widespread in India is *koftgari*, also a kind of inlaid metalwork. A hard steel needle (*salai*) is used to etch minute arabesque designs into a metal ground, after which fine wires of silver or gold are hammered into the channels and polished with a stone to cause the wire to spread evenly within the etched lines. The Punjab was noted for fine *koftgari* work, particularly the town of Sialkot, now in Pakistan. *Koftgari* craftsmen, originally makers of weapons for the Sikh rulers of the Punjab, switched production to domestic items such as trays, caskets, and vases after the annexation of the area by the British in 1849.

In southern India, encrusted inlaid metal was a specialty, particularly in the temple towns of Tanjore and Tirupatti. Brass or copper vessels were chased and inlaid with copper or silver, after which Tanjore craftsmen added hammered decoration in relief. The encrusting of trays and *lotas* with arcaded arches surrounding Hindu deities was known as "*swami*" work. Outstanding examples of all of these metalworking techniques were widely admired at the international exhibitions in the third quarter of the nineteenth century, though, in the wider market, demand for cheap examples led to less well-made pieces.

While numerous examples of enameled gold jewelry from the period survive, large enameled gold objects such as *huqqas* or *pan* boxes are rare. Gilt-copper or silver supports for the application of this technique were more common (fig. 14.13). Most enameling used what is now known as the *champlevé* technique. A design is cut into the metal surface and then filled with oxide paste. Multiple firings are required in a carefully planned sequence because different colors fuse at different temperatures. The result is a multicolored design that glows against its metal background.

Enameled jewelry was made in many places in northern India including Lahore, Bikaner, and Benares, but the most famous nineteenth-century center for *champlevé* enameling on gold was Jaipur in Rajasthan. Even today, the artisans of Jaipur produce jewelry that is often difficult to distinguish from that of earlier centuries. In Indian tradition, old jewelry (indeed any old object) may carry inauspicious associations from its previous owners; therefore, new is preferable to old, even if the design is the same.

Fig. 14.12. *Bidri* water pipe (*huqqa*), Deccan, c. 1780. Zinc-copper alloy, silver inlay; 6⅞ x 6¾ x 6¾ in. (17.4 x 17.2 x 17.2 cm). Courtesy of Simon Ray, London.

Fig. 14.13. Betel box (*pandan*), Lucknow, Uttar Pradesh, c. 1780. Enameled silver; 5 x 5¼ x 5¼ in. (12.7 x 13.3 x 13.3 cm). Los Angeles County Museum of Art (AC1993.137.1.1-.2).

Fig. 14.14. Turban ornament, Jaipur, Rajasthan, 1800–50. Gold, enamels, gemstones; 4¾ x 5⅛ in. (12 x 13 cm). Victoria and Albert Museum, London (IM.241-1923).

Fig. 14.15. Canopy finial from the throne of Tipu Sultan, Mysore, c. 1787–93. Later stand by Paul Storr, London. Gold, diamonds, emeralds, rubies, pearls, silver gilt; 16½ x 7⅞ x 11 in. (42 x 20 x 28 cm). Royal Collection, London (48482).

One particularly distinctive type of traditional enameled jewelry consisted of gold plaques decorated on the reverse with multicolored *champlevé* enamel depicting sprays of flowers, scrolling vines, animals, or a combination of motifs. After enameling, the piece was passed to a gem setter who

tightly set the front with rough- or flat-cut gems, sometimes arranged in patterns of many colors and backed with foil to increase the glitter. In a technique called *kundan*, a ribbon of pure gold beaten between the gems holds them in place. The plaques are then combined for a finished item: a necklace, for example, might consist of eight or nine such pendants, strung on a rope strand with small enameled gold beads and clusters of rough-cut stones or pearls hanging from the pendants. One-piece jeweled enamel items include bracelets and a rigid necklace called a *hasli*, as well as dagger and sword hilts, belt buckles, rose-water sprinklers, flywhisk handles, pendants, and turban ornaments (fig. 14.14). The *kundan* technique was practiced by jewelers throughout the country. In the large gold piece illustrated here (fig. 14.15), the emeralds, rubies, diamonds, and pearls were secured with this technique. Representing the phoenix, or *huma*, the piece served as a sort of finial on the canopy of the throne of Tipu Sultan of Mysore and was taken as loot by the British after his defeat in 1799.

Precious metals and gems have specific symbolic, religious, spiritual, and social meanings and have been a favorite store of wealth. Brides were given as lavish a dowry of jewelry as the family could afford, and this constituted her personal property. A princely bridegroom might outshine his wife, for, until the relatively recent demise of the royal courts, men also wore jewelry for formal occasions, including turban ornaments, arm bracelets, necklaces, earrings, finger rings, and jeweled swords and daggers. Until South African mines were opened in 1866, India was the only source of diamonds in the world. Other precious gems were imported through centuries-old trading patterns. Because gold was hoarded as a store of wealth, India held a disproportionate share of the world's supply, though only a small proportion was obtained locally. India's gold hoard built up over millennia, arriving as payment for goods and reaching a peak after the Spanish and Portuguese conquered South and Central America. Between 1660 and 1690 alone, the East India Company shipped 20 tons of gold to India in exchange for goods. Likewise, during the American Civil War, 420 tons of gold went to India in exchange for cotton goods, which were not otherwise available to the northern states.

In southern India and Ceylon (present-day Sri Lanka), jewelers used gold to stunning effect, usually for dowry items (fig. 14.16). Bold and sculptural, this jewelry reveals an aesthetic quite different from anything in northern India, one sharing more with other ancient Hindu cultures of south Asia, such as Cambodia and Indonesia. Hindu dynasties had ruled southern India for centuries, where they remained relatively untouched by successive Muslim invasions, and their material culture was less influenced by Indo-Islamic styles. Although fond of diamonds and rubies, wealthy southern Indians preferred predominantly gold jewelry. In the north, gold was more often used as a support for enameling and gem settings.

Like gold, only a small percentage of silver was mined locally but vast quantities reached India in payment for goods over many centuries. The ancient Greeks and Romans traded silver for goods. Later, the Portuguese in Goa (and other places) and the Dutch East India Company also used it in trade. Once in India, both silver and gold were privately

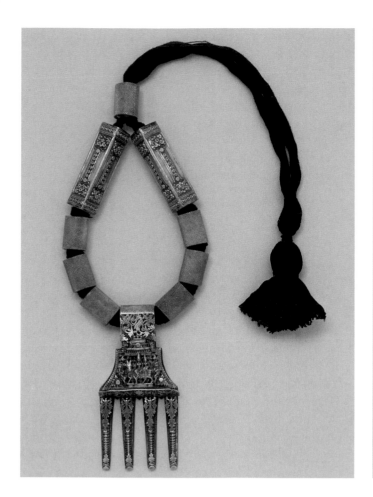

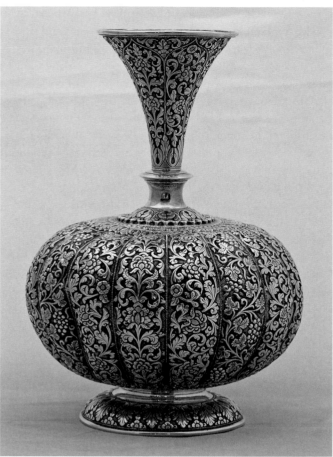

Fig. 14.16. Necklace (*kazhutthuru*), possibly Poodoocottah, Tamil Nadu, late 19th–early 20th century. Gold, black thread, red foil, copper, lac; pendant, 4⅞ x 2½ in. (12.5 x 6.4 cm). Victoria and Albert Museum, London (IS.90-1987).

Fig. 14.17. Vase (*surahi*), Bhuj, Gujarat, c. 1870. Silver; H. 10¼ in. (26 cm). Courtesy Indar Pasricha Fine Arts, London.

INDIA

hoarded, as the preferred form of wealth, more than anywhere else in the world.

Jewelery was important not just as ornament but as portable wealth. Throughout India, silver was widely used for jewelry for members of lower castes who could not afford gold or precious gems. Before the colonial period, Indian silver was not marked or stamped, and because objects were constantly melted down and recast, few can be dated before the mid-eighteenth century. Members of higher castes seldom wore silver jewelry, although they used high-quality silver *pandans*, trays, and sword and dagger hilts (as well as scabbards), and long-necked rose-water sprinklers (*gulabpash*) with silver fittings. Silver filigree work was particularly popular in the second half of the eighteenth century for boxes, trays, toiletry sets, and rose-water sprinklers, the overall forms of which were similar to contemporary designs in other techniques. Worked in patterns reminiscent of rippling water, the fine strands of filigree were strengthened by interspersing wider silver bands at regular intervals. Karimnagar in the Deccan was well known for this type of work, although its origins may be Spanish or Portuguese. The toiletry set depicted on Lady Impey's dressing table (see fig. 14.1) was probably done in this technique; other Indian filigree sets from the period survive in European aristocratic and royal collections.

By the late eighteenth century, British communities in India supported a number of European silversmiths who produced high-quality work that closely followed contemporary British silver styles. Marking, dating, and silver content followed British standards, but, because life expectancy of European settlers in India was short, the marks of most silversmiths were in use for only a few years. One notable exception was Hamilton and Company in Calcutta, which remained in business from 1815 until the 1970s. Calcutta silver of the late eighteenth and early nineteenth centuries was Neoclassical in form and sparsely ornamented in the manner of British silver of that period.

More original were the wares produced by Indian silversmiths in the mid- to late nineteenth century, which drew upon European forms and object types but were decorated with Indian motifs. Lucknow and Kashmir were among the main centers for this fine, richly ornamented silver, but the best-known work came from the town of Bhuj, capital of the princely state of Kutch in western Gujarat (fig. 14.17). Oomersi Mawji (b. c. 1850, act. 1870–90), the celebrated court silversmith there, was one of the few Indian master craftsmen known by name. In addition to supplying local demand in the late nineteenth century, he and his sons sold their wares through Liberty, a London department store (founded 1875). The Mawji family workshop used a traditional wax and resin technique to create rich surface decoration. An object such as a teapot was made to the required form and then filled with wax and resin. This solid core maintained the shape while it was decorated by punching and hammering intricate designs of flowers, animals, and dense scrolling foliage. Afterward, the wax was melted and removed, and the surface burnished. The Mawji family drew on tradition in their work, using motifs similar to those on the few known silver pieces from earlier centuries made in this technique.

As elsewhere in the world, the battle between quality handcrafts and profits intensified in the late nineteenth cen-

tury. A reduction in quality often resulted from speeding up production and increasing output. Artistic brass and copper items such as trays and vases are the most prevalent examples of surviving nineteenth-century Indian metalwork produced on a large scale. Long known for finely cast and sculptured brass images of Hindu deities, the holy city of Benares became famous worldwide in the later nineteenth century for handmade brassware. Indeed "Benares brassware" was used to describe inexpensive and mass-produced Indian metalware in general, and in the West it was found in even moderately prosperous households. George Birdwood (1832–1917), the Anglo-Indian author, described it as being rickety in form, its chasing in shallow, weak patterns, and as featuring excessive ornamentation, but many other Europeans found it evocative of the glamour and romance of India.[1] Other cities also had distinctive metalwares. Lucknow, for example, specialized in making attractive *repoussé* copper work that was more traditionally Mughal in style, whereas Moradabad brassware featured chased floral decoration inlaid with black lac (resin).

India's steel weapons equaled the finest in the world. During this period, blades for swords and daggers, maces, helmets, body armor for men and horses, animal trappings, and, later, guns and cannon were produced in abundance at many centers, notably in the Deccan, the Punjab, southern India, and Rajasthan, especially the princely states of Jaipur, Sirohi, and Alwar (fig. 14.18). Martial prowess was the caste function of the Rajputs, for whom fine weaponry carried a near-sacred meaning and hunting was a favorite pastime. The designs resemble those of Mughal weapons, many of which were also supplied from Rajasthan. By the early nineteenth century, the maharajas were largely submissive to British power, internecine battles had ended, and elaborate weaponry became largely symbolic of status.

FURNITURE

With a few exceptions—low platform beds, small low tables, stools, and portable storage boxes and chests—traditional Indian modes of living required little domestic furniture. Within the limited range of objects, however, there was great variety, from pieces made of rough-hewn wood in peasant homes to items of fine hardwoods inlaid with ivory or encased in gold and decorated with precious stones. Before the arrival of European colonists, the only chairs were thrones (fig. 14.19). For lesser mortals, comfort was provided by cushions and bolsters placed over a variety of floor coverings: wool carpets in winter; flatwoven cotton carpets (or *dhurries*) and embroidered "summer carpets" for the hot weather. Dishes

Fig. 14.18. Sword hilt, Rajasthan, 19th century. Steel, gold and enamel inlay; H. 7¼ in. (18.5 cm). Musée national des arts asiatiques Guimet, Paris (MA6821).

Fig. 14.19. Hafiz Muhammad of Multan. Throne of Maharaja Ranjit Singh, Lahore, c. 1820–30. Wood, resin core, gold; 37 x 35⅜ x 30⁵⁄₁₆ in. (94 x 90 x 77 cm). Victoria and Albert Museum, London (2518[IS]).

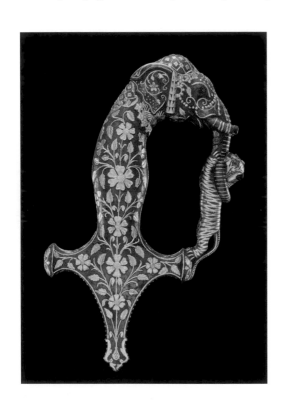

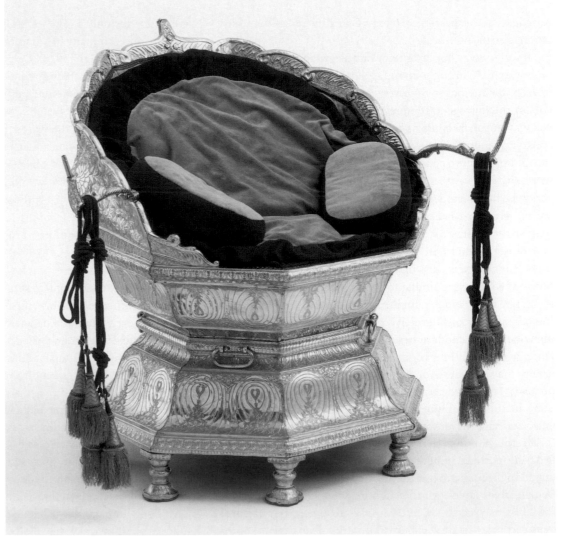

of food were laid on cloths on the floor or on small low tables. Depending on the season or time of day, everything could be moved to wherever it was most pleasant to sit, eat, or sleep. The notion that a room should have one fixed function was alien to Indian cultural conventions.

Between 1750 and 1900, furniture production on the Indian subcontinent was transformed from small-scale workshops creating well-established categories of luxury items to an industry, ranging from individual craftsmen through small to large workshops, capable of supplying the needs of the new Indian urban elite in large, Westernized cities. By the late eighteenth century, the richest households in Calcutta and Madras were palatial in scale and luxury, requiring large quantities of furniture, as did residences in princely cities such as Lucknow, Murshidabad, and Hyderabad. Production expanded with the consolidation of the British colonial administration in the second half of the nineteenth century, not only to furnish the elaborate civic and commercial buildings and European-style homes throughout British India, but also for export abroad. Calcutta, Madras, and Bombay became the leading furniture-producing centers and set the fashions. The princely states followed suit, competing with each other to furnish ever more extravagant new palaces. Somewhat isolated from British India, Goa continued to produce furniture in an Indo-Portuguese style, while the furniture industry of Ceylon prospered throughout the nineteenth century.

Well before this expansion of the furniture trade, in the second half of the eighteenth century, the long-established cabinetmaking industry at Vizagapatam, in Andhra Pradesh, was the foremost producer of furniture inspired by contemporary styles created by British furniture makers and designers such as Thomas Chippendale (see fig. 17.7). Famous for their skills in cabinetry with ivory inlay and veneering (fig. 14.20), Indian artisans produced furniture for local European residents and the Indian elite, but their products were also highly prized in Europe—indeed, most surviving pieces are found there in royal and aristocratic households. The most common Vizagapatam products from the period are chairs, miniature bureau-cabinets, desks, and an array of small boxes such as tea caddies, knife cases, and workboxes, all of which suggest a Westernized lifestyle when used in Indian houses.

Previously renowned for small-scale carved ivory objects such as combs, caskets, and chess pieces, the workshops of Murshidabad, north of Calcutta, came to rival those of Vizagapatam in the production of furniture influenced by European Neoclassicism at the end of the eighteenth century. Rather than using hardwood frames and carcasses inlaid or veneered with ivory, Murshidabad makers focused on seat furniture and tables carved of solid ivory, though a few miscellaneous items such as candelabra are also known. Specialties included a five-legged chair with round or serpentine seat, raised back, and curving arms related to both British designs and the so-called burgomaster chairs from the Dutch East Indies (fig. 14.21). In the late eighteenth and early nineteenth centuries, furniture designs published in England by Thomas Sheraton, George Hepplewhite, and others were interpreted in Murshidabad workshops, and the English Regency-style armchair with scrolling arms became a popular model.

Continuing to follow British late Georgian and Regency forms, furniture featuring fine woods from Ceylon and Burma, such as teak, ebony, rosewood, calamander, and padouk, was fashionable in the first half of the nineteenth century, mainly in Ceylon. Some of the finest furniture in these rare woods was also made there, where it was usually deeply carved with scrolling foliage, acanthus leaves, flowers, scallop shells, reeding, and turned legs. Closely associated with the Galle district of Ceylon were caned easy chairs with carved rails and arms, the raked rear legs slightly lower than those in the front to give an incline, and a round-seated chair with six cabriole legs and a hemispherical splat back, based on the Dutch burgomaster form that continued to be popular

Fig. 14.20. Cabinet and stand, Vizagapatam, Andhra Pradesh, c. 1765. Rosewood, ivory, silver; 68½ x 40½ x 21⅝ in. (174 x 103 x 55 cm). Victoria and Albert Museum, London (IS.289&A-1951).

Fig. 14.21. Armchair, Murshidabad, c. 1790. Gilded and painted ivory, velvet silver-gilt threads; 35¼ x 27½ x 19¹¹⁄₁₆ in. (89.5 x 70 x 50 cm). Peabody Essex Museum, Salem, Mass. (TD98.14.5).

Fig. 14.22. Tilt-top table with specimen woods, Galle, Ceylon, c. 1820. Ebony, ivory and rare wood inlay; unfolded, 28¹⁵⁄₁₆ x 29½ x 29½ in. (73.5 x 75 x 75 cm). Courtesy of Simon Ray, London.

throughout the nineteenth century. So-called specimen tables—heavily carved ebony with pedestal bases and round tops inlaid with many varieties (specimens) of rare woods radiating outward from a central medallion—were another specialty of Galle. The swirling rosette top of an example from about 1820 repeats petals of six different woods, each delineated by delicate, arrowhead-pattern borders of ivory and contrasting wood (fig. 14.22). Hardwood workboxes with painted ivory inlay or an overlay of porcupine-quill bands around the exterior were also made in this area of Ceylon.

Many of the plainer chairs produced in India in the nineteenth century were notable for their technical ingenuity, a feature of many British designs. A typical item made for the resident Europeans was the "planter's chair," a low, caned hardwood chair with simple plank arms and an unfolding footrest. As British control of India increased, British civil servants, military officers, travelers, and hunters required new types of folding and portable furniture that they could take with them as they moved about the country.

Mid-nineteenth-century Indian seat furniture changed in style, mirroring changes in Western design from late Neoclassicism to revival styles, such as the Rococo Revival. Mainly associated with the west coast regions of Gujarat and Bombay, a new so-called Bombay black-wood style was characterized by voluptuous, exaggerated curvilinear forms and intricate, pierced carvings of writhing foliage. Such objects were only possible because of the large numbers of local expert woodcarvers. The Gujarat capital city of Ahmadabad was famous for its traditional half-timbered, stuccoed brick houses with carved woodwork called *havelis*.

Visiting Ahmadabad in 1879, American aesthete and interior decorator Lockwood de Forest met Muggenbhai Hutheesing, a wealthy Jain businessman keen to promote traditional handcrafts. Together they established the Ahmadabad Wood Carving Company, which employed local woodworkers to provide hand-carved items—including paneling, doorways, mantelpieces, and smaller items—for Associated Artists, the New York firm headed by de Forest, Louis Comfort Tiffany, and Candace Wheeler (fig. 14.23; and see fig. 18.49). Eastern exoticism in Western interior design was often achieved with rugs, textiles, furniture, and ceramics from India, the Ottoman Empire, and Iran, and the association between de Forest and Indian craftsmen lasted until the Aesthetic Movement fell from fashion in the mid-1890s.

A wide variety of small wooden boxes—from tea caddies to jewelry, writing, and game boxes—that were popular in eighteenth- and nineteenth-century India followed both regional and European stylistic developments. Wooden boxes with ivory veneers from late eighteenth-century Vizagapatam, for example, were decorated with scenes of fantastical architecture inspired by European prints and framed with foliate borders. Generally rectangular, some were octagonal, others sarcophagus shaped, still others in the form of little houses. Intricate geometric patterns in micromosaic, or *sadeli* work, in wood and ivory were typical of game boxes made in Calcutta and Gujarat, while at Hosiarpur, in the Punjab, ivory and copper inlay boxes as well as octagonal tables, mirror frames, and other items carved in *shisham* wood were

produced. Some of these had scrolling vines and foliage radiating out from a central medallion, derived from Mughal traditions. In the town of Nagina in north-central India, Muslim carvers made beautiful ebony boxes and other small objects with Mughal-style trellis and diaper patterns in foliate and geometric designs. Perhaps the most widely admired of all late nineteenth-century Indian boxes were those carved in sandalwood in the Mysore district of south India, depicting Hindu deities in architectural settings, usually niches, against a background of intricately carved flora and fauna. Examples were displayed in international exhibitions in London and Paris in the third quarter of the century, and they became popular in the twentieth century (see fig. 20.1).

HARD STONE AND IVORY

Although the tradition of hard-stone carving and *pietra dura* inlay had passed its zenith by the second half of the eighteenth century, objects of exceptional quality were still produced. The magnificent pale green jade mirror back illustrated here was made in Delhi in the early nineteenth century (fig. 14.24). Set with precious stones and perforated in a flowering tree design, it was inspired by the *jali* screens in the tomb chamber of the Taj Mahal (see fig. 8.1). While the bold original design was reinterpreted in a more intricate and ornate manner popular in the nineteenth century, the skill of the master

carver equaled that of his ancestors. Jade and other hard stones continued to be carved for sword and dagger hilts in Delhi and Rajasthan, sometimes equaling the quality of earlier work. While fine hard-stone objects from this period are rare, other decorative objects are relatively common, such as long-necked bottles and covered jars made of various soft stones, the carving of which required less time and skill than that of jade carving.

Pietra dura inlay into white Makrana marble, a craft that continues in Agra today, often referred to the decoration on the Taj Mahal and other monuments, but it had little of the power of the early work (see figs. 8.4, 8.5). Objects including round trays, boxes, vases, game boards, and tabletops were produced in floral designs—sometimes in Mughal taste and sometimes copying European motifs—for a souvenir market that had grown in significance during the first half of the nineteenth century. A wave of building in the second half of the nineteenth century kept the stone carvers of Rajasthan well employed, from princely palaces to civic institutions. Traditional Mughal-style *jali* screens were widely incorporated in contemporary architecture, as were solid carved floral panels. Carved benches and chairs with pierced *jali*-work backs in the shape of Mughal arches became a new addition to the woodcarvers' repertory, and similar Mughal-style work in red and beige sandstone was even more common.

The carving of small decorative and devotional objects in ivory was an important aspect of decorative arts production in many places in India, including Delhi, Mysore, Travancore, and Ceylon (all with long histories of ivory work). To augment local supplies, ivory was imported from Africa, as was fossil ivory from the ancient mammoths of Siberia, which had been protected for millennia by the frozen earth. Objects from Delhi were characterized by lacelike perforated tracery surrounding arcades containing animals or mythological fig-

Fig. 14.23. Wall bracket, Ahmadabad, Gujarat, c. 1880. Teak; H. 45⅝ in. (116 cm). Courtesy of Arthur Millner.

Fig. 14.24. Mirror back, Delhi, early 19th century. Jade, precious stones; 9⅜ x 8¼ in. (23.7 x 21 cm). Ashmolean Museum, University of Oxford (EAX.2327).

ures. Miniature portraits on ivory of living and historical figures were widely produced from the mid-nineteenth century onward by the last generation of Mughal painters: oval-shaped and grouped together in elaborately carved black wood frames, they were sold as luxury souvenirs.

South Indian ivory designs resembled contemporary carved sandalwood and both drew on earlier design traditions. Ivory caskets adorned with Hindu deities in rectangular panels bordered by deeply carved scrolling foliage, for example, were inspired by the stone bas-relief decoration on ancient temples, such as Halebid and Belur near Mysore, whereas three-dimensional religious figures such as Krishna, or vignettes with elephant, rider, and vegetation, were more European in style. Craftsmen at Etawa, near Kota in Rajasthan, were famous for inlaid objects combining horn and mother-of-pearl in delicate diaper-pattern marquetry (fig. 14.25).

GLASS, CERAMICS, AND LACQUERWARE

Little is known about glassmaking in India, but a small group of fine glass *huqqas*, bowls, and trays dating to the late seventeenth and eighteenth centuries have survived. All are decorated with painted Mughal-style flowers, but it is a matter of debate as to whether or not the glass was of Indian manufacture and, if so, where it was made. Colored glass rose-water sprinklers are frequently found, though, again, their date and place of origin are often matters of conjecture. Decorative glassware was produced commercially in India in the nineteenth century, but the products were mainly poor imitations of British wares.

Earthenware potters continued producing plain or simply painted unglazed pots for water and grain storage, to which they added clay figures, painted and dressed in fabric clothing to represent the various castes, trades, and occupations of India, which proved popular with Europeans. The production of glazed earthenware tiles also continued in regions such as Multan and Sindh in present-day Pakistan. From the thirteenth century, brick tombs and mosques, heavily influenced by the traditions of Central Asia and Persia, had been adorned with tiles with geometric and floral designs in cobalt

blue and turquoise on a white ground, with occasional touches of green, yellow, and brown. When British administrators established schools of art and design in India, they encouraged potters not only to work in this traditional manner but also to produce new forms such as vases and trays inspired by modern European and ancient Greek models. After fabrication these objects would be given to others, many of whom had been tilemakers, for decorating, painting, and glazing. The Sir Jamsetjee Jeejebhoy School of Art in Bombay, founded in 1857, named after a Parsi benefactor but run by British educators, brought in potters from the town of Hala in Sindh and became known for pottery inspired by the ancient Buddhist paintings at Ajanta. A plethora of local styles emerged during the second half of the nineteenth century. Multan blue-and-white wares were particularly popular and imitated by potters in Jaipur, while Sindh pottery was made in two or three coordinated colors, such as a pale yellow ground with brownish decoration.

Lacquerware was another traditional craft adapted for new markets during the nineteenth century. In India, lac refers to the secretions of many varieties of insects that colonize host trees and cover their branches with the resinous substance. The branches are harvested, and the resin is processed, mixed with color, and formed into sticks. Bengal was the main center of Indian lac production, and craftsmen in nearly every village produced simple wooden toys, boxes, and bed legs using it. As the artisan turned a wooden object on a lathe, he pressed a stick of lac against it and the resulting friction caused the color to adhere. Multiple layers of different colored lacs were applied, and the surface was etched or carved to reveal the underlying colors. Tinfoil, mica, or ground glass were often incorporated to achieve glittering surfaces. Round, domed lac boxes from Sindh decorated with friezes of hunting scenes, animals in procession, and scrolling-vine patterns were especially prized.

The area of Kurnool in the Deccan was famous for painted gesso products. Made of resin, glue, and ground clay, gesso was applied to a prepared wooden object and the design worked in relief. The object was then painted white and covered in tin foil, which was in turn painted, heavily gilded, and varnished in rich reds and greens. Boxes, trays, toys, and lacquered images were the most common items, but wooden panels for furniture and interiors were also decorated in gesso. A typical panel had scrolling-vine borders enclosing floral designs radiating outward from a central point; relief work was lavishly gilded and set against white, green, or red backgrounds. Yet another gesso technique—one that was lacquered—was used to decorate hides, such as a rhinoceros-hide shield from the second half of the eighteenth century made in the Tonk area of Rajasthan (fig. 14.26).

Lacquer was also applied to papier-mâché products, made with a mixture of rags, paper, straw, and various binding agents poured into a mold. Among the most prized examples were those from Kashmir. Highly malleable, papier-mâché made possible the creation of vases, trays, and other objects in unusual, sinuous forms. Eighteenth-century Kashmir lacquered papier-mâché pen cases featured floral decoration in the Persian style, but nineteenth-century designs related

closely to those of Kashmir shawls and incorporated *botehs*. Like shawls, Kashmir lacquerwork was, in part, oriented toward European export, and for greater cost efficiency, less labor-intensive lightweight woods gradually replaced papier-mâché in the late nineteenth century. The distinctive shapes disappeared, and the quality of the painted decoration declined as production sped up.

ART AND DESIGN SCHOOLS

The British colonial administration established and funded schools of art and design in India, including Madras (1853, formerly a private institution), Bombay (1857), Calcutta (1864), and Lahore (1872). Patronizingly, these schools sought to improve the taste of the "native people" in relation to the beauty and form of everyday objects and to bring decorative arts production more in line with the types of goods favored by Europeans. Ironically, at the same time, leading British design reformers were greatly applauding Indian craft and design traditions and the high quality of the Indian handwork. Although their mission included preserving Indian crafts, the schools were based on British examples and located outside the main centers of crafts production where high levels of hand skills and design traditions were learned from an early age. In the British schools, by contrast, Indian students were forced to learn about Western ideals of beauty and to draw from casts of ancient Greek and Roman sculpture. Much of the work produced within these institutions, however, lacked the assurance and vigor seen elsewhere in

India. British art and design educator John Lockwood Kipling (1837–1911), father of writer Rudyard Kipling, was an instructor in architectural sculpture at the Bombay School (1865–75) and principal of the school in Lahore (1875–93); he commented that his best students were those who came direct from their villages and had never been near a British art school. Kipling, however, was something of an exception among British art school educators in India.

Indian handcrafts grew in popularity in Europe after the Great Exhibition of 1851 in London, where they were championed by British design reformers such as Owen Jones (see fig. 17.34). Even though they differed in some respects, other well-known British figures in the second half of the century drew attention to the beauty of Indian decorative arts objects and their highly-skilled makers: notably George Birdwood (see above), art critic John Ruskin, and designer William Morris, among others. Ruskin viewed Hindu visual arts with a cultural imperialist's eye. Accepting the conventional European cultural binaries of "high" and "low" and "fine" and "decorative" arts, he praised the decorative arts of India but did not consider the fine arts of the subcontinent to be in any way equal to those of the West. Birdwood, a champion of Indian decorative arts whose book, *The Industrial Arts of India* (1880), marked the transfer of Indian decorative arts from the old East India Company to the South Kensington Museum in London (present-day Victoria and Albert Museum), came to a similar conclusion. By contrast, Morris, a leading figure of the British Arts and Crafts Movement who helped raise the status of the decorative arts in Europe, saw British imperialism, greed, and narrow self-interest as responsible for both the underrecognition of and lack of support for India's famous historical crafts. To Morris, Indian decorative arts were the arts of India and should be recognized as such.

The period 1750 to 1900 saw a great deal of eclecticism in Indian design. Europeans introduced new furniture types, and the cultural preference for metal over ceramics continued, as did that for gold and silver. The Indian elite classes lived increasingly Westernized lifestyles, especially after the British consolidation of power in 1857, embracing Western-style civic and domestic architecture, furniture, and decorative arts. The mass of the population, by contrast, continued to wear traditional clothing and jewelry designed and made according to long-standing traditions and lived in dwellings decorated with textiles and objects only subtly different from those of previous centuries. This gradual pace of change in the decorative arts would continue into the twentieth century, amid the struggles for independence, the eventual end of British rule in 1947, and the partition of the subcontinent into the republics of India, Pakistan, Sri Lanka, and Bangladesh.

JOHN ROBERT ALDERMAN

Fig. 14.26. Shield, Tonk, Rajasthan, 1750–1800. Gessoed and lacquered rhinoceros hide; Diam. 22 in. (56 cm). Courtesy of Simon Ray, London.

THE ISLAMIC WORLD

Fig. 15.8

During the period 1750–1900, a sustained and more comprehensive contact with European ideas and culture affected many aspects of the arts, sciences, education, commerce, technology, and politics of the Islamic world. There was often an uneasy balance between long-standing values and design traditions and a certain attraction to, yet hesitation about, Western ideas and technologies. Changes in domestic production, together with cheap imports from Europe, spelled the end of some design and craft traditions, altered others, and created new ones. Patronage was transformed by the increasing consumption of the rising middle class—the urban bourgeoisie—both at home and in Europe, and by the end of the period, the notion of a traditional imperial style and the ruler as primary patron was over.

The major power bases were the Ottoman Empire (1281–1924) and the Qajar dynasty in Iran (1779–1925). For the Ottomans, the period has been categorized as one of decline, an ailing empire eroding under the financial control of European powers. That, however, is but one aspect of a wider picture. In Iran, it has been called the long Qajar century, bookmarked at either end by strong, long-reigning monarchs, Fath 'Ali Shah (r. 1797–1834) and Nasir al-Din Shah (r. 1848–96). Like the Ottomans, the Qajars suffered territorial losses, but they were better able to resist foreign armies (British and Russian), while European influences were tempered by centuries-long traditions of statesmanship. Both empires continued to have a rich, if fast-changing, visual and material culture.

OTTOMAN EMPIRE

After the relative economic prosperity and peace following the conclusion of the wars with the Habsburgs and Venetians in 1718, the last half of the eighteenth century was a particularly tumultuous time for the Ottomans. The Russo-Turkish War of 1768–74 ended in defeat for the Turks and the signing of the Treaty of Küçük Kaynarca. Thereafter, waves of immigrants, especially Tatars fleeing the Crimea, entered Istanbul, exacerbating the economic depression. Military reforms were begun under Selim III (r. 1789–1807), whose efforts were met with resistance by religious leaders as well as the Sultan's own guard, the elite Janissary corps. Under his successor, Mahmud II (r. 1808–39), came the more wide-sweeping Tanzimat (Reorganization) reforms (1839–76), which sought to protect the shrinking empire against local nationalist movements and the ambitions of foreign powers. Many areas underwent modernization, including the military, education, agriculture, industry, legislation, and dress. Citizens' rights were expanded and land reform introduced.

A strong patron of the arts, Mahmud II promoted Europeanized styles of art and architecture, particularly the Neoclassicism of Napoléon's Empire design idiom, which strongly influenced the Ottoman style known as "Ampir" by local elites. Elements of the Baroque, Rococo, and Empire styles were never simply copied, but rather interpreted in uniquely Ottoman ways. France, which during the Napoleonic Wars embarked on a military expedition into Egypt (1798–1801), was considered by the Ottomans as the most modern European country. Mahmud II commissioned oil paintings of himself for display in public places and miniature European-style portrait medallions of himself to use as gifts and that also appeared on coins. He sent military-school graduates to Paris to study painting and topographic and technical drawing. Sultan Abdülaziz (r. 1861–76), an amateur painter, not only continued to send artists to Paris but also established a French-style high-school and university system and the precursor to the Imperial School of Fine Arts (Sanayi-i Nefise Mekteb-i Alisi). The latter was founded in 1883 by Osman Hamdi (1842–1910), a Turkish painter who had studied in Paris under Gustave Boulanger and Jean-Léon Gérôme. In 1881, Hamdi became the director of the Archaeological Museum and helped to develop laws against the trafficking of antiquities.

OTTOMAN METALWORK

Metalwork, particularly that made in silver, copper, and brass, continued to be a central feature of Ottoman material culture, but the shapes, decoration, and styles changed significantly, reflecting European Baroque and Rococo influence. Born was the so-called Turkish Rococo style, with its floral bouquets, ribbons, fruit, and garlands inspired by eighteenth-century European Rococo elements and the sixteenth-century classical Ottoman style of *saz* leaves (curved serrated leaves; see fig. 3.25) and floral motifs such as tulips, carnations, and composite palmettes. Silver domestic objects, including platters, and mirrors were created in this style. Matching sets of ewers and washbasins became a staple in many households (fig. 15.1). The example shown here was inscribed with a woman's name, the date, and the *tuğra* (official stylized royal signature) of Sultan Abdülmecid I (r. 1839–61). The ewer rested on the raised central portion of the basin when not in use; during use, water was poured from the ewer and drained through the decorative openwork of the basin; soap was placed on the center of the basin.

Some silver objects were made in France but decorated in the Ottoman Empire, such as a silver tray (now in the Topkapı Sarayı Müzesi, Istanbul), used for arranging and presenting flowers, with a pear-shaped medallion containing the name of Sultan Abdülaziz's mother, Pertevnihal Sultan, and the date

Fig 15.1. Ewer and basin, Turkey, 1840–41. Silver; ewer, H. 11⅜ in. (29 cm); basin, Diam. 12¾ in. (32.5 cm). Topkapı Sarayı Müzesi, Istanbul (16/866 and 16/865).

Fig 15.2. Dish with lid, France, 1874. Silver; Diam. 9½ in. (24 cm). Topkapı Sarayı Müzesi, Istanbul (16/638).

equivalent to 1863. Four years later, she visited France on an official visit with her son, and in 1869, she received Empress Eugénie of France in Istanbul. Another French silver object inscribed with Pertevnihal's name is a dish with a segmented lid in the same form as Ottoman *tombak* dishes, which suggests that it was designed for the Ottoman market (fig. 15.2). *Tombak*, a mercury-gilded copper and zinc alloy, gave the appearance of gold but was achieved through less-expensive means and was especially characteristic of this period.

Producing *tombak* required the application of a mercury (one part) and gold (six parts) amalgam to a copper object that had been cleaned and washed in acid. It was a complicated and dangerous process, whereby the mercury evaporated as the object was heated, posing a serious health hazard for the craftsmen. A wide variety of domestic objects were made in *tombak*, especially ones for dining or coffee drinking, ritual washing, and bathing. They included covered serving vessels, platters, coffeepots, cups, *sitils* (suspended basins for coffee services), sprinklers, and ewer-and-basin sets. Most of the objects were hammered by hand and their surfaces decorated by means of various hand techniques, including repoussé, engraving, openwork, and colorful enameling.

Ottoman meals were extended affairs with as many as thirty to forty dishes eaten communally, although the sultan traditionally ate alone. The many serving dishes required is attested to by the large corpus of surviving examples (fig. 15.3). Depictions of meals in eighteenth-century Ottoman miniature paintings in the *Surnameh-i hümayun* (Book of

Festivals) made for Sultan Murad III (r. 1574–95) by the court poet Vehbi offer further evidence, as does an eighteenth-century French diplomatic gift of a table for twelve with an added centerpiece to fit up to forty dishes. The diner generally brought a personal spoon to the meal, one often opulently adorned with mother-of-pearl, diamond, turquoise, and coral details.

Gold, silver, or *tombak* coffee sets marked another important ritual in Ottoman life (fig. 15.4). Brought to the Ottoman Empire from the Yemen, coffee was a popular drink by the sixteenth century and was making its way around the Muslim world and beyond. In Ottoman lands, the coffee ritual was performed with an elaborate service of metalwork coffeepots, cupholders, platters, and accompanying textiles, with the coffee poured into a small ceramic cup (*finjan*) fitted in a metal cup holder (*zarf*).

OTTOMAN TEXTILES AND COSTUME

Textiles remained important, but there were major changes in production during this period. The era of sumptuous handwoven Ottoman silk cloths in complex pattern-weaving techniques was over, apart from some *çatma* fabrics produced in the eighteenth century in Selimiye and Üsküdar. (*Çatma* was voided velvet—that is, with the design in relief—and with silver- and/or silver-gilt-wrapped threads.) From the mid-nineteenth century, imperial palace furnishings were produced at a silk manufactory in Hereke (26 miles southeast of Istanbul), which in the last decade of the century turned to carpet production (see "Ottoman Carpets" below).

Several factors led to the decline of the Ottoman textile industry, notably European industrial production, European exports, and the French invention of the Jacquard loom, which allowed complicated patterns to be produced nearly automatically, by means of a system of cards punched with holes according to the desired pattern; the punch cards guided the positioning of the warps to create the design. High taxes on locally produced Turkish textiles, combined with favorable foreign import taxes such as those agreed upon at the Anglo-Turkish Commercial Convention of 1838, led to a market flooded with European mass-produced textiles. Examples created specifically for the Turkish market included some dress and furnishing fabrics from Lyons, France. Dress reforms instituted by the government, which involved European-

style clothing, and a vogue among the Ottoman royal and upper-class for European fashions and fabrics—usually French silks and Indian chintzes—nearly sealed the fate of the Ottoman textile industry in the second half of the nineteenth century. Rather late in the day, the government tried to revive the local industry by encouraging the introduction of foreign looms and the Western-trained labor to operate them, as well as to stem the tide of imported fabrics with high import levies. But it was too little too late.

The sultans used dress as a political symbol of change and a tool of modernization. When Selim III introduced changes in military dress starting in 1792 as part of his modernization reforms, the Janissary corps mutinied, and it was not until the guard was disbanded under Mahmud II in 1826 that European-style uniforms were adopted in the military. Addressing a broader segment of Ottoman society, the sultan's 1829 law on clothing regulations dictated that all men should wear dark frock coats, trousers, and shoes based on European-style garments, along with fez hats, which became the official headgear for the modernized military and set the style for the populace at large. Thus the sultan simultaneously modernized and homogenized Ottoman dress, eliminating centuries-old traditions of clothing distinctions that had separated classes, professions, and religious communities (except for the religious class known as the *ulema*, scholars of Islamic law, who were allowed to retain their special dress).

The adoption of European-style dress for women was less abrupt, but imported European fabrics began replacing locally produced ones in traditional-style clothing—trousers, dresses, tunics, and shawls—from the later eighteenth century. During the nineteenth century, European jackets and accessories such as gloves and stockings were added, and by the end of the century most fashionable Ottoman women living in large towns or cities wore clothing influenced by European styles. Sultan Abdülaziz's official visit to western Europe, where he attended the 1867 Exposition universelle in Paris, and Empress Eugénie's visit to Istanbul in 1869 helped popularize the vogue for European—especially French—fashions. Silk fabrics with French-style broad stripes of small floral sprays in pastel colors were worn by elite women, while the lower urban classes wore darker colored, less-expensive fabrics.

Embroidered textiles for daily and ceremonial use in domestic life also reflected the new interest in things European, especially floral patterns. A large corpus of Ottoman embroidered textiles from this period remains, everyday items such as clothing, decorative hangings, napkins, towels, and gift wrappings. Made by women at home, these textiles attested to their artistic and handcraft skills and were an important part of wedding trousseaus. Embroidered textiles were also used to celebrate personal events—births, circumcisions, and weddings—as in the embroidered towel illustrated (fig. 15.5). The groom's ceremonial haircut and shave were an integral part of prewedding festivities attended by his male relatives and friends and accompanied by music. The style of the embroidered floral motifs, garlands, and elaborate floral bouquet on the barber's towel typifies so-called Turkish Rococo design. There was a trend away from traditionally bright colors toward subtler, pastel colors dur-

Fig 15.3. *Tombak* bowls, Turkey, 18th–19th century. Gilt copper; each, 5¹¹⁄₁₆ x 6¾ x 6¾ in. (14.5 x 17 x 17 cm). Topkapı Sarayı Müzesi, Istanbul (25/3774).

Fig 15.4. *Tombak* coffeepot, Turkey, 18th–early 19th century. Gilt copper; H. 6¾ in. (17 cm). Topkapı Sarayı Müzesi, Istanbul (25/3839).

Fig 15.5. Barber's towel, Turkey, 19th century. Embroidered cotton, silk and silver-gilt–wrapped threads; 21¼ x 40⅜ in. (54 x 102.5 cm). The Textile Museum, Washington, DC (1985.48.1B).

One of the most popular forms was the Ghiordes carpet, woven first in and around the village of that name in western Anatolia and then in a number of different centers—some in Iran—capitalizing on the cachet of the Ghiordes name (fig. 15.6). The format of Ghiordes carpets was traditional: small, rectangular prayer rugs with a arched niche at one end of the main field. They became popular abroad in the second half of the nineteenth century, used as area rugs in interiors in Europe and North America. Pale colors (not favored in the East for rugs) were achieved through harsh chemical washes, and the pile was artificially worn down with pumice; the rugs were thus made to look "antique" and therefore more attractive to many Western consumers.

At the opposite end of the color spectrum were Ladik carpets with their vivid reds, blues, yellows, and greens produced in central Anatolia since the eighteenth century. Patterns consisted of geometrical motifs typical of nomadic and village rugs, along with angular adaptations of the classical sixteenth-century Ottoman format of triple-arch prayer rugs. By the end of the nineteenth century and the early twentieth, however, at Ladik and other more traditional centers, natural dyes began to be supplemented by the less-expensive synthetic dyes. Carpet production continued, but on a more commercial scale in response to increased demand from European and North American markets. It has been calculated that carpets exported from the Aegean port of Izmir, the usual shipping point, doubled three times between about 1850 and 1914.

Nomadic pile and flat-woven carpet design and production in Anatolia, as in Iran, however, remained largely unaffected by changes brought about by Western practices (except for the occasional use of a synthetic dyestuff after the 1870s), largely because of the autonomy and relatively unchanging nature of nomadic culture. Carpets remained functional and practical for their weaver-owners, and designs continued to be handed down for generations.

The most luxurious carpets were those made for imperial use and diplomatic gifts in the Hereke Imperial Manufactory, established in 1843 by Sultan Abdülmecid I to create the extra large carpets and textile furnishings for the European-influenced Dolmabahçe Palace (1843–56), built at the edge of the Bosphorus in Istanbul. Made of silk with wool and cotton, the finely knotted and labor-intensive carpets were often enhanced by silver- and/or silver-gilt-wrapped threads. The most lavish example of Hereke production was the 400-square-meter carpet created for the vast reception room of the Chalet Pavilion (Şale Kiosk) of Yıldız Palace. Sultan Abdülhamid II (r. 1876–1909) also furnished the pavilion with chandeliers of Bohemian crystal, marble from Italy, gold cutlery, a crystal service, and electricity in advance of the October 1898 visit to Istanbul by the German kaiser, Wilhelm II (r. 1888–1918), and his wife, Princess Augusta Viktoria of Schleswig-Holstein. The visit was primarily motivated by the kaiser's desire to construct a railway to run from Berlin to the Persian Gulf and beyond, through Iran to British India, in order to carry German exports, troops, and artillery.

Fig 15.6. Carpet, Ghiordes, Anatolia, 1840–1920. Wool, cotton; 74 x 51 in. (188 x 129.5 cm). Victoria and Albert Museum, London (T.83-1957).

ing the nineteenth century. As many as fifteen colors were used in one embroidery to create shading and suggest naturalism, and silver- and/or silver-gilt-wrapped threads, which in earlier periods were used only in the most precious textiles, became more widespread as more people were able to afford such embroideries.

OTTOMAN CARPETS

Carpet weaving continued across Anatolia (in present-day Turkey) and beyond, and during the nineteenth century, nearly all types of carpet weaving were affected in some way by European designs. Village or cottage-industry carpet production using traditional patterns and colors continued in the region, as in Iran, in centers associated with specific carpet types such as Ushak (see fig. 3.21), Ghiordes, and Ladik. Weavers also were asked by Turkish and European merchants to make carpets for export in patterns and colors geared to European and North American tastes.

OTTOMAN GLASS

The Ottomans imported considerable amounts of European glass, although they had a tradition of glassmaking. Lamp makers and mirror makers are mentioned in documents dating from the sixteenth century, and glassblowers are shown demonstrating their craft in the miniature paintings depicting the parade of the guilds in the *Surnameh-i hümayun*. The Venetian and Bohemian glass found in excavations of the Saraçhane Palace and in the Topkapı Palace, both in Istanbul, are of better quality than the local Ottoman creations, but the situation changed in the late eighteenth century when Selim III founded a glassmaking factory at Beykoz on the Asian side of the Bosphorus (but not far from Istanbul), the products of which rivaled European imports. It was headed by the Mevlevi dervish and celebrated glassmaker Mehmed Dede, who had been sent to Murano (outside Venice) to learn the craft. The name "Beykoz" is still used to refer to nineteenth-century Ottoman glass in general, although other glassmaking centers were established, including a factory at Incirköy in 1846–47 that became known for its *çeşm-i bülbül*, or "eye of the nightingale," technique. The latter was based on the Venetian technique of *vetro a fili*—the embedding of clear glass with opaque white or translucent colored threads in a spiral pattern. Cut and gilded glass and opalines also were produced to compete with the European versions.

Once Ottoman glass found its stride, finer quality objects were produced. Nineteenth-century items reveal a mix of European influences, including Baroque-style shapes and Venetian and Bohemian techniques, yet they were uniquely Ottoman objects. A striking blue-and-white lidded pitcher demonstrates the complex interaction between European-influenced shapes and the *çeşm-i bülbül* technique (fig. 15.7). Candy dishes and bowls were also made in this technique. Traditionally shaped long-necked bottles in opaque colored glass used as scent droppers were popular, such as two blue glass bottles adorned and reinforced by decorative gilt mounts (now in the Victoria and Albert Museum and the Khalili Collection respectively).

OTTOMAN CERAMICS

By 1750, the quality of Iznik ceramics had declined from the high point around the sixteenth century (see fig. 3.19). Ceramics and tile production had increased in other centers, however, particularly Kütahya, southeast of Istanbul. Ceramic vessels were small and included bowls, plates, jugs, censers, and ceramic "eggs," which hung on the suspension chains of oil lamps. Decorative motifs ranged from Christian subjects familiar to the Armenian population of Kütahya, including saints, angels, and the Virgin and Child, to more traditional floral motifs often sketchily painted in a lively palette of yellow, apple green, brown, blue, and turquoise. Kütahya production tapered off in the nineteenth century.

A provincial center at Çanakkale, on the Dardanelles, produced popular pottery recognizable by its distinctive shapes and palette. Everyday objects were transformed into whimsical anthropomorphic, zoomorphic, and other unusual shapes: animal-shaped jugs, candy dishes in the form of humans or animals, and gas lamps that looked like ships. Monochrome glazes in brown, yellow, purple, and green were sometimes enlivened by marbleized glazes. Simple decorative motifs such as cypress trees, rosettes, animals, and crescents were painted in red, yellow, blue, white, or black.

Modern European-style porcelain manufactories were established around Istanbul during the nineteenth century. In 1845, a factory was founded in Beykoz near Istanbul by Ahmet Fethi Pasha, marshal of the Imperial Arsenal and former ambassador to Moscow (1833), Vienna (1834–36), and Paris (1837–39), who was familiar with European manufacturing. Because it was stamped in blue, black, red, or green with the mark "Eser-i Istanbul" (Work of Istanbul), the porcelain has been known as Eser-i Istanbul ware. Production included tiles and a full range of everyday tableware, from plates to serving vessels. The influence of European royal porcelain can be seen in tableware featuring gilded floral patterns on a white ground or openwork plates in basket-weave patterns. Characteristic details were the flower-, fruit-, and vegetable-shaped knobs on the lids of dishes and pitchers. Production at Beykoz was short-lived due to financial mismanagement, but the endeavor illustrates yet another type of enterprise that looked to European models.

On the order of Sultan Abdülhamid II, an imperial Ottoman porcelain manufactory was constructed at the end of the nineteenth century in the gardens of Yildiz Palace, near

Fig 15.7. Pitcher with lid, Turkey, 19th century. Glass; H. 13 in. (33 cm). Sadberk Hanım Müzesi, Istanbul (9246-C.149).

Fig 15.8. Louis Léon Parvillée. Plate, Paris, c. 1884. Faience; Diam. 19⅛ in. (48.5 cm). Les Arts décoratifs–Musée des Arts décoratifs, Paris (445).

Istanbul, to serve the needs of the palace and officials and to provide diplomatic gifts. Production included large presentation plates, plaques, or vases painted with sweeping views of Istanbul and the Bosphorus as well as portraits of historical and contemporary sultans. Dinnerware with patterns based on European-style porcelains was created to suit Ottoman tastes. Colorful, gilded floral patterns and flower-, fruit-, and vegetable-shaped knobs on vessels recalled earlier production in the Beykoz factory. Yildiz Palace porcelain was easily distinguishable since it was stamped with a star and crescent motif and the last two digits of the year of production. Many pieces were also signed by their makers, and the reigning sultan's *tuğra* (official stylized royal signature) appeared on tea and coffee cups and saucers, to show that they were made for him. The factory closed after Sultan Abdülhamid II was deposed in 1909, only to reopen at the end of the twentieth century as a porcelain museum.

Just as the Ottomans looked west to European trends in porcelain production, Europeans cast their gaze eastward for new ideas. European designers, architects, and artists traveled to Turkey, Egypt, and Iran, bringing technical knowledge and seeking design inspiration. Well-known nineteenth-century European potters influenced by traditional Iznik ceramics included Joseph Théodore Deck (1823–1891) and Louis Léon Parvillée (1830–1885) of France and William de Morgan (1839–1917) of England. Parvillée was named architect for the imperial Ottoman commission to the 1867 Exposition Universelle in Paris; he encouraged the manufacture of *faïences*

orientales in France and exhibited his own ceramic objects and tile panels starting in 1867 (fig. 15.8).

Europeans were involved in multilayered artistic and economic trade relations, helping to revive the traditional designs, produce their own wares, and work on commissions to restore tiled buildings mainly in Istanbul and Cairo. Larger European companies manufactured traditional Islamic-style plates, vessels, and tiles, such as Minton & Company in England, Sèvres in France, Cantagalli in Italy, and Zsolnay in Hungary. The revival of traditional (late fifteenth–seventeenth-century) Islamic-style designs was limited to the late nineteenth and early twentieth centuries, when Art Nouveau-style tiles introduced by European companies became fashionable.

OTTOMAN ENAMEL WORK

Enamel work continued throughout the period and was used on watches, jewelry, and treasury items. The technique of enameling on metal, by which glass pastes colored by metal oxides were heat-fused to the surface of metal, and sometimes also of glass and ceramics, flourished in the seventeenth century in Iran, India, and the Ottoman Empire. The European techniques of champlevé (carving areas, but leaving raised outlines, filling the resulting cells with enamel to create a flush surface), painting, repoussé, and basse-taille (coating the surface with enamel and carving into it to create reliefs) were added to the repertory of enameling techniques. In the nineteenth century, the finest enamelwork in the Ottoman Empire were the small portrait medallions of Sultans Mahmud II and Abdülmecid I (fig. 15.9). Set in jeweled or ivory frames, they were awarded to local officials and foreign diplomats. As in the Qajar tradition in Iran (see below), the Ottoman tradition of enameling portrait medallions probably derived from eighteenth-century European examples. In the medallion brooch framed by diamonds illustrated here, Sultan Abdülmecid I is depicted in a Western-style military uniform of the type he instituted for the military. The signature at the sultan's left is that of Sebuh Manas (1816–1889), a member of an Armenian family of painters and diplomats, who, with his brother Rupen, had been sent by Sultan Mahmud II to Paris to study painting.

Fig 15.9. Sebuh Manas. Brooch: miniature portrait of Sultan Abdülmecid I, probably Istanbul, 1854-55. Enamels on metal, silver mount, diamonds; 1¾ x 1½ in. (4.5 x 3.7 cm). The Nasser D. Khalili Collection of Islamic Art (MSS 571).

THE QAJAR DYNASTY IN IRAN

In Iran, weak leadership and Afghan invasions from 1722 onward contributed to the demise of the Safavids. During the successor dynasty—the Afsharids (1736–96)—political instability was rife, with the exception of the reign of Nadir Shah (r. 1736–47), whose military campaigns included the sack of Delhi in 1739. The Zand period (1751–94) was one of relative political and economic stability, especially under its founder Karim Khan Zand (r. 1751–79). The new capital and cultural center at Shiraz (1765), with its palaces and mansions filled with life-size portraits and narrative paintings taken from literature and poetry, reflected a renewed interest in a wide range of artistic endeavors and laid the groundwork for the arts of the successor dynasty, the Qajars (1779–1925).

A period of peace and strong artistic patronage by two long-ruling leaders, Fath ʿAli Shah (r. 1797–1834) and his grandson, Nasir al-Din Shah (r. 1848–96), followed. Some of the most significant creative developments were in painting, from life-size and miniature work to painting on enamel and lacquerwork objects. Across many aspects of visual and material culture, images of these rulers became symbols of, and reinforced, monarchical power. Fath ʿAli Shah sought legitimacy in the centuries-old glorious past of ancient Persian kingship and adopted the title "King of Kings" in the manner of the rulers of ancient Persia. Court life was luxurious and court etiquette complex. Like all Qajar monarchs, Fath ʿAli Shah ruled with the support of Shiite religious leaders, who wielded great authority in judiciary matters and through religious endowments, educational institutions, and mosques.

Nasir al-Din Shah also cultivated his image as a monarch through aspects of visual and material culture, especially life-size paintings and public architecture. Instead of drawing inspiration from the past like his grandfather Fath ʿAli Shah, however, he sought to balance tradition and modernity and to maintain Iranian sovereignty while welcoming Western innovations. He made three European tours (1873, 1878, 1889) and promoted the use of Western technology to modernize the country's infrastructure, including the introduction of telegraph lines. Created in 1851, the Dar al-Funun, the first polytechnic and military academy in the country, produced a stream of surveyors, engineers, interpreters, artists, and musicians, at first for the army but later for society at large. Many of the best portrait painters were graduates. New Western techniques such as lithography and photography, a special interest of Nasir al-Din Shah, were also taught there.

QAJAR ENAMEL AND LAQUER

A careful balance of centuries-old but not static Persian traditions and European techniques, designs, and styles, as well as bolder colors, is reflected in all the decorative arts, including the meticulously painted enamels and lacquerwork that depicted historical and contemporary political themes. The art of enameling thrived under the later Safavids and the Qajars. Mughal and European (especially Russian) enamels arrived at the Persian court as diplomatic gifts during the seventeenth century and inspired native enamelers. Locally based European enamelers, jewelers, goldsmiths, and mer-

Fig 15.10. Muhammad Baqir. Miniature portrait of Fath ʿAli Shah, Iran, early 19th century. Enamels on gold; 2⁷⁄₁₆ x 1¾ in. (6.2 x 4.4 cm). The Nasser D. Khalili Collection of Islamic Art (JLY 1231).

chants also helped the industry to develop swiftly and successfully. The position of court enameler was created some time before the end of the seventeenth century, and by the 1730s a group of Persian enameled daggers was recorded as part of the Russian imperial collections (now in the State Hermitage Museum, St. Petersburg). Production increased, as did the quality and range of objects, including Koran boxes, other containers, arms and armor, mirrors, water pipe bases, cups, tableware, and headwear ornaments. In addition to extant examples, the enameled daggers, ornaments, and other objects in portraits of Qajar rulers help date and visually detail the design of contemporary enamel work. The most popular enamels were those that employed a distinctive palette of pink, turquoise, blue, and green set against a gold or opaque white ground.

Qajar enamels maintained a high level of craftsmanship. Some of the best examples at the court of Fath ʿAli Shah were the work of an enamel painter who has been identified as the lacquer-painter Muhammad Baqir. His miniature portrait of Fath ʿAli Shah, signed "the slave born in the household Baqir," shows the monarch as a handsome young man wearing official regalia including lavish jeweled armbands, epaulettes, and necklaces (fig. 15.10). The aigrette on the shah's astrakhan hat has been suggested to be a seventeenth-century Mughal turban pin looted from the Mughal treasury in Delhi by Nadir Shah in 1739. Although Baqir detailed Fath ʿAli Shah's long black beard, monobrow—which was a sign of beauty—and svelte figure, "The Sultan Fath ʿAli Shah Qajar" also appears in a teardrop-shaped cartouche on the left of the portrait, lest anyone be uncertain as to the man's identity. Fath ʿAli Shah distributed miniature portraits of himself to diplomats and Qajar officials in recognition of their services.

Among the finest of Qajar decorative arts was lacquerwork which included exquisite miniature paintings derived in part from the Safavid and earlier traditions of lacquerwork. Some of the most skilled painters signed their names to bookbindings, caskets, mirror cases, and other small objects. Islamic lacquer is different from Chinese lacquer.

Fig 15.11a–b. Lutf 'Ali Suratgar Shirazi. Lacquerwork mirror case (back and interior), Shiraz, 1845. Varnish over ink, opaque watercolor, metallic pigment, and gold on papier mâché, silvered glass, leather; 7½ x 6¼ in. (19.3 x 15.8 cm). Brooklyn Museum (36.940).

Fig 15.12. Muhammad Isma'il Isfahani. Lacquerwork casket: Siege of Herat, Isfahan, 1865. Varnish over watercolor, papier mâché, wood, and gold; 4⁹⁄₁₆ x 12¹¹⁄₁₆ x 10³⁄₈ in. (11.6 x 32.3 x 26.3 cm). Bernisches Historisches Museum, Bern (71/13).

In the Islamic world it referred to the application of a resin varnish to a painted surface of pasteboard or a papier-mâché surface covered with plaster or gesso. Bookbindings were covered by a varnish called *rawghan-i kaman*, or "bow gloss," according to literary references from the sixteenth to nineteenth centuries.

Starting in the second half of the seventeenth century, European-style subjects were incorporated into lacquer

Fig 15.13. Jacket, Iran, 1800–80. Silk, cotton, wool, silver-wrapped threads; 24¾ x 57⅛ in. (63 x 145 cm). Victoria and Albert Museum, London (954-1889).

painting in addition to the more traditional floral and vegetal representations found in book illumination. Imagery involving a rose and a nightingale (*gül-o-bülbül*) became popular during the Safavid period and ubiquitous during the Qajar. These elements each represented significant themes with a long history in Persian poetry, literature, and culture. The rose symbolized beauty, perfection, the beloved (worldly or spiritual), the prince, or the Prophet Muhammad, and the nightingale, the lover or the poet. Together, they represented earthly and spiritual love. It has been said that the nightingale's yearning for the rose was a metaphor for the soul's desire for union with God. Some objects combined both European and Qajar themes, like a mirror case signed by Lutf ʿAli Suratgar Shirazi (Persian, act. 1802–71), the front and back of which were painted with rose and nightingale imagery (fig. 15.11a). The naturalistic renderings of the rose in full bloom and nightingale on the mirror case were probably partially influenced by imported European herbals or Mughal interpretations of them. The use of specks of crushed metallic pigment in the background makes the composition seem to glow, further enhancing the painting.

The inside of the cover (fig. 15.11b) has a more eclectic composition: a landscape inhabited by an odd, scale-inconsistent group. Christian religious figures in Biblical-era dress form a triangular composition with a veiled Madonna figure at the top, above which figures in European costume form an inverted triangle, with a man in seventeenth-century English dress and, in a larger scale, by a young woman in contemporary nineteenth-century French- or English-style dress. While her clothing is based on European examples, she has large, almond-shaped eyes, prominent eyebrows (almost a monobrow), and long dark curls, symbols of Persian beauty.

Historical topics, including those of dynastic significance, were another characteristic of Qajar lacquerwork, as in a casket described as the most elaborate example of surviving Persian lacquerwork (fig. 15.12). It relates to the siege of Herat in 1833, which was meant to retrieve from the Afghans land that had been conceded in the eighteenth century. The casket's lid depicts a moment of victory—with Muhammad Shah (r. 1834–48; on horseback in the foreground) being presented with heads of Afghan soldiers in the midst of battle. Hundreds of miniscule soldiers in Western-influenced military outfits, as well as officials and military equipment, make up the tightly organized composition. The Afghan troops relied on elephants and swords. The scene represents the hallmark style of the shah's chief painter, Muhammad Ismaʿil Isfahani, who belonged to a dynasty of lacquer painters in Isfahan. Skilled lacquer painters also worked in Shiraz and Tehran, especially during the second half of the nineteenth century. On the interior, another painting shows Muhammad Shah wearing a European-style uniform, the first Qajar ruler to do so, but he sits on a Persian throne holding a Persian sword and belt in a conventional manner, as seen in some portraits of his uncle, Fath ʿAli Shah.

QAJAR TEXTILES

The many surviving textiles reflect the range of this genre as well as the important position it held in society and the economy. Silk, cotton, wool, and flax were available in Iran, and therefore domestic furnishings and clothing could be produced locally. Some of the major forms of Qajar textiles were compound silks, wool, and plain-weave cottons ornamented by printed, painted, and embroidered techniques. Early Qajar silks continued the floral patterns of the luxurious Safavid silks, sometimes complicating attribution, but Qajar examples, like the jacket illustrated here (fig. 15.13), on which the plants and birds are woven in silver-wrapped thread, featured a pattern of floral shrubs and confronted birds, and smaller repeats in rigidly organized rows, latticework, or stripes. During the nineteenth century, new characteristics developed, with many techniques and decorative motifs influenced by European examples. By the early twentieth century, Qajar textile production was dominated by European techniques and European-style motifs, and the urban elites often bought imported European fabrics.

Fig 15.14. *Kalamkari* hanging, Isfahan, c. 1850–1900. Wood-block–printed cotton, dye, paint; 65¾ x 41 in. (167 x 104 cm). The Textile Museum, Washington, DC(1980.8.5).

Qajar motifs included figures in Qajar dress and headgear (tall astrakhan hat), flowers in full bloom, and a *buta* (or *boteh*) motif, which has been referred to variously as a flowering shrub, pinecone, and the shah's aigrette. With its teardrop or pear shape, the *buta* is the most recognizable motif of the Qajar period, appearing on extant compound silks as well as wool twills from Kirman (usually in blue, green, yellow, and red) which were used for men's frock coats and long robes, and women's long skirts. The *buta* was seen on earlier Safavid and Mughal decorative arts, especially Mughal Kashmiri shawls, but the Qajar interpretation is easily recognizable by a stiff formality, at odds with the natural plant form from which it derived.

Plain-weave textiles decorated by a variety of techniques, including printing, painting, embroidery, and appliqué, comprised the greater part of Qajar textile production. Printed cotton *kalamkari* (Persian, *qalamkar*, or "pen-work") produced with hand-carved wooden blocks that were used to stamp resist and mordant in patterns appeared as early as the late seventeenth century in Isfahan, later in Tehran. Most of the extant pieces, however, date from the late nineteenth to early twentieth century, according to the dates and dedications that are hand-painted onto the fabrics, along with the name of the person who created the design. Cypress trees, peacocks, peonies, lotus, carnations, tigers, and floral stripes and bands were carved on individual pearwood blocks, which

could be combined to create a multitude of patterns. A single color, usually red, blue, or yellow, was used for each block. Some of the most interesting *kalamkaris* from this period are single-loom-width covers and wall hangings with a symmetrical pattern in a niche format (fig. 15.14). In the mid-nineteenth century, the laborious and costly manufacture of Persian printed cottons gave way to cheaper machine-printed cotton imports made in Manchester, England, expressly for Persian consumers.

Varying according to local styles and domestic traditions, the production of embroidered cottons, silks, and wool continued, but by the end of the nineteenth century, the influence of European designs had increased greatly in some instances. Tabriz, Yazd, and Rasht were the best-known centers of production for embroidery throughout the nineteenth century, with Rasht, a town south of the Caspian Sea, renowned for complex, tour-de-force wool and silk embroidery, appliqué, and patchwork. Most compositions featured flowers and birds, although one ambitious patchwork hanging (now in the Bern Historical Museum) depicts a portrait of Fath ʿAli Shah. Perhaps the most accomplished examples of Rasht woolen appliqué work were royal Qajar tents, panels, and banners—large-scale items so complex they were probably based on full-size cartoons or stencils.

Woolen Kirman shawl fabric was also very popular, especially given the Qajar rulers fondness for Kashmiri shawls which were made in narrow strips of about ten different, densely decorated patterns. Rather than wear the fabric as a shawl, Qajars preferred to use it for robes of honor, sashes, turban cloths, and garment linings, as depicted in Qajar court paintings. The colorful twill fabric could be produced more economically in local factories at Kirman, Mashhad, and Yazd, than Kashmiri imports. There was very little difference between the Kashmiri and early Amiri ("princely," as the Persian textiles were called) shawl fabrics in terms of pattern or colors, although Persian-produced fabrics seem to have had a deeper red (the main colors were red, black, blue, green, yellow) and the *buta* motif was more prominent. In the early nineteenth century, Fath ʿAli Shah required royals and the elite to use Persian-made shawls in order to support the local textile industry. To meet the demand, time- and cost-saving techniques, including embroidery, were introduced in Kirman. In many cases, the quality of craftsmanship was compromised, however, and elite consumers reverted to buying the better-quality Kashmiri shawls.

For the Qajar textile industry, much of the nineteenth century was a struggle against the cheaper, good-quality imports of textiles. England, Russia, and India, especially English and Indian cotton fabrics, all gained a foothold. The government tried to compete by establishing a silk-weaving mill in Kashan and calico-weaving and spinning mills in Tehran in the mid-nineteenth century, but the technical knowledge necessary to set up and run the mills had to be imported, thus raising costs. High costs and lack of effective government protection against imported goods doomed most of the domestic textile industry, and it was not until the early twentieth century that the industry recovered, with greater government protection and more favorable trading agreements.

QAJAR CARPETS

Carpets fared better, especially those made for export. Starting in the 1870s, carpet production was transformed from a cottage industry to a successful worldwide commercial enterprise, stimulated by local and foreign capital. Persian carpets were displayed at international expositions and found a place in European interior decorating schemes. Nasir al-Din Shah also promoted handmade carpets abroad. As a result, Persian carpets began to be exported in greater numbers to Europe and America. By the end of the nineteenth century, foreign firms such as Ziegler and Company of Manchester, which in the 1880s acquired the sixteenth-century "Ardabil" carpets (see fig. 3.9), and Hotz of London were involved in the organization, production, export, and marketing of Persian carpets. Foreign companies were involved in many aspects of the industry, from raising sheep to maintaining quality control of dyes (to avoid the use of cheap imported synthetic dyes in place of natural dyestuffs). They introduced more standardized carpet designs and established large-scale workshops and factories to supervise quality. This foreign intervention transformed the Persian carpet industry.

Carpets for export were usually designed with European tastes in mind. Floral vine-scroll and medallion patterns derived from Safavid carpets, the arts of the book, and architectural decoration were popular. Carpets were also sized for European and North American rooms or stairways. Weavers sometimes made small pattern samplers (*vagiras*) of main field and border motifs for inspection and approval by importers before producing a carpet. In 1876, Nasir al-Din Shah presented Queen Victoria with fourteen new Persian carpets from Kurdistan and Khorasan, which entered the South Kensington Museum (present-day Victoria and Albert Museum). The fourteen carpets have familiar floral and medallion designs, including the "Herati" pattern of stylized flowers and angular leaves on intersecting stems in Kurdistan carpets and the *buta* motif seen on Kirman shawls and copied in the carpets from Mashhad and other cities in Khorasan. Pictorial carpets reproducing imagery from Western paintings, books, newspapers, and photographs were made in the later nineteenth century. For example, an early twentieth-century Persian carpet now in the Victoria and Albert Museum depicts the painting *Fêtes Vénétiennes* (1718–19) by the French artist Jean-Antoine Watteau. Dated the equivalent of 1909, this rather stiff interpretation was woven in Kirman. According to an inscription, it was commissioned by Abdul Husain Mirza, governor of Kirman Province, from the workshop of Ustad ʿAli-yi Kirman. Carpets popular among Qajar princes and officials featured scenes from classical Persian poetry and literature, such as the *Shahnama* (Book of Kings, by Ferdowsi, c. 935–c. 1020/26) or the *Khamseh* (Quintet, or Five Tales, by Nizami, c. 1141–1203/17), perhaps in a wishful attempt to evoke the glory of Persia's ancient kings.

Most of the carpets made in Iran for export continued to be woven as they had been for centuries. Although Ziegler and Company established factories around Arak, southeast of the carpet-weaving area of Hamadan, it also relied on existing local village and town-based weavers working at home. In the nineteenth century, northwest Iran produced large wool car-

pets with geometrical designs of the Heriz type. Fine silk carpets with European- or Turkish-style designs came from Tabriz, and Kurdistan produced a technically diverse range of carpets. In the late nineteenth century, Kashan was well known in Europe for its traditional floral and medallion carpets of soft wool and sometimes silk; Kirman for its finely woven, long-lasting carpets based on the Kirman shawl textile patterns, as well as for more traditional models of Safavid floral medallion carpets and European prototypes. Nomadic carpet production continued to flourish across Iran and was largely untouched by Western tastes or the design trends seen in carpets produced for export. These carpets were usually smaller, with geometric designs based on lower-density knot count resulting in a looser weave. Pile weavings included Qashqai tribal carpets with stylized floral motifs and occasional tiny stick figures of animals, birds, and humans, and the colorful, compartment-patterned carpets of the Bakhtiari villagers of southwest Iran. Flat weaves in various techniques were also made by the Qashqai and Bakhtiari nomads.

QAJAR GLASSMAKING

The glassmaking tradition in Iran stretches back to pre-Islamic times. Notable examples were created during the Sasanian Empire (224–651) and the early Islamic period, but production was nearly dormant from the end of the medieval Islamic period until the seventeenth century, when there was a revival under the Safavids and, later, under the Qajars, centered around Isfahan and Shiraz. Most of the surviving glass from the 1750–1900 period is from the nineteenth century and was made in Isfahan, Tehran, and Shiraz. Examples include decanters, long-necked ewers, water-pipe bases, rosewater sprinklers, and other objects in elegant shapes, some in transparent and colored glass in striking hues of green, yellow, and blue (fig. 15.15).

Long-necked bottles, sometimes called *ashkdan*s, were supposedly used as containers for the tears of wives whose husbands were away. The hand-blown molded pattern of twisted ribs is consistent with the simple decoration seen on other examples of Qajar glass and shows Venetian influence. European glass, especially from Venice, had a profound impact on glassmaking traditions in the Islamic world, especially in Iran, India, and the Ottoman lands from the sixteenth century onward. Qajar long-necked bottles, in turn, served as a source of inspiration for many Americans and Europeans, some of whom collected them. Louis Comfort Tiffany, for example, was inspired to make his own versions of the long-necked bottles apparently after seeing examples in the collections of the Victoria and Albert Museum.

Fig 15.15. Bottle (*ashkdan*), Iran, 19th century. Mold-blown glass; H. 15 in. (38.1 cm). The Metropolitan Museum of Art (17.190.829).

Fig 15.16. Reverse-glass painting (*shamayil*), Iran, early 19th century. Glass, watercolor, painted frame; 46½ x 29⅛ in. (118 x 74 cm). The Nasser D. Khalili Collection of Islamic Art (MSS 1093).

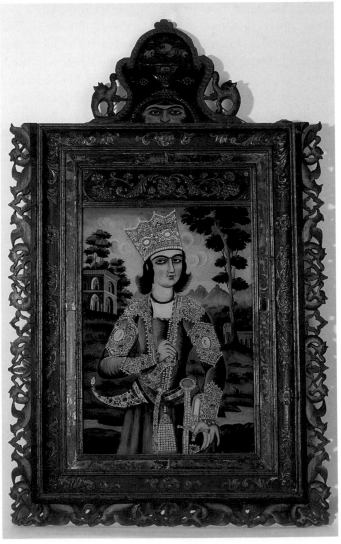

Reverse-glass painting (*verre églomisé*), the technique of painting a picture behind glass, thrived under the Qajars, starting with the court of Fath 'Ali Shah. Paintings in opaque watercolors on the reverse ("back") of a sheet of glass were visible through the transparent glass. Although this ancient technique bears the name of Jean-Baptiste Glomy (framer to kings Louis XV and Louis XVI), who revived the art in the eighteenth century, it probably came to Iran via Bohemian glass and mirror exports. It was a very exacting technique and surviving signed pieces indicate that some of the best-known Qajar court artists, including Mirza Baba and Mihr 'Ali, worked in this medium, creating images of the shah and his sons. A reverse-glass painting of a princely young man in elaborate dress and jewels set against a landscape demonstrates the high quality of early Qajar reverse-glass painting (fig. 15.16). This is one of a pair of paintings, the other depicting a woman probably from a princely cycle. The high level of detail continues in the frame carved with birds and dragon heads and painted with a female sun and a floral bouquet. Reverse-glass painting was practiced on several levels, and themes from popular folklore were depicted in simpler examples and other media, including lithographs, tilework panels, and the type of large-scale oil paintings found in coffeehouses, where they were used as props by itinerant storytellers.

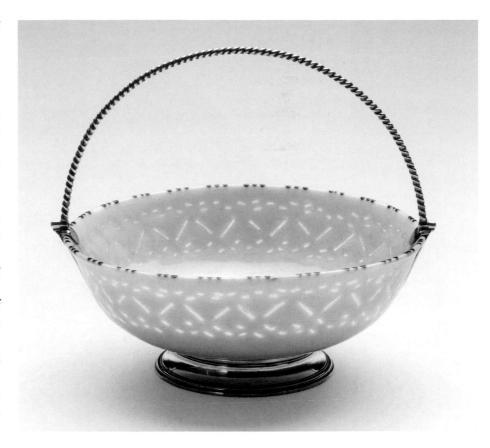

QAJAR CERAMICS

The period 1750–1900 was not a highpoint for Persian ceramics. Faced with better-quality and often cheaper Chinese and European imports, craftsmen struggled to survive. One of the more interesting examples was the Persian interpretation of the English chinoiserie-style willow pattern, itself an interpretation of Chinese ceramics. The blue willow pattern was one of the most popular mass-market motifs produced by English potters in the late eighteenth and nineteenth centuries. It answered the demand for extensive, single-pattern dinner services in keeping with the continued taste for chinoiserie. (Chinese potters in turn copied the English version of the willow pattern and exported pieces to Europe.) Qajar potters also tried to emulate Chinese *famille rose* porcelain, which was made in China mostly for export to Europe (see fig. 7.13), but the simple and often loosely executed patterns of butterflies, flowers, and Chinese-style figures in pagodas painted in pink, blue, green, yellow, and black enamels on earthenware had little to do with Chinese prototypes.

Other types of Chinese porcelain also inspired Persian potters. The most notable pieces created were the white so-called Gombroon wares, named after the city of Gombroon (modern-day Bandar Abbas, on the Strait of Hormuz), the site of a Dutch East India Company trading station and the shipping point to Europe for great quantities of Persian ceramics. Gombroon wares were characteristically white, thinly potted, and sparsely decorated in black with small floral or geometric motifs balanced by tiny black dots on the vessel's rim. The vessels were usually small dishes or bowls that could be easily held in one hand for eating or drinking, sometimes with a convex boss (raised element) in the center.

A centuries old form, these may more recently have derived from Western metalwork types. Patterns of small, pierced holes filled with transparent glaze on the walls of the vessels reflected a desired quality of translucency, as had Persian ceramics since the twelfth century that sought to capture the translucency of Chinese porcelain. This technique may have inspired the Chinese rice-pattern porcelain of the eighteenth and nineteenth centuries, further evidence of continuing cross-cultural exchange between Persia and China. The earliest dated Persian examples are from the eighteenth century when Gombroon wares were shipped to Europe, and such pieces are included in the 1779 inventory of the Dresden Porcelain Collection. In some cases silver or silver-gilt mounts were added to examples of Gombroon ware, as seen on a dish (c. 1600–1800) fitted with English silver-gilt mounts in 1817 (fig. 15.17). When the dish arrived in England is unclear. It may have been brought in the early nineteenth century by a diplomatic delegation during the Napoleonic Wars or exported to England earlier but not fitted with silver mounts until 1817.

The best-known and perhaps most talented Qajar-era potter and tilemaker was 'Ali Muhammad Isfahani (act. 1870s–88). In the tabletop commissioned in the 1880s by the director of the Persian Telegraph Department, Sir Rupert Murdoch Smith (1835–1900), Isfahani worked a central roundel framed by eight tiles, each portraying a scene from the *Shahnama* (Book of Kings), the Iranian national epic (fig. 15.18). Murdoch Smith, who had a deep interest in Persian cultural heritage, was an acquiring agent for the South Kensington Museum in the 1870s and 1880s. He commissioned and bought a wide range of contemporary objects, including pottery, textiles, and carpets, as examples of good "industrial design," meaning design for manufactured goods, be it by hand or machine.

Fig 15.17. Gombroon ware dish, Iran, 1600–1800, English mount, 1817. Fritware, silver gilt; 4⅜ x 4¾ x 4¾ in. (11.1 x 12.1 x 12.1 cm). Asian Art Museum, San Francisco (B60P2300).

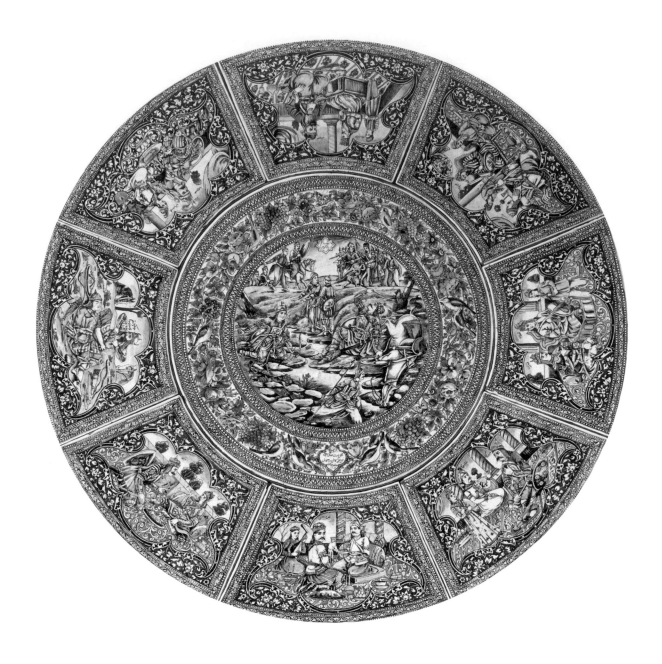

Fig 15.18. 'Ali
Muhammad Isfahani.
Tabletop, Tehran,
1887–88. Fritware;
Diam. 53½ in. (136 cm).
Victoria and Albert
Museum, London
(559-1888).

EGYPT AND NORTH AFRICA

The Ottoman Empire extended its power in North Africa
when it defeated the Mamluk dynasty in Egypt in 1517. By the
seventeenth century, however, the Ottoman governors had
little authority, and developing European colonial and com-
mercial interests further upset the balance of power in the
region. Decorative arts traditions incorporating North African
and Ottoman influences across North Africa survived, how-
ever, many adapting, in varying degrees, to new stylistic and
manufacturing influences from Europe.

After the Napoleonic Wars and French occupation (1798–
1801), Egypt was ruled by the autonomous Ottoman governor
Muhammad 'Ali (r. 1805–48), who created his own dynasty
and set in motion new agendas, many influenced by Western
ideas and practices. Students were sent to Europe to study
painting, sculpture, and engraving, and returned to teach in
new technical craft schools. In 1868 the School of Applied
Arts was established in Cairo. Members of the Egyptian elite

embraced a European culture, adapting it to suit their life-
styles, and this cross-cultural interest was reciprocal. The
French occupation had generated considerable interest in
Egyptology. *Déscription de l'Egypte* (1809–28), a series of vol-
umes, described Pharonic to Islamic art and architecture in
Egypt as well as contemporary crafts manufactures and
inspired European scholars, archaeologists, artists, and oth-
ers to visit Egypt. Its plates influenced many European
designs. The opening of the Suez Canal in 1869 accelerated
European interest in Pharonic and Islamic Egyptian visual
and material culture. At the same time, Egyptians admired
Europe and European cultures.

The Mamluk Revival style was born in the late nineteenth
century in Cairo, Damascus, and Jerusalem. There was a
large European market for inlaid metalwork, and examples
were influenced by the materials, shapes, and decorative
motifs of the Mamluk era (1250–1517). The Syrian bowl illus-
trated here resembles its fourteenth-century predecessors in
terms of the shape, high contrast between inlays and surface

colors, and rhythm of its decorative program of horizontal bands punctuated by large roundels (fig. 15.19). In addition to the Arabic proverbs inscribed in the panels, however, the motifs include nontraditional roundels with the Star of David and Hebrew inscriptions, indicating that this bowl was probably made for a Jewish client. Some copies of Mamluk metalwork were commissioned by European patrons or made by artisans on speculation. Mamluk Revival enameled glass was also produced in Damascus, in Cairo, and across Europe. Other decorative arts traditions continued to flourish in Egypt, especially woodwork, jewelry, ceramics, and metalwork.

The French invaded Algeria in 1830, and it became part of France's colonial territories. Agricultural production, particularly cotton and silk, and the commercial and industrial sectors were dominated by Europeans and tailored to the needs of European companies and consumers. Traditional decorative arts tended to survive in rural areas, such as earthenwares painted with black-and-red geometric designs (see fig. 16.28) and made by women in the Grand Kabylie, part of the Atlas Mountains. Embroidered curtains for bridal chamber beds, headdresses, headbands, and kerchiefs continued to be created. Algeria was also well known for its urban and village embroideries influenced by Ottoman embroideries (see fig. 9.27). In the nineteenth century, cotton was introduced and different stitches were used.

Morocco's traditional decorative arts included pottery, metalwork, jewelry, carpets, textiles, and leatherwork. Partly because the country was never part of the Ottoman Empire, the aesthetic is distinctive. Morocco protected its independence for nearly one thousand years, apart from a period as a French protectorate (1912–56). The 'Alawis (1631–the present) continue to rule Morocco, now as a constitutional monarchy, and many traditional crafts continue. In isolated or rural contexts, decorative arts such as silver jewelry or tribal carpets from the Atlas or Rif Mountains, were less susceptible to French, Spanish, and Turkish influences than similar items produced in urban contexts.

Fez, one of Morocco's main cities and a historic crossroads of trade and production, continued to make characteristic ceramics decorated in cobalt blue on white slip (a mixture of fine clay and water used to render vessels of coarser clay less porous and give them a white surface), often in imitation of finer Ottoman Iznik ceramics. In some examples, blue-and-white decoration was mixed with other colors—green and yellow-orange—with brown outlines. Other cities had their own ceramic traditions, such as Meknès with its monochrome green-glazed wares and Safi where salt-glazed earthenwares were made. There were distinctive regional styles in Moroccan embroideries, examples of which survive from the later eighteenth and nineteenth centuries, ranging from floral motifs (made in Tétouan) to geometric tree-based designs (Fez, Rabat, Salé), curvilinear floral-and-leaf patterns reflecting Italian influence, or interlaced and crenellated shapes recalling Nasrid and Mudéjar stucco- and tilework.

In general, North African textiles of the mid-eighteenth and nineteenth centuries were influenced by imported Ottoman and European (mainly French) textiles. Styles were copied or adapted to local fabrics and aesthetic predilections; likewise, Moroccan tailored and embroidered caftans, vests, and furnishings could be made using imported silks, often from Lyons, France. Imported plain fine cotton cloth and tulle were used as turbans and in making a light protective dress worn by women and men over silk caftans.

The impact of European political, economic, military, and technological power influenced all regions of the Islamic world during the nineteenth century. There was an uneasy balance between traditional values and "modern" ones. Traditional designs, whether continuing or revived, absorbed and adapted to a variety of foreign, usually European, examples. At the same time, design and decorative arts from the Islamic world fascinated Europeans. Egypt, Persia, and the Ottoman Empire were all represented at the major international exhibitions that gained momentum as the century progessed. Although intended as celebrations of modern manufacture, even in the most industrialized and urbanized countries, the majority of prize-winning objects were handmade. European artists, designers, architects, and travelers continued to visit lands of the Islamic world, returning with drawings, descriptions, and artifacts, and in 1856 the British design reformer Owen Jones published his influential *Grammar of Ornament* with chapters on Turkish, Persian, Moresque, and Indian design (see fig. 17.34). European museums included Islamic objects in their collections, examples of "good design" to inspire designers and manufacturers. The European idea of "Islamic art" was born, a concept that would continue to be debated in the century to come.

AIMÉE E. FROOM

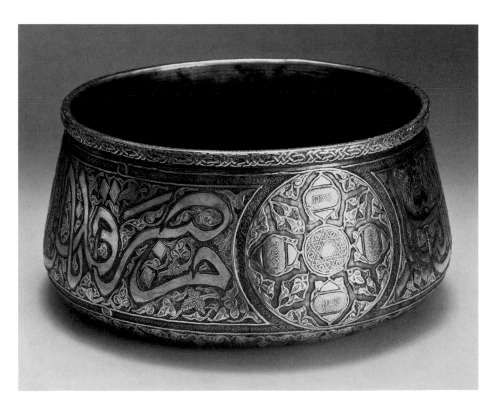

Fig 15.19. Bowl, Damascus, 1904–5. Brass, silver, copper, and gold inlay; 5⅜ x 11¹⁄₁₆ x 11¹⁄₁₆ in. (13.7 x 28.1 x 28.1 cm). The Jewish Museum, New York (F 919).

AFRICA

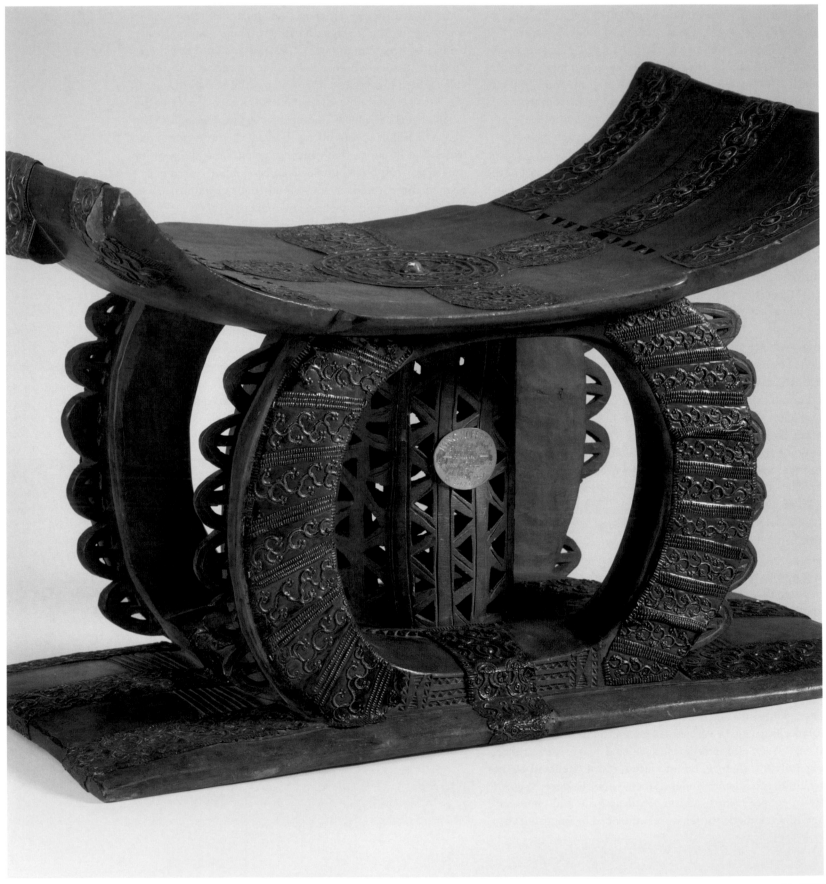

Fig. 16.13

The years between 1750 and 1900 were ones of dramatic transformation on the African continent. The transatlantic slave trade had accelerated. By the 1760s more than 90,000 Africans each year were sent to slave plantations in the Americas or died during the trans-Atlantic crossing. The Indian Ocean slave trade, sometimes called the Arab slave trade, continued unabated throughout this period, eventually surpassing in numbers the trans-Atlantic trade. Movements to abolish slavery and slave trading began in many places in the 1700s, but it was not until the end of the nineteenth century that the practice was outlawed in most countries. Thus throughout the 1750–1900 period, the slow population decline in Africa, which had begun in the 1600s, continued.

The end of slavery did not necessarily make life easier for many Africans as Africa's natural resources attracted the interest of outsiders. Europeans and Arabs used African labor to extract and transport lucrative forest products, such as ivory, palm oil, and rubber. As colonization began at the end of the nineteenth century, forced labor was used to build roads and process these raw materials. In South Africa, where European farmers had settled in the late seventeenth century, largely because of its more temperate climate, diamonds were discovered in 1867. A decade later, the gold rush was on, leading to the building of deep mines and the labor policies that eventually ushered in the system of apartheid, the separation of African peoples from European settlers, in the mid-twentieth century.

In some regions the trade in natural resources and slaves enriched local peoples and regions as well as foreign interests. Powerful and wealthy entities like the kingdoms of Dahomey, Benin, and Asante in West Africa, and the Kuba and Lunda in Central Africa rose to regional dominance on the strength of controlling resources and trade. Few Europeans ventured into the interior of West or Central Africa for fear of diseases and a dislike of the tropical climate. Most of the European traders worked along the Atlantic coast, as they had been doing since the late sixteenth century, and in East Africa, Arabs continued to dominate the trade networks, working with Swahili and African agents. Much of this changed beginning in the late nineteenth century, when Europeans became more systematic in terms of tapping into Africa's vast natural resources and securing markets for European manufactured products.

The period of European colonialism is generally considered to have started with the Berlin Conference of 1884–85. To better regulate increasingly contested claims to areas of Africa, delegates from thirteen European countries and the United States met to carve out the boundaries of African nations that have changed little to this day. By 1885, France, Britain, Germany, Italy, Portugal, Spain, and Belgium had partitioned the continent. Leopold II, king of the Belgians, claimed the entire Congo for himself, promising to make it a "free state," which meant granting mineral, rubber, and other concessions to government and private companies from all (non-African) nations. When, in 1908, protests and publicity against the brutalities of his regime became too heated, control over the Congo was transferred to the Belgian government.

The national boundaries that were drawn up at the Berlin Conference had nothing to do with cultural or linguistic boundaries. Some Yoruba-speaking people, for example, found themselves in Nigeria, while others were in Dahomey (present-day Republic of Benin); Akan peoples were in Ghana and Côte d'Ivoire; the nomadic Fulbe (or Fulani) scattered in Senegal, Mauritania, Mali, Niger, Burkina Faso, and Nigeria; and Hausa speakers lived in Nigeria, Niger, and Chad, as well as Ghana and Togo. The Mande—a number of diverse groups with common linguistic and cultural origins—straddled at least eight countries.

Duing this period, Europeans and Americans, more of whom ventured into the interior of Africa, acquired objects at a greater rate than in earlier times. Colonial administrators, missionaries, merchants, and all manner of scientists, travelers, and journalists collected objects for themselves, for sale, and for numerous new museums of ethnography and natural history in Europe and North America. Between 1885 and World War I (1914–18), an estimated 70,000–100,000 objects—including pottery, baskets, textiles, leatherwork, weapons, and woodcarvings (generally labeled as "fetishes")—were taken to the West, often in lots numbering in the thousands. Many were destined for museums or exhibited at World's Fairs, along with photographs taken at the time, as documentation of the colonial enterprise and evidence of now-discredited Western theories about race and culture.

In an effort to make sense of the multiplicity of languages, cultures, and social practices in Africa, colonial officials, scientists, and collectors endeavored to categorize the diversity they encountered. This led to labeling groups of people, cultures, and objects with "tribal" or ethnic names that often bore little relationship to social and political realities. Furthermore, as woodcarvings and masks became redefined as art in the twentieth century, the "one-tribe/one-style" paradigm, with its deep roots in colonial ethnography, informed the ways in which African objects were acquired, displayed, and understood in the West. Objects collected in the period 1750 to 1900, together with contextual sources, reveal some of the richness and variety of design and craft activities across Africa in this period. Some of these objects reflect ancient practices; others reveal fresh and vital approaches; still others are a combination of both.

WEST AFRICA

The three centuries of the trans-Atlantic slave trade had caused major shifts in populations and rivalries, and reconfigurations of power relationships. A number of centralized states prospered in this period as their rulers allied themselves with slave traders and merchants engaged in commerce with Europe. Yet despite significant changes, many cultural practices survived, and different groups came to accommodate each other. Throughout West Africa, there were many complementary communities with economic and craft specializations. Some focused on fishing, farming, or cattle-keeping, while others included blacksmiths, potters, leatherworkers, and dyers. Great market towns and rotating rural markets brought diverse groups of people together and objects circulated among them.

INDIGO

Blue cloth dyed with indigo is found throughout West Africa. It is closely identified with the Tuareg people, although ironically they do not actually produce the cloth. The Tuareg are descendants of the North African Berbers who have been crossing the Sahara desert since camels were introduced sometime during the first millennium BC. Following well-established caravan routes, they brought Islam to the Tuareg region in the seventh century. By the late eighteenth and nineteenth centuries, Tuareg society comprised a loose confederation of nobles from different regions, vassal groups of goat breeders, religious scholars and teachers, and craftspeople including *inadan* (metalsmiths), some of whom were descended from Jews forced out of southern Morocco in the fourteenth and fifteenth centuries. Then, as today, the independence and semi-nomadic lifestyle of the Tuareg promoted distinctive craft and design practices expressed in silverwork, leatherwork, pottery, and textiles.

A striking expression of Tuareg culture continues to be the dark blue, indigo-dyed cloth that shimmers when light catches it. The practice of wearing indigo *tagelmoust* (a combined turban and veil), along with the notion that indigo on the skin has both decorative and protective properties, has roots in Islamic North Africa. Tuareg men and women both wear indigo-dyed clothing, but the wearing of large, billowing, shiny dark blue gowns is reserved for men. They adopt this clothing when they are of marriageable age as a sign of status and identity. The high value of this type of cloth was noted by a Scottish traveler in 1820: having a robe dyed in Kano, a Hausa city in northern Nigeria, cost 3,000 cowries, plus 700 more to have it glazed. This was about 90 times the daily subsistence for a man and his horse!

In the nineteenth century, most Tuareg cloths were woven and dyed by Hausa craftsmen in Nigeria and Niger, from locally grown cotton, spun by women. Garments were

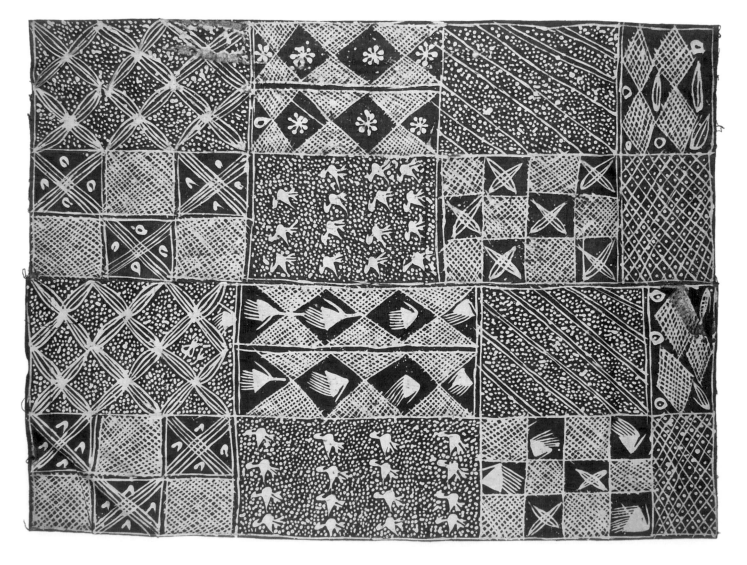

Fig. 16.1. Indigo cloth, Hausa, 19th century. Cotton with starch-paste resist; 55¼ x 72⅞ in. (140.5 x 185 cm). Trustees of the British Museum (Af1934,0307.290).

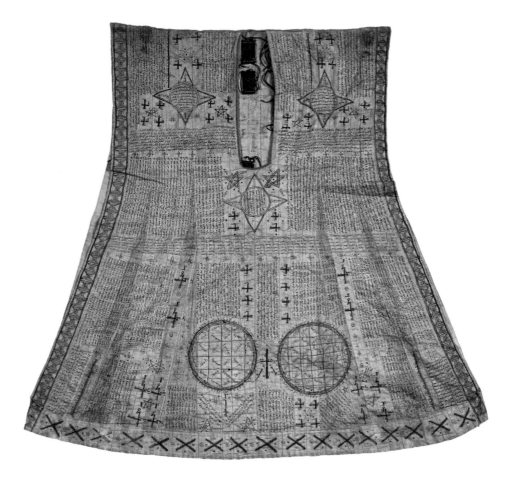

made of as many as one hundred narrow strips of cloth sewn together edge to edge into a finished cloth measuring about 120 to 160 inches wide (300 to 400 cm). Even when machine-made cotton cloth became available in the nineteenth century, the preference for garments made from narrow strips sometimes led people to cut the cloth into strips and stitch it together again, thus maintaining a connection to the past and the prestige of narrow strip weaving. Both factory-made and handmade cotton strips, woven on narrow strip looms by Hausa men, were dyed multiple times to obtain the darkest possible color. The cloth was then beaten with a wooden mallet until it glistened. Powdered antimony, cold water, and, sometimes, indigo powder itself, were sprinkled on the cloth to intensify the shine. The indigo powder would wear off on the skin—hence, the Tuareg are sometimes referred to as "blue people."

Indigo cloth was widely worn by men and women from Senegal to Cameroon before the twentieth century. Numerous accounts by nineteenth-century explorers and travelers describe the dye pits, the popularity of such cloths, and the markets in which they were sold. With the exception of the male Hausa dyers, women generally prepared the dye from two plants, *Indigofera* or *Lonchocarpus cyanescans*, by mixing the powdered pigment with ash. Patterns were created by using various resist methods, including tie-dying, freehand drawing or stenciling in a starch paste or wax, and embroidery (fig. 16.1). Each method resulted in areas of cloth being protected from dye. When the resists were removed, white patterns remained.

The French, British, and Dutch colonists and traders did their best to substitute imported cloth from Europe and Asia

for locally made textiles. By the mid-sixteenth century, the Portuguese had set up large cloth manufactories on Cape Verde, an island in the Atlantic, specifically to make cloth to sell to Africans. Thus, enslaved Africans grew and processed cotton and indigo and created finished cloths which the Portuguese used to finance further purchases of African slaves for Brazilian plantations. Between 1755 and 1777, for example, about 6,000 cloths a year were exchanged for slaves, boosting Portugal's bid to maintain its then diminishing position in the slave trade. The slave-made cloth, which circulated widely within Africa, was produced in different grades; the finest, which became popular in Senegambia, was resist-dyed with embroidery that replicated North African weaving designs.

One of the best-documented early collections of nineteenth-century African textiles (now in the British Museum) was assembled by Charles Beving (1858–1913), a British textile manufacturer who traveled to Africa biannually to obtain textile models for his Manchester company. A magnificent Hausa gown in his collection consists of 161 narrow woven bands of hand-spun cotton dyed with indigo and embroidered in white bleached cotton with Islamic-inspired designs. Men in many parts of West Africa continue to wear this type of garment, although those made from locally grown, spun, and woven cotton are rare.

Decorations that protected as well as adorned can be seen in the dazzling array of inscriptions and interlocking geometric patterns that cover the nineteenth-century Hausa man's cotton tunic illustrated here (fig. 16.2). Prayers from the Koran, magic squares, and other mystical inscriptions transform the garment into spiritual body armor. For added protection, the back, considered most at risk, is more densely adorned

than the front, while amulets line the interior to make it even more impenetrable. In addition, the tunic was dipped in water that was used to wash sacred verses from a wooden Koranic writing board. Like the Hausa tunic, a nineteenth-century paper and wood fan that originated in northern Togo, an area of Muslim and non-Muslim peoples, is similarly covered with mystical inscriptions (fig. 16.3). The outer band includes a repetition of one of Allah's names while the inner reads, "May God protect and preserve you."

MANDE AND HAUSA LEATHERWORK

In the mid-nineteenth century, the German traveler Heinrich Barth described sandals made by Hausa leather workers as the second most important export after indigo-dyed cotton cloth. Then, as earlier, much of the leatherwork made in sub-Saharan West Africa was imported across the Sahara and sold in Europe as Moroccan leather. At the same time, the leather workers who made slippers in Timbuktu, on the southern edge of the Sahara, were said by travelers to be "Arab" as they belonged to the Arma group, descendants of sixteenth-century Moroccan invaders. The red-and-black designs and incised geometric patterns used on boots, sandals, bags, knife sheaths, and quivers in the period 1750 to 1900 resembled leatherwork in this region dating back to at least the eleventh century.

The Tuareg nomadic lifestyle required that a family's belongings, food, and water periodically be packed on animals. Saddlebags, therefore, were among the essential furnishings of daily life. Tuareg women created goatskin bags as well as leather coverings for tent windows and entryways by using multiple layers of leather dyed in bright colors. The dyes were produced from such plants as sorghum, millet, turmeric, tamarind, and pomegranate. Designs were cut out in the various layers, which were overlaid to form complex geo-metric patterns similar to those used in Tuareg silver jewelry making and women's indigo body decoration. Other decorative techniques included stamping, creasing, appliquéing, painting, and embroidering with leather, cotton, or wool threads. Tassels and loose flaps jostled from the purses and bags, as the camel caravans followed seasonal migration routes.

Mande-speaking people, descendants of the inhabitants of the early Ghana Empire, live across a broad swath of West Africa from Senegal to Mali, and from the sub-Saharan savanna regions southward to the Atlantic coast. While there are many local cultural and ethnic groups, including the Bamana, Soninke and Dioula, within the larger Mande-speaking population, they all share a number of craft traditions, especially in ironwork, pottery, and leatherwork. Typical of Mande design is the horseshoe shape as seen in an eighteenth-century leather purse from Sierra Leone (fig. 16.4) with its pocket flaps, leather fringe, semispherical button (which may be an amulet), and the reddish brown and black dyes. The purse probably held amulets, medicine, gold, tobacco, ammunition, and other small items. The geometric decoration was made by stamping, incising, and peeling off layers of leather to create cutout patterns.

Men were the leather workers among the Mande and Hausa. Besides bags, shoes and boots, knife handles and sheaths, and saddles and horse trappings, leather workers in the region made casings for amulets, used by both Muslims and non-Muslims. Chiefs and hunters wore tunics covered with amulets; and amulets were attached to swords, bows, shields, caps, and virtually any portable object, especially those used in hunting and warfare. Children wore them as protection against disease; women to ease childbirth. The amulets contained folded pieces of paper on which verses of the Koran were inscribed. Leather-encased amulets for non-

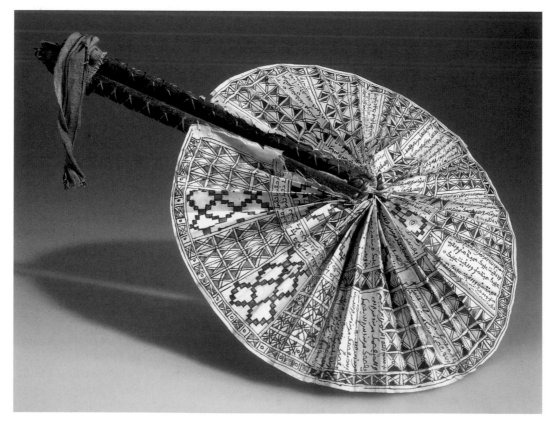

Fig. 16.3. Fan, Dagomba, 19th century. Paper, pigment, wood, cord, cloth; closed, L. 18⅛ in. (46 cm). Division of Anthropology, American Museum of Natural History, New York (1/6475).

Fig. 16.4. Purse, Mande, 18th century. Dyed leather; without strap, 4¾ x 3¹⁵⁄₁₆ in. (12 x 10 cm). Etnografiska Museet, Stockholm (1874.01.0254).

Fig. 16.5. Headpiece for a horse, Hausa, 19th century. Silver, fiber, hide, cloth; H. 23 in. (58.4 cm). Division of Anthropology, American Museum of Natural History, New York (1/6480).

Muslims might also contain substances like herbs and animal parts that were believed to have protective or curative powers. Amulets were also encased in silver or other metals, such as those on a nineteenth-century Hausa horse trapping (fig. 16.5). The bands across the headpiece are cut out, recalling the way leather is layered and cut out. For people of high status and wealth, amulets were also encased in gold.

WEST AFRICAN GOLD

Gold working was another West African practice that embodied strong continuities with the past and reflected the widespread reach of the gold trade in West Africa over many centuries. Finely crafted, nineteenth-century jewelry from Mali (then French Soudan), for example, resembled eleventh-to-fourteenth-century jewelry found at archaeological sites in Tegdaoust, Mauritania, and Rao, Senegal. The geometric forms of the pendants on the necklace shown here (fig. 16.6) relate to the shapes of West African Islamic amulets, yet the filigree and granulation were techniques brought to North Africa by Jewish goldsmiths who left Andalusia in Spain in the sixteenth century during the Inquisition. In Senegal, gold jewelry including pectorals, earrings, hair ornaments, and bracelets was, and still is, a sign of wealth and empowerment worn by Toucouleur and Wolof women. When the French conquered the town of Ségou in 1890 (effectively ending the power of the Toucouleur leader, Amadou Seku), the commander seized fifteen cases of gold, silver, and copper ornaments, known as the Treasury of Amadu. The cache, now in the Musée du Quai Branly in Paris, included the necklace and other jewelry that had belonged to a number of Mande kings.

The Asante kingdom in Ghana has been referred to as the Kingdom of Gold. When T. E. Bowdich, a British writer, traveler, and trade representative, visited the capital, Kumase, in 1817, he described the splendor of the court, including massive amounts of gold and fine woven cloths. Gold dust was the currency of the Asante kingdom, and the wealth of the king, or Asantehene, was based in part on his ability to tax and control the circulation of gold. When Bowdich met him, Asantehene Osei Tutu Kwame (r. 1804–24) wore a beautifully woven multicolored silk cloth of a type now known as *kente*, along with gold jewelry covering all parts of his exposed body. His cap and sandals were decorated with gold ornaments and even his drinking gourd had gold threads woven into its surface.

Fig. 16.6. Necklace, found at Ségou, 19th century. Gold; 11 x 4 34 x ¹¹⁄₁₆ in. (28 x 12 x 1.7 cm). Musée du quai Branly, Paris (75.8148).

Fig. 16.7. Torque, Asante, early 19th century. Gold; 8⁷⁄₁₆ x 8¼ x ¹⁵⁄₁₆ in. (21.5 x 21 x 2.3 cm). Trustees of the British Museum (Af,Ash.1).

Fig. 16.8. Pectoral badge, Asante, collected in 1817. Gold; Diam. 2⅜ in. (6 cm). Trustees of the British Museum (Af1818,1114.6).

Gold jewelry indicated rank. The Asantehene wore the largest and heaviest pieces, but other officials and lesser ranking chiefs commissioned jewelry when they took office. Gold was the predominant material, but valuable stone and glass beads were also used in royal ornaments. A magnificent gold torque (fig. 16.7) that belonged to the Asantehene Kofi Karikari (r. 1867–74) evokes the notion of strength through unity with its many twisted strands of gold making up a rope that culminates in a knot. The Asantehene was said to wear an iron or steel version of this necklace, painted black, at the funerals of important chiefs.

The most commonly worn insignia of office for lesser-ranked individuals was the pectoral disk known as *kra,* also referred to as a "soul-washers badge." These were worn, suspended from a cord around the neck, by young servants of the Asantehene who were selected, in part, because they were born on the same day of the week as the Asantehene. Believed to share his destiny, they participated in rituals to purify his soul. The disk shown here (fig. 16.8), obtained by Bowdich in 1818, resembles other disks known from the early eighteenth century. *Kra* motifs were varied; some bear the "Cross of Agades," widely found in North Africa; others have a floral motif thought to represent *aya,* a type of fern that can grow virtually anywhere and that symbolized defiance.

In addition to the famed Golden Stool, which was associated with the founding of the Asante Confederacy in the early eighteenth century, most Asante royal regalia was made of gold or ornamented with it. Gold leaf covered objects made of leather, iron, and wood—weapons, drums, canes, staffs, umbrella finials, fly whisks, iron gongs, pipes, and amulets. By the nineteenth century, the government had become a vast and complex bureaucracy. Regional chiefs and officials commissioned and displayed their own gold regalia, although it could only be made with permission of the Asantehene. When these chiefs and officers assembled for festivals, meetings of state, or the periodic rites to honor royal ancestors, dazzling gold objects were on display. These were obvious signs of wealth, but the intricate forms of Asante gold objects

also conveyed information relating to status and power, history, and diplomacy.

An impressive iron gong, now in the Houston Museum of Fine Arts, which would have accompanied a chief in procession, has a gold finial on the handle in the form of a backward-facing bird known as *sankofa.* Like many items of regalia, this carved figure embodies proverbial wisdom, in this case, signifying a warning to learn from the past. On other objects, cast gold sculptures of skulls or human teeth referred to captured enemies; animals or abstract forms could refer to well-known proverbs that were aphorisms relating to the conduct of human affairs.

A royal ceremonial helmet (fig. 16.9), was among the gold objects belonging to Asantehene Otumfuo Nana Prempeh I (1870–1931) or one of his predecessors and retrieved by the British after they burned the royal palace in 1900. The helmet is made of antelope hide and has a scalloped fringe and long

cheek straps and is covered with twenty gold-plated ornaments: human jawbones, heraldic-style lions mounted on rectangular plinths, miniature slain enemy heads, two antelope or bush cow horns, and a finial in the form of a pineapple. The cheek straps are decorated in a similar fashion, with gold ornaments representing a cockleshell, a red seashell, a human jawbone, as well as gold and silver bells. The interior of the helmet is lined with yellow silk, and the attached amulets are wrapped in red and black silk and white thread.

Like the helmet, swords often had gold appendages that indicated the status of the bearer and conveyed messages about battles or diplomatic missions. There were many different kinds of sword, each with its own name and function. Some were specifially for swearing oaths of allegiance and others were to protect the spiritual health of the ruler. The Mponponsuo (responsibility), as the most important sword belonging to the Asantehene was known, was used in royal installation ceremonies. Its hilt is covered with leopard skin, and there is a gold snake appended to it—animals, like people, being hierarchically ranked. A replica is used in Ghana today, replacing the original, which is now in the British Museum.

INNOVATIONS IN REGALIA

Court linguists in Asante society were high-ranking officials who played important roles as diplomats and counselors to the Asante chiefs. The gold-covered staffs they carried bear witness to the way regalia changed in tandem with the vicissitudes of statecraft and foreign contact. Before the nine-

teenth century, Europeans remained primarily on the coast and traded with the inland Asante through African emissaries. Evidence suggests that the Asante linguist staff was an adaptation of the European cane or walking stick. Eighteenth- and nineteenth-century staff finials were decorated with gold and silver geometric repoussé designs, but these gave way to elaborate figurative carvings covered in gold leaf.

The Asante practice of adding figurative imagery to staff finials may have been influenced by the Fante on the coast, who used figurative imagery on their flags, banners, and other objects to advertise alliances with European powers. A late nineteenth-century Fante flag (fig. 16.10) depicts two forts, probably St. George and St. Jago at Elmina, joined by a telegraph wire, probably a reference to the Africa Direct Telegraph Company running lines through Elmina to link Britain to her West African Colonies in 1885. The British Union Jack appears on this flag, as it does on all *asafo* flags made before Ghanaian independence in 1957 (at which time *asafo* flags and banners were embellished with the Ghanaian flag).

The imagery used by the Asante for linguist staffs and other objects was sometimes related to European objects, such as trophies acquired in battle, as diplomatic gifts, or as simply exotic curiosities. An 1884 photograph shows a sword belonging to the Asantehene to which a casting of a teapot is attached, but objects that reflected military might, such as European guns and canons, were more commonly represented in the nineteenth century. A massive gold ring in the Houston Museum of Fine Arts thought to have been made in

Fig. 16.9. Ceremonial helmet (*denkyemkye*), Asante, 19th century. Antelope hide, gold, silver, shell, silk; 9⁷⁄₁₆ x 22¹⁄₁₆ x 8¼ in. (24 x 56 x 21 cm). Trustees of the British Museum (Af1900,0427.1).

the nineteenth century or earlier, depicts a man-of-war complete with cannons, a waving flag, and two birds perched on the ship.

GOLD WEIGHTS

Representational imagery is most commonly seen in connection with the small brass weights that were used for measuring gold dust. Made in the hundreds of thousands, they accompanied scales, small boxes to hold gold dust, and hammered brass spoons required for weighing the precious material. Each weight was unique, made by the lost-wax casting technique. There are thousands of small geometric forms as well as representations of many kinds of objects common in Asante life, including plants, animals, people, and man-made objects. Some also depict people engaging in everyday activities—hunting, farming, pouring libations, nursing babies, or climbing trees to get palm wine. Chiefs were shown sitting in state under umbrellas or being carried on palanquins. Animals associated with power and aggression such as leopards, elephants, lions, crocodiles, and porcupines were common, as were birds, insects, crustaceans, and fish, shown in such detail that their species can be identified. Despite the ubiquity of the weights and the range of imagery, certain subjects were not depicted, including funerary rites, dwellings, and most domestic animals. European forms included boxes, furniture, scissors, tools, locks and clocks, keys, and guns. A weight in the form of a folding chair of a type known as *akonkromfi*—one of several kinds of Asante chairs that were based on eighteenth-century European models—gives a sense of how this European form was elaborated in Asante with the addition of finials, brass tacks, and according to descriptions at the time, foreign coins and gold and silver bosses (fig. 16.11).

The distinction between figurative and geometric forms is somewhat misleading when discussing Asante decorative arts. The association between the visual and verbal arts applies to both. Patterns that Western observers might describe as geometric or "abstract" are given names that refer to concepts or objects in the real world. The twisted knot on the gold torque mentioned above, for example (see fig. 16.7), expressed an idea about society in which there is strength through unity. In *kente* cloth, specific weaving motifs are given names—the seemingly geometric or abstract design may refer to a kind of plant, or medicine, or a cosmic event—and would be recognized by the community as such. The

embossed stucco or cement decorations on traditional Asante buildings, the *adinkra* stamps used to apply dyed patterns to textiles, and the intricate patterns carved into wooden stools, or incorporated into gold jewelry and brass weights, are further examples of such visual cues.

Another example of seeming abstractions that are in fact representational to those who know how to read them is a very rare *adinkra* textile (fig. 16.12). It bears the *aya* leaf design that also appears worked in gold on a *kra* (soul-washer's badge). The cloth was made of handspun and handwoven cotton strips in the Dagomba region, to the north of Asante, and then stamped with pieces of carved calabash dipped in an ink made from bark and known as "Adinkra medicine." This type of cloth, wrapped as a toga, was worn for funerals. *Adinkra* cloths today are usually of factory-made cotton, with either designs hand-stamped with calabash stamps, or factory printed with similar patterns. The *aya* design is just one of hundreds of seemingly abstract geometric patterns in the repertory of Asante design that refer to real things, events, and concerns of the human world.

Woodcarvers in Asante, like weavers, also varied the details and combinations of patterns to create innumerable

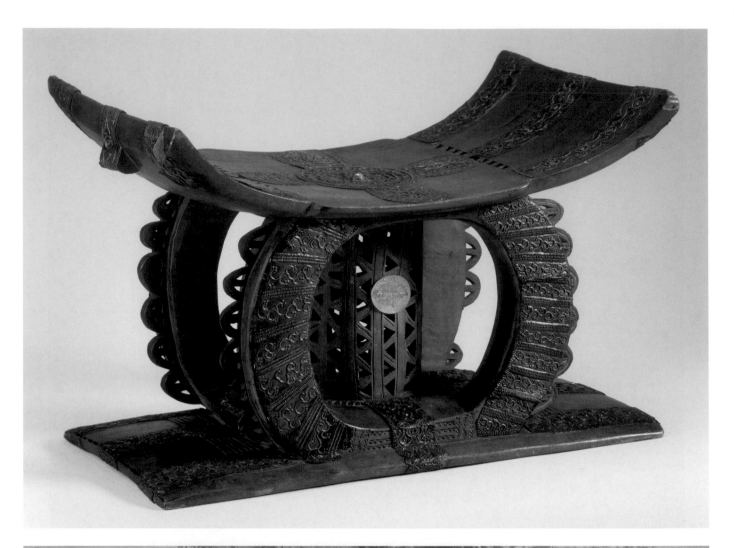

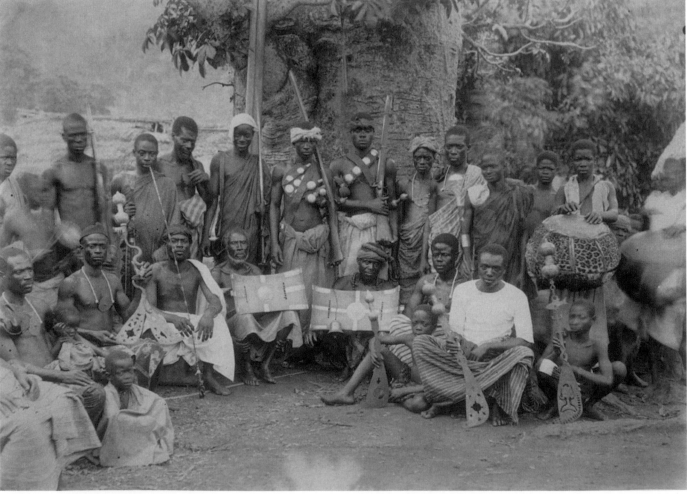

versions of it. The carved wooden stool, or *dwa*, was the most common form of seat in Asante. Some were made purely as utilitarian seats, but others, more elaborately decorated, were associated with kingship and office holding and were rarely if ever used. Indeed, the term used to refer to a political office in Asante was "stool." The Golden Stool, for example, was a symbolic representation of the state itself. The basic stool form—which was always carved from a single piece of wood—consisted of a rectangular base and seat connected by one or more carved wooden pedestals. Within the vast repertory of stool designs, names and meanings, sometimes associated with proverbial sayings, were, and still are, assigned to different types of stools. For instance, a stool with two semicircular pedestals, back to back, between the base and seat, was called Srane Dwa (literally, "The moon stool is for both men and women"). A stool supported by a column with carved openwork in a checkerboard pattern, by contrast, was called Mma Dwa (woman's stool), and traditionally a man gave this type of stool to his wife at marriage.

The Asante used silver as decoration on some stools, especially those that were associated with high office, carried in chiefly processions, or used in installation and funerary ceremonies. Throughout Asante history, kings gave their names to new stool designs. The wood stool shown here (fig. 16.13), which is covered with silver repoussé strips, dates from about 1860 and is said to have belonged to Asantehene Kofi Karikari until the British attacked his palace in 1874. A photograph taken in 1896 in Kwahu, one of the regional chieftancies of the Asante state, by the Swiss missionary Friedrich August Louis Ramseyer, reflects the importance of stools as a symbol of Akan leadership (fig. 16.14). Royal attendants pose with items of regalia pertaining to Akan chiefship. Two men (center) hold stools decorated with silverwork, while four others wear *kra*, soulwasher's badges. Others in the party, including two boys, hold ceremonial swords with handles covered in gold leaf.

THE KINGDOM OF DAHOMEY: METALWORK AND TEXTILES

Silverwork featured most prominently in the Kingdom of Dahomey (in present-day Republic of Benin). The kingdom, whose seafront became known as the "Slave Coast," prospered during the eighteenth and nineteenth centuries. Lavish sculptures and luxurious textiles were paraded through Abomey, the inland capital, to celebrate the military might of the king.

To protect the king and assure military advantage, sculptures called *bocio* were placed in palace shrines dedicated to Gu, the deity associated with war. Two silver-covered objects now in The Metropolitan Museum of Art—a cow and an elephant (fig. 16.15)—would have been filled with substances thought to be potent medicines. They were created by metalworkers in the court of King Guezo (r. 1818–58) and his son Glele (r. 1858–89), rulers who were associated, respectively, with the buffalo and elephant. The idea that African objects, if properly prepared, could have powers enabling them to

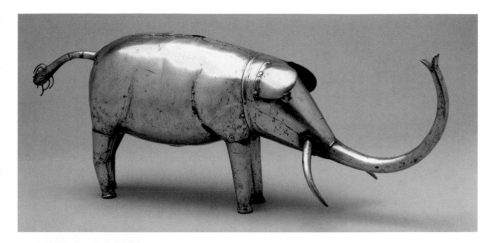

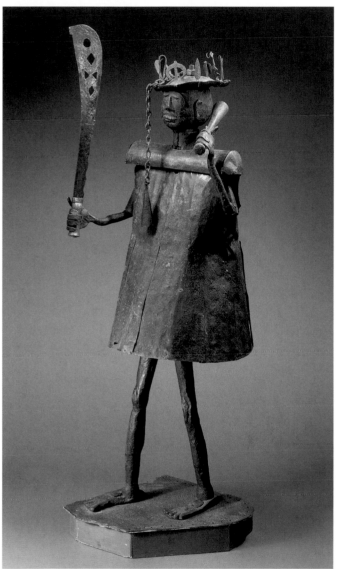

serve as intermediaries to deities and ancestors who can intervene in human affairs is found throughout the continent. Such items could also be made in costly materials for wealthy patrons.

A large mid-nineteenth-century statue of the deity Gu, made entirely of European scrap metal (fig. 16.16), demonstrates the Fon practice of making life-size objects to display the power of the king. Another near lifesize wood sculpture, by Sosa Adede, made of several pieces joined by nails, represents King Gbehanzin (r. 1889–94) as a shark. When his father designated him as heir to the throne, he was likened to a fero-

Fig. 16.15. Protective shrine figure (*bocio*), Abomey, Kingdom of Dahomey, 19th century. Silver; 12 x 23⅝ in. (30.5 x 60 cm). The Metropolitan Museum of Art (2002.517.2).

Fig. 16.16. Akati Ekplékendo. Statue of the god Gu, Abomey, Kingdom of Dahomey, before 1858. Iron, wood; 70¼ x 20⅞ x 23⅝ in. (178.5 x 53 x 60 cm). Musée du quai Branly, Paris (71.1894.32.1).

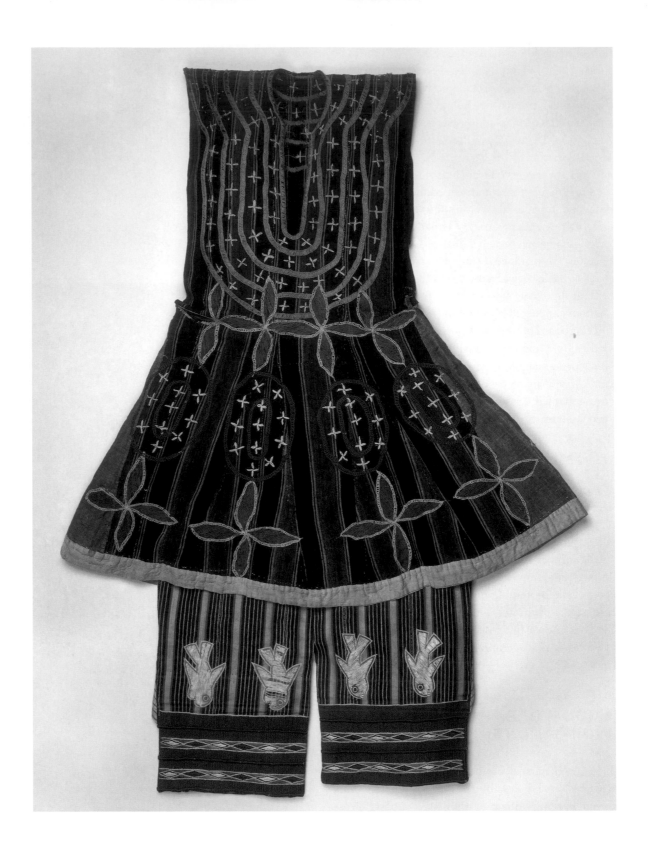

Fig. 16.17. Royal garments, Abomey, Kingdom of Dahomey, late 19th century. Cotton, velvet, silk threads; tunic, 34¼ x 27⁹⁄₁₆ in. (87 x 70 cm); trousers, 29½ x 26 in. (74.9 x 66 cm). Brooklyn Museum (22.1500a-b).

cious sea beast who could trouble the waves and stop the advance of French ships. Ultimately, the French forces defeated King Gbehanzin in battle and took the figure to France (now in the Musée du quai Branly).

Unlike the shark sculpture, most African wood sculptures are carved from a single piece of wood. King Gbehanzin's wooden throne (Musée du quai Branly) conforms more closely to African carvers' practice. More than 6½ feet (2 m) high, the throne gave the king a privileged vantage point during public spectacles. Sosa Adede also made four carved palace doors, with painted raised relief decorations that resemble textile appliqué. The reliefs showed guns, human

body parts, and animal symbols including lion, chameleon, and snake, some of which are important in Beninoise and Haitian voudou ceremonies to this day.

Large quantities of European textiles began to reach the Kingdom of Dahomey in 1732, after King Agadja conquered the coastal town of Ouidah. This infusion of fabrics in a broad array of colors led to the flowering of appliqué. By the nineteenth century, the main appliqué workshop in Abomey, the capital, boasted two hundred tailors. Fon appliquéd cloths were hung as wall decorations visually encoded with the names of successive kings, mainly through the incorporation of animal symbols and objects that represented their power.

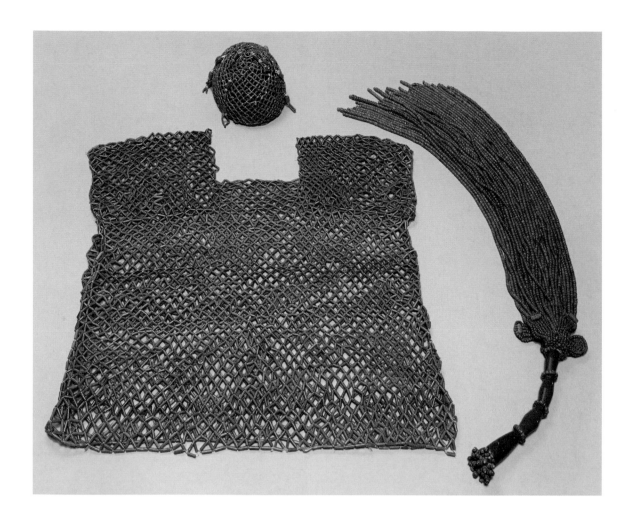

Appliqué was also used to embellish a royal tunic, hat, and pants that once belonged to King Gbehanzin. Made from handspun and woven indigo-dyed cotton, they were adorned with appliqué and embroidery in imported fabrics, silk thread, and velvet (fig. 16.17). Above the trouser's cuffs, appliqué outlines the sleek bodies of open-mouthed sharks, the king's symbol. Appliqué work remains the best-known of all Dahomean textile techniques.

BENIN AND BAMUM: BEADWORK

Beads continued to be important in Africa during the period 1750 to 1900. Mediterranean coral was considered to have a mystical, protective aspect, and only the king, or Oba, of Benin had the right to wear full garments made of netted coral beads. Such clothing could be extremely heavy, but weight was considered to enhance status. When Oba Ovonramwen faced the British after their 1897 invasion of his kingdom, he wore a white wrapper covered with coral and a massive coral headdress. An early nineteenth-century French visitor to the Kingdom of Benin reported that a coral net shirt, perhaps similar to the tunic illustrated here (fig. 16.18), weighed nearly twenty pounds.

Bamum is the largest of the many kingdoms in western Cameroon's Grassfields region, with a royal dynasty that was founded more than four centuries ago. At the end of the nineteenth century, the Bamum ruler had an elaborate palace with carved wooden columns and lintels. Enormous indigo-dyed cloths served as backdrops to the life of the court. Sculpture celebrated the power and wealth of the king and his ancestors, and some of it was covered with imported glass beads, their distribution controlled by the king. The surface of the life-size figure made in Fumban, Cameroon, during the reign of King Nsangu (r. c. 1865–c. 87) or his son Njoya (r. ca. 1886–1933), was covered with imported glass beads and a thin sheeting of brass. The zigzag pattern on the bracelets, armlets, and anklets represented the points of a spear, thus alluding to the king's battle prowess. Similar patterning appears on the clothing of four linked figures that feature on the base of a richly beaded stool from the Bamum royal palace, the seat of which is covered in cowries.

CENTRAL AFRICAN: PATTERNING AND POWER

Despite the caveats governing generalizations, African design is sometimes characterized by an abhorrence of plain surfaces. The profusion of beaded surfaces on wooden objects, the intricate patterns in African textiles, detailed incisions, and painted and inlaid surfaces of ceramics, leatherwork, wooden objects, not to mention the scarification marks on human skin, are all examples of this.

Kongo *minkisi nkondi* (sometimes translated as power figures), usually made in the form of human figures but sometimes also in the shape of a dog, bristle like porcupines with a profusion of African-made iron blades and spikes, sometimes

Fig. 16.19. *Nkisi nkondi* (power figure) representing Mangaaka, Kongo, mid–late 19th century. Wood, paint, metal, resin, ceramic; H. 46⁷⁄₁₆ in. (118 cm). The Metropolitan Museum of Art (2008.30).

Fig. 16.20. Cut-pile cloth with pom-poms, Shoowa Kuba, 19th century. Raffia; L. 55 in. (139.7 cm). Hampton University Museum, Virginia (11.174).

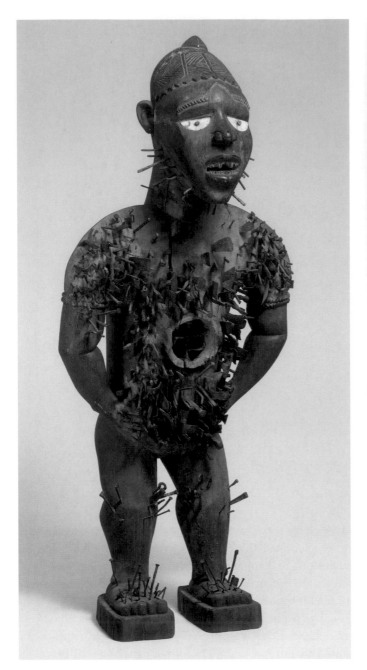

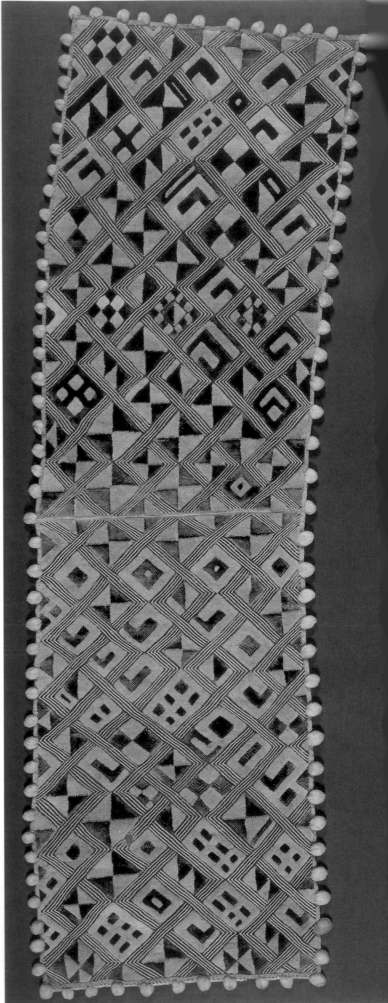

in combination with imported European nails. Made at the end of the nineteenth century and identified with Mangaaka, the preeminent force of jurisprudence, the figure shown here (fig. 16.19) wears the distinctive *mpu* (hat) of chiefs or priests (see fig. 10.21). In this example, a cavity in the abdomen once held empowering substances. Such figures served as witnesses to, and enforcers of, affairs critical to their communities. The iron blades and nails represented specific incidents and were attached individually over a long period of time, by a skilled practitioner known as a *nganga*, who owned the *nkisi nkondi* and gave consultations to those in need of help.

Kongo raffia textiles were an important form of decorative art and were used as currency (see fig. 10.20). The Bushoong, of the most populous Kuba kingdom, were eastern neighbors of the Kongo. They developed a kind of raffia technique known as "cut-pile embroidery." It was used for small squares that were pieced and made into burial cloths and floor and wall coverings. Larger embroidered raffia cloths, usually with less cut-pile, were worn by Bushoong men and

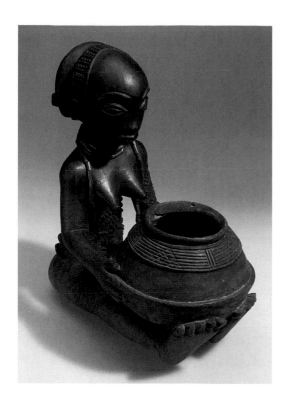

attract the attention of spirits who would aid the community (fig. 16.21). Among the Luba, scarification was performed after female initiation and before a woman married; women without scarification marks were regarded as unattractive and somehow unfinished. The female figure seen here bearing a pot—used to hold white kaolin powder during divination rites—represented the wife of the diviner's possessing spirit. She and the pot bear marks known as *nkak*a, a pattern that refers to the condition that a diviner enters into when in a trance. Her open cross-shaped hairstyle is one that was found on Luba chiefs and some of their wives in the nineteenth century. Until the early twentieth century, Luba aristocrats used neck rests to elevate their complicated hairstyles when sleeping and to keep their necks cool while reclining. While serving a quotidian purpose, the neck rests were also used to encourage communication with the ancestral realm through dreams.

BARK CLOTH

Cloth made from the bark of various species of ficus trees was common in many parts of Africa. In 1873, German explorer and botanist Georg Schweinfurth (1836–1925) spent five weeks in a northeastern Congo village where a Mangbetu king named Mbunza resided, the subject of one of his sketches (fig. 16.22). Schweinfurth also recorded his impressions of life there, including the magnificence of the court, an enormous meeting house made of fine woven reeds, and the body art of Mbunza's many wives. His account, *Im Herzen von*

Fig. 16.21. Divination figure, Luba, 19th century. Wood; 14¾ x 7½ x 12¼ in. (37.5 x 19 x 31 cm). Division of Anthropology, American Museum of Natural History, New York (90.0/2423 AB).

women. One of the earliest collections of such textiles, now in the Hampton University Museum, Virginia, was assembled by William Sheppard, an African American Presbyterian missionary who lived among the Kuba from 1890 to 1910 (fig. 16.20). After returning to the United States, Sheppard described the Kuba's taste for the beautiful and their impulse to use ornament on just about everything.

In making cut-pile raffia embroidery, men wove the base cloths on vertical heddle looms, and women embroidered them with dyed raffia threads that were clipped to create a plush pile effect. The small square format of, for example, burial cloth may have led these craftspeople to see such cloths as vehicles for virtuoso displays. Innovative designs were rarely repeated, even on the same piece, although interlaced geometric patterns based on triangles, squares, and rectangles were ubiquitous as in the piece shown here. The angularity may have come from the way the embroidery followed the warp and weft of the woven cloth base. On large embroidered pieces that were worn as skirts, the embroiderers added curved lines, giving the cloths a more flowing look. Bushoong woodcarvers also created interlaced designs on small containers, cups, and even wooden enema funnels, while bead workers applied them to belts, hats, pendants, and other items of regalia.

The Luba, another Central African kingdom, located farther east in what is the present-day Democratic Republic of Congo, rose to power in the seventeenth century, and had a decidedly different aesthetic from the Kuba. Luba woodcarvers created beautifully refined carvings of human figures that served both functional and ritual purposes. Neck rests, office holders' staffs, bow stands, receptacles, and seats were made to commemorate important leaders and their wives. Most carvings portrayed women with distinctive hairstyles and geometric scarification patterns etched into their skin, both marks of beauty and physical perfection that were thought to

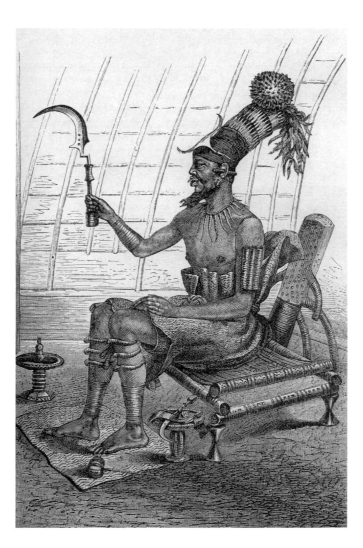

Fig. 16.22. "King Munza [Mbunza] in Full Dress," from Georg A. Schweinfurth, *In the Heart of Africa,* 1874; reprint, George Thomas Bettany, *The World's Inhabitants,*1888.

Afrika (1874; English edition titled *In the Heart of Africa*), although exaggerated in many respects, showed Mangbetu men wearing large bark cloth wrappers. They drew the deeply dyed black and beige cloths between their legs and then draped the cloths over waist belts made of fiber or hide. Photographs made forty years later by, among others, Herbert Lang for the American Museum of Natural History, prove that the Mangbetu continued to wear such garb into the early twentieth century. Women wore plain bark cloth skirts and carried small pieces of painted bark cloth over their shoulders, placing them on the finely carved wooden stools that they also carried as their personal seats. The patterns painted on these small pieces replicated the designs painted on their bodies.

In the nineteenth century, both men and women in this region bound the heads of infants causing their skulls to take on an elongated shape, considered a sign of beauty and status. As adults, they augmented the elongated look with elaborate woven fiber hats (as in fig. 16.22) and hairstyles that accentuated verticality. Long ivory hairpins ending in thin disks completed this look. The wooden figure of a Mangbetu woman (fig. 16.23) portrays this style of head and hair elongation. Beginning in the late nineteenth century, Mangbetu women became known as the "Parisians of Africa" and images of them were widely disseminated in Europe—on postage stamps, postcards, travel magazines, and posters.

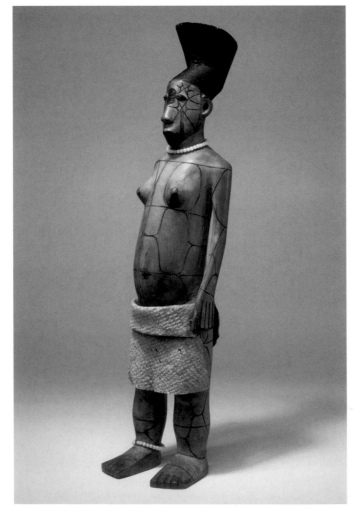

Fig. 16.23. Figure of a woman, Mangbetu, late 19th–early 20th century. Wood, beads, bark cloth, leaf, pigment, dye; H. 16⅞ in. (43 cm). Division of Anthropology, American Museum of Natural History, New York (90.1/4295).

SOUTHERN AFRICA

Portuguese survivors of sixteenth-century shipwrecks on the Eastern Cape Coast sometimes encountered the southernmost Xhosa people. In survivors' accounts, they note that the Xhosa wore skins and red beads imported from India. By the late eighteenth century, glass beads and buttons had begun to be imported into southern Africa in large numbers. Trade records from the London Missionary Society indicate that the missionaries, who supported themselves by trading with local people, struggled to meet very specific and ever-changing demands for different kinds of beads. In the early 1800s transparent beads were unpopular, while pinhead-sized blue, white, and black ones were in high demand. By the mid-1800s, in addition to beads and buttons, the missionaries ordered blankets, European clothing, metal tools, and utensils—items that eventually contributed to a transformation of the material lives of people in southern Africa.

By the end of the nineteenth century, southern Africa had become the world's largest market for European glass beads, and beadwork became an intrinsic part of African dress. There were many local variations in terms of color preferences and designs, but beadwork became a primary means of communicating cultural identity—including social and marital status, size of family, and home region—through aesthetic expression. Wearing traditional dress incorporating beadwork for special occasions, even in the twenty-first century, is considered a way of honoring one's ancestors.

Parallel rows of glass beads, and other ornaments such as mother-of-pearl buttons and fur, often encircled long skirts, known as *isikhakha* or *umbhaco*, which were worn by Xhosa women in the nineteenth century (fig. 16.24). When seen in motion, the effect of the beads would have been dazzling. The long *isikhakha* skirt was influenced by the Victorian fashions of white settlers and replaced the indigenous leather skirts, which were also colored with red ocher. This preference for red earned the Xhosa people the traditional name, *amaQaba* (Red People); they applied red ocher not only to cloth, but also to their bodies.

Besides beadwork, many cultural groups in South Africa made, and continue to make, fine baskets, ceramic pots, and small household objects like carved wooden spoons, bowls, and neck rests. Throughout Africa a great deal of care went into the crafting of weapons, both those used for warfare and serving as signs of identity and accomplishment. A rare ivory knife in the Dresden Ethnological Museum has carvings of a zebra, an ostrich, and a cowrie-shell motif. A copper breast-piece, collected in the 1840s, was worn by Sotho warriors as a symbol of bravery. Among the Sotho, different military units were distinguished by the color of their shields, all of which were topped by ostrich plumes. One missionary, Rev. Eugene Casalis, recorded in 1861 that "One phalanx can only bear white; another spotted, and, in certain cases, the spots must be arranged in a particular way."[1] A nineteenth-century Zulu shield (fig. 16.25) demonstrates how the maker took dark and light sections of fur and wove them into a design that personalized the shield and marked him as an accomplished warrior. Zulu shields continue to be used into the twenty-first

Fig. 16.24. Skirt, Xhosa, 19th century. Cloth, glass beads, mother-of-pearl buttons, fur. Collection of Michael R. Mack, Atlanta.

Fig. 16.25. Shield, Zulu, 19th century. Fur, hide, wood; 23¼ x 11⅝ in. (59.2 x 29.6 cm). Division of Anthropology, American Museum of Natural History, New York (17/159).

century in ceremonial displays, celebrating men's initiation rites and affirming the power and identity of the Zulu people.

Casalis also noted many forms of Sotho basketry. Men made enormous baskets for holding grain, while women made jewelry, hats, and smaller bell-shaped baskets so tightly woven that they could hold liquids. Watertight coiled baskets were widely used for brewing and serving sorghum and maize beer. Sharing beer was an important part of Sotho life, used in the celebration of men's initiation ceremonies, at weddings and funerals, rituals honoring ancestors, and simply to acknowledge neighbors for helping with communal tasks. Indeed, one of the first objects to enter the collection of the American Museum of Natural History in the nineteenth century was a Zulu beer basket.

In the later nineteenth century, Zulu women began to replace beer baskets with burnished black ceramic beer pots, some with geometric patterns made from raised bumps. One reason for the switch from basketry to pottery may have been because the blackened pots were believed to attract ancestors. Or the use of pottery may have been a surreptitious response to the missionaries' prohibition against both beer drinking and ancestor veneration in this period. A degree of cultural continuity was maintained: the new ceramic beer pots had coiled basketry lids. Over time, these lids, known as *imbenge*, were decorated with layers of glass beads; in the twentieth century even newer materials were introduced including plastic beads and telephone wire, which entirely replaced the fiber on some *imbenge*.

Fig. 16.26. Pectoral, possibly Segeju, late 19th century. Hide, glass and metal beads, seeds, fiber, chains; 20½ x 11⁷⁄₁₆ in. (52 x 29 cm). Trustees of the British Museum (Af1905,1022.2).

EAST AFRICA

In his description of East Africa, *The Uganda Protectorate* (1902), Sir Harry Johnston, Commissioner of the Protectorate, described the material cultures and customs of many different groups in the region of the Great Rift Valley and environs of Lake Victoria, extending from the Congo in the north to German East Africa (now Tanzania) in the south. There were centralized kingdoms like those of Bunyoro and Buganda (in present-day Uganda) and the Tutsi in Ruanda; farmers like the Kikuyu and Kamba; and cattle-keeping pastoralists such as the Turkana and Maasai whose homelands ranged from the Sudan to Tanzania. On the coast the Swahili continued to dominate. Johnston collected and photographed a wide range of material culture ranging from architecture to weapons and musical instruments to objects of personal adornment.

Johnston's descriptions of the architecture of the region show that, as among the Mangbetu in the Congo, buildings in Uganda were made with wooden posts overlaced with reeds and topped with thatched roofs. These dwellings could be coated with animal skins or with stucco made of dung and sometimes painted with colorful designs. There were many local styles, but in general the dwelling compound, in a pattern typical of many African homesteads, consisted of a number of separate rooms facing a central courtyard. In societies where polygamy was practiced, a man and his wives, or sometimes a group of brothers and their wives, or a three-generation family, would share such a compound. Cooking would be done in the central courtyard, and each woman had her own sleeping room.

Among many East African peoples, beadwork worn by both men and women indicated a person's gender, age, marital status, and local and clan identity. The elaborately beaded pectoral in figure 16.26, with glass and metal beads, chains, and seeds sewn onto a hide base, makes an impressive statement about the wearer's status. Collected by Sir Harry Johnston in present-day southern Kenya or northern Tanzania, it dates from the late nineteenth century, when many Italian and Bohemian glass beads were being imported into the region. The style of beadwork is not Maasai, but warriors in that group also wore a type of beaded pectoral known as *olkila enkoshoke*. This ornate work seems to be of a type worn by a medico-spiritual practitioner of the Segeju group who may have been emulating the Maasai spirit that he invoked as a source of power in curing spirit-based illnesses.

THE SUDAN AND ALGERIA

The Mahdi was a self-proclaimed prophet (Muhammad Ahmad bin Abd Allah, 1845–1885) who rose to prominence in 1881 in the region of Kordofan, Sudan. His followers committed themselves to austerity and joined him in opposing the Turco-Egyptian rulers who controlled the region at the time. A Sudanese fighter in the army of the Mahdi wore the patchwork and quilted coat illustrated here in the late nineteenth century (fig. 16.27). Quilting was not a common technique in

Africa, but it was found over a large geographic area from Mauritania to the Sudan. It was used to protect soldiers and their horses from spears, knives, and arrows. Layers of padded cloth were stitched together in ways that gave a pattern to the garments. The patchwork also found in shirts worn by the Mahdi's followers symbolized austerity. Contrasting bright colors made the outfits—and the warrior—highly visible.

For centuries, women of the Kabyle, a Berber group in Algeria, made beautiful textiles, jewelry, and hand-built earthenware oil and water containers. In the period 1750 to 1900, such jars continued to be decorated with colored oxides and kaolin and covered with a resinous glaze that turns the white kaolin to yellow. The whole was overlaid by black geometric designs that were both decorative and protective. The mid-nineteenth-century water jug illustrated here is shaped like a female torso (fig. 16.28), decorated with colored designs similar to the tattoo patterns favored by Kabyle women. While male potters in urban North Africa had been using potter's wheels for a millennium, rural women built pots by hand, either with the coiling method or using molds, as they did in sub-Saharan Africa.

The period 1750–1900 was one of great change and turmoil in much of Africa: the slave trade ended; the period of European colonization began; and aspects of Africa's material culture were drastically altered with these new foreign contacts. The decorative arts inevitably went through many developments in this period as new materials were incorporated, tastes took new directions, and the balance of wealth and power shifted. There are nevertheless surprising continuities. Africa's many artisans, from potters and weavers, to carvers, leather workers, and metalworkers, responded to change in unique ways. They and their patrons, from high status rulers to ordinary people, drew upon their knowledge and inherited practices and selected elements from foreign cultures that fit in with their aesthetic sensibilities. While no traditions remained static, seldom was there a complete break with the past. African decorative arts, like African music, language, religions, and beliefs, kept in touch with ancient practices and adapted them to a shifting world.

ENID SCHILDKROUT AND CAROL THOMPSON

Fig. 16.27. Quilted armor, Sudan, late 19th century. Cotton, fiber padding; 54⁵⁄₁₆ x 51³⁄₁₆ in. (138 x 130 cm). Trustees of the British Museum (Af1899,1213.1).

Fig. 16.28. Jug, Kabyle, mid-19th century (before 1868). Earthenware, kaolin, colored oxides, resin; H. 11 in. (28 cm). Victoria and Albert Museum, London (31:42-1868).

EUROPE

Fig. 17.21

EUROPE 1750–1830

By the mid-eighteenth century, rising household wealth, improvements in manufacturing, and an expanding middle class gave European consumers access to greater quantities and a wider range of goods and styles. Yet as the choices proliferated, many feared that standards were in jeopardy as autocratic courts lost influence to vibrant but potentially unruly urban milieus. The debates were not merely aesthetic, and in a period that saw revolutions in France and independence movements in parts of Europe and the Americas, discussions about style were increasingly seen to intersect with social and cultural politics.

Prompted in part by archaeological explorations and publications, many designers sought reassurance in the Greco-Roman past, spawning the self-conscious antique revivals often termed Neoclassicism. Others championed medieval and vernacular styles as ways to promote traditional and, increasingly, national values. At the same time, Europe's growing overseas trade increased the awareness and appeal of Chinese, Ottoman, Persian, and "Hindu" objects and ornaments, while a growing cult of sensibility encouraged individual experimentation and challenged inherited social and aesthetic rules. By the early nineteenth century, European design was shaped by a complex interplay of classical nostalgia, romantic nationalism, the lure of the exotic, and appeals to unfettered nature and emotion. Eclecticism was strong, and many designers were skilled at working in several modes.

Changes in taste coincided with changes in the ways objects were produced and distributed. Although skilled hand labor continued to account for most manufactures, an increase in factory-type production and the rise of new craft processes helped erode traditional guild and apprentice regulations. In furniture making or goldsmithing, for example, autonomous craftsmen gave way to larger units of production headed by entrepreneurs who united various specialist workers under one roof. Transformative inventions like the steam engine and the spinning machine—technologies at the heart of the "industrial revolution"—joined a steady flow of new machines into craft workshops, including drop presses and lathes for stamping and spinning silver, and cylindrical rollers for printing textiles. Although elite patrons continued to place individual commissions, products were increasingly made for wider local, national, and international markets, as momentum shifted from older courtly centers in Italy and Spain to dynamic commercial economies such as Britain, France, and Prussia.

FRANCE

Although 1750 is often taken as the threshold of Neoclassicism, the Rococo remained popular well after mid-century. Painter François Boucher (1730–1770), a favorite of Louis XV's mistress the marquise de Pompadour (1721–1764), continued to produce idyllic pastorals widely adapted in tapestries (both large-scale hangings and smaller versions for upholstery fabrics), snuffboxes, and ceramics. Pompadour was also a supporter of the porcelain manufactory at the château de Vincennes (established in 1740), which she persuaded Louis to move to Sèvres and purchase in 1759. A rival to Meissen (see fig. 11.38), Sèvres produced mainly soft-paste goods, including ornamental flowers, mantel garnitures, and dinner services with vivid grounds of apple green, turquoise blue, and "Pompadour" pink.

The Turinese bronzeworker Jean-Claude Duplessis, père (c. 1695–1774), expanded the factory's range, modeling vases with elephant-head candle arms, and potpourri containers conceived as men-of-war complete with cannons, portholes, shrouds, and reticulated rigging to diffuse the scent (fig. 17.1). Although the form may reflect renewed pride in France's navy during the Seven Years' War (1756–63), the decoration—pink and green with chinoiseries or peasant scenes inspired by Flemish painter David Teniers II (1610–1690) or deep blue with pebbled gilding and vignettes of exotic birds—seems apolitical. Perhaps the message of this Rococo version of the medieval *nef,* or ship-shaped spice box, was that France's prestige now rested in part on technically excellent luxury goods.

Pompadour was also among the first to order furniture in a new vein, including comparatively plain, straight-sided mahogany commodes (chests of drawers) in a "Greek style" partly inspired by contemporary English designs. This rising *goût antique*, with its "manly" emphasis on rules and historical pedigree, seemed to distill Enlightenment ideals of logic, rationality, and civic order, in contrast to the license and fantasy that critics often associated with the influence of women. A new interest in antique Greco-Roman models was promoted by passionate connoisseurs like Claude-Nicolas Cochin, who saw a return to ancient models as a cure for Rococo "ignorance" and "vulgarity," and the Prussian scholar Johann Joachim Winckelmann (1717–1768), who argued that moderns could become great only by imitating the ancients. These ideas resonated with students at the French Academy in Rome (established by Jean-Baptiste Colbert in 1666), including the painter Louis-Joseph Le Lorrain (c. 1714–1759). While still in Italy, Le Lorrain applied his study of ancient remains to designs for fireworks platforms in the form of archaic-looking temples and triumphal arches. On his return to Paris, he

found a sympathetic spirit in Ange-Laurent de La Live de Jully (1725–1779), a rich collector, diplomat, and amateur etcher who, like his friend Pompadour, admired furniture from the age of Louis XIV (see, for example, fig. 11.21).

About 1756, La Live commissioned Le Lorrain to design a suite consisting of a shell cabinet (*coquillier*), matching desk, filing cabinet, chair, clock, and inkstand, all in a strongly architectural mode with bold Neoclassical ornaments. The desk, executed by Joseph Baumhauer in ebony veneer with brass inlay (fig. 17.2), featured straight legs modeled on fluted columns, lion-paw feet, and heavy ropelike garlands. The Boulle-inspired ormolu (gilt-bronze) mounts by Philippe Caffieri I (1634–1713; son of Jean-Jacques Caffieri) included oversized scroll and fret (or "Greek-key") moldings and a lion's skin that seems to propose La Live as a modern Hercules. Much as the contemporary Belgian architect Jean-François de Neufforge (1714–1791) described his own furniture designs as recapturing "the masculine, simple, and majestic manner of ancient Greek builders," La Live's heroic desk was conceived as an antidote to the "feminized" Rococo.[1]

By the mid-1760s, design "à la grecque"—in the Greek manner—had spread to all kinds of objects from dishes and jewelry to fabric, hairstyles, and even shop signs. "Vasemania"—a pervasive fascination with ancient urns—inspired luxury vessels including the Sèvres factory's deep-blue *vase à bâtons rompus* ("snapped sticks," 1765), decorated with pseudo-Greek fretwork, oak garlands, and angular

handles, and the twenty-two fluted tureens made in Paris by Flemish goldsmith Jacques-Nicolas Roettiers for a 3,000-piece service ordered by the Russian Empress Catherine (r. from 1762) in 1775 as a gift for Count Gregory Orloff. Both shapes were probably created by Étienne-Maurice Falconet (1716–1791), a sculptor who served as head of design at Sèvres (1757–66) before traveling to St. Petersburg to create a colossal equestrian monument to Peter the Great. But when the fad for all things Greek threatened to spread too far, it was satirized by Ennemond-Alexandre Petitot (1727–1801), a former enthusiast, in engravings for a Greek-style "masquerade" (Parma, 1771) depicting soldiers, shepherds, and even newlyweds with torsos deformed into antique pillars and vases.

French patrons and designers who found the *goût grec* too extreme, including many who had never been to Italy, much less Greece, soon developed the more refined classicism associated with Louis XVI (r. 1774–93). The finest productions in that manner—by *bronziers* like Pierre Gouthière (1732–1813) and the young Pierre-Philippe Thomire (1751–1843), *menuisiers* (woodworkers) such as Georges Jacob (1739–1814) and Jean-Baptiste-Claude Séné (1748–1803), and *ébénistes* (cabinet-makers) including Martin Carlin (c. 1730–1785), Jean-Henri Riesener (1734–1806), and Adam Weisweiler (1744–1820)—tempered antique models with modern notions of elegance, comfort, and convenience. The *marchands-merciers* again led in inventing or recombining products for the burgeoning

luxury trade. Beginning in 1758, merchants Simon-Philippe Poirier and his successor Dominique Daguerre (d. 1796) ordered custom porcelain plaques from Sèvres painted with floral baskets and bouquets (or, later, copies of old masters), to be incorporated into stands, desks, and writing tables by the German-born Carlin. A tulipwood writing table by Carlin from the mid-1780s (fig. 17.3) exemplifies the tiptoe stance and jewel-like mounts, here featuring roses, morning glories, strings of pearls, and hearts, of refined Louis XVI design.

Carlin's table also indicates the growing taste for portable furniture (*meubles volants*, literally "flying furniture"), including specialized tables for dressing, drawing, writing, or gaming, that could be rearranged to supplement a room's fixed commodes and formal suites of seating. Some, like Carlin's, were themselves metamorphic. Opening the drop front reveals two small drawers once fitted with writing implements, while raising the porcelain top, with its retractable candle stands (accomplished via gilded knobs activating hidden wheels and ratchets), forms an adjustable rest for letters, books, or music

that could be further tilted and rotated to catch the light. Such mechanical furnishings embodied the "work of leisure" embedded in French high society, challenging (and allowing) elite consumers to demonstrate both technological sophistication and social poise by gracefully navigating luxurious domestic machines.

Other new furniture types, such as the *servantes* (dumbwaiters), small stands shown holding plates and bottles beside a table in draftsman Jean-Michel Moreau le Jeune's *Intimate Supper* (1781), a print in his *Monument du Costume* series, replaced potentially intrusive servants. The role of objects as social catalysts is patent in the 1758 novella *La Petite Maison* by Jean-François de Bastide, whose virtuous but impressionable heroine bet on her ability to resist the sumptuous furnishings of the marquis de Trémicour's love nest. Powerless against its luxuries—lilac-colored paneling, sconces of Sèvres porcelain, a silver toilette set by Thomas Germain—her resolve gradually weakened until she "shuddered, faltered, sighed, and lost the wager."[2]

Fig. 17.2. Louis-Joseph Le Lorrain. Writing table (*bureau plat*) with filing cabinet (*cartonnier*) for Ange-Laurent de La Live de Jully, Paris, c. 1756. Cabinetmaking attributed to Joseph Baumhauer, mounts by Philippe Caffieri. Oak, ebony veneer, brass inlay, gilt-bronze mounts, leather; bureau, 34¼ x 76⅝ x 42⅜ in. (87 x 194.7 x 107.5 cm); cartonnier, H. 61¹³⁄₁₆ (157 cm). Les Collections du musée Condé, Chantilly (OA357).

(about 9 m) gas chandelier incorporating a mirrored star, strands of pearls and rubies, and lotus flowers of tinted glass, all suspended from the claws of a flying dragon. The jewel-like fixture created, according to one observer, "in mid-air, a diamond blaze. Its effect is magical: it enchants the senses, and excites, as it were, a feeling of spell-bound admiration."[7] Such unbridled magnificence did not appeal to everyone. Russian princess Dorothea Lieven complained in 1822 that there was "something effeminate" in evenings spent "half-lying on cushions" amid "perfumes, music, liqueurs," reminding us that the Orientalist fascination with "the East" embodied fears of, and desires for, the forbidden.[8]

ITALY

Italy was a primary destination on the Grand Tour, as visitors from throughout Europe arrived seeking instruction, edification, and entertainment, along with souvenirs. In Venice, visitors might attend the theater and opera, visit gambling houses and private *conversazioni* (social gatherings), or sip coffee in piazza San Marco, a square reputedly praised by Napoléon as Europe's finest "drawing room." Like tourists everywhere, they profited from their travels by purchasing distinctive local specialities, which in Venice included blown glass from the island of Murano, lace from Burano, painted ivory snuff-boxes and pastel portraits by the famed Rosalba Carriera (1675–1757), or perhaps a new wardrobe of clothing made with imported luxury textiles. Aesthetically minded Grand Tourists were particularly eager to acquire topographical *vedute* (urban or landscape views), some in the form of paintings by Canaletto and Guardi, others as painted fans, largely anonymous products whose carved sticks sometimes featured other local motifs including those from the commedia dell'arte. Souvenir fans were not limited to Venice: one example, made around 1770 in Naples, had compelling images of the renewed eruptions of Vesuvius; a poem compared the nocturnal views of the glowing volcano with the emotional fires fanned by an unfaithful lover (fig. 17.13).

The treasures of the Uffizi gallery drew tourists to Florence, where visitors could buy copies of the most famous

antiquities in the form of porcelain figure groups created at Marquis Carlo Ginori's Doccia factory (founded 1735) after models by Florentine sculptors Massimiliano Soldani (1656–1740) and Giovanni Battista Foggini (1652–1725). Mythological centerpieces and devotional scenes were often brightly painted, whereas reproductions of Roman imperial busts or of the famed Medici statue of Venus—some at life size—were kept white. All were listed in detailed catalogues and stocked at the factory's Livorno warehouse.

In Naples visitors flocked to the ruined cities of Herculaneum and Pompeii, buried by the eruption of Vesuvius in AD 79. Rediscovered in 1738 and 1748, they offered an unparalleled glimpse of Roman domestic life, including far more colorful interiors than hitherto imagined. Choice wall panels were detached from the excavations and displayed at Portici palace alongside ancient bronze furniture, statues, jewelry, table silver, kitchen implements, and even fabrics preserved by the volcanic mud and ash. Although the Neapolitan authorities prohibited visitors from making notes or drawings, sketches circulated, alongside a few published engravings, offering potent templates for Neoclassicism.

The Neapolitan court was just as interested in modern innovations, and the 1738 marriage of King Charles III of Bourbon (r. in Naples 1734–59) to the "porcelain princess" Maria Amalia, daughter of Augustus III of Saxony, prompted him to found a royal porcelain manufactory in the palace garden at Capodimonte in 1743. Besides producing table services, snuff boxes, and walking-stick handles, the manufactory became known for paintings of animals and battle scenes and for groups of local characters—fish mongers, *pizzaioli* (pizza makers), and beggars—modeled by Giuseppe Gricci on the lines of the realistically clothed *pastori* (shepherds) in Neapolitan *presepi* (crèche scenes). Capodimonte's triumph was the colorful porcelain room in the Royal Palace of Portici (1757–59), sheathed from floor to vault with chinoiserie scenes set amid a trellis of vines and musical trophies, an experiment Charles replicated in Madrid after assuming the Spanish crown in 1759 (discussed below) and transferring the factory to the palace of Buen Retiro.

Charles's son Ferdinand IV revived Capodimonte in Naples in 1773, and in 1785 the manufactory produced an "Etruscan" dinner service as a gift to England's George III. More archaeologically exact than contemporary projects at Sèvres, the set (modeled by Filippo Tagliolini, d. c. 1812) included shapes like those found at Pompeii and Herculaneum, with applied red-figure decoration. The gift was accompanied by illustrated notes on sources and provenance.

Rome remained an essential stop on the Grand Tour, offering ample ancient and modern models for the perfection of taste. Many travelers had already been inspired by the influential and widely diffused topographic etchings of Giovanni Battista Piranesi (1720–1778), a Venetian printmaker, architect, and designer who canonized an image of the "Eternal City." After training in Venice, where he made designs for Rococo-style interiors, pulpits, and ceremonial barges, Piranesi settled in Rome in 1747, concentrating on large-format views of ancient and modern landmarks. By the 1760s, his ardent vision of Roman grandeur had captivated

Fig. 17.13. Souvenir fan with views of Vesuvius, Naples, c. 1770. Vellum, imitation lacquer, ivory, tortoiseshell; span, 19⅝ in. (50 cm). HA Collection, The Fan Museum, London.

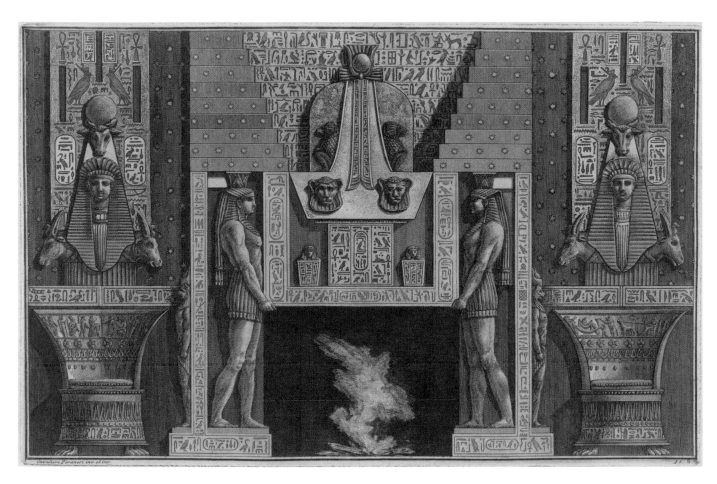

Fig. 17.14. Giovanni Battista Piranesi. Egyptian-style chimneypiece, from *Diverse Maniere d'adornare i cammini*, 1769. Etching; 9¹³⁄₁₆ x 15³⁄₁₆ in. (25 x 38.5 cm). The Metropolitan Museum of Art (41.71.1.20 [20]).

northern students like Le Lorrain and Robert Adam but drew him into escalating polemics with those who, like Winckelmann, promoted a more austere image of Greek classicism. At stake was not just national pride but whether designers and artists should view antiquity as a free and open library to stimulate their creativity or as a slimmer anthology of extracts to be copied verbatim.

The debate came to a head in the *Parere sull'architettura* (Opinion on Architecture, published 1765), a Platonic dialogue in which Piranesi defended inventive eclecticism against a "timid" purism. He demonstrated this approach graphically in a book of designs entitled *Divers manners of ornamenting chimneys and all other parts of houses taken from the Egyptian, Tuscan and Greek architecture* (1769, published in Italian, English, and French; fig. 17.14), which applied a dazzling array of ancient-inspired ornaments to mantelpieces, clocks, coaches, and other modern conveniences without precedent in antiquity itself. Although few designers made exact copies of Piranesi, his early embrace of Egypt—realized in decorations for Rome's popular Caffè degli Inglesi—sparked a vogue for archaeological models in design that may have encouraged the addition of colossal Egyptian granite telamons (male figures used on or as supports) to the entrance of the Vatican's new Pio-Clementino museum of ancient sculpture around 1780. That arrangement was itself echoed in Roman domestic furnishings, such as faux-granite pier tables with telamon legs, and an Egyptian-style hardstone table clock by the papal goldsmith Giuseppe Valadier.

Continuities between large and small also characterized micromosaics, another Roman specialty that addressed both tourist and domestic markets. Mosaic workshops had been founded at the Vatican in the sixteenth century to translate the damp basilica's canvas altarpieces into a more durable medium. As those large commissions dwindled, the mosaicists branched out to miniature compositions made of tiny tesserae (tiles) cut from vitreous filaments available in 20,000 shades. First shown around 1775 at the studio of papal mosaicist Giacomo Raffaelli (1753–1836) in the tourist zone near the piazza di Spagna, diminutive scenes of animals, mythological figures, ancient buildings, and Roman *vedute* were soon applied to jewelry, snuff boxes, perfume flasks, and table tops. By 1795 the Vatican studio was producing secular subjects, including an 1823 table by Michelangelo Barbieri depicting a naked Cupid (later purchased by Czar Nicholas I) inspired by Petrarch's *Trionfo d'amore*. Examples of the new craft were sent to the Capitoline Exhibition of Roman Arts and Industry of 1810 and, in 1851, to the Italian display at the Great Exhibition in London.

Italian and foreign patrons alike acquired reductions of Rome's principal ancient ruins and remains in a variety of materials and forms. Beginning in 1785, Giovanni Volpato offered authorized reproductions (to decorate tables and fireplaces) of sculptures from the city's private and papal collections, crafted in unglazed (or biscuit) porcelain, an ideal means to evoke the off-white color and fine texture of ancient marble. Ancient intaglio gems (made by carving a hollow or negative design) could be reproduced by casts or impressions in colored glass, sulphur, plaster, or wax, not to mention authentic-looking gems and cameos produced by modern carvers—including some meant to deceive.

Fig. 17.15. Vincenzo Coaci. Inkstand, Rome, 1792. Silver, silver gilt, lapis lazuli, rosso antico marble; 28½ x 20½ x 14¾ in. (72.4 x 52 x 37.5 cm). Minneapolis Institute of Arts (69.80.1a,b).

One specialty popular from mid-century involved the use of cork to imitate weathered stones and brick in architectural models. The Venetian patrician Filippo Farsetti (1703–1774) purchased several cork models as examples for art students alongside plaster casts of ancient and modern sculpture. The landgraves of Hesse-Kassel and Hesse-Darmstadt each acquired all thirty-six architectural subjects offered by cork craftsman Antonio Chichi (1743–1816), including the Arch of Titus, the Pantheon, and the Forum of Augustus. Far more precious materials—lapis lazuli and gilt silver—were used to create a clock in the form of Trajan's Column presented by Pope Pius VI to the visiting Grand Duke Paul of Russia in 1782, an idea that spawned imitations in alabaster, malachite, and ormolu.

Roman goldsmith Vincenzo Coaci pursued a similar idea a decade later in an inkstand (fig. 17.15) commissioned to commemorate Pius's removal and installation of an Egyptian obelisk from Augustus's mausoleum to the piazza in front of the popes' summer palace, an ambitious project that involved rotating two colossal ancient statues of the Dioscuri and adding a Bernini-inspired fountain. A concealed drawer in the inkstand housed writing implements, while flower baskets supported by four Piranesian sphinxes (not present in the monument itself) concealed candleholders. Coaci's boldest touch was a hidden mechanism that effortlessly swiveled the statues between their present and former positions. Crowning the pope's desk as the new monument crowned Rome's highest square, this gigantic inkstand confirmed that Italian Neoclassicism allowed room for grand gestures.

SPAIN AND PORTUGAL

In Iberia, the Bourbon and Braganza courts set patterns of design and consumption emulated by the peninsula's elite. The accession of Ferdinand VI of Spain in 1746 accentuated the trend toward French modes, while the arrival of his half-brother Charles III (r. 1759–88) from Naples in 1759 renewed the influx of Italian craftsmen and designers. These included the painter and decorator Matteo (known in Spain as Matías) Gasparini, who directed the Royal Workshop of Cabinetmaking, Bronzes, and Embroideries (1765–74). For the king's private dressing and audience chamber (the "Pieza de Vestir" or "Pieza de Parada," now known as Salón de Gasparini; fig. 17.16), Gasparini combined French forms, northern European craftsmanship, and Italian expressiveness. Swirling floral scrolls in the polychrome marble floor recur in the mantelpieces, mirror frames, and Louis XV-style armchairs and settees veneered in rare woods by the Flemish cabinetmaker Joseph (José) Canops in the 1770s, with gilt-bronze mounts by the Italian Giovanni Battista (Juan Bautista) Ferroni. Similar curves are carried upward in the luxuriant tendrils of the embroidered silk wall hangings and upholstery, designed by Matteo Gasparini and made by Luisa Bergonzini and Antonio Gasparini, but not installed until 1815. These culminate in brightly painted flowering vines in the stucco vault, rendered in such high relief that they nearly suffocate the sculptured chinoiseries at the four corners of the room. The search to create a unified visual environment, often identified by the German term *Gesamtkunstwerk* (total work of art), is also reflected in the two porcelain rooms created for Charles III in Madrid and at the palace of Aranjuez, which culminate trends modeled at Versailles and epitomize the international Bourbon court style.

Like his French ancestors, Charles saw economic and aesthetic benefits to royal manufactories, which formed part of his comprehensive program of enlightened reform and centralization. Their products included both necessities designed to supply popular markets and luxuries that, as one French diplomat noted, "prosper in the shadow of the throne and add to its éclat."[9] Outside Philip V's Versailles-inspired summer palace of La Granja de San Ildefonso, near Segovia, for instance, Charles founded a linen manufactory to boost local employment and reorganized the glassworks established by his predecessor. From 1770 to 1810, under new French and Swedish leadership, the factory produced mirrors (including those for the Salón de Gasparini) and high-quality enameled, engraved, and/or gilded vessels in Venetian and Neoclassical modes. Charles's desire to promote Spanish manufactures also lay behind his transportation, lock, stock, and barrel, of the Capodimonte ceramic works (discussed above) to the Buen Retiro. Together with the private manufactory founded in 1727 by the ninth Count of Aranda at Alcora, near Valencia, the Buen Retiro porcelain manufactory stepped into the void left by the decline in popularity of Talavera earthenwares, both at home and in Spain's American possessions. By mid-century, the Alcora workshop was specializing in Rococo designs executed in fine creamware (*tierra de pipa*) and soft-paste porcelain, while Buen Retiro produced porcelain decorative and table objects in an increasingly Neoclassical vein.

With the accession of Charles IV (r. 1788–1808) and his wife Maria Luisa of Parma, the "antique" style triumphed as these two Francophiles commissioned the extensive redecoration and construction undertaken by court architect Juan de Villanueva (1739–1811). As Prince and Princess of Asturias, they favored contemporary themes, stipulating that modern entertainments and clothing (as opposed to pastoral scenes) be featured on sixty-three tapestries designed from 1774 by Francisco Goya (1746–1828), then working for the Royal Tapestry Factory of Santa Bárbara. Adapting a genre associated with French painters Watteau, Boucher, and Fragonard, Goya and his brother-in-law Francisco Bayeu, the factory's director, designed scenes of merriment and relaxation populated by characteristically dressed and readily recognizable *Madrileños* from all walks of life, including flamboyant *majos* and *majas* (members of the lower classes distinguished by elaborate dress, manners, and comportment).

As king and queen, Charles IV and Maria Luisa sought out French artisans and designers, luring Jean-Demosthène Dugourc (1724–1825), former Dessinateur du Garde-Meuble de la Couronne under Louis XVI, to Madrid in 1800 and commissioning Percier and Fontaine to provide a mirrored "Platinum Room" (1800–1806), complete with furnishings, for the small but sumptuous Casa del Labrador or "Farmer's House" on the grounds of Aranjuez. The court's attachment to a delicate, Louis XVI-style Neoclassicism—rather than Napoléon's incipient Empire style—can be seen in Dugourc's designs for

delicate wooden marquetry and embroidered silks, often woven in Lyon, France. One such fabric created for the pavilion's main room, a yellow-and-blue damask "overembroidered" with figures of Jupiter, Juno, jugglers, dancers, and putti on a reddish background, was used to adorn the walls and to upholster twenty-four "Etruscan"-style chairs likely crafted in the royal workshops in 1801 (fig. 17.17). Befitting the Bourbon patrons, these motifs were copied from engravings of antiquities at Herculaneum. So too was the splat's inlaid "red-figure" frieze, an effect simulated with various shades of wood. Yet the taut, concave figure eights, so integral to the chair's design, added an Iberian gloss by evoking tortoiseshell hair combs (*peinetas*) worn by modern Spanish women.

In Portugal, the devastating Lisbon earthquake of 1755 spurred the Marquess of Pombal, the enlightened first minister of Dom José I (r. 1750–70), to rebuild the ruined capital as a commercial showpiece. A sworn enemy of the Jesuits, whom he expelled from Portugal in 1759, Pombal announced his reformist project in part by embracing the Rococo style, a preference visible in his patronage of deluxe scientific instruments, the decoration of new buildings at the University of Coimbra (from 1772), and the colorful *azulejos* (architectural tiles) the marquess used in his own garden. Influential British merchant communities in Lisbon and Oporto, known for its wine trade, inspired local craftsmen to copy English teapots, tea urns, and related items, and to adapt published furniture designs by Chippendale and others. Their products

Fig. 17.16. Matteo Gasparini. Dressing room and audience chamber of Ferdinand VI, Palacio Real de Madrid, largely completed 1774–86.

often betrayed distinctive Portuguese variations, including chairs and tables with unusually deep aprons or skirts, and settees conceived as elongated armchairs with multiple splats, both features that were also popular in Ibero-America. Other British-inspired forms crafted in Portugal, such as card tables and slant-topped desks (*papeleiras*), featured lustrous Brazilian hardwoods and Mudéjar-style ivory inlay.

More distinctively Portuguese were the gem-incrusted brooches and pendants popularized after the discovery of diamonds in Brazil in 1729. Often worn in sets, many featured elaborate bows studded with blooms or inlaid with precious emeralds, garnets, or amethysts (fig. 17.18). Even in more modest pieces such as this breast ornament, the ribbon is almost lost among roses, tulips, and pendant drops formed by a profusion of pavé-set quartzes (placed close together, like cobblestones) and pink topazes faceted in the new brilliant cut (with multiple facets on the crown to increase fire) and backed by reflective foil. The colonial dominance signaled in these jeweled flowers proved short-lived, however. In 1808, Iberia was invaded by the armies of Napoléon, putting the Bourbons to flight in France and Italy, while the Braganzas escaped with their court to Brazil. The bloody guerilla war that followed devastated the peninsula's economy and hastened the independence of its American possessions.

CENTRAL EUROPE

Central Europe embraced the Rococo well past 1750, pursuing new extremes of distortion and asymmetry. Unlike in France, the style was favored in sacred as well as secular contexts. At the Bavarian pilgrimage church of Wies (completed in 1754), the brothers Dominikus (d. 1766) and Johann Baptist Zimmermann (d. 1758), master masons and stuccoworkers, fused structure and ornament in the bright, oval nave, syncopated with sculptural confessionals, side altars, organ cases, lectern, and pulpit inlaid with mirror glass symbolic of divine illumination (fig. 17.19). In the narrower, tunnel-like narthex, gleaming columns of red scagliola (imitation marble) magnified the wounds on a venerated icon of the flagellated Christ, drawing pilgrims toward an ecstatic vision of rapture and redemption. German palace interiors were equally theatrical, including the octagonal *Kaisersaal* (Imperial Hall, 1752) at Würzburg, designed by Balthasar Neumann for the prince-bishops of Franconia, in which gilded plaster draperies set amid clouds of scagliola part to reveal historical frescoes by Giovanni Battista Tiepolo (1696–1770). Less formal residential rooms, such as the so-called Green Trellis Chamber at Prince-Bishop Adam Friedrich von Sensheim's Schloss Seehof near Bamberg (about 1764), strove to bring the garden indoors with naturalistically carved and painted settees, chairs, and laticework wall brackets invaded by scrolling vines.

Some German dining tables could also be perceived as pleasure gardens. Between 1759 and 1765 Friedrich Wilhelm von Westphalen, Prince-Bishop of Hildesheim, ordered a thirty-place service from Augsburg goldsmith Bernhard Heinrich Weye (1701–1782) that followed the newly popular *service à la française*, in which diners helped themselves from

Fig. 17.17. Design attributed to Jean-Demosthène Dugourc. Armchair (*silla de peineta*), probably made in the Royal Workshop of Cabinetmaking, Madrid, 1801. Carving by Gabriel Blanco. Mahogany, Spanish lime, ebony, boxwood, modern upholstery; 35⅞ x 23⅝ x 18⅞ in. (91 x 60 x 48 cm). Patrimonio Nacional, Madrid (10003353).

Fig. 17.18. Breast ornament, Portugal, 1750–1800. Silver, quartz, pink topaz; 5 x 2¹⁵⁄₁₆ in. (12.7 x 7.5 cm). Museu Nacional de Arte Antiga, Lisbon (361 Joa).

symmetrical arrangements of dishes. Although the service was entailed to the bishopric, its decoration was purely secular. The central trio of cruet and spice, and fruit stands, for example, took the form of lacy pagodas sheltering bands of exotic musicians wearing loincloths and feather headdresses (fig. 17.20). This conception evoked real garden structures such as the trefoil-shaped "Chinese tea house" built for Frederick the Great on the grounds of Sanssouci at Potsdam between 1755 and 1764, where full-sized, gilded Chinese figures sipped tea and played music beneath an undulating roof supported by columns shaped as date palms.

The exotic could also carry political overtones. Just as Frederick's teahouse linked him to China's learned scholar-emperors, Empress Maria Theresa's contemporary Vieux-Laque Zimmer (Old Lacquer Room) at Schönbrunn Palace in Vienna combined Asian black-lacquer panels with family portraits by Pompeo Batoni (1708–1787), celebrating a "global" dynasty whose control stretched from the Tyrol to Transylvania. That message was intensified in the nearby Millionenzimmer, whose imported rosewood paneling was inset with Mughal miniatures, cut out and recombined into vignettes that evoked the multicultural Habsburg empire.

By 1780, most wealthy Central European patrons had embraced Neoclassicism. Marie-Antoinette's older sister, Archduchess Marie Christine (1742–1798), announced her wish to follow fashion in the exquisite, Parisian-inspired silver service crafted in Vienna by Ignaz Joseph Würth (act. 1770–1800) for her wedding that year to Prince Albert of Sachsen-Teschen, marked by richly sculptural fluting and antique-inspired rinceaux. For others, including key Enlightenment thinkers, the philosophical component of the new classicism was paramount. In 1755 Winckelmann saw Greece's social and political liberty as the source of its pure and perfect art; in 1777 the writer and biologist Johann Wolfgang von Goethe represented the idea of Good Fortune in an "altar" for his garden at Weimar in the form of a simple sphere (representing the eternally mobile) atop a cube (representing the eternally stable).

In Vienna, Maria Theresa's successor, Joseph II (Holy Roman Emperor from 1765–90), embarked on a comprehensive program of civic and ecclesiastical reform that brought him into conflict with Rome. When commissioning a silver coffee pot from another member of the Würth dynasty, he chose a plain and stripped-down geometric style with no added ornament except a modest monogram. Expressive as this vessel seemed of Joseph's rationalist policies, simplicity and moderation were also part of a highly fashionable aesthetic.

Ideals of restraint and rationality were embodied in the early nineteenth-century style now known as "Biedermeier" after a fictional country schoolmaster. The name means something like "stolid Mr. Smith" and came to stand for the unpretentious bourgeois values prevalent in central and northern Europe between the Congress of Vienna (1815) and the revolutions of 1848. Social historians interpret the new emphasis on domesticity and sobriety as a rebuke of aristocratic values. In design, "Biedermeier" has come to signify an emphasis on shape over ornament and an appreciation of simple forms and the inherent beauty of materials.

Fig. 17.19. Dominikus and Johann Baptist Zimmermann. Interior of the church of Wies with plaster and scagliola "flying" pulpit, Steingaden, Bavaria, executed 1746–54.

Fig. 17.20. Bernhard Heinrich Weye. Centerpiece from the table service of the Prince-Bishop of Hildesheim, Augsburg, 1761–63. Silver; 28⅜ x 28¾ x 23¼ in. (72 x 73x 59 cm). Bayerisches Nationalmuseum, Munich (81/216).

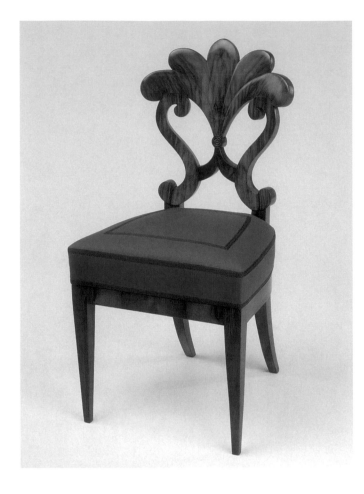

Fig. 17.21. Josef Danhauser. Side chair, Vienna, 1815–20. Walnut, modern upholstery; 36¹³⁄₁₆ x 19¹⁄₁₆ x 18⅞ in. (93.5 x 48.5 x 48 cm). Art Institute of Chicago (1987.215.4).

Hepplewhite in 1788) into a rudimentary palmette. Upholstery reflected a new preference for bold colors, stripes, and crisp edges. Some Biedermeier sofas entirely concealed their wooden frames, presenting only a geometric array of cushions.

Despite the emphasis on simplicity, many Biedermeier designs had a strong sensory appeal. Danhauser's chair, one of 153 patterns offered by the Danhauser company, eschewed heavily taxed imports like mahogany in favor of local, attractively figured, often light-colored woods like maple or poplar. In Bohemia, a taste for naturalistic patterning fueled the invention of colored hyalith glass, an opaque glass that sometimes resembled porcelain, in the 1820s, culminating in Friedrich Egermann's 1828 patent for "Lithyalin" glass, which replicated the swirling grain of agate or petrified wood. Luxurious-looking glass products, often cut with simple facets, were exhibited at manufacturing fairs in Prague and Vienna and appealed to budget-minded consumers. Yet Biedermeier was not simply a middle-class style; its "bourgeois" values appealed across the social scale from Stockholm to Budapest, appearing in aristocratic salons as well as modest apartments.

Berlin was an important center of Biedermeier culture in which urbanization and industrialization took place in tandem. Karl Friedrich Schinkel (1781–1841), a painter, designer, and architect, played a key role in adapting historical and contemporary styles for commercial production. Prussia's Royal Iron Foundry had been established in 1795, and Schinkel was particularly interested in developing cast-iron and zinc products ranging from statuary and bridge railings to paperweights, stoves, and neo-Pompeiian garden furniture. His research (which sometimes bordered on industrial espionage) took him to Britain in 1826, where he admired the famous Coalbrookdale Bridge, opened in 1780 as Europe's first cast-iron structure, as well as Nash's experiments with iron domes, columns, and staircases at Brighton's Royal Pavilion (discussed above).

Many Biedermeier designs echoed Neoclassical or Empire forms, minus the carving and ormolu. These traits are visible in a relatively modest chair made in the late 1810s in the workshops of Josef Danhauser, a leading Viennese furniture producer (fig. 17.21). The tapering legs and rails are without moldings, while the simplified splat abstracts a Prince-of-Wales's ostrich plume (probably taken from an English pattern book published posthumously by the widow of George

Fig. 17.22. Factory of Johann Conrad Geiss. Parure, Berlin, 1820–30. Cast iron, steel, gold; necklace, 18¾ x 1⅜ in. (47.5 x 3.6 cm). Nordiska museet, Stockholm (NM.0091972A-F).

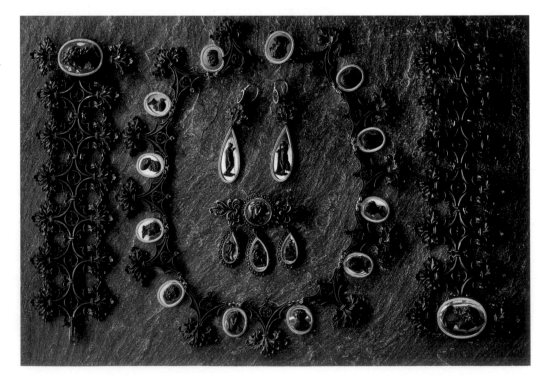

During the Napoleonic wars, iron came to demonstrate patriotism: Schinkel designed the now-famous German Iron Cross as military decoration, while the king encouraged Prussian women to exchange their gold and silver jewelry for iron substitutes. Dramatic refinements in casting helped propel Berlin iron, or *fer de Berlin* as it was known, into a global fashion statement. Johann Conrad Geiss (1771–1846) crafted particularly delicate parures, or jewelry sets, that complemented Neoclassical dresses while answering Biedermeier values (fig. 17.22). Their bold filagree combined Greco-Roman cameos evoking Mediterranean classicism with Gothic tracery and foliage recalling the Teutonic medieval heritage, thereby elegantly embodying the twin cultural ideals of German nationhood.

RUSSIA AND SCANDINAVIA

By the late eighteenth century, the balance of power in the Baltic had shifted toward Russia, which acquired territory from Poland and the Ottoman Empire from the 1770s, captured Finland in 1809, and defeated the French invasion of 1812. The German-born Empress Catherine II ("the Great," r. 1762–92) overthrew her Russian husband and modeled herself on Peter the Great (1682–1725), forging links with Western intellectuals, artists, architects, and designers. Whereas her predecessor, Elizabeth (r. 1741–62), had favored a magnificent late-Baroque style for the (Fourth) Winter Palace in St. Petersburg (1754–62, designed by Paris-born architect Bartolomeo Francesco Rastrelli), Catherine embraced Neoclassicism and sought out talents like the Italian architect and designer Giacomo Quarenghi (1744–1817) and the Scot Charles Cameron (1745–1812). The latter's 1772 treatise on ancient Roman bath buildings prompted the empress to give Cameron the commission for her Agate Pavilion at Tsarskoe Selo near St. Petersburg (completed in the 1780s) with Neoclassical interiors interpreted in Russian and Finnish alabaster, lapis lazuli, malachite, agate, jasper, and porphyry.

Catherine's love of the glyptic arts spurred her to order decorative vases, bowls, obelisks, columns, and tables from Peter's gem-cutting workshop and to send prospecting expeditions to the Ural mountains (1765) and the Altai region (1786), discovering over two hundred new deposits of ornamental stones. Catherine was equally fond of the marquetry-inlaid mahogany desks, tables, harpsichords, and cabinets crafted in the workshops of the enterprising German cabinetmaker David Roentgen (1743–1807) at Neuwied on the Rhine. Roentgen made at least five visits to Russia beginning in 1784, sending vast shipments of furniture to the court. All provided raw material for additions to Tsarskoe Selo and the new summer palace of Pavlovsk (1782–94), designed and decorated for Catherine's son Paul (r. 1796–1801) by Cameron and his Italian assistants Quarenghi and Vincenzo Brenna (1745–1820). With its soaring Roman rotunda and furnishings including antique statues, Gobelins tapestries, Savonnerie carpets, and 200 giltwood chairs, sofas, and beds executed in Paris by Henri Jacob to Cameron's designs (1782–86), Pavlovsk announced Russia's full participation in western modes.

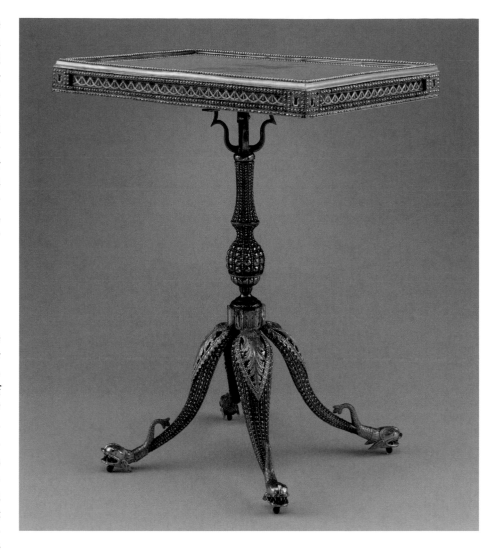

A distinctive local twist to the popular Neoclassical style is visible in a glittering steel table made in early 1780s at the Imperial Armory in Tula, south of Moscow (fig. 17.23). Although the pedestal form recalls French and British tea tables, its use of sparkling steel embellished with silver inlay, gilded copper alloys, and a mirrored top is uniquely Russian. Peter had founded the armory in 1712 to provide weapons for his wars of expansion. After the Peace Settlement of 1721, it also produced civilian luxury products ranging from portable items like jewelry, writing sets, candelabra, samovars, yarn swifts, and umbrella handles, to furniture, including toilet tables, folding chairs, and fireplaces. Tula craftsmen exploited steel's strength to make their products as thin and light as possible, bluing the surfaces to greenish purples and opalescent pinks and studding them with diamond-like nailheads faceted with hundreds of hammer blows. Catherine purchased some of the factory's finest products during visits in 1775 and 1787, storing them in her Chamber of Rarities. Indeed, Tula furniture rarely left Russia except as diplomatic gifts or in imperial dowries. The table illustrated here was used at Pavlovsk in the bedroom of Empress Maria Feodorovna (r. 1796–1801), who gave it to her brother-in-law as a memento.

Russian classicism took a new turn under Paul's successor Alexander I (r. 1801–25), patron of grandiose structures in St. Petersburg like the stock exchange (begun 1804), a Doric design by the French-born, Italian-trained architect and furniture designer Thomas de Thomon (c. 1754–1813), or the

Fig. 17.23. Russian Imperial Armory. Center table, Tula, c. 1780–85. Steel, silver, gilt copper and brass, basswood, replaced mirror glass; 27½ x 22 x 15 in. (69.9 x 55.9 x 38.1 cm). The Metropolitan Museum of Art (2002.115).

monumental Admiralty building (1806–15) designed by the St. Petersburg native Andreyan Zakharov (1761–1811). The Russian Empire style was reflected in imposing architectonic furnishings in burled Karelian birch, perhaps inspired by Roentgen's example, including towering bookcases and desks with multiple stories, marble columns, and domes, as well as matching scroll-armed or klismos-legged chairs.

After an 1803 fire, the Pavlovsk summer palace was redecorated by architect and painter Andrey Voronikhin (1759–1814), who designed archeologically inspired furniture painted to resemble gilt and patinated bronze, with zoomorphic forms (winged gryphons, eagles, and sphinxes), somewhat in the manner of those in Thomas Hope's mansion (discussed above). Voronikhin also provided Pavlovsk with colorful *athéniennes* (tripod stands) inspired by ancient perfume burners and consisting of cut-glass cups, or tazzas, on transparent blue or topaz-colored legs fabricated in St. Petersburg's Imperial Glass House. The inventive Neapolitan-born architect Karl Rossi (1775–1849), who succeeded Voronikhin at Pavlovsk in 1815, also exploited stark contrasts of color and materials. He favored simpler forms, however, in light-colored Russian poplar, walnut, maple, or birch (sometimes smoked or ebonized) with Greek-inspired foliate or floral accents in gilt or patinated bronze, an effect imitated in less lavish settings with inlays of citrus wood.

As under Peter, Russia's cosmopolitanism was slower to penetrate outside court circles, although the effects were felt even in popular and provincial milieus. One humbler sign of Westernization was the distinctive faience produced in and around the village of Gzhel, near Moscow, where Afanasy Grebenshchikiv established Russia's first private faience manufactory in 1724. By mid-century village, kilns were producing inexpensive and colorful ceramics designed to compete with local pewter and copper wares. Besides candlesticks and inkwells, Gzehl offered *kumgans*, disk-shaped pitchers for fermented mare's milk, and *kvasniks*, millstone-shaped ewers with a central hole, four squat legs, thin spout, and lidded funnels for serving an alcoholic cider brewed from rye bread (fig. 17.24). While the tin-glaze decoration was inspired by imported Delftware, the color scheme recalled seventeenth-century Russian enamels.

Besides adding dates and inscriptions, potters enlivened the *kvasniks* with painted or molded vignettes of rural Russian life, including strutting roosters, hunting parties, musicians, monasteries, and costumed villagers. Something of the same national pride was expressed at elite levels in the series of figures of "The People of Russia"—folk counterparts to Meissen's actors and aristocrats—produced at the Imperial Porcelain Manufactory (1799–1804), inspired by Johann Gottlieb Georgy's *Description of All Peoples Inhabiting the Russian State, as Well as Their Daily Rituals, Beliefs, Customs, Clothing, Dwellings, and Other Memorabilities* (1776, published in Russian, French, and German).

In Scandinavia, Neoclassical design was also tied to cultural and political reform. In Sweden its main proponent was the Francophilic King Gustav III (r. 1771–92), an enlightened autocrat determined to modernize his largely agricultural realm by encouraging commerce and manufacturing, limit-

ing the power of the nobility, expanding religious toleration, and establishing new cultural institutions. Gustav designed a new national costume for both the nobility and middle classes based on Renaissance styles associated with his hero, the French monarch and reformer Henry IV (r. 1589–1610). The king was equally interested in Italian and English innovations. While on a Grand Tour in 1783–84, Gustav paid multiple visits to the new Vatican Museum. This experience convinced him to plan similar galleries in a vast new palace at Haga, near Stockholm, designed by the French painter and court architect Louis Jean Desprez (1743–1804) and set in a vast landscape park studded with fountains, columns, obelisks, and garden follies.

Swedish interior planning had been revolutionized by Carl Johann Cronsted and Fabian Wrede's invention of an improved tiled stove (1767) that helped transform traditional Swedish halls into French-style salons for year-round use. At Haga, Desprez's design team planned the elegant King's Pavilion (fig. 17.25; c. 1790) as a Swedish version of the Petit Trianon. Wall decorations inspired by Pompeiian grotesques and Raphael's Vatican Logge surmounted a pale blue, Wedgwood-inspired frieze depicting events from the Swedish-Russian war (1788–90), while the chimneypiece featured native porphyry from the local polishing works Gustav was promoting. The seating, executed by Eric Öhrmark (1747–1813) to designs by the French-born painter Louis Adrien Masreliez (1748–1810), introduced a chair form based on the Greek *klismos* with its flaring, saber-shaped legs and curved backrest, as depicted in ancient wall paintings and vases. Haga and other Gustavian interiors were distinguished by subdued color palettes (in contrast, for example, to Robert Adam's brighter ones) featuring grays, whites, and pale blues that, together with wooden floors, brought an element of restraint to otherwise opulent ensembles and facilitated the style's adoption by middle-class patrons.

Although the *klismos* form was popular throughout Europe by the late eighteenth century, it reached its purest expression in Denmark in a beechwood chair designed in the early 1790s by the painter and architect Nicolai Abraham Abildgaard (1743–1809, fig. 17.26). Abildgaard, like Masreliez, had studied in Rome and wished to invoke the antique. But whereas Masreliez did little more than add saber legs to upholstered Louis XVI-style chairs and sofas, Abildgaard—inspired by Greek vase painting—created starkly linear designs of uncompromising Hellenism, with blue-stained wicker seats, bronze-toned gilding, and ornamental bolts reflecting his belief that Greek *klismoi* were made of metal. In 1794, Abildgaard designed a similar Greek-style throne for Levetzau Palace at Amalienborg, seat of the Danish Heir Presumptive. Abildgaard's spare and sober interior suggests how in Scandinavia, as in Napoleonic France, classicism had become more than a style—it was a mark of political, cultural, and moral authority. Indeed, the linkages between design and larger ethical and economic questions would only increase after 1830, as European designers, producers, and consumers grappled with balancing rapid industrialization and changing aesthetic and social ideals.

JEFFREY COLLINS

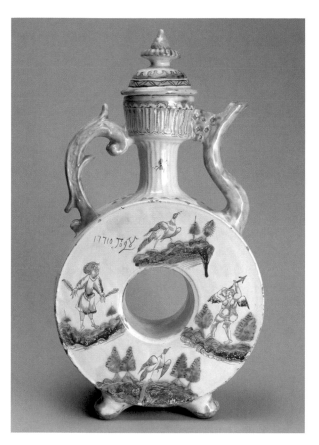

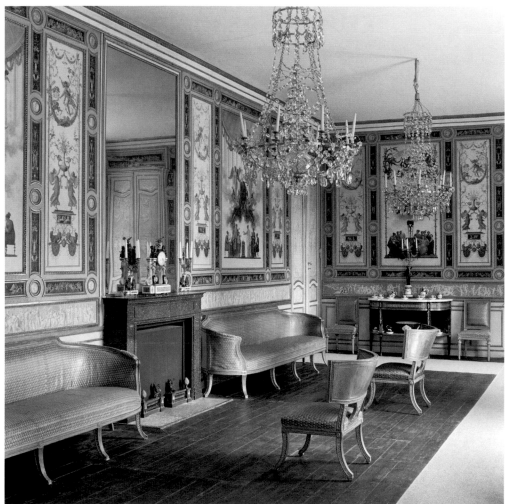

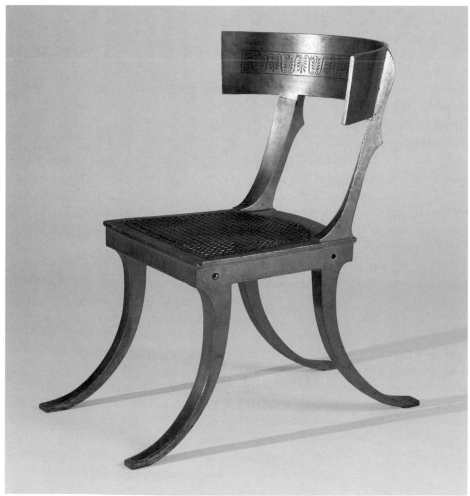

Above left: Fig. 17.24.
Jug (*kvasnik*), Gzhel,
1770. Tin-glazed
earthenware; H. 18½ in.
(47 cm). The State
Hermitage Museum,
Saint Petersburg.

Left: Fig. 17.26.
Nicolai Abraham
Abildgaard. *Klismos*
chair, Copenhagen,
early 1790s. Gilded
beech, cane; H. 35 in.
(89 cm). Designmuseum
Danmark, Copenhagen
(KIM 1320).

Above right: Fig. 17.25.
Louis Jean Desprez.
Grand Salon, King's
Pavilion, Haga, c. 1790.
Wall painting and
seating designed by
Louis Adrien Masreliez,
seating furniture made
by Eric Öhrmark.

EUROPE 1830–1900

Between 1830 and 1900, European decorative arts embodied many of the possibilities and contradictions of a so-called industrial age. Decorative arts industries, though closely tied to elite aesthetic traditions, also endeavored to exploit new technologies and materials to lower costs and appeal to new consumers. Large areas of production, however, continued to be unmechanized, with certain design and craft traditions remaining vigorous and others undergoing revivals. Some people saw industrialization as inherently progressive, a beneficent fruit of science, while others viewed the same industrialization and *laissez-faire* capitalism as culturally destabilizing, a threat to local crafts and folk traditions, and, at worst, inhumane. They decried the overcrowded cities, unprecedented pollution, unsavory labor practices, and increasing subdivisions of labor within the workplace that British novelist Charles Dickens claimed turned human beings into "hands."

Both enthusiasm for new technology and discontent over the effects of mechanization and the increasing division of labor helped renew interest in older craft traditions and the ornamental strategies of preindustrial societies, reinvigorating thinking about design, production, and consumption. The decorative traditions of nonindustrialized cultures of past and present, Western and non-Western, provided alternative ways of thinking about design and production. Primitivist ideas of untutored creativity, often a counterpoint to the view of contemporary society as overcivilized, were widely influential, from the Gothic Revival to Japonisme and Art Nouveau.

Production and consumption expanded, spurred on by a middle class that sought new products in unprecedented quantities, and improved transportation and communications hastened and widened the circulation of goods and designs. International exhibitions and illustrated publications drew public attention to design and decorative arts. Design continued to shape expressions of nation, class, and gender, and notions of the exotic, as well as of modernity and the past through revival styles. Designers who looked to the past for inspiration were often just as intensely engaged with the present as those who self-consciously rejected the past in their search for more overtly contemporary form. Design also achieved unprecedented visibility as a bearer of political values throughout Europe—in newly formed nations, such as Belgium (1830), Italy (1861), and Germany (1871); in places seeking independence, such as Finland or Hungary; and in realms with longer histories such as Britain, France, and Russia. The association of national character with particular visual forms, whether ancient Greek and Roman, Medieval, Renaissance, Rococo, or a fanciful combination, stimulated lively debates. Many of the styles and ideas were international in range yet acquired highly national and regional expression.

MECHANIZATION, NEW MATERIALS, AND TECHNIQUES

The sharp rise in patents from the 1820s and 1830s reflected the contemporary fascination with novelty, innovation, and the use of new materials and techniques. The idea of increasing production through subdividing labor was not new, but its application accelerated in this period in both hand and machine production. The degree of machine production and subdivisions within the manufacturing process varied from country to country, trade to trade, and product to product. Britain, the first country to industrialize, was known as the "workshop of the world" in the mid-nineteenth century, although only about half of the goods produced there were made by machine. In high-quality work, there was often little incentive to invest in expensive machinery because, even by the late nineteenth century, skilled workers in decorative arts industries could produce as good or better quality work as quickly, or almost as quickly, as machines. Equally, at cheaper levels of production, abundant and inexpensive adult and child labor undermined interest in such investment. Even when machines were used, hand finishing frequently remained important, as it does in the twenty-first century.

Britain, France, and Belgium, the most industrialized countries in Europe before the 1870s, led the way in decorative arts production, and in the 1860s and 1870s, the pace of industrialization speeded up in countries such as Sweden, Russia, and Italy. After unification in 1871, Germany sought to develop a strong manufacturing base and capture markets from Britain and France, but craft and folk traditions also remained strong, as they did in the countries least quick to industrialize, especially Spain and Portugal in the south, Norway and Iceland in the north.

TEXTILES AND WALLPAPERS

The only decorative arts industries that were extensively mechanized in this period were textiles and wallpaper, primarily produced in Britain and France, and a pronounced rivalry existed between the two countries, especially in printed cotton production. Britain often led in terms of technology, but French designs generally were considered superior, at least until the design reform movements of the second half of the century. The mechanized printing of patterns onto cotton fabric by means of engraved copper cylinders began in the 1820s and 1830s. The colors were stabilized by steam, as opposed to the time-consuming process of vat-dyeing. By 1860, machines could print up to eight colors simultaneously. The two main centers of this industry were Lancashire in Britain (the city of Manchester was known as "Cottonopolis") and the French Alsace region which, even after it was ceded to Germany following the Franco-Prussian War (1870–71), retained close ties with French buyers and manufacturers. Indeed, the independent design studios that flourished in Alsace not only

Fig. 17.27. W. & E. Orme. Commemorative textile panel, England, c. 1851. Glazed, roller-printed cotton; 15½ x 20 in. (39.5 x 53.3 cm). Victoria and Albert Museum, London (T.12-1951).

sold patterns to French and German manufacturers but also to those from Britain, Russia, Austria, and the United States.

By the late nineteenth century, printed cotton production had tripled in Britain, and finished goods from both France and Britain were exported in large quantities within Europe as well as to the United States, India, and Africa.

Extant fabrics and manufacturers' sample books attest to an enormous seasonal variety. Furnishing cottons often depicted topical, historical, allegorical, and genre scenes, while dress fabrics tended to feature an array of naturalistic and stylized flowers and foliage as well as abstract and geometric patterns. Although dress and upholstery cottons accounted for the bulk of production, commemorative panels were also produced, including views of the Great Exhibition of 1851, held in London (fig. 17.27). The designer of the cloth illustrated is not known, as is often the case. The floral framing is reminiscent of textile designs whereas the image of the building was probably based on one of the many engravings and lithographs of the Crystal Palace, which, in itself, stood for the potential of standardized components of glass and iron.

Cottons and other fabrics were affected by the introduction of mineral-based dyes in the 1820s and 1830s, followed in 1856 by synthetic (or aniline) ones that encouraged brighter palettes and rapidly led to the demise of natural (plant- and animal-based) dyes. Britain and France were the first to produce synthetic dyes on a large commercial scale, but by the late 1870s, German dyes accounted for half of the total world production. The bright saturation of "Perkin's purple" (1856), the first commercially produced synthetic dye, named after British chemist Henry Perkin who patented it, largely accounts for the vogue for mauve that was popularized in the 1860s by both Britain's Queen Victoria (r. 1837–1901) and the French Empress Eugénie (see fig. 17.36).

Wallpapers became widely affordable after a four-color steam-powered printing press capable of producing up to four hundred rolls of continuous paper was patented in Britain in 1839. Each color was applied on a separate roller, the relatively narrow width of which dictated the scale of the design repeat. The crudeness of the printing process meant that patterns had to be simple, as for example the vertical stripes popular for papers and fabrics between the 1840s and 1860s. Eight-color printing was available from 1850 and twenty-color by the mid-1870s, with ready-to-use wallpaper paste available in the 1890s. By 1900, wallpaper was one of the most popular household furnishing products in Europe and North America.

Expensive hand-printed papers with complex designs continued to be made throughout the period. France led the field. Large capital investment was required for the grandest. Réveillon & Cie. produced *Vues d'Amérique du Nord* (Views of North America, 1834), a sequence of five murals designed by artist Jean-Julien Deltil (1791–1863), featuring 223 different colors, while a scenic paper designed by Antoine Dury (1819–c. 1896) for the Délicourt firm, *La Grande Chasse* (The Great Hunt, 1851), required four thousand blocks to achieve its deep illusionistic spatial effects (fig. 17.28). At a time when rooms were increasingly allocated specialized uses, wallpaper could quickly add a particular character. Scenic wallpapers were often used in dining rooms, a relatively new space in the middle-class home, and hunting scenes were considered suitable for a room devoted to eating. Deeply carved ornament adorned formidable sideboards laden with serving sets and china. Images of game, wheat sheaves, and cornucopia of fruits and vegetables on objects, walls, and ceilings reflected and reinforced the abundance of the host's table and perhaps also of the system that made it possible.

EUROPE

SUBSTITUTES FOR CARVING AND PRECIOUS METALWORK

The renewed interest in carving and ornament from the 1820s and 1830s led to attempts to undercut the price of hand carving by using machines or molding soft materials, including papier-mâché (pulped paper), in imitation of carving. Production of the latter greatly increased after 1847 when Britain's Jennens and Bettridge (1816–64) patented a process whereby pulped paper was softened by steam, shaped in heated metal molds, and heat dried. Papier-mâché manufacturing flourished across Europe, particularly in France, Britain, Germany, and Russia. Not sufficiently strong enough for furniture unless produced in conjunction with wood or metal, it was generally used for smaller items, and in the second half of the century, the prices of ornamental mirror and picture

frames, ceiling centerpieces, and moldings made this way were a mere third the cost of hand-carved equivalents. Papier-mâché tea caddies, workboxes, trays, and fire-screens, especially those featuring shimmering mother-of-pearl, "japanning" in imitation of Asian lacquerwork, gilding, and shiny varnished surfaces, added glamour to middle-class homes (fig. 17.29). The Asian references in this example were strengthened by the basket-weave pattern while the laid-in shapes drew on Islamic carpet designs (see "Exoticism" below).

Several carving machines were patented in the 1840s, but they were more like routers and required extensive hand finishing, making them uneconomical for most work. They were best suited to large expanses of woodwork, such as that produced for the New Palace of Westminster in London (1834–68), designed by Sir Charles Barry (1795–1860) and Augustus Welby Northmore Pugin (1812–1852). Nonetheless, in the last quarter of the century, leading furniture firms in the more industrialized cities of Europe employed such machines to rough out the design before skilled carvers took over. Other machines were used for preparatory processes such as the cutting and planing of wood and the slicing of ever-thinner veneers, the cost of which dropped dramatically after the invention of steam-powered circular saws in the 1830s. By 1850, machines could cut fourteen veneers from a single inch of wood whereas most hand cutters only managed about six. As costs fell, veneers from expensive woods, including rosewood, were seen more often on furniture aimed at middle-class consumers.

The cost of decorative metalwork was dramatically reduced from the 1840s with the introduction of electroplating and electrotyping. Both processes used an electrical current to embellish objects, but the latter allowed for creating finely detailed three-dimensional objects entirely through electrochemical technology. In the second half of the century, many manufacturers across Europe and in North America used the cheaper, faster electroplating process patented in 1840 by the English firm of G. R. Elkington & Co. The company used electrotyping to create its more elaborate pieces, including objects copied from major European museums. Among those designing for Elkington were the French sculptors Léonard Morel-Ladeuil (1820–1888) and Auguste Willms (c. 1828–1899), and British sculptor John Bell (1811–1895).

In France, the leading fine metalworking firm Christofle & Cie immediately purchased rights to various processes and made a range of goods, from flatware to tea services, for middle-class consumers, as well as deluxe electrotype wares. Renowned for lavish designs, technical experimentation, and excellent reproductions, Christofle counted Emperor Napoléon III (r. 1852–70) among its clientele and employed well-known sculptors including Albert-Ernest Carrier-Belleuse (1824–1887), who modeled figural forms such as the life-sized one that was used for the electrotype candelabra on the grand staircase of the Paris Opéra (1861–75). Working for a variety of international manufacturers, Carrier-Belleuse created drawings and models for costly objects, such as clocks, jewelry, and coffee and tea services, as well as ceramic figural groups destined for middle-class consumers (fig. 17.30).

BENTWOOD FURNITURE

In the 1850s, German-born furniture maker Michael Thonet (1796–1871), then working in Vienna, patented a process for steam bending solid beech rods to create durable, lightweight chairs that could be mass-manufactured. Thonet had been experimenting with steam bending, lamination, veneers, and glues since the 1830s, collaborating with the Austrian firm Carl Leistler on designs for the Liechtenstein Palace in Vienna in the early 1840s. Thonet focused on standardized, often interchangeable parts, greatly reducing the price of furniture, especially chairs. The firm's No. 14 chair (1859) was the result of many adjustments in design. In its most popular form, it required only six beech rods—turned on a lathe and then steamed and bent under pressure—ten screws, and two washers, and it was packed unassembled for easy transportation (fig. 17.31).

The aesthetic appeal of No. 14 lay in the subtle swelling and attenuation of the legs and the paired curves of the crest rail and splat. It was also a commercial success, being used in cafés, hospitals, prisons, and public buildings, and as demand increased so did production as well as the range of bentwood designs. By 1865, just two Thonet factories in Moravia were making 150,000 items per year, and by 1900, outlets from Chicago to Moscow were selling a wide range of low-cost bentwood hat stands, cradles, rocking chairs, sofas, and other objects, all in various styles, particularly Renaissance Revival and Gothic Revival. After 1869, when the firm's patent on the bentwood process expired, other firms, including J. and J. Kohn of Vienna, also began producing bentwood furniture.

CAST AND BENT METALWORK

Improvements in metal casting meant that the intricacy of Gothic Revival and Neoclassical forms and ornament and the plasticity of naturalistic forms and Rococo Revival designs were readily captured in cast iron, a material that could be painted in imitation of wood or silver. The wide variety of objects made ranged from jewelry in Berlin (see fig. 17.22) to flowerpot stands by the Swiss firm Gebrüder Sulzer (1830–40), the railings around the Prince Gustav monument in Stockholm's Haga Palace Park (1854), and church pews from the George Smith foundry in Glasgow in the 1860s.

When the British Coalbrookdale Company, a major iron manufacturer in the eighteenth century, sought to extend its product range from iron bridges and rails, it looked to the domestic objects designed by the German architect-designer Karl Friedrich Schinkel (1781–1841) for the Prussian Royal Foundry. Around 1846, Coalbrookdale began producing a fruit dish with a gold finish from a Schinkel design of about 1820; the piece stayed in production until 1877. The quality of the casting suggests that the Coalbrookdale Company took a mold from a Prussian die made to Schinkel's design, but other Prussian designs produced by the British company, including garden furniture, were probably pirated. Such piracy points to the importance of design to capitalism and to the transnational flow of designs. The designer most closely associated with the Coalbrookdale's diversification was Christopher Dresser (1834–1904), a leading figure in the Aesthetic Movement (discussed below). Born and trained in Britain, he ran

Fig. 17.30. Albert-Ernest Carrier-Belleuse. Clock with a figure of Contemplation, Paris, 1860–67. Bronze-colored zinc, marble; H.10⅝ in. (27 cm). Victoria and Albert Museum, London (763:1, 2-1869).

Fig. 17.31. Michael Thonet. Chair *No. 14*, Gebrüder Thonet, Koritschan, Moravia, 1881 (designed 1859). Beechwood, cane; 36⅝ x 16¹⁵⁄₁₆ x 18¾ in. (93 x 43 x 47.6 cm). The Museum of Modern Art, New York (461.2008).

one of the most successful independent design studios of the era, which from the 1860s to the 1880s supplied Coalbrookdale with a range of designs, mainly for multipurpose hatstands and umbrella stands for the hall (fig. 17.32) and garden furniture.

The most ubiquitous metal furniture of the period, however, were bedsteads made from hollow brass rods. First produced in the 1820s, they became best sellers across Europe and the Americas, largely because they were cheaper and considered more hygienic than wooden ones. By 1875, demand was so great that the Birmingham area of England alone pro-duced nearly 300,000 per year, about half of which were exported. Most brass bedsteads were made from straight pieces of round hollow tubing, but some furniture forms were made from bent metal tubes. An upholstered seating suite in bent metal, designed by Rudolf Bernt (1844–1914) and made by August Kitchelt of Vienna, was shown at the opening exhibition of the Österreiches Museum für Kunst und Industrie in Vienna (1871) as an example of the union of "art and industry," meaning design and manufacture. By 1900, the Kitchelt firm had branches in Prague, Brunn (Brno), Bucharest, Trieste, and Constantinople (Istanbul).

DESIGN REFORM

From the 1830s, European governments increasingly recognized that better-quality design helped nations compete more effectively in lucrative international markets. Profits and national prestige fueled discussions about reforming design education, elevating public taste, and bringing together artists and designers with manufacturers. French aesthetics and British technology set standards of excellence, but both countries kept an eye on Belgian and Prussian products, particularly textiles, ceramics, and metalwork. Some pointed to artistic training as a reason for the success of French goods in foreign markets. After a recommendation by a British Parliamentary Select Committee (1835–36), a Government School of Design was established in London in 1837. The committee also recommended greater protection for patented inventions and designs, and the creation of museums and art galleries to raise public taste and exhibit to artisans and manufacturers examples of what was considered good design.

Under the guidance of Prince Albert (Prince Consort to Queen Victoria) and Henry Cole (1808–1882), a civil servant, the Society for the Encouragement of Arts, Manufactures, and Commerce (Royal was added to its title in 1847) began organizing competitions and exhibitions of goods manufactured in Britain, including everyday objects. Cole was an inventor and design reformer who espoused a version of Utilitarianism based on the philosophy that the most effective and ethical course of action was to maximize utility and produce the most good. His determination to raise the artistic level of products led him to examine Greek pottery at the British Museum and study production processes at Minton & Co. before designing a tea service with "as much beauty and ornament as was commensurate with cheapness."[1] He refused to cede the former to the latter, but cost could not be ignored. The Minton service won a Society of Arts medal and sold well for half a century.

In another effort to unite art and industry, Cole established the Summerly's Art Manufactures scheme in 1847, by which he (using the alias Felix Summerly) brokered collaborations between artists and manufacturers. Their collaborative work showed a strong literalness in the links between decoration and function. Indeed, such associations were a feature of many mid-century objects. The handle of a knife designed by painter and sculptor Richard Redgrave (1804–1888), for example, echoed in encaustic earthenware the foods eaten at

Fig. 17.32. Christopher Dresser. Hatstand, Coalbrookdale Company, Shropshire, c. 1880. Painted cast iron; 74¾ x 25⅝ x 8¾ in. (190 x 65 x 22.3 cm). Victoria and Albert Museum, London (M.22-1971).

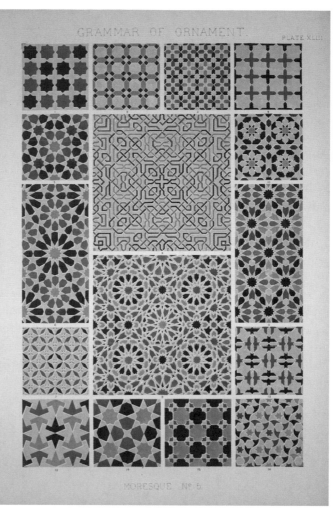

bourgeois dinner tables, while both the glass and porcelain versions of his *Well Spring* vase were decorated with painted rushes and tiny flowers thought appropriate for a vessel intended to hold flowers or rushes in water (fig. 17.33).

Cole and Prince Albert masterminded the Great Exhibition of the Works of Industry of All Nations in 1851 in London (sometimes called the Crystal Palace Exhibition), the first of a series of international exhibitions (see fig. 17.27). Triggered by French plans for the eleventh Paris Industrial Exhibition (1849), it provided an opportunity to take stock of the state of manufactured goods, display the benefits of industrial capitalism and free trade, and raise levels of public taste. The positivist emphasis on empirical knowledge meant that the material commodities shown were regarded as evidence of national productivity and taste, proof of a system able to provide both abundance and variety.

The London exhibition heightened competition among nations and among firms. Certain designs were widely copied or adapted, even in countries not officially represented at the exhibition, such as Sweden. Although the larger world exhibitions that followed were developed to display new materials and show off the latest processes, and machinery, they also demonstrated the continued importance of hand production and part-mechanized work. Many of the most widely admired goods were handmade, as for example the *La Grande Chasse* wallpaper (see fig. 17.28), which won a first prize in 1851, and the cabinet illustrated in figure 17.39.

In 1852, Cole was appointed superintendent of the Department of Practical Art, with responsibility for both the School of Design and the Museum of Manufactures established with profits from the exhibition. The museum, known as the South Kensington Museum from 1857 and the Victoria and Albert Museum from 1899, became an exemplar for museums of decorative arts across Europe and beyond, especially from the 1860s when other countries sought to emulate it as part of their programs of design reform.

Architect Owen Jones (1809–1874), who was one of the organizers of the 1851 exhibition, looked with dismay on many European objects and set out to establish universal principles of design appropriate to the modern world that, he believed, would raise design standards. His 1856 *Grammar of Ornament* drew on a wide array of sources in support of his call for "general laws" related to "the distribution of form in nature" (fig. 17.34).[2] Jones's ideas and illustrations helped popularize stylized forms and patterns, and contributed to a more scholarly understanding of non-European design traditions, including those of the Islamic world. Jones's view of design as an objective discipline based on the systematic analysis of nature, particularly plant forms, and his emphasis on other cultures, influenced designers such as Dresser, who had trained in botany as well as at the School of Design.

HISTORICISM

Nineteenth-century historicism—the revival, romanticization, and reinterpretation of the styles and forms of earlier periods—led to archaeological re-creations and interpretations of the past along with inventive combinations that drew on the past yet embodied distinctive features of the age. Most nineteenth-century revival styles were both national and international. In each case, theorists argued that the particular style, whether Gothic Revival, Renaissance Revival, Rococo Revival, or revivals of national vernacular traditions, was the most appropriate expression of indigenous cultural style and national identity.

Many Europeans believed that they had inherited the best aspects of past cultures and that these could inform the present. There was a strong tendency toward eclecticism, a plurality and mixing of styles. References to past cultures included those as recent as the eighteenth century. New seating forms, for example, such as the two-seat *causeuse,* or *confident,* or the three-seat *indiscret*, looked back to eighteenth-century furniture in the carved frame and cabriole leg, though their opulent shapes and larger scale were rooted in nineteenth-century preoccupations with comfort and social conventions. The mixture of old and new objects in the Grand Salon at the Château de Saint-Cloud, redecorated under the Empress Eugénie of France in the early 1860s, attests to the esteem in which eighteenth-century design was held (fig. 17.35). This room shows how a reverence for the past existed simultaneously with faith in the present. An *indiscret* is visible amid a balloon-back settee, armchairs, and a selection of eighteenth-century furniture set against the walls in an eighteenth-century manner.

As part of a concerted effort to associate with the monarchy of pre-Revolutionary France, Princess Eugénie collected furniture that had belonged to Marie Antoinette and pro-moted the revival of late eighteenth-century accessories such as fans, fichus, and bonnets. A fashion icon, she also helped popularize wide skirts worn over stiffened petticoats or ones with hoops inserted into them, generally known as crinolines (fig. 17.36). The mass production of cheap petticoats as well as lightweight, cagelike understructures of flexible metal hoops held together by vertical tapes (patented in 1856) brought this fashion within the reach of middle-class consumers. Contemporary criticisms included charges that crinolines (and the women wearing them) took up too much physical space, be it on city streets or in hot air balloons, and that such undergarments restricted the activities of those who wore them, though "cage crinolines" meant that women could move their legs more freely than when wearing the heavy petticoats previously necessary to achieve a similar shape.

GOTHIC REVIVAL

The term "Gothic Revival" describes the eighteenth- and nineteenth-century interest in medieval culture, which affected both religious and secular design. While elite collectors and scholars studied and debated the architectural survivals of the medieval past, middle-class consumers could purchase objects such as chairs, inkwells, lanterns, and jewelry embellished with details from medieval architecture: pointed arches, finials, crockets, and quatrefoils. From the 1830s, there was greater emphasis on archaeological correctness. British architect-designer A. W. N. Pugin was a key figure in the Gothic Revival movement. His *Contrasts; or, A Parallel between the Noble Edifices of the Middle Ages, and Corresponding Buildings of the Present Day* (1836) argued that the art and design of a society was a reflection of its morality. For him, medieval design embodied honesty and Christian virtue, qualities he felt lacking in the modern world. His *True Principles of Pointed or Christian Architecture* (1841) critiqued his earlier Gothic Revival furniture while offering new exem-

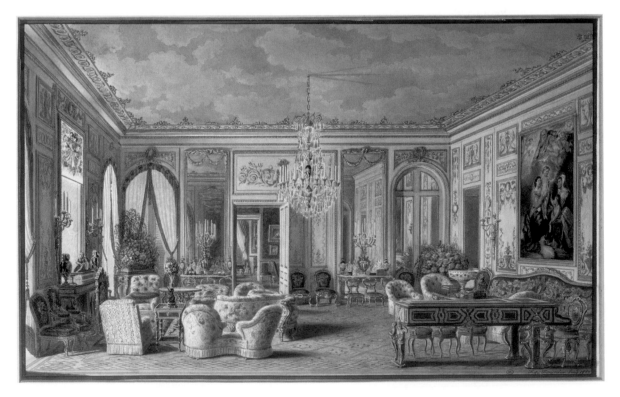

Fig. 17.35. Jean-Baptiste Fortuné de Fournier. The Grand Salon, Château de Saint-Cloud, France, c. 1863. Watercolor; 12⅛ x 17¾ in. (31 x 45 cm). Musées nationaux du Chateau de Compiègne (C.72D.2).

Fig. 17.36. Jules David. Fashion plate, for *The Englishwoman's Domestic Magazine*, London, 1860. Hand-colored lithograph; 6⅜ x 10½ in. (16.3 x 26.7 cm). Victoria and Albert Museum, London (E.267-1942).

plars. But objects did not have to be archaeologically accurate to evoke the medieval period and resonate with those who used, or aspired to use, them. Indeed, many of Pugin's own designs were as inventive as they were "authentic."

Pugin contributed to the New Palace of Westminster and the Medieval Court at the 1851 exhibition. In them, his more serious approach to Gothic design and assured use of pattern, color, and ornament was everywhere apparent. Objects of Pugin's design in the Medieval Court included metalwork by the company headed by John Hardman Jr. (1811–1867) and an armoire made by the firm led by John Gregory Crace (1809–1889), to whom Pugin paid homage in the piece itself by including heraldic-style shields referring to the Crace family (fig. 17.37). Although the armoire, which served as the center-piece of the Medieval Court, was based on the most elaborate surviving examples of medieval carved furniture, especially French cupboards, Pugin reconfigured the central section as bookshelves. The piece was selected for inclusion in the collection of the Museum of Manufactures as a model of excellent construction and carved detail.

The Stones of Venice (1851–53) by art critic John Ruskin (1819–1900) was a key text for the second half of the nineteenth century, particularly the chapter on "The Nature of Gothic," which drew parallels between the artistic, political, and moral demise of Venice after the Gothic period and the problems of modern Britain. The book inspired much work in the revived Gothic style and fostered greater appreciation of medieval craftsmanship. Ruskin judged the arts by the freedom of expression allowed the maker and considered the imperfections of medieval work as evidence of the humanity of the process. He denounced the perfections of both antique handwork and modern machine production as the outcome of slave labor.

Eugène Emmanuel Viollet-le-Duc (1814–1879), the leading French theorist of the Gothic Revival, believed that Gothic was a supremely rational architectural system and an ideal model for modern design. He also championed new materials associated with the industrial age, particularly iron. A prolific writer and historian, he published an influential architectural dictionary, portfolios of drawings, scholarly lectures, and a six-volume study of French medieval furniture, the *Dictionnaire raisonné du mobilier français* (1858–75). While historical precedents inspired his own designs, he

Fig. 17.37. Augustus Welby Northmore Pugin; drawing by H. Michael. Armoire for the Great Exhibition, London, 1851. Pencil and watercolor; 10½ x 13⅜ in. (26.3 x 34.1 cm). Victoria and Albert Museum, London (D.1050-1886).

Fig. 17.38. Eugène
Emmanuel Viollet-le-
Duc and Edmond
Clément Marie Duthoit.
Hanging cabinet
for the Château de
Roquetaillade, France,
1869. Painted and
gilded wood; 76¾ x 50 x
16½ in. (195 x 127 x
42 cm). Château de
Roquetaillade, Mazères.

RENAISSANCE REVIVAL

The association between the cultural accomplishments of the Renaissance and its aesthetic forms served national, political, and cultural ambitions in almost every European country in the second half of the century. In France, objects displayed at the Paris World's Fair in 1867 such as a two-part cabinet by Henri Auguste Fourdinois (1830–c. 1894), whose furniture firm was known for fine design, workmanship, and materials and for large-scale, architectonic forms, embodied the values of the Second Empire (1852–70), a period of economic expansion, increasing nationalism, and absolutism under Napoléon III (fig. 17.39). The two-part form, pediment, paired columns, niches, and references to Apollo and Diana invoked sixteenth-century French Renaissance design, but the hearty dimensions and abundance of decorative carving and inlay exemplify the nineteenth-century Renaissance Revival. The sphinxes in the lower register, emblems of Fecundity and Peace in the pediment, Roman mythological figures of Mars and Minerva in the niches, and central panels with reliefs depicting Apollo and Diana above and the Arts below, all directed the educated viewer to make associations with the learned culture and artistic excellence of the Renaissance. Other countries revived or reinvented their own national renaissances. The Flemish Renaissance Revival, a romantic

stressed that forms should correspond to modern needs. With his partner Edmond Duthoit (1837–1889), Viollet-le-Duc designed a Gothic Revival château near Bordeaux (1856–69), interiors and furnishings included. A hanging armoire conceived for this project evoked a medieval example published in his dictionary of French furniture (fig. 17.38). The crenellations, finials, and decorated panels recall the older model, but the form itself—a hanging cabinet with a small shelf and turned brackets—indicates the importance of displaying possessions in the nineteenth-century house.

Viollet-le-Duc's scholarly studies of medieval buildings and artifacts also made him the most renowned "restorer" of his era. Like George Gilbert Scott (1811–1878), who "improved" many Britain churches and cathedrals, however, Viollet-le-Duc's efforts were often destructive of the existing fabric. Restorations that sought to re-create new-looking, idealized versions of the past were declared "forgeries" by British design reformers and activists such as William Morris (1834–1896) and Philip Webb (1831–1915), who established the Society for the Protection of Ancient Buildings (SPAB) in 1877 so that the material heritage of the past might be better protected and conserved for future generations. Its manifesto was translated into French, German, Dutch, and Italian, and it intervened in major cases abroad, including an 1879 proposal to rebuild St. Mark's Basilica in Venice and the 1881 proposals for the "restoration" of the Great Mosque in Jerusalem. The SPAB approach to protection remains the basis of contemporary conservation polices. Morris and others were also interested in safeguarding the environment, and the last decade of the century saw the establishment across Europe of associations that campaigned on such issues.

Fig. 17.39. Henri-
Auguste Fourdinois.
Two-part cabinet, Paris,
c. 1867. Ornamental
designs by Nivillier,
figure modeling by
Party, carving by Primo,
Maigret, and Hugues
Protat. Walnut,
bloodstone, lapis lazuli,
ivory, silver; 99⅝ x
56⅛ x 23⅝ in. (253 x
143 x 60 cm). Les Arts
décoratifs–Musée des
Arts décoratifs, Paris,
Paris (29921).

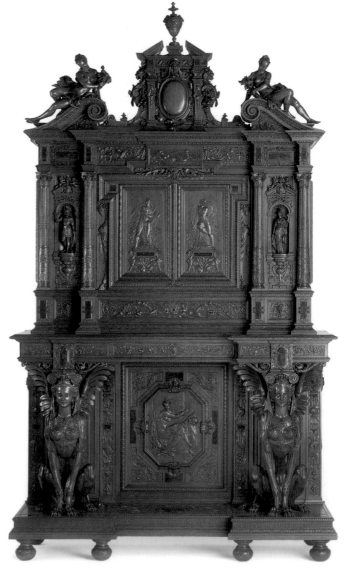

Fig. 17.40.
"Speisezimmer im Geschmack der Spaetrenaissance" (Dining Room in Late Renaissance Taste), from Georg Hirth, *Das deutsche Zimmer der Renaissance*, Munich, 1880.

reinterpretation of the Northern Renaissance that flourished in the fifteenth and sixteenth centuries, imaginatively reused combinations of historical motifs and forms for furniture, buildings, bronzes, ironwork, and other small objects.

Jacob Burckhardt's influential *Culture of the Renaissance in Italy* (1860) recast the Renaissance as a cultural and political model for the modern state. In the Gründerzeit (founding time) after German unification, a period of widespread speculation, industrialization, and debate about national identity, Renaissance forms were laden with political and social meaning. Designers seeking to symbolize the new modern Germany embraced the Renaissance as an expression of national ambition. The style was associated with restraint, harmony, and rebirth, values its champions anticipated in the new nation. The desire to throw off the artistic influence of France, its old enemy, made the Germanic late Renaissance especially appealing. Architect and designer Gottfried Semper (1803–1879), whose *Der Stil* (Style) was published in 1861–63, believed that style grew out of material conditions rather than personal taste and viewed the Renaissance as a virtuous, middle-class style appropriate for the new Germany. Others, such as Georg Hirth (1841–1916) and Jacob von Falke (1825–1897), who wrote important guides for interior decoration, created a body of criticism and imagery that proved influential for late nineteenth-century middle-class furnishings (fig. 17.40).

Ironically, the Renaissance Revival came later to newly united Italy (1861–71) where it quickly assumed nationalist associations and where its *Italianità* (or Italian-ness) was strongly asserted. The revival provided Italians with an image of virtue and morality while linking it with an esteemed national heritage. The critic Camillo Boito (1836–1914) and

others encouraged a tradition of Italian taste even as industrial methods of manufacture transformed the production of applied arts. Government-sponsored portfolios of historic works, published as models for contemporary manufacture, emphasized the Renaissance. Generally associated with "masculine" severity, Renaissance Revival was popular for public spaces and furnishings.

In Italian houses, the style was mainly connected with halls and dining rooms but also with "feminine" objects and pursuits such as women's clothing and needlework. Although most Italian lace was machine-made after 1840, collections of antique and handmade lace such as that of Crown Princess Margherita of Savoy encouraged the revival of lace collars and bodices as well as older designs. In the late nineteenth century, the Societa Aemilia Ars (Better Arts Society) in Bologna adapted Renaissance and Baroque lace and embroidery designs from printed sources, reproducing them by hand. To other Aemilia Ars needlework designs were added irises, orchids, and flowers popular at the end of the century.

The countries on the Iberian Peninsula revived their own historical traditions. In Portugal, production of *azulejos*, tinglazed tiles derived from Islamic Spain, which had been used extensively on exteriors and interiors of aristocratic Portuguese buildings in the early modern period, was revived in the nineteenth century. Returning from exile in Brazil in the 1820s and 1830s, the Portuguese court encouraged the use of tiles, and a number of tile-making factories established in the 1830s and 1840s in Oporto used mechanized decoration in a limited range of colors. In the 1880s, Rafael Bordalo Pinheiro (1846–1905) revived *azulejo* designs from the time of King Manuel I (r. 1495–1521), establishing a factory in Caldas da

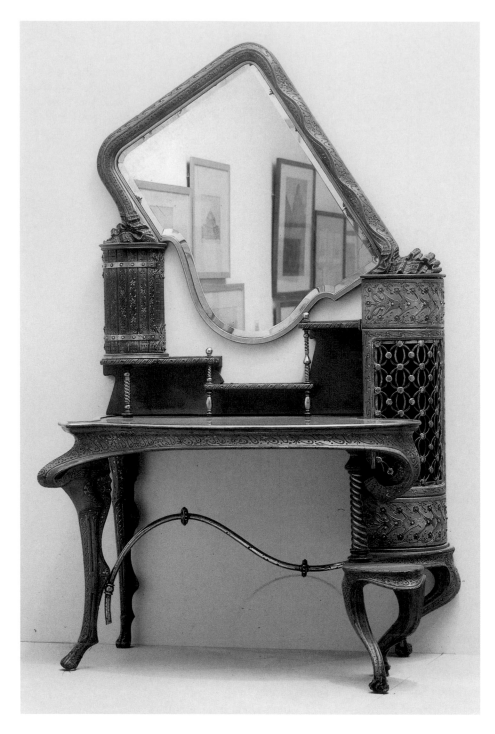

the private rooms in Eusebi Güell's grand six-story palace in Barcelona (1886–89), Gaudí created furnishings that evoked various historical styles without quoting them directly. An asymmetrical dressing table with an undulating canted mirror and five legs seems to dance in place, animating the space around it with playful Baroque cues (fig. 17.41). It brings together incised carving resembling leather tooling, a mirror frame that appears to peel off and arrange itself in a pile of sculptural ribbons, and two animal-like legs. The metalwork evokes medieval strapwork and seventeenth-century turning while the three asymmetrical shelves nod to Asian design.

EXOTICISM

The longstanding European fascination with non-Western culture was given new vibrancy and greater romantic appeal as imperialism, trade, and tourism expanded. Lavishly illustrated nineteenth-century studies by Owen Jones and Achille-Constant-Théodore Émile Prisse d'Avennes (1807–1879) presented Islamic ornament as a colorful yet rigorous system of decoration capable, they believed, of revitalizing European decorative arts. Designers reinterpreted Islamic forms for domestic needs; for instance, enameled glass vases borrowed the forms of mosque lamps while faience plates drew on tile designs. Entire rooms were created in what was called a "Moorish" style (a reference to Muslim Spain that served as shorthand for Islamic design). As in other parts of Europe, interest in Moorish and North African motifs appeared in Spanish design portfolios from the late 1850s, but the height of their adaptation for furnishings came in the 1870s and 1880s. Across Europe, patterned walls, small stools, and cushions with tassels were favored in gentlemen's smoking rooms because tobacco was linked with an idea of the Near East. A seat from a suite of furniture made in nineteenth-century Spain and taken to Cologne, Germany, exemplifies the inventive adaptation of Islamic interlace patterns, turning, ivory, and mother-of-pearl inlay for European seating conventions (fig. 17.42).

While trade between Europe and Asia was long established, the forced opening of Japan by admiral Matthew C. Perry of the United States Navy in 1854 resulted in new trade treaties and stimulated a Western vogue for Japanese goods. A flood of imported lacquered screens and boxes, hair combs, *netsuke* (miniature sculptures), and ceramic tea sets entered the drawing rooms of the educated middle class as "artistic" accessories. Pattern books with detailed images of exotic designs encouraged designers to experiment with unfamiliar compositions and new vocabularies for ornamentation. "Japanese" flowers, dragons, stencils, and emblems appeared on European ceramics, glass, metalwork, wallpaper, enamels, bookbindings, and textiles. The French art critic Philippe Burty (1830–1890) used the term "Japonisme" in 1872, and it continues to be used in connection with the European reception and interpretation of Japanese art and design, which often included a conflation of Chinese, Korean, and other Asian cultures.

One of the first European artists to see Japanese woodblock prints in the 1850s, Félix Bracquemond (1833–1914) etched plant, insect, and animal images from Japanese *ukiyo-e* prints (see, for example, figs. 13.27–13.29), especially Katsu-

Rainha in 1884 that specialized in new versions of older relief designs. Mechanization put colored tiles within the reach of all classes, and they were commonly used in bakeries, dairies, and restaurants, as well as bathrooms, kitchens, and railway stations for both hygienic and decorative purposes. Jorge Colaço (1868–1942) created a series of murals in tile (1887–1907) for an exuberant royal hunting lodge commissioned by King Carlos (r. 1889–1908). Returning to the older Portuguese tradition of blue-and-white pictorial tiles, created in imitation of Chinese porcelains, Colaço depicted a famous national victory over Napoléon at the Battle of Buçaco (1810).

Gothic, Baroque, and Mudéjar (Moorish) traditions in Spain informed Antoni Gaudí i Cornet's (1852–1926) inventive designs for buildings and objects such as furniture, clocks, tiles, and metalwork as well as surface decoration made from *trencadis* (fragments of ceramic tile and other materials). For

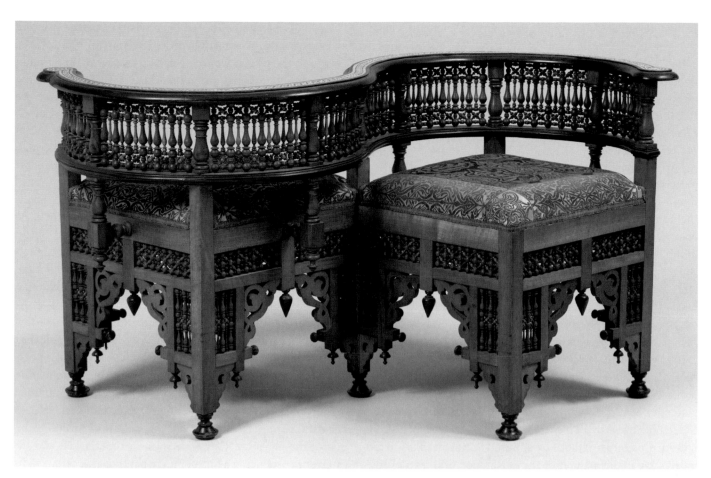

Fig. 17.42. Seat for two, Spain, 1876–1900. Walnut, pear and padauk wood, ebony, ivory, bone, mother-of-pearl, silk; H. 55½ in. (141 cm). Museum für Angewandte Kunst Köln (A 1630).

shika Hokusai's *Manga: A Book of Printed Sketches*. Together with Eugène Rousseau (1827–1891), Bracquemond drew on such sources to decorate a French faience service that was influential and popular throughout the second half of the century (fig. 17.43). The juxtaposition between the line drawings of the insects and the fluted edges and Rococo Revival faience ware highlights the contrast between Eastern and Western aesthetics and points back to eighteenth-century interests in Asian ceramics. Other French potters working in the second half of the nineteenth century, such as Ernest Chaplet (1835–1909), Auguste Delaherche (1857–1940), and Pierre-Adrien Dalpayrat (1844–1910), admired and reinterpreted the high-fire glazes, vitrified clay bodies, and gourd-shaped forms of Asian ceramic wares.

European interest in things Japanese grew apace after the 1862 International Exhibition held in London, at which Sir Rutherford Alcock (1809–1897), the first British consul in Japan, showed a collection of Japanese goods. The exhibition inspired Dresser to travel to Japan at the height of the Japonisme mania (1876–77), the first European designer to visit there after 1854. Commissioned by both the British government and Tiffany & Co. of New York to acquire objects for them, he traveled widely, studying the design and production of goods. His copious notes formed the basis of his influential *Japan, Its Architecture, Art and Art-Manufactures* (1882). Upon Dresser's return, he critiqued some of the early Japonist designs, arguing that they adopted Japanese forms but did not grasp the ideas and cultural significance behind them. He especially admired the irregular composition and flatness of pattern of Japanese objects.

THE ARTS AND CRAFTS MOVEMENT AND THE AESTHETIC MOVEMENT

The Arts and Crafts movement (c. 1861–1920) and Aesthetic Movement (c. 1865–1900), both of which began in Britain, were, in part, responses to anxieties about industrialization. The former owed much to the ideals and practice of a group of architects, designers, and artists including William Morris, Philip Webb, Edward Burne-Jones (1833–1898), Dante Gabriel Rossetti (1828–1882), and Ford Maddox Brown (1821–1893), who founded a firm of Fine Art Workmen in 1861. Influenced by Pugin and Ruskin, Morris and his friends looked for inspiration to nature and preindustrial societies, especially medieval Europe, in their search for alternatives to contemporary

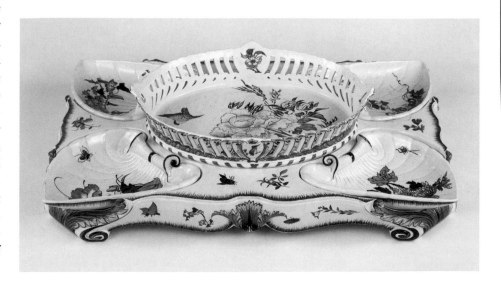

Fig. 17.43. Félix Bracquemond and Eugène Rousseau. Serving dish from *Service Rousseau* (Japanese Service), Lebeuf-Milliet et Cie, France, 1866–75 (designed 1866). Transfer-printed faience; 6 x 24½ x 16⅞ in. (15 x 62.2 x 42.2 cm). Musée d'Orsay, Paris (OAO904).

British design and society, but they never copied nor sought to revive particular designs. By the 1880s, Morris & Co., as it came to be called, was an influential and internationally known decorative arts and interior decorating firm. Its products, which ranged from embroideries and tapestries to furniture, stained glass, wallpapers, printed and woven textiles, and rugs, were mostly made by hand, using natural materials and dyes.

As a designer, Morris was best known for his facility with pattern and his efforts to master a range of crafts through intensive research into preindustrial materials and techniques, including embroidery, illuminated manuscripts, and dyeing. Nature dominated his designs. His love of indigenous, commonplace flowers, fruit, and fauna is evident in his early repeat patterns for textiles and wallpapers, such as *Daisy* (1862) and *Fruit* (c. 1865), which featured flat, stylized imagery evocative of medieval decorative arts. The patterns' bold colors and stylized representations of nature, however, had much in common with designs by Owen Jones and other reformers.

From the 1870s onward, Morris's more assured and complex designs, which were built up in two layers with larger scale repeats, drew on the Italian textiles of the fifteenth and sixteenth centuries that he studied at the South Kensington Museum. *Strawberry Thief* (1883), a block-printed furnishing cotton, used birds—a motif he admired in Italian silks—to tell a narrative in the manner of European medieval textiles (fig. 17.44). Produced using natural dyes—alizarin (red) and weld (yellow)—and indigo-discharge printing, it took several days to complete the complex printing process, thus making it one of the company's most expensive furnishing cottons. It was also one of its most successful commercially.

In 1881, the company established its own textile printing and weaving establishment in order to retain full control over every aspect of production. Such a degree of integration among design, production, and marketing was unusual at the time for a commercial company. The wallpaper designs were manufactured commercially by Jeffrey & Co., which specialized in high-quality hand-block printing. Some required between fifteen and thirty blocks and more colors than cheaper papers, but they remained far less costly than the elaborate French ones discussed above.

Although Arts and Crafts supporters preferred handwork, as did Morris, he was not against machines as such. He welcomed technology that eliminated or alleviated heavy, dirty, or repetitive work but pointed out that, under capitalism, the main motive for introducing machinery was not the saving of labor, as often claimed, but increasing production and profits. Still, machinery was used within Morris & Co. when deemed appropriate. The company produced a few cheaper lines of wallpaper, but they were neither colorfast nor durable, and Morris did not find them aesthetically pleasing. Similarly, he designed carpets for machine production (his first carpet designs of 1875 were made by commercial carpet companies using machinery) but found them less beautiful than hand-knotted ones. His designs for linoleum, one of the cheapest floor coverings on the market, and his interest in producing a line of inexpensive dress cottons indicate that he did not oppose inexpensive goods on principle. But he was against shoddily made items using inadequate materials, especially those aimed at a working-class market. Morris questioned the morality of designing homes and products for working people that were far inferior to any-

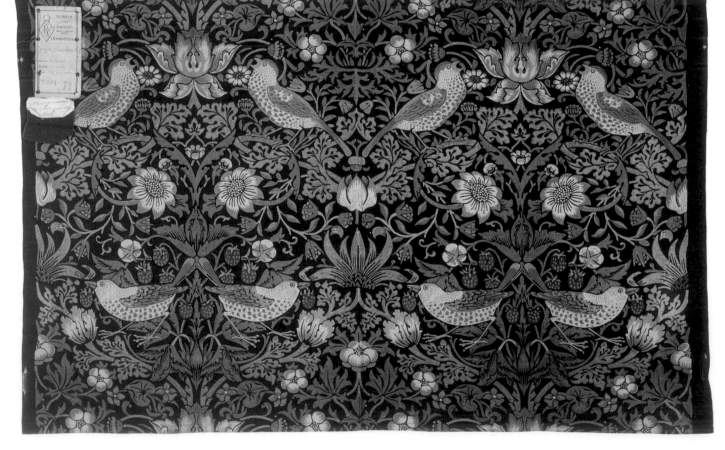

Fig. 17.44. William Morris. Furnishing textile: *Strawberry Thief*, Morris & Co., Merton Abbey Works, London, 1883. Indigo-discharged, block-printed cotton; 23¾ x 37½ in. (60.5 x 95.2 cm). Victoria and Albert Museum, London (T.586-1919).

thing that designers themselves would contemplate inhabiting or using; he was not prepared to sacrifice quality for profit. By the 1880s, Morris concluded that art and design alone could not transform society and became a Marxist, political activist, and environmental reformer. His lecture "Useful Work versus Useless Toil" (1884) railed against the enormous proliferation of objects and argued that, in a more perfect world, such things as adulterated foods and clothing marking social distinctions would not be considered acceptable. His message continues to inspire reformers.

One of Morris's last design projects, *The Works of Geoffrey Chaucer* (1896), was undertaken in collaboration with Edward Burne-Jones, who had created cartoons for stained glass since the beginning of the firm. Morris had established the Kelmscott Press (1891–98) to help raise the standards of book arts to at least those of medieval calligraphy and early printed books (which he admired for their type). As part of a series of hand-printed books for the press, the Kelmscott *Chaucer* was hailed as an exemplar of a book as a work of art and of the harmonious relationship between text and image (fig. 17.45). Burne-Jones, by then one of the most famous painters in Britain, created the illustrations while Morris focused on the decorative borders, illuminated letters, and type. This and other Kelmscott Press publications were a major inspiration behind the private press movement of the early twentieth century.

Morris's writings on decorative arts, crafts production, and the broader relationship of art and society, together with the example of Morris & Co. and the writings of Ruskin, helped trigger what was known from the 1880s as the Arts and Crafts movement. Workshops and organizations sprang up across Britain (360 were established between then and 1914), the largest and most influential being the Century Guild (founded 1882–83), the Art Workers Guild (1884), and the Arts and Crafts Exhibition Society (1887). The movement revalidated handwork, commonplace as well as grander objects, vernacular traditions, and local and natural materials while rediscovering surviving pockets of forgotten crafts, such as smocking, and reviving others. As the movement grew, it gave middle-class women across Europe (and North America) unprecedented access to commercial decorative arts production as both designers and makers, though some areas, such as china painting, were thought more suited to women while others, such as book-binding, tended to have a broader gender mix, and furniture remained male-dominated.

Supporters of the movement believed in honesty of construction and truth to materials (nothing was to be faked), joy in hand labor, equality of the fine and decorative arts (including folk arts), the regenerative nature of art and design, simpler ways of living, and socially responsible production. Materials were not showy; gold and precious stones were eschewed with semiprecious stones and silver used for jewelry, while oak or painted wood was preferred for furniture, along with loose cushions or rush-seating. Women adopted looser fitting clothes, often embroidered on plain linen using simple stitches and naturally dyed threads. There was no definitive Arts and Crafts style, but vernacular design traditions and local materials were greatly appreciated.

Fig. 17.45. William Morris and Edward Burne-Jones. Prologue, from *The Works of Geoffrey Chaucer*, Kelmscott Press, Hammersmith, 1896. Wood engraving by W. H. Hooper. Victoria and Albert Museum, London (E.1255-1912).

The notion of the aesthetic home was important. Morris advised people to have nothing in their home "that you do not know to be useful or believe to be beautiful" (1882), and stated that "If I were asked to say what is at once the most important production of Art and the thing most to be longed for, I should answer, A beautiful House" (1894).[3] Old and new were mixed; comfort, utility, and beauty united. Fireplaces focused attention on the hearth, the literal and metaphorical heart of the home, while window seats, inglenooks, and low ceilings created an ambience of coziness and conjured up a preindustrial past. "The great advantage and charm of the Morrisian method," stated fellow designer and socialist Walter Crane (1845–1915), "is that it lends itself to either simplicity or splendour. You might be almost as plain as Thoreau, with a rush bottomed chair, piece of matting or an oaken trestle table; or you might have gold and luster . . . gleaming from the sideboard, and jeweled light[s] in your windows, and walls hung with arras tapestry."[4]

The Arts and Crafts and Aesthetic movements were mutually influential, both advocating creativity, the centrality of art to life, and beauty in the home. The Aesthetic Movement, however, looked to a wider and different range of sources, notably Japanese, and was inspired by an ideal of art as an agent of self-fulfillment that could enter one's everyday life. Aesthetes, as the movement's supporters were known, opposed the crass commercialism and "philistinism" of the age, believed in "art for art's sake," and argued that art needs no moral foundation. The term "art" was self-consciously

Fig. 17.46. Frontispiece and title page, from William Watt, *Art Furniture Designed by E. W. Godwin*, London, 1877; 2nd edition, 1878. The Wolfsonian–Florida International University, Miami Beach (TD1990.40.62).

Fig. 17.47. James Abbott McNeill Whistler and Thomas Jeckyll. *Harmony in Blue and Gold* (The Peacock Room), London, 1876–77. Freer Gallery of Art, Smithsonian Institution, Washington, DC (F1904.61).

prefixed to ranges of furniture, pottery, and other household goods influenced by Aesthetic ideals, blurring distinctions between the fine and decorative arts. Combining the beautiful with the everyday, the past with the present, the exotic with the familiar, the greatest achievement of Aesthetic design was not in a single chair or vase, but in the ensemble of furniture, carpets, wall coverings, pictures, and decorative items placed deliberately to enshrine the "cult of beauty." Success was not in the creation of things but in their aesthetic selection, placement, and appreciation. Within the Aesthetic

Movement there was more emphasis on consuming aesthetic goods; it aimed to make the consumer an artist-designer, and there was a corresponding boom in household taste manuals.

Architect-designer E. W. Godwin (1833–1886), whose imaginative interiors and furnishings drew on many sources, from Egyptian and Greek to Anglo-Japanese, described himself as an "art-architect" (fig. 17.46), while his friend, the American-born painter James McNeill Whistler (1834–1903), broadened the definition of artist to include interior design. Influenced by Walter Pater's (1839–1894) description of art as aspiring toward the condition of music, Whistler thought in terms of harmonies and arrangements, giving them concrete form in the *Harmony in Blue and Gold* interior (1876–77) for ship owner Frederick Leyland's London home (fig. 17.47). Leyland had commissioned architect-designer Thomas Jeckyll (1827–1881) to create a dining room (1875–76) in which to display both Leyland's collection of blue-and-white porcelain and Whistler's painting *La Princesse du pays de la Porcelaine* (The Princess from the Land of Porcelain, 1863–64). When the scheme was almost complete, Jeckyll asked Whistler to help refine it. Whistler, however, made substantial and expensive changes without Jeckyll's or the client's approval. After Leyland refused to pay the enormous bill, Whistler painted the antique leather on the walls a deep turquoise blue and created a mural of peacocks fighting. The scattered silver coins represent the money Leyland refused to pay Whistler, who first called the mural *Art and Money; or, The Story of a Room*. Although the symbolism suggested he was a philistine, Leyland kept the room as it was; Whistler was never paid.

The Aesthetic Movement was influential abroad, including the United States where writer and Aesthete Oscar Wilde's (1854–1900) lecture tour of 1882 did much to promote it. But it also had its detractors. The popular press lampooned it for an excessive and effeminate concern with taste and home decoration, self-absorption at the expense of wider issues, and associations with decadence, as epitomized by Wilde's openly homosexual lifestyle of the early to mid-1890s and by Aubrey Beardsley's (1872–1898) sensual illustrations for Wilde's *Salome* (1893). Although still popular across a wide spectrum of society, the movement lost much of its fashionability in the mid-1890s with the sensationalist media coverage of Wilde's trials for gross indecency, in which he was found guilty.

NATIONAL ROMANTICISM

The Arts and Crafts movement, by contrast, had considerable international impact from the mid-1890s. The writings of Ruskin and Morris circulated widely, as did those of Crane. William Lethaby (1857–1931), an ardent advocate of the everyday and commonplace and others also carried the spirit of the movement into the new century after Morris's death in 1896. Design reformers visited England to discover more about craft workshops, retail outlets, and how Arts and Crafts ideals informed contemporary design and alternative modes of life.

The impulse to look back to idealized pasts coinciding with nationalist ambitions resulted in National Romanticism. Among the places where Arts and Crafts ideals found fertile ground was Sweden, where the Svenska Slöjdföreningen (Swedish Society of Arts and Crafts) had been established in the 1840s, and the ideas of Morris and Ruskin influenced the founders of the Föreningen för Svensk Hemslöjd (1899, Swedish Handicrafts Association), which sought to protect and encourage crafts and folk traditions. The artistic home Lilla Hyttnäs (1888–1910, largely completed by 1893) was the most influential exemplar of wholesome artistic "simple life" by the end of the century. It was created by Karin (1859–1928) and Carl Larsson (1853–1919), a sophisticated, well-traveled artist-couple who had lived in France and visited England. They transformed a small family cottage in Dalarna, an area steeped in folklore, into an evocation of the supposedly halcyon days of preindustrial Sweden and an idyllic present. While it was jointly conceived, Karin was largely responsible for giving it visual expression. She gave up painting for homemaking, caring for eight children, and creating embroideries, woven hangings, table runners, and curtains, while Carl painted and decorated the walls with chalk and distemper. Old and antique, including eighteenth-century Gustavian furniture, were mixed with new, and simple with elaborate. The green and red colors seen in the dining room were associated with peasant interiors, while other rooms showed the impact of the lighter Gustavian Revival (fig. 17.48).

Carl's watercolors of the interiors, shown at the Stockholm Exhibition of Art and Industry (1897) and published in *Ett Hem* (A Home; 1899), were hailed as models for modern living by Ellen Key (1849–1926), a leading home reformer and author of *Skönhet för alla* (Beauty for All; 1899). Other Swedes influenced by the Arts and Crafts movement included designer Carin Wästberg (1859–1942), who visited England in the 1890s and promoted lighter, more colorful interiors along English lines, and art historian Erik Folcker (1858–1926), who began selling English home furnishings after visiting Morris and Crane.

In Denmark, Carl Brummer (1864–1953) designed Ellehuset (1895) as a residence for author Alexander Svedstrup a few miles north of Helsingør (Elsinore), complete with "old Danish" interiors and richly carved and brightly painted beams in a neo-Viking style. Inspired by excavations of Viking ships, folk art, and ancient myths and sagas, the Viking Revival was popular across Scandinavia and featured in a wide range of media (fig. 17.49). In Norway (not independent from Sweden until 1905), artist-designer Gerhard Munthe (1849–1929) called for design with a distinctive Norwegian identity and proposed a national color palette. His work in the National Romantic mode included the Fairy Tale Room for the Hollmenkollen Tourist Hotel outside Oslo (1896–98), which drew on his *Fairytale Moods* paintings (1893), folk design, and ancient legends. In Finland, seeking independence from Russia, the remote eastern province of Karelia was considered the repository of "authentic" Finnish culture. Established in 1897 after artists Louis (1863–1964) and Eva Sparre (1870–1957) had visited English Arts and Crafts workshops and companies such as Morris & Co., Iris Works, the first interior design and furnishings firm in Finland, promoted Finnish National Romanticism of a "simple life" variety.

National Romanticism offered potent, vernacular sources for expressing national character in the emerging countries

Fig. 17.48. Carl Larsson. *Flowers on the Windowsill*, depicting a room in the Larsson house in Dalarna, 1894. Watercolor; 12½ x 17 in. (32 x 43 cm). Nationalmuseum, Stockholm (NMB 268).

Fig. 17.49. Lars Trondson Kinsarvik. Armchairs, Norway, c. 1900. Painted pine; left, 34½ x 21¼ x 29¼ in. (87.5 x 54 x 74.2 cm). Victoria and Albert Museum, London (5-1901 and 4-1901).

of Central Europe. In Hungary, which had gained autonomy in 1867 and a new status in the Austro-Hungarian empire, traditional patterns of land-holding remained relatively unchanged, thus allowing village or peasant culture to survive long after it had declined elsewhere. Fostered by paternalistic aristocrats, who encouraged crafts and home-industries in the 1880s and 1890s, the peasant crafts of embroidery, woodcarving, and ceramics became much admired and collected in metropolitan Budapest. Traditional patterns were published and later adapted for different materials and contexts; architect-designer Odön Lechner (1845–1914), for example, drew on textile patterns for architectural ceramics, murals, stucco work, and furniture. It was not until after 1900, however, that these activities assumed the character of a full-blown national revival in craft and design.

In Russia, in the aftermath of rapid industrialization and the emancipation of the serfs (1861), those seeking design and social reform looked to periods before the Westernizing and modernizing policies of Peter the Great (r. 1682–1725), particularly to the medieval Slavic past. Arts and Crafts workshops sprang up in the late nineteenth century, the two most famous being housed within artist colonies: Abramtsevo, founded in 1876 by industrialist Savva Mamontov (1841–1918) and his wife, Elizaveta, on their estate north of Moscow; and Talashkino, founded in 1898 by Princess Maria Tenisheva (1858–1928). As artistic director at Abramtsevo from 1885, artist-designer Elena Polenova (1850–1898), who was an associate of Sergei Diaghilev (1872–1929) and others in the circle around the journal *Mir iskusstva* (World of Art), brought together a passion for things Russian and a familiarity with movements in art and design across Europe, as reflected in the wall cabinet illustrated here (fig. 17.50). Fellow Slavophile designers working at Talashkino included Sergey Malyutin (1859–1937), who was interested in Russian antiquities, folk art, and legends, and is often credited with creating the *matryoshka* doll in 1890, carved by craftsman Vasily Zvyozdochkin (1876–1956).

In Germany, periodicals such as *Deutsche Kunst und Dekoration* and *Dekorative Kunst* kept readers abreast of international developments. The Munich Vereinigte Werkstätten für Kunst im Handwerk (founded 1897 as the United Workshops for Art in Handicraft) and the Dresdener Werkstätten für Handwerkskunst (Dresden Workshops for Arts and Crafts) were among the many workshops based loosely on British Arts and Crafts examples. A founder of the latter was Karl Schmidt (1873–1948), a trained woodworker who had visited England and was dedicated to quality production of everyday objects. His brother-in-law, the painter and designer Richard Riemerschmid (1868–1957), created numerous hand- and machine-made objects for everyday life, some of which made reference to popular folk traditions. Around 1900, Riemerschmid, who was part of a group that included the artist-turned-designer Henry Van de Velde (1863–1957), was hired to revive the Westerwald stoneware industry and give mass-produced products the touch of "art." Riemerschmid's wares combined German ceramic traditions—the salt-glaze and pewter lid—with new forms and surface designs that could be made using molds, as in a jug made by

Fig. 17.50. Elena Polenova. Wall cabinet, Abramtsevo Workshop, Russia, 1880–90. Painted and gilded birch; 22 x 19⅝ x 9 in. (56 x 50 x 23 cm). Victoria and Albert Museum, London (W.4-2004).

Fig. 17.51. Richard Riemerschmid. Jug, Reinhold Merkelbach, Grenzhausen, designed 1902. Stoneware, pewter; 9½ x 10⅜ x 8⅝ in. (24.1 x 26.4 x 21.9 cm). Philadelphia Museum of Art (1987-10-1).

the Reinhold Merkelbachfirm (fig. 17.51). Riemerschmid also designed interiors in luxurious materials with expensive furnishings for the wealthy, but in the early twentieth century would develop suites of furniture aimed at middle- and lower-middle-class consumers.

ART NOUVEAU

Art Nouveau was an international movement in architecture, art, and design that flourished at the turn of the century. Although it was known by many names across Europe, the term "Art Nouveau" derives in part from the name of a shop opened in Paris in 1895 by Siegfried Bing (1838–1905). Bing, who was also a dealer in Asian art, redirected his business to sell an international selection of new art and design. Self-conscious newness and modernity, evoked in sinuous abstract compositions, with references to exotic Japanese and Islamic forms and religious mysticism, all existed alongside representations of the past. Faltering confidence in positivism, industrial capitalism, and European high-style taste encouraged artists, designers, and architects to explore the abstracted decorative designs of non-Western cultures in addition to plants, animals, and peasant arts around the mid-1890s. By this time, industrialization and mass consumption were part of cosmopolitan European life, reflected in everything from railroads and trams to electricity and department stores.

Brussels, which Bing had visited, was vibrant with cultural experimentation. Victor Horta (1861–1947) completed a townhouse for Emile Tassel in 1893 with a sequence of rooms that flowed around the central stair. A pattern of undulating tendrils that repeated throughout the exposed metalwork, in the mosaic tile, in the stained glass doors, and on the walls emphasized cohesiveness and spatial unity. Synthesizing architecture and decoration to create a *Gesamtkunstwerk* (total work of art) became a hallmark of Art Nouveau design. Enthusiastic about the ideas and designs of the Arts and Crafts movement, Henry Van de Velde began to design furniture, wallpapers, carpets, lighting fixtures, and jewelry, establishing his own business in 1897. Van de Velde's armchair

follows a design in ash upholstered with William Morris fabric that he created for his own house. In this example, however, the frame is made from luxurious padouk, a fine-grained African hardwood, large quantities of which poured into Belgium with the colonial exploitation of the Congo (fig. 17.52). Moreover, the silk for the upholstery was designed by the Dutch artist Johan Thorn-Prikker (1868–1932) using the wax-resist batik technique adopted by Thorn-Prikker and other Dutch designers from the mid-1890s after textiles imported from what was then called the Dutch East Indies (later Indonesia). These materials and references demonstrate the respect that Art Nouveau designers accorded the crafts of traditional societies while creating a consumer demand for products of colonialism.

In addition to private domestic interiors, Art Nouveau was expressed in the urban facades of boutiques, cafés, and large department stores. Hector Guimard's (1867–1942) designs for the entrances to the Paris Métropolitan stations of the underground train system built for the 1900 Exposition universelle used prefabricated cast-iron parts to create economical stalk and shell-like forms from nature. Art Nouveau's first historians, writing in the 1930s, saw the use of iron and abstracted decoration as a culmination of nineteenth-century technical experimentation and proclaimed it a hinge between nineteenth-century Historicism and twentieth-century Modernism, whereas today it is understood in broader terms that encompass references to the past and to international handcraft movements.

When Bing, a dealer in Japanese art, opened his remodeled shop in 1895, he showed several ensembles by Van de Velde and Georges Lemmen (1865–1916). The integration of individual objects with commissioned suites of furniture, rugs, lighting fixtures, and paintings offered visitors new ideas about interior decoration. Bing came in for a great deal of criticism, however, including xenophobic charges that this modern decorative design was not sufficiently "French." By contrast, Georges de Feure's (1868–1943) boudoir, exhibited by Bing at the Paris Exposition universelle (1900), was an essay in modern "Frenchness," a cohesive, intimate space in refined pink, gray, and blue floral silks and slim gilt wood furniture that evoked late eighteenth-century models (fig. 17.53). The carved iris and other decorative flower forms that unify the ensemble were common motifs at the turn of the century.

Reverence for French traditions was also evident in the work of Emile Gallé (1846–1904), who created Rococo-inspired forms in ceramics and furniture, interpretations of Islamic and Japanese designs, and glass vessels replete with imagery from nature. Gallé's interests in literature, philosophy, and the natural sciences led him to combine literary symbolism with regional motifs, including plants that grew near his home in Lorraine. Gallé also experimented with new techniques: by including bits of foil and ash, and adapting processes from other techniques, such as cameo and marquetry, to glassmaking, along with using images of insects, flowers, and engraved quotes, he surpassed the expressive and technical standards of his peers. *Thistles*, a mold-blown vase, demonstrates Gallé's technical achievements and patriotic zeal (fig. 17.54). The vase takes the form of an unopened this-

Fig. 17.52. Henry Van de Velde. Armchair, Belgium, 1897. Upholstery designed by Johan Thorn-Prikker. Padouk wood, silk; 43¼ x 35½ x 32⅝ in. (110 x 90 x 83 cm). Nordenfjeldske Kunstindustrimuseum, Trondheim (NK1900-144).

tle bud. A mature thistle blossom is featured on the surface with marquetry inlays (bits of contrasting glass added to the surface), a glassmaking technique related to his interest in eighteenth-century furniture. This and similar objects evoked a fierce nationalism because the flower was a symbol of the Lorraine region, part of which had been ceded to Germany after the Franco-Prussian War. Gallé and his friends established an organization to educate and promote the work of artists and designers from the Nancy area in the Lorraine. He also signed the vase, suggesting, as is evident in his writings and activities, that he considered himself both artist and craftsman.

Gallé's signing of objects recalls the efforts of Arts and Crafts movement founders to raise the profile of design by giving credit to and naming designers. That movement also valued the role of crafts, which came increasingly under threat during the nineteenth century. Many decorative arts objects in Europe in the period 1830–1900 had as much to do with handwork as with machine production. At the same time, new materials and techniques made available more items to middle-class consumers than ever before. Many objects expressed modernity through references to the past and older craft traditions, and the impact of the design and ornamental traditions of non-Western societies greatly enriched the material and visual aspects of goods in what is often regarded as an industrial age.

PAT KIRKHAM AND AMY F. OGATA

THE AMERICAS

Fig. **18.14** detail

INDIGENOUS AMERICA: NORTH

Natural curiosities, sources of wealth, trading partners, and strategic allies against encroaching European powers—such were some of the many ways colonial governments viewed the Indigenous inhabitants of North America up to the mid-eighteenth century. With the English, French, Dutch, and Spanish vying to outflank one another on the continental chessboard, many Indigenous nations had achieved an uneasy middle ground with settlers through trade, marriage, and political alliances. Native peoples came to play decisive roles in the major conflicts that shaped the balance of power on the continent—the Seven Years' War and British Conquest (1756–63), the American War of Independence (1775–83), and the War of 1812 (1812–15). But the consolidation of colonial authority resulting from these wars also brought a breakdown in relations between settlers and Indigenous inhabitants, with devastating consequences for the lives of Native Americans. By the late eighteenth century, the centralized governments of the United States and, later, Canada came to view Native peoples in yet another way: as impediments to expansion.

In the United States, government policies toward Native peoples in the decades after independence were aimed primarily at securing land (by dictated treaties or unfair purchase), with an additional "civilizing" mission through farming, church, and trade. Land appropriations and encroaching settlers gave rise to increased hostilities along the frontiers, prompting drastic action on the part of the American government. The Indian Removal Act of 1830 saw the forced relocation of five southeastern tribes (Cherokee, Chickasaw, Choctaw, Creek, and Seminole) to what is now Oklahoma. Westward expansion and the annexation of southwestern territories—strenuously promoted by President Andrew Jackson in the 1830s—had grave consequences for Native Americans, now cast as "savage" hindrances to United States growth. Concepts of racial hierarchy, divine providence, and paternalism infused American political and economic discourse, justifying the state's appropriation of lands under the banner of "Manifest Destiny." A long series of bloody wars with Native tribes on the Plains led to the Indian Appropriations Act of 1851, which allocated funds and assigned tribes to reservations. Not surprisingly, the skirmishes continued. The defeat of George Custer's cavalry by the Sioux chief Sitting Bull at the Battle of Little Bighorn in 1876 precipitated a period of even harsher repression of Native Americans during the remainder of the century.

In broad strokes, events in the British colonies in Canada (from 1867, the Dominion of Canada) followed a parallel course—the westward expansion of colonial settlements and the emergence of reservations, except in the areas of the Arctic and Northwest Coast, in the nineteenth century. But treaties between Aboriginal bands and the British Crown enshrined various rights and entitlements for Native peoples and helped secure, on the whole, more peaceable relations with the state than in the United States. Those relations were not immune to strain, however. The near-disappearance of the buffalo on the Plains, unfulfilled treaty obligations, land appropriations, and a series of Métis Rebellion in the late nineteenth century (with *métis* coming from the French term meaning "mixed," referring to the people of combined European and Native heritage), had dire consequences for Canadian Aboriginals.

In addition to these political transformations, the early nineteenth century saw a general increase of urbanization, industrialization, and consumption of manufactured goods everywhere. Trade crisscrossed the continent on newly built railroads, which carried fashionable goods such as floral-print calico, metal tools, and painted Chinese ceramics, as well as raw commodities, to a wide range of consumers, including those in Native communities. Tourists, longing to escape the hustle and bustle of East Coast city life, traveled westward, creating a substantial market for Indian crafts and souvenirs. Such white migrants brought with them their own material culture, which likewise had an impact on Native designs, as in the purse in figure 18.1. The shape was typical of late-nineteenth-century American and European fashions of this period, as were the floral motifs.

By this period, the rapid economic, technological, and social changes imparted a sense of fragmentation, alienation, and social disintegration among certain members of America's cultural elite. An increasing number of North Americans looked to preindustrial and so-called primitive societies for alternative ways of living and working. For some people, Native American crafts exemplified an idealized, unchanging, and romanticized world that existed before divided labor turned "hands" into machines. Yet, as demonstrated in this chapter, Native crafts were also changing in sometimes dramatic fashion, as artisans across the continent reinvented and revived their craft traditions by an infusion of new materials and ideas. These changes were seldom appreciated as creative or opportunistic responses to outside stimuli, but rather as further evidence of the supposed "disappearance" of traditional Native crafts.

In North America, the notion of vanishing craft traditions was linked to that of the "vanishing Indian," the view that Native peoples were destined to disappear in the face of industrial society, disease, and loss of land. The "vanishing Indian" became a popular theme in "white" North American culture, from books to traveling stage shows, and prompted

Fig, 18.1. Purse,
Mohawk, Six Nations
Grand River Reserve,
Ontario, c. 1885. Velvet,
cotton, glass beads;
without strap, 7¼ x
7⅛ in. (18.5 x 18 cm).
National Museum of the
American Indian,
Smithsonian Institution
(1/6947).

parts of North America that illustrate the varying artistic responses to the social, cultural, and political upheavals that affected Native North American peoples in the late eighteenth and nineteenth centuries. Native crafts remained of vital importance to their producers, their communities, and local consumers during these turbulent times.

BASKETRY

Among the best-known nineteenth-century Native American crafts was basketry. Made in every corner of the continent, Native baskets were noted for their high quality of craft skills, functionality, and pleasing designs. Uses varied from region to region but included trapping animals; carrying babies, water, and other heavy loads; storing seeds; loosening and separating seeds from stalks; as gambling and sifting trays; and even for cooking. Styles differed too, but the most common techniques for construction were coiling, plaiting, and twining. Basketmaking required the spatial acuity to express flat woven, twined, or coiled patterns as three-dimensional forms, as well as sharp attention to detail, patience, and sensitivity to the differences among natural materials such as roots, grasses, reeds, woods, and baleen (the strong, hairlike material in a whale's mouth used to filter food from ingested water). Like engineers, basket makers had to account for the stress points, weight, and wear of a basket when choosing the appropriate structure, material, and technique.

Women created most of the baskets in Native communities. They knew where and how to locate specialized plant materials, when to harvest, and how to properly prepare the fibers. Women traded with other women when they could not prepare materials on their own, or when they wanted "exotic" materials to decorate their works, and they passed down weaving traditions across generations, innovating and borrowing techniques along the way. Although baskets were, and remain, expressions of tribal identity, basket makers also showed off their individuality through personal flourishes and new or signature motifs and forms. By the late nineteenth century, some weavers, such as Maggie Mayo James (1870–1952), Louisa Keyser (Dat so la lee, 1829–1925), and Lena Dick (1889–1965) had achieved name recognition among collectors. Even today, an experienced basket maker can identify the individual maker of a basket by running her fingers across the weave and assessing its tightness and evenness. This also suggests something about the technique of basket weaving itself, namely that weavers, like most other artisans, "see" with their hands as much as with their eyes.

A number of decorative techniques, differing from community to community, were used to ornament the surfaces of baskets. Sometimes dazzling designs were painted on the woven surface, as with the complex formline clan-and-crest designs painted (by men) on baskets and woven hats of the Northwest Coast. In other places, woven patterns were enhanced by using alternating or contrasting fibers (vibrant feathers or, most often, dyed vegetable fiber), a technique known as "imbrications" when the contrasting fibers were added to the undecorated basket. In the case of coiled and

many curio collectors and scholars to scour reservations, tourist markets, and attics for what they considered the last vestiges of a disappearing world.

Institutional support for large-scale collecting came in the form of public museums that were erected in many major North American cities in the mid- to late nineteenth century. The collecting paradigms of professional anthropologists and amateur collectors alike frequently placed the greatest value on supposedly "pure" objects, specimens thought to be untainted by "modern" or intertribal influences. At the same time that these seemingly premodern or "traditional" objects were deemed "authentic" and "culturally pure," many other Native-made objects created in response to growing tourism were disparaged as "inauthentic" corruptions of Native designs. Nevertheless, business-minded artisans learned to navigate a minefield of attitudes toward "authenticity" and "tradition" in Native crafts as they marketed their wares to outsiders.

By the end of the century, "Indian handicrafts" had become a valuable (and in most cases, badly needed) source of income for enterprising Native people, many of them women. In addition to their economic importance, tourist crafts afforded opportunities for Native groups to continue making ceremonial regalia at a time when assimilative government policies sought to eradicate such items by restricting their manufacture and use. Beading, basket making, sewing, and other craftwork brought family members together and helped keep alive cultural traditions. Although a comprehensive survey is not possible here, the following examples were selected to provide regional case studies from different

plaited baskets, the beauty came from the form rather than the ornament.

Some of the most outstanding baskets were created in the American Southwest by skilled Navajo and Apache women, and further westward along the California coast by diverse Native groups such as the Pomo, Yokuts, Hupa, Washoe, and Chumash. By the end of the nineteenth century, tourism and white patronage accelerated intertribal borrowing of popular designs and the creation of a market for baskets, which, if not intended solely for display, saw unfamiliar forms and uses such as sewing baskets, fishing creels, teacups, saucers, and covers for glass bottles.

This California Chumash bottleneck basket, so-named because of its short neck and mouth, was likely used to store valuables such as money, shells, or awls (fig. 18.2). It dates to the early nineteenth century and is fabricated with finely split and peeled juncus (a grassy rush) and sumac fibers, dyed and natural, coiled around a foundation of three juncus stems. (In some cases, Chumash women used bundled deer grass as their foundation.) To create the vessel, the weaver started at the bottom with a tight, spiral knot of juncus. The foundation rods were then introduced, around which the weaver wrapped a noninterlocking weft of split juncus (for the light) and sumac (for the dark). Consistently weaving from right to left, she created a continuous spiral from the base to the rim, alternating weft colors as necessary to continue the visual pattern, while maintaining an impressively high coil count and regular weave. The complete integration of ornament, form, and construction attests to the skill and experience of the basket's maker: The symmetrical geometric pattern—a checkerboard within a checkerboard design—elegantly swells and contracts in harmony with the jar's bulging form. The optical effect of the alternating colors breaks at the jar's shoulder, where the weaver has introduced a wider, primary band, the thickness of which is nearly in equal proportion to the width of the raised rim, a typical feature of Chumash basketry. In this example, the primary band consists of an erect diamond pattern, which serves to release the tension of the design. Although other Native California baskets include combinations of pictorial, blocky, and fine geometric elements, this basket adheres to a limited range of small geometric patterns to achieve a highly expressive effect.

There is much evidence to show that, long before they were traded at Spanish missions in the eighteenth century, woven baskets produced by Chumash women were highly prized by the many different Indigenous people in the region. Baskets were traded into the interior and along the coast, and women borrowed and creatively synthesized aspects of neighboring designs they admired—flaring or rounding sides, adding or removing raised rims, varying patterns and proportions, or altering materials. The Spanish missionaries, and later American settlers, appreciated the fine workmanship and aesthetic quality of Chumash baskets too. Soon after the establishment of the missions, Chumash weavers created baskets with magnificently detailed designs inspired by Spanish imports, including coats of arms (copied from Spanish coins) and textual inscriptions. The weavers responded to the new demand for their baskets by adopting novel forms from those seen in outside cultures—Chinese teacup shapes, sombreros, and rectangular boxes—as well as by using more realistic imagery in their baskets, such as rattlesnakes, people, birds, and the like. Similar to other nineteenth-century Native American craftspeople, Chumash weavers realized that their traditional geometric patterns carried little or no meaning for European and American collectors. This, in turn, prompted them to incorporate pictorial motifs that carried significance for collectors apart from that for the maker.

BLANKETS

Like the basket weavers in California, who have a long history of integrating local aesthetic concerns with both intertribal and outside influences, Navajo (Diné) textile weavers in the nineteenth-century Southwest responded to the changing contexts of reservation life, the availability of new materials, the demands of tourists and trading post entrepreneurs, and the influential presence of cultural middlemen (anthropologists and patrons). Most dramatically, weavers incorporated colorful wools from mills in the Northeast and decorative motifs influenced by Persian rugs and Spanish serapes, and adapted their work to new uses, from practical shoulder blankets to beautiful floor rugs and wall hangings.

Textile weavers in the Southwest, Navajo or otherwise, have been responding to change for many centuries. Loom weaving was imported from Mexico as early as the ninth century and adopted by the Pueblo Indians, who in turn passed along these traditions to the Navajo when they arrived in the Southwest, most likely in the fifteenth century. According to oral history, Navajo weaving began many ages ago when Spider Woman, one of the Holy People in the Navajo creation story, brought the knowledge of weaving to Navajo women. Spider Man, another mythic Navajo, taught men how to build the upright loom and fashion tools from wood, shell, and stone. The loom, batten, and comb—the essential weaving tools—were made by the Holy People and have significance in Navajo creation stories. An identifiably Navajo weaving style

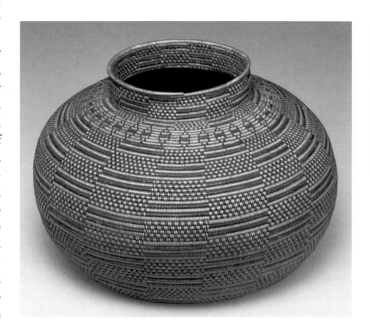

Fig. 18.2. Bottleneck basket, Chumash, Central California, early 19th century. Dyed sumac fiber, juncus (rush); 6⅛ x 8⅜ x 8⅜ in. (15.7 cm x 21.4 x 21.4 cm). Collection of Mr. and Mrs. Diker (DAC 363).

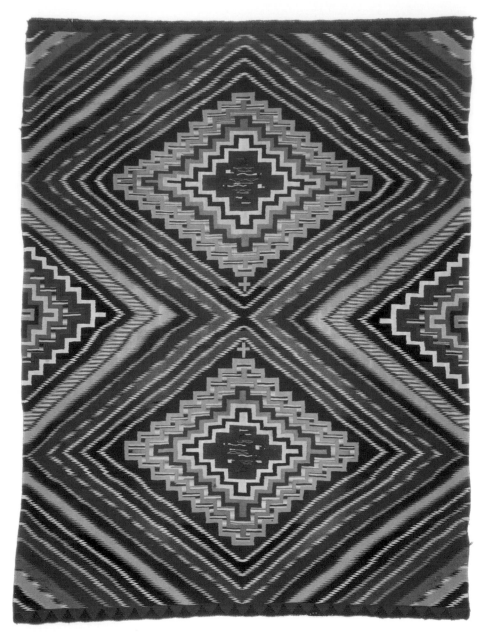

ers began introducing more complex visual "breaks" in the horizontal bands, such as ornamental diamonds, rectangles, or triangles positioned at the corners and centers of the blankets, with additional colors used to set off the dichromatic contrast. By the 1860s, these ornamental diamonds and rectangles became more elaborate, with the integration of internal embellishments, stepped triangles, and a wider array of colors. There was more variability in design, and some blankets in this third phase began to include pictorial elements or center bands of geometric patterns.

By the late 1870s, as weavers continued to master a more complex repertory of techniques, these bold motifs came to dominate the banded horizontal background in what is known as the fourth, or transitional, phase. During this phase, weavers shifted from making saddle- and chief's blankets (both of which were linked to life on horseback—a way of life that had largely ended after the beginning of the so-called reservation period in the 1860s), and began producing stylish woven rugs, bedspreads, and wall hangings for upper- and middle-class European-American households. Whereas in the past, Navajo women wove a wide variety of clothing for themselves and for trade, weaving was now done primarily for outside consumption. Reservation dealers and non-Native patrons frequently worked closely with weavers to suggest particular designs that could be marketed through the broader networks of distribution available once there was a network of railroads, including mail-order catalogues, tourist curio shops, and trading posts. Weavers attempted new techniques, including "wedge weave," in which the horizontal weft yarns are woven diagonally across the warp, resulting in scalloped edges, diagonal lines, and all-over zigzag patterns. The most popular designs featured central diamonds, stepped triangles, zigzags, and box motifs, with barely a suggestion of the earlier horizontal bands that defined Navajo weaving for almost a century.

"Eye-dazzlers," as one style of transitional-phase weaving became known, were wildly colorful, owing to the rainbow of aniline dyes and aniline-dyed commercial wools that became more readily available to weavers as early as the 1860s and in bulk around 1880 (fig. 18.3). Their daring and elaborate geometric designs reflect collectors' tastes for denser patterns, the possible influence of Rio Grande Spanish blankets and serapes, as well as the weavers' own interest in trying new techniques and more vibrant colors. As in the blanket shown here, the yarns came from Germantown, Pennsylvania, an eastern hub of woolen yarn factories. Although there were other sources of commercial yarn, weavings such as this one were often given the generic name of "Germantown" weavings. The irradiating design consists of two concentric stepped diamonds along the vertical axis and two half-diamonds at the edge, bound by narrow, zigzagging chevrons in alternating colors and patterns. The eye-dazzler pattern conveys movement and energy, not allowing the eye to rest on a particular motif, and there is little vestige of the earlier banded designs that characterized Navajo "chief's blankets" of earlier years. The availability of uniform Germantown yarn eliminated the time-consuming need to prepare and dye wool, allowing women more time to devote to weaving

Fig. 18.3. "Eye-dazzler" blanket, Navajo, Arizona, c. 1880. Wool, cotton; 84 x 61 in. (213.4 x 155 cm). Museum of Indian Arts and Culture/Laboratory of Anthropology, Santa Fe (09168/12).

can be traced to at least the early seventeenth century, although it incorporates many influences from Puebloan neighbors whose technique for weaving cotton dates back a thousand years. In Navajo weaving, local cotton and yucca root fibers gave way to the soft, warm wool of sheep, originally a Spanish import. By the close of the eighteenth century, Navajo women had achieved such high artistic and technical standards that their blankets had become prized goods in trade networks involving Spanish, English, Puebloan, and other Native traders on the southern Plains.

Some art historians assign so-called Navajo chief's blankets (a name that reflects their value as status objects among Plains Indians) to four phases. These are useful in explaining how this type of weaving changed during the nineteenth century, though they do not capture the full variety of the individual or regional styles. The first phase, commencing around 1800, was characterized by wide monochromatic (usually black or blue) bands on a simple background of white or red. Handspun woolen yarns dyed with indigo, cochineal, and local plants provided the material for these simplest of woven designs. The second phase occurred in the 1850s, when weav-

complicated patterns, increasing their output, or to creating new patterns.

Pictorial representations in Navajo weaving are rarely seen until the twentieth century, when the traditional restrictions on reproducing sacred imagery were partially lifted. In rare instances, however, a number of weavers did include depictions of secular objects from their changing world, such as the American flag, trains, Western-style houses, horses, and even copies of soap and milk labels, among other things. Within the two central diamonds in this example, the weaver has laid out two columns of miniature weapons—bows, arrow shafts, hatchets, pistols, and daggers. Perhaps these weapons were symbolic "guardians" to protect or heal individuals, much as a traditional chanter would create in an ephemeral sandpainting, also known as a drypainting. Or possibly the weapons were suggested by one of the many military personnel from nearby Fort Sumner, New Mexico. Although the meaning is not known, the symmetrical layout of the objects, much like the larger abstract pattern of the weaving itself, shows the weaver's desire for balance within her composition, and reflects the Navajo view of life as a constant effort to maintain harmony with the universe's many forces.

TEXTILES ALONG THE NORTHWEST COAST

Textile weaving was not limited to the Southwest, although that region became famous for the quality and quantity of its output. Thousands of miles to the north, among the Tlingit, who live along the Chilkat River in the Alaska panhandle, a complex method of twined tapestry-style weaving developed that used yellow cedar bark, mountain goat wool, and local dyes (fig. 18.4). Chilkat weavers produced spectacular woven blankets, shawls, tunics, and shirts, adapting the longstanding conventions of formline composition to flat textiles. Their blankets were status robes worn on ceremonial occasions by chiefs or high-ranking dancers descended from northern tribes. As they danced, the long fringes on the blankets swayed to the rhythms of a song or drum beat, thus contributing to the dramatic effect of the dancer and garment. Such blankets were, and are, worn wrapped around the body, with a centrally placed crest—a symbol of the wearer's identity—facing outward across the back. Mythic creatures depicted in profile at each side of the central crest would appear to converge at the front of the garment when the blanket was closed,

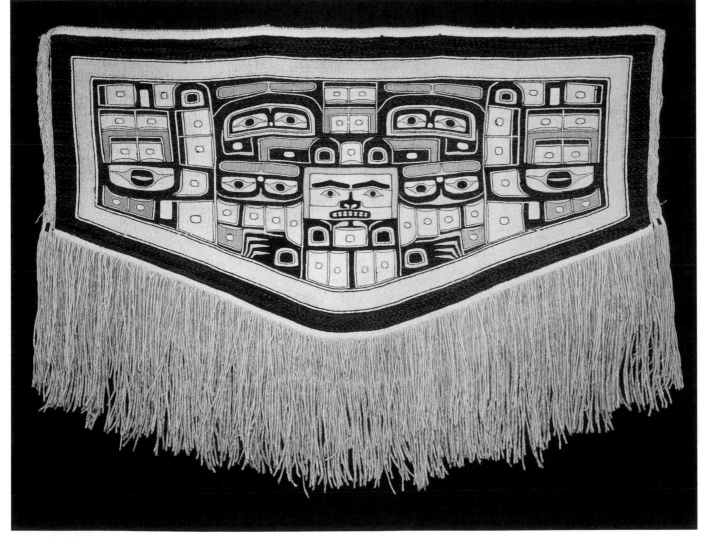

Fig, 18.4. Robe (*naaxein*), Chilkat Tlingit, Alaska, c. 1880. Mountain-goat wool, yellow cedar bark, natural dyes; 51⁹⁄₁₆ x 66¹⁵⁄₁₆ in. (131 x 170 cm). Seattle Art Museum (83.229).

creating changing imagery as the wearer shifted the blanket and danced. In many of the stories, songs, and dances of the peoples of the Northwest Coast, mythic creatures had the capacity to transform, disappear, and reappear. This rich iconography was expressed on other dance regalia used with the blankets—rattles, masks, hats, and head frontlets—and created a potent dramatic performance that celebrated life, creation, and identity.

The making of a Chilkat blanket involved the skills of both men and women. Tlingit men came up with the original designs and painted full-size templates for each blanket on wooden boards. It was up to the women weavers to translate the templates into woven imagery. The women began by twining a variety of fibers, such as cedar bark, mountain goat hair, and cotton, into threads. Using a bottomless, single-bar, upright loom, the weavers completed vertical half- or quarter-panel sections of the design, working from the top down, in a manner similar to (but not influenced by) European tapestry technique. This method allowed them to reproduce the difficult curves and complex lines of the formline style in a way that would have been nearly impossible in shuttle weaving, when yarn is carried horizontally across the weft on a loom. The last step in creating these weavings was to sew the separately woven panels together to form a continuous blanket. Employed for the blanket illustrated here, the

twine-weaving technique could also be used to make tunics, leggings, shirts, vests, bags, or hats.

Most likely, this weaving method first developed among the Tsimshian people to the south along the Skeena River, but by the nineteenth century, Chilkat Tlingit women had assimilated and refined it. Esteemed by Native peoples along the entire Northwest Coast, Chilkat blankets were commissioned at great cost for special occasions and traded amongst the Tlingit, as well as with neighbors to the south (the Haida, Tsimshian, Nuxalk, and Kwakwaka'wakw), throughout the nineteenth century.

BEADWORK

The use of colorful glass beads to decorate garments spread quickly across North America in the late eighteenth and early nineteenth centuries, but beading itself has much deeper roots in Native cultures. Like many other Aboriginal peoples across the continent, Algonquian and Iroquoian peoples along the East Coast had been making and trading small beads made from marine shells for over a thousand years. These shell beads, known as *wampum*, were made in various shapes—rounded, oval, or rectangular—but most were white and, in lesser numbers, dark purple. With the arrival in the seventeenth century of European metal and metal tools (which could drill fine holes through the shell), wampum beads could be made smaller, roughly the width of a pencil. Wampum was threaded into pictographic "belts" that were given out at public ceremonies to cement alliances. The beads were individually sewn on garments as decoration and, beginning in the seventeenth century, circulated as the continent's first currency. Such items were so important within the context of Native-colonial relations that factories to mass produce wampum were erected along the Long Island and New Jersey coasts by enterprising European Americans. Given this extensive network of bead exchange and use, it is not surprising that Native women began to employ the small European glass beads (typically made in Venice or the nearby island of Murano, originally for trade with West Africans) that began to trickle into North America as early as the 1600s.

By the late 1700s, imported glass beads began to replace shell wampum as currency, becoming a staple commodity that flowed through major trading posts on both coasts and traded along Native pathways deep into the interior of the continent. At that time, plain white beads began to be sewn into the borders of quill-decorated shoulder bags and woven into twined bark bags made by Native women around the Great Lakes and Northeast Coast. After 1800, Native women were using a greater variety of colored beads to decorate their hand-sewn garments while continuing to use existing designs, many of them generations old. Because they were easier to use, beads began to replace traditional quillwork as a decorative technique, although women and men continued to practice the more time-consuming art of quillwork and do so today.

The elaborately beaded full-length coat illustrated here was made by a Mi'kmaq woman in eastern Canada as a presentation gift from the Mi'kmaq tribal council to Henry Dunn

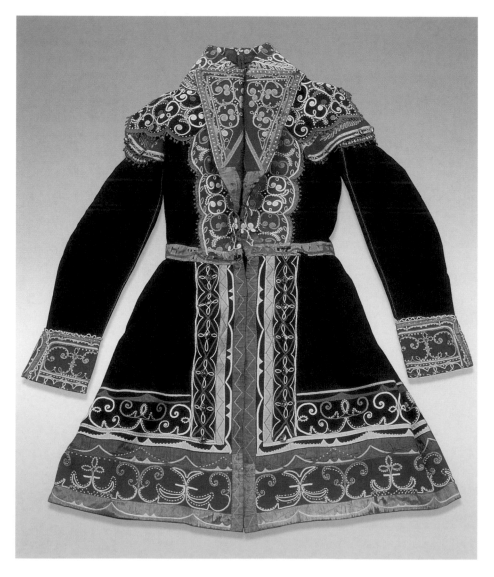

Fig, 18.5. Coat, Mi'kmaq, New Brunswick, 1841. Blue cloth, silk, beads; L. 41½ in. (105.5 cm). Canadian Museum of Civilization (III-F-306).

O'Halloran, a captain of the British Army, in 1841 (fig. 18.5). The gift acknowledged O'Halloran's assistance in the resettlement of Native tribes who were allies of the British Crown during conflicts with the French. The coat—part of a complete ensemble including leggings, moccasins, a knife sheath, pouches, and a pipe—is similar to a European frock coat in its cut and turned-down collar, but the rich colors, beaded double-curve motifs (see fig. 12.3), and other imagery are unmistakably Mi'kmaq.

Here the simple white beadwork border resembles those of earlier beaded garments, but the maker has added lavish "mosaics," floral designs and scrolls of brilliantly colored beads (totaling more than 15 pounds [7 kg] in weight), reflecting the greater availability of a variety of beads by the mid-nineteenth century. Selecting the colors with care to achieve the highest contrast and visual impact, the bead worker applied the beads to the coat with fine stitches in sinewy, continuous lines to create a bilaterally symmetrical arrangement. The double-curve pattern stitched across the collar and onto the shoulder panels may have resonated with an older, protective significance. The original meaning, however, had been likely forgotten (or reinterpreted) by the time this coat was created. At that point, most Native peoples on the eastern Canadian and American coasts had made the transition to Christianity, and the meanings of Indigenous designs frequently took on Christian overtones.

There was an explosion of similarly dazzling beadwork applied to a variety of needlework, from trays and tea cozies to hats, bags, and moccasins, made for the growing tourist and craft markets that developed near Native communities in the mid-nineteenth century. The flourishing of beadwork across the continent reflects the important roles assumed by Indigenous women during a difficult time of social and cultural upheaval. This era saw the slowdown and eventual end of armed warfare between Native peoples and the westward-settling governments of both the United States and Canada, but it also marked the beginning of an era of brutal state repression and forcible assimilation that continued well into the twentieth century. These changes in the late nineteenth century had particularly dire consequences for Native men, who gave up life on horseback on the Plains, saw the loss of hunting grounds in the East (and consequently their customary role as providers), and were robbed of their traditional positions of authority through the imposition of outside governments, "Indian agents," and missionaries. Within this context, with reservation life offering few other economic opportunities, Native women embraced small-scale entrepreneurship through craft production. Sewing, weaving, basketry, and ceramics afforded many Indigenous women artisans places of prominence and financial success in a rapidly changing world.

NAMPEYO AND THE EMERGENCE OF THE INDIVIDUAL CRAFTSPERSON

One of the earliest Native American artisans to achieve name recognition was Nampeyo (c. 1860–1942), a woman potter

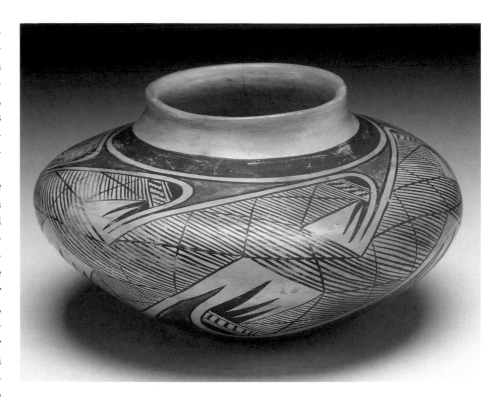

Fig, 18.6. Nampeyo. Painted jar, Hopi Reservation, Arizona, 1930s. Clay, pigment; 5⅛ x 8¼ x 8¼ in. (13 x 21 x 21 cm). National Museum of the American Indian, Smithsonian Institution (26/4462).

who learned the coil-and-scrape method of pottery (a tradition almost two thousand years old in the American Southwest) as a child in the Hopi village of Hano in the 1860s. Nampeyo quickly earned the respect of her elders as a potter who understood all aspects of pot- and jar-making—gathering and preparing the clay; coiling, shaping, and smoothing the form with a rounded stone; yucca-brush painting; and kiln-firing using sheep's dung for fuel—as well as the special songs and stories associated with each step. She took a keen interest in the intricate painted designs on ancient potsherds that she found around her community. In 1895, while visiting an archaeological excavation, Nampeyo was inspired by the complex, stylized motifs and broad shapes of Sikyatki-era (1400–1650, see fig. 6.5) pottery and even earlier ancestral Hopi pottery.

Her encounter with Sikyatki pottery spurred a creative revival of Hopi wares and brought her national recognition. Working with vegetal and mineral paints that fired to shades of red, yellow, brown, and black, Nampeyo borrowed and adapted ancient designs to create her own curvilinear imagery, with gracefully elongated animal and bird forms. In this example, abstracted bird wings encircle the vessel in decoration known as the migration pattern (fig. 18.6). The rhythmic lines also suggest waves of water. For the Hopi, human beings entered the Fourth World—the current world—after a long migration through three previous worlds, each marred by chaos and disharmony. Inspired also by the shapes of early vessels, many of Nampeyo's pots and jars are squat and bulging, with a distinctively elegant "flying saucer" shape. Collected by the Smithsonian Institution, sold through trading posts along the Santa Fe railroad, and prized by elite and institutional collectors in cities like New York and Chicago, Nampeyo's work stood out among her contemporaries, and she soon required the help of her family to meet the demand for it. Her success helped pave the way for

other Native women, like the Puebloans Maria Martinez (1887–1980) and Sara Tafoya (1863–1949), to achieve unprecedented recognition.

The role of artistic and traditional craft in Native North American life changed dramatically from 1750 to 1900. In the mid-eighteenth century, most Native crafts continued to serve ceremonial and utilitarian purposes, made primarily for use within the community and for intertribal trade. By the start of the nineteenth century, as the encroachment of settlers brought Native and non-Native peoples into more frequent contact, handcrafted objects were being produced in greater numbers for outside consumption by North Americans of European origins—high-quality baskets, decorated and undecorated clothing, textiles, beaded objects, and decorative pottery, among many other types. Those creating them adopted some of the new materials that were flooding in from abroad, creatively amalgamating their traditional forms and designs with those seen on Western goods. In this way they made saleable items that would appeal to the growing tourist markets springing up near reservations. While some craftspeople embraced the new, others, such as Nampeyo, looked toward the past to revive and reinvigorate their local craft traditions—a practice that would become more common in the twentieth century. In the face of the repressive assimilation policies of the governments of the United States and Canada, crafts were a vital means of economic and cultural survival during this turbulent era.

The popular consumption of Native American life in the late nineteenth century through novels, newspapers, and the new medium of photography reinforced the myths of the "noble savage" and "vanishing Indian," which in turn fueled more widespread collecting, both popular and systematic, of Native goods. Newly constructed museums were filled with bits and pieces of Native American material culture collected by professional and amateur archaeologists and ethnologists, the latter of whom typically sought examples of Native crafts that evoked and valorized a premodern, precontact past and reinforced rigid taxonomic distinctions among tribes. Between 1750 and 1900, an increasing number of Native craftspeople found creative ways to navigate through the emerging regime of "authenticity" that gripped the public's imagination well into the twentieth century.

NORMAN VORANO

INDIGENOUS AMERICA: SOUTH

In the period 1750 to 1900, European Neoclassicism permeated production in the guild workshops of the major cities of Spanish America, a response to both patron preference and craft training. Urban ateliers produced many of the high-status objects associated with the experience of Creoles (people of European descent born in the Americas) and for which Latin American decorative arts of this period are best known. Silversmiths cast and hammered plates and utensils for domestic use, and chalices, monstrances, and candlesticks for churches. Woodworkers carved life-size figural sculptures and decorative architectural elements for church *retablos* (altarpieces), as well as elegant mahogany chairs and settees. Some of these loosely followed examples from pattern books like Thomas Chippendale's *The Gentleman and Cabinet-Maker's Director* (first published in London in 1754, see fig. 17.7) or French models that came into vogue soon after among the Bourbon rulers who occupied the Spanish throne from 1700 onward.

In most of these workshops, indigenous craftsmen and laborers worked under a Spanish master, making furniture or silverwork for urban patrons. Outside of cities like Quito, Lima, and Mexico City, indigenous peoples were creating objects and images for local patrons typically based on forms that were originally Spanish or from elsewhere in Europe. Some native craftspeople worked under different circumstances. Purépecha (Tarascan) woodworking in Michoacan, Mexico, which took advantage of the wood from the rich forests that lie to the west of Lake Patzcuaro, probably existed well before the Spanish conquest, but in the colonial period, Archbishop Vasco de Quiroga (d. 1565) fostered the making of furniture modeled on Spanish types but using local woods. It supplied both regional markets and more distant ones in New Spain. Because indigenous craftsmanship took so many different forms in the late eighteenth and early nineteenth centuries in Spanish America, some indigenous works were nearly indistinguishable in style from those made by Spaniards or Creoles. This chapter focuses on the work of indigenous artisans working for indigenous patrons.

TEXTILES AND GARMENTS

Inexpensive fabrics, made for the Central and South American markets, were created in urban workshops. For instance, in Mexico City's southwest corner, skilled and semiskilled workers spun and wove coarse woolen fabrics (called *jerga* and *sayal*) and painted cotton cloth called *indianilla* (after the technique), which was imported from Asia. Some of these workers were urban Indians, while others were mestizos (people of mixed ethnic ancestry) and poor Creoles. Within these urban workshops there were divisions of labor among spinners, weavers, dyers, and painters, and large quantities of particular fabrics were mass produced on hand-powered looms, such as treadle looms. In other regions, traditional textiles continued to be made using a variety of techniques. In eighteenth-century Cuzco, for example, many elite women continued to wear the *acsu* and *lliclla* (lengths of cloth variously draped, see fig. 6.18), creating work for weavers familiar with these garments. This pattern of elite women helping to keep alive indigenous textile traditions and garment types

occurred across Spanish America. A portrait of a wealthy young indigenous woman, painted in 1757, shows her wearing a *huipil* as well as elegant jewelry (fig. 18.7). The *huipil*, a draped, upper-body garment made of uncut cloth, was worn by indigenous women across New Spain and was documented a millennia earlier among the Maya living in Guatemala.

A *huipil* made in the late eighteenth century survives in excellent condition (fig. 18.8). Known (erroneously) as the "Huipil de la Malinche"—because it resembles ones worn by Doña Mariana (d. ca. 1529), who was conquistador Hernán Cortés's indigenous translator and mistress—it combined indigenous technology with imported imagery and gives us an indication of the tastes of at least one privileged patron. The body of the garment is made out of three panels of fabric with a background pattern of narrow, white and light brown stripes, colors naturally occurring in cotton. The narrow panels of cloth, each about 12 inches (30 cm) wide, were created on a small and portable backstrap loom, a type commonly used by women. (Treadle looms, which were largely operated by men, produced wider fabrics.) The weaver would tie one end bar to a fixed post while holding the warp threads and the other to a strap running behind her waist, thus allowing her to change the warp tension by rocking back and forth. Such weaving techniques—documented over the previous millennium in Mesoamerica—are used by indigenous women throughout Mexico and Guatemala today.

Cotton is relatively difficult to dye, and therefore the maker of the "Huipil de la Malinche" used threads of wool and silk to embroider decoration featuring a bicephalic eagle, an emblem of the Habsburg dynasty widely used in New

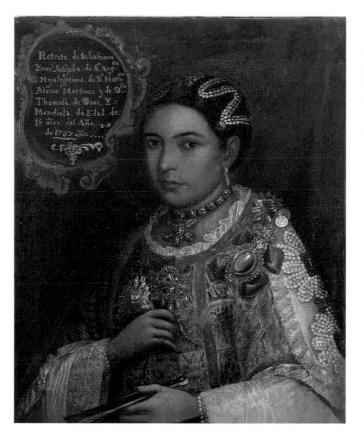

Fig. 18.7. Portrait of Sebastiana Inés Josefa de San Agustín, daughter of a *cacique*, 1757. Oil on canvas; 26⅜ x 22 in. (67 x 56 cm). Museo Franz Mayer, Mexico City.

Spain and possibly related to indigenous cosmologies. The silk thread may have been produced locally or acquired through the Asia trade. The velvet-like texture created by woven feathers is seen most clearly at the bottom border of the *huipil*. To weave feathers, their barbs are separated from

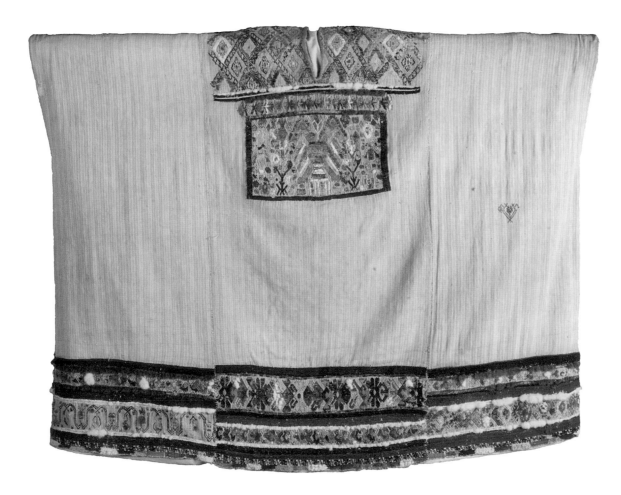

Fig. 18.8. Woman's tunic: "Huipil de la Malinche," Mexico, c. 1770–1800. Cotton, feathers, animal hair, silk, wax, gold thread; 55⅛ x 43⁵⁄₁₆ in. (140 x 110 cm). Museo Nacional de Antropología, Mexico City.

Fig. 18.9. Woman's coca cloth, Aymara, Chiquito, Peru, late 18th–19th century. Silk, alpaca wool; 19⅝ x 18½ in. (50 x 47 cm). Division of Anthropology, American Museum of Natural History (40.0/ 8878).

their more rigid rachis, or shaft, and then tied into the thread, a technology that relates to the long indigenous tradition of feather working (see fig. 6.11a), where feathers were used for clothing as well as feather mosaics.

In the Andes, textiles were so deeply connected to indigenous identity that after the suppression of the brief and violent Tupac Amaru uprising (1780) against Spanish rule, during which a native leader took on the name of the final sixteenth-century Inka ruler, the victorious viceregal government banned native dress. In particular, colonial officials cracked down on the male tunic (*unqo* to Quechua speakers, *ccahua* to Aymara speakers) and mantle, presumably because the leaders of the insurrection wore this patently indigenous costume to distinguish themselves from Spaniards and mestizos. The ban was not entirely successful, particularly in regions that were remote from Spanish political centers, and native men wore *unqo* and mantles as a matter of course.

In the Aymara-speaking regions of southern Peru and Bolivia, native weaving enjoyed a renaissance in the nineteenth century, before so-called reforms late in the century stripped the native *allyus* (kin-groups) of their communal lands. When the closed-sided *ccahua*, the Aymara male tunic, was banned, men simply took to wearing a similar, open-sided *ponchito*, a garment rendered safe from prosecution because of its close relationship to the longer poncho worn

by Spaniards and Creole men. An excellent example, in terms of condition and quality, of a late eighteenth- or early nineteenth-century Aymara woman's coca cloth is illustrated here (fig. 18.9). The fabric, like other Aymara ones, is warp-faced and made of alpaca wool. It was constructed by a weaver threading a backstrap loom with a complementary warp so that the resulting stripes in the cloth are two-faced (the reverse stripes appear on its back side). The vertically striped design draws attention to the vertical warp threads, as do other Aymara textiles of this period, although this one also features dense patterns in the stripes.

Other Aymara clothing types changed over time, as indigenous people saw and adopted certain Spanish garments or aspects of them, but the weaving technology remained constant: warp-faced fabrics created on backstrap looms. A good example of adaptation in Aymara weaving and garment types is the heavy pleated or gathered skirt called the *pollera*, a form borrowed from Spanish women's dress. When such skirts became fashionable among the Aymara in the nineteenth century, women stopped weaving the square panels used to make the *urku*—a traditional wrapped dress—in favor of much longer panels that they then gathered at one of the selvages to make a voluminous skirt. The result was a garment virtually identical to the *polleras* worn in other regions, but which Aymara women nevertheless called an *urku*.

While weaving technologies often remained traditional, some dyeing techniques changed. For instance, *ikat* textiles were widely used in nineteenth-century Spanish America, as they are today. In central Mexico, *ikat* technique was employed for *rebozos*, narrow shawls serving as head covers and infant carriers, among other functions; in the northern Andes, for the *paño*, or shawl; and in Guatemala, for skirts worn by Mayan women. Complex *ikat* patterning involves a resist technique done when threads are set on the loom. The warp threads are tied together into small bundles; when dyed, the tied parts resist the dye. Sometimes threads to be used for the weft are also resist dyed. While such dyeing techniques were known in pre-Hispanic times, *ikat* textiles were influenced by Asian *ikats* arriving in the Manila galleons from the early seventeenth century onward. Weavers who worked with cotton quickly embraced the imported aniline dyes developed in Europe in the mid-nineteenth century because of the brilliant and colorfast hues, particularly the reds, they produced.

BASKETRY

Across indigenous America, baskets, often made of woven grasses, were an important means of transporting goods, and storing and even cooking food. In 1822, María Marta (c. 1766–1830), a Chumash Indian who converted to Catholicism while living in or near the mission of San Buenaventura in southern California (the northernmost part of New Spain), wove the densely decorated basket seen in figure 18.10. It is one of the few objects known from before the twentieth century where the indigenous artisan included her name on the piece. Here, in addition to geometric patterns that are typical of many of the surviving California Chumash baskets of this period, she incorporated a European image—the coat of arms of Spain with the Pillars of Hercules—drawn from Spanish coins, which circulated throughout and beyond Spain's transcontinental empire. The border text—in Spanish—reads in translation, "María Marta, neophyte in the mission headed by the seraphic Doctor [of Mission] San Buenaventura made me in the year" with a chronogram for the year 1822 continuing below. One of six such presentation baskets known today that includes this coin imagery, it is the only one that is signed.

Historical evidence suggests that these strong and durable baskets, made from local juncus (a kind of rush), deergrass, and sumac, were fabricated by women within the missions and given to visiting dignitaries as gifts. The craft skills required of Chumash women to make this type of basket were undoubtedly honed in producing a range of less decorative, more obviously utilitarian objects, which Chumash women traded with other southern California indigenous groups or used in their own communities. By the late nineteenth and early twentieth century, after this region had been annexed to the United States, the Chumash, along with other California native groups, were already taking advantage of the patronage offered by tourists to turn basketmaking into a more lucrative occupation (see fig. 18.2).

METALLURGY AND METALWORK

While Spanish patrons tended to use silver as tableware and vessels, as well as for frames and ecclesiastical ornament, indigenous peoples more typically used it for personal adornment, a kind of wearable wealth, either individual or communal. Silver was an easily available material, not least because Spanish coin, made from silver minted in the New World, circulated widely. In South America, most of the silver originated in the Cerro Rico (rich mountain) of Potosí. An image of this mountain, a source of the silver that fueled Spain's territorial ambitions for two centuries and a part of indigenous history and cosmology, forms the central triangular ornament of a Bolivian hat adorned with pieces of silver either cast or individually worked and sewn into the velvet (fig. 18.11). The mountain is flanked by a sun at left and moon at right, conventions found in both Spanish colonial and indigenous objects. The hat was almost certainly used in the exuberant festivals sponsored by indigenous communities,

Fig. 18.10. María Marta. Presentation basket, San Buenaventura Mission, northern New Spain (California), 1822. Juncus (rush), sumac; Diam. 15½ in. (39.3 cm). Phoebe A. Hearst Museum of Anthropology, University of California at Berkeley (1-22478).

Fig. 18.11. Festival hat, Potosí, 18th century. Silver, velvet, glass beads, wire; 4^{15}⁄$_{16}$ x 13¼ x 13¼ in. (12.5 x 33.7 x 33.7 cm). Brooklyn Museum (41.1275.274c).

Fig. 18.12. James
Mooney. *Charley,
Weaver and Silversmith,
in Native Dress with
Blanket and Bowl outside
Winter Hogan; Snow on
Ground 1893*, Keams
Canyon, Arizona.
National Anthropological
Archives, Smithsonian
Institution (BAE GN
02415b4 06398600).

called "squash blossoms") derived from Spanish pomegranate designs, which, in turn, were Islamic in origin. On his wrist he wears a heavy silver *ketoh* (designed to protect an archer from the bowstring's recoil but later used as ornament), and his belt is decorated with *conchas*, large silver discs whose form was borrowed from the Plains Indians but developed into this decorative form by Navajo silverworkers.

Other Navajo silver included forms borrowed from Spanish-style horse tack, including the crescent-shaped silver pendant, called a *naja*, taken from a horse's headstall. Around the time railroads established by United States entrepreneurs connected the Navajo to the eastern seaboard in the 1880s, the *naja* pendant was added to the squash blossom necklace, thus establishing the form that became celebrated in the twentieth century as representative of Navajo jewelry.

In the Chilean south, Mapuche, or Araucanian, metalworkers made use of the abundant silver coming from Potosí in the form of coins. As with the Navajo, silver jewelry and horse tack were signs of social status for leaders and their many wives. In 1861, a German visitor compared the sound made by the abundant jewelry worn by Mapuche women following their husbands in procession to the music of a military band. Mapuche ornament flowered in the nineteenth century, when some Mapuche profited considerably from the animal trade both within Chile and across the Argentine border. Their silver coin was converted into wearable wealth.

The examples shown here include both a *süküll* (or *sequil*), a pectoral ornament made by Mapuche smiths and worn by Mapuche women, and a related decorative cross known as a *trapelakucha* (fig. 18.13). The forms were made of heavy silver

such as those to honor local patron saints or celebrate Corpus Christi, as part of a public display of communal wealth and artistic skill.

Across the New World, indigenous peoples used metal ornaments (particularly silver ones) as a sign of social status, and local smiths developed distinctive regional styles. Two of these styles are considered here: one associated with the Navajo, living north of what was then Mexico, and the other with the Mapuche, or Araucanian, people of southern Chile, a continent away.

Mexican metalsmiths, versed in designs and types familiar in New Spain, migrated into what later became the southwest of the United States and worked among the Navajo by the 1830s. Self-ornamentation with shiny metal discs, usually silver—a tradition of Plains people to the north—had also influenced Navajo tastes. During the nineteenth century, the Navajo, however, departed from Plains taste and came to favor deeper repoussé and cast ornaments, and often melted down Spanish silver coin to use as a source metal. An 1893 photograph of a Navajo weaver and silversmith—two preeminent Navajo crafts—shows him standing on a distinctive striped Navajo textile made of locally raised sheep wool, often known as a chief's blanket, and wearing silver jewelry typical of Navajo work of the period (fig. 18.12). Around his neck are hollow silver beads, the decoration of which (later

Fig. 18.13. *Süküll* and
trapelakucha (woman's
breast ornaments),
Mapuche, Chile, late
19th–early 20th
century. Silver; left, 11 x
4³⁄₁₆ in. (27.9 x 10.6 cm).
Brooklyn Museum
(36.929a-b).

plates by cutting and bending. At the top of the *süküll* is an abstracted version of the bicephalic eagle (see above). Three heavy chains connect it to a lower plaque with circular pendants that resemble hammered coins, characteristic of this type of Mapuche work. The second piece, a pendant that would have been attached to the larger one, features a *trapelakucha*. The sonic potential is evident; a similar example in the Museum of the American Indian in Washington, D.C., has bells as well as clanking coins. After 1883 and the end of devastating wars through which Chile annexed the Mapuche lands of Araucanía, the wealth of the Mapuche declined dramatically, and in the twentieth century, a silver-nickel-copper alloy then available in Chilean coinage became the material used for Mapuche ornament.

NATIONALISM

The wars of independence of the early nineteenth century left Spanish America divided into self-consciously modern nation states, whose leaders sought to forge a new sense of national identity. Most Latin American countries employed European Neoclassical models in architecture and design to express nationhood and continued to look to Europe in matters of visual culture. Although the newly founded Latin American countries often celebrated their (non-Spanish) indigenous pasts—the exultation in Mexico of Aztec culture from the late eighteenth century being the most salient example—powerful "modern" Creoles tended to disparage contemporary indigenous communities. Indeed, some historians argue that the postconquest colonial period, during which indigenous peoples enjoyed a special legal designation under Spanish colonial law (as members of *pueblos de indios*), was not as corrosive of indigenous cultures and craft and design traditions as the period of so-called reforms instituted by Liberal parties in many Latin American nations from the mid-nineteenth century. The goal of these reforms was to encourage modernization and industrialization, but they also ended the special legal and political status of indigenous peoples and communities.

By 1900, the nationalist celebration of the indigenous focused on the great empires of the distant past, like the Aztec, rather than contemporary Indians. Latin American nations participated in some of the world's fairs of the second half of the nineteenth century. In Madrid in 1892, for example, Mexico proudly displayed collections of pre-Hispanic art, replicas of indigenous manuscripts, and imaginary portrait sculptures made in the 1890s of sixteenth-century indigenous rulers depicted in a Neoclassical manner. Thus, by the end of the century, if indigenous objects played any role at all in the quest for a national style in decorative arts, it was to ancient rather than contemporary indigenous work that relatively recently founded countries continued to look.

DANA LEIBSOHN AND BARBARA E. MUNDY

SPANISH AND PORTUGUESE AMERICA 1750–1830

As Ibero-American communities grew and diversified under viceregal rule, their visual and material cultures reflected regional variations in resources, economics, and social structure. In Brazil, the discovery of gold and gemstones in the province of Minas Gerais transformed an economy long reliant on sugar cultivation (see fig. 17.18). By the late eighteenth century, the inland mining town of Vila Rica, renamed Ouro Prêto (Black Gold), was among the most populous in the Americas and the stage for works by the mulatto architect, sculptor, and designer Aleijadinho (c. 1738–1814, see below). Both the mines and plantations were built on slave labor, with Brazil receiving over one-third of the enslaved Africans transported to the western hemisphere—perhaps 4–5 million in all—before the Brazilian abolition of slavery in 1888. Another 1–2 million Africans reached the plantations of the Spanish West Indies, where slavery persisted until 1866 in Cuba and 1873 in Puerto Rico. Outside of Brazil and the Caribbean, and some coastal cities like Callao, Cartagena, Portobelo, and Veracruz, Ibero-America's population consisted mainly of Amerindians, *criollos* (Creoles), and a growing number of mestizos. The *audiencia* (judicial district) of Quito, whose economy was largely based on agriculture and livestock raising, textile manufacturing, and shipbuilding, was typical: in 1784, approximately 67 percent of its half-million inhabitants were indigenous, 27 percent white or mestizo (most living in Quito or Cuenca), 7 percent freed slaves and mulattos, and 1 percent African slaves. By the time the territories of New Spain achieved political independence in the 1820s, less than half their citizens were purely indigenous, a clear mark of colonialism's impact on the population.

European influence remained strongest in the cities, where *criollo* elites prospered as never before, thanks in part to their enthusiastic embrace of commerce. Traveling in Peru in the 1740s, the Spanish scientists Jorge Juan and Antonio de Ulloa offered a vivid picture of Lima, a bustling capital with few Indians but almost twenty thousand white inhabitants and an even greater number of blacks, mulattos, and their descendants, both free and enslaved. The Limeños' universal striving for wealth made a particular impression on Juan and Ulloa, who noted with approval that whites happily joined mulattos in practicing the "mechanical arts," while the nobility (unlike in Europe) felt no social, moral, or legal impediments to commerce. The result was a city consumed by fashion and appearances, seemingly heedless of expense.

In the streets, Ulloa counted hundreds of coaches, supplemented by up to five thousand two-wheeled calashes or chaises, all elaborately decorated and gilded. Fine clothes were the goal of all social ranks, with little distinction in cut

or fabric between domestic and grandee. Whereas men dressed largely as in Spain, women's dress was so different as to shock first-time European visitors. Instead of the French modes adopted by Iberian noblewomen, Limeñas wore what was to Spanish eyes an old-fashioned and indecently short petticoat (*faldellín*, also known as a *pollera*, or "chicken basket"), a bulging, gathered skirt that revealed the ankles and served as ground for a prodigious array of fringes, ribbons, and Flanders lace, sometimes in such abundance that the trimmings obscured the underlying cloth.

Although surviving garments are rare, portraits offer rich evidence of late colonial fashion. The clothing shown in a portrait of an elegant Limeña from around 1800—perhaps Petronila Carrillo de Albornoz y Salazar, who married the third Marquis of Casa Boza in 1790—is particularly striking (fig. 18.14). Her skirt, accompanied by an elaborately embroidered apron, updated the Liman *pollera* by using simpler, Neoclassical fabrics that may also have echoed the bold stripes of some native *cumbi* textiles (soft cloth woven from alpaca

wool). Apart from the lace-bedecked sleeves, bodice bow, and apron, the sitter's jewelry includes pearl- and diamond-studded hair combs, bracelets, shoebuckles, and an elaborate pendant and pair of earrings seen in earlier portraits of the Countess of Monteblanco and Montemar. According to Juan and Ulloa, such ensembles—even if they were not family heirlooms—raised the value of a single outfit to as much as thirty or forty thousand pesos.

Sartorial abundance did not stop at the cloister wall, as documented by eighteenth- and nineteenth-century ceremonial portraits of *monjas coronadas* (crowned nuns) of the Roman Catholic faith in religious finery (fig. 18.15). Portrayed at the moment of taking their final vows before withdrawing from secular society, well-born novices were typically shown as finely dressed brides. In this example from New Spain, a young neophyte, carrying a figure of the Infant Jesus in one hand and a scepter studded with wax or paper flowers in the other, seems almost smothered by her sumptuous, heavily adorned robe, stole, and pearl-studded wimple. She wears a crown, and at her chest is a huge "nun's badge" (*escudo de monja*) in a tortoiseshell frame painted or embroidered with the scene of the Annunciation. It seems positioned to deflect attention from the sitter's charms. Together with similar portraits made to commemorate a nun's death, these *monjas coronadas* testify to the rich visual and material culture of Ibero-American monasticism.

The same potent combination of prosperity and pride filled viceregal capitals with private family palaces (*casas solas*) of the utmost luxury and grandeur. Their facades were ornamented with carved portals, quoins, window surrounds, and other European architectural features that exploited local materials while reflecting colonial America's position as a cultural crossroads. In Lima, where stone and timber were scarce, the grandest houses boasted classicizing ashlar or stucco portals and enclosed, Andalusían-inspired balconies (*miradores*) with screens (*celosías*) made of imported Central American hardwoods, providing welcome privacy and breezes in dense urban settings. In highland Arequipa, chalky *sillar* (a whitish volcanic tuff) was favored as a building material among rich *criollo* families, including mine owners from Potosí. One observer remarked in 1752 that this elite's "stubborn determination to build houses of stone has created a great many [native] craftsmen expert in architecture, who carve pedestals, erect pilasters and columns [and] capitals . . . not only ordinary houses, but also eminent towers, lofty cupolas, and other works whose artifice shows them to be masterpieces."[1]

In Mexico City, the *criollo* architect-designer Francisco Antonio de Guerrero y Torres (1727–1792) also embraced native materials, setting off walls clad in a reddish volcanic tuff (known as *tezontle*) with Puebla tiles, wrought-iron balconies, and/or vigorous moldings of gray *chiluca* limestone, including oversized frets, scrolls, zig-zags, waves, and tightly coiled volutes (fig. 18.16). Although some of this ornament had classical roots, its exuberant coloration recalled local religious architecture more than contemporary European domestic modes.

Sometimes the decoration was tailored to the patrons. One of Guerrero y Torres's most elaborate designs, the palace rebuilt from the 1770s for the eighth Count of Santiago de

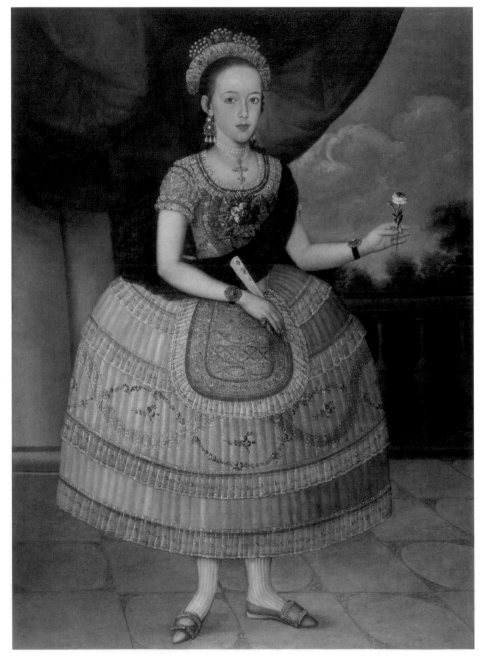

Fig. 18.14. Pedro José Diaz. Portrait of a young woman, c. 1800. Oil on canvas; 54¾ x 39¼ in. (139.1 cm x 99.7 cm). Davis Museum and Cultural Center, Wellesley College, Mass. (2011.17).

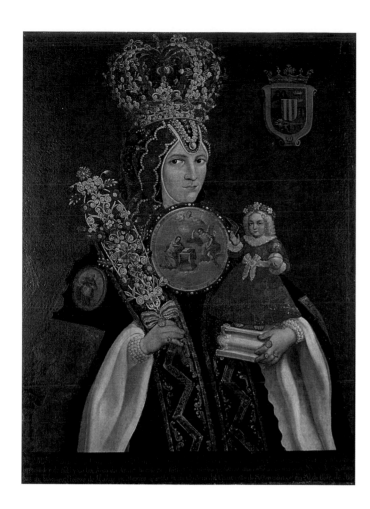

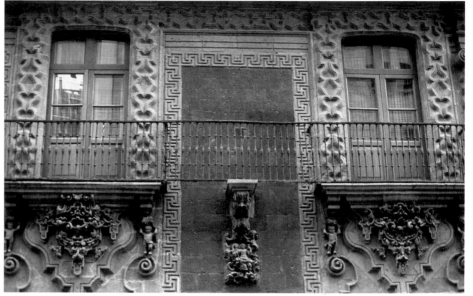

Calimaya (whose father is portrayed in fig. 12.16), showcased the family's history. An Aztec head of Quetzalcóatl served as the cornerstone, and there were cannon-shaped downspouts, ball-and-claw consoles, and cedarwood doors that framed the family's heraldic devices with Chinese-inspired lion masks. In the arcaded courtyard, a shell-shaped fountain with a guitar-playing siren evoked maritime trade, while two Asian-looking lions (often termed "foo dogs") guarded the grand staircase. Upstairs, a parade of reception rooms—a canopy or baldachin hall, *sala del estrado* (dais room for ladies, discussed below), dining rooms, anterooms, chapel, and private spaces for master and mistress—were likewise furnished with the fruits of global commerce.

Yet if cultural and aesthetic diversity had become an Ibero-American hallmark, the late viceregal period also witnessed impulses toward classification and control. In New Granada, the painter Vicente Albán (b. 1725) portrayed the principal ethnic types from the vicinity of Quito in 1783 with scientific precision, posing each representative in his or her distinctive dress, alongside carefully catalogued local produce. In New Spain, long sets of *pinturas de castas* (caste or casta paintings) inventoried *mestizaje* (ethnic blending) by depicting mixed families in characteristic locations—the Parián market in Mexico City, streets, servants' quarters, or craft workshops. He devised his own labels for the ethnic combinations: *lobos* ("wolves") or *zambos* for the children of Africans and Indians, *coyotes* for the offspring of Indians and mestizos, *albinos* for those of one-eighth African ancestry, and fanciful terms such as *albarazado* ("white spotted"),

torna atrás ("turn backwards"), or *tente en el aire* ("hang in mid-air") for less easily identifiable admixtures.

First recorded in 1711, series of casta paintings traced both the dilution of European blood and, at least for mestizos, the potential reascent to "whiteness" (fig. 18.17). In the example shown here, a *criollo* reclines in an Asian-style dressing gown and cap while his *castiza* wife (one-quarter Indian) super-

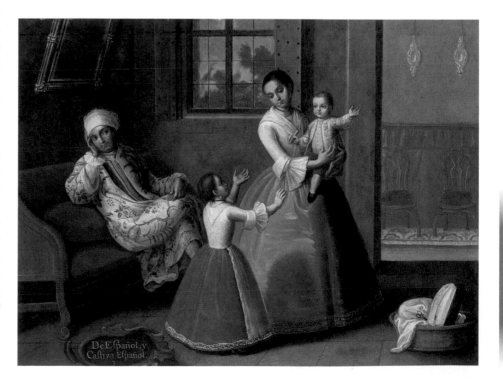

Fig. 18.18. Pedro Huizar.
Stone portal of the
Franciscan mission
church of San José y
San Miguel de Aguayo,
San Antonio, Texas,
1768–82.

Fig. 18.19. Attributed
to Antônio Francisco
Lisboa (O Aleijadinho).
Torchère, Ouro Prêto,
late 18th century.
Painted and gilded
wood; 68⅛ x 21⅝ x
20⅛ in. (173 x 55 x
51 cm). Museu da
Inconfidência,
Ouro Prêto.

vises their two "Spanish" children. Along with the caption in its Rococo cartouche, the family's dress and furnishings—from the upholstered sofa to the matched side chairs set against a fabric-covered dado below beribboned silver sconces—signal a European identity. Analogous scenes in other series similarly indicate "whiteness" with items such as settees, framed mirrors or pictures, floor and wall coverings, European-style cabinets, and formal gardens—all potent cultural as well as material markers in Ibero-America's multiethnic societies. What forms and styles such culturally loaded objects should take—and how, and by whom they should be made and used—became important topics for debate in the final generations of European rule.

FROM BAROQUE TO BUEN GUSTO

Although European patrons and designers had largely embraced Neoclassical styles by the late eighteenth century, clients and artisans in Spanish and Portuguese America ensured that the Baroque, broadly conceived, remained pop-

ular until the advent of independence in the early nineteenth century. This "colonial lag" may be partly attributable to distance and entrenched guild monopolies that resisted aesthetic change. In addition, *criollo* patrons found the familiar Baroque and Rococo styles to be the most appropriate ways to express local and regional identity.

The enduring appeal of Baroque and Rococo throughout the region is suggested by the remote Franciscan mission church of San José y San Miguel de Aguayo in San Antonio, Texas (fig. 18.18), whose intricate retablo-style facade, carved between 1768 and 1782 by the Mexican sculptor Pedro Huizar (1740–after 1790), features flowering garlands converging on images of St. Joseph and the Virgin of Guadalupe, the archetypal Mexican icon and embodiment of national pride.

A similar preference for profusion animated the arts of late colonial Brazil. Carved and gilded altars were further laden with ornaments of chased and repoussé silver, including light-reflecting tabernacles, lanterns, and the flattened palm branches or floral bouquets known as *mariolas* or *mayas* in Spanish contexts. Very little Brazilian silver was marked, especially after 1766, when a Portuguese royal decree

(enforced until 1815) officially suppressed all gold and silver workshops in the states of Rio de Janeiro, Bahia, Pernambuco, and Minas Gerais. Those regions' ample production then went underground.

The Brazilian Rococo's prevailing genius was the sculptor and architect Antônio Francisco Lisboa (c. 1738–1814), better known as "Aleijadinho" ("little cripple") from his battle with leprosy. The illegitimate son of a Portuguese master builder and his African slave, Aleijadinho designed churches in and around Ouro Prêto creating carved stone exterior ornaments, devotional images, and probably liturgical fittings including altars, pulpits, and episcopal thrones in painted and gilded wood. In one torchère, or monumental candle holder, attributed to him (fig. 18.19), a robust, beatific angel in flowing robes strides forward atop a tall Rococo pedestal, one hand on a shell-shaped scroll and the other supporting a candle atop a twisted cornucopia. Calm but forceful movement and a dynamic balance of figure and ornament epitomized Aleijadinho's religious work.

Designers of Ibero-American household furniture also creatively adapted European stylistic ideas. Status-conscious colonial clients were particularly drawn to benches or settees incorporating four or more chair backs, a modular design element that lent itself to use in front of equally repetitive, and flexible, *biombos*. Like Iberian examples, such settees derived from English Rococo models, as in the ribbon-like "Chippendale" splats and carved crest rails also found in contemporary Spanish-American chairs. In Mexico and Peru such benches were often made in sets of two or four, with twelve, twenty-four, or more matching side and armchairs; one *casta* painting depicts a settee that wraps around a corner, with at least ten interlaced splats.

A different and more distinctive colonial form of seating was the *butaque* or *butaca*, a comfortable, low-slung recliner sometimes known in English as a "Campeche chair" after the manufacturing and port city on the Yucatan peninsula. They were widely exported from there to the southern United States in the early nineteenth century. The type originated in Venezuela with the indigenous *putaca* (seat, in the Cumanagoto tribal language), a ritual or shaman's chair known throughout the Caribbean area. From at least the early seventeenth century, colonial woodworkers reworked this native model using European tools and techniques to produce light, X-framed *butaques* with suspended leather seats and heavier *butacones*, usually with arms, four legs, and upholstery. An armchair attributed to the mixed-race Caracas cabinetmaker Serafín Antonio Almeida (1752–1822; fig. 18.20) incorporates Rococo elements—including cabriole legs, ball-and-claw feet, and a curvaceous front rail—with delicate floral garlands in marquetry inlay that recalls British Neoclassical motifs popularized by Robert Adam and others. Thus a Caribbean ceremonial seat had been transformed into an archetypal colonial easy chair, its backward-sloping seat and padding—so different from upright Spanish models—ideal for comfortable reclining in private areas of the home.

A short-legged small table known as a *bufete de estrado* (from a region in present-day Argentina; fig. 18.21) also merges imported models with colonial social rituals, while paralleling European trends toward specialized domestic forms. In

an echo of Iberian Mudéjar customs, low tables of this type were used throughout Spanish America, with pillows as seating, on the *estrado*, a low platform or dais often located behind a balustrade or beneath a window. The *estrado* became synonymous with colonial parlors. First designed to avoid contact with cold floors, it was maintained among fashionable women as a space for eating, sewing, or drinking chocolate or *yerba maté* (a kind of tea) even after men began using chairs elsewhere in the room.

Buenos Aires retained the *estrado* into the nineteenth century (long after its abandonment in Lima), reflecting both the city's provincialism and its newfound prosperity after the establishment of the Viceroyalty of the Río de la Plata in 1776 as a bulwark against Brazil. The cabriole legs, ball-and-claw feet on this *bufete de estrado*, along with the pierced foliate or shell carving and cross-hatched cartouches on the knees and drawers, all reflect the European Rococo. Yet in this case Asian models proved equally inspiring. Low, Chinese *kang* tables imported via Manila were also used on raised platforms. A related, but different, modification is seen in console tables from Mexico and Brazil, in which pendulous wooden skirts suggesting folds of cloth increased the sense of long-legged elegance and height.

European styles also penetrated deep into South America's interior, where Jesuit missionaries were establishing new Indian communities or "reductions" (*reducciones*), partly modeled on native villages, in an attempt to consolidate scattered native populations and facilitate conversion and administration. The grandest stone churches, designed

Fig. 18.20. Attributed to Serafín Antonio Almeida. *Butacón*, Caracas, c. 1800. Hardwood, carretto wood inlay, cedar, modern upholstery; 40³⁄₁₆ x 32½ x 17¹¹⁄₁₆ in. (102 x 82.5 x 45 cm). Private collection.

Fig. 18.24a–b. Writing desk, Puebla, 1750–
1800. Wood, bone,
ivory, paint, *maque*
lacquer, gold pigment,
metal mounts; 87⅜ x
41⅜ x 25⅝ in. (222 x
105 x 65 cm). Museo
José Luis Bello y
González, Puebla.

Bold as this decoration is, this Mexican version of Al-Andalus nonetheless suggests the adoption of geometric motifs and classicizing ideals at the expense of Rococo curves. Related objects from the same workshop are more restrained, with abstracted fans, tapered legs, and repeated lozenges typical of the Federal style popular in the United States from about 1780 to 1820. Inside, however, the Puebla desk reveals its Spanish-American heritage with a display of bright red lacquer evoking costly Asian imports but created, like objects from Pasto and Michoacán (see fig. 12.18), using indigenous materials and techniques. The scene depicted is purely local: a rich landowner's hacienda, complete with roads, hunters, a corral, and miniature buildings. This acute consciousness of home, combined with expanding horizons, partly fueled the independence movements that eventually split Iberia from its colonies and inaugurated a new chapter in Latin American life and culture.

JEFFREY COLLINS

LATIN AMERICA 1830–1900

In the newly independent countries of Latin America, design and decorative arts were powerful means of conveying political and cultural ideas, values, and attitudes. The Roman Catholic Church had been the single main source of commissions, inspiration, and funding for many creative practices during the colonial period, but the emerging republics saw the church as part of the old order. They wanted new political and cultural icons, subjects, and themes that spoke of national unity, sovereignty, and modernity, as well as liberal values such as liberty and equality. They looked primarily to France and the United States for models of republican nationhood, and to those countries, together with Britain, for models of modernization.

The independence movements that took place during the first three decades of the nineteenth century profoundly shaped the history of what we now call Latin America. This term is generally defined as a geographic region of the Americas characterized by a common use of Romance languages, predominantly Spanish and Portuguese with some French, and has been used historically and strategically to tie the region to Latin Europe and the idea of pan-Latinism while referencing the region's colonial legacy. After overthrowing

French power in 1804, Haiti (formerly the colony of Saint-Domingue) was the first country in the region to declare itself a free republic. Brazil seceded from Portugal in 1822 as a constitutional monarchy (becoming a republic in 1889), and by 1830, the Spanish territories in the Americas, with the exception of Cuba and Puerto Rico (both of which remained under Spanish rule until 1898), had achieved independence. The once enormous Spanish Viceroyalties of New Spain, Peru, New Granada, and Rio de la Plata were progressively fragmented into smaller independent republics, twenty-one in all by 1903.

The struggles for independence from Spain took a tremendous toll in human life and caused great social and economic upheaval. Reconstruction was protracted in what were predominantly rural countries, with profoundly unequal and segmented societies, high rates of illiteracy, and economies heavily based on natural resources and farming and reliant on slave labor. (It took more than eighty years to fully abolish slavery in the region, from Haiti in 1804 to Brazil in 1888.) After 1830, trade with Spain and Portugal, previously a near monopoly (though smuggling had been a widespread practice), greatly diminished and was replaced by more dynamic networks that included Britain, France, Austria, Prussia, and the United States. Despite import tariffs (imposed to protect local manufactures but also to raise much-needed revenue), inadequate infrastructures within and among Latin American countries, especially the roads, meant that imported goods were often cheaper for those living in coastal areas to buy than were domestically made items produced inland. Nevertheless, there was a slow but gradual economic recovery between 1830 and 1860, and more rapid economic progress thereafter as the development of export economies based on the extraction of natural resources, raw materials, and foodstuffs permitted buying greater amounts of imported manufactured goods.

Although economic vitality shifted according to global market demands, Mexico, Argentina, Brazil, and Chile were among the wealthiest nations in the region. Mexico experienced considerable political turmoil and economic depression after independence and civil war, but by the 1880s, the recovery of both silver mining and textile manufacture to the levels of the colonial period improved the situation. Production of *henequen* (vegetal fibers) in the region of Yucatan also helped move the country toward economic recovery. Argentina experienced such significant economic growth from the late 1870s through agricultural exports such as beef, wheat, and corn that by the end of the century, it was one of the richest countries in the world. In the vast geographic area that constituted Brazil, development was particularly uneven, but it too became wealthy largely because of an export economy based on coffee and cattle products from the southern states, cotton and sugar from the northern, and, from the late nineteenth century, rubber from the Amazon region.

Pre-independence Chile primarily exported metals and wheat in the early 1800s, but from 1880 to 1913, after seizing land from Peru and Bolivia during the War of the Pacific (1879–83), two-thirds of its exports comprised the only commercially viable source of sodium nitrate in the world. Before Chile entered the fertilizer market, Peru dominated the market with guano from the 1840s to the 1870s, with silver, sugar, cotton, rubber, and wool exports gaining importance at the end of the century. The export economies of coffee (Brazil, Colombia, Costa Rica, and Venezuela); sugar (Cuba and the Dominican Republic); and beef, grain, and cattle products (Argentina) were largely responsible for generating the great wealth that funded much of the elite consumption discussed below.

In each country, elites looked to Britain and especially France on matters of taste and consumption. Imported goods were effective indicators of social and economic difference, and helped to maintain and mark class and other hierarchies in postindependence contexts. In the main ports and cities, new shops carried imported goods from Europe including food, furniture, textiles, and clothes. The demand by the upper and upper-middle classes for fashionable European luxury and household objects immediately after independence in the Chilean cities of Valparaiso (a key port for the Pacific trade before the Panama Canal opened in 1914) and Santiago led a number of British, French, and Prussian merchants to establish what became leading retail shops in those cities. At the same time, internal manufacturing improved along with communications as foreign investors took advantage of concessions offered by Latin American governments desperately seeking foreign investment to build railroads and telegraph lines and organize further cultivation, extraction, and export of natural resources. High rates of immigration, particularly in Brazil and Argentina, from the West Indies, Asia, and various parts of Europe, addressed potential labor shortages.

NATIONAL IDENTITIES

The iconography adopted by movements against colonial or autocratic rule, particularly France during the French Revolution and the United States during the War of Independence, inspired discourse in the young republics about visual matters and national identity. The conical Phrygian cap, which in both France and the United States was associated with liberty, for example, appeared on the coats of arms and coinage of several Latin American countries, while fasces, associated with the governance of the ancient Roman Republic, featured on the coat of arms of independent Great Colombia (1819–31; present-day Panama, Colombia, Ecuador, and Venezuela). Incorporated into national visual repertories at the same time were a wide variety of references to native flora and fauna, such as palm trees, nopal cactus, llamas, and Andean condors, as well as forms and motifs associated with pre-Columbian history and traditions. The foreign references often alluded to lofty ideals while local ones introduced specificities of place, history, memory, and tradition. Both aspects blended into new iconographies of nationhood. Ubiquitous national symbols and imagery featured on buildings, clothing, household goods, flags, coats of arms, coins, military uniforms, regalia, and other items.

Inspired by the laurel wreaths awarded to victors in ancient Greece and Rome, the gold wreath illustrated here (fig. 18.25) embodied Republican ideals while referencing

national identity and distance itself from other Latin American nations by highlighting an association with monarchic powers and a European heritage.

International exhibitions within Latin America included those in Lima, Peru (1872), and Santiago, Chile (1875), as well as the Continental South American Exhibition in Buenos Aires, Argentina (1882), and the Centro American Exhibition in Guatemala City (1897). Given the growing economic importance of the United States and its potential as a major commercial partner within the Americas, there was some Latin American presence at most of the larger United States–organized exhibitions, including the 1876 Centennial Exposition, Philadelphia. For the 1884 World's Industrial and Cotton Exposition, held in New Orleans, the Mexican engineer José Ramón Ibarrola Berruecos (1841–1925) designed the Mexican pavilion in the then popular "Moorish" style. Much admired, this "Mexican Alhambra" was built in Pittsburgh by the Keystone Bridge Company using prefabricated concrete panels and ceramic tiles. Many of the objects appearing at such exhibitions were specially produced to showcase the talents of the designers and craftspeople involved. One such piece, a sideboard with marquetry decoration made in Mexico City and probably designed by the makers Mariano and Jesús Fernández, won six major exhibition prizes between 1857 and 1880 (fig. 18.29).

Fig. 18.29. Attributed to Mariano and Jesús Fernández. Sideboard, Mexico City, c. 1856. Wood, mother-of-pearl. Centro INAH (Instituto Nacional de Antropología e Historia) Puebla.

CLOTHING AND ACCESSORIES

European influence remained strong in terms of elite and middle-class clothing and accessories. Textiles, primarily cotton and woolen fabrics, made up the bulk of imports to postindependence Latin America. Cloths from Britain alone increased from 56 million yards per year in 1820 to 279 million in 1840 and continued to grow thereafter. During the independence and postindependence periods, clothing and accessories often served as vehicles for expressing patriotism. From the 1820s, wealthy Argentinian women intervened in the male-dominated political discourse of the day by adopting *peinetones*, oversized versions of the *peineta*, a Spanish hair comb used to keep a mantilla or veil away from the head in order to protect the hairstyle, which was introduced in the Americas in the early eighteenth century and absorbed into nonindigenous clothing conventions. By adopting the *peinetón* and discarding the *peineta*, with its Spanish associations, women created a highly visible and distinctly gendered sign of active political engagement.

Part of the attraction of the larger *peinetón* came from its greater surface for display. Often made from tortoiseshell, *peinetones* were highly decorated. Surface ornamentation ranged from bejeweled patterns to painted scenes from nature and patriotic and political slogans. "Confederation or

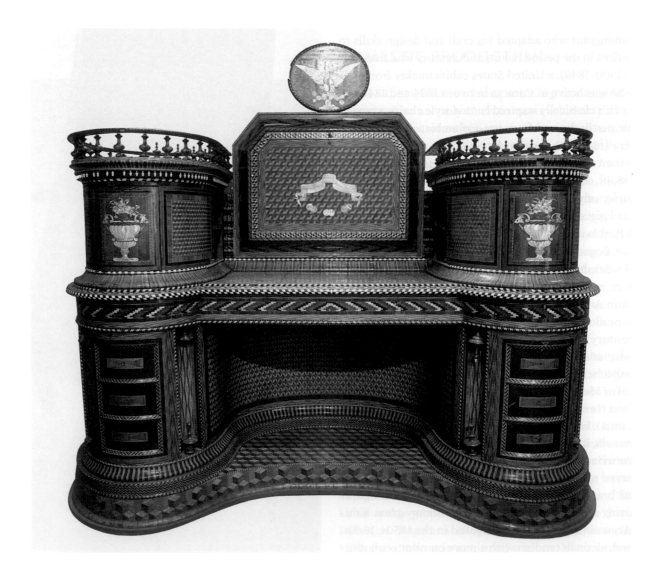

Death," for example, related to postindependence struggles in Argentina between those who supported a federal system (or confederation) and those who wanted a unitary state. Once the Argentinian Confederation (1829–52), under the leadership of Juan Manuel de Rosas, was reasonably well-established, however, the cultural tide turned against the *peinetones*, and by implication their wearers, for being too outspoken and visually assertive. Swiss-born lithographer César Hipólito Bacle (1794–1838; fig. 18.30), while sometimes caricaturing such items, also created images that reflect the popularity of this subject type, as well as to the many anxieties they aroused about women's roles and place in postindependence and postcolonial Argentina.

Other accessories that served as canvases for displaying political sentiments were fans and gloves, some of which bore the portrait of De Rosas. Slogans appeared inside the rims of men's top hats and thus were visible when doffed in greeting. De Rosas's 1832 legislation enforcing the wearing of the color red or red insignia, which was part of a ruthless campaign to force citizens to publicly declare their allegiance, significantly shaped Argentinian material culture as well as social behaviors during this period.

While elites generally wore European fashions, the broader populace continued to wear versions of regional clothing made according to local design and craft traditions. A folkloric style of women's dress called *china poblana* (Chinese Pueblan), which originated in the eighteenth century in the Puebla region, became mythologized as the invention of an Indian slave, Mirra, later baptized Catarina de San Juan, who was sent to Mexico. The style included an intricately embroidered and decorated full skirt, blouse, and silk shawl. In the nineteenth century, the *china poblana* was reinvented as a Mexican national costume. By the last quarter of the century, as upper-class interest in national and regional heritage grew, vernacular costumes, textiles, and jewelry increasingly influenced elite clothing, and so-called national dress was worn by members of the elite who had not done so before.

The familiar *poncho*—a simple, rectangular garment with an opening at the center—existed in many cultures but is closely associated with the precontact indigenous peoples of Peru. Its adoption by European immigrants in a hybridized form gained prestige in the late nineteenth century as a symbol of Latin American identity. In terms of materials, traditions were set aside as particular cloths were used to suit particular climates throughout Central and South America: vicuña, alpaca, and sheep wool for cold climates; silk, linen, and cotton for hot. Similarly, Mexican blanketlike *sarapes*, particularly those from Saltillo, became a customary part of male attire and a symbol of nationhood across the social classes from the mid-nineteenth century.

Along the Caribbean coast, especially in Venezuela, men wore a traditional linen or cotton suit called a *liqui-liqui*, distinguished by its ordinarily white or cream color and mandarin-style collar fastened by a chain-link *yunta*. Perhaps no other garment has signified Latin American menswear as strongly as the *guayabera*, an amply cut lightweight cotton shirt with front pockets, embroidery, and straight hem worn untucked. The origin of the *guayabera* is unclear, although it

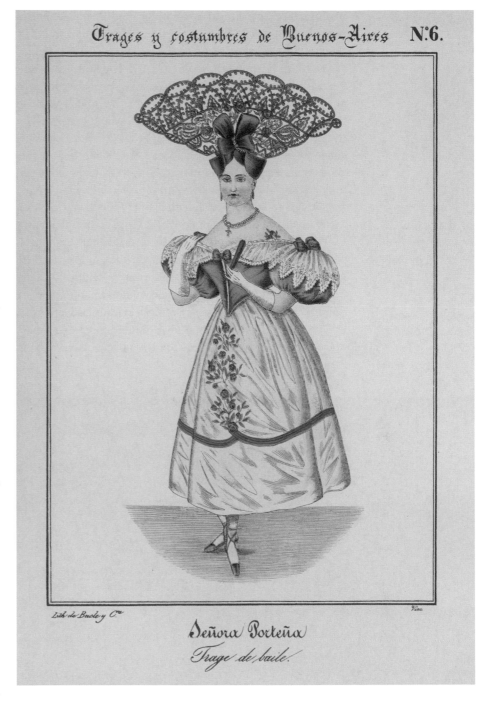

Trages y costumbres de Buenos-Aires N.º 6.

Lith. de Bacle y Cía.

Vinc

Señora Porteña

Trage de baile.

may have originated as a popular form of dress among Cuban plantation workers and was perhaps introduced by Filipino or Chinese laborers after the abolition of slavery.

"BELLE EPOQUE"

The last quarter of the nineteenth century was one of great prosperity for Latin American elites. The term "Belle Epoque"—referring to French elite culture of the period 1870–1914 and including a preference for luxurious interiors, furnishings, and clothing—is sometimes used to describe a similar time in Latin America. The era was characterized by lavish expenditures on palatial houses and furnishing, especially in richer countries such as Argentina, Brazil, Chile, and Mexico. Period advertisements indicate a wide array of foreign clothing and decorative arts goods, much of it of French

Fig. 18.30. César Hipólito Bacle. Woman wearing a *peinetón*, from *Trages y costumbres de la provincia de Buenos-Aires*, 1833 (facsimile reprint, 1947).

manufacture. The interior of an upper-middle-class home in Santa Fe de Bogotá, Colombia, of about 1874 as interpreted by the famous painter of custom-scenes Ramón Torres Méndez (1809–1885) is shown here (fig. 18.31). The wallpaper, and what is either a clavichord or piano, were probably of European origin, whereas the sofa and chairs could have been bought from a local cabinetmaker. The wealth generated by the export economies allowed prosperous individuals to purchase expensive items from abroad, but some high-status goods were made in Latin America. The dress might have been imported or made by the local dressmaker following a Parisian design and employing fine British or French fabrics. Both the woman and the interior convey culture and refinement.

European-trained native as well as foreign architects, designers, and engineers helped modernize cities based on models of, and standards set by, European capitals. Amidst the new neighborhoods and broad avenues emerging during the late nineteenth and early twentieth centuries in cities like Buenos Aires, Mexico City, Rio de Janeiro, and São Paulo, there were improvements to the infrastructure—new

aqueducts and sewage systems, railway stations, and transportation systems. New opera houses, social clubs, private mansions, and parks opened. The jewel in the crown of Rio de Janeiro's new Avenida Central was the Municipal Theater (1904–9; fig. 18.32), inspired by the Beaux-Arts Paris Opéra (1861–75) designed by Charles Garnier. Rio's theater was conceived just after the turn of the century but in many ways stands as a marker of the intention to continue re-creating the splendors of Paris in Brazil. Designed by Francisco de Oliveira Passos (1836–1913), the Brazilian engineer and son of the then-mayor of Rio de Janeiro, together with French architect Albert Guilbert (1866–1949), it reveals a more eclectic version of Beaux-Arts style that was popular at the turn of the century, exhibiting a rich medley of influences, from Neoclassicism, Baroque, and Mannerism to touches of neo-Byzantine and Gothic Revival. The theater also featured artwork by Brazil's most prominent fine artists, including the proscenium cupola friezes by Eliseu Visconti (1866–1944); murals by Rodolfo Amoedo (1857–1941); and statues, mosaics, ceiling paintings, and stained glass by Henrique (1857–1936) and Rodolfo Bernardelli (1852–1931).

During the boom in urban construction of the last few decades of the nineteenth century and into the early twentieth century, two- and three-story houses and mansions replaced single-story colonial and colonial-style courtyard homes. Many of the new domestic buildings adapted the French Second Empire style, popular in France from about the 1850s to 1880s, with mansard roofs, grand staircases, and gardens closed off from the street with wrought-iron railings and gates. Neoclassical influences continued within the Beaux-Arts style.

By 1900, the Art Nouveau style that began in Brussels and Paris about 1893 had also impacted the visual and material culture of Latin America. Among the new houses built in the prosperous and expanding Brazilian city of São Paulo, for example, was the Vila Penteado (1902; fig. 18.33) designed by Swedish architect Carlos Ekman (1866–1940), who emigrated to South America in 1888. He married into São Paulo's upper class in the early 1890s and thereafter designed mansions for several members of the local elite. Located in the suburb of Higienópolis amidst a host of Neoclassical mansions, its sixty rooms housed the family of Count Antonio Alvares Penteado, a wealthy coffee farmer and entrepreneur, and that of his son-in-law Antonio Prado, Jr. Elegantly decorated with woodwork, bas-relief, gilded plaster, and mosaic floors of floral-inspired motifs, it was furnished throughout with European furniture, stained glass, and marble, primarily Art Nouveau in style.

Fig. 18.31. Ramón Torres Méndez. Interior in Santa Fe de Bogotá, Colombia, c. 1874. Oil on cardboard; 13¾ x 10 in. (35 x 25.4 cm). Museo Nacional de Colombia, Bogotá (2096).

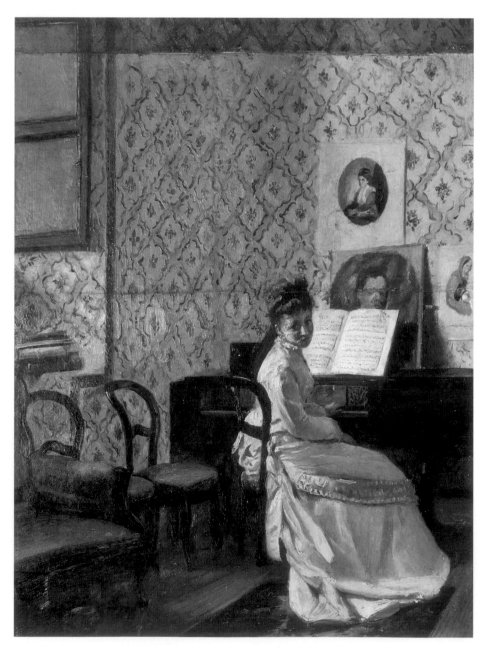

Fig. 18.32. Francisco de Oliveira Passos and Albert Désiré Guilbert. Theatro Municipal, Rio de Janeiro, 1904–9 (postcard, c. 1910).

Over the several decades presented in this chapter, Latin American cultures experienced significant transformations that were reflected in the material and visual culture. The birth of newly independent nations called for the construction of national symbols and identities that drew influences from a mix of indigenous and immigrant people, inherited traditions and novel interpretations, native and foreign materials, local craftsmanship and imported manufactures. Each country established new institutions for the cultivation of its citizenry alongside national displays, images, and representations for international circulation and consumption. As economies flourished through global trade networks, urban centers were reconstructed to accommodate growing populations, and social stratification adopted and reinvented diverse cosmopolitan tastes. By the early twentieth century, the stage had been set for the continued development of national identities in tandem with new material manifestations of industrialization and modernization.

PAT KIRKHAM, PATRICIA LARA-BETANCOURT,
CHRISTIAN A. LARSEN, JORGE F. RIVAS PÉREZ

Fig. 18.33. Carlos Ekman. Interior, Vila Penteado, São Paulo, 1902 (with 1990–2002 restorations).

NORTH AMERICA

In 1750, most residents in the North American colonies lived close to the Atlantic Coast in buildings and with furnishings patterned after European models. They had relatively few possessions and limited numbers of object types. By 1900, European Americans in what became the United States (effectively independent from 1781) and Canada (established 1867) would experience a dramatic increase in the amount and diversity of goods available to them. These changes were driven by shifts in demography, continental expansion, commerce, manufacturing, consumption, taste, and ideology that altered the material landscape. At the dawn of the twentieth century, the rest of the world saw the United States, and to a lesser extent Canada, as lands of prosperity and plenty.

France's North American colonies underwent great changes in the period. After the Treaty of Paris ended the Seven Years' War (known in the colonies as the French and Indian War, 1754–63), the northern sections of New France (including what are now Quebec, Ontario, and New Brunswick) were ceded to Britain and opened to British settlement. The southern section—the Louisiana Territory—was put under Spanish control (it was later returned to France in 1801, and sold to the United States in 1803). At about the same time, the fur trade, which had been an economic mainstay for New France, was suffering due to diminishing supplies and competition from British merchants. It was replaced by a lucrative trade in timber. Although areas like Quebec and Louisiana remained strongholds of French culture and style under their new governments, in general the once-pervasive influence of France dwindled as increasing numbers of British settlers moved in.

Urban areas experienced the greatest change. In the 1760s and 1770s, splendid carriages appeared in the streets of large cities, and portraits by painters such as John Singleton Copley (1738–1815) graced patricians' homes in Boston and New York. Copley's fame was so great that he was invited to the Nova Scotia city of Halifax in 1757 and again to Nova Scotia and Quebec in 1763–64. Although he declined due to his numerous Boston commissions, the invitations indicate that there was sufficient wealth in Canadian cities to employ him.

The same networks of trade and communication that carried goods from Europe across the Atlantic to the northern colonies brought increasing numbers of European artisans and ideas. Many settled mostly to the port cities, which were centers of government as well as commerce, with clusters of merchants, magistrates, and other professionals eager to patronize new artists and craftsmen. Some of the newly arriving craftsmen had trained in major manufacturing centers such as London and Edinburgh and came armed with new designs. Books of designs known as pattern books, including Thomas Chippendale's *The Gentleman and Cabinet-Maker's Director* (published in London in 1754, see fig. 17.7), provided information about stylish furniture forms and helped popularize the English Rococo style within both the British and French colonies. Imported Caribbean mahogany, and domestic walnut stained to imitate it, became increasingly popular for furniture and woodwork in this style, in part because it made possible crisper and more intricate carving.

The value of British imports to its North American colonies almost doubled in the 1750s, from £1.1 to 2.1 million. British manufactories turned out a cornucopia of ceramics, cutlery, textiles, and other goods, which crossed the Atlantic to eager consumers. In 1771, William Eddis, surveyor of customs and a merchant residing in Annapolis, Maryland, commented that new fashions were adopted earlier by affluent American colonists than by many of their sort in London, an observation that, while probably exaggerated, points to the demand for, and consumption of, fashionable goods in the colonies.

By the 1750s, one-third of all British vessels were made in New England, and British American colonists were trading with Europe, Africa, Asia, the West Indies, and South America. In a 1766 account of a visit to a Boston merchant's house, John Adams, the Boston lawyer and later second president of the United States, described some of the expensive luxury goods, including a chimney clock, marble table, and bed hangings of crimson damask, as "the most magnificent of any Thing I have ever seen."[1]

COLONIAL FURNISHINGS

In New England and the Middle Colonies, the domestic production of furniture involved groups of highly skilled artisans. In several cities, cabinetmakers banded together in trade societies to agree on prices for furniture and wages for journeyman craftsmen. In a price book published in Philadelphia in 1772, for example, a plain tea table with claw feet was priced at £3 5s in mahogany or £2 5s in walnut, and a journeyman was entitled to 12s 6d in wages for his work on it.[2] Colonial cabinetmakers were encouraged to construct elaborate items as demand grew for larger and more sophisticated pieces reflective of newly acquired affluence. Nonetheless, social unrest and economic uncertainty about the future, especially in revolutionary hotbeds such as Boston, caused some recent arrivals to move elsewhere. Thomas Harland, a watch and clock maker from London who arrived in Boston in 1773, for example, relocated to Norwich, Connecticut, a town of about 7,500 inhabitants and a growing cluster of craftsmen. There he made the latest designs of British-style clocks and trained a younger generation of Connecticut clock makers.

By the third quarter of the eighteenth century, Philadelphia had supplanted Boston as the largest and richest of the colonial port cities, with its spacious streets, large brick and stone houses, and busy docks. The thriving business center attracted a wave of artisans who enthusiastically applied the latest designs to architectural interiors, engravings, silver, and furniture, as well as upholstery and draperies. Scottish-trained furniture maker Thomas Affleck (1740–1795), who

arrived in 1763 and brought his copy of Chippendale's *Director* with him, eventually rose to become one of the most successful woodworkers in that city. In 1770–71, he drew on some of the city's local carvers and upholsterers when he served as primary contractor for the house renovation and refurnishing carried out by merchant John Cadwalader and his wife, the heiress Elizabeth Lloyd Cadwalader. They were Philadelphia's leading patrons of the Rococo style, and Affleck provided them with more than twenty pieces of richly carved and upholstered mahogany furniture, including three sofas for their parlor.

The so-called Pompadour high chest of drawers, named for the unidentified carved female bust at the top, exemplifies the high quality of cabinetmaking in prerevolutionary Philadelphia (fig. 18.34). Neither its maker nor its date are known, but the object is a fine example of a fashionable genre of case furniture made in that city in the second half of the eighteenth century. Many related high chests survive, all owned originally by affluent families and based on the same formula as that seen here—a larger case of drawers elevated above a smaller case, the latter supported by cabriole legs usually ending in ball-and-claw feet. Gilt cast-bronze mounts con-

Fig. 18.34. High chest of drawers, Philadelphia, 1762–65. Mahogany, tulip poplar, yellow pine, white cedar, gilt bronze; 91¾ x 44⅝ x 24⅝ in. (233 x 113.3 x 62.5 cm). The Metropolitan Museum of Art (18.110.4).

Fig. 18.37. Thomas
Fletcher and Sidney
Gardiner. Presentation
vase (one of a pair),
Philadelphia, 1825.
Silver; 23¾ x 20¾ x
14¾ in. (60.3 x
52.7 x 37.5 cm). The
Metropolitan Museum
of Art (1988.199).

trade. Prior to independence, colonists had not been able to trade directly with Chinese silk and porcelain manufacturers, and imported goods from China had to pass through Britain before going on to colonial ports. After independence, the China trade was opened to United States merchants in 1785, creating fortunes for ship owners and leading to increased growth for the Atlantic port cities of Boston, New York, Philadelphia, and Baltimore. New York outstripped the rest, however, in size and economic importance, thanks to its excellent harbor, growing financial infrastructure, and the Erie Canal.

To celebrate the opening of the canal and the prosperity it was expected to bring, a group of New York merchants commissioned a pair of grandly impressive silver vases from the Philadelphia firm headed by Thomas Fletcher (1787–1866) and Sidney Gardiner (1787–1827), then the country's leading producer of presentation silver, to be given to New York Governor DeWitt Clinton who had supported the canal project (fig. 18.37). Imposing two-handled cups had been staples of this type of silver in North America since 1700, but by the early nineteenth century, the cup form had been replaced by a Neoclassical urn, or vase on a raised base. Modeled after the so-called Warwick Vase, a monumental Roman marble urn found in fragments late in the eighteenth century near the site of Emperor Hadrian's villa at Tivoli in Italy, the Fletcher and Gardiner vases were adorned with scenes of the canal, showing its entrance near Albany, the falls at Cohoes, the Little Falls of the Mohawk River, and the aqueduct at Rochester, among others. To these were added figures of Mercury (representing commerce), Ceres (agriculture), Hercules (strength and great labor), and Minerva (wisdom and trade), as well as allegories of Fame, History, and Plenty. The intricate composition was triumphantly capped with an eagle. In capturing the ambitions of the expanding metropolis of New York City, these vases document the cultural authority of classicism in which the postrevolutionary United States clothed itself.

The heyday of the canal systems was short-lived. As railroads grew in number and coverage, they siphoned off much of the intercontinental trade that once depended on the waterways. The first railroads in the United States were built in the late 1820s, and by 1869, the Transcontinental Railroad took passengers and cargo from New York to San Francisco in six days. The Grand Trunk Railroad in Canada linked Montreal and Toronto by 1856, and by 1880, it too offered routes to cities in New England and west to Chicago.

The new middling market of consumers sought affordable objects that signified cultural authority. In order to advance their social claims in the bustling, mobile, commercial society of the early nineteenth century, they wished to own the same sorts of furniture, books, clocks, and portraits that had once been the province of the elite, aristocratic few. Cultural commodities became key props in the drama of proving and performing genteel status. Entrepreneurs and artisans found ways to change production methods in order to transform limited-quantity, high-end objects into mass-marketed goods. The new opportunities for craftsmen after the demise of the aristocratic and hierarchical colonial system were noted by French political historian Alexis de Toc-

iconography for a nation reaching a degree of maturity. Roman influences continued, and imperial eagles (now recast as American bald eagles, which became a national emblem on the Great Seal of the United States of America in 1782) graced tables, chairs, silver bowls, textiles, and other furnishings, both public and domestic.

DESIGNS FOR A NEW MIDDLE CLASS

Following the American Revolution, citizens of the new nation worked toward achieving economic independence from Europe. In the hinterlands, rural residents looked to manufacturing to provide locally available goods and foster regional growth. The new state governments promoted economic development, such as improved roads, canals, and, later, railroads, thus helping to create a vast national market over the course of the nineteenth century.

The 1825 opening of the Erie Canal linked Buffalo, New York, to Albany and the Hudson River, and made it faster to get goods from the Great Lakes to the Hudson and from there to the Atlantic Ocean. The 1837 Rideau Canal provided a similar function in Canada, linking Kingston, on Lake Ontario, to Ottawa. These new canals further facilitated international

queville on his tour of the United States in the 1830s: "In an aristocracy he [the craftsman] would seek to sell his workmanship at a high price to the few; he now conceives that the more expeditious way of getting rich is to sell them at a low price to all. But there are only two ways of lowering the price of commodities. The first is to discover some better, shorter, and more ingenious method of producing them; the second is to manufacture a larger quantity of goods, nearly similar, but of less value."[3] De Tocqueville also noted that whether rising or falling in society, consumers would want goods, thus dramatically expanding domestic markets.

One example of the new, more widely available furniture was the Windsor chair, a form of English origin notable for its solid wooden seat, sturdy construction, and interchangeable parts. Such chairs were assembled from several different woods, each selected for its distinctive structural properties—sturdy white pine or tulip poplar for seats, maple (a wood that is easily turned on a lathe) for legs, flexible hickory for bent back bows. The woods were then painted to mask their varying colors and to unify the design. In both the United States and Canada, Windsor chairs and settees provided seating in hallways, kitchens, and porches of large and small private homes, as well as in taverns and public buildings including Philadelphia's Independence Hall.

These cosmopolitan seating forms signified an owner's preference for fashionable goods while their production lent itself to efficiency through division of labor. The different parts could be made by workers at separate locations and stockpiled for assembly. Individual workshops varied greatly, but in the competitive climate of Northampton, Massachusetts, the probate inventories of the estate of cabinetmaker Ansel Goodrich (1773–1803) show that he employed up to five journeymen and apprentices but also hired rural craftsmen to supply roughed-out chair parts. He probably produced about four to five sets of six chairs each week.

The scale of production changed, however, with the colorfully decorated so-called Hitchcock chairs, named after cabinetmaker Lambert Hitchcock (1795–1852), whose Connecticut factory mass-produced them beginning in the late 1820s. Combining the European elegance of Neoclassicism with the efficient model of Windsor chair production, these chair types featured stenciled forms in place of freehand painted decoration while painted striping replaced turned elements. Hitchcock chairs (and numerous imitations), which were sturdy and cheap yet elegant in design and decoration, were widely used across social strata.

THE APPEAL OF DECORATION

In rural Connecticut, clock makers used wooden parts to replace expensive metal ones and adopted faster and cheaper methods of clock manufacture. Eli Terry (1772–1852) was one of these innovative clock makers. He had learned clock design and precision machinery under Daniel Burnap (1759–1838), who had apprenticed with clock maker Thomas Harland, and Terry combined this knowledge with his experience with the Cheney brothers—Benjamin (1725–1815) and Timo-

thy (1731–1795), makers of wooden movement clocks. In 1806, Terry, who used water power for sawing wood, received a three-year contract from two Waterbury merchants to build four thousand tall-clock movements, including dial hands, weights, and pendulums (cases would be supplied by other craftsmen)—all for four dollars apiece. The successful completion of this order led to even greater success. Among his later innovations was the 1810–12 reorganization of clock mechanisms to fit into short cases, as well as the fusing of the clock works and case into a single unit rather than placing the movement inside a separate wooden case.

Terry began producing shelf clocks in 1816 (fig. 18.38), with assistance from his brother Samuel, transforming the clock industry. Tall-clock movements were large, delicate, and difficult to transport. These movements were generally purchased from clock makers, while the cases had to be bought from cabinetmakers. In contrast, shelf clocks were compact and traveled well—a boon for the itinerant peddlers who sold them throughout the country. Before Terry's innovations, a clock maker could produce about 25 clock movements a year at $25 each without a case; afterward, a clock maker could produce up to 2,500 shelf clocks a year at $10 each, case included. Clocks thus became affordable and accessible to a much wider market than previously.

For a public enamored of decorated goods, the basic box clock, though cheap, was considered too plain, and the cases

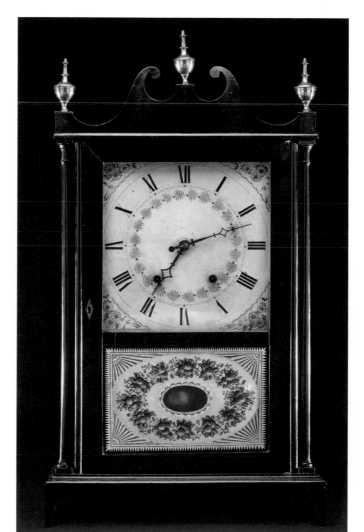

Fig. 18.38. Eli and Samuel Terry. Pillar-and-scroll shelf clock, Plymouth, Conn., 1825–28. Oak, cherry, maple, mahogany, glass, brass; 31½ x 17⅝ x 4⅝ (80 x 44.8 x 11.8 cm). National Museum of American History, Smithsonian Institution, Washington, D.C. (1984.0416).

were redesigned, with added ornamentation to make them more desirable (see fig. 18.38). The case acquired a pair of slender pillars on the side, scroll work on the top, and a set of graceful feet—embellishments inspired by the pillars and scrolled tops found on the hoods of many tall clocks. A separate dial was added. The pillar-and-scroll design became the basic form for the shelf clock from the 1820s, even in the far reaches of the frontier. One traveler in Arkansas, for example, noted that "in every cabin where there was not a chair to sit on there was sure to be a Connecticut clock."[4]

The exuberant and colorful decoration on Connecticut shelf clocks was extended to many other surfaces in a drive to embellish the home. Collectors and scholars have often labeled such domestic objects "folk" or "naive," and considered them unsophisticated products of the "preindustrial" countryside. Rural artisans and some urban ones, however, produced such goods to meet tastes for brightly painted furniture and lively, decorated interiors. In many instances, templates and stencils replaced hand-painting, thus maximizing production and keeping in line with the broader-based transformations of craft production going on at the time. The artisan-artist Rufus Porter (1792–1884) became the leading publicist for painted decoration. He painted ornamental landscapes on the walls of dozens of houses throughout Maine, New Hampshire, Vermont, Massachusetts, and Rhode Island in the 1820s and 1830s. Beginning in 1825, he also published six editions of *A Select Collection of Valuable and Curious Arts, and Interesting Experiments* and other manuals that provided recipes for paints and varnishes and instructions for the numerous decorative painting and finishing techniques which underpinned this approach to decoration.

SHAKER SIMPLICITY

The Shakers, a utopian religious society founded in Britain in 1747, boasted nineteen United States communities by 1826 and over six thousand members before the Civil War. While often celebrated in the twentieth century as folk artists with a distinctive aesthetic, Shakers were also part of the emerging consumer revolution in the United States. They embraced technological advances such as the circular saw, and took advantage of developments in marketing and transportation to promote and sell their furniture and medicinal herbs outside their communities. Their "plain and simple" design aesthetic represented order and utility and espoused emotional restraint.

The Shaker oval box, perhaps their most recognizable product, was used to store dry goods and made in standard graduated sizes. It was fashioned of side sheets of maple, split from the plank, wrapped around an oval mold, and secured with distinctive swallowtail joints and copper tacks (fig. 18.39). An industrious Shaker woodworker might make three to four dozen box walls a day in a hybrid mode of mass-and-hand manufacture. The lids were made separately.

Shaker chair makers reinterpreted the eighteenth-century New England ladder-back chair, making it more lightweight, with tilted legs. Finished pieces were painted yellow, red, or green like the oval boxes. Shaker building interiors featured built-in cupboards and pegs along the walls for hanging clothes or chairs, another aspect of their commitment to utility and simplicity, related to the belief that creativity and work were both forms of worship.

TEXTILES: HAND VERSUS MACHINE

Entrepreneurs and the rapid increase in industrialization remade once rural villages into burgeoning factory towns. Favored locations for factories and mills were along fast-moving streams and rivers that could provide water power to turn large wheels for machinery. British immigrant Samuel Slater (1768–1835) brought to the United States spinning and carding cotton machines developed by British inventor Richard Arkwright (1732–1792). In 1793, Slater built the first United States factory to produce cotton yarn, locating it on the Blackstone River in Pawtucket, Rhode Island.

Following Slater's success, Boston capitalists constructed a large-scale textile mill in 1814 in Waltham, Massachusetts, west of Boston. It included power looms for weaving and integrated all the processes of cloth production under one roof. In search of more ample water power, several mill owners moved their enterprises north to East Chelmsford, where they created a new community, Lowell, on the Merrimack River. Single young women from the area formed the bulk of the workforce, but Lowell soon drew workers from an ever-

Fig. 18.39. Shaker-made storage boxes with original paint. Top, probably Canterbury, N.H., 1830–40. Middle, attributed to James Johnson, Canterbury, N.H., 1835–45. Bottom, probably Alfred or Sabbathday Lake, Me., 1840–60. Maple, white pine, paint, copper tacks; top, 4¾ x 3½ x 2⅜ in. (12.1 x 8.9 x 6 cm). Jane Katcher Collection of Americana.

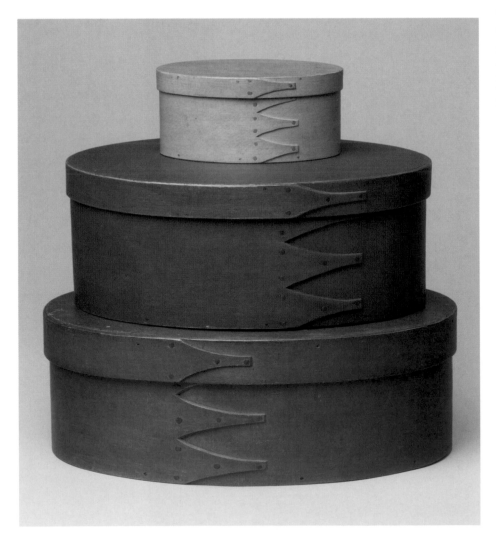

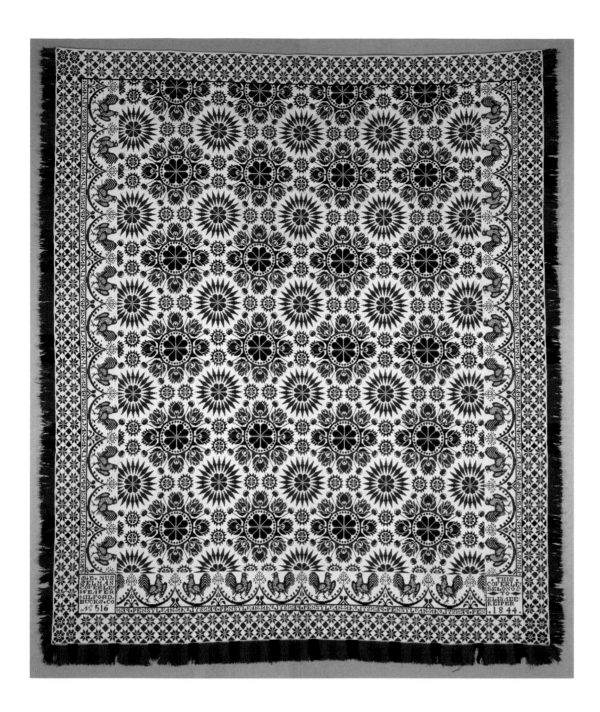

Fig. 18.40. Samuel B. Musselman. Coverlet, Milford, Pennsylvania, 1844. Cotton, wool. Columbus Museum of Art, Ohio (1989.010.264).

wider radius, and by 1850 its population had reached 33,000. The large, multistory brick factories were filled with rows of carders, spinning frames, and power looms, tended by "operatives" or "hands," each watching over several machines.

Outside these mill towns, some independent craftspeople, working in forms less immediately susceptible to industrial mass-production, prospered well into the nineteenth century. Itinerant weavers, for example, many of whom were immigrants from Germany, Britain, or France, traveled the Middle Atlantic and Midwestern states making coverlets beginning in the 1820s. Woven of cotton and wool in two, three, or sometimes four colors, these bed coverings typically had a central field composed of an elaborate repetitive design, sometimes abstract, sometimes figurative, surrounded by a border of flowers, birds, buildings, or numerous other decorative devices. Each coverlet bore the name and location of the weaver, the name of the customer (usually a woman), and the date of manufacture either in the border or, more typically, in a corner block. The spread illustrated here, for

example (fig. 18.40), identifies the weaver as S. B. Musselman (1802–1874), of Milford, Bucks County, Pennsylvania, and includes the number 516, probably signifying that it was the 516th coverlet woven by Musselman. Another corner block states, "THIS COVERLET BELONGS TO ELISABETH KEIPER" and gives the date 1844. The word "PENNSYLVAN," spelled forwards and backwards, appears as part of the border on three sides.

The intricate central design of starbursts alternating with a circular composition of flowers, the border, and the verbal corner blocks were all made possible through the use of a Jacquard attachment on the loom. This feature, developed in France about 1801 by inventor Joseph Marie Jacquard (1752–1834), was known in the United States by 1820. A series of punched cards regulated the movement of the warp threads, thereby facilitating the weaving of extremely complex designs. Hundreds of Jacquard coverlets made in the nineteenth century survive today, most from small towns and villages distant from major urban areas. Although Musselman

remained in the same region throughout his life, other weavers constantly moved westward, trying to keep ahead of the arrival of powered loom weaving and mass production. The weaving of coverlets such as this constituted one of the last types of textile production to be fully mechanized.

Sewing machines revolutionized both factory and domestic textile production. The first sewing machines were developed in Europe starting in the 1790s, but it was not until 1851, when American Isaac Singer (1811–1875) combined a variety of patented sewing machine design features—including foot treadles to power the machines, vertical needles, and presser feet to hold fabric in place—that such machines became practical to use. Sewing machines were initially intended for factory use, but they became smaller and cheaper by the 1860s and soon spread to the domestic sphere. Both urban pieceworkers, who contracted with clothing manufacturers to produce parts of garments, such as collars or sleeves, in their homes, and women in urban and rural areas who wanted to clothe themselves and their families more efficiently, were able to purchase sewing machines thanks to installment payment plans offered by the Singer Company. The company eventually built factories and lavishly decorated showrooms in cities around the world, including Paris (1855), Glasgow (1856), Rio de Janeiro (1858), Hamburg (1863), and Quebec (1882).

NORTH AMERICAN DOMESTIC TASTE AND THE EUROPEAN COURTLY IDEAL

An extremely high literacy rate in North America (90 percent in 1850) underpinned the popularity of prints such as the lithographs of Currier and Ives. Illustrations and advertisements in periodicals and *Harpers Weekly* (1857–1916) and *Godey's Lady's Book* (1830–98) spread fashion and ideas. Many householders turned to the published ideas of professional tastemakers for suggestions on the appropriate styles, floor plans, and furnishings for their homes. Andrew Jackson Downing's (1815–1852) *The Architecture of Country Houses* (1850), one of the most influential examples of the new domestic advice literature that proliferated in the second half of the nineteenth century, celebrated the single-family, free-standing "country" house in its own lot, then popular in villages, small towns, and the new suburbs emerging near large cities.

Downing subscribed to a Jeffersonian hostility to cities and a romantic embrace of the countryside and natural world as the ideal environment for the cultivation of health and moral living. He wrote for middle-class readers and clothed his text in a moralizing garb: "Certainly the national taste is not a matter of little moment. . . . Whether the country homes of a whole people shall embody such ideas of beauty and truth as shall elevate and purify its feelings; these are questions of no mean or trifling importance."[5] His mission was to civilize United States society by reforming domestic architecture: good houses would create good people. This vision was also influential in Canada, particularly with reference to landscaping and cottage-style residences.

Property ownership and the family were regarded as the bulwark of a democratic but socially differentiated culture with particular housing suited for specific classes: villas for the upper class, cottages for the middle class, and farmhouses for the working class. The housing of enslaved people and the urban poor was rarely discussed. Along with a number of his contemporaries, Downing created a literature of architecture for educated amateurs, including a chapter on interiors and furniture. Although he noted "almost a mania in the cities for expensive French furniture and decorations,"[6] and some of the book's illustrations came from British publications, he also showcased recognizably American furniture, such as inexpensive painted bedroom suites from Boston and costly Rococo Revival rosewood furniture from leading New York cabinetmaking firms.

From about mid-century, as mechanization took hold, the introduction of labor-saving machinery such as band saws and rotary planers greatly sped up the preparatory stages of American furniture making, but, as in Europe, many aspects continued to be done by hand. Carvers, often foreign-born, were among the most highly sought-after and best-paid employees, along with upholsterers. After the Parisian firm Fourdinois exhibited an immense walnut sideboard richly adorned with an extensive carved iconographic program of food and foodways at the London 1851 Great Exhibition, such pieces gained in popularity (fig. 18.41). At New York's own Exhibition of the Industry of All Nations in 1853, more than half a dozen prominent firms featured smaller versions of the sideboard with a startling profusion of carved fruits, vegetables, birds, sea creatures, and mammals—just about anything considered edible by omnivorous humankind—all shown in a raw or natural state. Many pieces featured carved stags, often depicted as if freshly killed. Compared to Downing's beneficent view of the natural world, here was a place where violence and predation dominated. In the prominent location of the mid-century upper-class dining room, these scenes offered a visual dialogue between the raw, uncooked foodstuffs displayed in carved form and the cooked versions enjoyed by those seated at the table, which suggested the cultural distance between civilized, affluent diners and the savagery of nature. Furthermore, if extended to humankind, the arguments for predation, violence, hierarchy, and domination paralleled contemporary discussions of the survival of the fittest, whether in nature or in society.

As the nineteenth century progressed, the range of historical styles and cultural references expressed in home furnishings and accessories became increasingly diverse. In both the United States and Canada, Japanese and Islamic forms and motifs began to appear, as did interest in the colonial past and in even earlier English vernaculars. Yet the European courtly paradigm—the manners and preferences of Europe's royalty—still retained cultural authority and was evident in most classes of formal furnishing. For example, to many nineteenth-century people, formal dining meant silver flatware, as well as a concern for etiquette and correct behavior at the table. The term "flatware" typically refers to spoons, forks, knives, and serving pieces used at the table. In 1800, the number of individual forms and the styles they came in were few. By 1900, North American silver manufacturers offered flatware in literally hundreds of different patterns,

with as many as eighty or ninety different pieces available in more popular lines.

The range of silverware forms was dazzling, reflecting the enduring appeal and luxury of silver tableware. In terms of the sheer number of patterns, the high quality of design and workmanship, and the broad range of potential consumers, nowhere else was so much silverware, so diverse and so fine, available to so many. In addition to traditional dinner forks, dessert forks, pie forks, fish forks, salad forks, pastry forks, oyster forks, and lobster forks, to name a few, were available. Other forms were equally elaborate and diverse, including those newly invented to serve specific fare such as tomatoes, croquettes, cucumbers,

and crackers. Among the hundreds of silverware forms and patterns produced, the majority paid homage to Western European courtly traditions. Between 1860 and 1895, for example, Gorham Manufacturing Co. of Providence, Rhode Island, the largest producer of sterling flatware in the United States, sold a variety of patterns whose names referenced European royalty and their world: Prince Albert, Josephine, Fleur de Lis, Louis XIV, Queen Anne, Empress, Fontainebleau, Old Medici, St. Cloud, Versailles, Marie Antoinette, among others. Gorham's bestseller toward the end of this period was *Chantilly*, an understated pattern of Rococo Revival curves and scrolls (fig. 18.42). Designed in 1895 by William C. Codman (1839–1921),

Fig. 18.45. Harriet Powers. Quilt, Athens, Ga., c. 1895. Quilted and embroidered cotton; 68⅞ x 105 in. (175 x 266.7 cm). Museum of Fine Arts, Boston (64.619).

Fig. 18.46. "Interior of the New England Kitchen," from *Frank Leslie's Historical Register of the United States Centennial Exposition, 1876,* 1877.

INTERIOR OF THE NEW ENGLAND KITCHEN.

freedom. Much of the work on her two surviving narrative Bible appliqué quilts—sermons in patchwork—was done on a sewing machine. The first of the two quilts, exhibited in the agricultural section at the Athens, Georgia, Cotton Fair in 1886, had eleven panels of Old and New Testament stories of man's fall and redemption. The second quilt was commissioned by the wives of Atlanta University professors (fig. 18.45; the university's student body was predominantly African American). It was most likely displayed at the 1895 Cotton States and International Exposition in Atlanta, where Booker T. Washington, an African-American educator and advocate, gave his address on economic cooperation and self-reliance. Many of the quilt's fifteen scenes refer to biblical stories featuring Moses and Jesus, with a message about freedom borrowed from African-American religious preaching and spiritual traditions in which Joshua and Moses, among others, delivered their people from persecution. Some scenes represent mysterious and symbolic weather events.

SCIENCE, ART, AND INDUSTRY: FAIRS AND EXPOSITIONS

The 1860s brought great political and economic changes to both the United States and Canada. The 1867 Constitution Act united the provinces of Canada into a federal dominion with its own government. This gave Canadian provinces the ability to work together to create new and improved infrastructure, such as railroads, and to enact protective tariffs. In the aftermath of the Civil War (1861–65), the United States consolidated its agricultural and industrial strength. A once-agricultural nation became a leading economic power as the population tripled and its manufacturing value jumped six times in the three decades after the war. Great fortunes were made in railroads and finance, along with new industries such as steel and petroleum, while older businesses like furniture making and silver manufacturing continued to operate out of large workshops. In both nations, working-class women contributed to the industrial economy, particularly as workers in textile factories and sweatshops. The reinvigorated feminist movement developed a critique of the nineteenth-century ideal of domestic culture with the parlor as its center, and many independent-minded women rebelled against the constraints of the traditional family. Women's colleges opened their doors in the second half of the nineteenth century offering women a wider range of educational opportunities.

A host of world's fairs celebrated the emergence of the United States and its achievements in science and technology. At the Centennial International Exposition, held in Philadelphia in 1876 to celebrate the one hundredth anniversary of the signing of the Declaration of Independence, however, a different American identity was also celebrated. At the exposition, the New England Farmer's Home and Modern Kitchen building featured a restaurant and display that became known as the Colonial Kitchen (fig. 18.46). This log house, complete with rocking chairs and spinning-wheel, offered a nostalgic vision of United States national identity through a New England past, a golden "Age of Homespun" with women guides dressed in colonial garb preparing "old-fashioned" meals. The Colonial Kitchen contributed to the Colonial Revival movement in design and architecture that, through its celebration of preindustrial artisanal labor and village life, served as a relief from industrial strife and urban disorder.

In one of the many contradictions at the Philadelphia fair, celebrations of the colonial past and the "savage" frontier were displayed alongside industrial machinery that promised a prosperous future, such as the Corliss engine turbine that powered the 450 acres of exhibits. Architects and designers derived inspiration from the vision of the seventeenth and eighteenth centuries as a simpler time of cultural homogeneity while simultaneously taking full advantage of modern technological innovations. The *Century Vase*, designed by Karl Müller (1820–1887), a German-born and French-trained sculptor, and exhibited in Philadelphia incorporates visions of both ideals in its decoration (fig. 18.47). Made in Greenpoint, now Brooklyn, by the Union Porcelain Works, this homage to American exceptionalism featured shaggy buffalo heads as handles and a prominent relief of George Washington on each side, with a grand eagle soaring above. Vignettes below included important national historical and technological milestones, from frontiersmen and William Penn's treaty with Native Americans to telegraph wires and sewing machines.

Fig. 18.47. Karl I H. Müller. *Century Vase*, Union Porcelain Works, Greenpoint, N.Y., 1876. Porcelain; H. 22¼ in. (56.5 cm). Brooklyn Museum (43.25).

RESPONSES TO INDUSTRIALIZATION

The proliferation of what design reformers considered poorly designed, mass-produced industrial goods in everyday life gave rise to the Aesthetic Movement's focus on the home and decorative arts, and the Arts and Crafts movement's promotion of handmade products and artisan workshops. Both movements looked to "preindustrial" societies for inspiration, including Asian and Medieval European design sources. They also encouraged women to participate in making and designing objects. Professionals, such as Louis Comfort Tiffany (1848–1933) and Candace Wheeler (1827–1923), focused on domestic interiors, interest in which had increased enormously in the second half of the nineteenth century. Oscar Wilde's 1882 lectures in the United States promoting the Aesthetic Movement were attended by people interested in that movement as well as Japonisme and the Arts and Crafts movement. Wallpapers, stained glass, and other products with designs by British Arts and Crafts luminaries William Morris (1834–1896), Walter Crane (1845–1915), and Edward Burne-Jones (1833–1898) were used in United States and Canadian interiors in the 1880s and 1890s. The Arts and Crafts concern with the vernacular fed into calls by Louis H. Sullivan (1856–1924) and later Frank Lloyd Wright (1867–1959) for an American and democratic style.

Fig. 18.48. Louis Comfort Tiffany. Chapel, created by the Tiffany Glass and Decorating Company for the World's Columbian Exposition, Chicago, 1893. Reassembled at The Charles Hosmer Morse Museum of American Art, Winter Park, Fla.

Louis Tiffany, son of Charles Lewis Tiffany, the founder of Tiffany & Co., established Louis Comfort Tiffany and Associated Artists in 1879 with Candace Wheeler and, from 1880, Samuel Coleman (1832–1920) and Lockwood de Forest (1850–1932). The firm was at the forefront of artistic interiors in the 1880s, redecorating the Connecticut home of author Mark Twain and the White House for President Chester Arthur. From the mid-1880s, Louis Tiffany concentrated on glass, but his Tiffany Glass and Decorating Company often undertook special interior commissions, frequently but not exclusively for religious institutions. He participated in the 1893 World's Columbian Exposition in Chicago, a modern urban vision of Roman and Renaissance Revival architecture planned by a group of prominent architects including Daniel H. Burnham (1846–1912) and Sullivan. Louis Tiffany's exhibition space took the form of a nondenominational chapel with Tiffany's stained glass, interior design, and church vestments (fig. 18.48). The altar wall mosaic was dominated by two peacocks, symbols of the Aesthetic Movement and of eternal life, with grapes (representing Communion wine), and the crown of God. The display, which was installed in his father's Tiffany & Co. exhibition space in the building dedicated to manufactures, represented a superb piece of exhibition design and advertising.

Inspired by the embroideries made by London's Royal School of Art Needlework and exhibited at Philadelphia in 1876, Candace Wheeler joined with Tiffany and his other partners in founding Associated Artists. By 1883, she retained the name for her own textile design business where she encouraged women, including her daughter Dora Wheeler (1856–1940), to create textiles and work as graphic designers and illustrators. Wheeler's textiles ranged from luxurious embroideries such as woven tapestries to printed cottons. The firm collaborated with the Cheney Brothers, silk manufacturers in South Manchester, Connecticut, to produce a pinecones-and-needles textile (fig. 18.49). With a combined twill and plain weave and most probably based on Japanese designs, it was among Associated Artist's more expensive products.

Wheeler served as the interior decorator of the Woman's Building in the Chicago fair in 1893, writing, "I have always felt that one great purpose of my work was to prove to women their abilities to make conditions & results which were entirely favorable & I should like to emphasize the fact of its accomplishment in the Womans Building."[8] She also served as the organizer of New York State's applied arts exhibition, where the objects made and designed by African-American women were shown separately.

Decorative arts and design in North America between 1750 and 1900 is a complex story. Sweeping political and social changes interacted with new forms, styles, and technologies. As colonies turned into nations, consumers, artisans, and manufacturers walked a fine line between following European fashions and making their own. Technological innovations turned largely agricultural societies into ones more focused on manufacturing and consumption. New labor forces—at various times consisting of women, immigrants, or freed African Americans—made these achievements possible, but these new members of the working class also demanded safe working conditions and equal rights, causing shock waves that continued to shape society and design in the twentieth century.

DAVID JAFFEE

Fig. 18.49. Associated Artists. Textile sample, Cheney Brothers, South Manchester, Conn., 1883-1900. Silk; 30 x 24½ in. (76.2 x 62.2 cm). The Metropolitan Museum of Art (28.70.6).

1900–2000

Fig. 23.106 detail

EAST ASIA

Fig. 19.27

CHINA

By 1900, China's last imperial dynasty—the Qing (1644–1912)—was in its death throes. Unable to feed a population that had increased by 50 percent in the previous century (from 300 million to over 450 million people); stop encroachment by European powers, the United States, and Japan; or cope with internal dissent, the dynasty collapsed in 1911. The Republic of China (1912–49) faced similar problems, as well as regional warlords competing for supremacy, but the end of Qing rule led to greater social and political reform, pride in nation, a revitalized economy, and a more forward-looking outlook in general. The New Culture Movement called for the setting aside of Confucian ideals and the veneration of the past in order to build a new, modern China based on greater individualism, rationality, democracy, women's rights, and modern methods of manufacture.

The 1919 Paris Peace Conference at the conclusion of World War I transferred German trading rights over Shandong, China, to Japan. Chinese cultural and anti-imperialist opposition forces then united in the May Fourth Movement (1919–21). Although Japan provided one model for modernization, it was increasingly identified as the main threat to Chinese sovereignty. From the 1920s, Marxist solutions to social inequalities, grinding poverty, and the illiteracy of millions of peasants increasingly appealed to many; others supported the Nationalist Party during what often amounted to an unofficial civil war. In 1931, Japan invaded Manchuria, ruling it as a puppet state (under the last Qing emperor) and using it as a base from which to attempt to take over the rest of China. The ensuing Second Sino-Japanese War (1937–45) is often referred to in China as the War of Resistance against Japan. The latter part of that war overlapped with World War II (1939–45), and the civil war that followed in China (1945–49) ended with a victory for the Communists over the Nationalists. The Nationalist ruling elite crossed to Taiwan and declared it the Republic of China; on the mainland, the Communist Party established the People's Republic of China (1949 to the present).

The strong craft and design traditions of the late nineteenth century continued into the twentieth. Some decorative arts flourished, especially in the more affluent 1920s and 1930s, when the amount of goods consumed increased substantially. There was a concomitant growth in "commercial art" as manufacturers and retailers sought to use advertising to sell their products. The 1950s saw a continuation of some traditional handcrafts. After years of war, all types of production were needed to keep the economy going and meet the most basic needs. Furthermore, the Communist Party sought to maintain a strong national identity while trying to establish a socialist state, and traditional crafts symbolized nation. During the Cultural Revolution (1966–76), when political decrees controlled content and style, many (but by no means all) aspects of decorative arts, design, and production, including fashion, were neglected or decried.

The influence of the United Soviet Socialist Republics (USSR) on the Chinese regime was considerable until the 1960s, and Chinese visual culture of the 1950s reflected the impact of Soviet socialist realism. From the 1960s, however, there was a long period when, caught between the competing interests of the Cold War superpowers (the United States and the USSR) and fearful of internal dissent, China was isolated from the rest of the world. That isolation, together with high levels of poverty, meant that older craft and design traditions survived. Many came under greater threat from the late 1970s when a more liberal "open-door" policy to Western influences accompanied a new focus on modernizing China's economic and industrial base. By the turn of the twenty-first century, China had become one of the fastest-developing nations in the world, and there was a revival of interest in China's material and visual past.

BUILDINGS AND FURNISHINGS

In the 1920s, a new generation of Chinese architects who had trained in Europe and the United States began to have a strong impact at home where the middle class was growing rapidly and entrepreneurs and others were amassing large fortunes. Many of these architects adapted the variants of Neoclassicism and the Beaux-Arts that they had learned abroad to local circumstances and the personal tastes of clients, resulting in a style known as "Chinese Classical." Examples of buildings influenced by Neoclassicism but featuring strongly Chinese characteristics, such as large concave roofs and colored tiles, included many of the missionary schools and hospitals constructed in the main cities.

European Neoclassicism also influenced the design of Chinese-made goods, such as carpets. High-quality rugs and carpets were an important export commodity, especially after supply routes from Turkey and Iran were disrupted during World War I (1914–18). Nichols Super Yarn and Carpets, established in 1924 by Walter Nichols, a U.S.-born resident of Tientsin (now Tianjin), became one of the most prominent among the hundreds of carpet-making enterprises in China in the first half of the twentieth century. In a promotional pamphlet from the late 1920s, Nichols described its carpet patterns as deriving from ancient Chinese (the most popular), Taoist, Buddhist, and Neoclassical traditions, as well as geometric forms, trees, and flowers. Although most of these carpets were designed for customers in North America

and Europe, some also graced fashionable homes and public buildings in major Chinese cities. Hand-woven or hand-tufted, they were made from natural fibers such as wool, cotton, and silk. Sometimes traditional vegetable dyes were augmented by synthetic, aniline dyes for a wider range of color tones and shades.

The Art Moderne style became popular in the late 1920s and 1930s, in the wake of the Exposition des Arts Décoratifs et Industriels (International Exposition of Modern Industrial and Decorative Arts) held in Paris in 1925. At this exposition, the elegantly restrained, yet densely decorated exhibition space for Chinese decorative arts (fig. 19.1) was designed by Liu Jipiao (1900–1992), a decorative artist and architect then studying architecture at the École des Beaux-Arts in Paris. He was known in France as Tepeou Liou. In China, Art Moderne was most prevalent in large cities such as Beijing, Shenyang, and Nanjing, and especially cosmopolitan Shanghai, then the third largest city in the world. The interiors and furnishings of bourgeois and elite homes, as well as fashionable nightclubs and hotels, incorporated Art Moderne–style carpets by Nichols and other companies. They were offered in bright, bold colors, such as purple, black, mauve, pink, orange, and olive green. László Hudec (1893–1958), a Slovak-Hungarian architect who had studied in Budapest and was a key figure in the modernization of Shanghai in the years between the two world wars, designed over sixty buildings but is best known for his twenty-two–story Art Moderne Park Hotel (1934). Asia's first skyscraper, it reflected Shanghai's sophisticated culture. The exterior was inspired by U.S. skyscrapers of the period, while the interior design was redolent with the more "streamlined" variations of U. S. Art Moderne.

The 1929 West Lake Expo in Hangzhou, the largest trade fair of the Republican era, illustrates the greater focus placed on industry and commerce in this period. Featuring 147,600 products from all over the world, it was compared to world's fairs or expositions such as those held in Chicago in 1893 and Paris in 1900. Over 20 million visitors saw the products of more than 1,000 Chinese companies, as well as those of foreign countries such as the United States, Japan, Britain, and Indonesia. Besides promoting Chinese products, the organizers stressed the importance of education to the improvement of design and manufacture. One of the sights of the fair was Liu Jipiao's Education Hall, with its distinctive, dramatic crown-shaped gate that deftly fused traditional palace architecture with European features in a manner evocative of a film set.

At the same time as fine, handmade furnishings and goods of the sort shown at the West Lake Expo were produced in fashionable styles for the wealthy, country dwellers relied on their own skills or those of fellow villagers to fashion items from local and abundant materials like elm or bamboo. From the mid-1930s, however, in urban workshops at least, furniture was made from laminated wood or particleboard.

CONSERVATION

Shortly before the fall of the Qing dynasty, a 1909 ordinance addressed the issue of protecting ancient cultural sites. This interest in cultural heritage may have been a Chinese response to heightened Western concern for such matters in the late nineteenth and early twentieth centuries. Chinese

architects studying abroad would have known of this trend, but a local issue was more likely the trigger. In 1907, textiles, paintings, and manuscripts were removed from the Mogao grottoes in the Dunhuang area of China, first by a joint British and Indian group led by Hungarian archaeologist Aurel Stein, and in the following year by a French group led by Paul Pelliot. Such pillaging continued after the ordinance (there were Russian and Japanese expeditions in 1911 and 1914, respectively), but interest in protecting the material cultural heritage of the past grew, especially in the 1920s and 1930s.

The Society for Research in Chinese Architecture (Yingzao Xueshe) was founded in 1930. Architect Liang Sicheng (1901–1972) and his wife Lin Huiyin (1904–1955), an architect and poet, joined, soon leading the movement to locate and document ancient buildings. Along with Mo Zongjiang (1916–1999), Ji Yutang (1902–c. 1960s), and others keen to preserve and learn about traditional buildings and craftsmanship, they studied the oldest surviving timber structures in China, many of them from the Tang dynasty (618–906). Between 1932 and 1941, members of the society documented more than 2,700 ancient buildings. Liang, who had studied architecture at the University of Pennsylvania in the 1920s at a time when the curriculum was based on the Beaux Arts, produced meticulous drawings and renderings of the buildings. His and the society's cautious approach to conservation, which was based on detailed research, accurately drawn records, and a belief that one should not interfere unnecessarily with the fabric of a building, reflected both traditional Chinese respect for the past and progressive Western practices.

CERAMICS

In 1910, just before the fall of the Qing dynasty and amidst an acutely weak economy and calls for reform, the Jiangxi Porcelain Company was established in Jingdezhen, site of the old imperial porcelain kilns dating to the Song dynasty. Although partly state run, the company was also privately capitalized, and the government hoped that the loosening of imperial controls would help to revitalize the porcelain industry. Many expert workers from the old imperial ceramics workshop were employed there, and, although the remit included promoting research and experimentation, the new company stuck mainly to tried and tested styles and methods. Indeed, in the new Republican era, there was a revival of interest in the imperial wares of the former ruling dynasty. Many of the high-quality imitations of Qing ceramic objects were signed with imperial reign marks that sought to mislead potential purchasers. By 1928, 114 large kilns were in operation at Jingdezhen employing 2,226 men, but the Chinese economy went into deep recession during the Sino-Japanese War, and by 1936, only 72 kilns remained employing 1,512 workers. The Japanese occupation led to the destruction of nearly all the kilns by the late 1930s, and matters did not significantly improve until after the revolution of 1949, when the state reassumed control and set about restoring production.

The upturn of interest in ceramics in the 1910s and 1920s produced a steady demand for skilled workers, both decorators and shapers of form. The decorators enjoyed greater status, and some of the individual painters who signed their work became well known. Pan Taoyu (c. 1887–1926), for example, was noted for his figure and bird-and-flower imagery, refined enamel colors, and inscriptions in elegant calligraphy. In 1928, a group of eight porcelain painters—Wang Qi (1884–1934), Wang Dafan (1888–1961), Deng Bishan (1874–1930), Xu Zhongnan (1872–1952), Wang Yeting (1884–1942), Tian Hexian (1894–1952), Cheng Yiting (1895–1948), and Liu Yucen (1904–1969)—formed an art society that became known as "The Eight Friends of Zhushan" (after Zhushan Hill in the city center, where the old imperial factory stood). Although there were ten members not eight, and they had different individual styles and specialized in various subject matter, such as traditional ink landscapes, religious and historical figures, plum blossoms, and so on, they all shared the aim of elevating the porcelain medium by treating it like silk or paper, namely as a surface for painting. Many of the items they produced were flat table screens made out of single slabs of clay. If they painted vessels, they used plain wares from local potteries. In the Guangxu period, the reign of the eleventh Qing emperor (1875–1908), an average of 1,523,350 kilograms of porcelain was exported from Jingdezhen; in the Republican era, the average was more than double, at 3,565,300 kilograms.

GRAPHIC MEDIA

There was an explosion of graphic media in the first half of the century, from newspaper advertisements and calendar posters to wood-block prints, especially between the 1910s and 1930s. As in certain European countries and North America, commercial art was professionalized in this period: the Chinese Commercial Artists Association was founded in 1934. The advertising agencies, both Chinese and Western, that sprang up introduced outdoor billboards and employed (either directly or on a freelance basis) some of the leading commercial artists of the day such as Xie Zhiguang (1900–1976). The tobacco and cosmetics industries spent the most on advertising; their products were closely associated with lifestyles at once "modern" and Western.

The products of those industries and others—from fabrics to sugar and mosquito repellants—were marketed through calendar posters or hangings that mixed Chinese and Western art and design influences. Many bore images of attractive young women, some in seductive poses, wearing either *cheongsams* (*qipao*; traditional Chinese dresses), Western dress, or a mixture of both, and sporting modern hairstyles and accessories (fig. 19.2). Many presented women in interiors influenced by Western styles and/or engaging in modern pastimes such as attending tea dances, smoking cigarettes, or flying, as in Ni Gengye's 1938 *Girl at Airfield* calendar poster for the Qidong Tobacco Company. Others, by contrast, featured distinctly Chinese imagery including landscapes, gardens, and cherry blossoms.

Chinese wood-block printmaking was popular and influential during this period. There was a clear division of labor

Fig. 19.2. Hu Boxiang. Advertisement for Hatamen Cigarettes, Shanghai, 1930s. Poster; 30⅛ × 20½ in. (76.5 × 52 cm). Collection of Vincent Lexington Harper.

became a center for politically committed printmaking. Yan Han (b. 1916), among others, learned printmaking there and shared his knowledge with the wider community. Trained as a painter in both Chinese and Western painting traditions at the National Art Academy in Hangzhou, Yan Han later chaired the Chinese Printmakers' Association. Mao Zedong, as leader of the Chinese Communist forces, set out the party's program on cultural production at Yan'an in 1942: to serve the masses and depict the ordinary activities of working people in ways understood by and accessible to them.

Wood-block printing easily lent itself to graphic reproduction in books and magazines. The impact of European interwar Modern Movement graphics contributed a distinctly Modernist flavor to some of this work, including cover designs, typography, calligraphy, and bookbinding by Qian Juntao (1906–1998), who explored geometric structures (fig. 19.4). As artistic editor of the Kaiming Bookstore in Shanghai, he designed numerous covers for books, many of which were by influential writers, including Lu Xun.

FABRICS, CLOTHING, AND FASHION

Commercial artists such as Zhang Guangyu (1902–1965), Ding Song (1891–1972), Ye Qianyu (1907–1995), and Hu Yaguang (1901–1986), along with women designers Zhang Lingji and He Zhizhen, established another graphic design specialization, namely fashion illustration. In 1928, the socialite Tang Yinghui was one of the founders of the Yunshang Fashion Company in Shanghai (*Yunshang Shizhuang Gongsi*, known as "China's Only Women's Clothes Company"), which aimed to provide services similar to those offered by foreign fashion houses. The most sophisticated fashion advertising of this period was designed for this company by Zhang Guangyu and Ye Qianyu in a manner that drew heavily on Western fashion magazines such as *Vogue*. By 1933, He Zhizhen was referred to as a fashion designer, suggesting that she had moved away from illustration.

In 1900, clothing fabrics continued to be made from natural materials such as silk but, from the 1920s onward, artificial fabrics including rayon and nylon became popular. The new synthetic materials looked like silk but were cheaper

between drawing, cutting or engraving, and printing, but in the 1920s and 1930s, individual printmakers, who came to consider themselves artists (as opposed to artisans), began to make prints from beginning to end. The leader of the Creative Print Movement of the 1930s, the pseudonymous writer Lu Xun (1881–1936), praised and drew inspiration from the boldly contrasting black-and-white images of everyday life popular in contemporary Western printmaking, not least because it was socially engaging. Soon Chinese printmakers featured the laboring classes, rural and urban, at work, as in the sinewy peasants dragging a plow in *Raging Tide 1* by Li Hua (1907–1994; fig. 19.3). Lu and others, however, also encouraged the use of Chinese art and design traditions as sources, from *qi pu* (embossed writing paper decorated with woodblock prints), stone engravings from the Han dynasty (206 BC–220 AD), and illustrations in Ming dynasty (1368–1644) books, to the hugely popular *nianhua* (New Year's pictures).

The Chinese print movement had a clear agenda of social reform, and there were strong links between printmaking, enlightened thought, and radical politics, not least because wood-block prints were a quick, inexpensive way of producing multiple copies of political imagery, often in "underground" circumstances. As Lu noted in *A Simple Introduction to the New Russian Wood-block*, in revolutionary times, wood-block printing was used extensively because it could be done quickly.

The Lu Xun Academy of Literature and Arts was established in 1938 in Yan'an, the main area of Communist Party influence between that time and the 1949 revolution. It soon

Fig. 19.3. Li Hua. *Nuchao zhiyi: Zhengzha* (Raging Tide 1: Struggle), probably Beijing, 1947. Woodblock print; 8⅛ × 10⅝ in. (20.5 × 27 cm).

and, in the cramped confines of many Chinese homes, also easier to wash and dry. Both natural and synthetic fabrics were used to tailor *qipao*, the costume of the Manchu people that Chinese women from the late Qing dynasty onward had adopted (see fig. 19.9). For men, Sun Yat-sen, who had played an important role in overthrowing the Qing dynasty, popularized a new style featuring jacket and trousers instead of robes. Adapted from Japanese student wear and first worn as a symbol of a modern, republican nation, this style of dress became known as the *Zhongshan* suit after one of Sun Yat-sen's given names in Chinese. It was later known in the West as the "Mao suit" (discussed below).

By the end of the 1920s, middle-class women in the major cities were wearing a modern version of the *qipao*, a hybrid of the traditional long man's robe (*changpao*) and fashionable Western women's wear. The length varied. They became fashionably shorter in the 1920s and longer again in the 1930s when they were worn with Westernized accessories, including leather shoes, handbags, and furs, in ensembles that signaled modernity. Some considered them risqué garments, especially in the later 1930s, when some versions became more revealing; the functional side slits sometimes reached the thigh, and the shape became progressively narrower and closer to the body. *Qipao* were closely associated with the glamorous lifestyle of Shanghai in the 1920s and 1930s as popularized by the Chinese movie and advertising industries. By the 1940s, the *qipao* was established as the standard formal wear for all classes of urban women, and while extreme versions were no longer typical, women achieved class distinction and individuality through a variety of fabrics, colors, patterns, and decoration.

DESIGN IN POSTWAR CHINA (1949–76)

Immediately before and after the revolution, Mao Zedong and the Chinese Communist Party sought to use design to convey appropriate images about the new republic. Mao consulted Liang Sicheng about which areas of architectural significance were most in need of protection before the Communist Party forces moved to take control of Beijing in 1949. Liang was interested in both modern and ancient architecture and had an international standing (he was the Chinese representative on the design team entrusted with the United Nations Headquarters commission in New York in 1947). Being the son of political reformer Liang Qichao also enhanced his stature with the Communist Party. After the declaration of the People's Republic of China, he was given responsibility for developing a national style of architecture and design. Liang believed that the system of rational functionality embodied in temple buildings was perfectly fitted for modern techniques and materials, including concrete. The most potent "Chinese" element in his distillation of what he considered the essence of Chinese architecture was large concave curved roofs and overhanging eaves popularly associated with temples. This fusion of modernity and a particular ancient past spoke to both the international and national aspects of the revolution and also to the ideology of the new regime,

Fig. 19.4. Qian Juntao. Cover, Shanghai Private Kaiming Correspondence School, *Members' Club Quarterly* 5, Kaiming Book Store, Shanghai, c. 1930.

becoming popular in the 1950s. Liang and his wife Lin designed the enormous Monument to the People's Heroes in Tiananmen Square and were part of the group that helped refine the design of the new national emblem. The latter, a red disk with five stars, features an image of the Tiananmen Gate (at the entrance to the Forbidden City) where Mao announced the new republic, together with wheat and rice, representing agriculture and peasants, and a cogwheel standing for workers and industry.

Mao had shown a sensitivity toward conserving ancient Beijing on the eve of assuming power, and he and other high-ranking members of the party were keen to retain the city as the center of power, which would require intervention. Liang was appointed vice director of the Beijing City Planning Commission in 1950. As both a Modernist urban planner and a conservationist, Liang wanted to build a new modern city outside the existing city—rather in the manner of European new towns and suburbs—and to leave the old city intact, almost as a museum. The issues were complex, with fears of

a new but culturally dead administrative city on the one hand and the lifeless remains of a fossilized feudal city on the other. The model of Moscow as a Marxist Leninist city that had transformed from a bourgeois city to a vibrant workers' city appealed to Mao. Despite Liang's efforts, in 1953, in the name of modernization, the widespread destruction of much of old Beijing city began, including most of the ancient gates and city walls. Denounced as a reactionary bourgeois academic during the Cultural Revolution, Liang died before he was rehabilitated shortly after that movement ended. In the early twenty-first century, he and Lin stand as heroes of the modern Chinese conservation movement. The Beijing Western Railway Station, designed by the Beijing Constructing and Designing Research Institute, was built in 1995 in a National Style blend of the type advocated by Liang, and an award for achievement in architectural design was named in his honor in 2000.

In the decade after the Chinese revolution of 1949, many areas of design and production continued as before. Woodblock prints continued to be extremely popular. Not all were as directly political as in the 1930s and 1940s, but even those like Li Shuqin's brightly colored and deftly illustrated *Spring Returns* (1962) served to brighten everyday life in a period of considerable austerity. The more directly political imagery took many cues from the socialist realism of the Soviet Union, which provided aid to the People's Republic of China until 1960. Photography was a cheaper and extremely popular graphic medium for depicting happy peasants and workers going about the task of building a new nation until the 1960s when large, bold, and colorful posters became the main means of mass propaganda.

Hundreds of thousands of posters were designed and produced during the Cultural Revolution (1966–76) initiated by Mao to reestablish what he considered the correct course for Chinese communism. The goal was to eliminate reformism and the remnants of bourgeois culture, to embed socialist ideals within the nation, communities, and individuals, and to increase production. Soviet poster traditions were influential during this mass campaign to establish the modern Communist state, but so, too, were Chinese sources, from prints and painting to paper cuts and other folk traditions of patternmaking and illustration. Brush strokes, colors, and lettering were bold. Red, an auspicious color according to Chinese traditions and also the color of revolution, predominated, while static gestures and tableau-like groupings drew on the traditions of the Peking Opera. Folk culture was a particularly acceptable source because of its close connections to "the people," especially the peasants whose support had helped secure victory in 1949 and whom Mao considered key to building Communism in China. Other characteristic imagery included designs and illustrations featuring soldiers, workers, the Red Guard, rural China, children (as representative of the future), collective life, and political leaders. Images of Mao as a benevolent father figure presiding over the building of a new future were ubiquitous. Indeed, his presence on a wide range of media, from large posters and massive outdoor statues to small lapel badges and imagery painted onto pottery, underpinned his cult of personality.

Poster designers were encouraged to work anonymously. Even the best known were not allowed to sign their work, their credit often subsumed within a general credit to a soldier-peasant-worker collective. Despite, or because of, the success of the *Long Live Chairman Mao* poster (1959), which ran to an edition of two million, graphic designer Ha Qiongwen (1925–2012) found it difficult to survive during the Cultural Revolution when he, like many others, were accused of political incorrectness. Recent research has allowed scholars to associate names with particular poster designs from this period. In some cases, the designers had enjoyed careers as commercial artists from the calendar posters of the 1930s, as, for example, Jin Xuechen (1904–1997), who worked with Li Mubai (1913–1991) from the 1920s through the Cultural Revolution. Li drew the figures and Jin the backgrounds. From 1954, they worked for the state-controlled Shanghai Poster Publishing House where they not only designed posters but also trained a new generation in the genre.

Clothing became more standardized and more obviously reflective of ideology during this period. Fabrics such as wool and cotton were rationed because of limited supplies. Many men and women typically wore the baggy trousers and jackets with upturned collars known as "Mao suits" and made from manmade materials in a limited range of colors. This became the uniform of the People's Republic of China. At first glance, its typical colors of khaki or dark blue appeared drab and standardized, and they were often referred to in this manner by Western opponents of both Chinese attempts to build socialism and garments that seemed "unisex." Like many uniforms, however, these garments were worn with pride by those who supported the ideas they embodied. During the Cultural Revolution, male and female Red Guards wore unofficial army-style uniforms, typically with a flat green cap, a brown leather belt, and a green shoulder bag, as they traveled the country disseminating Chairman Mao's thoughts and sayings. As in other situations involving uniform clothing, dress regulations, and periods of austerity, people found room for small expressions of personal style. Some women wore brightly colored, hand-knitted sweaters, as well as long johns and vests, which could often be found discreetly protruding from sleeves, necklines, and trouser legs. This style of dress has persisted in some rural areas of China.

The production of porcelain vessels for everyday use continued during the Cultural Revolution, but certain objects, such as plates and tea mugs with lids, were decorated with political slogans, quotations from Mao, and revolutionary scenes. Porcelain figurines were also popular. Still made as artistic sculptures, they now depicted heroic figures and characters from revolutionary operas such as *The Red Lantern*, a tale of Communist resistance to the Japanese invasion of 1937–45, whose heroine, Li Tiemei, guided a Communist guerilla group to a Japanese garrison by lantern light (fig. 19.5).

The most skilled china decorators were called on to paint the large and intricate pieces made as official gifts, either for Chinese or visiting dignitaries, or as official gifts presented during state visits abroad. Such pieces were sometimes

Fig. 19.5. Figure of Li Tiemei, Jingdezhen, 1969. Porcelain; H. 10⅝ in. (27 cm). Victoria and Albert Museum, London (FE.5-1990).

signed and dated, adding to their special significance, in contrast to the cult of anonymity encouraged in poster design. In order to improve production standards, the Jingdezhen Ceramic Institute was established in 1958 to train both Chinese and overseas students in pottery making and ceramic history and archaeology. It collaborated with ceramic factories and master craftsmen to ensure that students would graduate with an understanding of the practices and needs of the industry.

"OPEN-DOOR" DESIGN (1978–2000 AND BEYOND)

Mao Zedong died in 1976 and by 1978 Deng Xiaoping and other leaders had determined that China should "catch up" with other countries industrially and economically. The so-called open-door policy of allowing foreign ideas and practices into the country meant that political control over visual matters was loosened. Changes in production and consumption in China were so great between 1978 and the 2010s that many speak of a "revolution." But a faster rate of consumption of new types of goods was mainly restricted to a super-rich elite, although there was also a small but increasing middle class (estimated at 11–20 percent of the population in 2012). These changes notwithstanding, Chinese traditions—and various revivals and reevaluations of them—played a

huge part in the visual and material culture of the period. Increasing degrees of private enterprise operated within what remains a tightly controlled state system, and created a new, wealthy entrepreneurial elite. The massive social, economic, and cultural transformations from the 1980s onward affected many areas of visual and material culture and consumption, from new buildings to corporate identity design and new types of digital design and multimedia experiences.

When China decided to involve itself more closely with the global economy, the country lacked sufficient competitive industries, designers, and entrepreneurs to help improve products and advertising in ways that would help it better compete internationally. The path toward greater economic integration and recognition of the role of design has been uneven. In 1982, for example, China's first school of design was established at Hunan University, but though copyright regulations improved, they did not include design as a protected category until 2001. In certain areas, China chose to focus on manufacture—according to the specifications of entrepreneurs (both foreign and local)—rather than design, but the turn of the new century saw more goods designed as well as made in China.

From the mid-1980s to the 1990s, Postmodernism began to be influential in China and boundaries among art, design, and crafts were increasingly blurred. Ceramic artist Xu Yihui (b. 1964), for instance, created pieces that combine "kitsch" elements with subversive political messages. Critical commentary was also a feature of work by Shanghai-based artist-designer Li Lihong (b. 1974), who developed a series of ceramic works based on the famous McDonald's "golden arches." As a comment on cultural and economic imperialism, Li juxtaposed this iconic symbol of global capitalism and low-quality products, such as the chain restaurant's seating and plastic "giveaway" toys, with his highly refined, laborious porcelain craft based on centuries of tradition.

Sculptor-painter Shao Fan (b. 1964), who experiments with various media, is best known for his reconstructed, or rather deconstructed, *Chairs* series (1996), which played on the contemporary fascination with the Chinese language and ideograms (written characters). The *Moon* chair illustrated here alludes in multiple ways to the "moon" (fig. 19.6). Its shape imitates that of the Chinese character for moon (*yue*), and its frontal view evokes the image of the crescent moon. In a further twist, the seat breaks away from the continuity of the upright back and comes forward toward the viewer, emphasizing the transformation of two-dimensional imagery into a three-dimensional object.

In the 1980s and 1990s, major international clothing brands opened shops in China, and a reinvigorated Chinese fashion industry began to take hold in the early twenty-first century, in tandem with developments in education. While designers who came to prominence in the 1990s and earlier were the products of a state-run education system, in the twenty-first century, it was not unusual for them to have been educated according to international curricula or have studied abroad. Some chose to pursue careers abroad, in the global fashion and textiles industries. For example, Han Feng, known for her creative treatment of fabrics, moved to New

Fig. 19.6. Shao Fan. *Moon* chair, Beijing, 2004 (designed 1995). MDF, catalpa, Chinese elm; 56 x 23⅝ x 19¼ in. (142 x 60 x 49 cm). Victoria and Albert Museum, London (FE.329-2005).

Wuyong (Useless), a series of exhibitions and handmade clothes, which has led her to be considered an "artist."

In the 1990s, a new "global generation" of consumers emerged in China, fueling a media and communications explosion. Print newspapers, magazines, radio, television, mobile phones, and computers were all used to communicate design, including fashion, and a veritable host of consumer goods. By the end of the century, digital technology had replaced much of the print media, and many designers achieved a seamless integration of text, graphics, animation, audio, stills, and motion video. In 2007, China overtook the United States as the largest online population on the planet.

Digital and more traditional graphic imagery and references to both past and present coexist in objects of everyday life in the new China, as can be seen in a series of postage stamps issued by China Post, released in January 2010 to celebrate the traditional Chinese lunar Year of the Tiger (fig. 19.7). Created by graphic designer Ma Gang, head of Digital Media Studio at the Central Academy of Fine Art, Beijing, it mixes images and text—a cartoon-like tiger and the Chinese character for "tiger" in flowing red calligraphy. In the top right is "the geng-yin year" (the name of 2010 according to the traditional Chinese calendar), while the price of the stamp, "Chinese Post Office," and web-site address, all in the rounded script of computer-generated print, are in the lower half of the stamp, to either side of the tiger.

From the mid-1970s, custom-made and mass-produced furniture in Western styles, including cheaper plywood furniture and laminated kitchen units, flourished alongside designs incorporating elements reminiscent of traditional Chinese furniture. As part of their desire for more modern ways of living, the younger among China's middle-class consumers sought more contemporary looking furniture and carpets. These began to be more widely available from the 1990s. The multinational Swedish-based IKEA company, which sells relatively uniform and inexpensive home furnishing goods around the world with a few local variations to appeal to indigenous tastes and cultures, opened its first store in China in 1998 in Shanghai. By 2012, there were nine IKEA stores in such cities as Beijing, Tianjin, Guangzhou, and Nanjing, among others. Although most of its Chinese customers

York in 1985 after studying painting and sculpture at the Zhejiang Academy of Fine Arts in Hangzhou (founded as the National Academy of Art in 1928; renamed the China Academy of Fine Arts in 1993). She based herself between New York and Shanghai, having extended her design repertory to include clothing, accessories, and exhibitions as well as opera costumes.

Some designers are also educators. Wu Haiyan, who grew up in the textile center of Hangzhou, won China's first national art and fashion design competition in 1992, submitting designs influenced by women's dress styles during the Tang dynasty. She continues to teach at the China Academy of Fine Arts, as well as to design under her own name and consult for many large companies. Likewise, Wang Yiyang (b. 1970) studied and then taught fashion design at Donghua University in Shanghai before becoming the chief designer of the local fashion label Layefe. In 2002, he created a brand of women's clothing called Zuczug, noted for its simple and colorful designs and available in its own shops in major Chinese cities. Wang's other, more conceptual line, Cha Gang, by contrast, is available only in one shop in Shanghai and focuses on menswear. Ma Ke (b. 1971), who has won many prizes and acclaim outside of the country, began as the designer for the company producing the Exception de Mixmind label. She now focuses on more overtly artistic pursuits such as her

Fig. 19.7. Ma Gang. Postage stamp celebrating the Year of the Tiger, China, January 2010.

Fig. 19.8. Xing Tonghe. Shanghai Museum, People's Square, Shanghai, 1996.

are firmly middle-class—the typical customer is aged between twenty-five and thirty-five with a relatively high income and a higher level of education than the average—the company was forced to cut its prices in order to be more competitive with local entrepreneurs.

Chinese carpets with more contemporary patterns were in demand from the late 1970s and 1980s, but interest in styles and materials associated with China's past began growing at about the same time. Many Chinese carpets were and continue to be made of wool, but silk carpets became increasingly sought after. First made on a commercial scale in China in the 1970s, these carpets were heavily influenced by Chinese paintings, but thereafter their designs were either based on Persian and, to a lesser degree, Turkish rugs. By the early twenty-first century, carpets with Chinese themes were added to the repertory of designs.

Among those most interested in the furniture of the past was Tian Jiaqing (b. c. 1953), the leading authority on Ming and Qing dynasty furniture. He spent more than ten years studying the techniques of woodworkers in Beijing, which informed and inspired his own work. Among his many beautiful lines were the *Ming Yun* or "Charms of the Ming Dynasty." In 2011, the piano makers Steinway and Sons commissioned him to design a piano for both the Chinese and export markets. Tian focused on imbuing the design with a sense of Chinese spirituality and chose the dragon, symbol of vitality, as his inspiration. *Charm of the Dragon,* a commemorative edition piano, includes a dragon-shaped logo in the form of the letter S, written with a Chinese brush, a music stand shaped like a fan, and a sandalwood stool derived from Ming furniture.

Another furniture maker interested in craftsmanship is Shi Jianmin, who studied aspects of rural culture in Shaanxi province in northwest China. Now based in Beijing, he is a leading figure in the revival of interest in vernacular design, drawing on local design traditions as well as decorative arts of China's past, such as calligraphy. His more recent furniture expresses the energy and force of brushstrokes in Chinese calligraphy, and echoes the forms of organic rocks and wood long associated with classical Chinese scholars.

The ceramics industry continued to mass-produce affordable wares for the nation but reverted back to traditional designs and gradually began to make wares for export and the tourist industry. When the government initiated market reforms and abandoned the model of production solely through Communist state enterprises, the Jingdezhen ceramic industry went into a decline and by 1998, most state porcelain factories had been closed. As a result, many ceramic workers started independent businesses, concentrating on display pieces such as large painted vases or imitation antique wares. Today, whole workshops at Jingdezhen are devoted to replicating past styles, reflecting the continuing interest in China's older design traditions. Workshops specialize in copying particular imperial wares, and over this period, many modern pieces have undoubtedly been sold on the international market as genuine antiques.

China's increasing prosperity, and interest in the past, was reflected in impressive new public buildings such as the Shanghai Museum, completed in 1996 and designed by local Shanghai architect and designer Xing Tonghe (b. 1939; fig. 19.8). Built in the shape of an ancient bronze cooking vessel called a *ding*, it has a round top and square base, symbol-

Fig. 19.9. Women's dresses (*qipao*), Hong Kong, 1946-56. Left, embroidered silk satin; L. 45¼ in. (115 cm). Right, embroidered wool; L. 46 in. (117 cm). Victoria and Albert Museum, London (FE.52-1997 and FE.54-1997).

izing the ancient Chinese perception of the world as "round sky, square earth." Many of the new generation of Chinese architects and designers specialize in industrial and office buildings, as, for example, the China Architecture Design and Research Group, which was responsible for creating Desheng Uptown, an office complex in Beijing in 2006. The area just outside Deshengmen ("Gate of Virtuous Triumph" in the old city wall) had been a traditional residential quarter, full of narrow alleys and courtyard houses, but in 2000 it was razed to the ground. One of the architects on the project, designer Cui Kai preserved some of the trees of the old neighborhood and reproduced the layout of the former streetscape to pay homage to the past history and memory of the older site by incorporating elements of it into the new one.

When it came to the design of the principal stadiums for the 2008 Olympic Games in Beijing, however, the Chinese government commissioned renowned Western firms, to reinforce its reputation abroad as a modern nation. The Swiss architectural firm of Hertzog & de Meuron designed the main stadium, nicknamed the Bird's Nest, though noted Chinese artist Ai Weiwei (b. 1957) was a major artistic consultant. The Beijing Olympics opened with a spectacular ceremony choreographed by film-director Zhang Yimou (b. 1951). His ability to express in modern media China's long-established traditions of visual spectacle was also shown by his *Impression West Lake* (2007), a performance of light, music, dance, and theater on a stage 1.2 inches (3 cm) underwater at a popular lake in Hangzhou. The staging of the Olympics highlighted for many a slew of wider issues facing an ever industrializing China, from millions still living in poverty to devastating levels of pollution and the need for greater awareness of the necessity for sustainable and socially responsible design by government, designers, manufacturers, and consumers alike.

Traditions of visual spectacle also feed into Chinese exhibition design, as seen at the trade expositions that were revived in Hangzhou in the early twenty-first century. The hosting of the Shanghai World Exposition in 2010 marked China's full global engagement in design, production, and marketing.

TAIWAN

From the 1950s, Taiwan sought to maintain traditional mainland Chinese culture, not least to differentiate itself from the People's Republic of China. The National Palace Museum, for example, which opened in 1965 and houses treasures brought from the Forbidden City in Beijing, has traditional-style upturned eaves, tiled roofs, and marble balustrades, referencing but not directly copying those of the Forbidden City. At the same time, Taiwan sought to join the international mainstream but was mainly known for producing cheap products. Today, however, businesses such as ASUS (founded 1989), a computer hardware and electronics company noted for its computers and cellphones, produce goods that compare in both quality and price with international competitors. It also produces components for other manufacturers, including Apple, Dell, Falcon Northwest, and Hewlett-Packard; in

Opposite: **Fig. 19.10.** Vivienne Tam. Dress from the Mao Collection, Hong Kong, 1995. Imagery by Zhang Hongtu. Synthetic knit; L. 57 in. (144.8 cm). Victoria and Albert Museum, London (FE.44:1, 2-1998).

2009, for example, nearly 30 percent of personal computers sold worldwide had an ASUS motherboard. In 2010, it created the world's thinnest notebook, the ASUS U36, which was only three-quarters of an inch (19 mm) thick. Within the year, a new, even slimmer version was launched that measures only one-tenth of an inch (3 mm) at the front and a little over three-tenths (9 mm) at the rear.

Many Taiwanese fashion designers work outside the country while continuing to seek inspiration from their native land. Shao-yen Chen, for example, who graduated from Central Saint Martins College of Art and Design, London, in 2010, is inspired by the landscape of his hometown in Yilan. Although born in Taiwan, Jason Wu (b. 1982) was raised in the United States, where he studied fashion design at Parsons The New School for Design, in New York. He established himself in the U.S. fashion industry after creating First Lady Michelle Obama's gown for the presidential inauguration balls in 2009. Wu does not attempt to identify his Chinese heritage in his designs, favoring a contemporary aesthetic for a broad customer base, which in 2012 included a collection for the "big box" retailer Target. By contrast, one of the most internationally renowned up-market Taiwanese fashion brands, Shiatzy Chen, founded by Wang Chen Tsai-Hsia (b. 1951) in 1978, features an aesthetic based on contemporary versions of traditional Chinese handcraft techniques and designs applied to Western-style women's wear. The brand debuted at Paris Fashion Week in 2008.

In the more traditional crafts, contemporary objects bear historical resonance while being made in newly explored

media. Artist Loretta Yang, for example, works in glass, a material that has only recently become a popular sculptural medium in China. She is the principal designer for Liu Li Gong Fang, the first art-glass studio in Taiwan (founded 1987), which pioneered the use of traditional glass-blowing techniques to create modern sculptural forms. The eminent potter Sun Chao makes porcelain vessels in traditional forms, decorated with crystalline glazes. Introduced in art pottery the late nineteenth century, these glazes are specially formulated with a high zinc content to develop large intricate crystals during an exacting firing process. The glazes are difficult to perfect because the firing range is extremely precise, but new electronic kilns have made this easier to calculate and control.

HONG KONG

Britain retained sovereignty over Hong Kong until its return to China in 1997. In the 1950s and 1960s, rather like China itself in the 1990s and 2000s, Hong Kong became known for the manufacture of a range of cheap goods. Production was based on the OEM (Overseas Equipment Manufacture) system, by which overseas clients supplied designs to be manufactured. Such goods sold well abroad, as did objects associated with more traditional local craft skills, including tailoring.

The earlier *qipao* style was altered and adopted by fashionable women living in Hong Kong, where after 1949 it came to embody high fashion (fig. 19.9). The short sleeve length was derived from Western-style sleeveless dresses. The garment on the left is made from satin decorated with an asymmetric, embroidered design of red lilies; that on the right from fine wool with a top section in "apron" style, accentuated by embroidered bands that are older than the dress itself. The latter were probably made for a more traditional woman's robe of the late nineteenth or early twentieth century. Overtly modern features include the curvaceous silhouettes and easy-to-fasten press-studs.

From the 1960s onward, Hong Kong enjoyed an industrial and economic boom. In architecture, an acute lack of space, difficult terrain, and extreme weather conditions led to a vertical landscape of skyscrapers, many of them designed by world-renowned foreign architects as well as local ones. Landmark buildings like the centrally located Hong Kong Shanghai Bank headquarters (1979–86), designed by British architect Norman Foster, and the Hong Kong Academy for the Performing Arts (1986), by Simon Kwan, were counterparts to widespread building of public housing.

Fashion designer Vivienne Tam (b. 1957 in Canton, China) was educated in Hong Kong but moved to New York to establish her business. Her inaugural collection, "East Meets West" (1994), indicates the extent to which she explored her Chinese heritage through a knowing Postmodern lens that highlighted U.S. pop culture. Her Mao Collection included suits, dresses, coats, and T-shirts decorated with images of the former Chinese leader (fig. 19.10). Tam remains based in the United States but has shops in cities around the world, and retains strong cultural links with Asia.

Fig. 19.11. May Wong. *Bamboo* glasses, designed for the Living Gear line, Gear Atelier Limited, Hong Kong, 2008. Acrylic.

Among those who stayed in Hong Kong after graduation is industrial designer May Wong, who studied at Hong Kong Polytechnic University. After graduating, she worked in the design studio headed by Ken K. Shimasaki before establishing her own business in 1989. She has designed for "global" companies such as the Philips lighting company and Panasonic. Her *Cactus Orange Juicer* (1995) was the first item created by her product design company, Design Gallery, established in the same year, and her brand of gifts and household products, such as Living Gear (1995) and Tapas (1999), sells in more than fifty countries. By the 2010s, the company had retail outlets in Beijing and Quanzhou. She interprets classic shapes associated with traditionally handcrafted objects but renders them in contemporary materials. Her *Bamboo* glasses, for example, mimic bamboo, a material that evokes China past and present (fig. 19.11). Made of high-quality, durable acrylic with a high level of transparency, injection-molded to give even thickness, they can be mass-produced for markets around the world. When stacked, their likeness to bamboo cane is even more marked.

The Hong Kong furniture market was heavily European-dominated in the 1980s, but designs by architect-designer Barrie Ho for modern Ming dynasty–style furniture made of timber and stainless steel brought a refreshingly Chinese flavor to Hong Kong interiors. Chinese "retro" influences in Hong Kong increased in the lead up to and after Hong Kong joined mainland China in 1997.

ROSE KERR

KOREA

By the end of the nineteenth century, after a long period of isolation that earned it the name "Hermit Kingdom," Korea tentatively established political and economic ties with other countries, especially Russia, Japan, France, and the United States. Efforts were made to modernize and industrialize during the short-lived Korean Empire (1897–1910), but the annexation of Korea by Japan in 1910 brought this to an end. During the period of Japanese colonial rule (1910–45), traditional Korean crafts were discouraged. After World War II and the Korean War (1950–53), the country was in ruins and partitioned into north and south.

In North Korea, the Democratic People's Republic of Korea has fostered a range of design and craft practices, from architecture to calligraphy, poster design, and decorative arts production, some of which serve political ends. Not surprisingly, there were strong links between visual expression in North Korea and that of both the Soviet Union and Communist China. The North Korean version of socialist realism is known as Juche Realism, from the name of the North Korean state ideology. Orthodox Communists divide art and design into two types: that reflecting the needs of the populace ("people's art") and that reflecting the ideology of the exploit-

ing class ("reactionary art"). The poster is a favored vehicle for disseminating "people's art" and all manner of political messages. Inexpensive to produce, it can be mounted on a variety of surfaces in both public and private spaces, and can quickly convey directives from the ruling elite to the mass of the population, either overtly or covertly. The poster titled *Let's Build a Strong Native Land* (c. 2000), for example, played on national patriotism and security while encoding a message that sought to justify increased military spending at the same time as people struggled to feed themselves (fig. 19.12).

Many designers and craftspeople in North Korea today express traditional values in work characterized by technical excellence and high levels of commitment to craft traditions. A range of crafts are taught through a nationally approved network known as Art Creation Companies, run by various government agencies. The largest of these, the Mansudae Creation Company, employed about 3,700 workers in 2005, including some 200 potters who work in both celadon and porcelain. Im Sa-jun (1927–2007), a leading potter specializing in celadon, became a Merit Artist in 1984, a People's Artist in 1985, and in 1989 was awarded the Kim Il-sung prize, named after the first leader of North Korea (fig. 19.13).

Arts and crafts were slow to recover in the Republic of Korea (South Korea) after 1953, partly because of the physical destruction caused by war. Some Koreans refer to the first half of the twentieth century as the "state of unconsciousness"—a time before industrialization and modernization when production was mainly by hand and home-based. From the 1960s, economic recovery and growing levels of political stability accompanied greater mechanization and standardization. At the same time, and partly as a reaction to these new developments, there was a revival of interest in craft traditions and handwork.

Korea has a long tradition of excellence in ceramics, and from the 1950s, ceramists in South Korea have combined respect for those traditions with expanding the boundaries of craft and design. From 1958, ceramics was taught in South Korean universities, many of which had links to universities in the United States and elsewhere. Scholarships were available for talented students to study abroad, an experience that brought exposure to new ideas, design traditions, and methods of production. As a result of such cultural exchange, many Korean potters acquired new skills that were valuable for the preservation and maintenance of Korean ceramic traditions.

In the 1960s, a movement to produce "contemporary" ceramics grew apace. Fine artists tried their hand at designing and making pottery, some more successfully than others, as it became possible to earn a living in this field. A variety of groups and associations were founded to develop work in a contemporary mode, and some universities began to install kilns and firing systems in order to give students greater control over firing and glaze making. Today, universities continue to play an important role in contemporary ceramics.

Most contemporary potters choose to work within one of three main traditions: celadons, white porcelain wares, and *buncheong* wares—a dark stoneware covered with white slip and decorated in a variety of ways under a clear glaze. Although coarse in texture, *buncheong* pottery—once made for people forbidden by royal edict to use porcelain—has a lively spontaneity and remains popular. Unlike celadons and white porcelains which were developed from Chinese prototypes, *buncheong* originated on the Korean peninsula in the first half of the Joseon dynasty (1392–1897) and is seen as embodying an unostentatious simplicity that Koreans like to associate with their national character.

Buncheong techniques are seen in the work of Sang-ho Shin (b. 1947), former dean of the College of Fine Arts at Hongik University, Seoul, who works in clay in a manner valued for its technical and stylistic eclecticism. After graduating from Hongik, he began making traditional blue-green celadon as well as *buncheong* stoneware. After working in the United States as an exchange professor in the mid-1980s and in England in the mid-1990s, Shin changed his designs dramatically as he absorbed more Western influences. Today he continues to draw on various design traditions, including African, as in this model of an animal's head (fig. 19.14), in which stoneware clay was glazed and then slip-decorated by knife, stamping, and inlay—all *buncheong* techniques.

Yoon Kwang Cho (b. 1946) creates ceramics imbued with the ideas and practices of Buddhism and often represents

Fig. 19.12. Mansudae Studio. Design for a poster: *Let's Build a Strong Native Land*, Pyongyang, c. 2000. Ink and colors on paper; 27½ x 23¼ in. (70 x 59 cm). Trustees of the British Museum (2001,0607,0.13).

Fig. 19.13. Im Sa-jun. Vase, Pyongyang, c. 1990–2000. Stoneware, celadon glaze. Trustees of the British Museum (2001,0609.1).

Fig. 19.14. Sang-ho Shin. *Buncheong* figure, Korea, c. 1992. Stoneware; 16½ x 14⅝ x 9½ in. (42 x 37 x 24 cm). Victoria and Albert Museum, London (FE.2-1993).

decoration, seeking vitality in small gestures of spontaneity that strain against a larger discipline.

An additional Korean ceramic tradition that reflects both contemporary and historical preferences is white porcelain. Young Sook Park's plain, milky-white "Moon Jars" involve a technically demanding process whereby the large jars are thrown in two sections and pieced together edge to edge in the center, recalling wares of the eighteenth century. As representative of a national past, these have a strong emotional appeal. White porcelain is also used for contemporary expression as well as designs referencing historicist modes. Roe Kyung Joe (b. 1951), a professor in the Ceramics Department at the College of Design, Kookmin University, Seoul, became known for making Yunrimoon ceramics (marbled wares) after he revived a tradition of marbling found on both celadons and porcelain in the past.

INDUSTRIAL DESIGN

After the war that left the country divided, both sections promoted industrial design as a means of creating a sound economic base. In North Korea, issues related to industrial design, such as the registration and protections of design, were incorporated into legislation from the 1950s onward. But product design grew much faster in South Korea where American and European "lifestyle products," from televisions to typewriters, were influential.

The 1960s saw significant production of the first Korean-made radio, the A-501 (1959), designed by Park Yong-gul, the first corporate industrial designer in Korea, working for Gold-Star (later LG), who manufactured the radio. The company's VD-191 black-and-white television set (1966) was also the first of its type. Other popular objects included the Monami 153 ballpoint pen (1963) and the Kong Byung-woo typewriter with a Korean alphabet keyboard developed by an ophthalmologist in 1949 and named after him. These items were included in *Selling Happiness: 1960s–'80s Consumer Design in Korea*, an exhibition that toured the United States in 2012, organized by the Korea Craft and Design Foundation (KCDF—Korea Design Heritage).

The rate of urbanization and economic growth sped up in the 1970s, when a plethora of smaller lifestyle products, such as banana-milk bottles, flooded the domestic market. Kitchen appliances including the "automatic" rice cooker were further updated with brightly colored floral decoration. The burgeoning South Korean economy of the 1980s established the country as one of the "Asian Tigers" (along with Hong Kong, Singapore, and Taiwan), noted for maintaining exceptionally high growth rates and rapid industrialization. The greatest expansion of design activity was in electronics, white goods such as washing machines, and the transportation industry. Automobiles, computers, camcorders, and other objects associated with leisure activities, such as Samsung's MyMy cassette player (1981), became markers of modern "cool" for young South Koreans.

Automobile plants initially merely assembled parts imported from Japan and the United States, but by the 1990s,

aspects of the city of Gyeongju, with its many Buddhist sites, in his work. Born in North Korea, he graduated from Hongik University before studying in Japan at Karatsu, Saga prefecture, a traditional center for Korean-style ceramics. Yoon developed his own style of *buncheong* ceramics by modifying the technique and employing angular shapes decorated with white brushwork.

Another alumnus of Hongik University and later a professor at the Korean National University of Cultural Heritage, Choi Sung-Jae (b. 1962) believes in a ceramic beauty that emerges naturally from the process of dealing with clay and fire. His simple ceramic forms provide canvases for painting: when his pots are leather hard (partially dry), he applies white slip and paints the surface with bold, expressive images in the manner of traditional ink-painting, employing twigs, bamboo shoots, millet stalks, or even his own fingers as a brush. By contrast, Huh Sang Wook's more utilitarian ceramics have vigorous, floral sgraffito designs in the ornate decorative mode popular in contemporary Korean interiors. He also creates more restrained objects with simple stamped

companies such as Hyundai, Kia, Daewoo, and Samsung were designing their own models. Many sold well at home and abroad, including the Hyundai Sonata (1985). Graphic designers, such as The-D Ltd., for example, were employed to advertise these and other products, and in 2008, The-D Ltd. was awarded a prestigious national design prize for its annual report for Samsung Heavy Industries (fig. 19.15).

In the late twentieth century, many public buildings were designed to promote South Korea's national identity, an embodiment of traditional and contemporary aesthetics, as well as environmental sensitivity. Korean architects and designers worked on both public commissions and private dwellings, many of which were inspired by traditional Korean houses known as *Han-ok*. These new buildings employed exclusively natural materials and harnessed wind and sun energy for power. Younger designers, such as Kim Dongjin, Shin Seungsoo, Lim Dokyun, and Jo Junho, combine both traditional and contemporary "green" methods.

DOMESTIC WARES

The everyday use of bronze ware was drastically reduced in the second half of the twentieth century as stainless steel and plastic wares appeared. In recent years, however, certain craftspeople have revived traditional bronze and brass ware for use in the home, including tableware and candlesticks, such as those made by Yi Bong-ju, a "Master Yugi Artisan." Born in the North Korean town of Napcheong, home of *bangjja yugi* (forged brassware), Yi now works in the south, bringing handcrafted metalware objects back into the domestic domain.

In the early twentieth century, it was still the custom for well-to-do households to plant a tree on the birth of daughters so that by the time the girls married, the wood could be harvested and used to make wedding chests. By the last quarter of the century, however, such traditional chests were considered old-fashioned by many, with countless relegated to storage along with other outmoded furniture. In recent years, there has been a revival of interest in handmade wooden and inlaid furniture that reflects the skill of the maker. Designated a Master Carpenter by the government, Seol Seok-cheol, who hails from a family of woodworkers and learned his craft as an unpaid apprentice, works with a variety of native woods such as red oak, zelkova, and paulownia to create household and office furniture. His sons have followed him into the family business. Yi Sang-ji is another Master Craftsman, a maker of woven *wancho* baskets. *Wancho*, a white reed found in rice paddies and wetlands, is soft and durable. Baskets made of it once served as primary storage units in the home, but today *wancho* baskets are prized decorative objects.

Hwagak (literally, "brilliant horn") is a uniquely Korean craft involving paper-thin transparent strips of ox horn vividly colored and densely patterned which are inlaid into furniture. This demanding craft almost disappeard in the 1920s when the Yanghwajin region of Seoul specializing in it was devastated by flooding, and cheap imitations, many made from chemically treated celluloid, began to replace traditional materials. The craft was revived later in the century by artisans such as Eum Il-cheon, who, until his death in 1974, researched and created traditional *hwagak* objects. The craft is considered a national asset, as are leading exponents Yi Jae Man (b. c. 1953) and Han Chun Seop (b. 1949).

DRESS, FASHION, AND TEXTILES

Korean dress underwent many changes during the century. Chemical dyes and manmade fabrics altered the appearance of textiles used by all sectors of society, and households gradually ceased weaving their own fabrics and sewing their own clothes. Western clothing standards came to predominate, though the traditional Korean *hanbok* (dress) never disappeared. Today, musicians and actors perform in it, and women, girls, and (less often) men don traditional clothes for holidays, weddings, and other family gatherings.

Fashion and textile design are taught in universities and design colleges, and some South Korean fashion designers, such as Andre Kim (1935–2010), renowned for his evening wear and wedding dresses, and Ji Choon-hee (b. 1954) for her brand, Miss Gee, which became well-established in the country. Others, especially younger designers, regularly present collections in New York, London, Paris, and Beijing. The best-known Asian-American fashion designers of Korean descent include Richard Chai and Doo-Ri Chung (b. 1973), but their designs do not reflect their Korean heritage, unlike the work of some designers based in Korea.

A noteworthy feature of South Korean fashion is the reinterpretation of traditional items of dress, styling, and colors, and the fusion of new techniques of weaving, dyeing, and manufacture with traditional ones. Jin Teok contributed to a contemporary look for Korea's emerging "new woman" in the 1960s, helping to found the Korea Fashion Designers Association which continues to promote young designers. Her business empire grew from a single boutique opened in 1965 to a chain of forty-three by 1995. Jin draws from Korean culture

Fig. 19.15. The-D Ltd. Two-page spread, from Samsung Heavy Industries, *Spirit of Creation, Annual Report 2008*.

The Best
What does it take to be the best? While being first is critical in establishing brand recognition for innovation and efficient speed-to-market, being best is equally important.

It requires surpassing all competitors through rigorous and disciplined determination. SHI is the established market leader in the high value-added liquefied natural gas carrier shipbuilding category. As of the end of 2008, SHI claimed nearly 33 percent—60 of the 184—orders placed since 2003, maintaining its world-leading market share. This demonstrates the success of SHI's quest to be best.

Fig. 19.16. Chunghie
Lee. Skirt, Korea, 2001.
Machine-stitched silk
gauze; overall, 46 x
71 in. (117 x 180 cm).
Victoria and Albert
Museum, London
(FE.137-2002).

as well as the natural world, in simply shaped garments as well as those with more elaborate wrapping or pleating.

The revival of interest in traditional Korean clothing can be seen in the work of Lee Young Hee (b. 1936), a well-known designer of *hanbok* who graduated from Sungshin Women's University and opened her first shop specializing in such clothes in Seoul in 1976. Born in Taegu, the third largest city of South Korea, Lee learned much about clothing from her mother, a dressmaker who fashioned ceremonial garments for the aristocracy. Western fashion magazines stimulated Lee to mix Eastern and Western styles, and in 1993, she presented a ready-to-wear collection in Paris, opening a *hanbok* boutique there a year later. The Lee Young Hee Museum of Korean Culture opened in New York in 2004.

The work of fashion designer and artist Chunghie Lee reinterprets the colors and shapes of traditional Korean clothing and *pojagi* (Korean patchwork; see fig. 13.17). She is best known for her innovative and bold designs, worked with *gekki* (a traditional Korean stitching technique). Some garments are made in light, delicate, and boldly colored silk organza, while others use coarser hemp and (Korean) paper.

Typical of her work is a double-layered skirt with an asymmetric hem, made of patches of pastel-colored silk gauze stitched together asymmetrically, their ends encased in a sealed flat seam in some examples, while in others, a section of seam extends into loose sewing threads (fig. 19.16). Lee states that such garments honor women of the past, who created items of timeless beauty out of small scraps of fabric.

Norigae are traditional pendants made from cord, jewels, knotting, and tassels, sometimes combined with jade, coral, amber, or metallic ornaments. These tasseled pieces were worn on clothing and hung on doors, furniture, window shades, and other household furnishings, and the craft of producing them has continued to the present day. The extremely complex braiding and knotting process is known as *maedüp*. Silk strands form thread, which is then dyed, woven, and knotted. One modern "master" is Kim Eun Young, whose *norigae* refine the wearing of contemporary women's *hanbok*. Thus, in fashion as in other areas of design, both North Korea and South Korea have looked to the past while designing for the twenty-first century.

ROSE KERR

JAPAN

In modern Japan, as in many industrialized countries, old and new coexist. Throughout the twentieth century, local manufacturers producing familiar objects in traditional materials operated alongside unabashed modernists working in recognizably international styles using new techniques and materials. Others sought to fuse past and present through design. Consumers purchased and used all of these various goods in particular ways that reflected very different social identities. As the century progressed, craft production declined and professionally designed mass-produced goods gained ground, so much so that today, many traditional crafts such as lacquerware and metalwork are considered endangered. Handcrafting remained influential, however: indeed, local craftspeople, craft-trained in-house designers and engineers, and other "anonymous" designers were responsible for many, if not most, of the things "made in Japan" during the twentieth century.

DESIGN PRACTICE AND EDUCATION, 1900–1915

In 1900, most products for domestic use, display, and export were made by hand in traditionally organized workshops, each of which specialized in a particular type of product and used natural materials. As in earlier centuries, workshops either generated their own designs—often taking inspiration from competitors' products or pattern books (hinagata-bon)— or followed design instructions from regional wholesale brokers who organized distribution elsewhere in Japan and overseas. Several groups of younger people, however, were already working specifically as designers in Tokyo and Kyoto, Japan's political and artistic centers. Some had studied under painters in the workshop system, and translated skills learned there into patterns for kimono textiles, ceramics, and lacquerware. Others, largely chosen from the sons of former domainal officials in the Tokugawa regime, were products of a new academic system modeled on art and engineering education in Western Europe, instituted by the Meiji government. The most promising were sent by the Ministry of Education to study in Europe before returning to take leadership positions in polytechnic institutes specializing in arts and crafts.

In the old artistic capitol of Kyoto, industrialists and city officials sponsored a new institute, the Kyoto Higher School of Crafts (1902), with courses in textiles manufacturing and design taught by Western-style painter Asai Chū (1856–1907) and architect Takeda Goichi (1872–1938). Both men came from elite families and were well educated—Asai at the Art School of the Ministry of Public Works (Kōbu Bijutsu Gakkō), Takeda at the Tokyo Imperial University. They also had studied in Europe, where they were profoundly impressed by Parisian and Viennese Art Nouveau. For example, Asai's striking vase design masses scarlet poppies prominently against black leaves, strongly contrasting its olive base (fig. 19.17).

Asai, Takeda, and their students brought an Art Nouveau–inspired aesthetic to Kyoto's ceramics, textiles, and lacquerware industries, while mingling professionally and socially with craftspeople and wealthy clients. Elite, traditionally trained craftsmen like inlaid lacquer (maki-e) master Sugibayashi Kokō (1881–1913), who collaborated with Asai, found an affinity between the new style, with its spare backgrounds and lines inspired by nature, and the earlier Kyoto crafts in the Rinpa style (see figs. 7.23, 7.24).

Art Nouveau offered a more up-to-date style; in both interior design and products designed in Japan for domestic and export use, it contrasted strongly with the heavily detailed historicism associated with imported late-nineteenth century European styles. But export strategists also saw the production of Art Nouveau objects and decoration, from sinuously organic and asymmetrical to geometrical compositions, as a way to improve Japanese exports at a time when the ornately carved wooden furniture and other craft items that had sold well abroad since the 1860s were losing foreign sales. At home, the geometrical, spare visual language of the Viennese Secession (an Austrian variant of Art Nouveau, seen in work by the Wiener Werkstätte, for example, see fig. 23.28) in particular captivated furniture and interior designers interested in promoting social reform through the redesign

Fig. 19.17. Asai Chū. Design for *Poppy* vase, Japan, 1901. Watercolor; 18⅛ x 11⅜ in. (46 x 29 cm). The National Museum of Modern Art, Kyoto.

of everyday objects. *Bunriha* (literally, "Secession faction") style would dominate modern design and architecture in Japan through the early 1920s, well after the style had lost its momentum in Austria.

In Tokyo, the nation's political center, reformers created self-consciously technocratic design practices and schools as an attempt to modernize existing industries. Tejima Seiichi (1850–1918), principal of the Tokyo School of Technology and the leading advocate for formal, school-based technical education, worried that apprentices and young workers did not have the appropriate education for the needs of modern production. The school, which trained factory foremen, draftsmen who could communicate between architects and carpenters, and teachers for vocational schools, was the pinnacle of a national system aimed to redress this deficiency. During nationwide curricular reforms initiated by Tejima in the 1890s, the Tokyo School of Technology added a design department and was reclassified as a polytechnic (the Tokyo Higher School of Technology). Around the same time, the Tokyo School of Art created a course covering interior, pattern, and furniture design. Like its Kyoto counterpart, the Tokyo program trained its students in design drawing (*zuan*), rather than familiarizing them with a particular material or industry, and looked to department stores, building contractors, and schools to place graduates.

The Higher School of Technology published *Design* (*Zuan*, 1901–6), a magazine of sample pattern designs created by teachers, graduates, and associates. In 1914, however, the school's design department was scrapped, and the institution was reoriented toward heavy industry as part of a larger government shift following the Russo-Japanese War (1904–5). This move caused dissension among design reform advocates such as Tejima and his protégé Yasuda Rokuzō (1874–1942) and led directly to the establishment of the Tokyo Higher School of Arts and Crafts in 1920 as an institution devoted to research and education in making objects that were both functional and beautiful.

State and commercial concerns to improve Japanese material conditions and build economic might and political status in northeast Asia fueled research into design and manufacturing. In 1907, the Ministry of Agriculture and Industry sponsored Kogure Joichi (1882–1943), a graduate of the Tokyo Higher School of Technology, to research materials and processes for improving the quality of wooden furniture. Disseminated through publications, Kogure's findings helped the expansion of the furniture industry in the 1910s by providing small manufacturers, who made both Japanese- and Western-style goods, with ergonomic data and new wood-curing techniques. Kogure's efforts, along with those of many others, were motivated by a spirit of national contribution, of individuals helping to strengthen the national economy through growth in regional industries and improving the nation's quality of life by making better household furnishings more widely available. The Russo-Japanese War had heightened nationalist sentiment, and devotion to improving Japan's international standing and living standards characterized the careers of many designers of Kogure's generation.

During the economic prosperity that followed the Russo-Japanese War, department stores emphasized the importance of design to sales. In 1906, the elite Mitsukoshi department store promoted employee Hayashi Kōhei (1880–1934) to head a bespoke interior decoration service; clients included the Japanese Embassy in Paris. By the early 1910s, Mitsukoshi had expanded its stock to include more affordable items, such as rattan chairs, and was targeting a new market, namely upper-middle-class consumers living in the suburbs springing up around Tokyo and Osaka who were interested in furnishing and decorating their homes with tasteful objects—both Japanese and Western.

Mitsukoshi had begun as a sake shop before specializing in textiles and ultimately becoming a department store. Kimonos and their accompanying accessories continued to constitute an important area of business. Pattern designers for kimono textiles had access to Art Nouveau and other styles through *Design* magazine and personal connections. Most Japanese, however, continued to purchase kimono textiles dyed and woven in the traditional centers in north-central and western Japan where producers were less influenced by new trends. Still, the fashionability of Mitsukoshi, promoted through posters and an in-house magazine established in 1899, ensured that Art Nouveau–influenced designs had an impact in the major textile production centers around Japan.

The expansion of department stores, along with advertising graphics and illustrations, meant that patterns and products appeared on richly colored, finely detailed posters appealing to women's good taste (*shumi*; fig. 19.18). The Art Nouveau–influenced poster illustrated here was designed by Hashiguchi Goyō (1880–1921) and won Mitsukoshi's first advertising poster competition in 1911. It reveals an elegant housewife with a fashionable hairstyle and kimono perched on a Western-style bench and leafing through a book of Kabuki theater wood-block prints. Her "look" and that of the poster are elegantly restrained: sumptuous but not showy. Simplified vegetal forms in the wallpaper, kimono, *obi* sash, and decoration on the bench suggest a merging of current and traditional taste.

The complex printing process used for this poster involved thirty-five different color plates. Such posters pointed to the versatility of Japanese surface pattern designers, who worked across media in ceramics, textiles, book design, illustrations, and posters. This practice of operating in different media was not unusual, particularly in Kyoto with its strong tradition of artistic manufacturers and designer-artists. Several leading illustrators and graphic designers, such as Hashiguchi and Takeji Yumehisa (1884–1934), had studied under established artists rather than at one of the new design programs.

In the early twentieth century, graphic design was one of only a few professional design areas to affect the daily lives of most Japanese directly, and new imported styles and movements, such as Art Nouveau, were experienced through books, magazines, posters, and other graphic material, as well as through new building types such as schools, railway stations, factories, and government offices. The bulk of self-consciously modern design practice, however, was aimed at an elite clientele, while for most consumers, nineteenth-century modes of production and consumption persisted.

Japanese cities grew throughout the 1910s as people, especially the young, moved to urban centers for work and education. The attendant growth in housing included new residential suburbs, commuter rail networks, department stores, and other amenities that single corporations developed as part of comprehensive business strategies based on land acquisition and stimulating consumption. Inflation and rent increases exacerbated an acute housing shortage after World War I, when social reformers, design educators, designers, and architects called for more homes of better quality, and for improved furnishings, kitchens, and indoor bathrooms. The mid-1910s saw national newspapers, department stores, and the government's Education Museum sponsor exhibitions of model interiors and home furnishings. In 1919, Tokyo-based progressive women's educators, home economists, designers, architects, Christian reformers, and socially minded public servants formed the Everyday Life Reform League, which was dedicated to the rationalization, or efficient use of food, clothing, and housing (*ishokujū*).

A key characteristic of these officially sanctioned "reforms" was the call to replace the custom of dwelling and sleeping on the floor with a lifestyle based on chairs, tables, and beds, as part of the broader "rationalization" (*gōrika*) of daily life. Reformers posited that "improved" Western-style clothing, food, and dwellings increased productivity and social progress. Habits and customs that involved furnishing homes with both Western- and Japanese-style things (*nijū seikatsu*, literally "double life") were considered both wasteful and detrimental to health and household economy. For reformers, modernization meant the adoption of Western-style objects, spaces, and habits. Foreign or foreign-style objects had an exotic cachet, but their acquisition meant more than simply "copying" the West; it meant participation in a type of globally recognizable modernity.

Given the high cost of chairs (which were not easily used on *tatami* floors) and the fact that most urban householders were renters, only small numbers of middle-class families, mainly those in new suburban homes, could implement the reformers' recommendations. Nevertheless, images of model "modern" interiors, kitchens, domestic appliances, and furnishings circulated widely in books and magazines like *Shufu no tomo* (The Housewife's Companion, 1917), shaping readers' desires. The standard curriculum for girls' senior schools included principles of housing design, construction, and furnishing. Books like *Kore kara no shitsunai sōshoku* (Interior Decoration from Now On, 1927) by designer Moriya Nobuo (1893–1927), which walked the reader through the form, function, and furnishing of every room in a Western-style house, provided an aspirational image of what "modern" life might be and gave women ideas for how they might shape their own environments.

By the late 1920s, increased access to higher education and white-collar jobs, the electrification of the home, and expanding leisure and entertainment industries—including radio and cinema, shopping hubs around commuter rail terminals, and the expansion of print media—had created a dis-

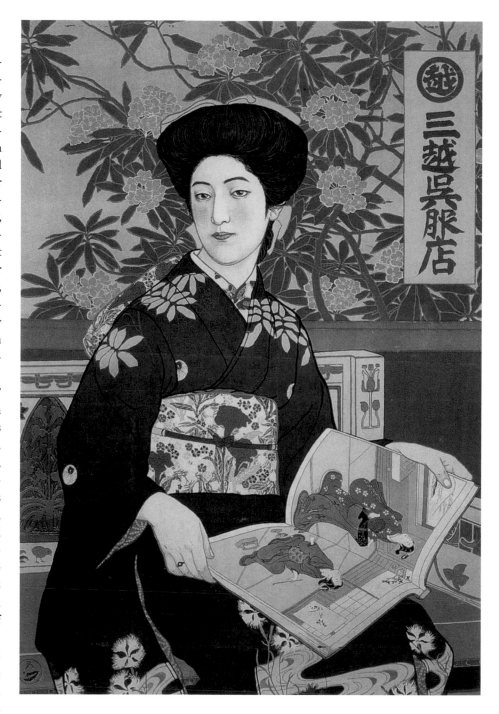

tinctive urban and modern culture in Japan's cities, with important ramifications for design. This new environment catalyzed industrial expansion and stylistic experimentation, especially in commercial art (*shōgyō bijutsu*, later known as graphic design).

Intensified competition in consumer goods encouraged cosmetics manufacturers like Shiseido and Kao to develop sophisticated corporate identities and advertising campaigns. From the early 1920s, Fukuhara Shinzō (1883–1948), president of the Shiseido cosmetic company, hired designers such as Maeda Mitsugu (1903–1967) and Yamana Ayao (1897–1980) to enhance the company's already extensive marketing programs, from product packaging, point-of-purchase displays, and advertising in Shiseido's monthly magazine (1924). Stylized lettering and line drawings of elegantly slouched women with bobbed, permed hair advertised the brand as the epitome of sophisticated urban femininity. At Kao, a cosmetics

Fig. 19.18. Hashiguchi Goyō. Advertising poster for the Mitsukoshi department store, Japan, 1911. Lithograph; 40 x 28³⁄₁₆ in. (101.7 x 71.6 cm).

Fig. 19.19. Kōno Takashi.
Magazine advertisement
for the film *Omohide
ooki onna* (A Woman
with Many Memories),
from *Kokusai eiga
shinbun* 65, Japan,
November 1931.

1920s and 1930s for the Shochiku movie studio employed bright colors, bold typography, and block graphics, all of which were easily printable with the new photographic polychromatic flat-plate "HB" process, imported in 1920 from the United States (fig. 19.19). Movies also conveyed the vigorous embrace of modern urban living in Japan back to cinema audiences: gangsters, molls, white-collar men, university graduates fighting for advancement, and families experiencing suburban life.

Textiles, particularly for women's kimonos, were another means by which modern visual imagery made inroads into everyday urban life. Most often designed by employees of textile manufacturers, they featured bright chemical dyes, eye-catching geometrical patterns, and motifs of airplanes and jazz sheet music. Inventions like the Toyota Type G automated loom (1924) and the mobilization of thousands of young, rural women to work in Japan's cotton and silk mills brought down the cost of textiles. Purchased in standardized widths for women to sew at home, as they had been in earlier periods, kimonos were worn with similarly modern-patterned *obi* higher up along the torso, creating a new silhouette. In the 1920s and 1930s, urban men often wore Western clothing to their jobs and changed into Japanese clothing for relaxation at home, but the vast majority of women continued to dress in kimonos. The wearing of kimonos, together with curled and bobbed hair, demonstrated how modern life included both the vernacular and the new and was never solely about Westernization. While dressmaking schools like Bunka Gakuen (1923) trained professional seamstresses, most women continued to sew and mend family clothes. Tellingly, fashion articles in women's magazines offered patterns and sewing instructions rather than shop details. Western-style homes and furniture remained too expensive for many consumers, but textiles such as *meisen*, a machine-spun warp-printed silk or rayon that imitated the look of expensive hand-woven and dyed *kasuri* silk, were accessible to women across class boundaries (fig. 19.20).

The Tokyo Higher School of Arts and Crafts both stimulated and benefited from the expansion of urban consumer culture. Largely inspired by the School of Applied Arts in Vienna, the school offered degrees in printing, photography, wood products, furniture, sculpture, and fine machine tools. Furniture department graduates found employment with department stores and regional vocational schools, while printing graduates joined advertising agencies, magazine staffs, and corporate publicity departments. The school encouraged collective work by professors and students. Many of these efforts went no further than prototypes, which were often exhibited in department stores and government-sponsored exhibitions. The Keiji Kōbō group led by graduate and teacher Kurata Shūzō (1895–1966) put its ergonomically designed, Bauhaus-influenced furniture into serial production, pointing to the appearance of a more solid middle-class market by 1930.

A hub of design activity, the school was home to seminal professional organizations like the Oak Leaf Society (Kenyō-kai, renamed the Woodcraft Association or Mokuzai Kōgei Gakkai in 1922), which linked school-educated furniture and

and soap manufacturer that targeted a more mass-market customer base, art director Ota Hideshige (1892–1982) harnessed the creativity of in-house designers Asuka Tetsuo (1895–1997) and Okuda Masanori (1901–1967) and freelance photographers like Kimura Ihee (1901–1974) to create the image for New Kao soap. The company's strikingly avant-garde print advertisements combined German Neue Sachlichkeit (New Subjectivity) or Neues Bauen (New Building)–style photographs of urban industrial environments with stark type and direct messages about the soap's purity, aligning Kao's products with a modern sensibility and lifestyle. This extensive attention paid to packaging indicates the growing mass market, or potential mass sales, for basic products. Developments in printing technology in the 1910s, notably the adoption of offset printing and the rotating gravure press, which increased image quality while reducing printing costs, also helped to bring down the price of printed materials.

Work for avant-garde theatrical performances or small print-run photography magazines allowed designers to explore typographic developments associated with the European Modern Movement, and soon new layouts, typography, illustrations, and photomontages were seen in mass-circulation, in children's magazines, and on the cinema screen, equating a foreign "look" with a consumable modernity accessible to everyone. Film was particularly important: by 1929, there were 1,270 cinemas in Japan screening Hollywood movies in addition to films from Japan's own burgeoning industry. Advertisements by Kōno Takashi (1906–1999) in the

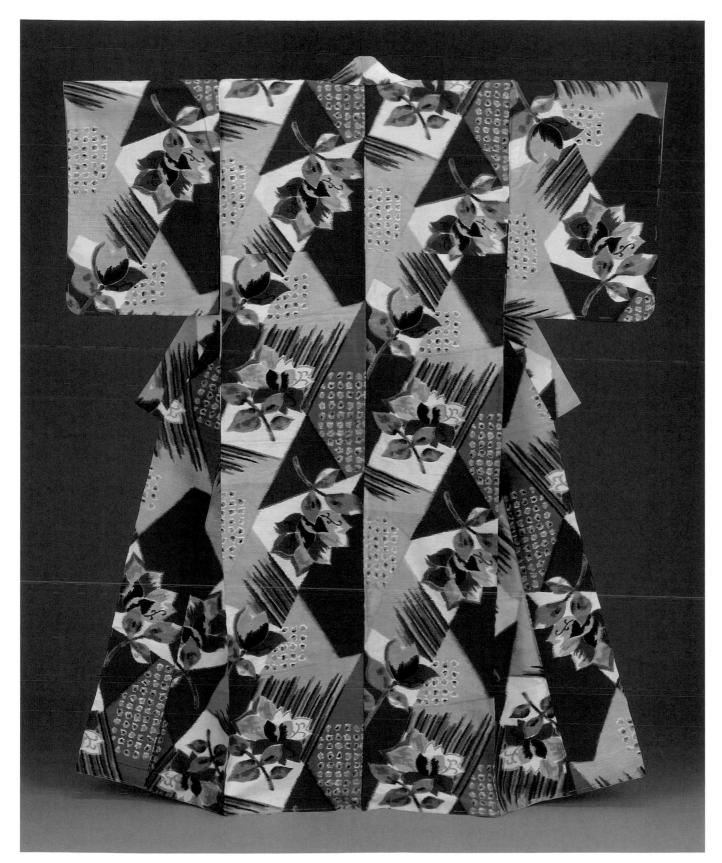

Fig. 19.20. *Meisen* kimono, Japan, 1900–50. Rayon, silk, cotton; 59½ x 49 in. (151.1 x 124.5 cm). Museum of Fine Arts, Boston (2004.115).

interior designers across Japan through a monthly magazine and regular exhibitions and lectures. The Commercial Artists Association (Shōgyō Bijutsuka Kyokai), a group of sixteen designers including professor Hamada Masuji (1892–1938), organized exhibitions and published the monthly magazine *Kōkokukai* (Advertising World) and the multivolume *Shōgyō Bijutsu Zenshū* (Commercial Art Compendium). Compiled by Hamada and Mitsukoshi Department Store's head graphic

designer, Sugiura Hisui (1876–1965), the compedium featured wide-ranging collections of graphics, from posters to neon signs and Japanese and Western typefaces.

Electrical appliance companies generally did not employ professional designers until the postwar period, and the design and crafts schools focused on furniture and crafts rather than industrial design. Many manufacturers who later became famous for their electrical appliances, however,

Tokyo School of Art, led lacquer research at the Okinawa Crafts Research Institute and created the Benbo corporation (1931), which specialized in modern lacquerware.

The goal of the ministry was to bring craft industries into the modern economy by finding products that would sell well abroad and thus aid rural economies that had abundant crafts skills and materials but little or no industry. The ministry also encouraged the development of new types of design and manufacture, including industrial design. Some research projects sought to create household products that would fit into Western markets but continued to use traditional materials and processes, as, for example, Benbo's Okinawan lacquerware. Others created new prototypes and explored new product types such as electrical fans and lighting fixtures. The German architect-designer Bruno Taut and French designer Charlotte Perriand were invited to Japan as foreign experts to advise on suitable product types for the foreign market, and to create prototypes that could serve as models for small manufacturers around Japan. Perriand's visits in 1940 and 1942, for example, culminated in an exhibition of furniture re-creating the *Chaise Longue* she had designed in collaboration with Le Corbusier and Pierre Jeanneret, along with other 1920s pieces, in local materials like bamboo and rice straw.

Regardless of reformers' activities, the bulk of design and manufacturing activity during this period continued to be in small workshops in towns scattered throughout Japan. Everyday objects like wooden buckets, metal and ceramic cookware, roof tiles, wooden clogs, combs, chopsticks, and wooden chests for home use, as well as agricultural implements, were produced for direct sale to local consumers or commissioned by middlemen for distribution in a larger region. Tokushima, on the island of Shikoku, for example, was known for mirror stands sold to wholesalers in neighboring Osaka, a commercial and industrial hub, for sales to shops throughout western Japan.

Fine craft practices such as ornamental metalwork and cloisonné persisted, both in the traditional workshop system and in schools of art and design. Cloisonné artist-designer Fujii Tatsukichi (1881–1964) began applying the aesthetic, materials, and methods of his craft to modern objects like clocks and lamps (fig. 19.21). For the most part, however, "artistic crafts" operated within a fine-art–style system of patronage and collection. Like the Folk Craft (*mingei*) movement led by Yanagi Sōri (1889–1961), who is known also as Yanagi Muneyoshi, and its appreciation of simple "folk" ceramics and lacquerware, these "artistic crafts" were valued and collected by the educated elite with limited impact on most people's lives. Japanese cities may have been growing, but the small scale of production made it difficult for manufacturers to refine products for successful international sales.

DESIGN AND WAR, 1930–1945

Japan colonized Taiwan in 1896 and Korea and parts of Manchuria in 1910, well before military expansion into other parts of China after 1931 and into Southeast Asia after the bombing

began operation around 1920. By 1924, 80 percent of homes had electricity, thanks in part to increased hydroelectric power provision. Most homes had a low electricity supply until the mid-1930s, but Japanese and foreign manufacturers identified a growing market. The Sharp company began making radios in 1925, after Japan's first radio station, JOAK, began broadcasting, and Matsushita (later Panasonic) founder Matsushita Kōnosuke (1894–1989), who had begun as an electrician in Osaka in 1918, expanded his company's product line to include electrical heaters and radios. Some electrical appliances were designed by employees with engineering backgrounds. Others were licensed from overseas manufacturers like General Electric in the United States or copied (some more carefully than others) from the pages of domestic and international competitors' catalogues by employees.

During the 1930s, the Ministry of Commerce and Industry (MCI) and manufacturers alike focused on enlarging Japan's share of the housewares market through improved product quality, range, and styling. In 1928, the MCI founded the Industrial Arts Research Institute (IARI) to study and develop new export products for regional crafts industries, disseminating results through its journal, *Kōgei Nyūsu* (Industrial Art News, 1932–74). On a smaller scale, lacquerware artisan Ikoma Hiroshi (1891–1991), a graduate of the

of Pearl Harbor provoked war with the United States and its allies in 1941. Japanese imperial expansionism brought suffering to Japan's population along with the victims of its military aggression, but also promoted development in design, partly because of the resources available as the result of large-scale contracts. The IARI's wartime remit supported materials research that fed postwar regional furniture manufacture, and commercial artists designed government propaganda alongside advertisements. While a small group of left-wing intellectuals, artists, designers, and activists protested the nation's militaristic right-wing shift, most aligned themselves with state efforts in the 1930s and 40s.

As the Japanese government became increasingly conservative in the 1930s, sympathetic graphic designers began to use styles for nationalist propaganda that earlier had been associated (both in Japan and internationally) with socialism and the European left. Art director Natori Yōnosuke (1910–1962) and photographer Kimura Ihee became known for Constructivist- and Bauhaus-influenced book designs, advertisements, and photomontage layouts. In 1933, they formed the design agency Nippon Kōbō ("Japan Workshop"). From 1934, they joined with other major artists and designers such as photographer Domon Ken (1909–1990) and designers Yamana Ayao, Kōno Takashi, and Kamekura Yūsaku (1915–1997), to create *NIPPON*, a multilingual, part-color magazine. The goal was to promote Japanese culture and tourism, and at the same time justify Japan's colonial expansion to Western nations, all with stylistic debts to the Soviet propaganda magazine *USSR in Construction*.

After the launch of the Citizens' (or National) Spiritual Mobilization Movement in 1937, a series of directives intended to instill unwavering unity, perseverance, and devotion to the nation marked a watershed in Japan's progression toward war. Nippon Kōbō members and other prominent individuals in the commercial art community in Tokyo formed the Society for the Study of Media Technology (*Hōdō Gijutsu Kenkyūkai*) to research and share effective propaganda techniques. By late 1944, the society was effectively a communications design production company geared to the war effort. Designers, photographers, and art directors convened daily to create maps, information graphics, propaganda magazines, and panels for traveling exhibitions. Some commercial artists were sent to the fronts in China and Southeast Asia, where they created pro-Japanese propaganda aimed at local communities.

Commercial advertising continued alongside propaganda, albeit with a change in tone and scale as the war progressed. Strict rationing laws mandated lower prices for many everyday products and outlawed the manufacture and sale of luxury items. Advertisers were required to include patriotic messages in all advertisements. The flavor enhancer monosodium glutamate, for example, might advertise itself while proclaiming citizens' solidarity with soldiers, and a shop window would advertise socks while exhorting passers-by to "support the troops." By the late 1930s, the editors of the seminal commercial art magazine *Advertising Art Monthly* (formerly *Publicity World*) had changed the journal's English name again—to *Industrial Art and Propaganda*. It mixed articles on selling typewriters and fashion with reports on German, American, and British techniques for visual persuasion. The mix of content reflected retailers' quandary: how to stay afloat amidst a wartime economy, with rationing, controlled production, and increasing shortages of materials and products.

Fashion responded to wartime pressures, even with textile rationing. Some enterprising textiles firms developed designs featuring patriotic motifs such as battleships and rising suns, sewn into under-kimonos for men or ceremonial kimonos for boy infants. Efforts to enforce the ideology of communal spirit and national solidarity through fashion were less popular. Committees of representatives from government departments and textile companies organized national competitions to design a "national civilian uniform" (*kokuminfuku*) for men who remained on the home front in 1939, and standardized clothing (*hyōjunfuku*) for women in 1942. Both the men's and women's clothing were made of cloth dyed in the "national defense color" (*kokubōshoku*), the government's preferred term for khaki. The men's uniform found some wearers, but standardized garments for either sex were not particularly popular, even patterns for women that retained the basic kimono form with shortened sleeves. Consumer taste still drove demand, even at the height of war. Patriotism through dress included upper-middle-class women's wearing white pinafores over kimonos to indicate membership in the Patriotic Women's Association (Aikoku Fujinkai); other women lopped off the "luxurious" long sleeves of prewar kimonos or sewed *senninbari* (thousand-stitched belts, each stitch by a different woman), which were given to soldiers as a talismen for safe return. Such were the hardships and shortages, however, that by the end of the war, many women, even in cities, had adopted baggy, indigo-dyed *monpe* trousers out of practical necessity, recasting what had been workwear for poor rural women—the last thing that fashionable urban women would usually want to wear—as wartime clothing.

Wartime regulations against luxury manufacture and consumption limited furniture and interior design activities. Department stores and makers of Western-style furniture lost their markets, and many designers and workers were drafted. On the other hand, designers at the IARI were able to develop ideas first prototyped in the 1920s. The utility furniture launched by Kogure Joichi at the beginning of the National Spiritual Mobilization Movement, for example, was an extension of Kogure's earlier ideas for standardized production. By 1944, IARI research focused on alternative materials for military hardware, including lightweight wood used to make airplanes that might allow the Japanese Air Force to stay aloft despite shortages of metal and fuel. When IARI researchers such as Kenmochi Isamu (1912–1971) and Watanabe Riki (b. 1911) became key figures in postwar furniture and product design, they openly credited the wartime demand for creativity with limited materials and tools as formative to their later approaches to design and manufacture.

Defeat by the Allied forces in 1945 left Japan exhausted, literally and psychologically: depleted of food, fuel, and manufacturing materials and equipment, and unable to house those returning from the front and former colonies, let alone the hundreds of thousands of residents who had lost their homes in Allied fire-bombings. The Allied Occupation administration (1945–52) under the leadership of U.S. General Dwight D. Eisenhower pursued political, economic, and social reconstruction including the promulgation of a new constitution, reestablishment of diplomatic and trade ties, educational reorganization, agricultural land reform, and the dissolution of Japan's powerful industrial combines (*zaibatsu*), but daily life remained difficult for most Japanese until the mid-1950s.

For designers, reconstruction brought opportunities for those who received government contracts but little for those dependent on consumer markets. In 1946, Occupation authorities commissioned the IARI to coordinate the furnishing of "Dependent Houses" for married officers with families. Designers produced plans for standardized wooden furniture, which were distributed to participating manufacturers nationwide and published for others to emulate. The

Fig. 19.22. Ekuan Kenji for GK Design Group. Soy-sauce dispenser, Kikkoman Corporation, Japan, 1961. Glass, polystyrene plastic; 5¼ x 2½ x 2½ in. (13.3 x 6.4 x 6.4 cm). The Museum of Modern Art, New York (145.2005.2).

project taught these manufacturers how to work with large volumes and maintain consistent standards of quality. It familiarized them with the tools and techniques necessary to create Western-style furniture and provided much-needed revenue. Appliance manufacturers such as Toshiba were contracted to supply domestic electric appliances and given access to steel and other key materials as well as capital to rebuild assembly lines.

A combination of postwar deprivation, social reforms, and the high profile given to the U.S.–based middle-class lifestyle, visible in magazines and Hollywood movies and promoted by the Occupation as a strategy for encouraging Japan to adopt American-style democracy, led to changes in fashion. Private dressmaking schools, which offered war widows and other women the opportunity to gain skills and make a living, appeared nationwide in the late 1940s, while popular magazines featured women in Western-style dress. While dress fashions changed, many women continued to sew their family's clothes or to engage neighborhood seamstresses, and fashion content in magazines continued to include sewing instructions and patterns rather than retail sources. Home-sewing helped women use a range of available materials, including traditional-weave cottons, for Western-style dresses. While many patterns required women to use Western sewing methods, some dresses were cut in more traditional shapes, facilitating the sewing process for women accustomed to producing kimonos. A ready-to-wear industry began to emerge in Tokyo—leading French couturier Christian Dior made a high-profile visit to Japan to judge a fashion show in 1955—but ready-to-wear brands did not substantially take off until the 1960s.

The professionalization of product and furniture design, including the social recognition of design as a distinct profession, was a feature of the 1950s. Well-publicized visits by famous foreign designers, like Raymond Loewy in 1951, boosted recognition of freelance design as a viable occupation. New professional associations like the Japan Industrial Design Association (JIDA, 1952) further promoted a public image of design and strengthened a collective professionalism. New design courses taught by men with close connections to the IARI, such as those established at Chiba University in 1951 and the Tokyo National University of Fine Arts in 1949, created the first generation of specialist "industrial" designers, sparked discourse about the role of design, and provided designers for new design divisions at manufacturers like Matsushita (Panasonic) and Sony.

Some furniture manufacturers established their own design departments in the early 1960s, but most continued to rely on commissioning from outside the company when necessary. Senior designers like Kenmochi left the IARI to work independently, and younger ones established consultancies like GK Design (1952). These changes created a new culture of consultants and led to the development of a range of popular products such as Kenmochi's Yakult drink bottle and the 1961 tabletop bottle by Ekuan Kenji (b. 1929) for Kikkoman soy sauce, created as part of his work at GK Design (fig. 19.22).

Practitioners debated what to call the discipline of designing things. Some preferred *kōgei* (literally "industry-art"), but

Fig. 19.23. Tanabe Reiko. *Murai Stool,* Tendo Co., Ltd., Japan, designed 1961. Plywood, teak veneer; 14¼ x 17 x 17 in. (36.2 x 43.2 x 43.2 cm). The Museum of Modern Art, New York (2237.1967).

this was also the word for traditional crafts. Many younger designers campaigned for *sangyō dezain*, a more contemporary translation of "industrial design" at a time when designers were arguing for their importance to the manufacturing process. The Mainichi newspaper went one step further in design promotion, establishing the Mainichi Design Award in 1952 for new products.

Graphic design and illustration became much more widely known in the 1950s. Designers such as Kamekura, Yamana, and Kōno founded the Japan Advertising Artists Club (JAAC, 1951) and were prominent in the emerging design press, contributing cover art, recent work, and commentaries to the influential bilingual monthly *IDEA: International Graphic Art* (1953), successor to *Advertising World*. Prominent participation in the international graphic design community was seen as key to promoting commercial art, increasingly called "graphic design" (*gurafikku design*) or "advertising art" (*senden bijutsu*). *IDEA* introduced Japanese designers to a substantial foreign readership, and regular coverage of foreign work ensured that Japanese designers had access to the latest international trends (if not always the

technology to produce them). Exhibitions like *Graphic 55*, a joint exhibition of work by Japanese and foreign designers held in Tokyo in 1955, promoted the idea of the designer as a creative artist, but critics argued that graphic design's rootedness in daily life and commerce should be embraced.

The rebuilding of Japanese cities continued into the 1960s. The ongoing need for new homes, and government interest in creating civic spaces such as concert halls and gymnasiums, meant that the furniture industry further expanded. Municipal and prefectural governments became major clients for furniture manufacturers, and from the late 1950s, large corporations and resort hotels required modern interiors and furnishings. Tendo Mokko (1940), a company founded by carpenters in northern Japan during the war to build munitions boxes, developed striking, technically innovative furnishings in a postwar modernist mode, such as Tanabe (née Murai) Reiko's (b. 1934) *Murai Stool* (fig. 19.23), which she designed to be used as a stool or side table in the manner of the *Walnut Stool* (1960) by Ray and Charles Eames for Herman Miller. It won the company's inaugural design competition in 1961, and its interlocking panels demonstrated

the technical skills within the company. The geometric form conformed to a modernist minimalist aesthetic while the rich wood grain added warmth.

For the most part, furniture manufacturers looked to domestic corporate clients. A few wealthy individual clients commissioned pieces for new homes, and department stores were reestablishing their furniture departments, but families in rural areas who had escaped the wartime bombings continued to use existing furnishings, and households in urban areas bought from local carpenters. Most new households acquired their furniture at marriage, when pieces like a chest for kimonos were part of a bride's dowry and purchased at the local department store or furniture retailer. Postwar product and appliance manufacturers like Matsushita, by contrast, focused on export markets in Asia, the Middle East, and South America in the late 1940s, and on the domestic market after 1952, but always with an eye to the lucrative U.S. market.

In 1951, the newly created Japan External Trade Research Organization (JETRO), a government agency, began promoting Japanese exports, leasing space at international trade fairs from 1955. While some products, most famously Sony's TR-610 transistor radio (1958), proved immediate hits, domestic and overseas reception was not always positive. Some Japanese designers criticized JETRO's exhibits as exotic kitsch or "Japonica," while European and U.S. manufacturers complained regularly about trademark and patent infringement. Many foreign consumers viewed "Made in Japan" as representing poor quality. To stem this negative tide, in 1957, the Ministry of Communications, Commerce, and Industry created a quality control system, the G-Mark System, to certify quality and design originality. As in the United States and parts of Europe, "Good Design" (*Guddo dezain*) became a buzzword: a traveling *Good Design* exhibition of objects from the collection of the Museum of Modern Art in New York was held at the National Museum of Modern Art in Tokyo and venues in western Japan in 1957–58, along with a well-publicized "Good Design Corner" at the Matsuya department store in Tokyo's busy Ginza shopping area.

As household incomes stabilized and then began to rise in the mid-1950s, domestic consumption also increased. The Toshiba RC-10K electric rice cooker (1958), created by Minami Yoshitada (1908–1966), owner of a small manufacturing firm subcontracted to Toshiba, was extremely popular. It made a regular domestic task easier, but at 3,500 yen—25 percent of the average starting monthly salary for a male university graduate—it remained a luxury purchase. Nonetheless, both urban and rural homes increasingly acquired electric appliances. By 1965, 90 percent of households owned a television, 69 percent a washing machine, and 51 percent an electric refrigerator. New home purchases and renovations remained expensive and beyond the means of many households, thus surplus income was frequently spent on acquiring appliances, which also helped households stay "up to date."

Postwar competition among appliance manufacturers brought work to advertising agencies and freelance graphic designers. Most designers used illustrations, solid block silk-screened color, and dramatic typography rather than photography. Although the aesthetic was bound by technical constraints, designers like Kamekura Yusaku (1915–1997) and Itō Kenji (1915–1991) were familiar with stylistic developments in Europe and the United States, including the International Typographic Style, also known as Swiss Style of the mid-1950s, which was characterized by clean sans serif type, asymmetry, and readability. They used this aesthetic to create designs on the cutting edge of international trends. Clients benefited as packaging for export products became more appealing to foreign consumers. Kamekura's poster for Nikon cameras (c. 1958) exemplifies this dependence on typography and curvilinear geometric shapes, asymmetrical composition, and block color (fig. 19.24). By 1959, however, the falling costs of photo-lithography led to greater use of color photography by graphic designers and art directors, who featured large and powerful photographs as the focal point of the composition, often redeploying text around the edges.

ECONOMIC GROWTH AND RISING DISSENT, 1960–1975

By 1960, the Japanese economic indicators had returned to, if not surpassed, prewar levels. Japan's economy averaged 10 percent annual growth between 1955 and 1972. Rumblings of social discontent, however, were evident from 1960. Tokyo saw massive street protests against the renewal of the United States–Japan Defense Treaty, which subordinated Japanese defense policy. In the same year, the city hosted the World Design Conference, an international gathering of major figures in design disciplines from graphics to architecture, including the architects Walter Gropius and Tange Kenzō (1913–2005) and graphic designers Josef Müller-Brockmann, Herbert Bayer, and Saul Bass. The conference reflected both Japan's rising economic importance internationally and Japanese designers' efforts to place themselves within international professional networks. Some conference delegates articulated a growing concern with the postwar focus on material prosperity and argued for design to engage with human, social, and political issues—debates that continued over the next thirty years.

The 1964 Olympic Games in Tokyo, the first held in Asia and the first to be simulcast worldwide on television, was a celebration of the nation's economic and political reconstruction and renewed sense of pride. The authorities had implemented massive infrastructural projects in preparation for the games: television screens showed the new Metropolitan Expressway over Tokyo, the *shinkansen* bullet train, and Japan's first expressway connecting Tokyo to tourist, industrial, and commercial destinations. Designers played an important role in creating the image of a modernized, electrified Japan that was broadcast to the world. In addition to architect Tange Kenzō's heroic Olympic arenas, Kamekura Yusaku developed easily understood pictograms indicating the different sports, as well as the official logo and poster.

As expendable income rose, ready-to-wear brands like Van, a menswear brand launched by Ishizu Kensuke (1911–2005) in 1951, gained recognition and sales. Many ready-to-wear items were made of rayon, a major Japanese industrial product, but now companies created finished garments, rather than distributing textiles and fibers for home sewing and knitting. Conglomerates like Toray and Renown used television commercials to popularize their ready-to-wear brands. Stylish advertisements for apparel included those for Mitsubishi's VONNEL rayon sweater and dress brand, which embedded the pop illustrations of graphic designer Yokoo Tadanori (b. 1936) into filmed footage of mini-skirted young women turning the heads of old women and monks. The majority of designers, however, continued to work anonymously or near-anonymously as part of company design divisions, collaborating and sometimes clashing with management and product engineers on all manner of design issues relating to a wide range of products, from cameras and radios for the export market to the "three Ks"—*karā terebi, kūrā, kuruma* (color television, air conditioner, and car)—for the domestic market.

Designers mobilized again for Osaka Expo '70, a world's fair drawing more than 64 million visitors. Like the Olym-pics, it was a chance for massive infrastructural work as well as overseas promotion. For designers, it offered support for experimentation with new technologies and brought some massive commissions, including corporate pavilions. Head design strategist Tange Kenzō and well-known architects Kikutake Kiyonori (b. 1928) and Isozaki Arata (b. 1931) designed trade pavilions, many of which had distinctive aesthetics that highlighted new technologies, materials, and emerging new-media art. These buildings and interiors, such as Pepsi Cola's installation by the New York–based media art group E.A.T. (Experiments in Art and Technology), visually expressed the arrival of the "Space Age" through curvilinear forms, geodesic structures, and immersive sound and light environments. Sculptor Okamoto Tarō's (1911–1996) organically formed Tower of the Sun looked out over the exposition site, and two giant robots patrolled the massive Festival Plaza.

The central role of designers in creating Expo '70's interactive environment attests to the degree of recognition they had gained. But some designers criticized colleagues associated with the Expo for their apparent unbridled support for state and corporate capitalism, which, some felt, harked back to prewar nationalism and endangered the democratic agenda of postwar civil society. This criticism, along with claims that particular professional organizations no longer represented the industry, polarized the design communities, particularly graphic designers, and led to the dissolution of the JAAC in 1971. Similarly, domestic unease surrounding Japan's continued military alignment with the United States, which increased throughout the 1960s, led many designers, particularly younger ones, to question both state authority and the industrial power structures. Some joined forces with visual and performing artists to produce avant-garde and/or "oppositional" work.

Many of these design changes were associated with the growth of a Japanese "counterculture" movement. By the mid-1960s, prominent designers such as Yokoo Tadanori and Awazu Kiyoshi (1929–2009), who had hitherto relied on corporate clients, were working increasingly in book design, illustration, publicity, and art direction for counterculture presses, street theater groups, and independent cinema. Director Kara Jūrō (b. 1940)'s Red Tent Theatre, a Tokyo street theater troupe whose politically charged productions lambasted consumerism and Japanese support for U.S. activities in Vietnam, commissioned psychedelically colored posters that combined traditional floral motifs, patterns, images from wood-block prints and European paintings and engravings, and grainy photographs (fig. 19.25).

The overall rise in household income, a shift from three- to two-generation households, and the introduction of relatively inexpensive prefabricated housing led to a spurt in new home construction in the early 1970s and wider markets for home furnishings. The furniture industry expanded in terms of the general consumer market, as Western-style beds, tables, and chairs began to replace futons for sleeping and low *chabudai* tables for dining in the majority of homes. For many commentators, the ability to purchase and furnish one's own house (*maihōmu*) provided proof of Japan's postwar recovery. But domestic consumption was dented by the

Fig. 19.25. Yokoo Tadanori. *The Rose-Colored Dance, À la Maison de M. Civeçawa,* poster for Tatsumi Hijikata's dance company, Japan, 1966. Silkscreen; 41 x 29 in. (103.8 x 72.8 cm). The Museum of Modern Art, New York (318.1966).

"Oil Shock" of 1973, and remained relatively low for the remainder of the decade. For exports, however, particularly automotive, the oil crisis provided an opportunity to crack the lucrative U.S. market. The lightweight, small engines of Honda, Toyota, and Datsun (now Nissan) cars and trucks, unpopular in the United States in the 1960s and early 1970s, became desirable for their fuel efficiency. Honda and Kawasaki motorcycles also gained in popularity.

FROM BUBBLE TO BURST, 1980–1991

Hyperaffluence from stock market speculation and inflated land prices allowed many Japanese consumers to enjoy high living standards until the "Bubble Economy" burst in 1991. Not only did Japanese auto exports thrive in the 1980s, but domestic car sales in Japan also flourished: the sports car, as epitomized by the Mazda RX-7 or Nissan Fairlady-Z, became an important status symbol for twenty-something male con-

sumers. Competition for such consumers drove rapid product differentiation, often based on market research conducted by a company's own research department or market research team, such as those at publicity giants Dentsu and Hakuhodo, which analyzed and charted trends. New product lines included the Robo series of home electronics from Sanyo (1988); the blocks of color and boxy, almost cartoon-like shape proved popular with adults as well as the initial target market of children. The Seibu Corporation's "no brand" brand Mujirushi Ryohin ("No Brand Good Quality") was launched in 1980 with "anonymous" contributions from key designers like graphic designer Tanaka Ikkō (1930–2002) and fashion designer Koike Kazuko (b. 1936). These items gained popularity, particularly with young urban residents, showing that, among other things, many consumers sought simple products that guaranteed straightforward good quality.

Fashion was another major vehicle and beneficiary of the explosion of high-profile conspicuous consumption. New domestic brands hired graduates from fashion schools such as the now-famous Bunka Gakuen. They sold their clothes at separate boutiques within department stores like Tokyo's Isetan or in dedicated "fashion buildings" like Parco, run by Seibu and opened in Tokyo's Shibuya area in 1974. Amid the large corporate brands that dominated the domestic fashion market, some designers struck out on their own. Together, their brands were known as "DC brands" (standing for designers / characters). Some Tokyo designers established outlets or ateliers in Paris, following the footsteps of Bunka Gakuen–trained Takada Kenzō (b. 1939), whose Jungle Jap shop opened there in 1970. The 1981 collections of Kawakubo Rei/Comme des Garçons (b. 1942) and Yamamoto Yohji (b. 1943) shocked, fascinated, and compelled fashion editors, buyers, and consumers, as did the designs of Issey Miyake (b. 1938; fig. 19.26). The stark, monochrome, and sculpturally asymmetrical aesthetic seemed visually radical next to the sharply pronounced, brightly colored French fashions of the early 1980s created by designers like Thierry Mugler.

For corporations like Seibu, real estate was a serious economic strategy: complexes like the Parco fashion building caught the baby-boom market and supported the redevelopment of urban neighborhoods like Shibuya in Tokyo into playgrounds for youthful conspicuous consumption with cafes, discos, and a vibrant street culture—as well as rocketing land prices. Youth subcultures like the *takenoko-zoku* ("bamboo shoot tribe") and rockabillies, styled after U.S. country-western culture, gathered in urban parks to dance and socialize. They became an alternative to more commercial celebrations of Japanese economic prosperity and the power of the baby-boom generation, as did the development of independent boutiques, second-hand shops, and music venues, many devoted to punk music and clothing.

For architects and interior and furniture designers, the transformation of large parts of cities into commodified, highly designed spaces for leisure and consumption meant new clients, larger budgets, and opportunities for experimentation. Interior designers like Sugimoto Takashi (b. 1945) competed with foreign "star" designers and architects for commissions: British architect Nigel Coates decorated Café

Bongo (1986), which anchored the Parco building, with a wild assortment of objects including a full-sized airplane wing, and French designer Philippe Starck notoriously crowned the Asahi Hall, a black glass cube next to part of the Asahi Group's headquarters in eastern Tokyo, with an amorphous gold blob (1990). Japanese designers like Kuramata Shirō (1934–1991) and Kita Toshiyuki (b. 1942) worked overseas, with Kita contributing pieces to the Memphis Group in Italy (see fig. 23.100). Both Kuramata's inventive work with

Fig. 19.26. Issey Miyake. *Kamiko,* Miyake Design Studio, Tokyo, 1982. Produced in Shiroishi City, Miyagi Prefecture. *Washi* (Japanese mulberry paper), nylon, leather.

materials, epitomized by his *Miss Blanche* chair (1988), which "froze" red roses into clear acrylic, and Kita's tongue-in-cheek reinterpretations of stereotypical Japanese objects like sumo wrestling rings and robots into Memphis's bright, blocky house style, gained them name recognition as members of an international design elite.

Like their counterparts in fashion, product, and furniture design, graphic designers and illustrators maintained an overseas profile through exhibitions and publications, while retaining their domestic focus and adding fashion buildings and domestic brands to client lists. Graphic design as a profession proved more women-friendly than product design, and women were among those who developed careers through work for customers like Parco. Illustrator Yamaguchi Harumi (b. 1941), who joined Parco's marketing department when the company was established in 1969, and graphic and fashion designer Ishioka Eiko (1939–2012), who also created movie sets and costumes, provided eye-catching posters for Parco's seasonal campaigns. Yamaguchi's air-brushed images of seductive, scantily clad Western women drew heavily on U.S. "pin-up" art but with more overt sexuality.

Mass-readership design journalism helped boost bubble-era consumption. Editors at Magazine House launched the fashion magazine *An-an* (1970) as the women's version of the company's popular men's magazine *Heibon Punch* (1964–88), promoting new brands and boutique shopping especially to young women who, unmarried and living at home, theoretically had money to spend. The magazine reached beyond the readership served by the fashion industry magazine *Sōen* (literally, "garden of sewing") since 1938. Lifestyle magazines like *Studio Voice* (1976–2009) offered an enticingly edgy mix of foreign and domestic design, art, and urban culture, while *Mono* (1982, literally "things" or "commodities") was a field guide to the season's hottest products and fashion items for young men desiring instant cool through consumption. As marketing and publicity surrounding the conspicuous consumption of designed, mass-produced goods created a public awareness of design or "designed-ness" as a commodity, a new popular genre of design criticism appeared, epitomized by magazines like *Designers' Workshop* and writing by critics like Kashiwagi Hiroshi (b. 1946). Advertising and design criticism drew greatly on semiotic theory and the Marxist commodity critique of conspicuous consumption by philosophers such as Asada Akira (b. 1957), creating a heady intellectual framework for reflecting on everyday life.

AFTER THE BUBBLE, 1991–2010

Land and stock prices crashed in 1991, leading to layoffs, diminished consumer confidence, and reduced work for designers and manufacturers. The situation was soon compounded by natural disasters, including the Kobe earthquake (1995), as well as competition from offshore manufacturing in China, Korea, and Southeast Asia. Somewhat paradoxically, the downturn in consumption led to a mini "design boom" as shops like Idée, in Tokyo's Aoyama furniture district, catered to shoppers who still had money and, having experienced the heady bubble years, wanted fewer but better designed things made from good quality materials. Designers like Jun Takahashi (b. 1969) of Undercover in fashion and Fukasawa Naoto (b. 1956) in product design became cult figures for aspiring urban sophisticates, while graphic design and packaging saw a generational shift to new stars like Kenya Hara (b. 1958) and Taku Sato (b. 1955). Japanese popular visual culture became known abroad for the brightly colored, compelling graphics of *anime* and *manga* publications, and contemporary art for the brashly disturbing pop of Murakami Takashi (b. 1962). At home, some commentators wondered whether the seeming aesthetic shift toward transparency, clarity, and lightness, seen for example in the work of Yoshioka Tokujin (b. 1967), might not be a response, somehow, to the question of how to design after a major economic crisis (fig. 19.27).

By the 2000s, many Japanese designers worked as part of regional and global networks—sending CAD (computer-assisted design) files for a chair contract for a Japanese manufacturer to a factory in China, for example, or working primarily with manufacturers in Italy. But others were looking again to local resources, to collaborations with specialist crafts, and to the rebranding and upcycling of older, well-made, well-designed Japanese products. Mori Toyoshi (b. 1969), a designer based in the traditional luxury crafts center of Kanazawa, chose to work with local metals, lacquerware, and gold leaf artists to create products like the Leaf Mirror (2004), which provided a market for craftwork by "updating" product types for contemporary life. D&Department Project, founded by Nagaoka Kenmei (b. 1965) in Osaka, runs a variety of upcycling and reuse projects, including Used G (2003), which resells castoff furniture and electrical goods awarded the G-Mark designation, and "d design travel," a national design travel campaign (2009).

Designers and manufacturers of all sizes began responding directly to changing social and economic conditions—local, regional, and global. The combined market imperative and sense of social responsibility to design for an aging population, for example, increasingly shaped the design brief at product and appliance companies, resulting in innovations like Matsushita/Panasonic's NA-V80 ergonomic washer-dryer (2008), whose diagonally angled door meant that users no longer had to bend over—especially important for older people. The washer-dryer proved a success in China, point-

ing to that nation's increasing importance as a market as well as a site for Japanese investment. Environmental concerns intensified, particularly in vehicle design, where the Toyota Prius (1997) became the world's first mass-market hybrid electric-gas passenger car. By 2000, Toyota had sold nineteen thousand Prius cars worldwide; by 2010 two million.

During the twentieth century, design, manufacturing, and consumption in Japan became a hybrid mix of local and transnational standards, practices, and preferences. At the beginning of the century, most design and manufacturing were for local or regional distribution, but Japan was already part of global networks, as imperial expansion and the con-

cern to increase exports indicate. Conversely, today's manufacturing base in local crafts has been largely replaced by mechanization, and hand-drawing by digital design, but it might be argued that robotics and software themselves constitute regional craft industries; they certainly require skills and creativity. And for every Miyake or Kawakubo, there remain hundreds of "anonymous" designers in corporate design divisions or small consultancies whose decisions shape the furnishings and spaces of everyday life—in Japan and elsewhere. Commonalities exist with other nations that have undergone extremely rapid industrialization, urbanization, and increasing dependence on foreign trade; seen in this light, Japan is not an exception but rather an exemplar.

SARAH TEASLEY

Fig. 19.27. Yoshioka Tokujin. *Honey-Pop Armchair*, Tokyo, 2000. Paper; folded, 31¼ x 36½ x ¾ in. (79.4 x 92.7 x 1.9 cm). The Museum of Modern Art, New York (262.2002.1-2).

INDIA

Fig. 20.4

Western influences on the decorative arts and design of India continued throughout the twentieth century. Until 1947, when British rule came to an end, the British, along with the Indian princely aristocracy, administrative elite, and wealthier merchants, set the fashions. They imported many goods but also bought a wide range of items designed and made in India, including luxury items. Native design traditions, especially those related to village and regional dress, continued to flourish during the first half of the century, especially in areas farthest from large urban centers. One of the champions of "traditional" Indian handcraft production was Mohandas Karamchand Gandhi (1869–1948, called the Mahatma), leader of the nationalist movement. For him and his many followers, traditional crafts came to symbolize the nation and national resistance to foreign rule.

After independence and Gandhi's assassination in 1948, successive governments, encouraged by the intelligentsia, attempted to bolster traditional crafts while simultaneously introducing modernizing programs of industrialization and urbanization. Support for crafts helped not only to alleviate poverty, especially in rural areas, but also to ensure the continuation of an important aspect of national identity. Handcraft production was nevertheless considered old-fashioned by urban and rural Indians alike, especially in relation to clothing and household goods of everyday life. As in many other places, however, there was a revalidation of handcrafts and of decorative traditions in the last quarter of the century. This resulted in a greater incorporation of traditional design, forms, motifs, materials, and techniques into contemporary manufactured goods, from simple earthenware jars affordable to a large section of the population, to high-end fashion available only to the older elite and the newly rich of the post-1991 economic boom. Grounded in information technology and the automobile industry, that boom has turned India into a primary player in a global marketplace where design is regarded as a key aspect of commercial production.

LATE COLONIAL RULE

British power in India had reached its zenith by the beginning of the twentieth century. The country was divided into territories under direct British rule, and local princely rulers served under tight British supervision. Rapid industrialization, continuously expanding railway and transport infrastructures, and a well-functioning central administration brought social, economic, and cultural change. Although the most senior administrative posts were reserved for the British, the day-to-day running of the country largely relied on

British-trained local elites with Westernized lifestyles. For the vast majority of Indians, however, life went on much as before, mainly untouched by modernization and with little contact with their foreign rulers.

The *durbar* (coronation celebration) of 1903 proclaimed Britain's King Edward VII to be emperor of India. As part of the festivities, the viceroy of India, George, Lord Curzon (in office 1899–1905), ordered there to be an exhibition of Indian arts and crafts, the largest yet known. Although an unabashed imperialist, Curzon had a profound respect for Indian handcrafts, greatly encouraging them and castigating Indian princes for preferring European goods. Influenced by the Society for the Protection of Ancient Buildings (SPAB, founded in Britain by William Morris and Philip Webb in 1877), Curzon promoted the work of the Archaeological Survey of India, an organization that sought to preserve and restore many of the country's greatest monuments.

Delegated by the British authorities to organize the exhibition, George Watt (1851–1930), a British educator then in charge of the Calcutta Industrial Museum, included historical objects and contemporary goods that were for sale across India. A pavilion in the so-called Indo-Saracenic style, the *Ajaipghar*, or House of Wonders—the interior of which was decorated by students from the British-run schools of art and design—became a prototype in both India and Britain for museum displays of Indian art and objects. Organized according to materials and illustrated with photographs of arrangements of objects and room settings from different regions, the catalogue that accompanied the exhibition offered a broad survey of decorative arts and crafts produced in India at that time. The largest group was textiles, followed by metalwares, wood, stone, and ivory carving, and ceramics. Many were products of the art and design schools. Although some visitors complained about a decline in quality, the techniques, categories, designs, and object types were little changed from those published in George Birdwood's survey, *The Industrial Arts of India* (1880).

Ernest Binfield Havell, another influential British champion of Indian visual and material culture, joined Watt and others of similar outlook in their desire to purge Indian decorative arts of what they considered corrupting European influences. They revered "authenticity" and considered classical sculpture such as that from the Gupta period (fourth to sixth centuries AD) and Buddhist murals in the Ajanta caves (second century BC to seventh century AD) to be among the highest artistic achievements of Indian culture. In this they differed fundamentally from British art critic John Ruskin and others who admired the motifs of Indian design but dismissed the idea that Indian art, including the decorative

Fig. 20.1. Sivappa
Gudigar. Casket,
Mysore, Karnataka,
early 20th century.
Sandalwood; 14⅜ x
20¼ x 15⅜ in. (36.5 x
51.5 x 39 cm). Victoria
and Albert Museum,
London (IS.146:1 to
11-1999).

arts, could bear comparison with arts of the Greco-Roman tradition.

In 1908, the extensive restoration work of major Mughal monuments (including the Taj Mahal) undertaken by the Archaeological Survey was completed. The skilled craftsmen who worked on the project carried over what they learned into commercial projects, as had been done by craftsmen in similar situations in Iran, Egypt, and Morocco. Many did this so successfully that, in some instances, the objects produced were mistakenly believed to be originals from earlier centuries and were sold to collectors, eventually finding their way into exhibitions.

Although not recorded as having been in the 1903 exhibition, the objects shown here represent the types of work exhibited. They serve to introduce Indian decorative arts of that period. A sandalwood casket made in the Mysore region illustrates the technical virtuosity then so greatly admired (fig. 20.1). Decorated with scenes from the Ramayana and Mahabharata—the two greatest Sanskrit epics of ancient India, which include much philosophical and devotional material such as the four "goals of life"—the casket is engraved with the name of the carver, Sivappa Gudigar. He belonged to the hereditary Gudigar community of carvers and worked in a traditional manner. A folding rosewood screen with sixteen lacquered panels also indicates the continuation of well-established traditions (fig. 20.2), while the silver *aftaba* (ewer) stamped by the maker "A. Bhida Jeeram, Bombay," shows the continued mixing of sources (fig. 20.3). The overall shape of this finely executed ewer recalls north Indian examples of the early Mughal period (sixteenth and seventeenth centuries). The naturalistic handle depicting a snake wrapped around a twig of wood, however, was derived from late nineteenth-century European silver and pottery. The deities in

the cartouches on the body resemble contemporary south Indian "Swami" work, while the traditional dragon spout was given European features, and the engraved design on the base of the spout drew on those found on British Victorian silver.

In 1911, at a tented encampment of the princely rulers near the Red Fort in Delhi, Britain's King George V and Queen

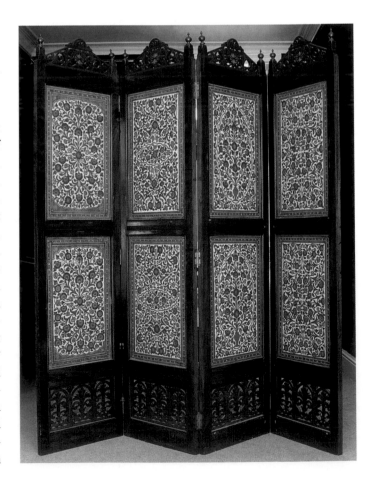

Fig. 20.2. Screen,
Baganapalle, Andhra
Pradesh, early 20th
century. Rosewood,
lacquered gesso; 75¼ x
74 in. (191 x 188 cm).
Indar Pasricha Fine
Arts, London.

Mary were crowned emperor and empress of India. The setting, which recalled the great encampments of the Mughal emperors, provided an appropriate backdrop for the new emperor to announce that the historic Mughal capital, Delhi, would replace Calcutta as Britain's Indian capital. In an attempt to outdo the imperial splendor of their Mughal predecessors, the British authorities entrusted the design and plan of New Delhi to Edwin Lutyens (1869–1944), a leading British architect, and his associate Herbert Baker (1862–1946). Lutyens professed to find little of interest in traditional Indian architecture but was pressed by the authorities to produce a style that mixed East and West. Nonetheless, the designs relied heavily on the monumental classical architecture of Greece and Rome for form, using Indian references mostly in the details, decorative motifs, and interior decoration. With boulevards radiating out of roundabouts, open spaces, and monumental vistas, the New Delhi city plan relates to that by Pierre Charles L'Enfant for Washington, D.C. (1791). Lutyens paid attention to every decorative detail, designing light fixtures, woodwork, stone carving, ironwork, and furniture for the major buildings, including pieces for the house of the Viceroy of India, in which he also designed a large Mughal-style garden. Important officials were housed in British-influenced Georgian Revival–style bungalows with extensive English-style gardens. At strategic intersections, Indian princes were given land plots on which to build grand residences, often designed by Lutyens or Baker. This ambitious project was barely finished when British rule ended in 1947. It was an Arcadian dream of *rus in urbe* (country in the city), built to house the administrative and aristocratic elite. Much has disappeared, but the main buildings provide a monumental and ceremonial focus for the Republic of India.

PRINCELY PATRONAGE

Continuing their ambitious projects of previous decades, the princely rulers built palaces and developed towns according to the latest European ideas in architecture, design, and planning. At the turn of the century, Neoclassical and Indo-Saracenic styles were still fashionable (fig. 20.4), but from the mid-1920s, Art Moderne (from the 1960s more often known as Art Deco) and Modern Movement influences began to dominate. Several of the princely palaces were among the grandest architectural and design commissions of the first half of the century. Started in 1929 for the Jodhpur maharaja Umaid Singh (r. 1918–47), the Umaid Bhawan Palace in Jodhpur, Rajasthan, almost rivaled in scale and splendor the viceroy's residence in Delhi. Designed by the London architectural firm of Lanchester and Lodge, the palace was based on traditional Hindu forms and precepts with touches that marked it as "modern." The interiors of the private apartments (c. 1940) constitute one of the strongest statements of Indian Art Moderne. The furnishings were all made locally or by firms in Bombay to replace those supplied by the London-based Maple & Company, which were lost at sea when the ship carrying them was sunk in a German attack during World War II. Other examples of Art Moderne in India can still be seen,

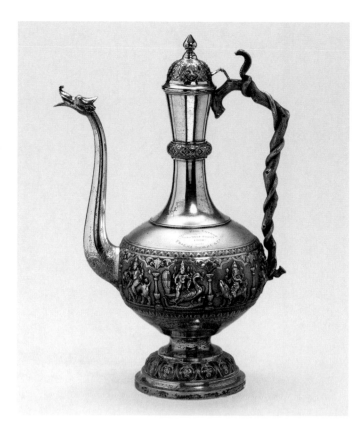

Fig. 20.3. A. Bhida Jeeram. Presentation ewer (*aftaba*), Bombay, c. 1900. Silver; H. 20½ in. (52 cm). Inscribed "Mons. Paul Entrop with best wishes from Pragjee Soorjee and Co." Private collection.

especially in Bombay, where several villas, apartment blocks, and cinemas were designed in that style.

Commissioned by Maharaja Lakhdhirji of Morvi, the much smaller New Palace (1931–44) arose from the arid landscape of the Kathiawar area of Gujarat. An Indian architect, Ram Singh, about whom little is known, designed the exterior in a streamlined version of the European Modern Movement style. Inside were lavish suites of rooms in Art Moderne style, designed with an emphasis on entertainment and luxury. Sliding etched-glass doors led into Lakhdhirji's private dining room with its chromium-plated lighting devices, a panel depicting a crouching tiger in a tree by the self-exiled Polish artist Stefan Norblin, black and red lacquered dining and side tables with wrought-iron bases, and black leather chairs with red lacquered frames. The maharani's marble bathroom, a masterpiece of cross-cultural connotations, interpreted the luxurious bathing chambers in Mughal palaces through both French and Hollywood versions of Art Moderne. Some of the furnishings were designed and made in France and England, but, because of World War II, many were made in India.

Manik Bagh (commissioned 1930), another palace built in a European Modern Movement style for the Maharaja Yeswant Rao Holkar (r. 1926–61) of Indore, central India, was the work of the German architect Eckart Muthesius (1904–1989). The technical installations, lighting, and serial-production furniture, by designers such as Marcel Breuer (see fig. 23.62) and the brothers Wassili and Hans Luckhardt, came from Germany. In contrast, the more luxurious furnishings came from Paris, where the prince gathered together a magnificent ensemble of pieces created by some of the most famous names in twentieth-century French design—Emile-Jacques Ruhlmann, Eileen Gray, Le Corbusier, René Herbst,

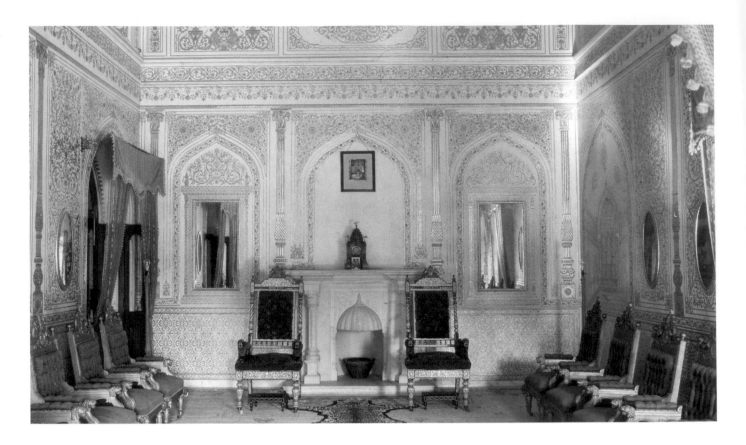

and Charlotte Perriand—as well as art by Marcel Duchamp, Man Ray, and Constantin Brancusi. Muthesius also designed a private railway car, airplane, and expanding aluminum trailer for hunting expeditions, creating, in collaboration with his connoisseur patron, a series of settings for a twentieth-century princely lifestyle.

Fig. 20.5. Cartier. Necklaces created for Maharaja Bhupinder Singh, Paris, c. 1928. Platinum, rubies, diamonds, pearls. Photographed in 1928.

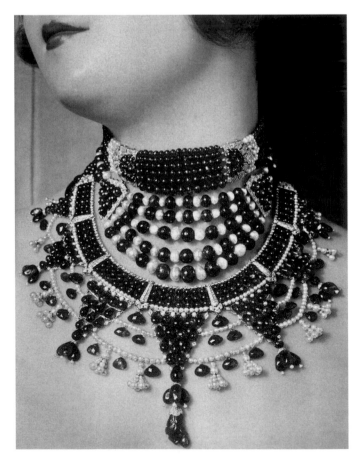

Living in these overtly modern and Westernized interiors required appropriate clothing, jewelry, and other luxury consumer goods increasingly favored by the Indian elite in the interwar years. The kinds of objects described in relation to the 1903 exhibition were put aside. Traditional garments were still worn at lavish court ceremonials, but suits tailored in the latest London styles for men and *saris* made of French chiffon for women dominated everyday wear for the very wealthy. European manufacturers of deluxe goods found many of their best clients among the Indian aristocracy. In a reversal of past practices, Europeans now rushed to create jewelry, *objets de vertú*, automobiles, and furnishings specifically for the Indian market.

Nowhere was this more marked than with jewelry. The traditional jewelry arts of *champlevé* enameling and *kundan*-set gems (see fig. 14.15) continued to thrive in India with little change in style, as did gold jewelry. At the top of the social pyramid, however, many princes deserted their court jewelers for the leading houses of London and Paris. Although using European techniques, designers at the Cartier, Boucheron, Chaumet, and Van Cleef and Arpels companies worked in close consultation with their princely clients to produce a range of items, including forehead or turban ornaments and armbands that were "Indian" in function. Clients often took their own gems and old jewelry to Paris to be reworked, usually in more modern-looking platinum mounts with claw settings. In the 1920s, the maharaja of Patiala sent the Parisian firm Boucheron six iron chests containing thousands of priceless gems that were reset into hundreds of new pieces. He also commissioned from Cartier a group of three spectacular platinum necklaces set with his rubies, diamonds, and pearls (fig. 20.5).

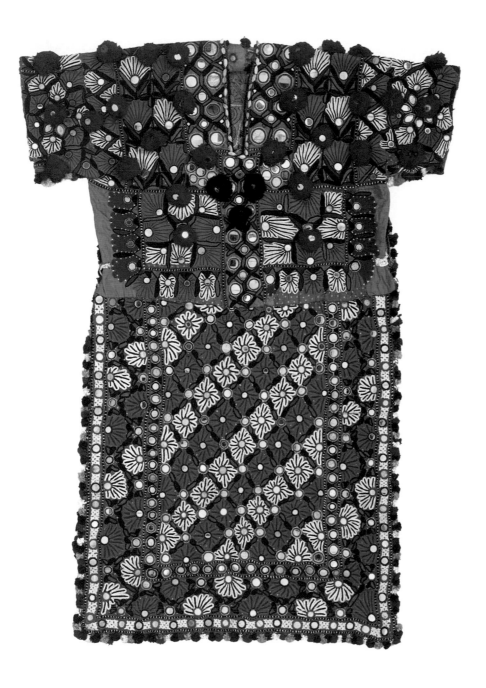

RURAL DRESS, TEXTILES, AND DOMESTIC DECORATION

The objects produced by rural settled and nomadic Hindu castes, their Muslim neighbors, and in hundreds of tribal areas throughout India are often referred to as "village and tribal arts." In 1900, they continued relatively little changed from the previous century, but by 2000, the links with past traditions were much weaker. As in previous centuries, variations were enormous, given the cultural differences among those producing and consuming them.

At the beginning of the century, textile traditions continued to thrive with only subtle shifts in patterns and designs. The area straddling what is now the border between India and Pakistan was particularly noted for embroidery. Muslim and Hindu groups shared some design traditions, including embroidery that communicated caste and status at a glance. Although most of the rural communities created items only for their own use, men from the Mochi group had long worked as professional embroiderers. In most Indian lan-

guages, the word "mochi", means cobbler, and the Mochi were the traditional cobblers of Gujarat. They are now found mainly in Ahmadabad, as well as in parts of north, central, and south India. Famous for their chain-stitching technique, they created many of the finest court and export embroideries. By contrast, Meghwar women in northwest India embroidered items for local use, such as caps and shawls given by brides to bridegrooms, and women's "traditional" dress, which included colorful embroidered silk or cotton tunic-like blouses (fig. 20.6), gathered skirts, and shawl-like head coverings (odhanis) of dark tie-dyed cotton.

Gujarati women continued to embroider clothing, elaborate coverlets, wall hangings, and door hangings (torans) into the twentieth century. Hung above the lintels of doorways, the latter consist of a frieze—of animal and religious figures or geometric patterns—above a row of pointed pendants embroidered with similar motifs. Square cloths (chaklas) were used to transport the bride's dowry items to the husband's home, where they were hung in the bridal chamber as auspicious emblems. Another popular technique for wall

Fig. 20.6. Meghwar woman's tunic (cholo), Tharparkar, Sind, early 20th century. Silk, cotton, mirrors; 34¼ x 17⅜ in. (87 x 44 cm). Collection of Nasreen Askari.

Fig. 20.7. Quilt (*ralli*), Sind, 20th century. Quilted and embroidered cotton; 86⅝ x 62¼ in. (220 x 158 cm). Victoria and Albert Museum, London (IS.1-1981).

hangings and large canopies was *katab*, or appliqué work on white or unbleached cotton with pictorial and floral ornamentation. At weddings and other ceremonies, exterior as well as interior spaces were, and still are, partitioned by such hangings, while colorful *ralli* (quilts) commonly serve as bed- or floor covers.

Another ongoing embroidery tradition is that of the Banjara, a tribe that came from Rajasthan and spread to the Deccan, working as laborers for the advancing Mughal armies. For centuries, the Banjara were widely dispersed throughout India, but, wherever they were located, women worked within the parameters of existing embroidery traditions. Rectangular, square, or long strips of rough cotton ground, with embroidered geometric patterns, were folded to make bags and *chaklas*, stitched onto blouse fronts, and also used as belts or headgear. Cowrie shells, mirror work, and small silver ornaments were used on borders or incorporated into designs.

To the north of Sind (now in Pakistan), the provinces of Baluchistan, the Punjab, and the frontier provinces with Afghanistan also have notable traditions of finely embroidered clothing and household goods. The *phulkari* embroi-

deries of the Punjab featured floss-silk threads on thick, handwoven cotton grounds dyed deep madder red, black, or indigo blue (fig. 20.7). Patterns of repeated geometric shapes, such as lozenges, triangles, and zigzags in deep yellow, ivory, red, or green, predominated. The more luxurious the piece, the more embroidery. Everyday pieces were worn as head coverings or skirts, with more elaborate pieces saved for ceremonial occasions. According to custom, at the birth of a girl, her grandmother would start a yellow and white *bagh-* (garden) pattern *phulkari* to cover the girl's head at her wedding. By contrast, the women of Bengal made quilted and embroidered coverlets (*kantha*) from recycled materials such as the white cotton fabric of old *saris* and *dhotis*, usually embroidered in muted colors. Not found anywhere else, these *kantha* were sometimes decorated with stylized floral, animal, and symbolic designs arranged asymmetrically in compartments.

The *bandhani* (tie-dyed) silk or cotton textiles associated with northwestern India were used for *saris*, skirts, turbans, and *odhanis*. Patterns were created from hundreds of little dots isolated during the tie-dyeing process, raised either by pressing the cloth down on a board on which the design had been laid out with nails, or by marking the cloth and picking out the pattern with a fingernail. As in other tie-dye techniques, the fabric is tied with thread to resist the dye. The designs often feature a central medallion in a large field surrounded by multiple borders, but so rich is the vocabulary of floral and figural motifs, from peacocks and elephants to circles of female dancers and geometrical forms, that every piece is distinctive.

PATAN PATOLA

The tradition of *ikat* (another tie-dyed resist process) fabrics continued for a time, with a wide variety of *saris*, *lunghis*, and *dhotis* woven in silk, cotton, or mixed cotton and silk throughout the subcontinent. But these *ikat* fabrics had almost fallen into disuse by the end of the twentieth century. Decoration was most often nonfigural, consisting of alternating plain and zigzag or arrowhead stripes or checked patterns. The most prized items were the luxurious silk *patola* textiles, in a demanding double-*ikat* technique from the town of Patan in Gujarat, where a few highly skilled family groups of weavers took months, even years, to produce a single piece. Although the art of weaving *patola* dates back to medieval times, when the Hindu Solanki dynasty ruled the northern Gujarat area of which Patan was the capital, few surviving examples can be dated before the late nineteenth or early twentieth century. Hindu, Jain, and Muslim communities in Gujarat had their own special designs for *saris* and scarves that were worn only on auspicious occasions, particularly weddings. In a *sari* associated with the Bohra Muslim merchant sect, the design comprises a geometric field of stylized leaves, stars, and flowers with multiple side and end borders (fig. 20.8). Pieces made by or for non-Muslims incorporated animal and human figural designs, including *patolas* featuring large elephant motifs made for export to the nobility of Indonesia for use as ceremonial hangings.

DHURRIES

Another traditional handwoven product still popular in the twenty-first century is the *dhurrie*, a cotton or wool flatwoven rug. *Dhurries* have a long history, but once again few examples survive from before the nineteenth century. Historically considered humble craft items, they were made in all sizes, sometimes of huge dimensions to cover stone or marble floors as a first layer under more precious wool carpets. Widely used in mosques are long and narrow *safs*—prayer *dhurries* with many repeating pointed-arch niches providing individual spaces for each worshipper. The most common *dhurrie* designs are overall stripes, floral or geometric motifs, and medallions (fig. 20.9). More ambitious pictorial rugs or interpretations of famous Mughal carpets were also woven, particularly at the turn of the twentieth century. The British established *dhurrie* weaving as an occupation for prisoners, with each prison known for its own patterns and techniques. Some prison production persists, but today the craft is based mainly in villages and supplies the considerable domestic and foreign demand.

JEWELRY

Popular jewelry traditions were strong for much of the century. Silver was widely used, particularly for pieces for members of the less prosperous castes unable to afford gold or

Fig. 20.8. *Patola* wedding sari, Patan, Gujarat, late 19th–early 20th century. Silk; 14½ x 3¾ ft. (4.4 x 1.1 m). Victoria and Albert Museum, London (IS.190-1960).

Fig. 20.9. *Dhurrie*, Bikaner, Rajasthan, c. 1910. Cotton; 12½ x 10¾ ft. (3.8 x 3.2 m). Private collection.

anklets were solid and massive, decorated in registers of geometric repeat patterns and bands of raised silver beads. The jewelry worn by traditional dancers is distinguished by rows of silver beads: attached to short chains, they add sound to the dancers' movements.

Amulets were worn as pendants or armbands to protect the wearer from evil. Members of the south Indian Hindu Lingayat community, for example, wore a little silver casket as a pendant containing a *Shiva linga* (literally, "auspicious sign," symbolizing Shiva, the great, all-auspicious god of the universe), whereas some Muslims wore cylindrical pendants covered with calligraphy and containing scrolls of Koranic scripture. In southern India, village jewelers produced gold ornaments of astonishing sculptural originality quite unlike the intricately worked *repoussé* and gem-set pieces made for higher-caste clients (see fig. 14.16).

PAINTED WALL DECORATION

Painted wall decoration in the home continued across the social spectra. Wallpaper or close-fitted fabric wall coverings have never been employed in India because of the humid climate and insects, but natural colors derived from local plants and minerals were widely used. Huts in Orissa, for instance, are decorated with a sticky white paste made from rice and applied on brown mud walls inside and out, typically depicting flowers, vines, harvested grain, and cornucopias, symbols of abundance and prosperity. Clay and mirror-work decorate Rabari huts of western Gujarat, whereas in the eastern areas of Gujarat, the Rathva tribe adorn their homes with murals illustrating the agricultural deity Pithoro or stories from their creation myth. In Madhubani in the Mithila area of Bihar, women painted their houses at festival times, to celebrate rites of passage, or to ward off evil. Hindu myths were brought to life in animated compositions of densely grouped and brightly colored figures. Previously little known beyond the locality, the work of these women in the 1960s was "discovered" and publicized by the All India Handicrafts Board,

precious gems. In the late nineteenth century, it was calculated that village women might wear forty-five to sixty-five pounds of "silver" ornaments as they worked in the fields, though the use of base metals significantly reduced the actual silver content. Precise dating is difficult because silver jewelry was continually melted down and refashioned in traditional styles—again, evidence of the Hindu belief that old objects might transmit the misfortunes of previous owners. Except for pieces collected and catalogued in earlier times, most extant jewelry in traditional styles is probably no more than a few decades old. By the late twentieth century, it was rapidly disappearing, as changes in village culture and traditional tastes led to its being considered old-fashioned.

The variety of village and tribal jewelry was, and remains, enormous. Necklaces often featured arrangements of embossed plaques decorated with Hindu deities or symbols strung on silver chains. These might be further ornamented with hanging droplets of silver beads and chains. Coins were frequently worked into designs, and pieces for members of the Muslim community featured geometric designs or a star and crescent—ancient pre-Islamic symbols of the cosmic powers, sun and moon, which were adopted by a number of Islamic-majority and non-Islamic groups and nations. Coiled silver rods produced rigid torque necklaces such as the one shown here (fig. 20.10), while armbands, wide cuff bracelets, and

Fig. 20.10. Torque (*varlo* or *hansuli*), Gujarat, 20th century. Silver; 7¼ x 7⅞ in. (18.4 x 20 cm). Victoria and Albert Museum, London (IS.61-1995).

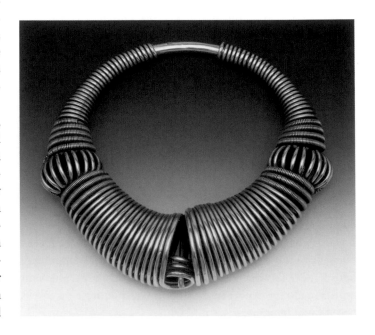

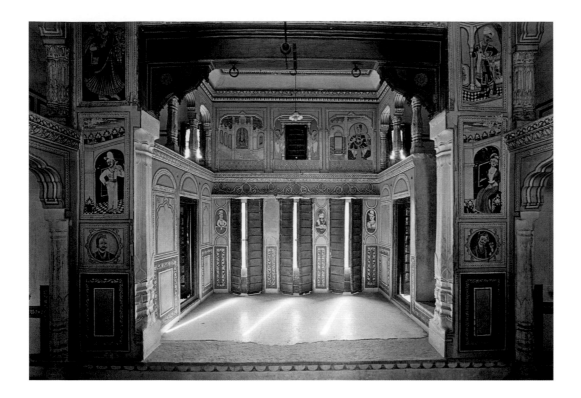

which encouraged them to paint on paper so that their efforts could be marketed commercially. This was part of a wider attempt by the Indian government to develop handcrafts on a more commercial basis.

The Shekhawati region of Rajasthan is famous for the frescoes in the richly decorated *havelis* (traditional half-timbered, stuccoed brick houses) of noblemen and wealthy business castes. Fine lime plaster was used as the ground for fresco (on wet plaster) or tempura (on dry plaster) painting. The early twentieth-century reception room in the Bhagat Haveli in the town of Nawalgarh in Rajasthan, for example, was decorated with portraits of Hindu deities, local notables, and Europeans, as well as putti-like winged attendants in Indian dress (fig. 20.11). Other rooms in the house featured Neoclassical-style decoration—niches, demilunes, and scrolling-vine borders—typical of Rajasthan.

TOWARD AN INDEPENDENT INDIA

While the British were building New Delhi as a monument to imperial rule, the movement for Indian Self-Rule and, later, independence gathered pace. Leading the struggle was Gandhi and the Congress Party, which advocated nonviolent protest as a way of opposing foreign rule. A social visionary and intellectual from a Hindu background, Gandhi advocated the abolition of caste distinctions and a return to a simple, traditional lifestyle, complete with homespun clothing and vegetarian diet. His concept of *swadeshi* (self-sufficiency) sought a path to economic freedom from British control and, ultimately, political independence, by relying on locally produced goods manufactured without harm to the workers. Gandhi's writings about the soulless nature of industrial society echo those of John Ruskin, William Morris, and Arts and Crafts disciples. More than anyone in the 1930s, a period during which politics and material culture were closely intertwined, Gandhi changed the way Indians dressed and lived their lives.

Nationalists began rejecting European goods and fashions and adopted the spinning wheel as a symbol of freedom and self-reliance. Gandhi and his followers wore either *khadi*—a slightly rough, white homespun cotton fabric that softens after washing—or another homespun cloth of cotton, silk, or wool. Throughout the country, people rallied to the call, burning British textiles as a sign of protest against British rule in general, and the British decimation of the Indian textile industry in particular. The politicization and revitalization of the *khadi* industry swiftly changed Indian dress. Women "Self-Rulers" wore plain *khadi saris*, while men who had taken up Western dress gave up suits and ties in favor of high-collared jackets (later known as "Nehru" jackets after India's first prime minister, Jawaharlal Nehru, who favored it) and *dhotis*. Based on traditional headgear worn in many parts of India, the wide-banded white *khadi topi* (cap), known as the Gandhi cap, was pointed at the front and back. Within the Congress movement, it replaced turbans and hats, both of which carried connotations of class and caste. This simple object became a symbol of national unity.

Another revered figure was the Bengali poet and artist Rabindranath Tagore (1861–1941), who, like Gandhi, respected all religions, found strength in India's traditions, and sought to harmonize Eastern and Western thought. In the last decades of the colonial experience, Tagore emphasized that Indian culture was equal to others, including the great civilizations of the past. In 1901, he founded Santiniketan, a school in the Bengali countryside that stressed the importance of art and aesthetics to everyday life, as well as the study of crafts, especially those of India, China, and Japan. Tagore felt a great affinity for Chinese and Japanese culture, to which he thought Bengal, being the easternmost region of India, was

Fig. 20.11. Reception room, Bhagat Haveli, Nawalgarh, Rajasthan, early 20th century.

closely allied. Like Gandhi, Tagore had a considerable influence on the development of crafts in twentieth-century India.

Exhausted and economically weakened by World War II, the British agreed to grant independence to India in 1947. Despite Gandhi's desire for India to remain unified, a long battle for a separate homeland for India's Muslim minority resulted in the partition of the country. Divided by the great expanse of an independent India, West Pakistan faced the Arabian Sea in the northwest, while East Pakistan was carved out of Bengal above the Bay of Bengal. The chaos, massacres, and suffering caused by partition, as well as continuing territorial disputes over Kashmir, have plagued relations between the two countries ever since. Following India and Pakistan, Ceylon gained independence in 1948, changing its name to Sri Lanka in 1972. In 1971, East Pakistan declared its own independence, becoming the state of Bangladesh.

THE NEW INDIA

In the early decades of independence, political life in India continued to be dominated by the Congress Party. Prime Minister Jawaharlal Nehru (in office 1947–64) was instrumental in founding the nonaligned group of nations, refusing to ally formally with either the Western capitalist countries or the Soviet communist bloc. Although India was nominally socialist and had close economic ties to the Soviet Union, Nehru and his government were open to ideas and business strategies for modernization from Western Europe and the United States. While India's borders were largely closed to consumer trade with the West, the resilient mercantile castes grew in power during the Nehru era, in part by financing the Congress Party and exploiting the opportunities of an internal market protected from outside competition. The princely rulers, who relinquished power in 1947, ceased to be the leading patrons of art, architecture, and the decorative arts. That role devolved to the state and the intelligentsia, business people, and professionals.

Dictated by the urgent need to provide hundreds of millions of poor people with basic consumer goods, there was an austere functionality in much of the product design in postindependence India. Automobiles and other modes of transportation provide one example. The Hindustan Motors' Ambassador car, based on the British Morris Oxford but greatly modified for Indian requirements, has been in continuous production since 1957. The manufacturers sought to make a car as inexpensive as possible and so simple that any village mechanic could repair it. Its high, rounded shape, spacious interior, simple mechanics, and rugged construction made it eminently suitable for taxis, families, and—with the addition of curtains, flag standard, and siren—VIPs and politicians. On basic models, equipment such as heaters and double windscreen wipers were eliminated. Although its longevity is partly due to decades of tariff protection from foreign imports, the Ambassador became a revered symbol of "India" and "Indianness," one rapidly disappearing with the upturn in the economy and the production in India of many new models of cars in the early twenty-first century.

The three-wheeled auto rickshaw also appeared on the roads in 1957. An indigenous design, it was based on the postwar German Tempo's Hanseat three-wheeler chassis and developed by Naralmal Kundanmal Firodia, a follower of Gandhi who wanted to help the country's push toward modernization by providing low-cost motorized transportation. With its characteristic black and yellow body, open sides, and black cloth top, the auto rickshaw, like the Ambassador, was highly adaptable. Many children could be accommodated or large quantities of goods could be hauled across otherwise inaccessible paths to remote villages. Both the Ambassador and auto rickshaw were often decorated, customized, and accessorized according to the owner's desires to express their individual taste and identity.

India's textile industry changed considerably after independence. At first, the Nehru government's policy of protectionism benefited both the traditional handloom industry and the large mills manufacturing suiting and other fabrics. Fashionable clothing remained relatively simple and often a mix of Indian and Western attire. Many men and women of the urban middle classes favored the *kameez* or *kurta* tunic tailored out of block-printed cotton and worn over slacks (and later jeans), or the traditional *salwar* or *paijama*, with sandals and a shoulder wrap of wool or silk. The use of *khadi*, with its associations with Gandhi and austerity, was widely promoted, but efforts to "modernize" it with bright, artificial dyes and admixtures of synthetic fibers were thought by some to negate the appeal of the traditional handloom product. Raw silk fabric and a rougher wool *khadi* were produced in a range of subdued tones for elegant coats and jackets, the rough, uneven quality of the materials adding to their appeal.

Besides the beauty of Indian design traditions and high levels of hand skills, labor was far cheaper in India than Western Europe and North America (here defined as the United States and Canada). In the 1960s and 1970s, Indian textiles (including clothing) and Indian culture in general were extremely popular with young Westerners, from hippies to middle-class homemakers, who wore cheap Indian cotton shirts and used Indian bedspreads as draperies and covers for sofas and tables, as well as beds. From the 1970s, Indian embroidery workshops began replacing French ones for French haute couture. In the late 1970s, for example, the designer Yves Saint Laurent used Indian fabrics and embroidery in his Paris collections.

The main activity of both the power-driven looms in India's textile mills and many of the small dressmaking and tailoring workshops was the supply of cloths and finished garments to Western fashion brands. The Delhi-based firm Fabindia was established in 1960 in the ancient central textile town of Chanderi by John Bissell (1922–1998), one of the many U.S. citizens who visited India courtesy of the Ford Foundation in 1958 to advise on centralizing handloom weaving. Bissell used his experience as a buyer for Macy's department store in New York to create home furnishings and clothing made with traditional Indian materials and techniques, such as *khadi* and cotton *ikat*. Products were appropriate for both foreign markets (mainly North America and Western Europe) and for young middle-class Indians

setting up homes. The British designer and entrepreneur Terrence Conran introduced Indian *dhurries* (many ordered through Fabindia), fabrics, and other wares to British (and later international) consumers through his Habitat stores (established 1964; and, from 1973, Conran shops) as part of a wider movement to bring affordable, everyday goods from around the world to middle-class consumers who wanted interiors filled with objects making cross-cultural references.

Graphic images—on calendars, posters, advertising billboards, and product packaging—continued to be omnipresent in postindependence India as part of a visual communications network and as decoration in homes, particularly of the poor. Today, nearly every shop or modest home has a corner with religious images, idyllic landscapes, or posters of favorite movie stars. The oleograph was an extremely popular graphic form early in the century. In the hands of an expert practitioner, this technically complicated form of chromolithography on cloth can produce near-exact reproductions of paintings. In India, it owed its success to Ravi Varma (1848–1906), an artist whose scenes from Hindu epics like the Ramayana were noted for their attractive goddesses. His chromolithography press, founded in 1894 in Bombay, reproduced images in the tens of thousands, making them widely available. Indeed, for much of the century, the oleograph of Varma's *Lakshmi, Goddess of Fortune*, was one the most popular images, hanging above the head of nearly every bazaar shopkeeper in the hope she would bring riches. It continues to be popular throughout India today.

The 1950s and 1960s saw the golden age of Indian cinema, in which set and costume designers and art directors contributed to the aesthetic of individual films, be they melodramas, patriotic epics, or musicals. The overall "look" of a film, however, was the ultimate responsibility of the film director, and the most sophisticated, artistic, and internationally acclaimed Indian director of this period, Satyajit Ray (1921–1992), a former student at Santiniketan, had worked in graphic design before entering the film industry. He designed a range of advertising, typefaces, and book covers. His Signet Press covers, which include those for Nehru's *The Discovery of India* (1946) and *Khai Khai*, a collection of nonsense verse by his father, Bangali author Sukumar Ray (1887–1923), combined Modernist forms and sensibilities with those of Indian folk and classical art, architecture, and design. As a filmmaker, he often served as his own art director as well as designing the credit titles and advertising.

MODERN SYMBOLS FOR THE NEW ORDER

The decision to commission the Swiss-born, French-based Le Corbusier (Charles-Edouard Jeanneret), then the most famous architect in the world, to create a new Punjabi capital at Chandigarh, after the old capital of Lahore was ceded to Pakistan, indicates something of the determination to create a new, *modern* India. By selecting the person who epitomized modernity in architecture and design, the Indian government

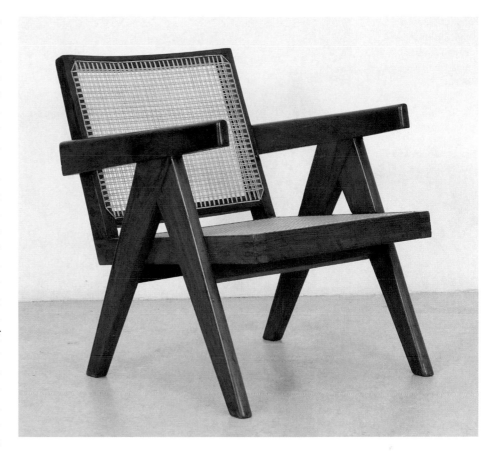

attempted to show the rest of the world just how up-to-date it was. The use of exposed reinforced concrete and brick further emphasized that message, but the forms, spaces, and functions reveal Le Corbusier's admiration for Fatehpur Sikri, the capital created in 1570 for the Mughal emperor Akbar.

Le Corbusier, his collaborator (and cousin) Pierre Jeanneret, and their team designed the office furniture for the main buildings in a clean-lined, European Modernist style. Made by local craftsmen, no object better illustrates India's break with both its imperial and aristocratic past than the wooden-framed caned armchair shown here—one of hundreds made to furnish Chandigarh (fig. 20.12). These relatively cheap and easy-to-make objects, with their mass-produced frames, blended European Modernist ideals of clean, functional design at prices affordable by ordinary people with Gandhi's ideals of simply crafted, low-cost products made by local craftsmen with natural, local materials. Le Corbusier also worked on private commissions in the former Gujarat capital of Ahmadabad, including a cast-concrete and brick house (1951–55) for Mrs. Manorama Sarabhai, a member of the wealthy Sarabhai textile-manufacturing family. The Sarabhais promoted design in postindependence India, encouraged traditional handcrafts, not least by helping establish the Calico Museum of Textiles in Ahmadabad in 1949, campaigned for a national school of design, and commissioned individual designers and craftsmen.

The Modernist Sarabhai house helped popularize open-plan houses with large windows in India as well as a new type of interior decoration, which brought together contemporary Western furnishings and art, objects from earlier periods, and a variety of native handcrafts. In the house, fabrics such

Fig. 20.12. Pierre Jeanneret. *Easy armchair*, Chandigarh, Punjab, 1952–56. Teak, cane; 27⅛ x 20½ x 28⅜ in. (69 x 52 x 72 cm). Galerie Patrick Seguin, Paris.

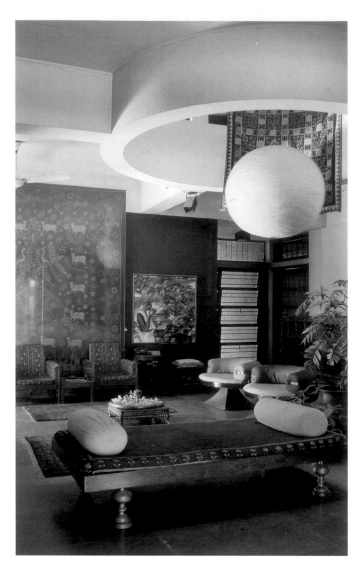

direct link with Mughal and Bengali Islamic architecture;
others note classical influences and cite Kahn's background
in Beaux-Arts design, the Baths of Caracalla, and the Pan-
theon. Kahn, who had traveled extensively in the subconti-
nent and was knowledgeable about local traditions, informed
his Modernist preferences with references to both classicism
and local design traditions.

These two "big names" of twentieth-century Modernism
aside, most Indian buildings and objects in the Modernist
mode were designed by Indians. Some had trained abroad. Of
Le Corbusier's principal assistants at Chandigarh, three—
Balkrishna Vithaldas Doshi (b. 1927), Charles Correa (b. 1930),
and Raj Rewal (b. 1934)—designed extensive social housing
schemes as well as major public institutions. For the British
Council building in New Delhi (1987–93), Correa referenced
both "India" and "British India": a series of interlinking gar-
den and courtyard spaces represented the Hindu axis of the
world, an Islamic garden of paradise, and European values of
science and progress. The main entrance, which recalls the
open *iwans* of Islamic architectural tradition, is dominated by
a black-and-white marble facade in a tree design symbolic of
India by the British artist Howard Hodgkin (b. 1932).

More recently, for the Parliament Library in New Delhi
(2003), Rewal looked to India's Mughal and Hindu design
traditions (fig. 20.14). The main entrance features the rich
ornamental decorative traditions, notably sandstone cladding,
marble flooring, stone *jali* (pierced) work, and geometric
domes. The elegantly detailed courtyards, pools, and formal
gardens harmonize with the vaulted interior spaces. The roof
is planted with grass, providing another garden space in fine
weather and insulation in the scorching heat, while allowing
the visitor to contemplate the multiple domes and courtyards
of the library and New Delhi beyond.

Keen to modernize India at the height of the Cold War,
the Nehru government welcomed individuals and teams of
designers and specialists from the United States, many funded
by the Ford Foundation, in the hope of fostering goodwill and
minimizing Soviet influence in India. Such "experts" advised
on how to make various aspects of Indian design and manu-
facture more marketable in the West. In 1956, for example, in
collaboration with the Indian Ministry of Commerce, the
foundation selected a team to report on handwoven textiles
suitable for export to North America; members included U.S.
fashion designer Bonnie Cashin, textile entrepreneur Boris
Kroll, and Robert Hickerson, who had advised the Japanese
government about reestablishing the silk industry after World
War II. The recommendations invariably resulted in altera-
tions to design or materials, often both.

In 1958, the Nehru government, advised by Pupul Jayakar
(1915–1997), the Sarabhai family members, and others, invited
U.S. designer Charles Eames to report on design in India as
part of a wider program of modernization. Jayakar, an author-
ity on Indian craft and design traditions, was a tireless pro-
moter of them abroad, especially in the United States. Nehru,
who expected Eames to suggest ways to develop industrial
design in India, was surprised when the Eames Report (pre-
pared by Charles Eames and his wife and collaborator, Ray)
quoted the Bhagavad Gita, a sacred Hindu scripture, and rec-

as block-printed cottons from villages in the Barmer region of
Rajasthan (similar ones are still traded in the Ahmadabad
bazaar) were mixed with rosewood and wicker divans
designed by Le Corbusier and inspired by traditional Indian
charpoy beds, along with Modernist chairs and south Indian
cast-bronze low tables, vases, and candlesticks. The house of
artist Amit Ambalal, designed in the same city in the 1970s by
the French architect Bernard Kohn, continued this fashion
for interior decoration with a cross-cultural flavor (fig. 20.13).

A world-famous architect was also brought in to design
the National Assembly governmental complex in Dacca, Ban-
gladesh (started in 1962 before independence from Pakistan
but not finished until 1974). Originally the commission was
given to a Western-trained Indian architect, Muzharul Khan
(1923–2012), but he brought in Louis Kahn (1901–74), his for-
mer teacher at Yale University, and acted thereafter as Kahn's
assistant. Worked in a mixture of exposed brick, natural
materials, and concrete, the building's organic and sculptural
forms attracted many local followers. Like Le Corbusier,
Kahn received other important commissions on the subcon-
tinent, including several in Ahmadabad, of which the Indian
Institute of Management (1961) is the most impressive. Both
there and in the Dacca National Assembly Hall, the massive
forms of the internal spaces are lit with large circular or geo-
metric openings pierced in the walls. Some scholars see a

ommended a study into the values and qualities that Indians considered essential for a good life, starting at the village level. The report recognized the power of established social and cultural patterns and design traditions, and noted that they were threatened by a society in rapid flux in a period of increasing industrialization and expanding mass communications. The Eameses greatly admired Indian handcrafts, considering the simple brass *lota* (water vessel) an excellent example of a form developed over time in response to a complex variety of needs. Their report accelerated the establishment of a National Institute of Design in Ahmadabad in 1961, which has been a powerful force in shaping design in India in areas as diverse as product design, interior design, textiles, furniture, graphics, advertising, film, and animation.

In 1956, the government opened the National Handicrafts and Handloom Museum in New Delhi to showcase tribal and village arts, and around the same time created the Handicrafts and Handlooms Export Corporation to market village products, particularly textiles, metal and wooden objects, and floor coverings. In addition, state governments established handcraft emporia in every major city to market local goods. During the years of strict import controls, these were major repositories for those wishing to furnish homes. Innumerable private entrepreneurs also manufactured handcrafts, particularly throughout Rajasthan. Government agencies remain a prime factor in shaping the development of the decorative arts.

LATE TWENTIETH AND EARLY TWENTY-FIRST CENTURIES

In the 1980s, Prime Minister Rajiv Gandhi (in office 1984–89) sought to place India more squarely within the global economy as the power of the Soviet Union, its greatest trading partner, faded. During the last two decades of the century, India's growing middle class increasingly focused on Western consumer lifestyles. Indian professionals who had trained and worked in the United States, including information technology specialists, brought American cultural and business practices back to India, while changes in broadcasting regulations in the early 1990s paved the way for the viewing of television programs from the United States, including such soap-operas as *Dallas* (1978–91) and *Dynasty* (1981–89). Factors for change in the early 1990s included the deregulation of the financial service sectors. This, together with the availability of a low-wage, well-educated, English-speaking workforce, has made India a new powerhouse in computing, information technology, and related services. Thereafter the relative discretion and restraint practiced by wealthy Indians in the postindependence era gave way to more opulent displays of wealth, including ornate residential and hotel interiors in both "real life" and films. At the same time, Postmodern design embraced excess and opulence.

A sign of the changing times, luxury hotels sprang up in Delhi and Bombay, and then across India, in the late twentieth century. They accommodated tourists and became meeting places for local society and locales for lavish weddings and other events. The interiors of the public rooms often resembled the sets of Hindu films: from ornate re-creations of Rajput or Mughal palace decoration to elaborate fantasies of village India. By 2000, resort hotels near the major tourist sites, such as the Taj Mahal, had reached new levels of opulence, some vying with historical monuments as destinations in their own right, as, for example, Devi Garh (1995), near Udaipur, an audacious renovation of an eighteenth-century hilltop fort palace (fig. 20.15). Designed by the Mumbai-based self-taught architect and interior designer Rajiv Saini in collaboration with the owners, Lekha Poddar and Anupam Poddar, the main reception room features furniture by Saini Brass and mirrored lighting fixtures, specially woven Benares silk hangings, and a range of brass objects that further enhance the subtle grandeur of the space.

In the house of Rajshree Pathy, architect, designer, and founder of the India Design Forum, in Coimbatore, south India (c. 2000), tradition coexists with (post)modernity (fig. 20.16). In the verdant gardens, dyed cement stepping-stones, resembling giant water-lily pads, were set in a pond filled with lotus blossoms, providing a spiritually uplifting path to the house. Inside, visitors are greeted by depictions of the incarnations of the god Vishnu created by students from the College of Fine Arts in Kerala but in the style of those in the late sixteenth-century Mattancheri Palace in Kochi (Cochin). Handcrafts from different regions are found throughout the house, and the walls of the rooms were painted by artists from the Mithila area of Bihar using decorative techniques and patterns long associated with festivals or to guard against evil.

Fig. 20.14. Raj Rewal. Entrance hall of the Parliament Library, New Delhi, 2003.

By the latter part of the twentieth century, many Indians were no longer wearing "traditional" dress, which was increasingly regarded as old-fashioned and incompatible with modern life. Thus many of the design skills and aesthetic repertoires related to such dress waned. In rural areas today, the outward forms of traditional attire can still be seen, but the fabrics, designs, and dyes are often noticeably different. Once a common cultural heritage of all castes and communities, India's textile traditions are kept alive in the early twenty-first century mainly by museum curators, collectors, and so-called Revival-style enthusiasts, who favor contemporary goods that draw on past Indian traditions. Some see the changes as evidence of the adaptivity of traditions in the face of a vastly different India in a fast-changing world. Increasing numbers, including upper- and middle-class Indians who do not themselves wear "traditional" clothing every day, are engaged in finding ways to preserve the craft and design traditions of "preindustrial" India. During the struggle for independence and in the early postindependence era, these traditions stood for India itself.

Metalware craftsmen hammering simple, utilitarian tin, brass, and copper utensils and pots can still be heard in India's bazaars, and decorative objects closely based on examples from the nineteenth and early twentieth centuries continue to be made for both domestic and tourist consumption as well as for export. But the handmade metal crafts are far less vigorous than in earlier periods. There are some exceptions. In the Tamil Nadu temple towns of south India, skilled bronze workers continue to cast deities, oil lamps, and other devotional items as well as utilitarian wares. The metalworkers in central and eastern India, such as the Bastar

region of Madhya Pradesh, remain famous for their bronzes. Artisans still practice the "lost wax" technique, whereby a mold of clay and wax is prepared, filled with molten metal, and broken when cooled to reveal the finished form. Because they have animist as well as Hindu beliefs, they fashion bronzes to represent Hindu deities, animals, and clan ancestors or village heroes usually depicted as "spirit riders" on horses. Popular with Western collectors, these sticklike figures with elongated bodies and roughly hatched surfaces are now produced mainly for urban and foreign markets.

Partly because of the Hindu tradition of eating from metal rather than ceramic objects, the most common items used for cooking and eating in India today are factory-made objects of stainless steel. The utensils include *thali*, the large round rimmed plates, with small *katori* (bowls) for various cooked dishes. In many places, lighter plastics have replaced metal, especially for the buckets and *lotas* used for carrying water. The wealthy use the same types of tableware as others but in silver. Another common object is the *dabba* or tiffin lunchbox. Stacking round containers are enclosed and locked in place with a metal handle. Because caste dietary restrictions vary so greatly, many people want to eat only food prepared at home, and in Bombay, a complex delivery system has developed whereby an office worker's *dabba* is collected at home, relayed by runners known as *dabbawallas* via cart and train, delivered to the workplace, and collected and returned home afterward. Functioning like clockwork, the system employs thousands.

The last quarter of the century also saw great changes in Indian textiles, as designers and manufacturers sought to retain references to past traditions in modern products. The Textile Art of India Trust (founded in 1996), headed by Rahul Jain, a scholar and technical expert on silk weaving, has helped revive the art of draw-loom weaving and the reproduction of Mughal and Ottoman Turkish silks and velvets. The shawls, *saris*, and coats produced there are perhaps the most skillfully made and luxurious in present-day India.

The late twentieth century saw Indian fashion designers make an international impact while at the same time maintaining their identity and links with India. Many of the designs were in the popular Revival style. The French-born designer Brigitte Singh, who has lived in Jaipur since the 1970s, specializes in the Sanganer tradition of block printing floral motifs on cotton. Every stage of production is done in her workshop, from the carving of the wooden blocks to the hand printing of cloth and tailoring of garments. In the example shown here, a scrolling lotus-and-vine border surrounding a field of wave or tiger-stripe design is based on an eighteenth-century model used at the Jaipur court (fig. 20.17).

In 1975, Asha Sarabhai (b. 1949) founded a workshop (Raag) in Ahmadabad in an effort to help revive traditional Indian textiles and techniques such as quilting and hand pleating. Her simple, understated, designs, which adapted traditional garment types to modern tastes, attracted wealthy customers at home and abroad and were featured in exhibitions of Indian textiles in Japan and Europe. Another designer with international appeal is Peachoo Datwani. Living between Paris and New Delhi since the 1980s, she developed the design concept for the Nitya label (1976) and later founded Peachoo+Krejberg (2004) with the Danish designer Roy Krejberg. Datwani's monochromatic tunic and trouser outfits in luxury silks, cottons, and wools clearly signal their Indian origins while appealing to a wider international clientele seeking a particular type of elegant, comfortable chic. Whether based in India, abroad, or both, most Indian fashion designers draw on India's rich inheritance of fabrics and pattern,

Fig. 20.17. Brigitte Singh. Sanganer-style textile, Jaipur, Rajasthan, c. 2000. Block-printed cotton.

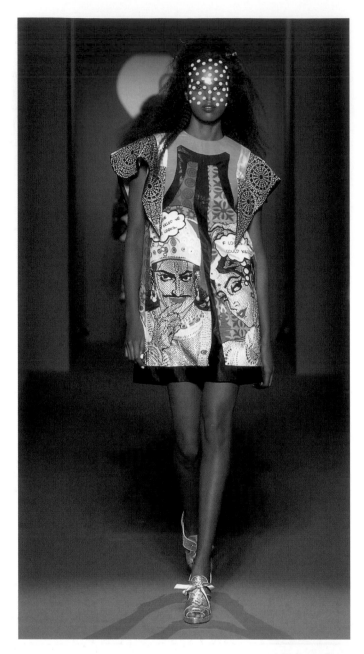

Fig. 20.18. Manish Arora. *Look 3*, Fish Fry label, Three Clothing Company, Uttar Pradesh, 2008.

Fig. 20.19. Scene from the film *Jodhaa Akbar*, India, released 2008.

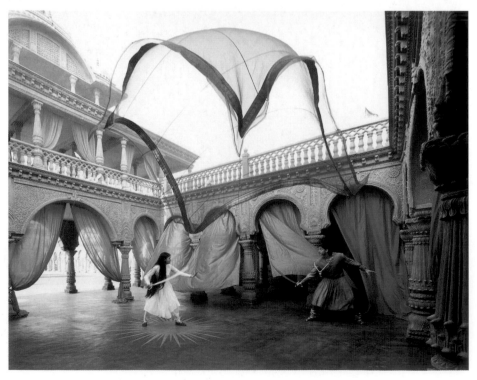

and many have their garments produced in India even if they alternate living in India and Europe.

Tarun Tahiliani, who trained at the Fashion Institute of Technology in New York and set up a business in India in 1995, is known for lavishly embroidered *saris* and garments for weddings and ceremonial occasions. From the mid-1990s onward, his extravagant and expensive creations have combined tradition with Bollywood-style glamour. In 2007, another contemporary designer, Manish Arora, became the first Indian designer to show his work at Paris Fashion Week. He draws from folk costume, Hindu religious epics, modern painting, and popular film in his designs. His witty Spring 2008 collection included fluorescent colors, three-dimensional appliqués, and Pop Art–inspired imagery of gods and goddesses in comic book discourses about love and war (fig. 20.18). Arora's appreciation of Postmodern excess and contemporary art and design is matched by a love of silk and chiffon fabrics, a talent for structuring garments, and audacious but nuanced color palettes.

India is now the world's leading producer of films and some of the most vibrant designs—including clothing, interiors, and jewelry—come from this sector. Manish Malhotra (b. 1965), a leading film costume designer, gained valuable experience working for the boutique Equinox before entering the world of Bollywood. By contrast, Ann Singh first studied art and design, specializing in textiles and cloth cutting. Neeta Lulla, who has worked on more than three hundred films, moved to design after working as an assistant choreographer in the late 1980s. The award-winning costumes she created for *Jodhaa Akbar* (2008, directed by Ashutosh Gowariker; fig. 20.19), a romance between the Mughal Emperor Akbar and his Hindu wife, were translated into a clothing line and sold through the retail chain Samsaara. The armor for the film was made by artisans in Jodhpur, and the jewelry was created by designers in the leading firm of Tanishq in collaboration with Lulla and the film's director. Like her film costumes, Lulla's bridal collection both reflects and contributes to shifting styles and notions of wedding glamour.

The changes on the Indian subcontinent between 1900 and the early twenty-first century were vast. Yet throughout those years, respect for the design and craft traditions of the past remained strong. One of the most vibrant aspects of popular material culture on the subcontinent today visually encompasses this merging of past and present, of old cultures and new: the decoration of haulage trucks. This decorative-arts practice is known in India but reaches its most creative and audacious form in Pakistan. The iconography of the painted panels includes secular, sacred, and patriotic subjects as varied as film stars, local heroes, religious shrines, ancient epics, green or mountainous landscapes, verses from the Koran, fighter pilots, and the Ghauri missile capable of carrying the country's nuclear warheads. Finely applied in many layers and glazes, the paintings are framed by dazzling arrangements of chrome, reflecting tape, plastic reflectors, and mirror work. The interiors of the cabs are upholstered in fabrics featuring patterns derived from village textile traditions.

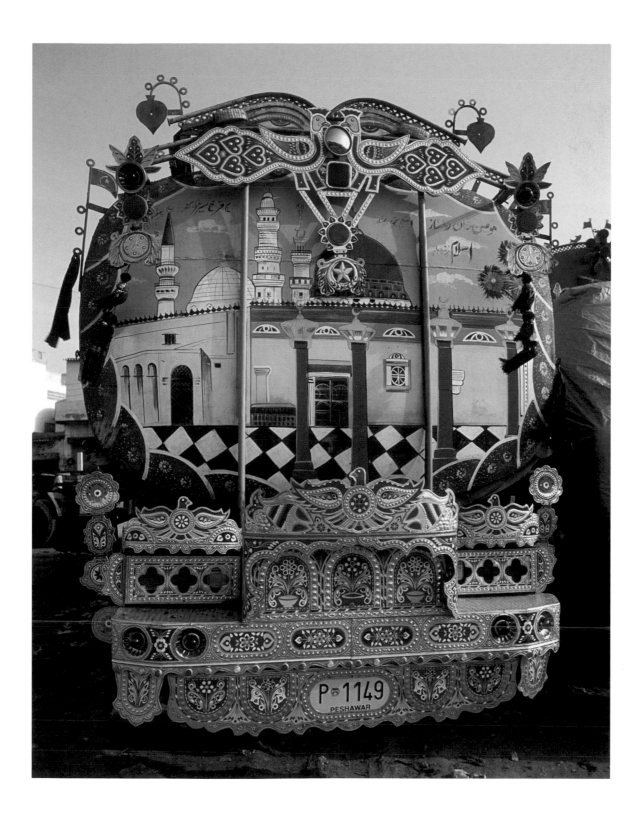

In one example, created on the back panel of a tanker truck, the metal and reflector bumper and a fanciful cornice elaborately frame an image of the Prophet Muhammad's mosque in Medina, north of Mecca in Saudi Arabia (fig. 20.20). The decoration made of chrome and reflectors recalls traditional textile and ceramic patterns as well as Mughal wall decoration: no Mughal palace was complete without its *shish mahal*, or mirror-work chamber, where the light of a single candle could produce a glittering cascade of images. Flashing by in the sunlight, or caught in a headlight at night, the decorated trucks produce a similar effect, and with thousands of such trucks, the roads resemble a gallery of art and design in motion.

Such an expression of their artistic sensibilities by "ordinary" inhabitants of the Indian subcontinent is a hopeful sign that increasing homogeneity of product type and design, and the spread of "global culture," will not mean the end of popular traditions or human creativity. The vibrancy of Bollywood design points in a similar direction. But the consolidation and strengthening of both domestic design communities and manufacturing bases remain key issues, especially in a rapidly changing India. Preservation of values associated with "simpler" lifestyles is another focus, especially at a time when a robust economy is seen to be feeding rampant and often highly conspicuous consumption amid dire poverty and all its ramifications.

JOHN ROBERT ALDERMAN

Fig. 20.20. Tanker truck, Karachi, Pakistan, c. 2000.

THE ISLAMIC WORLD

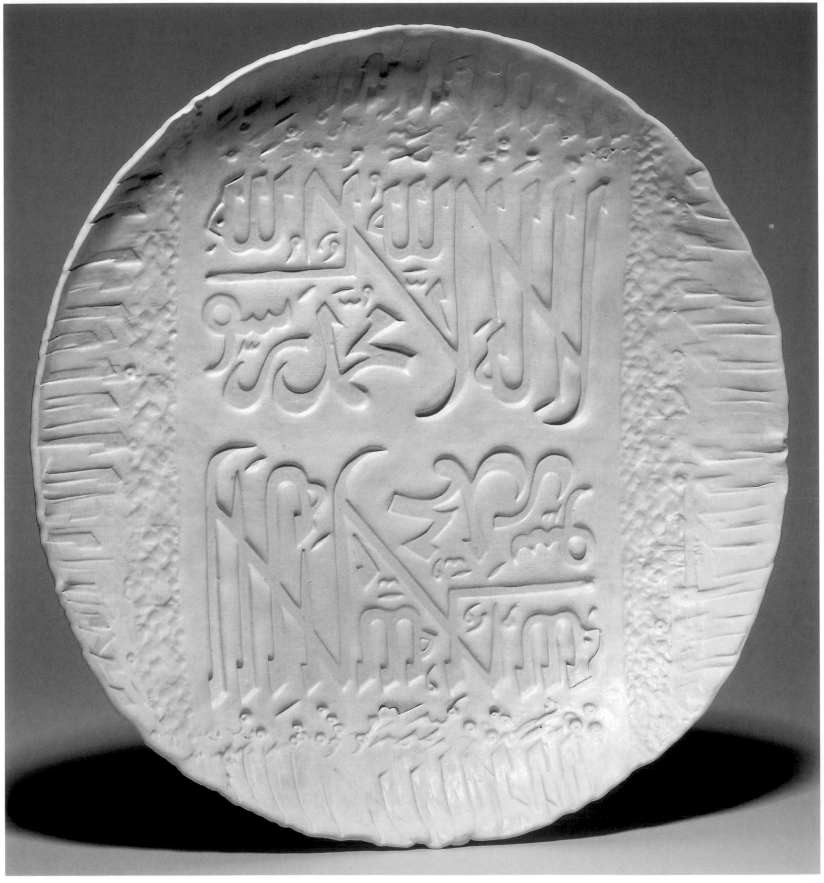

Fig. 21.10

Changes in design and decorative arts production and consumption in the Islamic world continued in the twentieth century and early years of the twenty-first. The leading Western countries had a strong presence in the Middle East in the early 1900s, especially as Western demands for oil increased. Long-established, but still fluid craft and design traditions began to change more rapidly, often in association with wider social, political, economic, and cultural developments. At the same time, Western products, which were reaching customers in larger urban centers in the Middle East, had begun to make an enduring mark on the everyday lives of wealthier members of the upper and middle classes. Those who had traveled and studied in Europe were more attuned to European-inspired stylistic elements and object types. Aspects of modern art and design from Western Europe and North America were influential from the 1930s to the 1960s. While many indigenous craftspeople and designers thus pursued a greater plurality of forms and motifs in their work in response to new influences, the traditional forms and techniques lived on—mainly in the crafts of more rural, less industrialized and less Western-oriented regions. Ironically, their preservation was championed by the same members of the urban elite and middle classes who were acquiring increasing numbers of Western products.

Throughout the twentieth century, efforts to revive, sustain, and reinterpret indigenous traditions occurred in various parts of the Islamic world and at different times. These intensified during the second half of the century as an Islamic identity was sought beyond the common ground of religion. There was great pride in the local and national cultural heritage expressed through native decorative arts. Calligraphy, for example, long considered an outstanding and characteristic achievement of Islamic cultures, served as both an embodiment of, and vehicle for, expressions of identity and as a means of uniting cultural as well as spiritual matters across the diverse regions of the Muslim world.

WESTERN INFLUENCES AT THE TURN OF THE CENTURY

The late nineteenth century was a period of self-conscious, often state-driven modernization in many countries in the Islamic world as they tried to compete with the huge increase in imports of European goods. For the most part, these initiatives met with little success. Within the weaving industry, after Ziegler and Company, a British–Swiss carpet firm, opened a branch in Sultanabad, Iran, in 1867 and established contact with local workshops, Western taste influenced the

types of carpet produced in the region. In ceramics during the last quarter of the nineteenth century, firms from France, Britain, Germany, and Italy began to sell tiles in Turkey, Egypt, Iran, and India. Around 1900 Villeroy and Boch, a German ceramic company, marketed its tiles in Istanbul, helping to introduce the European Art Nouveau style. Its vividly drawn floral-, vine-, and leaf-patterned tiles were used, for example, in the bathroom of the Ahmed Ratip Pasha Mansion (1901–8), in the Çamlica neighborhood of Istanbul, designed by the Turkish architect Kemaleddin Bey who had trained in Europe, while those with vine and geometric designs covered the entrance and interior panels of the so-called Çinili Khan (Tiled Khan, 1910) in the city's Beyoğlu neighborhood. In Egypt, Shepheard's Hotel in Cairo, as well as some hospitals, power stations, and other public works, were ornamented with tiles from the same company that featured Islamic motifs.

Also influential were the buildings and interiors by the Italian architect and designer Raimondo d'Aronco (1857–1932) whose designs reinterpreted Ottoman forms, often through integrating them with Art Nouveau and a revived Classicism. Examples in Istanbul include the fountain of Sultan Abdülhamid II (1901), the Karaköy Mosque (1903), and a tomb at the Fatih Mosque cemetery (1905). The hiring of d'Aronco and other foreign architects and the Western references in many of their designs, however, antagonized many Turkish designers and intellectuals.

INFLUENCE OF EARLIER ISLAMIC DESIGNS

In the early twentieth century, there continued to be interest in replicating specific ceramic vessels and tiles, richly decorated with floral motifs that had been developed in the sixteenth and seventeenth centuries. The appearance of such objects and the techniques used to make them were studied intensively, especially in Turkey at the flourishing state-funded ceramics manufactories in Kütahya and Çanakkale. The efforts of the Ottoman authorities to preserve and restore decorative tilework on historic buildings further heightened interest in the production of copies of original examples.

Among the numerous copies of "classical" patterns is the one illustrated here (fig. 21.1), showing a repeat pattern of floral elements—palmette or *hatayi* flowers in two variations, combined with tulips, carnations, and hyacinths arranged on curved stems with small pinnate or smooth leaves. The decoration derived from the *türbe* (tomb) of the Ottoman prince Şehzade Mustafa, built in Bursa in 1555, a time regarded as marking the zenith of Ottoman ceramic production. Tiles on

Fig. 21.1. Tiles based on
16th-century designs,
probably made in
Kütahya, 1900–10.
Earthenware; overall,
19¼ x 17¼ in. (48.8 x
43.7 cm). Pera Museum,
Istanbul (162/378-381).

the 1555 tomb were being studied in Kütahya in the early 1900s, making it likely that this group of four was created there at the time. Indeed, in 1907, copies of this design were used to decorate the mosque in Kütahya's main government building.

INITIATIVES IN EDUCATION AND PRODUCTION

Many late nineteenth- and early twentieth-century projects dedicated to revitalizing and improving the quality of artistic education and craft production were influenced by the ideals of the European Arts and Crafts movement, many followers of which admired Islamic decorative arts and design traditions, and several Middle Eastern schools of art and design were established along European lines. In Egypt, which had been under British rule since 1882, for example, the government-funded School of Arts and Decoration (founded 1835) became the Academy of Applied Arts in 1908. Several of the designers who trained there went on to work with local manufacturers to raise standards of design and production across the country. In the same year in Algeria (under French rule since 1830), the Service des arts indigenes (Service of Indigenous Arts) was founded on the initiative of French Governor-General Charles-Celestin Jonnart (1857–1927). Attached to the Académie d'Alger, it was established in Bouzareah, close to Algiers.

In an effort to bolster the local Moroccan industry, the French supplied carpet manufactories and rug makers with pattern books showing examples in traditional styles. Funded by the French government, Prosper Ricard (1874–1952) produced a four volume survey of traditional patterns, the *Corpus des tapis marocains* (Complete Collection of Moroccan Carpets, 1923–27), which set standards of "authenticity." He also provided "corrected and purified" drawings on squared

paper in order to guide rug makers and help guarantee the authenticity, quality, and character of rugs in accordance with laws passed in the French Protectorate of Morocco in 1919 and 1921. Rugs were not to include any decorative motif that was not in Ricard's official corpus. By about 1920, after contemporary high-quality Moroccan rugs were exhibited in Paris, such rugs sold well in European markets. In the French protectorate of Tunisia, the preservation of indigenous and local traditions was also taken seriously, albeit initially more by French officials than by locals.

In Iran, the Madrasa-ye Sanayi-e Mustazrafa (Academy of Fine Arts) was founded in Tehran in 1911 under the patronage of Shah Ahmad (r. 1909–25) and with the support of a leading painter, Muhammad Kamal al-Mulk (1847–1941). Although the institution was dedicated to the fine arts, the curriculum included classes in carpet making, woodcarving, and wood inlay (*khatam*) which enjoyed a major revival. In various regions of Iran, such as Hamadan and Tabriz, large new manufactories, controlled at first by Western entrepreneurs and later by Iranian state authorities, functioned alongside the smaller rural carpet makers. Characteristic designs from each of the carpet-producing areas were compiled into a comprehensive inventory by the Iran Carpet Company (founded 1935), but carpet makers were already catering to customers' expectations of "Oriental" carpets among wealthy Europeans and North Americans in terms of dimensions, designs, and colors. At the same time, however, there were

CAIRO
Library Khedivial

many continuities and a hand-knotted carpet made in Isfahan in 1945 (fig. 21.2) exemplifies the continued transmission of traditional colors and patterns through objects for the home. Its color scheme, overall design, and the disposition of the motifs accord with regional traditions. Several borders enclose the central field, which has a medallion at its center and corner segments separated by curved tendrils, and the same is true of the outer bands composed of arabesques and tendrils with palmetto flowers.

In the Ottoman Empire, textiles, calligraphy, and ornament were taught at the Sanayi-i Nefise Mekteb-i Alisi (Imperial School of Fine Arts) in Istanbul (founded in 1883), while the Sanayi Mekteb (Academy of Textile Crafts) in Bursa (established in 1876) included machine-weaving in its curriculum to help its graduates keep pace with European competitors. In the ceramic center of Kütahya, initiatives to stimulate production included new types of decoration, colors, and motifs. By the mid-1910s, innovation, modernization, and tradition came together in several small workshops and manufactories producing high-quality work, such as the Société Ottoman de Faïence (Ottoman Society of Faïence), which involved only a few craftspeople, its French name reflecting widespread French influence in the Ottoman world. At about the same time, Turks and Armenians living in Turkey focused on reviving historic Turkish ceramic techniques in small, family studios.

NATIONAL IDENTITY

Architecture, design, and the decorative arts were central to expressions of national identity in the Islamic world. In Egypt, for example, the interest in past achievements in the decorative arts was part of a wider movement to assert and reformulate national identity, especially during the period of British domination (1882–1952). Examples from past design traditions that were closely associated in the popular imagination with national and cultural achievements, particularly the pharaonic era and medieval Islamic culture, provided references for architects, designers, artists, and craft workers alike. The styles selected to symbolize Egyptian national identity varied, often according to the type of building or object. For example, the architecture of the Dar al-Kutub (Khedival Library, the Museum of Islamic Art), in Cairo, which was designed by Alfonso Manescalo and completed in 1902, was in a Mamluk Revival style (fig. 21.3). By contrast, references to the period of the pharaohs were evident in such buildings as the Tomb of Saad Zaghloul, built in 1927, in downtown Cairo, or the Giza train station, built in the early 1930s.

Following the fall of the Ottoman empire and the founding of the Turkish Republic by Mustafa Kemal, better known as Atatürk, in 1923, most designers and architects veered away from Ottoman styles. They, together with the ruling elite, intellectuals, and "progressives," looked instead to the formal language and ideas of European Modernism in their search for more self-consciously modern and Westernized expressions of identity, with the Turkish language and culture providing unifying elements. A period of modernization ensued, and in the 1930s architecture and decorative arts were strongly influenced by the European Modern Movement, and local interpretations of European Modernism positioned Turkey not just as a modern state but one with an international outlook. Some Turkish students of art and design studied in Europe, especially Germany, which had long-standing economic and political ties to the area, Paris, and London. "Modern" design, including the concept of the "modern home," were symbolic of the new rationalist, secularist state. But links continued to be made between past and

Fig. 21.3. Alfonso Manescalo. Dar al-Kutub (Khedival Library), now housing the Egyptian National Library and Archives and the Museum of Islamic Art, Cairo, 1902.

present by means of stressing a similar underlying rationality and functionality in both Modernist and traditional Turkish designs. By the time Atatürk died in 1938, however, and especially thereafter, Western architectural and design influences, especially from Germany and Italy, were in evidence, as were Central Asian and pre-Islamic Turkish design traditions. The decorative arts were not forgotten; indeed, only a year after the new republic was founded, the Academy of Art in Istanbul established a department dedicated to them which by 1929 had its own ceramics studio. That studio was later supervised by Füreyya Koral (1910–97), the first woman potter in Turkey to combine Islamic art and design traditions with Western forms, including abstraction.

In Palestine, which was part of the Ottoman empire until 1917 and also had centuries-old crafts and decorative arts traditions, the situation was different. From the nineteenth century, pilgrimages by Western Christians to the "Holy Land," particularly Bethlehem, Nazareth, and Jerusalem, had brought tourists to the region and consequently a considerable amount of decorative arts production was adapted in varying degrees to suit the desires of this type of customer. From 1917, when Britain defeated the Ottoman forces during World War I, Palestine was under British control (it was a British Protectorate from 1920 to 1948). Many British administrators and educators greatly admired the craft and design traditions they found there, and embroidery, weaving, jewelry making, and woodcarving, especially in olive wood, played such a significant role in local production and daily life that they came to symbolize Palestine itself. The production of ceramics increased as a result of Western influence, and quality ceramics have been made there since the 1930s.

Close contact and cultural exchange were maintained with neighboring Arab countries, and consequently, in the 1930s some young Palestinians studied decorative arts in Cairo from whence many returned to teach in Palestine and elsewhere in the Middle East. The Badran family, for example, represents efforts to secure the best possible training and to reinvigorate Palestinian arts and crafts in the first half of the twentieth century. Between 1922 and 1927, the brothers Jamal, Abdul Razak, and Khayri Badran studied decorative arts and design—weaving, ceramics, glass, photography, and other genres—at the Hamzaoui School in Cairo. They went on to study painting and design at the Central School of Arts and Crafts in London and in 1940 founded the Badran Brothers' Studio and Workshop in Jerusalem. There, until 1948, they trained many designers in calligraphy, arabesque design, and decorative arts.

Hanna Said Musmar (1898–1988) typifies a different path open to Palestinian craftspeople, designers, and artists. After studying ceramics in Germany in the 1920s, he returned to Palestine and opened the first ceramic studio in Nazareth, which, in the twenty-first century, is run by his grandchildren. Others who went to Europe to study also later taught in schools of art, crafts, and design in Jerusalem, Nazareth, and Amman.

When the state of Israel was created in 1948, however, many Palestinian designers, craftspeople, and artists emigrated to Lebanon, Jordan, Egypt, and the Gulf states, or to Western countries, rather than face resettlement. Others stayed and

contributed to the rich material culture. Some of the firms extant under the Ottomans have survived into the twenty-first century, including the Hebron Glass and Ceramics Factory, which attracted an international clientele soon after it was established in 1910.

INTERCHANGES: ISLAMIC TRADITIONS AND WESTERN DESIGN, C. 1950–75

The 1950s and 1960s constituted a distinct phase of cultural globalization in the Middle East. While the ruling elites of the Central Asian republics of the Soviet Union remained wedded to the ideas and aesthetics of communist internationalism, other parts of the Islamic world were more open to ideas from Western Europe and the United States, including contemporary forms of architecture and design. "Western" ideas, designs, and products influenced design in the Islamic world in complex ways in the second half of the century. Iran and Egypt are representative examples, as are the especially strong traditions of carpet making and ceramics in the Islamic world.

In Iran, beginning in 1953 when the United States backed a military coup that deposed the democratically elected government and reinstated Muhammad Reza Shah Pahlavi (r. 1941–79), the visual and material culture of the elite grew even more Westernized, although rarely without reference to Persian traditions. The authoritarian government sought to assume the glory of ancient Persia while projecting the image of a modern up-to-date state. In the Saadabad Palace, the shah's residence in Tehran, for example, a private cinema (a modern room type) designed by Paris-based Jean Royère in about 1958, was a curious pastiche, a mix of traditional Iranian and contemporary European design, along with strong touches of Hollywood-style Orientalism.

"East" and "West" also mingled at the shah and shahbanu's imperial coronation in 1967, but in terms of the splendid coronation robes and crowns it was largely a case of Western designers interpreting and incorporating aspects of Iranian craft and design traditions in collaboration with their royal Iranian clients. The coronation robe of Shahbanu Farah Pahlavi (b. 1938), who had studied at the École Spéciale d'Architecture in Paris, had been designed by Marc Bohan of the Parisian couture house of Christian Dior, but it was embroidered with Iranian motifs by Pouran Daroudi (fig. 21.4). Her much-publicized bridal gown also came from Dior, the work of Parisian couturier Yves Saint-Laurent. Her crown, designed by Parisian jeweler Pierre Arpels of Van Cleef and Arpels, incorporated gems from Iran. While her clothes thereafter often bore "ethnic" touches (popular in Western fashion in the 1960s), they spoke more of Paris than Tehran.

The shahbanu was a major patron of art and design, particularly contemporary fine arts, but she also promoted Iranian decorative arts and handcrafts. She launched a campaign to build national collections of Iranian artifacts, in part by repurchasing works from foreign collections. Most of the population, however, had little to gain from such initiatives. Policies of Westernization or modernization too often involved Western companies selling goods and making profits in Iran without any transference of the technologies or infrastructure necessary for domestic production. "Self-reliance"

Fig. 21.4. The newly crowned Shahbanu Farah Pahlavi of Iran, Tehran, October 26, 1967. Robe designed by Marc Bohan of Christian Dior, embroidered by Pouran Daroudi; crown designed by Pierre Arpels, Van Cleef and Arpels, Paris.

Fig. 21.5. Craftsmen at work on a metal tabletop, from *Cairo: A Life Story of 1000 Years, 959–1969*, Cairo, 1969.

more accurate copies of "masterpieces" of the past, especially the most widely admired examples from the time of Iran's Safavid dynasty (1501–1736).

Since the 1960s, however, many of the carpets sold on the international market with Persian-style patterns have come from lower-wage countries, such as India, Pakistan, and China. By the end of the twentieth century, less expensive examples from those countries had replaced traditional-style carpets from Iran, Afghanistan, and the Caucasus area of Russia in the lower and middle sections of the trade. In response, many manufacturers, rug makers, and merchants involved with the quality market placed even greater focus on their authenticity and tradition.

In Egypt, which experienced something of a cultural renaissance after the Egyptian Revolution of 1952, crafts were also used to showcase the national culture and help the state accrue authority. State cultural organizations promoted the production of objects that reflected what were considered iconic forms and decorative traditions and also urged their acquisition by museums. Photographs of craftspeople working metal with traditional tools were used to illustrate books such as *Cairo: A Life-Story of 1000 Years, 969–1969*, published by the Egyptian Ministry of Culture in 1969 in a variety of languages (fig. 21.5). In such ways, the Egyptian Republic promoted itself by association with folk art and design, and signaled that it sought to respect the past and preserve those traditions.

INTERCHANGES: EAST AND WEST AFTER 1975

Since the 1970s, in part as a reaction against extremes of Western taste and Western notions of development, there has been a greater emphasis on local, indigenous, and Islamic traditions throughout the Islamic world. The Arabic language (except in Iran, where Farsi is spoken) and script, for example, have served as common cultural and cross-national bonds, particularly, but not solely, through the Koran. Western-influenced trends, be they economic, ideological, or social, often were perceived as alien. At the same time the increased Western demand for oil transformed the economic base of the oil-exporting nations of the Islamic world and contrib-

became a popular demand both then and during the 1979 Iranian Revolution.

Under Shah Pahlavi, the design and production of traditional carpets were both preserved and "modernized" in the 1950s and 1960s, the latter with a view to increasing worldwide sales. The preservation of native carpet-making traditions was a key concern in many of the Islamic countries in the second half of the century, as was maintaining high standards under the pressure of increasing demands from buyers in the West for cheaper examples. Reports by foreign consultants, including economists, suggested paler colors for both silk and wool carpets and sizes more suitable to Western domestic interiors. Many carpets of this type from this period survive in residences in Europe and the United States as well as the Middle East.

Western interest in traditional carpet models persisted and international demand tended to focus on "Oriental," "Eastern," and especially "Persian" hand-knotted carpets using hand-spun cotton and wool dyed with natural materials. Color illustrations in books on "Oriental" carpets published in Europe in about 1900 were used in order to produce

uted to a new fulcrum of power in relations between oil-producing and oil-purchasing countries. The new mood of self-confidence in the Islamic world was both reflected in and impacted the visual and material cultures.

Accurate reproductions of early pottery continued to be popular into the twenty-first century, and wall tiles especially found a wide market. The design and craft traditions of the past continue to feature in decorative arts production in Islamic countries, including Tunisia and Morocco, where repetitions of, or variations on, classical Ottoman tiles are still used to decorate a range of interiors, from private lounges and bathrooms to restaurants.

In the later twentieth century, various strategies were devised for creating decorative arts products that merged indigenous craft and design traditions with modern Western, especially Anglo-European, art and design. Such efforts found novel expression in the patterns on a group of Iranian hand-knotted carpets made in the late twentieth and early twenty-first centuries featuring figurative designs derived from Western photographs, paintings, prints, and fashion images. The subjects range from portraits of rulers and representations of young women to scenes borrowed from miniature paintings.

One example is a relatively small rug that features a double portrait of a young woman (fig. 21.6). The choice of a central motif, which is likely to have been based on a photograph, corresponds to the bold Pop Art imagery of human faces as well as international modern graphic conventions of using images of young women to advertise commercial products. At the same time, the translation of the image into a carpet takes account of nineteenth-century Islamic traditions that not only incorporated portraits as decoration, but also used them as mirror images and increased their size, thereby relinquishing part of the lifelike quality in favor of stylization. The symmetrical arrangement of the two faces flanking a small vase, the two-dimensionality of the graphics, and the accentuation of line also follow Islamic design traditions, while the ornamental frame alludes to the borders of traditional Persian carpets.

In the twenty-first century, figurative representation has become much more frequent than in the past, and this type of relatively inexpensive hand-knotted decorative rug is popular in both the domestic and export markets. This also applies to rugs of a finer quality, more closely knotted, in which the figurative representations include landscape motifs and monumentally enlarged extracts from complex compositions found in Persian miniature paintings.

Another attempt to combine Islamic traditions with those of modern Western art and design is demonstrated by a carpet designed in the 1990s by the Iranian artist 'Abbas Mostafawy (b. 1930) featuring a representation of a young woman nursing an infant (fig. 21.7). The model for this motif was the well-known color lithograph *La petite maternité* (1963) by Pablo Picasso, which was reproduced many times over in magazines and postcards. Picasso's linear image corresponds to the tendency in the Islamic world to refrain from realistically rendered representations of humans and animals in religious art. The language of the lithograph is Western in that it is free and personal, but Picasso's fascination with calligraphic form—in the composition of the young mother's hair and hair ornaments, and the background—resonated with the Islamic dedication to calligraphy. This connection through calligraphy offered the Iranian designer a starting point that had already crossed cultural boundaries. Mostafawy extended Picasso's representation with additional doodle-like lines that surround the woman's head; their complement is a pattern of Persian lettering below the baby. The text, a quotation from "Mader" (Persian, Mother), a poem by Iraj Mirza (1874–1926)—"When my mother gave birth to me she also taught me to guide her breast to my mouth"—further links West and East.[1] Mostafawy's placing of Picasso's motif inside a medallion-like oval frame fused devices found in both Western and Eastern design vocabularies. This designer thus transformed an iconic image from Western art into a design more in the

Fig. 21.6. Rug, Iran, late 20th century. Wool, cotton; 20⅛ x 41⅜ in. (51 x 105 cm). Private collection.

into the wider unity of the Soviet Union, which defined itself as multicultural. Conversely, within that wider union, the central government was forced to pay attention to regional, nationalist, and separatist issues in the Islamic regions.

Many design and craft traditions survived because of the physical distance from the main centers of power. One example, a silver ewer with niello inlay (black enamel-like alloy, usually with silver, copper, and lead; fig. 21.8), represents a long-established craft tradition in what was then part of the Soviet Union. It was produced in 1979 in the eastern Caucasian republic of Dagestan, in Kubachi, a town famous for its metalwork (especially arms and armor) as early as the eleventh century. From the eighteenth century, objects decorated with engraving and niello were offered for sale in Russia and other European countries, North America, and other decorative arts markets. Scholars and collectors showed interest in this type of metalwork from the second half of the nineteenth century, and items of traditional Kubachi niello work were exhibited and admired at the Exposition Internationale des Arts et Techniques dans la Vie Moderne, held in Paris in 1937.

The form of the ewer illustrated here has been produced in the Caucasus and in the region around Bukhara in Uzbekistan since the nineteenth century. In material and decoration, the vessel is oriented toward Kubachi metalwork traditions. Shortly after it was made, it was purchased by the Museum of Ethnography in Moscow and appeared in a publication on folk art, an example of the central government supporting traditional crafts. It also seemed to herald the broader revival of interest in Islamic pasts and traditions (real and imagined) associated with the late 1980s. In 2009, eighteen years after

Fig. 21.7. 'Abbas Mostafawy after Pablo Picasso. Carpet with a nursing mother, Iran, 1990s. Wool, cotton; 10 x 6¾ ft. (3 x 2 m). Private collection.

manner of Persian decorative arts and carpet making. In its unconventional open referencing of diverse art and design models, the carpet offers a striking example of how stimuli and influences from modern art and design, as well as an emphasis on startling juxtapositions, can be handled in a contemporary decorative arts field firmly rooted in indigenous traditions.

THE SOVIET REPUBLICS

In the Soviet Republics of Central Asia, the lines between continuity and revival of Islamic decorative arts and design traditions were often blurred. Decorative arts production in traditional techniques was practiced in many parts of the USSR from its formation in 1922, hard on the heels of the Russian Revolution of 1917, until its breakup in 1991. The most popular sources for the forms and techniques of the past in Islamic regions of the Soviet Union were mostly found within indigenous craft traditions. The central government in Moscow supported such activities as part of a longstanding Russian interest in folk arts and crafts which were regarded as esteemed forms of popular culture and, seen to spring directly from the peasantry, were considered appropriate expressions of a socialist state. The fostering of indigenous crafts was meant to encourage the integration of these regions

Fig. 21.8. Ewer, Kubachi, Dagestan, 1979. Silver, niello inlay; H. 13¾ in. (35 cm). All-Russian Museum of Decorative–Applied and Folk Arts, Moscow.

CALLIGRAPHY

Two exemplary objects dating from the end of the twentieth century are reminders of the importance of calligraphy in the Islamic world, as perhaps the most significant, idiosyncratic form of Islamic art and design. Since the 1970s, there has been a rekindling of interest in calligraphy, in the classical form and in its use in the fine arts, decorative arts, and graphic design. In painting, for example, following a period of experimentation with figurative composition from the 1950s to the 1970s, individual motifs from Arabic script were translated into large-format compositions by artists and designers across the Islamic world.

As in earlier times, inscriptions were often incorporated into or added to a diverse range of objects. The close integration of script and object can be seen in a group of ornamental tiles created by an unnamed Iraqi ceramist, whose work was offered for sale in Amman, Jordan, at the beginning of the twenty-first century (fig. 21.9). Intended as wall decoration, the object itself has become script, leading to an unusually close connection between text and object.

The transcendence of both decoration and object is further manifest in the religious texts selected. In this case it is formed from the words *Masha' Allah* (whatever God wills), a frequently used Arabic phrase that refers to Muslim believers' willingness to subordinate themselves to the will of God. The characters are written in Kufic script, which, in its angularity, comes close to the formal concepts of Western Modernism, but the overall impression of modernity emerges more from the particular combination of tradition and contemporary ideas. The association of decorative arts with intellectual concepts can be found time and again in the Eastern tradition—a feature that has always given to the decorative arts a special significance.

A second example demonstrates the relationship of contemporary ceramics to calligraphy and fine art (fig. 21.10). This monochromatic ceramic dish with relief decoration was created by the Iraqi artist-designer Wasma'a Chorbachi (b. 1944), whose work features calligraphy on both ceramics and fabric. The white plate has been repeatedly embossed with the *shahada*, the declaration of Islamic faith. Although this quotation does not extend beyond the traditional treatment of inscriptions, the artist treats the text differently by embossing the lettering in various directions into the ceramic ground of the plate, thus creating a large mass of ornamental forms to fill the inner space and transcend the traditional use of the plate form as a support for script. A self-identified Arab-American, Chorbachi refers consciously to Islamic traditions in her work, as have increasing numbers of Arab-American designers and artists since the 1970s.

Chorbachi's creations result from self-consciously artistic ambitions that reach beyond what many consider the boundaries of decorative arts, and into the fine arts. Distinguished by her attempt to expand the boundaries of what a plate might be, one of her plates was displayed at the British Museum in London in 2010 alongside ceramic objects from the Islamic world dating back to the medieval period.

the dissolution of the USSR, the State Hermitage Museum in Saint Petersburg held an exhibition of 115 objects from its collection, representing work from the early fifteenth to the early twentieth century and including a range of genres, among them architectural decoration and metalwork from Dagestan, with many pieces from the Kubachi region. The breakup of the USSR in 1991 led to freer expressions of regional, national, religious, cultural, and personal identities. In the now autonomous countries, Islam replaced a bureaucratic form of state socialism as an equally international, identity-giving philosophy of life.

WOMEN'S CRAFTS

While many of the objects and ideas discussed above have illustrated the close orientation in the twentieth century to past traditions, another strand of tradition-oriented production developed largely independently of such efforts. The examples discussed here grew out of very different contexts—Central Asian embroidery of the early twentieth century and a type of ceramics developed in the Tell Atlas Mountains in northern Tunisia at the turn of the twenty-first century. Both examples illustrate how the preservation of domestic rural crafts continues to rest in the hands of women, and how, in each case, the crafts survived more or less independently of official initiatives.

In Uzbekistan and Turkmenistan, special embroideries, such as so-called *susani*s (derived from Persian *suzan*, meaning "needle"), traditionally have been made by the women of an extended family or village community and used primarily as dowry objects or in family rituals and village ceremonies

(fig. 21.11). The production of these embroideries has taken place for centuries in domestic or semidomestic contexts, but since the nineteenth century, the designs have often been developed by professional specialist designers, usually women trained outside the community, rather than by the women making them. Sometimes these designs were created without reference to family and local traditions. Invariably made in the name of progress, they represent an effort to expand sales and sustain jobs in rural areas. The execution of the designs remains within immediate families or neighborhood communities and is often collaborative.

Such changes are not altogether unusual. Craft and design traditions in the region have never been static. Although some of the preferred patterns and color combinations that distinguish local products date back to the fourteenth century, variations have occurred from one generation to the next. In the *susani* (c. 1900) illustrated in figure 21.11, the backing fabric was formed of a machine-woven cotton material, rather than a traditional hand-woven base, while the embroidery

Fig. 21.11. Embroidered hanging (*susani*), Samarkand, c. 1900. Cotton, silk; 108¼ x 80¾ in. (275 x 205 cm). Ethnologisches Museum, Staatliche Museen zu Berlin (I B 13677).

Fig. 21.12. Eljia. Wide dish (*maâjna*), Sejnane, Tunisia, early 21st century. Earthenware; 2 x 14⅛ x 14⅛ in. (5 x 36 x 36 cm). Badisches Landesmuseum Karlsruhe (2004/619).

was executed, as in the past, using cotton and silk yarn. The wall hanging also differs from other *susanis* of the period in coloring and motifs. It relies on a limited palette of restrained colors, whereas most *susani*s, past and present, are associated with bright colors—a strong red being the most characteristic. The main motifs diverge from tradition. Needleworkers covered the central area of the backing fabric with a uniform arrangement of five rows of delicate, stylized trees or shrubbery, thus creating a very particular decorative but restrained effect quite different from those seen on other *susani* embroideries, which adhere more closely to folk traditions. This indicates that variation from tradition existed at the beginning of the twentieth century, even in work produced in rural and domestic surroundings.

By contrast, the second example, a ceramic *maâjna* dish, made in Sejnane in northern Tunisia in about 2004, demonstrates the seemingly continuous preservation of local traditions (fig. 21.12). For many centuries, in this remote region, women continued to make pottery by hand, without the aid of a potter's wheel, and also painted the decoration on it. In the twenty-first century, pottery making continues to offer employment in an area where work is difficult to obtain and many people migrate to the cities. Painted with geometric forms or stylized animals in a limited color palette, the vessels and dishes are part of a repertoire of decoration stretching back to Punic-Roman antiquity.

Made by the potter Eljia (b. 1961), the form of the dish illustrated here follows tradition with its wide, flat sides but the form has been altered slightly; a small bowl has been added in the center for honey-butter or sauces. The decoration consists of a ground painted with a light-colored slip (a mixture of fine clay and water applied to vessels of coarser clay to render them less porous) onto which various geometric patterns are applied in black and red, with motifs related to traditional Tunisian weaving.

This type of ceramic dish was made primarily for local, domestic use until the 1990s, when household crockery produced from plastic, aluminum, and glass increasingly found its way to remote regions of Tunisia. Less expensive and often more durable than pottery equivalents, these new products greatly reduced the purchase of domestic ceramic tableware for everyday use. The women potters of Sejnane began to focus more on the tourist market, selling items as souvenirs through wholesale merchants or, less often, in small stores they established and operated. Some of this pottery was, and is, sold as "Berber ceramics" even though there is no connection to the Berber population of Tunisia, and these Tunisian sellers, in their own lifestyles, emphasize their Arabic ancestry.

By the late 1900s, state organizations, such as the Institut National du Patrimoine Tunisien (founded in 1885), began to foster high-quality ceramics in Sejnane by means of exhibi-

tions and prizes, thereby helping to preserve traditional forms and decoration as well as quality craftwork, while also boosting the economy. The results of these initiatives can be seen in the work of the circle around potter Jama'a Sa'idani (b. c. 1950) who is considered the "master" of traditional Sejnane ceramics. A new openness to external influences as a result of greater contact with objects and ideas from other areas is seen in the work of another potter, Sabiha Ayari (b. 1964), who in 2004 won a national art award. Unlike most women in Sejnane, Ayari is unmarried and owns and operates a small shop. In both cases, these potters find inspiration in past traditions while following their own artistic inclinations. Like many others in Tunisia and elsewhere, they have begun to identify themselves as artists rather than craftworkers, or even designer-craftworkers.

THE TOURIST TRADE

The explosion of the tourist industry, especially since the mid twentieth century, has influenced the production of decorative arts in the Islamic world, from high-end furnishings to inexpensive souvenirs sometimes at odds with state efforts to promote traditional craftwork and maintain high standards of craftsmanship and design. In the twenty-first century middle-income and wealthy tourists could still find good quality rugs, glass, and other items designed and made within the parameters of established craft and design traditions. Sometimes "vintage" rugs and jewelry from the 1930s and 1940s

were, and are, offered to tourists by rug and jewelry merchants along with newly made items, expanding that aspect of retailing to fit consumer interests and concerns for "authenticity."

Inexpensive "new" kinds of tourist goods of the type sold mainly in department stores, souvenir shops, hotels, and airports have also found their way into the export market and are sold in "Middle Eastern" shops in cities around the globe. Some feature handwork, but most bear little relation to past handcrafts. Some use nontraditional materials; others employ nontraditional techniques. The example illustrated here, a number of small glass perfume bottles from Egypt, are widely sold, even on the Internet (fig. 21.13). They represent an old product type taken in a new, populist direction. The makers have taken the *concept* of the scent bottle but ignored the traditional forms, while still selling them as "authentic" representatives of the material culture of the past. Although advertised as traditional craft objects, neither in form nor decoration do they relate to historical Egyptian glassware, which was decorated with enamel or gold.

For the most part, as elsewhere in the world, familiar traditional forms and styles mass-produced using cheaper materials than previously dominate the tourist market. For some consumers, they represent "Islamic decorative arts" and the countries in which they were bought. For those who associate the cultures of the Muslim world with "the Orient" and exoticism, these souvenirs can sometimes confirm or intensify outdated "Orientalist" associations. Tourist souvenirs of all sorts now form part of the decorative arts production in the region.

Fig. 21.13. Perfume bottles, Egypt, late 20th century. Glass; tallest, H. 4¾ in. (12 cm). Private collection.

Fig. 21.14. Etem Sevil. Plate, Altın Çini Seramik, Kütahya, Turkey, 2003. Earthenware; Diam. 14⅛ in. (36 cm). Private collection.

GLOBAL MARKETS, NEW OBJECTS AND MATERIALS, CONTINUITIES

Rising economic and media networks at the turn of the twenty-first century and the growth in global markets reshaped everyday material culture, not least through the proliferation of goods, including new object types, such as computers and cell phones. Older items, such as tableware and kitchen-utensils, sometimes took on new forms and were made in new materials. As before, the changes have been most marked in urban and industrialized areas. Many household goods are machine mass-produced and made of relatively cheap materials, such as plastic. Many are designed in the West but manufactured elsewhere, in places with lower wage rates, including East Asia.

Highly affordable dishes, pots, pans, and furnishings have become available through a variety of outlets. Long-established marketplaces sell "modern" goods made by traditional manufactories, such as glassware and pottery from Turkey and textiles and tiles from Morocco, while stores such as the Swedish-based IKEA operate internationally and encourage a large degree of homogeneity of taste. IKEA makes few concessions to local conditions, but its emphasis on harmony of forms and proportions helps make its products acceptable within cultures that also appreciate such ideals. IKEA's low prices, resulting from high-volume sales, are also attractive, and, furthermore, the company offers for sale objects from within the Islamic world that the Western world has long accepted as beautiful, as, for example, carpets from Turkey and Morocco.

For the new and prosperous generation in the Islamic world, IKEA and other stores selling Western and Western-style goods offer an opportunity to express modern ways of living and to identify with a global society. Many customers prefer this aesthetic to copies of object types associated with traditions of their countries. There are also many who support and encourage new designs that draw inspiration (wholly or in part) from past traditions. There has been an increasing emphasis on indigenous decorative arts, as part of a wider revivalist trend throughout the Islamic world, especially within the field of ceramics.

Since the mid-twentieth century, Iran and Turkey have been trailblazers in developing modern ceramics industries in traditional pottery centers, such as Çanakkale in Turkey and the ancient pottery towns of Maybud and Lalajin in Iran. In Lalajin (northwest of Hamadan), for example, in the early twenty-first century, there are about 3,900 potters in 900 ceramics workshops, most of which are relatively small and frequently family-run concerns. They focus on creative interpretations of historical vessels, especially Persian faience ware of the sixteenth to eighteenth century. Lalajin pottery is sold throughout Iran and exported to Europe, the United States, and the Arabian Peninsula, with business contacts extending as far afield as China and Japan.

In Turkey traditional decoration has been partly reinterpreted for a "progressive" contemporary market. This new take on old motifs is apparent in a group of plates decorated by Etem Sevil (active since the 1990s) and sold by a specialist ceramics dealer in Ankara in 2005 (fig. 21.14). Although the forms themselves have been industrially precast (by mechanical molding machines), each plate has been hand-painted. Sevil, a member of the Turkish Association of Ceramic Artists, chose motifs from the classical sixteenth-century Iznik repertoire, including three balls, each filled with an off-center dot similar to the *çintamani* motif (which usually comprises three balls and tiger stripes), and large, feathery *saz* leaves (see figs. 3.24, 3.25). Traditionally linked, here these elements are isolated, fragmented, and enlarged, and form the primary decoration of the plate. Furthermore, the well-balanced arrangement of the leaves around the center deviates from Ottoman examples. Similar artistic ceramics of many forms are sold at markets and by ceramics dealers all over Turkey. As in Sevil's work, the decoration reduces and reworks in novel combinations elements of historical Iznik design traditions.

One strand of modern Islamic design focuses on objects that, in terms of concept, formal language, and excellence of execution, are often elevated as works of fine art. These include ceramics, textiles, and carpets and tend to appeal to the wealthier, well-educated strata of society, particularly patrons interested in Islamic history and culture. At the same time, a broader interest in past traditions prevails, supported partly by popular memory and partly by ideological currents that foreground craft and design traditions as part of longer historical traditions, both secular and religious.

Charting new territory in the twenty-first century, interior architect and designer Faruk Malhan (b. 1947), whose company, Koleksiyon Mobilya, has offices in Istanbul and other Turkish cities, is known for his unconventional approach to design and his dislike of convention. Malhan has reworked and transformed past decorative arts styles, colors, motifs, forms, and object types including the glass vessels in which hot tea is served throughout the Islamic world. Malham's *Istanbul* tea glass of 2006 (fig. 21.15) references the traditional Turkish vessel form with its pronounced "waistline."

He refashioned it, however, as a strikingly clean form with subtler contours. With its associated saucer, it creates a formal and functional unit in accordance with Modernist ideals of rationality and clarity of expression.

Another Turkish designer, Çan Yalman (b. 1967), deals with Islamic design traditions in a different, more intensely concept-oriented, manner. For him, innovation supersedes the notion of continuity, especially in terms of function, materials, and techniques but even for his elegantly simple line of *AH* cutlery, which is hugely indebted to Western precedents (fig. 21.16), Yalman drew upon the principles of Turkish architecture for inspiration. Yalman's designs for monochromatic modern-looking tiles for Çanakkale Seramik, a company that trades internationally, may not directly reflect traditional designs but, as claimed in the marketing material, Ottoman traditions in fabrics, rugs, and ceramics provide the basis of the color palette.

Designers in other Islamic countries, especially toward the end of the twentieth century, also showed a determination to maintain tradition while responding more freely to international trends in art and design. Several of these designers completed their art education and training at leading academies in Middle Eastern, European, North American, or East Asian countries (sometimes in more than one of these places) or had the opportunity to spend time in different regions or countries. Some designers balance open-mindedness to other cultures with respect for their own traditions more easily than others. For some younger designers, architects, and artists, their connections to contemporary international trends are as important as those to their native cultural heritages. In the twenty-first century, the influence of international trends is being felt in almost all areas of design and the decorative arts, from designer rugs to dinner services, from clothing to cell phones, and in virtually all regions of the Islamic world, insofar as they have opened up to international trade and cultural exchange.

Since 1900 in the various countries of the Islamic world, newly complex and varied interrelationships have spread across a spectrum of decorative arts practice, from the preservation of tradition at one end to the contemporary blurring of boundaries between decorative and fine arts at the other. Questions about ways of continuing to reference tradition and searches for identity (personal and national), as well as a concern for economic "development," global markets, internationally readable styles and images, and an orientation toward the future, led to shifts and changes in the decorative arts over the last century or so. Issues of affordability, mass production, and consumption have become prevalent and are as central for product designers working in Islamic regions as they are in other areas of the world. It remains to be seen how the globalization of design, production, and consumption of objects will further affect the Islamic world, but there are strong signs that unique cultural identities will be preserved and that Islamic design and the decorative arts will retain the vigor of past centuries, while indigenous, traditional, international, and future-oriented aspects of those activities continue to be brought together in creative combinations.

ANNETTE HAGEDORN AND SILKE BETTERMANN

Fig. 21.15. Faruk Malhan. Tea and whiskey glasses from the *Istanbul* series, Koleksiyon Mobilya, Turkey, 2006. Glass, ceramic; left, 3¾ x 2½ x 2½ in. (9.6 x 6.4 x 6.4 cm).

Fig. 21.16. Çan Yalman. "Şah" flatware from the *AH* series, Hisar AŞ, Turkey, designed 2004. Stainless steel.

AFRICA

Fig. 22.24

In Africa, the twentieth century was a time of widespread change. The political map had been transformed by the Berlin Conference in 1884–85, when European nations divided up the African continent, claiming distinct areas as their own. Through the first half of the century, France, Britain, Belgium, Portugal, and Germany (until it lost its colonies after World War I) governed their colonies in their own ways, thus leaving different legacies in the post-colonial period. By mid-century, African nations, whose boundaries had been set by the colonizers, began to achieve independence, beginning with Ghana in 1957. Since then, Africa's fifty-four nations have dealt with the legacies of colonialism, attempted to develop their economies, and have taken their place in the global arena.

Colonial powers were driven by the promise of Africa's rich natural resources—from gold, copper, and other minerals, to rubber, cotton, cocoa, and peanuts. The construction of deep underground mines and the introduction of cash crops changed long-standing methods of artisanal mining and small-scale farming. The colonial powers built the infrastructure they needed, including ports, railways, roads, and, eventually, airports. Quantitatively, Africa's population recovered from the ravages of the slave trade, but people faced new challenges and opportunities, particularly as economies changed and more people worked for wages in mines and on large plantations geared to export crops. As urban populations expanded, small-scale farmers were unable to meet the demand for food, and staples such as rice and corn had to be imported. Changing demographic patterns, as well as imported consumer goods, changed the tastes and lifestyles of many Africans. Although poverty rates continued to be high, the middle class grew steadily; by 2012 demographers estimated that one-third of Africans could be categorized as middle class.

With the exception of South Africa, which had seen the influx of white settlers starting in the seventeenth century, few Europeans other than those employed by Western governments or businesses settled permanently in Africa. The cultural influence of the West, however, was profound. Across Africa, new forms of education, generally taught in the language of the colonial powers, led to changes in people's aspirations and expectations, especially among educated and middle-class Africans. Many well-educated Africans traveled to the United States, Europe, and the Soviet Union, or worked abroad and sent money and consumer goods to relatives back home. As elsewhere in the twentieth century, new forms of transportation and communication were life transforming.

All of these and other factors affected the material culture of Africa. Images of new kinds of objects, from tables to telegraph poles, were woven into textiles and baskets, or painted on bark cloth or shop signs. At the same time, certain traditional objects such as Asante stools, Dogon masks, Mangbetu hairstyles, and Zulu shields took on new meaning as signifiers of ethnic, regional, and sometimes national identity. New materials were incorporated into older forms: telephone wire was used to make baskets; shiny Lurex thread was used in clothing; coffins were carved in the form of cars, airplanes, or mobile phones. African design and craft traditions changed, continuing to embrace innovation, as in centuries past.

SIGN PAINTING

Twentieth-century transformations in African material culture can be seen in the vast open-air markets that have long been places where people both manufactured and exchanged goods. These markets brought people from the remotest villages into orbits of long-distance trade. Especially in large cities, tailors, blacksmiths, butchers, dyers, weavers, herbalists, and cooks set up workshops, restaurants, and small factories in the markets. Foodsellers create colorful displays of stacked oranges or dried fish. Dressmakers hang finished garments and paper dress patterns on the walls of their stalls; cobblers make and repair footwear; herbalists string amulets from the lintels of their stalls.

As African cities and towns grew, some shops moved inside permanent structures. Shopkeepers and artisans needed signs to advertise their trades, and sign painting in the twentieth century became a vibrant urban art. Signs advertising barbers and hairdressers, for example, showed different hairstyles, each with its own name. Butcher shop signs depicted cuts of meat, while herbalists and pharmacies graphically depicted the symptoms of diseases. For people who could not read, the graphic images explained the business at hand. Some signs were painted on cloth banners, others directly on buildings or on Masonite and plywood, usually in commercial housepaint. Trucks too are decorated with drawings and sometimes incorporate sayings that beg God for protection. Political and religious figures also appear on billboards, posters, and vehicles.

Some of the most accomplished sign painters, like Kwame Akoto (a.k.a. Almighty God, b. 1950), from Kumasi, Ghana, have become celebrities in their own right. Akoto's images are deeply affected by his Christian faith, and many of them include a mixture of wry irony and moral advice. In the Democratic Republic of Congo (DRC), a group of painters who started out making street signs and small scenic images for sale to Europeans—palm trees and sunsets—began creating

Fig. 22.1. Seydou Keïta. Studio portrait, Bamako, 1956–57 (1995 print). Gelatin silver print; 15⅜ x 21¾ in. (39.1 x 55.2 cm). The Metropolitan Museum of Art (1997.267).

Opposite:

Fig. 22.2. Malick Sidibé. *Nuit de Noel (Happy-Club)*, Bamako, 1963. Silver gelatin print; 38 x 37½ in. (96.5 x 95.3 cm).

Fig. 22.3. Machine-printed textile for the African market (detail), Netherlands, c. 1995. Cotton with dye and resin resist; overall, 48 x 108⅝ in. (122 x 276 cm). Division of Anthropology, American Museum of Natural History, New York (90.2/8928).

biting commentaries on Congolese history, politics, and morality in the 1970s. Their paintings, on old burlap flour sacks, were displayed in Congolese living rooms and cafes beside other forms of decoration, such as images of Christian saints and pictures cut from European magazines and catalogues. Using irony and symbolic language of animals and objects—snakes, leopards, piles of money, or chains and weapons—many images show colonial and post-colonial struggles.

Eventually some of these painters gained an international reputation. Tshibumba Kanda Matulu (b. 1947), for example, created a series of one hundred paintings called the *History of Zaire* (1973–74), a visual commentary on his country. Chéri Samba (b. 1956) started out as a sign and billboard painter and worked for a magazine where he encountered comic strips. His brightly colored canvases include bubbles of text that wryly comment on colonialism, corruption, racism, and the mismanagement of resources.

PHOTOGRAPHY AND FASHION

Photography was a central feature of African popular culture and provides a window on lifestyles in the twentieth century. In the late nineteenth century, many Europeans used photographs and film to document African cultures. For Africans photography, especially studio photography, became a way to keep track of relatives who moved away or to assert new identities by posing in the latest fashions, or against painted backdrops of modern homes, motorcycles, expensive cars or airplanes. In 1948 Seydou Keïta (1923-2001) opened his studio in Bamako, the bustling capital of the French Soudan (present-day Mali). In 1994, he described his studio practice, recalling that European-style clothing, especially French, had become popular with men. Not everyone could afford these outfits, however, and he kept a wardrobe and accessories, like fountain pens, a radio, and a telephone, for his clients in his studio. Most Malian women did not wear Western clothing until the end of the 1960s; instead most were photographed in long flowing dresses (fig. 22.1), often wearing jewelry, as a sign of elegance, wealth, and beauty. The woman shown here lounges on a distinctive strip woven blanket in front of a printed cloth background. Multiple patterns were a signature of Keïta's work, while also reflecting the preference for juxtaposed patterns in Malian textiles. The woman's forehead bears scarification marks, and she wears her headwrap *à la de Gaulle,* after the jaunty way General Charles de Gaulle, who was then president of France, wore his cap. Keïta captured the cosmopolitanism of his subjects—the new urban elite of Bamako.

Another Malian photographer, Malick Sidibé (b. 1936), documented the youth culture of Mali in the 1960s and 1970s. Eschewing studio practice, he photographed at parties and picnics, capturing his subjects in everyday life, smoking cigarettes, wearing miniskirts and flared trousers, riding moto-

cycles, dancing to jukeboxes playing the Beattles, Rolling Stones, and James Brown (fig. 22.2). The models that many youth followed came from movies, posters, and magazines, and connected them to international political and cultural movements, to Civil Rights and Pan-Africanism, in ways that defied their parents and government authorities at the time. They rejected the more traditionally influenced clothing shown in Keïta's work.

The modernity portrayed by Sidibé resonates with a fashion movement in the Republic of Congo that developed after independence in 1960. Known as *sapeur* or *La Sape*, short for Societé des Ambienceurs et Personnes Elégantes, a phrase that embodies its members' aspirations to sophistication and style, it began on the streets of Brazzaville, the capital and largest city, when young men began to create a virtual cult of haute couture menswear. They struggled to gather funds for travel to Europe, where they sought jobs that would enable them to return home with Dior suits and Armani shoes. While the clothes are Western, the *sapeur* phenomenon is distinctively African, drawing ideas from haute couture and inserting them into a local system of values and meaning. La Sape has continued for four decades, and today men who cannot afford to buy these cloths sometimes rent them by the day.

TEXTILES, NEEDLEWORK, AND CLOTHING

Machine-printed fabrics made for African markets date from the nineteenth century. Using roller-printing machines with engraved copper cylinders and dye-resistant resins, companies in the Netherlands created cloths, popularly known as "Dutch wax prints," resembling Indonesian batik. Originally intended for an Asian market, in the second half of the nineteenth century, such textiles were made in several European countries with patterns tailored specifically for African buyers. By the 1960s, a number of factories, including some subsidiaries of European companies, opened in Africa to produce cloth locally. Factory and handmade textile production in Africa increased dramatically in the twentieth century, for both internal consumption and export, but the expiration of trade agreements in 2005 and the rapid growth of Chinese imports have forced many African textile factories to close in the twenty-first century.

Early textiles printed for sale in Africa were based on plant and animal motifs that were thought to have universal appeal, but manufacturers and importers soon learned that there was little profit in a "one-size-fits-all" approach. Local preferences in Africa varied and also changed quickly. As the twentieth century unfolded, inanimate objects that carried signs of modernity or recorded specific historical events appeared on printed fabrics. A cloth printed in the Netherlands and purchased in Côte d'Ivoire in 1995, for example, includes a repeat pattern of a living room furnished with an upholstered sofa and armchair, area rug, wall clock and pictures, television set, and refrigerator, all representing modernity and affluence (fig. 22.3), in a setting that assumes a supply of electricity and other middle-class amenities.

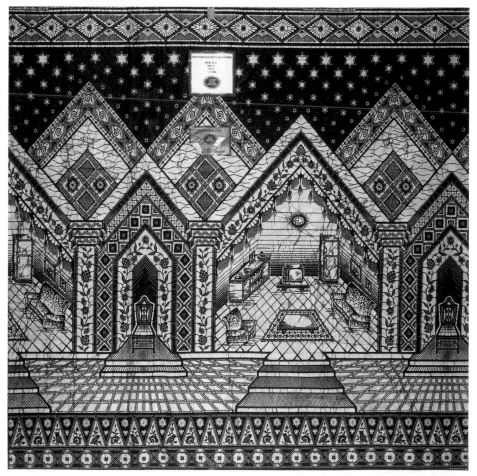

Fig. 22.4. Machine-printed cloth commemorating the 1939 Accra earthquake, Ghana, 1939. Cotton with wax resist; 9¾ x 4 ft. (2.9 x 1.2 m). Samuel P. Harn Museum of Art, University of Florida, Gainesville (2002.31.9).

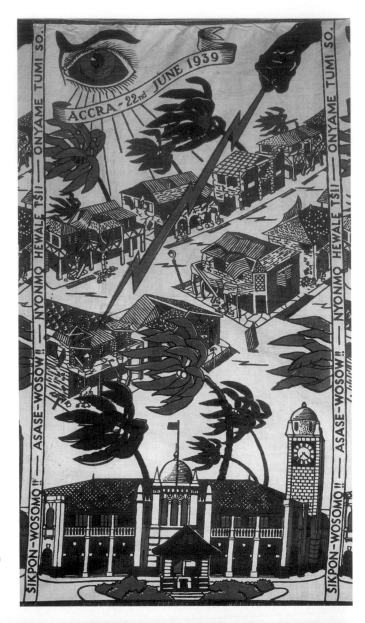

Fig. 22.5. *Adire* cloth with a *Jubilee* pattern, Lagos, 1960s. Cotton, indigo dye, starch resist; 33⅛ x 80¼ in. (84 x 204 cm). Division of Anthropology, American Museum of Natural History, New York (90.2/6698).

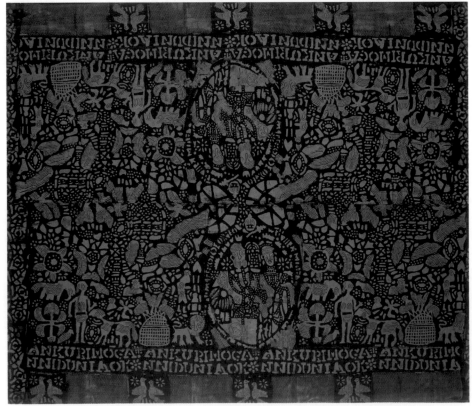

African printed textiles often include images of notable persons, events, or objects. Commemorative cloths have been popular in Africa since the early twentieth century. Like the Fante *asafo* flags with appliqué images associated with international events (see fig. 16.10) and the Fon appliqué cloths from Dahomey celebrating various rulers (see fig. 16.12), these commemorative cloths encode messages, record history, express group affiliations, and mark major events such as elections, visits of famous persons, and the installation or death of a political leader.

One of the earliest printed cloths to honor a political leader dates from 1929 and pictures Asantehene Nana Prempeh I (1870–1931) of Ghana, five years after his return from exile. Another cloth commemorated a 1939 earthquake in Ghana (fig. 22.4). In the colonial period, images of European rulers, including Queen Victoria and Elizabeth II, were common, but by the mid-twentieth century, when independence movements were underway, textiles and clothing with images of African political leaders became more common. Recent commemorative cloths and T-shirts have been decorated with images of African statesmen, such as Nelson Mandela, as well as visiting foreign dignitaries, such as U.S. presidents Bill Clinton, George W. Bush, and Barack Obama.

Another example of a commemorative textile is the Yoruba indigo resist-dyed *Jubilee* cloth. First made in Nigeria in 1935 to celebrate the Silver Jubilee of Britain's King George V (r. 1910–36) and Queen Mary, the pattern was revived in the 1960s when indigo dying, which had begun to decrease, experienced a revival in the wake of Nigerian independence (1960). The example shown here (fig. 22.5), made in the 1960s in western Nigeria, features a central medallion of the king and queen, surrounded by lions, birds, and winged horses, derived from a popular print of *al buraq*, the horse that carried the Prophet Mohammed from Mecca to heaven. While the base cotton is machine made, the design and its execution are done by hand. The pattern is applied with cassava starch paste with some parts drawn by hand and other parts stenciled. Once the paste is applied, the cloth is submerged in deep blue indigo dye. *Jubilee* cloths are just one example of *adire* cloth, in which patterns can be made by either tying the cloth or applying starch or candle wax to define resist areas.

In Kenya, a type of printed cloths known as *kanga* was first made in the nineteenth century when people would stitch together six imported cotton handkerchiefs. The form gradually developed into rectangular cloths used for skirts, blouses, and head ties. The earliest *kangas* were printed in India and Japan, but today they are made primarily in Kenya, Tanzania, and China. *Kanga* designs feature a border surrounding a central area; they often include Swahili sayings in the Latin or Arabic characters. From the 1950s, geometric motifs, portraits of political figures, and objects such as shoes, cups and saucers, airplanes, and corporate logos, appeared on many *kangas* replacing the fruit and floral motifs of earlier days. More recently, *kangas* have been used by development organizations to garner support for causes like AIDS/HIV prevention and family planning. "Mother's Milk is Sweet," for

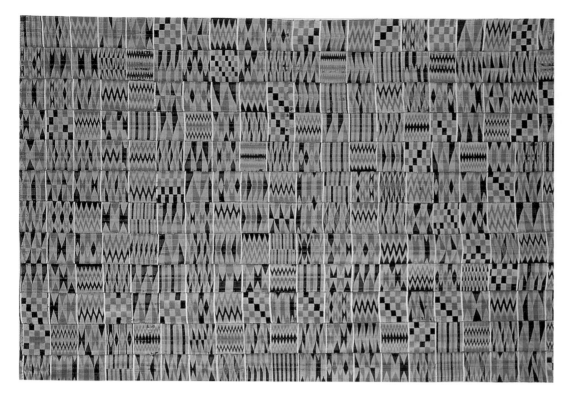

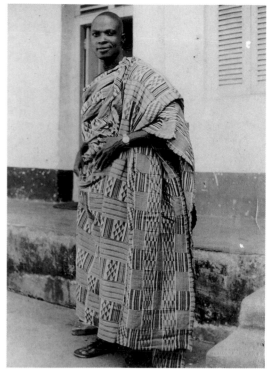

example, is found on a cloth distributed by the NGO (Non-Government Organzation) Massbreastfeeding.org. Other sayings relate to more personal themes—"My heart is yours," or "I have no secrets but I have an answer."

ENDURING TEXTILE TRADITIONS

The production of printed cloth for African markets highlights the intersection of global trade and African tastes. At the same time, certain long-standing textile traditions have become stronger as they serve new purposes as markers of cultural identity. Weavers among the Asante and Ewe (who live in southern Ghana and Togo) continue to make *kente* cloth as they have done for several centuries. It is still highly valued and worn on important occasions, from family ceremonies to presidential inaugurations. Both Ewe and Asante cloths, made by men on narrow strip looms, are distinguished by the use of supplementary weft inlays which allow the weavers to create intricate designs and add texture to the woven cloth. On the most elaborate royal examples of Asante *kente*, the entire cloth is covered with delicate geometric motifs. Ewe weavers, in contrast, often incorporate images of recognizable objects such as turtles, keys, umbrellas, or combs into their work; the first known example of this type of cloth dates from the mid-nineteenth century.

Silk threads in vibrant colors—obtained through trade with China and sometimes by unraveling Chinese silks—greatly expanded the color palette and design repertory of weavers. On a silk Asante *kente* cloth thought to have been made in the 1920s, a red accent floats across a rich field of rhythmically complex patterns in yellow, blue, green, black, and white (fig. 22.6). This pattern is known as *oyokoman adweneasa*, with *adweneasa* meaning "full of ornament" or "I have exhausted all of my skills" and *oyokoman* referring to the founding lineage of Asante rulers and designating the warp-stripe pattern, which, in this example, consists primar-

ily of wide, red stripes. In the past, silk *adweneasa* were reserved for the Asantehene and his close associates.

In the 1940s, the weaver Kwaku Neyeh made a predominantly blue silk *kente* cloth (now in the American Museum of Natural History), which he wore in a photograph taken in 1947. He has draped the cloth over one shoulder and wrapped it around his body in the customary way (fig. 22.7). The pattern name, *Adjirivirinsu* (literally, "small animal walking in a river"), makes a reference to a snail, perhaps alluding to the long, slow labor involved in weaving the cloth.

The colors of many *kente* cloths—red, green, black, and gold—became associated with African liberation movements in the second half of the twentieth century and, at the same time, for African Americans, it came to symbolize their links to the African continent. For this external market, and for many nonroyal Asante who cannot afford silk, *kente* is made using cotton and rayon. In addition, the patterns of Asante weavings are sometimes replicated on machine-made printed cloth or reproduced in weavings made on wide vertical looms. Such looms are used by women in parts of Nigeria but not by male weavers in Asante or regions to the north where narrow strip weaving originated.

Another type of African textile that has achieved widespread recognition outside Africa is the Malian cloth known as *bogolan,* or *bogolanfini,* sometimes called "mud cloth" in the West (fig. 22.8). When made by hand, the process begins with locally grown cotton, first spun by women, and woven by men on a narrow strip loom. Six or seven strips are then sewn together, edge to edge. Older women often undertake the dyeing process, which begins by soaking the cloth in a bath of dried, pounded, and boiled leaves that turn the cloth yellow. (The yellow is later treated to make it lighter.) With a small iron spatula, the dyers apply a pigment, consisting of highly concentrated and fermented mud, in geometric motifs to render them dark brown, while the areas without pigment remain light.

Fig. 22.6. *Kente* cloth, Asante, Ghana, probably 1920s. Silk; 38½ x 55½ in. (97.8 x 141 cm). High Museum of Art, Atlanta (2004.166).

Fig. 22.7. Asante weaver Kwaku Neyeh wearing one of his own silk *kente* cloths, Kumasi, Ghana, 1947. Division of Anthropology Archives, American Museum of Natural History, New York (1997-11).

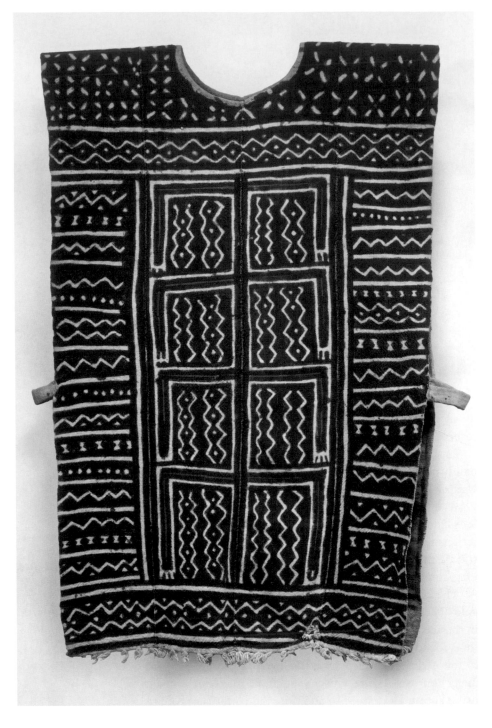

Fig. 22.8. *Bogolan* tunic, Bamako, Mali, 1930s. Cotton, vegetable dye, fermented mud pigment; 31½ x 23¼ in. (80 x 59 cm). Musée du quai Branly, Paris (71.1934.106.12).

In the courts of Hausa and Fulani emirs in present-day northern Nigeria, embroidered garments are considered "robes of honor" and are stored in the palace treasury. To mark the beginning and end of Ramadan, the emir, elaborately garbed, rides on horseback in parade. Robes with sparkling arabesque designs, voluminous embroidered trousers, and turbans made of brightly colored or indigo-glazed cloth—worn by the emir, his attendants, and other aristocrats—produce a dazzling display, matched by an equally stunning kaleidoscope of equestrian adornment including colorful saddle blankets with complex leather appliqué and silver horse trappings (see fig. 16.5). Such displays date to the early nineteenth century when Fulani horsemen conducted a series of *jihads* to reform and take over governance of the Hausa states.

Sumptuous robes have long been treasured throughout West Africa, handed down from one generation to the next. The form of the Muslim prestige robe dates at least to the fourteenth century based on descriptions of the Malian King, Mansa Musa. The flowing robes feature wide sleeves, a slit neckline, and large front pocket on the left side. These robes are elaborately embroidered by men, although women embroider hats and horse coverings. The work begins with a designer sketching out the patterns, using a pen made of a guinea-corn stalk and ink or white chalk—or in recent times a ballpoint pen. Following the lines of the design, the embroiderer begins with the large pocket, continues to the right front, and finally moves to the back of the cloth. Sometimes several embroiderers collaborate on a single robe which can take weeks to finish.

The dense spiral designs on prestige robes have practical and protective functions. The embroidery strengthens the neck and pocket of the gown while symbolizing the path of spiritual revelation toward a divine center. The ample sleeves generally extend beyond the wearer's hand and are draped over the shoulder. During the first decade of the twentieth century, a British colonial visitor to Northern Nigeria described how a local leader turned up his sleeves, layer by layer, to reveal a rainbow of colors, with a light green cape embroidered with silver lace, and robes of sky blue, pink silk, dark blue silk, and crimson silk, all topped with a white silk robe. Wide embroidered trousers fastened at the waist with a drawstring are worn underneath.

The cloth itself was usually woven from handspun cotton, in plain white or dyed indigo, but some robes were made from handspun beige wild silk or imported magenta-colored silk. This palette gradually expanded to include a wide range of fibers and dyes. By the 1970s, Lurex, a synthetic element used for metallic fibers then being imported into Africa from Japan, entered the West African design repertory, not least because West African aesthetics placed a high value on radiance and shininess. Apotropaic properties—power to deflect evil—were sometimes ascribed to the sparkle of luminous surfaces, such as highly polished metals, mirrors, and shimmering textiles.

Prestige robes were exchanged across a broad geographic region in West Africa. A robe belonging to a Muslim Mossi chief in Ghana (the Mossi are originally from Burkina Faso

The motifs on *bogolan*, which often refer to real objects, also function as medicines or mnemonic devices for moral precepts and historical facts. *Bogolan* was felt to have protective properties. In the past, only Bamana women dyed the cloth and used it as a form of protection in specific ritual contexts, such as excision and first intercourse. Hunters also wore shirts made of this cloth, sometimes covered with amulets.

Beginning in the 1990s, new techniques, forms, and meanings have brought *bogolan* to international markets. Like the Dogon *kanaga* mask discussed below, however, it remains a symbol of Malian identity. It has also become a valuable commodity in global trade. *Bogolan* motifs are sometimes printed on machine-made fabric marketed in the West. Like *kente* cloth, *bogolan* continues to have rich local meanings, even when the form has been adapted to modern techniques, materials, uses, and markets.

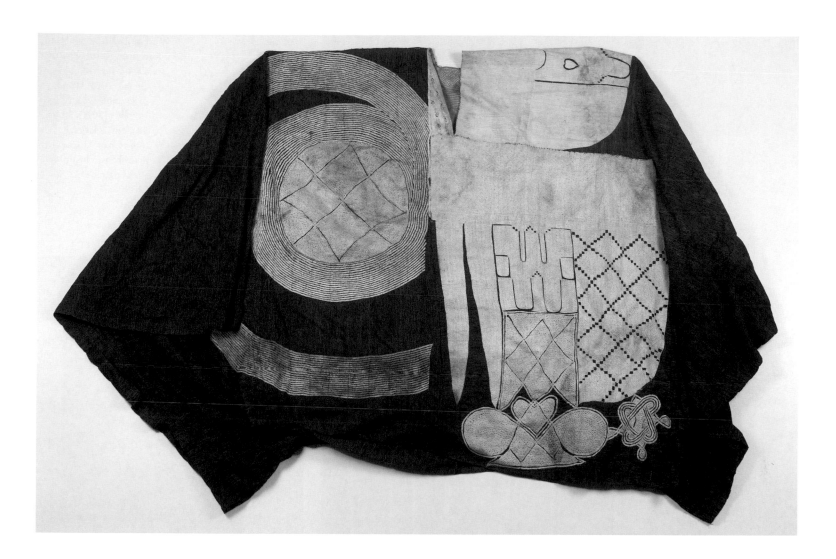

but many live in Ghana) was passed down through three gen-
erations (figs. 22.9, 22.10). Made of strips of hand-spun
indigo-dyed cotton, it was embroidered in elaborate patterns
that evoke Islamic talismans and magic squares, designs that
incorporate calligraphy and, specifically, the name of Allah
written in many ways.

MADAGASCAR SILK

In the island nation of Madagascar, woven textiles were used
for shoulder cloths, baby carriers, gifts, and, when made of
silk, burial shrouds. The term *lamba* refers to cloth in gen-
eral, both the silks discussed here and cotton cloths similar to
the *kangas* of East Africa. The most prestigious Madagascan
cloth, *lamba akotofahana,* is associated with the Andriand-
rando clan of the Merina people. Until the early nineteenth
century, when sericulture was introduced, pre-dyed silk thread
used for such textiles was purchased from Arab and Indian
traders. Indigenous weaving flourished and then almost dis-
appeared in the late nineteenth century.

There has been a revival of Merina silk weaving in the
twentieth century, in part the result of a weaving studio,
Lamba Sarl, founded in the 1990s in Antananarivo, the capi-
tal, by Simon Peers, a British art historian living in Madagas-
car. The Lamba Sarl weavers make silk cloths inspired by
nineteenth century examples found in the British Museum.
In the past most weavers were women, but today men also
make these intricately patterned textiles. The weavers work

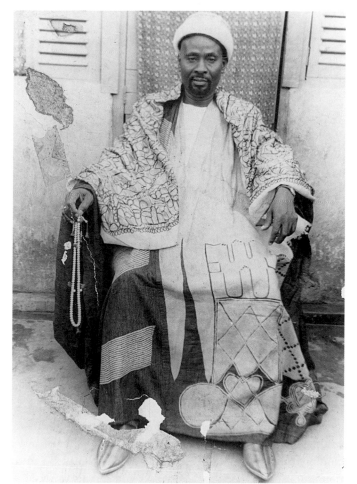

Fig. 22.9. Prestige robe
of the Mossi chiefs of
Kumasi, Ghana, early
20th century. Cotton,
indigo dye, silk
embroidery; 51⅛ x
119¾ in. (130 x
304 cm). Division of
Anthropology, American
Museum of Natural
History, New York
(90.2/8936).

Fig. 22.10. Mossi chief
Alhaji Abdul Rahman in
the prestige robe shown
in fig. 22.9, Kumasi,
Ghana, c. 1960. Division
of Anthropology
Archives, American
Museum of Natural
History, New York
(1997-11).

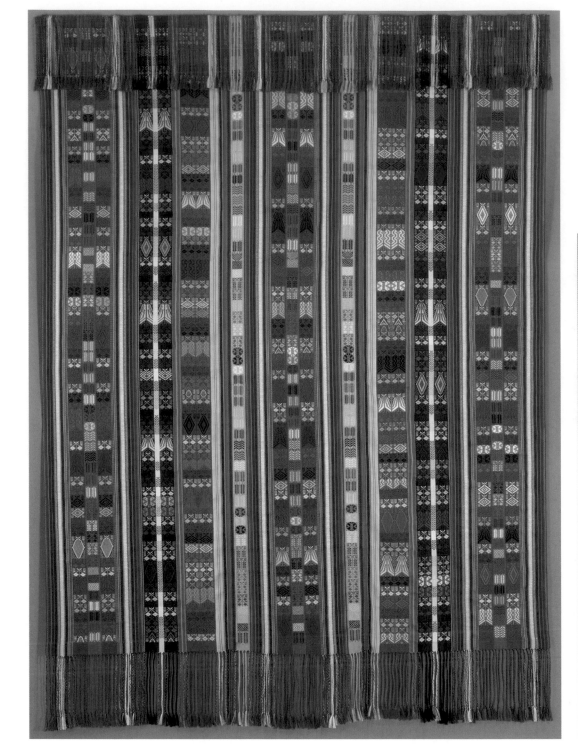

Fig. 22.12. Samuel Narh Nartey. *Nokia Cell Phone Coffin*, Teshi-Nungua, Ghana, 2007. Wood, paint, cloth; 71 x 23 x 14½ in. (180.3 x 58.4 x 36.8 cm). National Museum of African Art, Smithsonian Institution, Washington, D.C. (2009-3-1).

Fig. 22.11. Martin Rakotoarimanana. Ceremonial mantle (*lamba mpanjaka*), Lamba Sarl workshop, Antananarivo, Madagascar, 1998. Silk; 108 x 70⅛ in. (274.3 x 178.1 cm). The Metropolitan Museum of Art (1999.102).

on horizontal looms, using extra heddles to create raised brocade patterns, as seen in the example illustrated here, which was created in 1998 by Martin Rakotoarimanana (b. 1963), a member of Lamba Sarl (fig. 22.11).

CLOTH, CARVING, AND THE FUNERARY ARTS

In many parts of Africa, funerals take place over a relatively long period, the exact length of time varying from culture to culture. Burial rites are usually followed by a series of ceremonies to complete the disposition of the deceased's soul. Ceremonies to honor the dead were, and remain, occasions for considerable expenditure and for creativity in dress, performance, and practices associated with mourning.

Objects relating to these rites include cut-pile embroideries made by Kuba people (see fig. 16.20) and Asante *adinkra* cloth (see fig. 16.12). Among the Merina in Madagascar, red *lamba mena* (burial cloth) plays an important role in the ceremony called *famadihana,* during which the Merina exhume bones of the dead and celebrate their ancestors. The bones are cleaned, wrapped in new shrouds, and reburied in family tombs.

An example of how traditions shift in accordance with wider cultural changes can be seen in a new type of wooden coffin introduced the 1950s, in southern Ghana, among the Ga-speaking people. In Teshie, a fishing community near

Accra, Ghana's capitol, an enterprising and imaginative carpenter, Kane Kwei (1924–1992), created a coffin for his grandmother in the form of an airplane. Making coffins that responded to a person's accomplishments, aspirations, and dreams resonated with many people, and coffins were made in many forms: a cocoa pod for a cocoa farmer, a fish for a fisherman, as well as cars, airplanes, bibles, and a gun. As with other wooden coffins, the interiors were lined with shiny fabrics, and sometimes contained mirrors and bouquets of plastic flowers. Kane Kwei went on to train apprentices, many of whom opened their own shops. While most of the coffins were made for burial, some—such as the one shown here, made by Samuel Narh Nartey—were created for museums and collectors (fig. 22.12).

Masks play an important role in the funerary rites of many African people. Mask dances are customarily performed by men, even when the masks and associated costumes represent women and animals. There are some notable exceptions such as the Mende women Bundu dancers of Sierra Leone. Among the Dogon people in Mali, about two years after the burial of an important person, men who have been initiated into the mask society perform for a period of two weeks. The dancers usually make the wooden masks themselves, and wear them with an assortment of raffia skirts, ruffs, vests, indigo pants, and other accessories associated with the specific mask. The dances and accompanying rites, some of which are performed in secret, are meant to send the souls of the dead to the next world. While these postburial ceremonies (*dama*) are performed as an important part of funerary practice, Dogon dancers have also created versions of mask performances for tourists in Mali and abroad.

Dogon funerary masks have changed over time. Animals such as the lion have now disappeared from the region, and lion masks are no longer used. New masks have been made to represent policemen, tourists, and even visiting anthropologists. When the Dogon perform *dama* for funerary ceremonies the masks are new or freshly painted and may incorporate shiny objects like aluminum foil from packaging and strips of tin from food containers such as sardine cans. When performing for tourists, however, the Dogon wear masks that omit any signs of modernity and often have faded colors, qualities mistakenly associated by some outsiders as a sign of authenticity. The writing on the mask shown here (fig. 22.13), collected in 1998, identifies the dancer by name, and demonstrates that the maker has been to school.

THE BUILT ENVIRONMENT: SECULAR AND RELIGIOUS

Some striking examples of Africa's enduring yet changing traditions are associated with the built environment. In the late twentieth and early twenty-first centuries, depending on economic circumstances, many people moved to one-family houses or modern apartment buildings. The very poor, however, continue to live in inadequate structures, often assembled from found materials. In rural areas, people continue to fashion homes in time-honored ways, from local materials

such as mud brick and various grasses. Some distinctive forms of traditional architecture have thus persisted through the twentieth century, surviving either because they are well suited to the landscape and environment or because they are associated with religious or ceremonial practices that remain vital to local culture.

Patterns applied to plastered mud walls in northern Nigeria and Niger, for example, resonate with the aesthetic vocabulary of the embroidered decoration on men's robes. Cities and towns in this part of West Africa are composed of a maze of sun-baked clay structures and narrow alleys. The buildings, sometimes several stories high and very large, are built by specialist masons. The most elaborate homes, mosques, and palaces in the Sahel region of West Africa are labyrinths of interconnected round and square rooms with interior courtyards; wooden beams support vaulted ceilings and archways, and raised plasterwork and paintings decorate

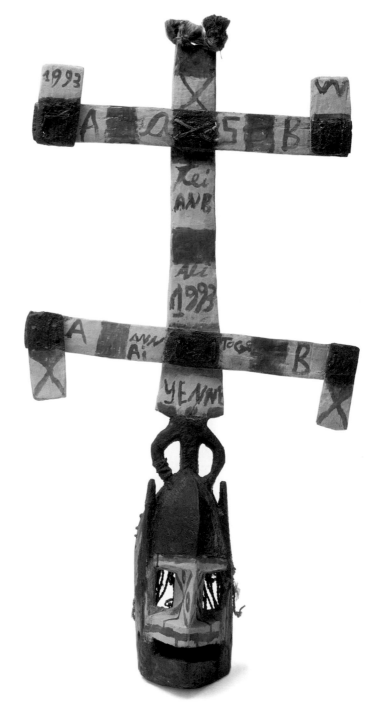

Fig. 22.13. *Kanaga*-type funerary mask, Dogon, Mali, collected 1998. Wood, paint, fiber; 39⅜ x 19¼ in. (100 x 49 cm). The Horniman Museum and Gardens, London (1999.1).

building surfaces. As on men's robes, the patterns on the walls of a Hausa home are often derived from Islamic designs including magic squares and calligraphic script. The entire mud brick facade of the Bicycle House in the town of Zaria, northern Nigeria, designed by Jibril Dan Abubakar in the 1940s, for example, was decorated with hand-molded low relief designs (fig. 22.14). To give the entrance portal special focus, Islamic patterns were centered above the doorway, but among these older motifs were carvings of a bicycle and a car—1940s symbols of modernity. In predominantly non-Muslim communities in west and central Africa, sculptures of humans and animals hold up roofs, adorn lintels, and decorate building facades.

In 1989 Dogon villages on the Bandiagara cliffs in Mali were designated as a UNESCO World Heritage site, while continuing to be homes and religious sites for Dogon people. Many architectural elements here are well-adapted to the climate, landscape, and the cultural values of the inhabitants.

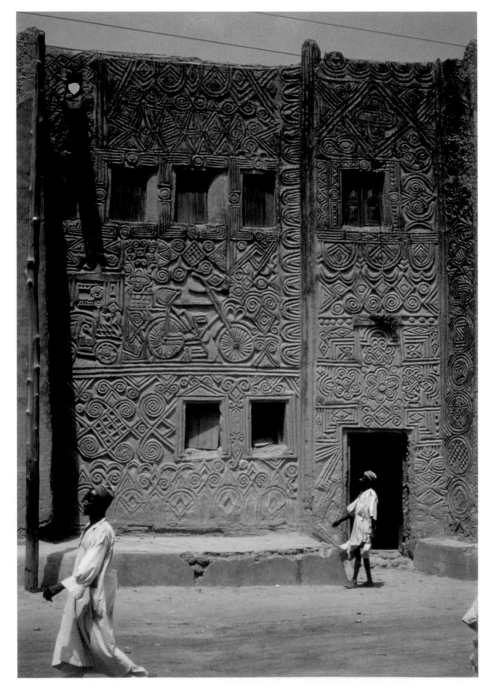

Fig. 22.14. Jibril Dan Abubakar. Facade of the Bicycle House, Zaria, Nigeria, designed in the 1940s. Frank Willett Papers, University of Glasgow Library (ACCN 3120/31).

These include carved wooden doors and door locks, sculpted columns that hold up the roofs of open air shelters, known as *toguna* (and used only by men), and the notched logs that serve as ladders to the roofs and terraces where people congregate, sleep, or store grain.

In Ghana, traditional Asante buildings and religious shrines are embossed with cement reliefs of the *adinkra* symbols that are also found on textiles, pottery, woodcarving, and gold work, thus integrating these structures into a wider readily recognizable aesthetic. Among the Fante in southern Ghana, the meeting houses of men's *asafo* associations in the twenty-first century continue to be embellished with life-size sculptures of people, ships, and animals.

In eastern Nigeria, Owerri Igbo sculptors make life-size figures to honor deities, particularly Ala, the goddess of the earth, which are displayed in shrines known as Mbari. These sculptures were not meant to be permanent monuments, but rather ephemeral creations that would return to the earth as offerings. As many as seventy-five sculptures in a single shrine showed people (including images of Europeans in the colonial period), animals, Mami Wata (the half mermaid, half human deity popular in Nigeria and the Congo), items of food, and household objects. In the 1930s tin roofs replaced thatching, making the Mbari shrines somewhat more permanent, but after the Biafran war in the 1960s, many of them fell into disrepair. Since the late twentieth century, there has been a revival of interest in building and maintaining these shrines. New sculptural forms, now made of cement, serve more as a testament to Igbo creativity, cultural identity, and memory than as offerings to the gods.

Architectural sculpture remains important in western Nigeria, where one of the most prominent carvers, Olowe of Ise (c. 1873–1938), made doors and columns for the palaces of Yoruba kings. Olowe frequently mixed traditional and modern object types—spears or crowns with modern elements such as cars and bicycles. He also made chairs, stools, bowls, drums, and other personal and ritual objects, commissioned by rulers and wealthy Yoruba. The relief carvings on a magnificent door carved by Olowe for the royal palace in Ikere, Nigeria, depict the 1901 reception of Captain Ambrose, the British Commissioner of Ondo Province, by Aàfin Ogògà of Ikere (fig. 22.15). This Yoruba king, wearing a beaded, conical crown, is seated on a Western-style folding chair as the captain is carried toward him on a litter held by two porters. This door was displayed in 1924 at the British Empire Exhibition which was held in London, in which the African pavilion was modeled on the northern Nigerian walled city of Zaria. After the close of the exhibition, colonial officials wanted to purchase the door, but the Yoruba king refused to sell it. He eventually agreed to exchange it for an English throne, while commissioning a replacement copy of the door from Olowe.

Masonry and woodcarving are usually the province of men in Africa, but women often paint bold and beautiful wall murals on their homes (fig. 22.16). Such painting tends to connect with women's other artistic practices. Among the Igbo people in eastern Nigeria, women paint the facades of their homes with curvilinear drawings known as *uli*, similar to the designs they apply to the faces and bodies of young

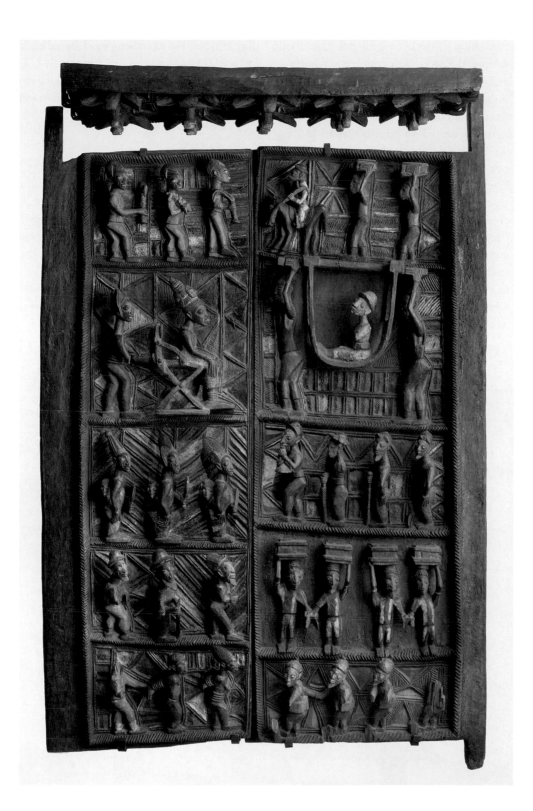

women who are about to be married. Ndebele women in South Africa also paint murals on their homes and make beaded aprons that they wear for marriage ceremonies and special occasions (fig. 22.17). Both the walls and the aprons are covered with bold blocks of bright color, often incorporating geometric images of houses, a tradition that is now waning. Faced with harsh economic realities, many Ndebele women now make beaded dolls, aprons, and blankets for tourists.

For much of the century, the furnishings of most African homes, particularly in rural areas, consisted of a variety of hand-carved wooden chairs or stools, storage chests, beds, headrests, a variety of ceramic, metal, fiber, or gourd containers, and textiles of many kinds. Hausa women in Nigeria

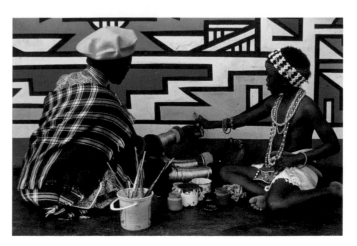

Fig. 22.16. Renowned Ndebele artist Franzina Ndimande shares her knowledge with a student, Nomsa, South Africa, 2000.

assemble dowries consisting of cloth, cooking pots, and food containers which, before the twentieth century, were often made from ceramics, basketry, and delicately incised gourds, each of which had a unique design. In the twentieth century, however, these handmade containers were sometimes replaced with glassware, possibly acquired on pilgrimages to Mecca, and imported aluminum bowls, often made in China, covered with floral designs. A woman's collection of bowls, teapots, and dishes, called *kayan daki* (things of the room), remained her property after marriage, a form of wealth that could ease widowhood or divorce and be passed on to her daughters.

In southern Africa, in addition to baskets and pottery, wooden headrests, spoons, and containers, some with figurative carvings of animals on their lids (made by Lozi carvers in present-day Zambia), were treasured possessions. A Zulu spoon from South Africa carved in the form of a female figure

(fig. 22.18) might have been exchanged between families during wedding arrangements. The motif of raised dots on the back of the spoon's handle, called *amasumpa*, represents a herd of cattle, formerly an essential part of a woman's dowry.

CERAMICS

Relatively inexpensive, practical, and durable, handmade pottery continues to be used throughout Africa for cooking, brewing beer, storing water, serving food, or making offerings to deities or ancestors. In ritual contexts, pots are often placed on altars, and in many cultures a broken pot is left on the grave after burial.

Pottery is nearly always made by women, who learn their skills from their mothers. Most pots are made by coiling

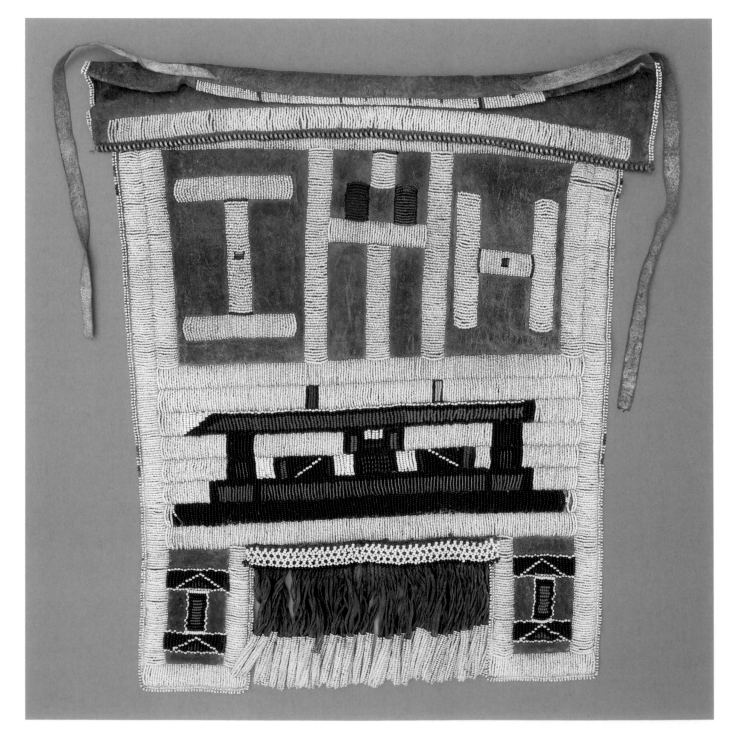

Fig. 22.17. Ceremonial apron, Ndebele, South Africa, 20th century. Hide, beads, brass, cotton fiber; 21⅞ x 19⅝ x 1⅝ in. (55.5 x 49.8 x 4 cm). The University of British Columbia Museum of Anthropology, Vancouver (2790/5).

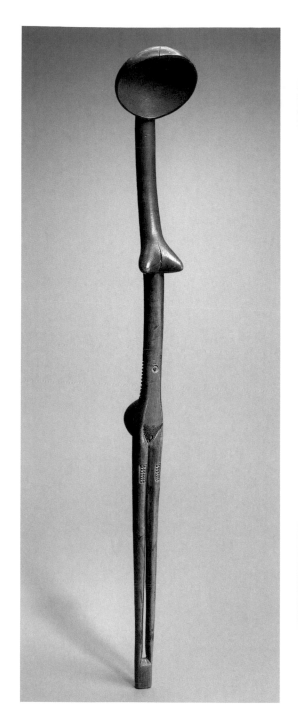

Fig. 22.18. Spoon, Zulu, South Africa, late 19th–early 20th century. Carved wood; L. 21½ in. (54.5 cm). Musee du quai Branly, Paris (71.1977.52.14).

Fig. 22.19. Vessel, Lozi, Zambia, early 20th century. Burnished clay, pigment; H. 12 in. (30.5 cm). Division of Anthropology, American Museum of Natural History, New York (90.0/804).

pieces of clay into pot forms and then smoothing the surface. Another method used by Mande potters in West Africa involves pressing a slab of clay into a concave indentation made in the earth and then gradually building the spherical form with increments of clay. Whether coiled or pressed, the vessels are fired in the open air resulting in vessels with porous walls that can withstand dramatic temperature changes. Such pots keep water cool through evaporation from the surface, and are also suitable for cooking. Potters often embellished their wares with designs that evoke the female body (see fig. 16.28). Some pots have breasts, others have designs that suggest the umbilicus, and still others bear marks resembling scarification.

Shells, combs, sticks, and pebbles are used to create designs on the surface. African potters do not use glazes—except in urban North Africa where men make pottery using high temperature kilns. When potters wish to achieve a shiny surface,

they burnish the pots by applying slips before firing or by applying a pigmented plant-based solution immediately after firing. In the early twentieth century, Lozi potters made beautiful red and black burnished jars (fig. 22.19).

In most cases, when men worked in ceramics in Africa, it was primarily to make pots with figurative sculptures. As with terracotta sculptures of human figures or heads (see fig. 4.3), such pots are made for ritual purposes, generally to be placed on shrines or altars. An Igbo pot from Nigeria, for example, supports a group of human figures, perhaps representing a single family (fig. 22.20). Placed on an altar during a harvest festival, it represented a plea to the deities for fertility of crops and humans.

In northeastern Congo and southern Sudan, especially in the early twentieth century, figurative pots sometimes featured the hairstyles and elongated heads of Mangbetu women (see fig. 16.22). A woman sometimes made the vessel, often

decorating it with incised designs and raised dots. but a male sculptor would then sculpt and attach a head to the basic form. These figurative pots were made in the early twentieth century as prestige items, collected by local dignitaries and given or sold to foreigners.

Neither the potter's wheel nor the electric kiln is used in sub-Saharan Africa. During the 1940s, however, British potter Michael Cardew (1901–1983) introduced students in what is now Ghana and Nigeria to these technologies, but ultimately without success. Lack of consistent supplies of electricity, problems with clay unsuited to high-temperature firing, and insufficient demand for glazed Western-style tableware doomed the projects. Ladi Kwali (c. 1925–1984), already a well-known African potter, learned from Cardew how to throw pots, but she preferred to hand-build them in the manner of traditional water pots.

Kenyan-born Magdalene Anyango Odundo (b. 1950) learned traditional pottery-making techniques in Nigeria and Kenya and studied at the Royal College of Art in London. Now a British citizen, she builds her pots with the coiling technique, achieving a smooth satin finish in deep reds and blacks with slips and burnishing (fig. 22.21). Like many forms of African pottery, her work often relates to the human body. She sometimes includes small bumps that evoke the scarification patterns she saw and admired as a child, and the elongated necks of some of her works, although abstract, suggest the elongated hairstyles and head shapes that appear in the more literally rendered Mangbetu pots.

Fig. 22.21. Magdalene Anyango Odundo. Two vessels, England, 2009. Earthenware; left, H. 19½ in. (49.5 cm).

RECYCLING AND APPROPRIATION

African artisans have long appropriated materials from every available source—from British woolen army blankets and Chinese silks unraveled for their threads and then rewoven into African textiles, to metal basins and coins melted down and recast into sculptures, ornaments, and new kinds of containers. Shells, buttons, bullet cartridges, and mirrors have been incorporated into a wide variety of objects. Chinese and European pottery has been strategically set into the walls above the doorways of houses. This continued in the twentieth century, when great quantities of Western second-hand clothing, plastics, and other scrap material entered the repertory of African decorative arts in new and ingenious ways.

Recycling often involves serendipitous innovation in the appropriation of objects and materials. Sometimes an object enters its new cultural home in the interstices of the rules, in the visual and conceptual space left for personal preference and "style." Other times the co-opting develops from a perfect fit between the found material and the aesthetic or symbolic need of the maker. When a Turkana man in Kenya decided to use a dappled red reflector from a car to make dangles for his earrings, he cut them in a traditional Turkana shape, an elongated trapezoid. Even the most adventurous recyclers, such as the Wodaabe (Fulani) of Niger, who are highly eclectic in the foreign items they integrate into their work, pursue an aesthetic governed by strict syntactical rules. Safety pins, zippers, and keychain pulls, when used to decorate a skirt, are integrated into a checkerboard pattern similar to the juxtaposed blocks of color in West African weavings. Whatever their reasons for selecting items from the pool of recyclables, artisans across Africa confront the flotsam and jetsam of the industrialized world with a predisposition born of their own belief systems.

Decisions about appropriation and the use of recycled objects also depend on context. Certain found objects may be used in ordinary dress to signify aspects of personal status.

Maasai elders use blue pen caps, for example, to signify membership in particular age groups. Other objects may fit special occasions, as in the elaborate Ode-lay costumes that are worn in masquerades in Freetown, Sierra Leone. Christmas ornaments, fake pearls, upholstery fringe, plastic flowers, and mirrors, most purchased new and not strictly recycled, are reconstituted into new assemblages of personal adornment.

Perhaps the most significant recycling is the global distribution of used clothing. Millions of tons of used clothing are sold in bales from the United States and Europe to Africa and elsewhere in the world. This generates income for thousands of distributors, middlemen, and sellers, both in and out of Africa. Critics claim that these imported castoffs suppress the development of local clothing manufacturing industries, but many people in developing countries cannot afford new clothing, even when locally made. When such industries are located in developing countries, the clothes are usually exported, perhaps to return eventually as second-hand clothing. The clothing—called *bruni wawo* (dead white peoples' cloth) in Ghana—is sorted, sold, and then tailored to local tastes, refashioned into garments that fit into the local sense of appropriate dress. These tastes change rapidly and vary regionally, but for the most part refashioned garments have little relationship with changing styles in the West.

Many recyclers work at home or in open-air markets. A large sprawling market called Suame Magazine in Kumasi, Ghana, is devoted to recycling old cars and trucks. Little goes to waste; from disassembled seats, steering wheels, and gear boxes, to gas tanks, pistons, and just about everything else. Mechanics, some of whom were trained in European car and construction companies operating in Africa, reassemble these parts into working vehicles, but they are also used to make other useful things: children's swing sets, furniture, windows, shoes, and cooking pots. Elsewhere in the market people specialize in reworking cell phones, computers, air conditioners, and refrigerators and making useful objects from salvageable parts.

Throughout Africa recycled material is commonly used to fashion ornaments, souvenirs, and toys. Not only are new materials reworked in old forms, but new industries incorporating industrial discards have grown up specifically for tourists. These consumers from postindustrial societies are repurchasing their own recycled items transformed into "ethnic" toys and ornaments. In a workshop in Senegal for "street children," eleven-year-old girls learn to make purses and dolls out of unraveled cassette tapes and plastic bags, while boys make wire cars (fig. 22.22), airplanes, and empty eyeglass frames. Children all over Africa have always made their own toys—cars from palm stalks, for example—but the making of wire toys has become a business that can help support a family. Similarly, in Mali, Dogon children made miniature masquerade figures from the colored foam from flip-flops.

African basket makers often incorporate found materials, while usually honoring well-known functional forms, as in a footed Gambian basket (fig. 22.23). This example follows a traditional coiled form, but the basket maker used cut-out pieces of plastic bags to create the multicolored triangular patterns. In Senegal, imported supplies of flour, onion, corn,

and rice arrive in sacks made of different colors of an industrially produced material such as Tyvek. Basket makers carefully unravel the sacks and substitute the threads for, or use in addition to, raffia palm, as the wrapping material in coiled basketry mats. These beautifully patterned mats continue to be used to cover large gourd bowls filled with milk and grain (fig. 22.24) and also serve as gifts and wall decorations next to family photographs. In South Africa, baskets are being made entirely of new materials such as copper wire and colored plastic-covered telephone wire. Men began using telephone-wire in basketry, but today women also make baskets with this material. Telephone companies supply craft workshops, and such baskets have become an important source of income.

From these few examples, it is clear that plastic is perhaps the most important recycled material in the late twentieth and twenty-first centuries, especially for jewelry. Borana jewelers in northern Kenya use it as enamel in cloisonné work. They make the cloisons, or cells, from melted cooking pots and fill them with melted plastic. Maasai men, who traditionally do not participate in making any of the decorative arts (that being considered women's work), often work in secret, melting lumps of discarded plastic and shaping them into pendants to form spiral ear ornaments. Synthetic industrial waste is often cheaper and easier to obtain than natural materials, such as shells or ivory. Exotic objects often have to be taken apart and reworked to be useful. Some imported materials were introduced as deliberate substitutes by Europeans. In the colonial period, Bakelite, an early plastic developed

around 1907, substituted for copal and amber, other plastics for conus shells and ivory, and glass beads for seeds and shell disks. When imported glass beads became scarce or too expensive, they were made locally by crushing and melting down bottle glass. Bead makers have also developed techniques of adding color to clear glass and making beads that juxtapose ribbons and drops of different colored glass from recycled bottles. These beads are African-made versions of the trade beads that were formerly imported into Africa from Italy and Czechoslovakia.

The substitution of one material for another, especially if one is rare or costly, has been practiced for centuries in cultures around the world. In northern Mali and Nigeria, straw jewelry designed and made by women, and known as "Timbuktu gold," replicates the designs of real gold jewelry, with intricate filigree patterns. Tuareg silversmiths make jewelry from melted down coins as well as from locally mined silver. Recycled materials also can save artisans hours of labor and provide practical solutions to everyday needs. Shoes made from recycled car tires are easy to clean and repair. Inner tubes are used to make buckets for lifting water out of wells. Flat beads for stringing into necklaces and bracelets are made from recycled plastic phonograph records, cut into disks in the same way ostrich egg-shell disks were made in the past. Machine-made buttons and glass and plastic beads also substitute for these labor intensive ostrich egg-shell disks, which were made and used by the !Kung and San in Botswana in headbands, belts, and tortoise shell cosmetic containers, like this !Kung example with a powder puff made of soft fur (fig. 22.25).

Fig. 22.22. Wire car, ENDA workshop (Environmental Development Action in the Third World), Dakar, 1997. Wire, rubber; 7⅞ x 17⅜ x 7¼ in. (20 x 44 x 18.5 cm). Division of Anthropology, American Museum of Natural History, New York (90.2/9100).

Fig. 22.23. Basket, Gambia, 2001. Palm fiber, recycled plastic bags; Diam. 14 in. (35.6 cm). Museum for African Art, New York (2006.07.02).

Fig. 22.24. Ramata Sy. Basketry mat, Boundaum Est, Senegal, 1998. Grass, Tyvek plastic threads; 1⅛ x 16 x 16 in. (3 x 40.5 x 40.5 cm). Division of Anthropology, American Museum of Natural History, New York (90.2/9069).

THE CONTEMPORARY SCENE: INTO A NEW CENTURY

The rich traditions of African design have inspired some of Africa's most prominent contemporary artists as well as African fashion and furniture designers who work in an international context. African and European printed fabrics, like those discussed earlier in this chapter, figure prominently in the work of Yinka Shonibare (b. 1962), MBE (Member of the British Empire). Shonibare, who was born in London but grew up in Nigeria, mines the intermingled European and African histories of "Dutch" wax prints to explore themes of wealth, colonial commodity production, power, excess, memory, desire, and seduction. Romauld Hazoumé (b. 1962) from the Republic of Benin uses plastic jerricans and other repurposed materials to make sculptures that evoke African masks. His work, too, is a comment on the long history of trade and interaction between Africa and the global economy, as well as on the West's tendency to fetishize African religious objects (in this case masks) as art. Recent work by the Ghanaian-born artist El Anatsui (b. 1944), who lives and works in Nigeria, includes shimmering wall sculptures made out of the metal neckbands and caps from liquor bottles (fig. 22.26). He uses these and other found objects because the materials are readily available in Africa and have historical and cultural associations. Neither Hazoumé nor El Anatsui describe their work as "recycling," but both men stress the need to work with local materials. As seen throughout this chapter, however, what is local often has deep historic connections to global patterns of trade and cultural interaction.

African fashion and furniture designers, some with formal academic training and some not, have acquired an international clientele beyond their African roots. Many of them also draw on what they see as an African aesthetic, juxtaposing materials, patterns, and colors in ways that update African design to be relevant in new contexts. Fashion designer

Fig. 22.25. Powder puff and cosmetic case, !Kung, Botswana, before 1971. Tortoise shell, fur, ostrich shells, leather; case, 5⅝ x 4 in. (14.4 x 10 cm). Division of Anthropology, American Museum of Natural History, New York (90.2/6139).

Fig. 22.26. El Anatsui. *They Finally Broke the Pot of Wisdom*, Nsukka, Nigeria, 2011. Aluminum liquor-bottle caps, copper wire; 15½ x 23 ft. (4.7 x 7 m).

Duro Olowu, for example, Nigerian-born and now London-based, works with surprising combinations of bold colors and patterns pieced together in unexpected ways in his signature women's wear. Furniture designer Cheick Diallo of Mali has created sinuous chairs and chaises from nylon cord, and similarly Senegalese designer Bibi Seck and his Turkish-born partner Aysa Birsel produce colorful chairs made out of plastic. The plastic, like the colored strips from a local mat factory used in Senegalese baskets or the telephone wire used in South African baskets, is not necessarily recycled, but represents a new use for an inexpensive industrial material, sometimes produced in African factories. Under the trademark Deconstruction:Reconstruction, Birsel+Seck have also created a line of *Taboo* stools (that also serve as tables), a contemporary version of Africa's iconic seating form, which are made in Senegal from 75 percent recycled garbage bags and

plastic bottles. They are used in the cafe at the Museum of Modern Art/P.S.1. A number of marketing collaborations have grown up to promote the work of these and other designers working in Africa.

Many contemporary African designers invoke "traditional" African forms, but adapt them to contemporary tastes and international markets. The word "tradition," however, must be used with care, because as noted above, traditions are always changing and being reinterpreted. In Africa, as elsewhere, designers and craftspeople are continually updating their practices as they draw upon what is useful from the past and adapt it to the present. Furniture and fashion designers, jewelers, architects, potters, and others, are mining and transforming Africa's rich heritage as their work spirals out from local and regional contexts to national and global arenas.

ENID SCHILDKROUT AND CAROL THOMPSON

EUROPE AND THE AMERICAS

Fig. 23.23

INDIGENOUS AMERICA: NORTH

For many people in North America, which here refers to the United States and Canada, the twentieth century began with bright optimism. Quality of life was on the rise, immigration and industry boomed, universal prosperity was an imaginable dream. But the story for Native Americans—at least at the start of the century—was dramatically different. The last of the "Indian Wars" between the United States Army Cavalry and Native Americans on the Plains in 1890 was followed by several decades of brutal ideological, economic, and legislative repression in which the Canadian and United States governments sought to fully assimilate Indigenous peoples into settler society. Government administrators, missionaries, and politicians believed that the only way Native Americans could survive in a modern world was to reject their culture and language: "Kill the Indian in him, and save the man," said Captain Richard H. Pratt, the influential superintendent of the Carlisle Indian School in Pennsylvania.[1] Many ceremonial dances and gatherings, such as the Ghost Dance on the Plains and the Potlatch along the Northwest Coast, were outlawed in the late nineteenth century, while land allotment programs and treaties alienated tribes from their traditional lands, forcing people into confined areas and boarding schools, and imposing systems of outside governance. The first two decades of the twentieth century were some of the most painful chapters in Native–settler relations, and populations of Native North Americans declined to an all-time low.

Yet in the early twentieth century, public attitudes toward Indigenous North Americans were shifting. American Indians were enfranchised in 1924, and new policies, such as the 1934 Indian Reorganization Act, or "Indian New Deal," reinforced a variety of new Aboriginal rights. In Canada, conditional voting rights were granted to First Nations people in 1920 (provided they give up their Indian status—a provision removed only in 1960), and a 1939 Supreme Court ruling recognized and reinforced the government's obligations toward the Inuit. Many of these gains, slight as they were, proved short lived: for much of the twentieth century, the attitudes and policies toward Native peoples in North America swung, pendulum fashion, among cultural affirmation, social reform, and outright assimilation. In the context of this ever-changing backdrop, Native peoples slowly gathered strength and laid some of the groundwork for the activism of the 1960s. The design and crafting of objects, as well as the wider visual and material culture, played a vital role in the ongoing political and cultural reawakening that continued from then until the present.

Since the mid-nineteenth century, Native crafts (typically beadwork, basketry, quillwork, hunting implements, and Northwest Coast carvings) had been exhibited as ethnographic artifacts at national and international exhibits. Wider marketing efforts to sell contemporary Native crafts remained underdeveloped, mostly restricted to local curio shops, mail-order companies, and roadside trading posts near tourist destinations. By the start of the twentieth century, as efforts to market Native American crafts grew more professionalized and systematic, Native artisans made unprecedented inroads into the fledgling commercial arts-and-crafts markets across the continent. This was due to the promotional efforts of the enterprising and creative artisans themselves, as well as of a variety of non-Native patrons (often affluent and socially progressive East Coast European American women philanthropists), Arts and Crafts societies, and mission or boarding schools. With greater frequency, marketers began to promote the aesthetic value of works by named individuals—the basket makers Mary Benson (1878–1930, Pomo) and Louisa Keyser (Dat so la lee, 1835–1925, Washoe), and the potter Nampeyo (1859–1942, Hopi) were among the first—whereas in the past, Native crafts were appreciated for their ethnological or historic value.

The greater visibility and admiration for the products of Indigenous craftspeople reflected changing public attitudes following the end of the Indian Wars of the nineteenth century. No longer seen as a "threat" to colonial expansion, Native regalia, designs, and objects were widely appropriated for nationalist or commercial purposes within settler society. But the repackaging of Native crafts was also tied to a much broader valorization of handicrafts in the early twentieth century. The desire for handmade articles to decorate the home was a response to the proliferation of cheap, factory-made goods of industrial modernity. Interest in the handmade—Native-made or not—was influenced by the sense of alienation citizens felt as they moved in increasing numbers out of the countryside and into bustling modern cities. For many collectors, Native crafts evoked a more exotic America, and at other times fed nostalgia for the frontier or longing for an apparently simpler way of life.

The greater appreciation of Native crafts began in the opening years of the 1900s through the efforts of artists and writers associated with the American Arts and Crafts movement who celebrated the aesthetic, formal, and technical qualities of Native American designs in magazines such as *The Craftsman*, *Brush and Pencil*, *Handicraft*, and *The Studio*. After World War I, a number of museums and private entrepreneurs found novel and exciting ways of promoting Indigenous crafts. The Santa Fe Indian Market, established in 1922 as an "Indian Fair and Industrial Arts and Crafts Exhibit," became one of the main hubs for Native crafts in the United States, attracting tourists, progressive collectors, and craftspeople to the arid Southwest for a festival-like celebration of

Fig. 23.1. Beshthlagai-ithline-athlsisigi (Slender-Maker-of-Silver). "Squash blossom" necklace, Arizona, c. 1885. Silver, turquoise; L: 17 in. (43.2 cm). Wheelwright Museum of the American Indian, Santa Fe (2007.28.1).

styles that blended uniquely Native symbols, meanings, and styles with "outside" materials, artistic formats, and techniques. This type of work, which came to prominence in the 1920s, was especially suited to those skilled in two-dimensional design. The Southwest hide painters and ledger draftsmen Stephen Mopope (1898–1974, Kiowa), Fred Kabotie (1900–1986, Hopi), and Harrison Begay (1917–2012, Navajo), for example, translated their graphic talents to wall murals, easel-style oil and tempera painting, and printmaking using Western materials and modern techniques. Working with non-Native cultural intermediaries—Oscar Jacobson, Elizabeth DeHuff, and Dorothy Dunn, who helped them break into the art world—they invented novel styles of modern Indian painting, which paved the way for the efflorescence of contemporary Aboriginal art in the latter half of the century. Among their many accomplishments, they helped situate Native graphic traditions in a living present rather than the distant, mythic past.

The growth of Indigenous contemporary arts and handicrafts in many media over the twentieth century has been phenomenal, and has mirrored the empowerment of Native American peoples more generally. The Santa Fe Indian Market has today become the largest Native crafts festival on the continent: drawing more than 100,000 people from around the globe and attracting thousands of artisans from over 100 different tribes; it brings an estimated $100 million to the region. Managing and developing the billion-dollar Native crafts economy has involved various levels of government, from the Indian Arts and Crafts Board, created in 1935 during the Depression as a federal agency in the U.S. Department of the Interior, to tribal councils or band associations across the continent, as well as private corporations, Indigenous cooperatives, museums, and local cultural centers. American and Canadian federal agencies have attempted over the years to address the proliferation of fakes or non-Native-made objects marketed as genuine "Indian" ones. Various attempts to legislate, trademark, and brand have met with some success in addressing this problem, but these efforts also raise wider issues that continue to be debated by practitioners, critics, scholars, and curators about "authenticity," long-established art and design traditions versus modern ones, and the reification of Native styles.

This chapter presents several historical vignettes that offer a variety of interwoven and sometimes seemingly contradictory leitmotifs that can be found in other historical and cultural contexts throughout much of the twentieth century: the presence of revivalist ideals and the idealization or romanticization of premodern craft typologies and styles in the marketing of Indigenous crafts; the frequent use of Native American crafts in promoting a distinct national culture; the recognition that Indigenous arts share "affinities" with modern art (which itself had a problematic fascination with "primitive" non-Western traditions of art and design). One thing holds true for each of the examples that follow: Native craft and design is a living, breathing tradition. As it was throughout the entire twentieth century, craft continues to be an important arena in which Indigenous identities are shaped, contested, invented, remixed, and reappropriated. From this perspective, craft has played a role in the decolo-

Native culture aimed at preserving and reviving older design and craft traditions, authenticating works, and establishing fair prices for artisans.

By the 1920s, major art institutions were experimenting with new exhibition contexts to position Native-made objects more as "fine art" than craft. In 1927, the National Gallery of Canada hosted the *Exhibition of Canadian West Coast Art: Native and Modern*, which placed Northwest Coast carvings and weavings alongside paintings by the contemporary Canadian painter Emily Carr (1871–1945). In the United States, notable art gallery exhibitions of Native crafts included *Indian Tribal Arts* at the Grand Central Art Galleries (1931) in New York City, and, as the United States entered World War II, the blockbuster *Indian Art of the United States* at the Museum of Modern Art (MoMA) in New York (1941), which validated the aesthetic power of Native craft while positioning it patriotically as the first truly American art.

As the categories of Native craft, art, souvenir, and ethnographic artifact shifted and blended in provocative ways, a number of Indigenous craftspeople began to work in Western artistic formats thus producing transcultural contemporary

nizing process by providing continuity with the past, a degree of financial independence, and culturally affirming creative narratives for the future.

JEWELRY MAKING AMONG THE NAVAJO AND HOPI

Jewelry and body adornment have long been part of Native American life. Often with a spiritual or ritual function, jewelry fashioned out of stone such as turquoise, along with copper, ivory, shell, and nut, were worn as marks of beauty and prestige, used as shamanistic tools and charms, and viewed as symbols of identity and family. In the twentieth century, silver jewelry from the American Southwest flourished. Made specifically for the secular craft markets, silver work became one of the most economically and artistically important examples of living Native American design and craft traditions.

Sources of twentieth-century silver jewelry can be traced back to eighteenth-century Spanish prospectors who established silver mines in what is now Arizona. They also brought with them the practice of silversmithing. After the United States gained administrative control over the territory in the 1850s, the silver boom that followed brought an influx of American mining companies and entrepreneurs. In the 1860s, Navajo silversmith Atsidi Sani (c. 1830–c. 1918) was the first Native American to gain recognition for his finely decorated belt buckles, stirrups, bolos, pins, and rings. Initially using melted American and Mexican silver coins, and later silver "slugs," he employed a simple hammer-and-file technique to create fine and detailed work with basic and sometimes makeshift tools—hammer, punches, files, and stamps. A dedicated teacher, he passed the craft on to many other Navajo men, such as Slender-Maker-of-Silver (d. 1916) and his son, noted silversmith Fred Peshlakai (c. 1896–1972), who carried the tradition into the twentieth century (fig. 23.1). Silversmithing fanned outward to Zuni and Hopi pueblos, and by the 1890s, spurred by entrepreneurs of the tourist industry, southwestern jewelry grew more elaborate with the inlay of turquoise and other semiprecious stones. In 1920, there were 8 silversmiths at Zuni pueblo; by 1938, there were 90, and by 1958, there were roughly 1,000 out of a population of just over 3,500.

Over the course of his remarkable career, Charles Loloma (1921–1991), the most influential Native American jewelry maker of the twentieth century, established a diverse and cosmopolitan network of artistic mentors and patrons, many of whom were luminaries of modern art, design, and architecture. Loloma's father was an accomplished weaver who raised his son to be attentive to beautiful design as well as to his Hopi heritage. While studying at the Phoenix Indian School in the late 1930s, the young Loloma met Lloyd Kiva New (1916–2002), the enterprising and successful fashion designer and teacher of Cherokee descent. New inspired Loloma to pursue the arts and introduced him to the architect Frank Lloyd Wright, who in turn strengthened Loloma's desire to blend contemporary and modern artistic elements with his Native identity. While studying painting in Phoenix,

Loloma's talents were spotted by the Kiowa artist Fred Kabotie, who invited Loloma to paint Native-themed murals for the Golden Gate International Exposition in San Francisco in 1939, which included an exhibition of contemporary Native crafts and design. This brought Loloma into the orbit of the exhibition's organizer, René d'Harnoncourt, then the general manager of the Indian Arts and Crafts Board. Kabotie again enlisted Loloma to assist in the creation of a mural at d'Harnoncourt's next major exhibition *Indian Art of the United States*, at MoMA in 1941. (D'Harnoncourt would become director of MoMA in 1949.)

Loloma began to make silver jewelry in the mid-1950s, after moving from the School for American Craftsmen at Alfred University in New York to Lloyd Kiva New's crafts center in Scottsdale, Arizona. Loloma sometimes used Hopi symbols in his jewelry, but he also pushed in new directions inspired by abstract sculptural forms, the concept of massing as seen in Modernist buildings, and the abstract visual qualities of random stone textures. Loloma's breakthrough pieces came in the 1960s, reputedly after seeing couture garments by Oleg Cassini (1913–2006), a French-born American designer, with their minimal though dramatic simplicity, bright colors, and refined elegance. Loloma's signature "height" bracelets were so-called because they comprised long slabs of strikingly colorful inlay—turquoise, lapis lazuli, coral, fossil ivory, exotic woods, and other colorful stones such as malachite, charoite, and sugilite—that rose from the surface of the bracelet (fig. 23.2). Each piece was composed and crafted with great attention to form and balance. In the case of a bracelet, for example, the stones were weighted to rest along the inner curvature of the arm and accentuate the line to the shoulder. Such pieces helped establish Loloma's reputation as a jeweler of the Southwest, and by the 1970s, as major museums began to hold solo exhibitions of his work, he was considered one of the most accomplished jewelers in the United States. His influence continues into the present through artists such as Verma Nequatewa (b. 1946) and Eveli Sabatie, a Moroccan jeweler who apprenticed with Loloma in about 1968–72.

Fig. 23.2. Charles Loloma. *Height* bracelets, Arizona, c. 1975. Left, 14-kt gold, wood, fossilized ivory, coral, lapis lazuli, turquoise, jade; Diam. 3½ in. (8.9 cm). Right, 14-kt gold, lapis lazuli, turquoise, coral, wood. Private collections.

century, an era described in the accompanying catalogue as the "golden age" of Northwest Coast art, covering the period from roughly 1850 to 1920. In framing the late nineteenth century this way, it reflected the dominant ways in which anthropologists, collectors, and museum curators viewed the changes in arts and crafts along the Pacific Coast of North America.

According to this historical narrative, the high-water mark in the late nineteenth century—a "classic" phase—was followed by a three-decade "decline" that began in the 1920s, brought on by earlier smallpox epidemics that ravaged populations as well as the federal government's enforcing of the Potlatch ban (1884–1951), which restricted the production and use of dance paraphernalia. The Potlatch, a communal feast at which wealth is redistributed through extensive gift-giving, was seen by the federal government as being a hindrance to assimilation and antithetical to the Christian capitalist values it was trying to impart. Openly defied until 1919, the government took steps to enforce the ban through the late 1920s by prosecuting Potlatch participants and confiscating their dance paraphernalia. After World War II, the Potlatch law was repealed and there was a cultural "renaissance" along the Northwest Coast; to quote again from the catalogue *Arts of the Raven*, artists "rediscovered and revived" the grand style of art made by their ancestors from the nineteenth century, prior to its descent into tourist art.

Within the last twenty years, however, scholars, artists, and Aboriginal critics have increasingly challenged this narrative—golden age, decline, and rebirth—by critically examining how the narrow Western concepts of "authenticity" have helped define a canon of Northwest Coast art, effectively excluding or downplaying in significance many early twentieth century woodcarvers such as Ellen Neel (1916–1966), Willie Seaweed (1873–1967), and Mungo Martin (1879–1962), all of whom had careers coinciding with the ban. It is important to be critically reflexive about "authenticity" when considering how to narrate history with discourses of artistic "revivals."

Just such narratives have been woven into the public perception of Bill Reid, who is credited with spurring the rebirth of Haida carving in the 1950s. Born in Victoria, British Columbia, to mixed-descent parents (a Scottish-German father and Haida mother), Reid was pressured by his father to assimilate into settler society. He grew up with little knowledge of his Aboriginal ancestry but slowly began to learn more about his heritage in his late teens and twenties. After taking a jewelry course in 1948 while living in Toronto and working as a radio announcer, Reid begin to integrate Haida designs and symbolism into his work, inspired in part by the large Haida house poles and other carvings he saw in urban museums and anthropology books. In 1950, he established a jewelry workshop in Vancouver and saw firsthand the work of the famed Haida master jeweler and carver Charles Edenshaw (1839–1920)—one of those "classic" carvers venerated by collectors and curators who was active at the turn of the twentieth century.

Reid regarded Edenshaw as a preeminent Haida artist whose work captured the brilliance of the totem-pole and mask carvers of the early contact period. Like Reid himself,

Edenshaw was by no means an enclaved artist unaffected by outside forces and stimuli. Having lived through the progressive intrusion of outsiders, the transition to Christianity, and the imposition of external systems of authority, Edenshaw took advantage of the growing tourist and anthropological interest in Haida carving by translating the formline style found on the monumental carvings of his ancestors into smaller-scale carving for personal adornment, museum display, and home decoration. Having carved several major ceremonial house poles for families on Haida Gwaii, Edenshaw gradually explored new materials (such as precious metals) and exploited new object types (such as earrings, brooches, bracelets, finger rings, and miniatures) for museums and the home. These new types of objects were especially important for Edenshaw's immediate successors—Neel, Seaweed, and Martin—during the Potlatch ban in the 1920s, when ceremonial carving went underground—and others who became dependent on the tourist market for economic survival.

In time, Reid became recognized not as a tourist artist but as a modern Aboriginal artist who synthesized his past with the present. This came about after he became involved in totem-pole restoration projects with the Royal British Columbia Museum and the University of British Columbia, the latter of which erected a totem-pole park on its campus in the 1950s. There was a resurgence in, and growing appreciation of, contemporary Northwest Coast carving after the Kwakwaka'wakw carvers Neel and Martin were commissioned to restore poles that had been brought to the university campus from village sites to the north. Reid joined the teams of anthropologists and Aboriginal carvers who traveled along the coast to study, collect, and restore decaying poles. In 1958, both Reid and Northwest Coast carver Doug Cranmer (1927–2006) began to design, carve, and raise brand new poles on the campus, setting in motion the public "revival" of Northwest Coast carving. For Reid, this snowballed into major commissions and exhibitions at Expo '67 in Montreal (1967) and *Arts of the Raven* at the Vancouver Art Gallery (1967), both of which were watershed exhibitions that positioned Reid as a contemporary artist. Thereafter, the reemergence of "traditional" Northwest Coast carving became an entrenched part of the national mythology in Canada.

Reid extended the principles of Haida design and woodworking skills while reinterpreting Haida design within a contemporary artistic sensibility, one that appreciated naturalism and abstraction (fig. 23.5). Whereas classical Haida imagery is characterized by the principles of containment and control, which give the impression of various visual elements—mythological creatures and ovoid or U-forms, principally—being locked together in perpetual tension on a single plane, Reid broke with long-standing convention by allowing creatures to step into the audience's world. Creating gold and silver pendants, bracelets, brooches, and containers, as well as large- and small-scale carvings in wood, plaster, and bronze, Reid played with the restrained energy found in the work of his ancestors while striking a new balance between containment and freedom.

Other talented artists and craftspeople along the Northwest Coast, such as Davidson and James Hart (b. 1952; great-

CEREMONIAL DRESS FOR THE POWWOW

The contemporary powwow is an intertribal social gathering involving dance, drumming, song, and celebration, and varies in size from several dozen to several thousand people. Its origins are not clear, but its modern form can most likely be traced to the ceremonial grass dances of the Pawnee, which were introduced to other tribes such as the Lakota and Kiowa on the southern Plains, and then spread through the northern Plains to the Omaha and eventually the Algonquian-speaking people of the Great Lakes and Northeast. In the early twentieth century, as the powwow diffused across North America (with the exception of the Arctic), it came to incorporate local clothing styles, dances, stories, and ceremonies.

While American and Canadian governments sought to repress many ceremonial and religious dances in the late nineteenth century by banning their performance, powwows became an acceptable form of public gathering and dance that eventually attracted sizable non-Native audiences who viewed these celebrations as a popular entertainment, like Buffalo Bill's Wild West tours or traveling medicine shows. As the size of the audiences grew, powwows became increasingly spectacular, with the addition of more elaborate dances, pageantry, fancy clothing, and colorful regalia. When bans on religious dances were lifted after World War II, powwows adopted more spiritual overtones (and honored returning war veterans, a tradition that continues), but they did not shed their entertainment value. Growing larger in scale and more formalized, intertribal powwows flourished in the 1970s as highly competitive festivals expressing pride in Native American traditions and identities that attract professional and semiprofessional dancers, dressmakers, drum-

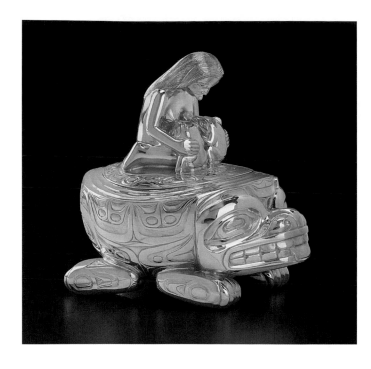

great grandson of Charles Edenshaw), had significant success in the fine-art world beginning in the 1970s. In the 1990s, clothing designer Dorothy Grant (b. 1956) began to incorporate Haida designs into the world of contemporary retail fashion by offering her own product lines of jackets, scarves, sweaters, ties, and handbags, which combine industrially produced natural and synthetic materials, Western clothing formats (such as t-shirts and zippered, collared jackets), and appliquéd or screen-printed Haida imagery. Today, Grant's product lines include opulent silk, as in a coat she designed with artist-carver Robert Davidson (fig. 23.6).

Fig. 23.5. Bill Reid. *Haida Myth of Bear Mother*, British Columbia, 1972. Gold; 2⅞ x 2¾ x 2 in. (7.3 x 7 x 5.2 cm). Canadian Museum of Civilization (VII-B-1574 a-b).

Fig. 23.6. Dorothy Grant. *Eagle Sleeve Coat*, Vancouver, 1989. Motif design by Robert Davidson. Wool, silk, beads, snaps; L. 48½ in. (123.2 cm). Burke Museum of Natural History and Culture, University of Washington, Seattle (1999-12/1).

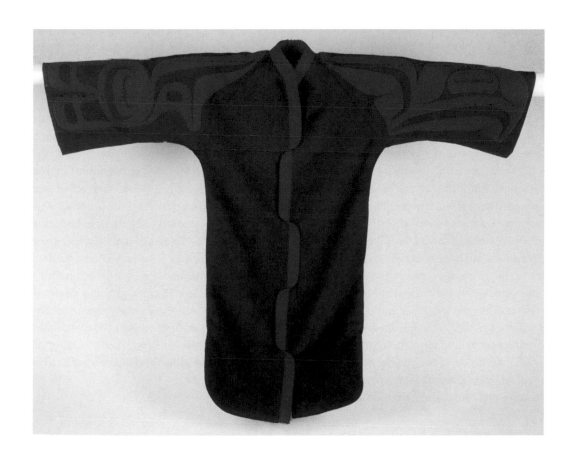

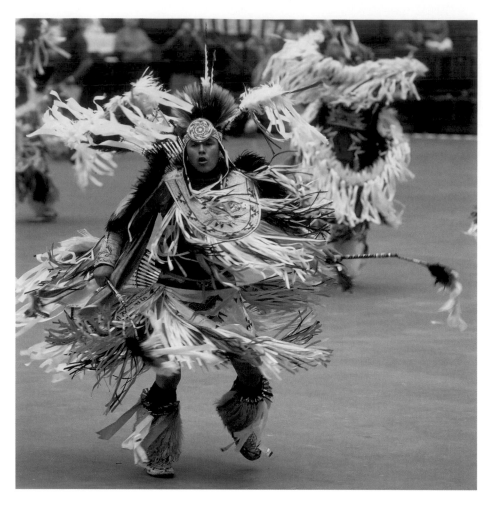

Fig. 23.7. Spike Draper performs in the Fancy dance competition, Red Earth Festival, Oklahoma City, 2011.

from a worn-out garment, and resewn onto a new one, while new additions might be made from synthetic fabric or in intense neon colors. As powwows have grown in size and attracted an increasingly diverse roster of participants, many of the more popular designs have become "intertribal," borrowed by one and all, and reflect no particular affiliation. New styles and variants are constantly invented or rediscovered every year, as local and regional identities are shaped and reshaped by new designs.

The men's Fancy dance, for example, is a dance competition judged on a combination of dress and dance. Bright, dazzling, and carefully color-coordinated, the garments are crafted to bounce, flow, clack, and chime in harmony with the dancer's movement and footwork (fig. 23.7). Regalia typically includes a feather bustle (a round or semicircular arrangement of feathers worn on the back), headdress or "roach" (a crownlike cap of tied porcupine hair or feathers named after the arched back of a fish), spreader (to maintain the splayed shape of the roach hairs), belts, armbands, cuffs, headbands, breastplates, aprons, chokers, and moccasins, all of which may be decorated with intricately colored beads in shocking neon effect, that contrast oranges and bright yellows. Objects used to accentuate the dancers' movements include fans, symbolic shields, dance sticks, hoops, whistles, and scarves. Assembled individually by each dancer over many years, and acquired piece by piece at powwows, trade fairs, or crafts shops, a dancer's regalia is typically the product of many makers, reflecting his unique aesthetic choices as well as the makers' skills, both in traditional beading and garment construction and in the use of new materials.

mers, and singers, all vying for sizeable prizes and honor as they showcase their talents in large stadiums, dedicated arenas, parks, reserves, and campuses. The powwow circuit has become a major opportunity for Native-made "crafts" to receive wide exposure and sales, as well as a place to share traditional craft techniques and inspire others to explore new materials and design approaches.

There are different categories of powwow dances, each with their own prizes, for men and women, as well as a corresponding style of dress and regalia. A powwow begins with a blessing and the majestic Grand Entry, when the master of ceremony invites all dancers into the dance arbor or arena for the first time, following a procession of flags and eagle feathers. Resplendent in their colorful, impressively decorated regalia, the dancers sway and jump to the beat of the drum and song as they proceed past the audience. The competitive dancing includes categories such as Traditional dance, Fancy dance, Grass dance, and Jingle dance, as well as a variety of special (nonprize) dances, such as hoop- or social-dancing, among many other regional and seasonal variants.

Dancers are judged not only on their technique but also on the style, quality, and overall impression of their regalia, and are penalized if part of their regalia or dress falls off. Thus, dancers invest a great deal of time, thought, and money into the design and making of their outfits. Some special pieces, such as a beaded decorative strip on a deer hide backing, may be passed down through the generations, removed

By the end of the twentieth century, while important changes had taken place, Native American decorative arts continued to reflect long-standing craft and design traditions. Through the tumult of the colonial encounter, they provided an important continuity with the past as well as a means by which people creatively responded to their changing worlds. The world will, of course, continue to change—as will contemporary Indigenous artisans. In the twenty-first century, artisans young and old are embracing digital technologies to produce and market their wares, as well as to share their creativity and ideas. While remaining locally engaged, Indigenous artisans in North America are becoming increasingly global in their influence and outlook, and more active as curators, entrepreneurs, and critics. Like other artisans, they will continue to create work that challenges the boundaries between fine art and the decorative arts, and between fine art and crafts, embracing the latest advances in materials, and exploring cultural and artistic identities on the world stage. To that end, versions of craft, art, and design will continue to play a vital role in the larger process of decolonization, the healing of the trauma caused by assimilation efforts, while enhancing public understanding and appreciation of the diverse cultural values and histories of the Indigenous people of North America.

NORMAN VORANO

INDIGENOUS AMERICA: SOUTH

What did it mean to be indigenous and modern in Latin America in the twentieth century? Did it mean to speak an Amerindian language within a world of Spanish or Portuguese speakers? Did it mean to live in an isolated rural community rather than a town? A photograph taken in the early 1930s by Martín Chambi (1891–1973)—himself a native Quechua speaker—suggests something of the complexities (fig. 23.8). *Brothers, Cuzco, Peru* is a posed studio portrait, made in an important indigenous center and the former capital of the Inka empire. Four men stand stiffly facing the camera, hats in hand. Three brothers wear woven caps and belts and handmade shoes. Their shirts, of factory-made cotton, reveal the circulation of manufactured commodities. The clothing of the fourth brother, the robes of a Franciscan friar, resonates not only with references to the colonial period, which saw the Roman Catholic Church established in Latin America, but also to the continued influence of that institution in indigenous communities: such garb was well known in the Andean highlands in the 1930s.

At the time of the photograph, *indigenismo*, an ideological and political project dedicated to the promotion of indigenous ways of life and socio-economic improvement, and embraced especially by writers and artists in Peru from the 1930s to the 1940s, was thriving. Chambi, who often took pictures of native people, ran a well-established studio, which, between 1921 and 1936, gained recognition through participation in exhibitions, including *Motivos Andinos* (Andean themes, 1927) held in Lima, Peru, and *Motivos del Cuzco* (Cuzco Themes, 1936), in Santiago, Chile. A product of technologies and artistic practices closely associated with "the modern," this image invites contemplation of "tradition" while blurring any dichotomy between the two by suggesting their coexistence. The twentieth-century present, for many indigenous communities and urban residents, was marked by continuities in the use of materials and technologies, as well as an embrace of new things and new modes of production, markets, and patrons. Chambi's portrait is poignant because, deliberately or otherwise, it evokes precisely those dualities.

Information about indigenous production and consumption across the twentieth century is uneven. Scholarly knowledge has been shaped by research projects spaced many decades apart, by discussion with indigenous craftspeople at particular moments in time, and by collections. Motivations behind the forming of collections have ranged from a desire to "save" aspects of "true" indigenous cultures before they disappeared in the face of "modernity" (often described as the "salvage paradigm") to nationalist ambitions. Personal aesthetics and preferences of individual collectors have also played a role. It is therefore sometimes difficult to trace precisely when new practices began or when others faded in importance. From 1900 to 2000, indigenous people in Latin America—as elsewhere in the world—increasingly relied on everyday goods made outside the parameters of indigenous craft and design traditions. The availability (and affordabil-

Fig. 23.8. Martín Chambi. *Brothers, Cuzco, Peru*, 1933. Archivo Fotografico Martín Chambi, Cuzco.

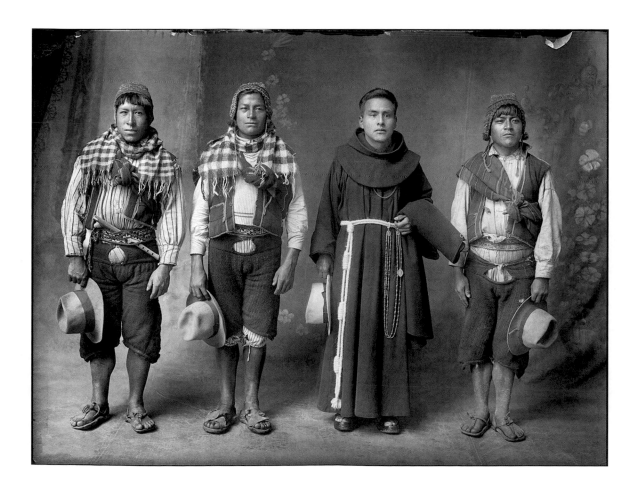

ity) of plastic dishes, aluminum pots, steel shovels, and velvet skirts shifted older patterns of consumption and creation. Indigenous people and communities responded to such shifts in a variety of ways, and therefore simplistic interpretations of the period as one marked by "loss" of indigenous identity and autonomy simply do not hold. From Mexico to Chile, handcrafted objects did not disappear but rather more often served the desires and needs of people living outside the immediate community in which it was produced. In what follows, we consider both the variety of materials used across the century and, where possible, discuss objects well represented in private and public collections in Latin America, the United States, and Europe.

TEXTILES AND GARMENTS

Textiles continued to be produced and continue to hold pride of place in the visual and material cultures of many indigenous communities in Latin America. When the Guatemalan human-rights activist Rigoberta Menchú Tum accepted her Nobel Peace Prize in 1992, she wore the *traje* (garment), traditional indigenous dress of Maya women: a skirt of *ikat* fabric held with a woven belt, a *huipil* (draped length of cloth; see fig. 18.8), a *rebozo* (shawl), and head-wraps. In Menchú's native country, Maya women have long used back-strap looms to create such fabrics.

Huipiles, perhaps the most famous element of *traje*, have their origins in pre-Hispanic clothing. Patterns and colors distinctive to specific communities existed from at least the 1900s, although later in the century individual Maya weavers increasingly developed their own styles. In some twentieth-century garments, the panels emphasized color contrasts and strong vertical and horizontal patterns. In others, dating from the mid-twentieth century, designs embroidered in wool, silk, acrylic, or rayon—in geometric shapes, birds, or flowers—framed the yoke or filled registers across a whole garment. Silk or rayon ribbons, which became ever more available along with other goods manufactured outside indigenous communities, also adorned *huipiles*.

Huipiles became a symbol of Central American indigeneity during the twentieth century, as Menchú's choice of dress indicates. Yet the level of workmanship of certain garments has also made them objects worthy of museum collections; the Victoria and Albert Museum in London, for example, collected them as early as the 1880s, and they are also in the collections of the Museo Ixchel del Traje Indígena in Guatemala (founded 1977), the Museo Nacional de Culturas Populares in Mexico (founded 1982), and the private Museo de Textil de Oaxaca (founded 2008). A sign of shifting taxonomies, many of the first collections of indigenous Latin American textiles were assembled for anthropology museums whereas today, such textiles can also be found in museums of art and decorative arts.

Apart from *traje*, Maya women continued to weave altar cloths, garments used to clothe religious statues, and cloths used in local celebrations often associated with *cofradías* (religious brotherhoods). Indigenous textiles also linked different generations. Both older and younger women who could not afford store-bought clothing wore, and continue to wear, *traje*. Young, urban women also wore (and continue to don) such clothing, particularly on special religious and political occasions, as a mark of respect. In some cases their garments are newly made; others are heirlooms.

In the Andes, particularly outside of urban centers, garment types with long histories remained in use throughout the twentieth century. In Bolivia's highlands, for example, many Aymara-speaking women wore *mantas* (shawls), *polleras* (pleated skirts), belts, and *awayos* (squares of wool to carry babies or burdens on the back). Men wore pants, shirts, and vests, as well as ponchos, neck scarves, and *lluchos* (hats with flaps, similar to those seen in Chambi's photograph). Bolivian textile weaves continued to be warp-faced and reversible in many cases. Through much of the century, Bolivian weavers worked both individually and cooperatively, with multiple "hands" making the larger fabrics.

In Peru, both men and women continued to weave, and the symbolic attributes of materials—even those distinctive

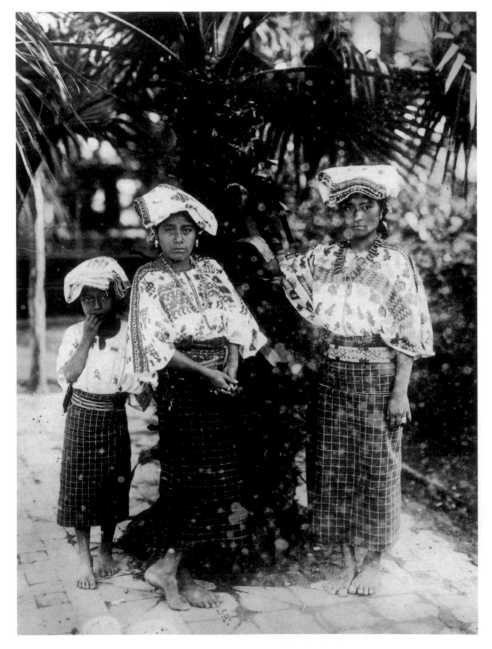

Fig. 23.9. Alberto G. Valdeavellano. *Mujeres kaqchikeles de San Pedro Sacatepéquez* (Kaqchikel women from San Pedro Sacatepéquez), Guatemala, c. 1890. Fototeca Guatemala, Centro de Investigaciones Regionales de Mesoamérica, Antigua Guatemala (GT-CIRMA-FG-006-01-011).

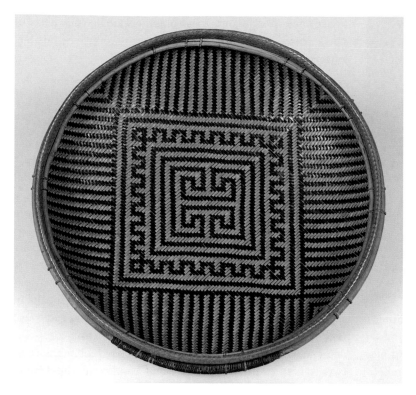

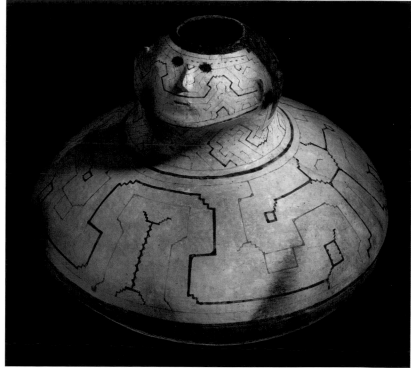

to the twentieth century—continued to be important. For instance, in some Peruvian Andean communities, factory-made items such as sequins, which became popular in the latter half of the century, were understood to reflect light in a manner similar to the surfaces of lakes and were used to invest garments with this symbolism. In the Andean highlands, a longstanding taste for eye-popping color combinations was given an additional boost with the bright acrylic yarns that came on the market in the second half of the century. And, as in Central America, community-based aesthetics exerted their pull. At the same time, individual weavers continued to have their own preferred combinations and designs.

FEATHERWORK AND BASKETRY

In South America, weaving is also used for featherwork and basketry. Among the Kayapó, for instance, links between featherwork, performance, and aesthetics have been particularly powerful. Relatively little is known about Amazonian featherwork before the late nineteenth century as little survives, so it is difficult to trace continuity and change. In the latter half of the twentieth century, though, U-shaped head and back ornaments were made from split-cane frames rimmed with brightly colored feathers, which, when worn, appeared to radiate from a dancer's head or body. Placement of the feathers often mirrors a vertical perception of the world, based on an understanding of the layered life of the rainforest canopy: eagles live in a higher realm than parrots, and certain ornaments place eagle feathers above, or outside, those of the brightly colored birds that dwell below. The symmetry and syncopation of Kayapó featherwork, one of its most striking aspects, was, and is, accentuated when danced. The feathers become energized, stressing relationships between materials and visual effects, voice and gesture.

Basketry made in regions drained by the Amazon and Orinoco, in Colombia and Venezuela, revolved around aesthetics bound to and shaped by cosmic geometry and male-female relations. *Waja* (circular serving trays), for example, crafted through the late twentieth century and, in some communities, into the present, had long been made by Ye'kuana men for use within their communities (fig 23.10). The dramatic geometries were typically of two colors, with dark patterns juxtaposed against a lighter ground. Often a central element was framed by a contrasting linear pattern. Through metaphors that refer to both cosmic myths and other Ye'kuana creations—especially houses, which themselves encode symbolic references to the cosmos—these baskets metered the maturity and character of developing males. To support a wife, a man had to be able to make the baskets that enabled her to do her work. In addition, *waja,* like many objects created by the Ye'kuana, had mythic origins; the baskets, in particular, were linked to myths about cultural reckoning with chaos, darkness, and immorality. While today these objects are sometimes woven for outsiders to purchase, across the twentieth century (and perhaps earlier), *waja* powerfully bound cosmic myths to weaving and social relations.

CERAMICS

One of the most complex topics in discussions of indigenous aesthetic practices since 1900 relates to design inspiration: how much, for example, depends on an individual craftsperson, community practices, outside influences, or divine inspiration? In Shipibo-Conibo ceramics from the Amazonian region of Peru, individual creativity and community style often established parameters for designs (fig. 23.11). Although outsiders have recorded only a few names of ceramic makers and ceramic painters during the twentieth century, Shipibo-

Fig. 23.10. *Waja* (circular serving tray), Ye'kuana, Amazonas or Bolívar State, Venezuela, c. 1925. *Arumã* and other vegetal fibers, cordage, paint; Diam. 9¼ in. (23.5 cm). National Museum of the American Indian, Smithsonian Institution (25/700).

Fig. 23.11. Water vessel, Shipibo, San Francisco de Yarinacocha, Peru, c. 1965. Clay, paint; 9 x 11 x 11 in. (23 x 28 x 28 cm). National Museum of the American Indian, Smithsonian Institution (23/9608).

to see the other's work, the women create a synesthesia of music, visual patterning, and painting to produce exquisitely patterned and valued ceramics.

WOODWORKING

Wood was worked by native craftsmen throughout the century. Among the Purépecha of Michoacan, Mexico, furniture-making has been central to the region's economics and visual culture since the sixteenth century. In the 1910s and 1920s, a taste for "Mission Revival" and "Spanish Colonial" furniture flourished in the United States as part of a wider revival of things both American and Spanish. These preferences resurfaced in the 1980s, where there was a strong revival of interest in vernacular forms—an interest that helped expand transnational markets for pine furniture made by the Purépecha in small factories and workshops in towns in the Lake Pátzcuaro region. Equally if not more influential in spurring consumer demand, and therefore export production, which in the early twenty-first century extends from Mexico to the United States, the Caribbean, and Europe, was the North American Free Trade Agreement (NAFTA, 1994). Programs sponsored by the Mexican government throughout the 1980s to support indigenous craftsmanship, which included instruction in painting furniture to develop a distinctive local style and thus invent new traditions, also supported production.

In the state of Oaxaca, carved wooden figures of fantastic animals (sometimes called *alebrijes*) became so popular in the late twentieth and early twenty-first centuries that by 2007, the Museo de Artes Populares in Mexico City began sponsoring an annual contest and parade of monumental *alebrijes*. The woodworking seen in small *alebrijes* is rooted in communities that are historically Zapotec (although few of the carvers who make such items speak Zapotec today). The region has an ancient tradition of working with wood, including the production of wooden masks. In the later decades of the twentieth century, woodworkers shifted their material preferences from zompantle (used commonly between 1930 and 1970) to copal wood, and from brighter, more durable water-based aniline paints to house paints. Copal is easier to work, and paint adheres to it well but by the 1990s its overuse created shortages, and carvers turned to a wider variety of woods. This reminds us that while some indigenous materials, like those used for the baskets and featherwork discussed above, may have been chosen for symbolic reasons, other choices were strategic: to minimize costs, guard against overuse, or enhance visual effects.

While some Oaxacan craftspeople have emphasized painting or highlighted carving techniques, others have specialized in particular iconographies such as angels or animals (fig. 23.12). Still others specialized in large and complex figures. Such specialization has been true from the 1970s to the present, when Mexican artisans have worked primarily, although not exclusively, in family workshops. During this time, woodworkers have taken commissions from patrons and dealers but have also produced items for the open market. Mexico's Fondo Nacional para el Fomento de las Artesa-

Conibo women recognized and evaluated one another's designs. Women used human-hair brushes and ocher-based slip paints to create dense patterns of thick and thin lines. The symmetry and interlocking forms were deeply embedded in daily life: well through the 1980s, designs of this type extended to textile painting and embroidery, plaited beadwork, and occasionally face painting. Indigenous collecting practices, in which individual women kept pots as heirlooms, sometimes affected creative practice in that the pieces inspired other ceramic paintings. These patterns were not static, however, as changes across time in filler lines and forms confirm.

There were multiple sources of inspiration for painted ceramic decoration. For much of the twentieth century, Shipibo-Conibo people understood that invisible patterns could be projected onto human bodies during shamanic healing and that these designs marked individuals even after death and thus identified them in the afterlife. Anthropological research has suggested that by the early 1980s (if not before), the allusions evoked by specific designs may have been known only to shamans, although women executed the patterns, and related woodcarvings suggest that male carvers may have worked from women's sketches.

Moreover, local vocabularies used by ceramic painters to discuss these and other designs emphasized descriptive rather than spiritual or symbolic terminology. Through the 1980s, however, some women credited Ronin—a cosmic anaconda whose skin pattern embraces all forms of design—as one of their pattern sources. Design compilations, set down by indigenous people into bound books of designs and glyphic patterns (originally related to copy-books and other books introduced by European missionaries in the late eighteenth and early nineteenth centuries) or on long cotton cloths, seem to have been used mainly from the 1920s to the 1970s. These sources were used for personal contemplation of the spiritual realm or, more often to teach women and young shamans about designs and their meaning.

Shipibo-Conibo people also have a long history of creating powerful connections between song and visual imagery. Highly skilled painters, working on opposite sides of a large pot, harmonize their design through chants. Although unable

nias (The National Fund for the Development of Crafts) was founded in 1974, certainly with an eye to the tourist economy, but also out of a nationalist and preservationist desire to sustain and promote the work of traditional artisans. By the early twenty-first century, it was marketing these small *alebrijes* in its six stores.

COLLECTING, EXHIBITING, AND MARKETING

Indigenous people were and are themselves collectors. The high value placed on heirlooms can be traced from the pre-Hispanic and colonial periods into the present. Since about the 1970s, indigenous people, including craftspeople, have formed their own collections of objects—for aesthetic and personal reasons. Collecting by outsiders dates from the time of the first conquistadors and continued sporadically through the colonial period. In the twentieth century, largely through the 1960s but also up to the present, public institutions and private individuals—both in Latin America and abroad—assembled major collections of indigenous objects.

In the United States, indigenous objects were often purchased for ethnographic or folk art collections. Herbert Spinden, working for the Brooklyn Museum of Art in the 1930s and 1940s, oversaw a major acquisition of objects from Mexico, Central America, and South America. Spinden and others saw the "folk" art and design of these regions as a potentially invigorating source for contemporary design in the United States. Much of the Brooklyn material was exhibited at the museum in 1942, shortly after the United States entered World War II and when "Pan-American" policies were popular. *America South of the U.S.*, as the exhibition was titled, sought to demonstrate not only how European and indigenous traditions mixed, but also to chart the reassertion of Indian "traditions" in the wake of colonization.

In Mexico, concerted efforts to establish an institution with ambitious ethnographic collections took root by mid-century. After nearly seventy expeditions to collect objects for exhibition and study, the Museo Nacional de Antropología e Historia opened in 1964 in Mexico City. Displays of what were considered "typical" contemporary indigenous works ranged from ceramics, shamanic tools, and jewelry, to backstrap looms, ponchos, and stones for grinding corn (*metates*). The exhibitions mounted at the museum not only documented craft production at a particular moment of time but also became exemplars for national endeavors across the Americas to honor indigenous-made objects and aesthetics.

The exhibition illustrated here at the Museo Nacional de Antropología in a photograph from 2008 framed a Seri basket with photographs of native people in different modes of "modern dress" (fig. 23.13). As part of a national collection, this and other displays in the ethnographic galleries were intended to highlight connections and bonds between the history of Mexico as a multicultural nation and its indigenous residents, especially the histories of their craft and design traditions. In 1993, Enrique Florescano, the former head of the museum, noted that "the ethnographic halls both under-

scored the extension of those [indigenous] cultures into the present and affirmed the multi-ethnic and multicultural character of the nation."[1]

In the last quarter of the century, national and regional narratives in Latin America increasingly invoked indigenous visual and material culture. Since the 1970s, museums of indigenous clothing and crafts have become widespread, with national exhibition spaces created in Antigua (Guatemala), Quito (Ecuador), and Lima (Peru). Regional collections are often exhibited in smaller towns, as, for example, Sutiaba (Nicaragua), Sucre (Bolivia), and Puno (Peru). Yet another mode of collecting—the preservation of cultural heritage—came about through the 2004–8 incorporation of Latin American countries (including Cuba, Mexico, and Panama, to Argentina, Colombia, Ecuador, and Venezuela) in the UNESCO project on the "Intangible Cultural Heritage of Humanity." These intangibles included traditions, customs, and cultural spaces. The project highlighted indigenous performance and lived experiences across the world. In Mexico, for example, the indigenous festivities recognized by the project were those dedicated to the Day of the Dead and the ceremony of the Voladores.

From the 1960s onward, in towns like Otovalo (Ecuador), Tarabuco (Bolivia), and Chichicastenango (Guatemala), thriving indigenous marketplaces fulfilled the needs of local and regional consumers as well as tourists (fig 23.14). Indigenous marketplaces, many with colonial or pre-Hispanic antecedents, were, and remain, performative spaces, important settings for the purchase, sale, and exchange of objects bound to daily life. As local economies respond to the tastes of outsiders, visual experiences of indigeneity—not only objects—are often on offer. Across the Andes and Central America, it is not uncommon for women to produce and sell finely crafted objects while knowingly dressed in "traditional" clothing, the better to ply their wares. Since the late 1980s, an increasing number of indigenous people involved with art, design, and crafts have traveled to cities in Latin America, the United States, and Europe. Mostly sponsored by dealers, galleries, and museums, these trips provide opportunities for selling wares (mainly weavings, pottery, and clothing), making useful contacts with potential purchasers, and exchanging ideas with fellow craftspeople from different cultures. Billed—and critiqued—as sites of exotic encounter,

Fig. 23.13. Seri basket in the ethnographic galleries at the Museo Nacional de Antropología, Mexico City, 2008.

Fig. 23.14. Market, Otovalo, Imbabura Province, Ecuador, 2007.

these trips also offer educational opportunities: people in urban centers are given a chance to learn about modes of weaving and wood carving.

In Latin American towns and cities in the last quarter of the century, there was a greater and increasing appreciation of indigenous craft production, not least because it evoked memories and stories told by parents or grandparents. Furthermore, crafts became further intertwined with expressions of national and local identities. Beginning about 1975, craft cooperatives formed in increasing numbers, many based in rural areas. These were often aligned with regional and national initiatives to relieve rural poverty and unemployment. In addition to boosting local economies, such cooperatives often revived and reinvigorated craft traditions that had begun to disappear, while they reinvented others. They also developed new crafts, such as *arpilleras* (cloth, appliqué collages) and *amate* paintings, and new types of goods for sale to outsiders.

Such projects, however, can be complex and fraught with problems. Second-guessing tastes and fashions is not easy, and professional "experts," including economists and designers, who advise people on how best to create products that sell well, often exert considerable pressure to alter designs, object types, and materials in order to make existing products more acceptable to the bourgeois consumers at whom the products are aimed. At the same time, craftspeople are strongly encouraged to continue certain traditions ("authentic," invented, or revived) because of their alleged popular appeal. In Oaxaca, for example, ceramists who know that lead content in the glazes that they use in their work affects their health and that of their families face a major dilemma, because their livelihoods depend on the production of such goods for sale.

Nonetheless, some cooperatives have been quite successful, including Artesanía Sorata (founded in La Paz, Bolivia, in 1978), which involves both rural and urban craftspeople and promotes a range of activities from spinning, dyeing, and weaving, to literacy and health workshops. Increasingly, a wide range of handicrafts cooperatives depend on online sales as well as foreign importers, who sell their crafts to museum gift shops, galleries, and at trade fairs. These cooperatives, some of which are allied with Fair Trade organizations and NGOs (nongovernmental organizations), bring indigenous creations directly into the competitive world of transnational craft marketing.

Whether indigenous crafts are "authentically indigenous" has long been a topic of debate, especially outside native communities. Since the late 1880s, when the salvage paradigm, with its emphasis on anthropological research, collecting, and photography was in full swing, views of indigenous culture as static were popular. Notions of static traditions remain strong, especially among those living outside particular indigenous cultures. From the 1990s onward, however, both within and outside indigenous towns and urban centers, greater emphasis has been placed on recognizing the individual achievements of those who design and make objects, as well as the complex cultural and economic conditions of production under which they work. Some scholars debate the implications of including indigenous objects in "foreign" categories, such as that of "art" or "arts" or indeed decorative arts and crafts, asking, for instance, whether this renders these fields more elastic and inclusive, or whether inclusiveness dilutes the indigenous meanings of craftsmanship in these particular cultures.

Greater emphasis on crafts, and the formerly marginalized area of craft history, within both design history and material culture since the 1980s, and especially after 1990, has raised the status of crafts. Craft as an area of study has been additionally revalidated by anthropologists. Furthermore, postmodernism greatly boosted scholarly interest in nonindustrial products, especially crafts made by women.

Across the whole of the twentieth century and into the twenty-first, the visual, material, and aesthetic qualities of indigenous objects—and the skill and inspiration of those who make them—have formed shifting sites of value and respect among indigenous producers, consumers, and outsiders. Since 1900, national politics in Latin America, tensions between local and international aesthetics, and global economic forces have led to complex and sometimes disobliging histories for and of indigenous arts, the very name of which suggests an exclusion of crafts and of design. As this volume demonstrates, focusing on handcrafted objects and their history—considering them under many categories and from many angles, and as part of a wider culture, both visual and material, inside and outside indigenous communities—seems to offer a way forward.

DANA LEIBSOHN AND BARBARA E. MUNDY

LATIN AMERICA

The term "Latin America" is sometimes used to describe those countries in the Americas (excluding French Canada) where Latin languages, especially Spanish and Portuguese, are dominant. More generally, and in this chapter specifically, however, it refers to Mexico, the countries of the Caribbean, and Central and South America. In 1903, this vast and diverse region was composed of twenty countries, all different in size, geography, natural resources, climate, demographics, and degrees of industrialization, as well as visual and material culture. Developments in decorative arts and design varied greatly from region to region, and are best considered across a broad spectrum, ranging from local and national concerns to participation in global trends.

With the exception of a few large cities, such as Buenos Aires, Rio de Janeiro, and Mexico City, in the early 1900s, Latin America was still overwhelmingly rural and relatively underpopulated, with economies based on agriculture and the export of natural resources to "developed" countries. Large pockets of indigenous peoples lived isolated from the institutions of central government, and communications were difficult, especially in territories with little in the way of infrastructure. Contact among countries was also limited, not least because of poor communications, arduous terrains, wars, and border disputes.

In 1900, thriving artisanal industries, anchored in old craft traditions (sometimes dating back to pre-Columbian times), supplied basic consumer goods, typically furniture, textiles, and household items. In most areas of decorative arts manufacture, there were few workshops sufficiently large or mechanized to be called factories. Machinery, tools, materials, and manufactured luxury goods were commonly imported from Europe, particularly Britain, France, Germany, Austria, and, to a lesser extent, the United States. At the same time, however, emergent national industries, oriented to local demand, were developing in cities and larger towns, which offered greater market opportunities and abundant cheap labor. Such places provided the best employment for craftspeople, designers, and entrepreneurs, as well as a public arena for professional designers.

At the turn of the twentieth century, no other place in the region was more open to creativity, new styles and design trends, and new object types than Buenos Aires. Fueled by a fast-growing economy, the city was experiencing rapid industrialization and immigration. (By 1900, nearly one in every two inhabitants was a foreigner.) The aspirations of an ambitious elite and growing middle class to create cities, societies, and material worlds that outshone those of the Old World generated an environment highly conducive to creative interpretations of European styles. As demand for goods grew, adaptations of up-to-date movements in art and design, including the fashionable historicist Beaux-Arts and various forms of Art Nouveau, especially those from France, Italy, Spain, and Austria, were embraced. But even then, local craft and design traditions, color palettes, materials, and techniques were evident.

As elsewhere, design at the turn of the century frequently involved a mixing of new and old—be it materials, object types, or styles—that was more obvious in some objects and interiors than others. Decorative arts items in fashionable styles were sought after by a growing urban middle class eager to display its taste and status through such accoutrements. Even though new styles were enthusiastically embraced at the beginning of the century, there were sufficient continuities with the past, or references to local elements, to ensure acceptance by more conservative consumers.

BEAUX-ARTS DESIGN

Grandiose and infused with the allure of history, Beaux-Arts design was adopted by local elites from the late nineteenth century until the 1930s as the style most appropriate to display their conspicuous consumption and social status. The richest and most populous city of the region, Buenos Aires, was a center for the style, and Beaux-Arts projects there ranged from the monumental National Congress Palace (built 1897–1906) by the Italian-born engineer Victor Meano (1860–1904), to private mansions such as the Anchorena Palace by the Norwegian-born architect-designer Alejandro Christophersen (1866–1946) for Mercedes Castellanos de Anchorena. Built between 1909 and 1916, the latter housed three separate apartments with common reception rooms. The complex featured different styles and color schemes reflecting the use and nature of each room. The grand ballroom, for example, emulated the grandeur of the Hall of Mirrors at Versailles, with *boiseries* (carved wood paneling), mirrored walls, and a frescoed ceiling in an eighteenth-century French style. The white-and-gold *boiseries* followed a color palette favored by the elite of Europe and the United States, and these palatial Latin American residences were furnished with fine European antiques along with contemporary Beaux-Arts–style furniture—either imported or custom-manufactured (fig. 23.15). Local firms such as Thompson Muebles (Thompson Furniture), which was founded in 1888 in Buenos Aires by British furniture maker and retailer H. C. Thompson, provided custom-made furniture.

But Buenos Aires was not the only fertile ground for Beaux-Arts design. This transnational style, closely associated with France, was popular with the Francophile elites and upper middle classes across Latin America. Originally designed by Adamo Boari (1863–1928) but with numerous changes and adaptations by other designers, the Palacio de Bellas Artes (Palace of Fine Arts) in Mexico City (built 1904–34) encompassed a wide variety of historicist and historicist-inspired styles, from Beaux-Arts classicism and classical motifs to Art Moderne infused with pre-Columbian elements.

The Beaux-Arts style also influenced the design of decorative arts objects, particularly ceramics and metalwork, in which European-style designs were combined with various

Fig. 23.15. Beaux-Arts–style parlor suite, Argentina, from Harold E. Everley, *Furniture Markets of Argentina, Uruguay, Paraguay, and Brazil*, Washington, D.C., 1919.

Fig. 23.16. Cándido Villalobos. Poster for Cigarrillos París, Buenos Aires, 1900. Museu de la Garrotxa, Olot, Spain.

FIG. 4.—PARLOR SUITE MADE AT BUENOS AIRES FACTORY UNDER FOREIGN MANAGEMENT.

All materials are imported and are of the very best quality.

indigenous decorative motifs and materials to suit local markets. Such pieces were generally produced in small- to medium-sized artisan workshops. A representative example of a medium-sized enterprise was the Fábrica de Loza El Ánfora (Amphora Earthenware Factory) in Pachuca, Mexico. Founded in 1920, the company specialized in the manufacture of utilitarian pottery but also produced special editions, such as the collection presented in 1921 to mark the centenary of Mexican independence. It included a variety of vases and decorative pieces in which Beaux-Arts elements were combined with pre-Columbian–inspired motifs to create "authentic" Mexican objects.

MODERNISMO

"Modernismo" or "Estilo Moderno" (Modern Style) were the main terms used in Latin America to designate Art Nouveau. In the late 1890s, the style rapidly gained ground in the region, particularly in the fields of decorative and graphic arts. The latter provided effective vehicles for disseminating new designs and products as well as promoting particular companies and materials.

Magazines, almanacs, and commercial advertising introduced a range of design styles, including Modernismo, to vast audiences. A sustained increase in literacy, especially in urban areas, had a considerable impact on the publishing world. Examples of illustrated publications, often dealing with modern artistic and cultural matters, included the *Peuser* almanac (founded in 1888 and named after Jacobo Peuser, its pub-

lisher); *Caras y Caretas* (Faces and Masks, 1898–1941), which was published weekly in Buenos Aires; *La Revista Moderna* (The Modern Magazine, 1898–1911), a literary journal published in Mexico City; *O Malho* (The Mallet, 1902–59), a humor magazine published in Rio de Janeiro; and *Social* (1916–33; 1935–38), published in Havana, among others.

In disseminating contemporary graphic styles, particularly Modernismo and later Art Moderne, these publications were conveying a clear sense of modernity to their readers. Some had subscribers in other Latin American countries and competed with European (Spanish and French) illustrated magazines such as *La Ilustración Española y Americana* (Spanish and American Illustration, Madrid, 1869–1921), *Blanco y Negro* (Black and White, Madrid, 1891–1939), and *L'Illustration* (The Illustration, Paris, 1843–1944).

As in Europe and North America, fine artists sometimes applied their talents to the growing field of commercial illustration, a profession that provided extra income and helped to promote artistic reputations. Cándido Villalobos, a Spanish painter living and working in Buenos Aires, for example, won first prize in a 1900 poster contest sponsored by Cigarrillos París (Paris Cigarettes), the oldest tobacco company in Argentina (fig. 23.16). His winning poster, which drew on international Art Nouveau, indicates how illustrators and advertising agents could use humor and popular culture to help sell products. The naked boy forcing a bat to smoke alludes to a popular Spanish saying, *Fuma como un murciélago* (literally, "to smoke like a bat"). The figure of the boy is set against a flat red ground and framed by a molding with delicate ornamentation. The form of the boy vaguely recalls

The Thorn-Puller, a celebrated third-century BC Hellenistic sculpture, but the swirling smoke and lines behind him are in a restrained Modernismo style. This combination of an association to a familiar saying with an internationally recognizable design style proved popular. Local interpretations of international Art Nouveau styles appeared across the region, especially in Argentina, Brazil, and Mexico. Elements of the forms and decoration were absorbed into Latin American design vocabularies to be drawn upon as appropriate, depending on the objects and potential consumers.

In Rio de Janeiro, a thriving cultural center in the early twentieth century, the painter-designer Eliseu Visconti (1866–1944) designed a series of prototypes in Modernismo style for ceramic vases around 1900 (fig. 23.17). The stylization of the local Brazilian *maracujá* (passion fruit) flower, with its fleshy, contorted stamen and pistil suggestive of female anatomy, helped make the eroticism implied in the design more acceptable, a strategy often found in international examples of Art Nouveau. Visconti's *maracuyá* designs were exhibited to considerable public acclaim in Rio de Janeiro in 1901 and São Paulo in 1903, but never went into production.

Born in Italy and educated in Brazil and France, Visconti was at the peak of his career as a painter when he began designing decorative arts objects. Influenced by the commercial work of the French artist-designer Eugène Grasset, his teacher at the École Guérin in Paris, and the writings of John Ruskin and William Morris, Visconti's work reflected the emphasis on nature within both the Arts and Crafts movement and Art Nouveau. His numerous designs for ceramics, lamps, posters, stamps, stained-glass windows, and interiors often referred to Brazilian flora and fauna, particularly wildflowers and insects. His interest in creating local expressions of Modernismo was shared by many other Latin American designers

and architects, and his calls for a regional approach to art and design had strong resonance in later years.

In other large centers, such as Mexico City, a number of designers created furniture and interiors in a Modernismo manner, most for the newly built homes of middle-class individuals made wealthy during a period of rapid industrialization. Although more modest in scale than some of the new dwellings, the Casa Requena in Mexico City (c. 1905) achieved a high level of originality in its interiors and furnishings. A renovation of a seventeenth-century house near the Alameda Park, the project was a collaboration between the owner, José Luis Requena, and the artist, Ramón P. Cantó. Strongly influenced by Symbolism, Cantó designed rooms around particular themes such as "The Peacock," a symbol of the Aesthetic Movement (see fig. 17.47), and the European fairy tale of Little Red Riding Hood. Overlooking the courtyard, the breakfast room featured a trompe l'oeil garden with a border of Art Nouveau–style flowering plants set against an open sky (fig. 23.18). An actual trellis decorated with faux climbing roses and prune branches, on which perched strategically

Fig. 23.17. Eliseu Visconti. Vase, Manufaturas Ludolff & Ludolff, Rio de Janeiro, 1902. Ceramic; 6¼ x 8¼ x 8¼ in. (16 x 21 x 21 cm). Private collection.

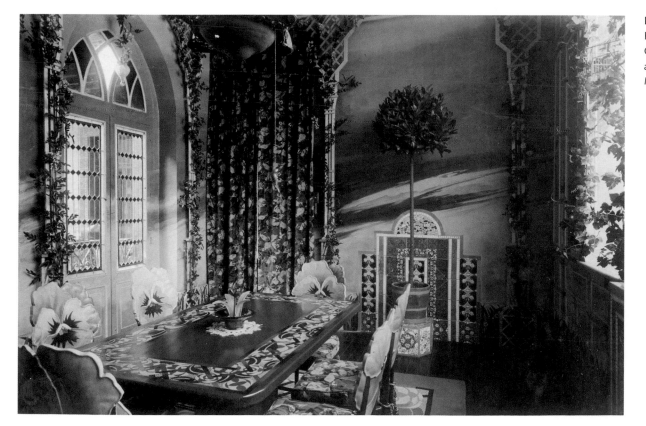

Fig. 23.18. José Luis Requena and Ramón P. Cantó. Breakfast room at the Casa Requena, Mexico City, c. 1905.

FIG. 9.—EXAMPLES OF HOSPITAL FURNITURE MADE IN ARGENTINA.

placed stuffed birds, continued in three dimensions the illusionistic effect of the two-dimensional wall painting. The flower theme played out in the furniture and furnishings designed for the space, including a set of chairs with backs in the shape of giant pansies.

1910–1918

The Exposición International del Centenario (International Centennial Exhibition) of 1910, which was held in Buenos Aires to commemorate the centennial of the May Revolution that led to Argentinean independence, marked a high point of design and manufacture in the region before World War I. The exhibition sought to showcase Latin American goods for the rest of the world to admire. Although only the host country and Paraguay had separate national pavilions, most Latin American nations sent groups of items—ranging from fine art to industrial and artisanal products—for display. The rising pride in regional achievements was short-lived, however, because the economies of all Latin American countries suffered badly from the effects of war in Europe.

World War I disrupted international trade on a massive scale, and like other regions, Latin America suffered from shortages of raw materials and machines previously imported from Europe. The worsening economic situation heightened discussions about self-sufficiency that raised issues of national and regional identity. The consequent wartime isolation led to a greater awareness of Latin America's own rich cultural heritage and served as a catalyst for changes in design and manufacture. As in the United States before it entered the war, greater emphasis was placed on local designs, designers, materials, and design traditions, and both the colonial past and indigenous cultures opened up a wide array of visual and area-specific references for designers, producers, and consumers alike.

Local production expanded during the war as trades and industries, as well as designers, adapted or redesigned products in line with locally available materials and manufacturing processes. Specialized items such as the hospital furniture designed and produced in Argentina before 1919 (fig. 23.19) or low-priced products such as the *Cama Patente* (Patent Bed), exemplify products developed as alternatives to imported goods. The *Cama Patente,* a wooden version of European metal beds that had sold well in Latin America, was designed in 1915 by the Spanish-born Brazilian designer Celso Martínez Carrera (1883–1955).

SPANISH COLONIAL REVIVAL

By the early twentieth century, anti-Spanish attitudes prevalent during much of the previous century had diminished considerably, and a renewed interest in the arts and crafts of the Hispanic period gained momentum. Wealthy collectors, such as Isaac Fernández Blanco in Buenos Aires, Alfredo Machado Hernández in Caracas, and Franz Mayer in Mexico City, amassed large repositories of colonial antiques and helped boost public awareness of, and promote scholarship on, the subject. Colonial decorative arts became the topic of specialized publications such as Manuel Romero de Terreros's *Las artes industriales en la Nueva España* (The Industrial Arts in New Spain, 1926), which included sections on metalwork (gold, silver, bronze, and iron), arms and armor, horse trappings, furniture, ivory, textiles, ceramics, glass, and featherwork. It also offered information on the colonial trade guilds and their organization.

The vogue for colonial decorative arts was part of a wider revival of interest in colonial design across the Americas, including Canada and the United States. Spanish Colonial Revival styles were popular in the United States, and Modern versions of Spanish and Baroque revival buildings, interiors,

objects, and decoration were so popular in both Spain and Latin America that most of the national pavilions for the 1928 Ibero-American Exposition, held in Seville, were designed and furnished in styles that evoked "Spanish" pasts. In the interwar years, Spanish antiques of the colonial period, reproductions of these antiques, and Spanish Colonial Revival furniture sold well. Antiques dealers such as Casa Pardo in Buenos Aires issued lavish publications depicting room settings decorated in a mix of antiques and contemporary objects in modern interiors into the 1940s in order to promote sales (fig. 23.20).

Colonial Revival design became a staple in the furniture market, especially high-quality reproductions of colonial pieces. The antiques dealer Teófilo Gendrop (1893–1958) from Oaxaca, Mexico, for example, became well known in the 1940s for stylized versions of Mexican eighteenth-century furniture made according to traditional methods with traditional materials. Other people reinterpreted colonial designs in more overtly modern ways: for example, Argentinean architect Alejandro Bustillo (1889–1982), in collaboration with the French designer Jean-Michel Frank, designed furniture for the 1939 Hotel Llao-Llao in Bariloche. The furniture had a clean, modern look but also referenced vernacular Argentinean and Spanish colonial pieces.

Still thriving in many localities, traditional crafts were revitalized by this renewed interest in the Hispanic past, especially those types and media most closely associated with the colonial period. In the bigger production centers such as Puebla, Mexico, glazed pottery, a medium redolent of Spanish heritage, enjoyed a new popularity and was used to produce objects for modern consumers. A Puebla tin-glazed charger by Enrique Luis Ventosa (1868–1935), from the workshop of Ysauro Uriarte Martínez (1885–1971), references motifs and production methods found in both Mexican and Spanish pottery within a new design vocabulary (fig. 23.21). While based on standard Puebla shapes, floral-inspired decoration, and a green, ocher, and blue on white ground palette of colonial Spain, its unmistakably contemporary features included a young woman with fashionably short hair and modern clothing.

In the 1930s and 1940s, silver manufacturers adapted colonial-inspired designs for serial production, sometimes on a large scale. The objects were still largely handmade, although machinery was used for manufacturing specific object types such as flatware and for polishing. Makers and retailers of silverware, such as Casa Banchero of Lima (run by the Banchero brothers) and Sanborns in Mexico City, where American expatriate Frederick W. Davis (1877–1961) was chief designer, included in their inventories whole ranges of items loosely inspired by colonial types. Among the more common ones were double-handled bowls based on eighteenth-century *bernegales* (drinking vessels), and trays and platters with scalloped rims, a feature often seen in Spanish colonial silverware.

In addition to the Spanish colonial heritage, pre-Columbian and vernacular traditions also inspired designers in the 1930s and 1940s. The "recovery" of the pre-Columbian heritage as a source for a national identity in design began in the late nineteenth century, but interest grew in the twentieth, when it

was associated with specific types of materials or designs in each nation. Known as "Neo-Indigenism" in Mexico and Peru, and "Nativism" in other Latin American countries, the movement for reestablishing—under contemporary parameters—indigenous artistic and cultural traditions echoed some of the discussions about national identity and design that were taking place in Europe.

Nativist design had a considerable impact in Brazil, and a local variation, known as "Marajoara," was inspired by the design traditions of the Amazonian Marajoara culture, as well as by local flora and fauna. The leading figures working in this manner were Theodoro Braga (1872–1953), Manoel de Oliveira Pastana (1888–1984), and Fernando Correia Dias (1892–1935). Braga's Guatambu wood vases were exhibited at the 1927 National Salon of Fine Arts in Rio de Janeiro. Instead of using ceramics, the traditional material for Marajoara wares, however, Braga opted for hardwood to give his pieces

Fig. 23.20. Pierre Nicolas. Design for an interior, from *El Mueble en America del Sur*, Buenos Aires, 1945.

Fig. 23.21. Enrique Luis Ventosa. Charger, workshop of Ysauro Uriarte Martínez, Puebla de Los Ángeles, 1920–22. Tin-glazed earthenware; Diam. 16⅜ in. (41.5 cm). The Hispanic Society of America, New York (LE1862).

Neo-Indigenist influences were even more evident in Mexican graphic design, especially among postrevolutionary illustrators, including the muralist Diego Rivera (1886–1957). The latter's cover for Rosendo Salazar's 1926 *México en pensamiento y en acción* (Mexico in Thought and Action), with its stylized, feathered serpent based on an Aztec stone sculpture of the deity Quetzalcoatl, offers a good example of the appropriation of pre-Columbian imagery into postrevolutionary aesthetics (fig. 23.22).

Contemporary silverware with pre-Columbian–style decoration was made for local and tourist markets. One of the most prolific makers of silver jewelry and hollowware in Latin America in the 1930s and 1940s was U.S. expatriate William Spratling (1900–1967). A friend of Rivera's, he established a workshop in Taxco, Mexico, in 1931 to design and make a wide assortment of items inspired by traditional Mexican designs. Such handmade pieces became extremely popular, especially with tourists—many of them from the United States—and other Taxco silvermakers made pieces similar to those from the Spratling workshop. Nativist design generated less interest in other Latin American countries, but notable exceptions included a neo-Inka set designed by Rodolfo Franco (1890–1954) in 1926 for the opera *Ollantay* at the Colon Theater in Buenos Aires, and the pre-Columbian–inspired garden furniture in cast stone designed by the Venezuelan sculptor Alejandro Colina (1901–1976) in the 1930s.

EUROPEAN MODERNISM

The aims and ideals of the European Modern Movement in architecture and design were influential in Latin America throughout the twentieth century. The movement began to gain ground with local architects, designers, and intellectuals after the publication of *Vers une architecture* (Toward an Architecture, 1923) by architect-designer Le Corbusier. In 1929, the *Asociación Amigos del Arte* (Friends of the Arts Society, 1924–42), Buenos Aires, invited Le Corbusier to lecture in Buenos Aires, Montevideo, and Rio de Janeiro. During that visit, Victoria Ocampo, a wealthy Argentinean writer and patron of the arts, approached him to design what became the first Modernist house in Argentina, Villa Ocampo. Alejandro Bustillo carried out the final project based on Le Corbusier's sketches. Despite heavy criticism by many people of the building's "industrial" look, the clean lines, whitewashed walls, and Spartan interiors offered a model for future projects.

In the 1930s, architects and designers worked within a minimal Modernist aesthetic to design a range of products. The *B.K.F.* chair (1938), named for its three designers—Antonio Bonet (1913–1989), Juan Kurchan (1913–1972), and Jorge Ferrari Hardoy (1914–1977)—enjoyed public and critical success after it was presented at the 1940 Winter Interior Design Show in Buenos Aires (fig. 23.23). It became one of the most popular chairs of the 1950s when "knock-offs" sold in the United States for as little as six dollars. The Modernist interest in industrial materials and new technologies was reflected in the enameled steel-rod support structure, while the leather seat, handmade using traditional Argentinean saddlery tech-

a more contemporary look. To achieve the effect of the subtle color variations typical of the Marajoara slipware decoration, Braga inlaid different woods to create stylized Marajoara motifs with strong Art Moderne references.

In Mexico and Peru, both of which had visually rich pre-Columbian cultures, many designers looked back to indigenous traditions for inspiration. Peruvian designer Elena Izcue (1889–1970), who trained as a design teacher in Lima, did so only after emigrating to Paris in 1927 in search of better work opportunities. There, between 1927 and 1939, she adapted ancient pre-Columbian textile motifs into patterns for fabrics, which she sold to Jean-Charles Worth's French couture house and to leading stores in the United States, including Saks Fifth Avenue in New York.

Mexico presents a special case, largely because the Mexican Revolution (1910–20) exalted the "Mexicanness" of pre-Columbian visual and material cultures more than a decade before other Latin American countries saw their national cultures through a strong pre-Columbian lens. In Mexico, early neo-Indigenism coalesced around the figure of Dr. Atl, a pseudonym for designer, painter, and writer Gerardo Murillo (1875–1964). Together with traditional Tonalá earthenware potters in 1915–18, he organized a school and cooperative workshop aimed at producing modern adaptations of "authentic" ancient Aztec and Toltec wares. Unfortunately, the commercial results were disappointing. In the 1930s, Atl again tried to design and produce pre-Columbian–inspired ceramics, this time in collaboration with the artist-designers Roberto Montenegro (1887–1968) and Carlos Mérida (1891–1984). The resulting wares featured prismatic shapes and geometric motifs and decoration.

niques, evoked local references. The form related to a growing interest in more organic sculptural forms, known as Organic Modernism (see fig. 23.81).

A key event for Latin American Modern design, particularly furniture, was the international design competition and exhibition *Organic Design in Home Furnishings*, organized in 1940 by the Museum of Modern Art (MoMA) in New York, which had a special section devoted to Latin American designers. All the Latin American prizewinning projects, which were included in the 1941 catalogue that accompanied the exhibition, incorporated local materials. Mexican Xavier Guerrero (1896–1974) and Cuban-Mexican Clara Porset (1932–1981), for example, presented a suite of pine furniture influenced by vernacular Mexican types with *ixtle* (agave fibers) used for the hand-woven seats, while another Mexican team—Michael Van Beuren (1911–2004), Klaus Grabe, and Morley Webb—proposed an adjustable chair in primavera wood with woven *mecate* (sisal rope) straps. Román Fresnedo (1903–1975) designed tubular steel chairs but made extensive use of skins and leather straps from his native Uruguay, while Julio Villalobos from Argentina designed a set of furniture to be manufactured in Argentinean giant cactus wood and pithy reed. Moravian-born Brazilian designer Bernardo Rudofsky (1905–1988) specified knitted or woven fabrics made of jute, *cánhamo*, and *caroã* fibers for the upholstery of his wood and metal chairs. This linking of overtly Modernist designs, which claimed a universality, with national and local traditions resonated all over Latin America and was soon reflected in commercial production.

The three-legged chair shown here, designed in 1947 by the Portuguese-born Brazilian designer Joaquim Tenreiro

(1906–1992), was produced in a small series by his Rio de Janeiro–based company, Tenreiro Móveis e Decorações (Tenreiro Furniture and Decoration; fig. 23.24). It illustrates the impact of European and North American Organic Modern forms. The design is simple, a shell with three conical wooden legs, but the shells were cut from a single block of laminated wood. By juxtaposing five different and contrasting Brazilian timbers in the laminate, Tenreiro achieved a vibrant striped pattern. The sensuous curves and patterning evoke the rhythm and contrasts of the geometric pavement designs on the Copacabana beach sidewalk in Rio de Janeiro, and thus impart a distinctively *Carioca* (Rio de Janeiro) identity, pulled from popular culture, to the sight and experience of this chair.

Latin American Modernists discussed how far they should follow the Machine Age aesthetic, often referred to as the International Style, and use new materials and techniques, and how far they could, or should, reference Latin American cultural heritage. Some purists argued for taking up the style without any local mediation, something almost impossible to achieve. Others, like Porset, drew upon local traditions, often simplifying regional furniture types to their essential elements while retaining a Modernist sensibility. Porset's "Butaque" chairs from the 1950s, for example, were based on the Colonial Mexican *butaque*, a low chair with inclined seat and back; the type itself is a Spanish colonial adaptation of pre-Columbian ritual chairs from the Caribbean region (see fig. 18.20). In 1952, Porset curated the milestone exhibition *El Arte en la Vida Diaria* (Art in Daily Life) at the Fine Arts Museum in Mexico City. It featured objects made in Mexico that Porset deemed well-designed, whether

Fig. 23.23. Antonio Bonet, Juan Kurchan, and Jorge Ferrari Hardoy. *B.K.F.* chair, Artek-Pascoe, Inc., New York; designed in Buenos Aires, 1938. Painted wrought iron, leather; 34⅜ x 32¾ x 29¾ in. (87.3 x 83.2 x 75.6 cm). The Museum of Modern Art, New York (715.1943.a-b).

Fig. 23.24. Joaquim Tenreiro. Three-legged chair, Tenreiro Móveis e Decorações, Rio de Janeiro, c. 1954. Contrasting hardwoods including *imbuia*, *roxinho*, jacaranda, ivorywood, *cabreúva*; H. 28¾ in. (73 cm). Private collection.

Fig. 23.25. Miguel
Arroyo. Living room of
Alfredo Boulton's beach
house, Margarita Island,
Venezuela, designed
1953–54.

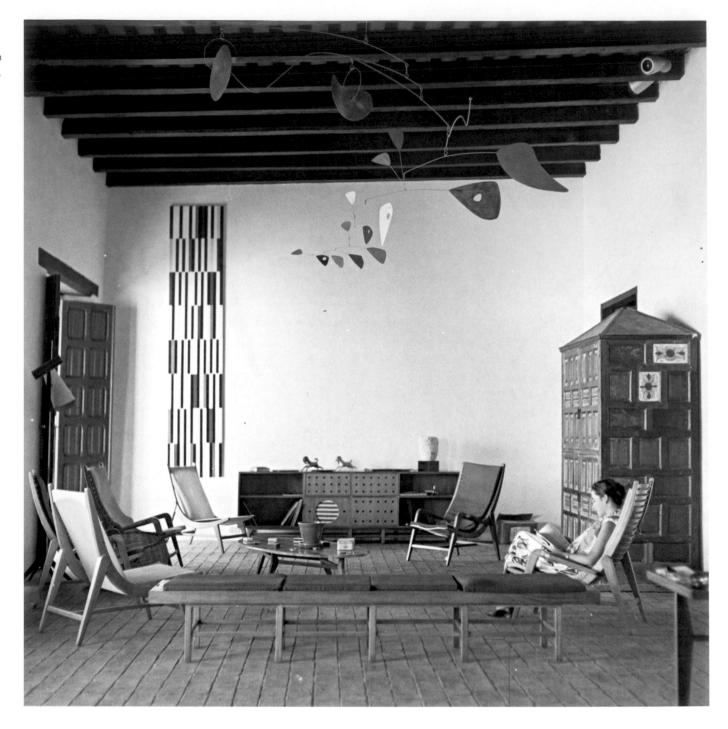

by people working in Latin America or not. Pieces in the exhibition by U.S.-based designer Eva Zeisel, for example, were produced in Mexico exclusively for the Mexican branch of Sears, Roebuck & Co. The exhibition featured a wide range of handcrafted and mass-produced products selected to highlight design as opposed to production methods, and reflected the mid-century interest in Modernism as well as local heritage and past traditions.

Other mid-century Modernist designers, such as the Venezuelan Miguel Arroyo (1920–2004), were also interested in national and local traditions. Arroyo's interior design for the vacation home of the art critic and collector Alfredo Boulton on Margarita Island, Venezuela (1953–54; fig. 23.25), reveals a strong respect for local design traditions of the colonial period. Without altering the architecture and structure of the eighteenth-century house, Arroyo proposed an interior

including furniture made solely of local materials but subtly influenced by Scandinavian and Italian postwar designs. This furniture was mixed with colonial antiques, as well as modern artworks by the U.S. sculptor Alexander Calder and the Venezuelan painter Alejandro Otero (1921–1990). Such interiors were often designed as backgrounds against which to display objects and, through those objects, cultural capital.

Modernist design reached its zenith in Latin America during the 1950s, when postwar economies were expanding, accompanied by an influx of European and North American designers and entrepreneurs. At the same time, several large-scale infrastructure developments, implemented by governments as a means of modernizing both national economies and identities, began to be realized. Among the impressive Modernist architecture and design projects were the new city of Brasilia (design began in 1957) by Lúcio Costa (1902–

1998) and Oscar Niemeyer (1907–2012), and the University City of Caracas (design began in 1943) by Carlos Raúl Villanueva (1900–1975). The choice of a style widely accepted as both modern and international was a deliberate move on the part of nations and institutions to identify themselves as willing participants in the "march of progress."

The widespread economic optimism and greater openness of manufacturers and retailers to new ideas led to an expansion of consumer goods. This generated opportunities for designers, and affordable middle-class furniture became an important segment of light manufacturing. Items designed by Cornelis Zitman (b. 1926), a Dutch designer working in Venezuela, and produced by the Caracas firm Tecoteca, included the 1953 chairs offered in their catalogue (fig. 23.26). The frame structure meant that several different models could be offered simply by changing the seat and back designs. Similar low-tech design was characteristic of furniture made throughout the region, and native materials were widely used. Firms manufacturing high-end pieces included Domus in Mexico City, where the U.S.-born, Bauhaus-trained architect Michael Van Beuren was chief designer, and Branco & Preto in São Paulo, a furniture and design firm founded in 1952 by architects Miguel Forte (1915–2002), Jacob Ruchti (1917–1974), Plínio Croce (1921–1984), Roberto Aflalo (1926–1992), Carlos Millan (1927–1964), and Che Y. Hwa. Companies oriented toward more moderately priced furniture included Unilabor, a São Paulo Christian workers' cooperative founded in 1954, which produced designs by Geraldo de Barros (1923–1998).

CLOTHING AND TEXTILES

Discussions about modernity and regional identity continued throughout the postwar period. Flávio de Carvalho's *New Look* summer fashions for a "new man" from 1956 offer one example of overtly modern design as it relates to clothing and identity (fig. 23.27). De Carvalho (1899–1973), a São Paulo architect, designer, and avant-garde artist, proposed the wider use of so-called unisex clothing, which he also referred to as the future work outfit for the "Tropical Man." His controversial apparel, composed of a skirt and light shirt, was presented as an alternative to the customary work suits worn by contemporary Latin American middle- and upper-class men. The name was a direct reference to Parisian couturier Christian Dior's famous "New Look" of 1947 (see fig. 23.80), which was popular at many class levels in Latin America. More a conceptual artwork than design project, De Carvalho's proposal was a commentary on the place of Western-influenced fashion in Latin American contexts.

European trends generally influenced fashionable dress throughout the century. Wealthy Latin Americans continued to be important clients of European (especially French) fashion houses, designers, and retailers as they had been in the late nineteenth century. In 1914, the high-end London department store Harrods opened a branch in Buenos Aires, and its wares included fashionable garments. Four decades later, in 1954, Dior opened a boutique in Caracas, his first such enterprise in Latin America and only his second store in the Americas. Department stores that retailed luxury items and clothing, such as Casa Mappin in São Paulo (1913–1999), originally a branch of the British metalworking company Mappin & Webb, also contributed to the spread of European styles, mostly French and British, among native elites.

The textile industries in Argentina, Mexico, and Brazil grew significantly in the 1930s and 1940s, and local fashion houses, such as Astesiano in Buenos Aires (established 1916), began to play a more significant role in establishing and disseminating designs. Films also helped form and promulgate ideas about fashion, as movies from Argentina, Mexico, the United States, and Europe all circulated in postwar Latin America. This spread of both intercontinental and international influences indicates something of the complex design trends that constitute fashion at any given point in any given place. The cross-fertilization of ideas and images was enormous, with strong influences coming from Mexican actresses such as Maria Félix and Dolores del Río, on and off screen.

Fig. 23.26. Cornelis Zitman. Chairs *No. 51*, *No. 52*, and *No. 53*, Tecoteca, Caracas, 1953. Mahogany, molded plywood, cloth; each, 32½ x 20 x 23½ in. (82.6 x 50.8 x 59.7 cm).

Fig. 23.27. Flávio de Carvalho performing *Experiência no. 3*, a presentation of his *New Look: Moda de verão para o novo homem dos trópicos* (New Look: Summer Fashion for a New Man of the Tropics), São Paulo, October 18, 1956.

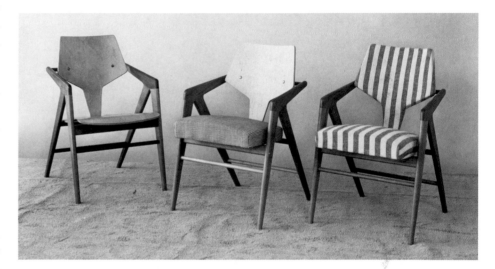

EUROPE AND THE AMERICAS

The former starred in Latin American films, the latter in both Hollywood and Latin American productions. These style icons, together with other public figures such as Eva Duarte de Perón, *primera dama* (First Lady) of Argentina from 1946 to 1952, contributed to international as well as Latin American fashion culture. Perón's personal style and clothing, including garments by the Argentinean couturier Paco Jamandreu (1925–1995), as well as Christian Dior and Italian shoemaker Salvatore Ferragamo, were widely imitated across the classes.

Traditional garment types, some of them with pre-Columbian origins like ponchos in South America, *huipiles* (Mayan dresses) and *sarapes* (long blanket-like shawls) in Mexico, and the *guayabera* (an embroidered male shirt of Asian origin) in the Spanish Caribbean, continued to be worn into the twentieth century. They were not considered "fashionable" garments, but by the late 1930s and 1940s, some middle- and upper-class nationalists promoted the adoption of traditional garment types, albeit updated versions and often in finer fabrics. Folk-inspired clothing, such as that depicted in Frida Kahlo's self-portraits, was particularly popular in artistic and Leftist intellectual circles.

Mexican fashion designer Ramón Valdiosera (b. 1918) drew on customary textiles and clothing for high-style garments (fig. 23.28). He adopted Mexican embroidered trimmings and fabrics and a bright color palette associated with that country for his garments inspired by French couture. In the 1960s and early 1970s, as elsewhere, other trends, including the counter-culture movement, deeply influenced fashion and clothing. Designers such as the Brazilian Zuzu Angel (1921–1976) embraced pre-Columbian and colonial as well as African-American traditions, designing colorful folk-inspired garments that incorporated traditional textiles with contemporary design trends.

During the last two decades of the twentieth century, in countries with developed fashion, textile, and shoe industries such as Brazil, Mexico, Peru, and Colombia, there was remarkable market consolidation in the Latin American fashion industry. Companies like the Brazilian São Paulo Alpargatas (founded 1907), which manufactured the now ubiquitous "Havaianas" brand of plastic flip-flops from 1962, gained access to international markets through the development of new product types and thus positioned themselves in the global fashion context. Other designers opted for a pan-regional market approach. For example, in 1972 the Colombian designer-entrepreneur Mario Hernández (b. 1941) founded an eponymous manufacturing and retailing company specializing in high-end leather products. Today, with numerous luxury boutiques in six different Latin American countries and an online marketplace, Hernández's company is among the few fashion and luxury goods conglomerates in the region.

INDUSTRIAL DESIGN

It was not until the late 1940s that large-scale industrial development took place in Latin America, the result, at least in part, of government policies aimed at substituting local products for imported goods. Usually carrying strong political overtones and often dissociated from market realities, a good number of such initiatives failed.

Automobiles and other products of heavy industry, which require large capital investments and appropriate markets, posed major challenges to investors, entrepreneurs, and designers alike. Latin American companies often began by assembling imported North American or European parts and copying European and U.S. automobile designs. The Mexican production of Borgward cars in the 1960s began when a local entrepreneur acquired the manufacturing equipment formerly belonging to Borgward, a Bremen-based German automaker that went bankrupt in 1961. Except for a few changes, including a new corporate logo featuring the Aztec calendar placed on the steering wheel, Mexican Borgwards were virtually identical to German models. Some Latin American companies were the result of joint-ventures or licensing agreements with European and North American companies. These corporations designed and manufactured models that were assembled using U.S.- or European-designed car chassis, together with a significant number of parts designed and

manufactured in Latin America. Noteworthy examples include the Argentinean *IKA–Torino* (Industria Kaiser Argentina, 1966), which had an AMC (American Motors Company) chassis, and the Brazilian *Volkswagen Brasilia* (1973), which had a Volkswagen *Beetle* chassis.

Home appliances and small industrial products, which generally required more modest capital investment and employed more readily accessible technologies, offered opportunities for designers who understood local needs and preferences. In the late 1950s, kitchen designs by José Carlos Bornancini (1923–2008) and Nelson Ivan Petzold (b. 1931) for Metalúrgicas Wallig and Jackwal in Brazil, for example, featured cooking ranges designed to a standard height lower than that used in Europe and North America to accommodate the shorter average height of Brazilian women. (It was assumed that women did the cooking.) Some household products became so successful that production crossed national borders within South America and farther afield. The *Magiclick* (1963), for example, a low-cost piezoelectric gas kitchen lighter designed by Hugo Kogan (b. 1934) while he was the head of the design department at the Argentinean home appliance manufacturer Aurora, was an instant bestseller, and Aurora established additional production facilities in Brazil and Spain.

In Chile, both industrial design training and product manufacturing developed under direct state supervision during the government of Salvador Allende (1970–73). The German designer Gui Bonsiepe (b. 1934), who studied and later taught at Hochschule für Gestaltung Ulm (Ulm School of Design), created proposals for new, well-designed, and affordable consumer products such as school furniture, food containers, ceramic dinnerware, and wooden toys. Bonsiepe also led a team that worked on a sophisticated government computer network system named Project Cybersyn but, because of changed political circumstances, it did not go beyond the prototype stage.

The Cuban Revolution of 1959 put the collaboration between designers and industry, and the creation of new object types for the "new society," onto the political agenda. Pressing issues, such as fighting poverty and improving education and health care, and economic blockades, however, meant that many projects remained at the prototype stage or were produced only in small series, such as the furniture and household artifacts designed by Gonzalo Córdova (b. 1924) and María Victoria Caignet (b. 1927). Córdova had designed numerous commercial interiors in prerevolutionary Cuba, including the Miramar Yacht Club (c. 1950). He and Caignet began working together in 1959 after the Cuban Revolution.

DESIGNER ENTREPRENEURS

Some designers ventured into manufacturing and retailed pieces made to their own designs. Brazilian designer Regina Gomide Graz (1897–1973), for example, ran a rug factory, Indústria de Tapetes Regina Ltda. (Regina Carpet Industry Ltd.) in the 1940s, and in 1948 the Italian-born designer Lina Bo Bardi (1914–1992), in partnership with Giancarlo Palanti

(1906–1977), began the Estudio de Arte Palma to manufacture stackable wood furniture. In Caracas in the same period, Gego (Gertrud Goldschmidt, 1912–1994)—a German-born architect, designer, and sculptor—established Talleres Gunz (Gunz Workshops, 1940–44) to make lamps and furniture to her designs. The number of such enterprises increased during the second half of the century, especially in countries like Brazil where there was considerable consumer demand for modern design. Oca Industries was among the most successful ventures. Founded in 1955 by the designer Sergio Rodrigues (b. 1927), it manufactured and retailed highly acclaimed designs such as the 1957 *Mole* (soft) armchair (fig. 23.29).

Estudio Churba (CH–Centro de Arte y Diseño), founded in 1960 in Buenos Aires by artist-designer Alberto Churba (b. 1932), produced the very popular *Cinta 5* armchair (1970) which Churba designed. The studio also sold furniture, textiles, rugs, and glass objects designed by Churba but manufactured by companies elsewhere as, for example, the *Villiruusu* (Wild Rose) pattern glassware (1982), which was made by the Iittala company in Finland. From the early 1970s, the Colombian designer Jaime Gutiérrez Lega (b. 1932) became a business partner in several successful manufacturing projects, most notably the production of the *Ovejo* (sheep) armchair (1970), produced by Modulíneas in Bogotá, which combined new forms with traditional materials. The frame was a simple, unadorned wooden structure made of farmed eucalyptus wood. A sheepskin from Villa de Leyva (a small town in Colombia celebrated for its sheep) was used for the seat. The chair, which was produced as an "exclusive" item, retailed at high-end furniture stores. Other high-end products included chairs in laminated bentwood and leather by Chilean designer Cristián Valdés (b. 1932); they retailed through Valdés Muebles in Santiago and have been popular in Chile since the launch of the first series in 1977.

Fig. 23.29. Sergio Rodrigues. *Mole* armchair, manufactured by Oca, Brazil, 1957. Jacaranda, leather; 29 x 40 x 32½ in. (73.7 x 101.6 x 82.6 cm). R 20th Century, New York.

GRAPHIC DESIGN

Latin American graphic design and the teaching of it greatly benefited from the arrival of European printers, typographers, illustrators, and binders in the late 1930s. Refugees from the Spanish Civil War played an important role in such developments, especially in Mexico and Argentina. An active supporter of the Second Spanish Republic (1931–39), designer and illustrator Miguel Prieto (1907–1956), for example, had enjoyed a successful career in Spain, including illustrating Federico García Lorca's *Romancero Gitano* (Gypsy Ballads, Madrid, 1928), before he fled to Mexico in 1939. Minimalist and elegant, Prieto's 1940s typography-based cover designs for magazines, books such as Juan Rejano's 1949 *Oda Española a Dolores Ibárruri* (Spanish Ode to Dolores Ibarruri), and numerous catalogues for the Instituto Nacional de Bellas Artes (National Institute of Fine Arts) in the 1940s and early 1950s, inspired graphic designers in most Latin American Spanish-speaking countries.

Fig. 23.30. Alexandre Wollner. Package designs for Coqueiro sardines, Brazil, 1958.

Graphics became a vibrant and diversified specialty in the 1940s and 1950s, especially in nations with strong literary traditions such as Argentina, Mexico, and Brazil. Alexandre Wollner (b. 1928) was a key figure in mid-century Brazilian graphic design. Born in São Paulo and educated in Brazil and Germany, he created the packaging for Coqueiro sardines in 1958 which became a design standard (fig. 23.30). It reflects Wollner's interest in abstraction and in both European and U.S. Modernist graphic and corporate identity design. The packaging featured a highly stylized fish with the company logo wittily replacing the eye of the fish. Products were differentiated by background color: yellow for sardines in oil, red for tomato sauce, and green for lime sauce. The design proved so successful that the company continued to use it, virtually unchanged, until 2000.

Many graphic designers bridged decorative and fine arts. In the 1960s, the Argentineans Edgardo Giménez (b. 1942) and Juan Carlos Distéfano (b. 1933), for example, were associated with the Instituto Di Tella (Di Tella Institute, founded 1958), a Buenos Aires nonprofit cultural center, working in both graphic design and fine arts. Fresh influences continued to come from abroad. In Venezuela, two outstanding graphic designers in the 1960s and 1970s, the German Gerd Leufert (1914–1988) and Italian Nedo Mion Ferrario (1926–2001), were also abstract painters.

Special events generated patronage and stimulated creativity, such as the design program for the 1968 Olympic Games and the 1970 FIFA World Cup (football), both held in Mexico. The design team for the Olympic Games was coordinated by Pedro Ramírez Vázquez (1919–2013), with graphics by U.S. designer Lance Wyman (b. 1937) working with Eduardo Terrazas (b. 1936) of Mexico. Wyman won the international competition to design graphics for the Olympics. His *Mexico 68* logotype skillfully and dramatically mixed elements from Mexican traditions with the Op-Art kinetic imagery and typography then in vogue (fig. 23.31). The poster, and Wyman's graphic program for the Olympics as a whole (itself influenced by pre-Hispanic Mexican imagery and folk art), proved both popular and influential in Latin America.

In Cuba after the 1959 revolution and Peru under the Military Government (1968–75), graphic design, especially posters, was used to great effect as a means of mass communication. Posters by the noted Cuban designers Alfredo Rostgaard (1943–2004) and Eduardo Muñoz Bachs (1937–2001), as well as those by the Peruvian illustrator Jesús Ruiz Durand (b. 1940), were inspired by a desire to transform society as well as by Pop-Art aesthetics and popular poster traditions. In Cuba, despite a prerevolutionary literacy rate of between 60 and 76 percent (relatively high compared to some other Latin American nations), a new communications program sought to reach the least privileged levels of Cuban society and the literacy rate was raised to over 95 percent. Employing bold colored posters with high contrast, the program covered a wide range of topics, from defense of the Revolution to the building of a new society, health and education, ballet, music, and sports. The Cuban poster tradition remains strong, as seen by the work of Nelson Ponce Sánchez (b. 1976) and the Camaleón Group (founded 2000).

Graphic design, especially advertising and corporate identity graphics, expanded alongside consumer markets, becoming a dynamic area of design across the entire region during the last quarter of the century. Since the late 1990s, other specialties, such as web-design, were folded into the field. Local firms and designers specializing in graphics and package design evolved into more complex regional or international structures capable of producing global design solutions. Designer Eduardo Calderón (b. 1950), for example, founded Design Associated in 1978 in Mexico City, and in 2004 he, Claude Salzberger (b. 1953), and Maria Gabriela Pulido (b. 1968), together formed Emblem with headquarters in New York, which became MBLM in 2010, with partners in Latin American countries, the United States, and around the globe. An international branding agency that integrates significant digital components, it functions as a network of local agencies. The firm's design portfolio includes projects such as "MéXICO" (2005), a brand developed for the Mexican government to launch the country as a tourist destination.

CRAFT AND DESIGN

As in many other parts of the world, both traditional and studio crafts gained relevance during the second half of the century. Craft has been an important component in daily life in Latin America since pre-Columbian times. At mid-century, there was considerable public appreciation and awareness of the importance of craft traditions, especially in relation to cultural heritage. Several factors helped to generate a new momentum, as intellectuals, artists, and designers supported and promoted craftwork among both local elites and the general public. In some instances craft was buoyed by governments that recognized its centrality to national identity and national and local (rural) economies.

In Mexico, craft promotion was encouraged at home and beyond national borders, thanks in part to connoisseurs and scholars such as René d'Harnoncourt, who organized a pioneering exhibition of Mexican fine and decorative arts (1929–30) at The Metropolitan Museum of Art, and *Twenty Centuries of Mexican Art* (1940) at the Museum of Modern Art, both in New York. Both exhibitions included a substantial selection of traditional Mexican craft. Some wealthy North American collectors such as Nelson A. Rockefeller, who had major business operations in Latin America, amassed important collections and helped reinforce the importance of crafts—albeit crafts as "art"—among Latin American and intercontinental audiences.

By the 1950s, interest in studio crafts had increased. These were crafts practiced outside the continuing indigenous craft traditions, though influenced by them, in individual studios or small workshops, and outside mainstream commercial production, though linked to it. In some countries such as Venezuela, studio crafts flourished. A thriving economy, institutions devoted to teaching and promoting what became a new area of study, public interest in the subject, and collectors all generated an ecosystem capable of sustaining communities of independent artist-craftspeople.

Fig. 23.31. Lance Wyman. Poster with *Mexico 68* logotype for the Mexico City Olympic Games, designed 1967. Art direction by Eduardo Terrazas and Pedro Ramirez Vásquez. Offset lithograph; 34⅛ x 34⅜ in. (86.7 x 87.3 cm).

In the 1950s and 1960s, a group of studio potters and enamelists coalesced around Miguel Arroyo. The group included many women potters, among them María Luisa Zuloaga de Tovar (1902–1992; fig. 23.32), Seka Severin de Tudja (1923–2007), Cristina Merchán (1926–1987), Reina Herrera (b. 1923), and Tecla Tofano (1927–1995). Those who were Modernists, or had been influenced by Modernist ideals and aesthetics, sought to reduce traditional forms or decoration to what they considered essentials. Even while venerating traditional crafts, they felt pressured to modernize colors, decoration, and object types to such an extent that some wondered if the link between change and continuity might be stretched to breaking.

The Peace Corps, established in 1961 by U.S. President John F. Kennedy to promote world peace and friendship and American interests, helped to promote crafts in Latin America as part of the United States' "good neighbor" policies, as did other U.S. institutions like the Ford Foundation. Likewise, some Latin American government agencies, such as Artesanías de Colombia (Colombian Crafts, founded 1964), developed commercially oriented programs wherein professional designers redesigned existing craft products to be sold at craft fairs or through specialized stores, sometimes without much sensitivity to local traditions and materials. Some government and private enterprises produced craft objects especially for urban bourgeois consumers, as for example Artesa (founded 1973 in Cuenca, Ecuador), a ceramics manufactory established and directed by the Ecuadorian designer Eduardo Vega (b. 1938), which specialized in folk-inspired con-

EUROPE AND NORTH AMERICA 1900–1945

Fig. 23.36. Charles Frédéric Mewès and Arthur Joseph Davis. Drawings for furniture, Mewès and Davis, London and Paris, c. 1910. Pencil and wash; 12¼ x 8¼ in. (31.1 x 21.1 cm). Inscribed "Bonheur du jour a etagere Louis XVI ebenisterie et bronze" and "Toilette Louis XVI bois sculpte peint blanc." Victoria and Albert Museum, London (E.866:73-1975).

In 1900, interest in design and the decorative arts in Europe and North America (used here to refer to the United States and Canada) was widespread. The validation of the decorative arts in the second half of the nineteenth century had raised their status, and consumer culture had expanded. The circulation of design ideas and images increased in the years between 1900 and 1945, particularly through exhibitions, stores, magazines, photography, and film.

Many products remained wholly or partly handmade throughout this period, and an appreciation of handcrafts, traditional materials, and tried and tested techniques persisted. At the same time, machine production and the use of new materials increased, and industrial design, which covered goods from tea kettles to trains, emerged as a new profession in the 1930s. So too did "commercial art" (later called graphic design), which helped to promote all manner of products, events, retail outlets, and lifestyles.

Design as an index of identity, particularly national identity, recurs throughout this chapter. There was also a broadening of the character of design itself across national, international, and transnational borders. Designers took on commissions outside their native lands, moved to other countries to work, or collaborated with designers and manufacturers from elsewhere, and more ideas and goods circulated globally. These interrelationships form another theme throughout the chapter.

In the late nineteenth and early twentieth centuries, women entered the world of professional design as a part of wider movements toward equality with men. Within the decorative arts, women found easier access in areas traditionally associated with women, such as embroidery, weaving, china-painting, jewelry-making, bookbinding, dress design, and interior design. They met resistance in other fields such as landscape design, architecture, and product design because such work was coded as "male." And the gendering of objects and spaces continued. The hairbrushes advertised for women in the 1908 British Army and Navy Stores' catalogue, for example, were more delicate, frequently with mirrors attached, than those designed for men.

Twentieth-century design and decorative arts are often misrepresented within narratives that privilege innovation, technological improvements, mass production, and mass consumption. This chapter offers a more plural picture than is common in an effort to emphasize the rich diversity within design and design thinking, the many continuities and overlaps, and the simultaneity of various ideas and movements.

BEAUX-ARTS, LOUIS, AND "PERIOD"

Between 1900 and World War I (1914–18), Beaux-Arts, Louis, and "Period" design reached new heights of prestige, particularly with the social elite. Named after the École des Beaux-Arts in Paris, the French national academy where symmetry, balance, harmony, and proportion of classical and Renais-

sance design were stressed, Beaux-Arts architecture and design epitomized elite status, wealth, and tradition from the 1870s until World War I and beyond. Around 1900, contemporaries noted a more grandiose and eclectic engagement with classicism, as Baroque, ancient Roman, and Neoclassical elements often featured in the Beaux-Arts mix. French design from the reigns of Louis XIV (r. 1643–1715), Louis XV (r. 1715–74), and Louis XVI (r. 1774–92)—a period considered the peak of French taste and craftsmanship—was also extremely popular. The various Louis styles were often mixed, hence the term "tous les Louis" for designs that drew from all three reigns.

A more loosely defined "Period" look that evoked eighteenth-century design, mainly from France but additionally from England and Italy, was similarly suited to both official and private spaces. Luxurious materials and finishes added grandeur to all manner of objects and places, from velvet drapes and candelabra to palaces and brothels. Antiques acquired a new allure, and trade in them, along with fakes and reproductions, flourished. Given that it was often easier to find a complete eighteenth-century ceiling than to procure

a large set of matching chairs, and that the desire for "period" effect was greater than any concern for authenticity, reproductions were in great demand, and top-quality ones cost almost as much as the originals from which they were copied.

Beaux-Arts, Louis, and Period, together with mixes of all three, resonated with an international elite. An example of the transnational circulation of ideas, styles, patrons, and companies is the makeover of Castle Forbes in Ireland from 1909 by Beatrice Mills Forbes, an American heiress who became the Countess of Granard. Familiar with Beaux-Arts and Period styles from the United States, she hired both French and British interior design firms to transform the main rooms: French interior designer Ferdinand Allard for the grand hall and staircase, and Lenygon & Morant, a leading London firm, for a "Palladian" dining room in the manner of English designer William Kent (1685–1748).

Swiss hotelier César Ritz also embraced this trend for his luxury hotels. In Paris, the Ritz Hotel (1898) was designed by Swiss-born French Beaux-Arts–trained architect Charles Frédéric Mewès (1858–1914) in a mix of Louis styles. An even more glamorous version in London (1903–6) was designed by Mewès and his new English partner, Arthur Joseph Davis (1878–1951), who also trained at the École des Beaux-Arts. Surviving drawings by the partnership made shortly after the furnishing of the London hotel show the types of pieces that might have been used therein, including a so-called *bonheur-du-jour* ("daytime delight," lady's writing desk) in the style of French furniture-maker Martin Carlin (c. 1730–1785), complete with Sèvres-style porcelain plaques (fig. 23.36; see fig. 17.3).

Other projects by the Mewès and Davis partnership include the Ritz Madrid (1910), designed in association with Spanish architect Luis de Landecho (1852–1941), and commissions for an ocean liner company, the Hamburg-Amerika Line. In order to better compete with British and French companies over the North Atlantic passenger trade, this German company hired this Anglo-French partnership to transform its liners into floating hotels. *Amerika* (1903) included an elegant Louis XVI–style restaurant run by Ritz, while *Imperator* (1913) featured a magnificent Pompeian-style men's swimming pool in first class, which evoked the male culture of ancient baths. Mewès and Davis's first British liner, Cunard's *Aquitania* (1914), with its double-height Palladian-style lounge and Louis XVI–style dining room, helped Britain regain the lead in the race for passengers after the 1912 sinking of White Star's *Titanic*.

In the United States, whose wealthiest citizens formed the backbone of the transatlantic passenger trade, Beaux-Arts architecture and design in public spaces often alluded to the grandeur of ancient Rome, the democratic associations of Republican Rome, and to the elevation of public taste and education. The New York Public Library (1902–11; fig. 23.37), for example, was designed as a "people's palace" by the Beaux-Arts–trained architects John Merven Carrère (1858–1911) and Thomas Hastings (1860–1929), with decorative paintings by James Wall Finn (1866–1913). In what was the largest library reading room in the world, the quiet dignity and uniformity of the library furniture and fittings (also by Carrère and Hast-

ings) were offset by the magnificence of the ceiling, emblematic of enlightenment through knowledge. Other designs that presented New York as a civic center on par with Renaissance Florence or ancient Rome included McKim, Mead & White's main concourse of the Pennsylvania Railroad Station in New York (1904–10), which was modeled on the Roman baths of Caracalla.

The same firm remodeled the exterior of the White House (1901–2) in Washington, D.C., in the Federal style associated with early American nationhood. For the interiors, they drew from the Empire style in place at the time of the 1814 fire that destroyed much of the original building. For the East Room, however, which had not been decorated by 1814, the firm created a fashionable Beaux-Arts space. Its paneling was based on the 1780 Salon de Famille in the Château de Compiegne in France, which had been built for Louis XV and restored by Napoléon. The White House's oak parquetry flooring was reminiscent of that at the French Renaissance Château de Fontainebleau, and there were enormous bohemian crystal chandeliers.

Private mansions owned by rich industrialists and bankers in the United States were as glamorous as any in Europe, from the 60,000-square-foot Italianate mansion in Palm Beach, Florida, for Henry Flagler, a Standard Oil tycoon, to Vizcaya (1910–16), a forty-three-room Italianate palace in Miami, Florida. At the former, Carrère and Hastings and interior decorating firm Pottier & Stymus created a series of period rooms from "Italian Renaissance" to Louis Quinze. At Vizcaya, owner James Deering, a vice president of the International Harvester Company, hired painter Paul Chalfin (1874–1959) as artistic supervisor for the project. The two worked together to create the illusion of a villa renovated and redecorated many times over four hundred years through period rooms furnished with antiques bought in Europe.

Fig. 23.37. John Merven Carrère and Thomas Hastings. Main Reading Room, New York Public Library, 1902–11; photographed (lantern slide) c. 1911–20. Ceiling paintings by James Wall Finn.

Stanford White (1853–1906), a partner in the firm of McKim, Mead & White, advised on antiques and interior decoration. This business involved the transportation of antique interiors, paneling, and furnishings across the Atlantic. White saw rooms and objects as backdrops to the high life and was noted for using top-quality antiques and materials in imaginative period mixes. The huge budget ($300,000) for the interiors of the New York mansion (1902–9) of White's clients William Payne Whitney and Helen Whitney, for example, included a reception room with mirrored walls in eighteenth-century Venetian style. The late eighteenth-century French furniture with painted insets, marble clock, and antique Italian portraits for the room were among the items the Whitneys purchased when White accompanied them on a European buying trip. The painted ceiling, glass panels, marble chimney piece, and door surrounds and latticework coving were created in workshops in the United States.

The cinematic presentation of domestic opulence as a newly public spectacle was one means to attract middle- and upper-class audiences. The film industries of North America and Europe made concerted efforts to raise the standards of design on screen in the 1910s. The Italians led the way, with three-dimensional sets and props (as opposed to painted backdrops) in the epics *Brutus* (1910) and *Quo Vadis* (1912), which, like the Pennsylvania Railroad Station and New York Public Library, brought grandiose versions of classicism to a wider public. The high production values of *Cabiria* (1914) and *Intolerance* (1916) led to claims in the late 1910s and 1920s that films had greater power than international expositions to influence taste in design and architecture. *Cabiria* had been directed by Giovanni Pastrone (1883–1959), who also helped design the sets, while for *Intolerance* director D. W. Griffith (1875–1948) hired Italian craftsmen to create the sets.

ARTS AND CRAFTS, ART NOUVEAU, AND NATIONAL ROMANTICISM

Arts and Crafts ideals and practices continued to be influential internationally in the 1900s and 1910s (and often beyond). Several of the leading designers involved in this broad movement in Europe and North America in the early twentieth century had visited Britain or were well acquainted with developments there and with the writings of John Ruskin and William Morris. As industrialization increased and folk and craft traditions waned, the idea of them as expressions of local, regional, and national identity gained ground. The movement in architecture and design now known as National Romanticism was informed by both the Arts and Crafts movement and Art Nouveau, another influential design idiom in the early twentieth century. All three movements overlapped, so much so that some European scholars now refer to the resultant expressions by a new umbrella term, "New Art."

VIENNA, GLASGOW, AND THE HAGUE

Although founded on the model of an Arts and Crafts workshop, the Wiener Werkstätte (Vienna Workshops), established by Koloman Moser (1868–1918) and Josef Hoffmann

(1870–1956) in 1903, was concerned more with aesthetic than social reform. It produced exquisitely made objects in small numbers that appealed to the refined tastes of upper- and middle-class Viennese society, and saw design within the framework of *Gesamtkunstwerk* (total work of art).

The sophisticated restraint of the Werkstätte's furniture, interiors, and objects evoked the solidity and refinement of early nineteenth-century Biedermeier (see fig. 17.21). Characteristic motifs included silhouettes of classical columns, stylized flowers, and contrasts of dark and light colors. Hoffmann, following the example of Charles Robert Ashbee (1863–1942) of the Guild of Handicraft and other British Arts and Crafts metalworkers and jewelers, rejected gold and bombastic gems in favor of the more humble beauty of semiprecious stones, silver, and decorative hammer patterns (fig. 23.38).

Viennese architect-designer Adolf Loos (1870–1933), who admired the efficiency of North American plumbing and understated English tailoring and club chairs, reviled the Werkstätte's focus on precious objects and inward-looking aestheticism. In his polemical essay "Ornament and Crime" (c. 1908–10), Loos argued that applied ornament was a mark of "primitive" culture and that its use in contemporary European societies indicated cultural degeneracy. The idea that "the evolution of culture is synonymous with the removal of ornament from utilitarian objects" had far-reaching effects on the theory, if not the practice, of Modernist design in the 1920s (discussed below).[1]

The main center of British Art Nouveau was Glasgow, Scotland, where a group of designers, many of them steeped in Arts and Crafts ideals, established a more lyrical and harmonious decorative language and created interiors and objects as expressions of a *Gesamtkunstwerk*. Signature elements of what is often called "Glasgow Style" included light, stylized, elongated (and often female) forms; pale palettes; and Celtic, Symbolist, and Japonisme motifs. They appeared on a wide variety of objects, including book covers by Talwin Morris (1865–1911), book illustrations by Jessie King (1875–1949), metalwork by De Courcy Lewthwaite Dewar (1878–1959), and the "New Embroidery" associated with Jessie Newbery (1864–1948) and Anne McBeth (1875–1948). As in most close creative communities, there were many cross-influences.

Fig. 23.38. Josef Hoffmann. Brooch, Vienna, 1904. Made by Karl Ponocny for the Wiener Werkstätte, Silver, partial gilt, diamonds, moonstones, opal, lapis lazuli, coral, leopardite; 2 x 2 in. (5.1 x 5.1 cm). Neue Galerie, New York.

DEIN-WETTBEWERB FÜR EIN HERRSCHAFTLICHES WOHNHAUS EINES KUNST-FREUNDES

EMPFANGS---RAUM U.D MUSIK---ZIMMER PANELS VON MARGARET MACDONALD MACKINTOSH

Fig. 23.39. Charles Rennie Mackintosh and Margaret Macdonald Mackintosh. Competition design: lounge and music room, Glasgow, 1901, from *Haus eines Kunstfreundes* (House of an Art Lover), Darmstadt, 1902. Lithograph; 15½ x 20⅞ in. (39.4 x 52.8 cm).

Scottish architect-designer Charles Rennie Mackintosh (1868–1928) and his wife, designer Margaret Macdonald (1865–1933), took conventional gender coding to extremes, contrasting highly aestheticized, light-colored "feminine" bedrooms, drawing rooms, and music salons with darker "masculine" dining rooms, libraries, and halls. They further played with gendered conventions in their own white drawing room (doubly coded as "feminine" by room type and color), by designing furniture with both "feminine" and "masculine" references, and opposing dark and light, solidity and space, "male" and "female." Influential abroad, they showed room-settings at exhibitions in Vienna (1900), Turin (1902), and Moscow (1902–3). Their jewel-like music salon for a 1901 competition sponsored by Alexander Koch, a German publisher, garnered considerable acclaim and, as with the exhibitions, led to commissions abroad (fig. 23.39).

In the Netherlands, the Art Nouveau style was called Nieuwe Kunst (New Art), and The Hague was the main center. Cornelis van der Sluys's (1881–1944) poster for the shop called Arts and Crafts Den Haag highlights the enfolding of Arts and Crafts elements within Nieuwe Kunst (c. 1902; fig. 23.40). Architect-designer Eduard Cuypers (1859–1927) promoted Nieuwe Kunst in the journal *Het Huis* (The House, 1905–27), which he edited. Cuypers preferred more angular forms and decoration whereas the Rosenburg porcelain company, also in The Hague, was known for its vases, candle-

ARTS AND CRAFTS DEN HAAG HOLL: KUNST EN KUNSTNIJVERHEID

Fig. 23.40. Cornelis van der Sluys. Poster for Arts and Crafts Den Haag, The Hague, 1902. Printed by S. Lankhout & Co. Japan paper; 39⅜ x 27½ in. (100 x 70 cm). Haags Gemeentearchief, The Hague (201118).

sticks, and other objects with more curving forms and naturalistic floral and leaf decoration. Rosenburg's designers included W. P. Hartgring (1874–1940), Sam Schellink (1876–1958), and J. M. van Rossum (1881–1963). Socialist-minded architect-designers based in Amsterdam, including Hendrik Berlage (1856–1934) and Jacob van den Bosch (1868–1948), were among those who found Nieuwe Kunst too showy, foreign, and unrepresentative of what they considered the Puritan Dutch character. The shop and workshop 't Binnenhuis (The Interior, founded 1900) presented their type of rational, sober, restrained design, which emphasized honest workmanship and revealed construction.

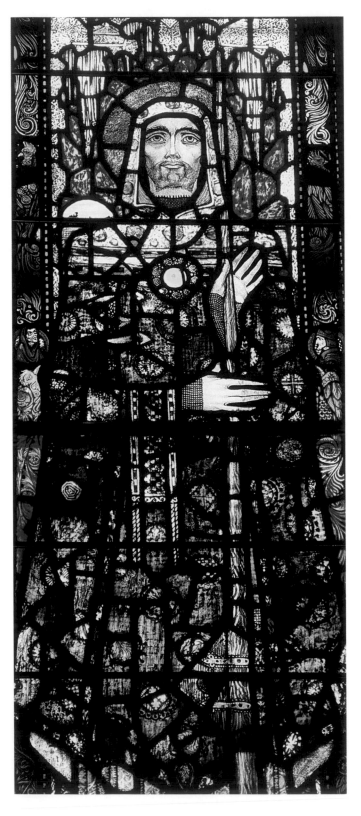

Fig. 23.41. Harry Clarke. Window depicting Saint Brendan, Honan Chapel, University College, Cork, c. 1916. Stained glass, lead; 11 x 2½ ft. (3.3 x 0.7 m).

IRELAND, POLAND, AND HUNGARY

National Romanticism, which drew inventively on vernacular design and folk handcraft traditions believed to embody national characteristics, flourished in several countries, especially those seeking or achieving political independence, such as Ireland, Poland, and Hungary. In Ireland, it was part of a wider revival of interest in ancient Celtic culture and was associated with the struggle against British imperialism. No single national style emerged, but National Romantic images of Irish saints by Harry Clarke (1889–1931), Wilhelmina Geddes (1887–1955), and other stained-glass artists signified a continuity with early Christianity, as opposed to the official Protestantism of the British state (fig. 23.41). Ancient Celtic symbols evoked even older legends and myths and later featured prominently in the visual culture of the Irish Free State (established 1922).

The Polish lands within the Austro-Hungarian Empire enjoyed a sufficient degree of autonomy for "Poland" to be represented as a Slavic state and Cracow (Kraków) as a modern, cosmopolitan Polish city. Hopes for an independent Poland were expressed through modern designs inspired by folk traditions, such as Stanisław Wyspiański's (1869–1907) farmhouse-style furniture and colorful wall decorations for churches. Wyspiański and Józef Mehoffer (1869–1946), a leader of the Mloda Polska (Young Poland) movement, were members of the Polish Applied Art Society (founded 1901), which documented objects from the past in *Materialy Polskiej Sztuki Stosowanej* (Records of Polish Applied Arts, 1902–12). Another member, painter and set designer Karol Frycz (1877–1963), designed Michalik's Den (1911), a café in Cracow, which became a gathering place for nationalist artists, designers, and intellectuals. The Kraków Workshops (established 1913) continued to stress the importance of folk crafts to contemporary decorative arts after Polish independence in 1918.

In Hungary, the junior partner in the Austro-Hungarian Empire, the need for greater autonomy, if not independence, also underpinned design discourse. In a rapidly industrializing country, the remote area of Transylvania was hailed as the cradle of Hungarian (Magyar) culture. It became a place of pilgrimage for designers exploring folk traditions and seeking to document and represent "authentic" Hungarian culture. Artist-designer Aladár Körösfői-Kriesch (1863–1920) collaborated with the ethnologist Dezső Malonyay (1866–1916) on *A Magyar Nép Müvészete* (Art of the Hungarian People, 1907–22), a five-volume survey of the costume, folk arts, and vernacular architecture of the historic kingdom of Hungary (fig. 23.42). *Studio* (an international journal published in London beginning in 1893) deemed this documentary approach to design overly archaeological, but, as in Poland, designers and artists drew creatively on both the past and the surviving crafts of the present.

The Arts and Crafts colony at Gödöllő, near Budapest (1901–20), embraced Arts amd Crafts ideals, including simple living and believed in the transformative power of the arts. Founded by Körösfői-Kriesch, Gödöllő members included his sister Laura Nagy (1879–1966), an artist and textile designer; her artist-designer husband, Sándor Nagy (1869–1950); and Swedish-born artist-weaver Leo Belmonte (1875–

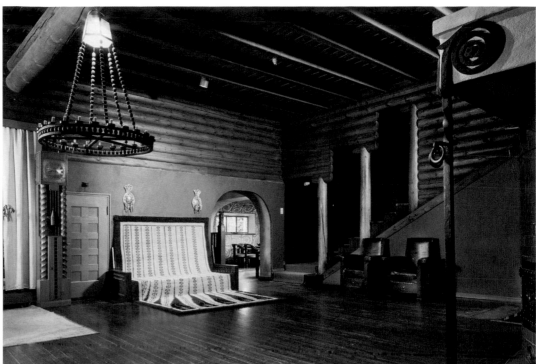

1956). Craft production began in 1904–5 with weaving, furniture, stained glass, mosaics, embroidery, book illustration, and leatherwork following. Most members and associates were political progressives who eschewed luxury while embracing decoration. Collaborative projects included the Palace of Culture at Marosvásárhely (now Târgu Mureş, 1910–13), with frescoes by Körösfői-Kriesch and stained glass by Sándor Nagy, Ede Toroczkai-Wigand (1869–1945), and Miksa Róth (1865–1944), all of which drew on the past to symbolize the national Magyar spirit.

SCANDINAVIA, FINLAND, AND RUSSIA

In Sweden, both the relatively simple manor houses of the eighteenth century and peasant-style cottages continued to inform National Romantic designers' concepts of the home and products to go in it. Some fused the two, as in Gunnar Asplund's (1885–1940) model kitchen/living room at the Hemutställningen (Home Exhibition, 1917), which featured a suite of relatively cheap furniture in stained wood, as well as rag rugs, curtains, and fabric lampshades designed so that working-class women could make them at home. Also in 1917, Wilhelm Kåge (1889–1960), art director at the Gustavsberg pottery, designed inexpensive tableware called Liljeblå (Blue Lily), popularly known as Arbetarservis (Workers' Service), but its studied simplicity and folk references appealed more to progressive bourgeois consumers than the working-class buyers for whom it was intended, much in the same fashion as Asplund's furnishings.

Although Finland did not gain independence from Russia until 1917, the Grand Duchy of Finland was allowed a separate pavilion at the 1900 Paris Exposition. The architectural design partnership of Herman Gesellius (1874–1916), Armas Lindgren (1874–1929), and Eliel Saarinen (1873–1950) wielded architecture and design as a political manifesto. Inside the pavilion, the imagined national past was power-

fully expressed by Akseli Gallén-Kallela (1865–1931) in frescoes depicting scenes from the *Kalevala*, an epic from Karelia, the area where Finnish culture was thought to have survived at its most authentic. A ryijy rug, a traditional, long-pile, knotted wool rug, strengthened national vernacular references in both the pavilion and at Hvitträsk, Saarinen's family home (1901–3; fig. 23.43). At the latter, log walls recalled the medieval wooden houses then being enshrined in open-air museums in northern Europe, and Saarinen mixed periods and forms within the design vocabulary of a medieval hall to create a romantic sense of history across time.

In Russia itself, the most fluid and French-influenced example of Art Nouveau was the hall and staircase area in the Ryabushinsky mansion (1900–1903/4), designed by Fyodor Shekhtel (1859–1926), whose Slavophile designs, such as the Russian pavilions at the 1901 Glasgow Exhibition, were equally spectacular. National Romantic reinterpretations of Russia's Slavic past continued at the Talashkino workshops (1894–1905). There, artists and designers such as Sergey Malyutin (1859–1937), who was interested in Russian antiquities, folk art, and legends, and Nicholas Roerich (1874–1947), who focused on archaeology and admired pre-Christian Slavic culture, created all manner of objects, from embroideries to chairs, that fed into other areas of Russian cultural production, including the Ballets Russes (discussed below).

ITALY AND SPAIN

In an effort to highlight the up-to-date nature of Italy's decorative arts industries, historicism was excluded from the Prima Esposizione Internazionale d'Arte Decorativa Moderna (First International Exposition of Modern Decorative Arts, 1902) in Turin. The interior of the main hall by chief architect Raimondo D'Aronco (1857–1932) achieved expressive modern form through melding Austrian-influenced Art Nouveau with classical elements, an allusion to a specifically

Fig. 23.42. Aladár Körösfői-Kriesch. Cover for Dezső Malonyay, *A Magyar Nép Művészete*, vol. 3, Budapest, 1911.

Fig. 23.43. Eliel Saarinen and Loja Saarinen. Interior, main living area at Hvitträsk, Kirkkonummi, Finland, 1901–3. Architecture by Herman Gesellius, Armas Lindgren, and Eliel Saarinen.

Company (1894–1920) in Revere, Massachusetts; the Newcomb Pottery (1895–1940) in New Orleans; and the Rookwood Pottery Company (1880–1941) in Cincinnati, Ohio. Native American portrait vases, such as those produced by the Rookwood Pottery, exemplify the fascination with Native American culture, objects, and imagery at a time when white European Americans believed native culture was destined to disappear. The primitivist view that Native Americans were closer to nature and that Native aesthetics and goods were unspoiled by "civilization" added to their appeal. Arts and Crafts designers were among those who greatly admired the baskets, rugs, pottery, blankets, and other types of wares bought from Indian agents, handcraft shops, and larger firms.

In the British Dominion of Canada, the Arts and Crafts movement reaffirmed Canadian identity as white and Anglo-Saxon at a time of high immigration from Eastern Europe and China. Several leading members of the movement had been born in Britain or had close connections to the movement there. Both British- and U.S.-based magazines circulated in Canada, particularly *Studio* and *The Craftsman*, and some Canadian designs were published in the latter, including bungalows by Samuel Maclure (1869–1929). The Applied Art Exhibition series that began in Toronto in 1900 included book arts, and C. W. Jefferys' (1869–1951) illustrations for *Uncle Jim's Canadian Nursery Rhymes* (1908) featured stylized Canadian motifs. The Canadian Handicrafts Guild (founded 1905) and the Vancouver Island Arts and Crafts Society (founded 1909) helped raise the status of all handcrafted and decorative work, as did many commercial workshops such as the Artistic Metal Workers, established in about 1906 by Paul Beau (1871–1947), who produced top-quality metalwares in Montreal into the 1930s.

As in the United States, European Canadians admired crafts by indigenous peoples such as baskets, rugs, and totems, and by the mid-1920s, references to indigenous cultures were accommodated within official expressions of Canadian and regional identities. The summer house and interior Maclure designed for the lieutenant-governor of British Columbia in the mid-1920s featured First Nations rugs and a dining table decorated with First Nations motifs, tokens of inclusion within frameworks of institutionalized racism as elsewhere on the continent.

AMERICAN REVIVALS

Romantic Nationalism flourished in North America in a variety of American revival styles. The Colonial Revival, a widespread fascination with the architecture and design of an idealized early "America," peaked between the 1880s and the 1940s. The revival reflected a growing interest in historic preservation and the burgeoning trade in Americana, typically objects dating from the colonial era through the early nineteenth century. Art museums began to acquire American antiques in earnest in the 1910s, 1920s, and 1930s, collecting furniture, ceramics, glass, metalwork, textiles, and needlework, among other genres. Participants in the Colonial Revival shared the Arts and Crafts reverence for handcrafted goods produced by skilled craftsmen whose engagement with their work was spiritual as well as manual; they likewise praised such objects' capacities to elevate the aesthetic sensibilities of the consumers who bought and used them.

In tandem with this veneration of the colonial past, architects, interior decorators, builders, designers, craftspeople, and manufacturers created new products and environments inspired by them. Faithful reproductions of historic models were relatively few. Some designs freely mixed forms and motifs from a variety of times and places, including high-style European antecedents and American vernacular forms. Romanticized quasi-period settings were also popular. In the United States, the entrepreneur Wallace Nutting (1861–1941) was known for marketing hand-tinted photographs of idyllic landscapes and scenes of costumed women in imaginatively staged historic interiors as in this example, photographed in his Southbury home (fig. 23.47). He also adapted the designs of colonial Windsor chairs, giving them greater visual impact by increasing the splay of the legs and deepening the curves of the bulbous turnings and scrolling crest rail. Such versions manifested a desirable "quaintness," a quality described as "lovable and livable" rather than "aristocratic" by Virginia Robie, author of a popular collecting guide aptly titled *The Quest of the Quaint*.[3]

The Colonial Revival was (and remains) a popular decorating idiom partly because of its versatility. In Canada, it began relatively soon after the three British North American colonies were confederated as Canada in 1867. There it evoked the material culture both left behind and reestablished by the approximately fifty thousand loyalists (many from New York) whom the British relocated after the American War for Independence, the American Revolution (1775–83). The revival focused on the range of British-influenced Georgian-style architecture and design that developed in

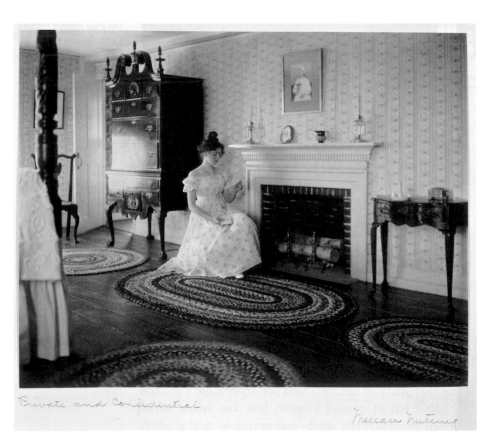

Fig. 23.47. Wallace Nutting. *Private and Confidential,* Wallace Nutting Art Prints Studio, Southbury, Conn., c. 1910. Hand-tinted platinum print; 7½ x 9⁷⁄₁₆ in. (19.1 x 24.3 cm). Auerbach Art Library, Wadsworth Atheneum Museum of Art, Hartford, Conn.

what became Canada after 1783, and embraced the cultural inflections that came with the Irish, Scottish, Dutch, German, and Huguenot French immigrants who arrived thereafter, as well as from native cultures.

In the United States, the Pilgrim style recalled New England clapboard houses, hardy British settlers, open-beam ceilings, broad hearths, high-backed settles, spinning wheels, turned spindle-back chairs, and heavily carved oak chests, while Dutch Colonial was associated with the romance of New Amsterdam, houses with stepped gables, and blue-and-white Delft tiles. By contrast, those working in Georgian or Federal revival styles (part of a wider renewal of interest in classicism; discussed below) aspired to evoke the environs of colonial and early republic elites along the eastern seaboard. Characteristic of their designs were red brick edifices planned and rescaled for modern-day use, sweeping staircases, black-and-white checkered floors, and crisp Neoclassical ornament in painted wood and plaster. Furnishings tended toward reinterpretations of high-style British pieces of the eighteenth and early nineteenth centuries, from "Queen Anne" to "Chippendale" and "Sheraton."

Alongside such high-style manifestations, Colonial Revival accoutrements, often described as "Early American," evoked simpler country farmhouses, complete with pine paneling, brick fireplaces, braided rugs, Windsor chairs, or even coffee tables fashioned after, and sometimes from, antique cobbler's benches. Middle-class homes often used such Colonial Revival decoration in casual spaces, such as family rooms, dens, and kitchens, while maintaining more formal interpretations in living and dining areas.

Collectors of what became known as folk art—such as sleek painted duck decoys, molded copper weathervanes, or oval Shaker boxes (see fig. 18.39)—also appreciated a vernacular aesthetic. Among them were those who valued the abstract and supposedly "naive" qualities they saw in these objects, just as they applauded the primitivism and abstract nature of certain African objects. Many considered them worthy models for contemporary artists and designers to draw upon.

Craft revivals ran parallel to folk art collecting and to the larger Colonial Revival and Arts and Crafts movements. Reformers and philanthropists fostered and in some cases revived traditional crafts. In the southern Appalachian mountains, for example, rural craftspeople had a long history of making slat-back hardwood chairs, split oak baskets, woven coverlets, utilitarian pottery, and musical instruments. The Cherokee Indians were especially known for their river-cane baskets and woodcarvings. As in similar projects across North America, social workers, teachers, missionaries, and researchers came to the region in the interwar years and established schools, cottage industries, and shops to increase the production and sales of crafts. By doing so, these reformers aspired to preserve what they saw as the region's distinctive culture while improving the living conditions of the resident population according to standards of the progressive middle class.

Other revivals drew on the Hispanic past. The Mission Revival (1890–1930) romanticized the culture of the southwestern United States in the days of the Spanish Franciscan

missions. This term was also loosely applied to Arts and Crafts furnishings. The Spanish Colonial Revival (1900–40) embraced the architecture and decorative arts of colonial Spain. Designs that reflected both Colonial Baroque and Baroque Revival elements were particularly popular in California, where it was the official style for the Panama-Pacific Exposition (1915). Spanish-style interiors ranged from rustic simplicity to hacienda-style splendor. Hand-wrought metalwork, colorful folk-influenced pottery, rugs, and heavily carved furniture supplied modern American consumers with the means to create environments evocative of "Spanish" pasts. A more exotic variation was the Mediterranean Revival, which conflated elements of Spanish Colonial with those of the Spanish and Italian Renaissance and Beaux-Arts. Popular during the 1920s and 1930s in California and Florida, this style was sometimes inflected by Orientalist, Moorish-inspired design.

DESIGN FOR INDUSTRY

The forging of more effective links between designers and manufacturers remained a key aim of design reformers throughout the century. Inspired by architect William Lethaby's (1857–1931) example at London's Central School of Arts and Crafts at the turn of the century, leading designer-educators, particularly in Britain, Germany, and Austria, prioritized workshop practice and worked closely with local trades and manufacturers in the 1900s and 1910s. An ambitious economic and political power, Germany sought to extend its reputation for high-quality chemicals, printing, and optical goods to everyday products. In 1904, the economist and politician Friedrich Naumann (1860–1919) called for affordable machine-made *Volksmöbel* (people's furniture). Designer and architect Richard Riemerschmid (1868–1957), in association with the Dresdner Werkstätten at Hellerau, developed what they called "machine furniture" (1905). The Werkstätten had been founded in 1898 by his brother-in-law Karl Schmidt (1873–1948), a trained woodworker. Although hand-finished and assembled, these furniture designs were made from standardized parts using machine-sawn wood and simple wooden bolts. Flat-packed for home assembly, the sets were available in living room, bedroom, and kitchen suites, and in various price ranges. *Typenmöbel* (standardized furniture, 1908), designed by Bruno Paul (1874–1968) in association with Schmidt, is generally considered the first modular furniture. In 1914, *Studio* claimed that about eight hundred variations of it were available, and that more than twenty designers used it in interiors.

In 1907, the Deutscher Werkbund (German Work League) sought to consolidate the interests of manufacturers, designers, artists, salesmen, and cultural critics; improve the German economy; and elevate popular taste through lectures, exhibitions, illustrated yearbooks, and a catalogue of approved goods. Schmidt, Paul, Riemerschmid, Peter Behrens (1868–1940), and others were among its organizers, along with Hermann Muthesius (1861–1927), an official in the Prussian Ministry of Trade and Commerce, and Henry Van de Velde

(1863–1957), a Belgian designer then working in Germany. The Werkbund model derived in part from Arts and Crafts ideals but placed greater focus on serial production and the creation of design forms according to demands of production and consumption. Debates were lively, with Muthesius eventually heading a group that pressed for greater standardization, while Van de Velde and others argued for the artistic freedom of the designer.

Similar organizations sprang up in other countries, including Austria, Switzerland, Britain, and the Czech and Polish lands. In Sweden, Gregor Paulsson (1889–1977) published *Vackrare Vardagsvara* (Better Things for Everyday Life, 1919) and worked within the Svenska Slöjdsföreningen (Swedish Society of Arts and Crafts or Swedish Society of Industrial Arts) to achieve Werkbund-style goals. In 1912, an exhibit of Werkbund goods was seen in several United States cities, and in 1917, The Metropolitan Museum of Art in New York established an Industrial Art section that displayed commercial goods.

Cooperation between designer and manufacturer was exemplified by Behrens's 1907 appointment to redesign products, advertising, and factories for AEG (Allegemeine Elec-

tricitäts Gesellschaft), one of Europe's largest companies. The expansion of electrification created new possibilities for electrical products in the home, and Behrens's poster for AEG gave invisible electricity an alluring and stable image (fig. 23.48). The clarity and directness of the AEG poster is similar to that seen in German *Sachplakate* (object posters), a form of commercial advertising developed around 1906 at the Berlin lithographic printers Hollerbaum & Schmidt. Conveying messages by means of a single bold image and trademark or company name, these prints were among the most graphically sophisticated in the Western world, particularly examples by Lucien Bernhard (1883–1972), Ludwig Hohlwein (1874–1949), and Julius Klinger (1876–1942).

The typography of the AEG logo eliminated traditional black-letter Germanic *fraktur* in favor of a Roman typeface. Behrens also preferred a modernized classicism for the electric kettles, fans, lamps, clock faces, and other items he designed for the company, while the machine-hammered metal surfaces of certain items conjured up Arts and Crafts associations. Behrens was not the first corporate identity designer, as is often claimed. Creating visual identities for

Fig. 23.48. Peter Behrens. Poster for the Allgemeine Elektricitäts-Gesellschaft, Hollerbaum & Schmidt, Berlin, 1907. Lithograph; 26⅜ x 20½ in. (67 x 52 cm). Kunstbibliothek, Staatliche Museen zu Berlin (14055069).

Fig. 23.49. Paul Iribe.
Gowns by Paul Poiret,
from his album *Les
Robes de Paul Poiret*,
Paris, 1908.
Photomechanical
pochoir print; 11 x
11¼ in. (28 x 28.5 cm).
National Art Library,
Victoria and Albert
Museum, London.

Fig. 23.50. Edward
Hald. Fruit bowl and
saucer: *Draperiskålen*,
Småland, Sweden, 1920.
Made by Orrefors
Glassworks. Glass;
bowl, 9⅜ x 11 x 11 in.
(23.7 x 27.9 x 27.9 cm).
Nationalmuseum,
Stockholm (NMK
21/1920).

companies and institutions was not new, but such large-scale campaigns that even included factories were. More international in scale than the AEG commission was British designer George Walton's (1867–1933) turn-of-the-century visual identity for the United States-based Eastman Kodak company. As Kodak expanded into Europe and beyond, Walton's Art Nouveau house-style was seen in stores as far afield as London, Milan, Vienna, Moscow, and Alexandria, Egypt. But in terms of promoting corporate identity via posters of products, Behrens's work was unequaled until the second half of the century.

CLASSICAL REVIVAL: THE NEW CLASSICISM

In the first decade of the twentieth century, designers in France and Germany reengaged with Classicism, particularly as seen in the more pared-down examples of early nineteenth-century Neoclassicism. In Germany, Paul, Muthesius, Behrens, and others increasingly drew inspiration from that period, particularly German Biedermeier and British Georgian designs. In 1908, a group of Munich-based designers with close associations to the Werkbund, exhibited elegant, harmonious, historicist interiors and furnishings that reflected the revival of interest in Classicism. When the group displayed similar room settings at the 1910 Salon d'Autômne in Paris, French critics recognized the German challenge to France in this field.

Meanwhile, French designers, seeking something closer to French design traditions than Art Nouveau, had also begun looking back to earlier periods. Couturier Jeanne Paquin (1869–1936) exhibited an Empire-style gown at the 1900 Exposition universelle in Paris, and fellow couturier Paul Poiret (1879–1944) designed gowns in revived Directoire and Empire styles in 1908 and 1911 respectively (fig. 23.49). These were named after the Directory (1795–99) and Empire (1804–14/15) periods in France. Paul Follot's (1877–1941) dining room shown at the 1912 Salon d'Autômne drew on French Neoclassicism of the 1820s and 1830s.

In Scandinavia and Finland, what was sometimes called Nordic Classicism marked a shift from folkloric romanticism to universal forms, rationality, and simplicity. Some critics felt that an excessive concern with formal clarity and objectivity led to cold, impersonal products and buildings, but many designers tempered austerity with elegance, as at the Woodland Chapel in Stockholm (1918–20). Gunnar Asplund countered the austerity of a small funeral space by including wooden chairs in a vernacular style familiar to mourners and setting it within a copse of fir trees to remind them of the cycles of death and rebirth in nature. Classicism was widely adopted in Sweden, and the national pavilion at the Exposition internationale held in Paris in 1925 included engraved glass by Edward Hald in that style (1883–1980) for the Orrefors Glassworks (fig. 23.50). The term "Swedish Grace" was coined by British critic Morton Shand after viewing the work of Hald and others in Paris. A similar graceful elegance is seen in the armchairs with caning and curved backs designed by Kaare Klint (1888–1954) for the Faaborg Museum (1912–15) in Denmark, in collaboration with the architect Carl Petersen (1874–1923). They illustrate Klint's extensive fine handcraftsmanship, knowledge of classical design, interest in ergonomics, and love of natural materials.

In Italy, the new classicizing tendencies were linked to a glorious national past and, from 1922, a Fascist present. Italian architect-designer Giò Ponti (1891–1979), artistic director of the Richard-Ginori ceramics manufactory from 1923, was among the artists, architects, and designers associated with the Novocento Italiano movement (1923–43), which argued for purified designs rooted in Italy's classical past. Artist

Fig. 23.51. Giò Ponti. Plate: *Le attività gentili. I progenitori*, Doccia, Italy, 1924. Made by Manifattura Ceramica Richard-Ginori. Porcelain; Diam. 12⅞ in. (32.7 cm). The Wolfsonian–Florida International University, Miami Beach (84.7.51).

Margherita Sarfatti (1880–1961), the mistress of dictator Benito Mussolini, called for a strong masculine aesthetic, but Ponti had an altogether lighter touch. His plate *Le attività gentili. I progenitori* (Noble Activities. Our Ancestors, 1924) exemplifies his admiration for Etruscan art, using a specifically Italian antiquity to link the historical past with present ideals (fig. 23.51).

BOLD, BIZARRE, EXOTIC, AND EXPRESSIONIST DESIGN

Flourishing alongside the more restrained Classical Revival were designs characterized by bold, bizarre (a contemporary term), expressive, and unconventional forms or color combinations. Although many such designs were seen in private homes, they were often also associated with performance spaces, including film and theater sets. The color palettes of the Munich designers in 1908 and 1910 were described as violent and shocking, exploding against each other. German design magazines of the time are replete with bold stripes, zigzags, triangles, chevrons, and startling color combinations, such as lilac and purple stripes set against blood-red, and acidic greens with bright yellows and pinks. Bruno Paul's beer hall for the 1914 Werkbund exhibition, for example, included dazzling zigzag wall decoration. Equally bold was a private English house—78 Derngate, Northampton—by Charles Rennie Mackintosh for manufacturor W. J. Bassett-

Lowke (1877–1953), a supporter of the Design and Industries Association (established in 1915 in emulation of the Deutscher Werkbund). Mackintosh set yellow, green, and red triangles against matte black walls to dramatic effect in the lounge hall (1916) and employed eye-dazzling stripes in ultramarine, black, and white in the guest bedroom (1919).

Sergei Diaghilev's Ballets Russes (1909–1929) had a huge impact on the more exotic aspects of design across Europe and North America. Aleksandr Golovin (1863–1930), Léon Bakst (1866–1924), Ivan Bilibin (1876–1942), and others created fantastical sets and costumes replete with symbolism, dramatic patterns, and bold colors that reworked Western aesthetics through the lens of Slavic folk art and Eastern cultures within the Russian Empire. For the harem scene in *Scheherazade* (1910), a ballet based on a story from *A Thousand and One Nights*, Bakst's sets were a virtual orgy of saturated color and pattern, appropriate to the story (fig. 23.52). Mounds of cushions, huge jeweled lamps, and billowing fabrics added to the effect.

Ballets Russes premieres in Paris (1908) and London (1911) triggered a craze for things Russian, exotic, and Orientalist, including Poiret's so-called harem trousers (1911). Poiret had visited the Wiener Werkstätte a year earlier, and soon afterward, he established a design school and studio-workshop that became known for sensual, colorful, and boldly patterned textiles, wallpapers, ceramics, and murals. Meanwhile, at the Werkstätte, bolder colors, patterns, and forms redolent of Neo-Baroque and folk design tempered classicizing and Art Nouveau strains, particularly from Dagobert Peche (1887–1923), who worked there from 1915 until his death. In Hungary, designers such as Lajos Kozma (1884–1948), whose expressive designs reflected folk and Baroque traditions, were active supporters of the Budapesti Műhely (Budapest Workshops), a design collective founded in 1913 along the lines of the Wiener Werkstätte.

Viennese émigrés such as Josef Urban (1872–1933) and Winold Reiss (1886–1953) took some of the bolder aspects of European design to New York. Urban, who arrived there in 1911, created sets for plays, revues, cabarets, and operas before designing for the Ziegfeld Follies (1915–31) and Cosmopolitan Pictures (1920–25). His sets for the Metropolitan Opera's *Madame Butterfly* (1913) filtered Japanese design through a Viennese Art Nouveau lens, and though he had visited Egypt, his Sultan's Palace, Cairo, set for Bizet's opera *Djamileh* (1913) owed more to the Ballets Russes, Poiret, and Austrian boudoirs than to Egypt. Reiss, a German painter who moved to the United States in 1913, favored Viennese-style designs in the 1910s but gradually incorporated African and Expressionist references, especially into his graphics.

Expressionism informed the eclectic, idiosyncratic design of the Amsterdam School, a group of architect-designers previously associated with Dutch Art Nouveau who favored free expression, distinctive imagery, soft surfaces, exotic forms, and harmoniously integrated designs. Michel De Klerk (1884–1923) designed furniture and interiors for the Amsterdam firm 't Woonhuys (The Dwelling) in the 1910s, including pieces made with sumptuous materials and featuring carved detail and the parabolic forms common to the Amsterdam School.

Fig. 23.52. Léon Bakst. Set design for the Ballets Russes: harem scene in *Scheherazade*, 1909. Watercolor. Les Arts décoratifs–Musée des Arts décoratifs, Paris.

Strong in Germany and the Czech region, the impact of Expressionism, which sought to "express" the freedom and individualism of the human spirit, was far reaching. It was characterized by distorted and exaggerated forms. The emotive qualities of the glass and crystalline forms as propounded in Paul Scheerbart's (1863–1915) *Glasarchitektur* (Glass Architecture, 1914) encouraged the expression of spirituality in visual form. One of the most dramatic Expressionist projects was the remodeling of the Grosses Schauspielhaus (Grand Theater, 1919) in Berlin. For impresario Max Reinhardt, Hans Poelzig (1869–1936) created gigantic, fantastical pillars in the manner of honeycomb-like stalactites in a massive 3,500-seat auditorium. When the Nazis took over the theater in 1933, they installed a false ceiling to hide this "degenerate" design. Film sets characterized by extremes of form, light, and shadow also helped popularize Expressionism, including *The Golem* (1920) with designs by Poelzig, and *The Cabinet of Dr. Caligari* (1920) by designer Hermann Warm (1889–1976) and artists Walter Reimann (1887–1936) and Walter Röhrig (1892–1945; fig. 23.53).

In Czechoslovakia, which was carved out of the Austro-Hungarian Empire in 1918, Expressionism was inflected with cultural nationalism. Czech designers such as Pavel Janák (1881–1956), Josef Gočár (1880–1945), and Josef Chochol (1880–1956), who merged Expressionism with ideas from Cubist art, sought to represent in three dimensions the fracturing of objects into prisms, pyramids, triangles, and other forms while also including overtly Czech elements, from late

Fig. 23.53. Erich Ludwig Stahl and Otto Arpke. Poster for *The Cabinet of Dr. Caligari* featuring sets by Hermann Warm, Walter Reimann, and Walter Röhrig, Germany, 1920. Lithograph; 54⅝ x 34⅜ in. (138.9 x 87.2 cm). Deutsches Historisches Museum, Berlin (P 58/64).

Omega (1913–19), a British decorative arts workshop that art critic Roger Fry (1866–1934) and a group of artists and intellectuals including Duncan Grant (1885–1978) and Vanessa Bell (1879–1961) established. Omega sought to re-create the spontaneity of peasant work in fabrics, pottery, furniture, and interiors that offered a self-consciously artistic and bohemian aesthetic through which consumers could express unconventional modern identities. Art was literally applied to objects, usually in abstract or stylized geometric patterns and palettes. Many of these Expressionist, Cubist, and "Bizarre" forms and motifs of the period 1900 to 1918 fed into the more popular veins of Art Moderne (discussed below).

FUTURISM, MACHINES, AND WORLD WAR I

Originating in Italy, Futurism fetishized speed and machines, rejected the past, and embraced modernity, as outlined in the "Fondazione e Manifesto del Futurismo" (Founding and Manifesto of Futurism), written in 1909 by the poet Filippo Tommaso Marinetti (1876–1944). As champions of industrial dynamism and cultural nationalism, Futurists lauded the potential of machines to transform social and aesthetic hierarchies and create a heroic new world. Fortunato Depero's (1882–1960) and Giacomo Balla's (1871–1958) *Recostruzione futurista dell'Universo* (Futurist Reconstruction of the Universe, 1915) imagined apartments full of objects designed in a dynamic, mechanistic, and abstract aesthetic. Few Futurist projects were realized and, ironically, most were created in limited numbers by hand, including Balla's designs for Futurist suits that offered angular, fragmented "force lines," asymmetrical cutting, brilliant hues, and unconventional materials as alternatives to the dark sobriety of conventional men's suits (fig. 23.55).

World War I increased the pace of technological developments while revealing their devastating effects, from poison gas to machine guns. Designed so that the energy of the bullet's recoil ejected the spent ammunition and automatically accepted continuous rounds fed from a belt, the machine gun was patented in the United States in the 1880s and was thereafter copied and developed throughout industrialized Europe, increasing in capacity until by 1914 such guns had the firepower of at least a hundred rifles. Such lethal weapons led to improved protective headgear. In 1915, the French *Adrian* steel helmet was introduced, followed by a version for British and Commonwealth troops (later adapted for the U.S. military), while in 1916 the German *stahlhelm* (steel helmet), designed by Friedrich Schwerd of the Hanover Technical Institute, replaced the older boiled-leather helmet with spike.

Propaganda reached new levels of sophistication and distortion. Posters, which had only become widespread in the urban landscape in the 1880s and 1890s, were one of the most popular forms of wartime propaganda and were issued by all the combatant countries. The designs reflected differing graphic traditions and goals. German propaganda focused largely on raising funds and preserving resources for the war effort. Many posters exploited the simplified forms of the

Fig. 23.54. Josef Gočár. Chandelier designed for the actor Otto Boleškak, Prague Art Workshops, 1912. Brass, glass; including stem, 41⅜ x 30⅜ in. (105 x 77 cm). The Museum of Decorative Arts in Prague (50895).

Gothic diamond vaulting to Bohemian Baroque and folk designs. Janák, Gočár, and others founded the Prague Artistic Workshops in 1912 and showed a room setting with Cubistic furniture and furnishings at the 1914 *Werkbund Exhibition* (fig. 23.54). Cubist influences continued after 1918, when round and curved forms and circles of so-called Rondo-Cubism played a role in expressing the identity of the newly independent state of Czechoslovakia.

Cubism, particularly the work of Pablo Picasso and Georges Braque, fused with Arts and Crafts practices at

Fig. 23.55. Giacomo Balla. Design for a suit, from *Il Vestito Antineutrale: Manifesto Futurista* (The Antineutral Suit: Futurist Manifesto), Direzione del Movimento Futurista, Milan, 1914.

Sachplakat (discussed above) and the talents of leading exponents of the genre such as Hohlwein and Bernhard. In Britain, where a narrative tradition in illustration and advertising was more entrenched, more naturalistic images of dramatic scenes, including those featuring wounded soldiers or atrocities (real and fictitious), were common. Many proved effective for strengthening national resolve, as did British recruitment posters. Savile Lumley's (act. 1910–50) *Daddy, What Did YOU Do in the Great War?* (1914–15), dramatized the moral pressure on men to enlist (conscription was not introduced until 1916 in Britain), as did the first British recruiting image by Alfred Leete (1882–1933) which showed Secretary of State for War Lord Kitchener pointing his finger at the viewer with the caption "Wants YOU." U.S. illustrator J. Montgomery Flagg (1877–1960) adopted this idea for his 1917 recruitment poster depicting "Uncle Sam" in a similar stance.

ART MODERNE

After the war, the inventive decorative style known at the time as Art Moderne revitalized ancient and Neoclassical sources, including ancient Greece, Rome, Egypt, and Mexico, for a wide range of designs. The Exposition internationale des arts décoratifs et industriels modernes (International Exposition of Modern Industrial and Decorative Arts) held in Paris in 1925 aimed to show the self-consciously modern products of French and international decorative arts industries. Unlike other French world's fairs, the emphasis was on consumption rather than production, and glamorous surfaces rather than new processes. Boutiques, such as artist-designer Sonia Delaunay's (1885–1979) Boutique Simultanée, defined the hypothetical exposition visitor as an upper-middle-class consumer. Like her husband, the painter Robert Delaunay (1885–1941), she embraced simultaneity as the quintessential modern experience, as seen in the syncopated patterns of her colorful fabrics, which were used for garments including sportswear, bathing suits, and touring outfits, and even the surface of a *Citroen B12* automobile.

Major department stores presented plush, cohesive interior ensembles created in their in-house design studios. Members of the French Société des Artistes Décorateurs (Society of Artist-Decorators, founded 1901) collaborated on a group of reception and private rooms for a model French embassy. The grand public spaces, particularly a lavish salon and dining room with suites of furniture updating eighteenth-century forms, along with carpets, bas-reliefs, and decorative vases, reflected the tradition of fine craftsmanship so closely tied to the official French national image. Other rooms, such as Franz Jourdain's (1847–1935) Physical Culture room and Jean Dunand's (1877–1942) Smoking Room, with its black lacquer furniture and wall panels, were more intimate and overtly modern in design. Gender differences were written into the materials and ensembles: a man's bedroom by Léon Jallot (1874–1967) and Georges Chevalier (1894–1987) featured angular black lacquer furniture, for example, while a woman's bedroom by André Groult (1884–1966) was filled with pale, opulent furnishings including a curvaceous chest

ENSEMBLES MOBILIERS

GRAND SALON

of drawers covered in shagreen (sharkskin) with ivory hardware. Only Pierre Chareau's (1883–1950) Study and Library, with its exotic woods and ceiling louvers that controlled the amount of direct light above the desk, suggested that this model embassy might be destined for a French colony.

The exposition reaffirmed the classical roots of French culture and the contribution of decorative arts and elite craftsmanship to national prestige. Jacques-Émile Ruhlmann's (1879–1933) interiors in the Pavilion for a Collector presented a glamorous ensemble of fine furniture and art. Like the model embassy, the grand salon—with its trompe l'oeil ceiling, massive crystal chandelier, walls hung with silk, and marble fireplace and mantel framing Jean Dupas's painting *Les Perruches* (The Parakeets)—was designed to impress (fig. 23.56). It reflected Ruhlmann's role as a modern *ensemblier*, an updated version of an eighteenth-century *marchand-mercier* who assembled and sold the finest products of French designers, craftspeople, and artists. The Art Moderne style was also popular across much of the rest of Europe, from ceramics by Clarice Cliff (1899–1972) and Susie Cooper (1902–1995) in Britain and by Hungarian Eva Stricker (later Zeisel, 1906–2011) working in Germany, to metal goods by companies such as Tétard Frères in France.

In North America this style was known in the interwar years by a variety of terms—Art Moderne, Moderne, French Modern Style, and Modernistic. From the 1960s, Art Deco, derived after the exposition name, became the preferred term. The United States did not participate in the 1925 Paris Exposition citing a lack of "modern design," but many people believed that had the United States displayed a skyscraper, this would have represented the most modern exhibit there. Paul Frankl (1886–1958), a Viennese-born designer who emigrated to America in 1914, saw the skyscraper as an icon of modernity and translated its stepped forms into a bookcase and other furniture (c. 1927).

Several U.S. designers, including Donald Deskey (1894–1989) and Gilbert Rohde (1894–1944), visited the exposition,

Fig. 23.56. Jacques-Émile Ruhlmann. *Grand Salon*, from Maurice Dufrène, *Ensembles mobiliers: Exposition internationale 1925*, vol. 2, Paris, c. 1925.

which had considerable exposure in the United States. In 1926, the American Association of Museums organized a traveling show of more than four hundred objects from it, while department stores around the country mounted displays of French Art Moderne goods. The *Exposition of Modern French Decorative Art* (1928) at the Lord & Taylor store in New York alone drew 100,000 visitors. Some top-quality French furniture was sold, but, as in other countries, many items were domestically made, often using cheaper materials, imitative processes, and less-exacting standards of fabrication to bring them within the reach of middle-class consumers.

Art Moderne fused with other stylistic elements, including Cubism, Expressionism, the Egyptian Revival, which flourished after the opening of the tomb of Tutankhamun in 1922, and streamlining in the 1930s (discussed below) in ways that privileged decoration, pattern, reflective surfaces, and glamour while toning down historicism. Ruth Reeves's (1892–1966) *Manhattan* fabric (1930) captured the modernity of New York City, while the articulated, Cubist forms of Erik Magnussen's silver *Cubic* coffee service (1927) emulated the light and shadows of the Manhattan skyline (fig. 23.57). Bakelite and other plastics, which were easily molded into complex forms, were widely used for jewelry, radio casings, and furnishing surfaces throughout the interwar years.

In cinema, *Our Modern Maidens* (1929), with sets by art director Cedric Gibbons (1893–1960), and other films helped popularize American Moderne, as did hotels in Miami Beach, Florida, and skyscrapers in Manhattan. The seventy-seven-story Chrysler Building (1926–30), the tallest building in the world when completed, showed the power of U.S. capitalism to produce objects and buildings equal to anything in Europe. The magnificent elevator doors featured exotic lotus flowers and palm frond motifs associated with the Egyptian Revival (fig. 23.58). The entry to the executive suite in the fifty-six-story Chanin Building (1928–29) featured stacks of coins resembling the city skyline and machine gears symbolizing the capitalist system that made such buildings possible. Although the U.S. stock market crash of 1929 and the ensuing Great Depression revealed the instability of capitalism, Art Moderne, a signature style of the 1920s, continued to find favor, not least at Radio City Music Hall in New York (1932), designed by architect Edward Durell Stone (1902–1978) with interiors by Deskey and carpeting by Reeves.

INDUSTRIAL DESIGN

From the 1920s and 1930s, the term "industrial design" became widely understood as pertaining to objects made using industrial processes and involving the repeat production of uniform objects. Examples include pottery cast in molds in factories employing hundreds of workers; watches made in the Junghans factory, which boasted one of the first continuous assembly lines in Germany; and Ford *Model T* cars (1908–27) made in the United States by approximately fifteen thousand workers in the mid-1920s.

In 1900, Europe produced the most cars, many of them handmade luxury products. By the 1910s, however, the United

States, with its sizable domestic market, became the largest producer, partly because Henry Ford (1863–1947) reorganized production. After reducing a car to four basic parts (engine, chassis, and two axles), he concentrated on a single design, the *Model T* (fig. 23.59), in a single color—black—using interchangeable parts, subdivided labor, and, beginning in 1912–13, a moving assembly line. Prices fell by nearly half, and Ford sold millions. In the 1920s, the company increasingly courted women as potential customers, from Northern Europe to Latin America as the advertisement shown here demonstrates.

In 1923, however, Alfred P. Sloan (1875–1966), chief executive officer of General Motors (GM), began offering annual model changes and greater color and price ranges. By the late 1920s, GM adopted flexible mass production, using a set of parts that could be combined in ways that allowed for design variation. Cars such as the Cadillac *LaSalle* (1927), designed by Harley Earl (1893–1969), who headed GM's Art and Color Department, eroded the Ford company's market share. Ford abandoned his one-model, one-color policy with the new Ford *Model A* (1928), developed by Hungarian-born chief designer József Galamb (1881–1955) at a retooling cost of 18 million dollars. It had a more elongated, elegant body than the *Model T* and came in one of four colors. Both companies offered purchase by weekly payments.

As demonstrated by the automotive industry's embrace of the annual model change, more and more manufacturers saw redesigned products as a means of boosting sales. The massive spread of electricity as an energy source in the 1920s increased demand for electric-powered household appliances, opening up new opportunities for designers. The term "industrial designer" (or variants of it) began to be used to describe a new type of specialist who designed for industrial mass production. By mid-century, it was most closely associated with the creation of durable goods such as washing machines, refrigerators, telephones, cars, trains, and airplanes. The fledgling profession drew people from advertising, commercial illustration, fine art, theatrical design, architecture, and craft production, and new courses were created to train practitioners. Although the Depression of the 1930s saw falling sales, many manufacturers engaged designers for the first time in the hope of surviving those uncertain times. Planned obsolescence became their key strategy, as some designers were hired to restyle products rather than rethink them. The concept was not new, but it took on special prominence given the economic impact of decreased consumption.

In the United States and, to a lesser degree, other countries, the restyling (as opposed to redesign) of products became associated with streamlining in the 1930s. Developed by engineers as a means to reduce the wind resistance of vehicles such as trains and airplanes, streamlining was both functional and aesthetic. It became a metaphor for speed and modernity. The teardrop-shaped car and other streamlined designs in *Horizons* (1932), published by Norman Bel Geddes (1893–1958), an industrial designer with a background in theatrical design, inspired the Chrysler Corporation to incorporate streamlined elements into its *Airflow*

car (1934). *Horizons* also influenced the restyling of trains at a time of diminishing ridership: both the Union Pacific *M-10,000* and the Burlington *Zephyr* trains toured the United States in 1934, amazing crowds along the tracks with their streamlined, metallic bodies.

Sleek teardrop forms rarely enhanced the functional performance of nontransportation products, but they aided sales. Streamlining entered the home through goods and appliances, from Frederick Rhead's (1880–1942) *Fiesta* flat-sided ceramic pitchers (1936) to Lurelle Guild's (1898–1985) model 30 vacuum cleaner for Electrolux (1937; fig. 23.60) and Henry Dreyfuss's (1904–1972) *Model No. 150* for Hoover (1936), the first upright cleaner to have a Bakelite hood to cover the inner workings. Raymond Loewy (1893–1986), with engineer Herman Price, transformed Sears's *Coldspot* refrigerator (1934) from a visually undistinguished object into a streamlined, unified mass (the hinges were concealed) with modernized handles and logo. So successful was Loewy's restyling that sales greatly increased in the first year, as did the status of the industrial designer's role, and Loewy in particular.

The fashion industries of Europe and North America already understood a great deal about obsolescence. Although the large-scale manufacture of ready-made clothing had existed in Britain and France since the second half of the nineteenth century and grew apace in those countries and many others in the interwar years, by then the United States led the way in the manufacture of mass-produced ready-to-wear clothing. The demands of the American middle and working classes, intent on dressing well at affordable prices, were met

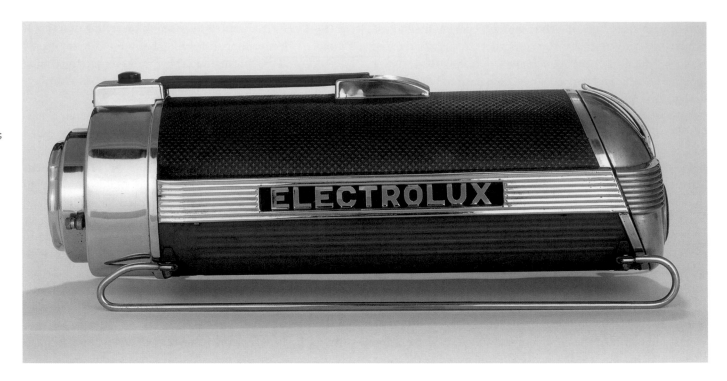

by an industry based on domestically produced textiles, widespread use of machinery (from mechanized looms to electric-powered cutting knives and sewing machines), efficient transportation, and cheap (often immigrant) labor.

Greater emphasis on more casual lifestyles in the interwar years, and on health and fitness, led to a new category of clothing known as sportswear. In France, the primary exponents of such clothing for affluent clients were couturiers Gabrielle "Coco" Chanel (1883–1971) and Jean Patou (1880–1936), who introduced traditionally "masculine" fabrics such as wool knit jerseys and tweeds into their elegantly simple designs. These understated, easy-to-fit styles in plain, easy-to-maintain fabrics, including cottons and woolen knits, were soon regarded as characteristically American, and sportswear flourished in the United States in the 1930s and 1940s.

EUROPEAN MODERNISM

The Modern Movement in architecture and design, often known as Modernism, is an umbrella term for various developments in interwar Europe—from the Bauhaus in Germany to the Rationalists in Italy—that embraced abstraction, rationalism, functionalism, new ways of handling space, and the aesthetics of machinery. A key premise was that modern materials, new technologies, and industrial mass production could transform society. Modernists sought universally valid forms. They thought of the contemporary world as a "Machine Age" and considered clean-edged, geometric, and abstract forms to be the appropriate means of expressing the spirit of the times, a position contested then and since. By the late 1930s, the movement had influenced many designers and architects across Europe and farther afield. The emphasis on design as a rational problem-solving process led to claims that superficial style had disappeared, but many recognized that the "machine aesthetic" was as much a style as Art Mod-

erne. The term "International Style," taken from the Museum of Modern Art's *Modern Architecture: International Exhibition* (1932), was also used, in precisely this way.

THE BAUHAUS

In Germany, Modern Movement ideals were closely associated with the Bauhaus (1919–33), a school founded by architect-designer Walter Gropius (1883–1969) in Weimar, a city that wanted a combined decorative arts institution and art academy. The name "Bauhaus" (from the German "to build" and "house") evoked medieval masons' lodges and underpinned Gropius's belief that building was the aim of all the arts. Gropius also believed art could not be taught, but that skilled craftsmanship could. Therefore, he appointed both a technical master and a form master (an artist or designer) to each department or workshop: ceramics, weaving, metalwork, woodwork, and wall-painting. Beginners spent six months exploring materials, questioning conventional thinking, and moving from one workshop to another before specializing in a particular craft.

In the ceramics studio, located in an existing pottery in nearby Dornburg, Max Krehan (1875–1925), the technical master, and artist-designer Gerhard Marcks (1889–1981), the form master, helped students create a variety of designs, some inspired by German ceramic traditions, as in a stoneware jug (1922–23) by Marguerite Friedländer (later Wildenhain, 1896–1985) with its salt glaze and cobalt imagery of a cow. Others explored more geometrical shapes with sharp rims. In the metal workshop, which was initially established for fine gold and silversmith work, Marianne Brandt (1893–1983) handcrafted her brass, silver, and ebony tea service (1924). While the tea infuser was based on the fundamental geometrical forms that the Bauhaus stressed (fig. 23.61), other pieces in the service drew on more conventional forms. Brandt and Friedländer were among the few women designing metalwork or ceramics at the Bauhaus. Many women

entered the school but, by Gropius's order, most were directed to the weaving workshop.

The Weimar authorities reduced subsidies to the school, and in 1925 the Bauhaus moved (without its ceramics workshop) to Dessau, a manufacturing city with a sympathetic mayor. Former students were hired as masters: Herbert Bayer (1900–1985), known for his advertising graphics and his *Universal* alphabet design (1925) of lowercase sans-serif letters made from circles and straight lines; Gunta Stölzl (1897–1983), whose weaving workshop produced handmade prototypes for industrial manufacture; and Marcel Breuer (1902–1981), who created a variety of seating furniture. Breuer's *Wassily* chair (1925–26), named later for fellow Bauhaus master Wassily Kandinsky (1866–1944) who admired it, developed out of a desire to create furniture to suit the spatial forms of modern architecture (fig. 23.62). With its lightweight frame of tubular steel and fabric from the weaving workshop, it seemed to suspend the sitter in space. It was produced in the late 1920s but had nowhere near the commercial success it enjoyed in the postwar period.

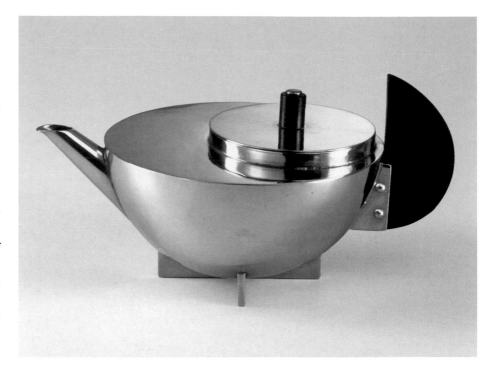

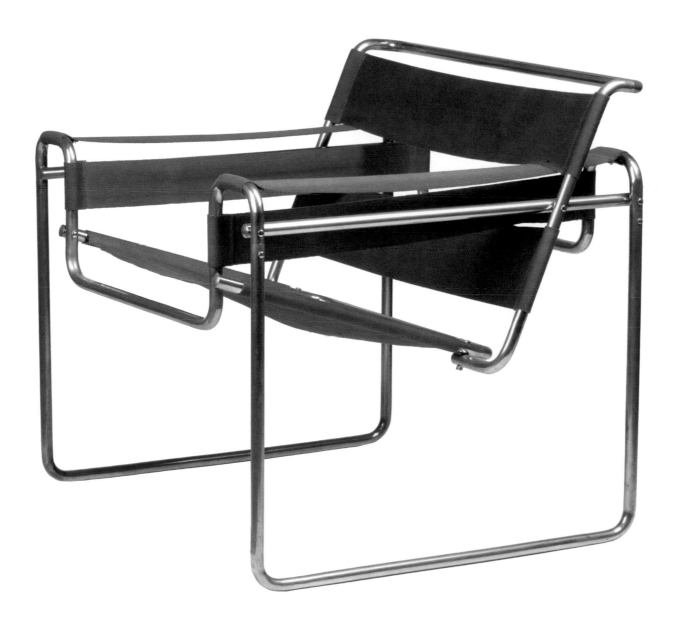

Fig. 23.61. Marianne Brandt. Tea infuser and strainer, Weimar, 1924. Brass, silver, ebony; 2⅞ x 6⅜ x 4⅛ in. (10.6 x 16.1 x 7.3 cm). Bauhaus–Archiv Museum für Gestaltung, Berlin (739b).

Fig. 23.62. Marcel Breuer. *Wassily* chair, model *B3*, Standard Möbel, Berlin, or Thonet Möbel, Frankenberg, Germany, 1927–28 (designed 1925–26). Nickel-plated tubular steel, cotton canvas; 28¾ x 30¾ x 26¾ in. (73 x 78 x 68 cm). Victoria and Albert Museum, London (W.2-2005).

Fig. 23.63. Margarete Schütte-Lihotzky. Kitchen (known as the Frankfurt Kitchen) for the *Römerstadt* housing project, Frankfurt, 1926, from Walter Müller-Wulckow, *Die deutsche Wohnung der Gegenwart*, Leipzig, 1930.

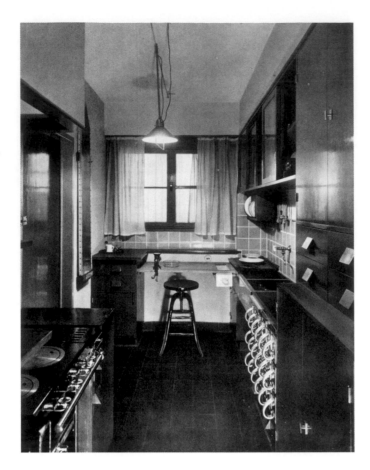

FRANKFURT HOUSING AND THE FRANKFURT KITCHEN

Wartime promises of a better world and social unrest, or fear of it, resulted in many governments addressing chronic housing shortages after World War I and seeking to improve the living conditions of the working class. In Britain, which had assured returning veterans of "homes fit for heroes," over one million government-subsidized two-story single-family homes, with a vernacular flavor and individual gardens, were built during the interwar years. They were influenced by the ideas of the Garden City movement (1898–c. 1939) which sought to combine the best aspects of rural and urban life and offer working class families healthy, hygienic homes. The movement began in Britain and was strong in Germany where cottage-style homes featured in garden cities and garden suburbs alike.

At the same time, some social housing was designed according to Modernist ideals. In Frankfurt, Germany, between 1926 and 1930, for example, city architect Ernst May (1886–1970) and his team, which included architects and urban planners Mart Stam (1899–1986) and Margarete (Grete) Schütte-Lihotzky (1897–2000), created over ten thousand apartments and houses for middle- and working-class citizens in low-density, low-rise municipally funded developments. A proponent of the rationalist movement known as Neues Bauen (New Building), referring to the spatial, aes-

Fig. 23.64. Gerrit Rietveld. *Red Blue Chair*, Netherlands, c. 1923 (designed 1918). Made by Rietveld and Gerard van de Groenekan. Painted wood; 34⅛ x 26 x 33 in. (86.7 x 66 x 83.8 cm). The Museum of Modern Art, New York (487.1953).

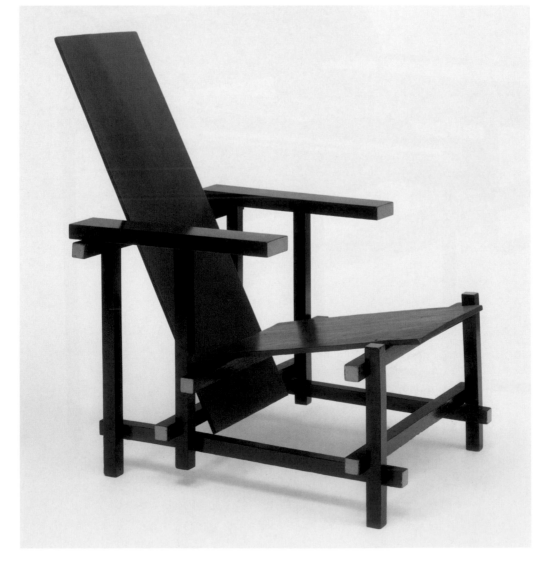

thetic, and material qualities of modern architecture, May advocated improved sanitary standards and efficient apartments made from prefabricated parts. Space-saving devices were encouraged, from half-size bathtubs to folding beds.

Small kitchens, such as Schütte-Lihotzky's Frankfurt Kitchen, aimed for maximum efficiency (fig. 23.63). The space separated, for hygienic reasons, the preparation of food from its consumption and other household activities. Schütte-Lihotzky had absorbed American productivity studies by Frederick Taylor and those of U.S. household efficiency expert Christine Frederick. In *The New Housekeeping: Efficiency Studies in Home Management* (1913), Frederick plotted housewives' movements and used them to determine a practical layout for every aspect of the kitchen, such as the placement of the sink and the distance from it to the stove.

DE STIJL

In Holland, designers such as Stam and members of the De Stijl (The Style) group of fine artists, architects, and designers (founded 1917) sought to create a singular style, without associations to the past, for the new society they hoped would emerge after World War I. Valuing harmony, balance, and purity, members such as painter Piet Mondrian (1872–1944) turned to abstraction and a palette composed mostly of the primary colors of red, yellow, and blue. The planar surfaces of the *Red Blue Chair,* which was originally unpainted, by architect-designer Gerrit Rietveld (1888–1964) seem suspended in space because the black painted frame and chair stretchers do not intersect in this careful study in composition and balance (fig. 23.64). Under Theo van Doesburg (1883–1931), this group published a journal and established links with like-minded people across Europe.

LE CORBUSIER

Charles-Edouard Jeanneret (1887–1965), a Swiss architect-designer who worked in France and adopted the name Le Corbusier after 1920, likened a house to a *machine à habiter* (machine for living in) and an armchair to a "machine for sitting in." His Pavilion for the Esprit Nouveau (The New Spirit), an idealized apartment interior at the 1925 Paris Exposition, shocked many. He had extensive experience as an interior designer, and his pavilion was a riposte both to former colleagues and the types of decorative arts the exhibition celebrated. It declared his faith in industry to create anonymously the most suitable products for modern urban living. He favored objects that functioned as extensions of the body or served the user like a tool.

Like the mass-produced bottles and industrial porcelain that Le Corbusier depicted in his Purist still-life paintings, and in the spirit of the cars, ocean liners, steamer trunks, and office furniture he admired for their efficiency, he included in his pavilion bentwood café chairs by Thonet (see fig. 17.31) and English-style club armchairs of the type admired by Adolf Loos. Despite Le Corbusier's faith in mass production, the chairs, factory-type window, and metal stair were custom-made.

In *The Decorative Art of Today* (1925), Le Corbusier claimed that modern decorative art should be "undeco-

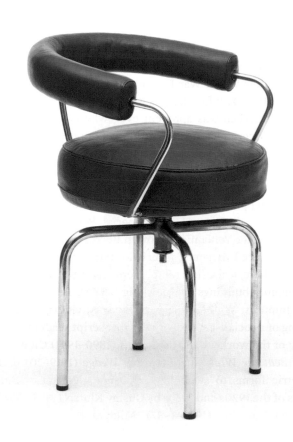

Fig. 23.65. Charlotte Perriand, Le Corbusier, and Pierre Jeanneret. *Siège Tournant*, Thonet Frères, Paris, 1928. Chrome-plated steel, leather; 29¾ x 22 x 21¼ in. (75.6 x 55.9 x 54 cm). The Museum of Modern Art, New York (162.1958).

rated."[4] In 1927, he began collaborating on furniture prototypes for mass production with his cousin Pierre Jeanneret (1896–1967) and Charlotte Perriand (1903–1999), already known for using industrial materials. The tubular steel frame and canvas cushions of the *Fauteuil Grand Confort* (Easy Chair, 1928) updated conventional armchairs, whereas the *Chaise Longue (LC/4)* (1928) and *Siège Tournant* (Turning Armchair, 1928) reflected a greater concern for the movement of the sitter's body (fig. 23.65). Perriand, Le Corbusier, René Herbst (1891–1982), Robert Mallet-Stevens (1886–1945), and others who established the Union des Artistes Modernes (Union of Modern Artists, 1929) rejected the opulent designs given prominence at the 1925 Paris Exposition and embraced industrial materials. This more widespread acceptance of industrial materials, however, did little to unseat the luxury tradition in France.

THE USSR

After the Russian Revolution of October 1917, which finally ended czarism and established the Russian Socialist Federative Soviet Republic (from 1922, the Union of Soviet Socialist Republics or USSR), Constructivism, a radical utopian movement that grew out of Russian Futurism and Expressionism and featured geometric forms floating and interacting in space, symbolized the commitment of artists, writers, designers, and architects to building a workers' state. Aleksandr Rodchenko (1891–1956), Varavra Stepanova (1894–1958), Lyubov Popova (1889–1924), and Vladimir Tatlin (1885–1953) were among the painters, sculptors, and architects who turned their attentions to everyday designs, from textiles and graphics to work clothes, sleighs, teapots, and stoves, thus

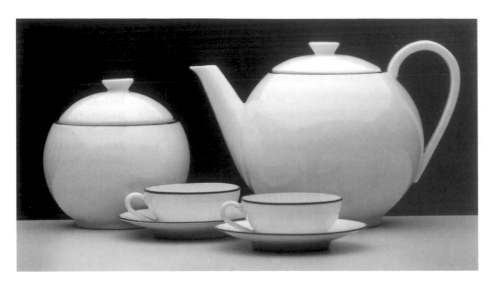

had considerable impact on information and corporate identity graphics.

At the entrepreneurial level, Tomáš Baťa (1876–1932), head of the Bata shoemaking firm, which had been based in Zlín, Moravia, since the 1890s, established a new modern identity for his company, from factories to shoe shops, window displays, and advertising, and founded a series of new factory towns. For the town of Zlín, he engaged František Gahura (1891–1958), a Czech pupil of Le Corbusier, to create a new garden city. Like other Modernists, Gahura sought to establish a basic unit for domestic living: the so-called *existenzminimum* or subsistence apartment, complete with built-in furniture and lightweight freestanding pieces. Dual purpose furniture, such as sofa-beds, helped save space, while textiles hung as screens to demarcate areas within open-plan interiors. In the main apartment blocks at Zlín, small galley kitchens with running water and electricity had standardized cooking and washing facilities similar to those developed by Schütte-Lihotzky in Frankfurt.

Poland, newly restored following World War I, had a weaker industrial base and stronger craft traditions than Czechoslovakia. Nonetheless, even textile designers such as Eleonora Plutynska (1886–1969) and Lucjan Kintopf (1898–1979), both members of the Spółdzielnia Artystów ŁAD (ŁAD Artists Cooperative, founded in 1926 in Warsaw) who worked hand-operated looms for kilim carpets and Jacquard upholstery fabrics, envisaged their designs as prototypes for industrial production. A more overtly Modernist approach was adopted by two married couples (all trained as architects): Helena (1900–1982) and Szymon Syrkus (1893–1964) and Barbara (1899–1980) and Stanislaw Brukalski (1894–1967). Each couple worked mainly as furniture and interior designers, aligning themselves with the journal *Praesens* (founded 1926) and its commitment to mass-produced consumer goods.

Hungary under the right-wing government of Admiral Miklós Horthy was not receptive to Modernism, and many Hungarians wanting to work in that mode trained or worked abroad. Hungarians formed the second largest national group (after Germans) among staff and students at the Bauhaus. Many Hungarian Modernists were socialists or social demo-

crats, but when the distinguished Hungarian architect-designer Lajos Kozma (1884–1910), who had previously worked in a rich idiosyncratic Neo-Baroque style, turned to Modernism in the late 1920s, he did so for formal, rather than ideological, reasons. Like Gunnar Asplund in Sweden, the adoption of Modernism by such a well-known figure helped popularize a style without any obvious national roots.

ECLECTICISM, HISTORICISM, AND SURREALISM

In the eclectic reworkings of historical designs across Europe and North America in the interwar period, French and British eighteenth-century styles remained popular. Revivals of the Baroque, Rococo, Empire, and Regency styles had an increasing impact, along with Art Moderne and, to a lesser degree, Modernism. Considered both historicist and modern, European Neo-Baroque offered consumers a sophisticated, fashionable, and international style with strong regional associations. It was particularly popular with Central European designers, who saw in it their own high and popular culture traditions. The most skillful exponent of Neo-Baroque was Lajos Kozma who, in the early to mid-1920s, innovatively combined historical sources with wit and sophistication, creating harmonious and highly expressive interiors, as well as lacquered sculptural furniture and quirky graphics that revealed his fascination with pattern. At the same time, many influences feeding Western taste continued to flow from distant places, including excavations of ancient Egyptian, Mycenaean, Mayan, and Chinese sites—all of which were reflected in contemporary designs.

Period and Modern were frequently mixed in creative ways that eschewed stylistic correctness or "authenticity" of finish or materials, as in the work of British interior designer Syrie Maugham (1879–1955). The music/drawing room of Maugham's London home (1927), which reflected a brief trend for so-called all-white interiors, featured Louis XV chairs stripped of their original finish and updated with white lacquer (fig. 23.69). Maugham employed various shades of white, off-white, and pale beige with a variety of textures, including a cut-pile rug in two tones of off-white designed by Marion Dorn (1896–1964), an American designer with a strong affinity for both Modernism and Art Moderne, then working in Britain. Mirrors and other reflective surfaces added depth to this sophisticated space. Some designers used black flooring or carpets to emphasize paleness elsewhere, as in early 1930s interiors by Hungarian designer János Beutum, while in Hollywood films, Ginger Rogers and Fred Astaire danced across gleaming black floors within all-white sets by art directors such as Cedric Gibbons (1893–1960) at the MGM studios and Hans Dreier (1885–1966) at Paramount.

United States exponents of updated historicism ranged from Elsie de Wolfe (1865–1950) to Eleanor McMillen Brown (1891–1991) and Dorothy Draper (1889–1969). Brown had trained in historical styles at the New York School of Fine and Applied Arts, which was renamed Parsons School of Design in 1941, after Frank Alvah Parsons (1866–1930), who taught

her, along with many others. Her elegant interiors, flair for composition, and preference for subtle palettes, reflected this background. Neither de Wolfe nor Draper had any formal training, but they nonetheless brought a sense of style and flair for design to interiors and furnishings. Although de Wolfe is best known for eclectic Period Modern interiors that drew on French and English eighteenth-century designs, her interwar work sometimes demonstrated strong Art Moderne influences and exotic chinoiserie. Theatrical effect was paramount for Draper, who loved the Neo-Baroque, was fearless with color and pattern, and happily mixed historical styles in unconventional ways. A design and lifestyle guru, she attributed her more "liberated" and fantastical approach to design to psychoanalysis. Like de Wolfe and others, she regarded design as a means of self-expression. She encouraged women to try their own hand at it through her radio program (a television program came later) and her how-to guide, *Decorating Is Fun!* (1939).

Leading United States textile designer Dorothy Leibes (1897–1972) likened eclecticism to self-development, arguing that people rarely model themselves on only one person. By the mid-1930s, Italian architect-designer Carlo Mollino (1905–1973) saw it as a mark of wholeness and civilization at a time when self-expression and the psychological aspects of design were under attack by Modernists. Leibes used the term "Fantasy Modern" for designs characterized by artifice and pastiche, which she felt stood in opposition to Modernism. Among the items she included as the organizer of the decorative arts section of the Golden Gate International Exposition in San Francisco (1939) were Cora Scovil's exuberant console tables with white plaster frames and tops of Lucite (a clear plastic), and historicist Lucite chairs that outdid Modernist chairs in terms of transparency. In 1936, Emilio Terry (1890–1967), a Cuban artist-designer based in France and known for fantastical plaster tables and decorating props, parodied the notion of bourgeois drawing rooms in a Surreal rooftop "drawing room" complete with a "carpet" of daisy-strewn turf for his Mexican millionaire client Carlos de Beistegui (1895–1970).

Surrealism's emphasis on subconscious associations broadened both the design repertory and the ways in which people thought about objects. When in the mid-1930s British painter-designer Paul Nash (1899–1946) considered what Surrealist design might look like, he proposed atmosphere and mood, and cited a side table by British designer Denham Maclaren (1903–1989) with "fingerprints" pressed into it. Other examples include objects designed for the late-1930s makeover of the country home of Edward James (1907–1984), a British aesthete, collector, and sponsor of Surrealist painter Salvador Dalí (1904–1989). Surreal features included carpeting patterned with dogs' paw prints, Dalí's lipstick-colored *Mae West's Lips* sofa (1936), a lamp resembling a tower of champagne glasses, and a witty lobster telephone (fig. 23.70). The sofa also featured in Jean-Michel Frank's (1895–1941) atelier for Parisian couturier Elsa Schiaparelli (1890–1973), one of Frank's many clients associated with Surrealism. Schiaparelli commissioned Dalí to design clothing and accessories, and he inspired her *Lobster* gown (1937). The large

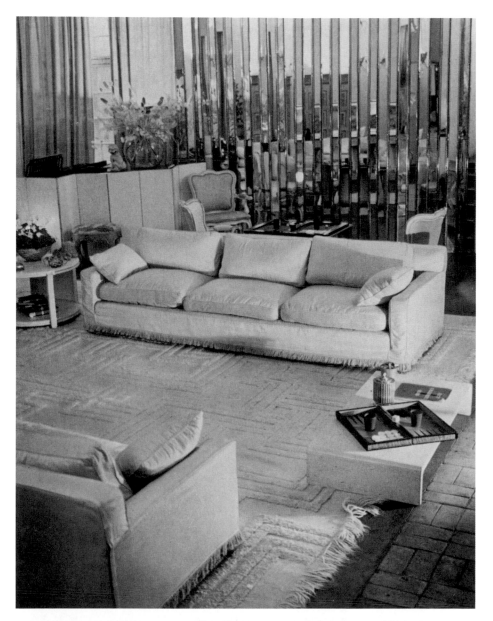

bamboo cage Frank designed for Schiaparelli's perfume boutique (1937) played with suggestions of caged desires and women as caged birds.

FASCIST AND NAZI DESIGN

In the last thirty years, scholars have shown that design in both Fascist Italy and Nazi Germany was far more complex than previously assumed. The pluralism of design under Fascism (1922–43) partly stemmed from Benito Mussolini's belief that the full richness of Italian national culture was best expressed through diversity. Contemporary magazines show Arts and Crafts, Art Moderne, and Modernist influences, and, as elsewhere, there was overlap between them: Rationalists, as Italian Modernists were known, sometimes introduced references to earlier Italian culture while some classically influenced designs specified modern materials and techniques.

Handmade decorative arts production remained strong—from lace-making, glassblowing, embroidery, and leatherwork to furniture—and vernacular design was appropriated to the Fascist cause. The finest Italian decorative arts, whether made by hand or machine, were shown at the Esposozione internazionale d'arte decorativa (International Exhibition of Decorative Arts, 1923) in Monza, which became a biannual event (and later the Milan Triennale). Admirers of both vernacular and more overtly modern design complained that there was too much historicism, but classicism was deeply rooted; even before his main imperialist ventures, Mussolini favored designs related to Imperial Rome.

Fasces, the bundled rods and axe carried by Roman lictors, or attendants, was adopted as the symbol of party and state in 1926. This insignia adorned many products including lamps, jewelry, radios, and textiles, thus helping domesticate Fascist ideology. Giò Ponti's pattern for a silk textile by the Vittorio Ferrari Company (1930), for example, gave the product its name, *Fasci e Bandieri* (Fasces and Flags). Older traditions, such as ceramic Renaissance birth cups, were renewed under Fascism and given as gifts to women who produced large numbers of children.

Italian politicians and designers embraced images of technological modernity as a flattering reflection of the regime. Futurism may have predisposed some Italians to favor materials like tubular steel and aluminum, of which the country was a major producer, but that movement had waned by 1922. Many industrial designers were Modernists, but those with more catholic tastes also undertook industrial design projects that showed Italy as an up-to-date, modernized state. Ponti and Paolo Masera, for example, created interiors for the high-speed electric train *ETR 200*, which went into service on the Milan–Rome line in 1936. The use of marble and luxurious materials in the Federal Hall of the Casa del Fascio (House of Fascism, 1932–36) in Como by Rationalist architect-designer Giuseppe Terragni (1904–1943) suggested ancient ties, but upholstered tubular steel armchairs emphasized the modernity of the regime (fig. 23.71).

Fig. 23.71. Giuseppe Terragni. Director's Room, Casa del Fascio, Como, Italy, 1932–36, from the journal *Quadrante,* Milan, October 1936. Mural by Mario Radice.

Similarly, leaders of the National Socialist German Workers' (Nazi) Party (1933–45) allowed for variety in design, partly because of shifting political, military, and cultural agendas. In the public sphere, Adolf Hitler, whose rise to power culminated in his becoming the *Führer* (leader) and chancellor of Germany in 1934, and his architect Albert Speer (1905–1981) conceived a grandiose plan for transforming Berlin into a new world-center, called Germania, complete with an enormous *Volkshalle* (People's Hall) modeled on the Parthenon in Rome. The Cabinet Room at the New Chancellery (1938–39), by contrast, featured elegant Art Moderne wall paneling and uplights alongside vernacularizing chairs with swastikas (a symbol appropriated from Asia by the Nazis) on the upholstery. At Berghof, Hitler's country retreat, Gerdy Troost (1904–2003) and Leonhard Gall (1884–1952) created a modern version of the German country house in the mode of those designed by Werkbund founder Hermann Muthesius.

Craft traditions contributed to the reimagining of a new Germany. Vernacular forms and decoration took on increasingly nationalist and supremacist overtones when expressing the supposedly "pure" German culture of what was seen as a master race. Paul Schultze-Naumburg (1869–1949) and other architects and designers espoused the notion of a national style based on *Blut und Boden* (Blood and Soil), racial purity in which vernacular traditions represented authentic German values. Many came to regard folk-influenced textiles, clothing, pottery, and furniture as expressions of race and fatherland. Vernacular-style design was often associated with the freestanding single-family home, a central focus of Nazi propaganda, but it was also a feature of hostels, youth camps, Nazi meeting rooms, and government and military buildings. Mess halls and meeting rooms in various military headquarters featured practical, rationalized furnishings resembling those the Werkbund promoted.

After 1936, when war preparations sped up, the Schönheit der Arbeit (Beauty of Work) section of the German Labor Front presented Modernist architecture and design as the best means of providing more rationally planned, efficient factories and improved working conditions. Facilities such as canteens and comradeship houses (some had gymnasiums and swimming pools) helped allay labor unrest. Speer employed several designers who had been active in the Werkbund to create modernized, vernacular-style objects suitable for efficient serial or mass production, such as ceramics whose forms echoed the sleek shapes of the 1920s but were reframed for consumers as objects whose affordability enhanced German domesticity.

While seemingly contrary to Nazi images of wholesome agrarian culture rooted in the family and soil, Nazi leaders admired modern technology and serial mass production. Transportation designs combined technological modernity and reactionary values. Indeed, Hitler ordered the mass production of a popular low-cost molded-plastic radio originally designed in 1928 by Walter Kersting (1889–1970). The *KDF-Wagen* (*Kraft durch Freude*, Strength Through Joy Car), the small Volkswagen car developed for the *volk*, or people, was a pet project of National Socialism, though the cars were not made in any quantity until after the war (fig. 23.72). One of

Der Innenlenker

Fig. 23.72. The *KDF-Wagen*, from a Volkswagen promotional brochure, Germany, c. 1938. Illustration by Ernst von Demar.

the most visible statements of German faith in technological modernity was the design of the Zeppelin airships, gigantic blimps that promised a two-day journey from Europe to America. The Zeppelin *Hindenburg* (constructed 1931–36; destroyed by fire 1937) was designed to emulate the luxurious accommodations of Atlantic steamers.

Overtly anti-Semitic objects included the door knockers at Laufen City Hall. Refurbished in the late 1930s, they were adorned with swastikas designed to be struck against a caricatured Jewish face on the back-plate, thus making visual the brutality of the regime's anti-Semitism. More often, imagery and slogans transformed existing products and spaces into "Nazi" ones.

WORLD WAR II (1939–45)

Design played a key role in World War II. New or improved materials and technologies developed for the war effort included plastics used for radar shields, new super-glues, and stronger plywoods, which led, among other things, to splints for wounded United States sailors, aircraft parts, and the British de Havilland *D.H.98 Mosquito* airplane (fig. 23.73). Proposed in 1939, the latter went into production in 1941. The look and consumption of many familiar objects changed, as particular materials and skills were reserved for the war effort, while new items, such as blackout curtains and ration cards, became part of everyday life. Military uniforms and national symbols took on greater visibility, and objects such as engagement and wedding rings and "keepsakes" gained more personal and patriotic meaning.

The field of ergonomics, or "human factors" design, expanded as part of the military imperative to reduce operator error, notably in tanks and aircraft. Time and motion studies, which became popular in the early twentieth century, had prompted designers to focus on the placement and form of controls in aircraft. The greatest strides forward in terms of user-centered design practices resulted from the

work of psychologists and engineers in Britain, the United States, and Germany during World War II. Concern for a good fit between design and the human body and mind was hardly new, nor was the term "ergonomics," which is often attributed to Polish scientist and inventor Wojciech Jastrzębowski (1799-1882). The English use of the word is traced to psychologist Hywel Murrell, who worked with the British Admiralty and scientists during World War II. Industrial designer Henry Dreyfuss helped the U.S. military improve radar equipment, anti-aircraft guns, prostheses for amputees, and the interiors of naval destroyers. After the war, he championed ergonomic approaches to designing commercial goods, from tractors to telephones, most famously through the anthropometric charts he published in *Designing for People* (1955). Such charts give average human body measurements and had long been used for classification and comparison by physical anthropologists.

The designers of many war-related objects remain anonymous, partly because they worked in teams on projects shrouded in secrecy. Those known by name include Karl Probst (1883–1963), the U.S. engineer-designer who headed the group responsible for what became the "Jeep," and Donald Bailey (1901–1985), a British civil servant and amateur model-maker who devised the portable truss-bridge, known as the Bailey Bridge, which was widely used by the Allies. On the Axis side, Austrian-German automotive engineer Ferdinand Porsche (1875–1951) designed tanks, including the *Tiger* and *Elefant* (1942 and 1943–44 respectively), and worked on

airplanes such as the *Junkers Ju 88* (1936) and weapons such as *V-1* flying bombs (first used in 1944). The German *Winkeltürm*, a conical air-raid shelter that held up to five hundred people, was named after its inventor, civil engineer Leo Winkel (1885–1981).

Graphic skills were crucial, from camouflage to propaganda. In the USSR, the news agency TASS produced morale-boosting posters almost on a daily basis, some as large as 10 by 5 feet (about 305 x 152 cm) for shop window display. In Canada, Harry Mayerovitch (1910–2004), a well-known designer and cartoonist, created posters for wartime campaigns under the pseudonym Mayo, and in Britain, graphic designer Abram Games (1914–1996) was appointed an Official War Artist with responsibility for posters. Posters with abstract, stylized, and symbolic designs were often found to be too ambiguous—some factory workers in the United States, for example, read a stylized image of a German steel helmet (meant to represent a Nazi soldier) as the Liberty Bell, a patriotic symbol associated with national independence—and in most countries, officials preferred posters with a clear appeal to the war effort or patriotism.

Several nations, particularly Germany (from 1939) and Britain (from 1941), regulated the production and supply of clothing in order to privilege materials and labor for the war effort and to stave off profiteering. Policies varied, but the longer the war, the greater the restrictions, with civilians encouraged to produce new clothes from old ones and follow "make-do-and-mend" practices. Pleats, turn-back cuffs,

trouser turn-ups, double-breasted jackets, embroidery, and deep hems were among the things banned within the British Civilian Clothing Scheme (popularly known as the Utility Scheme, 1941; extended to furniture in 1942); the U.S. policy was similar. In Germany, army service jackets were refashioned several times to save materials and labor.

The German occupation of France opened up an opportunity for other countries to gain leadership of the Western fashion industry. British efforts could not be sustained, but exports of British couture to South Africa and the United States helped to fund war production, just as fashion exports from Vienna and Berlin helped the Nazi cause. Italy seized the moment to cultivate a more distinctive national aesthetic and industry. German plans to relocate French couture and its infrastructure to Berlin and Vienna were stalled by Lucien Lelong (1889–1958), president of the Chambre Syndicale de la Haute Couture (Syndicate of High Fashion), and postponed because of German military priorities. In France, the fashion houses that remained open supplied some prewar clients as well as the wives and mistresses of the Nazi elite.

When the war ended in 1945, it left behind great devastation and destruction—of human lives as well as the built environment and other aspects of material culture. There were many differences between the pre- and postwar worlds, but there were also continuities and similarities. These themes and others in the period between 1945 and the early twenty-first century are considered in the text below.

PAT KIRKHAM, AMY F. OGATA, AND CATHERINE L. WHALEN

EUROPE AND NORTH AMERICA 1945–2000

The period 1945 to 2000 began with great optimism about the potential of design for building a new and better world after a devastating world war. It ended with large numbers of designers involved in efforts to hold back environmental degradation and sustain the planet on which we live. The status of design and designers grew considerably during this period, and in the last quarter century, "design" became a buzzword and "designer" was used as an adjective, as in "designer T-shirt" or "designer kitchen."

Most of the goods produced during this period were made wholly or in part by machine. Hand production and craft skills, however, continued to be important throughout the century, even as the relationships among them were constantly in flux, as in the shift from analog to digital design which often included more "hands-on" design experiences. The later decades saw a far greater use of computers in design, by amateurs as well as professionals, with far-reaching results. The global character of design was even more evident in the second half of the century than in the first. Products, ideas, and designs circulated freely, particularly after the introduction of the World Wide Web in 1991.

The United States emerged from World War II (1939–45) as the most powerful nation in the world. The conflicting ideological, political, economic, cultural, and imperial ambitions of the United States, Union of Soviet Socialist Republics (USSR), and their respective allies, known as the Western and Eastern Bloc countries respectively, soon hardened into the so-called Cold War (1947–89). The resulting conflicts of interest underpinned attitudes toward goods and the ways in which people thought about, designed, and consumed them. Indeed, in the 1950s and 1960s, the abundance of consumer goods in North America (here defined as the United States and Canada) and Western Europe was offered as proof of the superiority of capitalism over state-planned socialism (more generally referred to as communism). In a period characterized at the time as both an age of anxiety and an age of scientific utopianism, the future loomed large: the threat of nuclear war and annihilation brought many fears in its wake while other aspects of science and technology seemed beneficent.

Modernism remained a strong force in design circles, and earlier debates about the standardized nature of industrially produced products and homes versus individual expression continued through the second half of the century. The shift in Western Europe and North America from industry-based societies to "postindustrial" ones, wherein a service economy replaced former staple manufactures and nations emphasized cultural production, had a profound impact on design. In the 1950s and 1960s, aspects of Modernism and what came to be known as Postmodernism encouraged cultural broadening, diversification, and the reclaiming of the underrepresented. One effect was an upsurge of interest in the crafts and design traditions of "preindustrial" societies. Another was that in the last three decades of the century, more women and minorities worked as professional designers than ever before, even in the areas most dominated by white men, such as industrial design.

What follows is not a sequential history. Although broadly framed within three loosely chronological bands (1945–60, 1960–75, and 1975 into the twenty-first century), the discussion is organized around diverse topics and themes, some of which overlap within and across those timeframes. Diversity and eclecticism are now accepted ways of thinking about the period after about 1965, and the structure of this chapter seeks to highlight their importance in the preceding two decades, a period still too often portrayed as one of hegemonic Modernism.

MODERNISM

The immediate postwar years saw continued austerity as Europe dealt with the physical and psychological aftermath of the war and war debts. Austerity continued in the Eastern Bloc satellite states of the Soviet Union, but in the United States, Canada, and Western Europe, the late 1940s, 1950s, and 1960s were years of affluence. Postwar design was much more heterogeneous than is usually portrayed in histories that focus on the continuing heritage of interwar European Modernism.

Although of great significance, postwar Modernism was never as dominant as some of its later critics claimed, nor was it as crudely reductive or naively universalist or utopian. It flourished in many areas of design and survived the advent of Postmodernism, which, through its appropriation of the stylistic language and vocabulary of Modernism, ensured that many of the movement's formal elements remained in circulation.

In Europe, leading prewar practitioners who continued to espouse Modernist ideals included Mart Stam (1899–1986) and Charlotte Perriand (1903–1999). Stam's Modernist plan for the reconstruction of bombed-out Dresden was rejected for its failure to acknowledge traces of the former city, including remaining landmarks. By contrast, Perriand's stackable *Air France* table and *Nuage* shelves (both 1954), which adhered to strict Modernist attributes and a concern for industrial production, drew on non-Modernist traditions, in her case the design traditions of Japan where she had served as an official advisor on industrial design between 1940 and 1941. Max Bill (1908–1994), a former Bauhaus student, helped found the Hochschule für Gestaltung (Ulm School of Design, 1953–68) in Ulm in the Federal Republic of Germany (West Germany) with left-wing activist Inge Aicher-Scholl (1917–1998) and graphic designer Otl Aicher (1922–1991). Financially supported by the United States and the German Federal Financial Directorship, the school hired several former Bauhaus instructors and continued that institution's commitment to the rigor and formalism of Modernism, the integration of art and science, and (later) semiotics.

Bill spearheaded the "Neue Grafik" of International Typography, employed at Ulm and elsewhere. It rejected naturalistic illustration in favor of concentrated photographic images and reductive graphics using gridlike arrangements and sans-serif typefaces. Bill's precisely proportioned *1–5* wall clock (1957), for example, was so minimal that it dispensed with numbers. The school worked closely with the German Braun company: in 1956, company designer Dieter Rams (b. 1932), one of the most respected postwar industrial designers, and Hans Gugelot (1920–1965), head of product design at the school, designed the model SK 4 record player. This functionalist endeavor is sometimes referred to as "Snow White's Coffin" because of its color; reductive, rectilinear shape; and clear plastic lid (fig. 23.74). In Finland, industrial designer Kaj Franck (1911–1989) also strove for rational solutions, simplicity of form, industrial precision, and technological innovation while creating low-cost, mass-produced everyday ceramics for the Finnish company Arabia of which he was head of design planning (1945–61) and continued to design for them until the 1980s.

Walter Gropius (1883–1969) and Ludwig Mies van der Rohe (1886–1969), the first and last directors of the Bauhaus, were among the leading prewar European Modernists working in the United States. Also influential were graphic designer Herbert Bayer (1900–1985), fellow Bauhausler László Moholy-Nagy (1895–1946), and György Kepes (1906–2001). Moholy-Nagy helped establish the "New Bauhaus" in Chicago in 1937 (later the Chicago School of Design, the Institute of Design, and the ITT Institute of Design). Kepes, a colleague and compatriot of Moholy-Nagy, argued for a universal visual language and promoted graphic design and film as the most effective communications media. But it was not simply a case of older

Fig. 23.74. Dieter Rams and Hans Gugelot. Radio-phonograph, model SK 4, Braun AG, Frankfurt, 1956. Painted metal, wood, plastic; 9½ x 23 x 11½ in. (24.1 x 58.4 x 29.2 cm). The Museum of Modern Art, New York (205.1958).

By the 1960s, the public housing sector represented the failure of the Modernist dream of working-class lives transformed through quality homes, partly because broader social, economic, and other problems had not been sufficiently addressed. At worst, in the name of postwar slum clearance and urban renewal, the poorest members of society were massed together in badly maintained concrete high-rise blocks in environments with few public amenities and limited opportunities for social interchange. Symbolic of the disillusionment with Modernism were the fatal gas explosion at London's Ronan Point tower block in 1968 and the demolition of the Pruitt-Igoe housing complex in St. Louis mid-1970s. Designed by Japanese-American architect Minoru Yamasaki (1912–1986), Pruitt-Igoe had long been a segregated ghetto rife with crime and poverty.

Olivetti, the Italian typewriter and office equipment company, set high design standards from the late 1940s when artist-designer Marcello Nizzoli (1887–1969) took charge of both corporate identity and product design. His 1951 poster shows both aspects of his work (fig. 23.76). It features his design for the compact portable *Lettera 22* typewriter (1949, voted best-designed product of the century in a 1959 poll at the Illinois Institute of Design). *Olivetti Design in Industry* (1952), an exhibition held at New York's Museum of Modern Art (MoMA), drew attention to the company in the United States, and within four years, its U.S.-based competitor IBM (International Business Machines) had appointed the exhibi-

Fig. 23.75. Saul Bass. Poster for *The Man with the Golden Arm*, Otto Preminger Films and Carlyle Productions, 1955. Lithograph; 35½ x 25 in. (90.2 x 63.5 cm).

designers pushing interwar agendas. Young designers turning to more minimal design in the 1940s and 1950s included U.S. graphic designer Saul Bass (1920–1996), who studied with Kepes in the mid-1940s and was best known for the powerful reductive images (moving and static) he created for Hollywood films. For *The Man with the Golden Arm* (1955, directed by Otto Preminger), for example, Bass signaled a film about drug addiction with the form of a petrified arm (fig. 23.75). Even younger designers, such as Italians Lella (b. 1934) and Massimo Vignelli (b. 1931), who moved permanently to America in 1964, worked within a Modernist aesthetic, creating elegant, minimal graphics, product designs, and interiors, and have continued to do so during illustrious careers that have stretched into the twenty-first century.

Modernism became closely associated with both corporate capitalism and mass public housing. The promotion of "good design" as good business and part of responsible corporate culture was most apparent at the International Design Conferences (IDC), which were founded in the United States in 1951 by Walter Paepcke (1896–1960), chief executive officer of the Container Corporation of America (CCA), together with Bayer and Egbert Jacobson (1890–1966), who was in charge of corporate identity graphics at CCA. U.S. business led the way, commissioning Modernist glass and steel buildings with stylish interiors by designers such as Florence Knoll (b. 1917) and identity graphics by William Golden (1911–1959), Lester Beall (1903–1969), Paul Rand (1914–1996), Bass, and others. Large Western European corporations followed suit.

Fig. 23.76. Marcello Nizzoli. Poster for Olivetti SpA, Italy, 1951, featuring the *Lettera 22* typewriter (designed 1949). Lithograph and photolithograph; 27¾ x 19½ in. (70.5 x 49.5 cm). The Museum of Modern Art, New York (1574.2000).

tion's curator, Eliot Noyes (1910–1977), as company design director. A former member of Gropius's and Marcel Breuer's (1902–1981) architectural office, Noyes brought in Rand, George Nelson (1908–1986), and the designers Charles (1907–1978) and Ray Eames (1912–1988) to update the company's image and products. Noyes personally headed the research and design team responsible for IBM's groundbreaking compact *Selectric* typewriter (1961), which featured a "golf-ball" type head that allowed for different fonts and facilitated the typing process. The huge investment, lengthy development process, and aesthetic appeal of its sleek, sculptured form paid off: *Selectric* typewriters captured much of the lucrative business market with over thirteen million units sold during the following quarter century.

OTHER MODERNISMS

There were many modernisms, and some designers referred to themselves as modernists with a small "m" to distinguish themselves from Modernists (with a capital "M"). Many designers believed in modern expression and were happy to design for mass production but felt that the Modernist aesthetic was too prescriptive. They sought greater personal expression and espoused more playful, intuitive, psychological, and whimsical approaches to form and decoration.

Some embraced the softer, more fluid, curvilinear, and sculptural idiom known as Organic Modernism or "biomorphic" design. The latter term was coined in 1949 by George Nelson to describe the amoebic-like forms in the work of artists such as Joan Miró and Jean (Hans) Arp (1886–1946), which were appearing in designs such as Eero Saarinen's (1910–1961) "Womb Chair" (1946–48) and ceramics by Russel

Wright (1904–1976) and Eva Zeisel (1906–2011). The term "Humanistic Modernism" is sometimes used for such forms as well as for approaches to design reminiscent of Alvar Aalto's (1898–1976) call to focus on the human face of design. The Eameses, for example, believed that the problem with modern design was not that it was too functional but rather that it was insufficiently functional in human terms. They articulated the role of the designer as a good host attentive to the needs of her or his guest, while Zeisel, who called for close contact between designer and user, saw design as akin to gift-giving.

The term "Contemporary," or variations of it, was used to describe playful, exuberant, and self-consciously modern designs that often signaled modernity through abstractions of nature, science, and technology, and bold, gay colors. British designer Lucienne Day's (1917–2010) colored fabric *Calyx* (1951; fig. 23.77), inspired by plants and flowers as well as by modern art, especially the paintings of Wassily Kandinsky (1866–1944) and Paul Klee (1879–1940), was among many designs suggesting a bright postwar future. At the Festival of Britain exposition (1951), which commemorated the centenary of the Great Exhibition of 1851 (see fig. 17.27) and the end of postwar austerity, *Calyx* featured in room settings designed by Day's husband, furniture designer Robin Day (1915–2010). The displays were greatly admired at home and abroad. Another festival success, Ernest Race's (1913–1964) steel-rod *Antelope* chairs and benches, with "atomic" ball feet and plywood seats painted in red, yellow, blue, or gray, also epitomized Contemporary design (fig. 23.78), as did architect Victor Gruen's (1903–1980) vision for Barton's Bonbonniere in San Francisco (1952)—a delightfully light-hearted space for the sale of ephemeral delights that employed a similarly vibrant palette.

Another strand of modern design, which is sometimes described as a postwar version of Fantasy Modern design, is perhaps best seen in the look of cars and hotels. Architect-designer Morris Lapidus (1902–2001), who was well-versed in historical styles, created fantastical interiors and furnishings for hotels in Miami Beach, Florida. At a time when France was the leading destination for tourists from the United States, Lapidus brought the cachet of France to Florida's Fontainebleau Hotel (1954), where statuettes evocative of Ancien Régime France graced the coffee area. Grand staircases and spacious lobbies that drew on Art Deco enhanced the theatricality of spaces evocative of Hollywood glamour.

Fantasy and glamour were also evident in U.S. car design and marketing in the 1950s. Color continued to be a major attraction. Pinks and turquoise were introduced to attract women buyers, and in 1954 alone, Chevrolet cars came in over 140 exterior color combinations. Advertisements often featured fashionable clothing, homes, or vacation destinations alongside the latest offerings from the auto industry to underline their desirability. The 1948 Cadillac *Coupe*, designed under the direction of Harley Earl (1893–1969), General Motors' vice president of styling at the time, was the first car to employ tailfins, a feature Earl claimed was inspired by the stabilizing tailfins of the Lockhead *P38* airplane. As cars became lower and longer, tailfins, exhausts, and rear

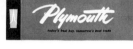

lights grew larger and more jetlike, and windshields more panoramic. To counter criticisms that such styling had gone to extremes, advertisements such as one for the 1959 Plymouth *Sport Fury* sought to assure potential buyers that this convertible, with its exaggerated chromium-edged tailfins, large rear lights, and massive fender, was in "good taste" and "deliberately designed with flair, and with restraint" (fig. 23.79). Such "jet-age" styling was reflected in many foreign models, albeit generally in more restrained versions.

"VICTORIAN" AND "EDWARDIAN" INFLUENCES

Derided by Modernists as the antithesis of the new, the rich repertory of nineteenth- and early twentieth-century material culture offered designers a means of engaging, or reengaging, with decoration, luxury, glamour, symbolism, and nostalgia. In 1947, French couturier Christian Dior (1905–1957) introduced the "New Look" (fig. 23.80). His feminine ideal was rooted in the elegant Belle Époque gowns of his childhood, and this clothing line, with its full calf-length skirts, soft shoulders, tightly fitted waists and bodices, and added emphasis to the hips, was redolent with references to French fashions of the Second Empire (1852–70). Indeed, the understructures necessary to obtain the new silhouette provoked comparisons with crinolines and leg-of-mutton sleeves. High Edwardian-style collars were reintroduced by another of Paris's couturiers, Elsa Schiaparelli (1890–1973). With wartime fabric restrictions still in force in many countries, the lavish amounts of fabric used to obtain the new silhouette seemed shocking: some Dior day dresses used as much as 10 to 25 yards of material. But this new, modern sartorial identity proved enormously popular with war-weary women. Furthermore, Dior's triumph marked the reestablishment of Paris as the center of Western women's fashion and boosted fabric sales.

Fig. 23.79.
Advertisement for the Plymouth *Sport Fury*, Chrysler Corporation, from *Life* magazine, Chicago, February 9, 1959.

142

Paris

25 yards
fan pleated.

Dior's dinner taffeta;
your own shoulders; padded hips

Boned chin-high.
Gibson Girl shirtwaist
with flat, boned
cummerbund.

Eyelet blouse and horsehair hat by Schiaparelli

BALKIN

Many people were also shocked by the dandification of the clothing worn by certain postwar British upper-class young men, who favored neo-Edwardian tapered trousers, longer jackets, velvet collars, and fancy waistcoats. Those elements, along with greased-back hair, were absorbed into the dress codes of the 1950s British Teddy Boy subculture. A few Teddy Girls wore trousers, but most favored full skirts with tight waists adapted from New Look and jitterbug skirts. The "Teds" (a diminutive of "Edwardians") were among the first groups of young people in Europe identified as teenagers, a phenomenon closely associated in the European imagination with U.S. popular culture, from James Dean and the film *Rebel Without a Cause* (1955) to Elvis Presley, jeans, T-shirts, and, in the minds of manufacturers on both sides of the Atlantic, niche marketing.

Postwar reconstruction involved the demolition of many nineteenth- and early twentieth-century buildings and interiors, and the Victorian Society was founded in London in 1958 in order to protect them. That interest was marked by the exhibition *Victorian and Edwardian Decorative Arts* (1952) at the Victoria and Albert Museum, also in London. Idealized references to supposedly more idyllic periods were popular across a range of media, especially pottery, textiles, and wallpapers. The whimsicality—a strong element within postwar design that is rarely discussed—marked them as modern. Many of those who designed such patterns had a

background in illustration. Among the most famous were Bjørn Wiinblad (1918–2006), a Danish artist-designer whose work ranged from book illustrations to stage and tapestry designs and ceramics, and the French illustrator Raymond Peynet (1908–1999), whose humorous, whimsical illustrations of a cartoonish couple, *Les Amoureux* (The Lovers, the first iteration of which appeared in 1942), were among the most popular fictional "courting couples" of the postwar period. They appeared on a variety of objects from greeting cards to scarves, medals, and ceramics. Both Peynet and Wiinblad were commissioned by the German ceramics company Rosenthal, one of the largest in the world in the 1950s and 1960s, to create patterns for china.

Imagery influenced by popular "Victorian" and "Edwardian" advertising graphics and typography was also evident in many areas of 1950s design, as was a revival of interest in Art Nouveau. Proponents included graphic designers such as Seymour Chwast (b. 1931), Milton Glaser (b. 1929), and Edward Sorel (b. 1929), who together founded Pushpin Studios in New York in 1954. This design studio became known for sophisticated syntheses of wide-ranging eclectic imagery from other periods, from the Renaissance to Russian Constructivism and "Art Deco" to all manner of Americana. The increasing embrace of eclecticism during the 1950s and early 1960s fed into what came to be called Postmodernism (discussed below).

NEW MATERIALS AND TECHNOLOGIES

After 1945, there was considerable interest in using materials developed or radically improved during the war for peace-time production. Both plywood and plastics embodied a belief in progress through science and technology, and both could be shaped into the more sculptural forms of Organic Modernism. Wartime work on plywood splints for wounded sailors had given the Eameses access to top-secret developments in plywood and "super-glues," which led directly to their molded plywood chairs of 1946. The chairs were widely copied, especially the single dining chair of 1946 (visible in the background of fig. 23.83) and inspired hundreds of other designs, from Gerrit Rietveld's (1888–1964) *Danish* chair (1949–50) for Holland's Metz & Co. and Robin Day's stackable chairs for Britain's Hille Company (1950) to Arne Jacobsen's (1902–1971) *Ant* chair (1951) for the Danish company Fritz Hansen (fig. 23.81). Teresa Kruszewska's (b. 1927) *Scallop* chair and Maria Chomentowska's (b. 1924) *Lungs* chair, both designed in Poland in 1956, demonstrate the ubiquity of ply-wood seating throughout Eastern Europe.

Plastics were used for myriad items, from surfboards to sports cars with fiberglass bodies, such as General Motors's Chevrolet *Corvette* (1953), designed by Harley Earl. The Deutsche Demokratische Republik's (DDR; German Demo-cratic Republic, commonly known as East Germany) compact *Trabant* (1957) had roof, doors, hood, bumpers, and trunk-lid of lightweight Duroplast, a hard plastic made of recycled cotton waste and phenol resins from dye making, while the Polish *Syrena Sport* (1960), a two-door prototype sports car designed by Cezary Nawrot (1931–2004), had a fiberglass body.

Plastics were popular for furniture because they could be readily formed into "biomorphic" shapes. U.S. examples include the Eamses' fiberglass shell dining chair and arm-chair (1949 and 1950, respectively) and Eero Saarinen's ele-gant, sculptural *Womb Chair*—he trained as a sculptor as well as an architect—which was upholstered in latex foam and fabric partly for comfort and partly to avoid finishing the fiberglass shell. Saarinen's integration of seat, back, and arm-rest inspired many other designs, most famously Jacobsen's

Swan and *Egg* chairs (1957–58). Although access to synthetic materials was limited in Poland, Roman Modzelewski (1912–1997) and Czeslaw Knothe (1900–1985) pioneered furniture made from synthetic fibers in the late 1950s. Le Corbusier (1887–1965) was interested in mass-producing Modzelews-ki's fiberglass chair (1959–60; patented 1961; fig. 23.82), but Polish bureaucracy and Cold War politics intervened, and Le Corbusier died in 1965. Dinnerware made from Melamine (melamine formaldehyde), a hard thermosetting plastic developed in prewar Germany and the United States, was so popular in the 1950s and early 1960s that ceramics manufac-turers, such as Gustavsberg in Sweden and Britain's Midwin-ter Pottery, began producing lines of plastic products. Russel Wright's *Residential* line (1953) proved a best-seller for Northern Plastic Company of Boston, while the DDR, with its well-established chemical industry and access to Soviet oil, supplied the Eastern Bloc with plastic products such as Albert Krause's rainbow-colored nesting dishes (1959).

INFORMAL LIVING AND PERSONAL EXPRESSION

Informal living, with an emphasis on open-plan interiors and easy access between indoors and out, was a key characteristic of postwar life in North America and Western Europe. Mary (c. 1904–1952) and Russel Wright's *Guide to Easier Living* (1950) stressed informality, personal expression, open-plan spaces, lightweight and easy-to-clean furnishings, and hus-

bands helping with chores. Wright's best-selling dinnerware lines *American Modern* (1937–57) and *Casual* (1946–67) connoted and facilitated more modern and informal ways of living. Zeisel's colorful mass-produced *Town and Country* earthenware (1947), and Kaj Franck's heatproof *Kilta* pieces (1953) helped popularize the notion that items within a line could be mixed and matched in terms of color. Many lines now came in "starter sets" for young homemakers, while sturdy oven-to-table ware added to the informality of mealtimes while reducing the number of dirty pots.

Informal clothing also grew in popularity, with U.S. sportswear designers leading the way. Claire McCardell (1905–1958), Clare Potter (1903–1999), Vera Maxwell (1901–1995), Bonnie Cashin (1907–2000), and others continued to create attractive, affordable, and comfortable clothing that was influential abroad. In Europe, German designer Sonja de Lennart (b. 1920), who was best known for her stylish, casual Capri pants (1948), attracted American celebrity clients along with European ones. In the 1950s, tapered, ankle-baring Capri pants and the more sporty "pedal-pushers" (which came above the calf to clear bicycle chains) epitomized as much as tableware or barbecues the increasingly casual lifestyle of the postwar period.

Some designers urged homemakers to create and personalize their living environments in what were inceasingly standardized and mass-produced homes. Handcrafted, "preindustrial," and natural objects served as popular visual and cultural counterpoints to what was perceived as the increasing uniformity of modern life. New approaches to home decoration included the juxtaposing of disparate objects from different cultures, continents, and time periods in group settings created to achieve what British architect-designer Peter Smithson (1923–2003) called "extra-cultural surprise."[1] Objects from all over the world were readily available in the 1950s and 1960s in North America and Western Europe, and eclectic groupings of them expressed both the fashionable cultural pluralism of the day and the cultural capital of those who created them. In the example illustrated here, the Eameses mixed items bought abroad with ones available at home, old with new, and found with made (fig. 23.83). Objects from Japan (paper lanterns, combs, and ceramics) mingled with those from India (brasswares, embroidered pillows, and low chairs), Africa (wooden stools), and the United States. The cost or rarity of the items was not a deciding factor in these displays. Indeed, because the aesthetic could be achieved with "found" and cheap objects, from starfish, driftwood, and pebbles to old toys, souvenirs, candlesticks, textiles, and flowers, this type of design was considered democratic becase it gave greater agency to homemakers (mainly women) who could personalize and thus humanize living spaces.

COLD WAR FRAMEWORKS

By 1950, both the United States and the USSR had atomic and hydrogen bombs, and fear of Soviet nuclear attacks led Western Bloc governments to institute civil defense programs. Graphic designers conveyed information to fellow citizens about campaigns such as Operation Lifesaver (1955), which included a simulated nuclear attack on the Canadian city of Calgary. Over the border in the United States, Hungarian-born Paul László (1900–1993) envisioned *Atomville USA* (1950), a city with an underground community center surrounded by a bomb shelter (fig. 23.84). Within this technological utopia, homes were placed underground not only for protection against nuclear fallout but also to provide room for individual home heliports. Benign representations of atomic power circulated alongside more dystopic visions. The former included the *Ball* clock (1948), suggestive of a nucleus surrounded by orbiting electrons designed by the office of U.S. industrial designer George Nelson, the "atomic balls" on Race's *Antelope* chair (see fig. 23.78), and Walt Disney Productions' children's book *Our Friend the Atom* (1956) by physicist Heinz Haber, together with an eponymous film and exhibition. At the same time as Erik Nitsche's (1908–1998) poster preached *Atoms for Peace* (1955) on behalf of the U.S. nuclear technology firm General Atomics, Swiss designer Hans Erni's (b. 1909) *Atomkrieg Nein* (Nuclear War No, 1954) poster featured atomic mushroom clouds emerging from a globe shaped like a human skull. British designer F. H. K. (Frédéric Henri Kay) Henrion's (1914–1990) *Stop Nuclear Suicide* poster (1963) used similar imagery and incorporated the peace symbol created for the Campaign for Nuclear Disarmament (CND) in 1958 by Gerald Holtom (1914–1985), a British designer and pacifist (fig. 23.85). It became one of the most widely recognized symbols of the second half of the century.

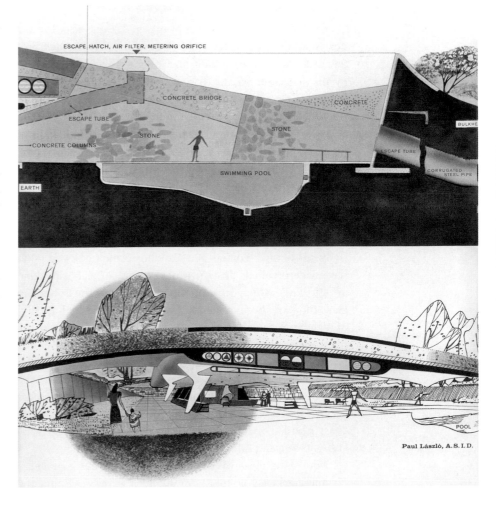

Fig. 23.84. Paul László. *Atomville USA,* designed 1950, from *Paul László,* Beverly Hills, Calif., 1958.

Paul László, A.S.I.D.

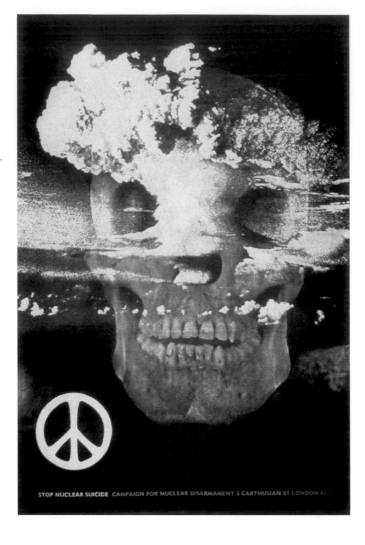

Attitudes toward consumption, and thus also toward design, shifted in Eastern Bloc countries after the death of Soviet dictator Joseph Stalin in 1953 and revelations in 1956 by his successor Nikita Khrushchev about the brutality of Stalinist rule, on the one hand, and fear of internal protest on the other. Even during the resultant "thaw" in the Cold War, however, which led to a period of relative liberalization of official policies between about 1953 and 1968, the rate of production of clothing, home furnishings, and decorative arts objects, let alone cars and televisions, rarely met demand in Eastern Europe. Nevertheless, designers were allowed greater freedom of expression. Furthermore, most decorative arts media, unlike the fine arts, were not considered potentially subversive. Poland and Czechoslovakia enjoyed what have been called design renaissances. Czechoslovakian artistic glass, which drew on the craft skills of the Bohemian glass industry, became famous worldwide. The high quality of Czechoslovakian design in general was reflected in the many prizes won at the 1958 Brussels World's Fair including: reliefs in cut-glass by Stanislav Libenský (1921–2002) and Jaroslava Brychtová (b. 1924), which were inspired by the seeming modernity of ancient cave paintings; the *Elka* coffee service by Jaroslav Ježek (1923–2002); and the design for "best pavilion" by František Cubr (1911–1976), Josef Hrubý (1906–1998), and Zdeněk Pokorný (1909–1984).

Mid-1950s pleas by the Polish architect-designer Jerzy Hryniewiecki (1908–1988) for modern expression and the banishment of ugliness from everyday life were echoed in Polish "New Look" objects, ranging from Danuta Duszniak's (b. 1926) boldly colored and equally boldly patterned *Columbus* tea service (1956) to Alicja Wyszogrodzka's (b. 1928) silkscreen–printed textile, *Maidens* (1958), featuring stylized women set against a vivid background of green and white stripes (fig. 23.86). By contrast, the main impact of a coffee service by Lubomir Tomaszewski (b. 1922) comes from its sensuous shapes (influenced by the Organic Modernism of Zeisel and Wright), elegantly swirling lines of graffiti decoration, and tensions resulting from the interactions between the two.

Eastern European magazines, books, and films of the 1950s and 1960s reveal considerable interest in forging overtly modern lifestyles, from clothing and hairstyles to furniture and textiles. Many of the products emanating from the DDR, including furniture and toys, were coveted elsewhere in the Eastern Bloc for their design and high quality of manufacture. The magazine *Die Neue Mode* (New Fashion) promoted fashionable dress, and fashion-show films were screened in factories and community centers in several Eastern Bloc countries. The stylish garments shown were usually only available to a small minority, including prominent Communist Party officials, but many women sewed or knitted items using patterns. Clothing bought in the West by those allowed to travel, or smuggled in, also influenced domestic design, and second-hand and black (and gray) markets thrived. Furthermore, as elsewhere during times of scarcity, a headscarf worn differently or a hemline shortened or lengthened could be used to signal modernity.

Despite the massive U.S. investment in military and space programs, in 1959 during the so-called Kitchen Debate between United States Vice President Richard Nixon and Soviet Premier Nikita Khrushchev about the merits of capitalism and communism, Nixon chose not to focus on technology. Only two years earlier, the launch of *Sputnik 1*, the first unmanned satellite, into space had confirmed the perception of Soviet scientific and technological preeminence. Instead,

Nixon emphasized capitalism's ability to create an abundance of consumer goods, an area where the United States far outstripped any other nation in terms of per capita ownership. The ideological power of goods was nowhere more evident than in the yellow model kitchen by General Electric at the American National Exhibition in Moscow (1959, design directed by George Nelson for the United States Information Agency), which gave the "Kitchen Debate" its name because much of the discussion took place there. His bluster at the time notwithstanding, Khrushchev thereafter paid greater attention to consumer desires, as did other Eastern Bloc leaders, if only as a means of controlling dissent.

Most Westerners welcomed access to an abundance of consumer goods, but some people felt that displays of materialism, such as the exhibition in Moscow, reflected badly on the United States as a nation. Wider concerns about excessive consumption, waste, industrial and environmental pollution, and the relentless pressure on consumers from manufacturers via the advertising industry were voiced by critics, including Vance Packard (1914–1996), whose *The Hidden Persuaders* (1957), *The Status Seekers* (1959), and *The Waste Makers* (1960) critiqued planned obsolescence, manipulative advertising, and status anxiety or "keeping up with the Joneses."

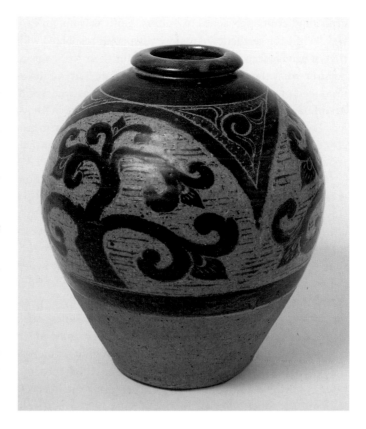

Fig. 23.87. Bernard Leach. Jar, Leach Pottery, St. Ives, UK, c. 1948–52. Stoneware; H. 12½ in. (31.8 cm). The British Council Collection (C501).

STUDIO CRAFTS

In the postwar era, crafts stood for many things, from the reinvigoration of Arts and Crafts values to lifestyles that eschewed much of the materialism of the era to greater self-expression. What became known as the studio craft movement encompassed a wide range of practitioners but is most often associated with makers working in small studios and using media-specific craft-based processes, such as hand-weaving, woodworking, metalworking, glass-blowing, and wheel-thrown or hand-built pottery. Against a background of continuing and increasing industrialization, craftspeople strove to find a place for their practices and products in contemporary life. Those described as "designer-craftsmen" advocated developing prototypes for large-scale industrial production via craft-based techniques, arguing that direct experience with materials and processes was essential for generating superior consumer goods. Others created functional wares through small-batch production or "one-offs." There were also makers, however, who aspired to align their work with modern art, and over time began to consider themselves "artist–craftsmen" or simply artists.

Three years after World War II, the British government-funded Crafts Center was established in London to promote "fine craftsmanship,"[2] a concept supported by many individuals and organizations across North America and Western Europe where craft studios sprang up after World War II, both individual studios and small group ones. Crucial support for postwar craftspeople in the United States came from philanthropist Aileen Osborn Webb (1892–1979), who, in the early 1940s, helped found what would become the American Craft Council and *Craft Horizons*, an influential magazine with an international audience. Subsequent initiatives included the Museum of Contemporary Craft (1956) in New York City and the World Congress of Craftsmen, established in 1964 in global support of indigenous craftspeople, from which emerged the World Crafts Council. Webb strongly influenced the movement to professionalize crafts elsewhere, particularly across the border in Canada where the Canadian Craftsmen's Association was founded in 1964.

A major source of inspiration for craftspeople across all media, but ceramics in particular, was *A Potter's Book* (1940), authored by preeminent British potter Bernard Leach (1887–1979). The volume offered examples of alternative ways of production and living, particularly in "preindustrial" societies such as medieval Japan, and in the Japanese Mingei crafts movement (c. 1926–45). Leach lived in Japan from 1909 to 1920. When he returned to England with Japanese potter Shoji Hamada (1894–1978), they established a pottery in St. Ives, drawing on the traditions of Japanese, Korean, and Chinese ceramics along with those of European, especially English, examples as in the vase shown here with its "tree-of-life" decoration (fig. 23.87). Versed in both Arts and Crafts and Mingei ideals, they posed crafts as ethically opposed to materialism. Leach's ideas and aesthetic were evident across the world, particularly in the work of his followers in Britain, such as Michael Cardew (1901–1983) and Katherine Pleydell-Bouverie (1895–1985), as well as that of his U.S. apprentices including Alix MacKenzie (1922–1962) and Warren MacKenzie (b. 1924), who stressed the value of well-made pots for everyday use.

Other makers championed functional studio pottery from a Modernist viewpoint. Marguerite Friedländer Wildenhain (1896–1985) trained at the early Bauhaus, where there was a strong crafts emphasis, but also worked for mass-production ceramics factories before emigrating to the United States in 1940. She tried to reconcile the contradictions between Mod-

ernist and craft approaches to pottery, but it was not an easy task. While the aesthetics of many craftspeople resonated with that of Modernism, a prime motivation for their work was to counter what they saw as the stultifying uniformity of mass-produced products and the materialism of the postwar world. An influential teacher and writer, Wildenhain argued in *American Pottery Form and Expression* (1959) for the freedom to create "modern" forms that she felt were "American" rather than rooted in Asian or European traditions.

Other Bauhaus émigrés in the United States, including weavers Marianne Strengell (1909–1998) and Anni Albers (1899–1994), were also strong advocates for bringing together craft and Modernist design. The more commercially successful Strengell designed printed fabrics for industrial production as well as woven fabrics, while Albers's most renowned pieces included one-off tapestries that contributed to her reputation as a fine artist. Albers, like many Modernists, disparaged the revival of vernacular "mountain crafts," such as those being promoted in the Appalachian highlands, which she believed thwarted the innovation so highly valued by modern art and design. Her textiles, some of which incorporated innovative additions of modern materials such as cellophane and aluminum, were the subject of the first solo exhibition dedicated to a textile designer-craftsperson at the Museum of Modern Art in New York, held in 1949.

For many studio makers, the lure of craft lay in the freedom to create objects in their own workshops independent of manufacturing constraints. Here they could choose their own timetables, construction methods, and materials, whether new (like Albers) or traditional. Wood remained the preferred medium of most studio furniture makers, many of whom employed machine tools and a Modernist idiom. George Nakashima (1905–1990), a Japanese American trained as an architect, for instance, learned traditional Japanese carpentry while detained in a U.S. internment camp during World War II. Although he designed furniture for mass-production companies such as Knoll, his most renowned pieces are tables or benches made from large slabs of wood featuring distinctive grain patterns and uncut edges, coupled together with carefully hand-executed butterfly joints (fig. 23.88).

The successful blending of crafts and Modernism and hand- and machine-production was exemplified by the Gustavsberg factory in Sweden where selected studio potters designed not only one-off pieces but also items for mass production. Established in 1917, the policy was continued by Artistic Director Stig Lindberg (1916–1982), whose own work epitomized the more playful and whimsical approach to design evident in the 1950s, and ranged from television sets to ceramic tiles. Encouraged by Lindberg, Lisa Larson (b. 1931) crossed the boundaries between mass production and one-offs on a regular basis at Gustavsberg from 1954 to 1980. Among her most popular creations were several series of fanciful small animal and human figurines that looked as if they were handmade but were mass produced from hand-modeled prototypes. At the same time, and for the same company, she created one-off hand-thrown vases and bowls with incised markings that were inspired by pieces seen in ethnographic museums and by the incised ceramics of Anders Liljefors (1923–1970). Larson's work shows a rougher, more "primitive" aesthetic that stands at one end of the broad spectrum constituting "Scandinavian Modern" design, which could also be characterized by elegance and refinement (see below).

Across North America and Western Europe, as more and more people received craft education in college and university settings, increasing numbers of practitioners began to see themselves as artists working in craft media outside of commercial production. By the early 1960s, those institutions not only nurtured new generations of artist-craftspeople but also supplemented the uncertain incomes of solo makers who now taught, thus making it possible for them to continue their creative practices. Meanwhile, the impetus to recast crafts as art grew. U.S. artist-potter Peter Voulkos (1924–2002), whose

Fig. 23.88. George Nakashima. Table, Nakashima Studio, New Hope, Penn., 1986–87. Book-matched American walnut; tabletop, L. 76⅜ in. (194 cm). The Metropolitan Museum of Art (Inst.1987.1).

roughly formed, large-scale sculptural work was influenced by Abstract Expressionism, both epitomized and informed the move toward greater free expression within the studio pottery movement in the later 1950s and 1960s.

The studio glass movement took off after the 1962 workshops conducted by Harvey Littleton (b. 1922) and Dominick Labino (1910–1987) at the Toledo Museum of Art (Ohio), which demonstrated to artists and craftspeople that they could blow glass using a small pot furnace outside of a factory setting. Many makers followed suit; while some produced functional pieces, others turned to sculpture. Littleton's demonstration at the first World Craft Congress in New York City in 1964 inspired an international audience to pursue studio glass-blowing. At the same time, handmade textiles increasingly became known as fiber art, as, for example, the tall, open-warp hangings made beginning in the early 1960s by Lenore Tawney (1907–2007) and the monumental sculptures and hangings of her contemporaries Shelia Hicks (b. 1934) and Claire Zeisler (1903–1991). All three women were influenced by older traditions and techniques, including pre-Columbian weaving, as was Ed Rossbach (1914–2002), known for his sculptural basketry. In general, fiber art was greatly informed by international crossover as were many parts of the crafts revival. Especially influential were the gigantic rope sculptures of Poland's Magdalena Abakanowicz (b. 1930), while Colombian artist Olga de Amaral (b. 1932) became renowned for shimmering large-scale tapestries, incorporating gold and silver leaf.

ITALY AND SCANDINAVIA: NEW DESIGN IDENTITIES

In the postwar period, both Italy and Scandinavia gained reputations for design excellence and integrating craft traditions with modern technologies and styles. In Italy, craft and industrial production were revitalized during a period of reconstruction after military defeat and the end of Fascist rule, and design helped forge a new national identity. Exhibitions promoted traditional crafts such as ceramics, straw work, and *pietra dura* (an inlay technique using highly polished colored stones), alongside industrial design, while the reestablishment of the Milan Triennale exhibitions in 1947 and 1951 helped revive Italy's association with contemporary design. By the early 1950s, features in international design magazines and exhibitions, such as the Brooklyn Museum of Art's *Italy at Work: Her Renaissance in Design Today* (1950), had further boosted that association.

Established craft traditions remained strong in the leather and clothing industries, both of which blossomed in the postwar period. Handmade shoes and leather goods sold well abroad, as did couture clothing by designers such as Emilio Pucci (1914–1992), Duchess Simonetta (b. 1922), and the Fontana sisters—Zoe (1911–1978), Micol (b. 1913), and Giovanna (1915–2004)—who established Sorelle Fontana (1944–92). They and others with strong upper-class connections provided French-style couture at cheaper prices. Such garments proved popular with both the social elite and a slew of international

Fig. 23.89. Corradino D'Ascanio. *Vespa GS 150*, Piaggio SpA, Pontedera, Italy, 1955. Painted steel, rubber, leather, plastic; 42½ x 67¼ x 28¼ in. (108 x 170.8 x 71.8 cm). The Museum of Modern Art, New York (352.2004).

film stars who wore Sorelle Fontana off and on screen, from Hollywood star Myrna Loy in the British film *That Dangerous Age* (1949, directed by Gregory Ratoff) to Swedish-American star Anita Eckberg in *La Dolce Vita* (The Good Life, 1960, directed by Federico Fellini). Prospective sales to leading U.S. department stores prompted many Italian designers and manufacturers to pay greater attention to more informal clothing and to high-quality ready-to-wear garments.

In industrial design, Gio Ponti (1891–1979; see fig. 23.51) rose to even greater prominence, designing the gleaming, curvaceous *La Pavoni* coffee machine (1948) that exemplified *la dolce vita* of postwar Italy. In the 1950s, coffee bars complete with various Italian coffee-making machines epitomized modernity and youth culture as far north as Iceland. Another icon of postwar Italian industrial design associated with young people was the scooter, a civilian vehicle developed from those used in Italy by the U.S. military during World War II. Relatively cheap, easy to ride, and mainly meant for urban use and short distances, scooters had a broad footrest and a high front that protected clothing far better than motorcycles (fig. 23.89). The *Vespa* (1946) and *Lambretta* (1947) were developed by rival Italian teams involving aeronautical engineers Corradino D'Ascanio (1891–1981) and Cesare Pallavicino respectively, in factories formerly employed in war production. The Hollywood film *Roman Holiday* (1953, starring Audrey Hepburn and Gregory Peck, directed by William Wyler) promoted the scooter internationally as a quintessentially youthful form of transport, and advertisements by *Vespa* and *Lambretta* franchises across the world increasingly placed them within the emerging youth culture.

Postwar Sweden became more competitive in the field of industrial design with products like the Hasselblad *1600F* camera (1948) and the stylish aerodynamic Saab *92* car (1949),

both designed by Sixten Sason (1912–1967), and the *Cobra*, the first one-piece telephone (1954, named for its cobra-like profile) designed by Ralph Lysell (1907–1987) for Ericofon. The contemporary term "Scandinavian Modern," however, was associated mainly with modern designs that reinterpreted folk and craft traditions and used natural materials. Characteristics included minimal shapes; tightly grained woods, especially teak; leather; and textured, brightly colored textiles, both handwoven and machine-woven in ways evocative of handwork. Some of the leading Scandinavian mass-production designers had craft backgrounds. After serving as an apprentice with a cabinetmaker, for example, Hans Wegner (1914–2007), designer of mid-century furniture, also studied cabinet making at the Danish School of Arts and Crafts. Wegner, who stripped down forms to basics, is perhaps best-known for the *Wishbone* chair (1949), which drew inspiration from Chinese chairs of the Ming dynasty (1368–1644). Even designers focused solely on industrial production, such as Astrid Sampe (1909–2002), never lost sight of Scandinavian traditions while creating emphatically modern imagery. As head of textile design at Nordiska Kompaniet (one of Stockholm's most design-conscious stores), Sampe created and commissioned textiles for mass-production.

Scandinavian Modern design was already making an impact abroad by 1950 when Sampe received an honorary Royal Designer for Industry Award in Britain. International exhibitions played a key promotional role, from *Scandinavian Design for Living* in London (1951) and the Milan Triennale of that same year to *Formes Scandinaves* (1958) in Paris. The Scandinavian-organized *Design in Scandinavia: An Exhibition of Objects for the Home* toured North America from 1954 to 1957. Although not officially part of Scandinavia, Finland contributed goods to the exhibition, including the laminated birch plywood platter by Tapio Wirkkala (1915–1985) that was featured on the promotional poster (fig. 23.90). *House Beautiful* declared it the most beautiful object of all those shown by the eleven countries at the Milan Triennale of 1951. As design director at the Iitalla glassworks in Finland, Wirkkala created everything from a limited edition *Kantarelli* sculptural glass vase (1946) to low-cost items such as *Ultima Thule* glassware

(1968), which was cast from wooden molds hand-carved by Wirkkala to replicate the effect of melting snow. So great was the interest in Scandinavian Modern goods abroad that companies in the United States, the Netherlands, Britain, West Germany, East Germany, and elsewhere began manufacturing Scandinavian Modern–inspired products.

MOD, POP, OP, PAPER, AND PLASTIC

Modernism had a strong influence on "youth revolution" designs of the 1950s and 1960s, including the minimalist Mod clothing by British fashion designer Mary Quant (b. 1934) and the short, starkly geometric haircut created for her in 1964 by Vidal Sassoon (1928–2012). Like many Mod designs, her fashions were created by young people for young people, and Quant's London boutique, Bazaar, which opened in 1955, brought more fun and informality to shopping for clothes. Quant's simple shift-style garments with their increasingly shorter skirt lengths offered young working women and students greater freedom of movement, especially when worn with opaque tights and flat footwear, as opposed to nylon stockings and high-heeled shoes. Quant is credited with inventing the miniskirt in the early 1960s, along with another British designer, John Bates (b. 1938), and Parisian couturier André Courrèges (b. 1923).

Courrèges, an admirer of Modernism and Futurism, created emphatically modern forms for the "new women" of the 1960s. His *Moon Girls* collection (1964)—designed shortly after American astronaut John Glenn orbited the earth—featured white and silver angular mini-dresses and trouser suits, accessorized with helmets, goggles, and flat-soled white boots inspired by astronaut gear (fig. 23.91). They gave sartorial expression to women's changing roles and attitudes as well as to a scientifically and technologically oriented future full of new materials for clothing, such as wet-look PVC (polyvinyl chloride) and "drip-dry" easy-care acrylics. Pierre Cardin (b. 1922) created French couture versions of the futuristic "space age" look in 1964, pairing short, shift-style dresses with visors and helmets. This look was widely copied, includ-

Fig. 23.90. Tapio Wirkkala. Platter, Martti Lindqvist, Helsinki, 1951. Laminated birch; 1 x 19 x 9⅞ in. (2.5 x 48.3 x 25.1 cm). The Museum of Modern Art, New York (242.1953).

momentum. Trousers were also very much a part of the "retro" look in vogue in the early and mid-1970s, when designers in Europe and North America created 1930s-inspired versions of tailored menswear in wool for day and wide-legged pajama-style ones in softly draped, fluid silks and satins for evenings.

Plastics remained a major marker of modernity through the 1960s and early 1970s, not least because they were relatively cheap and easily molded. Italian designer-architect-sculptor Gaetano Pesce (b. 1939), for example, saw plastics as a means of achieving free expression while meeting Modernist goals of affordable, industrially produced products. Italy led the field in the application of injection molding techniques, and Joe Colombo's (1930–1971) *Universale* chair (1965) for Kartell in a plastic known as ABS was one of the most successful stacking chair designs of the decade, both aesthetically and commercially. Other plastics that enjoyed greater commercial use and new applications included PVC (polyvinyl chloride), which was employed for a range of goods such as inflatable furniture aimed at young people with peripatetic lifestyles. The cheapness, transparency, and easy portability of the *Blow* chair (1967), designed by Italians Paolo Lomazzi (b. 1936), Donato D'Urbino (b. 1935), and Jonathan de Pas (1932–1991) for Zanotta, epitomized the contemporary emphasis on "fun" as well as function and the focus on young, mobile consumers (fig. 23.92).

In France, Vietnamese-born Quasar Khanh (b. 1934) created inflatable PVC "environments" as well as furniture. Hard plastic quarters were more durable, as for example the "total living" spaces created by Colombo between 1969 and his death in 1971. Commissioned by Bayer AG, the German-based chemical and pharmaceutical company that also produced plastics, Colombo's *Visiona 1* reduced the essentials of living to a Kitchen Box, Central-Living Block, and Night-Cell (fig. 23.93). Spherical and circular forms added a "space age" feel while the bed, ceiling-mounted television, and privacy screen in the Night-Cell evoked the bachelor pads featured in

Fig. 23.91. André Courrèges. Coat, dress, and boots, Paris, 1965. Hat by Frederick Waters, Sydney, Australia, c. 1965. Wool, acrylic, vinyl, plastic, leather, metal. Powerhouse Museum, Sydney (A8939, A9389 and A9086).

Fig. 23.92. Paolo Lomazzi, Donato D'Urbino, and Carla Scolari. *Blow* inflatable armchair, Zanotta SpA, Italy, 1967. PVC plastic; inflated, 33 x 47⅛ x 40¼ in. (83.8 x 119.7 x 102.9 cm). The Museum of Modern Art, New York (SC3.1972.1).

ing by designers in Eastern Bloc countries. Franco-Spanish designer Paco Rabanne (b. 1934) expressed modernity somewhat differently, creating dresses out of plastic and metal disks joined with metal links over naked (or body-stockinged) flesh. Shorter skirts also exposed more body, and by the late 1960s, "see-through" fashions mirrored the taste for "see-through" furniture (see below).

Women's trousers moved out of the casual wear category into high fashion in the mid-1960s, when Courrèges, Cardin, and Yves Saint Laurent (1936–2008) included them in their Paris collections. Saint Laurent's black wool "le smoking," or "smoking suit" (1966), explored notions of femininity and gender, reflecting wider societal changes, as did many of his other trouser ensembles. Although workplaces and restaurants frequently continued to ban the wearing of trousers by women, the clothes became increasingly popular, especially in the 1970s as the Women's Liberation movement gained

Fig. 23.93. Joe Colombo. *Visiona 1* futuristic habitat for the Cologne furniture fair *Interzum*, 1969.

Fig. 23.94. *The Souper Dress*, USA, c. 1966–67. Sold by the Campbell Soup Company. Silkscreen-printed cellulose and cotton paper; L. 32 in. (81.3 cm). The Metropolitan Museum of Art (1995.178.3).

men's magazines such as *Playboy*. Experiments in plastics slowed, however, as environmentalists increasingly questioned the wisdom of producing things that were difficult to dispose of, and the Organization of the Petroleum Exporting Countries (OPEC) oil embargo of 1973 drove up the cost of petroleum-based materials.

Paper products were part of what contemporaries described as the "throw-away" or "Kleenex" culture. In Sweden, the saying "köp-slit-och-släng" (buy-wear-and-dispose) was used in relation to paper furniture and clothing. Designed in Britain in 1963 and manufactured by International Paper of the United States (1964–65), Peter Murdoch's (b. 1940) laminated paperboard chairs led the way, and the idea spread quickly to France, Germany, Scandinavia, and North America. Although cheap (the chairs sold for a few pounds sterling), they did not wear well. More durable was the furniture made of industrial waste cardboard tubes from designs conceived simultaneously by British designer Bernard Holdaway (1934–2009) and French designer Jean-Louis Avril (b. 1935) in 1966. In the same year, Scott Paper, a U.S. company, sold its *Paper-Caper* mini-dresses made from Dura Weve, a combination of paper and rayon, for a dollar each, and by 1968, there was a craze, albeit short-lived, for paper dresses across North America and much of Europe. British fashion designer Zandra Rhodes (b. 1940) designed paper wedding dresses, but the most iconic garment was *The Souper Dress* (1966–67; fig. 23.94), a marketing ploy by the multinational soup company to capitalize on Andy Warhol's (1928–1987) famous 1962 painting *Campbell's Soup Cans*.

Pop Art began in Britain in the mid-1950s with attempts by the Independent Group, including artist Richard Hamilton (1922–2011), to incorporate popular culture into art and design practices, from magazine advertising to comic books and all manner of ephemeral graphics. It quickly took root there and in the United States, bringing celebrity to graphic designer-turned-artist Warhol, who featured celebrities in many of his paintings alluding to the mechanical reproduction of popular culture images. Pop Art readily blurred back into Pop graphics, as in British Pop artists Peter Blake's (b. 1932) and U.S.-born Jann Haworth's (b. 1942) cover for the 1967 Beatles' album *Sgt. Pepper's Lonely Hearts Club Band*. The image offered a cross-cultural mix of, among other things, fairground art, floral designs of a type seen in municipal gardens, advertising-style cardboard cutouts of celebrities, and old-style uniforms (an anti-Mod gesture) that evoked the worlds of fancy dress and vaudeville.

Op Art, or Optical Art, explored the illusionistic and perceptive aspects of pattern in painting, and had a short but powerful impact on design, particularly the bold, dynamic black-and-white spatial geometries of Hungarian-French graphic designer-turned-artist Victor Vasarely (1906–1997) and British artist Bridget Riley (b. 1931). Op Art translated most easily into two-dimensional design; Vasarely, for example, designed textiles for Edinburgh Weavers (1962–63), while Danish designer Verner Panton (1926–1998), best known for his one-piece cantilevered plastic chair (1960), created some of the boldest patterns for the Danish textile company Unika Vaev (fig. 23.95). In Italy, Gae Aulenti (1927–2012) designed black-and-white Op Art–style interiors for the Centro-Fly department store in Milan (1966), and master glassmaker Archimede Seguso (1909–1999) drew on Op Art for glass vases and bowls in the late 1960s.

Op-Art designs found new audiences via U.S. designer Lance Wyman's (b. 1937) identity graphics for the 1968 Olympic Games in Mexico, seen in color on television around the world (see fig. 23.31). Graphic designers increasingly helped unify the overall look and experience of such major sporting events. Otl Aicher, for example, created a system of pictograms and visual expressions of multiculturalism for the 1972 Munich Olympic Games, while Deborah Sussman (b. 1931), who has a background in performance as well as design, led the urban environmental efforts of the Sussman/Prejza firm, in collaboration with the Jerde Partnership (architects), for the 1984 Los Angeles Olympics. For the latter they created a kit-of-parts of signage and environmental graphics that was easily assembled in site-specific installations and as stage sets for the televised celebrations and performances. The predominant palette of hot pinks and oranges evoked the regional identity of southern and Baja California, while the contemporary forms presented both the city and the nation as modern.

Fig. 23.95. Verner Panton. Sales exhibition at Möbel Pfister, Zurich, 1961. Featuring *Panton Wire* (1958–59) and *Cone* (1959–60) furniture designed for Plus-linje, *Geometri* furnishing fabric for Unika Vaev (1960), and the *Topan* lamp for Louis Poulsen (1959).

NEO-ART NOUVEAU AND PSYCHEDELIA

In the 1960s, the more swirling Op-Art designs intersected with an Art Nouveau revival which has been dubbed "Neo–Art Nouveau" and was part of the wider revival of interest in design from the late nineteenth and early twentieth centuries (see above). Op Art and Art Nouveau contributed to the near-delirious, kaleidoscopic mélanges of posters for rock concerts and festivals in the San Francisco area in 1966 and 1967 by Robert Wesley (Wes) Wilson (b. 1937) and other designers including Victor Moscoso (b. 1936), Stanley Mouse (b. 1940), Alton Kelly (1940–2008), and Rick Griffin (1944–1991). Griffin created posters and record covers for the band Grateful Dead, but Wilson's posters, which feature stylized female heads with undulating hair and near-illegible, freehand block lettering, best captured the contemporary desire for free expression and the sensations created by mood-enhancing drugs. At the same time, Milton Glaser took psychedelia into more mainstream music promotion. His stylized image of singer-songwriter Bob Dylan for CBS Records (1966; fig. 23.96) evoked the bold simplicity of German *Sachplakate* (object posters) of the 1900s and 1910s. In the 1970s, designs by psychedelic artist-illustrator Peter Max (b. 1937) were featured on product lines for over seventy companies, including clock faces for General Electric. Parts of the eclecticism and cultural pluralism here fed into what came to be called Postmodernism (see below) and both informed and was shaped by the counterculture movement, which was closely aligned with certain types of crafts practice.

Fig. 23.96. Milton Glaser. *Dylan* promotional poster, USA, 1966. Offset lithograph; 33 x 22 in. (83.8 x 55.8 cm). The Museum of Modern Art, New York (773.1983).

CRAFTS

The counterculture of the 1960s created a hospitable environment for craftspeople. While some were politically active advocates for key political movements—Civil Rights, peace (or antiwar), women's and gay liberation, and ecological awareness—many (who often hailed from the white middle class) saw their choice of an independent, creative, and non-corporate lifestyle in itself as a rejection of mainstream society. By the 1970s, craftspeople in North America and Western Europe were part of an increasingly professionalized field, with growing numbers of patrons, galleries, museums, publications, and academic departments devoted to "fine craft," or craft as art. More and more makers pursued successful careers, producing a greater variety of work and drawing on a wider range of influences, including hitherto marginalized crafts. The revival of blacksmithing, for instance, was exemplified in the United States by the creations of Albert Paley (b. 1944), known for large-scale sculptural and architectural work characterized by vertical forged metal rods undulating into swirls and scrolls at times reminiscent of Art Nouveau forms.

Meanwhile, those involved in what became an international studio glass movement (it was particularly strong in Scandinavia, Britain, Czechoslovakia, and North America) also found inspiration in both modern art forms and long-established craft traditions. British glass artist John Cook (1942–2012), later a chair of World Craft Council UK and a founder of British Artists in Glass (1976), learned about experimental artistic glass and older traditions of Bohemian glass in Czechoslovakia as an exchange student at the Academy of Art in Prague (Vysoká škola uměleckoprůmyslová v Praze). After graduating from the Royal College of Art in 1968, Cook was invited to work at the Venini glass factory on the Venetian island of Murano. American Dale Chihuly (b. 1941) likewise worked with Venini's master glassblowers and was inspired by their virtuosity. Chihuly, who cofounded the Pilchuck Glass School in Washington State in 1971, went on to commercial and popular success and is probably best known for installations of highly colored undulating forms based on sources ranging from Native American baskets to undersea life to Renaissance putti.

During the 1970s, feminist artists, designers, and craftspeople increasingly explored craft as a mode of production historically aligned with women's work, techniques, and skills. In their concern for the lesser status of both women and craft, many of them, like the practitioners of postwar studio crafts, reappraised craft within a fine art context. Artist Judy Chicago (b. 1939), for example, collaborated with researchers, ceramists, and embroiderers to realize the monumental installation *The Dinner Party* (1974), which literally gave historical women seats at the table, each identified by a specially designed place setting. This shift toward more narrative content in activist art made with craft media is evident in the sewn and painted story quilts made by Faith Ringgold (b. 1930), which she began to produce in the 1980s, well into her successful career as a painter. *Echoes of Harlem* (1980) recalled people from the neighborhood in which she grew up (fig. 23.97). Ringgold painted a series of faces on cotton,

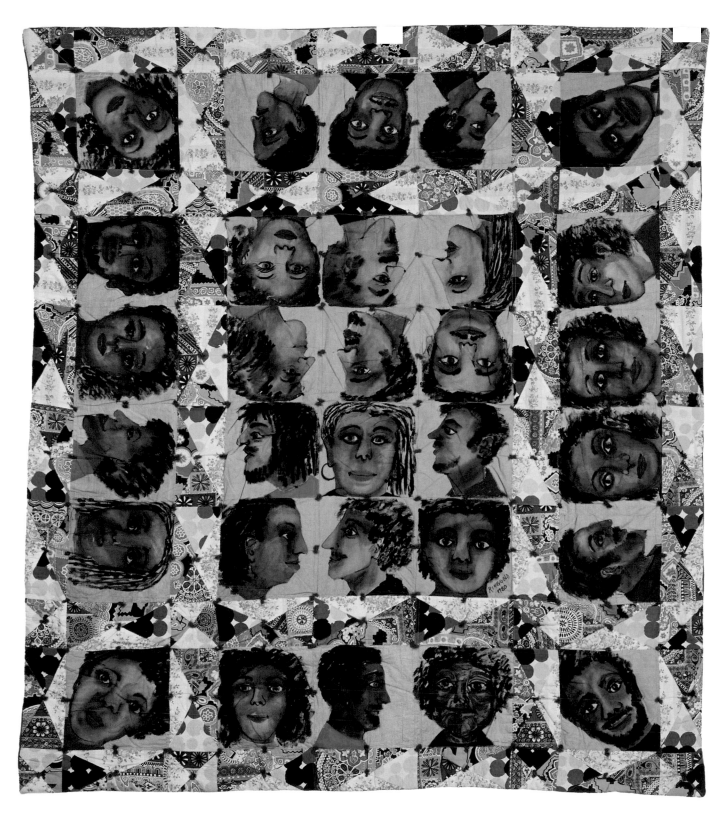

Fig. 23.97. Faith Ringgold. *Echoes of Harlem* quilt, USA, 1980. Quilted by Willi Jones. Acrylic on cotton; 89½ x 80½ in. (227.3 x 204.5 cm). Studio Museum Harlem (08.13.10).

which were then pieced together and quilted by her mother, Willi Jones (1903–1981), also known as fashion designer Madame Posey.

By the 1980s, many studio craft artists had embraced the narrative impulse associated with Postmodernism, resulting in playful and explicitly conceptual work often destined for gallery settings. Furniture maker Wendell Castle (b. 1932), for example, produced the trompe l'oeil sculpture *Ghost Clock* (1985) in bleached mahogany, which gave the impression of a tall case clock draped in a white sheet. Wendy Maruyama (b. 1952) moved from making furniture of naturally finished wood in curved and asymmetrical forms to overtly sculptural, humorous pieces with painted and textured surfaces. Her *Mickey MacIntosh* chair (1981), which she made in a limited edition of twenty, parodied the fashion for reproducing furniture designed by Charles Rennie Mackintosh (1868–1928) by abstracting the form of his high-back *Argyle* chair (1898–99) into flat vertical and horizontal planes and by transforming the headrest into Mickey Mouse ears. This piece is one of many showcasing studio craft artists' inventive engagements with Postmodernism.

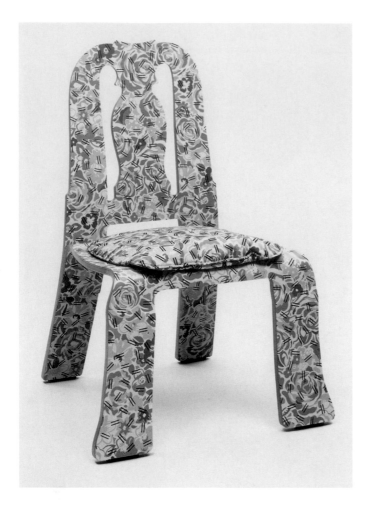

Fig. 23.98. Robert Venturi and Denise Scott Brown. *Queen Anne* side chair, Knoll International, Inc., East Greenville, Penn., 1983. Maple plywood, plastic laminate; 38½ x 26⅝ x 23¾ in. (97.8 x 67.6 x 60.3 cm). The Museum of Modern Art, New York (302.1984).

POSTMODERNISM

Postmodernism, by definition, resists definition. The term generally describes a philosophical and cultural change that emerged in certain architecture and design circles in the 1960s, at a time when capitalism was shifting to service-led economies. The broader movement became known as Postmodernism after 1975 when Charles Jencks (b. 1939), a U.S. architectural historian and critic, applied the term to a set of common characteristics in architecture, design, art, literature, and philosophy: the critique of rationality and functionalism and the embrace of playfulness, wit, irony, ambiguity, affectivity, bricolage, and layered juxtapositions of images. Postmodernism fostered pluralism and diversity rather than a singular way of thinking and designing. There was a renewed interest in the marginalized and peripheral aspects of design, including the decorative, handmade, historical, and vernacular. Many of these characteristics of Postmodernism were evident in certain postwar designs, but Postmodernism's advocates directly challenged Modernism itself. Indeed, ideas and designs emerging in the 1960s and 1970s often responded to standardized, large-scale mass production and universal models for a largely undifferentiated market, as designers and consumers expressed frustration at Modernism's failure to deliver the utopia it promised.

An early critic of Modernism was U.S. architect-designer Robert Venturi (b. 1925). In his influential *Complexity and Contradiction in Architecture* (1966), he portrayed Modernism as too narrow, restrictive, and predictable, as well as insufficiently reflective of the messy vitality of contemporary life. Favoring hybridity and ambiguity, he advocated thinking about design as "both-and" rather than "either-or." Venturi's approach to design developed in tandem with that of Denise Scott Brown (b. 1931), the South African–raised architect and town planner whom he married in 1967. *Significance for A&P Parking Lots, or Learning from Las Vegas* (1972), by Venturi, Scott Brown, and Steven Izenour (1940–2001), lauded the vernacular, particularly as seen in and on the motels and casinos of Las Vegas. They proposed the concept of "decorated sheds"—buildings with elaborate facades and surface decoration that could indicate the building's type or purpose, or simply delight the eye. Venturi, in collaboration with Scott Brown and others, further explored surface decoration in designs for a series of molded-plywood chairs and tables with patterned plastic lamination. These pastiches alluded to historical styles from the 1700s to the 1930s and sought to capture the essence of a particular period without regard for historical accuracy or "authenticity" (a concept questioned during the 1970s and 1980s). In the *Queen Anne* version illustrated here, the *Grandmother* floral pattern was inspired by a favorite tablecloth of a colleague's grandmother, to which short black parallel lines were added in homage to artist Jasper Johns (b. 1930; fig. 23.98).

New directions also came from the radical design movement in Italy known as Anti-Design. Key practitioners included the organization Archizoom Associati (1966–74), formed by Andrea Branzi (b. 1938), Gilberto Corretti (b. 1941), Paolo Deganello (b. 1940), and Massimo Morozzi (b. 1941). This group sought to undermine the notion of "good taste," and the Modernist emphasis on functionality, through irony, provocation, and confrontation. Its *Safari* sofa (1968), for example, consisted of four modular plastic units upholstered in fake leopard-skin, a material then widely considered to epitomize vulgarity and "bad taste." At the same time, Archizoom deliberately subverted the creed of functionalism by invoking the forms and materials associated with it.

Another radical design practice was Studio Alchimia (1976–1992), cofounded by architect-designer Alessandro Guerriero (b. 1943), who with his sister Adriana wrote *Elogio del banale* (Eulogy of the Banal, 1980), which in part grew out of the "anti-design" stance of groups such as Archizoom. Studio member Alessandro Mendini (b. 1931) also championed "banal design" in which everyday objects were transformed into works of art through ironic references communicated via decoration and surface articulation. His *Proust* armchair (1978) was part of the *Bauhaus* collection, which challenged that institution's ideas about form, function, and decoration (fig. 23.99). Named after Marcel Proust, whose book, *À la recherche du temps perdu* (In Search of Lost Time, or Remembrance of Things Past, 1913–27), explores the power of involuntary memory, the chair evoked the Rococo Revival and old-fashioned furnishings. The chair's painted surface alluded to Pointillist paintings, visual counterparts to Proust's impressionistic writing style. Mendini's *Redesign* series (begun 1978) further challenged Modernism by daring to "redesign" Modernist icons, such as Marcel Breuer's *Wassily* chair (see fig. 23.62), or objects ven-

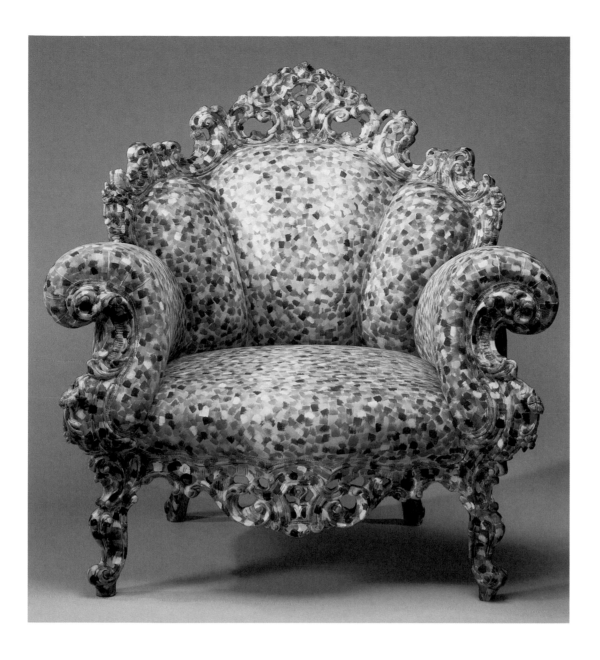

Fig. 23.99. Alessandro Mendini. *Proust* armchair, Atelier Mendini, Milan, 1998–99 (designed 1978). Painted upholstery and wood; 42½ x 40 x 40 in. (108 x 101.6 x 101.6 cm). Philadelphia Museum of Art (2000-118-1).

erated by leading Modernists, such as the *Thonet No. 14* chair (see fig. 17.31).

The Memphis Group, which became famous for eccentric, unconventional forms that blurred the boundaries between elite and low culture and between design and fine art, was founded in 1981 by Studio Alchimia member Ettore Sottsass (1917–2007) and did much to popularize Postmodernism. Fascinated by U.S. mid-century popular culture (the name Memphis came from both Memphis, Tennessee, center of American Blues music, as well as the ancient capital of Egypt), members embraced and recontextualized commonplace industrially produced materials. Formica and other brightly colored and boldly patterned plastic laminates of the type popular in 1950s North American diners and kitchens were referenced in Sottsass's irreverent *Carlton* room divider (1981). His sense of playfulness is also evident in his smaller works, such as the *Tahiti* lamp (1981), the forms of which resemble a comic bird (fig. 23.100), and in the group's jewelry for Acme (1985–1986), which featured expressive, whimsical, complex forms derived from simple geometries in a rich array of colors characteristic of Memphis designs.

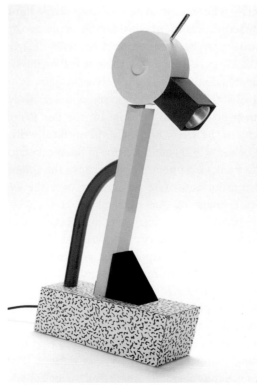

Fig. 23.100. Ettore Sottsass. *Tahiti* table lamp, Memphis Group, Milan, 1981. Enameled metal, plastic laminate; 26⅜ x 15 x 4 in. (67 x 38 x 10 cm). National Gallery of Australia, Canberra (NGA 88.1506).

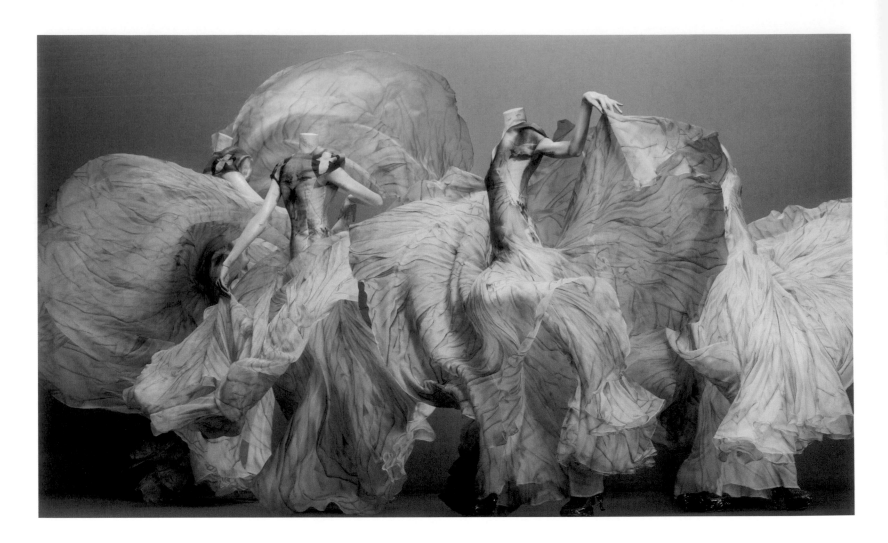

Fig. 23.101. Alexander McQueen. Dresses from the fall/winter collection, Paris, 2010–11. Silk.

PUNK, PLURALISM, AND POSTMODERN FASHION

Punk Rock, a music genre that developed more or less simultaneously in the United States and the United Kingdom, was in part a rebellious, sometimes anarchic response to a "post-industrial" society wherein the demise of once-staple industries and manufacturing brought considerable economic and cultural dislocation in its wake. Anarchist artist-designer Jamie Reid (b. 1947) gave Punk Rock, the musical expression of this movement, a distinctive graphic style through record covers, concert flyers, and other promotional materials. His antiestablishment promotional material for the Sex Pistols' singles "Anarchy in the UK" (1976) and the ironically titled "God Save the Queen" (1977) included one of the most enduring icons of the Punk movement. For "God Save the Queen," Reid collaged ransom-note-style typography over the eyes and mouth of an image of Queen Elizabeth II (r. 1952–). Sometimes the image was set against a background of the British flag and sometimes a safety pin was added to the nose, juxtaposing a symbol of the dispossessed with a symbol of state, church, inherited wealth, and privilege.

The Sex Pistols' manager, Malcolm McLaren (1946–2010), together with Vivienne Westwood (b. 1941), created garments that appealed to antiestablishment working-class youth. Reappropriating a wide variety of cultural references while subverting mainstream clothing conventions, Punk garments were often deliberately distressed, or designed to

look as if they had been, held together with safety pins, slashed with razors, and adorned with provocative, sometimes obscene messages.

Westwood went on to become a hugely influential fashion designer. Westwood's and McLaren's ever-changing imagery epitomized the Postmodern appropriation of images out of their original contexts, especially their *Pirates* and *Savages* collections (1981 and 1982 respectively), which refer to a variety of ethnic cultures. Westwood went solo shortly thereafter, and her African-inspired boutique, Nostalgia of Mud (1984), reflected the massive reembrace of ethnic design. Primitivism abounded, underpinning the appeal of garments by designers such as Mary McFadden (b. 1938), who was sometimes referred to as an archaeologist of clothing because of her knowledge of African and Asian garments. McFadden, however, like other American and Western European designers, consistently wrenched past forms and motifs out of their cultural contexts, creatively adapting them for modern couture and ready-to-wear Western clothing.

Since the nineteenth century, Western fashion has consistently mined and reinterpreted a wide range of sources—historical, political, and ethnographic—as well as its own past in the deliberately self-referential creation of new styles. Not surprisingly, therefore, fashion became one of the most visible and expressive forms of Postmodernism, and its role in identity formation became more widely appreciated. Since at least the 1980s, Postmodern fashion has been characterized by eclecticism, exaggeration, irreverence, sexually provoca-

tive references, and the use of unusual materials such as leather, metal, feathers, and molded plastic. It exploits and comments on perceptions of the body, notions of ideal beauty, the constructed nature of gendered identities, the increasing fragmentation of life, the globalization of fashion, and fashion itself. Those most involved with overturning and questioning preconceived notions of clothing include the British designers Westwood, Alexander McQueen (1969–2010), John Galliano (b. 1960) at Dior; the British/Turkish Cypriot Hussein Chalayan (b. 1970), who has worked out of Paris since 2001; Belgian designer Martin Margiela (b. 1957); and French designer Jean-Paul Gaultier (b. 1952).

Also in the late 1970s and early 1980s, Japanese designers such as Issey Miyake (b. 1938; see fig. 19.26), Rei Kawakubo (b. 1942) for Comme des Garçons, and Yohji Yamamoto (b. 1943) had an impact on Western fashion (mainly outside the world of couture), with their over-scaled, deconstructed garments that drew on traditional shapes and textiles as well as the Japanese aesthetic of *wabi-sabi,* or imperfect beauty. Asymmetrical, multilayered, and often black, these clothes were the antithesis of the soigné elegance characteristic of Western couture.

In the 1980s, Gaultier was greatly influenced by street wear and popular culture, and his designs had an impact, especially his questioning, as an openly gay man, of the gendered and transgendered nature of clothing through raising issues around androgyny and creating new garment types such as his man-skirts (1985). He also designed film and performance costumes, including the sexually provocative cone-bra corsets and dresses for Madonna's 1990 *Blonde Ambition* tour. Alexander McQueen similarly designed for performers, including David Bowie in the late 1990s, and directed the music video for Björk's song "Alarm Call" (1998). McQueen is best remembered, however, for his compelling, often controversial, and sometimes disturbing reiterations of high fashion as high theater, and for his blurring the boundaries of design, fine art, and performance. His runway shows, which presented some of the most widely acclaimed couture collections of the early twenty-first century, were dramatic "happenings" in their own right, and ranged from dark social and historical commentaries to artistic fantasies (fig. 23.101).

CELEBRITY PRODUCT DESIGNERS, LIMITED EDITIONS, AND MASS PRODUCTION

Fashion design had long been associated with big-name couturiers, and by the 1980s more and more designers were heralded as celebrities in their own right. So too were "starchitects," a term often used to describe Postmodern architects whose work had become especially well-known and who became sought after as product designers. At the high end of the product market, companies like Alessi (Italy) and Swid Powell (United States) commissioned limited edition pieces from Postmodern architect-designers, including the Italians Alessandro Mendini, Aldo Rossi (1931–1997), and Paolo Portoghesi (b. 1931); Hans Hollein (b. 1934) from Austria; the Spaniard Óscar Tusquets (b. 1941); and Venturi, Michael Graves (b. 1934), and Charles Jencks from the United States. In 1983, Alessi introduced silver *Tea and Coffee Piazzas.* The trays symbolized the piazza or open urban space on which the individual "buildings" of the tea and coffee sets stood (fig. 23.102). Graves, who designed the example illustrated here, was told that it did not matter whether or not the pieces were functional; at a cost of about twenty thousand dollars each, these sets were not intended for everyday use. Like a fine art print, each design came in a limited edition—in this case, ninety-nine. They were shown through galleries and exclusive department stores in large Western cities such as New York and Milan, and bought for museum collections.

A year later, Swid Powell launched its own series of architect-designed porcelain dinnerware, glassware, and silver-plated objects, consolidating a fashion for "designer" home wares. The brand-name appeal of famous designers continued to sell goods into the early twenty-first century, with the addition of mainstream retailers, including the U.S.-based Target at the popular end of the market. Fourteen years after Graves's enormously successful stainless steel tea kettle with "bird" whistle for Alessi (1985; the brief for this piece insisted on functionality), the Target Corporation, the second-largest discount retailer in North America, approached him to create a version for the lower end of the market. Graves went on to design over eight hundred products for Target stores.

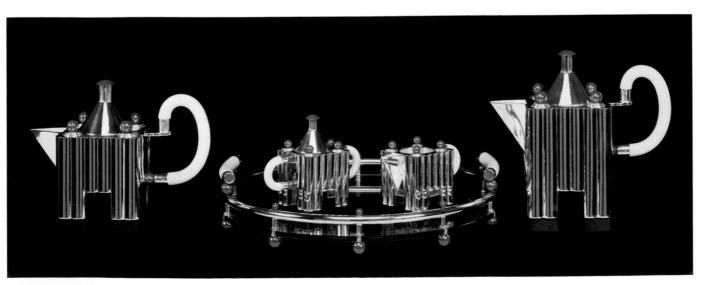

Fig. 23.102. Michael Graves. *Tea and Coffee Piazza*, Alessi SpA, Omegna, Italy, 1983. Silver, Bakelite, mock ivory, glass, lacquered aluminum; coffeepot, H. 9¾ in. (24.8 cm); tray, Diam. 16¼ in. (41.3 cm). Groninger Museum, Netherlands (1989.0106).

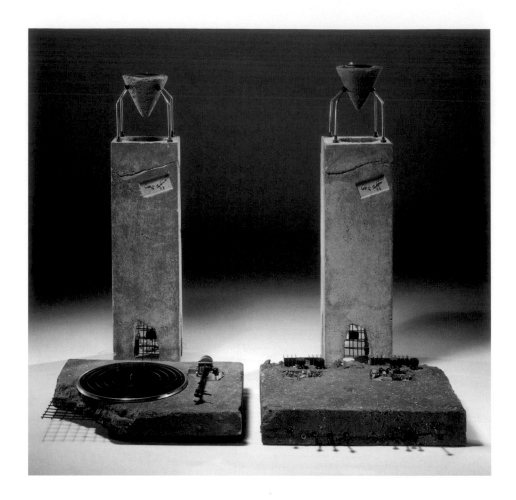

Fig. 23.103. Ron Arad. *Concrete* stereo, One Off, London, 1983. Stereo system set in concrete, plastic, metal; overall, H. 35 in. (89 cm). Victoria and Albert Museum, London (W.7:1-2011).

Many designers capitalized on the trend for limited production pieces as a means of experimenting with expensive materials and "high-tech" production techniques not otherwise available to them. Even more exclusive than the Alessi limited editions were the one-of-a-kind objects by such leading figures as Gaetano Pesce, Ron Arad (b. 1951), Marc Newson (b. 1963), and others who were the subjects of solo exhibitions at fine-art galleries and museums. Objects such as Arad's *Rover* chair (1981), which used a seat from a Rover car bolted to scaffolding pipes, and *Concrete* stereo (1983), which subverted notions of what a stereo should look like (fig. 23.103), were collected by museums and the wealthy design-conscious elite, much like art objects.

When architect Frank Gehry (b. 1929) used shards from a shattered piece of Colorcore plastic laminate to create "scales" for *Fish* lamps (1984), thus highlighting the unique color properties and translucent nature of the material, critics classified him as a Deconstuctivist. He considered the label too grandiose and too suggestive of a predetermined approach to design. Regarded as a trend with distinctly anarchical gestures rather than a movement, Deconstructivism emphasized the decontextualization of an object (signifier) from its original usage or intended meaning (signified) in order to create an entirely new thing (sign), and was associated with a visual vocabulary of spatial fragmentation, structures based on complex geometries that were often digitally modeled and fabricated, and an emphasis on the skin and surface of a building or object. In architecture and design, Deconstructivism was predicated on the literary theory of Deconstruction formulated by French philosopher Jacques

Derrida (1930–2004) in *Of Grammatology* (1967). Derrida's questioning and inversion of hierarchical binaries appealed to architect-designers who rejected the order and rationality of Modernism but eschewed any embrace of historicism and ornament, such as Peter Eisenman (b. 1932), Rem Koolhaas (b. 1944), and Zaha Hadid (b. 1950). An Iraqi-British architect, Hadid created furniture for various manufacturers including the *Z-Scape* line (2000) for Sawaya & Moroni in Italy.

Among the designers who attained celebrity status in the late twentieth and early twenty-first centuries, Philippe Starck (b. 1949) took quite a different approach from others by embracing historicism. The mahogany and leather form of his *Pratfall* lounge chair (1982–85), for example, referenced both French Louis XV and Art Moderne designs. His interest in the sculptural and expressive potential of plastics is more evident in his *Dr. Glob* armchair and *Miss Balu* table (both 1988), while his *Louis Ghost* armchair (2002) is a meld of high-tech and French decorative arts traditions (fig. 23.104). The Neoclassical form of the chair derives from furniture at the court of Louis XVI (r. 1774–92), but instead of carved and gilded wood and rich silk upholstery, Starck used injection-molded polycarbonate in a variety of translucent and opaque colors.

One of the most influential forces in cutting-edge design in the 1990s was the Dutch conceptual group Droog Design (founded 1993). Group member Tejo Remy's (b. 1960) use of "found" or second-hand objects in the creation of new ones is evident in his *Rag* chair (1991), a commentary on consumer culture and waste, which features rags bound together with metal strips. It recast refuse as high culture while encourag-

ing the reuse of everyday things. Similar ideas informed the *You Can't Lay Down Your Memories* chest of drawers (1991), a group of "found" drawers strapped together with a furniture mover's belt. Former Droog designer Marcel Wanders (b. 1963) subverted conventional design processes when creating the molds for his amusing *Egg* vase (1997, developed in a Droog Design project for the Rosenthal ceramics company) by filling condoms with hard-boiled eggs, thus creating forms not usually found in porcelain (fig. 23.105). Following the examples of Michael Graves and others, Wanders entered mass-production projects for low- to middle-priced giftware and home goods, in 2009 for Target and in 2012 for the British High Street store Marks & Spencer. Wanders's emphasis on design as gift-giving recalls ideas articulated by designers such as Eva Zeisel and the Eameses in the 1950s (see above).

FROM ANALOG TO DIGITAL DESIGN

The Postmodern era saw the conversion to digital modes of design and fabrication as well as the advent of new interfaces, both physical and graphic, that aided producers and designers and also made technology accessible to a broad consumer base. Designers and manufacturers embraced a wide range of production methods, including long-established and traditional techniques. Handwork and batch production, traditionally allied with craft and artisanal production, continued alongside and in some instances combined with industrialized, mechanized, and computer-controlled forms of production, such as flexible manufacturing systems (FMS), computer-aided design (CAD), and computer-aided manufacture (CAM). An example of the hybrid approach between craft and CAD-CAM production is Jeroen Verhoeven's (b. 1976) *Cinderella* table (2005–6). It formally and conceptually alluded to the woodworking skills involved in making a Rococo-style commode, but Verhoeven redrew it in a form only conceivable using three-dimensional (3D) modeling software, and manufactured it in digital "slices" of plywood that were then assembled and finished by hand (fig. 23.106). In this and other instances, digitized design files created using drafting and 3D modeling software are sent directly to computer numerical control (CNC) equipment that mechanically "translates" the 3D rendering into a physical object, thus increasing flexibility, variation, customization, and speed in the design and manufacturing processes. The twenty-first century has already seen a proliferation across the globe of digital workshops first conceived in places like the Massachusetts Institute for Technology (MIT) Media Lab (founded 1985) in the United States and equipped with rapid prototypers and 3D printers, CNC milling machines, various kinds of cutters using lasers, plasma, or water, and other digitally driven equipment. These so-called FabLabs offer the potential for localized, mass-customized production. Such innovations will perhaps one day present a real alternative to the extensive distribution networks and economies of scale associated with traditional mass production.

Steve Jobs (1955–2011), cofounder of Apple, understood the essential role of design in making the computer's esoteric technology accessible to and usable by the average consumer.

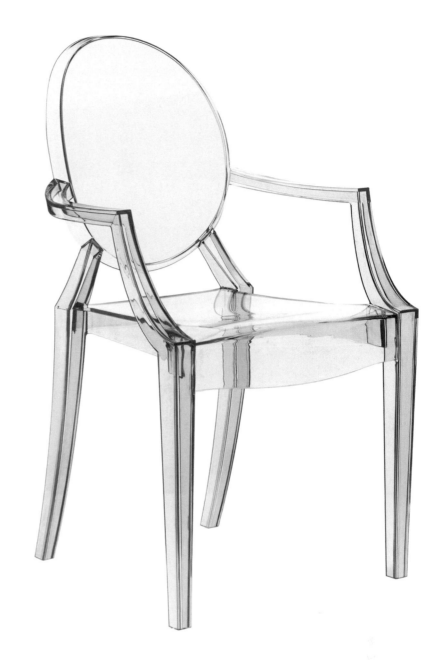

Fig. 23.104. Philippe Starck. *Louis Ghost* armchair, Kartell, Milan, 2007 (designed 2002). Injection-molded polycarbonate; 37 x 21¼ x 21⅝ in. (94 x 54 x 55 cm).

Fig. 23.105. Marcel Wanders for Droog Design. *Egg* vase, Rosenthal AG, Selb, Germany, 1997. Porcelain; H. 6 in. (15.2 cm). Victoria and Albert Museum, London (C.131-2009).

Fig. 23.106. Jeroen Verhoeven. *Cinderella* table, Demakersvan, Rotterdam, 2005. Birch plywood with computer numerically controlled cutting; 31½ x 52 x 40 in. (80 x 132.1 x 101.6 cm). The Museum of Modern Art, New York (564.2006).

A relatively small home computer, the Apple *Macintosh* (1984) incorporated hardware designed by Hartmut Esslinger (b. 1944), founder of Frogdesign, with graphic user interface icons designed by Susan Kare (b. 1954). It came packaged with graphic design programs that brought desktop publishing within the reach of a broader demographic. The Macintosh changed the way large firms designed while decentralizing the production of design by placing it in the hands of anyone with a home computer, blurring distinctions between professional and amateur. The design of the *iMac* computer (1998) visually separated Apple from competitors such as IBM and Dell and encouraged a form of consumer enthusiasm that would become known as a "cult of Mac." The translucent gum-drop or egg-shaped plastic housing, available in various candy-colored hues, was designed by British product designer Jonathan Ive (b. 1967). An admirer of the minimal Modernist designs of Dieter Rams (see fig. 23.74), Ive, in collaboration with the Apple Industrial Design Team, also designed the *iBook* (1999), *iPod* (2001), and *iPhone* (2007).

Digital design was a growth area in the 1980s. Among the earliest to grasp its potential was April Greiman (b. 1948), a United States-based graphic designer well versed in Postmodernism. Her 1986 design for the Walker Art Center's serial publication *Design Quarterly* was a revaluation of digital technology and its underrated role in design practice (fig. 23.107). Her radical design used multiple innovations—including an unorthodox poster-magazine format, synthesis of digitized video, and bitmapped type, and an early use of MacDraw software to clone an image of her left breast to replace her right—all creating a graphic assertion of her multimedia work, and indeed her own body, into the male-dominated design profession. Greiman trained with the Swiss

Fig. 23.107. April Greiman. *Does it make sense?* poster-magazine, published by MIT Press/ Walker Art Center as *Design Quarterly* 133, 1986. Digitized video imagery, bitmapped type; 25⅝ x 76 in. (65 x 193 cm).

graphic designer and typographer Wolfgang Weingart (b. 1941), who had deconstructed what he regarded as overly rigid and formulaic Modernist International Typography (also known as Swiss Typography) and ushered in "New Wave" or "Swiss Punk" typography.

Greiman and Dan Friedman (1945–1995), who also studied under Weingart, took their European digital and Postmodern sensibilities to the United States. With most advances in digital technology emanating from the area around San Jose that came to be known as "Silicon Valley," California became the main hub for digital design. There Rudy VanderLans (b. 1955, Holland) and Zuzana Licko (b. 1961, Slovakia), themselves émigrés, founded the design firm Emigre and distributed digital fonts via *Emigre* magazine (1984–2005), a leading international forum for alternative approaches to design, particularly graphics and typography.

The proliferation of desktop publishing facilitated online forms of decentralized, mass, and niche design. This highly creative, though often technically "untutored," type of design production exploded in the form of websites, blogs, and various linked and networked media after the introduction of the World Wide Web in 1991. MIT's Visible Language Workshop, founded in 1975 by Muriel Cooper (1924–1994), a pioneer in electronic communications, with Ron MacNeil (b. 1941), and later a part of MIT's Media Lab, produced many alumni, including John Maeda (b. 1966) and David Small (b. 1965), who would go on to become innovators of the interactive media, motion graphics, and digital aesthetics that continue to give shape to the Internet.

SOCIALLY RESPONSIBLE, "GREEN," AND SUSTAINABLE DESIGN

During the postwar era, as the numbers and range of manufactured goods increased, some designers and consumers criticized industrial products and processes for perceived social and ecological failures. Some called for more user-centered design, while others pointed to the harmful environmental impact of toxic manufacturing byproducts and nonrecyclable materials. Although these concerns were not synonymous, both evidenced the greater public visibility of design and its positive and negative consequences.

The field of ergonomics, also known as human factors, expanded significantly. This approach to design aimed at enhancing user interactions with objects and environments through close study of human physiology, cognitive abilities, and social behavior. While such considerations predated World War II, the field consolidated during this period, as military personnel, psychologists, engineers, and industrial designers collaborated to improve the design of complex combat vehicles such as tanks and airplane cockpits. Notable nonmilitary applications ranged from telephones to tractors to office chairs, redesigned to increase worker productivity as well as comfort.

In addition, certain demographic groups, such as people with special needs and the elderly, which had been traditionally ignored by the design profession, began to receive greater attention in the 1960s and 1970s. Designers and manufacturers pursued a range of solutions to meet their requirements, some of which were originated by users themselves or their family members. One method was to develop highly specialized products for specific needs. Another, more visible strategy was to create objects of "universal design," usable by a wide range of the population, despite differences in age and ability. This inclusive design approach has been practiced internationally, but Swedish designers were among the pioneers. Maria Benktzon (b. 1946) and Sven-Eric Juhlin (b. 1940), for example, founded a company specializing in this field, Ergonomi Design Gruppen (Ergonomic Design Group, now Ergonomidesign) in 1969. Their products' functional as well as formal qualities helped bring special-needs consumers into the mainstream marketplace (fig. 23.108).

In the United States, SmartDesign was established in 1980 by Dan Formosa (b. 1953), Davin Stowell (b. 1953), Tom Dair (b. 1954), and Tucker Viemeister (b. 1948) with the aim of using design as a tool for greater social equality. They integrated user perception and feedback into the design and prototyping processes, aspiring toward universal design with the belief that developing products for the excluded and marginalized segments of society can also benefit the wider population. Their line of *OXO Good Grip* kitchen tools, with their improved grips and ease of use, demonstrates how designs originally intended for those with limited manual dexterity, such as people living with arthritis, achieved commercial success because they worked well for most consumers.

As public concern grew from the 1970s about the health and environmental repercussions of toxic materials, industrial pollution, and other aspects of modern living, as well as ethical issues related to design practice, manufacturing processes, and limited natural resources, design professionals began to take a greater interest in such matters. Polymath Buckminster Fuller's (1895–1983) *Operating Manual for Spaceship Earth* (1969), which promoted technological utopianism and introduced the concept of the planet as an "integrally-designed machine which to be persistently successful must be comprehended and serviced in total," spawned a new generation of "design outlaws" dedicated to such service.[3] Fuller saw production and consumption as part of a larger, interrelated ecological system, and his long-term interest in alternative social and physical structures for modern living resonated

Fig. 23.108. Ergonomi Design Gruppen (Maria Benktzon and Sven-Eric Juhlin). Knife and cutting board, AB Gustavsberg, Sweden, 1973. Stainless steel, polypropylene, plastic; cutting board, 5¼ x 15¹⁄₁₆ x 5⅜ in. (13.3 x 38.3 x 13.7 cm). The Museum of Modern Art, New York (437.1983.1-2).

with members of the counterculture movement seeking alternative ways of living. His impact is evident in the *Whole Earth Catalog* (1968–72 and intermittently until 1998), compiled by Stewart Brand (b. 1938), which was both a reflection of, and major influence on, the counterculture movement in the 1960s and 1970s, especially in North America. Organized as a clearinghouse of information and products, the catalogue advocated conservation of the environment and self-sustaining, simple living, including non–material-intensive building types, solar energy, and organic food.

Fears about toxic industrial pollution resonated widely in North America and Western Europe. Anxieties about ever-depleting natural resources were further triggered by the 1973 OPEC oil embargo and the 1979 "oil crisis" (as it was known in the West). Grassroots activism in response to these and other concerns gave rise to the Green movement, which sought an ecologically sustainable and socially responsible society. Its beginnings in North America and Europe included the founding of Friends of the Earth in the United States in 1969 (by 1971, there were branches in Sweden, the United Kingdom, and France), the first Earth Day in 1970 (see fig. 23.111), the emergence of Greenpeace in Canada in 1971, and the formation of the Ecology Party in Britain in 1973. The movement takes its name from the German die Grünen (the Greens) Party, which first contested European Union elections in 1979.

One of the most outspoken critics of contemporary Western design and consumption was Austro-American designer Victor Papanek (1927–1998), whose *Design for the Real World: Human Ecology and Social Change* (1971), with an introduction by Fuller, was first published in Swedish in 1970 as *Miljön och miljonerna: design som tjänst eller förtjänst?* (The Environment and the Millions: Design as Service or Profit?). Papanek challenged industrial and advertising practices and the close interconnectedness of design, rapid styling changes, and obsolescence. Castigating designers for playing a role in what he considered unnecessary consumption by the affluent, he urged them to use their talents to create socially and morally responsible products that served humanity and the environment, and to address the needs of the human global community, many members of which lived (and continue to

live) in poverty. Design for Papanek was a cross-disciplinary tool which was responsive to needs and focused on providing useful, low-cost, ecologically sound products. Papanek's radio receiver (1962–67) for the "developing world" would allow isolated communities to communicate cheaply with the outside world while taking into account limited resources, including electricity. His student George Seeger from North Carolina State College, where Papanek was then teaching, worked with him on the electronics. Costing approximately nine cents to produce in small batches, the radio used renewable natural energy sources such as wax and dung, and reused juice cans. Other designs featured in his book included a cooling unit for perishable foods that ran without electricity.

Design for the Real World had a huge impact internationally (it remains one of the most widely read books on design) and had inspired new generations of students to be aware of the environmental and human impact of their choices at every stage of the design and manufacturing process. Today, consideration of these effects—from the extraction of materials to the product's later disposal—on human, plant, and animal populations, and from the preservation of scarce materials to the reduction of greenhouse gases and chlorofluorocarbons, is known as cradle-to-grave analysis, life-cycle assessment, or eco-balance. Many of the projects influenced by such ideas have included international collaborations. A request from field workers in Africa for a solar-powered lantern, for example, prompted the United Kingdom's BP Solar to team with Moggridge Associates (founded by Bill Moggridge [1943–2012] in London in 1969) to design the *SL48* solar lantern (1985; fig. 23.109). The needs of Médecins sans Frontières (Doctors without Borders, founded 1971) resulted in simple, inexpensive equipment for medical triage and intervention, and, in collaboration with local health workers, Architecture for Humanity (founded 1999) created a mobile AIDS clinic for use in rural Africa. A global network of building professionals, Architecture for Humanity, brings design, construction, and development services to communities in need.

With increasing numbers of consumers taking an interest in the preservation of the environment, certain manufacturers changed their policies and products. In 1991, for example,

Fig. 23.109a–b. Hedda Beese with Moggridge Associates. *SL48* portable solar lantern (front and back), BP Solar (British Petroleum Solar), Aylesbury, 1985. Polycarbonate, silicon, stainless steel; 13¾ x 22¼ x 3½ in. (35 x 56.5 x 8.9 cm). The Museum of Modern Art, New York (100.1989).

Herman Miller (which had established an Environmental Quality Action Team in 1989) stopped using rosewood veneers on the Eameses' *Lounge Chair and Ottoman* (1956; see fig. 23.83, right foreground) because the Brazilian trees that supplied them were disappearing, and slash-and-burn methods of clearing tropical rainforests were endangering an entire ecosystem. The new veneers were not so visually striking, but the company held firm and only reintroduced rosewood in 2006 when a sustainable Bolivian species (*Santos Palisander*) harvested from well-managed, certified forests became available. Herman Miller's high-selling *Aeron* office chair (1994), designed by Don Chadwick (b. 1936) and Bill Stumpf (1936–2006), features over 50-percent recycled materials and is 94-percent recyclable.

Eco-labeling schemes and a desire to break into the German market, the most environmentally aware consumer market in Europe, forced the United States-based Hoover Company to invest over 20 million dollars to create its more eco-friendly *New Wave* washing machine (1993). That investment, along with successor products, helped the company double its market share in Germany. At the same time, pressure to end or reduce ozone-damaging coolants prompted German-based Siemens to develop hydrocarbon gas refrigerants for its *Greenfreeze* refrigerator (1993). Zanussi of Italy is another example of a major appliance manufacturer revising its products, in this case washing and dishwashing machines, in order to save water, energy, and detergent while incorporating more recyclable materials in modular, easy-to-disassemble components.

Unnecessary and excessive packaging made from nonrenewable materials like plastics was regularly targeted by reformers from the 1970s. Biodegradable plastics such as Materbí, made of cornstarch, and Biopol, made of fermented sugars, became available in 1990 and are increasingly used for packaging. In 1995, the French multinational corporation Danonere redesigned the plastic water bottles for its popular Evian brand in PET (polyethelene terephthalate), a more chemically inert, UV-unstable, and recyclable plastic than the one previously used (polyvinylchloride), thus achieving a lighter weight, recyclable bottle made of 37 percent less material that can be collapsed to less than one-fifth its size. In 2010, the German-based international footwear and apparel company Puma introduced the *Clever Little Bag* by designer and sustainability advocate Yves Behar (b. 1967) to replace conventional shoeboxes of laminated cardboard, a combination of paper and plastic that cannot be recycled and is resource- and energy-intensive in the manufacturing process (fig. 23.110). The reconceptualization involved turning the box into a cradle of simple cardboard and a recycled plastic bag, thus eliminating laminated cardboard and reducing the cardboard used by 65 percent, and the water, energy, and fuel needed for manufacturing and shipping by about 60 percent.

Like the Evian redesign, the Puma statistics are commendable, as are many ongoing creative efforts to create more ethically and socially responsible and environmentally friendly products. Such efforts, however, are insignificant when weighed against the continued design, production, and consumption of ecologically harmful items, packaging, and processes, to say nothing of those that are damaging to humans in other ways. In the early twenty-first century, climate change and pressing social and environmental issues are leading some designers, together with political and environmental reformers, to conclude, as William Morris and others did more than a century ago, that design alone as currently constituted cannot bring about the types of broad changes necessary to save the planet or to sustain ethically driven production and consumption. The grave prediction conveyed in design terms by Robert Leydenfrost's (1924–1987) poster for the first Earth Day seems all too apt nearly a half-century later (fig. 23.111).

PAT KIRKHAM, CHRISTIAN A. LARSEN, SARAH A. LICHTMAN, TOM TREDWAY, AND CATHERINE L. WHALEN

Fig. 23.110. Yves Behar. *Clever Little Bag* shoe packaging for Puma, Germany, 2010. Polypropylene with 10% recycled content, recycled cardboard; without handle, 14 x 7¼ x 4 in. (36 x 18 x 10 cm).

Fig. 23.111. Robert Leydenfrost. Earth Day poster, issued by the United States Environmental Protection Agency, 1970. Photograph by Donald Brewster. Offset lithograph; 25¼ x 19⅜ in. (64.1 x 49.2 cm). Victoria and Albert Museum, London (E.329-2004).

Fig. 23.40

RESOURCES

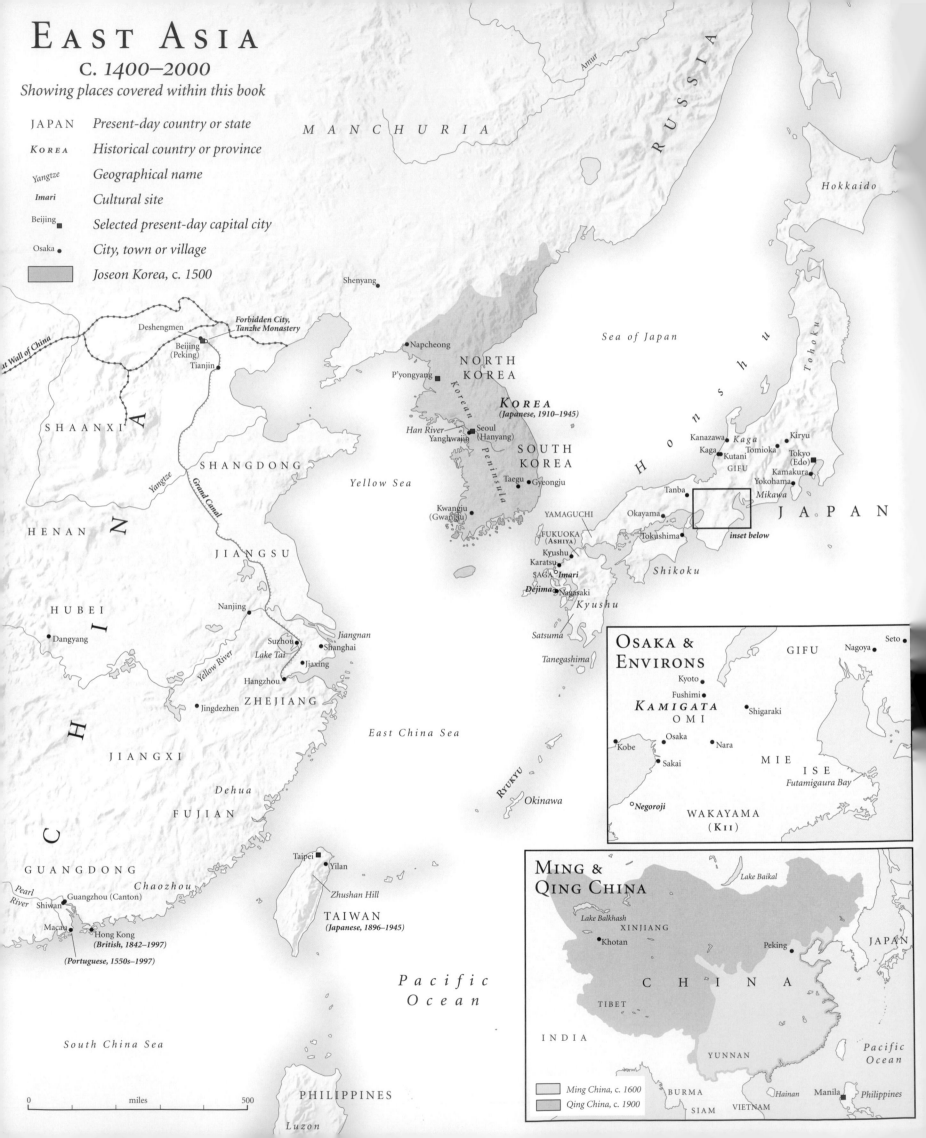

EAST ASIA
C. 1400–2000
Showing places covered within this book

JAPAN Present-day country or state

KOREA Historical country or province

Yangtze Geographical name

Imari Cultural site

Beijing ■ Selected present-day capital city

Osaka • City, town or village

 Joseon Korea, c. 1500

MANCHURIA

RUSSIA

Amur

Hokkaido

Shenyang

Great Wall of China

Deshengmen

Forbidden City, Tanzhe Monastery

Beijing (Peking) ■

Tianjin

SHAANXI

Yangtze

SHANGDONG

Grand Canal

HENAN

Napcheong

NORTH KOREA

P'yongyang ■

Korean Peninsula

KOREA (Japanese, 1910–1945)

Han River

Seoul (Hanyang) ■

Yanghwajin

SOUTH KOREA

Taegu

Gyeongju

Yellow Sea

Sea of Japan

Kanazawa

Kaga

Kaga

Kutani

Tomioka

Kiryu

Tokyo (Edo) ■

GIFU

Kamakura

Yokohama

Mikawa

H o n s h u

T o h o k u

Tanba

Okayama

Tokushima

inset below

JAPAN

Shikoku

Kwangju (Gwangju)

YAMAGUCHI

FUKUOKA (ASHIYA)

Kyushu

Karatsu

SAGA *Imari*

Dejima Nagasaki

Kyushu

Satsuma

Tanegashima

CHINA

JIANGSU

HUBEI

Dangyang

Nanjing

Yellow River

Suzhou *Jiangnan*

Lake Tai Shanghai

Jiaxing

Hangzhou

ZHEJIANG

Jingdezhen

JIANGXI

Dehua

FUJIAN

East China Sea

Ryukyu

Okinawa

GUANGDONG

Chaozhou

Pearl River

Guangzhou (Canton)

Shiwan

Macau

Hong Kong
(British, 1842–1997)

(Portuguese, 1550s–1997)

Taipei ■
Yilan

Zhushan Hill

TAIWAN
(Japanese, 1896–1945)

Pacific Ocean

South China Sea

PHILIPPINES

Luzon

0 miles 500

OSAKA & ENVIRONS

GIFU

Seto

Nagoya

Kyoto

Fushimi

Shigaraki

KAMIGATA

OMI

Kobe

Osaka

Nara

Sakai

MIE

ISE

Futamigaura Bay

Negoroji

WAKAYAMA
(KII)

MING & QING CHINA

Lake Baikal

Lake Balkhash

XINJIANG

Khotan

Peking •

JAPAN

CHINA

TIBET

INDIA

YUNNAN

BURMA

SIAM

VIETNAM

Hainan

Manila ■

Philippines

Pacific Ocean

 Ming China, c. 1600

 Qing China, c. 1900

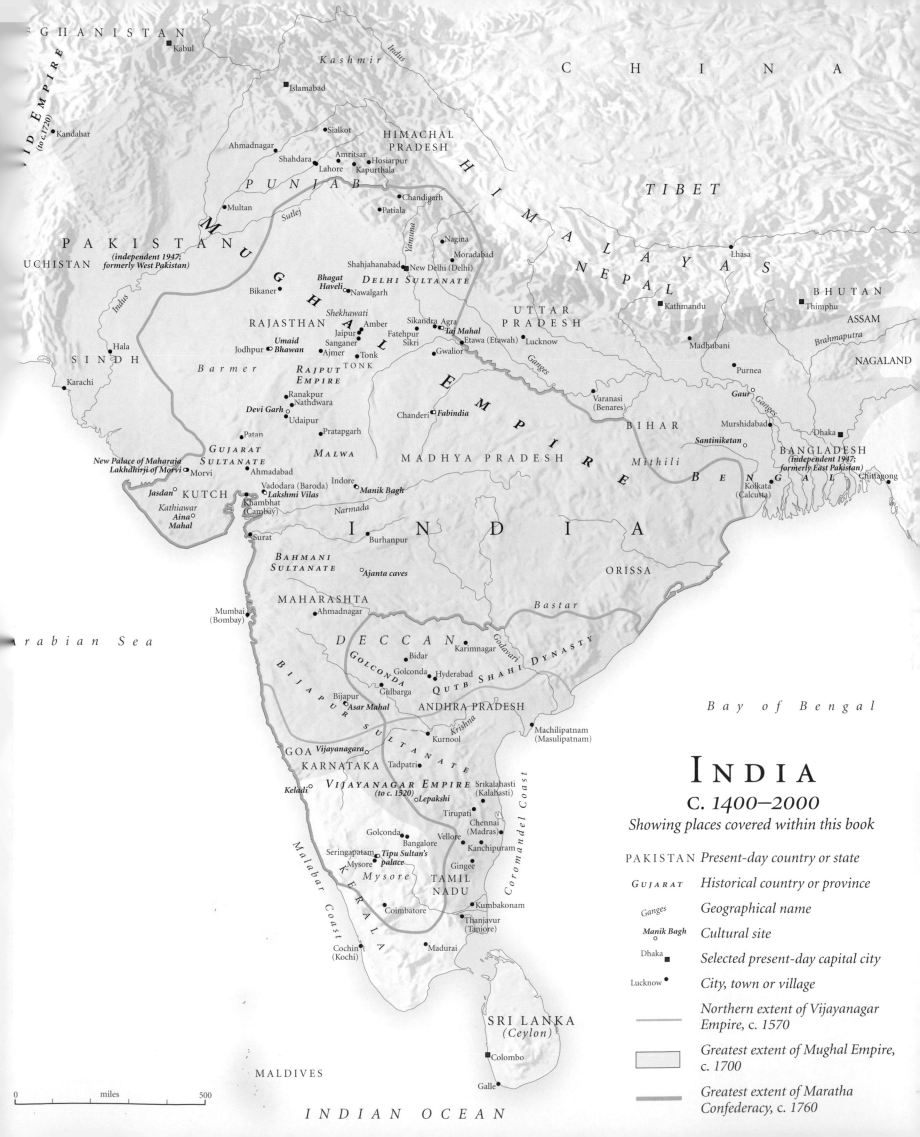

AFGHANISTAN

Kabul

Kashmir

Indus

C H I N A

Islamabad

Kandahar

(to c.1720)

Sialkot

HIMACHAL
PRADESH

T I B E T

Ahmadnagar

Amritsar Hosiarpur

Shahdara Kapurthala

Lahore

P U N J A B

Chandigarh

Patiala

Sutlej

Multan

Indus

U C H I S T A N

*(independent 1947;
formerly West Pakistan)*

P A K I S T A N

Nagina

Moradabad

Shahjahanabad New Delhi (Delhi)

*Bhagat
Haveli*

Bikaner Nawalgarh

DELHI SULTANATE

Shekhawati

RAJASTHAN

Amber Sikandra Agra

Jaipur *Taj Mahal*

Sanganer Fatehpur Etawa (Etawah)

Ajmer Sikri

Tonk

Gwalior

*Umaid
Bhawan*

Jodhpur

Barmer

*RAJPUT
EMPIRE*

TONK

B a r m e r

Ranakpur
Nathdwara

Devi Garh

Udaipur

Chanderi *Fabindia*

Pratapgarh

Patan

M a l w a

M A D H Y A P R A D E S H

*GUJARAT
SULTANATE*

*New Palace of Maharaja
Lakhdhirji of Morvi*

Morvi

Jasdan KUTCH

Vadodara (Baroda)

Lakshmi Vilas

Khambhat
(Cambay)

Ahmadabad

Indore *Manik Bagh*

*Kathiawar
Aina
Mahal*

Narmada

I N D I A

Surat

Burhanpur

*BAHMANI
SULTANATE*

Ajanta caves

O R I S S A

MAHARASHTA

Mumbai
(Bombay)

Ahmadnagar

Bastar

Godavari

D E C C A N

Karimnagar

GOLCONDA

Bidar

Golconda Hyderabad

QUTB SHAHI DYNASTY

Bijapur Gulbarga

Asar Mahal

ANDHRA PRADESH

Krishna

Kurnool

Machilipatnam
(Masulipatnam)

GOA *Vijayanagara*

KARNATAKA

Tadpatri

VIJAYANAGAR EMPIRE
(to c. 1520)

Srikalahasti
(Kalahasti)

Keladi

Lepakshi

Tirupati

Golconda

Bangalore

Seringapatam *Tipu Sultan's
palace*

Mysore

Mysore

Chennai
(Madras)

Vellore

Kanchipuram

Gingee

TAMIL
NADU

Coimbatore

Kumbakonam

Thanjavur
(Tanjore)

Cochin
(Kochi)

Madurai

SRI LANKA
(Ceylon)

Colombo

MALDIVES

Galle

A r a b i a n S e a

I N D I A N O C E A N

0 ——— miles ——— 500

Kashmir
Kathmandu

NEPAL

H I M A L A Y A S

BHUTAN

Thimphu

ASSAM

Brahmaputra

NAGALAND

Lucknow

UTTAR
PRADESH

Ganges

Madhubani

Purnea

Lhasa

Varanasi
(Benares)

B I H A R

Gaur *Ganges*

Murshidabad

Santiniketan Dhaka

Mithili

B E N G A L

BANGLADESH
*(independent 1947;
formerly East Pakistan)*

Kolkata
(Calcutta)

Chittagong

Bay of Bengal

Malabar Coast

Coromandel Coast

KERALA

I N D I A

INDIA

C. 1400–2000

Showing places covered within this book

PAKISTAN *Present-day country or state*

GUJARAT Historical country or province

Ganges Geographical name

Manik Bagh ○ Cultural site

Dhaka ■ Selected present-day capital city

Lucknow • City, town or village

—— *Northern extent of Vijayanagar
Empire, c. 1570*

☐ *Greatest extent of Mughal Empire,
c. 1700*

—— *Greatest extent of Maratha
Confederacy, c. 1760*

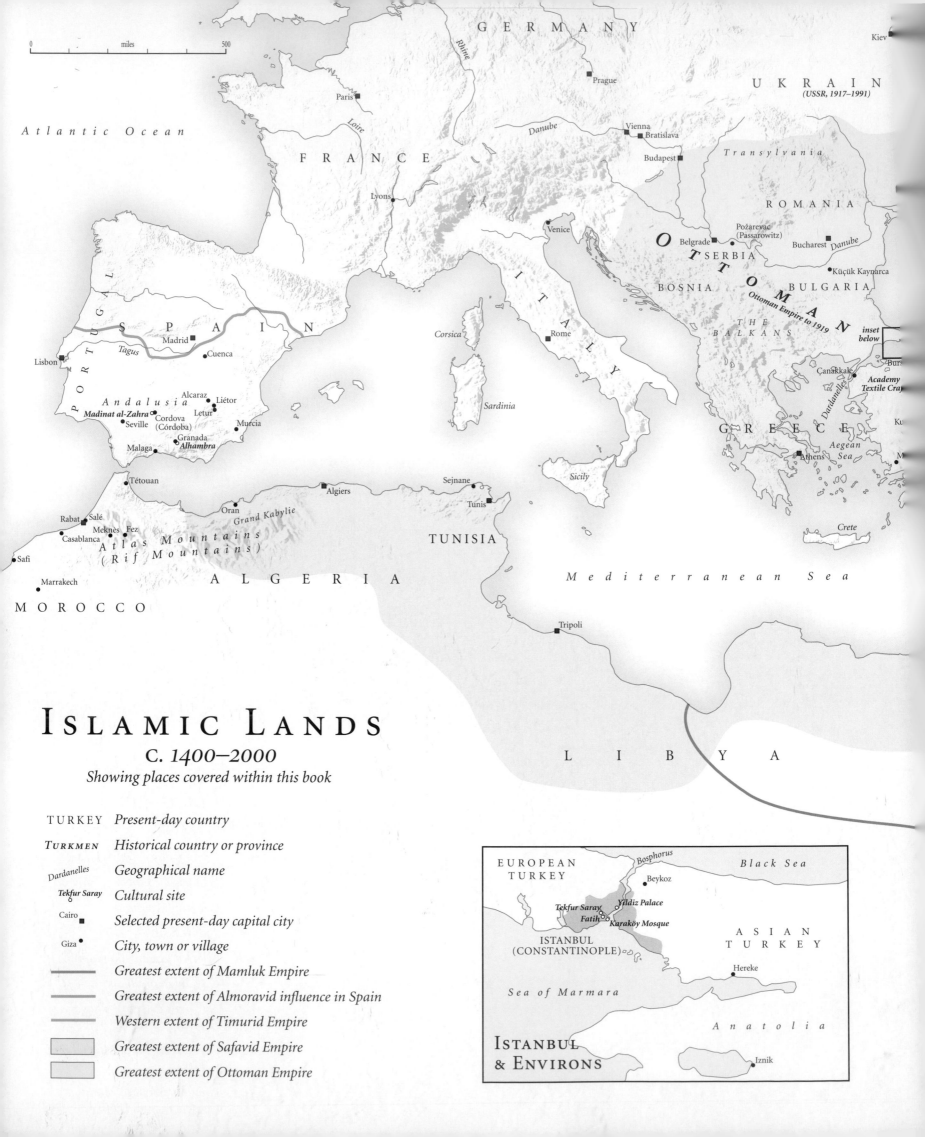

Atlantic Ocean

GERMANY

Rhine

Prague

Paris

Loire

Danube

Vienna
Bratislava

Budapest

UKRAIN
(USSR, 1917–1991)

Kiev

FRANCE

Transylvania

Lyons

ROMANIA

Venice

Belgrade

Požarevac
(Passarowitz)

Bucharest

Danube

Küçük Kaynarca

PORTUGAL

S P A I N

Madrid

Cuenca

Tagus

Corsica

Rome

SERBIA

BOSNIA

BULGARIA

Ottoman Empire to 1919

inset
below

O
T
T
O
M
A
N

THE
BALKANS

Lisbon

Andalusia

Alcaraz
Liétor

Madinat al-Zahra

Letur

Cordova
(Córdoba)

Seville

Murcia

Granada

Alhambra

Malaga

Tétouan

ITALY

Sardinia

Sicily

Çanakkale

Burs

Dardanelles

Academy
Textile Cra

GREECE

Kü

Aegean
Sea

Athens

M

Algiers

Sejnane

Oran

Grand Kabylie

Tunis

Crete

Rabat
Salé

Meknès Fez

Casablanca

Atlas Mountains
(Rif Mountains)

Safi

TUNISIA

Mediterranean Sea

Marrakech

A L G E R I A

MOROCCO

Tripoli

L I B Y A

ISLAMIC LANDS

C. 1400–2000

Showing places covered within this book

EUROPEAN
TURKEY

Bosphorus

Black Sea

Beykoz

Tekfur Saray

Yıldız Palace

Fatih

Karaköy Mosque

ISTANBUL
(CONSTANTINOPLE)

A S I A N
T U R K E Y

Hereke

Sea of Marmara

Anatolia

ISTANBUL
& ENVIRONS

Iznik

miles
0 500

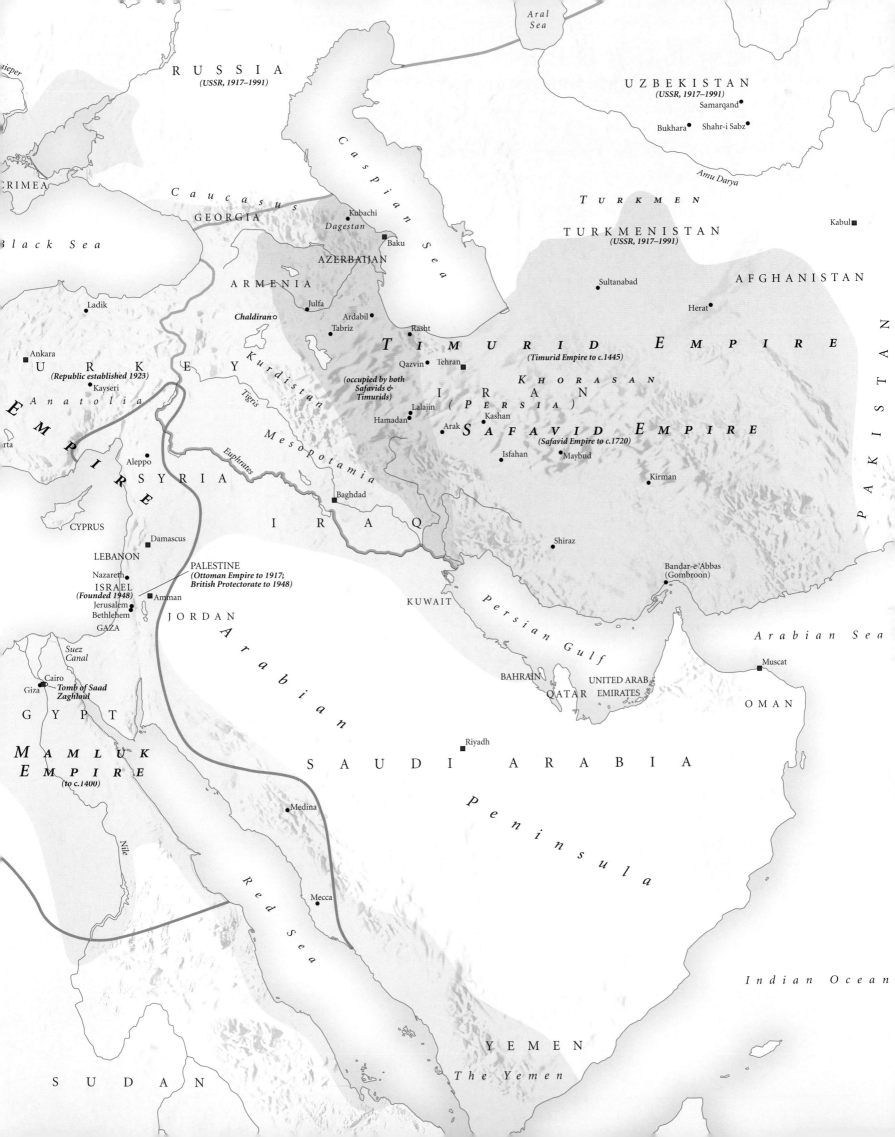

Aral Sea

RUSSIA
(USSR, 1917–1991)

UZBEKISTAN
(USSR, 1917–1991)

Samarqand

Bukhara Shahr-i Sabz

Amu Darya

CRIMEA

Black Sea

Caucasus

GEORGIA

Dagestan

Kubachi

Baku

AZERBAIJAN

ARMENIA

T U R K M E N

TURKMENISTAN
(USSR, 1917–1991)

Kabul

Julfa

Chaldiran ○

Tabriz

Ardabil

Rasht

Ladik

Ankara
(Republic established 1923)

U R K *E* *Y*

Kayseri

Anatolia

Kurdistan

Tigris

Qazvin Tehran

*(occupied by both
Safavids &
Timurids)*

Sultanabad

AFGHANISTAN

Herat

T I M U R I D E M P I R E
(Timurid Empire to c.1445)

K H O R A S A N

I R A N
(P E R S I A)

Lalajin

Hamadan

Kashan

Arak

S A F A V I D E M P I R E
(Safavid Empire to c.1720)

PAKISTAN

Mesopotamia

Euphrates

Aleppo

E M P I R E

SYRIA

CYPRUS

Damascus

LEBANON

Nazareth

ISRAEL
(Founded 1948)

Jerusalem
Bethlehem

GAZA

PALESTINE
*(Ottoman Empire to 1917;
British Protectorate to 1948)*

Amman

JORDAN

A r a b i a n

Isfahan

Maybud

Kirman

Baghdad

I R A Q

KUWAIT

P e r s i a n G u l f

Shiraz

Bandar-e 'Abbas
(Gombroon)

Arabian Sea

BAHRAIN

QATAR

UNITED ARAB
EMIRATES

Muscat

OMAN

*Suez
Canal*

Cairo
Giza *Tomb of Saad
Zaghloul*

G Y P T

*M A M L U K
E M P I R E*
(to c.1400)

Nile

Riyadh

S A U D I A R A B I A

P e n i n s u l a

Medina

R e d S e a

Mecca

Indian Ocean

S U D A N

Y E M E N

The Yemen

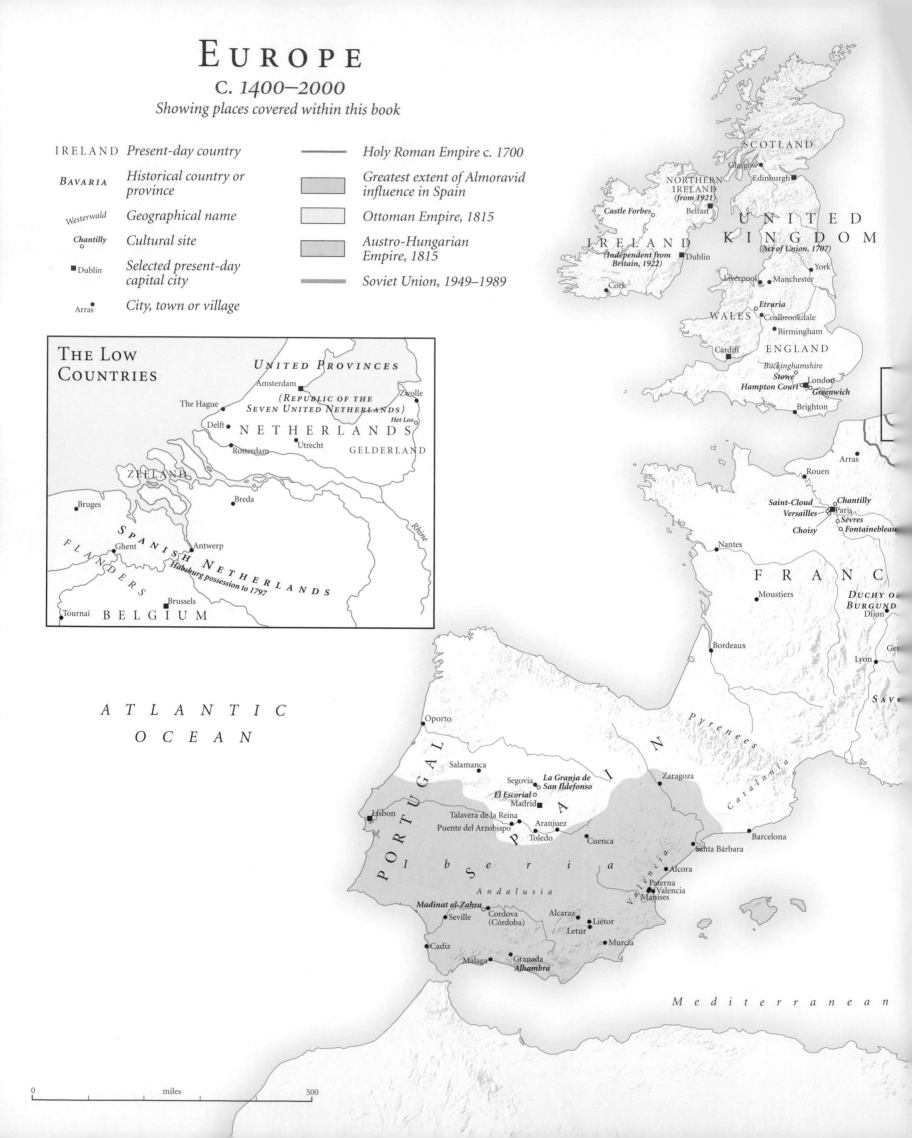

EUROPE
C. 1400–2000
Showing places covered within this book

IRELAND Present-day country

Bavaria Historical country or province

Westerwald Geographical name

Chantilly ○ Cultural site

■ Dublin Selected present-day capital city

Arras ● City, town or village

——— Holy Roman Empire c. 1700

Greatest extent of Almoravid influence in Spain

Ottoman Empire, 1815

Austro-Hungarian Empire, 1815

Soviet Union, 1949–1989

THE LOW COUNTRIES

UNITED PROVINCES
(REPUBLIC OF THE SEVEN UNITED NETHERLANDS)

Amsterdam ■
Zwolle
The Hague ●
Het Loo ○
Delft ●
NETHERLANDS
Utrecht ●
Rotterdam ●
GELDERLAND
Bruges ●
Breda ●
Rhine
ZEELAND
SPANISH NETHERLANDS
Ghent ●
Antwerp ●
FLANDERS
Habsburg possession to 1797
Tournai ●
Brussels ■
BELGIUM

SCOTLAND
Glasgow ●
Edinburgh ■
NORTHERN IRELAND (from 1921)
Castle Forbes
Belfast ●
UNITED KINGDOM
IRELAND (Independent from Britain, 1922)
Dublin ■
WALES (Act of Union, 1707)
Liverpool ●
Manchester ●
York ●
Etruria
Coalbrookdale ●
Birmingham ●
Cardiff ●
ENGLAND
Buckinghamshire
Stowe ○
Hampton Court ○
London ■
Greenwich
Cork ●
Brighton ●

ATLANTIC OCEAN

Arras ●
Rouen ●
Saint-Cloud
Chantilly ○
Paris ◇
Versailles ◇
Sèvres
Choisy
Fontainebleau
Nantes ●
FRANCE
Moustiers ●
DUCHY OF BURGUNDY
Dijon ●
Bordeaux ●
Lyon ●
Savoy

Oporto ●
Salamanca ●
Segovia ●
La Granja de San Ildefonso
El Escorial ○
Madrid ■
Zaragoza ●
Catalonia
Pyrenees
PORTUGAL
Lisbon ■
Talavera de la Reina ●
Puente del Arzobispo ●
Toledo ●
Aranjuez ●
Cuenca ●
SPAIN
Iberia
Barcelona ●
Santa Bárbara ●
Alcora ●
Paterna ●
Valencia ●
Valencia
Manises ●
Andalusia
Madinat al-Zahra ○
Cordova (Córdoba) ●
Alcaraz ●
Liétor ●
Letur ●
Murcia ●
Seville ●
Cadiz ●
Malaga ●
Granada ●
Alhambra

Mediterranean

0 miles 500

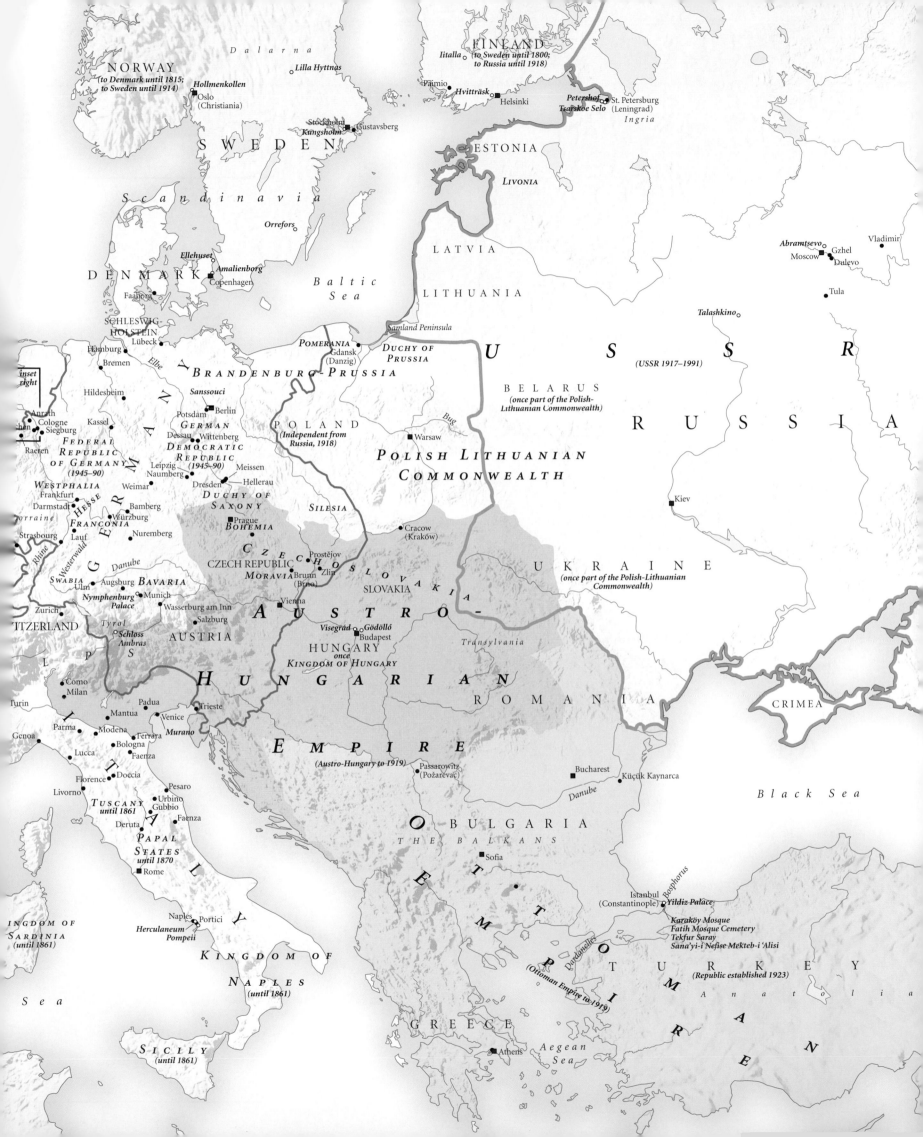

NORWAY
*(to Denmark until 1815;
to Sweden until 1914)*
Hollmenkollen
Oslo
(Christiania)

Dalarna

• *Lilla Hyttnas*

FINLAND
Iitalla *(to Sweden until 1800;
to Russia until 1918)*

Paimio
• **Hvitträsk**
Helsinki

Petershof ■ St. Petersburg
Tsarskoe Selo (Leningrad)

Ingria

S W E D E N

Stockholm
Kungsholm ■ • Gustavsberg

ESTONIA

LIVONIA

Abramtsevo ○ Gzhel
Moscow ■ •○
Dulevo

• Vladimir

S c a n d i n a v i a

LATVIA

• Tula

• *Orrefors*

LITHUANIA

Talashkino

Ellehuset
• **Amalienborg**
Copenhagen

*Baltic
Sea*

U S S R

DENMARK

• Faaborg

Samland Peninsula

POMERANIA
Gdansk
(Danzig)

DUCHY OF
PRUSSIA

(USSR 1917–1991)

SCHLESWIG-
HOLSTEIN
• Lübeck

Elbe

BRANDENBURG-PRUSSIA

BELARUS
*(once part of the Polish-
Lithuanian Commonwealth)*

R U S S I A

• Hamburg

• Bremen

Sanssouci

• Hildesheim

Potsdam • Berlin
GERMAN
Dessau • Wittenberg
DEMOCRATIC
Leipzig • **REPUBLIC**
Naumberg *(1945–90)*
• Meissen
Dresden • Hellerau

POLAND
*(Independent from
Russia, 1918)*

Bug

• Warsaw

POLISH LITHUANIAN
COMMONWEALTH

*inset
right*

Anrath
…hen ○ • Cologne
Siegburg

FEDERAL
REPUBLIC
OF GERMANY
(1945–90)

Raeren ○

WESTPHALIA
Frankfurt • Weimar
• Darmstadt
HESSE
FRANCONIA • Bamberg
• Würzburg

*DUCHY OF
SAXONY*
• Prague
BOHEMIA

SILESIA

• Cracow
(Kraków)

orraine
• Strasbourg

• Nuremberg

Rhine • Lauf *Westerwald*

CZECH REPUBLIC
C z e c h o • Prostějov
MORAVIA Brunn
(Brno) • Zlín

• Kiev

• Darmstadt

Danube

SLOVAKIA

UKRAINE
*(once part of the Polish-Lithuanian
Commonwealth)*

SWABIA
• Augsburg
• Ulm

BAVARIA

*Nymphenburg
Palace* • Munich
SWITZERLAND
• Zurich

• Wasserburg am Inn

A U S T R O -

• Vienna ■

Tyrol

*Schloss
Ambras*

• Salzburg

AUSTRIA

Visegrád ○ ● Gödöllő
Budapest ■

HUNGARY
*once
Kingdom of Hungary*

Transylvania

A L P S

• Como
• Milan

• Padua

H U N G A R I A N

R O M A N I A

CRIMEA

Turin •

• Mantua
Venice •
Murano

• Trieste

• Parma

• Modena
• Bologna
• Ferrara
• Faenza

• Lucca

E M P I R E
(Austro-Hungary to 1919)

Genoa •

I
T
A
L
Y

• Florence • Doccia

• Livorno

*TUSCANY
until 1861*

• Pesaro

• Passarowitz
(*Požarevać*)

• Bucharest

Danube

• Küçük Kaynarca

Black Sea

• Urbino
○ Gubbio

• Faenza

O

BULGARIA

• Deruta

*PAPAL
STATES
until 1870*

• Rome

THE BALKANS

T

• Sofia

• Naples • Portici

*Herculaneum
Pompeii*

KINGDOM OF

Sea

*NAPLES
(until 1861)*

SICILY
(until 1861)

T

• Istanbul
(Constantinople) *Bosphorus*
○ **Yildiz Palace**

M *Karaköy Mosque
Fatih Mosque Cemetery
Tekfur Saray
Sana'yi-i Nefise Mekteb-i 'Alisi*

O

A

Dardanelles

(Ottoman Empire to 1919)

T U R K E Y
(Republic established 1923)

N

Anatolia

G R E E C E

• Athens

*Aegean
Sea*

E

*KINGDOM OF
SARDINIA
(until 1861)*

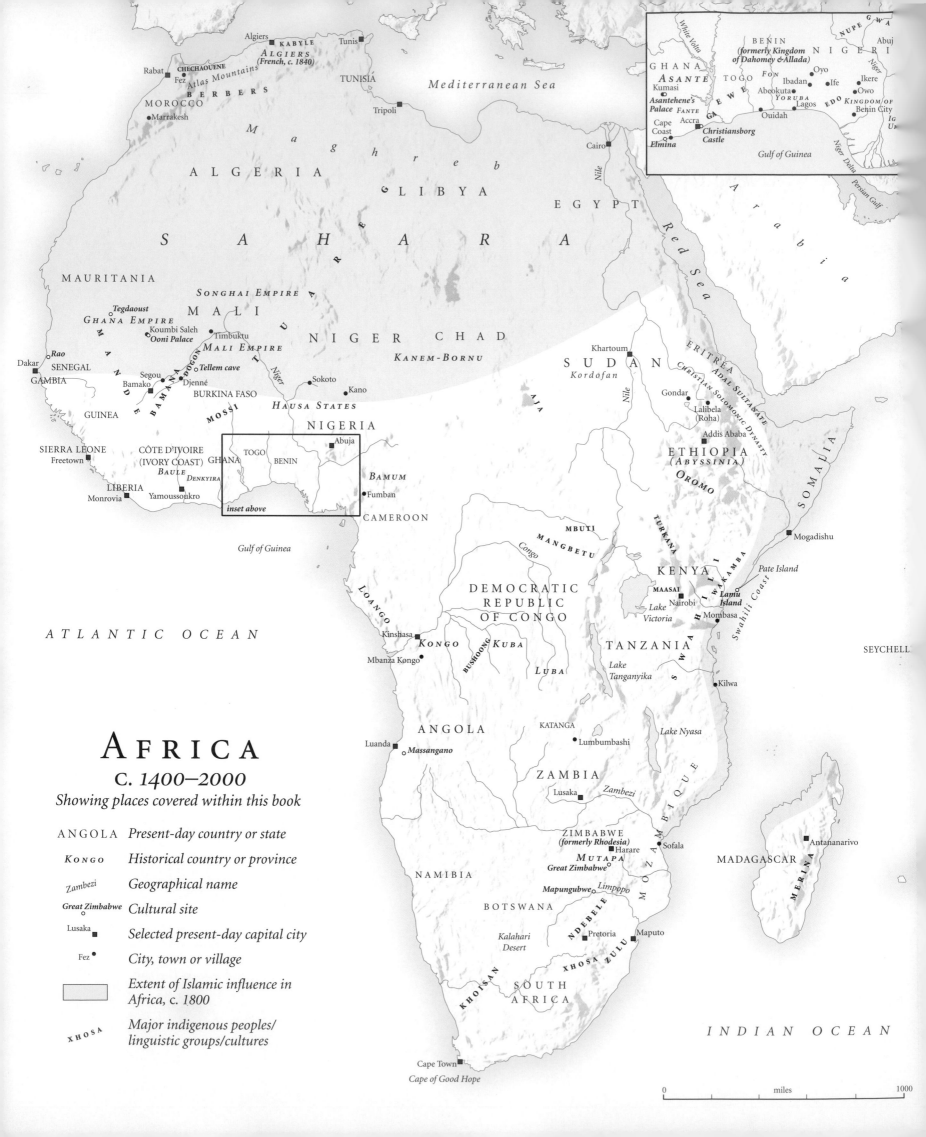

Algiers
KABYLE Tunis
ALGIERS
(French, c. 1840)
CHECHAOUENE
Rabat
Fez Atlas Mountains
MOROCCO **B E R B E R S**
• Marrakesh

M a g h r e b

Mediterranean Sea

Tripoli Cairo

A L G E R I A L I B Y A E G Y P T

S A H A R A

Nile

MAURITANIA

Songhai Empire
Tegdaoust
Ghana Empire
Koumbi Saleh • Timbuktu
Ooni Palace
M A L I N I G E R C H A D
Mali Empire *Kanem-Bornu*

Rao • *Rao*
Dakar • SENEGAL
GAMBIA
Segou *Tellem cave*
Bamako • Djenné
B A M A N A
BURKINA FASO
GUINEA **M O S S I**
HAUSA STATES
Sokoto •
Kano •

SIERRA LEONE
Freetown •
CÔTE D'IVOIRE
(IVORY COAST)
GHANA TOGO
Baule BENIN
LIBERIA *Denkyira*
Monrovia • Yamoussoukro •
inset above

N I G E R I A
Abuja •
Bamum
Fumban •
C A M E R O O N

Gulf of Guinea

L O A N G O

D E M O C R A T I C
R E P U B L I C
O F C O N G O

M B U T I
M A N G B E T U

Congo

K H A R T O U M •
Kordofan
S U D A N

A J A

Nile

E R I T R E A
A D A L S U L T A N A T E
Gondar •
C H R I S T I A N S O L O M O N I C D Y N A S T Y
Lalibela •
(Roha)
Addis Ababa •
E T H I O P I A
(A B Y S S I N I A)
O R O M O

S O M A L I A

Mogadishu •

A T L A N T I C O C E A N

Kinshasa •
K O N G O
Mbanza Kongo •
B U S H O O N G **K U B A**
L U B A

T A N Z A N I A

K E N Y A
M A A S A I
Nairobi •
Lake Victoria
W A K A M B A
Lamu Island
Mombasa •
S W A H I L I
Swahili Coast
Pate Island

Kilwa •

Lake Tanganyika

SEYCHELL

Lake Nyasa

A N G O L A
Luanda • *Massangano*
KATANGA
Lumbumbashi •

Z A M B I A
Lusaka • *Zambezi*

M O Z A M B I Q U E

ZIMBABWE
(formerly Rhodesia)
Harare •
Mutapa
Great Zimbabwe
Sofala •

Mapungubwe *Limpopo*
N A M I B I A
N D E B E L E

B O T S W A N A
Kalahari Desert
Pretoria •
Z U L U
Maputo •

K H O I S A N
X H O S A
S O U T H
A F R I C A

MADAGASCAR

• Antananarivo

M E R I N A

Cape Town •
Cape of Good Hope

I N D I A N O C E A N

A F R I C A

C. 1400–2000

Showing places covered within this book

ANGOLA *Present-day country or state*

KONGO *Historical country or province*

Zambezi *Geographical name*

Great Zimbabwe *Cultural site*

Lusaka ■ *Selected present-day capital city*

Fez • *City, town or village*

▭ *Extent of Islamic influence in Africa, c. 1800*

XHOSA *Major indigenous peoples/ linguistic groups/cultures*

0 miles 1000

Inset:

W H I T E V O L T A
White Volta
N U P E **G W A**
B E N I N
(formerly Kingdom of Dahomey & Allada)
N I G E R I A
Abuja •
G H A N A
Asante
Kumasi •
Asantehene's Palace *Fante*
T O G O **G A**
E W E
Fon
Oyo •
Abeokuta •
Ibadan • Ife •
Yoruba
Ikere •
Owo •
E D O
Lagos • *Kingdom of Benin City* •
Ouidah •
Cape Coast
Accra •
Christiansborg Castle
Elmina
Gulf of Guinea
Niger Delta
Niger
Ig
U

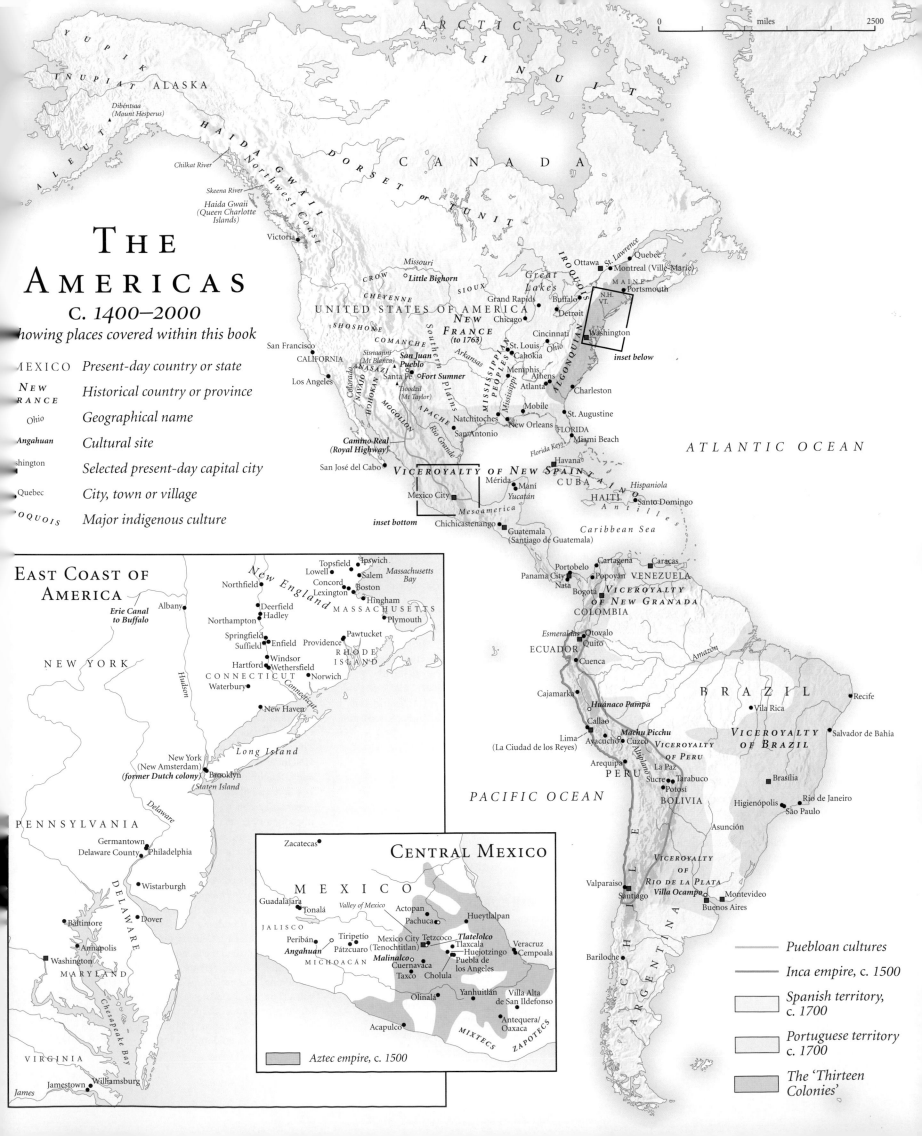

QUOTATION SOURCES

1400–1600

CHAPTER 2: INDIA

1. Gaspar Corrêa, *The Three Voyages of Vasco da Gama. . .* , trans. Henry E. J. Stanley, Hakluyt Society, 1st ser., no. 42 (1869; facsimile reprint, New York: B. Franklin, 1963), p. 306; cited in Donald F. Lach, *Asia in the Making of Europe*, vol. 2: *A Century of Wonder*, bk. 1 (Chicago: University of Chicago Press, 1965), p. 10 n. 12.

CHAPTER 4: AFRICA

1. Ibn Khaldun, *Histoire des Berberes*, trans. Baron de Slabe (Paris: Paul Geuthner, 1927), vol. 2, p. 113, quoting Abu Abdullah al Koumi. Quoted in Labelle Prussin, *Hatumere: Islamic Design in West Africa* (Los Angeles: University of California Press, 1986), p. 120.
2. Ibn Batouteh, *Voyages*, trans. C. Defrémery and B. R. Sanguinetti (Paris: Imprimerie Nationale, 1874–79), vol. 4, pp. 413–14. Quoted in Prussin, *Hatumere*, p. 120.
3. Valentim Fernandes, *Description de la Côte Occidentale d'Afrique, (Sénégal du Cap de Monte Archipels)*, ed. Théodore Monod, Avelino Teixeira da Mota, and Raymond Mauny (Bissau, 1951), cited in Ezio Bassani and William B. Fagg, *Africa and the Renaissance: Art in Ivory* (New York: The Center for African Art; Munich: Prestel-Verlag, 1988), p. 111.
4. W. M. Conway, trans., *The Writings of Albrecht Dürer* (London, 1911), cited in Donald F. Lach, *Asia in the Making of Europe*, vol. 2, *A Century of Wonder*, book 1, *The Visual Arts* (Chicago: University of Chicago Press, 1970/1994), p. 17.

CHAPTER 5: EUROPE

1. Felix Fabri [Faber], *Wanderings in the Holy Land*, ed. Aubrey Stewart, 2 vols. (London: Palestine Pilgrims Text Society, 1892–93), vol. 1, predicatory epistle, p. 2.
2. Sabba da Castiglioni, *Ricordi* (Venice, 1534), p. 119v, quoted in Maria Ruvoldt, "Sacred to Secular, East to West: The Renaissance Study and Strategies of Display," *Renaissance Studies* 20 (2006): 640–57.
3. Heinrich Vogtherr the Elder, *Ein Frembds und wunderbars Kunstbüchlin allen Molern, Bildschnitzern, Goldschmiden, Steinmetzen, Schreinern, Patnern, Waffen unn Messerschmiden hochnutzlich zu gebrauchen* (Strasbourg: Heinrich Vogtherr, 1538), preface.
4. Samuel Quiccheberg, "Inscriptiones vel Tituli Theatri Amplissimi," 1565. See Lorenz Seelig, "The Munich Kunstkammer, 1565–1807," in Oliver Impey and Arthur MacGregor, eds., *The Origin of Museums: The Cabinet of Curiosities in Sixteenth- and Seventeenth-Century Europe* (Oxford: Clarendon Press; New York: Oxford University, 1985/2001), p. 101.

CHAPTER 6: THE AMERICAS
INDIGENOUS AMERICA: SOUTH

1. Bernardino de Sahagún, *Historia general de las cosas de nueva España* (General history of the things of New Spain), 2nd ed., 2 vols., ed. Alfredo López Austin and Josefina Gardia Quintana (Mexico City: Consejo Nacional para la Cultura y las Artes y Editorial Patria, 1989), 2:582. Author's translation.

SPANISH AND PORTUGUESE AMERICA

1. Baltasar Gracián, *El Criticón* (Zaragoza: por Juan Nogues, 1651), part 1, para. 1: "Sirve, pues, la isla de Santa Elena (en la escala de un mundo al otro) de descanso a la portátil Europa" Reprinted as Baltasar Gracián, *El Criticón*, edited by Evaristo Correa Calderón, 3 vols. (Madrid: Espasa-Calpe, 1971).
2. Gonzalo Fernández de Oviedo, *Historia Natural y General de las Indias*, ed. José Amador de los Rios, part 1 (Madrid: Real Accademia de la Historia, 1851), pp. 340–41 (book 9, chaps. 8, 9).
3. *Memoriales de Fray Toribio de* [Benavente] *Motolinia*, ed. Luis García Pimentel (Mexico: En casa del editor, 1903), p. 91.
4. *Documentos inéditos relativos a Hernán Cortés y su familia*, Publicaciones del Archivo General de la Nación, vol. 27 (Mexico: Talleres gráficos de la nación, 1935), p. 249.
5. *Historia eclesiástica indiana* (1596; reprint, Mexico City: Antigua Libreria, 1870), book 4, chap. 17, p. 422. Author's translation.
6. Quoted in Heinrich Berlin, "The High Altar of Huejotzingo," *The Americas* 15 (July 1958): 63–73.
7. Fernando de Montesinos (d. 1652?), *Anales del Peru*, published by Victor M. Maurtua, vol. 2 (Madrid: Imp. de Gabriel L. y del Horno, 1906), p. 51. Author's translation.

1600–1750

CHAPTER 8: ASIA
CHINA

1. *The Reminiscences of Tung Hsiao-wan*, transl. Pan Tze-yen (Shanghai: The Commercial Press, 1931), pp. 52–53.

CHAPTER 11: EUROPE

1. "sentirono una gran fragranza et odore grandissimo." Biblioteca ApostolicaVaticana, Cod. Vat. Urb. 1094, Avvisi (1624), cited in Franco Borsi, *Bernini architetto* (Milan: Elecat, 1980), p. 291.
2. Ibid.
3. Marie Mancini, *La vérité dans son jour, ou les véritables mémoires de M. Manchini, connectable Collone* ([Madrid, 1677]), transcribed by Stefanie Walker in Stefanie Walker and Frederick Hammond, eds., *Life and Arts in the Baroque Palaces of Rome: Ambiente Barocco* (New Haven and London: Yale University Press, published for the Bard Graduate Center for Studies in the Decorative Arts, New York, 1999), p. 142, n. 2. Author's translation.
4. "Pons, plus heureux que le conservateurs des Trésors de Dresde e de Vienne, possédait un cadre du fameux Brutolone, le Michel-Ange du bois." Honoré de Balzac, *Le cousin Pons* (1847; reprint, Paris: Société d'Éditions Littéraires et Artistuques, 1900), pp. 113–14.
5. Thomas Gray to Richard West, November 16, 1739 (n.s), letter XI, in *The Poems of Mr Gray to which are prefixed Memoirs of his Life and Writings by W[illiam] Mason* (York, Eng.: J. Todd; London: J. Dodsley, 1775), p. 65, online at the Thomas Gray Archive, www.thomasgray.org.
6. Peter Mundy, *The Travels of Peter Mundy in Europe and Asia, 1608–1667*, vol. 4, ed. Richard Carmac Temple, Hakluyt Society, 2nd series, no. 55 (London: printed for the society by Cambridge University Press, 1925), p. 71, from Rawlinson Ms. A. 315, Bodleian Library, Oxford, and online under "texts" at www.archives.org.
7. Joost van del Vondel, "Op de toetssteene feesttafel der Goden" (1660), partially translated in Reinier Baarsen, *Furniture in Holland's Golden Age* (Amsterdam: Rijksmuseum, 2007), p. 107.
8. Abraham Bosse, *La Galerie du Palais*, c. 1638, etching, reproduced in *Abraham Bosse, savant graveur: Tours, vers 1604–1676* (Paris: Bibliothèque nationale de France; [Tours]: Musée des beaux-arts de Tours, 2004), p. 187, cat. 158. Author's translation.
9. Richard Lassels, *A Voyage of Italy, or A Compleat Journey Through Italy . . .* , part 1 (London: John Starkey, 1670), preface.
10. Quoted from Robert Herrick, "Upon Julia's Clothes" ["liquefaction"], in *The Oxford Anthology of English Literature*, vol. 1, ed. Frank Kermode and John Hollander (New York: Oxford University Press, 1973); and "Delight in Disorder" [other quotations], in ibid.
11. "In Praise of the Needle," in John Taylor, *The Needles Excellency . . .* (London: James Baler, 1631), introductory poem.
12. Entry for February 4, 1684, in *Diary of John Evelyn*, with an introduction and notes by Austin Dobson, vol. 3 (London: Macmillan and Co. Ltd., 1906), p. 141.
13. Alexander Pope, *An Epistle to the Right Honourable Richard Earl of Burlington. Occasioned by his Publishing Palladio's Designs of the Baths, Arches, and Theatres of Ancient Rome* (London: Printed for L. Gilliver, 1731), online at Eighteenth Century Collections Online, http://quod.lib.umich.edu/e/ecco/.
14. Horace Walpole, "History of the Modern Taste in Gardening," in *Anecdotes of Painting in England . . .* , vol. 4 (London: J. Dodsley, 1782), p. 289.
15. "Approximate description of the amber gifts for the Moscow Tsar," attached by Michael Redliin to his bill for 2,282 florins, tendered on September 4, 1688, to Jan

Reyer, counsellor to Frederick III, cited in Janini Grabowska, *Polish Amber*, trans. Emma Harris (Warsaw: Interpress Publishers, 1983), pp. 19–20.

CHAPTER 11: THE AMERICAS
SPANISH AND PORTUGUESE AMERICA

1. Bernardo de Balbuena, *Grandeza Mexicana* [1604], ed. J. C. González Boixo (Rome: Bulzoni, 1988), p. 80: "En ti se junta España con la China / Italia con Japón, y finalmente / un mundo entero in trato y disciplina." Author's translation.
2. Inés de Solís to her sister Angela de Solís, Mexico City, October 25, 1574, in Enrique Otte, *Cartas privadas de emigrantes a Indias, 1540–1616* (Seville: Consejería de Cultura, Junta de Andalucía, Escuela de Estudios Hispano Americanos de Sevilla, 1988), p. 89, cited and translated in Sofia Sanabrais, "The *Biombo* or Folding Screen in Colonial Mexico," in *Asia and Spanish America: Trans-Pacific Artistic and Cultural Exchange, 1500–1850*, ed. Donna Pierce and Ronald Y. Otsuka (Denver: Denver Art Museum, 2009), pp. 78, 80.

BRITISH, FRENCH, AND DUTCH NORTH AMERICA

1. Neal W. Allen, Jr., ed., *Province and Court Records of Maine* (Portland, ME, 1975), vol. 6: 72 –76.
2. Carl F. Bridenbaugh, ed., *Gentleman's Progress: The Itinerarium of Doctor Alexander Hamilton, 1744* (Chapel Hill: Institute of Early American Culture/ University of North Carolina Press, 1948), p. 13.
3. James T. Lemon, *The Best Poor Man's Country: A Geographical Study of Early Southeastern Pennsylvania* (Baltimore: Johns Hopkins University Press, 1972), xiii n. 1.
4. *The Autobiography of Benjamin Franklin* (1818; reprint, New York: Houghton, Mifflin, 1888), p. 99.

1750–1900

CHAPTER 14: INDIA

1. Sir George Christopher Molesworth Birdwood, *The Industrial Arts of India*, vol. 1 (London: Chapman and Hall, 1884), p. 159.

CHAPTER 16: AFRICA

1. Eugene Casalis, *Among the Basutos; or, Twenty-three Years in South Africa* (London: James Nisbet & Co. 1861), p. 136.

CHAPTER 17: EUROPE
1750–1830

1. *Mercure de France*, June 1756, cited in Svend Eriksen, *Early Neoclassicism in France*, trans. Peter Thornton (London: Faber, 1974), p. 47.
2. Jean-François de Bastide, *The Little House: An Architectural Seduction*, trans. Rodolphe el-Khoury (New York: Princeton Architectural Press, 1996), p. 110.
3. Georges Touchard-Lafosse, *Chroniques de l'Oeil-de-Boeuf* [1800], 7th series (Paris: Collection Georges Barba, 1864), chap. 5, p. 243.
4. Cited in Victoria and Albert Museum, *Rococo: Art and Design in Hogarth's England* (London: Trefoil Books and V&A Museum, 1984), p. 48.
5. Robert Adam and James Adam, *Works*, vol. 1 (London: Printed for the authors, 1773), part 1, p. 6.

6. Mrs. Montagu to the Duchess of Portland, July 20, 1779, cited in Geoffrey Beard, *The Work of Robert Adam* (London: Bloomsbury Books, 1978), p. 23.
7. R. Sickelmore, *The History of Brighton* (Brighton: Printed for the author, 1823), p. 28.
8. *The Private Letters of Princess Lieven to Prince Metternich, 1820–1826*, ed. Peter Quennell (New York: E. P. Dutton & Co., 1938), p. 150.
9. Jean-François de Bourgoing, *Nouveau Voyage en Espagne*, 3 vols (Paris: Chez Regnault, 1789), vol. 1, p. 147. Author's translation.

1830–1900

1. Elizabeth Bonython and Anthony Burton, *The Great Exhibitor: The Life and Work of Henry Cole* (New York: Abrams, 2003), p. 93.
2. Owen Jones, *Grammar of Ornament* (London: Day and Son, 1856), p. 2.
3. Quoted in William S. Peterson, *The Kelmscott Press: A History of William Morris's Typographical Adventure* (Berkeley and Los Angeles: University of California Press, 1991), p. 4.
4. Walter Crane, *William Morris to Whistler* (London: G. Bell and Sons, 1911), pp. 54–55.

CHAPTER 18: THE AMERICAS
SPANISH AND PORTUGUESE AMERICA 1750–1830

1. Jorge Juan and Antonio de Ulloa, *Relación historica del viage a la America meridional hecho de orden de S. Mag.*, part II, v. 3 (Madrid: Antonio Marin, 1748), pp. 67–78.
2. José Joaquin Fernández de Lizardi, "Diálogo entre un francés y un italiano sobre la América septentrional," in *El Pensador Mexicano* II, no. 16 (December 16, 1813): "no es más que un acopio de leña dorado a lo antiguo y bien indecente." Author's translation.

NORTH AMERICA

1. Diary entry, June 16, 1766, in John Adams, *Diary and Autobiography of John Adams*, ed. Lyman H. Butterfield et al., 4 vols. (Cambridge, MA: Belknap Press of Harvard University Press, 1961), 1:294.
2. *Prices of Cabinet and Chair Work* (Philadelphia: James Humphries, Jr., 1772), 16; reprinted in Alexandra Alevizatos Kirtley, ed., *The 1772 Philadelphia Furniture Price Book: An Introduction and Guide* (Philadelphia: Philadelphia Museum of Art, 2005).
3. Alexis de Tocqueville, *Democracy in America*, trans. Henry Reeve, 2 vols. (New York: J. & H. G. Langley, 1840), 2:50.
4. G. W. Featherstonhaugh, *Excursion through the Slave States, from Washington on the Potomac to the Frontier of Mexico; with Sketches of Population, Manners and Geological Notes*, 2 vols. (London: John Murray, 1844), 2:27.
5. Andrew Jackson Downing, *The Architecture of Country Houses* (1850; reprint, New York: Appleton, 1859), p. 1.
6. Ibid., p. 410.
7. Catharine E. Beecher and Harriet Beecher Stowe, *The American Woman's Home; or, Principles of Domestic Science* (1869; reprint, New York: J. B. Ford, 1872), p. 84.
8. Candace Wheeler to Mrs. Potter Palmer, October 2, 1891, World's Columbian Exposition, 1893, Board of Lady Managers, box 2, folder 3, Chicago Historical Society; quoted in Amelia Peck and Carol Irish, eds.,

Candace Wheeler: The Art and Enterprise of American Design, 1875–1900 (New York: Metropolitan Museum of Art; New Haven: Yale University Press, 2001), p. 65.

1900–2000

CHAPTER 21: THE ISLAMIC WORLD

1. Quoted from Andreas Seim, "Textile Identifikation unter dunklen Vorzeichen, in Schoole Mostafawy and Harald Siebenmorgen, eds., *Das fremde Abendland. Orient begegnet Okzident von 1800 bis heute* (Karlruhe: Badisches Landesmuseum, 2010), p. 164. Translated by Nicola Imrie.

CHAPTER 23: EUROPE AND THE AMERICAS
INDIGENOUS AMERICA: NORTH

1. Richard. H. Pratt, "The Advantages of Mingling Indians With Whites," *Official Report of the Nineteenth Annual Conference of Charities and Correction* (Boston: George H. Ellis, 1892), p. 46.

INDIGENOUS AMERICA: SOUTH

1. Enrique Florescano, "The Creation of the Museo Nacional de Antropología of Mexico," in Elizabeth Hill Boone, ed. *Collecting the Pre-Columbian Past: A Symposium at Dumbarton Oaks, 5th and 7th October 1990* (Washington, DC: Dumbarton Oaks Research Center, 1993), p. 100.

EUROPE AND NORTH AMERICA, 1900–1945

1. Adolf Loos, "Ornament and Crime," in *The Theory of Decorative Art: An Anthology of European and American Writings, 1750–1940*, ed. Isabelle Frank (New Haven and London: Yale University Press for the Bard Graduate Center, 2000), p. 167.
2. "The Furniture of Our Forefathers: How It Embodies the History and Romance of Its Period," *The Craftsman* 24 (May 1913): 148–57 (quotation p. 150).
3. Virginia Robie, *The Quest of the Quaint* (1916; reprint Boston: Little, Brown, 1927), p. 1.
4. Le Corbusier, *The Decorative Art of Today*, trans. James I. Dunnett (Cambridge, MA: The MIT Press, 1987).

EUROPE AND NORTH AMERICA, 1945–2000

1. Peter Smithson, "Just a Few Chairs and a House: An Essay on the Eames-Aesthetic," *Architectural Design* 36 (September 1966): 443.
2. Tanya Harrod, *The Crafts in Britain in the Twentieth Century* New York: Bard Graduate Center; New Haven: Yale University Press, 1999), p. 211.
3. Buckminster Fuller, *Operating Manual for Spaceship Earth* (New York: Pocket Books, 1970), p. 47.

FURTHER READING

GENERAL

Adamson, Glenn, ed. *The Craft Reader*. Oxford and New York: Berg, 2010.

Adamson, Glenn, and Jane Pavitt, eds. *Postmodernism: Style and Subversion, 1970–1990*. London: Victoria and Albert Museum, 2011.

Adamson, Glenn, Giorgio Riello, and Sarah Teasley, eds. *Global Design History*. London and New York: Routledge, 2011.

Alfoldy, Sandra. *NeoCraft: Modernity and the Crafts*. Halifax: Press of the Nova Scotia College of Art and Design, 2007.

Appadurai, Arjun, ed. *The Social Life of Things: Commodities in Cultural Perspective*. Cambridge and New York: Cambridge University Press, 1986.

Attfield, Judy. *Wild Things: The Material Culture of Everyday Life*. Oxford and New York: Berg, 2000.

Attfield, Judy, and Pat Kirkham, eds. *A View from the Interior: Feminism, Women, and Design*. London: Women's Press, 1989.

Aynsley, Jeremy. *A Century of Graphic Design*. Hauppauge, NY: Barron's, 2001.

Aynsley, Jeremy and Charlotte Grant, eds. *Imagined Interiors: Representing the Domestic Interior Since the Renaissance*. London: V & A Publications, 2006.

Baudrillard, Jean. *The System of Objects*. Translated by James Benedict. London and New York: Verso, 1996.

Benton, Charlotte, Tim Benton, and Ghislaine Wood, eds. *Art Deco 1910–1939*. London: Victoria and Albert Museum, 2003.

Benton, Tim, and Charlotte Benton, eds. *Form and Function: A Source Book for the History of Architecture and Design, 1890–1939*. London: C. L. Staples with the Open University Press, 1975.

Bourdieu, Pierre. *Distinction: A Social Critique of the Judgment of Taste*. Cambridge, MA: Harvard University Press, 1984.

Brewer, John, and Roy Porter, eds. *Consumption and the World of Goods*. London and New York: Routledge, 1993.

Buchanan, Richard, and Victor Margolin, eds. *Discovering Design: Explorations in Design Studies*. Chicago: University of Chicago Press, 1995.

Clark, Hazel, and David Brody, eds. *Design Studies: A Reader*. Oxford and New York: Berg, 2009.

Clarke, Alison J., ed. *Design Anthropology: Object Culture in the 21st Century*. Vienna and New York: Springer, 2011.

Colomina, Beatriz, ed. *Sexuality & Space*. New York: Princeton Architectural Press, 1992.

Conway, Hazel, ed. *Design History: A Student's Handbook*. London and Boston: Allen & Unwin, 1987.

Crowley, David, and Jane Pavitt, eds. *Cold War Modern: Design 1945–1970*. London: Victoria and Albert Museum, 2008.

Curtin, Philip D. *Cross-Cultural Trade in World History*. Cambridge: Cambridge University Press, 1984.

Dant, Tim. *Material Culture in the Social World: Values, Activities, Lifestyles*. Buckingham, UK: Open University Press, 1999.

De Grazia, Victoria, ed. *The Sex of Things: Gender and Consumption in Historical Perspective*. Berkeley: University of California Press, 1996.

Elliott, Bridget, and Janice Helland, eds. *Women Artists and the Decorative Arts, 1880–1935: The Gender of Ornament*. Aldershot, UK, and Burlington, VT: Ashgate, 2002.

Erlhoff, Michael, and Tim Marshall, eds. *Design Dictionary: Perspectives on Design Terminology*. Boston and Basel: Birkhäuser, 2008.

Esslinger, Hartmut, ed. *Design Forward: Creative Strategies for Sustainable Change*. Stuttgart: Arnoldsche, 2012.

Fallan, Kjetil. *Design History: Understanding Theory and Method*. Oxford and New York: Berg, 2010.

Fleming, John, and Hugh Honour. *The Penguin Dictionary of Decorative Arts*. London and New York: Viking, 1989.

Forty, Adrian. *Objects of Desire: Design and Society Since 1750*. London and New York: Thames and Hudson, 1992.

Frank, Isabelle, ed. *The Theory of Decorative Art: An Anthology of European and American Writings, 1750–1940*. New Haven: Yale University Press, 2000.

Gorman, Carma, ed. *The Industrial Design Reader*. New York: Allworth Press, 2003.

Greenhalgh, Paul, ed. *Art Nouveau: 1890–1914*. London: Victoria and Albert Museum, 2000.

Harvey, David. *The Condition of Postmodernity: An Enquiry into the Origins of Cultural Change*. Oxford and New York: Blackwell, 1989.

Harvey, Karen, ed. *History and Material Culture: A Student's Guide to Approaching Alternative Sources*. London and New York: Routledge, 2009.

Heskett, John. *Industrial Design*. London and New York: Oxford University Press, 1980.

Highmore, Ben. *Everyday Life and Cultural Theory: An Introduction*. London and New York: Routledge, 2002.

Hobsbawm, Eric, and Terence Ranger, eds. *The Invention of Tradition*. Cambridge and New York: Cambridge University Press, 1983.

Howells, Richard, and Robert W. Matson, eds. *Using Visual Evidence*. Maidenhead, UK, and New York: Open University Press, 2009.

Jackson, Anna, and Amin Jaffer. *Encounters: The Meeting of Asia and Europe, 1500–1800*. London: Victoria and Albert Museum, 2004.

Jameson, Fredric. *Postmodernism, or, The Cultural Logic of Late Capitalism*. Durham, NC: Duke University Press, 1991.

Jervis, Simon. *The Penguin Dictionary of Design and Designers*. Harmondsworth, UK, and New York: Penguin Books, 1984.

Julier, Guy. *The Thames and Hudson Encyclopaedia of 20th Century Design and Designers*. London and New York: Thames and Hudson, 1993.

Kinchin, Juliet, and Aidan O'Connor. *Century of the Child: Growing by Design, 1900–2000*. New York: Museum of Modern Art, 2012.

Kingery, W. David. *Learning from Things: Method and Theory of Material Culture Studies*. Washington, DC: Smithsonian Institution Press, 1996.

Kirkham, Pat, ed. *The Gendered Object*. Manchester, UK, and New York: Manchester University Press, 1996.

Lamonaca, Marianne, ed. *Weapons of Mass Dissemination: The Propaganda of War*. Miami Beach, FL: Wolfsonian, Florida International University, 2004.

Lees-Maffei, Grace, and Rebecca Houze, eds. *The Design History Reader*. Oxford and New York: Berg, 2010.

Livingstone, Karen, and Linda Parry, eds. *International Arts and Crafts*. London: V & A Publishing, 2005.

Mackenzie, Dorothy. *Green Design: Design for the Environment*. London: Laurence King, 1997.

MacKenzie, John M. *Orientalism: History, Theory, and the Arts*. Manchester and New York: Manchester University Press, 1995.

Martin, Richard, ed. *The St. James Fashion Encyclopedia: A Survey of Style From 1945 to the Present*. Detroit: Visible Ink, 1997.

Martinez, Katharine A., and Kenneth L. Ames, eds. *The Material Culture of Gender, the Gender of Material Culture*. Winterthur, DE: The Henry Francis du Pont Winterthur Museum, 1997.

Massey, Anne. *Interior Design of the 20th Century*. London and New York: Thames and Hudson, 1990.

Meggs, Philip B., and Alston W. Purvis. *Meggs' History of Graphic Design*. 4th ed. Hoboken, NJ: Wiley, 2005.

Miller, Daniel. *The Comfort of Things*. Cambridge, UK, and Malden, MA: Polity Press, 2008.

———, ed. *Home Possessions: Material Culture Behind Closed Doors*. Oxford and New York: Berg, 2001.

———, ed. *Material Cultures: Why Some Things Matter*. Chicago: University of Chicago Press, 1998.

Noblet, Jocelyn de, ed. *Industrial Design: Reflection of a Century*. Paris: Flammarion, 1993.

Norman, Donald A. *The Design of Everyday Things*. New York: Doubleday, 1990.

Papanek, Victor J. *Design for the Real World: Human Ecology and Social Change*. New York: Pantheon, 1971.

Parker, Rozsika. *The Subversive Stitch: Embroidery and the Making of the Feminine*. London: Women's Press, 1984.

Pepall, Rosalind, and Diane Charbonneau, eds. *Decorative Arts and Design. The Montreal Museum of Fine Arts' Collection: Volume II*. Montreal: Montreal Museum of Fine Arts, 2012.

Raizman, David Seth. *History of Modern Design*. Upper Saddle River, NJ: Pearson Prentice Hall, 2011.

Said, Edward W. *Orientalism*. New York: Pantheon, 1978.

Sparke, Penny. *An Introduction to Design and Culture in the Twentieth Century*. New York: Harper & Row, 1986.

——. *As Long as it's Pink: The Sexual Politics of Taste*. London: Pandora, 1985.

Steele, Valerie, ed. *Encyclopedia of Clothing and Fashion*. New York: Scribner / Thomson Gale, 2005.

Strasser, Susan. *Waste and Want: A Social History of Trash*. New York: Metropolitan, 1999.

Taylor, Lou. *The Study of Dress History*. Manchester, UK, and New York: Manchester University Press, 2002.

Trench, Lucy, ed. *Materials & Techniques in the Decorative Arts: An Illustrated Dictionary*. Chicago: University of Chicago Press, 2000.

Wilk, Christopher, ed. *Modernism: Designing a New World, 1914–1939*. London: Victoria and Albert Museum, 2006.

Woodham, Jonathan M. *A Dictionary of Modern Design*. Oxford and New York: Oxford University Press, 2004.

——. *Twentieth Century Design*. Oxford and New York: Oxford University Press, 1997.

EAST ASIA: CHINA, KOREA, JAPAN

Alcock, Sir Rutherford. *Art and Art Industries in Japan*. London: Virtue & Co, 1878.

Atkins, Jacqueline M. *Wearing Propaganda: Textiles on the Home Front in Japan, Britain, and the United States, 1931–1945*. New York: Bard Graduate Center; New Haven, Yale University Press, 2005.

Barsac, Jacques. *Charlotte Perriand et le Japon*. Paris: Norma, 2008.

Berliner, Nancy Zeng, and Edward S. Cooke. *Inspired by China: Contemporary Furnituremakers Explore Chinese Traditions*. Salem, MA: Peabody Essex Museum, 2006.

Brandt, Kim. *Kingdom of Beauty: Mingei and the Politics of Folk Art in Imperial Japan*. Durham, NC: Duke University Press, 2007.

Butler, Michael, Margaret Medley, and Stephen Little. *Seventeenth-Century Chinese Porcelain from the Butler Family Collection*. Alexandria, VA: Art Services International, 1990.

Carpenter, John T., ed. *Hokusai and His Age: Ukiyo-e Painting, Printmaking, and Book Illustration in Late Edo Japan*. Amsterdam: Hotei, 2005.

Choi, Seoyoun, ed. *Korean Contemporary Crafts Now: The 36th Korean Crafts Council Exhibition*. Seoul: Korean Crafts Council, 2009.

Chung, Young Yang. *Silken Threads: A History of Embroidery in China, Korea, Japan, and Vietnam*. New York: Abrams, 2005.

Clunas, Craig. *Art in China*. New York: Oxford University Press, 1997.

——. *Empire of Great Brightness: Visual and Material Cultures of Ming China, 1368–1644*. Honolulu: University of Hawaii Press, 2007.

——. *Superfluous Things: Material Culture and Social Status in Early Modern China*. Urbana and Chicago: University of Illinois Press, 1991.

Cort, Louise Allison. *Seto and Mino Ceramics*. Washington, DC: Freer Gallery of Art, Smithsonian Institution, 1992.

Denison, Edward, and Guang Yu Ren. *Modernism in China*. Chichester, UK, and Hoboken, NJ: Wiley, 2008.

Deuchler, Martina. *The Confucian Transformation of Korea: A Study of Society and Ideology*. Cambridge, MA: Council on East Asian Studies, Harvard University, 1992.

Dresser, Christopher. *Japan: Its Architecture, Art, and Art Manufactures*. London: Longmans, Green, and Co., 1882.

Earle, Joe. *Splendors of Imperial Japan: Arts of the Meiji Period from the Khalili Collection*. London: Khalili Family Trust, 2002.

Earle, Joe, and Gōke Tadaomi. *Meiji no Takara, Treasures of Imperial Japan*. Vol. 6 of *The Nasser D. Khalili Collection of Japanese Art*. London: The Kibo Foundation, 1996.

Faulkner, Rupert. *Japanese Studio Crafts: Tradition and the Avant-garde*. Philadelphia: University of Pennsylvania Press, 1995.

Furuto, Kazuie, ed. *The Shogun Age Exhibition: From the Tokugawa Art Museum, Japan*. Tokyo: Shogun Age Exhibition Executive Committee, 1983.

Gluckman, Dale Carolyn, and Sharon Sadako Takeda. *When Art Became Fashion: Kosode in Edo-Period Japan*. Los Angeles: Los Angeles County Museum of Art, 1992.

Gordon, Andrew. *A Modern History of Japan: From Tokugawa Times to the Present*. Oxford and New York: Oxford University Press, 2003.

Guth, Christine. *Art of Edo Japan: The Artist and the City, 1615–1868*. New York: Abrams, 1996.

Hall, John Whitney. *Early Modern Japan*. Vol. 4 of *The Cambridge History of Japan*. Cambridge: Cambridge University Press, 1991.

He, Li. *Chinese Ceramics: A New Comprehensive Survey from the Asian Art Museum of San Francisco*. New York: Rizzoli, 1996.

He, Li, and Michael Knight. *Power and Glory: Court Arts of China's Ming Dynasty*. San Francisco: Asian Art Museum, 2008.

Hickman, Money L. *Japan's Golden Age: Momoyama*. New Haven: Yale University Press with the Dallas Museum of Art, 1996.

Hiesinger, Kathryn B., and Felice Fischer, eds. *Japanese Design: A Survey since 1950*. Philadelphia: Philadelphia Museum of Art with Abrams, 1995.

Hon'ami, Kōetsu, Felice Fischer, and Edwin A. Cranston. *The Arts of Hon'Ami Kōetsu: Japanese Renaissance Master*. Philadelphia: Philadelphia Museum of Art, 2000.

Impey, Oliver R., and Joyce Seaman. *Japanese Decorative Arts of the Meiji Period, 1868–1912*. Oxford: Ashmolean Museum, 2005.

Insatsu Hakubutsukan. *1950-nendai Nihon no gurafikku dezain: dezaina tanjo* [Japanese graphic design in the 1950s: The designer is born]. Tokyo: Kokusho Kankokai, 2008.

——. *1960-nendai gurafizumu* [1960s graphics]. Tokyo: Insatsu Hakubutsukan, 2002.

Jackson, Anna. *Japanese Country Textiles*. London: Victoria and Albert Museum, 1997.

Jacobsen, Robert D. *Imperial Silks: Ch'ing Dynasty Textiles in The Minneapolis Institute of Arts*. 2 vols. Minneapolis: Minneapolis Institute of Arts, 2000.

Jacobsen, Robert D., Nicholas Grindley, and Sarah Callaghan. *Classical Chinese Furniture in the Minneapolis Institute of Arts*. Minneapolis: Minneapolis Institute of Arts with Paragon, 1999.

Jahn, Gisela. *Meiji Ceramics: The Art of Japanese Export Porcelain and Satsuma Ware, 1868–1912*. Stuttgart: Arnoldsche, 2004.

Jansen, Marius B., and Gilbert Rozman. *Japan in Transition, from Tokugawa to Meiji*. Princeton, NJ: Princeton University Press, 1986.

Japan Industrial Design Promotion Organization. *Design Japan: 50 Creative Years with the Good Design Awards*. Berkeley, CA: Stone Bridge Press, 2007.

Kerr, Rose, ed. *Chinese Art and Design*. London: Victoria and Albert Museum, 1991.

Kim, Hongnam, ed. *Korean Arts of the Eighteenth Century: Splendor and Simplicity*. New York: Asia Society with Weatherhill, 1993.

Kim, Kumja Paik. *The Art of Korea: Highlights from the Collection of San Francisco's Asian Art Museum*. San Francisco: Asian Art Museum, 2006.

Kim-Renaud, Young-Key. *Creative Women of Korea: The Fifteenth through the Twentieth Centuries*. Armonk, NY, and London: M. E. Sharpe, 2004.

Ko, Dorothy. *Teachers of the Inner Chambers: Women and Culture in Seventeenth-Century China*. Stanford, CA: Stanford University Press, 1994.

Kumiko, Doi, ed. *Japan Goes to the World's Fairs: Japanese Art at the Great Expositions in Europe and the United States, 1867–1904*. Los Angeles: Los Angeles County Museum of Art, 2005.

Kushner, Barak. *The Thought War: Japanese Imperial Propaganda*. Honolulu: University of Hawaii Press, 2006.

Kyōto Kokuritsu Hakubutsukan. *Miyako No Mōdo: Kimono No Jidai* [Kyoto Style: Trends in 16th–19th Century Kimono]. Kyōto-shi: Shibunkaku Shuppan, 2001.

Lee, Soyoung. *Art of the Korean Renaissance, 1400–1600*. New York: The Metropolitan Museum of Art, 2009.

Leidy, Denise Patry, Wai-fong Anita Siu, and James C. Y. Watt. *Chinese Decorative Arts*. New York: The Metropolitan Museum of Art, 1997.

Levenson, Jay. *Circa 1492: Art in the Age of Exploration*. Washington, DC: National Gallery of Art, 1991.

Li, Chu-tsing, and James C. Y. Watt, eds. *The Chinese Scholar's Studio: Artistic Life in the Late Ming Period: An Exhibition from the Shanghai Museum*. London and New York: Thames and Hudson, 1987.

Lillehoj, Elizabeth. *Art and Palace Politics in Early Modern Japan, 1580s–1680s*. Leiden and Boston: Brill, 2011.

McClain, James L., John M. Merriman, and Kaoru Ugawa. *Edo and Paris: Urban Life and the State in the Early Modern Era*. Ithaca, NY: Cornell University Press, 1994.

McKillop, Beth. *Korean Art and Design*. London: Victoria and Albert Museum, 1992.

Meech, Julia. *The World of the Meiji Print: Impressions of a New Civilization*. New York: Weatherhill, 1986.

Minick, Scott, and Jiao Ping. *Chinese Graphic Design in the Twentieth Century*. London and New York: Thames and Hudson, 1990.

Morris-Suzuki, Tessa. *The Technological Transformation of Japan: From the Seventeenth to the Twenty-First Century*. Cambridge: Cambridge University Press, 1994.

Murase, Miyeko, and Mutsuko Amemiya. *Turning Point: Oribe and the Arts of Sixteenth-Century Japan*. New York: The Metropolitan Museum of Art with Yale University Press, 2003.

Newland, Amy Reigle, ed. *The Hotei Encyclopedia of Japanese Woodblock Prints*. Amsterdam: Hotei, 2005.

Nishi, Kazuo, and Kazuo Hozumi. *What is Japanese Architecture?* 1st English ed. Tokyo and New York: Kodansha International, 1985.

Parker, Lauren, Zhang Hongxing, and Beth McKillop. *China Design Now*. London: Victoria and Albert Museum, 2008.

Pitelka, Morgan. *Japanese Tea Culture: Art, History, and Practice*. London and New York: Routledge-Curzon, 2003.

——. *Handmade Culture: Raku Potters, Patrons, and Tea Practitioners in Japan*. Honolulu: University of Hawaii Press, 2005.

Portal, Jane. *Art Under Control in North Korea*. London: Reaktion, 2005.

——. *Korea: Art and Archaeology*. London and New York: Thames and Hudson with the British Museum, 2000.

Quette, Béatrice, ed. *Cloisonné: Chinese Enamels from the Yuan, Ming, and Qing Dynasties*. New York: Bard Graduate Center; New Haven: Yale University Press, 2011.

Rawski, Evelyn Sakakida, and Jessica Rawson, eds. *China: The Three Emperors, 1662–1795*. London: Royal Academy of Arts, 2005.

Rawson, Jessica, ed. *The British Museum Book of Chinese Art*. London and New York: Thames and Hudson, 1992.

Rousmaniere, Nicole Coolidge. *Vessels of Influence: China and the Birth of Porcelain in Medieval and Early Modern Japan*. London: Bristol Classical Press, 2012.

Rousmaniere, Nicole Coolidge, and Tsuji Nobuo, eds. *Kazari: Decoration and Display in Japan, 15th–19th Centuries*. New York: Japan Society, 2002.

Sand, Jordan. *House and Home in Modern Japan: Architecture, Domestic Space, and Bourgeois Culture, 1880–1930*. Cambridge, MA: Harvard University Asia Center, 2003.

Sezon Bijutsukan. *Nihon no me to kukan: mo hitotsu no modan dezain* [Japanese aesthetics and sense of space: Another aspect of modern Japanese design]. Tokyo: Sezon Bijutsukan, 1990.

——. *Nihon no me to kukan II: soshoku to erosu 1900–1945* [Japanese aesthetics and sense of space II: Ornamentation and eroticism 1900–1945]. Tokyo: Sezon Bijutsukan, 1992.

Shimizu, Yoshiaki. *Japan: The Shaping of Daimyo Culture, 1185–1868*. Washington, DC: National Gallery of Art, 1988.

Shirahara, Yukiko. *Japan Envisions the West: 16th–19th Century Japanese Art From Kobe City Museum*. Seattle: Seattle Art Museum, 2007.

Siebold, Philipp Franz von. *Manners and Customs of the Japanese in the Nineteenth Century: From the Accounts of Dutch Residents in Japan and from the German Work of Philipp Franz von Siebold*. Rutland, VT: C. E. Tuttle Co., 1973.

Smith, Judith G., ed. *Arts of Korea*. New York: The Metropolitan Museum of Art, 1998.

Spence, Jonathan D. *The Search for Modern China*. New York: Norton, 1990.

Steinhardt, Nancy Shatzman, ed. *Chinese Architecture*. New Haven and London: Yale University Press, 2002.

Stinchecum, Amanda Mayer, Naomi Noble Richard, and Margot Paul. *Kosode, 16th–19th Century Textiles From the Nomura Collection*. New York: Japan Society with Kodansha International, 1984.

Tian, Jiaqing. *Classic Chinese Furniture of the Qing Dynasty*. London: Philip Wilson, 1995.

Tipton, Elise K., and John Clark. *Being Modern in Japan: Culture and Society from the 1910s to the 1930s*. Honolulu: University of Hawaii Press, 2000.

Tokyo National Museum. *Meiji dezain no tanjō: Chōsa kenkyū hōkokusho "Onchi zuroku."* Tokyo: Kokusho Kankōkai, 1997.

——. *Arts of East and West from World Expositions: 1855–1900: Paris, Vienna and Chicago*. Tokyo: NHK, 2004.

Tokyo National Museum of Modern Art. *Art Nouveau in Japan 1900–1923: The New Age of Crafts and Design*. Tokyo: National Museum of Modern Art, 2005.

Traganou, Jilly. *The Tōkaidō Road: Traveling and Representation in Edo and Meiji Japan*. London and New York: Routledge, 2004.

Tseng, Alice Yu-Ting. *The Imperial Museums of Meiji Japan: Architecture and the Art of the Nation*. Seattle: University of Washington Press, 2008.

Vollmer, John, and Elinor L. Pearlstein. *Clothed to Rule the Universe: Ming and Qing Dynasty Textiles at The Art Institute of Chicago*. Chicago: The Art Institute of Chicago, 2000.

Watt, James C. Y., and Wen Fong. *Possessing the Past: Treasures from the National Palace Museum, Taipei*. New York: The Metropolitan Museum of Art, 1996.

Watt, James C. Y., and Barbara Brennan Ford. *East Asian Lacquer: The Florence and Herbert Irving Collection*. New York: The Metropolitan Museum of Art, 1991.

Watt, James C. Y., and Denise Patry Leidy. *Defining Yongle: Imperial Art in Early Fifteenth-Century China*. New York: The Metropolitan Museum of Art, 2005.

Wilson, Ming, and Ian Thomas. *Chinese Jades*. London: Victoria and Albert Museum, 2004.

Wilson, Richard L. *Inside Japanese Ceramics: A Primer of Materials, Techniques, and Traditions*. New York: Weatherhill, 1995.

——. *The Potter's Brush: The Kenzan Style in Japanese Ceramics*. Washington, DC: Freer and Sackler Galleries, Smithsonian Institution with Merrell, 2001.

Wilson, Verity. *Chinese Textiles*. London: Victoria and Albert Museum, 2005.

Wilson, Verity, and Ian Thomas. *Chinese Dress*. London: Victoria and Albert Museum, 1986.

Wittner, David G. *Technology and the Culture of Progress in Meiji Japan*. London and New York: Routledge, 2008.

Wu, Juanjuan. *Chinese Fashion: From Mao to Now*. New York: Berg, 2009.

Yong, Yun-i, and Regina Krahl, eds. *Korean Art from the Gompertz and Other Collections in the Fitzwilliam Collection: A Complete Catalogue*. Cambridge and New York: Cambridge University Press, 2006.

INDIA

Askari, Nasreen, and Rosemary Crill. *Colours of the Indus: Costume and Textiles of Pakistan*. London: Merrell Holberson with the Victoria and Albert Museum, 1997.

Bala Krishnan, Usha R., and Meera Sushil Kumar. *Dance of the Peacock: Jewellery Traditions of India*. Mumbai: India Book House, 1999.

Barnard, Nick. *Indian Jewellery: The V&A Collection*. London: Victoria and Albert Museum, 2008.

Barnes, Ruth, Steven Cohen, and Rosemary Crill. *Trade, Temple and Court: Indian Textiles from the Tapi Collection*. Mumbai: India Book House, 2002.

Birdwood, George C. M. *The Industrial Arts of India*. London: Chapman and Hall, 1880.

Chaldecott, Nada. *Dhurries: History, Technique, Pattern, Identification*. London and New York: Thames and Hudson, 2003.

Crill, Rosemary. *Indian Embroidery*. London: Victoria and Albert Museum, 1999.

——. *Indian Ikat Textiles*. London: Victoria and Albert Museum, 1998.

Dhamija, Jasleen, and Jyotindra Jain, eds. *Handwoven Fabrics of India*. Ahmadabad: Mapin, 1989.

Dye, Joseph M., III. *The Arts of India: Virginia Museum of Fine Arts*. Richmond: Virginia Museum of Fine Arts, 2001.

Elgood, Robert. *Hindu Arms and Ritual: Arms and Armour from India, 1400–1865*. Delft: Eburon Academic Publishers, 2004.

Elson, Vickie C. *Dowries from Kutch: A Women's Folk Art Tradition in India*. Los Angeles: Museum of Cultural History, University of California Los Angeles, 1979.

Gray, Basil. *The Arts of India*. Oxford: Phaidon, 1981.

Guy, John. *Woven Cargoes: Indian Textiles in the East*. London and New York: Thames and Hudson, 1998.

Guy, John, and Deborah Swallow, eds. *Arts of India 1550–1900*. London: Victoria and Albert Museum, 1990.

Head, Raymond. *The Indian Style*. Chicago: University of Chicago Press, 1986.

Irving, Robert Grant. *Indian Summer: Lutyens, Baker, and Imperial Delhi*. New Haven: Yale University Press, 1981.

Jaffer, Amin. *Furniture from British India and Ceylon*. London: Victoria and Albert Museum, 2001.

——. *Luxury Goods from India: The Art of the Indian Cabinet-Maker*. London: Victoria and Albert Museum, 2002.

——. *Made for Maharajas: A Design Diary of Princely India*. New York: Vendome, 2006.

Jain, Jyotindra, and Aarti Aggarwala. *National Handicrafts and Handlooms Museum, New Delhi*. Ahmadabad: Mapin, 1989.

Keene, Manuel. *Treasury of the World: Jeweled Arts of India in the Age of the Mughals, the al-Sabah Collection, Dar al-Athar al-Islamiyyah*. London and New York: Thames and Hudson, 2001.

Lynton, Linda, and Sanjay K. Singh. *The Sari: Styles, Patterns, History, Techniques*. London and New York: Thames and Hudson, 2002.

Martinelli, Antonio, and George Michell. *Palaces of Rajasthan*. London: Frances Lincoln, 2004.

Mathur, Saloni. *India by Design: Colonial History and Cultural Display*. Berkeley: University of California Press, 2007.

McCutchion, David. *Architecture and Art of Southern India: Vijayanagara and the Successor States*. Vol. 1.6 of *The New Cambridge History of India*. Cambridge: Cambridge University Press, 1995.

——. *The Majesty of Mughal Decoration: The Art and Architecture of Islamic India*. London and New York: Thames and Hudson, 2007.

Michell, George, ed. *The Islamic Heritage of Bengal*. Paris: UNESCO, 1984.

Michell, George, and Snehal Shah, eds. *Ahmadabad*. Bombay: Marg Publications, 1988.

Michell, George, and Mark Zebrowski. *Architecture and Art of the Deccan Sultanates*. Vol 1.7 of *The New Cambridge History of India*. Cambridge: Cambridge University Press, 1999.

Musées de Bordeaux. *La Route des Indes: Les Indes et l'Europe: Échanges artistiques et héritage commun 1650–1850*. Bordeaux: Musée d'Aquitaine and Musée des arts décoratifs with Somogy, 1998.

Nath, Rabindra. *History of Decorative Art in Mughal Architecture*. Delhi and Varanasi: Motilal Banarsidas, 1976.

Pant, Gayatri Nath. *Swords and Daggers*. Vol. 2 of *Indian Arms and Armour*. New Delhi: Army Educational Stores, 1980.

Raheja, Dinesh, and Jitendra Kothari. *Indian Cinema: The Bollywood Saga*. London: Aurum, 2004.

Riboud, Krishna, ed. *Samit & Lampas: Indian Motifs*. Paris: Association pour l'étude et la documentation des textiles d'Asie (A.E.D.T.A.), 1998.

Sethi, Sunil, and Deidi von Schaewen. *Indian Interiors*. Cologne: Taschen, 1999.

Skelton, Robert, ed. *The Indian Heritage: Court Life and Arts under Mughal Rule*. London: Victoria and Albert Museum, 1982.

Skelton, Robert, Andrew Topsfield, Susan Stronge, and Rosemary Crill, eds. *Facets of Indian Art*. London: Victoria and Albert Museum, 1986.

Slesin, Suzanne, and Stafford Cliff. *Indian Style*. London and New York: Thames and Hudson, 1990.

Vassallo e Silva, Nuno, ed. *The Heritage of Rauluchantim*. Lisbon: Museu de São Roque, 1996.

Walker, Daniel. *Flowers Underfoot: Indian Carpets of the Mughal Era*. New York: The Metropolitan Museum of Art, 1997.

Watt, George. *Indian Art at Delhi, 1903: Being the Official Catalogue of the Delhi Exhibition 1902–1903*. Reprint. Delhi: Motilal Banarsidass, 1987.

Wilkinson, Wynyard R. T. *Indian Silver 1858–1947: Silver from the Indian Sub-Continent and Burma by Local Craftsmen in Western Forms*. London: Wynyard R. T. Wilkinson, 1999.

Wilson, Henry. *India Contemporary*. London and New York: Thames and Hudson, 2007.

Zebrowski, Mark. *Gold, Silver & Bronze from Mughal India*. London: Alexandria Press, 1997.

THE ISLAMIC WORLD

Akalin, Đebnem, and Hülya Yilmaz Bilgi. *Delights of Kütahya: Kütahya Tiles and Pottery in the Suna and Inan Kiraç Collection*. Istanbul: Suna and Inan Kiraç Research Institute on Mediterranean Civilizations, 1997.

Ali, Wijdan, ed. *Contemporary Art of the Islamic World*. London: Scorpion Publishing with the Royal Society of Fine Arts Amman, 1989.

Atasoy, Nurhan, Walter B. Denny, Louise Mackie, and Hülya Tezcan. *Ipek: The Crescent and the Rose, Imperial Ottoman Silks and Velvets*. London: Azimuth Editions, 2001.

Atasoy, Nurhan, and Julian Raby. *Iznik: The Pottery of Ottoman Turkey*. London: Alexandria Press, 1989.

Atil, Esin. *Ceramics from the World of Islam*. Washington, DC: Freer Gallery, Smithsonian Institution, 1973.

Baker, Patricia. *Islamic Textiles*. London: British Museum, 1995.

Behrens-Abouseif, Doris, and Stephen Vernoit, eds. *Islamic Art in the Nineteenth Century: Tradition, Innovation, and Eclecticism*. Islamic History and Civilization 60. Leiden: Brill, 2006.

Bier, Carol, ed. *Woven from the Soul, Spun from the Heart: Textile Arts of Safavid and Qajar Iran, 16th–19th Centuries*. Washington, DC: Textile Museum, 1987.

Blair, Sheila S., and Jonathan M. Bloom. *The Art and Architecture of Islam, 1250–1800*. New Haven: Yale University Press, 1994.

———. *Cosmophilia: Islamic Art from the David Collection, Copenhagen*. Chestnut Hill, MA: McMullen Museum of Art, Boston College, 2006.

Bloom, Jonathan M., and Sheila S. Blair. *Islamic Arts*. London: Phaidon, 2003.

Canby, Sheila R. *Golden Age of Persian Art, 1501–1722*. London: British Museum, 2000.

———. *Shah 'Abbas: The Remaking of Iran*. London: British Museum, 2009.

Canby, Sheila R., Aimée E. Froom, and Azim Nanji. *Splendori a Corte: Arti del mondo Islamico nelle collezioni del Museo Aga Khan*. Milan: Olivares, 2007.

Carboni, Stefano. *Glass from Islamic Lands*. London and New York: Thames and Hudson, 2001.

———. *Venice and the Islamic World, 828–1797*. New Haven: Yale University Press, 2007.

Carswell, John. *Iznik Pottery*. London: British Museum, 1998.

Crowe, Yolande. *Persia and China: Safavid Blue and White Ceramics in the Victoria & Albert Museum, 1501–1738*. Geneva: La Borie; London and New York: Thames and Hudson, 2002.

Diba, Layla, ed. *Royal Persian Paintings: The Qajar Epoch, 1785–1925*. New York: Brooklyn Museum, 1998.

Dodds, Jerrilyn, ed. *Al-Andalus: The Art of Islamic Spain*. New York: The Metropolitan Museum of Art, 1992.

Edwards, Cecil. *The Persian Carpet: A Survey of the Carpet-Weaving Industry of Persia*. London: Gerald Duckworth & Co., 1953.

Ettinghausen, Richard, Maurice S. Dimand, Louise W. Mackie, and Charles Grant Ellis. *Prayer Rugs*. Washington, DC: Textile Museum, 1974.

Ettinghausen, Richard, Oleg Grabar, and Marilyn Jenkins-Madina. *The Art and Architecture of Islam, 650–1250*. New Haven: Yale University Press, 2001.

Froom, Aimée E., ed. *Spirit and Life: Masterpieces of Islamic Art from the Aga Khan Museum Collection*. Geneva: Aga Khan Trust for Culture, 2007.

Glassie, Henry. *Turkish Traditional Art Today*. Bloomington: Indiana University Art Museum, 1994.

Gluck, Jay, and Sumi Hiramoti Gluck, eds. *A Survey of Persian Handicraft: A Pictorial Introduction of the Contemporary Folk Arts and Art Crafts of Modern Iran*. Tehran: Survey of Persian Art, 1977.

Golombek, Lisa, Robert B. Mason, and Gauvin A. Bailey. *Tamerlane's Tableware: A New Approach to Chinoiserie Ceramics of Fifteenth- and Sixteenth-Century Iran*. Costa Mesa, CA: Mazda, 1996.

Golombek, Lisa, and Maria Subtelny, eds. *Timurid Art and Culture: Iran and Central Asia in the Fifteenth Century*. Leiden: Brill, 1992.

Grabar, Oleg. *The Formation of Islamic Art*. New Haven: Yale University Press, 1987.

———. *The Mediation of Ornament*. Princeton, NJ: Princeton University Press, 1992.

Gülnaltay, Güven, and Anne Kohl, eds. *Turkish Delight / Design aus der Türkei / Türkiye'den Tasarim*. Berlin: Museum für Islamische Kunst and Staatliche Museen zu Berlin, 2008.

Hagedorn, Annette. *Islamic Art*. Cologne: Taschen, 2009.

Hillenbrand, Robert. *Islamic Art and Architecture*. London and New York: Thames and Hudson, 1999.

Irwin, Robert. *Islamic Art in Context: Art, Architecture, and the Literary World*. London: Laurence King, 1997.

Khalili, Nasser D., B. W. Robinson, and Tim Stanley. *Lacquer of the Islamic Lands*. Vol. 22 of *The Nasser D. Khalili Collection of Islamic Art*. London: The Nour Foundation with Azimuth Editions and Oxford University Press, 1996–1997.

Krebs, Melanie. *Zwischen Handwerkstradition und globalem Markt: Kunsthandwerker in Usbekistan und Kirgistan*. Berlin: Klaus Schwarz Verlag, 2011.

Krody, Sumru Belger. *Flowers of Silk and Gold: Four Centuries of Ottoman Embroidery*. Washington, DC: The Textile Museum, 2000.

Kühnel, Ernst. *The Minor Arts of Islam*. Ithaca, NY: Cornell University Press, 1971.

Labrusse, Rémi, ed. *Purs Décors? Arts de l'Islam, regards du XIXe siècle*. Paris: Les Arts Décoratifs and Musée du Louvre, 2007.

Lane, Arthur. *Later Islamic Pottery: Persia, Syria, Egypt, Turkey*. London: Faber, 1971.

Lentz, Thomas W., and Glenn D. Lowry. *Timur and the Princely Vision: Persian Art and Culture in the Fifteenth Century*. Los Angeles: Los Angeles County Museum of Art, 1989.

Lovatt-Smith, Lisa. *Moroccan Interiors*. Cologne: Taschen, 2005.

Mack, Rosamond. *Bazaar to Piazza: Islamic Trade and Italian Art, 1300–1600*. Berkeley and Los Angeles: University of California Press, 2002.

Melikian-Chirvani, Assadullah Souren. *Le chant du monde: L'art de l'Iran safavide, 1501–1736*. Paris: Editions du Louvre, 2007.

———. *Islamic Metalwork from the Iranian World, 8th–18th Centuries*. London: Victoria and Albert Museum, 1982.

Musée national des châteaux de Versailles et de Trianon and Topkapi Sarayi Müzesi. *Topkapi à Versailles: Trésors de la cour ottomane*. Paris: Réunion des musées nationaux, 1999.

Nitzsche, Ingo, ed. *Von der Ewigkeit des Augenblickes: Die Entwicklung türkischer Fayencemotive: Seldschukischer Stil, osmanischer Stil, Gegenwartskunst*. Schramberg, Germany: Stadtmuseum Schramberg, 2003.

The Nasser D. Khalili Collection of Islamic Art. London: Nour Foundation with Azimuth Editions and Oxford University Press, 1997.

Petsopoulos, Yanni. *Tulips, Arabesques and Turbans: Decorative Arts from the Ottoman Empire*. London: Alexandria Press, 1982.

Pinner, Robert, and Walter B. Denny, eds. *Carpets of the Mediterranean Countries, 1400–1600*. London: Hali, 1986.

Raby, Julian. *Qajar Portraits*. London: Azimuth Editions with the Iran Heritage Foundation, 1999.

Razina, Tatyana, Natalia Cherkasova, and Alexander Kantsedikas. *Folk Art in the Soviet Union.* Leningrad: Aurora Art Publishers, 1989.

Rice, David Talbot. *Islamic Art.* London and New York: Thames and Hudson, 1965.

Robinson, Francis. *Atlas of the Islamic World since 1500.* London: Phaidon, 1982.

Rogers, John Michael. *Empire of the Sultans: Ottoman Art from the the Khalili Collection.* Alexandria, VA: Art Services International, 2000.

——. *Islamic Art and Design, 1500–1700.* London: British Museum, 1983.

Rogers, John Michael, and Rachel M. Ward. *Süleyman the Magnificent.* London: British Museum, 1988.

Roxburgh, David J., ed. *Turks: A Journey of a Thousand Years, 600–1600.* London: Royal Academy of the Arts, 2005.

Safadi, Yasim Hamid. *Islamic Calligraphy.* London and New York: Thames and Hudson, 1978.

Sakip Sabanci Müzesi. *Three Capitals of Islamic Art: Istanbul, Isfahan, Delhi: Masterpieces from the Louvre Collection.* Istanbul: Sakip Sabanci Müzesi; Paris: Editions du Louvre, 2008.

Scarce, Jennifer M. *Women's Costume of the Near and Middle East.* 2nd ed. London: RoutledgeCurzon, 2003.

Schimmel, Annemarie. *A Two-Colored Brocade: The Imagery of Persian Poetry.* Chapel Hill: University of North Carolina Press, 1992.

Siebenmorgen, Harald. *Erbe von Jahrtausenden: Sejnane: Berberkeramik von Frauen aus Nordtunesien.* Karlsruhe: Badische Landesmuseum, 2005.

Stanley, Tim, Mariam Rosser-Owen, and Stephen Vernoit. *Palace and Mosque: Islamic Art from the Middle East.* London: Victoria and Albert Museum, 2004.

Thompson, Jon, and Sheila R. Canby, eds. *Hunt for Paradise: Court Arts of Safavid Iran, 1501–1576.* New York: Skira, 2003.

Vernoit, Stephen. *Occidentalism: Islamic Art in the 19th Century.* Vol. 23 of *The Nasser D. Khalili Collection of Islamic Art.* London: Nour Foundation with Azimuth Editions and Oxford University Press, 1997.

——, ed. *Discovering Islamic Art: Scholars, Collectors, and Collections, 1850–1950.* London: Tauris, 2000.

Watson, Oliver. *Ceramics from Islamic Lands.* London and New York: Thames and Hudson, 2004.

AFRICA

Ajayi, Jacob Festus Ade, ed. *Africa in the Nineteenth Century Until the 1880s.* Vol. 6 of *General History of Africa.* Paris: UNESCO; Oxford: James Currey; Berkeley: University of California Press, 1998.

Barley, Nigel. *Smashing Pots: Feats of Clay from Africa.* London: British Museum Press, 1994.

Bassani, Ezio. *Arts of Africa: 7000 Years of African Art.* Monaco: Grimaldi Forum with Skira, 2005.

Bassani, Ezio, and William Fagg. *Africa and the Renaissance: Art in Ivory.* New York: The Center for African Art with Prestel Verlag, 1987.

Bassani, Ezio, and Malcolm McLeod. *African Art and Artefacts in European Collections: 1400–1800.* London: British Museum, 2000.

Berns, Marla, and Barbara Rubin Hudson. *The Essential Gourd: Art and History in Northeastern Nigeria.* Los Angeles: Museum of Cultural History, University of California Los Angeles, 1986.

Binkley, David A., and Patricia Darish. *Kuba.* Milan: Five Continents, 2009.

Blier, Suzanne Preston. *The Royal Arts of Africa: The Majesty of Form.* New York: H.N. Abrams, 1998.

——. *Kingship and Art in Africa.* New York: H. N. Abrams, 1995.

Boahen, A. Adu. *Africa under Colonial Domination 1880–1935.* Vol. 7 of *General History of Africa.* Paris: UNESCO; London: Heinemann; Berkeley and Los Angeles: University of California Press, 1998.

Bocola, Sandro, ed. *African Seats.* Munich: Prestel, 1995.

Bravmann, René A. *African Islam.* Washington, DC: Smithsonian Institution, 1983.

Brienen, Rebecca Parker. *Visions of Savage Paradise: Albert Eckhout, Court Painter in Colonial Dutch Brazil.* Amsterdam: Amsterdam University Press, 2006.

Cerny, Charlene, and Suzanne Seriff, eds. *Recycled, Re-Seen: Folk Art from the Global Scrap Heap.* Santa Fe, NM: Museum of International Folk Art with Abrams, 1996.

Cole, Herbert M., and Doran A. Ross. *The Arts of Ghana.* Los Angeles: University of California, 1977.

Davidson, Basil. *Africa in History: Themes and Outlines.* 2nd ed. New York: Macmillan, 1991.

Debrunner, Hans Werner. *Presence and Prestige: Africans in Europe, A History of Africans in Europe Before 1918.* Basel: Basler Afrika Bibliographien, 1979.

Dewey, William Joseph, ed. *Legacies of Stone: Zimbabwe Past and Present.* Tervuren, Belgium: Royal Museum for Central Africa, 1997.

Drewal, Henry J., and John Mason. *Beads, Body, and Soul: Art and Light in the Yoruba Universe.* Los Angeles: Fowler Museum of Cultural History, University of California Los Angeles, 1998.

Drewal, Henry, and Enid Schildkrout. *Dynasty and Divinity: Ife Art in Ancient Nigeria.* New York: Museum for African Art, 2009.

Eicher, Joanne B., and Doran H. Ross, eds. *Africa.* Vol. 1 of the *Berg Encyclopedia of World Dress and Fashion.* Oxford and New York: Oxford University Press, 2010.

Enwezor, Okwui, and Chinua Achebe. *The Short Century: Independence and Liberation Movements in Africa, 1945–1994.* Munich: Prestel Verlag, 2001.

Ezra, Kate. *Art of the Dogon: Selections from the Lester Wunderman Collection.* New York: The Metropolitan Museum of Art, 1988.

Fabian, Johannes. *Remembering the Present: Painting and Popular History in Zaire.* Berkeley and Los Angeles: University of California Press, 1996.

Frank, Barbara E. *Mande Potters and Leatherworkers: Art and Heritage in West Africa.* Washington, DC: Smithsonian Institution, 2001.

Garlake, Peter. *Early Art and Architecture of Africa.* Oxford: Oxford University Press, 2002.

Gillow, John. *Printed and Dyed Textiles from Africa.* London: British Museum, 2001.

Gott, Suzanne, Kristyne Loughran, and Joanne B. Eicher. *Contemporary African Fashion.* Bloomington: Indiana University Press, 2010.

Isichei, Elizabeth. *A History of African Societies to 1870.* Cambridge: Cambridge University Press, 1997.

Jewsiewicki, Bogumil, and D. Dibwe dia Mwembu. *A Congo Chronicle: Patrice Lumumba in Urban Art.* New York: Museum for African Art, 1999.

Kasfir, Sidney Littleton. *Contemporary African Art.* London and New York: Thames and Hudson, 1999.

Kriger, Coleen E. *Cloth in West African History.* Lanham, MD: Alta Mira Press, 2006.

LaGamma, Alisa. *Heroic Africans: Legendary Leaders, Iconic Sculptures.* New York: The Metropolitan Museum of Art, 2011.

LaGamma, Alisa, and Christine Giuntini. *The Essential Art of African Textiles: Design Without End.* New Haven: Yale University Press, 2008.

Mack, John, ed. *Africa, Arts and Cultures.* London and New York: Oxford Univesity Press, 2000.

MacGaffey, Wyatt, and Michael D. Harris, eds. *Astonishment and Power.* Washington, DC: National Museum of African Art, Smithsonian Institution, 1993.

McLeod, Malcolm D. *The Asante.* London: British Museum, 1981.

Ogot, Bethwell A., ed. *Africa from the Sixteenth to the Eighteenth Century.* Volume 5 of *General History of Africa.* Paris: UNESCO, 1992.

Picton, John, and John Mack. *African Textiles.* London: British Museum, 1979.

Plankensteiner, Barbara, ed. *Benin Kings and Rituals: Court Arts from Nigeria.* Ghent: Snoeck with the Museum für Völkerkunde Wien, 2007.

Prussin, Labelle. *Hatumere: Islamic Design in West Africa.* Berkeley and Los Angeles: University of California Press, 1986.

Romero, Patricia. *Lamu: History, Society, and Family in an East African Port City.* Princeton, NJ: Markus Wiener, 1997.

Ross, Doran H. *Elephant: The Animal and Its Ivory in African Culture.* Los Angeles: Fowler Museum of Cultural History, University of California Los Angeles, 1992.

——. *Gold of the Akan from the Glassell Collection.* Houston, TX: The Museum of Fine Arts, Houston, 2002.

——, ed. *Wrapped in Pride: Ghanaian Kente and African American Identity.* Los Angeles: Fowler Museum of Cultural History, University of Los Angeles, 1998.

Ross, Doran H., and Georg Eisner, eds. *Royal Arts of the Akan: West African Gold in Museum Liaunig.* Neuhaus/Suha, Austria: HL Museumsverwaltung GmbH, 2008.

Ross, Doran H., and Timothy F. Garrard, eds. *Akan Transformations: Problems in Ghanaian Art History.* Los Angeles: Museum of Cultural History, University of California Los Angeles, 1983.

Rovine, Victoria. *Bogolan: Shaping Culture through Cloth in Contemporary Mali.* Washington, DC: Smithsonian Institution Press, 2001.

Schildkrout, Enid, and Curtis A. Keim. *African Reflections: Art from Northeastern Zaire.* Seattle: University of Washington Press; New York: American Museum of Natural History, 1990.

——. *The Scramble for Art in Central Africa.* Cambridge: Cambridge University Press, 1998.

Seligman, Thomas K., and Kristyne Loughran. *Art of Being Tuareg: Sahara Nomads in a Modern World.* Los Angeles: Fowler Musem, University of California Los Angeles with the Iris & B. Gerald Cantor Center for Visual Arts at Stanford University, 2006.

Sieber, Roy. *African Furniture and Household Objects.* Bloomington: Indiana University Press, with the American Federation of Arts and Indianapolis Museum of Art, 1980.

——. *African Textiles and Decorative Arts*. New York: Museum of Modern Art, 1972.

Svalesen, Leif. *The Slave Ship Fredensborg*. Bloomington: Indiana University Press, 2000.

Thornton, John. *Africa and Africans in the Making of the Atlantic World, 1400–1800*. 2nd ed. Cambridge: Cambridge University Press, 1998.

Vansina, Jan. *Art History in Africa: An Introduction to Method*. London: Longman, 1984.

——. *Being Colonized: The Kuba Experience in Rural Congo, 1880–1960*. Madison: University of Wisconsin Press, 2010.

Van Wyk, Gary. *African Painted Houses: Basotho Dwellings of Southern Africa*. New York: Abrams, 1998.

Visonà, Monica Blackmun, Robin Poynor, and Herbert M. Cole. *A History of Art in Africa*. 2nd ed. Upper Saddle River, NJ: Pearson/Prentice Hall, 2008.

Vogel, Susan, and Ima Ebong, eds. *Africa Explores: 20th Century African Art*. New York: Center for African Art with Prestel Verlag, 1991.

Walker, Roslyn A. *Olówè of Isè: A Yoruba Sculptor to Kings*. Washington, DC: National Museum of African Art, Smithsonian Institution, 1998.

Willett, Frank, with Barbara Blackmun and Emma Lister. *The Art of Ife: A Descriptive Catalogue and Database*. Glasgow: University of Glasgow, 2004.

EUROPE

Aav, Marianne, and Nina Stritzler-Levine, eds. *Finnish Modern Design: Utopian Ideals and Everyday Realities, 1930–1997*. New York: Bard Graduate Center; New Haven: Yale University Press, 1998.

Aguiló Alonso, María Paz. *El mueble en España, siglos XVI–XVII*. Madrid: Consejo Superior de Investigaciones Científicas and Ediciones Antiqvaria, 1993.

Ajmar-Wollheim, Marta, and Flora Dennis, eds. *At Home in Renaissance Italy*. London: Victoria and Albert Museum, 2006.

Alcouffe, Daniel, ed. *Furniture Collections in the Louvre*. Dijon: Editions Faton, 1993.

Aynsley, Jeremy. *Designing Modern Germany*. London: Reaktion, 2009.

Baarsen, Reinier. *17th-Century Cabinets*. Rijksmuseum Dossiers. Amsterdam: Rijksmuseum with Waanders Publishers, 2000.

Bartolomé Arraiza, Alberto, and Fernando de Olaguer-Feliú y Alonso. *Artes Decorativas*. Vol. 45 of *Summa Artis: Historia General del Arte*. Madrid: Espasa Calpe, 1999.

Bayer, Andrea, ed. *Art and Love in Renaissance Italy*. New York: Metropolitan Museum of Art; New Haven: Yale University Press, 2008.

Belozerskaya, Marina. *Rethinking the Renaissance: Burgundian Arts across Europe*. Cambridge and New York: Cambridge University Press, 2002.

Bremer-David, Charissa, ed. *Paris: Life & Luxury in the Eighteenth Century*. Los Angeles: J. Paul Getty Museum, 2011.

Brunhammer, Yvonne, and Suzanne Tise. *The Decorative Arts in France, 1900–1942: La Société des Artistes Décorateurs*. New York: Rizzoli, 1990.

Calloway, Stephen, and Lynn Federele Orr, eds. *The Cult of Beauty: The Aesthetic Movement, 1860–1900*. London: V & A Publishing, 2011.

Camón Aznar, José. *La arquitectura y la orfebrería españolas del siglo XVI*. Vol. 17 of *Summa artis, historia general del arte*. Madrid: Espasa-Calpe, 1987.

Campbell, Thomas P., ed. *Tapestry in the Baroque: Threads of Splendor*. New York: The Metropolitan Museum of Art with Yale University Press, 2007.

——. *Tapestry in the Renaissance: Art and Magnificence*. New York: The Metropolitan Museum of Art with Yale University Press, 2002.

Cassidy-Geiger, Maureen. *Fragile Diplomacy: Meissen Porcelain for European Courts, ca. 1710–1763*. New York: Bard Graduate Center; New Haven and London: Yale University Press, 2007.

Clegg, Elizabeth. *Art, Design, and Architecture in Central Europe, 1890–1920*. New Haven and London: Yale University Press, 2006.

Coffin, Sarah, Gail Davidson, Ellen Lupton, and Penelope Hunter-Stiebel. *Rococo: The Continuing Curve, 1730–2008*. New York: Cooper-Hewitt, National Design Museum, Smithsonian Institution, 2008.

Conforti, Michael, and Guy Walton, eds. *Royal Treasures of Sweden, 1550–1700*. Washington, DC: National Gallery of Art; Minneapolis: Minneapolis Institute of Arts, 1988.

Coutts, Howard. *The Art of Ceramics: European Ceramic Design, 1500–1830*. New Haven and London: Yale University Press, 2001.

Edwards, Clive. *Victorian Furniture: Technology and Design*. Manchester: Manchester University Press, 1993.

Fuhring, Peter. *Juste-Aurèle Meissonnier: Un génie du Rococo, 1695–1750*. Torino: Allemandi, 1999.

Gaimster, David. *German Stoneware 1200–1900, Archaeology and Cultural History: Containing a Guide to the Collections of the British Museum, Victoria & Albert Museum and Museum of London*. London: British Museum, 1997.

Goldthwaite, Richard A. *Wealth and the Demand for Art in Italy, 1300–1600*. Baltimore: Johns Hopkins University Press, 1993.

González-Palacios, Alvar. *Il tempio del gusto: Le arti decorative in Italia fra classicismi e barocco, Roma e il regno delle due Sicilie*. 2 vols. Milan: Longanesi, 1984. Reprint, Vicenza: Neri Pozza, 2000.

Groër, Léon de. *Decorative Arts in Europe, 1790–1850*. New York: Rizzoli, 1986.

Gruber, Alain Charles, ed. *The History of Decorative Arts*. 2 vols. New York: Abbeville Press, 1996.

Harrod, Tanya. *The Crafts in Britain in the 20th Century*. New Haven: Yale University Press, 1999.

Hess, Catherine, ed. *The Arts of Fire: Islamic Influences on Glass and Ceramics of the Italian Renaissance*. Los Angeles: J. Paul Getty Museum, 2004.

Hiesinger, Kathryn B., and George H. Marcus, eds. *Design since 1945*. Philadelphia: Philadelphia Museum of Art, 1983.

Hills, Paul. *Venetian Colour: Marble, Mosaic, Painting and Glass, 1250–1550*. New Haven: Yale University Press, 1999.

Honour, Hugh. *Neo-classicism*. Harmondsworth, UK: Penguin, 1968.

Husband, Timothy B., ed. *The Luminous Image: Painted Glass Roundels in the Lowlands, 1480–1560*. New York: The Metropolitan Museum of Art, 1995.

Impey, Oliver, and Arthur MacGregor, eds. *The Origins of Museums: The Cabinet of Curiosities in Sixteenth and Seventeenth-Century Europe*. London: House of Stratus, 2001.

Irwin, David G. *Neoclassicism*. London: Phaidon, 1997.

Kaplan, Wendy. *The Arts & Crafts Movement in Europe & America: Design for the Modern World*. Los Angeles: Los Angeles County Museum of Art with Thames and Hudson, 2004.

Kaplan, Wendy, ed. *Designing Modernity: The Arts of Reform and Persuasion, 1885–1945: Selections from the Wolfsonian*. Miami Beach, FL: Wolfsonian Foundation with Thames and Hudson, 1995.

Kaufmann, Thomas DaCosta. *Court, Cloister, and City: The Art and Culture of Central Europe, 1450–1800*. Chicago: University of Chicago Press, 1995.

Kisluk-Grosheide, Daniëlle O., Wolfram Koeppe, and William Rieder. *European Furniture in the Metropolitan Museum of Art: Highlights of the Collection*. New Haven and London: Yale University Press, 2006.

Levenson, Jay A., ed. *The Age of the Baroque in Portugal*. Washington, DC: National Gallery of Art with Yale University Press, 1993.

Mack, Rosamond E. *Bazaar to Piazza: Islamic Trade and Italian Art, 1300–1600*. Berkeley and Los Angeles: University of California Press, 2002.

Martínez Caviró, Balbina. *Cerámica hispanomusulmana: Andalusí y mudéjar*. Madrid: El Viso, 1991.

Marx, Bridget, and Isabel Morán Suárez, eds. *Royal Splendor in the Enlightenment: Charles IV of Spain, Patron and Collector*. Dallas, TX: Meadows Museum, Southern Methodist University; Madrid: Patrimonio Nacional, 2010.

McCormick, Heather Jane, Hans Ottomeyer, and Stefanie Walker. *Vasemania: Neoclassical Form and Ornament in Europe, Selections from the Metropolitan Museum of Art*. New York: Bard Graduate Center and The Metropolitan Museum of Art; New Haven and London: Yale University Press, 2004.

Miller, R. Craig, Penny Sparke, and Catherine McDermott. *European Design since 1985: Shaping the New Century*. London: Merrell with Denver Art Museum and the Indianapolis Museum of Art, 2009.

Morrall, Andrew, Melinda Watt, and Cristina Balloffet Carr. *English Embroidery from the Metropolitan Museum of Art, 1580–1700: 'Twixt Art and Nature*. New York: Bard Graduate Center and The Metropolitan Museum of Art; New Haven and London: Yale University Press, 2008.

Mundt, Barbara. *Historismus: Kunstgewerbe zwischen Biedermeier und Jugendstil*. Munich: Keysersche Verlagsbuchhandlung, 1981.

Nouvel, Odile, ed. *Symbols of Power: Napoleon and the Art of the Empire Style, 1800–1815*. New York: Abrams with the American Federation of the Arts; Paris: Les Arts Décoratifs, 2007.

Oman, Charles. *The Golden Age of Hispanic Silver, 1400–1665*. London: Victoria and Albert Museum, 1968.

Philadelphia Museum of Art, Detroit Institute of Arts, and Galeries Nationales du Grand Palais. *The Second Empire, 1852–1870: Art in France Under Napoleon III*. Philadelphia: The Philadelphia Museum of Art; Detroit: Wayne State University Press, 1978.

Piera, Mónica, and Albert Mestres. *El mueble en Cataluña: El espacio doméstico del gótico al modernismo*. Manresa, Spain: Angle, 1999.

Pradère, Alexandre. *French Furniture Makers: The Art of the Ébéniste from Louis XIV to the Revolution*. Los Angeles: J. Paul Getty Museum, 1989.

Ray, Anthony. *Spanish Pottery, 1248–1898: With a Catalogue of the Collection in the Victoria and Albert Museum*. London: Victoria and Albert Museum, 2000.

Ribeiro, Aileen. *Dress in Eighteenth-Century Europe, 1715–1789*. 2nd ed. New Haven and London: Yale University Press, 2002.

Sargentson, Carolyn. *Merchants and Luxury Markets: The Marchands Merciers of Eighteenth-Century Paris*. Victoria and Albert Museum Studies in the History of Art and Design. London: Victoria and Albert Museum, 1996.

Schultze, Jürgen, and Hermann Fillitz, eds. *Prag um 1600: Kunst und Kultur am Hofe Rudolfs II*. Freren, Germany: Luca Verlag, 1988.

Scott, Katie. *The Rococo Interior: Decoration and Social Spaces in Early Eighteenth-Century Paris*. New Haven and London: Yale University Press, 1995.

Silverman, Debora. *Art Nouveau in Fin-de-siècle France: Politics, Psychology, and Style*. Berkeley and Los Angeles: University of California Press, 1989.

Snodin, Michael, ed. *Rococo: Art and Design in Hogarth's England*. London: Trefoil Books with the Victoria and Albert Museum, 1984.

Snodin, Michael, and Nigel Llewellyn, eds. *Baroque, 1620–1800: Style in the Age of Magnificence*. London: Victoria and Albert Museum, 2009.

Snodin, Michael, and John Styles. *Design and the Decorative Arts: Britain, 1500–1900*. London: Victoria and Albert Museum, 2001.

———. *Design and the Decorative Arts: Tudor and Stuart Britain, 1500–1714*. London: Victoria and Albert Museum, 2004.

Syson, Luke, and Dora Thornton. *Objects of Virtue: Art in Renaissance Italy*. Los Angeles: J. Paul Getty Museum, 2001.

Thornton, Peter. *Form and Decoration: Innovation in the Decorative Arts, 1470–1870*. New York: Abrams, 1998.

———. *The Italian Renaissance Interior, 1400–1600*. New York: Abrams, 1991.

———. *Seventeenth-Century Interior Decoration in England, France, and Holland*. New Haven and London: Paul Mellon Centre for Studies in British Art and Yale University Press, 1978.

Troy, Nancy J. *Modernism and the Decorative Arts in France: Art Nouveau to Le Corbusier*. New Haven and London: Yale University Press, 1991.

Trusted, Marjorie. *The Arts of Spain: Iberia and Latin America 1450–1700*. London: Victoria and Albert Museum; University Park: Pennsylvania State University Press with the Hispanic Society of America, 2007.

Verlet, Pierre. *The Eighteenth Century in France: Society, Decoration, Furniture*. Rutland, VT: Charles E. Tuttle, 1967.

Wainwright, Clive. *The Romantic Interior: The British Collector at Home, 1750–1850*. New Haven: Paul Mellon Centre for British Art and Yale University Press, 1989.

Walker, Stefanie, and Frederick Hammond, eds. *Life and the Arts in the Baroque Palaces of Rome: Ambiente Barocco*. New York: Bard Graduate Center; New Haven and London: Yale University Press, 1999.

Waterer, John W. *Spanish Leather: A History of Its Use from 800 to 1800 for Mural Hangings, Screens, Upholstery, Altar Frontals, Ecclesiastical Vestments, Footwear, Gloves, Pouches and Caskets*. London: Faber, 1971.

Welch, Evelyn S. *Art and Society in Italy, 1350–1500*. Oxford; New York: Oxford University Press, 1997.

Westerman, Mariët C., Willemijn Fock, Eric Jan Sluijter, and H. Perry Chapman. *Art and Home: Dutch Interiors in the Age of Rembrandt*. Zwolle, Netherlands: Waanders, with Denver Art Museum and Newark Art Museum, 2001.

Whiteley, Nigel. *Pop Design: Modernism to Mod*. London: Design Council, 1987.

Widenheim, Cecilia, ed. *Utopia & Reality: Modernity in Sweden 1900–1960*. New Haven and London: Yale University Press, 2002.

Zerner, Henri. *Renaissance Art in France: The Invention of Classicism*. Paris: Flammarion, 2003.

Zorach, Rebecca. *Blood, Milk, Ink, Gold: Abundance and Excess in the French Renaissance*. Chicago: University of Chicago Press, 2005.

THE AMERICAS

Academia Nacional de Bellas Artes. *Historia general del arte en la Argentina*. 10 vols. Buenos Aires: Academia Nacional de Bellas Artes, 1982–2005.

Adelson, Laurie, Arthur Tracht, and the Smithsonian Institution Traveling Exhibition Service. *Aymara Weavings: Ceremonial Textiles of Colonial and 19th Century Bolivia*. Washington, DC: Smithsonian Institution, 1983.

Aguilera García, María del Carmen. *El mueble mexicano: historia, evolución e influencias*. México DF: Fomento Cultural Banamex, 1985.

Albiñana, Salvador, ed. *México ilustrado: libros, revistas y carteles, 1920–1950*. México DF: Editorial RM, 2010.

Ames, Kenneth L. *Death in the Dining Room and Other Tales of Victorian Culture*. Philadelphia: Temple University Press, 1992.

Anawalt, Patricia Rieff. *Indian Clothing before Cortés: Mesoamerican Costumes from the Codices*. The Civilization of the American Indian 156. Norman: University of Oklahoma Press, 1981.

Armas Alfonso, Alfredo. *El diseño gráfico en Venezuela*. Caracas: Maraven, 1985.

Aste, Richard. *Behind Closed Doors: Art in the Spanish American Home, 1492–1898*. New York: Monacelli, 2013.

Bauer, Arnold. *Goods, Power, History: Latin America's Material Culture*. Cambridge: Cambridge University Press, 2001.

Benson, Elizabeth P., and Michael D. Coe. *Pre-Columbian Metallurgy of South America: A Conference at Dumbarton Oaks, October 18th and 19th, 1975*. Washington, DC: Dumbarton Oaks, 1979.

Berlo, Janet Catherine, and Ruth Phillips. *Native North American Art*. London and New York: Oxford University Press, 1999.

Bernstein, Bruce. *The Language of Native American Baskets: From the Weavers' View*. Washington, DC: National Museum of the American Indian, Smithsonian Institution, 2003.

Blackburn, Roderic H., and Ruth Piwonka. *Remembrance of Patria: Dutch Arts and Culture in Colonial America, 1609–1776*. Albany, NY: Albany Institute of History and Art, 1988.

Blanco, Ricardo. *Diseño industrial argentino*. Buenos Aires: Ediciones Franz Viegener, 2012.

Bolger, Doreen, ed. *In Pursuit of Beauty: Americans and the Aesthetic Movement*. New York: The Metropolitan Museum of Art, 1986.

Boone, Elizabeth Hill, ed. *Collecting the Pre-Columbian Past*. Washington, DC: Dumbarton Oaks, 1993.

———. *Stories in Red and Black: Pictorial Histories of the Aztecs and Mixtecs*. Austin: University of Texas Press, 2000.

Borrell, Héctor Rivero, Gustavo Curiel, Antonio Rubial Garcia, Juana Gutiérrez Haces, and David B. Warren. *The Grandeur of Viceregal Mexico: Treasures from the Museo Franz Mayer / La grandeza del México virreinal: tesoros del Museo Franz Mayer*. Houston, TX: Museum of Fine Arts, Houston, 2002.

Braun, Barbara. *Arts of the Amazon*. London and New York: Thames and Hudson, 1995.

Burks, Jean, ed. *Shaker Design: Out of This World*. New Haven: Yale University Press, 2008.

Bushman, Richard Lyman. *The Refinement of America: Persons, Houses, Cities*. New York: Knopf, 1992.

Carson, Cary, Ronald Hoffman, and Peter J. Albert, eds. *Of Consuming Interests: The Style of Life in the Eighteenth Century*. Charlottesville: University Press of Virginia for the United States Capitol Historical Society, 1994.

Child Williamson, Harry, ed. *Diseño en Colombia*. Bogotá: Prodiseño, 1989.

Comisarenco Mirkin, Dina. *Vida y diseño: en México siglo XX*. México DF: Fomento Cultural Banamex, 2007.

Consejo Nacional para la Cultura y las Artes. *México en el mundo de las colecciones de arte: Nueva España*. 2 vols. México, DF: Secretaría de Relaciones Exteriores, Universidad Nacional Autónoma de México, Consejo Nacional para la Cultura y las Artes, 1994.

Deagan, Kathleen A. *Artifacts of the Spanish Colonies of Florida and the Caribbean, 1500–1800*. 2 vols. Washington, DC: Smithsonian Institution Press, 1987.

Deetz, James. *In Small Things Considered: The Archaeology of Early American Life*. Rev. ed. New York: Anchor Books, 1996.

Edgerton, Samuel Y. *Theaters of Conversion: Religious Architecture and Indian Artisans in Colonial Mexico*. Albuquerque: University of New Mexico Press, 2001.

Eidelberg, Martin P., ed. *Design 1935–1965: What Modern Was*. Montreal: Musée des arts décoratifs de Montréal; New York: H.N. Abrams, 1991.

Ellis, Clyde, Luke E. Lassiter, and Gary H. Dunham, eds. *Powwow*. Lincoln: University of Nebraska Press, 2005.

Falino, Jeannine J., ed. *Crafting Modernism: Midcentury American Art and Design: The History of Twentieth-Century American Craft*. New York: Abrams with Museum of Arts and Design, 2011.

Fane, Diana, ed. *Converging Cultures: Art and Identity in Spanish America*. New York: Brooklyn Museum with Abrams, 1996.

Ferguson, Leland. *Uncommon Ground: Archaeology and Early African America, 1650–1800*. Washington, DC: Smithsonian Institution Press, 2004.

Fernández, Silvia, and Gui Bonsiepe, eds. *Historia del diseño en América Latina y el Caribe: Industrialización y comunicación visual para la autonomía*. São Paulo: Blucher Editorial, 2008.

Frelinghuysen, Alice Cooney. *American Porcelain, 1770–1920*. New York: Metropolitan Museum of Art, distributed by Harry N. Abrams, 1989.

Fundación El Legado Andalusí. *El mudéjar iberoamericano: del Islam al Nuevo Mundo*. Granada, Spain: El Legado Andalusí; Barcelona: Lunwerg, 1995.

García Canclini, Nestor. *Transforming Modernity: Popular Culture in Mexico*. Translated by Lidia Lozano. Austin: University of Texas Press, 1993.

Grier, Katherine C. *Culture and Comfort: Parlor Making and Middle-Class Identity, 1850–1930*. Rev. ed. Washington, DC: Smithsonian Institution Press, 1997.

Guss, David. *To Weave and Sing: Art, Symbol and Narrative in the South American Rain Forest*. Berkeley and Los Angeles: University of California Press, 1989.

Hanks, David A., and Anne Hoy. *American Streamlined Design: The World of Tomorrow*. Paris: Flammarion, 2005.

Harrison, Julia D., ed. *The Spirit Sings: Artistic Traditions of Canada's First Peoples*. Calgary, AB: The Glenbow Museum with McClelland & Stewart, 1987.

Heckscher, Morrison H., and Leslie Greene Bowman. *American Rococo, 1750–1775: Elegance in Ornament*. New York: Metropolitan Museum of Art, 1992.

Hiesinger, Kathryn B., and George H. Marcus, eds. *Design Since 1945*. Philadelphia: Philadelphia Museum of Art, 1983.

Hill, Tom, and Richard W. Hill, eds. *Creation's Journey: Native American Identity and Belief*. Washington, DC: National Museum of the American Indian, Smithsonian Institution, 1994.

Holm, Bill. *Northwest Coast Indian Art: An Analysis of Form*. Seattle: University of Washington Press, 1965.

Horse Capture, George P., Anne Vitart, and W. Richard West. *Robes of Splendor: Native North American Painted Buffalo Hides*. New York: New Press, 1993.

Jaffee, David. *A New Nation of Goods: Material Culture in Early America*. Philadelphia: University of Pennsylvania Press, 2010.

Jernigan, E. W., ed. *White Metal Universe: Navajo Silver from the Fred Harvey Collection*. Phoenix, AZ: Heard Museum of Anthropology and Primitive Art, 1981.

Kaplan, Wendy, ed. *"The Art That Is Life": The Arts & Crafts Movement in America, 1875–1920*. Boston: Little, Brown, 1987.

Kardon, Janet, ed. *Craft in the Machine Age, 1920–1945: The History of Twentieth-Century American Craft*. New York: Abrams with the American Craft Museum, 1995.

———, ed. *The Ideal Home 1900–1920: The History of Twentieth-century Craft in America*. New York: Abrams with the American Craft Museum, 1993.

———, ed. *Revivals! Diverse Traditions, 1920–1945: The History of Twentieth-Century American Craft*. New York: Abrams with the American Craft Museum, 1994.

Kaufman, Alice, and Christopher Selser. *The Navajo Weaving Tradition: 1650 to the Present*. New York: Dutton, 1985.

Kirkham, Pat, ed. *Women Designers in the USA, 1900–2000: Diversity and Difference*. New York: Bard Graduate Center; New Haven: Yale University Press, 2000.

Koplos, Janet, and Bruce Metcalf. *Makers: A History of American Studio Craft*. Chapel Hill: University of North Carolina Press, 2010.

Leibsohn, Dana, and Barbara E. Mundy. *Vistas: Visual Culture in Spanish America / Cultura visual en Hispanoamérica, 1520–1820*. Austin: University of Texas Press, 2010.

Leon, Ethel. *Design brasileiro: quem fez, quem faz*. Rio de Janeiro: Viana & Moseley, 2005.

Matos Moctezuma, Eduardo. *The Aztecs*. New York: Rizzoli, 1989.

McEwan, Colin, ed. *Precolumbian Gold: Technology, Style, and Iconography*. Chicago: Fitzroy Dearborn; London: British Museum, 2000.

Meikle, Jeffrey L. *Design in the USA*. Oxford and New York: Oxford University Press, 2005.

Morris, Craig, and Adriana Von Hagen. *The Inka Empire and Its Andean Origins*. New York: Abbeville Press, 1993.

Museo de América. *Siglos de oro en los virreinatos de América, 1550–1700*. Madrid: Sociedad Estatal para la Conmemoración de los Centenarios de Felipe II y Carlos V, 1999.

Nash, June, ed. *Crafts in the World Market: The Impact of Global Exchange on Middle American Artisans*. Albany: State University of New York Press, 1993.

Orlove, Benjamin, ed. *The Allure of the Foreign: Imported Goods in Postcolonial Latin America*. Ann Arbor: University of Michigan Press, 1997.

Pauketat, Timothy R. *Ancient Cahokia and the Mississippians*. Cambridge: Cambridge University Press, 2004.

Penney, David W. *North American Indian Art*. London and New York: Thames and Hudson, 2004.

Pérez de Salazar Verea, Francisco, ed. *El mobiliario en Puebla: Preciosismo, mitos y cotidianidad de la carpintería y la ebanistería*. Puebla de los Ángeles, México: Fundación Mary Street Jenkins, 2009.

Phipps, Elena, Johanna Hecht, and Cristina Esteras Martín, eds. *The Colonial Andes: Tapestries and Silverwork, 1530–1830*. New York: The Metropolitan Museum of Art with Yale University Press, 2004.

Pierce, Donna, and Ronald Y. Otsuka, eds. *Asia and Spanish America: Trans-Pacific Artistic and Cultural Exchange, 1500–1800*. Papers from the Mayer Center Symposium. Denver: Denver Art Museum, 2009.

Priddy, Sumpter T. *American Fancy: Exuberance in the Arts, 1790–1840*. Milwaukee: Chipstone Foundation with Distributed Art Publishers, 2004.

Rapaport, Brooke Kamin, and Kevin L. Stayton, eds. *Vital Forms: American Art and Design in the Atomic Age, 1940–1960*. New York: Brooklyn Museum with H.N. Abrams, 2001.

Richter, Daniel K. *Facing East from Indian Country: A Native History of Early America*. Cambridge, MA: Harvard University Press, 2003.

Rishel, Joseph J., and Suzanne L. Stratton, eds. *The Arts in Latin America, 1492–1820*. Philadelphia: Philadelphia Museum of Art with Yale University Press, 2006.

Rivas Pérez, Jorge F. *El repertorio clásico en el mobiliario venezolano: Siglos XVIII y XIX*. Colección Patricia Phelps de Cisneros Cuaderno 9. Caracas: Fundación Cisneros, 2007.

Root, Regina A., ed. *The Latin American Fashion Reader*. New York: Berg, 2006.

Rushing, Jackson W., III. *Native American Art in the Twentieth Century: Makers, Meanings, Histories*. New York: Routledge, 1999.

Russo, Alessandra, Gerhard Wolf, and Diana Fane. *Images Take Flight: Feather Art in Mexico and Europe / El vuelo de las imágenes: arte plumario en México y Europa*. México, DF: Instituto Nacional de Bellas Artes; Instituto Nacional de Antropología e Historia, 2011.

Safford, Frances Gruber. *American Furniture in The Metropolitan Museum of Art*. 2 vols. New York: The Metropolitan Museum of Art, 1985–2007.

Schevill, Margot, Janet Catherine Berlo, and Edward Bridgman Dwyer. *Textile Traditions of Mesoamerica and the Andes: An Anthology*. New York: Garland, 1991.

St. George, Robert Blair, ed. *Material Life in America, 1600–1860*. Boston: Northeastern University Press, 1988.

Stone-Miller, Rebecca. *To Weave for the Sun: Ancient Andean Textiles in the Museum of Fine Arts, Boston*. London and New York: Thames and Hudson, 1994.

Sullivan, Edward J. *The Language of Objects in the Art of the Americas*. New Haven and London: Yale University Press, 2007.

Taborda, Felipe, and Julius Wiedemann. *Latin American Graphic Design*. Cologne: Taschen, 2008.

Townsend, Richard F., and Robert V. Sharp, eds. *Hero, Hawk, and Open Hand: American Indian Art of the Ancient Midwest and South*. Chicago: Art Institute of Chicago, 2004.

Ulrich, Laurel Thatcher. *The Age of Homespun: Objects and Stories in the Creation of an American Myth*. New York: Knopf, 2001.

Vasconcellos, Marcelo, and Maria Lúcia Braga, eds. *Móvel brasileiro moderno*. Rio de Janeiro: Aeroplano Editora and FGV Projetos, 2011.

Venable, Charles L., ed. *China and Glass in America, 1880–1980: From Tabletop to TV Tray*. Dallas: Dallas Museum of Art; New York: Distributed by H.N. Abrams, 2000.

———. *Silver in America, 1840–1940: A Century of Splendor*. Dallas: Dallas Museum of Art, 1995.

Votolato, Gregory. *American Design in the Twentieth Century: Personality and Performance*. Manchester: Manchester University Press, 1998.

Wilson, Richard Guy, Shaun Eyring, and Kenny Marotta, eds. *Re-Creating the American Past: Essays on the Colonial Revival*. Charlottesville: University of Virginia Press, 2006.

Wilson, Richard Guy, Dianne H. Pilgrim, and Dickran Tashjian. *The Machine Age in America, 1918–1941*. New York: Brooklyn Museum, 1986.

Wroth, William, and Robin Farwell Gavin, eds. *Converging Streams: Art of the Hispanic and Native American Southwest*. Santa Fe: Museum of New Mexico Press, 2010.

INDEX

Webb, Philip, 424, 427, 515

Wedgwood, Josiah, 402–3, *403*

Wegner, Hans, 638

Weickmann, Christoph, 215, 218

Weights (Asante), *382*, 382–83

Weingart, Wolfgang, 651

Weisweiler, Adam, 396

Welser family, 96

Wenfang sibao (Chinese four treasures of the scholar's studio), 153

Wen Zhenheng, 147, 151–52, 154, 156

Werkbund model, 605–6

Werkstätte, Wiener, 499

West Africa: 1400–1600, 67, 70–74; 1600–1750, 214–23, 299; 1750–1900, 375–85; 1900–2000, 546–65

West Bengal, 39

Western Sudan, 72

West Lake Expo (Hangzhou 1929), 484

Westminster Abbey, 94, 404

Westphalia, 141

Westwood, Vivienne, 646–47

Wethersfield chests (colonial America), 295

Weye, Bernhard Heinrich, 410, *411*

Wheeler, Candace, 354, 478–79

Wheeler, Dora, 479

Wheelwright, Mary Cabot, 571

Whistler, James Abbott McNeill, *430*, 431

White, Stanford, 598

Whitehall palace (Britain), 256, 260

Whiting, Joseph P., 459, *459*

Whitney mansion, 598

Wies church (Bavaria), 410, *410*

Wigs, 251

Wiinblad, Bjørn, 630

Wilde, Oscar, 431, 478

Wildenhain, Marguerite Friedländer, 635–36

Wilhelm II, Kaiser (Germany), 362

William and Mary (England), 243, 259, 299

Williams, Roger, 294

Williamsburg, Virginia, 302

Willms, Auguste, 418

Wilson, Robert Wesley, 642

Wilton House (Britain), 256

Wiltshire, 105–6

Wincklemann, Johann Joachim, 395, 407, 411

Windsor Castle, 341

Windsor chairs, 469

Winkel, Leo, 624

Winter Interior Design Show (Buenos Aires), 586

Winthrop, John, 294

Wirkkala, Tapio, 638, *638*

Wishbone chair (Wegner), 638

Wistar, Caspar, 305

Wistar, Richard, 305, *305*

Wittelsbach dynasty (Bavarian), 264

Wodaabe people (Niger), 561

Wodeyar rulers, 195

Wölfflin, Heinrich, 231, 240

Wollner, Alexandre, 592, *592*

Wolsey, Thomas (Cardinal), 93

Womb Chair (Saarinen), 631

Women: Africa (1900–2000), 556–57; Britain (1600–1750), 258; China (1750–1900), 318; Chinese Ming and Qing period, 153–54; Cree (1600–1750), 269; India (1750–1900), 343; Islamic (1900–2000), 541–43; Japan (1600–1750), 170; Korea (1600–1750), 163–64; North America (1750–1900), 477; Plains tribes (1600–1750), 272; Zuni (1600–1750), 278

Women's quarters: China (1600–1750), 154–56; India (1750–1900), 341, *342*; Korea (1600–1750), 162, 164; Korea (1750–1900), 321

Wong, May, 494, *494*

Wood-block printmaking, 485–86, *486*, 488

Woodland Chapel (Stockholm), 607

Woodwork: Africa (1900–2000), 556; carving machines, 418; Indigenous North America (1400–1600), 121, *121*; Indigenous South America (1900–2000), *578*, 578–79; Mali (1400–1600), 72, *72*; United States (1750–1900), 472, *473*. *See also* Carving; Household objects

Wool carpets, 199

Woolley, Hannah, 258

World Design Conference (Tokyo), 509

World's Columbian Exposition (Chicago 1893), 478–79, 570

World's Fair (Paris 1867), 424

World's Industrial and Cotton Exposition (New Orleans 1884), 460

World War II, 504–5, 623–25, *624*

Wren, Christopher, 302

Wright, Frank Lloyd, 478, 569, 602–3, *603*

Wright, Mary, 631

Wright, Russel, 619, 628–29, 631, 633

Writing instruments and furnishings: China (1600–1750), 151, *151*, *153*, 153–54, 159; France (1750–1830), *397*, *397*; Islamic world (1900–2000), 540, *540*; Italy (1750–1830), 408, *408*; Japan (1400–1600), 24, *24*, 28; Japan (1600–1750), 166, *166*, *168*, 168–69; Korea (1600–1750), 162, *162*, 162–63, *163*; Korea (1750–1900), *320*, 321; New World *escritorios* (writing desks), 252–53, 283–84, *283–84*; Ottomans (1600–1750), 205–9; Scandinavia (1600–1750), 265; South America (1600–1750), 277; Spanish America (1750–1830), 455–56, *456*

Wu, Jason, 492

Wu gong (Chinese five-offering vessels), 309, *310*

Wu Haiyan, 490

Wunderkammern (Bavarian rooms of natural wonders), 262, 265

Würth, Ignaz Joseph, 411

Würzburg (Germany), 52

Wyatt, James, 404

Wyman, Lance, 592, *593*, 641

Wyspiański, Stanisław, 600

Wyszogrodzka, Alicja, 634, *634*

X

Xanto Avelli, Francesco, 89, *89*, 90

Xavier, Francis, 22

Xhosa people (Southern Africa), 390, *391*

Xie Zhiguang, 485

Xing Tonghe, 491, *491*

Xu Yihui, 489

Y

Yali (Indian leonine beast), 34–35, 45

Yalis (Indian fantastic leonine beasts), *182*, 183

Yalman, Çan, 545, *545*

Yamaguchi Harumi, 512

Yamaguchi prefecture (Japan), 27

Yamamoto, Yohji, 511, 647

Yamana Ayao, 501, 507

Yamasaki, Minoru, 627

Yanagi Muneyoshi, 504

Yang (Chinese cosmic principle), 154

Yang, Loretta, 493

Yangban (Korean literati class), 162–64

Yangtze River, 145

Yan Han, 486

Yanhuitlán (Oaxaca), 136

Yan Song, 5

Yasuda Rokuzō, 500

Yazdi, Mahmud Mi'mar, 202, *202*

Ye'ii Bicheii healing ceremony, 571, *571*

Ye'kuana people (Amazon region), 577, *577*

Yellow Seto (Kiseto), 26

Yeolsui-bae (Korean key holder), 163–64, *164*

Yeongjo (Korean ruler), 160

Ye Qianyu, 486

Yeshaq (Ethiopia), 81

Yi Bong-ju, 497

Yi Jae Man, 497

Yildiz palace (Ottoman), 363–64

Yin (Chinese cosmic principle), 146, 149, 154

Yi Pinghogak, 163

Yi Sam-pyeong, 172

Yi Sang-ji, 497

Yi Seong-gye (King Taejo), 18

Yi Yul-gok, 21

Yokohama, 333

Yokoo Tadanori, 509, *510*

Yongle (Chinese emperor), 3, 8–9, 11

Yongzheng (Chinese emperor), 157–60

Yoon Kwang Cho, 495–96

Yoruba, 67, 69, 78, 219, 225, 375

Yoshimasa, 23

Yoshinori, 23

Yoshioka Tokujin, 512, *513*

Yoshiteru, 28

Yoshiwara licensed brothel district (Edo), 331

Young Poland movement, 600

Youngs, Seth, 304

Yuan dynasty, 3–4, 6, 8–9, 11, 23, 52, 310

Yucatán, 136

Yunshang Fashion Company (China), 486

Yun Shou-ping, 159

Yup'ik, 118

Yuyaochang (Chinese porcelain manufactory), 311

Yūzen design and technique (Japan), 171–72, *172*

Z

Zaghloul, Saad, 535

Zagwe dynasty, 80

Zakharov, Andreyan, 414

Zaman, Muhammad, 205

Zambezi River, 80

Zand period (Iran), 365

Zapotecs, 136

Zaragoza (Spain), 252, *252*

Zara Ya`qob (Ethiopia), 81

Zardozi (Indian embroidery), 345

Zari, 202, *202*

Zaydan (Timbuktu), 72

Zbaraski, Krzysztof, 262

Zeeland, 105

Zeisel, Eva, 588, 611, 629, 633

Zeisler, Claire, 637

Zen, 20, 23, 25, 28, 31. *See also* Buddhism

Zeppelin airships, 623

Zhang clan, 15

Zhang Dai, 13, 15

Zhang Guangyu, 486

Zhang Lingji, 486

Zhang Mingqi, 15, *16*

Zhang Xihuang, *151*, 152

Zhang Yimou, 492

Zheng He, 80

Zhengtong (China), 5

Zhongshan suit (China), 487

Zhou dynasty, 17

Zhuanzhu Alley (Suzhou), 153–54

Zhu Gui, 154

Zhu Yuanzhang, 3

Zidaka (Swahili storage niches), 227, *227*

Ziegler and Company, 369, 533

Zimbabwe, 228

Zimmermann, Dominikus, 410, *410*

Zimmermann, Johann Baptist, 264, *264*, 410, *410*

Zitman, Cornelis, 589, *589*

Zodiac signs, 194, 202, 331

Zulu people (Southern Africa), 390–92, *391*

Zuni Pueblo, 121, 278–79, *279*

Zurbarán, Francisco de, 251

Zurich, 99–100

Zushidana (Japanese cabinet shelf), 165–66, *166*

Zwolle, 94

AUTHORS' ACKNOWLEDGMENTS

In addition to the people cited in "Further Reading" and endnotes, the authors of the chapters in this book thank the editors, designers, production team, consultants, readers, fellow authors, and:

Roland O. Abiodun, Monni Adams, Donald Albrecht, Megan Aldrich, Anthony Alofsin, Yoshinori Amagai, Léonard N. Amico, Tanya Anderson, Rebecca Arnold, Celal Esad Arseven, Juliet Ash, Paul Atkinson, Jenny Balfour-Paul, Jonathan Batkin, Timothy G. Baugh, Roger Beck, Carl Heinz Becker, Rogier Bedaux, Roger Benjamin, Peter Betjemann, Dipti Bhagat, Elizabeth Bigham, Rita Bolland, Andrew Bolton, Alexander Bortolot, Julius Bryant, Cheryl Buckley, Peter Burke, Dorothy Burnham, Michael Duncan Chibnik, Jean-François Clément, Annie E. Coombes, Margaret Courtney-Clarke, Alan Crawford, Thomas B. F. Cummins, Gustavo Curiel, Kathy Curnow, Bente Dam-Mikkelsen, Arthur Coleman Danto, Julie Nelson Davis, Carolyn Dean, Christopher DeCorse, Walter Denny, Dennis Doordan, Els De Palmenaer, William Dewey, Manthia Diawara, Clive Dilnot, Silvia Dolz, Margaret Dubin, Stefan Eisenhofer, Thomas E. Emerson, Okwui Enwezor, Jonathon E. Ericson, Caroline Evans, Cheri Falkenstien-Doyle, Diana Fane, Felice Fischer, Fiona Fisher, Willem Floor, Enrique Florescano, Alice T. Friedman, Timothy F. Garrard, Christraud M. Geary, Angelika Gebhart-Sayer, Katalin Gellér, Paula Girshick, Usam Ghaidan, Gordon D. Gibson, Nicholas Goodison, Paul Gowder, Tag Gronberg, Ernst Grube, Elizabeth E. Guffey, Claus-Peter Haase, Peter Haiko, Karen Halttunen, Byron Ellsworth Hamann, Fujita Haruhiko, Marilyn Heldman, Steven Heller, Mimi Hellman, Eugenia W. Herbert, Alan Hess, Thomas Hine, Thomas S. Hines, Joel Hoffman, Deborah E. Horowitz, Ella Howard, Jeremy Howard, Barbara Rubin Hudson, Ronald L. Hurst, Elizabeth Hutchinson, Halil İnalcık, John Irwin, Anatol Ivanov, Lesley Jackson, J. Stewart Johnson, Marian Ashby Johnson, Frank Jolles, Adam Jones, Mark Jones, Daniela Karasová, Sidney Kasfir, Ilona Katzew, Trevor Keeble, Peter M. Kenny, Sandra Klopper, Harold Koda, Linda Komaroff, Lorenz Korn, Melanie Krebs, Jens Kröger, Deborah L. Krohn, Ernst Kühnel, Ronald J. Labaco, Vincent Lafond, Milena Lamarová, Barbara Lasic, Sarah E. Lawrence, Ulrich Leben, Martin P. Levy, C. F. Liberato de Sousa, Henrietta Lidchi, Jack L. Lindsey, Angus Lockyer, Christopher Long, Leonardo López Luján, Torben Lundbaek, Fiona MacCarthy, Otakar Máčel, André Magnin, Natalia Majluf, Ana Elena Mallet, Caroline Maniaque Benton, Brenda Martin, Meredith Martin, Phyllis Martin, Tom C. McCaskie, Colin McEwan, Mary McWilliams, James Middleton, Terry Satsuki Milhaupt, Schoole Mostafawy, Alla Myzelev, Gillian Naylor, Gülrü Necipoğlu, Jeffrey D. Needell, Malyn Newitt, J. Claire Odland, James Oles, Gönül Öney, Derek E. Ostergard, Octavio Paz, Maria Perers, Helen Philon, Donna Klumpp Pido, John M. D. Pohl, John Potvin, Jonathan Prown, Jules David Prown, Robert Pruecel, Donald Quataert, Bill Reid, Aileen Ribeiro, Polly Richards, Betty Ring, María Astrid Ríos, Allen F. Roberts, Polly Nooter Roberts, Richard Roberts, B. W. Robinson, Peter Roe, Jean Néréé Ronfort, Phyllis Ross, Victoria Rovine, Christopher D. Roy, Wendy Salmond, Antonio Sánchez Gómez, Eike D. Schmidt, Daniel Shapiro, Fronia Simpson, Beverley Skeggs, Elizabeth A. T. Smith, Henry D. Smith II, Lillian Smith, Shauna Stallworth, Carolyn Steedman, Jewel Stern, Martha H. Struever, John A. Stuart, Bobbye Tigerman, Jon Thompson, Robert Farris Thompson, Kevin W. Tucker, Wouter Van Beek, Gilbert T. Vincent, Jean-Louis Vullierme, Lynne Walker, Barbara Ward, Gerald Ward, Ian Wardropper, Wilcomb E. Washburn, Toshio Watanabe, Gennifer Weisenfeld, Richard White, Ivor Wilks, Eugen Wirth, Elizabeth Wilson, Christian Witt-Dörring, Gwendolyn Wright, Luis Eduardo Wuffarden, Yuan Xiyang, Kohle Yohannan, Shunya Yoshimi, Margaret Young-Sánchez, Jeanne Ziegler.

ILLUSTRATION CREDITS

Imaging Department © President and Fellows of Harvard College), **10.5–10.6** (© Ulmer Museum. Photo: Bernd Kegler, Ulm), **10.7** (Courtesy National Museums Liverpool), **10.9** (Photo: Maggie Nimkin), **10.10** (Photo © John Bigelow Taylor), **10.11** (© Ulmer Museum. Photo: Bernd Kegler, Ulm), **10.12** (© Rijksmuseum Volkenkunde, Leiden), **10.15** (Werner Forman/Art Resource, NY), **10.16** (bpk, Berlin/Ethnologisches Museum, Staatliche Museen, Berlin, Germany/Dietrich Graf/Art Resource, NY), **10.17** (bpk, Berlin/Ethnologisches Museum, Staatliche Museen, Berlin, Germany/Claudia Obrocki/Art Resource, NY), **10.21** (© *National Museums Scotland*), **10.22** (© Linden-Museum Stuttgart), **10.24** (Photo: Deidi von Schaewen), **10.25** (© Bibliothèque Sainte-Geneviève, Paris. Photo: N. Boutros), **11.1** (Scala/Art Resource, NY), **11.2** (Supplied by Royal Collection Trust/© HM Queen Elizabeth II 2012), **11.8** (© Museo Nacional del Prado, Madrid, Spain), **11.10a–b** (© Royal Museums of Art and History, Brussels), **11.14** (Supplied by Royal Collection Trust/© HM Queen Elizabeth II 2012), **11.20** (Photo © Christie's Images/The Bridgeman Art Library), **11.22** (Schloss Charlottenburg, Berlin, Germany/The Bridgeman Art Library), **11.24** (Scala/Art Resource, NY), **11.25** (Photo: Guillem Fernández-Huerta), **11.27** (Direção-Geral do Património Cultural/Arquivo e Documentação Fotográfica (DGPC/ADF). Photo: Arnaldo Soares), **11.34** (Courtesy Bard Graduate Center. Photo: Bruce M. White), **11.35** (© National Trust Images/Andrew Butler), **11.39** (Erich Lessing/Art Resource, NY), **11.40** (© The Royal Court, Sweden. Photo Alexis Daflos), **11.41** (© Photo: Nationalmuseum, Stockholm), **11.42** (Photo: A. D. Alekseev © State Historical and Cultural Museum-Preserve "The Moscow Kremlin" 2013), **12.1** (Photo courtesy of Glenbow Museum, Calgary. Reproduced with permission from the Dean and Chapter of Canterbury), **12.2** (© The Field Museum, Digital ID A114396_02d), **12.6** (Corsham Court, Wiltshire/The Bridgeman Art Library), **12.12** (Purchased with funds provided by the Restricted Textile Fund and those provided by Marshall and Patsy Steves in memory of Virginia Carrington. Courtesy of the San Antonio Museum of Art), **12.13** (Photo: Addison Doty), **12.22** (Photo: Daniel Giannoni), **12.23** (Courtesy Archivo Criollo. Photo: Judy de Bustamante), **12.24** (Photo: Jeffrey Collins), **12.25** (*surrounded by gold*, Photo: Rosino/Flickr), **12.28** (Photo: Daniel Giannoni), **12.29** (Photo: Rômulo Fialdini), **12.30** (With permission of the Royal Ontario Museum © ROM), **12.31** (From Irving Whitehall Lyon, *The Colonial Furniture of New England*, 1891, fig. 1), **12.33** (From the collections of The Henry Ford, Digital Image ID THF68261. Photo: Jim Orr), **12.34** (Gift of Ephraim, Wilder Farley, Class of 1836), **12.38** (Museum of the City of New York, Decorative Arts Collection), **12.39** (Courtesy of the South Carolina Institute of Archaeology and Anthropology, University of South Carolina, Columbia), **12.40** (Courtesy, Winterthur Museum, Side Chair, museum purchase, 1973.382, **12.41** (Gift of Col. and Mrs. Miodrag R. Blagojevich), **12.42** (Gift of Louise C. and Frank L. Harrington, Class of 1924), **12.43** (Courtesy Drayton Hall, A National Trust Historic Site. Photo: Ron Blunt), **12.45** (Courtesy Bucks County Historical Society), **12.46** (Gift of Elizabeth Wistar), **13.1** (Museum purchase from the Robert H. Clague Collection), **13.3** (Provided by the Palace Museum Beijing. Photo: Hu Chui), **13.4** (Gift of Mr. George Peabody Gardner, 1959. Photo courtesy of the Peabody Essex Museum), **13.5** (© Asian Civilisations Museum, Singapore. Gift of Frank and Pamela Hickley), **13.6a** (Provided by the Palace Museum Beijing. Photo: Hu Chui), **13.6b** (© Michael Freeman), **13.7** (Provided by the Palace Museum Beijing. Photo: Feng Hui), **13.19**

(Photo: Takanori Sugino), **13.31** (Photo © MAK/Georg Mayer), **14.1** (Image courtesy of the National Portrait Gallery, London), **14.3** (Photo: Antonio Martinelli), **14.4** (Photo: Deidi von Schaewen), **14.8** (Robert A. and Ruth W. Fisher Fund. Photo: Katherine Wetzel © Virginia Museum of Fine Arts), **14.15** (Supplied by Royal Collection Trust/© HM Queen Elizabeth II 2012), **14.21** (Photo courtesy of the Peabody Essex Museum), **14.23** (Photo: Angelo Plantamura. © Arthur Millner), **15.5** Gift of Mr. and Mrs. William O. Baxter), **15.8** (Photo Les Arts décoratifs, Paris/Jean Tholance. All rights reserved), **15.14** (Gift of Isabel T. Kelly), **15.19** (Gift of Dr. Harry G. Friedman. The Jewish Museum, New York/Art Resource, NY. Photo: John Parnell), **16.6** (© RMN–Grand Palais/Art Resource, NY. Photo: Denis Rouvre), **16.10** (Purchase with African Art Acquisition Fund and funds from the Fred and Rita Richman Special Initiatives Endowment Fund for African Art), **16.13** (Purchase: William Rockhill Nelson Trust. Photo: Jamison Miller), **16.14** (Basel Mission Archives/Basel Mission Holdings QD-30.041.0104), **16.20** (Hampton University Museum Collection, Hampton University, Hampton, VA), **16.22** (Private Collection/Ken Welsh/The Bridgeman Art Library), **16.23** (Image # 3942. American Museum of Natural History Library), **16.24** (Courtesy Michael R. Mack. Photo: T. W. Meyer), **17.2** (© RMN–Grand Palais/Art Resource. Photo: René-Gabriel Ojéda), **17.6** (akg-images, London/Laurent Lecat), **17.7** (University of Wisconsin Digital Collections), **17.8** (By courtesy of the Trustees of Sir John Soane's Museum), **17.11** (Courtesy Bard Graduate Center. Photo: Bruce M. White), **17.12** (Private Collection/Bridgeman Art Library), **17.13** (© The Fan Museum Trust), **17.16–17.17** (© PATRIMONIO NACIONAL), **17.18** (Instituto dos Museus e da Conservação, IP/Divisão de Documentação Fotográfica. Photo: José Pessoa), **17.19** (akg-images, London/Bildarchiv Monheim), **17.20** (© Photo: Bayerisches Nationalmuseum, Bastian Krack), **17.21** (Gift of The Antiquarian Society from the Capital Campaign Fund. Photo © The Art Institute of Chicago), **17.22** (Photo: Mats Landin, Nordiska museet), **17.24** (Hermitage, St. Petersburg, Russia/The Bridgeman Art Library), **17.25** (© Fritz von der Schulenburg/TIA Digital Ltd.), **17.26** (Photo: Pernille Klemp), **17.28** (Photo Les Arts décoratifs, Paris/Jean Tholance. All rights reserved), **17.38** (Courtesy Sébastien de Baritault. Photo: Michel Geney), **17.39** (Photo Les Art décoratifs/Laurent Sully Jaulmes. All rights reserved), **17.41** (Photo: Ramon Manent), **17.42** (Photo © Rheinisches Bildarchiv Köln, rba_d030588), **17.46** (The Wolfsonian–Florida International University, Miami Beach, Florida, The Mitchell Wolfson, Jr. Collection, TD1990.40.62), **17.47** (Gift of Charles Lang Freer), **17.48** (akg-images, London), **17.53** (Photo: Pernille Klemp), **17.54** (Photo Les Arts décoratifs/Jean Tholance. All rights reserved), **18.3** (Museum of Indian Arts and Culture/Laboratory of Anthropology, Department of Cultural Affairs, New Mexico. www.miaclab.org. Photo: Blair Clark), **18.4** (Gift of John H. Hauberg. Photo: Paul Macapia), **18.8** (Photo: Nahin Cortés Villanueva with Ricardo Aparicio Alavez. CONACULTA.-INAH.-MEX. Reproducción Autorizada por el Instituto Nacional de Antropología e Historia), **18.10** (© Phoebe A. Hearst Museum of Anthropology and the Regents of the University of California), **18.14** (Museum purchase with funds provided by Wellesley College Friends of Art), **18.16** (age fotostock/SuperStock), **18.18** (Album/Art Resource, NY), **18.19** (Photo: Denise Andrade), **18.23** (Museum of International Folk Art, IFAF Collection, Santa Fe, NM. Photo: P. J. Smutko), **18.24a–b** (Photos by Michel Zabé), **18.26** (Photo: Daniel Giannoni), **18.27** (Foto: © Museo Nacional de Colombia/Antonio

Castañeda), **18.30** (General Research Division, The New York Public Library, Astor, Lenox and Tilden Foundations), **18.31** (Foto: © Museo Nacional de Colombia), **18.33** (Photo: Lucí Brâga), **18.35** (Courtesy, Winterthur Museum, High Chest, museum purchase with partial funds from anonymous donors, 1993.55), **18.38** (Gift of James Arthur Collection, New York University, Division of Work & Industry, Archives Center, National Museum of American History, Smithsonian Institution), **18.39** (Courtesy Bard Graduate Center. Photo: Bruce M. White), **18.40** (The Don and Jean Stuck Coverlet Collection given in memory of Don Frederick Stuck of Lancaster, Ohio, by his wife Jean Griffith Stuck-Monger and their family), **18.41** (Gift of Anaruth and Aron S. Gordon), **18.42** (From Gorham Manufacturing Company, *Chantilly*, New York City, 1895; facsimile reprint, Atlanta, 1995), **18.43** (Gift of John Rogers and Son. Smithsonian American Art Museum, Washington, DC/Art Resource, NY), **18.44** (Courtesy of The Charleston Museum, Charleston, South Carolina), **18.46** (Courtesy, The Winterthur Library: Printed Book and Periodical Collection), **18.48** (© The Charles Hosmer Morse Foundation, Inc.), **19.1** (© Estate of Liu Jipiao, used with permission, **19.2** (Image digitally restored by Vincent Lexington Harper, courtesy of Edward Raison), **19.7** (With permission of the artist), **19.8** (© claudiozacc–Fotolia.com), **19.11** (Courtesy Gear Atelier Limited), **19.15** (Courtesy of The-D Ltd.), **19.18** (Courtesy Isetan Mitsukoshi Holdings Ltd.), **19.26** (Reproduced with permission of Miyake Design Studio. Photo: Eiichiro Sakat), **20.2.** (Courtesy Indar Pasricha Fine Arts, London), **20.3** (Courtesy Bonhams 1793 Limited, London), **20.4** (Photo: Henry Wilson), **20.5** (Cartier Archives © Cartier), **20.9** (David Black Oriental Carpets, London), **20.11** (Photo: Antonio Martinelli), **20.12** (Courtesy Galerie Patrick Seguin, Paris. © 2013 Artists Rights Society [ARS], New York/ADAGP, Paris), **20.13** (Photo: Henry Wilson), **20.14** (© Aga Khan Award for Architecture/Raj Rewal), **20.15–20.17** (Photo: Henry Wilson), **20.18** (Courtesy Manish Arora Fish Fry, Three Clothing Company), **20.19** (Courtesy Ashutosh Gowariker Productions Pvt. Ltd.), **20.20** (Shahidul Alam/DRIK/Saudi Aramco World/SAWDIA), **21.1** (Courtesy Suna and İnan Kıraç Foundation), **21.2** (Courtesy J. Nazmiyal Inc. DBA Nazmiyal Collection, New York (45242)), **21.4** (Carlo Bavagnoli/Time & Life Pictures/Getty Images), **21.5** (Ministry of Culture, Egyptian Publishing Organisation), **21.7** (© Thomas Goldschmidt, Badisches Landesmuseum Karlsruhe), **21.11** (bpk, Berlin/Ethnologisches Museum, Staatliche Museen, Berlin, Germany/Claudia Obrocki/Art Resource, NY), **21.12** (© Thomas Goldschmidt, Badisches Landes-museum Karlsruhe), **21.15** (© Koleksiyon), **21.16** (© Can Yalman Design), **22.2** (Courtesy of the artist and Jack Shainman Gallery, New York), **22.4** (Gift of Lewis Berner and Family), **22.6** (Purchase with funds from Fred and Rita Richman), **22.12** (Anonymous donor. Photo: Franko Khoury), **22.14** (University of Glasgow Archive Services, Frank Willett Collection. Photo: Frank Willett), **22.16** (Photo © Margaret Courtney-Clarke), **22.17** (Feuchtwanger Family Collection. Photo: Jessica Bushey, Courtesy UBC Museum of Anthropology, Vancouver, Canada), **22.21.** Courtesy Anthony Slayter-Ralph Fine Art. © Magdalene Odundo), **22.26** (Courtesy of the artist and Jack Shainman Gallery, New York), **23.1** (Photo: Addison Doty), **23.2** (Courtesy Wheelwright Museum of the American Indian, Santa Fe, New Mexico. Photo: Addison Doty), **23.3** (Courtesy Kennedy Museum of Art, Ohio University), **23.4** (The Gloria F. Ross Collection of Contemporary Navajo Weaving of the Denver Art Museum), **23.6** (Courtesy Burke Museum of Natural

History and Culture), **23.7** (Photo: Paul Gowder), **23.9** (Collection of Alberto G. Valdeavellano, Fototeca Guatemala, CIRMA), **23.13** (Photo: John S. Mitchell), **23.14** (Photo: Judd Rogers), **23.17** (Courtesy Projeto Eliseu Visconti), **23.18** (Fotografía cortesía familia Fossas-Alcocer), **23.22** (© 2013 Banco de México Diego Rivera Frida Kahlo Museums Trust, México, DF/Artists Rights Society [ARS], New York), **23.24** (Courtesy Sotheby's New York), **23.25** (Photo: Alfredo Boulton (1908–1995). *Pampatar (La Casa)*, c. 1953. © Alberto Vollmer Foundation Inc), **23.26** (From Tecoteca, *Catálogo No. 1*, Caracas, 1953. Cornelis Zitman archive), **23.28** (Fotografías cortesía Fundación Ramón Valdiosera, AC), **23.30** (Courtesy Alexandre Wollner), **23.31** (Courtesy of Lance Wyman), **23.33** (Courtesy Indio da Costa AUDT), **23.34** (Courtesy Ariel Rojo Design Studio), **23.35** (© Edra), **23.37** (NYPL MssArc RG10 5928/Digital ID 1153329 © The New York Public Library Archives, The New York Public Library, Astor, Lenox and Tilden Foundations), **23.38** (Neue Galerie New York/Art Resource, NY), **23.39** (V&A Images, London/Art Resource, NY), **23.41** (Photo: Fergal MacEoinin), **23.43** (Photo: Rauno Träskelin), **23.45** (Photo: Biff Henrich/IMG_INK, courtesy Martin House Restoration Corporation. © 2013 Frank Lloyd Wright Foundation, Scottsdale, AZ/Artists Rights society [ARS], NY), **23.47** (Wadsworth Atheneum Museum of Art/Art Resource, NY), **23.48** (bpk, Berlin/Kunstbibliothek, Staatliche Museen, Berlin, Germany/Art Resource, NY), **23.50** (© Nationalmuseum, Stockholm. © 2013 Artists Rights Society [ARS], New York/BUS, Stockholm), **23.51** (The Wolfsonian–Florida International University, Miami Beach, Florida, The Mitchell Wolfson, Jr. Collection, 84.7.51), **23.52** (Bridgeman-Giraudon/Art Resource, NY), **23.53** (© 2013 Artists Rights Society [ARS], New York/VG Bild-Kunst, Bonn), **23.57** (The Gorham Collection, Gift of Textron Inc. Photo: Erik Gould, courtesy of the Museum of Art, Rhode Island School of Design, Providence), **23.58** (© Angelo Hornak/Corbis), **23.59** (From the collections of The Henry Ford, Digital Image ID THF101650), **23.61** (Image courtesy Bauhaus–Archiv Berlin. © 2012 Artist Rights Society [ARS], New York/VG Bild-Kunst, Bonn), **23.68** (© Ladislav Sutnar, printed with the permission of The Ladislav Sutnar Family), **23.69** (Mary Evans Picture Library), **23.71** (Avery Architectural and Fine Arts Library, Columbia University), **23.72** (INTERFOTO/Alamy. Sammlung Rauch), **23.73** (© Bonnier Corporation), **23.75** (Courtesy Estate of Saul Bass © Academy of Motion Picture Arts and Sciences), **23.80** (Photos: Serge Balkin/Vogue © Condé Nast), **23.82** (Private collection of Mrs. Wera Modzelewska), **23.83** (© J. Paul Getty Trust. Used with permission. Julius Shulman Photography Archive, Research Library at the Getty Research Institute [2004.R.10]), **23.85** (© Henrion Estate. Image from the FHK Henrion Archive, University of Brighton Design Archives, appears by kind permission of the Henrion Estate), **23.86** (From Anna Demska, Anna Frackiewicz, and Anna Maga, *We Want to Be Modern: Polish Design, 1955–1968, from the Collection of the National Museum in Warsaw*, 2011), **23.87** (Used with kind permission of Leach Pottery), **23.91** (Photo: Andrew Frolows), **23.93** (Ignazia Favata/Studio Joe Colombo, Milano), **23.95** (Verner Panton Archive VP 02 H902 © Panton Design), **23.97** (Gift of Altria Group, Inc. Photo: Marc Bernier. Faith Ringgold © 1980), **23.101** (Image © Sølve Sundsbø/Art + Commerce), **23.102** (Acquired with support of Alessi, 1989. Photo: John Stoel), **23.104** (Courtesy Philippe Starck), **23.107** (Courtesy April Greiman), **23.110** (Photo: fuseproject).